DATE DUE -AUG 0 1 2003

ITALIAN Renaissance Sculpture

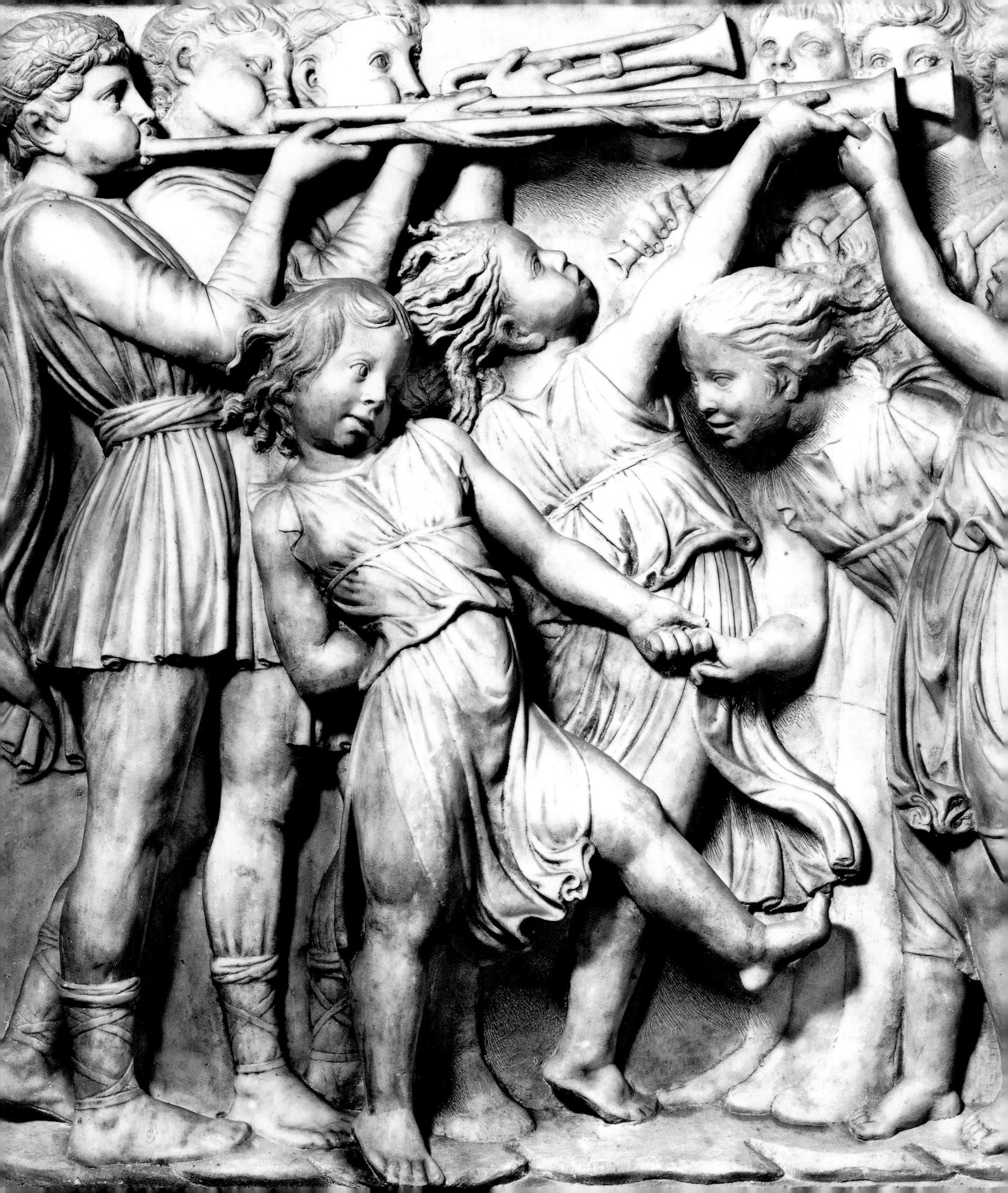

An Introduction to Italian Sculpture Volume II

ITALIAN Renaissance Sculpture

John Pope-Hennessy

Fourth edition

Phaidon Press Limited Regent's Wharf All Saints Street London N1 9PA

Fourth edition 1996

First published 1958 Second edition 1971 Third edition 1985

© 1996 Phaidon Press Limited Text © 1958, 1971, 1985, 1996 Estate of John Pope-Hennessy

A CIP catalogue record for this book is available from the British Library

ISBN 0 7148 3015 1

All rights reserved. No part of this publication may be reproduced, stored in a retrieval system or transmitted, in any form or by any means, electronic, mechanical, photocopying, recording or otherwise, without the prior permission of Phaidon Press Limited.

Printed in Hong Kong

Frontispiece Luca della Robbia **Trumpeters** Museo dell'Opera del Duomo, Florence (detail of plate 78) marble

- 7 Preface to the Fourth Edition
- 9 Introduction
- 15 Donatello and the Renaissance Statue
- 44 Donatello and the Renaissance Relief
- 79 Luca della Robbia
- 103 The Relief and Statue in Florence in the Later Fifteenth Century
- 139 The Humanist Tomb
- 181 The Portrait Bust
- 199 The Equestrian Monument
- 214 Sienese Renaissance Sculpture
- 225 The Renaissance in Rome and Naples
- 243 Agostino di Duccio and the Tempio Malatestiano
- 257 Niccolò dell'Arca and the Renaissance in Emilia
- 265 The Lombard Renaissance
- 287 The Bronze Statuette
- 311 Venetian Renaissance Sculpture
- 343 Notes on the Artists
- 428 Index of Places
- 437 General Index
- 444 Photographic Acknowledgements

An Introduction to Italian Sculpture

Volume I Italian Gothic Sculpture

Volume II Italian Renaissance Sculpture

Volume III Italian High Renaissance and Baroque Sculpture

THE THREE VOLUMES of this Introduction to were published separately. The first, Italian Gothic Sculpture, was issued in 1955. Its text and notes were more summary than those of the two succeeding volumes, and both were substantially expanded for the second edition of 1972. The second volume, Italian Renaissance Sculpture, was published in 1958, and was revised for a second edition in 1971. The third, Italian High Renaissance and Baroque Sculpture, was published in 1963 and was reissued in 1970. In 1985 a facsimile edition was published of all three volumes, with an appendix of updated bibliography. In this new edition every attempt has been made to assimilate the ever growing literature of Italian sculpture. Once more the bibliographies have been brought up to date, now to the year ending 1993, and notes on individual sculptors have been extended. It should, however, be stressed that the catalogue of each sculptor's work has been conceived, not as an annotated bibliography but as an informed, though none the less personal response to works of art. In the forty-odd years that have gone into the writing and rewriting of this book I am happy to say that the personal nature of that response has only increased.

As in the second and third editions I have been indebted to assistants for help with the notes and bibliographies. Many of them are mentioned individually in the catalogue, but a specific acknowledgement must be made to Dr Jonathan Nelson, who has contributed great time and insight to the matter of the bibliographies. Once again, I owe an incalculable debt to Mr Michael

Mallon, without whose selfless help these volumes could never have been produced.

The form of previous editions was determined jointly by me and the publishers, Phaidon Press. This new edition was planned by Phaidon Press alone, who have also redesigned the illustrations.

In the preface to the first edition of Italian Gothic Sculpture I wrote that 'these volumes will have served their purpose if they are successful in inducing the art lover to consider Italian sculpture pari passu with Italian painting and in persuading students to devote some part of their energies to this rewarding and neglected field.' The situation is very different today. The galleries of the Museo Nazionale in Florence, once destitute of visitors, are now uncomfortably full, and the history of Italian sculpture is taught in universities and colleges on the same basis as the history of Italian painting. Scholars have ranged freely over the whole field. The results they have produced vary according to the nature of the problems and the capacity of individual art historians to solve them. On every major sculpture there is still ample scope for historical, documentary, stylistic and technical research, and on no artist has the last word been said. For this reason the three volumes are once more described, not as a history but as an introduction to Italian sculpture.

John Pope-Hennessy* Florence, March 1994

* John Pope-Hennessy died in Florence on 31 October 1994.

Though he did not live to see these volumes through the press, he did personally attend to all revisions and additions made to the text.

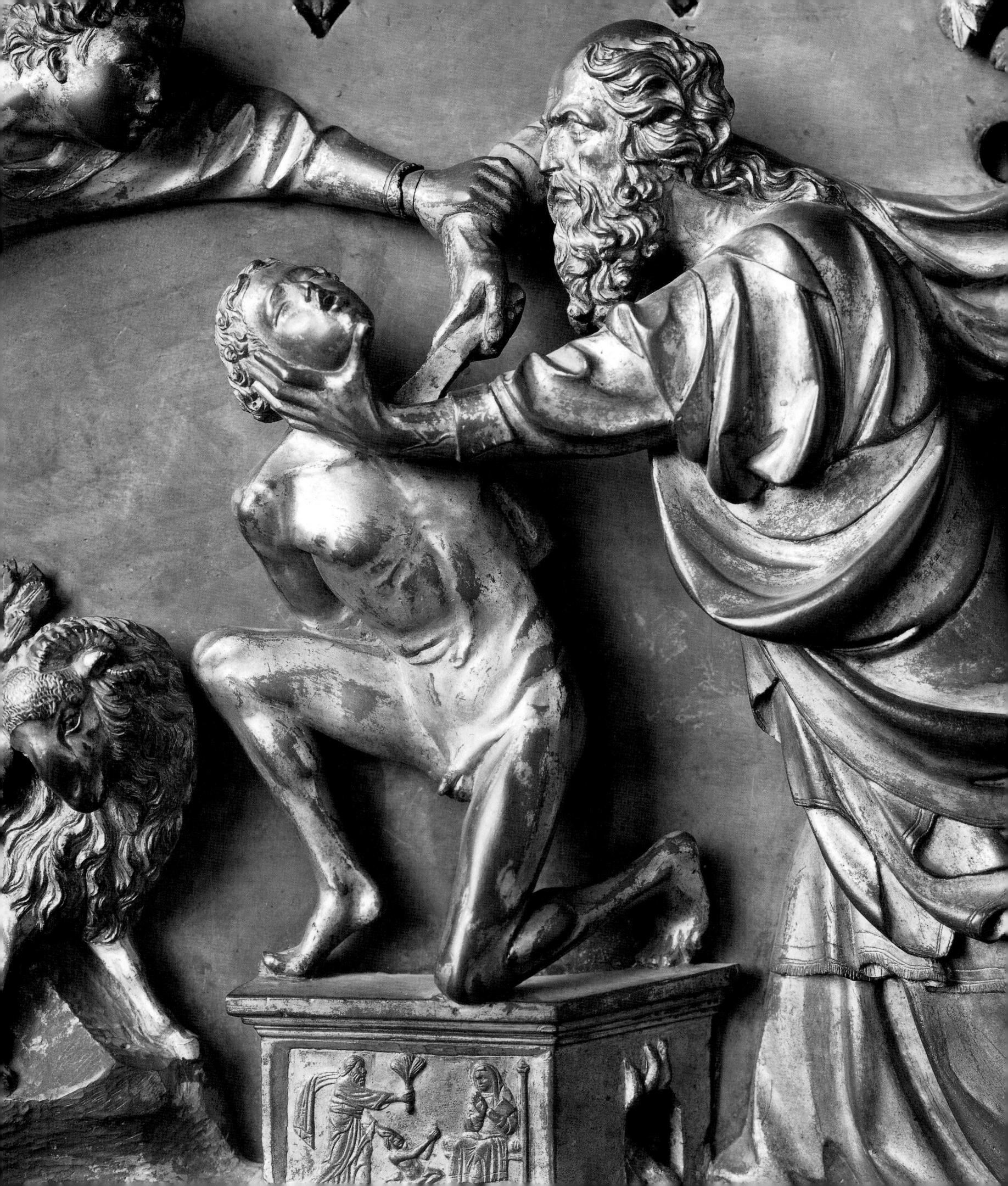

THE HISTORY OF Renaissance sculpture is the story of a journey made by artists in the fifteenth century towards a common goal. It opens in Florence, when Brunelleschi and Donatello set out from the confines of the Middle Ages, and it closes in the serene climate of Venetian humanism with the sculptures of Tullio Lombardo. As on all expeditions, detours were made and false trails were explored, but the objective remained unchanged and the course from first to last was guided by the pole star of the antique. The unity of Renaissance sculpture is to be sought not in the diverse forms that it assumed, but the the scale of values and sense of conscious purpose by which it was inspired.

In philosophy and literature, the Renaissance was a gradual growth to which the concept of 'rebirth' is in many respects inappropriate. In sculpture, however, we know the precise point in time at which Renaissance style was born. The year was 1401, and the occasion was the competition for the second bronze door of the Baptistery in Florence. The contest for the door – the first artistic competition of its kind - was open to 'skilled masters from all the lands of Italy', and the sculptors taking part in it were required to represent a single scene, the Sacrifice of Isaac. Not only did this subject (as Vasari later pointed out) involve 'scenery, nudes, draped figures and animals', but it presented problems of a more far-reaching kind an expressive problem, in that it imposed upon the sculptor the need to portray two contrasting figures, the unwitting victim and unwilling executioner; a narrative problem, in that the apparition of the Angel must be represented pointing towards the

ram and staying Abraham's hand; and a spatial problem, in that two youths with their ass must be depicted at some distance from the scene.

Four of the seven sculptors who took part in the competition must have found it far beyond their capabilities. The fifth was a more celebrated artist, Jacopo della Quercia. Quercia's trial relief is lost, but he later portrayed the scene again in a carving at Bologna where the Abraham and Isaac are placed in the foreground, the attendants are omitted, and the angel is set behind an altar at the back. The remaining competitors were Brunelleschi and the victor of the competition, Ghiberti, both of whose trial reliefs survive (plates 2, 3). At Bologna Quercia accepted the challenge of the expressive problem; with the narrative problem he was less successful, and the spatial problem he ignored. Ghiberti, on the contrary, solved the narrative problem with consummate ease, and rendered the space in his relief so smoothly that the eye of the spectator is carried effortlessly back to the angel and the distant ram. The new door was intended as a counterpart to the door by Andrea Pisano which was already in position on the Baptistery (Vol. I, plate 94), and for this reason the trial reliefs were framed in quatrefoil medallions like those used in the earlier door. For Ghiberti the quadrilobe was a congenial frame, and he utilized it as the basis of his design, placing the Angel and the ram in the two projecting sections at the top and the feet of the attendants in the lower projection on the left. The figures make use of the suave rhythms of late Gothic save for the Isaac, kneeling on the altar, for which a Hellenistic torso seems to have been employed. Brunelleschi's Isaac

plate 1 Filippo Brunelleschi

The Sacrifice of Isaac

Museo Nazionale, Florence (detail of plate 3) plate 2 Lorenzo Ghiberti

The Sacrifice of Isaac

Museo Nazionale, Florence bronze, parcel-gilt, 45 × 38 cm was also based on a headless classical original, but unlike Ghiberti he rebelled against the form of the relief, and though he too filled three of the projecting lobes with figures, his scheme was a rectangular design cut by the Gothic frame. The two attendants were strung out across the foreground, one of them imitated from the Spinario and the other bending down to collect water from a spring, and the Angel and the ram were placed on the same plane as the Abraham and Isaac, since to his rational mind it was unthinkable that the Angel should not intervene physically in the scene. The contrast between the creative processes of the two artists transpires most clearly in the central groups. Ghiberti's are ideal figures; the Abraham stands with a ritual knife in his right hand, and Isaac kneels resignedly upon the altar as he awaits the blow. With Brunelleschi (plates 1, 3) the figures are realistic; the Abraham moves forward with horrorstruck expression, wrenching back Isaac's head and plunging the knife into his throat, and the face of Isaac is deformed by fear and pain. As we cross the frontier between these two conceptions, we enter the territory of Renaissance art.

Already in the fifteenth century the emergence of Renaissance style in sculpture was regarded not as a slow transition, but as an abrupt advance. This view is implicit in the second of Ghiberti's *Commentaries*, which opens with the triumph of Christianity, when 'grave penalties were laid down for those who might make statues or paintings, and thus ended the arts of sculpture and painting and the science on which they were based', and which continues the story of art to the sculptor's own time. Eight and a half pages of Ghiberti's printed text

describe the revival of painting at the hands of Cimabue, Giotto and other artists. Next he turns to sculpture, but instead of an eight-page account of the history of Italian sculpture from the time of Nicola Pisano to the early fifteenth century, he offers one perfunctory paragraph, in which the names of many of the greatest Italian Gothic sculptors do not appear at all. Ghiberti was both an art historian and a sculptor, and lack of curiosity or knowledge cannot have been responsible for this neglect. At Pisa he must have seen the pulpit of Nicola Pisano in the Baptistery and Nino Pisano's Annunciation in S. Caterina. At Siena he must have gazed at Giovanni Pisano's statues on the front of the Cathedral. A group by Tino di Camaino stood over the entrance of the Baptistery in Florence, and day after day he must have raised his eyes to this and to Arnolfo di Cambio's sculptures over the Duomo doors. Yet none of them did he discuss, since he believed that the change effected by Cimabue and Giotto in painting had occurred in sculpture only in his own day, that about 1400 contact was resumed with the severed tradition of Rome.

For Renaissance artists, as for their Roman predecessors, the art of sculpture was bound up with portrayal of the human frame. In the only theoretical treatise on sculpture surviving from the fifteenth century, Alberti's *De statua*, it is expressly claimed that sculpture has a natural origin. Sometimes, argues Alberti, tree-trunks or clods of earth possess an adventitious likeness to living forms. Initially man must have adapted these to the forms which they resembled, and thus there arose 'the arts of those who set about producing simulacra of bodies generated by nature'. Alberti uses the term

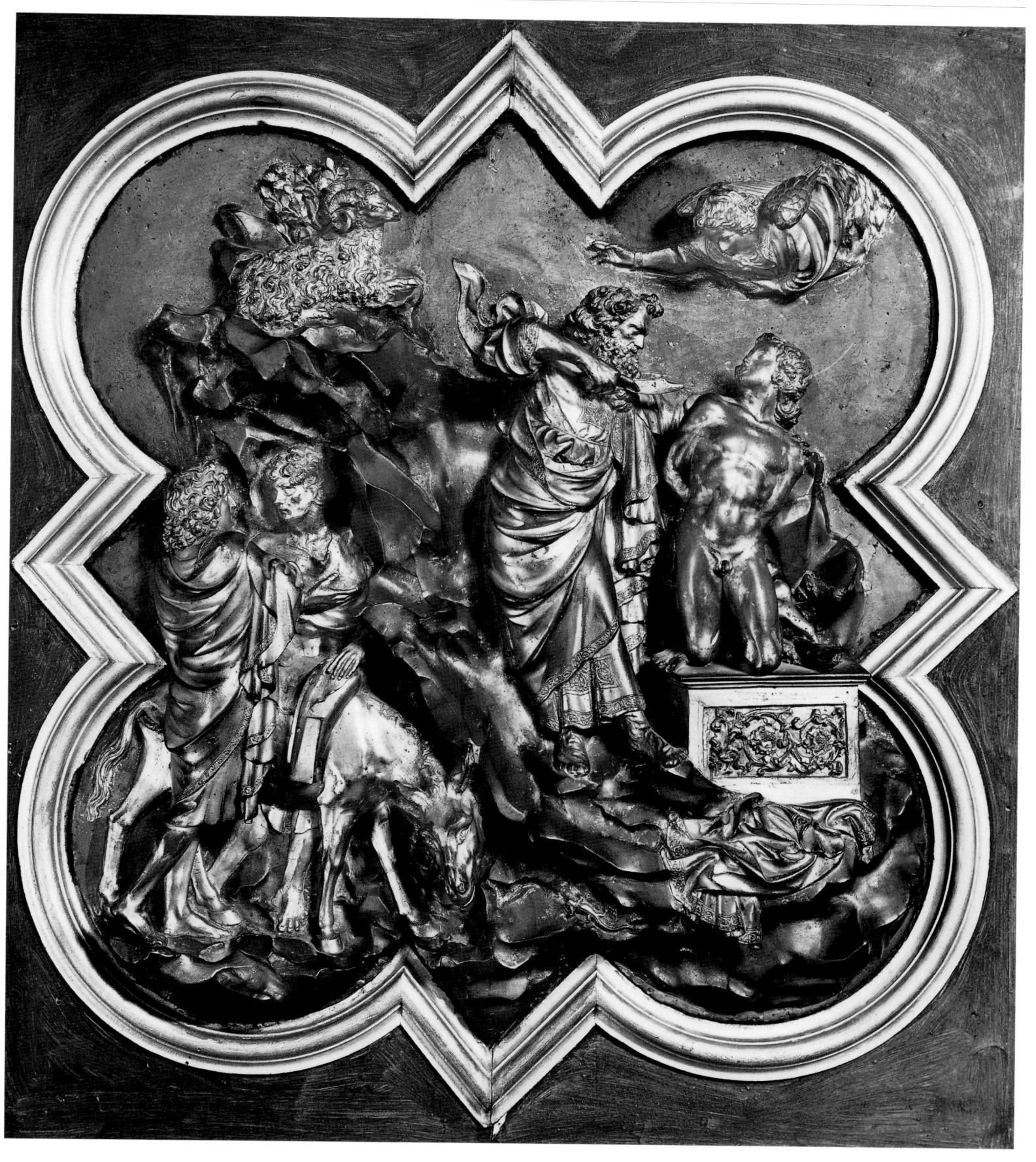

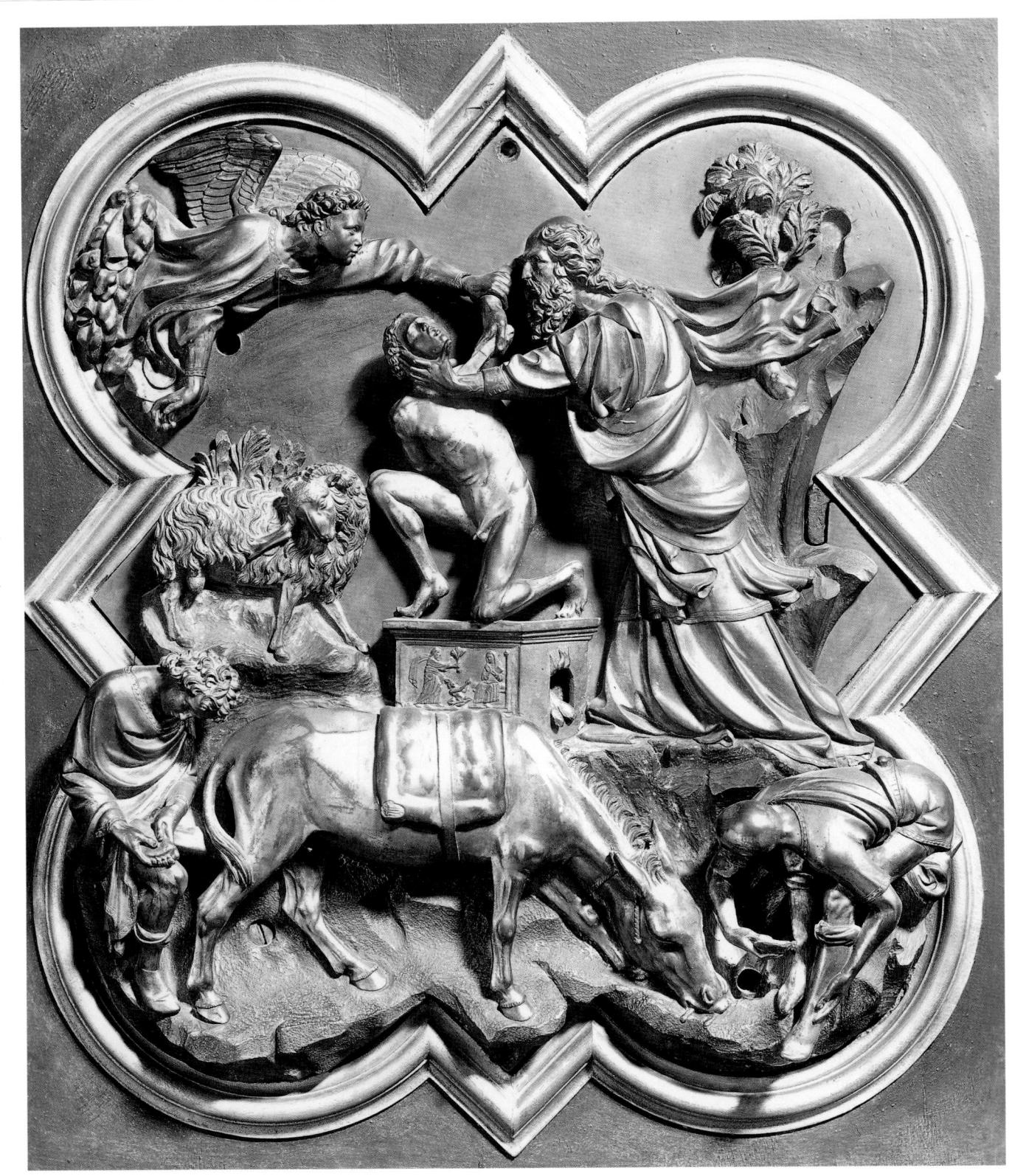

plate 3 Filippo Brunelleschi

The Sacrifice of Isaac

Museo Nazionale, Florence bronze, parcel-gilt, 42×39 cm

'arts', because he distinguishes between three types of sculptor - modellers, carvers and metal workers all of whom have the same objective, 'that the works on which they are engaged (whatever they may be) should appear to those who look at them to be extremely like real natural forms'. Roman sculpture, therefore, was first and foremost a guide to the rendering of appearances. Granted that in the Pisa and Siena pulpits Nicola Pisano had imitated classical originals, granted that Arnolfo di Cambio had based the head of his St Reparata on a Roman model, granted that Giovanni Pisano in the Cathedral at Pisa had introduced a Hercules masquerading as a Samson and a Venus Pudica representing Temperance, the fact remained that these transcriptions of classical motifs (however significant they may appear today) were incompatible with the Renaissance view of Roman art.

Moreover, at the very beginning of the fifteenth century the art of sculpture assumed a new significance. For a decade and more Florentine life had been dominated by the struggle against Milan. One after another Siena, Pisa and Perugia fell under Milanese control, and when in July 1402 Gian Galeazzo Visconti entered Bologna, it seemed that the long years of economic strangulation, famine and blockade were about to end in military defeat. Fate, however, intervened, and in September, before launching his decisive operation, the Duke of Milan died. While the crisis was at its height, fresh thought had been given to the place of Florence in Italy and to the values for which she stood, and there was minted a new image of the city as the intellectual heir of Athens and the

institutional legatee of Rome. Rinuccini describes how there grew up in Florence at this time 'a brigade of young men of eminent talents, worthy of Athens, most cultured of all cities', and the humanist Bruni based his apostrophe of Florence, the *Laudatio florentinae urbis*, on Aristides. This awareness of a recoverable past spread over into the fine arts, and since sculpture was the only classical figurative art for which adequate evidence survived, it was natural that sculptors should lead the search for a commemorative style which would reflect the facts of contemporary existence, contemporary preconceptions and states of mind, as faithfully as Roman sculpture had reflected the Roman world.

Above all it was evident that Roman sculptors had touched life at many points, that in their work a culture lay embalmed in bronze and stone. Here were commemorative statues and portraits and religious images, here were sarcophagi and cinerary urns, here were allegories and mythological reliefs, here was a vast wealth of architectural ornament. As the fifteenth century advanced, Renaissance sculpture took on this same comprehensive character. How were the features of the individual to be perpetuated? By reviving the portrait bust. How was the hero to be commemorated? By reviving the equestrian monument. New attention was given to the tomb, and once again in the bronze statuette a whole mythology was housetrained for domestic use. The Renaissance. therefore, initially in Florence and later in other centres, brought about not merely a revival of sculptural illusionism, but a revision of the intellectual basis of the sculptor's art.

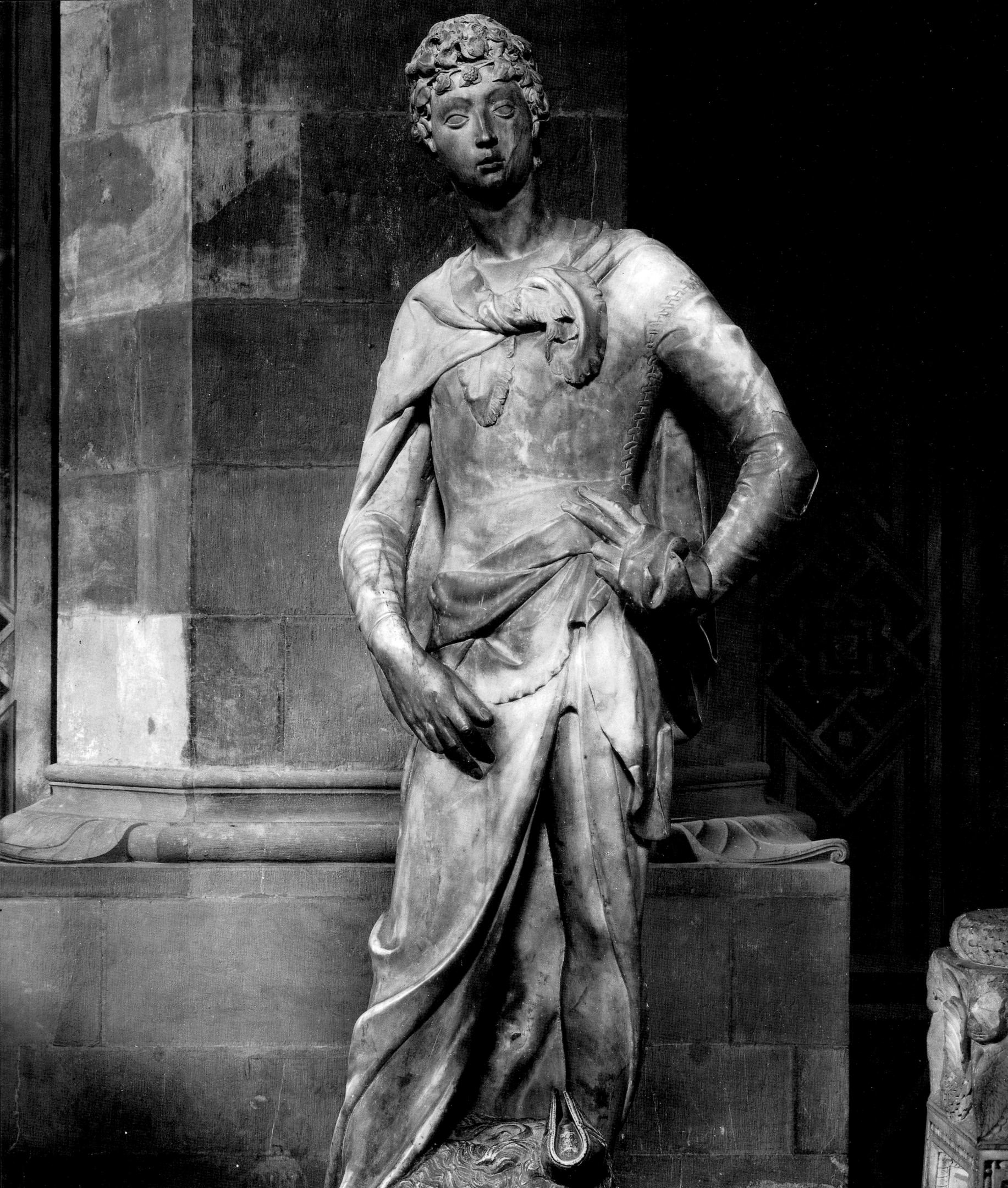

Donatello and the Renaissance Statue

plate 4 *(opposite)* Donatello

David

Museo Nazionale, Florence marble, height 191 cm

plate 5 Donatello

St John the Evangelist

Museo dell'Opera del Duomo, Florence marble, height 210 cm

ONATELLO IS THE GREATEST sculptor of the fifteenth century. Like Michelangelo, he employs a plastic language that resists translation into words, and his creative intentions are often hard to reconstruct. The framework of his life is a comparatively simple one. Born in Florence in 1386, he was trained as a marble sculptor in the workshop of the Cathedral, and served for two periods in the studio of Ghiberti, to whom he owed his knowledge of bronze sculpture. Ghiberti was eight years his senior, and Donatello can have had small sympathy for him or for his work. For Brunelleschi, on the other hand, he must have felt a temperamental affinity, and Brunelleschi's Sacrifice of Isaac has an importance for Donatello's figure sculpture second only to that of his perspective system for Donatello's relief style. Donatello worked on in his native town for thirty-seven unvaryingly successful years, until in 1443, attracted by the prospect of carrying out a major work in bronze, he moved his studio to Padua, where he was active for ten years. From 1453 until his death in 1466 he lived once more in Tuscany. His career therefore falls into three phases, a long period of adolescence and maturity in Florence, a short but vitally important North Italian interlude, and an epilogue in which he developed the first style of old age in the history of art. He was 58 when he moved to Padua, 68 when he returned to Florence, and 80 when he died.

In 1400 the focus of sculptural activity in Florence was the Cathedral. The south entrance, the Porta dei Canonici, was almost finished, and the statues in the lunette above it, a stiff Virgin and

Child with two adoring angels, had been put in place. On the north side the Porta della Mandorla (Vol. I, plate 20) was completed to a considerable height, and Donatello's name appears for the first time in the account books in connection with a figure of a Prophet for a pinnacle above this door. On the lower part of the façade there were four vacant niches beside the central door, and in 1408 it was decided to fill these with seated statues of the Evangelists. One of them, the St Mark, was entrusted to Niccolò di Pietro Lamberti, another, the St Luke, to Nanni di Banco, and a third, the St John, to Donatello. The commission for the fourth, the St Matthew, was at first reserved as an incentive for the sculptor who made the best showing on the other statues, but was entrusted in 1410 to still another sculptor, Ciuffagni. Four artists, therefore, were engaged on one and the same task in the same term of years. The Cathedral sculpture at the beginning of the century was undistinguished, and Niccolò di Pietro Lamberti's St Mark (Vol. I, plate 197), a lay figure covered with a tangle of Gothic drapery, illustrates almost all of its defects. The St Luke (Vol. I, plate 195) is a more serious and ambitious work. Recognizing that a niche figure must fill its niche, Nanni di Banco widened the pose, turning the elbows outwards and placing the feet apart. He had moreover studied Roman sculpture, and the results of this are seen both in the classic head and in the full drapery. The figure's deficiencies are less formal than psychological; it lacks the specific character with which it might have been invested by a more imaginative artist. In Donatello's St

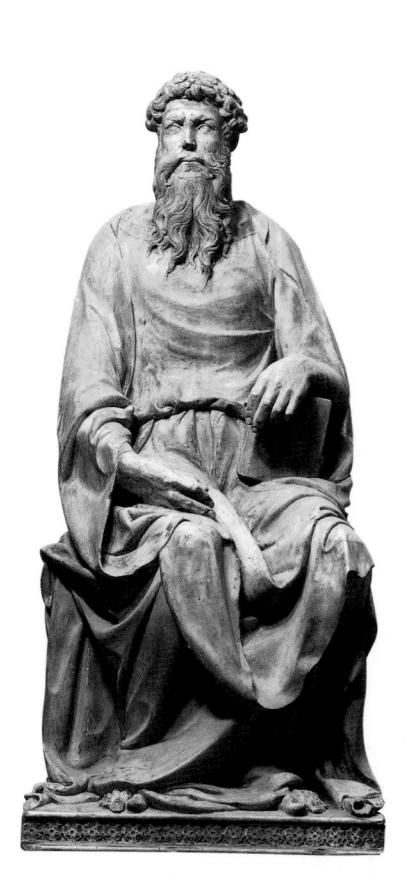

plate 6 Niccolò di Pietro Lamberti

St Luke

Museo Nazionale, Florence

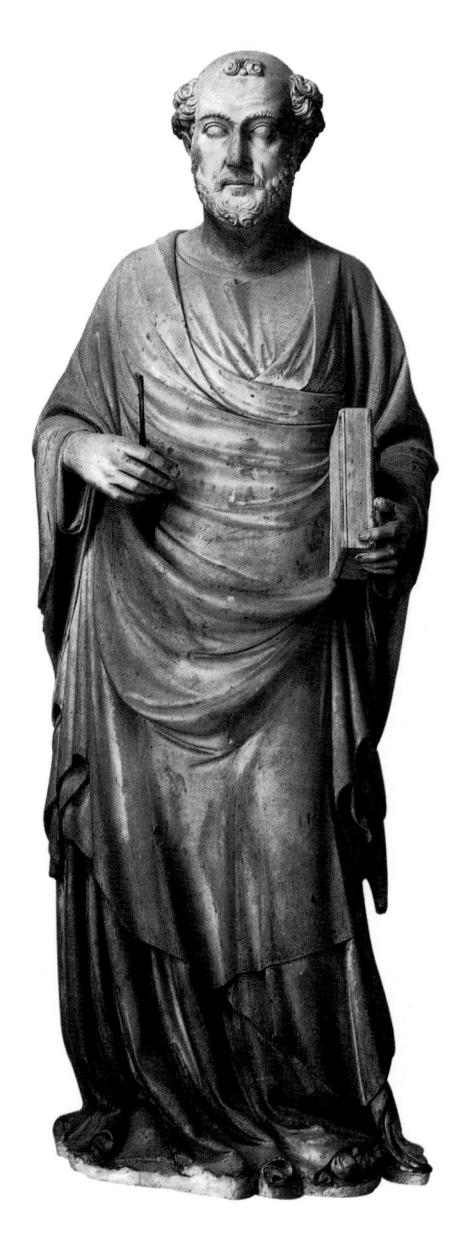

John (plate 5), on the other hand, the content seems to dictate the form. Like the Moses of Michelangelo, it is an interior vision hewn out in marble, not a work contrived from the outside. The planes of the drapery recede in heavy cavernous folds, and the hands are used to accentuate the recession of the thighs. Whereas in the St Luke the planes of the body and knees tend to coalesce, in the St John they are differentiated to the greatest possible extent. The pose, with the body parallel to the base and the knees turned slightly to the left, is natural and unforced, and the hair and beard are not reduced to a classical convention, but are treated realistically with a strong sense of surface texture that is found again in the furrowed eyebrows and deep visionary eyes.

Our picture of Donatello's development in these early years is filled out by two other statues. The first of these, a marble figure of David with the head of Goliath (plate 4), was commissioned for the Cathedral, along with a statue by Nanni di Banco, in 1408. In form both the David and Nanni di Banco's Isaiah (Vol. I, plate 192) are Gothic statues, but Gothic style is treated very differently by the two artists. In the Isaiah the head and drapery folds derive from the antique, while in the David the language differs from orthodox Gothic mainly in its realistic emphasis. Nanni di Banco's Isaiah is less classical than his St Luke, and Donatello's David is less realistic than his St John, but in each statue the future of its sculptor is disclosed. More than this, the David is a first halfarticulate expression of the Renaissance hero cult. Though today we see it through the veil of

Donatello's more communicative later works, we know that it was looked on in the early fifteenth century as an achievement of great significance. Unlike the Isaiah, which proved to be too small for its intended site and was eventually set on the façade, the David was never put in place, but in 1416 was purchased by the Signoria and exhibited in the Palazzo Vecchio as an allegory of the victory of justice over force, a symbol of the conflict in which Florence a short time earlier had been engaged.

The scene of Donatello's subsequent experiments with life-size statuary is the guild-hall of Or San Michele. Or San Michele had been built in 1336, and three years later it was decided that the outer walls should be decorated with 14 tabernacles containing statues of the patrons of the Guilds. By the early fifteenth century only four sculptures had been produced. One of these is the St Luke of Niccolò di Pietro Lamberti (plate 6), which was ousted by another statue in the sixteenth century and is now in the Bargello. When this unadventurous figure was in position in its niche, its flat frontal plane must have read as a relief. To artists of a younger generation the conception of a figure standing stiffly in its niche, like a sentry in a sentry box, was unacceptable, and when Nanni di Banco and Donatello planned their earliest statues for the oratory, their first preoccupation was to establish a sense of implied movement within the niche. In the St Philip, which must have been begun soon after the Isaiah was complete, Nanni di Banco followed the same procedure as in his earlier statue, and produced an

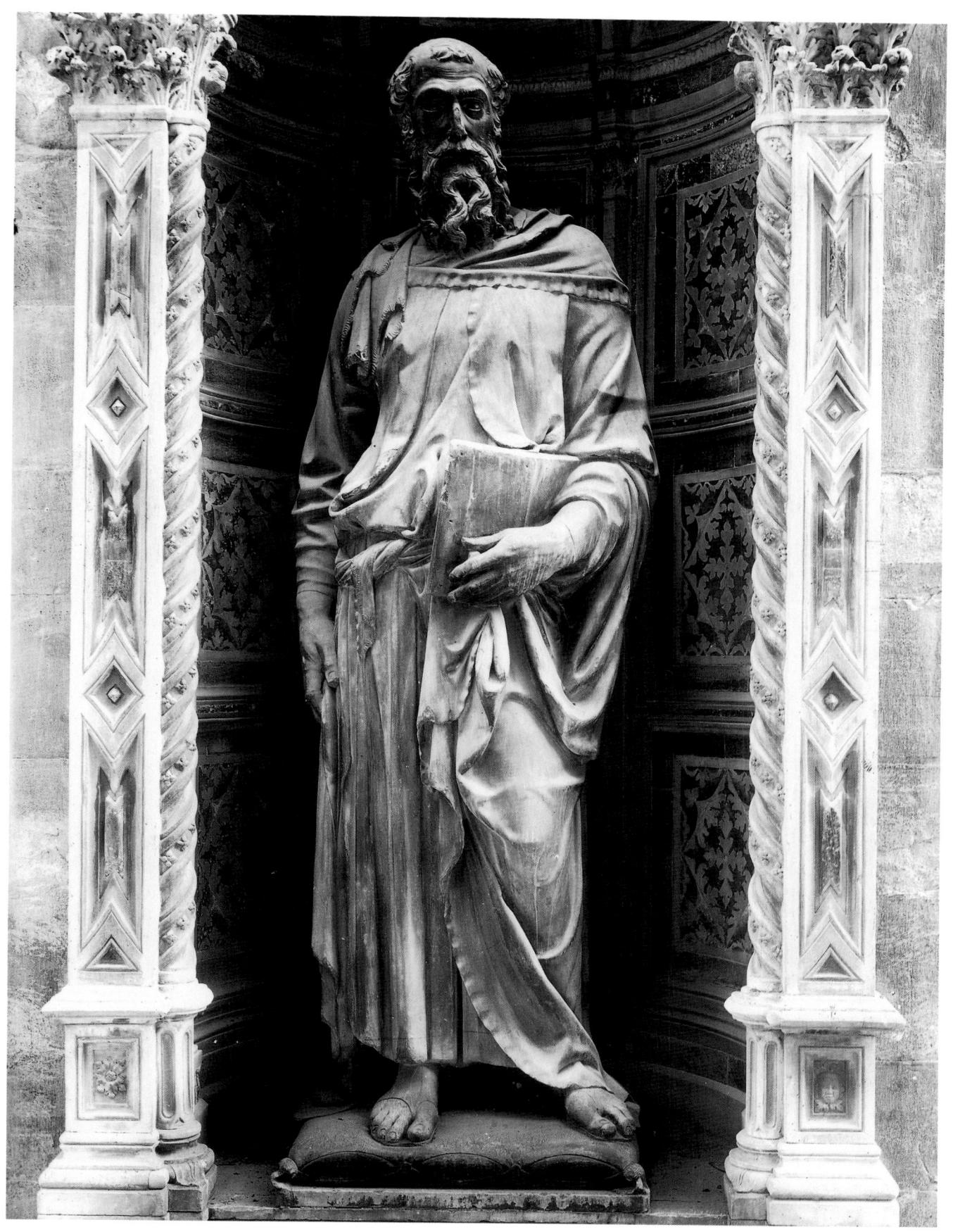

plate 7 Donatello

St Mark

Or San Michele, Florence (formerly) marble, height 236 cm

plate 8 *(opposite)* Donatello

St George

Museo Nazionale, Florence (detail of plate 10)

plates 9–10 Donatello

St George

Museo Nazionale, Florence marble, height overall with base 214 cm

inexpressive figure in which the idealism of late Gothic is covered by a classic dress. For Donatello, on the other hand, the statue embodied an imaginative concept, and great as is the gulf between Niccolò di Pietro Lamberti's St Luke and Nanni di Banco's St Philip, it is greater still between the vacant head of the St Philip and the infinitely expressive features of the first of Donatello's statues for Or San Michele, the St Mark (plate 7). As in the St John, the form is determined by an integral conception of the statue. The weight rests on the right leg, with the left knee bent; the right shoulder is retracted and the head is slightly turned; and the illusion of mobility is made more real by the broken drapery. Donatello was 22 when he began work on the marble David, and 25 when he started work on the St Mark, and in the years between them he had learned the syntax of Roman art. Vasari tells us how, after the competition for the bronze door of the Baptistery, Brunelleschi and Donatello together left for Rome, 'the one to study architecture and the other sculpture'. As late as 1409, however, Donatello was still largely ignorant of the antique, whereas by 1411 he had acquired a deeper understanding of Roman sculpture than any of his Florentine contemporaries.

The St Mark stands on a cushion, and not, like the earlier figures at Or San Michele, on a moulded base. Perhaps in Donatello's view a moulded base would have reduced its life-likeness; at all events (and his consistency in this respect is typical of his whole creative mentality) he made use of this expedient again forty years later in the Judith in the

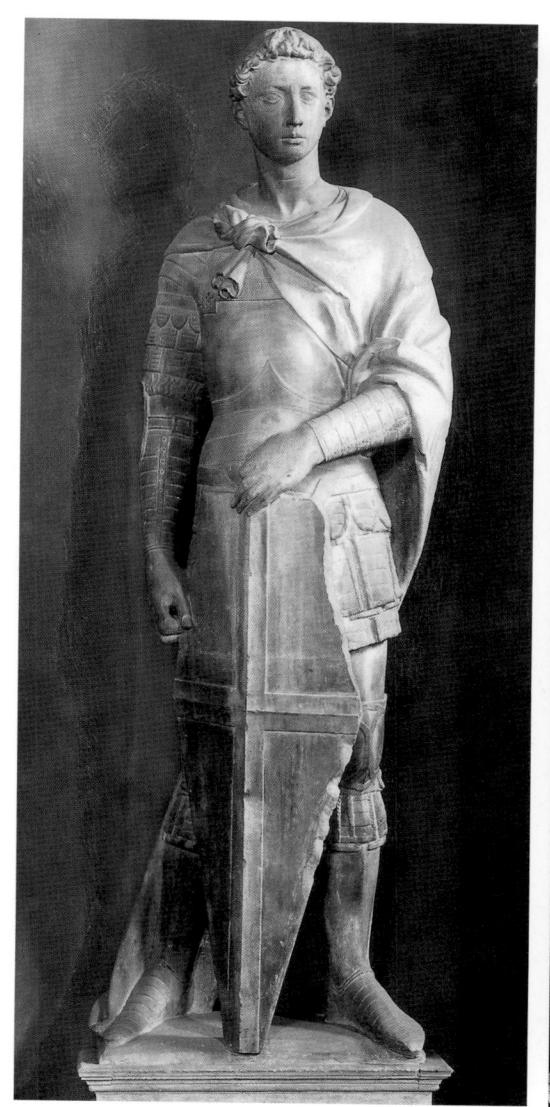

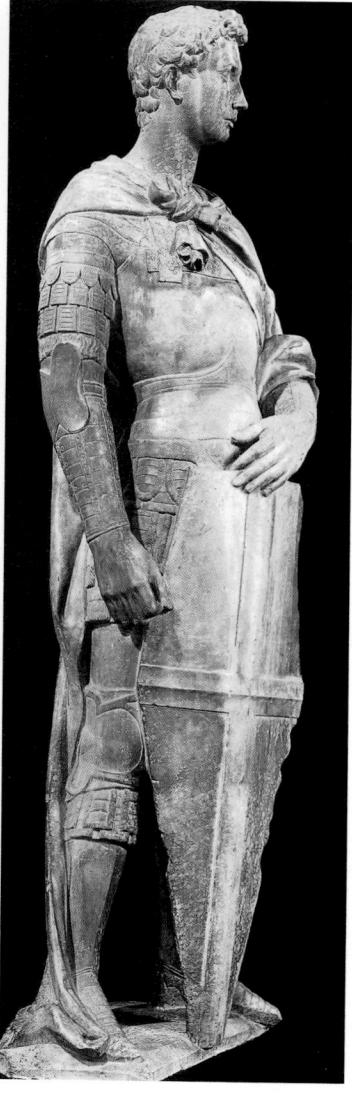

plate 11 Donatello

Unidentified Prophet

Museo dell'Opera del Duomo, Florence marble, height 193 cm

plate 12 Donatello

Unidentified Prophet

Museo dell'Opera del Duomo, Florence marble, height 190 cm

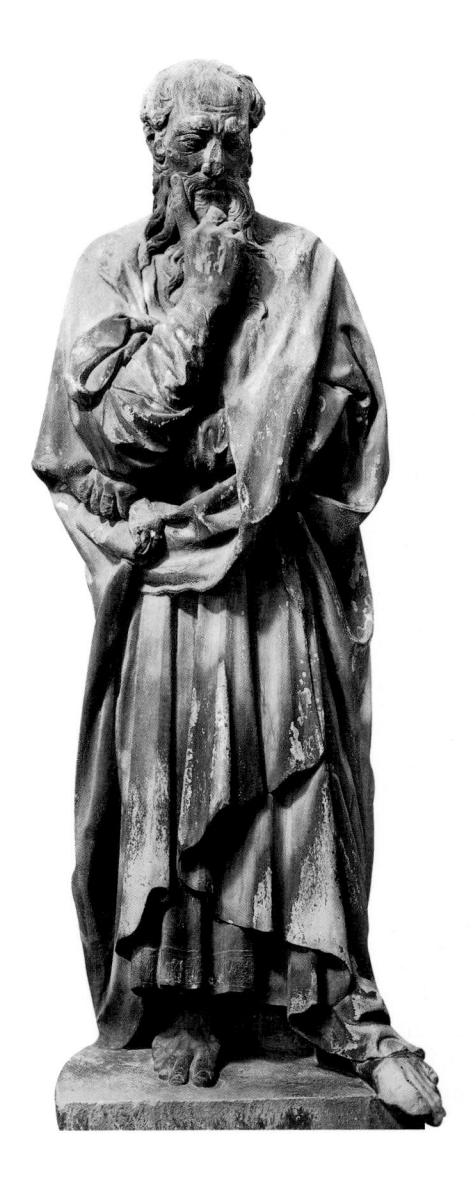

Piazza della Signoria. None the less, the deep tabernacle in which the St Mark rests to some extent neutralizes its effect, and when Donatello was commissioned, about 1416, to carve a figure of St George for Or San Michele, he addressed himself not only to the statue but also to the niche. The statue (plates 8–10) was destined for a part of the Oratory in which for structural reasons a deep tabernacle was impracticable, and for it he prepared a shallow niche which would project it towards the onlooker. Like many later Renaissance artists. Donatello was concerned with the statue in its linear character as a silhouette. This preoccupation leaves its mark upon the marble David, but the St George is the first work in which the factor of the silhouette is dominant; in this respect it sounds a note which reverberates through the fifteenth and sixteenth centuries. The conception, however, is more complex than the term 'silhouette' might in itself suggest. Since it was set in a niche, the figure had one main view, but since the niche was shallow, it had subsidiary three-quarter views as well, and from these the profile was equally harmonious and equally compact. In embryo, therefore, the St George is a free-standing statue, and the principles Donatello established in it were the same that he applied twenty years later when he came to produce figures which were intended to be seen from every side.

The story which opens on Or San Michele continues on the Campanile of the Cathedral. The Campanile was decorated with 16 niches, four on each face. Like the early niches on Or San

Michele, these were narrow and deep, and when eight of them were filled with figures by Andrea Pisano (Vol. I, plate 98), the statues were planned (like Niccolò di Pietro Lamberti's St Luke on Or San Michele) with a flat frontal plane. Two factors, however, operated on the Campanile which were not present on Or San Michele; first, the niches were uniform and could not be modified, and second, they were at a great height from the ground. The problem therefore was the same that had confronted Donatello at Or San Michele but was proportionately more acute. In the earliest of his Campanile statues, a Prophet (plate 11)begun in 1415 soon after the St Mark was finished. Donatello produced a figure that is recognizably related to the statue on Or San Michele, though the drapery forms read in a more intelligible fashion than would those of the St Mark at the same distance from the ground. The St Mark, moreover, is self-contained; there is no bridge between the statue and the onlooker. The Prophet, on the other hand, is shown with chin resting on his raised hand gazing down; his left foot protruded beyond the niche, and this must have enhanced the illusion that here was a real figure meditating on the crowds below. The style initiated in this figure and developed in the later Prophets is not solely an aesthetic phenomenon, but was inspired by Donatello's wish to establish a psychological connection between the statues in the niches and the spectators beneath.

The second Prophet (plate 12) was carved between 1418 and 1420, after the St George. This time the figure is shown moving forwards,

plate 13 Donatello

Jeremiah

Museo dell'Opera del Duomo, Florence marble, height 191 cm

Overleaf
plate 14 (left)
Donatello

Head of Unidentified Prophet

Museo dell'Opera del Duomo, Florence (detail of plate 12)

plate 15 (right) Donatello

Head of Jeremiah

Museo dell'Opera del Duomo, Florence (detail of plate 13)

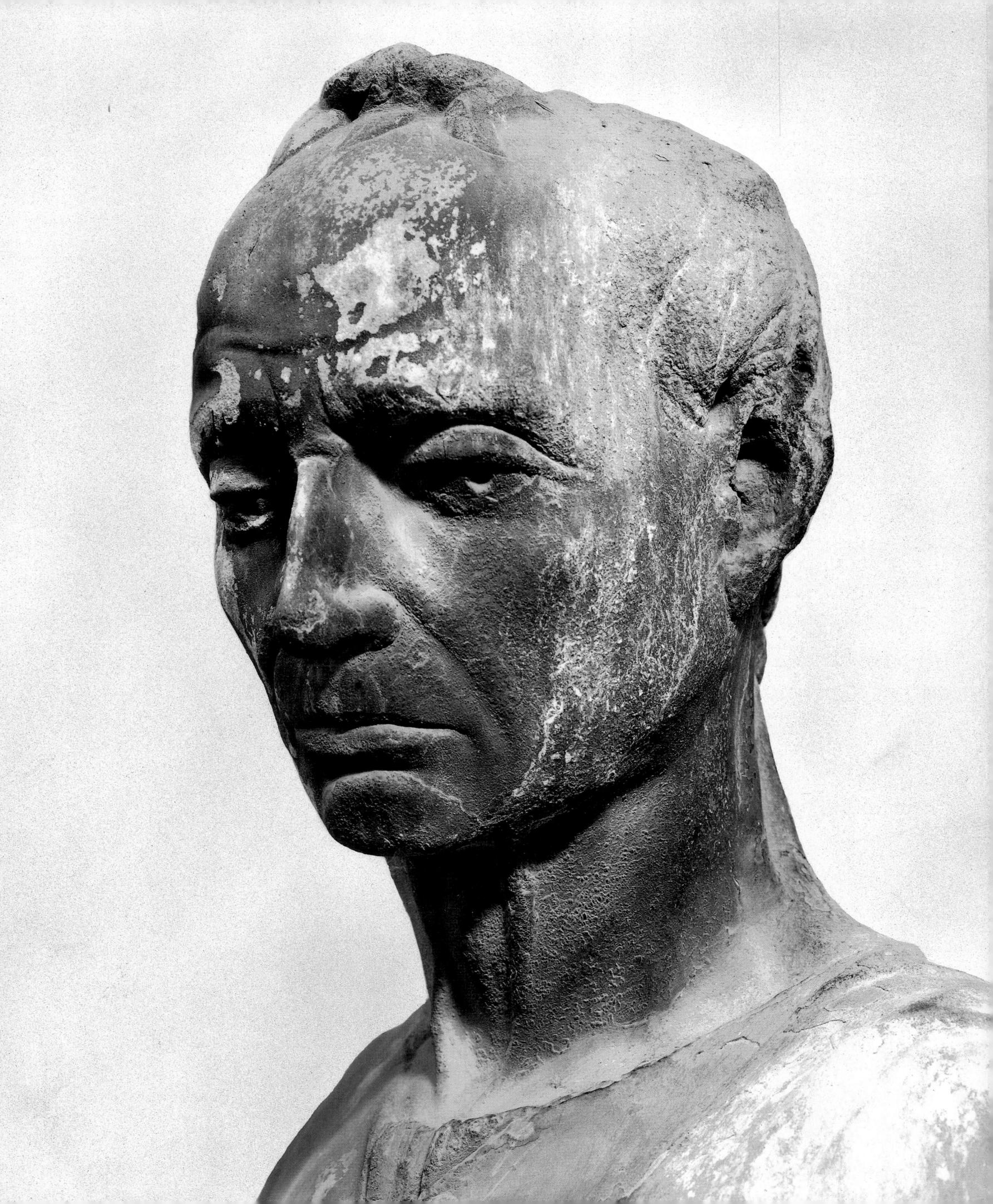

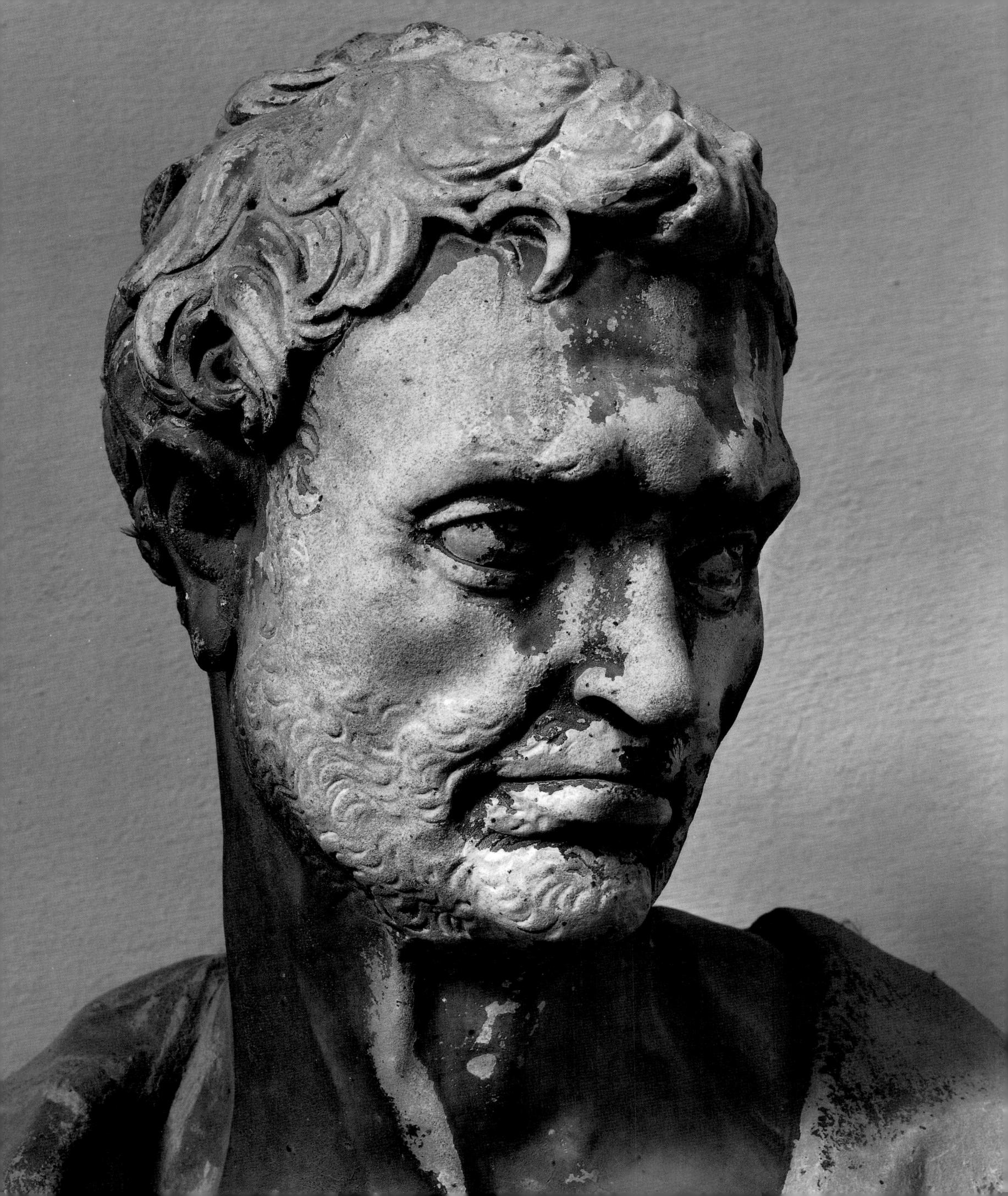

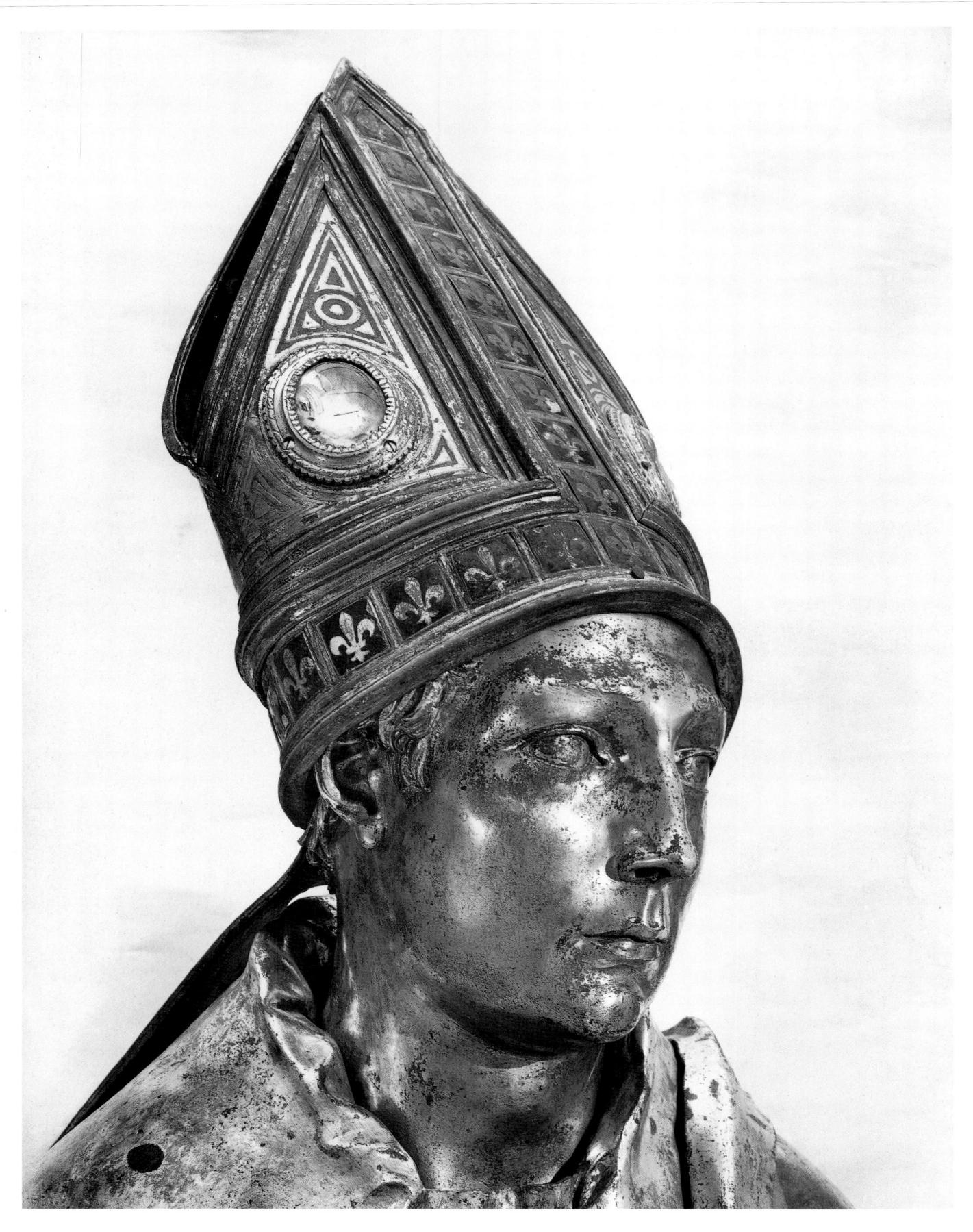

plate 16 (opposite) Donatello

Head of St Louis of Toulouse

Museo dell'Opera di S. Croce, Florence (detail of plate 17)

plate 17 Donatello

St Louis of Toulouse

in niche on Or San Michele; now Museo dell'Opera di S. Croce, Florence gilt bronze, height 266 cm

pointing with one hand to a scroll, with lips compressed as though about to speak. When he carved it, Donatello must have given close attention to Roman portrait busts, and these explain the insistent naturalism of the head (plate 14). But, as we might expect in a figure destined for so great a height, the carving is bolder than in Roman portrait sculptures, and from this breadth of treatment the head takes on new expressiveness. There was a three-year interval before the third of the Campanile Prophets was begun, and during this time Donatello's view of the niche figure underwent a change. The reason for this was that he had started work on a bronze statue for Or San Michele, the St Louis of Toulouse (plates 16, 17). Large-scale bronze statues had been introduced on Or San Michele by Ghiberti with figures of St John the Baptist (1414) and St Matthew (1419) (Vol. I, plates 165, 167). For Ghiberti these represented the revival of a classical art form, and his attitude towards them was determined by the uses of bronze sculpture in antiquity. Donatello was not fettered in this way, and guided by a flawless sense of medium, he devised a new type of bronze statue for which there was no precedent, with swelling robes and ample forms. When he began work in 1423 on the third of the Campanile Prophets, the Jeremiah (plates 13,15), he determined to adapt the swollen drapery forms of his St Louis to marble sculpture. In the two earlier Prophets and in the St Mark the dress adheres closely to the body, and is the means through which the structure beneath it is defined. In the Jeremiah, on the other hand, body and dress are treated as opposing elements, and the

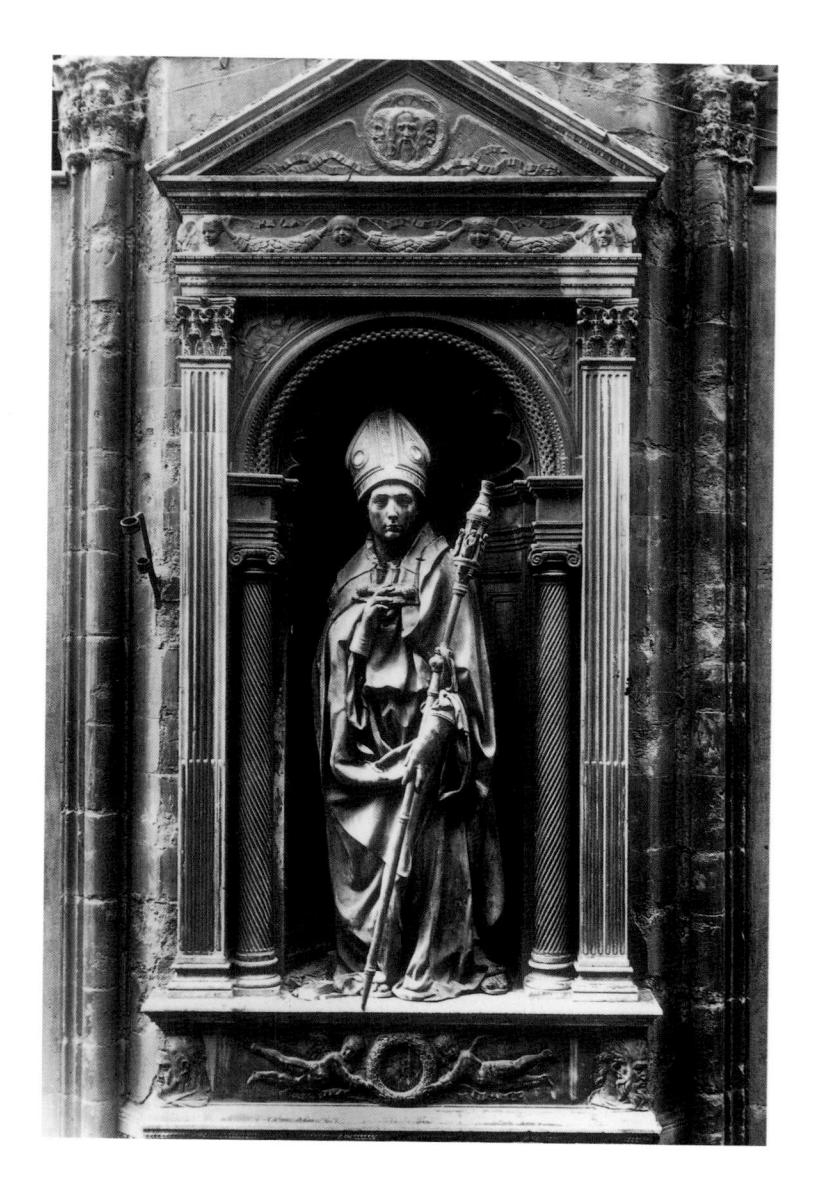

tight forms of the bare right arm and shoulder, the chest and the left leg, contrast with the undulating rhythms of the loose full cloak. In this way the plastic emphasis is heightened, and Donatello takes the first step on a path which leads ultimately to Bernini. The latest and most sharply characterized of the four statues is the Habakkuk (plate 18), which was begun in 1427 and was completed nine years later in 1436. The impact of this powerful figure is heightened by its attenuated limbs and heavy drapery. As we see this and its companion figures at eye level in the Museo dell'Opera del Duomo today, they lose much of their force, but on the Campanile they appeared the products of dynamic imagination and unerring dramatic sense. To the spectators who looked up at them the four Prophets, one meditating silently upon the crowd below, another moving forward about to speak, the third reading from his scroll, and the fourth exclaiming with parted lips, opened the way to a new imagery in which persons from the Old and the New Testaments were presented for the first time as real figures, with a liveliness that was more vivid than life itself.

In the 1430s Donatello's dramatic sense found direct expression in a narrative scene, the Cavalcanti Annunciation in S. Croce (plate 20). This is a relief, but a relief so deep-cut that it seems to consist of two figures in the round placed on a shallow stage. The Virgin, rising from her chair as though to leave the scene, turns back in arrested motion to listen to the Angel who kneels in front of her. There is no parallel in painting for this theatrical device, and when the relief was carved it

must have seemed astounding in its imaginative authenticity. The stage of the Annunciation is framed in a proscenium arch, and an extraordinary frame this is, with its consoles supporting a curved base and its capitals with human masks (plate 19). The singularity of this design must be borne constantly in mind when we move to Padua to consider Donatello's most complex work, the high altar of S. Antonio.

The Padua altar (plates 21, 22) was dismantled in the sixteenth century, and only the bronze reliefs and statues and one stone carving from it are preserved. The main elements in the scheme were seven statues, each nearly five feet high. Two of them, as we might expect, are figures of St Francis (plate 26) and St Anthony of Padua (plate 27). St Francis is shown moving forwards in a pose which recalls the figures on the Campanile, with a crucifix resting against his shoulder and a book between his hands, and St Anthony, again holding a book, is represented with head turned to his right. A third Franciscan Saint, St Louis of Toulouse (plate 28), has his head slightly turned, as though his attention were directed to some object on his left; his right hand is raised. Another, St Prosdocimus (plate 29), the patron Saint of Padua, holds his emblem, a ewer, and gazes downwards to his right. Two more are Paduan Saints: St Daniel (plate 23), dressed in a dalmatic, holds a basin in his right hand and points outwards with his left, and St Giustina (plate 25) holds a palm in her left hand and points outwards with her right. Last comes the Virgin and Child (plate 24). The Virgin wears a crown and holds the Child in front of her, and

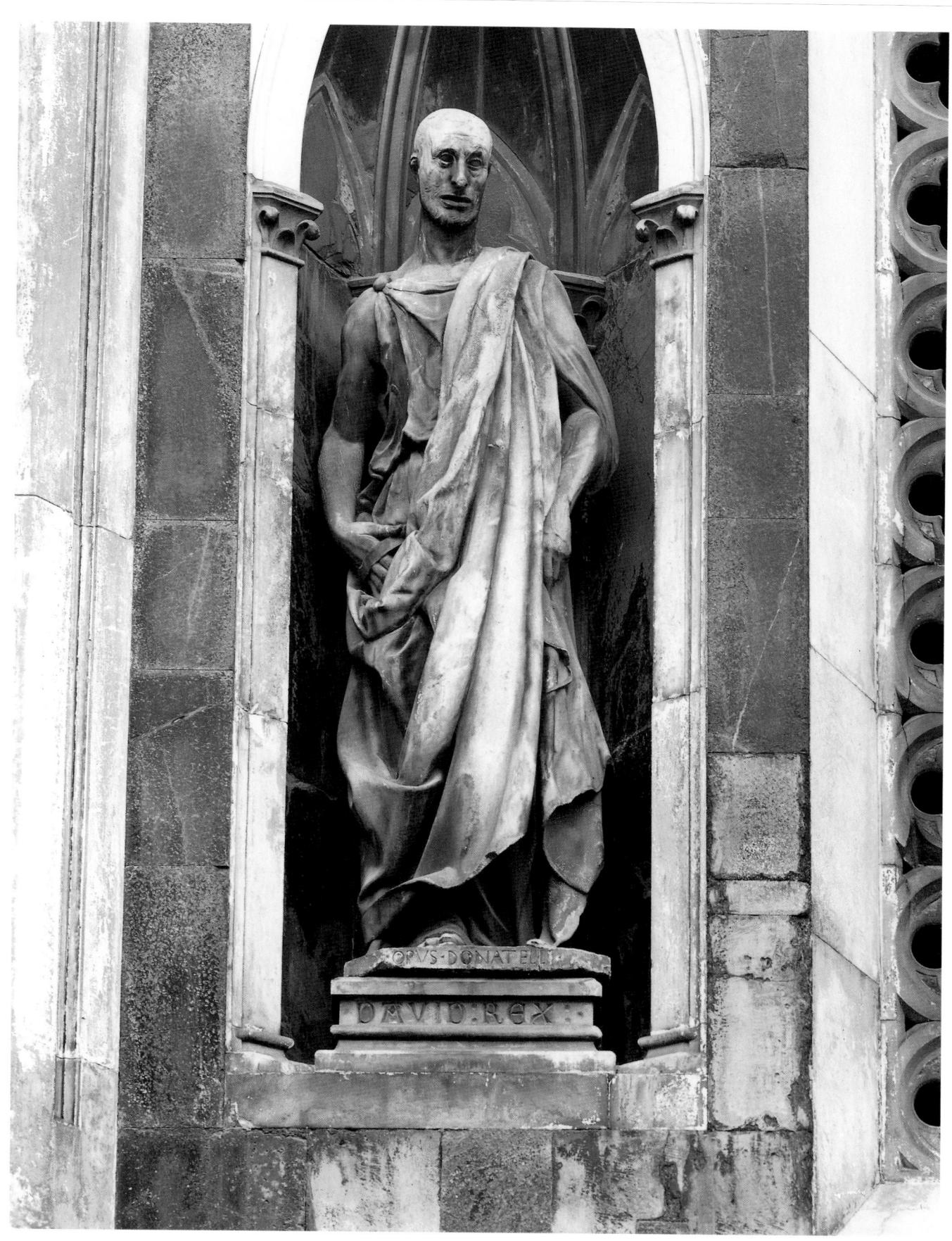

plate 18 Donatello

Habakkuk

in niche on Campanile; now Museo dell'Opera del Duomo, Florence marble, height 195 cm plate 19 Donatello

The Annunciation

S. Croce, Florence stone, height 419 cm

plate 20 *(opposite)* Donatello

The Annunciation

S. Croce, Florence (detail of plate 19)

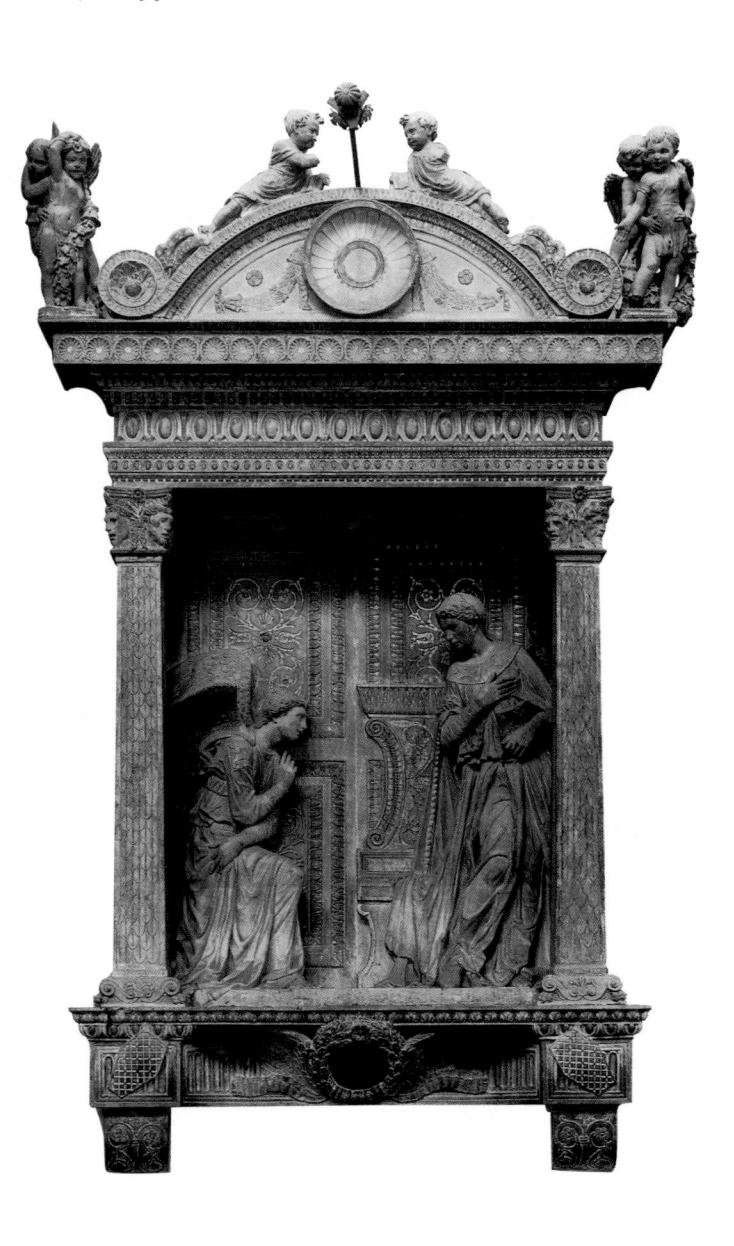

beneath are two sphinxes forming the arms of a seat. The motif of the Child held in front of the Virgin occurs in thirteenth-century paintings, and it has been suggested that Donatello in the Padua altar was deliberately imitating one of these. This is unlikely, and if instead we look at the group in the light of the Cavalcanti Annunciation we reach a contrary conclusion, that the Virgin is shown in arrested motion, rising from her seat and exposing the Child (whose right hand is raised in benediction) to the adoration of the onlookers.

From a cursory inspection of this kind, it becomes clear that the interest of the altar was greater than that of its parts, and a number of attempts have been made to reconstruct it. One of them shows the figures in line against a background, like actors taking a curtain call. Another shows the figures in line without a background, on a ledge above a mass of bronze reliefs. Yet another shows the Virgin and Child raised on a plinth in the centre with two Saints at the sides gesticulating into the void, and a fourth shows the episcopal Saints separated from their companions on little plinths. None of the earlier reconstructions, however, takes serious account of the meaning of the individual figures or of the broad tendency of Donatello's style. So far as the architecture of the altar is concerned, no progress is possible. There are documentary references to a cupola, and one or two fragments survive which may have formed part of the frame. But we should never succeed in reconstructing the frame of the Cavalcanti Annunciation from comparable material, and with the Padua altar, which was

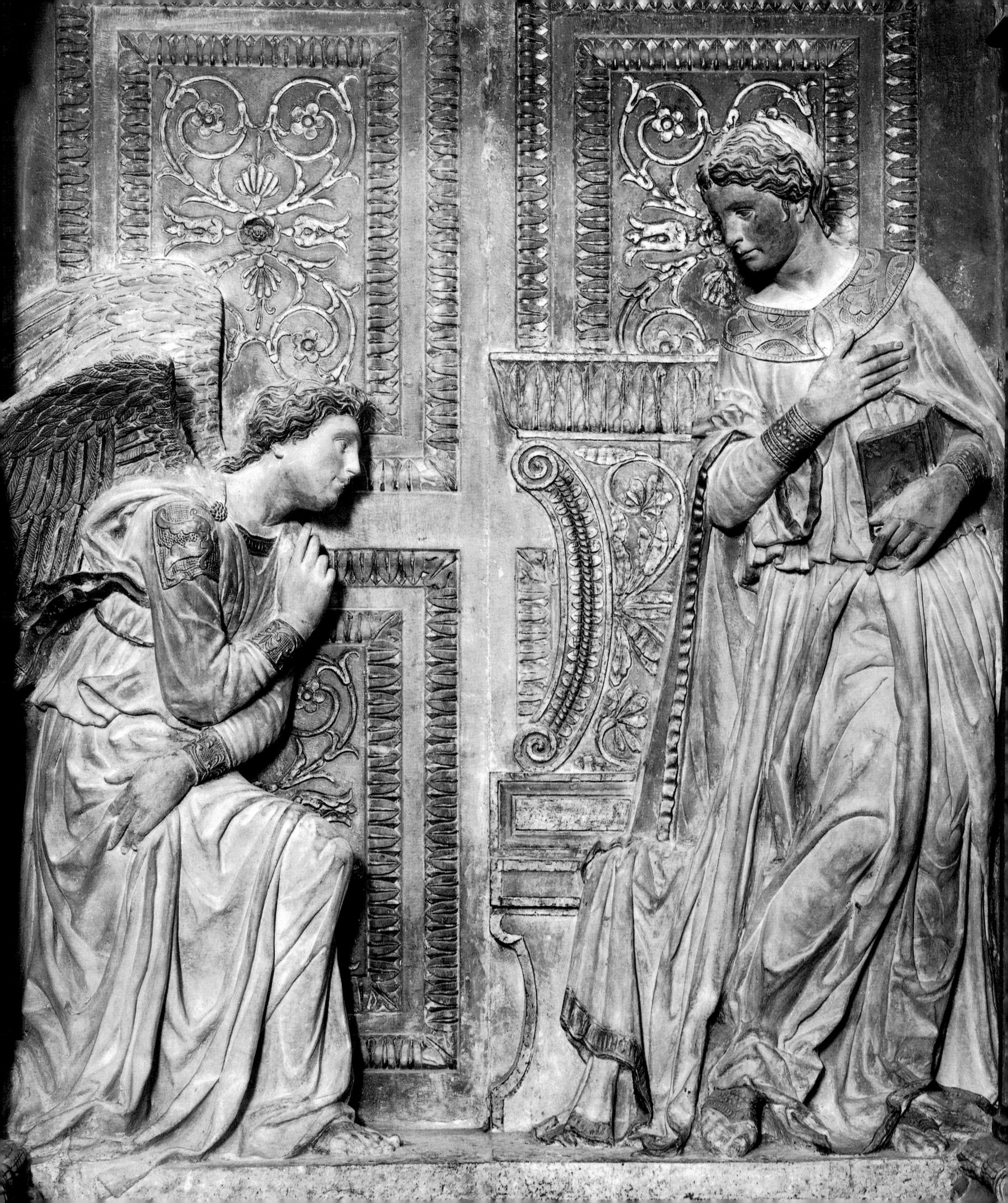

plate 21 Donatello

The High Altar of S. Antonio, Padua

(front)

plate 22 Donatello

The High Altar of S. Antonio, Padua

(back)

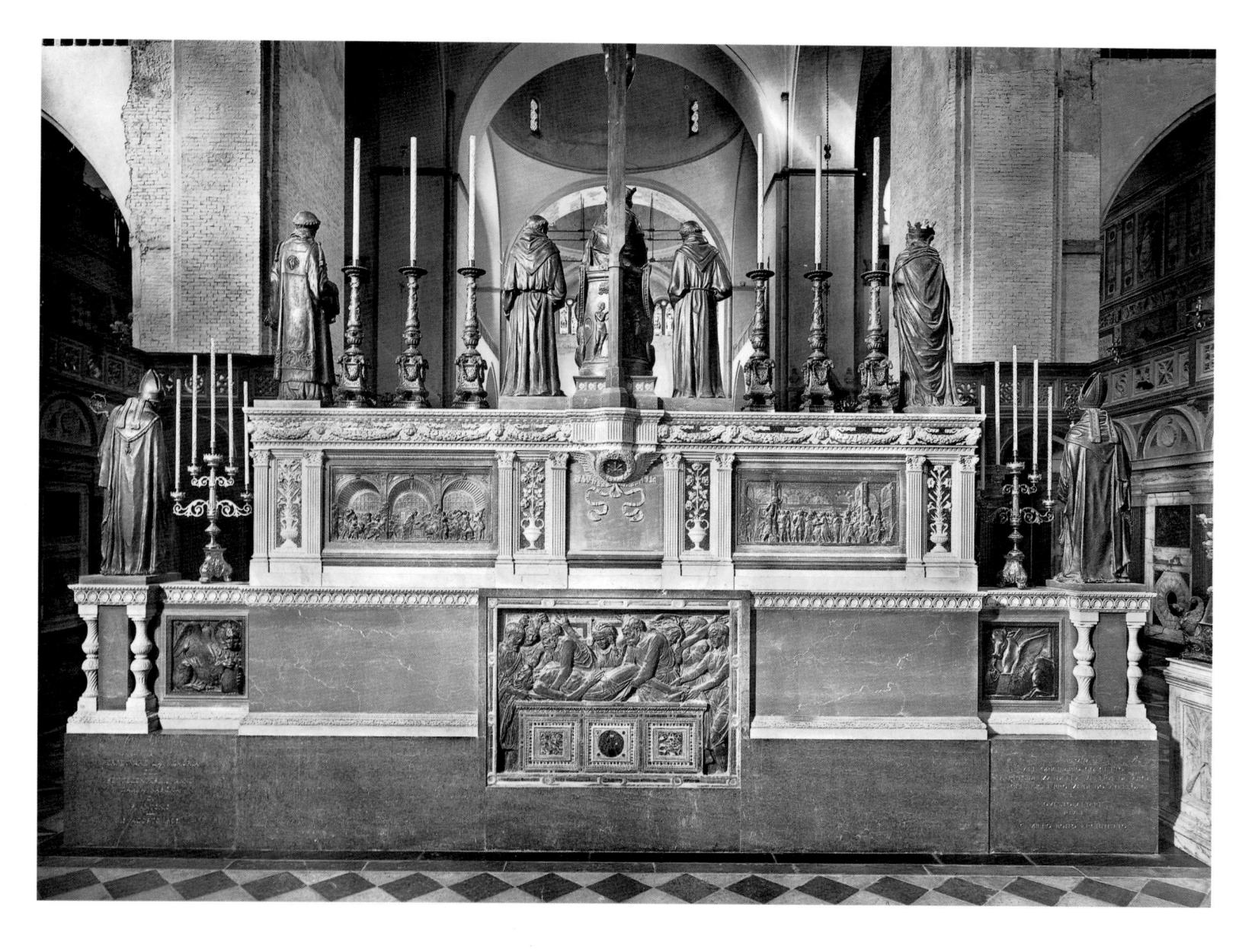

plate 23 Donatello

St Daniel

S. Antonio, Padua (detail of plate 21) bronze, height 123 cm

plate 24 Donatello

Virgin and Child

S. Antonio, Padua (detail of plate 21) bronze, height 159 cm

plate 25 Donatello

S. Giustina

S. Antonio, Padua (detail of plate 21) bronze, height 154 cm

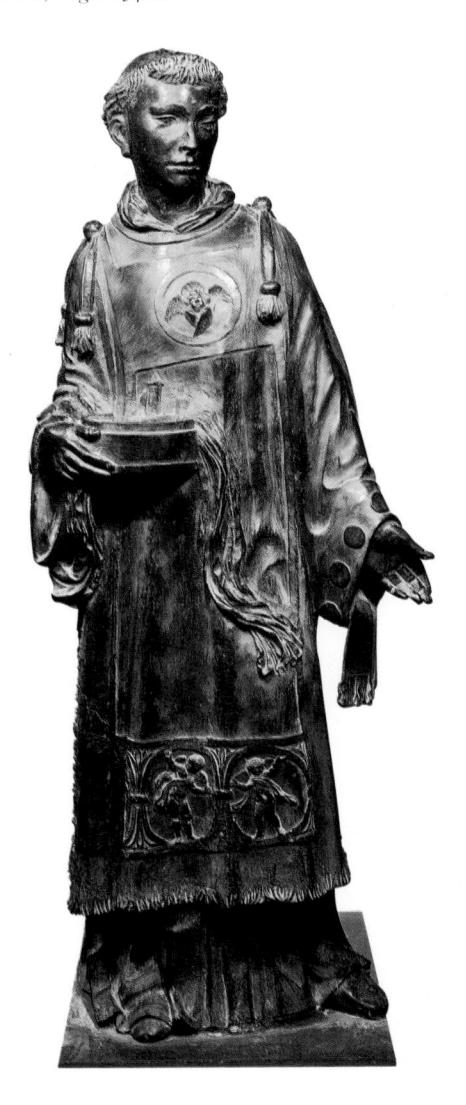

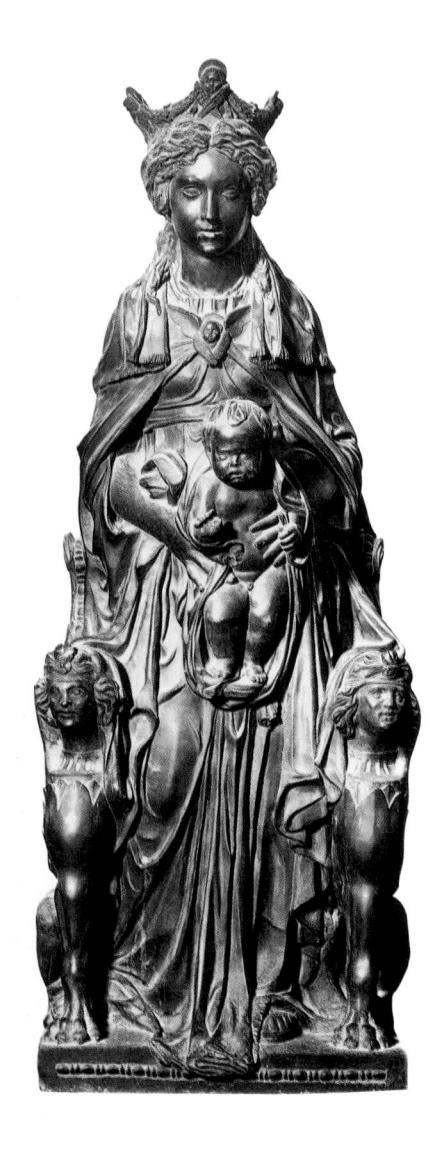

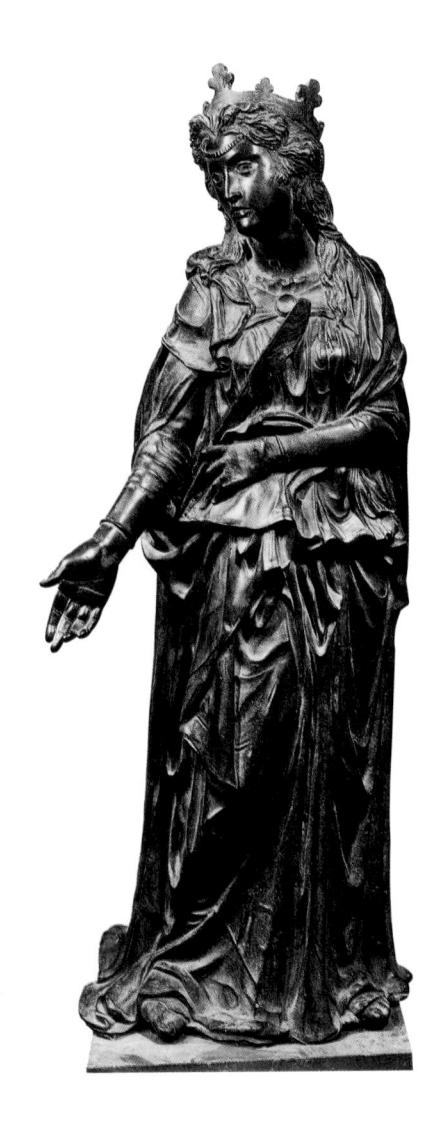

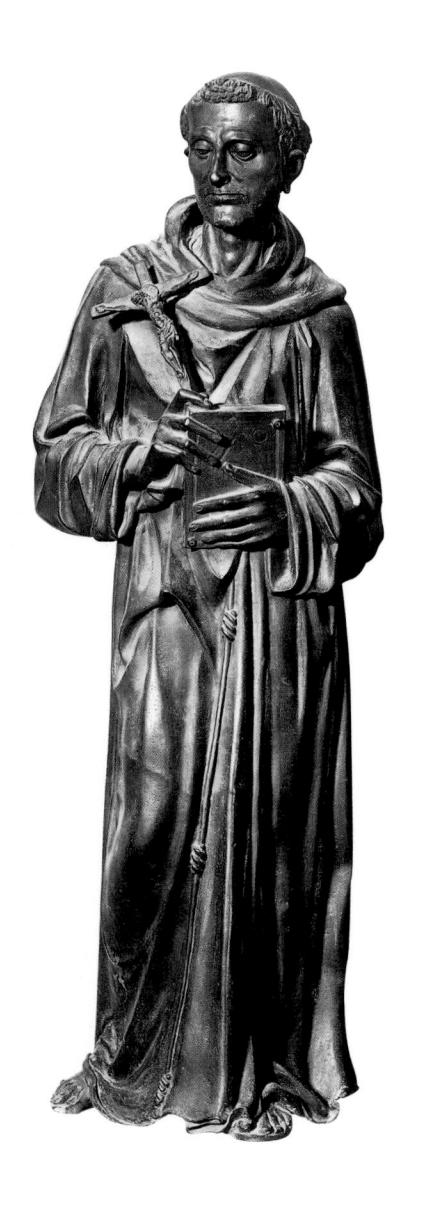

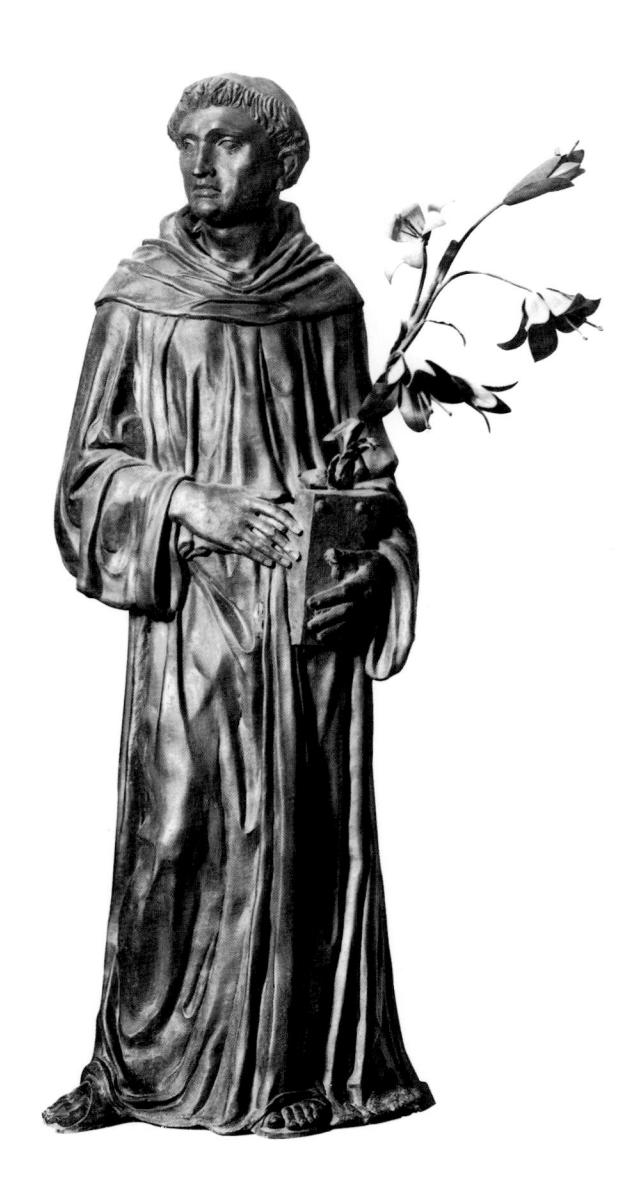

plate 26 *(far left)* Donatello

St Francis

S. Antonio, Padua (detail of plate 21) bronze, height 147 cm

plate 27 *(left)* Donatello

St Anthony of Padua

S. Antonia, Padua (detail of plate 21) bronze, height 147 cm plate 28 Donatello

St Louis of Toulouse

S. Antonio, Padua (detail of plate 21) bronze, height 164 cm

plate 29 Donatello

St Prosdocimus

S. Antonio, Padua (detail of plate 21) bronze, height 163 cm

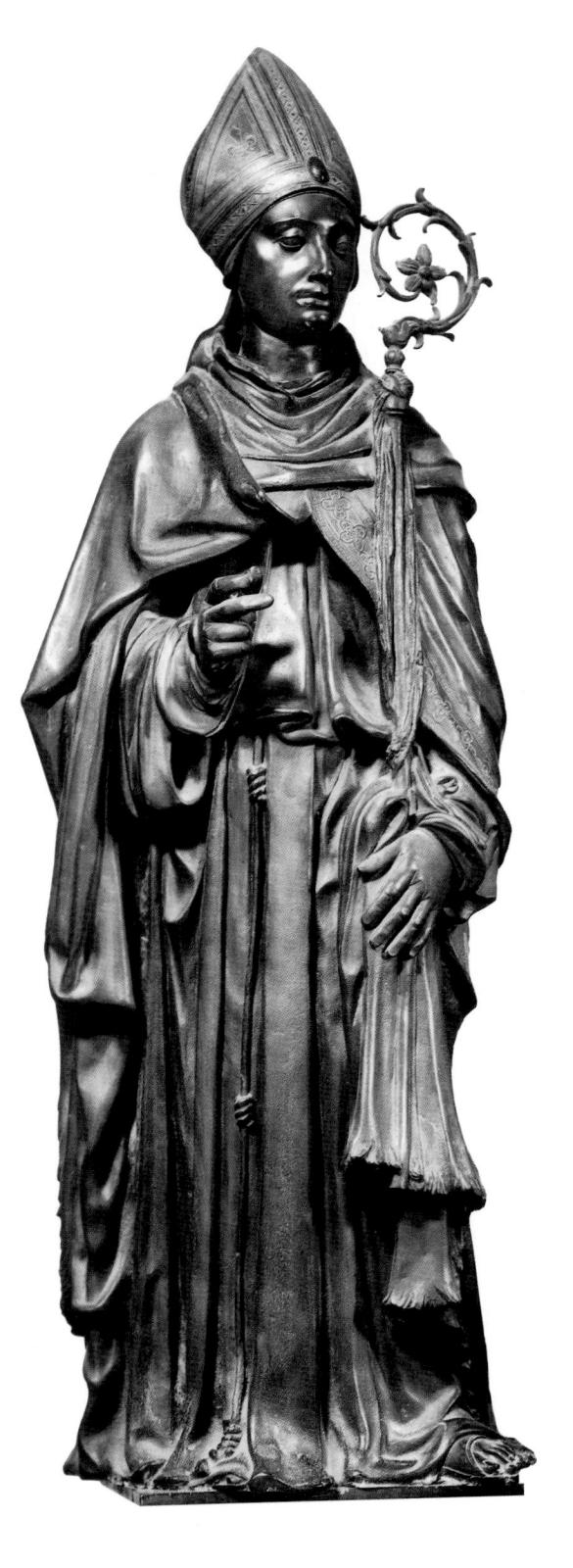

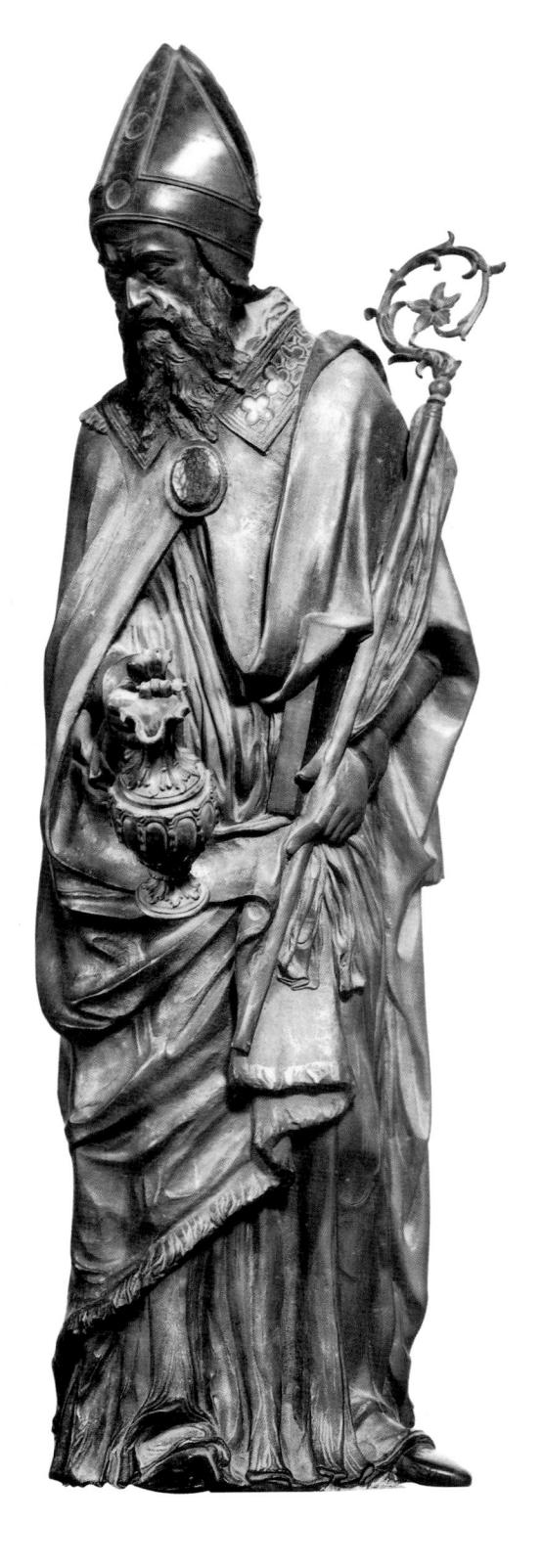
larger and more complex, the chances of success are lower still. The only account of the altar when it was intact is summary and inaccurate, but reveals one significant fact, that it was double-sided, and this the figures confirm, for all of the six Saints are finished off behind, and at the back of the Virgin's throne are two reliefs which would have been visible only if the group stood free. The nature of the group can be established from the figures themselves. Sts Daniel and Giustina, with their extended hands, form a convenient starting point. Obviously these gestures are not rhetorical, as they would have been in the seventeenth or eighteenth century, and if they are not rhetorical they can apply only to the Child. They are, moreover, pointing down, and this would have no meaning if the central group were raised. It follows, therefore, that the Virgin and Child was set on precisely the same level as the other figures of the altar. If this was so, it must also be to the Child that the hand of St Louis of Toulouse and the eyes of St Prosdocimus were addressed. When all that is said, we are still far from knowing how the pieces of the altar interlocked, but, whatever its final form, we can be sure it was an active scene of deep devotional significance.

In the Padua altar the use of bronze is for the first time thoroughly explored. It was created a mere quarter of a century after the St Matthew of Ghiberti, yet it stands intellectually more than halfway between Ghiberti and Rodin. The search for a physically convincing image supplied the motive power of this advance, but its consequences were felt far beyond a realistic

plate 30 Donatello

Putto

Baptistery, Siena (detail of Baptismal Font)

plate 31 Donatello

Amor-atys

Museo Nazionale, Florence

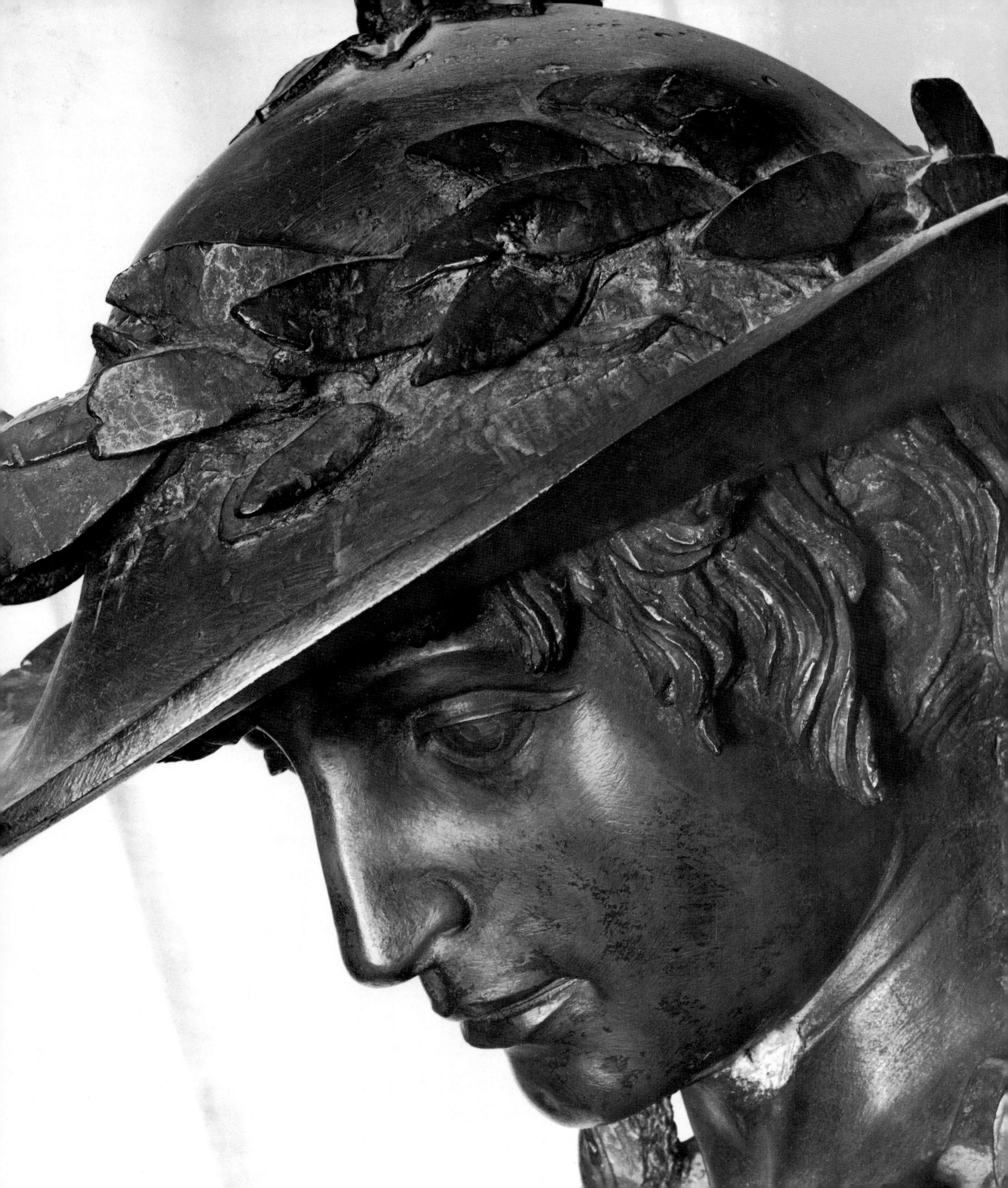

plate 32 *(opposite)* Donatello

David

Museo Nazionale, Florence (detail of plate 33)

plate 33 Donatello

David

Museo Nazionale, Florence bronze, height 159 cm

sphere, and in the individual figures from the altar the enhanced verisimilitude to which it led opened the door to a world of richer communication and heightened spiritual experience.

Donatello also left evidence in Florence of his capacity as a bronze sculptor in two free-standing statues executed for the Medici. The first of them, the David (plate 33), now in the Bargello, was cast before he left for Padua; the second, the Judith (plate 34), now in the Piazza della Signoria, was made about 1455 after his return. The freestanding bronze statue, like the bronze niche figure, was the revival of a classical art form. Donatello must have studied Roman statuettes when, in the 1420s, he planned the putti for the tabernacle of the Siena font. Though they formed part of an architectural complex, these little putti (plate 30) were fully visible on three of their four sides, and in them Donatello was confronted, albeit on a microcosmic scale, with the problems of pose and ponderation peculiar to free-standing statuary. Not till the 1430s did he encounter these problems again, and then on a more substantial scale in another putto statue, the Amor-Atys in the Bargello (plate 31). By this time he had secured a firmer command of his new medium, and the surface of the figure is treated illusionistically, with special emphasis upon the contrast between the heavy hair and the smooth contours of the face. When, about 1440, Donatello started work on the bronze David, he brought these preconceptions once more into play, showing the hair falling on the shoulders

and a winged helmet resting against the inside of the thigh.

The torso of the David was almost certainly inspired by a fragmentary classical bronze statue. The method by which it is constructed, on the other hand, has no precedent in the antique. It rises from a circular base, and is composed on a system of diagonals, with the right leg and left elbow retracted and the left knee and right hand advanced. The left foot is set higher than the right, and the head is slightly turned. Not only are its front and rear views incomparably beautiful, but from whatever position we inspect it the silhouette resolves itself into one lyrical line. Nowadays the making of free-standing statues is regarded as an essential feature of the sculptor's art, but when it was produced the David was an entirely novel work, which must have entailed unparalleled intellectual effort and self-criticism of the most ruthless kind. Its importance was recognized in 1495 when it was moved from the Palazzo Medici to the Palazzo della Signoria, where the marble David (plate 4) was also housed. None the less, it stands apart from the heroic line of David images that leads from Donatello's marble David, through Verrocchio, to the David of Michelangelo. Its sensual, meditative features are fraught with meaning, yet meaning too ambiguous to be defined. Possibly Donatello was familiar with a classical Antinous head, in the light of which his David image was revised.

For the subject of Judith classical models were of no avail, and the difficulty of creating a consistent and acceptable free-standing statue was

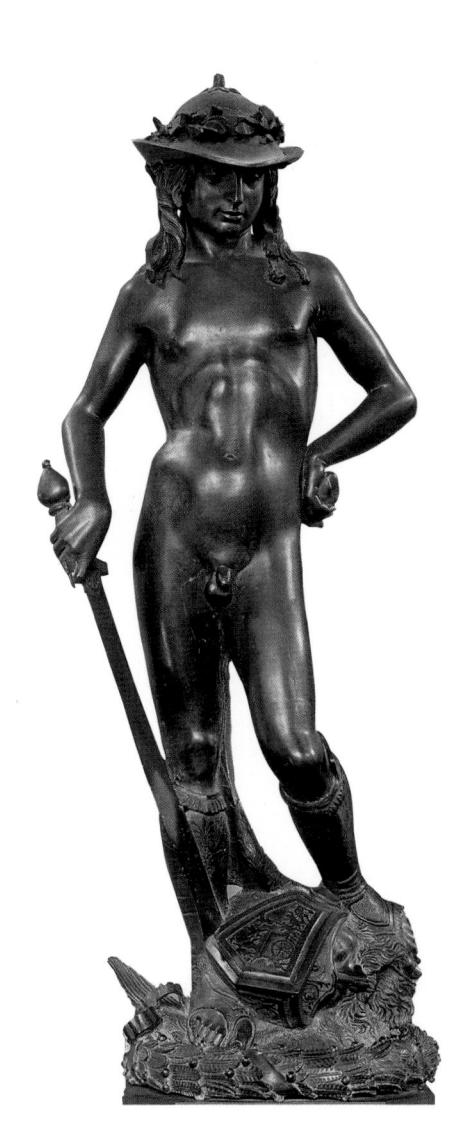

plates 34–7 Donatello

Judith and Holofernes

Palazzo della Signoria, Florence bronze, height with base 236 cm

plate 38 *(opposite)* Donatello

Head of Holofernes

Palazzo della Signoria, Florence (detail of plate 34)

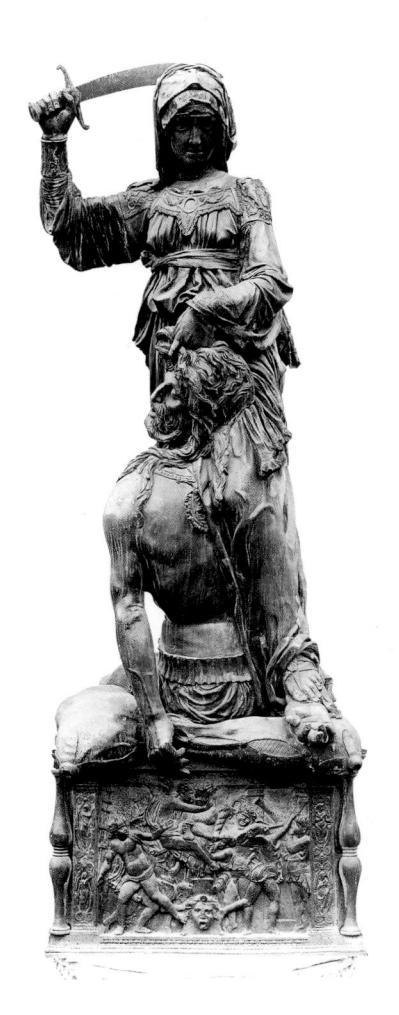

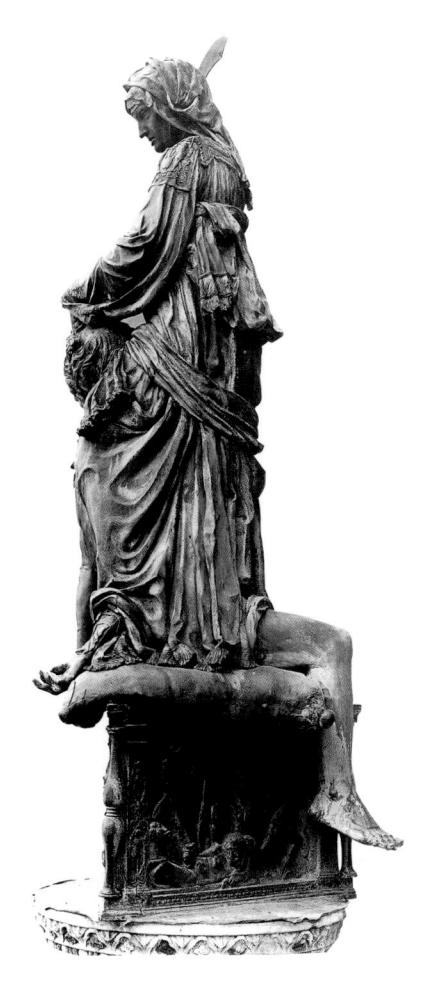

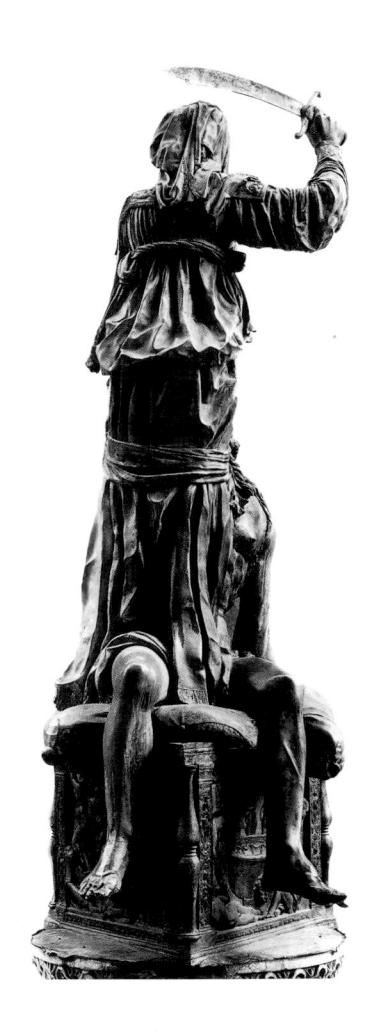

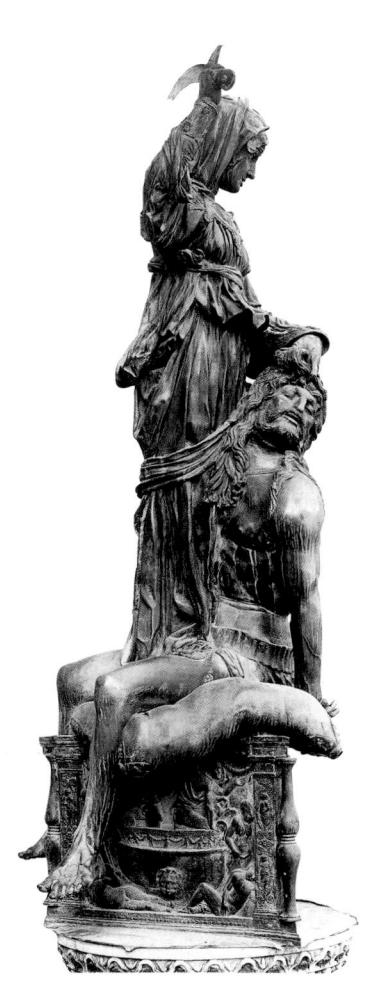

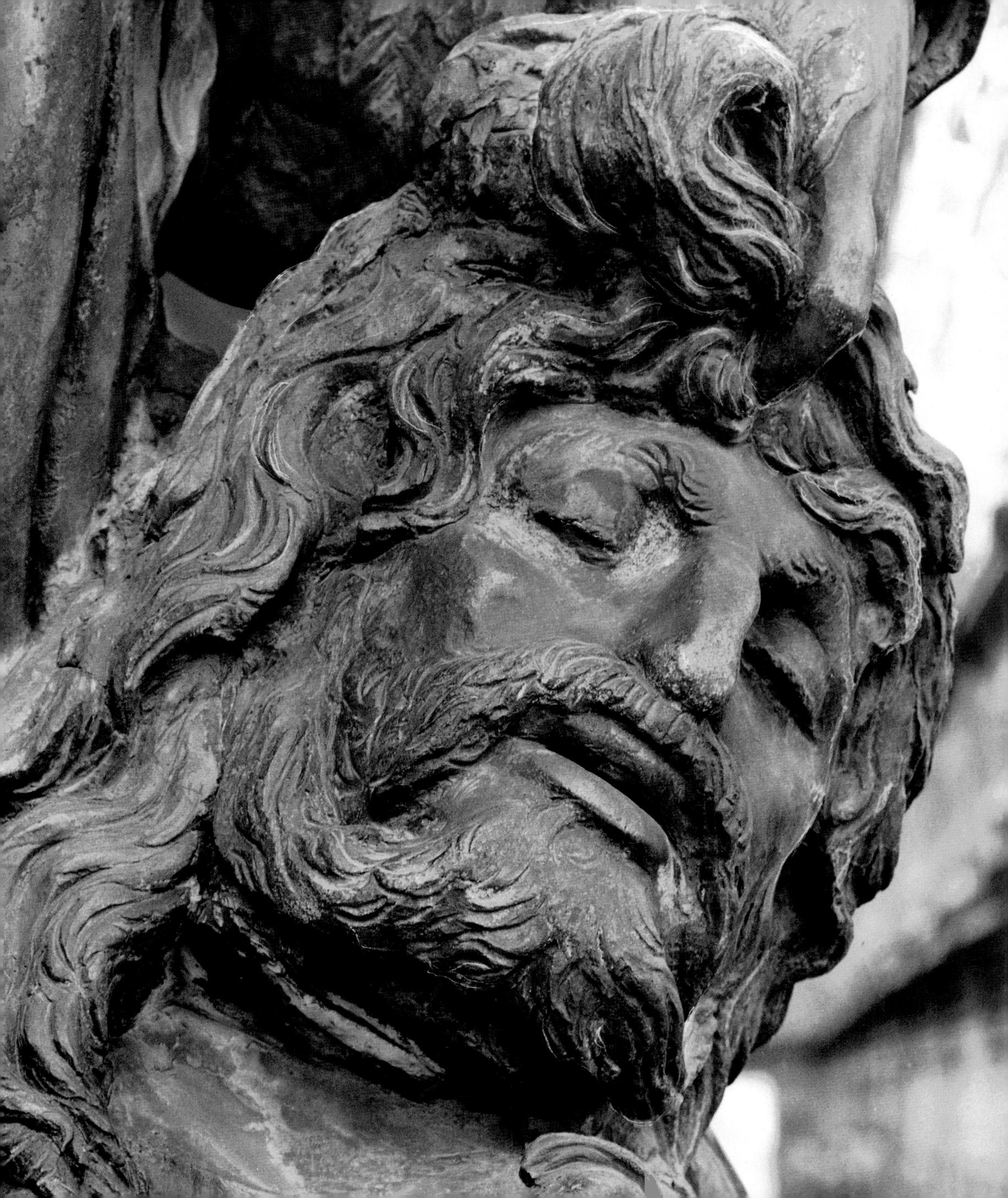

plate 39 Donatello

St John the Baptist

Duomo, Siena bronze, height 185 cm

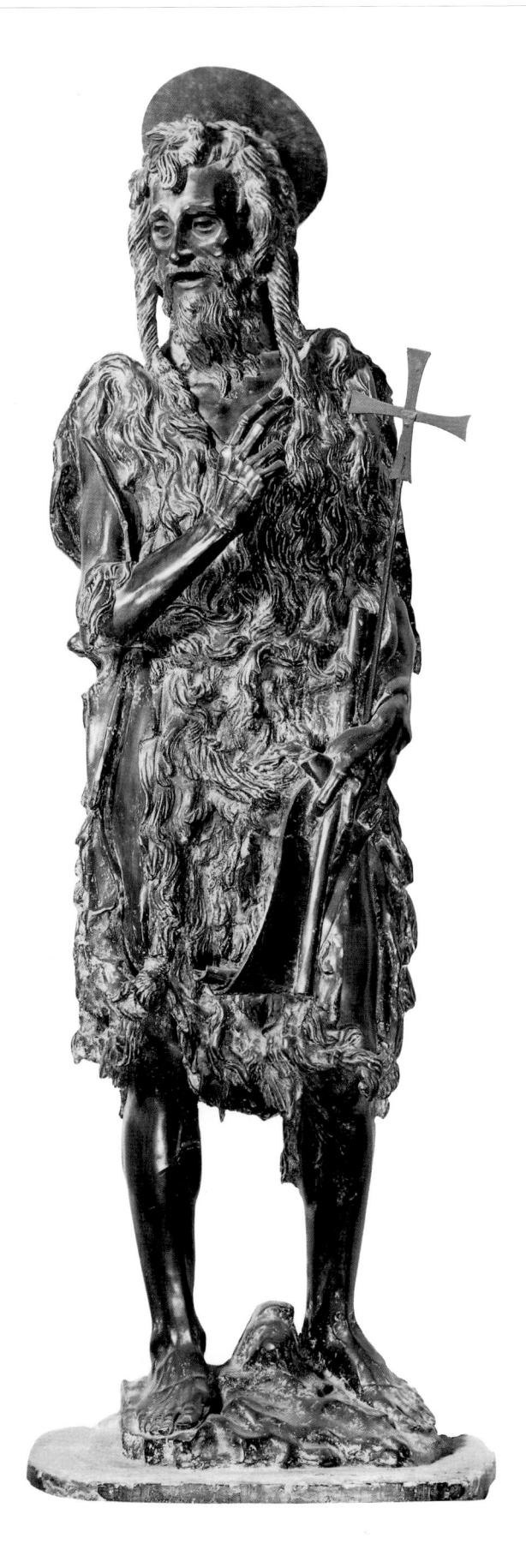

the greater in that two figures were involved instead of one. On one earlier occasion Donatello had been engaged, with another sculptor, Rosso, in planning a two-figure group of Abraham and Isaac for the Campanile. In this Isaac was shown kneeling below Abraham with head in profile and one knee protruding from the base. This motif was elaborated thirty-five years later in the Judith. Faced with the commission for the statue. Donatello might well have represented Judith holding a severed head. Instead he chose what no other sculptor in the fifteenth century would have attempted, an active pose, and showed Judith in arrested motion with sword raised, and Holofernes (like the Isaac in the Campanile group) in front of her. In Donatello's hands, however, this momentary action takes on a final character, and the reason for this becomes clear when we examine the construction of the group. The Judith stands on a rectangular cushion set on a triangular base. The front of the cushion and the front of the base are aligned, and from this dominant view (plate 34) we see Judith in full face with right arm raised; beneath her is the back of Holofernes with head turned in profile to the left. Moving round the statue to the left (plate 37) the positions are reversed; Judith is seen in profile and Holofernes in full face. At the back (plate 36) the angle of the base protrudes beyond the cushion and is straddled by Holofernes's legs, while on the fourth side (plate 35) Judith appears once more in profile treading on Holofernes's wrist. If Donatello had confined himself to devising a group of two figures with four independent faces,

this would have been astonishing enough. But the Judith reveals a synthesis of form and content so perfect that each of the four faces enriches its interpretative character, and extends our knowledge of the conflict that is expressed in marvellously graphic fashion in the head. Not only is this in its formal aspect one of the greatest of all statues, but it reaches a level of maturity and penetration which no later sculptor save Michelangelo attains.

The handling of the Judith is freer than that of the figures on the Padua high altar, and in the head of Holofernes (plate 38) the surface working is reduced, as though roughness of texture were a prerequisite of its effect. This same brusque handling is found again in the late 1450s in a bronze statue of St John the Baptist (plate 39) cast for Siena Cathedral. The Siena Baptist is not freestanding like the David and the Judith; rather is it an ultimate derivative of the Campanile statues, impelled by still greater emotional abandon and still stronger nervous force. It seems that Donatello in this last phase of his career grew increasingly intolerant of the barrier of technique, and that this led him on to investigate the possibilities of wooden sculpture. His earliest wooden statue is a figure of St John the Baptist in S. Maria dei Frari in Venice, carved in 1438 before he left for Padua; and wood is the medium of his last statue, the St Mary Magdalen in the Museo dell'Opera del Duomo in Florence (plates 40, 41). Here the formal sophistications of the Judith are set aside, and the figure is shown advancing on the right leg with the body slightly turned. In the

plate 40 Donatello

St Mary Magdalen

Museo dell' Opera del Duomo, Florence pigmented wood, height 184 cm

plate 41 *(opposite)* Donatello

Head of St Mary Magdalen

before cleaning Museo dell' Opera del Duomo, Florence (detail of plate 40)

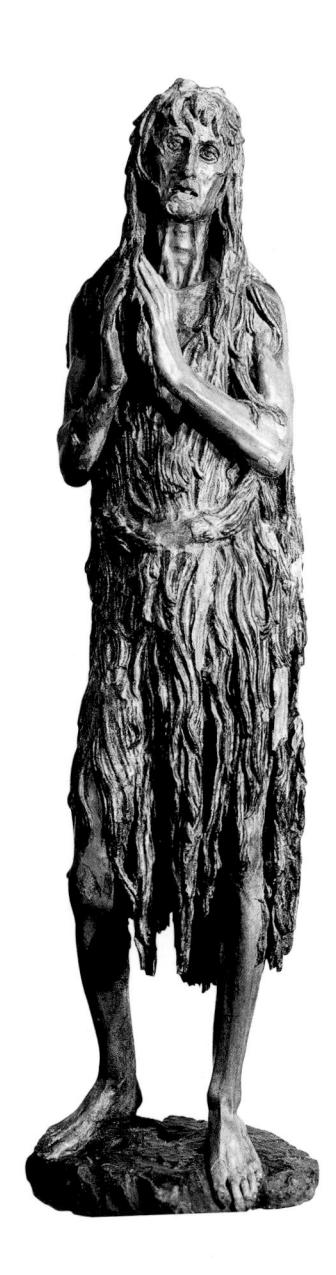

stained-glass window of the Coronation of the Virgin which he designed for the Duomo in Florence in the 1430s, Donatello reveals himself as a painter of the first rank, and his reliefs betray a constant interest in the pictorial potentialities of sculpture. This is reflected in the Magdalen in the vivid pigmentation of the parched flesh and the gilded surface of the hair robe. When we compare this mystical, introverted image with the marble David of fifty years before, it can be seen that Donatello has worked his way forward to a new conception of the art of sculpture, in which the figure has the extemporized character of a clay model, and is saturated in the sculptor's personality. In this last stage his progress seems to have been due not to objective, rational thought, but to some infinite enrichment of his whole creative machinery. An artist of superhuman capacity, deep-seated convictions, turbulent emotions, boundlessly inventive and inexhaustibly selfanalytical, Donatello when he died in 1466 had developed from the lingua franca of Gothic sculpture the language of sculpture as we know it now, had mapped out the future and broken irrevocably with the past, and through unaided intuition had formulated almost all the problems with which later sculptors have been concerned.

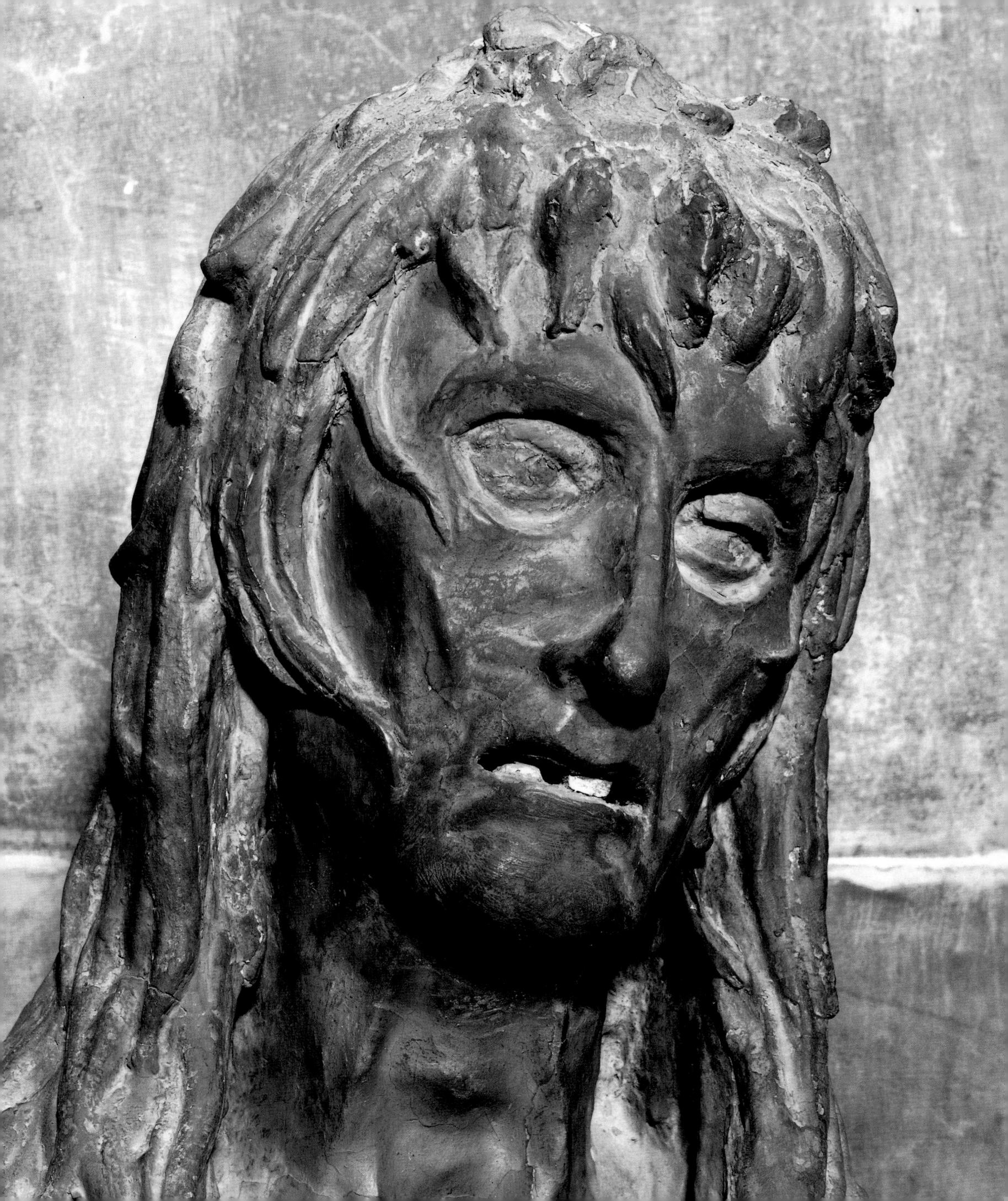

Donatello and the Renaissance Relief

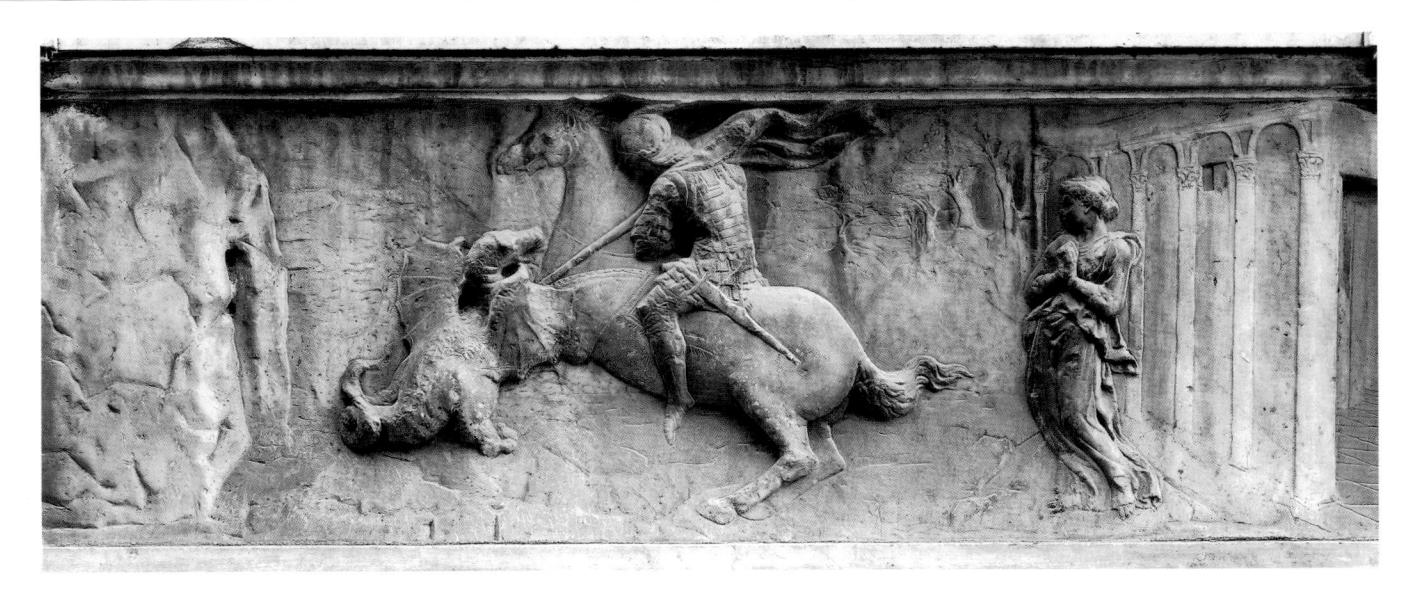

plate 42 Donatello

St George and the Dragon

Museo Nazionale, Florence marble, overall 39 × 120 cm

plate 43 *(opposite)* Donatello

St George and the Dragon

Museo Nazionale, Florence (detail of plate 42)

E ENCOUNTER DONATELLO as an artist in relief in a carving of St George and the Dragon on Or San Michele (plates 42, 43), set beneath the tabernacle containing the statue of St George. From the standpoint of construction, technique and narrative, this is a truly revolutionary scene. The tradition of narrative painting in Florence had been laid down by Giotto, and through the fourteenth century Giotto's frescoes in S. Croce remained a model of coherent story-telling. The tradition of narrative sculpture also stemmed from Giotto, not at first hand but through Andrea Pisano, who in the bronze door of the Baptistery (Vol. I, plate 94) adhered to a conception of the relief field that was essentially Giottesque. Ignoring the quadrilobe medallion which circumscribed each of his scenes, he set them on a kind of stage thrown out from the flat ground. On this he raised some elementary scenery, with strong horizontal accents and vertical supports, and inside or in front of it he placed the figures, which were planned as little statuettes though they were actually in relief. This type of relief became a norm. When Orcagna after the middle of the century began work on the tabernacle in Or San Michele, he employed it once more in carvings (Vol. I, plate 110) in which the octagonal frame serves as a window and the scene seems to be set in a real room. The notional space in these reliefs is greater than the actual space, but the relief style is dependent upon physical recession, and the theoretical relationship of the carved figures arises from their real relationship in space. When Nanni di Banco about

1413 carved a narrative relief for the niche of the Quattro Santi Coronati on Or San Michele (Vol. I, plate 201), he constructed it in the same way; it shows the side and rear walls of a room and the floorspace between them, and once more it is filled with figures in deep relief which register as statuettes. Immediately to the right of the niche with the Quattro Santi Coronati is Donatello's St George, and when we walk from one tabernacle to the other, the complete originality of Donatello's relief style becomes manifest.

The main distinction between the two reliefs is that in Donatello's the notional space is greater, while the physical recession is less. So long as the notional depth of a relief was directly related to real depth, its spatial potentialities were limited. But once notional depth was separated from real depth, they could be enormously enhanced. This divorce was achieved by Donatello in the St George relief. Instead of setting the figures against a flat ground which corresponded to the visual limits of the scene, he projected space through the background, and set the action behind the relief plane, not in front of it. It was linear perspective that made this possible, and in a few inches on the right side of the St George relief, for the first time since antiquity, linear perspective creeps back into Western art.

The St George and the Dragon is the first example of *rilievo stiacciato*, or flattened relief, a system of carving in which effects are made through minute variations of surface modelling, and by cutting so shallow that the forms seem to be drawn rather than carved. At this time and for

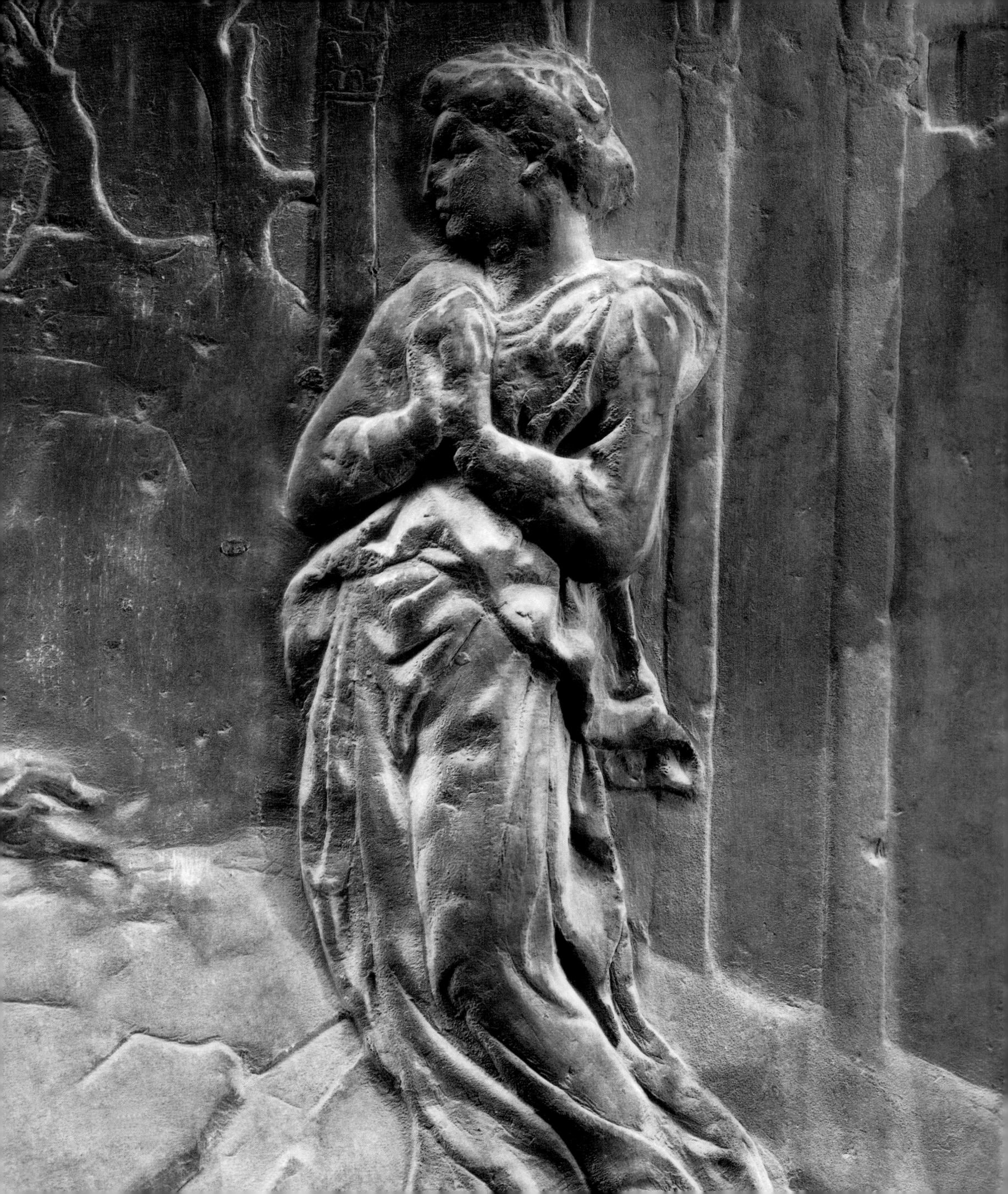

plate 44 Donatello

The Assumption of the Virgin

S. Angelo a Nilo, Naples (detail of plate 130) marble, 54×78 cm

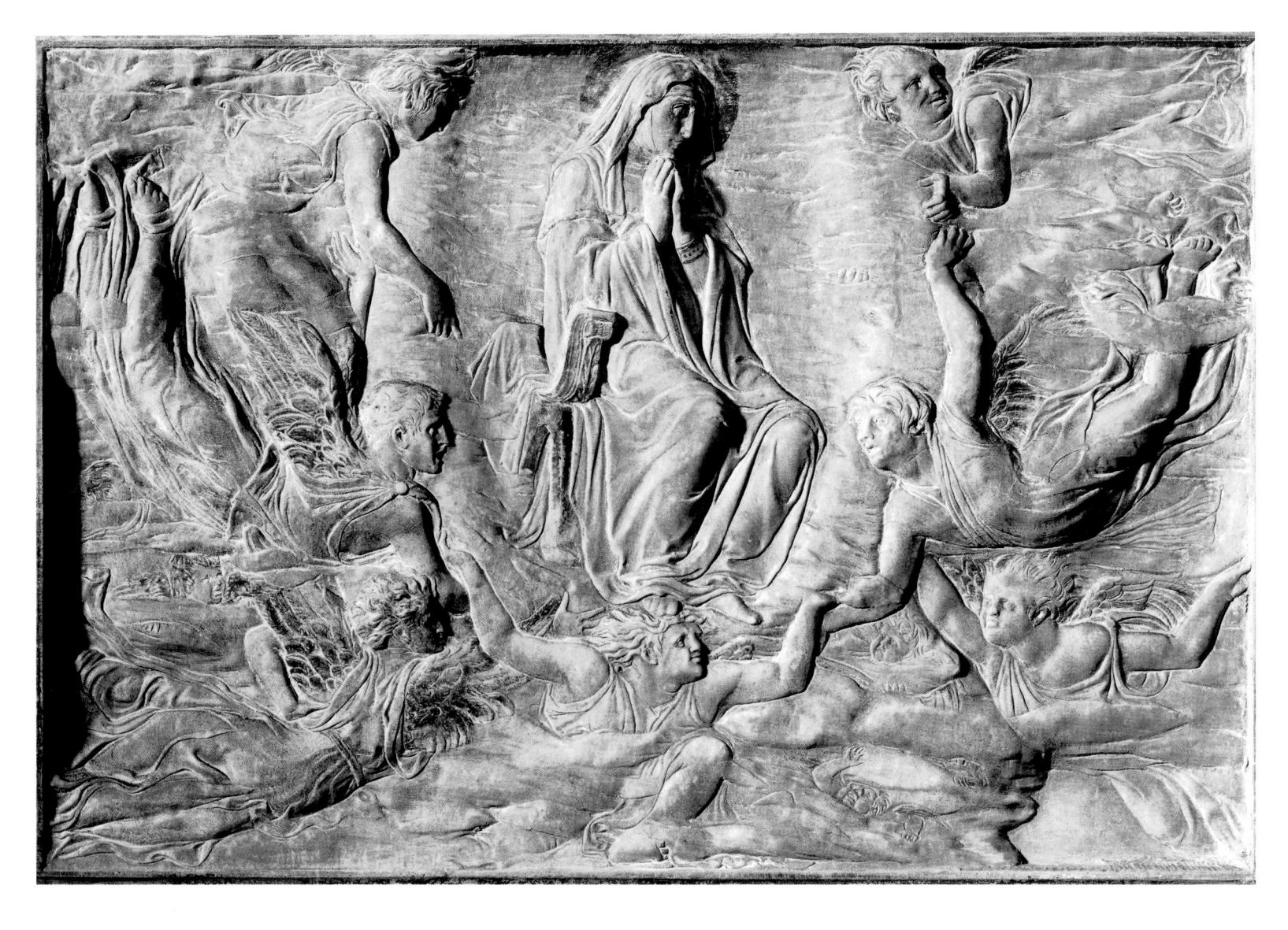

long afterwards rilievo stiacciato remained peculiar to Donatello. What was it that led him to explore its possibilities? The motive was probably a double one. Linear perspective was a technique for projecting space, and as it was practised in the first half of the fifteenth century it presupposed the existence of a flat projection plane. Physical recession invalidated the construction, and for that reason if it were to be applied to sculpture, a type of relief which made use of the maximum admissible depth had to be replaced by a new type in which actual depth was reduced to a bare minimum. At the same time the precedent of Roman carvings suggested that movement could be truthfully depicted only in low relief. The introduction of flattened relief therefore enabled Donatello to revive both the use of linear perspective and the conception of the figure in movement established in antiquity. Moreover, the visible world was not confined to the human figure and the buildings in which it dwelt; it was composed of natural forms and light and atmosphere. In the St George relief Donatello attempted to render all these things, and to render them not in terms of some existing concept but perceptually as they struck the eye. At a time when the earliest of Masaccio's frescoes was still more than five years away, the effects depicted in the background of this scene must have appeared miraculous. Later Donatello advanced further along these lines, but the relief itself records one of the most remarkable advances in sheer seeing that has ever taken place.

In Masaccio's paintings rational methods of

pictorial construction bring in their wake a rational attitude to religious iconography; thus the fresco of the Trinity in S. Maria Novella depicts a symbolic subject in terms of the real world, with God the Father elevated on a platform supporting the Crucified Christ, and the Virgin, prematurely aged by suffering, pointing towards the Cross. Exactly the same development occurs in Donatello. The first relief in which it is apparent is an Assumption of the Virgin (plate 44) carved for Naples about ten years after the St George relief. With the subject of St George and the Dragon there was no stable iconographical tradition from which to break away. With the Assumption of the Virgin, on the other hand, there was just such a tradition, in sculpture and in the immediate past. Behind Orcagna's great tabernacle in Or San Michele was a relief of the Assumption (Vol. I, plate 111), where the Virgin was shown seated in an almond-shaped glory, a mandorla, attended by six angels with St Thomas kneeling at one side, and over the north door of the Cathedral which Nanni di Banco, when he died in 1421, had left unfinished an Assumption of the Virgin (Vol. I, plate 204) faithful to the same formula. So far as Donatello was concerned, these two reliefs might never have been carved, and so radically does he reject them that at first sight it is difficult to realize he is portraying the same scene. The mandorla has been reduced to an indefinite depression in the centre; the neutral ground has been replaced by clouds; and the Virgin has been transformed into an aged figure, elevated by genii on a small draped seat. Yet no more than with Masaccio's Trinity

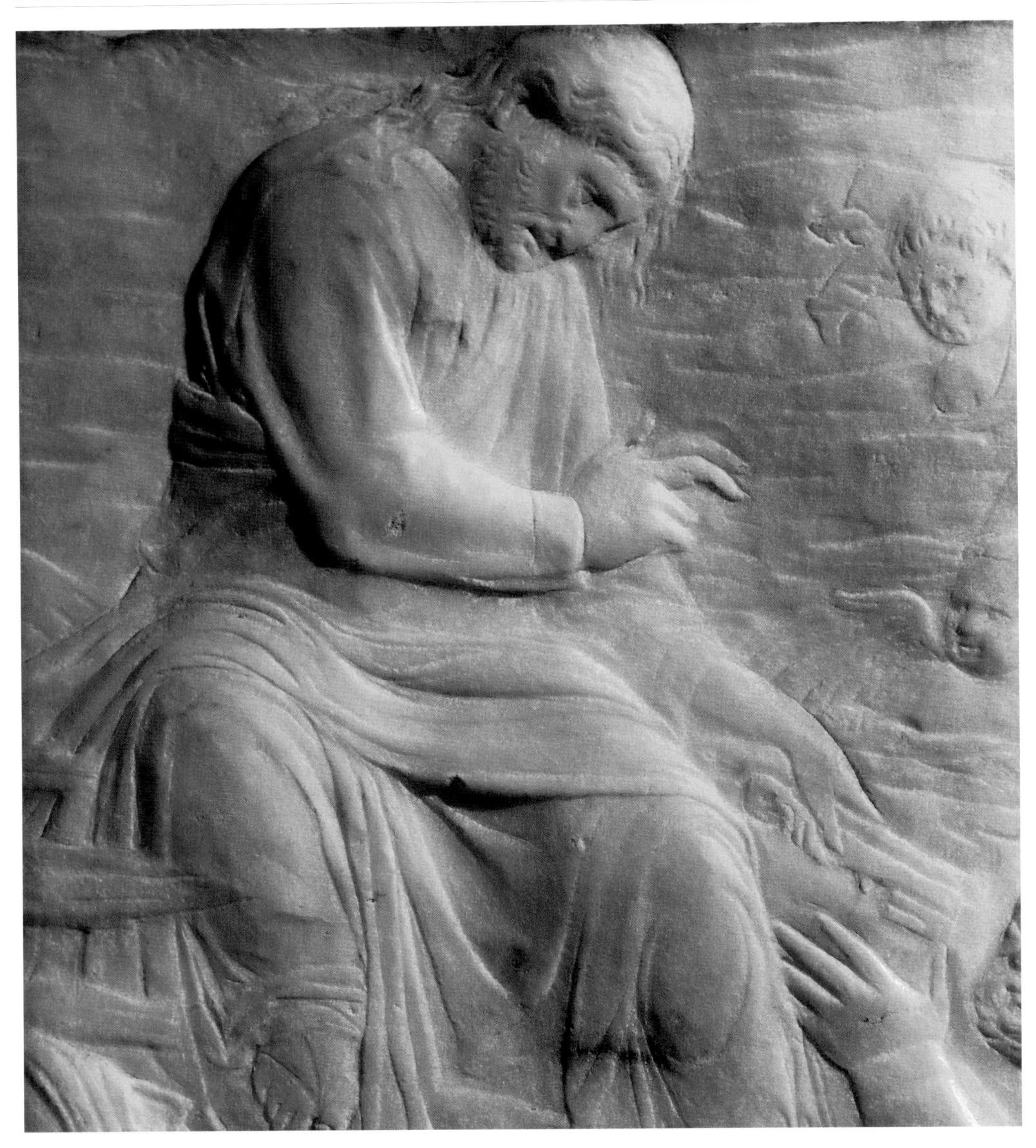

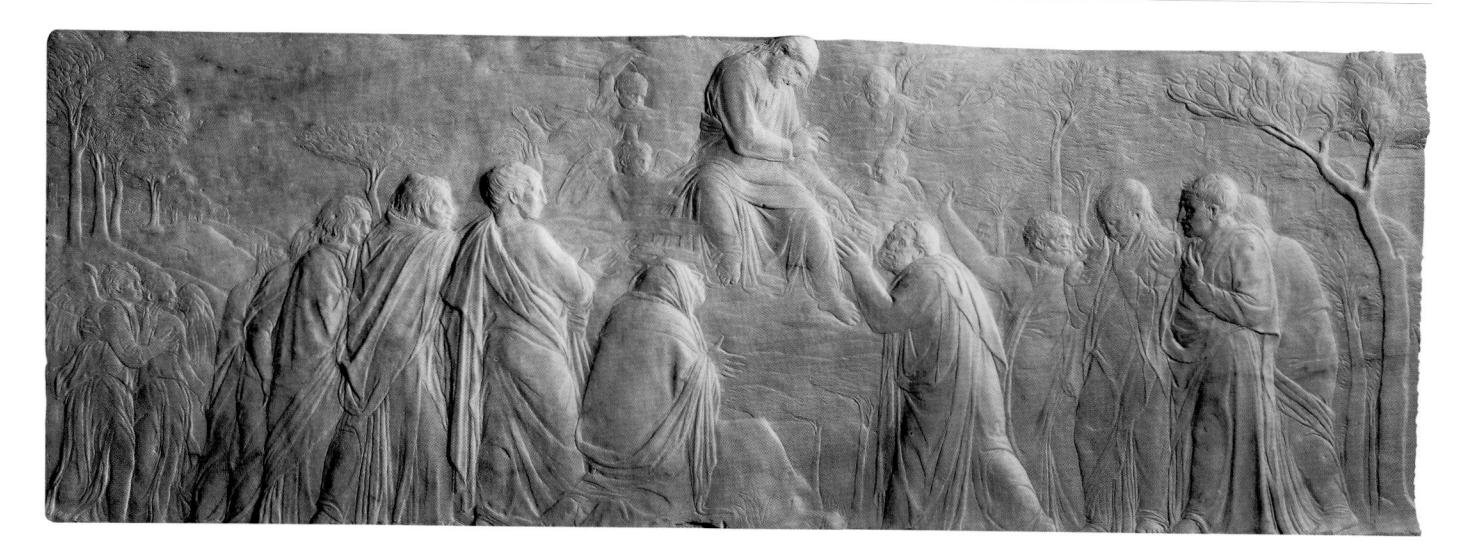

does the term rational imply prosaic, and Donatello's scene has a visionary intensity that is in the highest degree moving and personal.

This aged Virgin is found again in what is in some respects the most completely realized of Donatello's low reliefs in marble, the Ascension with Christ Giving the Keys to St Peter in London (plates 45, 46). Once more there was an iconographical tradition, established by Orcagna in the Strozzi altarpiece in S. Maria Novella, whereby the keys of heaven were presented to St Peter by a symbolic Christ. In Donatello's relief it seems that the conventional narrative has been reanimated by a poet of inexhaustible humanity and consummate metrical resource. The centre is filled by a triangle with Christ at its apex and the Virgin and St Peter at the limits of the base; to the left the Apostles are arranged in a descending line, and behind them, in the distance, a receding line of trees leads the eye to the city of Jerusalem. The system of composition recalls that of Masaccio's Tribute Money in the Brancacci Chapel; the ratio of figures to picture space is almost the same in both, as is the layout with its central Christ and its Apostles ranged in a semicircle on the right and deployed diagonally opposite. But Donatello's scheme is the more progressive of the two. Where Masaccio uses linear perspective to establish the physical validity of the main scene, Donatello not only disposes the 16 foreground figures rationally in space, but creates round them a sense of distance and recession far greater than the narrative necessitates. The distant panorama and the cloudy sky again capture effects that remained

beyond the reach of painters till the extreme end of the century.

For the ancillary figures of the Ascension and Assumption classical models were undoubtedly employed. Our main evidence for Donatello's attitude to the antique, however, is provided by two works on which he was engaged between 1433 and 1439, the Singing Gallery or Cantoria of the Duomo in Florence (plates 47, 48) and the external pulpit of Prato Cathedral (plate 49). Both are carved with life-size putti and were inspired by Roman sarcophagus reliefs, yet in both the invention is so turbulent that the carvings as they issued from Donatello's brain took on a character that is positively anti-classical. The Singing Gallery and pulpit were carved at the same time and depend from the same models, but basically they are two different works. The first is a rectangular structure projecting from the wall on carved supports, with a single relief running the whole length of the front. The second is circular, with seven isolated panels. In one the carving is continuous, in the other it is subdivided into separate fields. In the Cantoria the dancing putti are set behind protruding columns, whereas in the pulpit they occupy the front plane of the balustrade, and the carving for this reason is less emphatic and is in shallower relief. But the spirit that infects them is the same; they dance and stamp and sing, they kick and shout with superhuman zest. The unclassical intention behind these orgiastic carvings is reflected in the structures in which they are placed. The ornament and mouldings of the Cantoria are ebullient and

plate 45 *(opposite)* Donatello

Christ giving the Keys to St Peter

Victoria and Albert Museum, London (detail of plate 46)

plate 46 Donatello

The Ascension with Christ giving the Keys to St Peter

Victoria and Albert Museum, London marble, overall 41 × 115 cm plate 47 Donatello

Cantoria

Museo dell'Opera del Duomo, Florence marble with mosaic inlay, 348 × 570 cm

plate 48 *(opposite)* Donatello

Cantoria

Museo dell'Opera del Duomo, Florence (detail of plate 47)

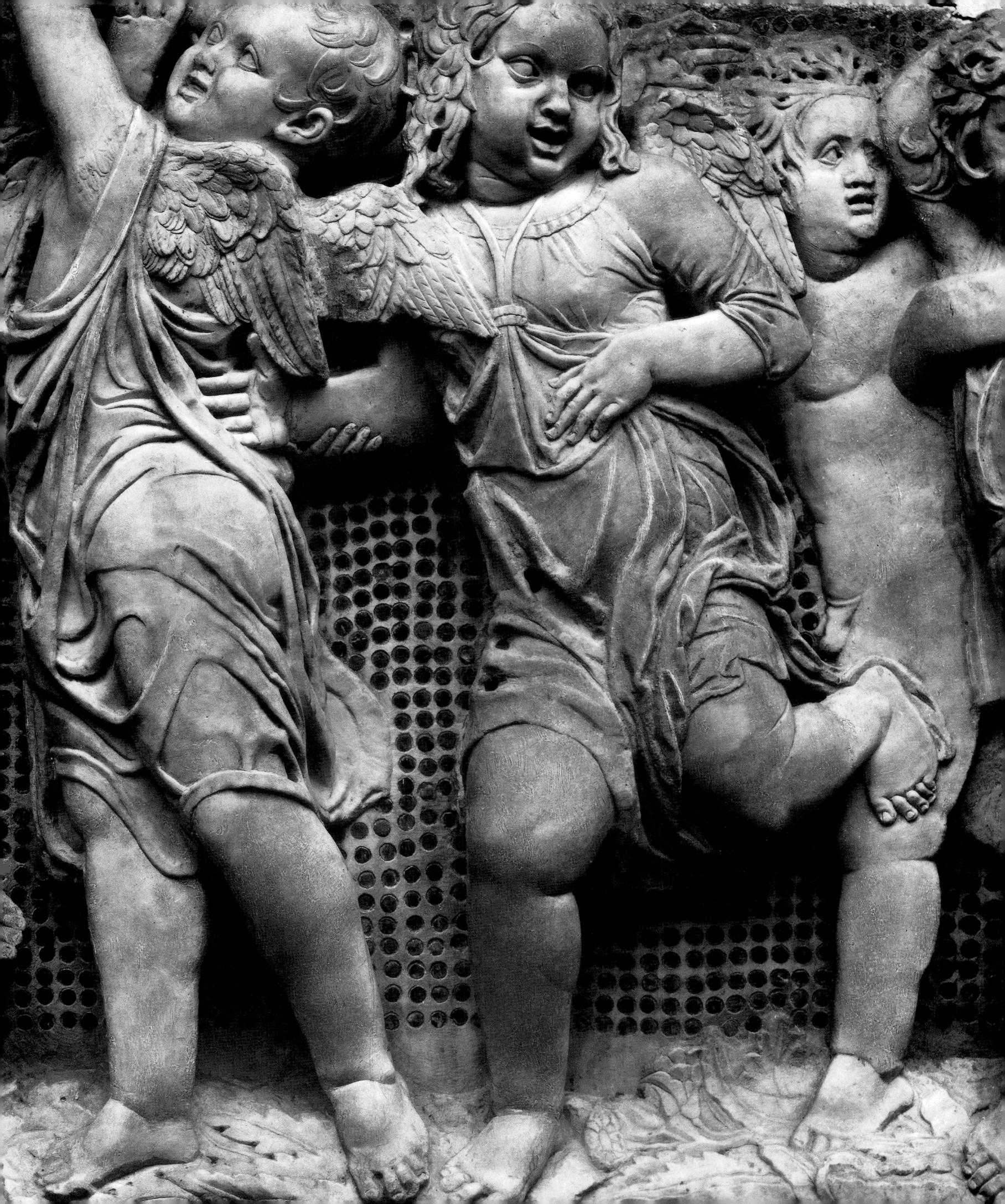

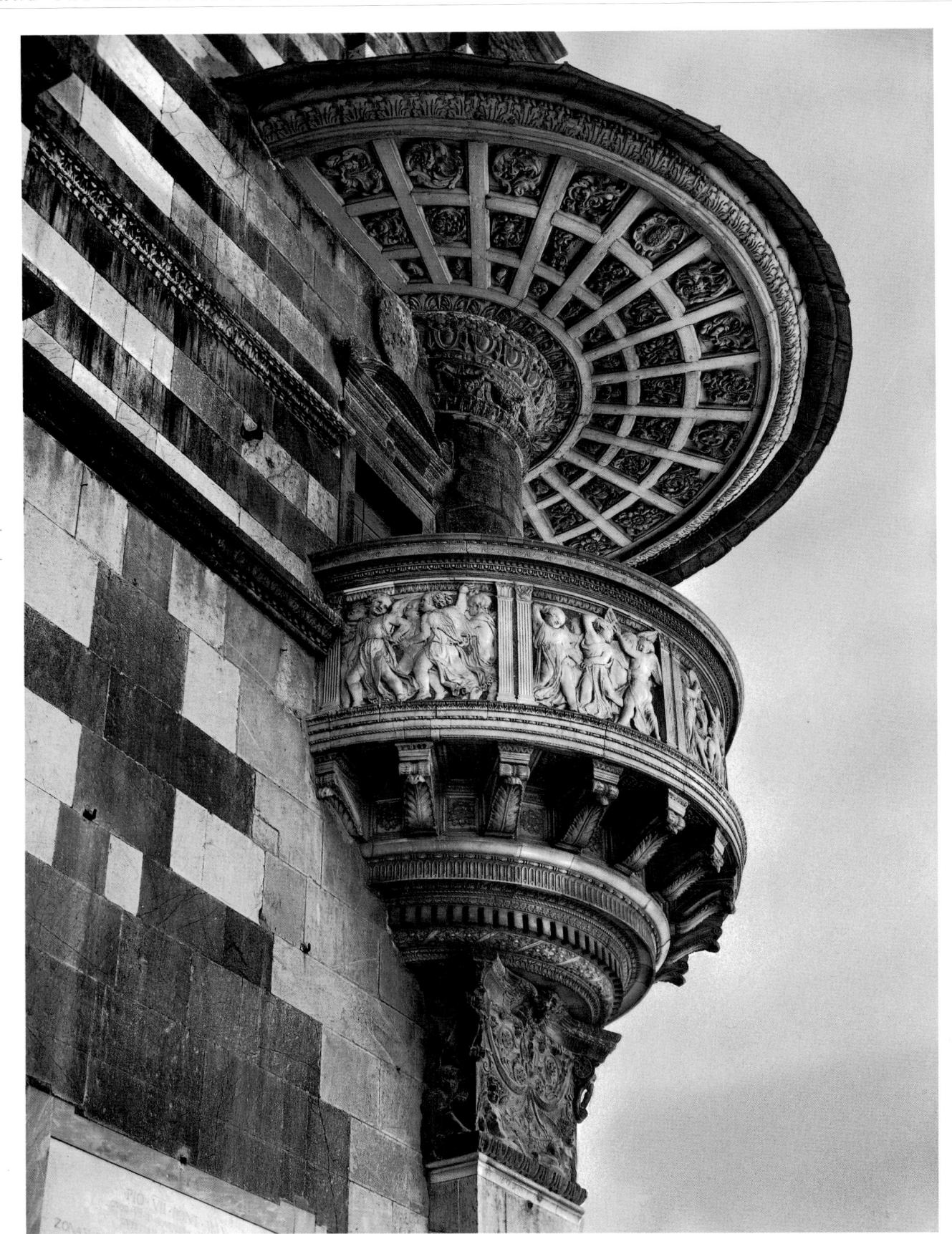

plate 49 Donatello

External Pulpit

Duomo, Prato marble with bronze capital individual panels 74×79 cm baroque, and the pulpit is enriched with a wealth of decorative detail, much of it classical in origin but treated in a spirit that is far from classical.

We receive this same sense of tumultuous inventiveness from the bronze door (plates 50, 51) which Donatello cast about 1440 for the Old Sacristy in S. Lorenzo. The doors of Andrea Pisano and Ghiberti on the Baptistery are filled with narrative scenes. Donatello's door, on the other hand, represents Saints. Each wing of the door contains five rectangular reliefs, and each relief contains two figures and no more. These figures might have been represented in stiff equilibrium, but instead Donatello establishes a connection between them. Sometimes this is a conversation on equal terms; sometimes one Saint disturbs another who is meditating at the side; sometimes they meet unexpectedly and salute each other with their palms; and sometimes, as though late for an appointment, they just hurry by. The genesis of this idea is found in the Byzantinizing carvings at the entrance to the Baptistery at Pisa, where Saints and Apostles are represented in pairs in rather the same way. In the panels of the doors, however, this motif is interpreted with a freedom and variety of which no other artist in the fifteenth century save Donatello – and perhaps no other artist at all – would have been capable. Once again this freedom is achieved not merely through exercise of the imagination, but by close study of human gestures and deportment; and the reliefs contain some of the most eloquent dialogues of hands in the whole of art.

In the spandrels of the cupola of Brunelleschi's

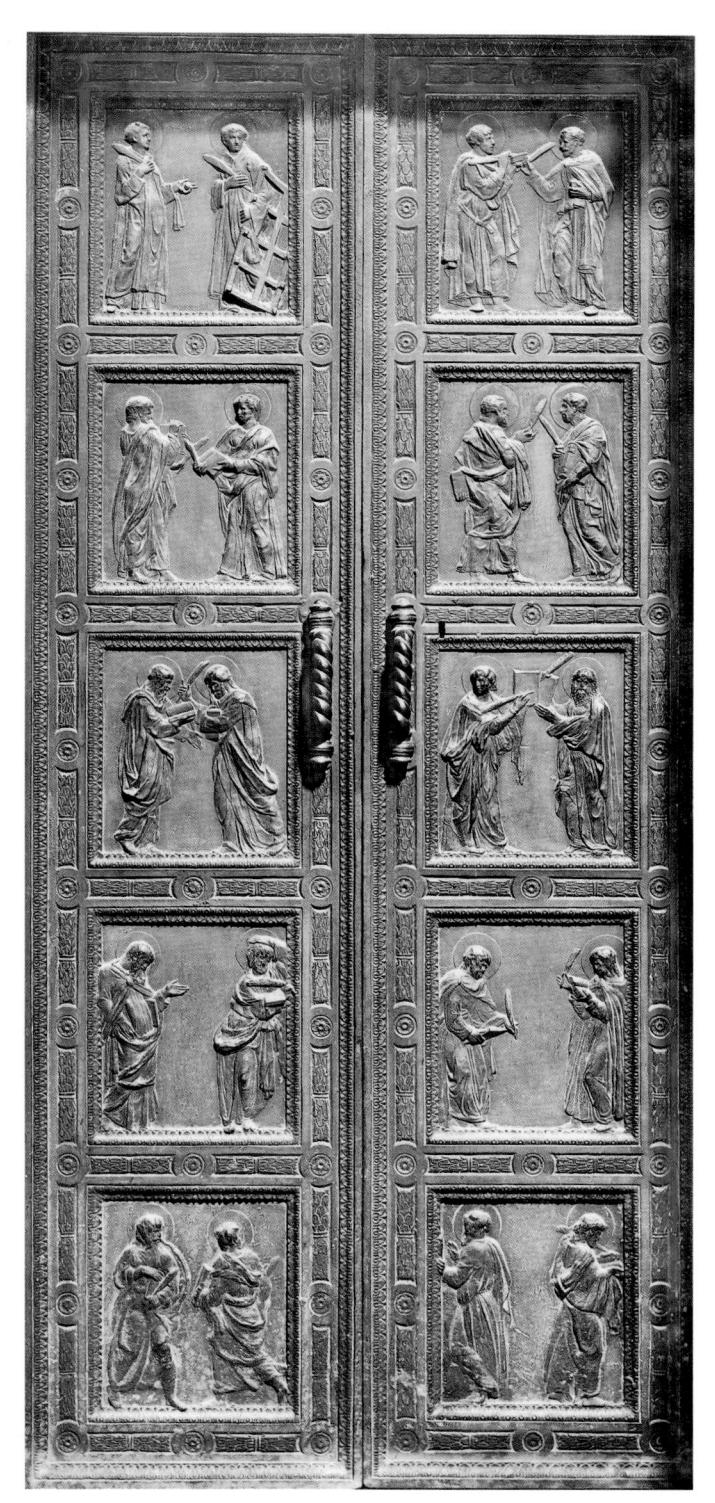

plate 50 Donatello

Sacristy Door

Sagrestia Vecchia, S. Lorenzo, Florence bronze, 235 × 109 cm

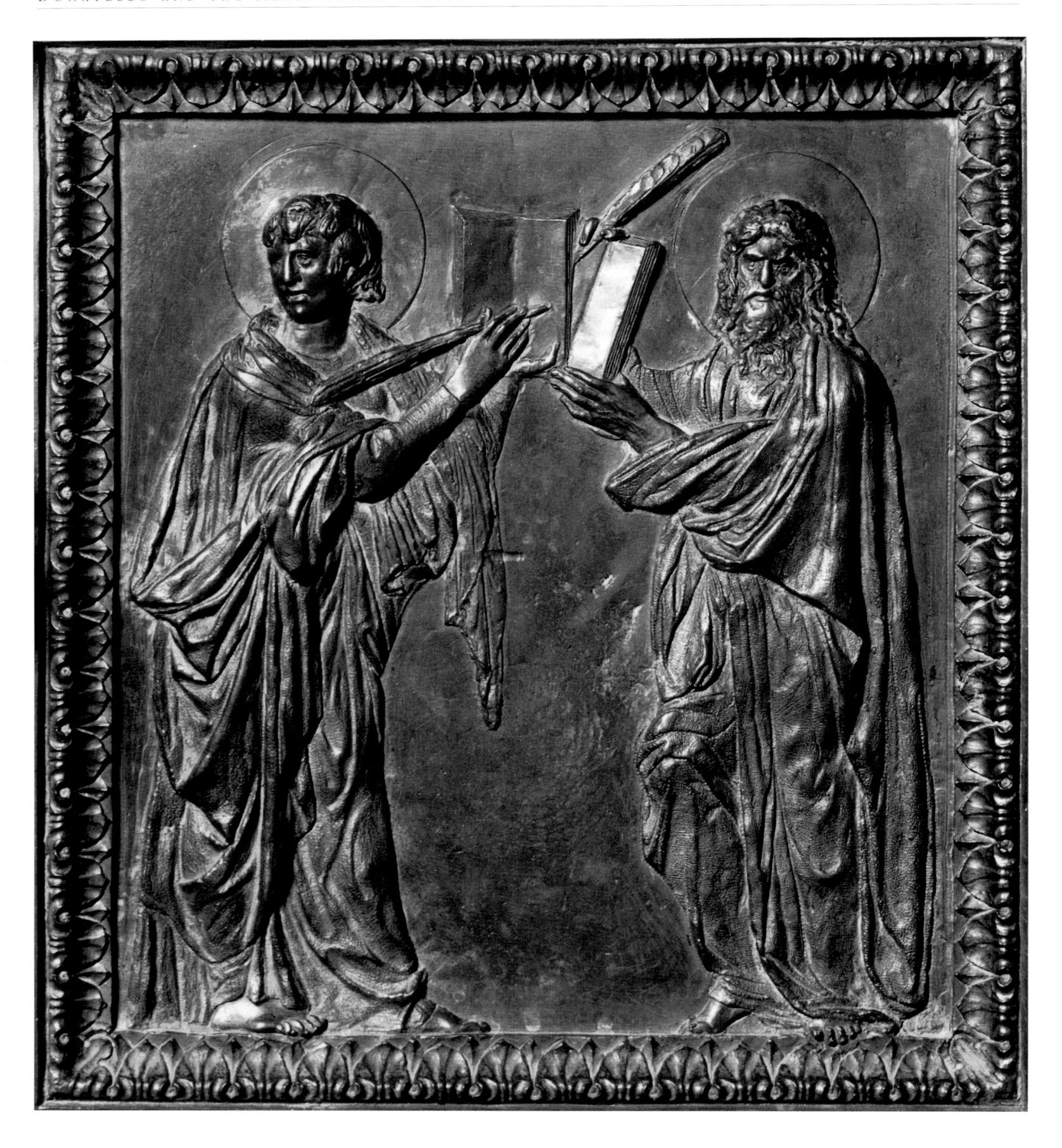

plate 51 (opposite) Donatello

Bronze Door Panel

Sagrestia Vecchia, S. Lorenzo, Florence (detail of plate 50)

plate 52 Brunelleschi

The Old Sacristy

S. Lorenzo, Florence

plate 53 Donatello

Sts Stephen and Lawrence

Sagrestia Vecchia, S. Lorenzo, Florence pigmented stucco, height c. 215 cm

plate 54 (opposite) Donatello

The Assumption of St John the Evangelist

Sagrestia Vecchia, S. Lorenzo, Florence (detail of plate 52) pigmented stucco, diameter inside moulding c. 215 cm sacristy, and in corresponding positions on the walls, were eight circular pietra serena frames (plate 52). Four of these Donatello filled with painted stucco reliefs of the Evangelists, and four with scenes from the legend of St John. It will suffice to look for a moment at one of the narrative reliefs (plate 54), the Assumption of St John. In this linear perspective is used more freely than in the Ascension (plate 46). The projection plane is set high in the design, leaving a neutral segment in the foreground which is filled with a low wall, and the construction that is projected from this artificial base is of astonishing depth and complexity. The main action takes place between two open loggias filled with figures that stare up into the sky. In the marble reliefs the focus of narrative interest is invariably placed in the centre of the composition on a forward plane. At S. Lorenzo, on the contrary, the narrative focus is set in the middle distance at a point determined by the exigencies of the individual scene. Brunelleschi is said to have protested that Donatello's doors and roundels formed a disturbing element in the architectural complex of his sacristy, and it is difficult not to feel some sympathy with him in this view. But the aggressively theoretical construction of the narrative reliefs displays the full range of a technique that was employed again at Padua in the four bronze reliefs for the high altar of the Santo.

Donatello's first bronze statue was cast about 1423 for Or San Michele (plate 17), and his first bronze relief was made soon after for the Siena font (plate 55). On Or San Michele he was measuring himself against Ghiberti, and we have

already seen how different his conception of the role of the bronze statue was. On the Siena font (Vol. I, plate 155) he was again measuring himself against Ghiberti, who contributed two of its six gilt bronze reliefs. On its own terms of reference the more vigorous of these, St John Preaching before Herod (Vol. I, plate 156), is a reasonably dramatic work, but its idiom is that of International Gothic, and the scene is dramatic only in so far as the limited repertory of gesture and the dance-like movements allow. The terms of reference of Donatello's Banquet of Herod, on the other hand, are realistic. The architecture is solidly constructed, the types are physically convincing, and the action is forthright and direct. On the Siena font, however, Donatello was working in a relief style laid down by Ghiberti, in which the foreground was recessed and the foreground figures were cast in deep relief. For that reason the spatial scheme is less consistent than in the Ascension, and the figure of Salome is more rigid than the corresponding figure in the St George relief. In bronze, as in marble, it was necessary to flatten the relief, if these faults were to be redressed, for only when its physical recession was reduced, could the principle of continuous action - established in this scene by the Herod shrinking back in horror from the severed head, the reassuring gesture of the man beside him, the nausea of the fellow guest, and the two panicstricken children on the left – register as Donatello intended that it should.

Almost the only orthodox aspect of the Padua altar (1444–53) was that, like a painted altarpiece, it

plate 55 Donatello

The Presentation of St John the Baptist's Head to Herod

Baptistery, Siena gilt bronze, 60 × 61 cm

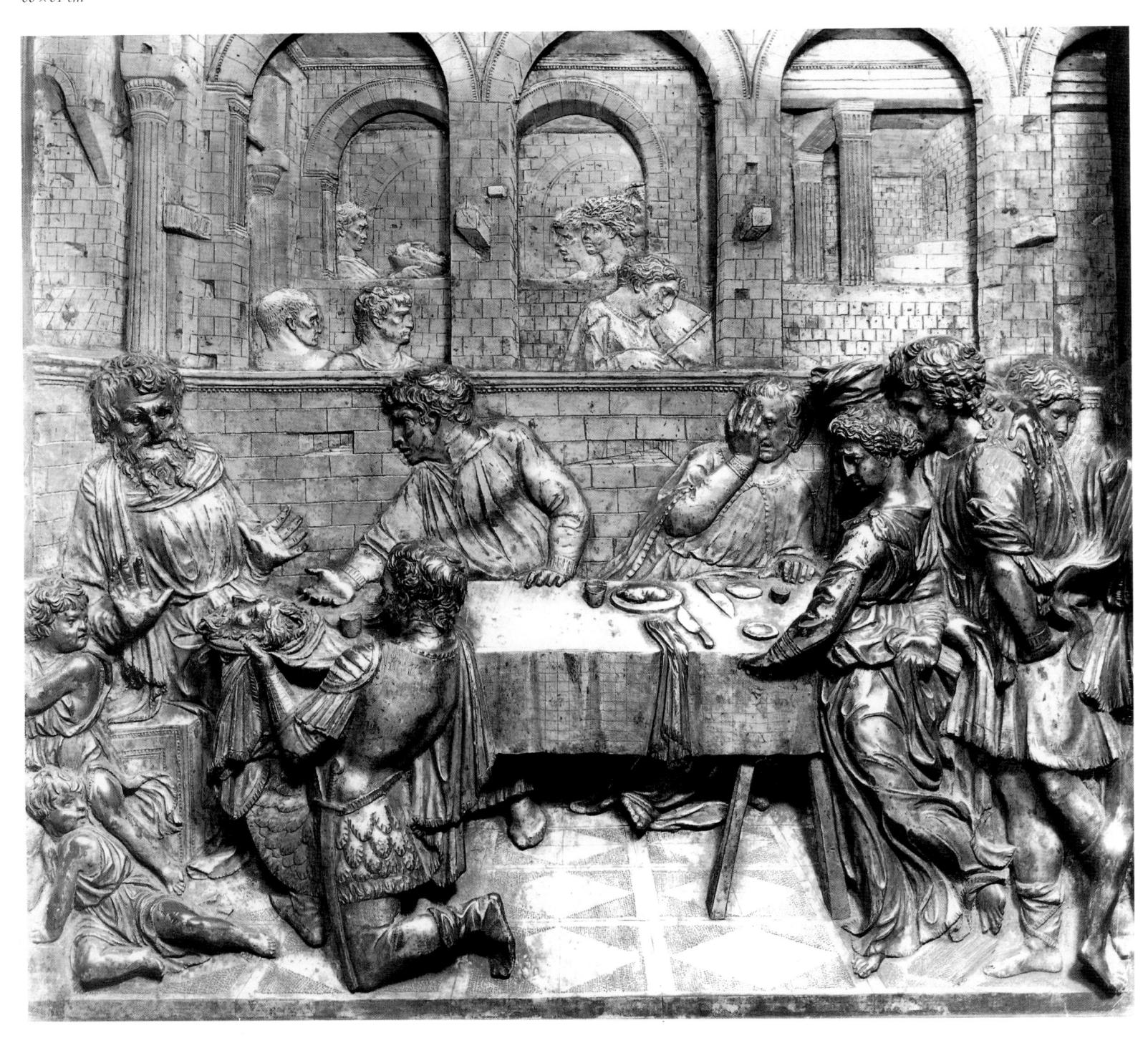

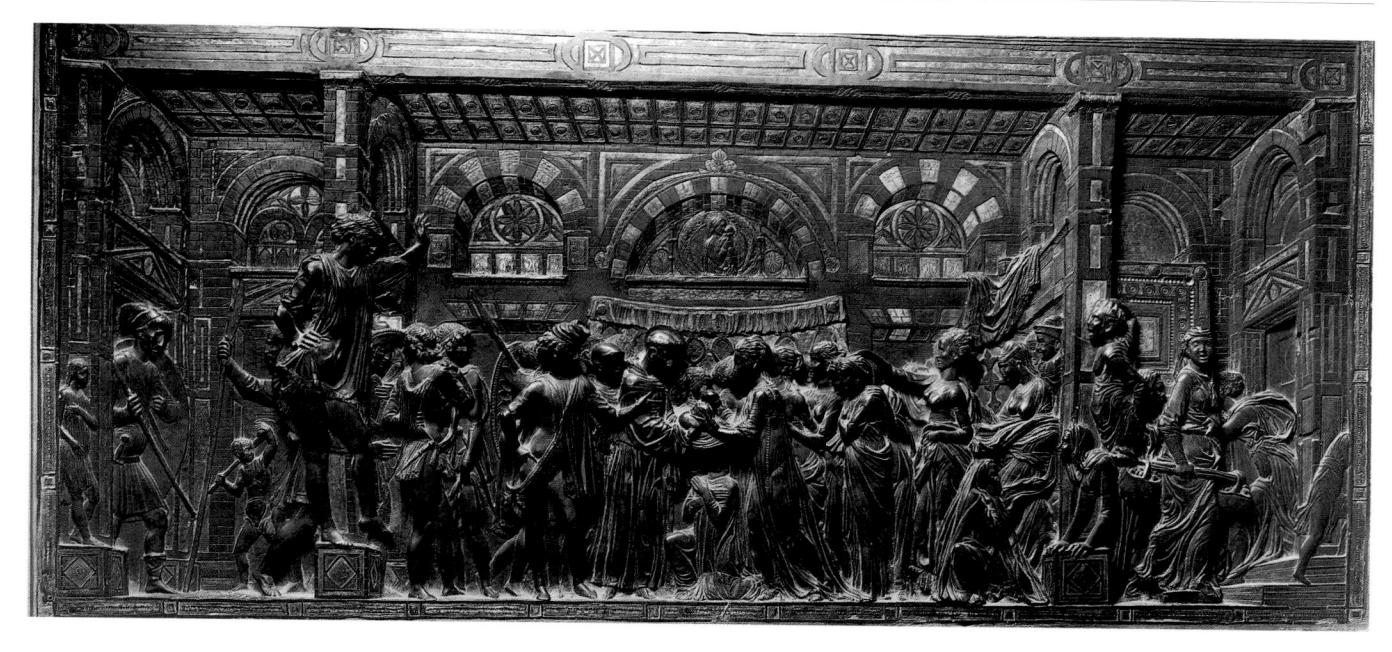

included a predella, with four horizontal scenes from the life of St Anthony, two on the front of the altar and two at the back (plates 21, 22). The perspective construction of these scenes is so remarkable that it is tempting to regard them as a spatial vacuum into which figures have been casually introduced. This is a misunderstanding of their style, for in no previous reliefs by Donatello does the pulse beat so fast or the temperature run so high. The iconography is based upon a local source, an abstract of the life of St Anthony prepared by a Paduan notary in 1433, and it is the local cult, with all its fervour and abandon, that is summed up in Donatello's scenes. The events portrayed are the Saint's most celebrated miracles, the Miracle of the New-Born Child, the Miracle of the Mule, the Miracle of the Repentant Son, and the Miracle of the Miser's Heart. In each relief the miraculous occurrence fills the centre of the scene, so that we see the thaumaturge facing the mother with her new-born child and the young father standing at the left (plate 56), the Saint holding out the host towards the genuflecting mule which neglects the oats proffered by two men behind (plate 57), the Saint kneeling in profile clasping the foot of the repentant youth (plates 58, 60), and the Saint standing at the miser's bier while a group of figures on the extreme left search in a coffer for the dead man's heart (plate 59). In the Banquet of Herod at Siena the event is reflected in the faces of the onlookers. This technique is employed again at Padua, in a more ambitious fashion and to far greater effect. There are 26 figures in the earliest of the reliefs, and in

the latest more than 70 are shown. They raise themselves on every ledge to secure a clearer view, they cling to columns lest they should be trampled by the throng, they crane forward, the old carried by the young, they kneel and prostrate themselves upon the ground. Nowhere in the whole fifteenth century is the contagion of emotional fervour represented with such power and passion as in these extraordinary works.

But (and this is a miracle as well) the emotional turmoil is combined, on Donatello's side, with rigorous intellectual discipline. By the time that he reached Padua, linear perspective had become for Donatello not merely a method of establishing a space illusion, but the means of imposing a unifying pattern on the surface of the relief. In what is chronologically the earliest of the scenes, the Miracle of the New-Born Child, a flat rear wall runs parallel to the projection plane, and the scene is divided into five equal areas, two on the right and left demarcated by projecting walls, and a third, in the centre, marked out by a canopy. In the second scene, the Miracle of the Mule, the field is divided into three equal sections by means of an arcade in front, and the rear wall is pierced by a semicircular grille or window, through which a second, more distant grille is visible. This curious device has no narrative significance, and represents play of perspective in its purest form. In the third interior relief, the Miracle of the Miser's Heart, actually the latest of the four, the side sections are closed by walls, but the centre shelves sharply away towards a distant doorway at the back. This formula is repeated in the Miracle of the

plate 56 Donatello

The Miracle of the New-Born Child

S. Antonio, Padua bronze, parcel-gilt, 57 × 123 cm

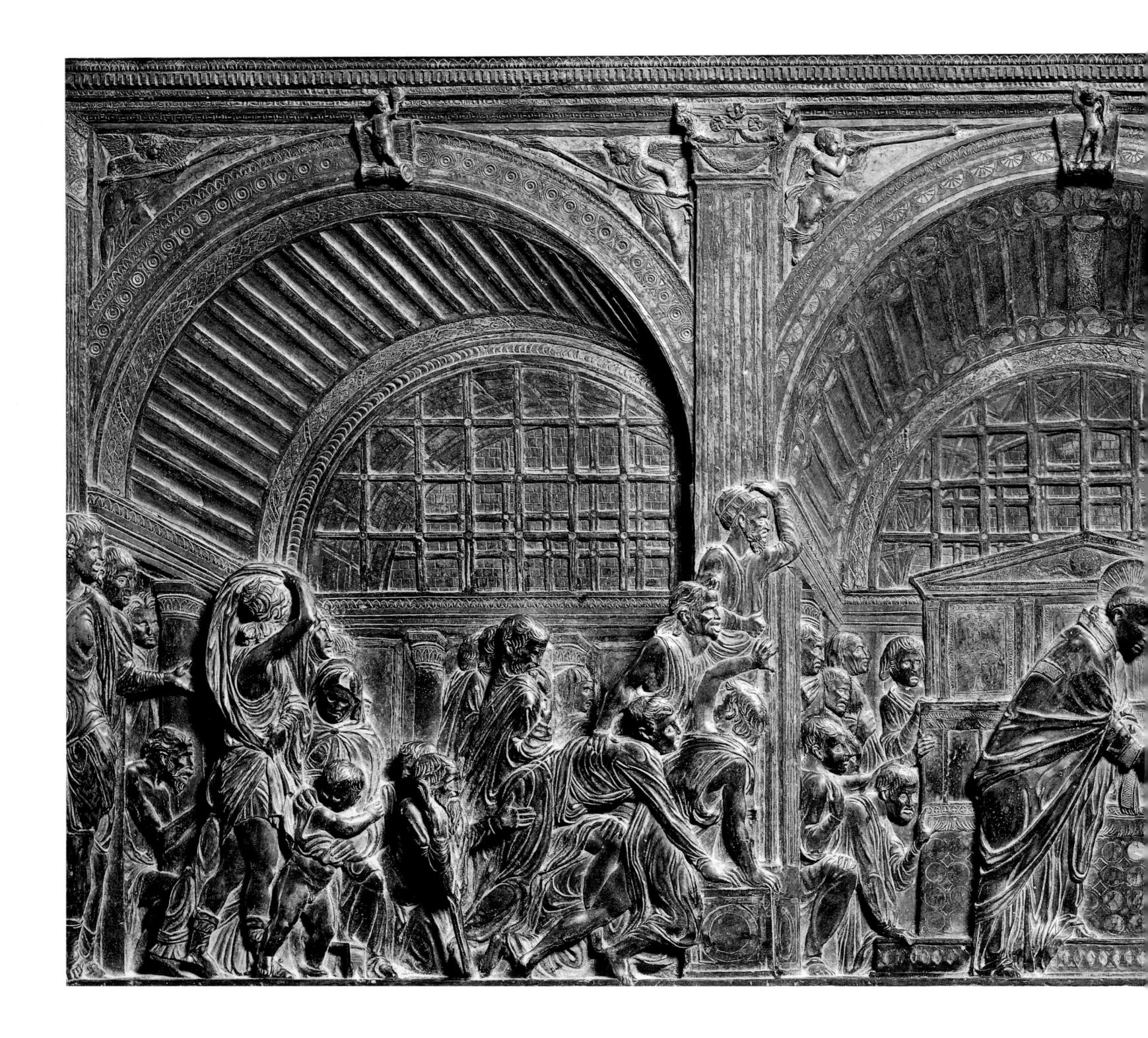

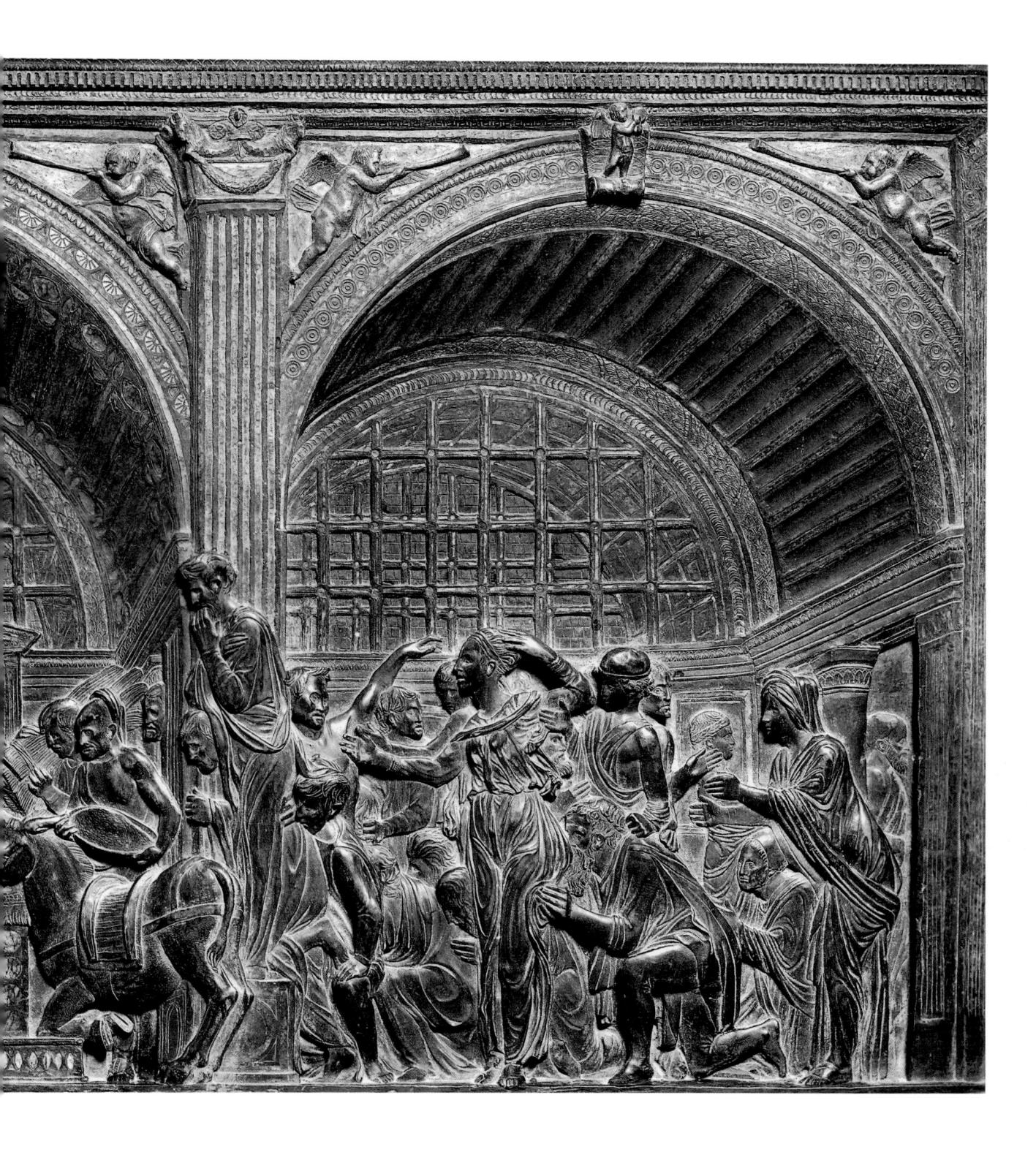

plate 57 Donatello

The Miracle of the Mule

S. Antonio, Padua bronze, parcel-gilt, 57×123 cm

plate 58 Donatello

The Miracle of the Repentant Son

S. Antonio, Padua bronze, parcel-gilt, 57×123 cm

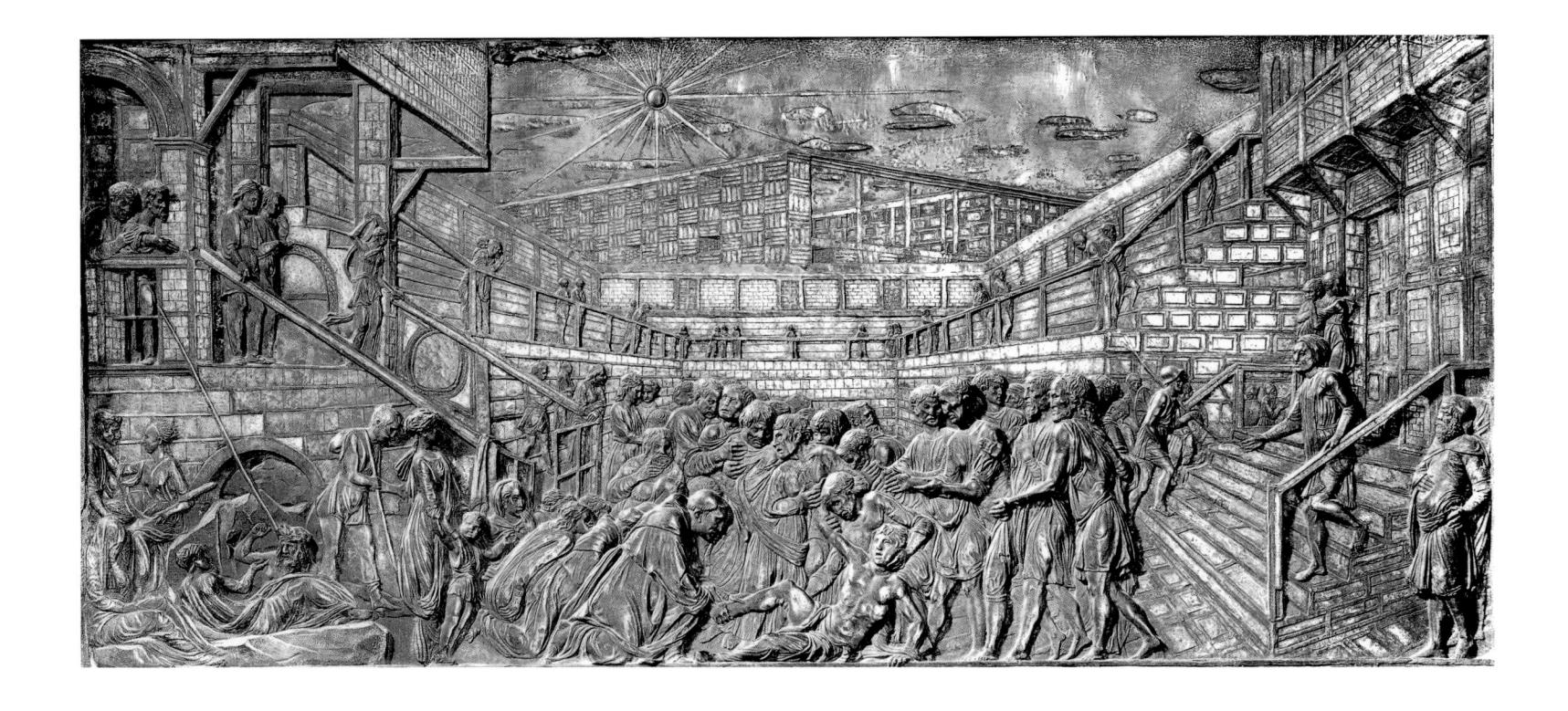

plate 59 Donatello

The Miracle of the Miser's Heart

S. Antonio, Padua bronze, parcel-gilt, 57×123 cm

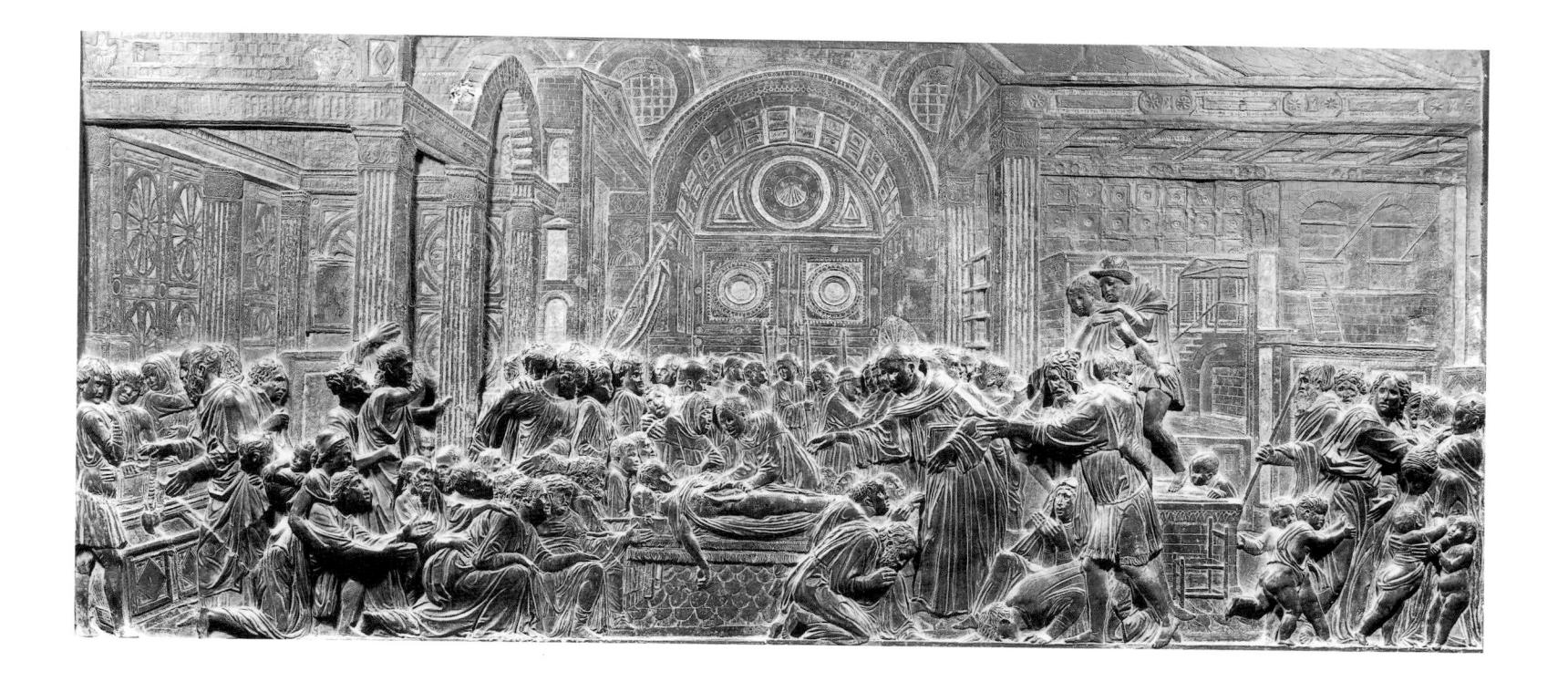

plate 60 Donatello

The Miracle of the Repentant Son

S. Antonio, Padua (detail of plate 58)

plate 61 *(opposite)* Donatello

The Miracle of the Repentant Son

S. Antonio, Padua (detail of plate 58)

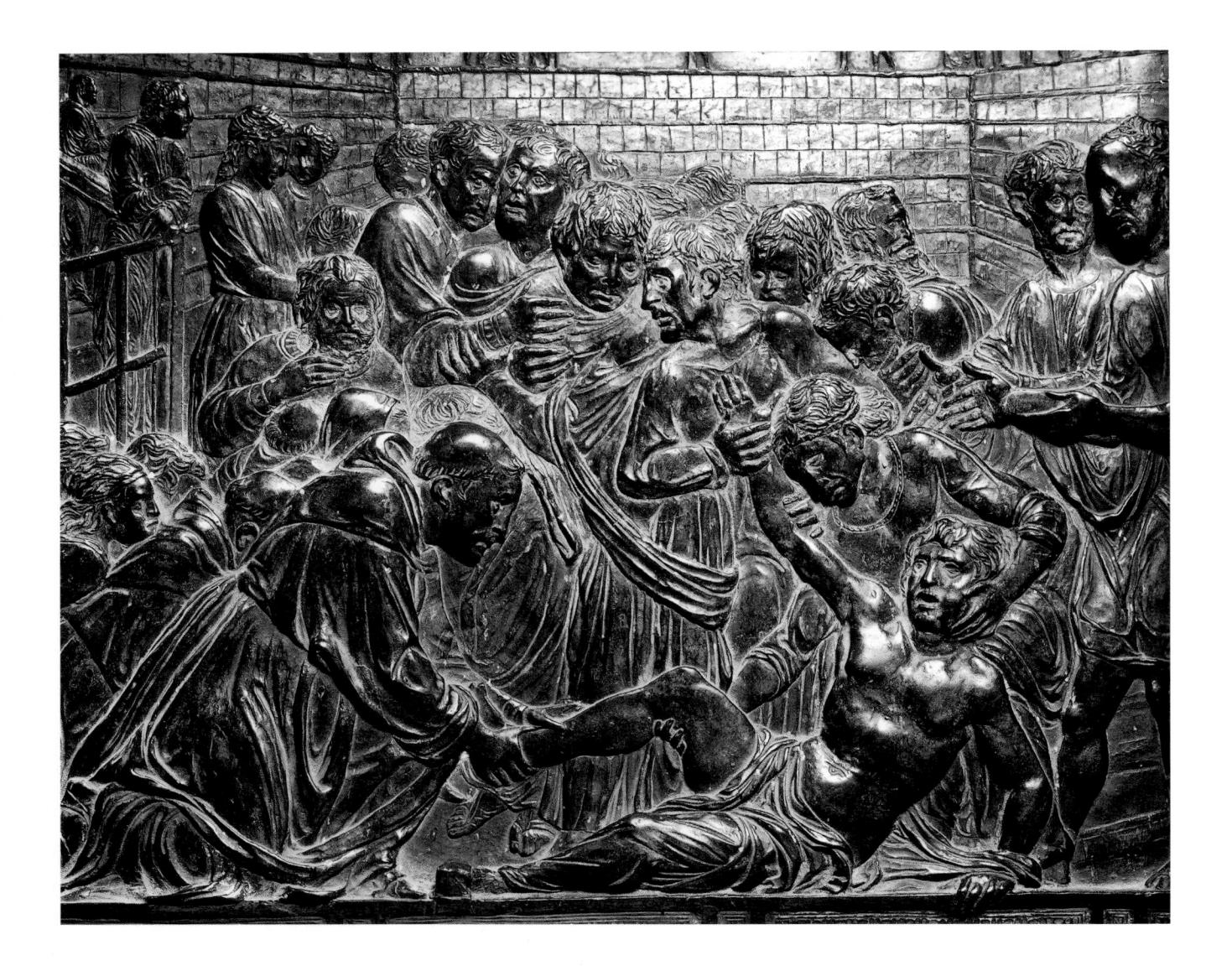

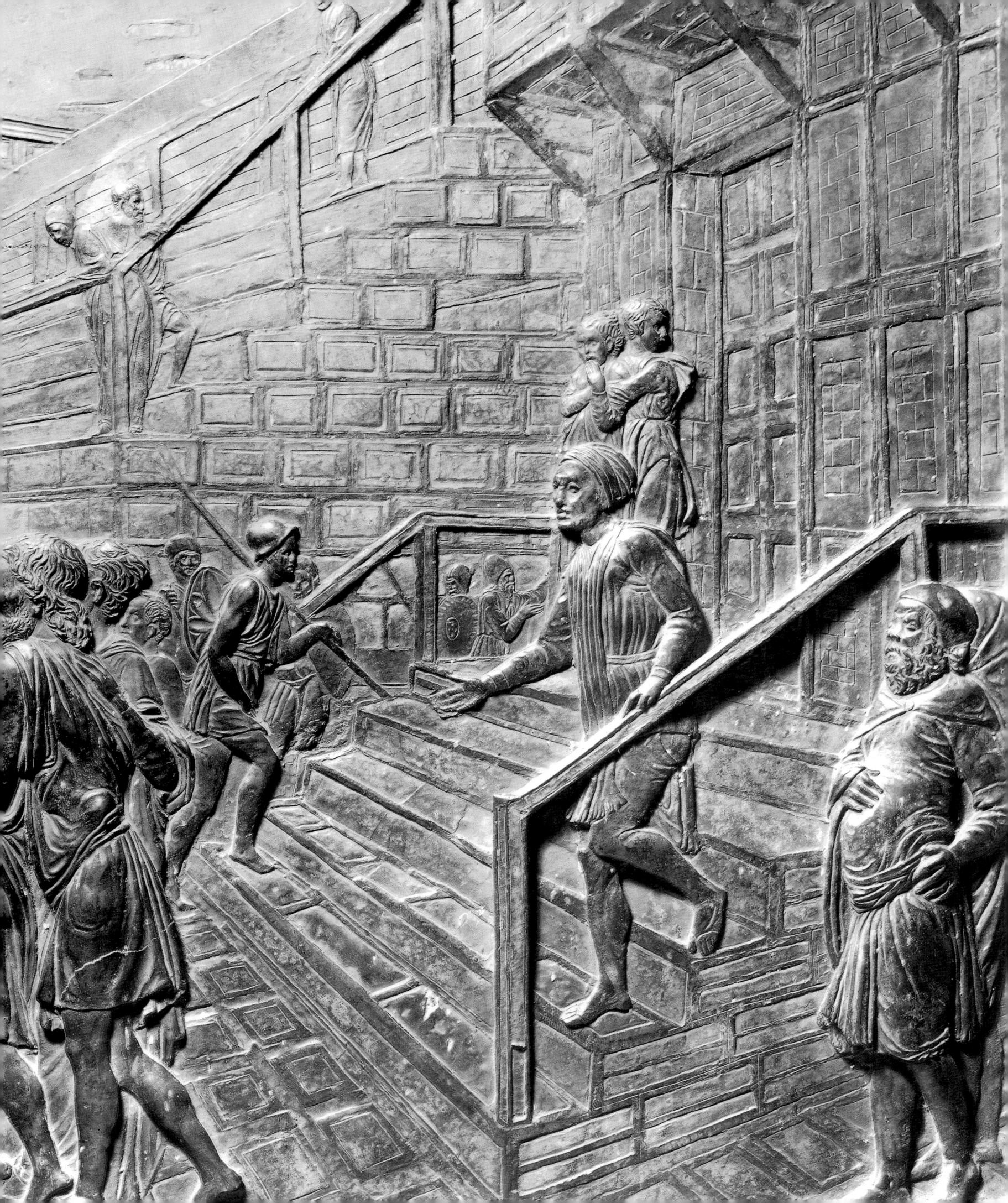

plate 62 Donatello

Pazzi Madonna

Staatliche Museen, Berlin-Dahlem marble, 75 × 70 cm Repentant Son (plates 58, 60, 61), which takes place in an amphitheatre, approached from right and left by flights of steps, with a receding central feature in even greater depth. Historically the four reliefs are of great importance. Just as the St George relief on Or San Michele anticipates Masaccio's use of linear perspective in painting by about eight years, so the Miracle of the Repentant Son anticipates by about the same period of time the perspective scheme employed by Uccello in his fresco of the Flood. Artistically they are unique, for nowhere else do we find this fantastic union of the real and the unreal, the logical and the irrational, of head and heart, of mind and eye.

At this point mention must be made of another type of composition which reached its climax during these Paduan years, the Madonna relief. We have only one authenticated relief of the Virgin and Child by Donatello; it is the size of a florin, and it occurs at the back of the Miracle of the New-Born Child (plate 56). But there are a number of reliefs on a larger scale for which Donatello must be held responsible. The first of these is the so-called Pazzi Madonna in Berlin (plate 62), a great square of marble with the Virgin and Child represented at a casement in low relief. This Madonna dates from about 1420, and a very remarkable work it must have seemed when it was carved. At a time when the painted Madonna was still placed on a neutral gold ground, Donatello's Virgin was set in an architectural frame which gave the figures unprecedented actuality. Yet for Donatello this novel realism was not an end, but a means of reaching forward to a more intimate and

penetrating presentation of the group. We might expect that later Madonna reliefs by Donatello would preserve this inward-looking character, and at the same time reveal the formal preconceptions of his documented works. The first of the disputed reliefs which fulfils these conditions is a painted terracotta Madonna in the Louvre (plates 63, 64), where the Virgin's head is again shown in profile gazing seemingly into the future, and the Child, who is held away from her, looks out meditatively to the left as well. The poses of the figures, both turned in the same direction at the extremities of the relief, relate it to the panels of the doors in the Old Sacristy, and on that account there is a strong presumption that it dates from shortly before Donatello moved to Padua.

In the Virgin and Child on the Padua altar, the Child is contained within the Virgin's silhouette, and in two Madonna reliefs Donatello experiments along these lines. The first is a painted terracotta formerly in the Kaiser Friedrich Museum (plate 65), now, in a sadly damaged state with scarcely the least trace of pigmentation, where the Child is propped against the Virgin's breast and the Virgin's hands are clasped in prayer. From a formal point of view this resolution of the figures as a pyramid is one of the most satisfactory inventions of its time. In a second relief of the same period – the Verona Madonna (plate 66), which is known only through copies – it was employed once more. After he returned to Florence the story of Donatello's Madonna compositions becomes less clear, though a gilded terracotta relief in the Victoria and Albert Museum, London, seems to have been modelled at

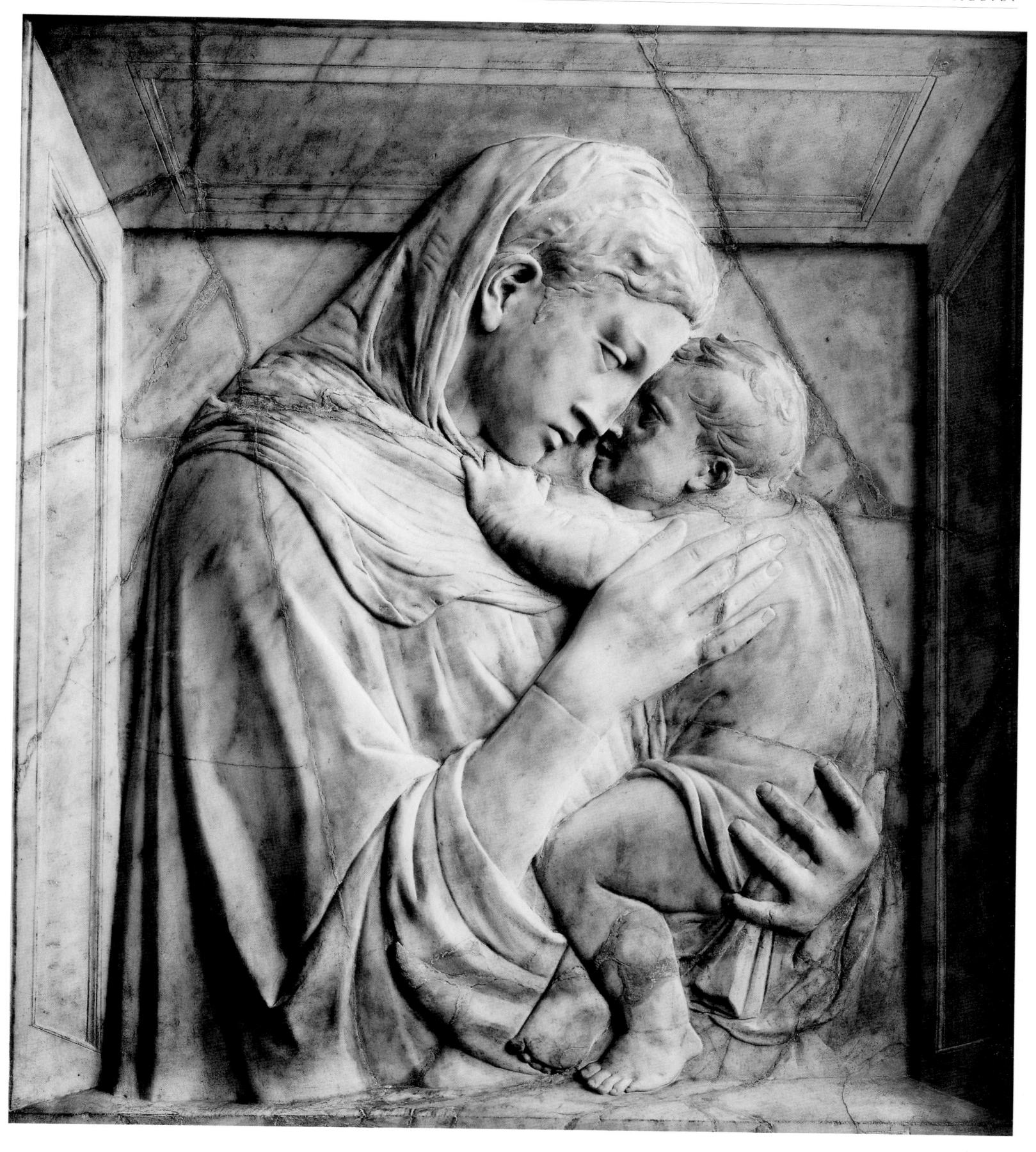

plate 63 Donatello

Virgin and Child

Louvre, Paris

pigmented terracotta,
102 × 74 cm

plate 64 *(opposite)* Donatello

Virgin and Child

Louvre, Paris (detail of plate 63)

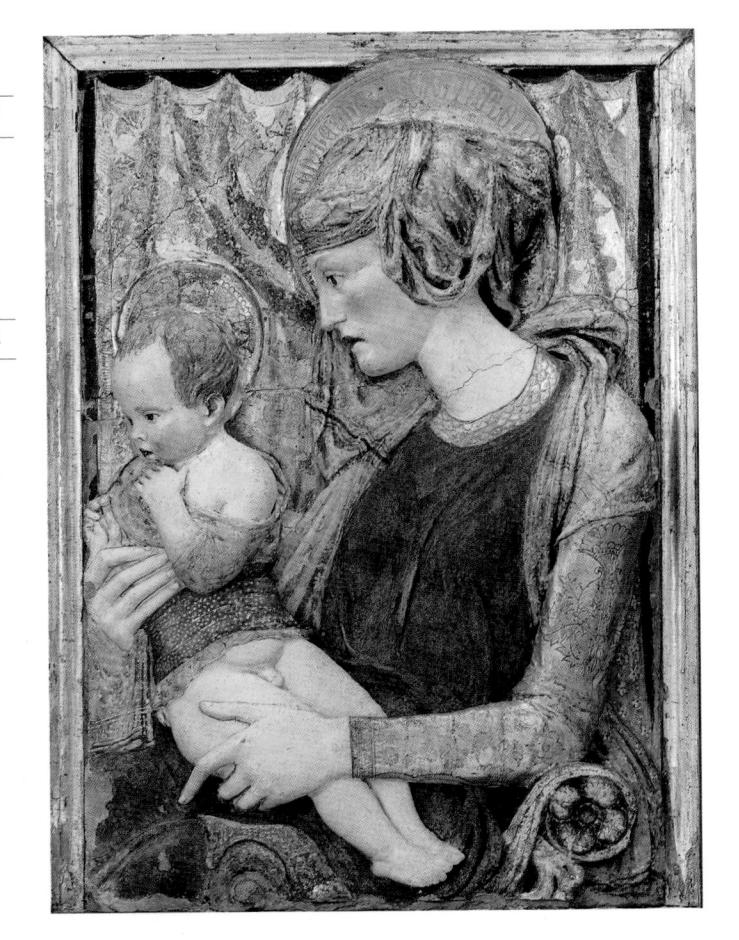

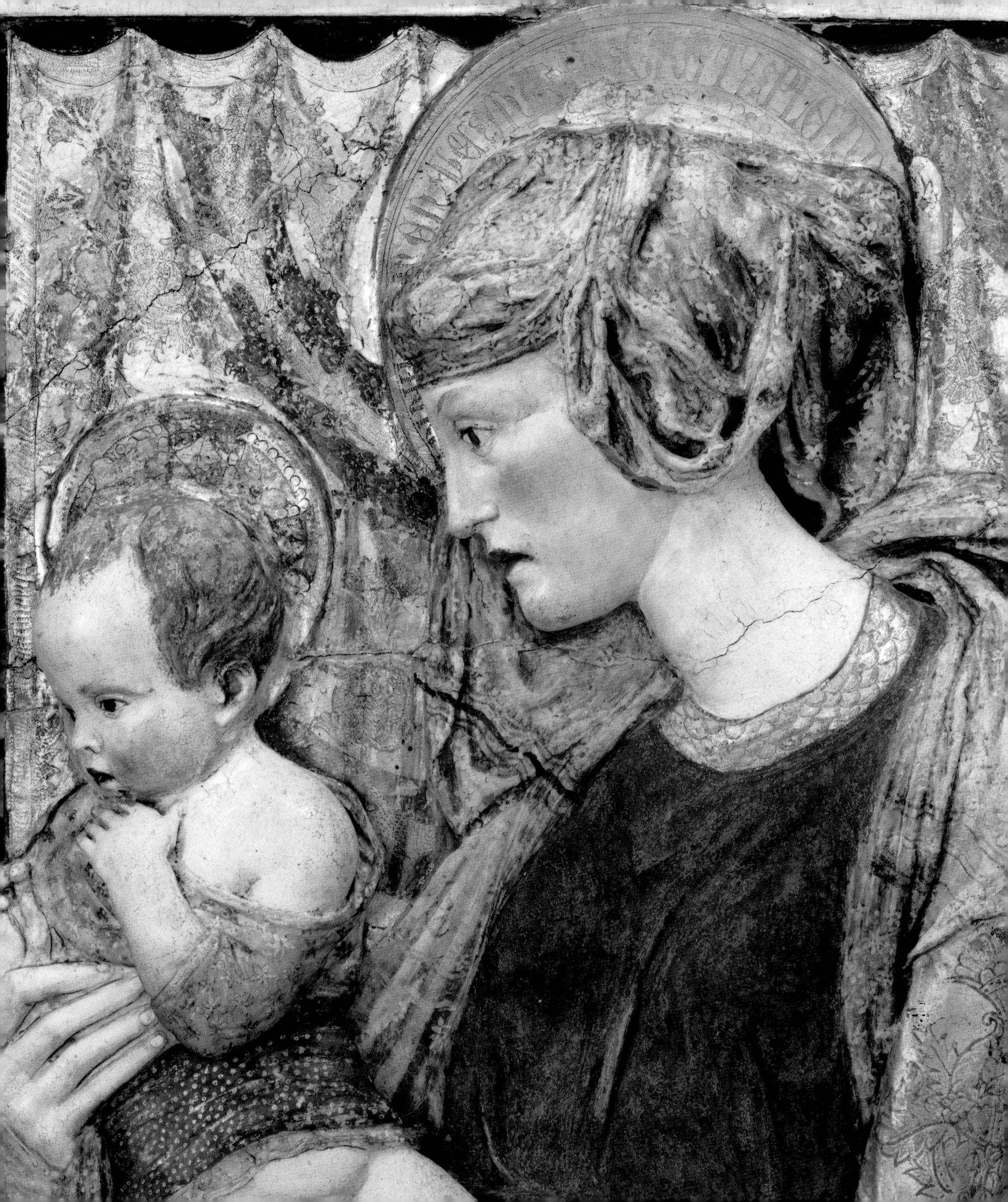

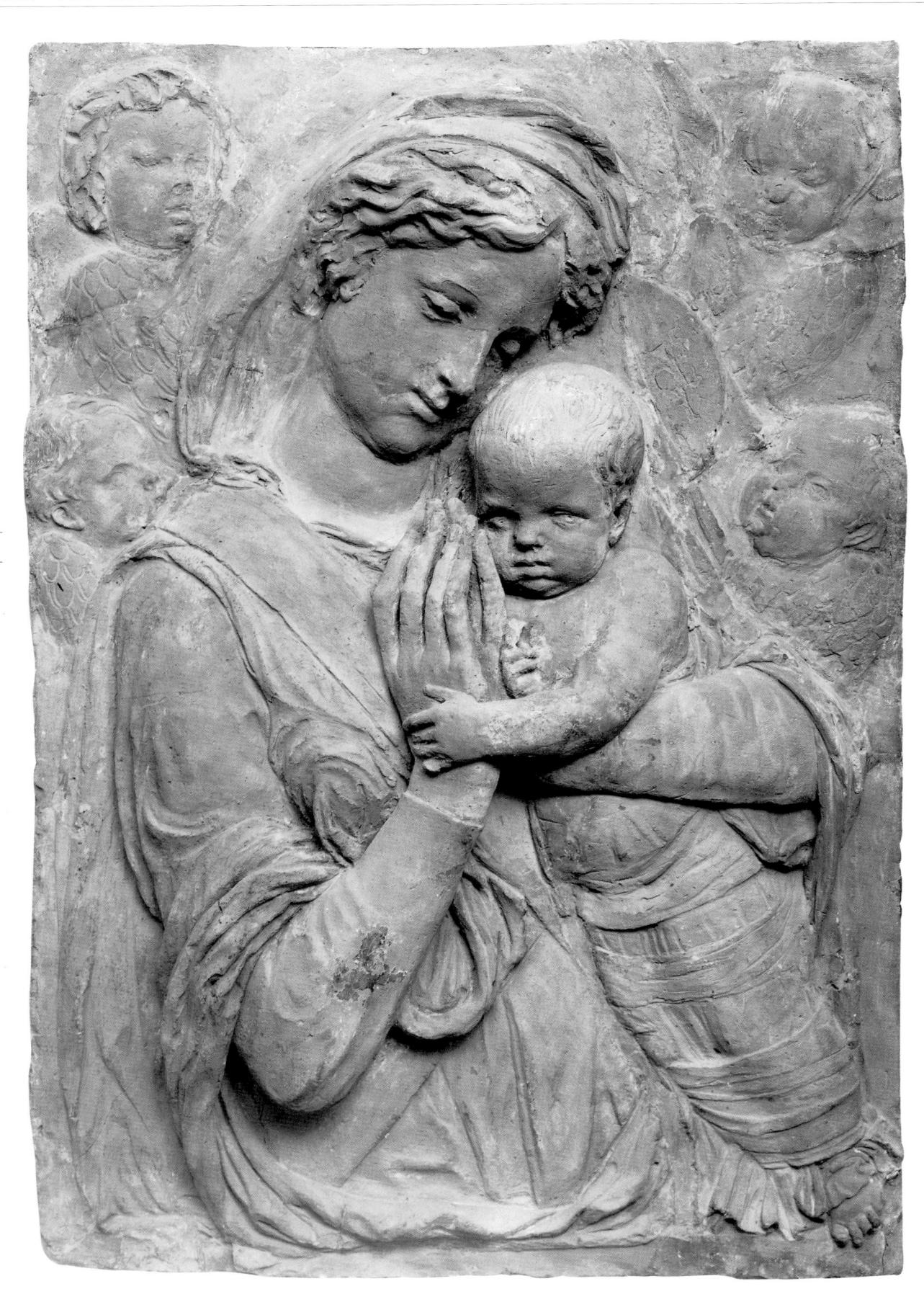

plate 65 Donatello

Virgin and Child

Staatliche Museen, Berlin pigmented terracotta, 102 × 72 cm
plate 66 after Donatello

Virgin and Child

Via delle Fogge, Verona terracotta, height 95.3 cm

plate 67 Donatello (assisted)

Virgin and Child

Museo dell'Opera del Duomo, Siena marble, 89 × 95 cm

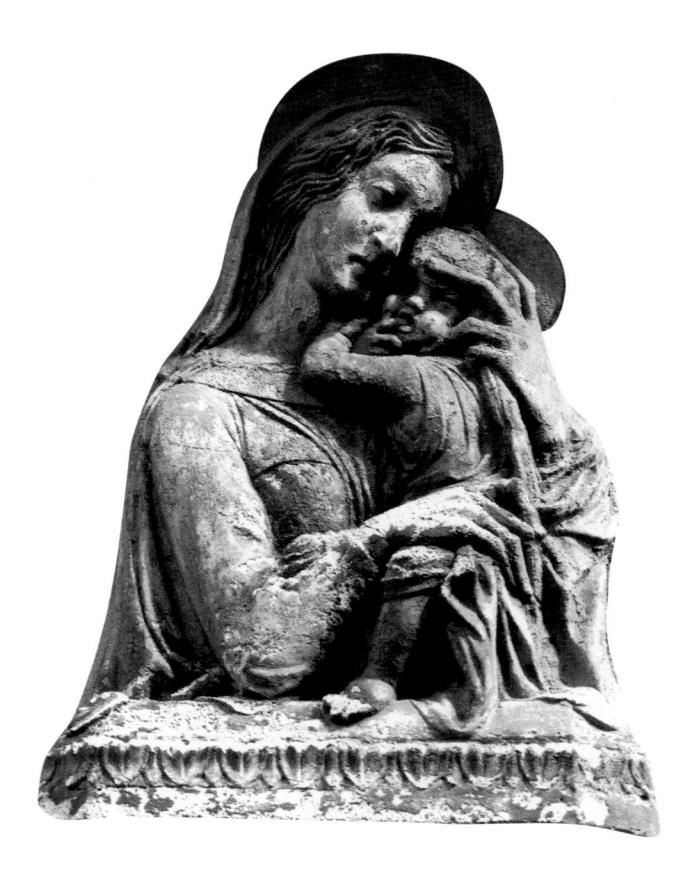

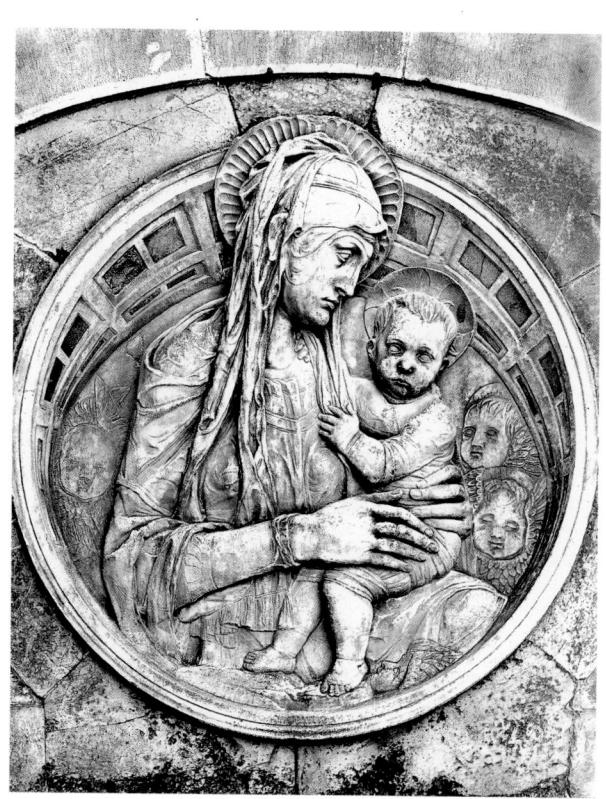

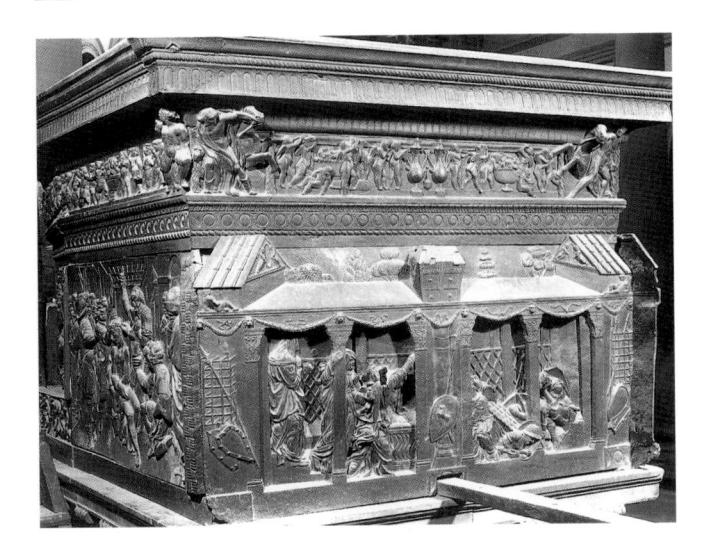

plate 68 Donatello

Pulpit

S. Lorenzo, Florence bronze, 75×145 cm

plate 69 (opposite) Donatello

Pulpit

S. Lorenzo, Florence bronze, 123×292 cm about this time. There is also one marble relief for which he must have been in large part responsible (plate 67). At one time set over the side door of Siena Cathedral, this relief shows the Virgin and Child in an *œil-de-bœuf*, with the Virgin's head protruding through the window at the front. It is in marble, but Donatello, who was then over 70, had virtually abandoned marble carving by that time, and it was carried out with the help of an assistant. If, however, we disregard the stolid cherubs and sullen Child, there can be little doubt that in the heroic Judith figure in the centre we have Donatello's last thoughts on this theme.

There is always a temptation to romanticize a great artist's old age. With Donatello this need not be resisted, since we have proof of unwonted restlessness in the last phase of his life. In Padua he was ill at ease and anxious to return to Florence. Back in Florence, he decided to make his home permanently in Siena. But Siena disappointed him, and he returned to Florence once more. There leadership in sculpture had passed to a number of young artists, marble sculptors of incomparable skill, who fundamentally were out of sympathy with the committed character of Donatello's art. Between 1453 and 1466 Donatello was engaged on two works which were planned as aggregations of bronze reliefs. The first of them was the bronze door of Siena Cathedral. This project proved abortive, and though Donatello stayed for upwards of two years in Siena, the Cathedral was left without bronze doors. The second is his last great masterpiece, the pulpits in S. Lorenzo (plates 68, 69), where his relief style is suddenly revised.

The pulpits are unfinished, and the reliefs designed for them are best regarded as a Passion sequence, but a Passion sequence of a rather special kind. It begins with the Agony in the Garden, Christ before Caiaphas and Christ before Pilate, the Crucifixion, Deposition and Entombment, the Marys at the Sepulchre, the Resurrection, Christ in Limbo, Christ Appearing to the Apostles, and Pentecost, and includes one extraneous scene, the Martyrdom of St Lawrence to whom the church was dedicated. The scale varies from scene to scene, but the reliefs are about double the height of the reliefs at Padua, so that the figures, even where they are smallest, are considerably larger, and where they are large are more fully modelled than any in the Padua reliefs. The reliefs with small figures seem to precede those with large. It appears that Donatello wished increasingly to project his scenes towards the spectator with the greatest violence he could command. To some extent this was bound up with the function the reliefs fulfilled. The predella of an altar was visible only to the priest or to those who went up to inspect it, whereas pulpit reliefs were intended for the congregation, and must for this reason be legible from some distance away. Consequently in the earlier reliefs the space construction is not theoretical, as it had been at Padua, but a synthesis of theoretical and actual space, and in the later scenes, like the Christ Appearing to the Apostles on the second pulpit (plate 69), the rear wall is treated as a backcloth, and the scene takes place in front of it in actual space marked out by walls projecting from the relief plane. The most

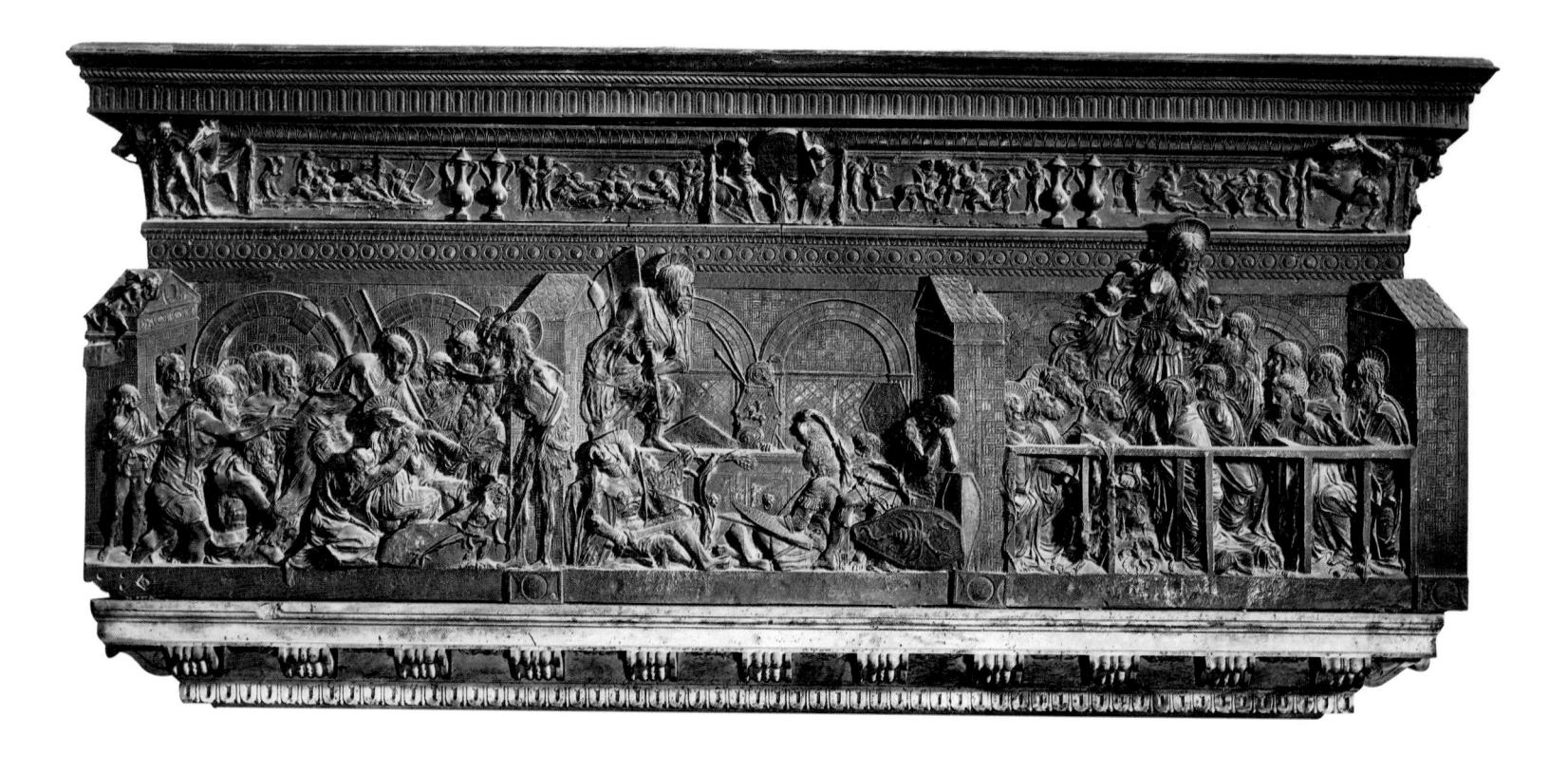

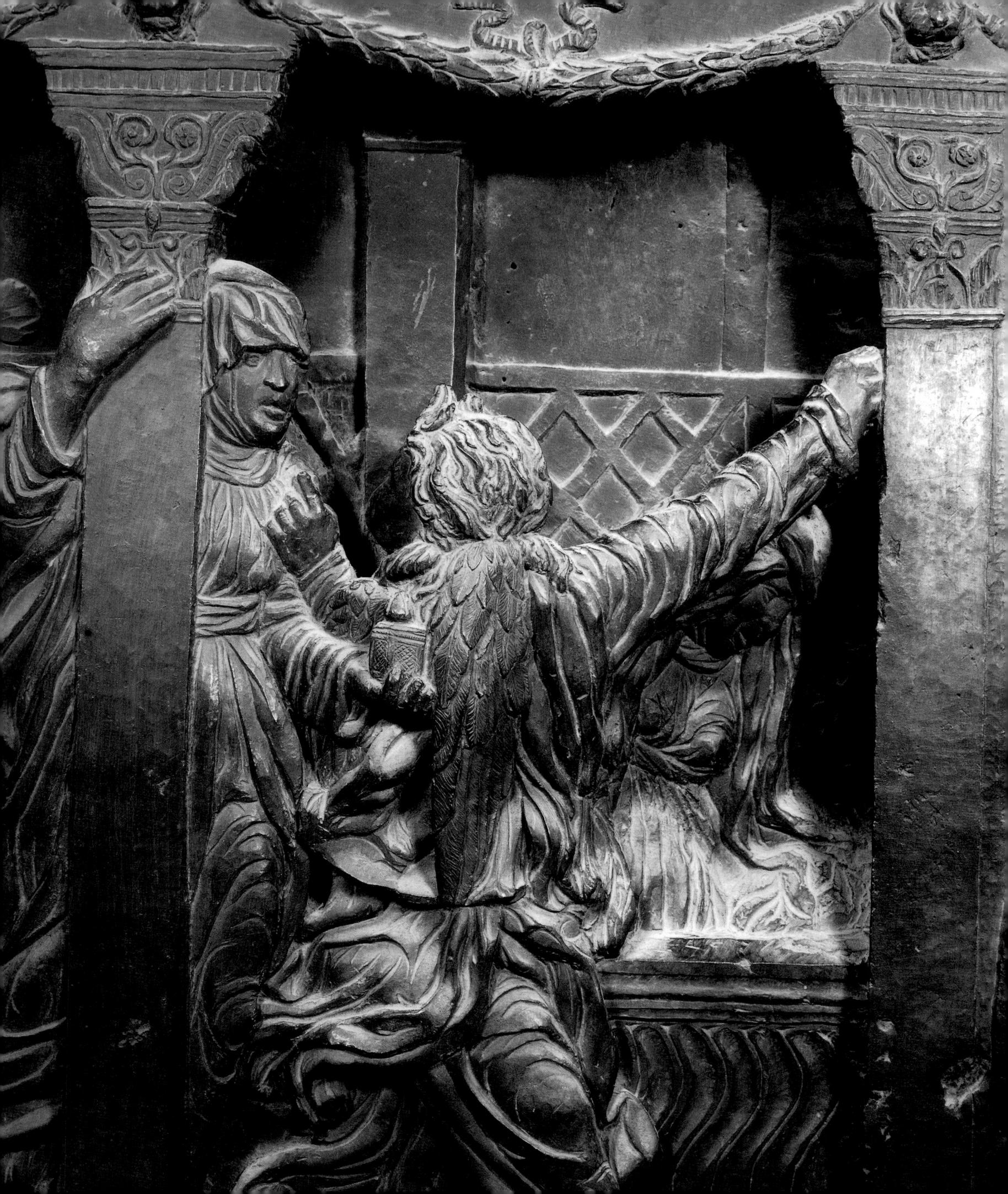

plate 70 *(opposite)* Donatello

The
Three Marys
at the Sepulchre

S. Lorenzo, Florence (detail of plate 68)

plate 71 Donatello

The Resurrection

S. Lorenzo, Florence (detail of plate 69)

advanced of the compositions from this point of view is the Three Marys at the Sepulchre (plate 68), where the scene is set in a protruding building, complete with roof, front, sides and back.

The iconography of Donatello's earliest reliefs sprang from a reaction against conventional religious symbolism; the image owed its authority solely to the imagination of the artist. The pulpit reliefs in S. Lorenzo are also entirely without precedent; they form indeed the only case in the whole fifteenth century in which an artist portrayed a cycle of scenes from the New Testament with complete originality. How far the convictions embodied in them were personal to Donatello may be judged from the fact that they were never followed by other sculptors, and even today there is something disconcerting in the physical insistence of their imagery. In the unruly Deposition (plate 73) the three crosses recede diagonally through the picture space, so that one thief is cut off at the shoulders, while the other is severed at the knees. Beside the central cross stands Nicodemus meditating on the nails, and in front a throng of mourners press round the dead Christ. The relief of the Entombment was not modelled by Donatello, and he takes up the story again with the Three Marys at the Sepulchre (plate 70). Here the setting is clear enough: an open loggia with two rows of columns set against a fence, with trees visible over the roof. To the right are the sleeping soldiers, in the centre is a classical sarcophagus, and on the left the Angel, with back turned to the spectator and a

preternaturally long right arm, announces the tidings of the Resurrection to the heavily draped women who drape themselves wearily towards the tomb. On the front of this pulpit is the Resurrection (plate 71), but once more it is a Resurrection that has no precedent; its protagonist is not the young victorious figure of Piero della Francesca or Castagno, but a harrowed Christ, His grave-clothes carefully portrayed, stepping furtively out of the tomb. To the left of this scene (plate 72) the worn, persecuted figure carries His message of redemption to the emaciated souls in Limbo like a liberator bringing succour to the inmates of some prison camp.

These reliefs introduce us to a world of feeling which no other artist penetrated in the fifteenth century, and to which few have been admitted since. Analogies (for with works of this stature we must seek analogies rather than parallels) may be found in the sixteenth century in the work of Tintoretto, who at S. Stefano and S. Cassiano and S. Rocco was impelled by an overpowering emotional response to adopt some of the expedients used by Donatello in the pulpits, and in the seventeenth century in Rembrandt's etchings, where the Deposition by Torchlight and the last great Entombment re-create the climate of Donatello's Marys at the Sepulchre and its companion scenes. But neither with Tintoretto nor with Rembrandt do we feel ourselves trespassers among private beliefs and personal emotions, as we do in S. Lorenzo when we read the pages where an artist's soul is for the first time laid bare.

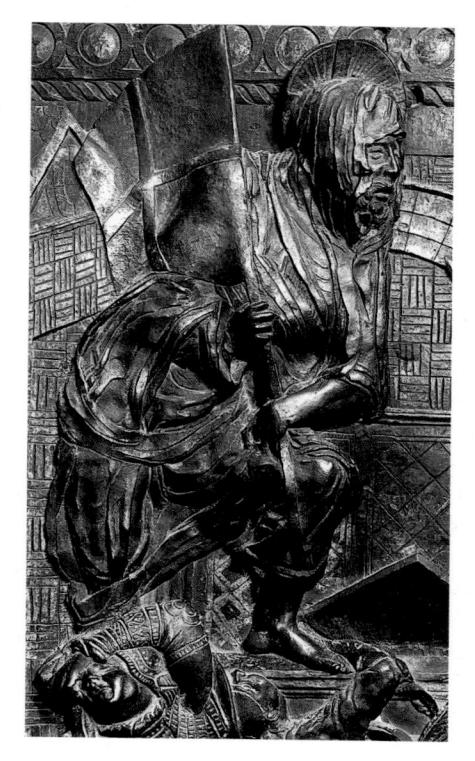

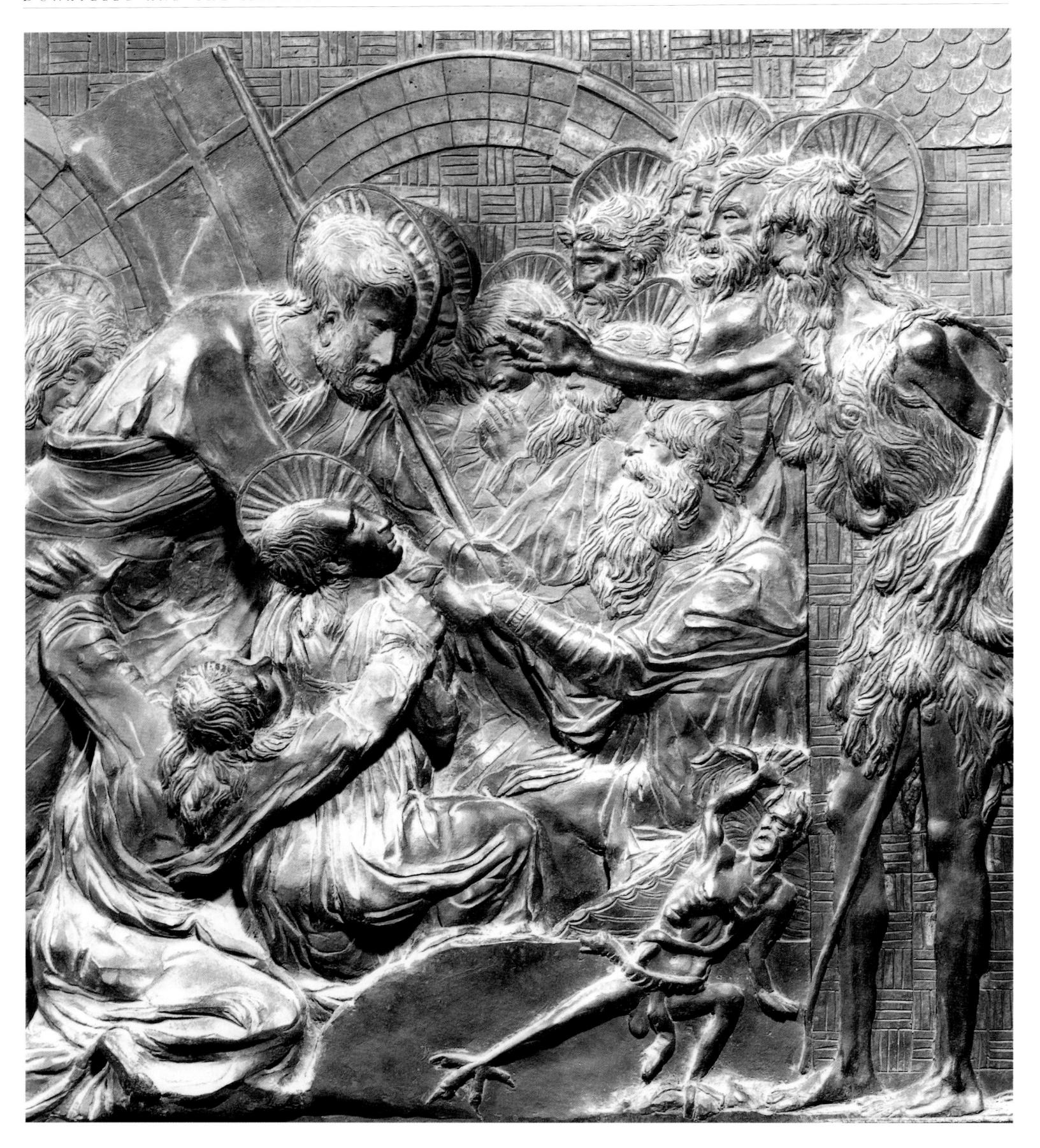

plate 72 *(opposite)* Donatello

Christ in Limbo

S. Lorenzo, Florence (detail of plate 69)

plate 73 Donatello

The Lamentation over the Dead Christ

S. Lorenzo, Florence (detail of plate 68)

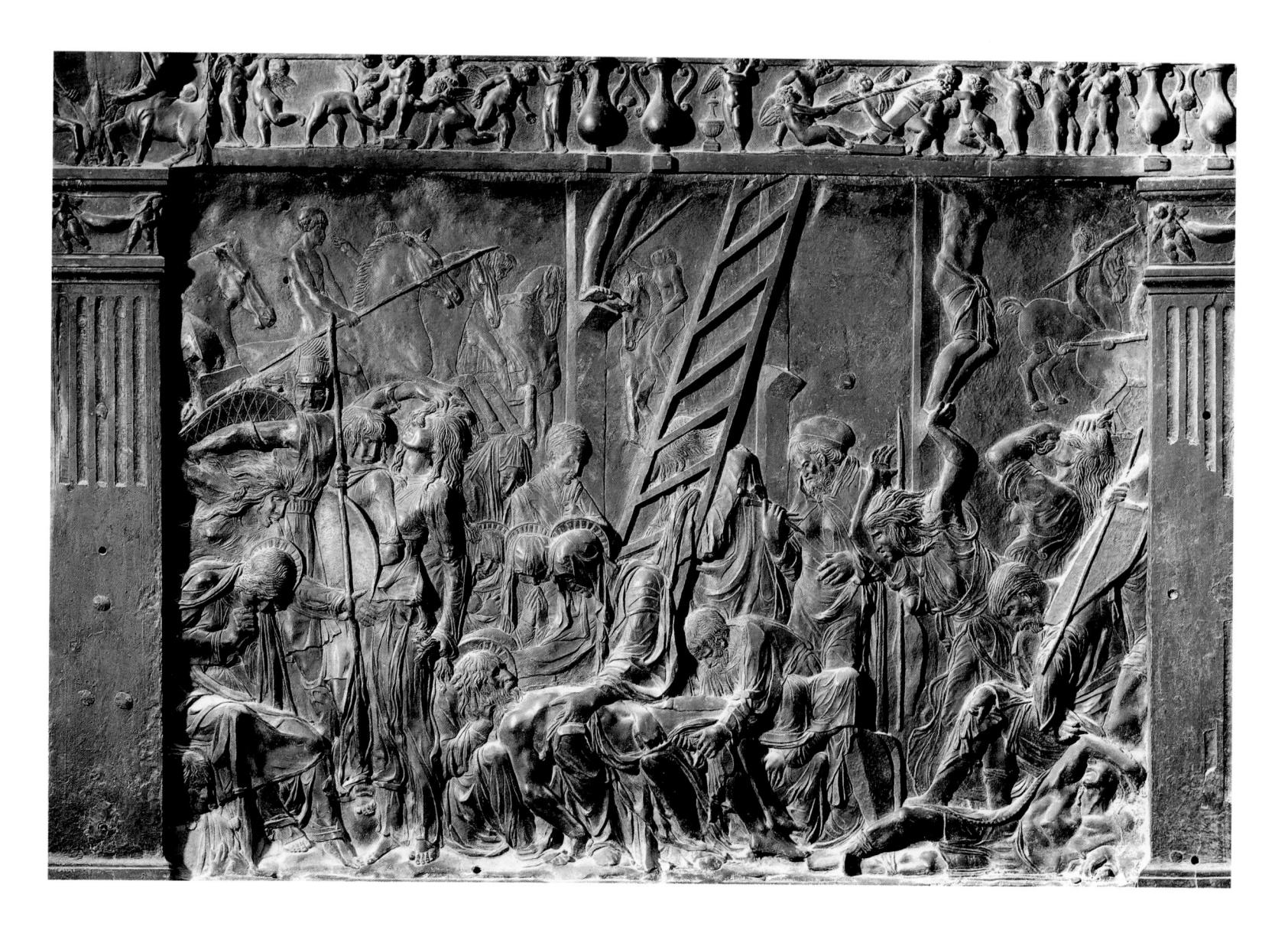

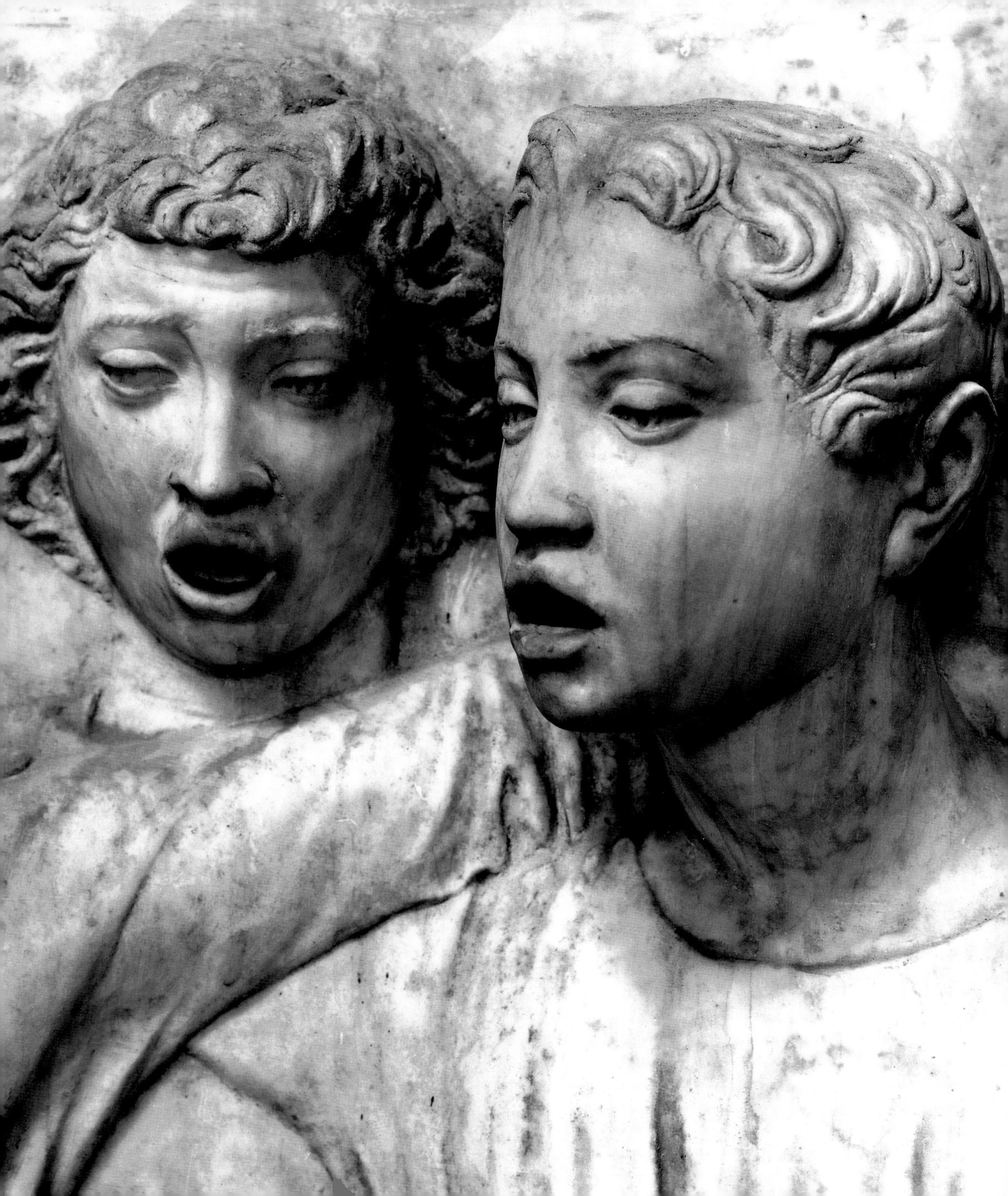

N THE PREFACE TO THE Della pittura Alberti f I describes how, on his return to Florence from exile in 1434, he has 'come to understand that in many men ... there is a genius for accomplishing every praiseworthy thing'. The sources of this lesson were an architect, Brunelleschi, a painter, Masaccio, and three sculptors, Donatello, Ghiberti and Luca della Robbia. Luca della Robbia was born in Florence in 1399 or 1400. Where he was trained we do not know, but there is one marble sculptor of whose creative procedure we are constantly reminded by his later work. This is Nanni di Banco, who had died in 1421 leaving his Quattro Santi Coronati standing all'antica in their niche on Or San Michele, his relief of the Assumption (Vol. I, plate 204) unfinished on the Porta della Mandorla, and his seated figure of St Luke (Vol. I, plate 195) on the façade of the Cathedral. The St Luke in particular seems to have haunted Luca della Robbia, and years later it served as a springboard when he came to design his figures of Apostles in the Pazzi Chapel. What holds good for Luca's figure style holds good also for his narrative reliefs. He was faithful to Nanni di Banco's relief style long after it had been abandoned by other artists, and in 1439, when he carved the unfinished predella of the St Peter altar in the Duomo, he still employed the idiom Nanni di Banco had used beneath the Santi Coronati. There is thus a strong presumption that Luca was trained by Nanni di Banco. Certainly he was an established marble sculptor by 1431, when he was awarded the commission for a major work, the Cantoria of the Cathedral.

Luca's Cantoria (plate 75) was moved at the end of the seventeenth century from its position high above the door of the north sacristy, and much of the framing, though not the supporting consoles. has disappeared. But it has been established that the reliefs in the upper section of the front were originally separated from each other by pairs of small pilasters. Not only does this same detail occur in the portico of the Pazzi Chapel designed by Brunelleschi at about this time, but the proportions of the upper section of the portico have much in common with those of the upper section of the reconstructed Cantoria. Since Brunelleschi's was the guiding hand in the Duomo when the Cantoria was commissioned, we may be confident that the gallery, if not actually designed by Brunelleschi, owes its form to Brunelleschi's influence. Certainly the conception was one of deep significance, for this was the first case in the fifteenth century in which a classical architectural project was enriched with sculptured decoration, and a sculptor was presented with the problem of evolving an appropriate figure style. Let us look for a moment at the way in which Luca della Robbia set about his task.

The Cantoria sculptures illustrate Psalm 150, and consist of 10 reliefs, four on the front of the gallery, two at the ends, and four between the consoles. There are two main documents relating to the sculptures. The first tells us that in 1434 four reliefs, two large and two small, were complete. The second dates from 1435, when it was resolved that the sums paid to the sculptor should be increased, because work on the carvings then in

plate 74 Luca della Robbia

Singing Boys

Museo dell'Opera del Duomo, Florence (detail of plate 76) progress was more arduous than it had been, and the carvings themselves were more beautiful. When we carry these documents round with us to the Opera del Duomo, the story of the Cantoria reliefs becomes relatively plain. In the first place there are only two small reliefs, the reliefs on the ends of the gallery, and these must therefore be among the earliest of the sculptures. In the second place the increased payment of 1435 could arise only from technical change, and a technical change in the form of cutting in greater depth is evident in certain of the carvings. The two carvings of singing boys from the ends of the gallery (plates 74, 76) are couched in the serene classical language in which Luca habitually speaks. Yet for all the freshness of their inspiration these are tentative reliefs, as we discover soon enough when we try to determine the connection between the heads in the background to right and left and the feet beneath, or explain the exaggeratedly long arms with which the forward figures embrace. The documents do not specify which of the large reliefs were executed at this same time, but a clue to this is offered by the reliefs themselves, for when we look at all eight of them in sequence we notice that there is a change in scale. In six the relation of the putto to the relief field is uniform, but in two it varies, once no more than slightly but in the second case in a most striking way. In the six uniform reliefs the children fill the whole height of the field, whereas in the eighth the seated children, if they stood up, would be little more than half its height. Midway between the two types falls another of the reliefs, where the standing figures

appear younger, and the seated figures have begun to grow. Significantly enough, it is the six reliefs with full-size children that are the most deeply cut.

What was the reason for the change? The reason in a word was Donatello, who after 1433 was engaged upon the Prato pulpit (plate 49) and the second Cantoria (plate 47), and had addressed himself to the task of devising a relief style which would register from the height at which his reliefs were to be placed. The architectural sections of Donatello's Cantoria are instilled with an exuberance foreign to Luca's scheme. But Luca none the less was influenced by Donatello's boisterous figure style. This is reflected in deeper cutting and in the use of movement. Suddenly Luca's putti, like Donatello's, start to dance (plate 77), not with the Bacchanalian zest of the putti on the Prato pulpit, but sedately, with short firm steps. The relief in which the dancing children come closest to Donatello is the Trumpeters (plate 78), where three little girls in the centre seem for a moment to have thrown off all restraint. Yet paradoxically enough it is this same relief that shows most clearly the essential difference between the personalities of the two artists. Where Donatello's figures establish a continuous rhythmic pattern, Luca's are enclosed within a static frame, and the trumpeters themselves, their instruments held to their lips, establish the firm system of verticals and horizontals on which his compositions from first to last depend.

The term 'from first to last' is no hyperbole. When we turn to the Federighi Monument (plate

plate 75 Luca della Robbia

Cantoria

Museo dell'Opera del Duomo, Florence marble, 328×560 cm

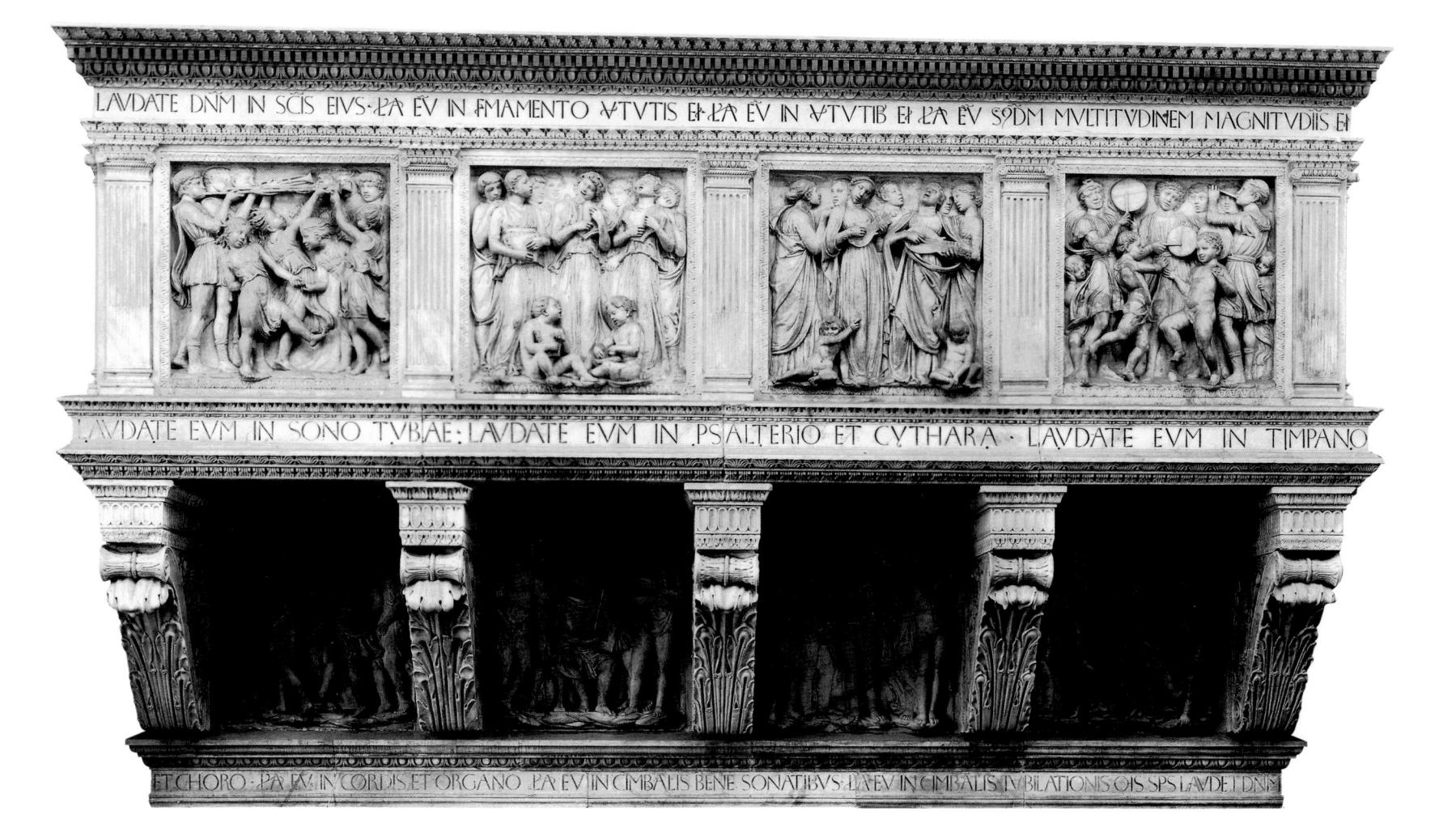

plate 76 Luca della Robbia

Singing Boys

Museo dell'Opera del Duomo, Florence (detail of plate 75) marble, 103 × 64 cm

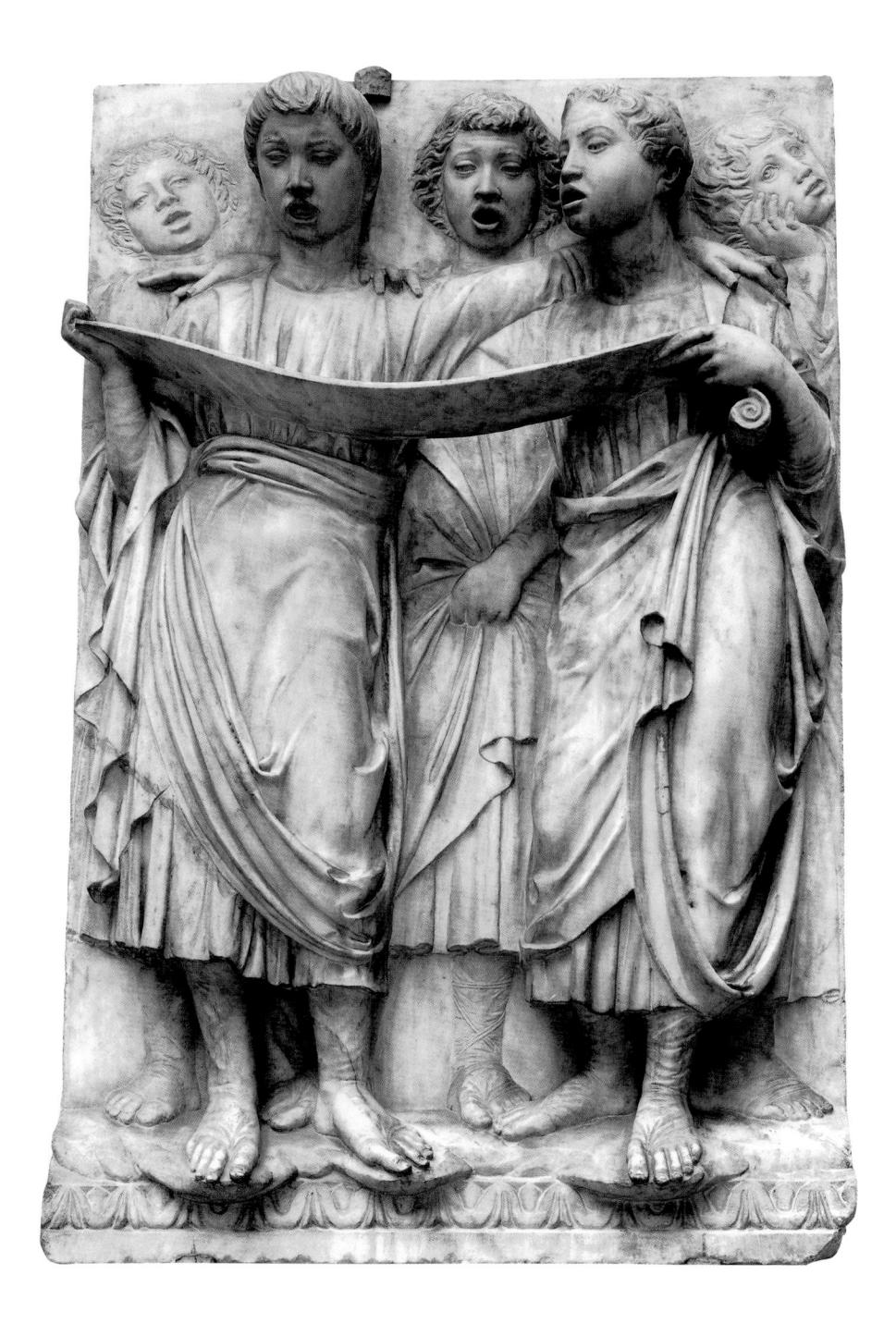

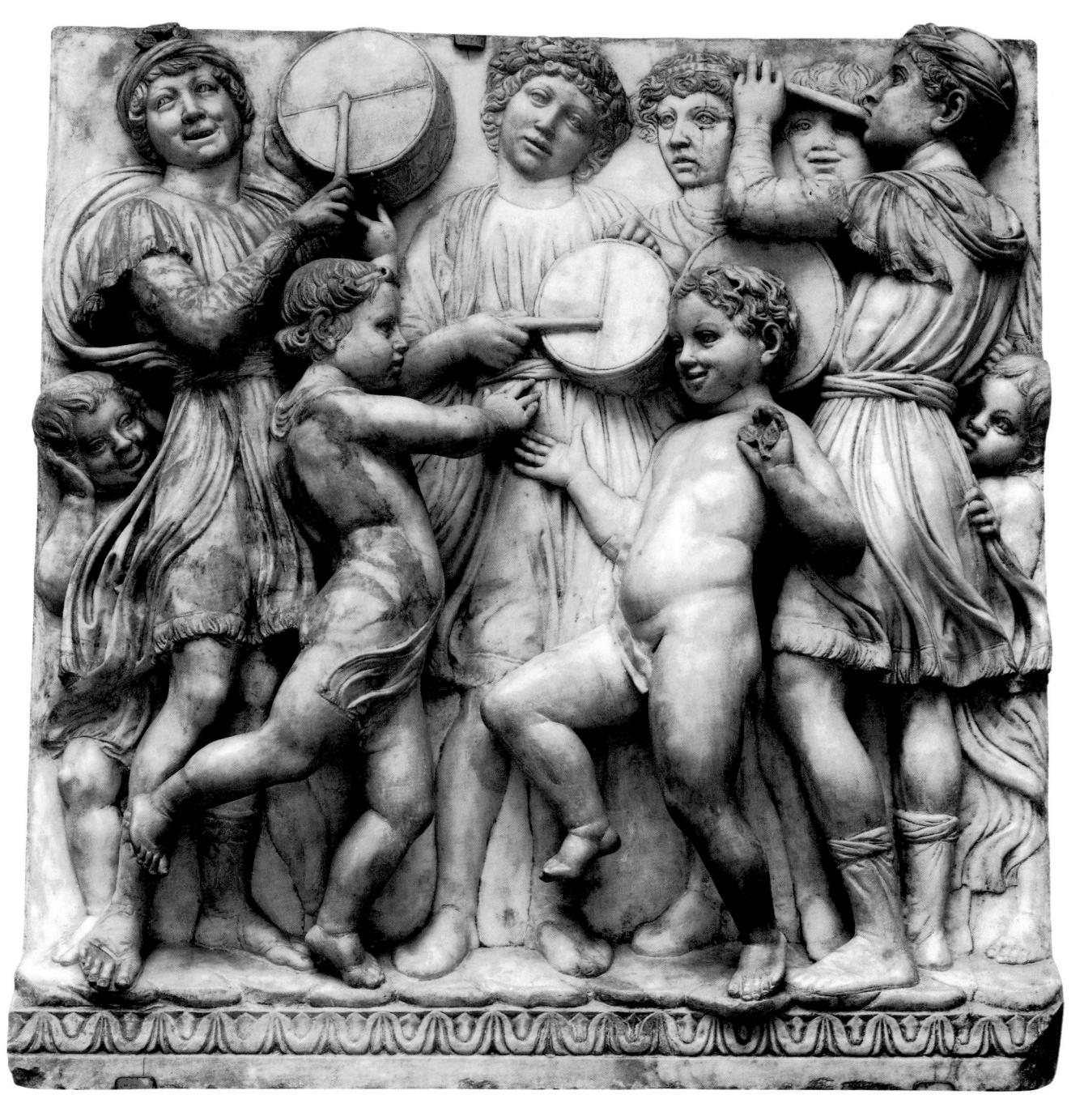

plate 77 Luca della Robbia

Drummers

Museo dell'Opera del Duomo, Florence (detail of plate 75) marble, 103 × 93.5 cm

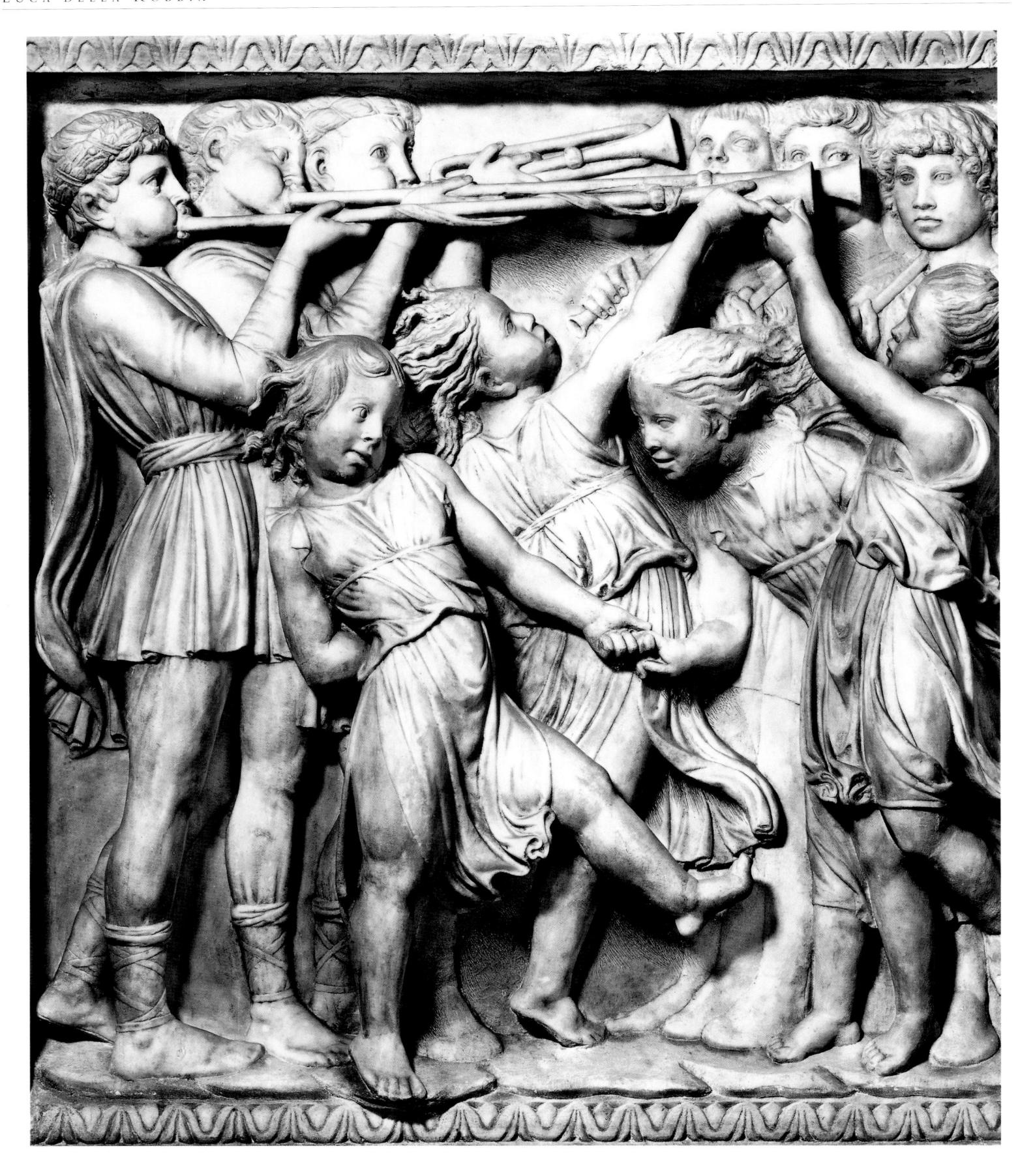

80) which Luca designed for S. Pancrazio in 1455, we find that the same principles are worked out on a larger scale. Nine years go by, and Luca begins work on the reliefs of the bronze door of the Cathedral (plate 79), in which the frame was designed by Michelozzo under the inspiration of Donatello's doors in S. Lorenzo. Whereas in Donatello's doors the function of the frame is to link each scene to the next, in Luca's the moulding shuts in the scenes, and each relief is constructed with its familiar system of verticals and horizontals as a unit independent of the rest. The bronze door, if not literally the end, is virtually so, since it was completed in 1469, and in 1482, at the age of over eighty, Luca della Robbia died.

Luca may have produced other works in bronze and marble, but if he did so, they have not survived, and after about 1440 the emphasis within his work shifts to a third medium, enamelled terracotta. From Vasari's day down to our own the legend has held currency that Luca's works in enamelled terracotta were an inexpensive substitute for works in other mediums, and were glazed in order to protect them from decay. The truth is the inverse of this, that enamelled terracotta was used initially not as a substitute for marble sculpture, but in contexts in which marble sculpture would have been inapposite, and that the function of the glaze in the first instance was colouristic and not preservative. On both these points the works speak for themselves.

The first dated work in which enamelled terracotta is employed is a tabernacle from S. Maria Nuova in Florence, now at Peretola

(plate 81), on which Luca was engaged between 1441 and 1443. Its design once more is Brunelleschan, and the style of the beautiful victory Angels in the centre conforms exactly to that of the Cantoria reliefs. Certainly there is no question of the substitution of one medium for another here; the tabernacle is made of marble, and the use of enamelled terracotta is limited to blue inlay behind the marble group in the lunette, to the spandrels above, and to a polychrome strip of cherub heads beneath the pediment. The enamelled terracotta fulfils no organic function, but adds the ancillary element of colour to the rather frigid scheme. For reasons which are not hard to divine, the tabernacle remained sui generis, and only in two later works by Luca. the Federighi Monument and the chapels at Impruneta, are enamelled terracotta and marble juxtaposed. But in the more elevated sphere of architecture, in Brunelleschi's Pazzi Chapel, glazed terracotta plays precisely the same role as in the tabernacle.

Almost from the first Brunelleschi seems to have made provision in his interiors for some form of sculptured decoration. The earliest building in which this is apparent is the Old Sacristy in S. Lorenzo (plate 52), which contained in the spandrels four circular spaces framed in *pietra serena*, and equivalent spaces, at the same height, over the altar arch and on the three remaining walls. The Old Sacristy was completed in 1428, but the eight circular fields were left unfilled till the late thirties, when Donatello modelled for them four stucco reliefs of the Evangelists and four

plate 78 Luca della Robbia

Trumpeters

Museo dell'Opera del Duomo, Florence (detail of plate 75) marble, 103 × 93.5 cm

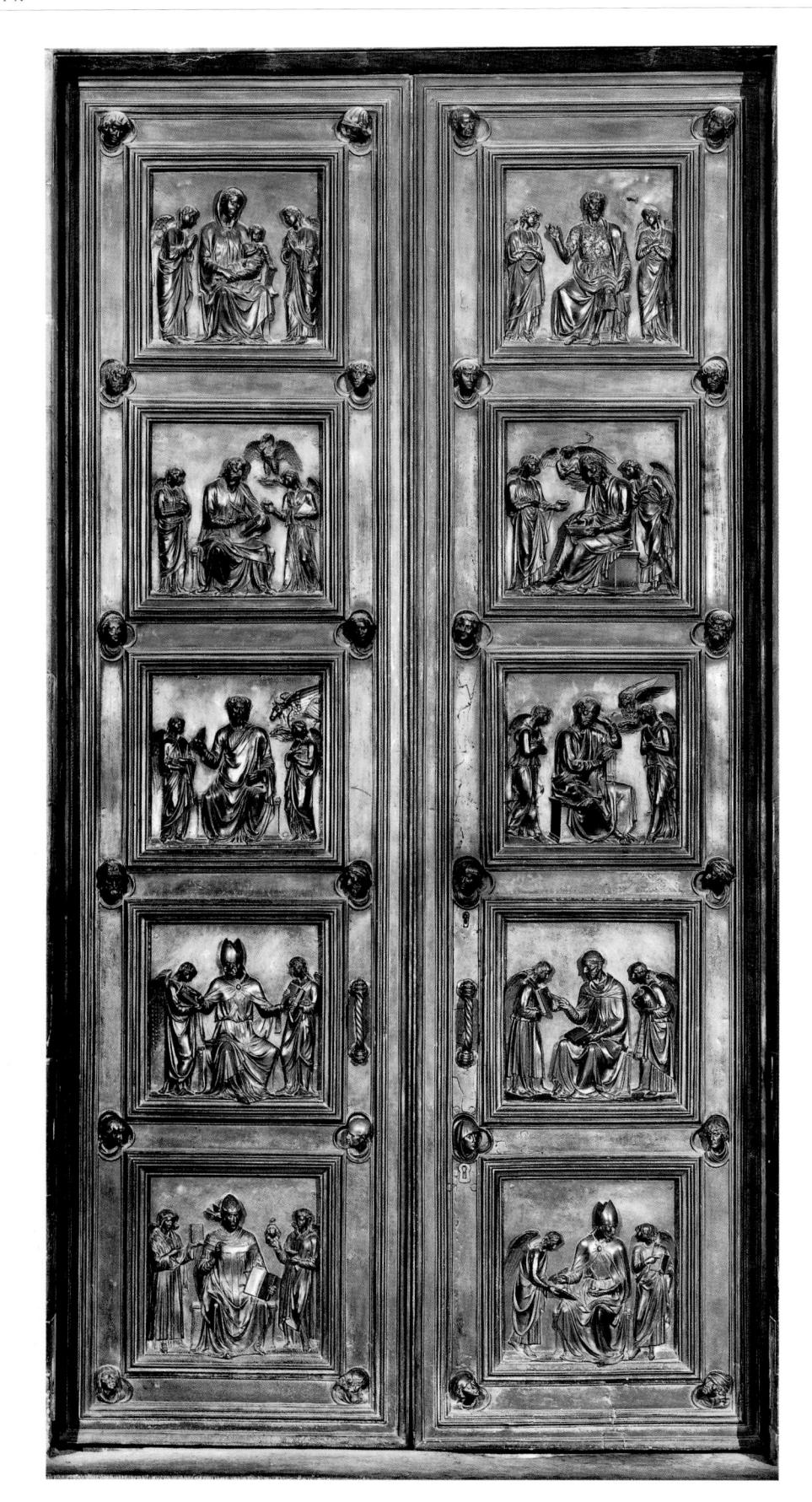

plate 79 Luca della Robbia

Sacristy Door

Duomo, Florence bronze, 410 × 200 cm

plate 80 Luca della Robbia

The Federighi Monument

S. Trinità, Florence marble with enamelled terracotta surround, overall 270 × 257 cm

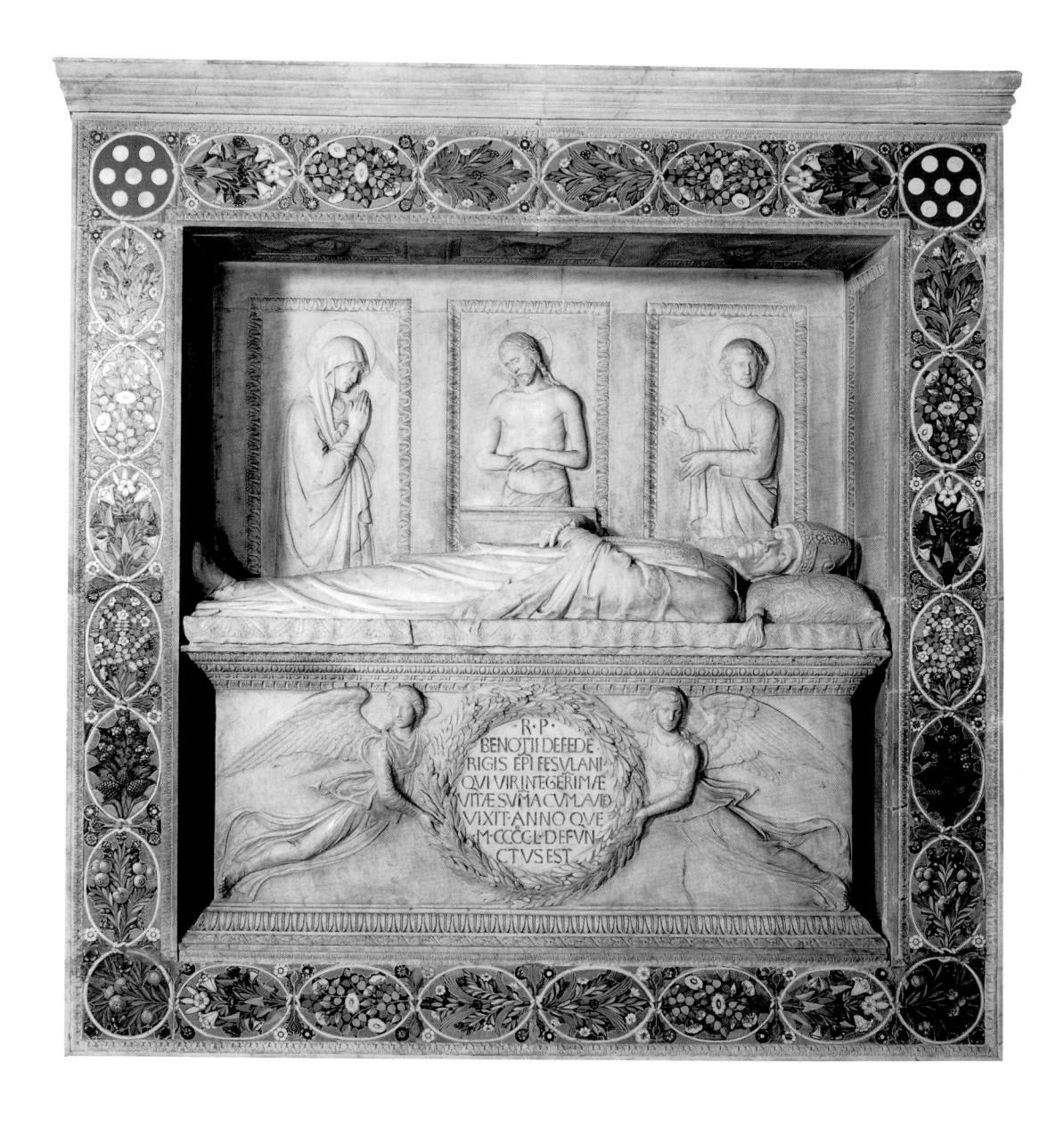

scenes from the life of St John (plate 54). These same fields are present in the Pazzi Chapel (plate 82). There are 17 of them in all, filled with enamelled terracotta roundels, four in the spandrels with the Evangelists (plate 83), 12 round the walls with the Apostles, and one on the outer wall over the entrance with St Andrew, the patron of the chapel. The presence of the 12 frames round the walls can hardly be fortuitous, and from the first the mouldings must have been conceived as frames for a cycle of Apostles. When the problem of filling the frames in the Old Sacristy arose, the minds of Brunelleschi and Donatello reverted to antiquity, and pigmented stucco was chosen as the medium of the reliefs. There was no precedent in Florence for employing stucco in this way; and since stucco was not employed again in Florence for quite this purpose, we must conclude that the experiment was not looked on as a success. The reliefs in the Old Sacristy were presumably completed before Donatello left Florence for Padua in 1443, and in that year the structure of the Pazzi Chapel was already far advanced.

the Pazzi Chapel was already far advanced. Luca's enamelled terracotta roundels, therefore, must date from about the time when the failure of the stucco decoration of the Old Sacristy was becoming evident.

It is generally claimed that Luca della Robbia must have worked in enamelled terracotta long before the making of the Peretola tabernacle. But if the technique was still unknown when the decorations in the Old Sacristy were planned, and was still experimental when the spandrels of the Pazzi Chapel came to be filled, it must be

concluded that there are no emanelled terracottas before the earliest datable examples, and that the technique of enamelled terracotta was worked out by Luca della Robbia at Brunelleschi's instance for architectural use.

Though there is no documentary reference to the Apostle roundels in the Pazzi Chapel, Vasari ascribes all 13 of them to Luca della Robbia himself, and there is no reason to dispute this view, for each individual relief is a work of great elevation and nobility. The roundels are slightly concave, and the background is sometimes a uniform deep blue, and sometimes consists of blue concentric circles like those in the frieze beneath the tabernacle. Each figure sits on a ledge of cloud, with the feet supported on a cloud beneath, and almost the only touch of colour in the white raised surfaces occurs in the green cross held by St Andrew over the entrance door. Within their deliberately restricted range, the poses reveal great variety, and an instinctive sense for the circular form of the reliefs. It has sometimes been suggested that the Apostle roundels in the Pazzi Chapel were executed at a considerably later date, in conjunction with Luca's nephew Andrea, who was not born till 1435. But over and above the fact that Andrea's saccharine touch is not evident in the reliefs, there is one overwhelming argument against this view, and that is their connection with a securely dated work, the Resurrection relief in the Cathedral (plates 85, 86), which was commissioned by Brunelleschi in 1443 and was completed in 1445. The relief is placed above the doorway of the north sacristy, below the position

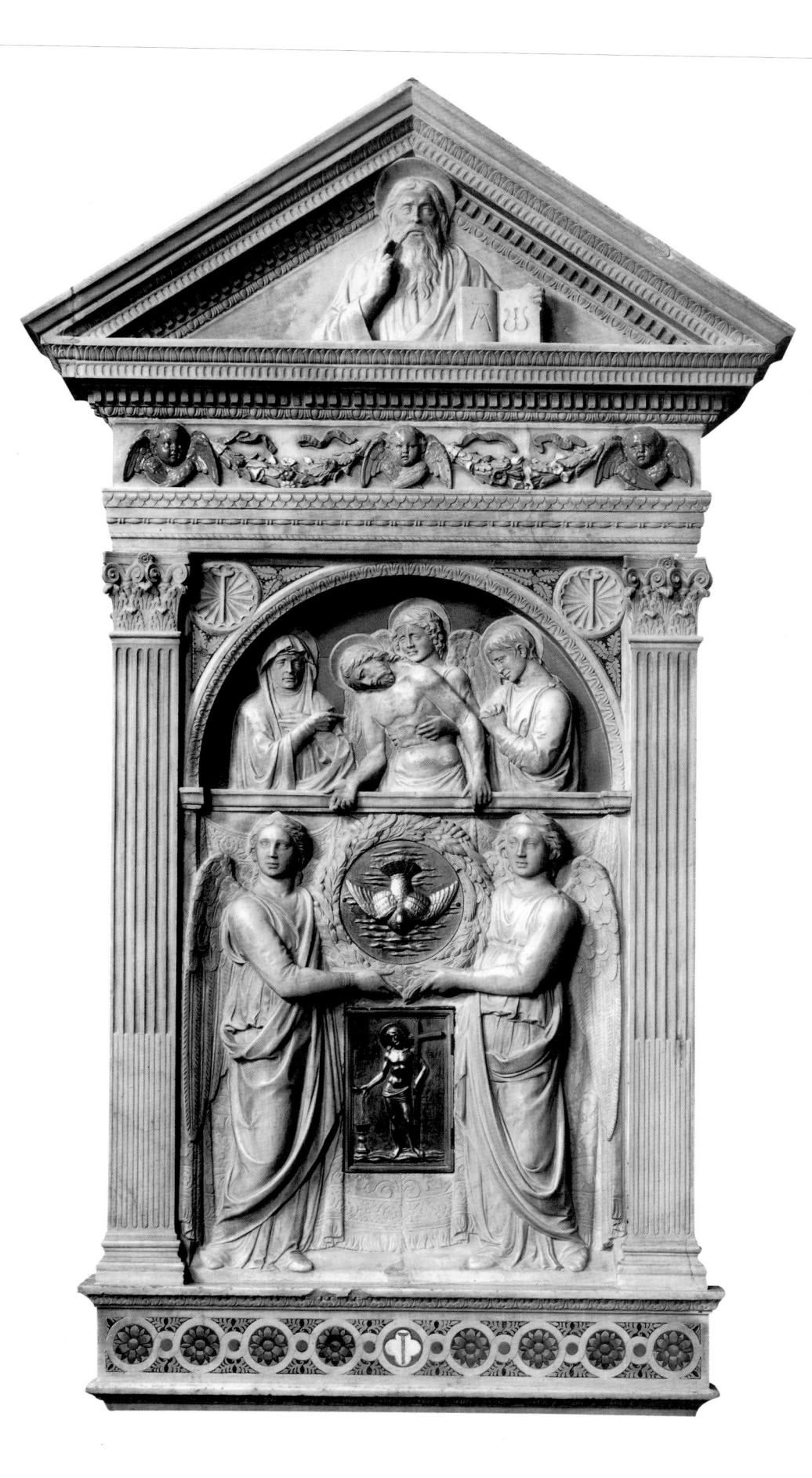

plate 81 Luca della Robbia

Tabernacle

S. Maria, Peretola marble and enamelled terracotta, 260 × 122 cm plate 82 Filippo Brunelleschi

The Pazzi Chapel

S. Croce, Florence

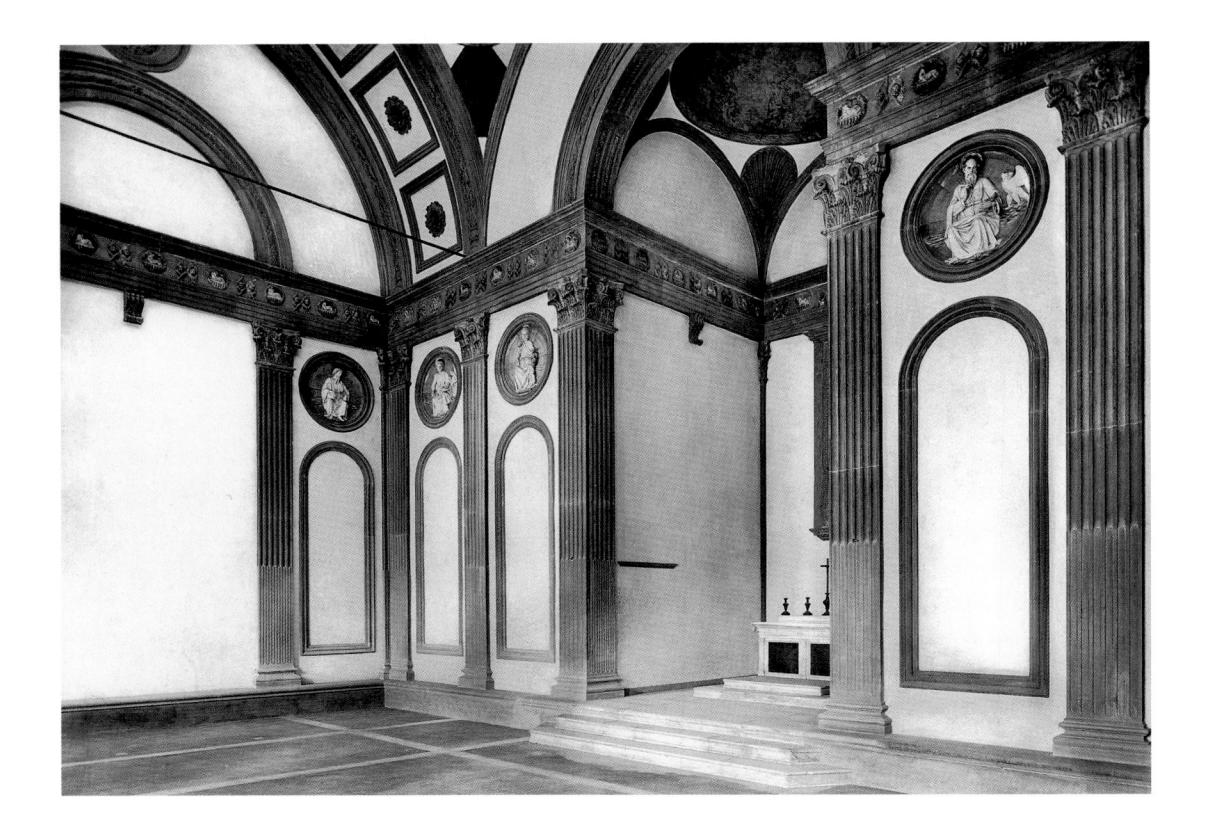

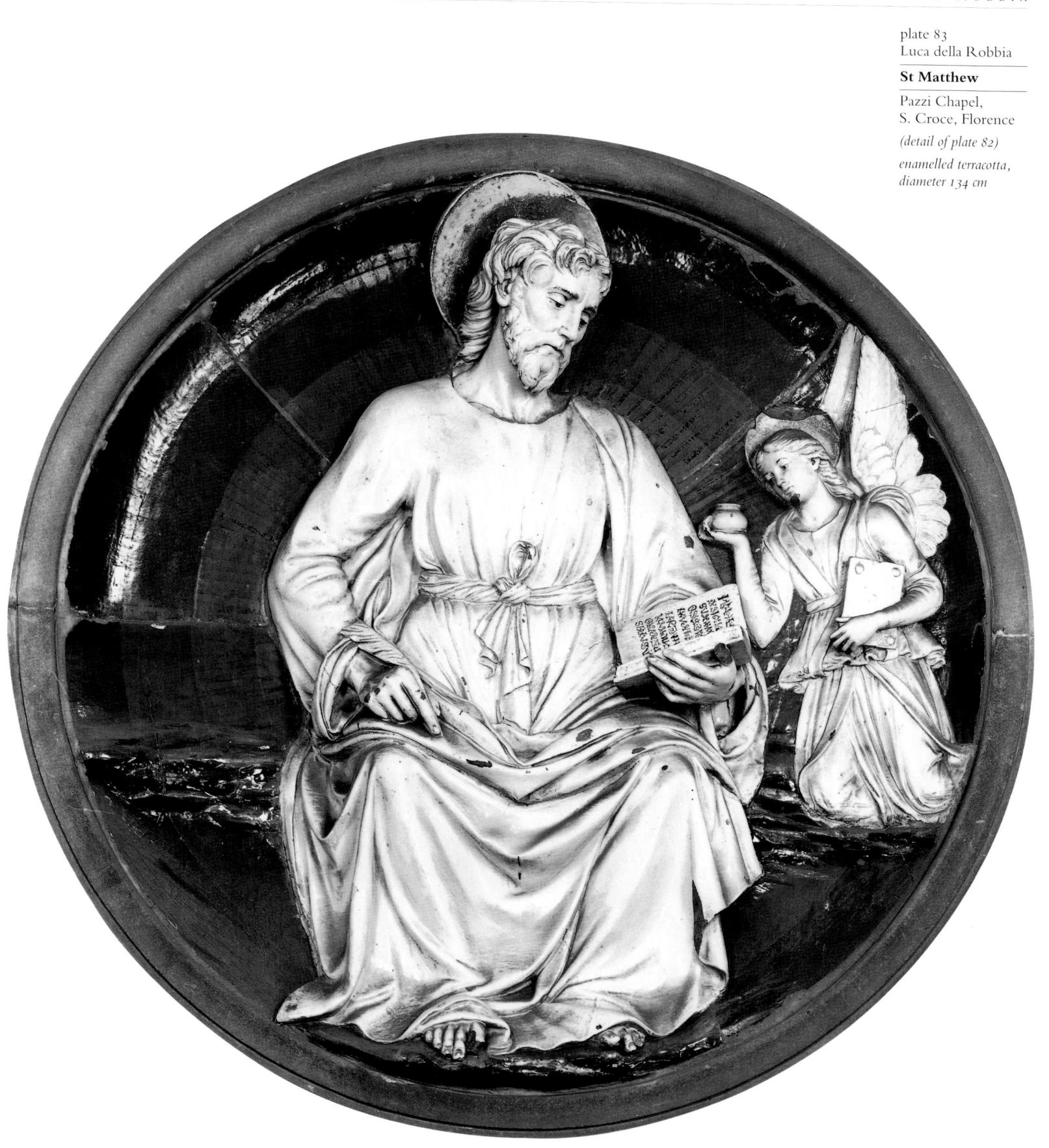

plate 84 Luca della Robbia

Visitation

S. Giovanni Fuorcivitas, Pistoia enamelled terracotta, 184×153 cm originally occupied by the Cantoria, and fills a Gothic lunette. The lunette is comparatively high and is inadequately lit, and on both counts the use of marble would have been inappropriate. More than this, the relief, like the roundels in the Pazzi Chapel, supplies a point of colouristic emphasis in the cold architecture of the church. Countless writers on Luca della Robbia have drawn attention to the relation between this relief and the Resurrection by Ghiberti on the first bronze door. A relationship there unquestionably is, but it is one of composition not of style. Ghiberti's Christ is an insubstantial Gothic spectre rising phantomlike from the sarcophagus, whereas Luca's is a static, boldly modelled figure, wearing a robe resolved in antique folds.

In 1446, a year after the Resurrection was completed, a corresponding relief of the Ascension (plates 87, 88) was commissioned from Luca for the lunette over the door of the south sacristy, but it was not begun immediately, and was not completed till 1451. In this scene rather surprisingly Luca does take a leaf out of Ghiberti's book, and uses the Christ from Ghiberti's Resurrection as the basis of his own ascending Christ. As a result the composition becomes less classical. The palette also undergoes a change. In the Resurrection the modelled areas are white and the ground is blue, and colour is confined to the eyes of the figures and to surface gilding. In the Ascension, on the other hand, the trees are green and the ground is a smudgy greenish brown, so that the whole effect is less homogeneous and less forcible. Perhaps these changes are connected with

the fact that Brunelleschi died after the completion of the first and before the commencement of the second of the reliefs.

Once the technique of enamelled terracotta was brought to the consummate state in which we find it in the Pazzi Chapel roundels, there was no reason why it should be limited to architectural use. It could be employed for free-standing figures, like the beautiful pyramidal group of the Visitation at Pistoia (plate 84), which dates from before 1445, and for reliefs planned in the same schematic way. It is difficult to describe these works, so simple and expressive and restrained, without striking that note of over-emphasis, that suspicion of excessive sentiment which Luca himself, in his own autograph reliefs, avoids with such success

Luca's Madonnas reveal him from a formal point of view as one of the most fertile sculptors of the fifteenth century. Never does he repeat a composition, never does his invention flag, and in work on an extended scale like the beautiful Stemma of the Guild of Doctors and Apothecaries on Or San Michele (plate 89), he produces a design which would not have shamed Domenico Veneziano. From below the effect of this relief is mainly decorative. But when we look at it more closely (and owing to the height at which it is set that can be done only in photographs) we find that the treatment of the central group is one of extraordinary subtlety. Indeed, to those who approach Renaissance sculpture from the standpoint of the present day, and derive their satisfaction from abstract relationships of form,

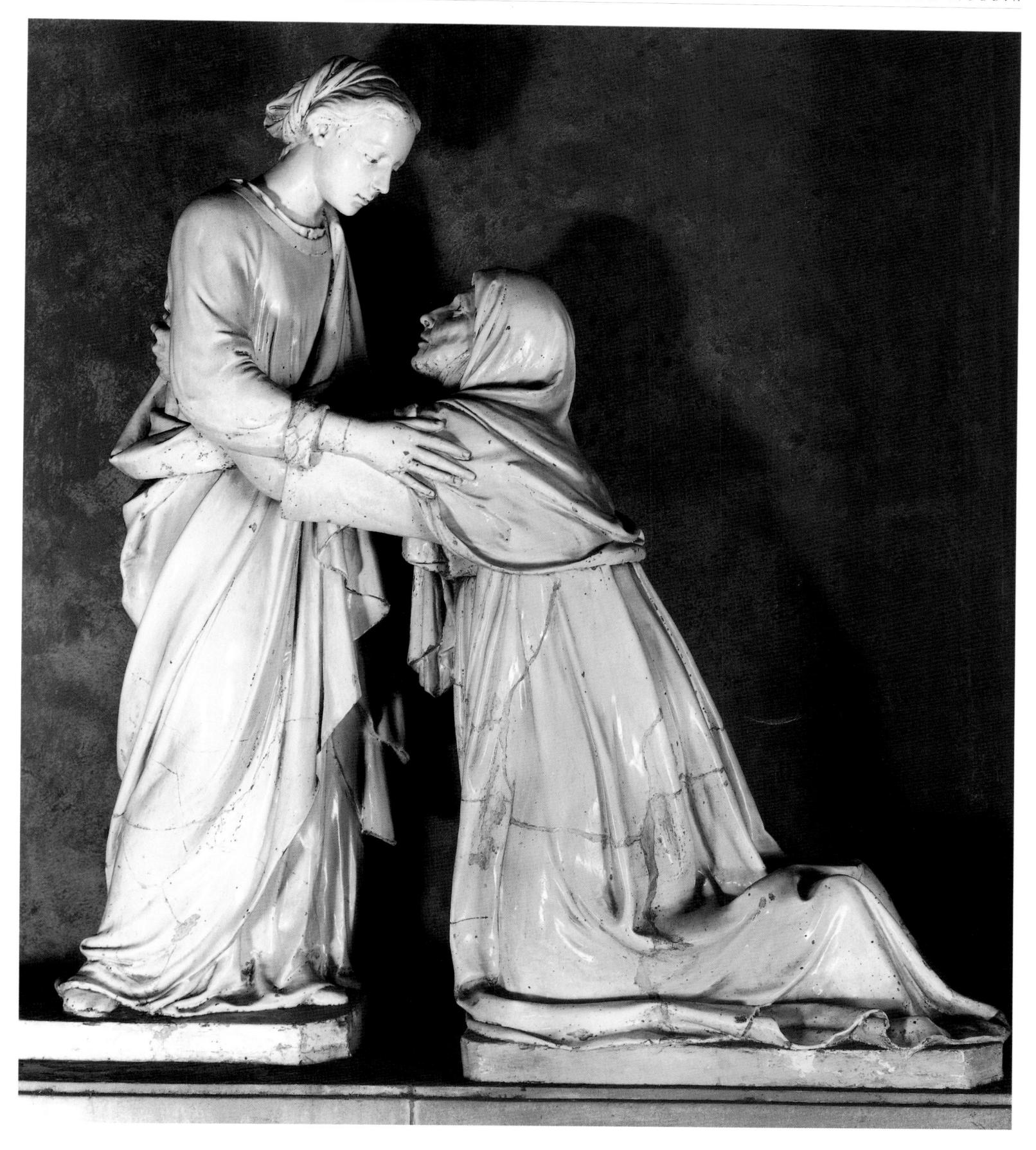

plate 85 Luca della Robbia

The Resurrection

Duomo, Florence enamelled terracotta, 200 × 260 cm

plate 86 *(opposite)* Luca della Robbia

The Resurrection

Duomo, Florence (detail of plate 85)

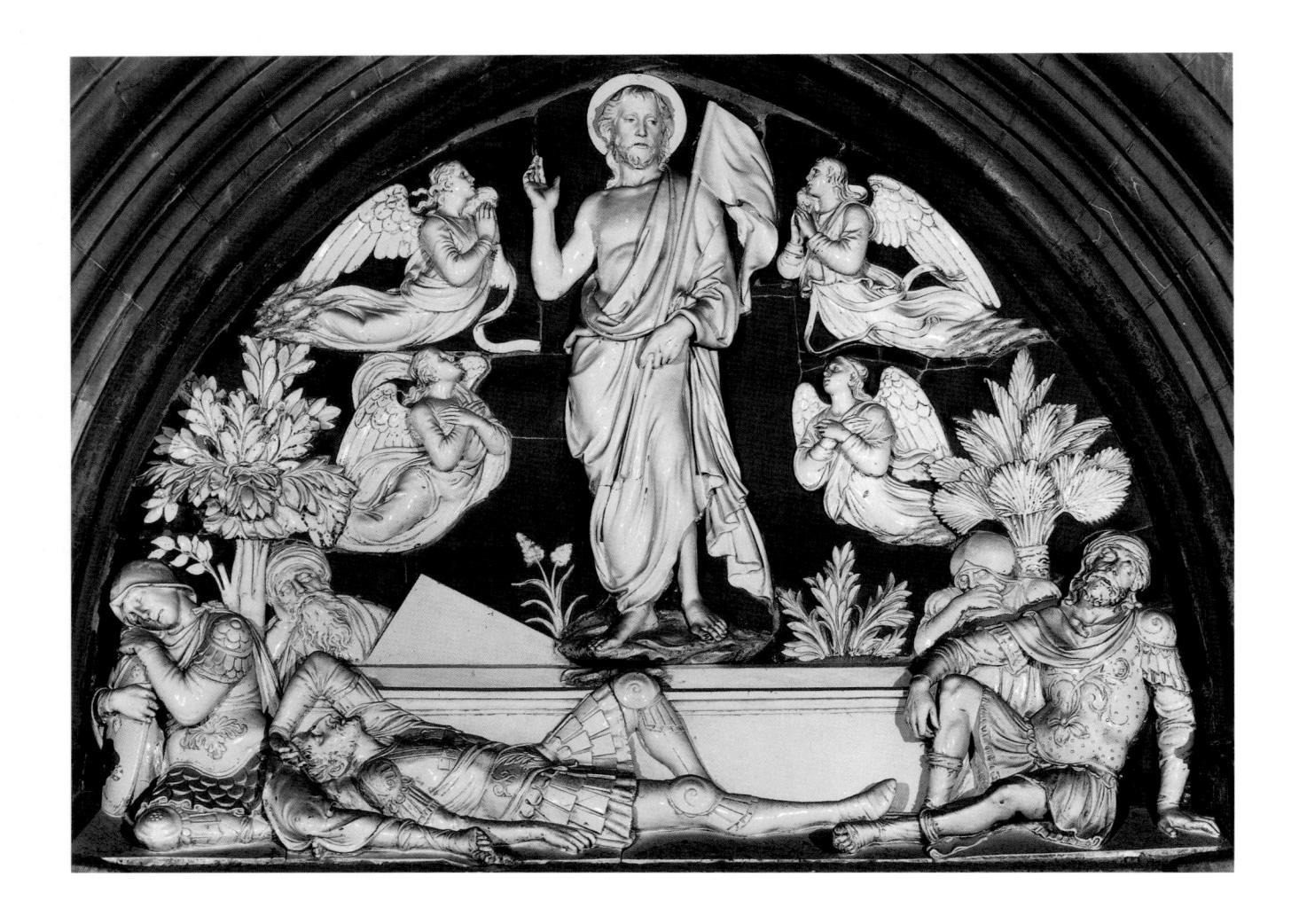

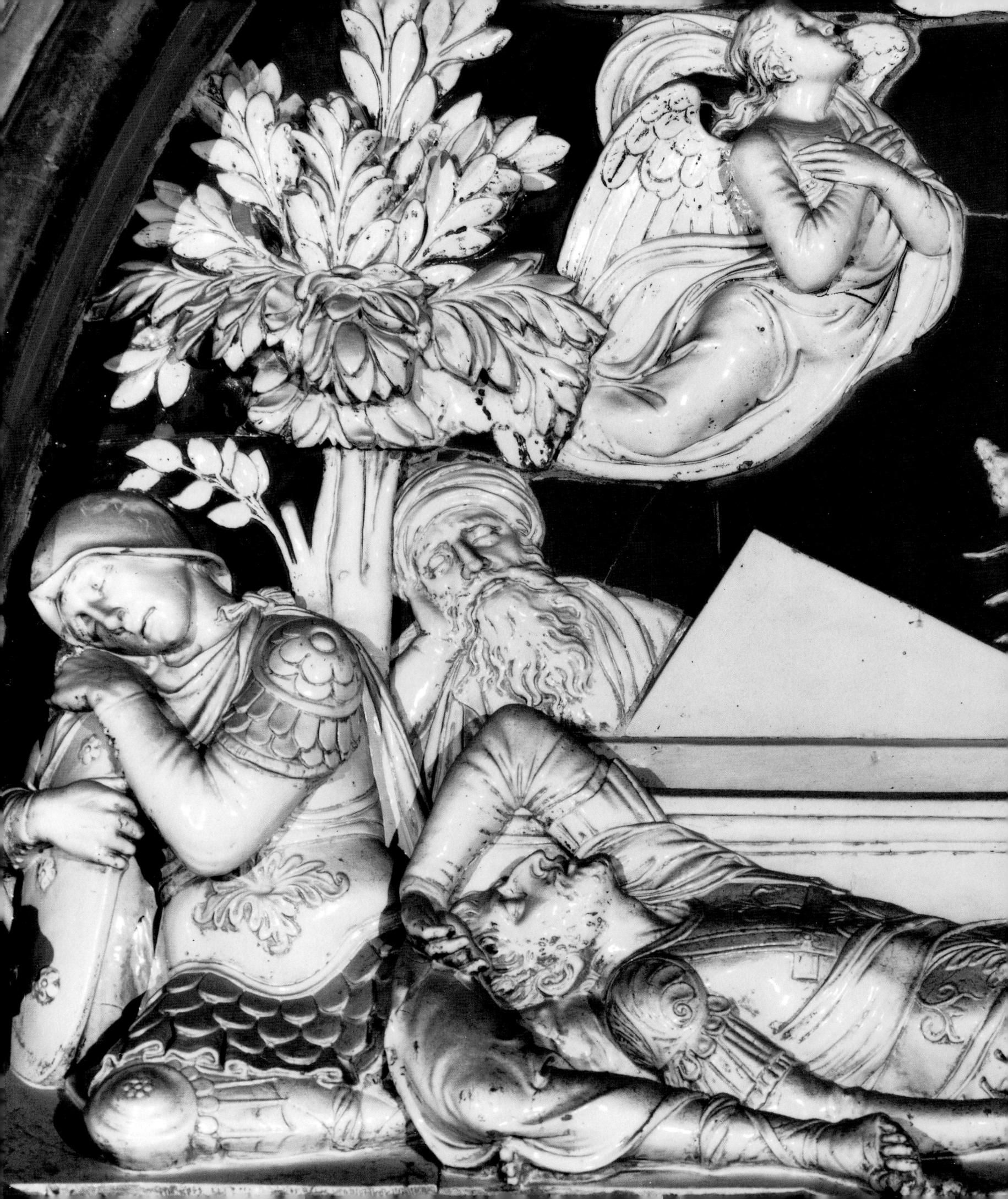

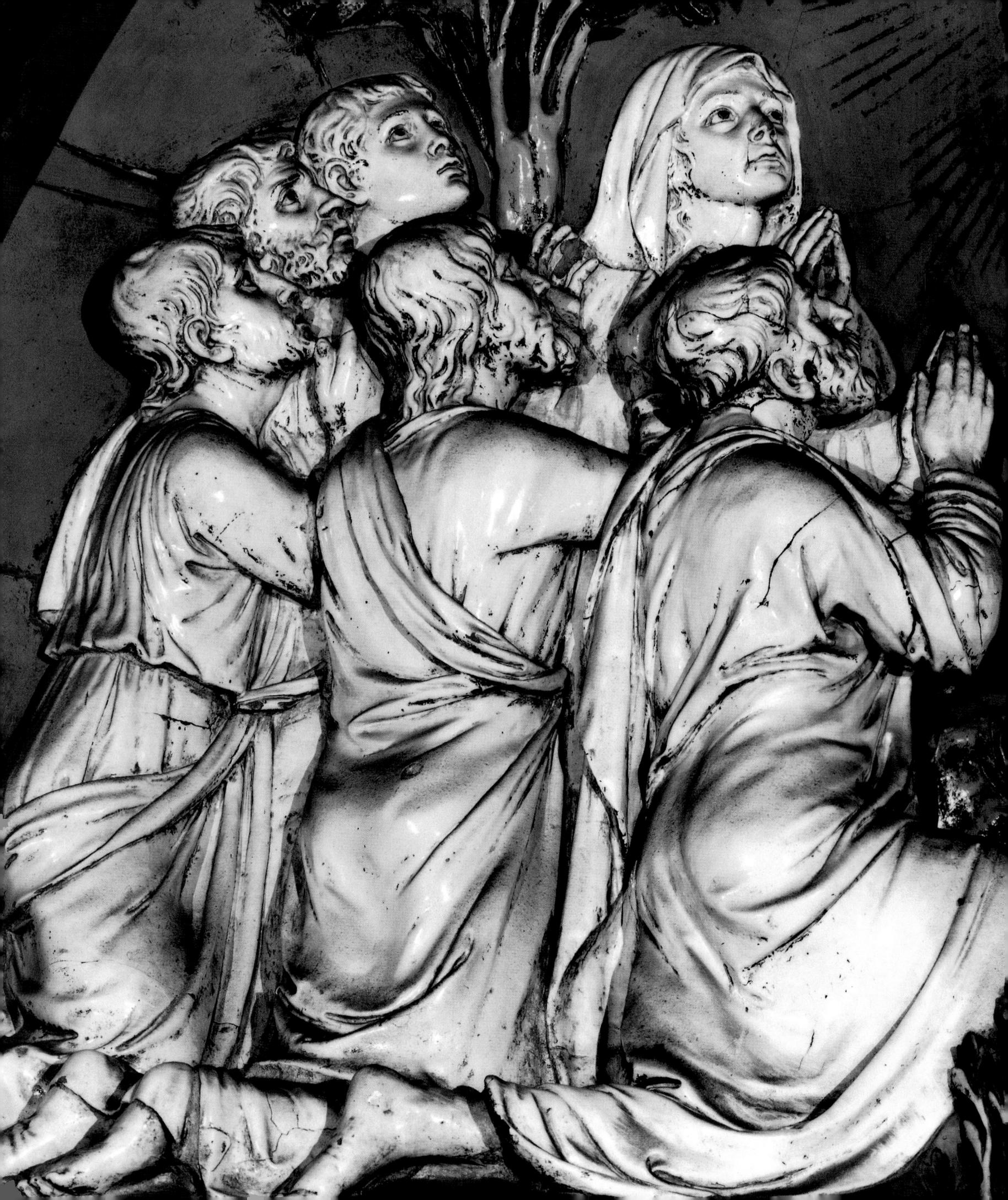

plate 87 *(opposite)* Luca della Robbia

The Ascension

Duomo, Florence (detail of plate 88)

plate 88 Luca della Robbia

The Ascension

Duomo, Florence enamelled terracotta, 200 × 260 cm

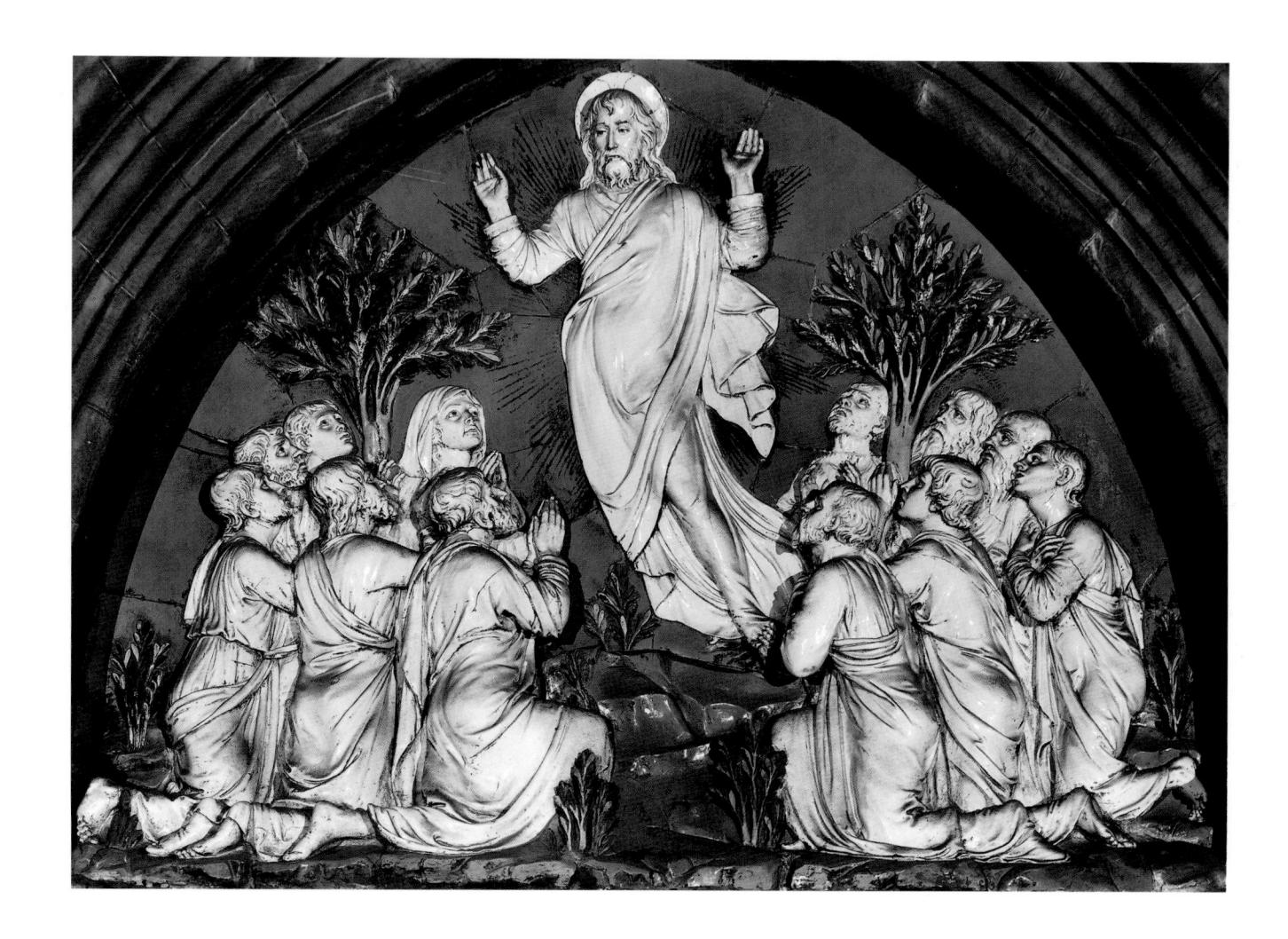

Luca della Robbia must speak more directly than any fifteenth-century Italian sculptor, not excluding Donatello.

As Luca aged, his style became more linear, and its decorative tendency grew more pronounced. When, for example, he was required to fill the little cupola of the loggia in front of the Pazzi Chapel, years after the roundels inside had been completed, he produced an astonishing design with the Pazzi arms in the centre inside a wreath of flowers and fruit, and outside it four concentric circles of medallions bounded by laurel wreaths. It was in this same spirit that he approached the commission for the ceiling of the Chapel of the Cardinal of Portugal at S. Miniato al Monte. The ceiling (plate 91) shows in the centre the Holy Spirit, with seven candlesticks ranged round it, and in the corners in roundels the Virtues of Prudence, Temperance (plate 92), Fortitude and Justice. The roof is slightly arched, and the five medallions are set on a surface of flat tiles. But the intention is illusionistic, and the tiles read as green and yellow cubes, while the four medallions of the Virtues are surrounded by circles of blue scales which suggest that each of them is recessed above a little cupola. Only when one of the roundels in the chapel is juxtaposed with one of the Apostle roundels (plate 83), does it become clear how fundamentally Luca's style has changed. The Apostles are posed frontally, and each figure is contained within its silhouette. Of the Virtues two are in profile and two are in three-quarter face, and no expedient is spared to avoid aligning the four figures on the relief plane. The arms (with

the exception of the left arm of Fortitude, holding a shield with Cardinal's arms, and the right arm of Prudence, holding a serpent) are outstretched, and establish an elaborate linear pattern on the relief field.

When Luca died in 1482, the work of his studio was continued by his nephew Andrea (1435–1525) and by five of Andrea's sons, headed by Giovanni della Robbia (1469–1529). A sensitive but facile sculptor, Andrea lacked Luca's seriousness. At his hands, Luca's naturalistic borders became conventionalized frames, Luca's Madonnas were weakened and sentimentalized, and Luca's spacious compositions were constricted and debased. The gulf that separates the artists may be gauged in the difference between the virile children on Luca's Cantoria and the foundlings by Andrea which ogle at us from the spandrels of the Ospedale degli Innocenti. In particular, the pictorial tendencies latent in Luca's lunette of the Ascension (plate 88) were developed by Andrea and Giovanni in a long series of polychrome terracotta altarpieces which are acceptable enough when seen at Santa Fiora or La Verna (plate 90) or Camaldoli in the context of the Tuscan countryside, but have little significance as works of art.

plate 89 *(opposite)* Luca della Robbia

Stemma of the Arte dei Medici e Speziali

Or San Michele, Florence enamelled terracotta, diameter 180 cm

plate 90 Andrea della Robbia

Madonna della Cintola

S. Maria degli Angeli, La Verna enamelled terracotta, 388×236 cm plate 91 Luca della Robbia

The Ceiling of the Chapel of the Cardinal of Portugal

S. Miniato al Monte, Florence

plate 92 *(opposite)* Luca della Robbia

Temperance

S. Miniato al Monte, Florence (detail of plate 91) enamelled terracotta, diameter of medallion 200 cm

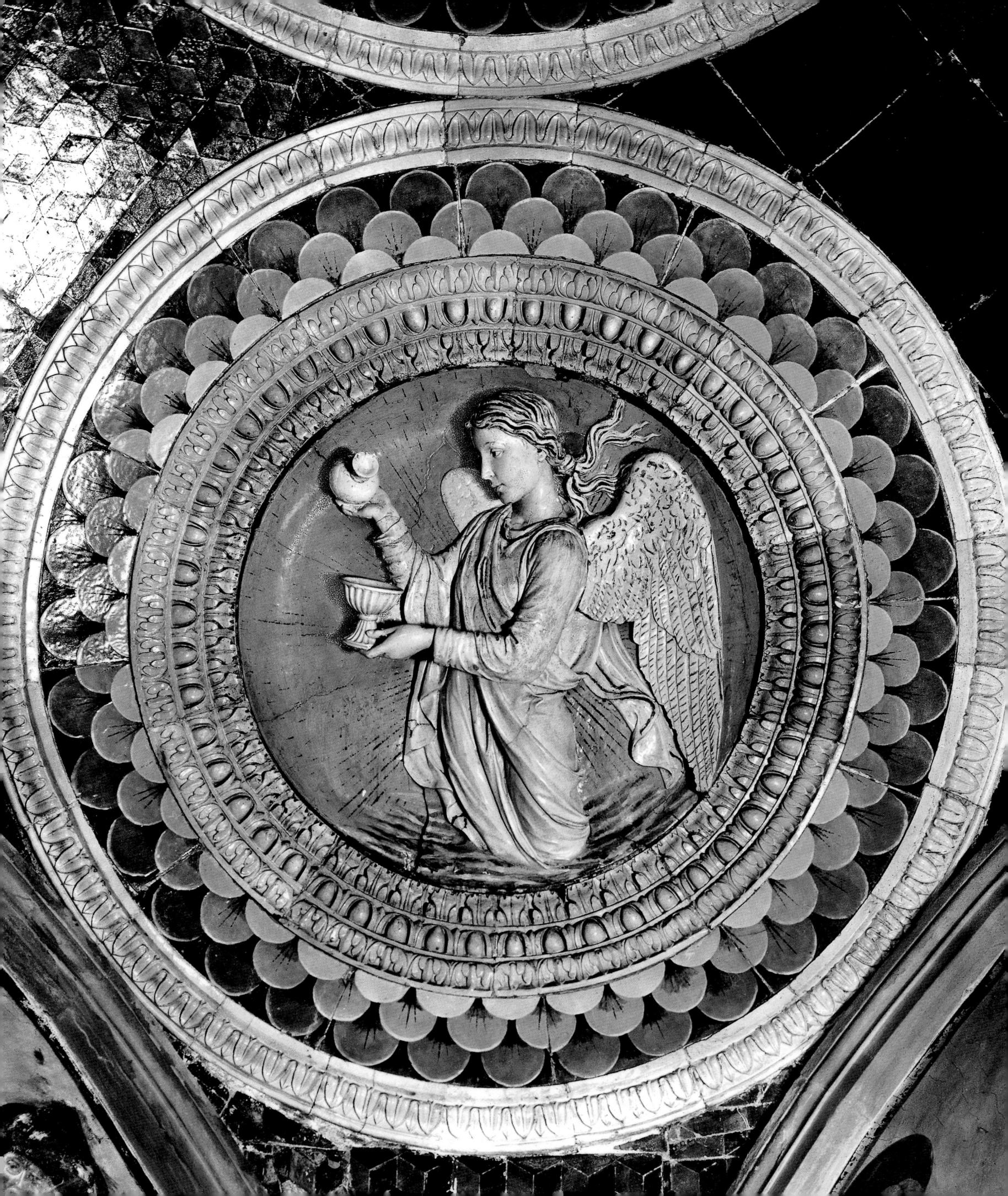

The Relief and Statue in Florence in the Later Fifteenth Century

plate 93 *(opposite)* Bernardo Rossellino

The Façade of the Misericordia

Arezzo

plate 94 Filippo Brunelleschi and Buggiano

Lavabo

Duomo, Florence *marble*

During the years when Luca della Robbia and Donatello were working on their Cantorias, a third sculptural project was under way in the Cathedral. This was the construction of the lavabo in the North Sacristy (plate 94), which was designed in 1432 by Brunelleschi and was carried out by his sculptural amanuensis Buggiano. Brunelleschi was probably responsible for the planning of the figure sculpture as well as of the frame, and the equation between sculpture and architecture set up in this work was fundamental for the sculptors of the middle of the century, above all for Bernardo Rossellino (1409–64).

At this very time, between 1433 and 1436, Bernardo Rossellino was himself engaged upon an architectural scheme relieved by figure sculpture, not in Florence but at Arezzo where he was completing the Misericordia façade (plates 93, 95). The pre-existing lower part of the façade consisted of a central doorway flanked by windows, and was divided by spiral columns in the familiar ratio of two to one, with a central section equal in width to the sum of the two sections at the sides. Rossellino preserved this ratio in the upper part, replacing the spiral columns by linked pilasters. The narrow outer sections were filled with tabernacles derived from the Parte Guelfa tabernacle of Donatello and Michelozzo on Or San Michele (plate 17), and in the centre was an irregular lunette with the Madonna of Mercy adored by members of the confraternity. Though the tabernacles depend from Donatello, Bernardo's sympathies were rather with Brunelleschi and Luca della Robbia, and the

figures which fill the niches are staid and classical. Even in the beautiful relief in the lunette the sculptural style is unemphatic, and is subdued by an exceptionally heavy moulding, as though Rossellino were determined that the figure sculpture should not disturb the serene equilibrium of his scheme.

From the 1430s on, the moral influence of Brunelleschi and the practice of Bernardo Rossellino lent a new emphasis to categories of sculpture in which the figurative content was subordinate to the decorative whole. The most important of these were the tabernacle and the pulpit. The impact of Donatello's tabernacle in St Peter's in Rome (plate 96) is made primarily through its figure sculpture; at the base statuettes of Angels are employed to bridge the awkward interval between the lateral pilasters and the tabernacle door. Bernardo Rossellino, on the other hand, in a tabernacle carved for S. Egidio in Florence in 1450 (plates 97, 98, 99), reduces the figure sculpture to a bust of God the Father, two tiny half-length figures in prayer before a chalice. and two groups of adoring angels at the sides. Where Donatello places his praying angels in front of the lateral pilasters, Bernardo Rossellino treats the centre of the tabernacle as a kind of hall, with a receding barrel-vaulted roof which leads the eye back to the tabernacle door, and his angels are shown inside this artificial space, advancing from doorways at the sides. This beautiful scheme established a tradition which was carried on by two pupils of Bernardo Rossellino, his younger brother Antonio (1427-79) and Desiderio da

plate 95 Bernardo Rossellino

Madonna of Mercy

Misericordia, Arezzo (detail of plate 93) stone, width of lunette 350 cm

plate 96 *(opposite)* Donatello

Tabernacle

Sagrestia dei Beneficiati, St Peter's, Rome marble, 225 × 120 cm

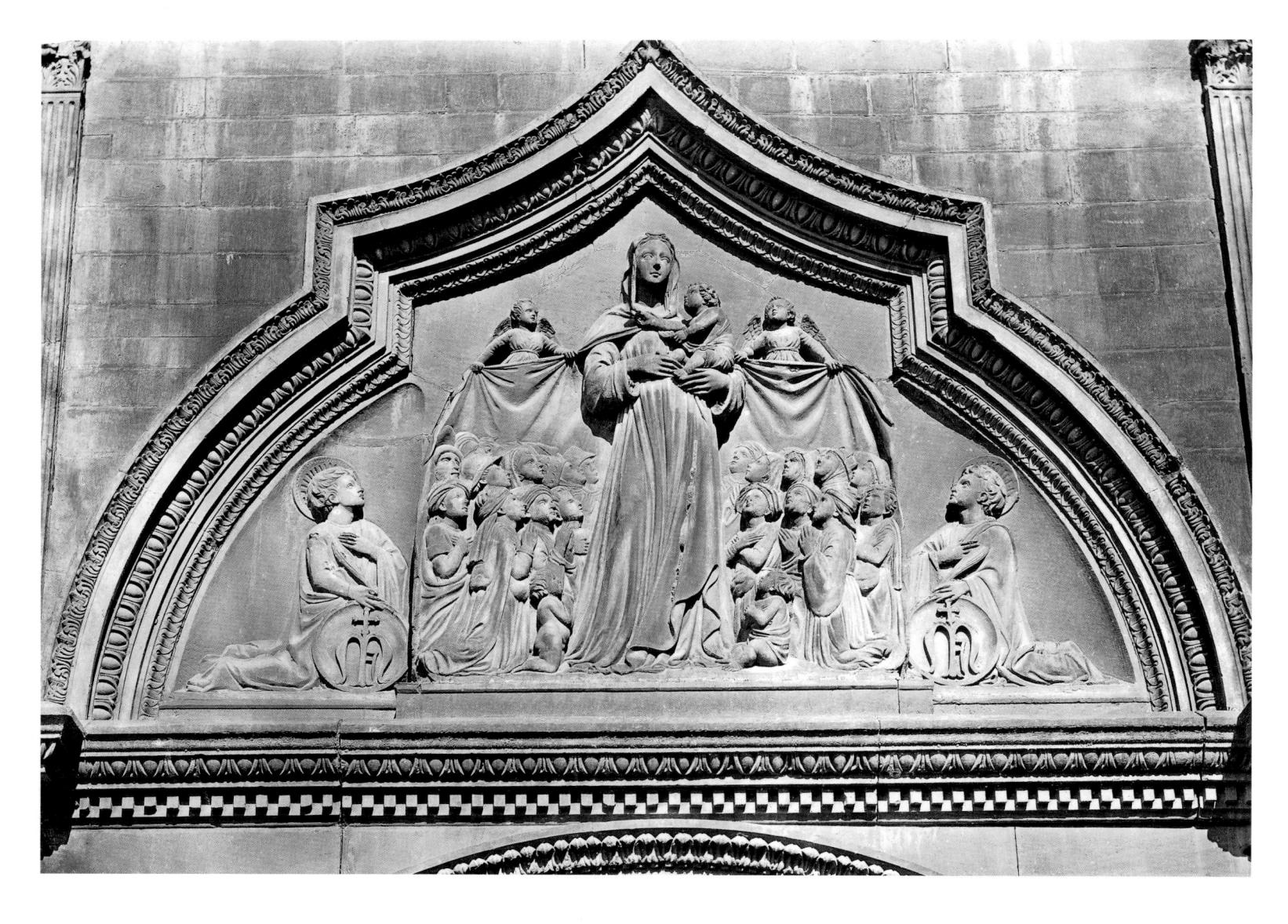

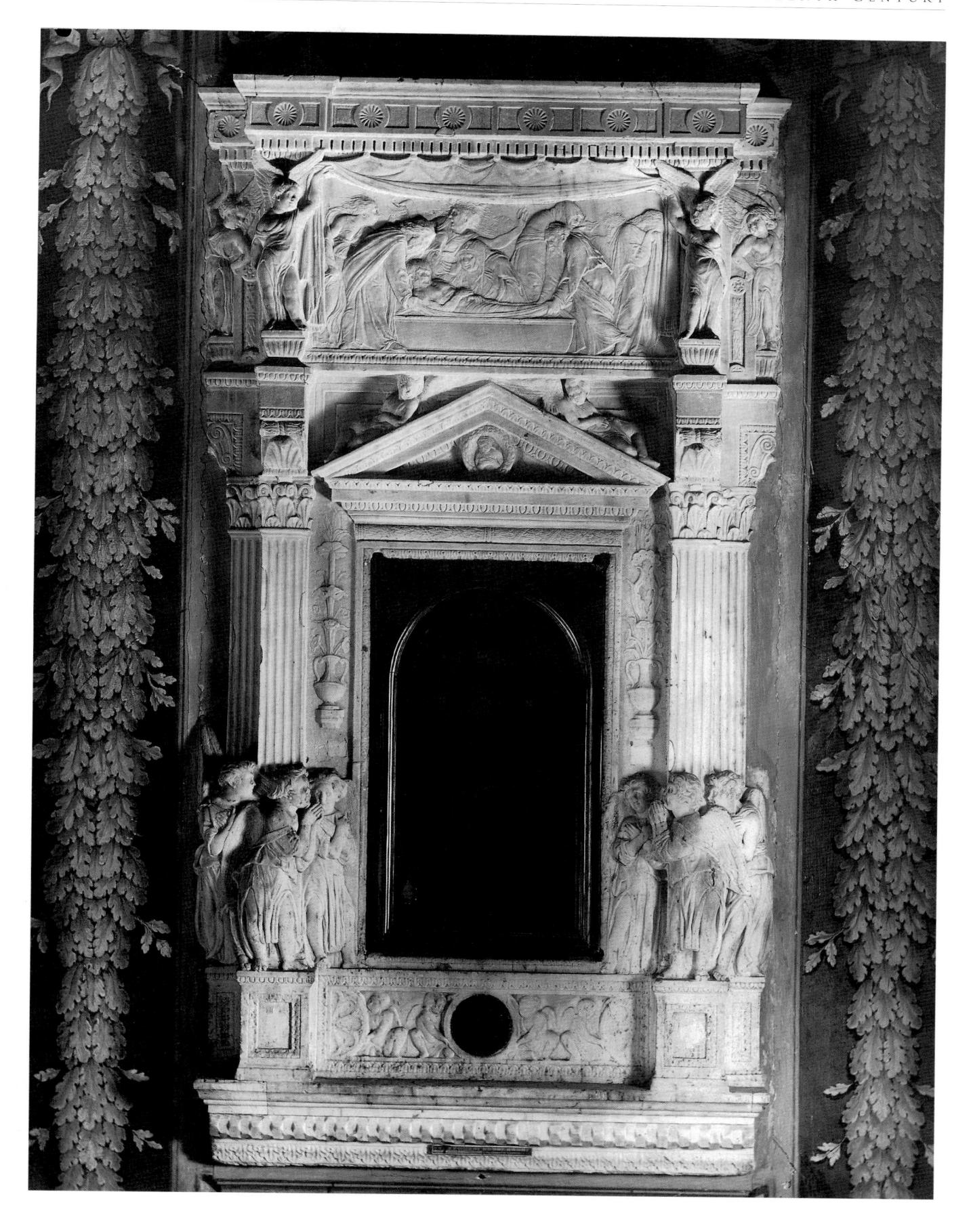

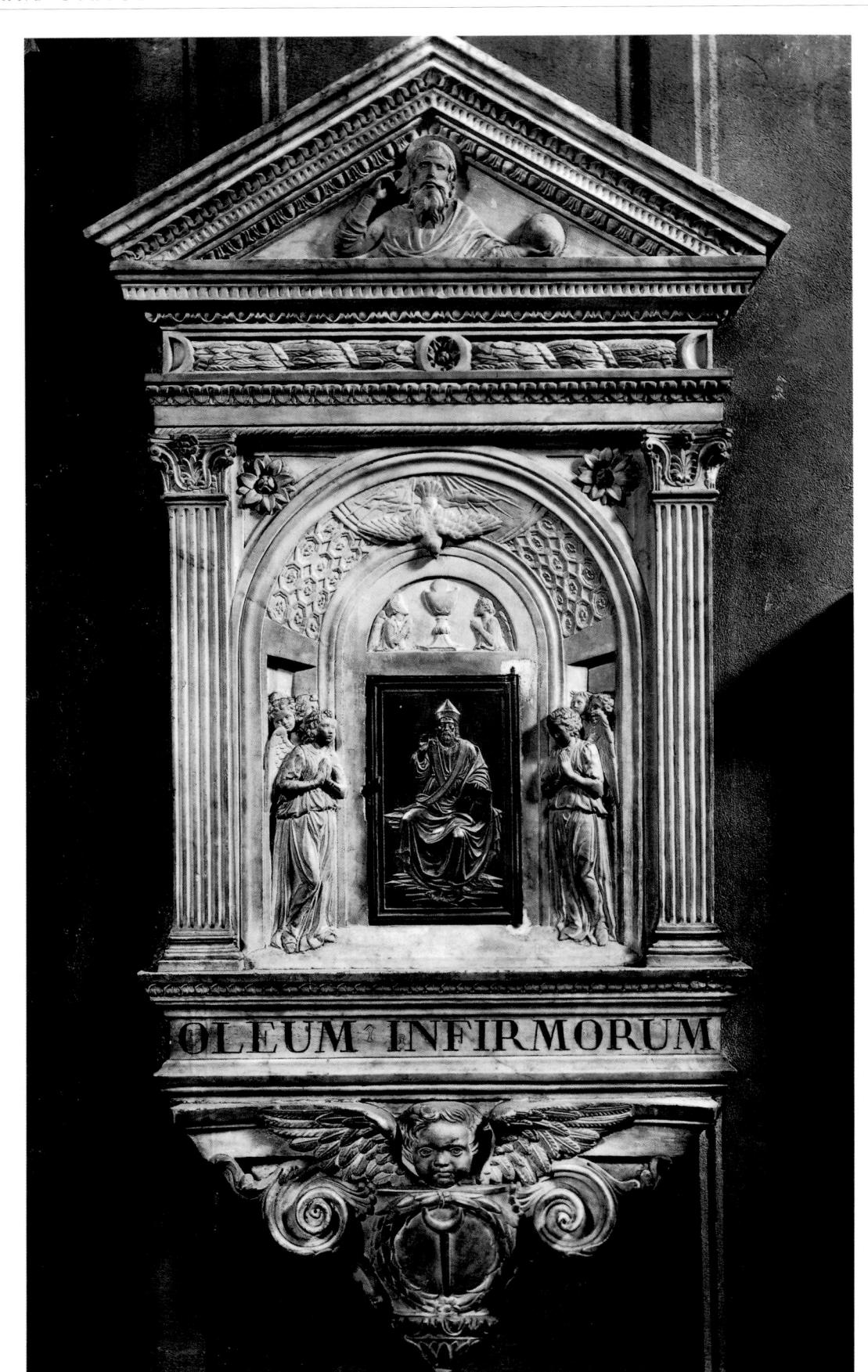

plate 97 Bernardo Rossellino

Tabernacle

S. Egidio, Florence marble, 140 × 91.7 cm
Settignano (c.1430–64), and by two putative pupils of Antonio Rossellino, Benedetto da Majano (1442–97) and Matteo Civitali (1436–1501).

In pure artistry the tabernacle in the centre of Desiderio's Altar of the Sacrament in S. Lorenzo (plate 100) is the outstanding decorative achievement of the century. Considerably larger than Bernardo Rossellino's, it forms part of a complex which includes two statuettes of candlebearing angels (plates 102, 103), a lunette with two angels and a standing figure of the Child Christ, and an antependium relief of the Lamentation over the Dead Christ (plate 101). In Desiderio's tabernacle the hall is more spacious than Bernardo Rossellino's, and the recession of the pavement and the roof is more severe. With a touch of incomparable virtuosity the cornice is supported not by pilasters but by fluted columns, whose rotundity is suggested by slight deformation at the sides. In order to establish the necessary sense of scale, the angels are reduced in size, and are shown dancing in ecstasy before the tabernacle door. Not only was Desiderio's tabernacle more elaborate in form, but it had at the same time a new programmatic character, for the mystical Adoration of the Sacrament was combined with a statuette of the Child Christ in benediction and a relief of the suffering Christ. Desiderio was a lyric poet, not a writer of heroic verse, and for the violent gesticulation of Donatello's Entombment on the St Peter's tabernacle he substitutes a passive melancholy. His relief is a tranquil meditation on the Passion, not a narrative scene. The contrast between the radiant Child of the Nativity and the

suffering Christ beneath is not the less affecting on that account. Both the Child Christ at the top and the candle-bearing angels beside the tabernacle speak with the innocence, the childlike rapture, that is the essence of Desiderio's interpretative art.

The pulpit also set a premium on decorative carving. Throughout the fifteenth century the suspended pulpit devised by Donatello retained its popularity. It was adopted by Brunelleschi for S. Maria Novella (plate 104), in a beautiful design in which the pulpit proper is approached by a staircase encircling a pier of the nave, and by Benedetto da Majano for S. Croce (plate 106), in a scheme in which access to the pulpit is gained through the pier. At Prato it was modified by Antonio Rossellino (plate 105) in the form of a circular basin balanced on a single central support. Before his pulpit was completed Brunelleschi died, and his plans were once more realized by Buggiano, who supplied the upper part with four inferior narrative reliefs. Less organic in design, the Prato pulpit is technically the superior work. Based on the external pulpit of Donatello, the upper section contains five narrative reliefs, and in the three of these for which he was responsible Antonio Rossellino achieves remarkable success in creating a space illusion on the convex relief surface and in reconciling this with the decorative requirements of the pulpit as a whole. In the five scenes from the life of St Francis on the S. Croce pulpit (plate 107), Benedetto da Majano, avoiding the challenge of a convex surface, produced some of the most accomplished narrative reliefs of the later fifteenth century. From the time they worked plate 98 Bernardo Rossellino

Adoring Angels

S. Egidio, Florence (detail of plate 97)

plate 99 *(opposite)* Bernardo Rossellino

Adoring Angels

S. Egidio, Florence (detail of plate 97)

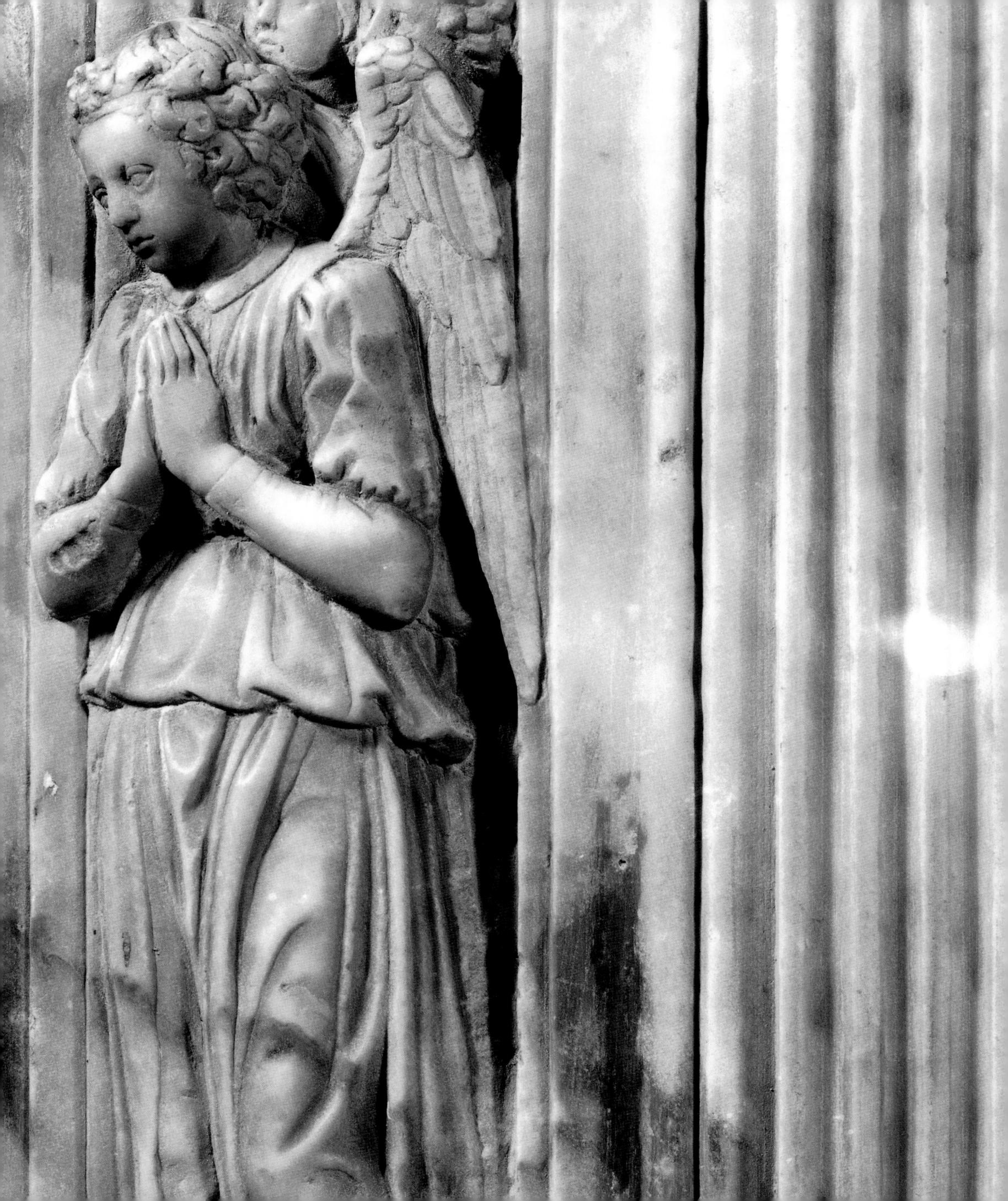

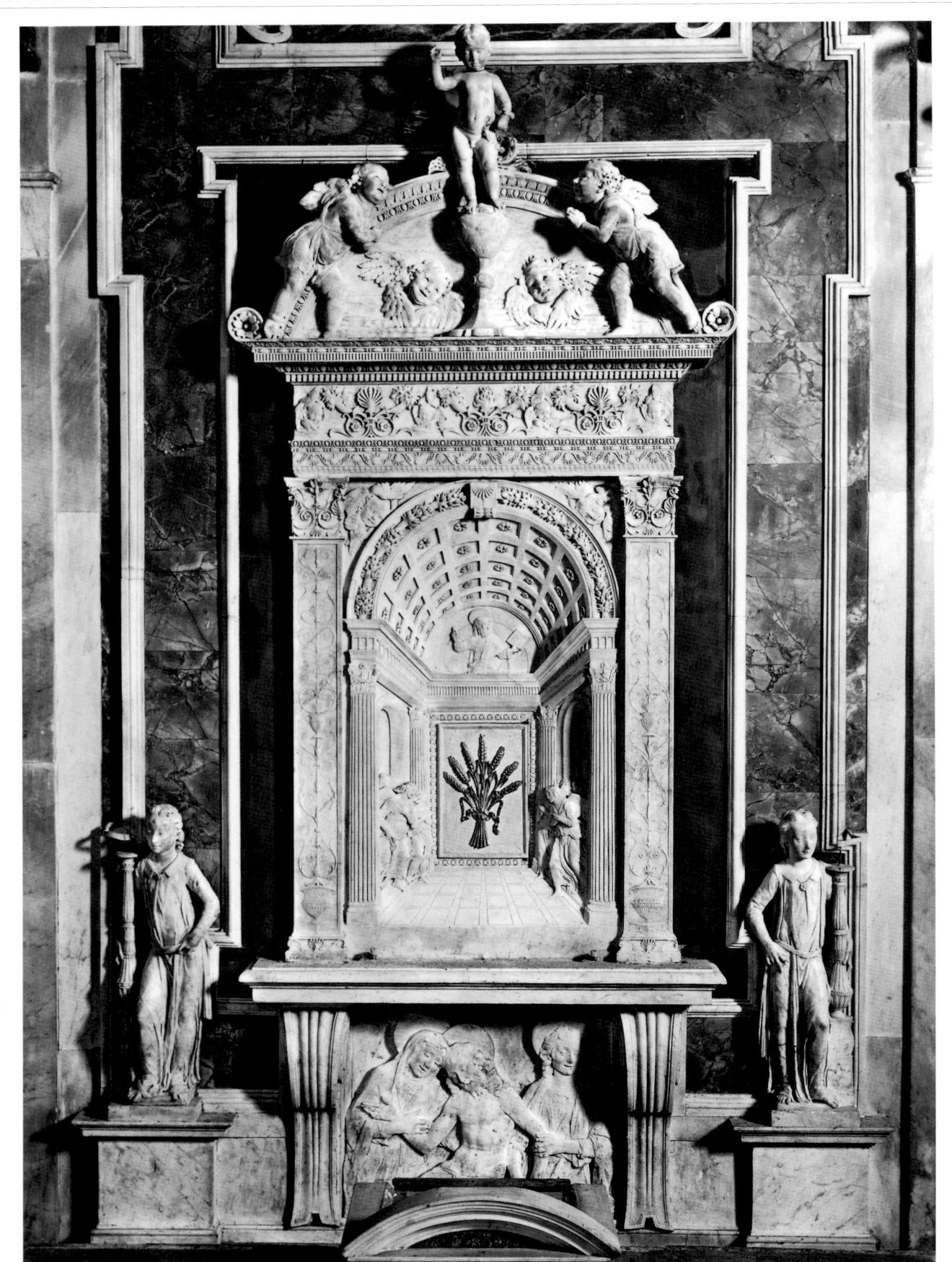

plate 100 Desiderio da Settignano

The Altar of the Sacrament

S. Lorenzo, Florence marble, 147 × 87 cm

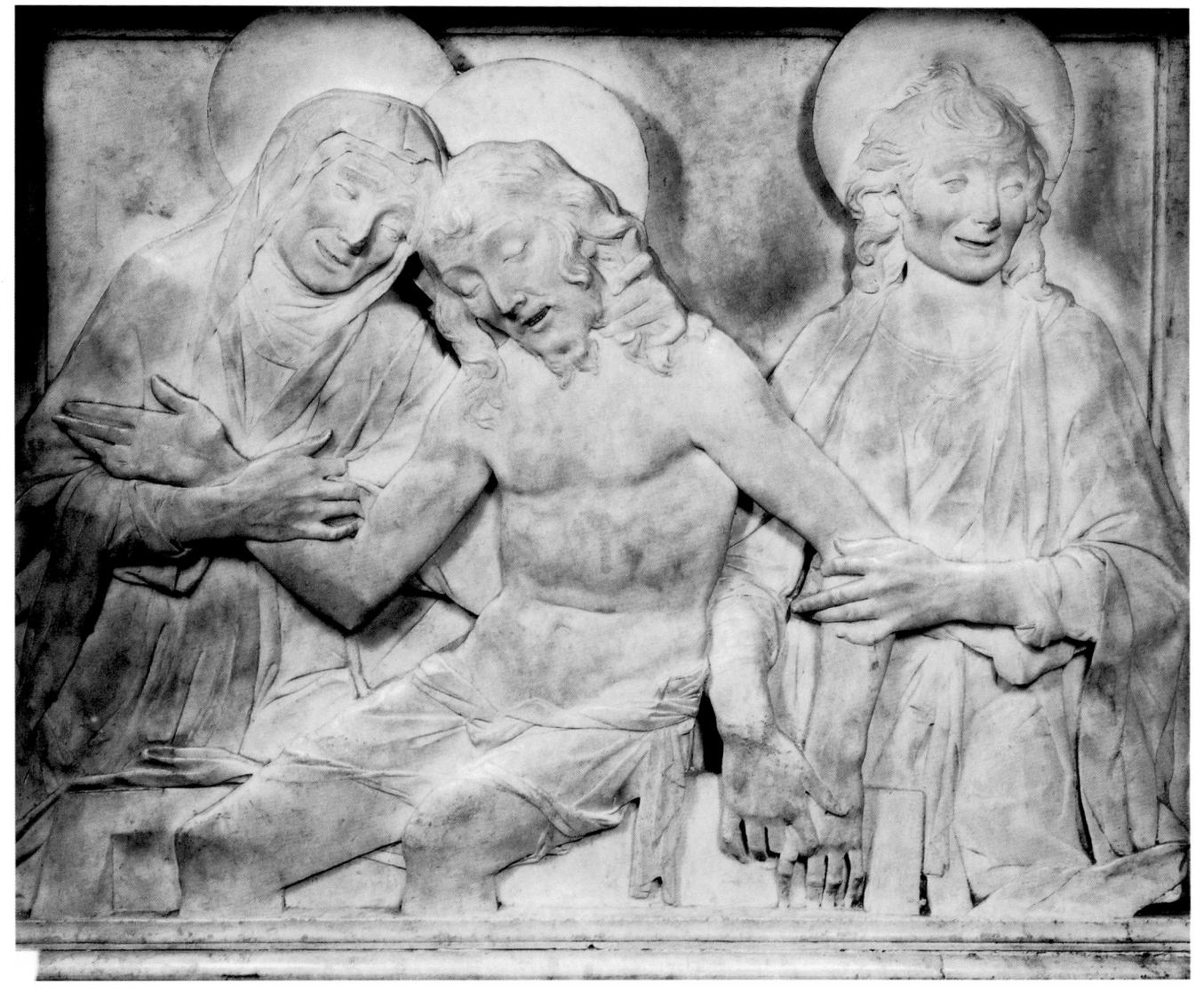

plate 101 Desiderio da Settignano

The Dead Christ with the Virgin and St John

S. Lorenzo, Florence (detail of plate 100)

Overleaf plate 102 (left) Desiderio da Settignano

Head of an Angel

S. Lorenzo, Florence (detail of plate 100)

plate 103 (right) Desiderio da Settignano

Head of an Angel

S. Lorenzo,
Florence
(detail of plate 100)

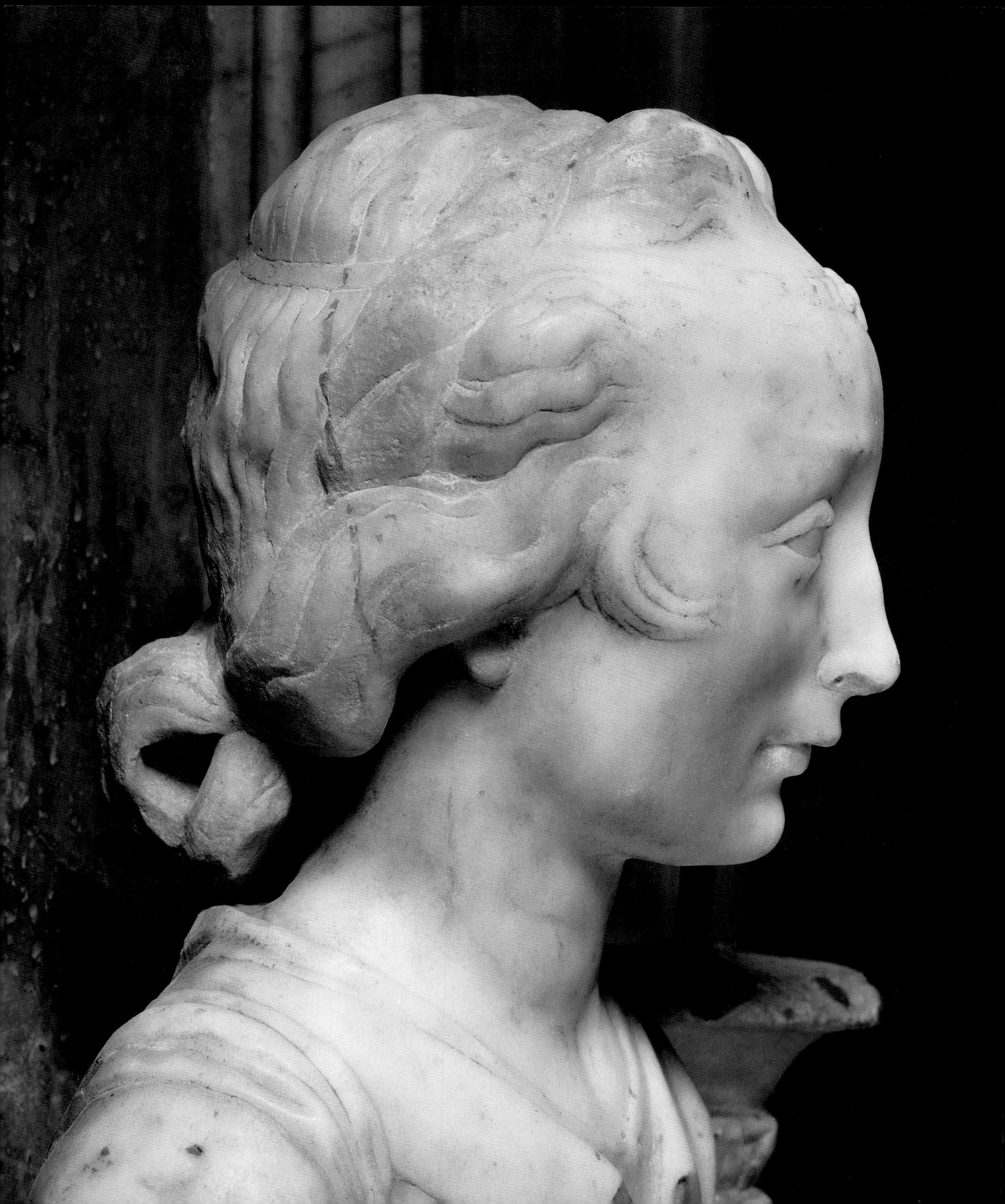

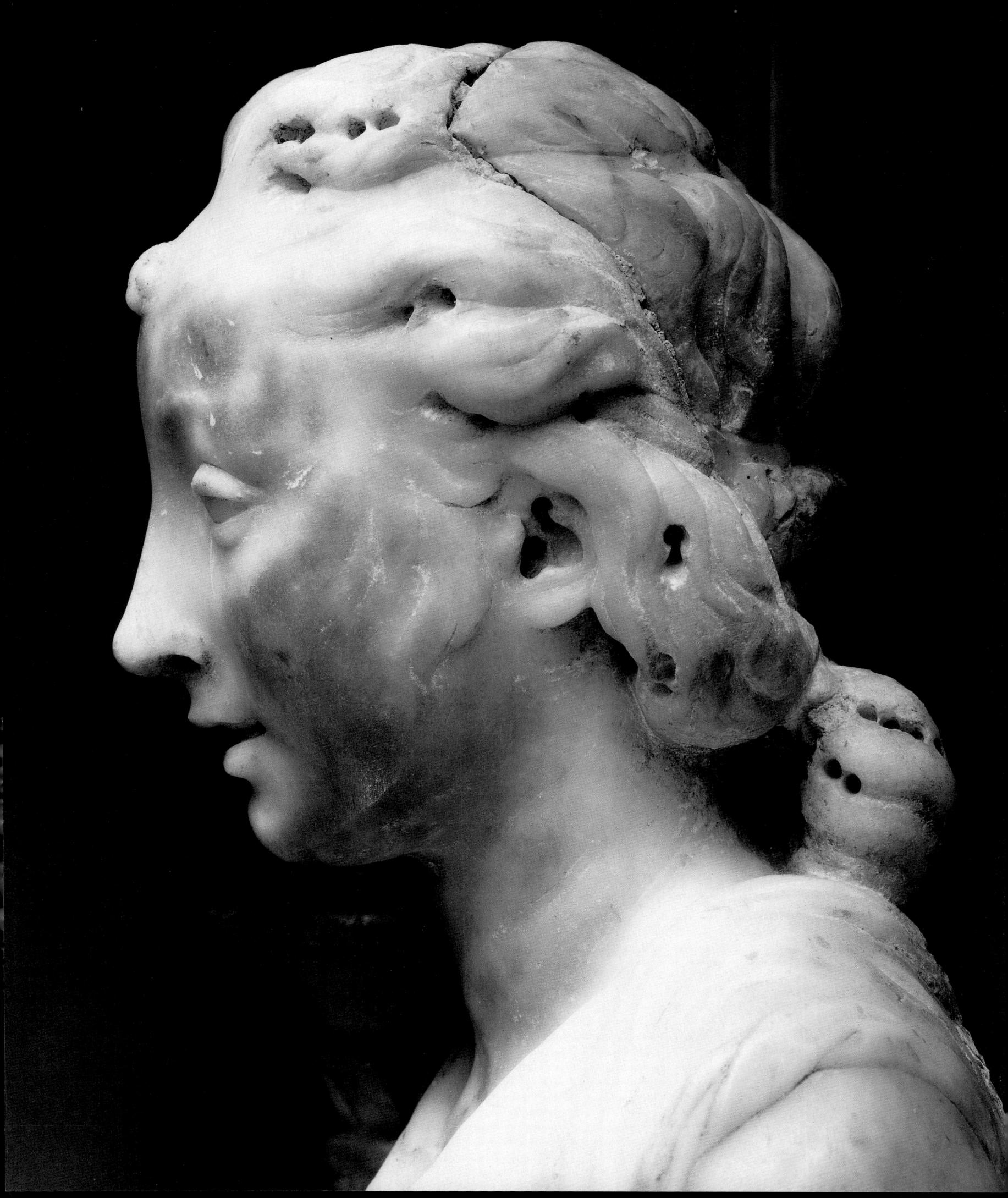

plate 104 Filippo Brunelleschi and Buggiano

Pulpit

S. Maria Novella, Florence marble, height 238 cm together in the chapel of S. Fina at S. Gimignano, Benedetto was associated with the painter Ghirlandaio, and the style of his pulpit reliefs is that of the frescoes which Ghirlandaio was painting simultaneously in the Sassetti Chapel in S. Trinita. Of the two artists, it was Benedetto who was gifted with the more poetic sense of narrative, and his Stigmatization of St Francis on the pulpit has a lyrical refinement that is seldom found in Ghirlandaio's work.

With the S. Croce pulpit the barrier between painting and sculpture all but disappears. In two altarpieces carved for Naples it is eliminated. The first of these was executed by Antonio Rossellino concurrently with the Prato pulpit, and represents the Adoration of the Shepherds between two statuettes of Saints (plate 108). No previous Renaissance sculptor had faced the problem of constructing a monumental pictorial relief, and had the scene no other merits its spatial content – the foreground delimited by the receding stable roof, the middle distance by a foreshortened wheel of angels in the sky, and the far distance by a landscape on the right - would entitle Antonio to a place among the most resourceful sculptors of his time. A corresponding altarpiece with the Annunciation was completed fifteen years later by Benedetto da Majano (plate 109), and is a work of exquisite decorative taste, in which the statues at the sides, leaning forward from their niches, augment the depth of the perspective vista in the central scene. By strict sculptural standards the ambivalent style of the relief represents a sad decline from the heights of the Cavalcanti

Annunciation of Donatello, but it is impossible to repress a sense of pleasure at the delicate handling of the figures (plate 110) and at the subtlety with which the sculptor merges the interior architecture with the architecture of the frame.

When Donatello transferred his studio to Padua in 1443, Antonio Rossellino was aged 16 and Desiderio da Settignano was three years his junior. As they matured, both artists must have been familiar with Donatello's work, though neither can have had direct experience of his overpowering personality. Desiderio was a draughtsman of the first rank, and alone of the sculptors of the middle of the century he employed the technique of rilievo stiacciato. At first the facility with which he carved in low relief proved a source of weakness rather than of strength. In the Foulc Madonna at Philadelphia (plate 111) the Virgin and Child gaze out to the right of the relief with open eyes and parted lips. The execution of this carving is beyond all praise, for Desiderio, better than any other marble sculptor of the fifteenth century, knew how to portray those slight surface variations - the Virgin's breasts beneath her robe, creases in the Child's neck, shallow indentations beneath the evelids and the lips – which communicate a sense of lifelikeness. But when it is compared with Donatello's terracotta Madonna in the Louvre (plate 63), we find that Desiderio, in reducing his relief to one continuous plane and eliminating visual emphasis, has sacrificed not only the physical weight of Donatello's work, but also its spiritual gravity. His values are human, not divine. After Donatello returned to Florence from Siena, he

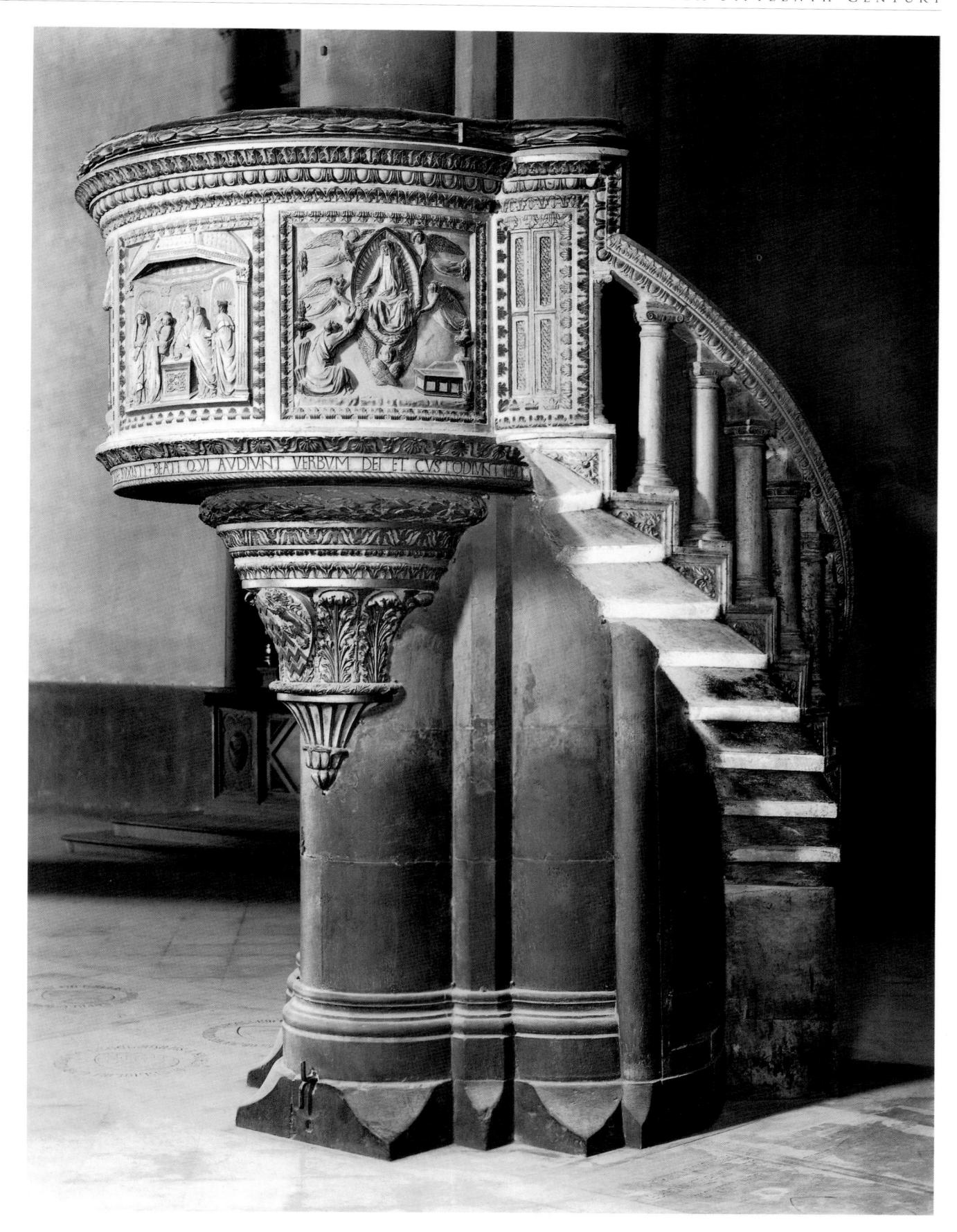

plate 105 Antonio Rossellino

Pulpit

Duomo, Prato marble, height 390 cm

plate 106 *(opposite)* Benedetto da Majano

Pulpit

S. Croce, Florence marble, 262 × 599 cm

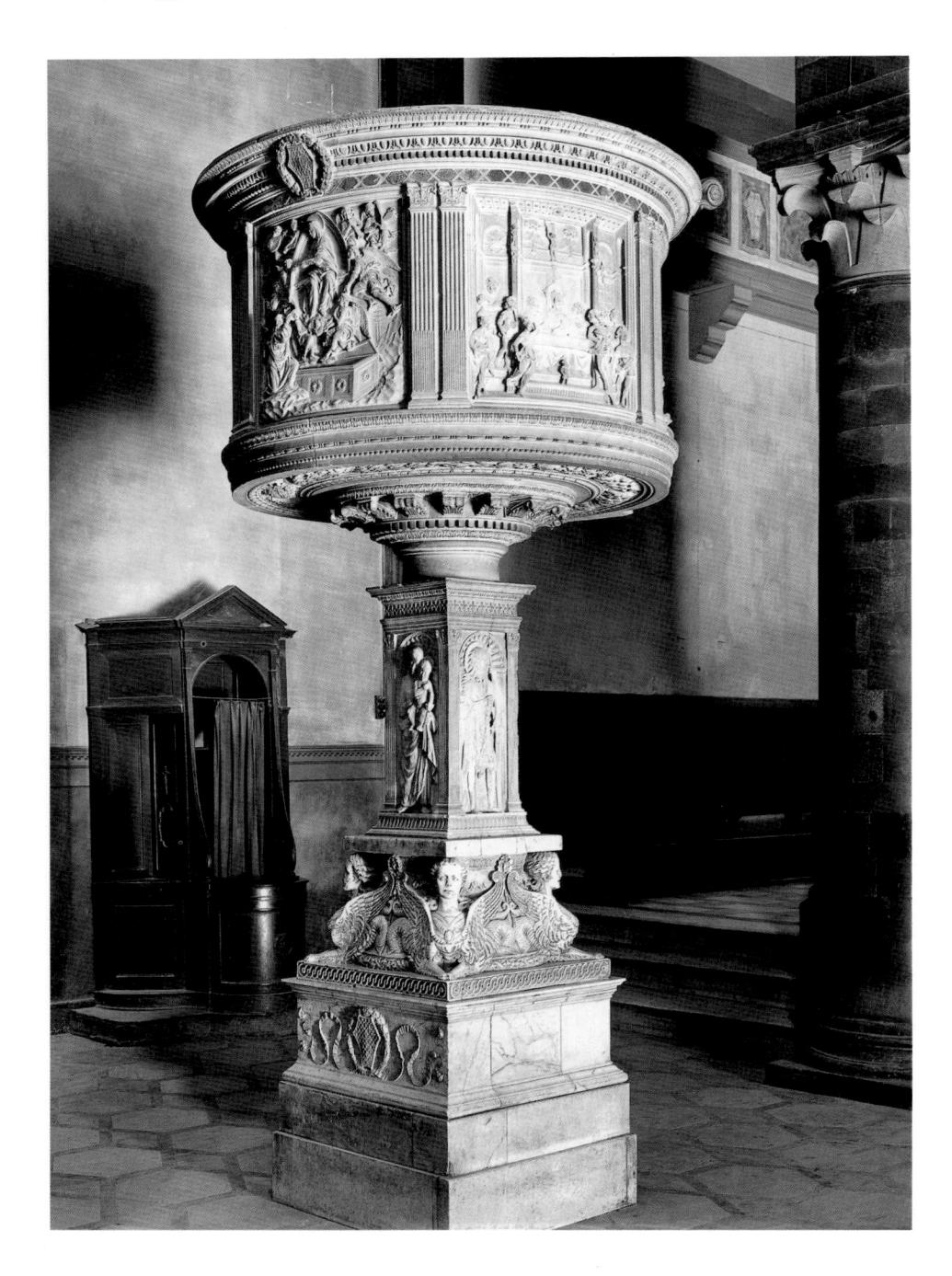

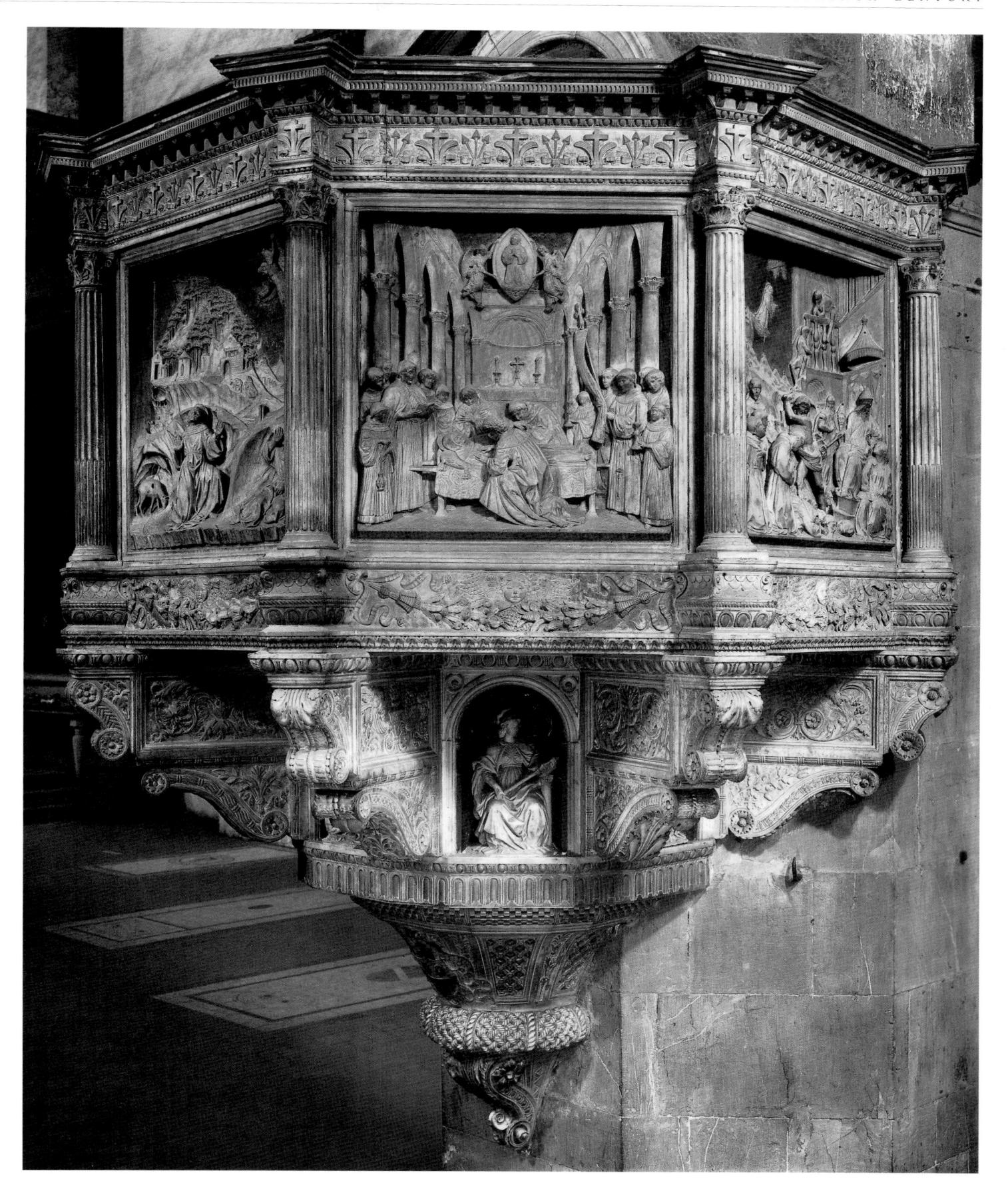

plate 107 Benedetto da Majano

The Stigmatization of St Francis

S. Croce, Florence (detail of plate 106) marble, 71 × 68 cm

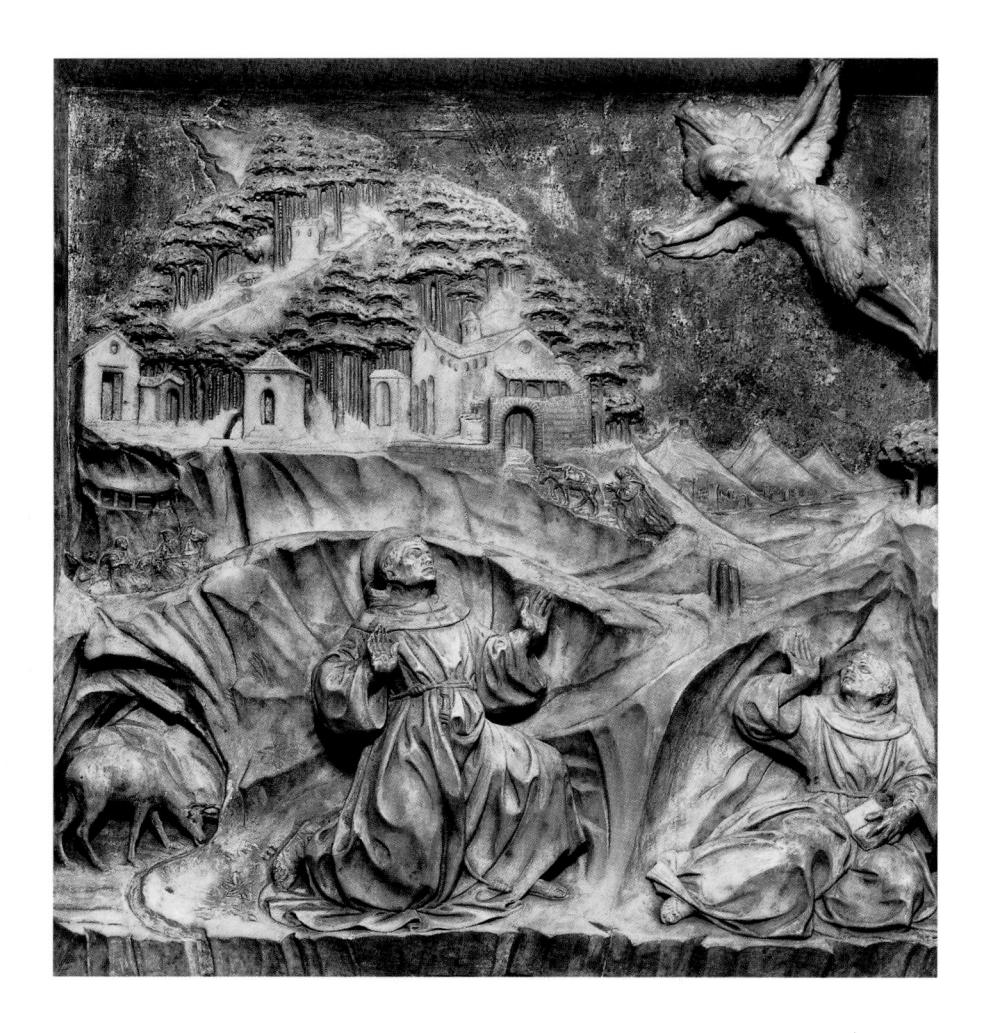

seems, however, to have exercised a direct influence on Desiderio's work. The main evidence for this is a little group of carvings, probably executed after the Altar of the Sacrament (plate 100), which reveal a more ambitious attitude towards relief sculpture. Among them are the socalled Panciatichi Madonna in the Bargello (plate 112), a circular relief of Christ and the young St John in the Louvre, and last and most remarkable the St Jerome before a Crucifix in Washington (plate 113). The content of this scene differs from Donatello's much as the predella panels of Fra Filippo Lippi differ from Masaccio's; the conception is less forceful, the space is less firmly apprehended, and the sense of narrative is less secure. None the less in its use of visual halfstatement, its rendering of atmosphere, and its relatively strong plasticity, the relief is proof of the rich promise that was cut short at Desiderio's death.

Antonio Rossellino's command of low relief was never comparable with Desiderio's. As we look at the surface of his carvings, it seems that the calm of Desiderio has been succeeded by a gentle swell. Antonio's interest in movement and his facility in rendering it were less great, and the effect of his reliefs is solider and in conventional terms more sculptural. Desiderio died at the age of 36, and his carvings have the freshness and urgency of youth. Rossellino, on the other hand, lived on through middle age, and in his late reliefs, such as the Madonna del Latte in S. Croce, the tide of inspiration seems to have receded, and the handling is placid and dull. There is nothing placid, however, in the sculptures of his middle years, and the best of his reliefs, the Madonna in the

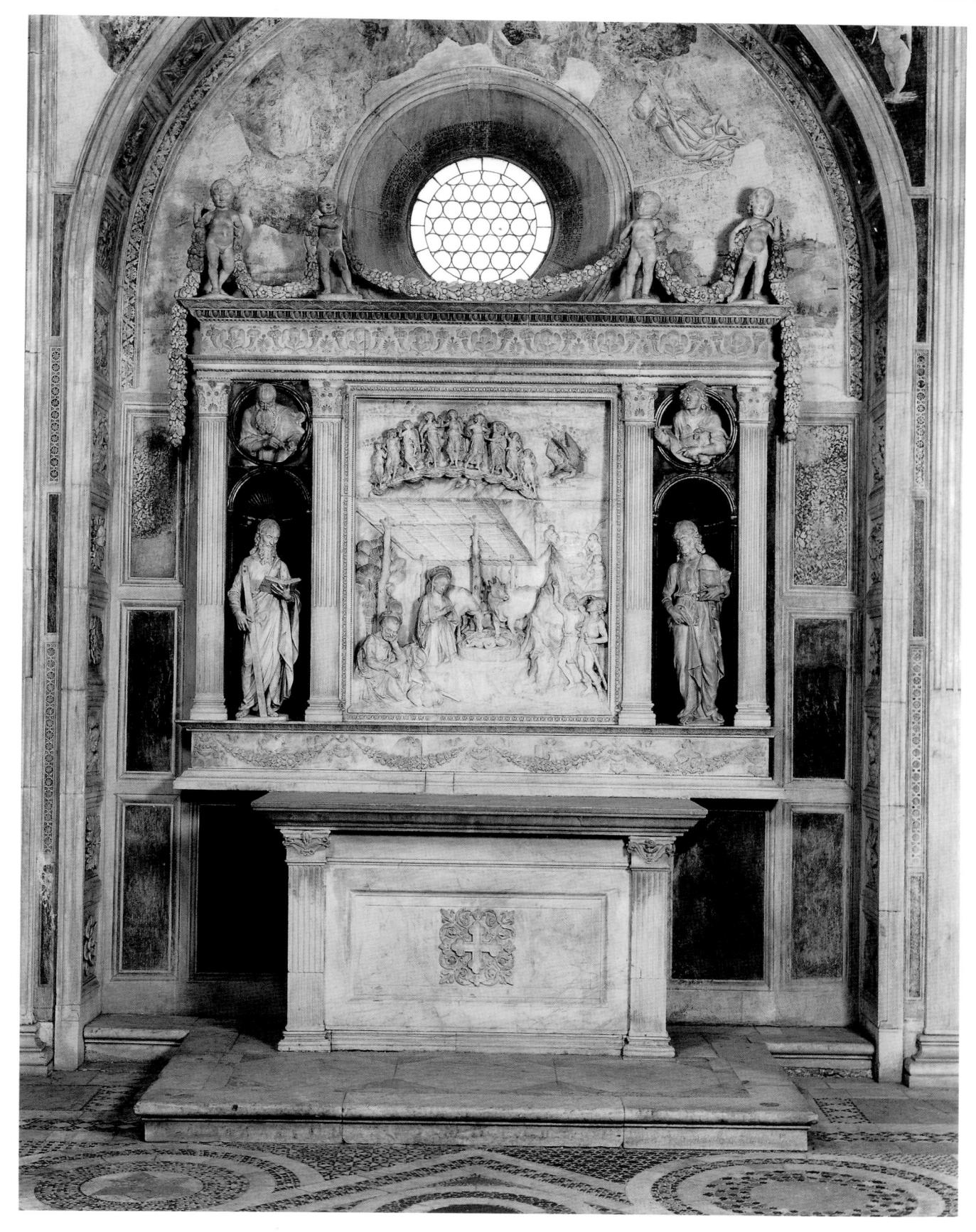

plate 108 Antonio Rossellino

The Adoration of the Shepherds

S. Anna dei Lombardi, Naples marble, altarpiece 248×311 cm plate 109 Benedetto da Majano

The

Annunciation

S. Anna dei Lombardi, Naples *marble*

plate 110 (opposite) Benedetto da Majano

The Annunciation

S. Anna dei Lombardi, Naples (detail of plate 109)

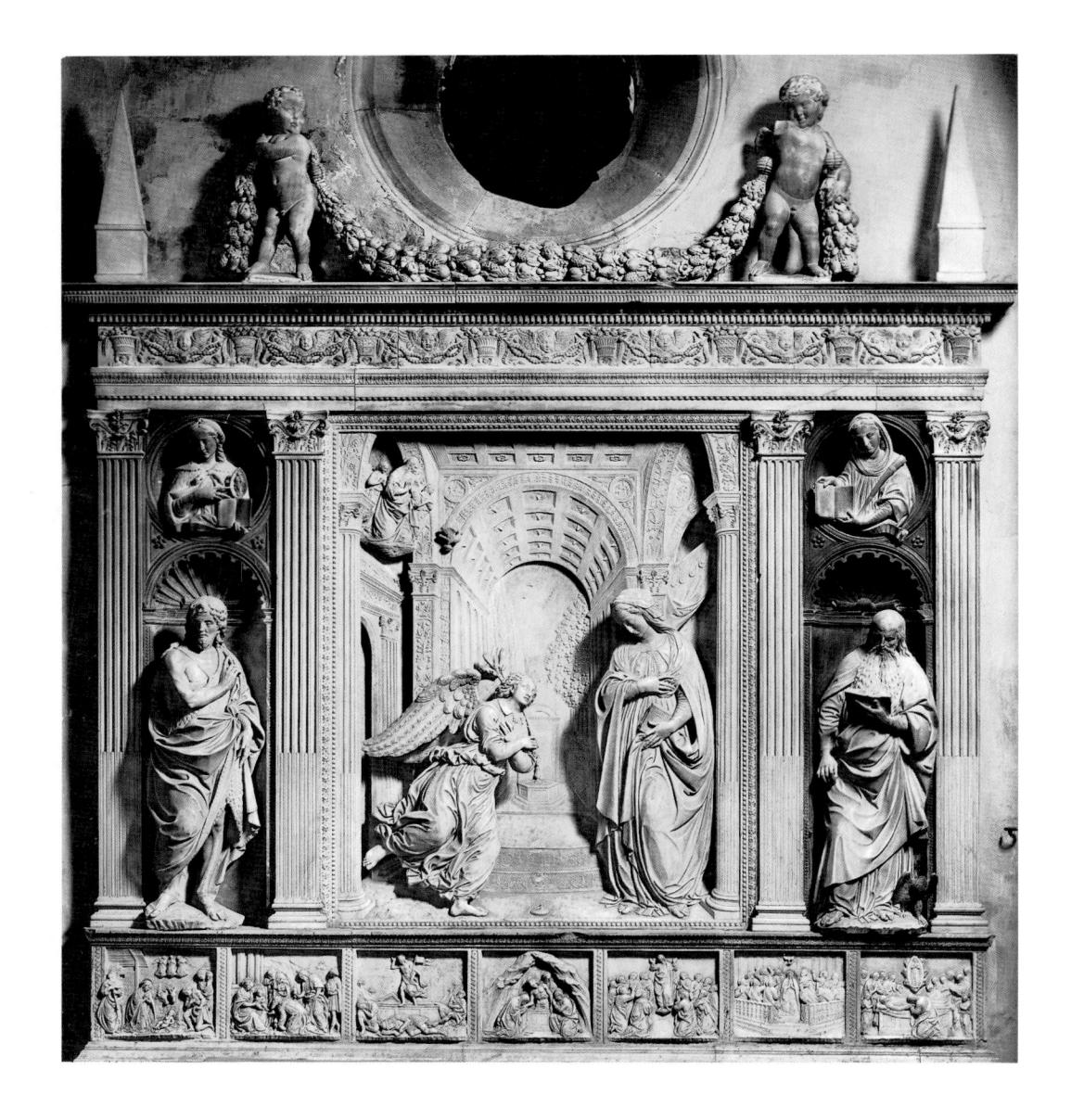

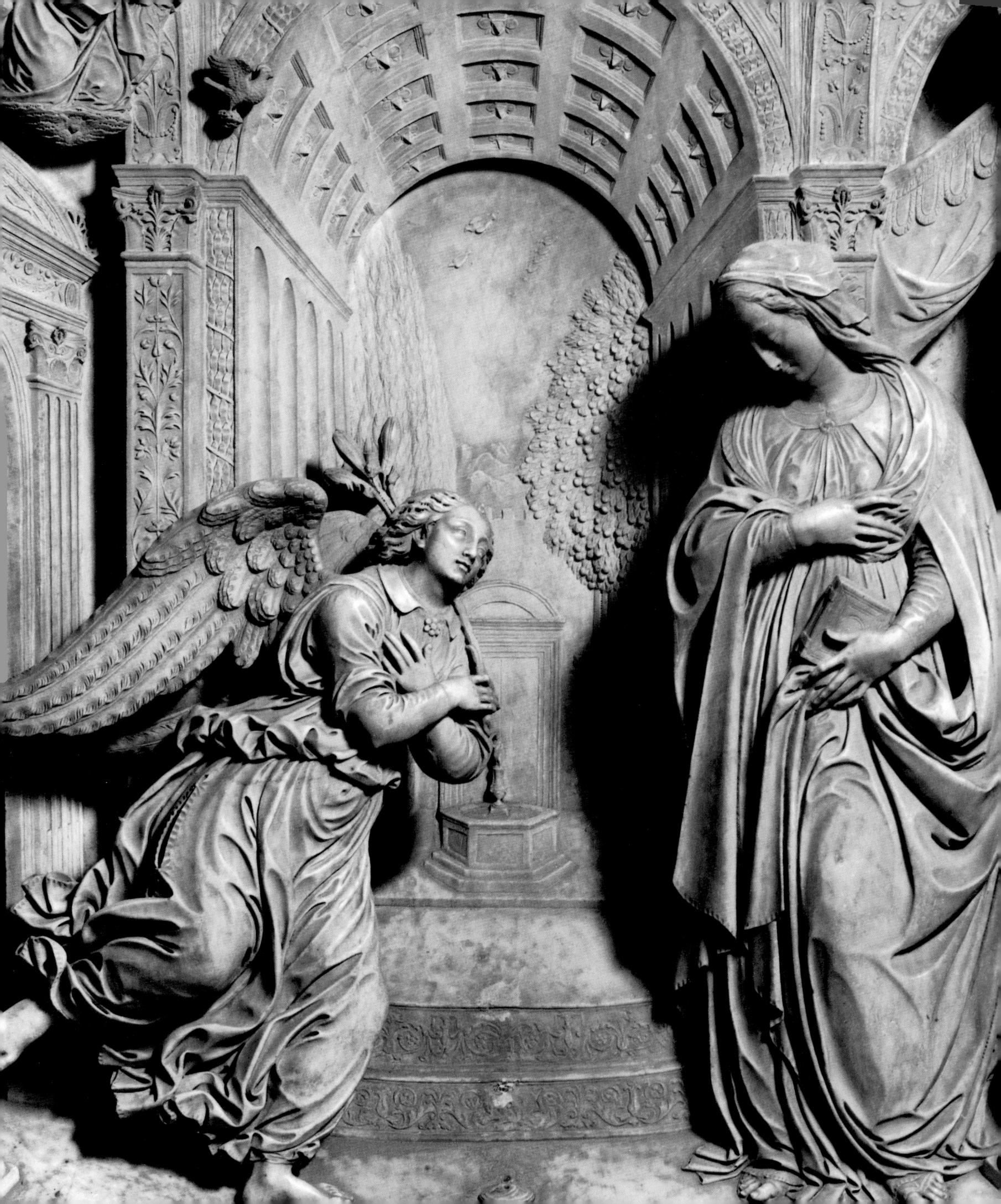

plate 111 Desiderio da Settignano

Virgin and Child

Philadelphia Museum of Art marble, 59 × 45 cm

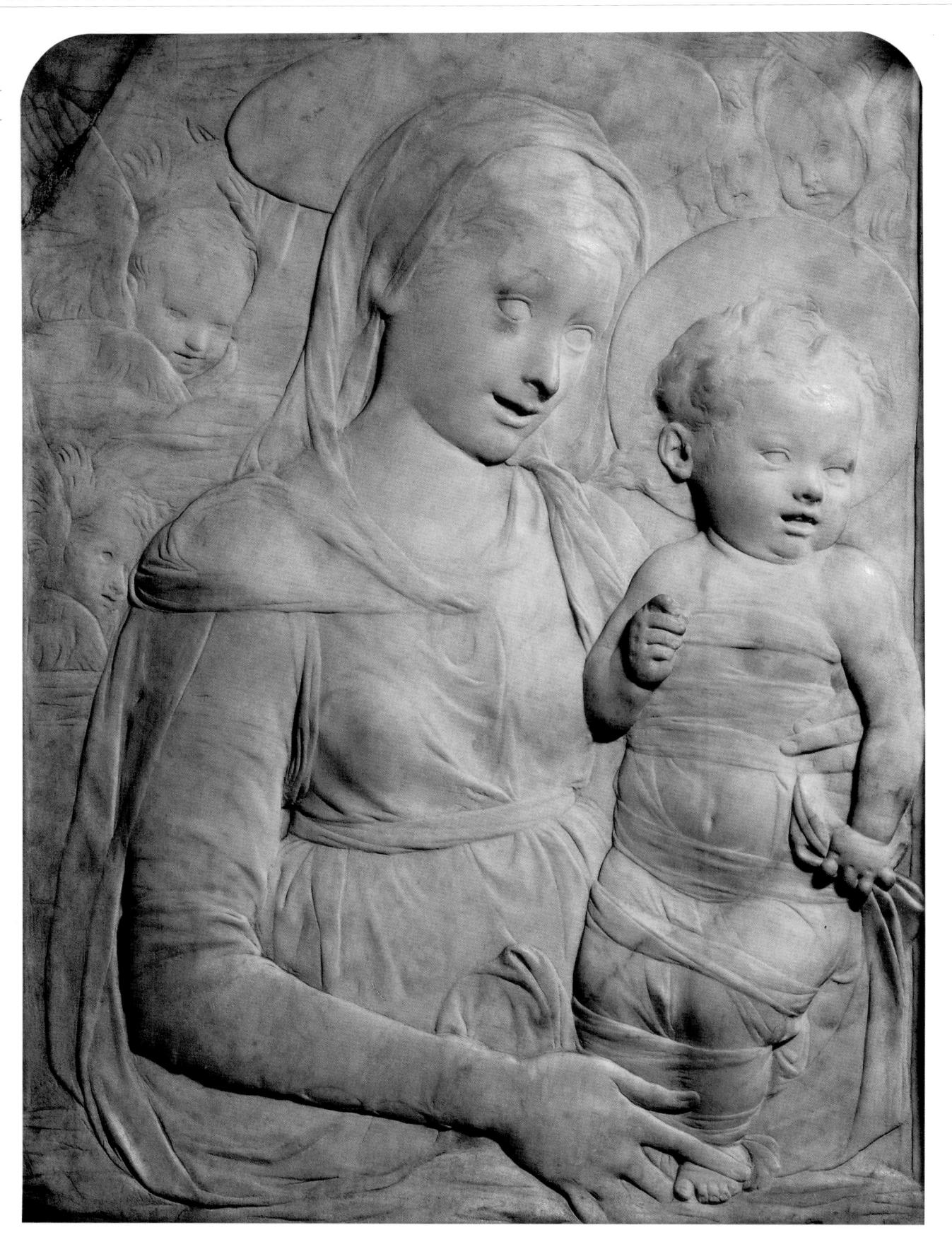

plate 112 Desiderio da Settignano

Panciatichi Madonna

Muzeo Nazionale, Florence marble, 68 × 53 cm

plate 113 Desiderio da Settignano

St Jerome before a Crucifix

National Gallery of Art, Washington marble, 43×55 cm

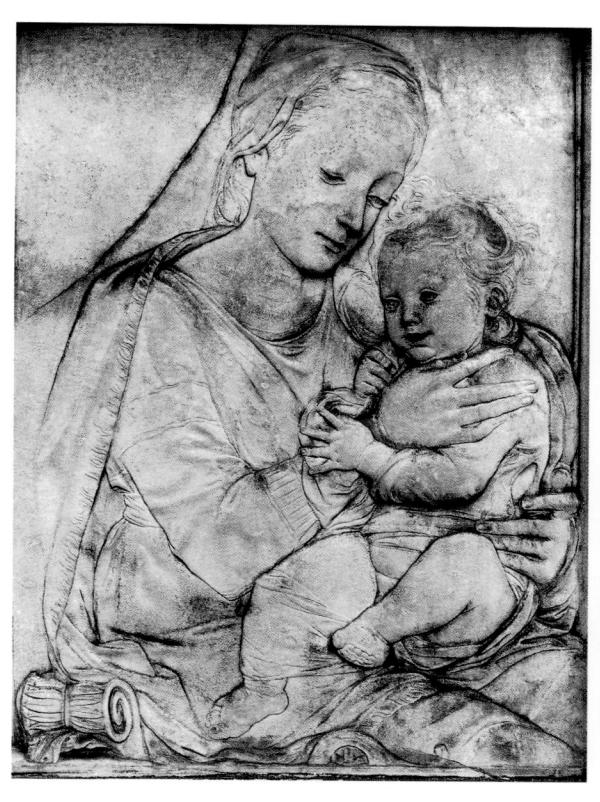

plate 114 Antonio Rossellino

Virgin and Child

Metropolitan Museum of Art, New York marble, 74×55 cm

plate 115 (opposite) Antonio Rossellino

Virgin and Child

Metropolitan Museum of Art, New York (detail of plate 114)

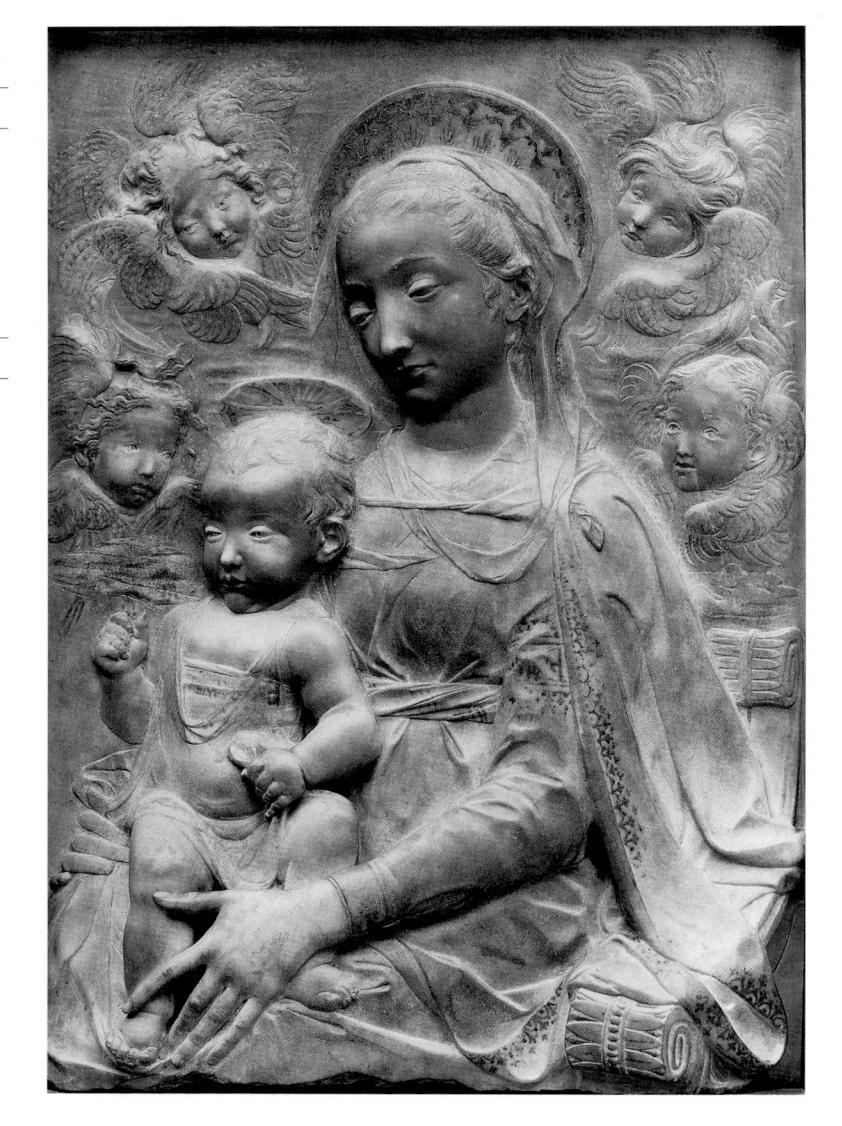

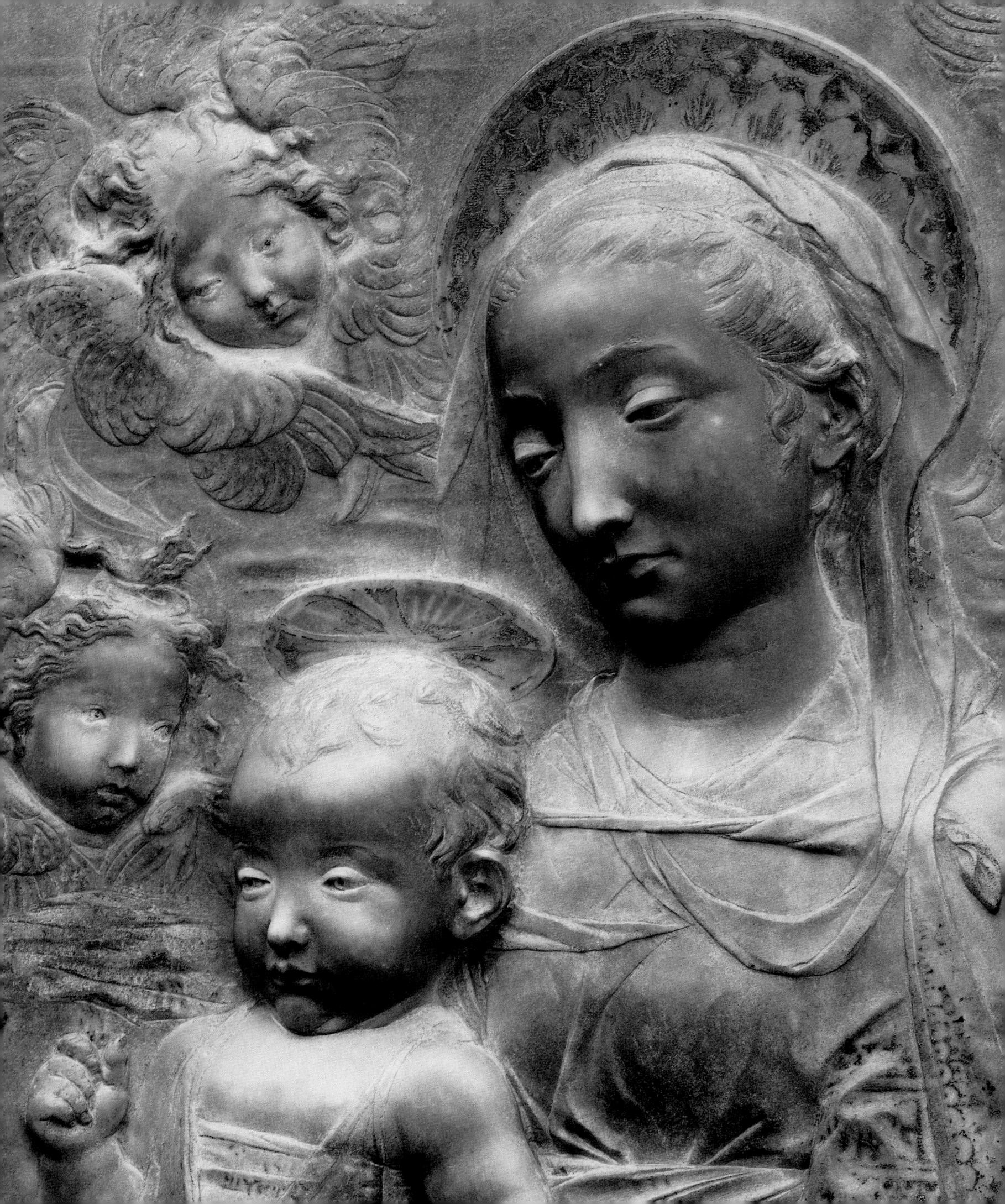

Metropolitan Museum in New York (plates 114, 115), while it is less appealing than the Foulc Madonna, displays the grasp of form and the emotional stability of a great artist.

About 1470 a pupil of Antonio Rossellino, Andrea del Verrocchio, brought this pictorial tradition to a close. The single autograph Madonna from Verrocchio's hand is a terracotta relief (plate 116) made for the hospital of S. Maria Nuova, now in the Bargello. This splendid work is modelled in such depth that the Child seems to stand free of the ground, and the scheme is worked out as an equipoise between two solid heads. Even the drapery is no longer flattened, as it was in the middle of the century, but is treated with new exuberance. No marble Madonna by Verrocchio survives, but a powerful head of Alexander the Great in the National Gallery of Art in Washington proves that he found an equivalent for this style in marble sculpture.

The story of the statue runs parallel to that of the relief. The only independent statues by Bernardo Rossellino, two figures of the Annunciatory Angel and Virgin Annunciate at Empoli, are planned as reliefs rather than as figures in the round. Through most of his career Desiderio too was most at ease with figures destined for a flat complex like the Altar of the Sacrament, where the angels at the sides are used pictorially and are limited to a single view. At the end of his life, however, he came to terms with Donatello's statues, as he did with his reliefs. At this time he carved a wooden Magdalen for Santa Trinita (plate 117), which was based on Donatello's Magdalen in the Baptistery and was

finished at his death by Benedetto da Majano, and a free-standing marble statue of St John the Baptist now in the Bargello (plate 118). This, the so-called Martelli Baptist, has been persistently ascribed to Donatello, but its handling and conception are not consistent with Donatello's style. In the hands and head the plastic contrasts are minimized, while the hair is represented by surface drawing in somewhat greater depth but with the same rhythmical character as in the Panciatichi Madonna and Desiderio's other late reliefs. It is characteristic, moreover, of Desiderio that the figure is posed on a single plane, as though the bronze David of Donatello, the figures on the Campanile (plates 11-13), even the St Mark (plate 7), had never been. Antonio Rossellino's only completed statue of this class, a marble figure of St Sebastian at Empoli (plate 119), is based not on Donatello but on the antique, and is conceived more plastically than Desiderio's, with a new tension in the pose and the body turned above the hips. This admirable statue finds a lineal successor in the beautiful figure of St John the Baptist carved by Benedetto da Majano for the doorway of the Sala dei Gigli in the Palazzo Vecchio (plates 120, 121), where the stance gives an illusion of mobility, the lips are parted and the muscles are relaxed. While the reliefs of Antonio Rossellino and Benedetto da Majano have no importance for the future, these two statues are of considerable significance, in that they form two of the antecedents of the Bacchus of Michelangelo. In one of Benedetto da Majano's last works, the St Sebastian in the Misericordia in Florence (plate 122), we sense the physical stresses

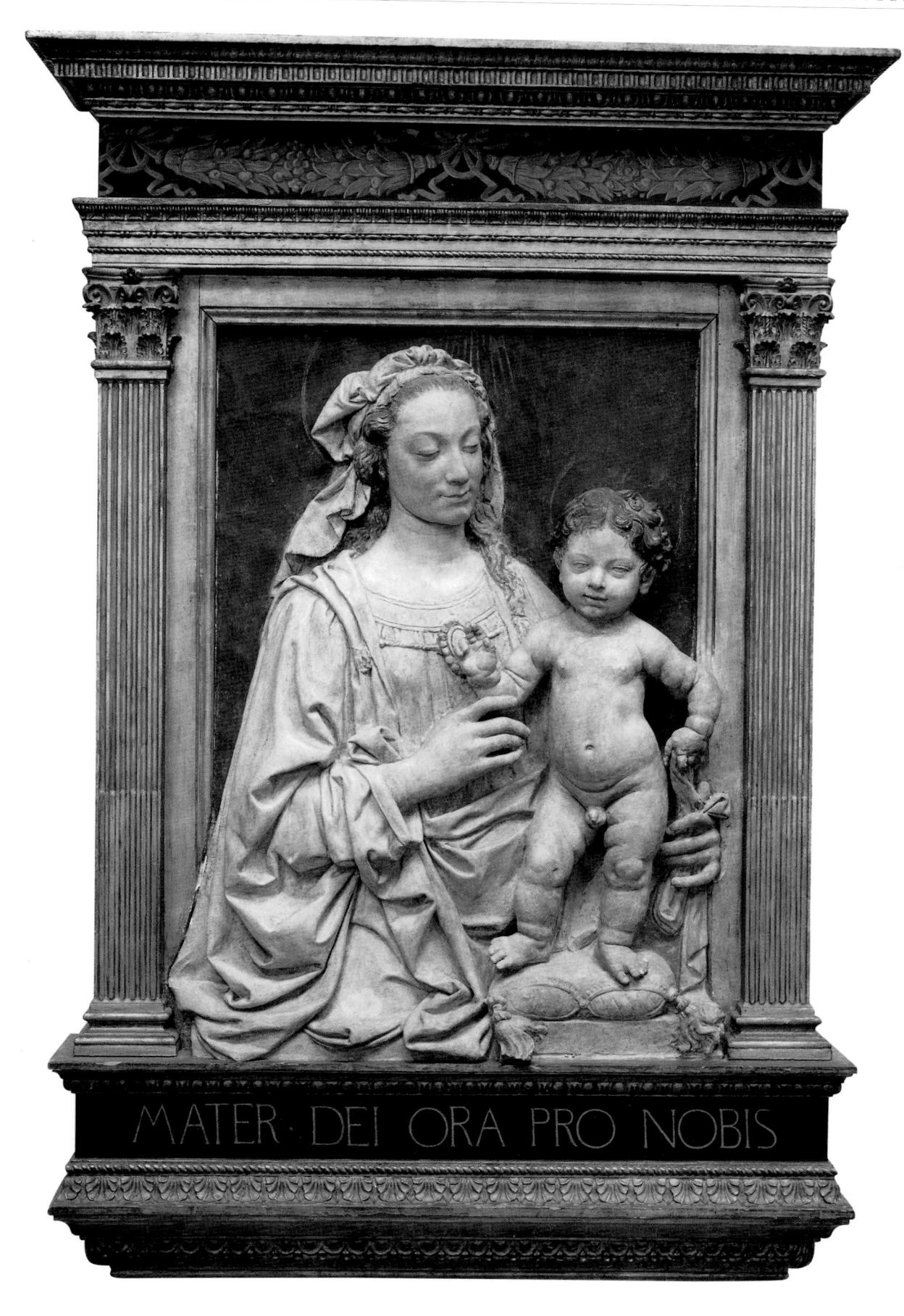

plate 116 Andrea del Verrocchio

Virgin and Child

Museo Nazionale, Florence terracotta, partially pigmented, 86 × 66 cm plate 117 Desiderio da Settignano

St Mary Magdalen

S. Trinità, Florence pigmented wood, height 183 cm

plate 118 Desiderio da Settignano

St John the Baptist

Museo Nazionale, Florence marble, height 160 cm

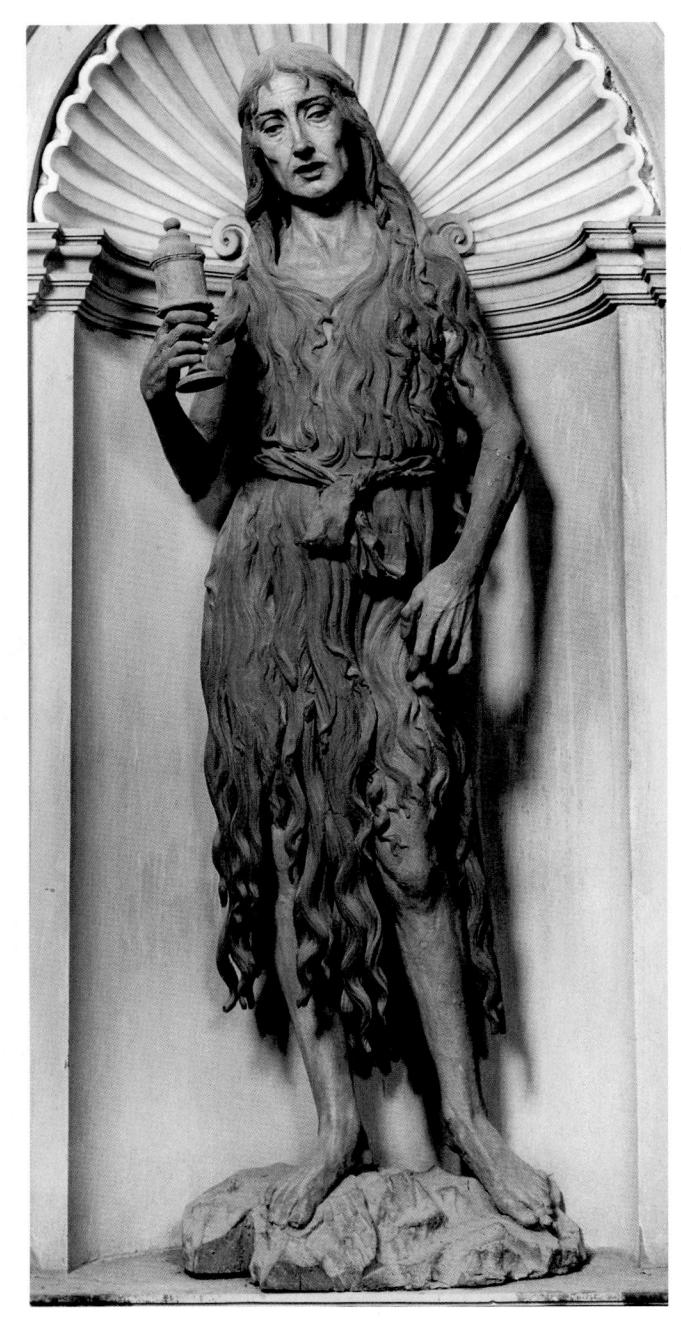

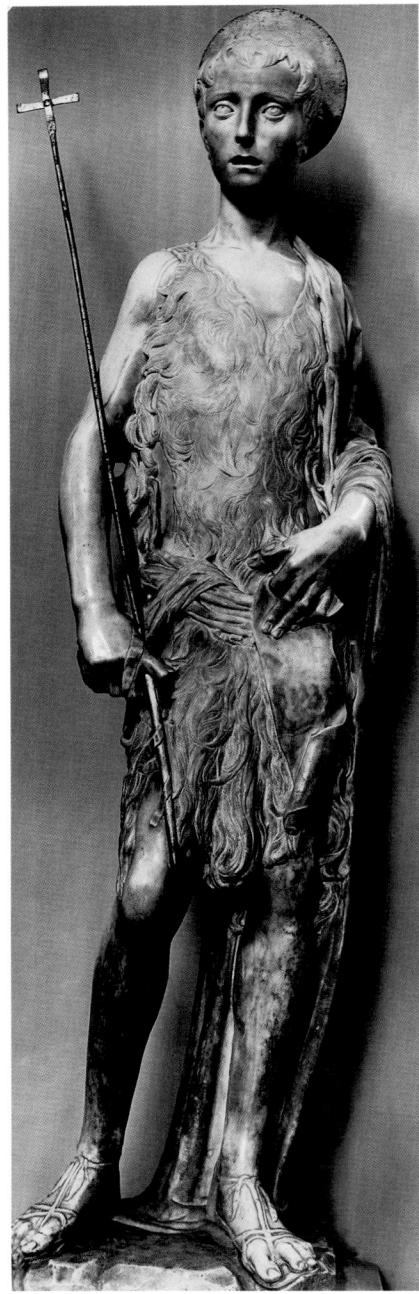

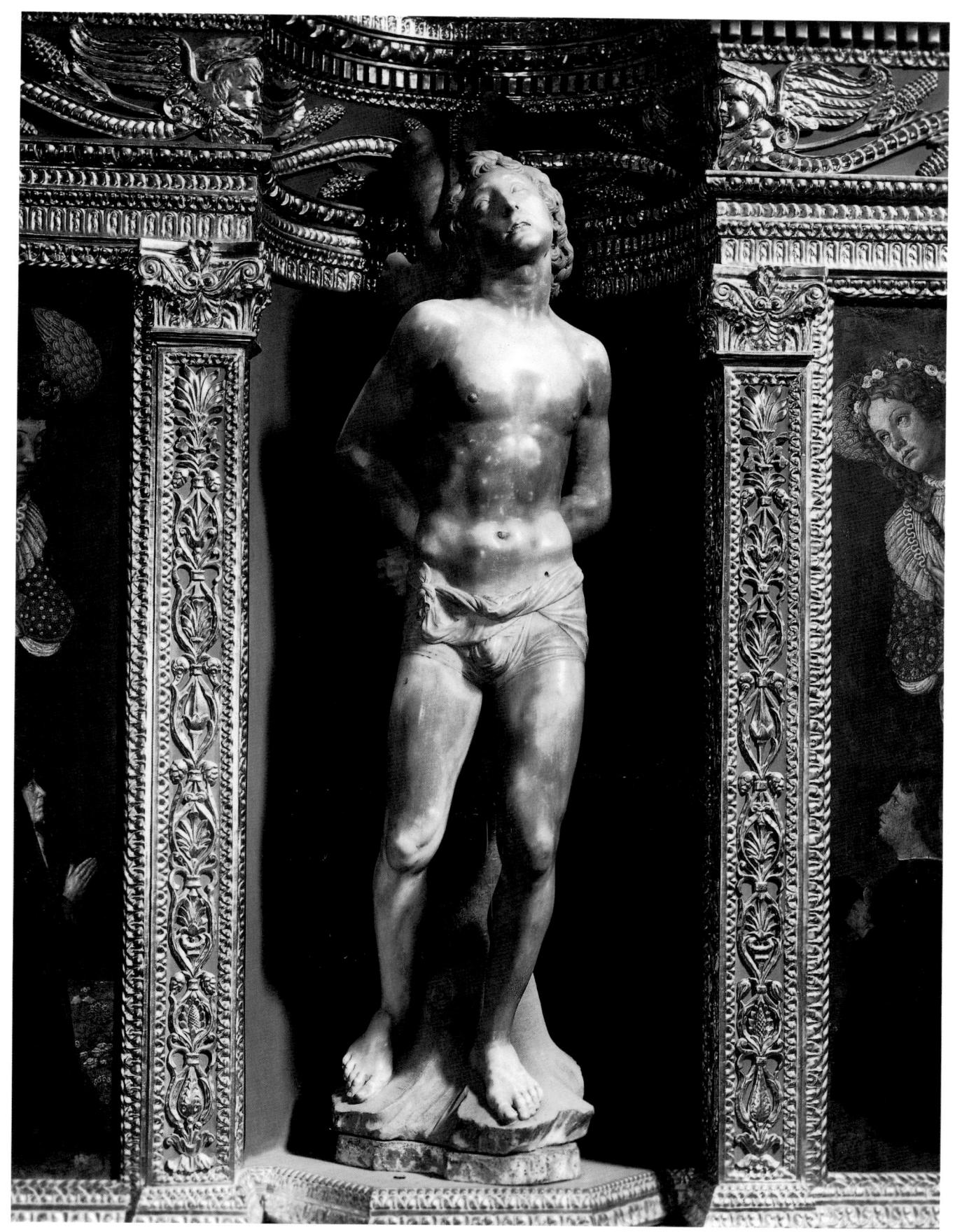

plate 119 Antonio Rossellino

St Sebastian

Collegiata, Empoli marble, height 155 cm plate 120 Benedetto da Majano

St John the Baptist

Palazzo Vecchio, Florence marble, height 134 cm

plate 121 *(opposite)* Benedetto da Majano

St John the Baptist

Palazzo Vecchio, Florence (detail of plate 120)

The free-standing figure as it was evolved by Donatello was bound up with the medium of bronze, and could be realized only by an artist who was also a proficient bronze caster. Here too it was Verrocchio who returned to the second se

seen at eye-level, and is relatively small in size. Its base is oval, not circular, and the figure is represented clothed, not in the nude. The placing of the legs and the left arm derive directly from Donatello, but the diagonals of Donatello's statue are replaced by a new scheme whereby the left elbow and left knee protrude from the main plane of the figure, and the right arm is drawn back behind the leg. Verrocchio's David is virile and tense. The loose folds of the buskins set off his muscular calves, the skirt emphasizes the spare thighs, and at the back the corselet, shown free of the body, sets in relief the tensely modelled spine and shoulder blades. A less original achievement than Donatello's David, Verrocchio's figure had greater influence. This lithe youth, gazing

resolutely out from beneath an aureole of hair, was at once adopted as the type David of the late fifteenth and early sixteenth centuries, and even when this David symbol was in turn replaced by the colossal David of Michelangelo, it continued to be reproduced in terracotta statuettes.

The central niche on the east side of Or San Michele had been constructed in 1422-5 on the commission of the Parte Guelfa, and in the latter vear was filled with Donatello's St Louis of Toulouse (plate 17). The St Louis remained in position till 1459/60, when the tabernacle was sold by the Parte Guelfa to the Arte della Mercanzia, who in 1463 appointed a commission to supervise the filling of the newly acquired niche. Two years later the Christ and St Thomas (plates 124, 125, 126) was commissioned from Verrocchio. Not only was the Parte Guelfa tabernacle the most ostentatious of the niches on the Oratory, but the relation between Donatello's statue and its setting was more intimate than with any of the other statues. For Verrocchio, therefore, the commission formed a challenge on two counts: first, it obliged him to design sculptures for a tabernacle with strong architectural idiosyncrasies; and second, it imposed the duty of placing two figures in a niche designed for one. His success in solving these two problems is one of the miracles of Florentine Renaissance sculpture. Taking as his points of departure the Quattro Santi Coronati of Nanni di Banco, where four figures were shown together, and the Cavalcanti Annunciation of Donatello, where the relief surface was treated as a stage, Verrocchio set his Christ with right hand raised

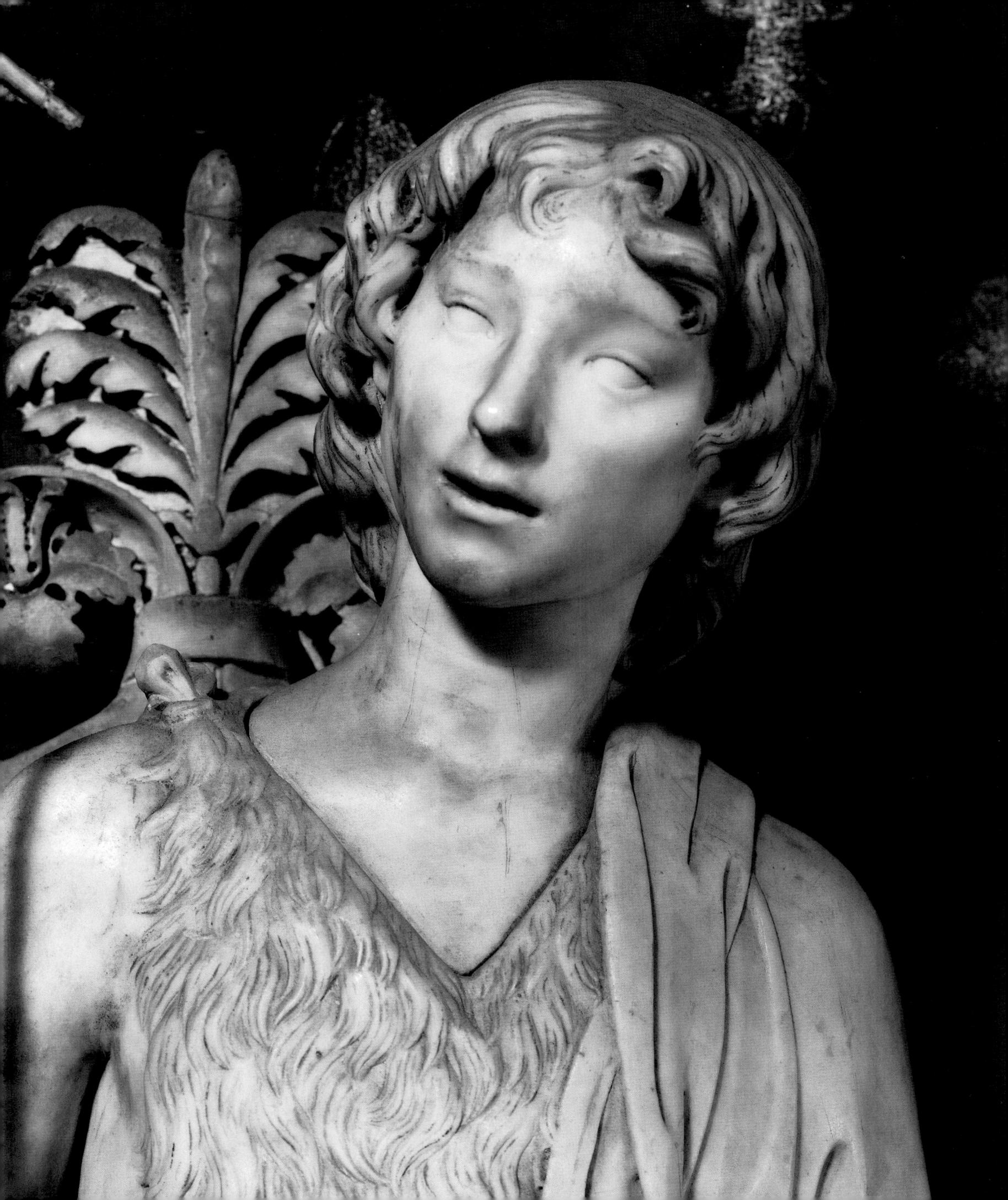

plate 122 Benedetto da Majano

St Sebastian

Misericordia, Florence marble, height c.130 cm

plate 123 (opposite) Andrea del Verrocchio

David

Museo Nazionale, Florence bronze, height 126 cm

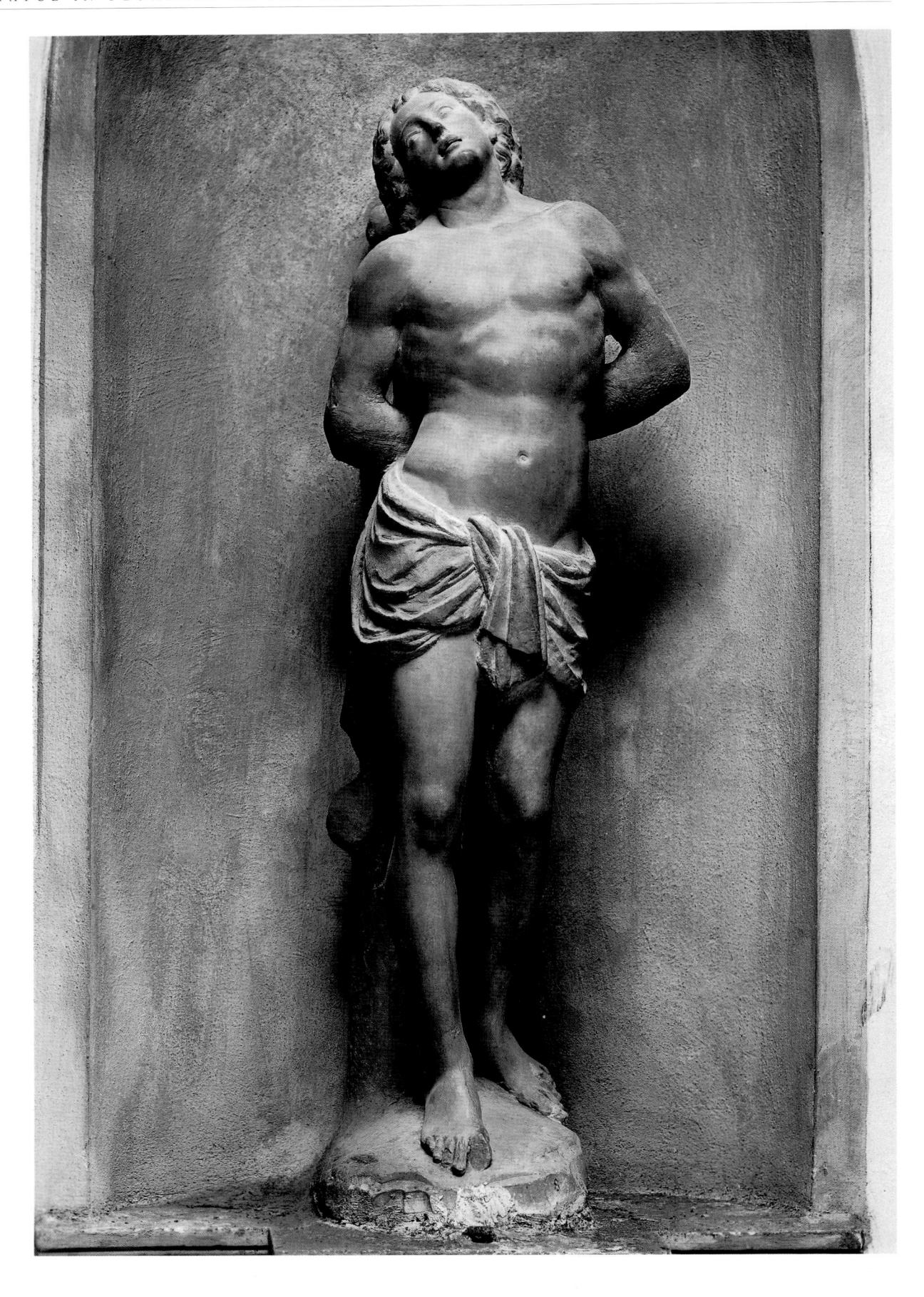

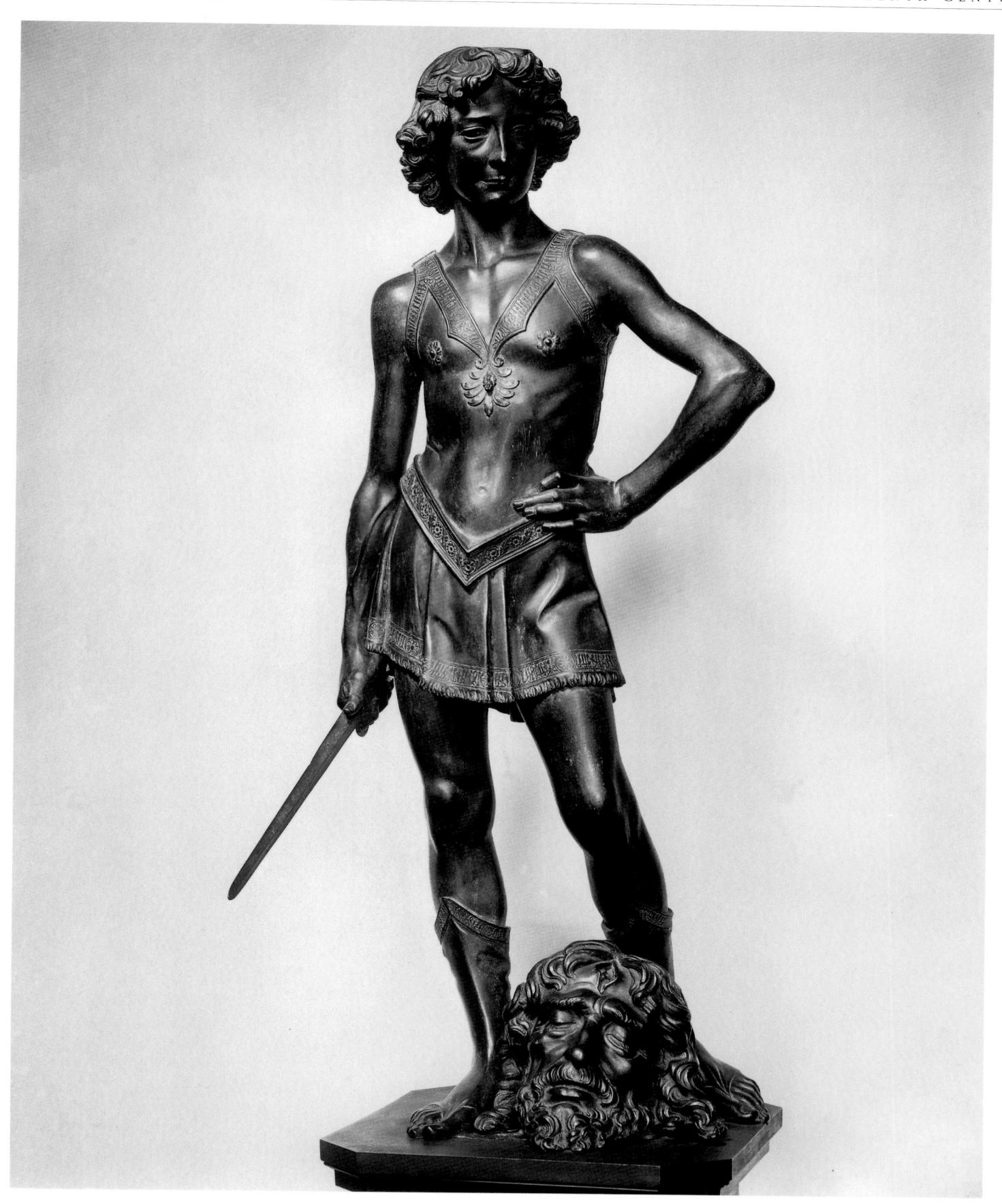

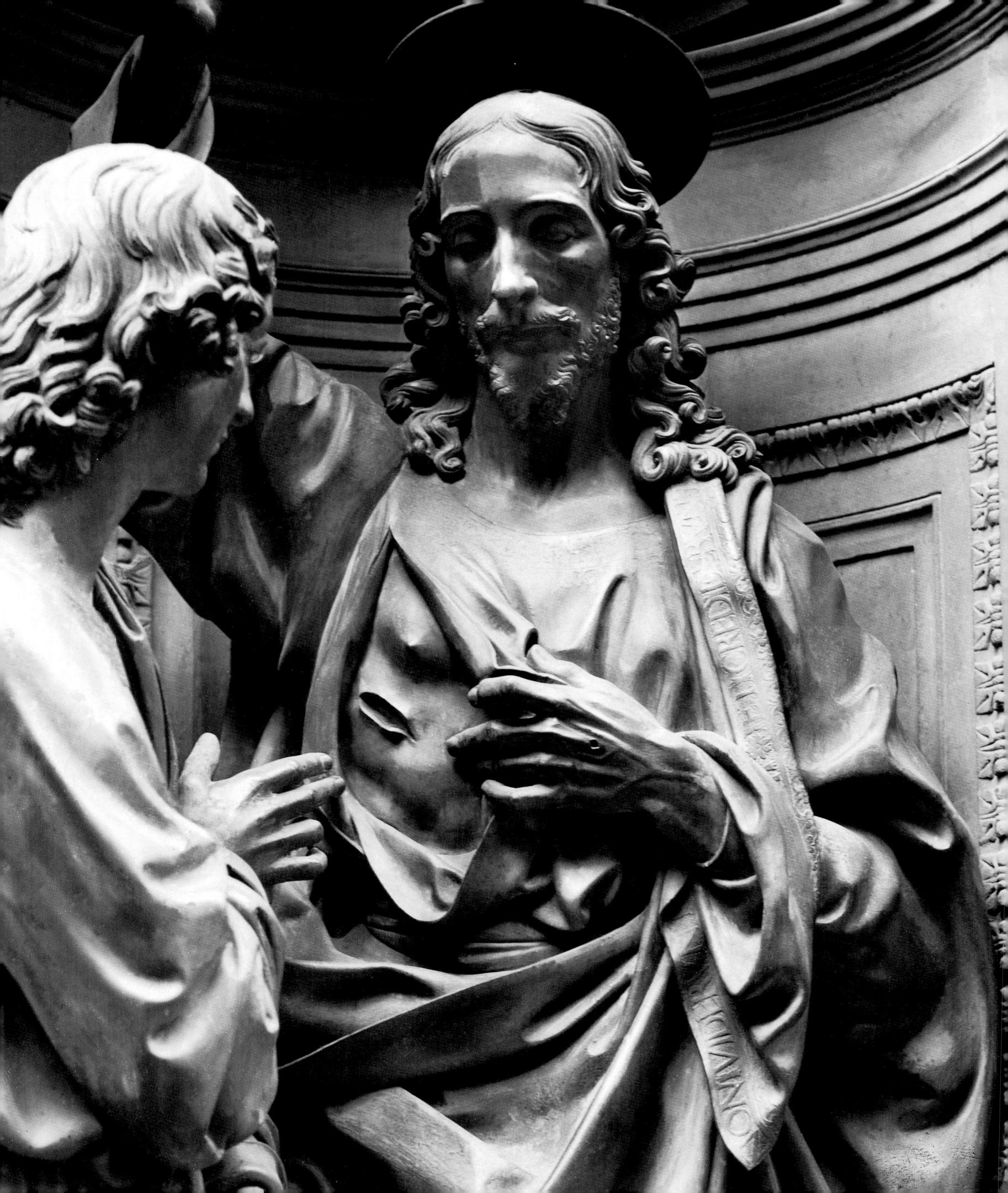

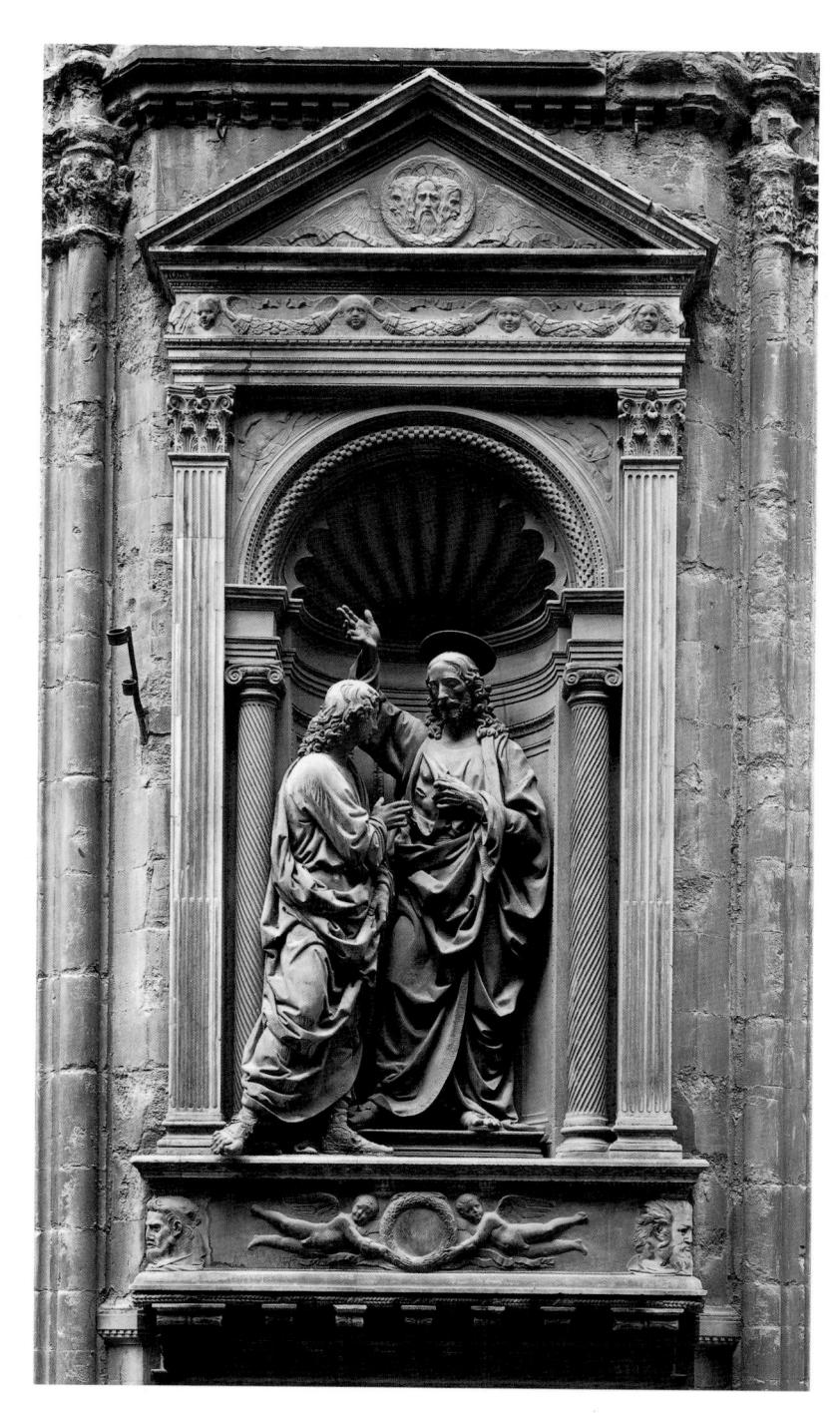

plate 124 (opposite) Andrea del Verrocchio

Christ

Or San Michele, Florence (detail of plate 125)

plate 125 Andrea del Verrocchio

Christ and St Thomas

Or San Michele, Florence bronze, height of Christ, 230 cm, St Thomas, 200 cm plate 126 Andrea del Verrocchio

St Thomas

Or San Michele, Florence (detail of plate 125)

plate 127 (opposite) Andrea del Verrocchio

Putto with a Fish

Palazzo Vecchio, Florence bronze, height of figure without base 60 cm

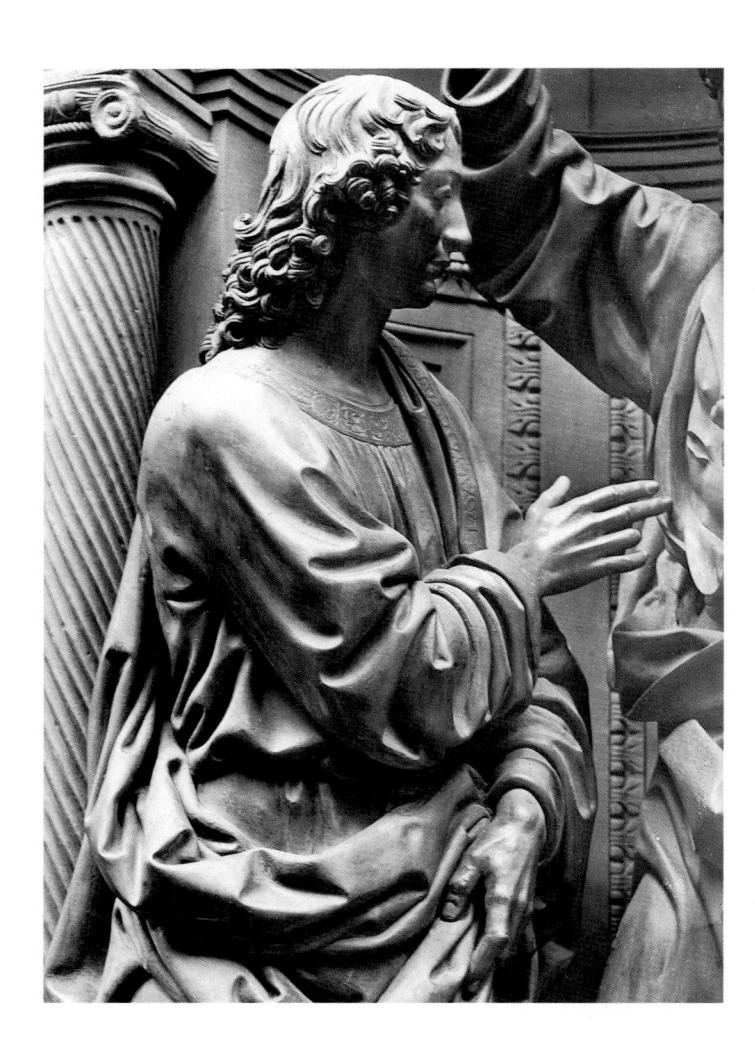

against the back wall of the niche, somewhat to the right of centre, and his St Thomas facing inwards on the left, half in and half out of the tabernacle. In this way he reduced the significance of the architectural forms, and imposed upon the group a calculated disequilibrium which looks forward to the Baroque. From the standpoint of imagery the group is no less notable, and in a company which includes the St Matthew of Ghiberti and St Mark of Donatello, Verrocchio's Christ and St Thomas is conspicuous for its intellectual elevation and moral seriousness.

The third of Verrocchio's three statues, the bronze figure of the Putto with a Fish (plate 127), is not specifically linked with Donatello, though it was Donatello who had first developed the free-standing bronze putto in the statuettes of the Siena font. Since Verrocchio's Putto with a Fish stood on a fountain, it was, like Donatello's Judith, visible from every side. But where the Judith was planned as a figure with four static faces, Verrocchio in the Putto with a Fish achieved a design in which the eye is never still but is carried on relentlessly from one view to the next. Just as the Christ and St Thomas reaches out to the seicento, so the spiral movement of this statue is the source of the *figura serpentinata* of the sixteenth century.

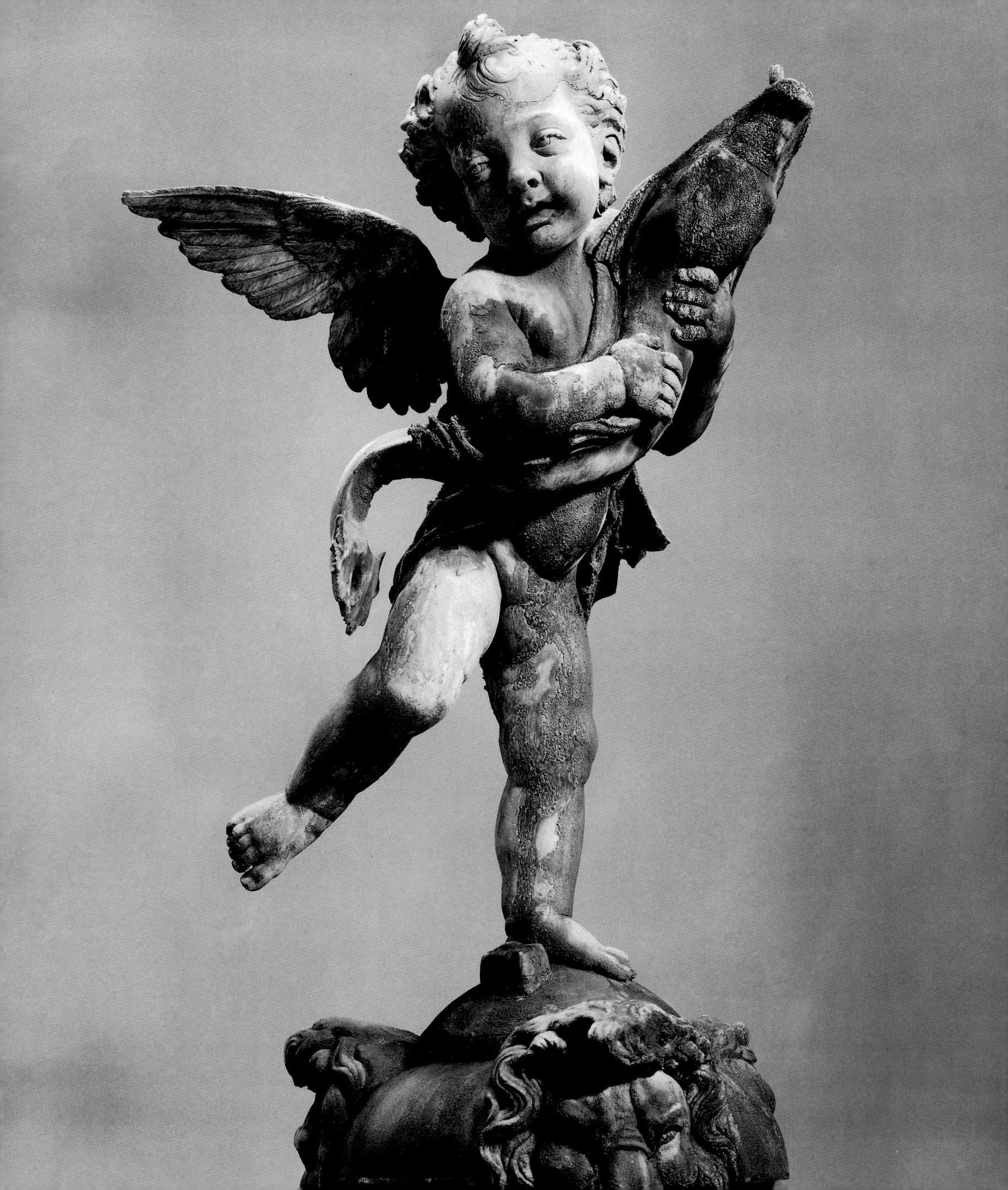

during the Renaissance, one of the most potent was what Macchiavelli calls 'the desire to perpetuate a name'. It supplied the inspiration for biographical collections like Vespasiano da Bisticci's *Uomini illustri*, where the achievements of the principal figures in Florence in the earlier fifteenth century are recorded, as though by a Renaissance Plutarch, in short lives, and it impinged on art in the sepulchral monument. Just as the role of the biographer was to protect the reputations of great men from the ravages of time, so the sculptor's role was to present them to posterity.

The story of the humanist movement goes back to a day, probably in 1430, when Leonardo Bruni, the translator of Aristotle and historian of Florence, on his way from Florence to Arezzo, met two stationary carts. His curiosity was aroused when he saw that they were filled with marbles, and he began a conversation with one of the men goading the oxen on. 'Damnation take all poets past and future,' exclaimed the man, wiping the sweat from his face. 'But what,' asked Bruni, 'have you had to do with poets, and what harm have they done you?' 'It was like this,' the man replied. 'This poet, the loquacious fool, died not long ago in Rome, and left orders that he should have a marble monument in his native town. So we are taking these marbles to Montepulciano, though heaven knows if we shall get them there. That is his effigy that you are looking at, and this is the portrait of his mother.' What Bruni saw when he looked into the cart were the pieces of the

Aragazzi Monument, the effigy of Bartolommeo Aragazzi, with his hands folded on his breast and his eyes closed in death, and a scene in the manner of a classical sarcophagus showing Aragazzi, like some figure from antiquity, bidding farewell to his family (plate 128). He may also have seen a second relief, in which the traditional scene of the dead man presented to the Virgin and Child was treated in a quite unprecedented fashion, with Aragazzi's mother, the youths portrayed in the first scene, and the three children interceding with the Virgin on his behalf. So rigorously classical are these two carvings that in one the religious content is not immediately discernible, and in the other there is no religious content to discern. Perhaps Bruni also saw the extraordinary figure of St Bartholomew (plate 129) which originally stood behind the effigy. This statue belongs in the company of Nanni di Banco's St Luke and Ghiberti's St Matthew, the Saint disguised as a philosopher. Bruni may even have inspected the classical Virtues from the monument. Today at Montepulciano we see less than Bruni saw, for the monument has been disassembled, and lacks two features he mentions, the columns that originally framed the sides, and the arch or superstructure which closed it at the top. Yet enough of it remains to show what Bruni also must have seen, that this is the first tomb which consciously reflects the humane ideals of Renaissance life. The Aragazzi tomb is by Michelozzo, the associate of Donatello, and it was Michelozzo who presided at the birth of the Renaissance monument.

This was the first humanist monument, but it

plate 128 Michelozzo

Bartolommeo Aragazzi Bidding Farewell to his Family

Duomo, Montepulciano *marble*

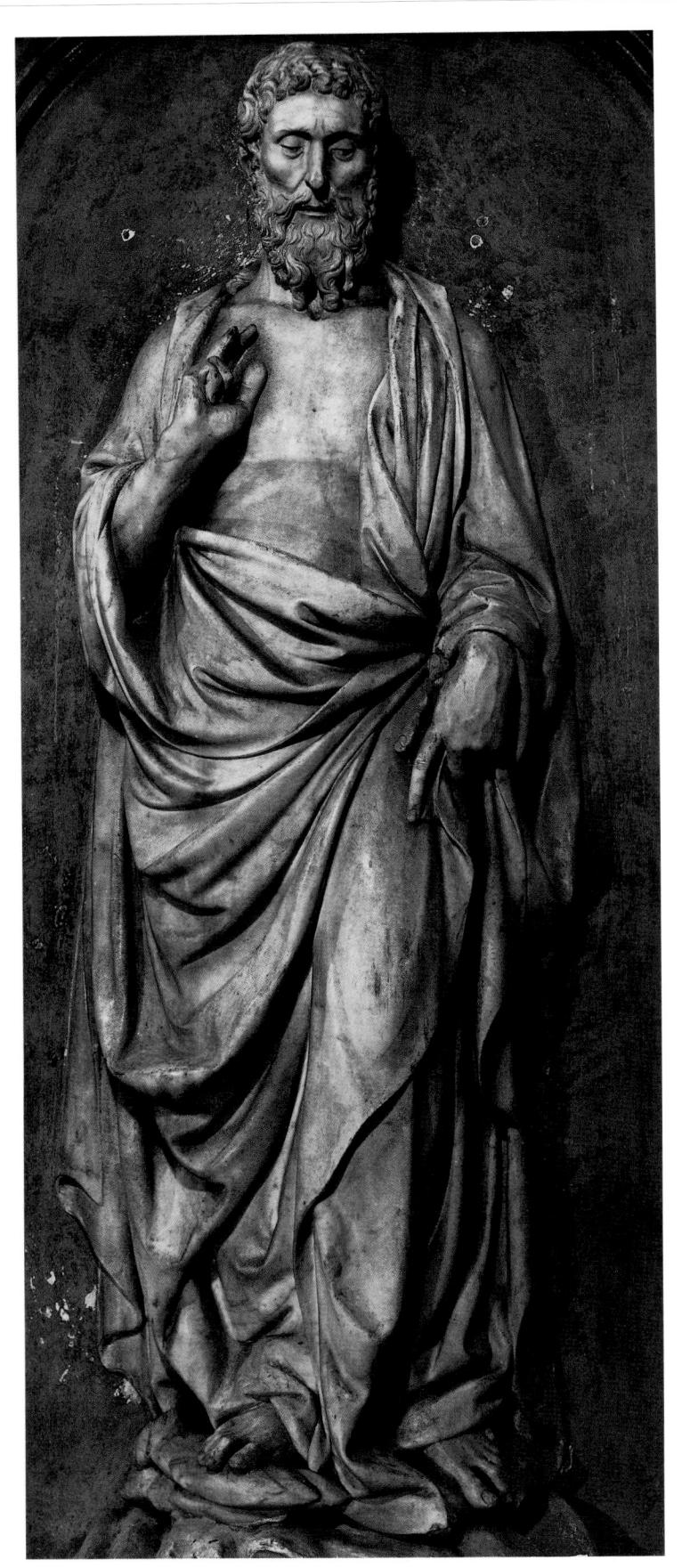

plate 129 Michelozzo

St Bartholomew
Duomo,
Montepulciano
marble

was not the first Renaissance tomb, for chronologically it was preceded by two monuments which were commissioned from the joint studio of Donatello and Michelozzo. In both cases Michelozzo's seems to have been the designing mind. The first, the tomb of Cardinal Brancacci (plate 130), is in Naples, and its form was determined by that fact. Almost a hundred years earlier Tino di Camaino had introduced in Naples a tomb type consisting of an architectural tabernacle with a decorated gable and a sarcophagus resting on caryatids and surmounted by a sculptured lunette (Vol. I, plates 65, 71). Through the later fourteenth century this Angevin tomb type was retained, so it was not unnatural that it should be adopted once again for the Brancacci tomb. But a world of spiritual endeavour separates this from earlier tombs. Michelozzo's monument is classicized: the tabernacle rests on massive columns, the wall surface is broken by pilasters, and in the superstructure there are the paired pilasters that appear again in the Arezzo façade of Bernardo Rossellino (plate 93) and in the Cantoria of Luca della Robbia (plate 75).

This change also affects its figure sculpture. The familiar motif of angels holding back curtains (as we find it in Tino's tombs) recurs once more, but instead of Gothic angels Roman youths are shown meditating on the corpse. The Virtues supporting the sarcophagus (plate 131) are preserved as well, but here there is a still more fundamental change. This is not the case of an old concept clothed in a new dress; rather the concept has itself been revised, and the romantic Petrarchan virtues of the

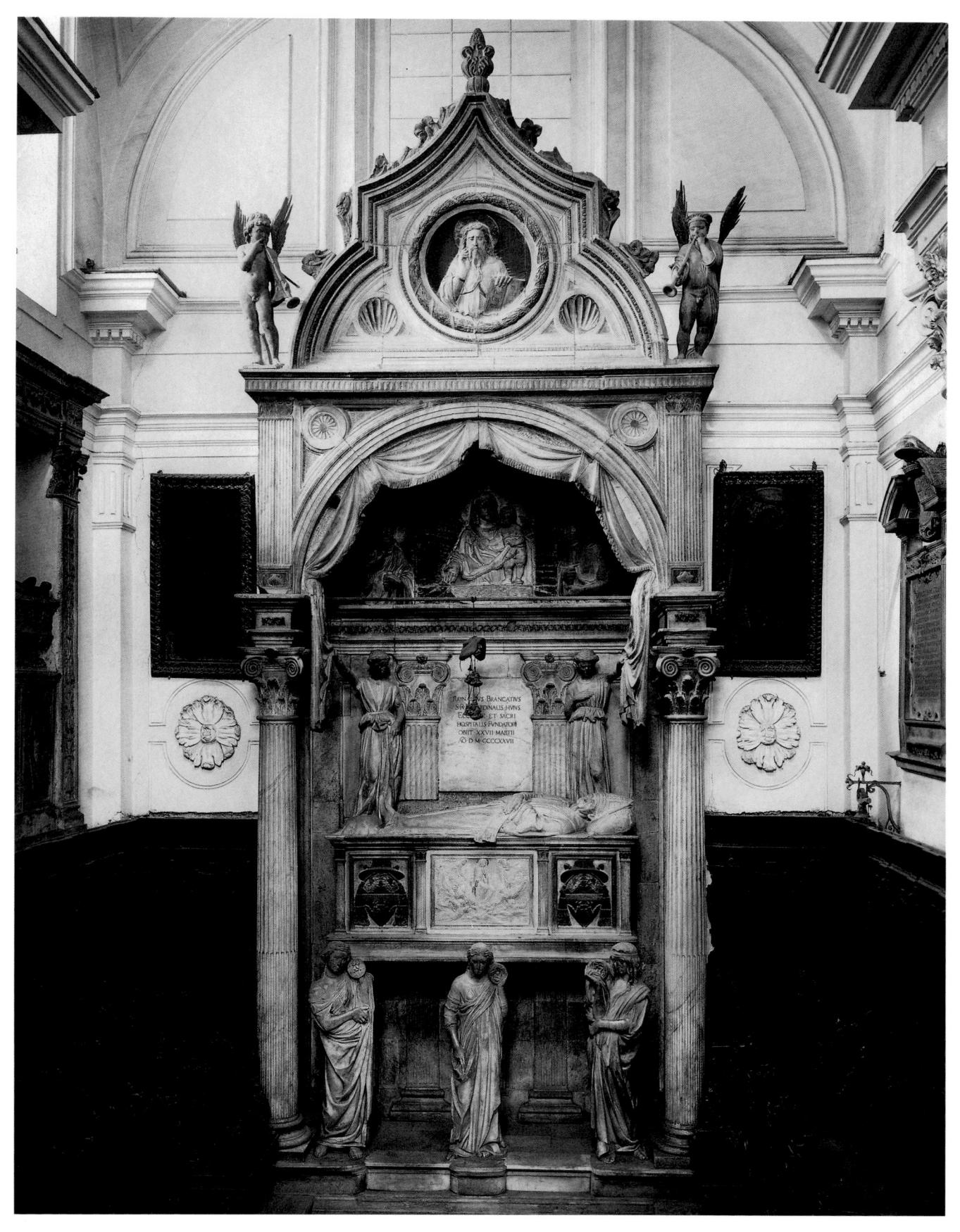

plate 130 Donatello and Michelozzo

The Brancacci Monument

S. Angelo a Nilo, Naples marble, height 907 cm plate 131 Michelozzo

Virtue

S. Angelo a Nilo, Naples (detail of plate 130) Middle Ages have been ousted by the austere virtues which were revered in the Renaissance because they had been reverenced in antiquity.

Before he began work on the Brancacci Monument, Michelozzo had undertaken a monument in Florence jointly with Donatello, the tomb of Pope John XXIII in the Baptistery (plate 132). From the point of view of imagery this is a less notable work than the Brancacci Monument, but it has great historical importance, since it was the first monument in Florence that was planned as a rational entity. The space it was to fill was narrow and disproportionately high, and the tomb was designed by Michelozzo as a flat architectural unit with a moulding at the top and a classical frieze beneath. Above was the Virgin and Child in a semicircular lunette, below were the Virtues in relief, and between them was a protruding sarcophagus which Michelozzo must have designed as well. At this point it seems that Donatello intervened, first with the brilliant device of the suspended curtain, which relieves the rather rigid plan and links the tomb to the architecture of the church, and second with the bronze figure of the dead Pope, an effigy of unprecedented authenticity (plate 133). Two features of this scheme were repeated in countless Renaissance tombs; one is the geometrical division of the wall surface behind the effigy, and the other the frieze on which the whole tomb rests. But Donatello's devices were ignored by later sculptors, and it was from foundations laid by Michelozzo that the humanist tomb grew.

The first of these monuments, the tomb of Pope

John XXIII, was begun by 1424 (plate 133), the second, the Brancacci Monument, was in course of execution in 1427, and the third, the Aragazzi Monument, was partially complete when Bruni saw it, but was not assembled until 1437. In Bruni's character there was a strain of Emersonian priggishness, and his meeting with the Aragazzi marbles led him to reflect on the vanity of Aragazzi's thirst for immortality. Yet when the Aragazzi tomb found a successor, its subject was Leonardo Bruni. Bruni died in 1444, and there is an account by Vespasiano da Bisticci of his funeral, held 'according to the custom of the ancients', with the corpse dressed in a long silk robe, and a copy of Bruni's History of Florence between his lifeless hands. As the ceremony reached its climax, the humanist Gianozzo Manetti encircled the head of the dead man with a laurel wreath. When the tomb of Bruni came to be erected in S. Croce (plate 134), it was in this way that the great Greek scholar was shown on his monument. The moral was pointed in an epitaph written for the tomb by Bruni's successor as State Chancellor, Carlo Marsuppini: 'After Leonardo departed from life, history is in mourning and eloquence is dumb, and it is said that the Muses, Greek and Latin alike, cannot restrain their tears.'

Aragazzi was a poet of no great distinction, but Bruni was one of the most eminent figures of his time, and just as his funeral was conducted in conformity with antique ceremonial, so it must from the first have been intended that his monument should embody something of the intellectual detachment, the peaceful equilibrium
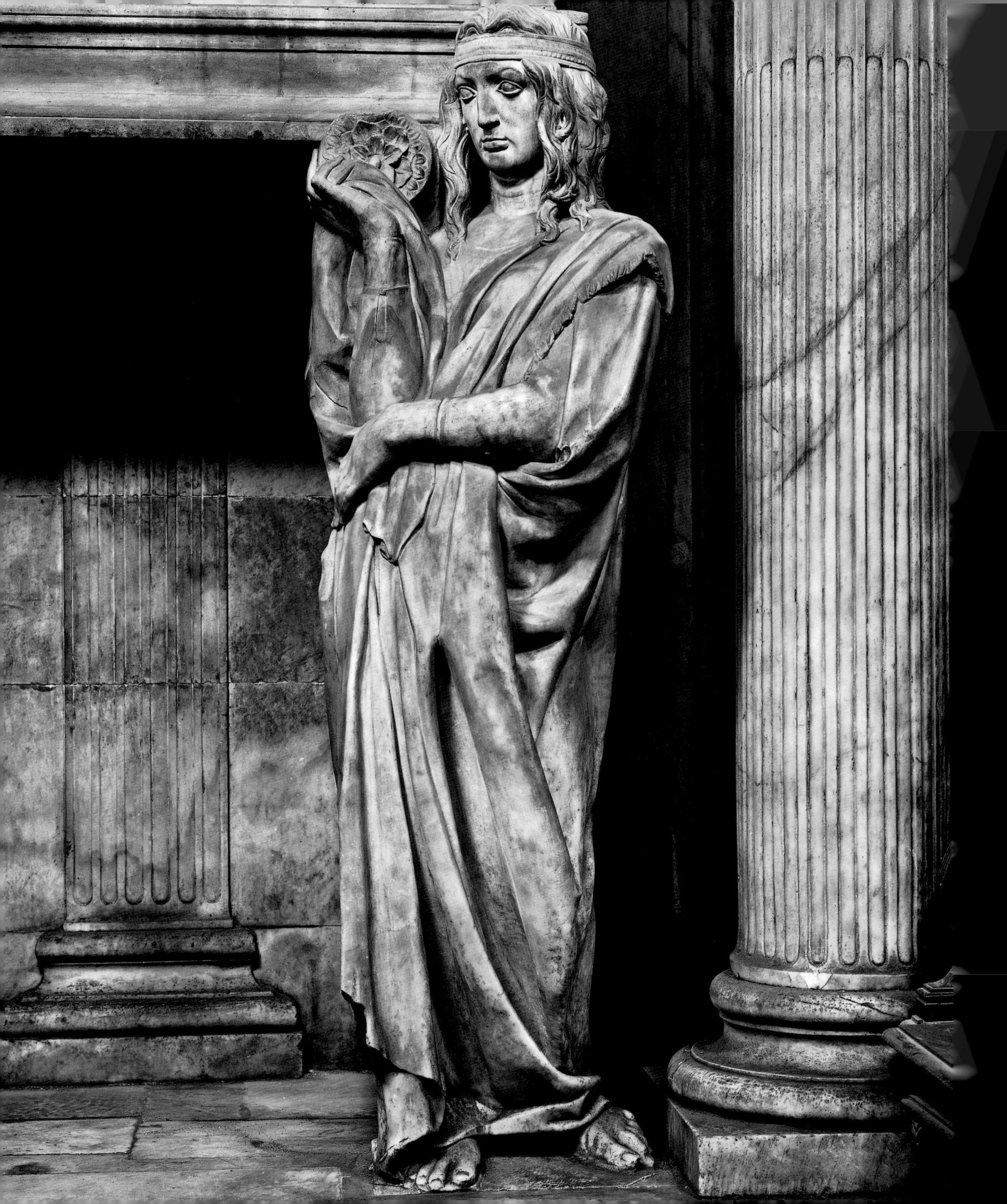

plate 132 Donatello and Michelozzo

The Monument of Pope John XXIII

Baptistery, Florence marble and bronze, height 732 cm

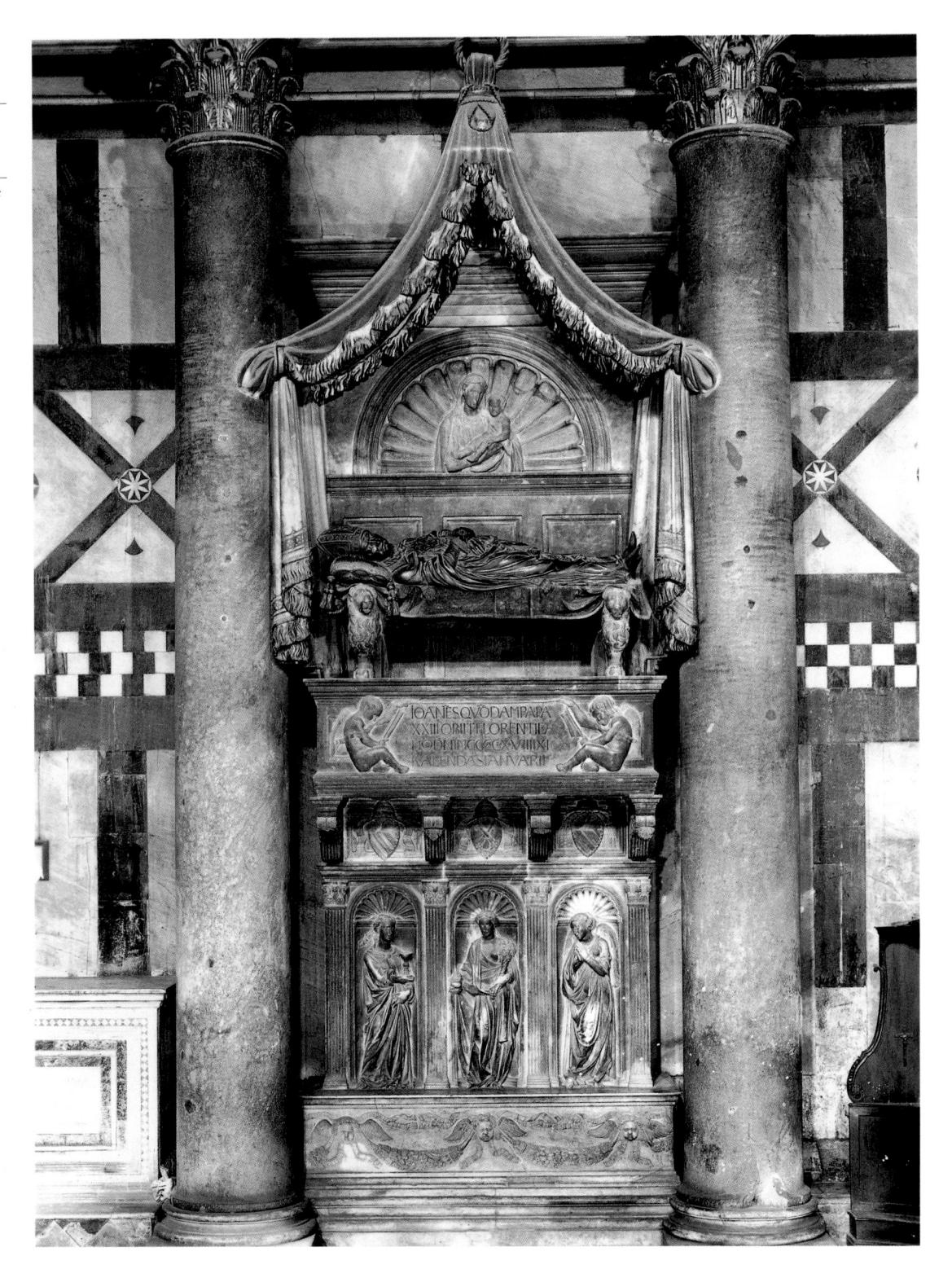

plate 133 Donatello and Michelozzo

The Monument of Pope John XXIII

Baptistery, Florence (detail of plate 132)

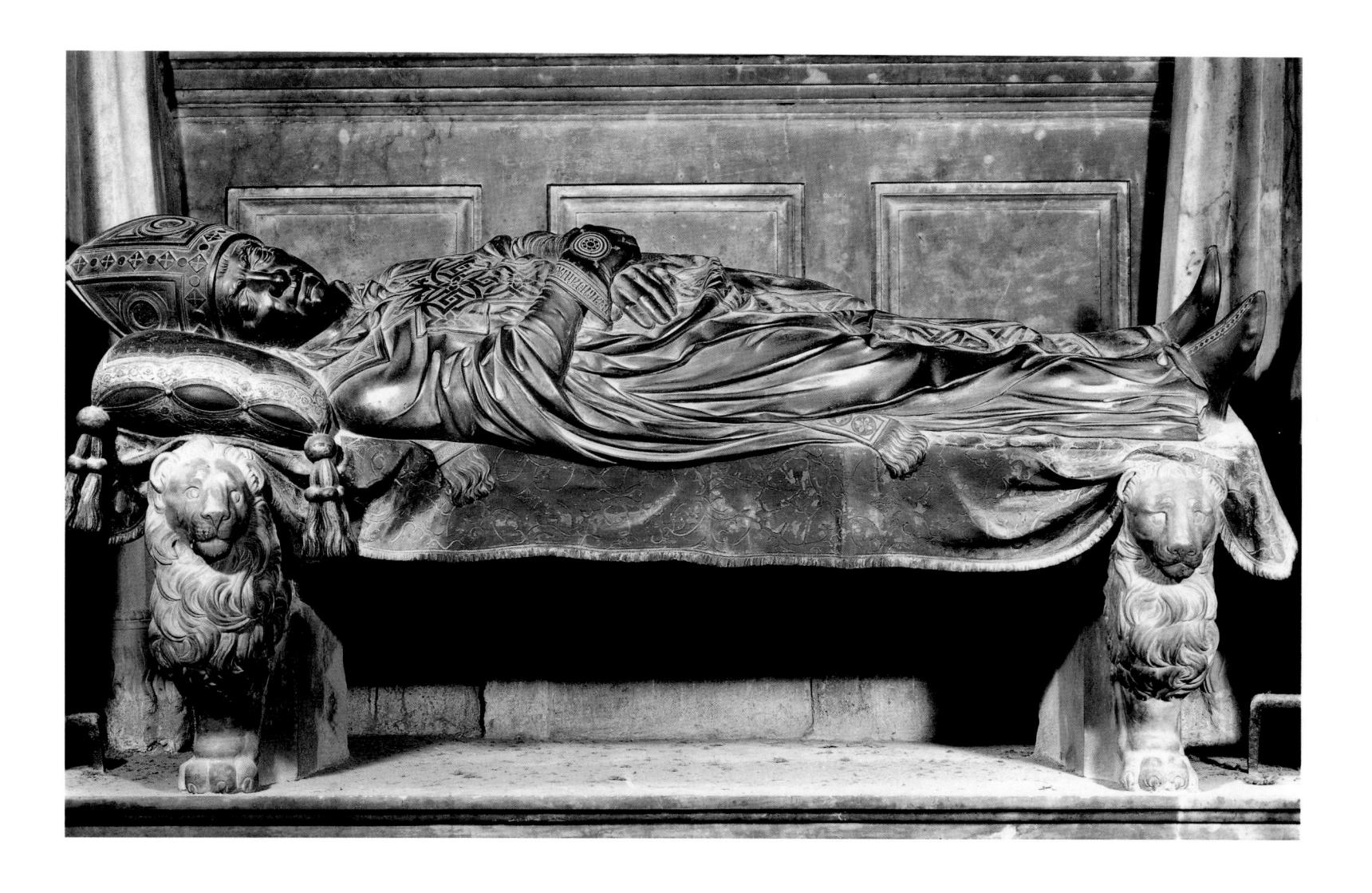

plate 134 Bernardo Rossellino

Bruni Monument

S. Croce, Florence marble, height 715 cm

plate 135 Bernardo Rossellino

Head of Leonardo Bruni

S. Croce, Florence (detail of plate 134)

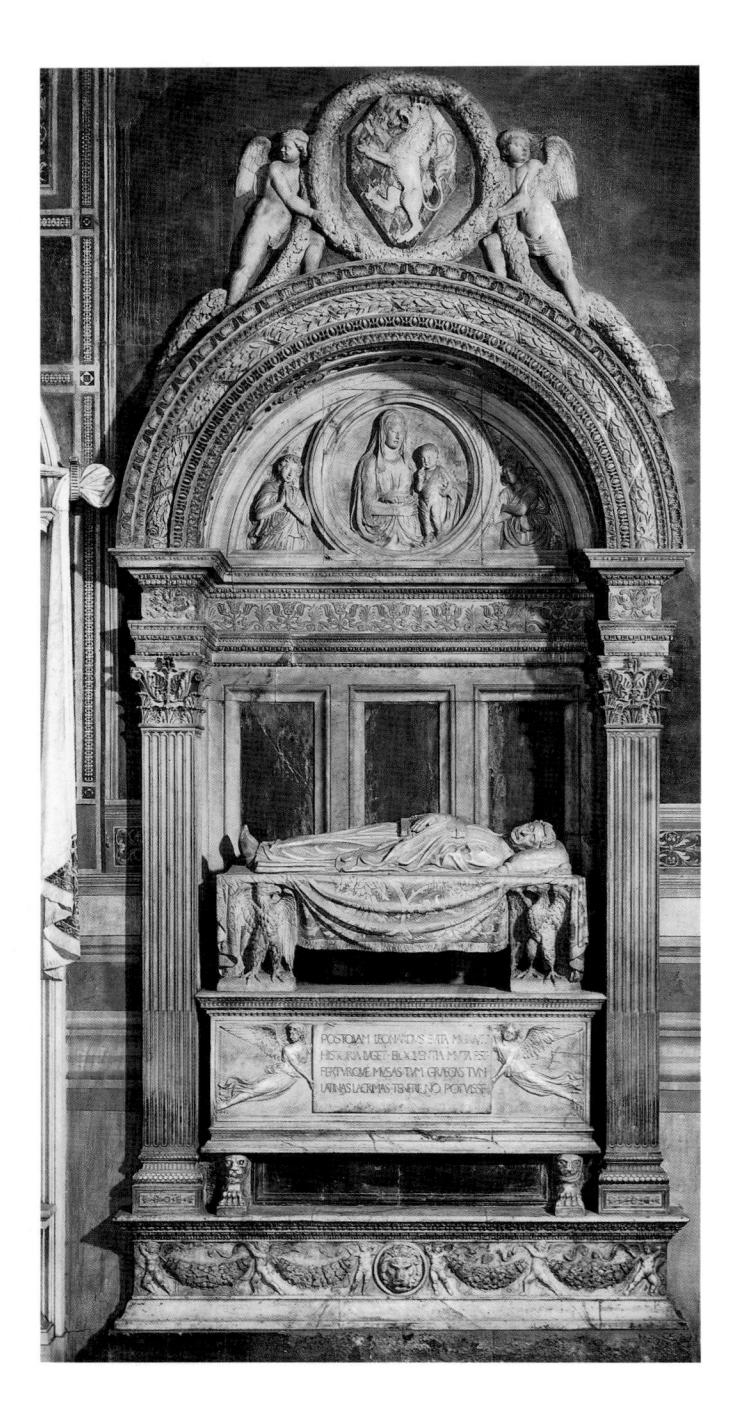

of his life. It was designed by Bernardo Rossellino. Bernardo Rossellino was trained by Brunelleschi, and in the Bruni tomb he applied the principles of Brunelleschi to the sepulchral monument. Where the architecture of Michelozzo's tombs is a static background for the sculpture disposed in front of it, in the Bruni monument it dictates the whole form of the tomb. The only features in which we are specifically reminded of Michelozzo's monuments are the base beneath and the triple division of the rear wall. What Rossellino introduced in the Bruni tomb was a new conception of the sepulchral monument as a triumphal arch set against the wall. It contains a Virgin and Child in the lunette, but otherwise there is no religious imagery. There are no caryatid figures, the bier rests on classical eagles, and beneath are two flying Victories on the sarcophagus. Throughout the tomb the sculpture is subordinate to the architectural scheme, and only at the top does it finally break free of the frame with two putti who hold up a laurel wreath. None the less Bernardo Rossellino was a great figure sculptor as well as a great architect, and the head of Bruni (plate 135), tranquil and idealized, is among the noblest creations of its time.

No Florentine tomb exercised so great an influence as the Bruni Monument. In it Bernardo Rossellino achieved the quintessential memorial of Renaissance man, an ideal embodiment of the aspirations and achievements for which it was felt that he should be immortalized. The most important of the monuments that derive from it in Tuscany stands opposite it in S. Croce, and is dedicated to Carlo Marsuppini (plate 138), who

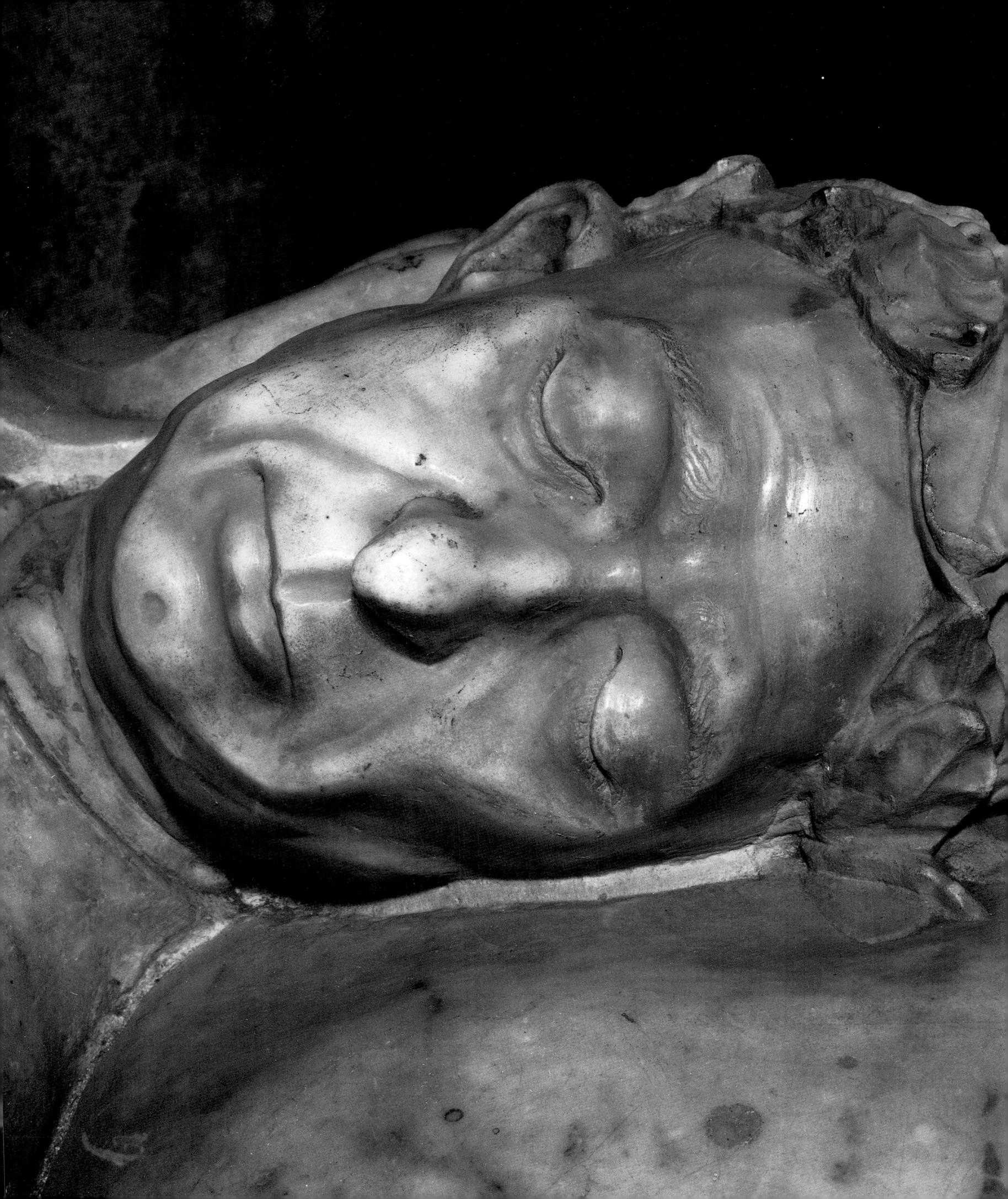

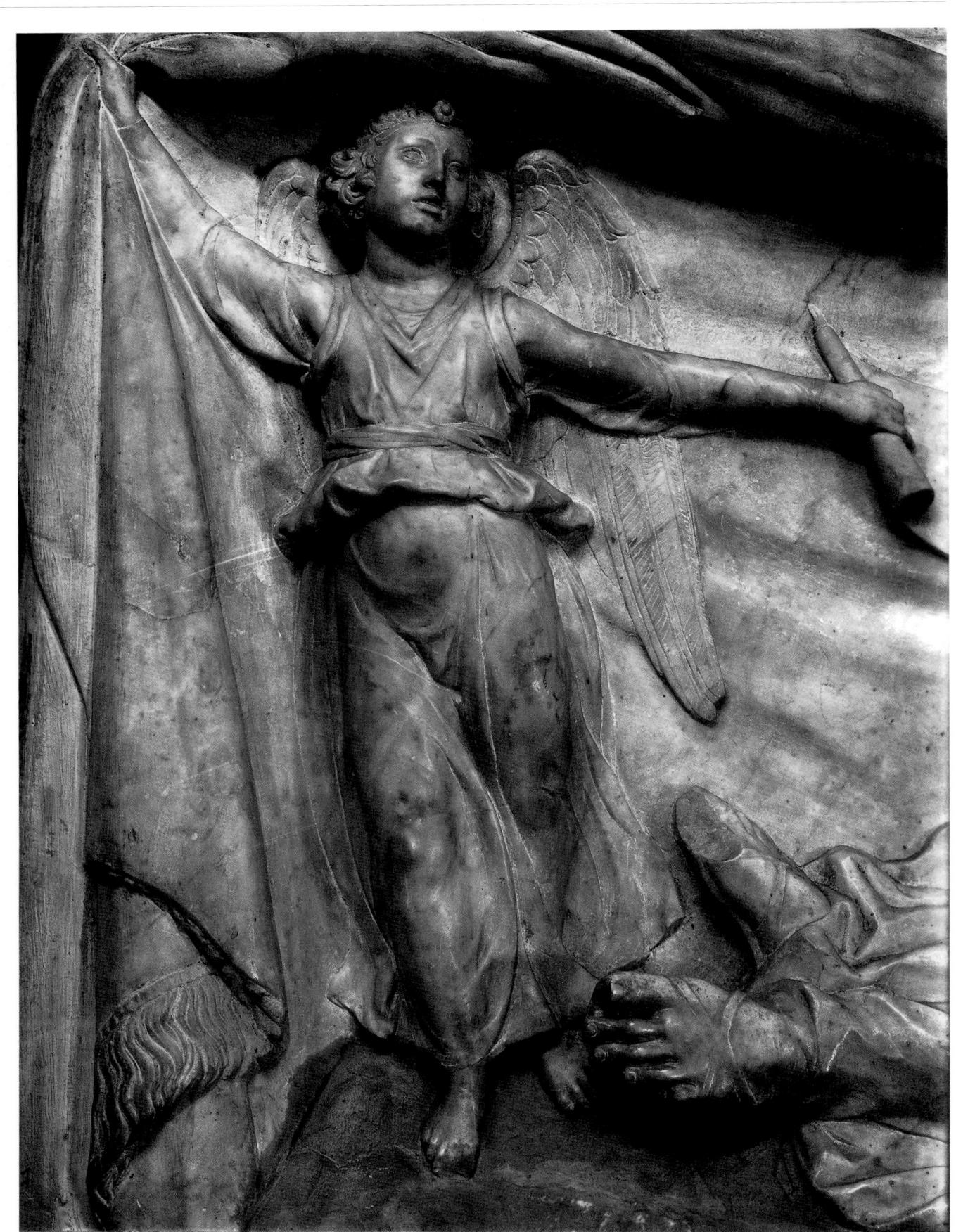

plate 136 Bernardo Rossellino

Angel drawing back a Curtain

S. Maria Novella, Florence (detail of plate 137)

had written the inscription for the Bruni tomb. Marsuppini died nine years after Bruni, in 1453, and his tomb was entrusted to Desiderio da Settignano. Desiderio's design is imitated from the Bruni tomb, but the forms are less functional and the ornamental detail is more deeply undercut. For that reason it lacks the grandeur and austerity of the Bruni Monument. Desiderio's gifts were lyrical; so personal was his message that the idiom of Donatello and Bernardo Rossellino was of little use to him, and almost as a boy he seems to have worked out a vocabulary of his own. In the Marsuppini Monument the roles of sculpture and architecture are reversed. At the top two Angels stand on the cornice, disrupting the architectural scheme, and at the bottom the pilasters are relieved by putti (plate 139) at either side. What Desiderio contributed to the sepulchral monument was some of the most elegant figure sculpture of the whole Renaissance, and this invests the tomb with its liveliness and buoyancy. Desiderio's concern was with the transitory movements of the body and the fleeting expressions of the face. The Madonna of the Bruni Monument (plate 140) is shown in a static, monumental pose, circumscribed by a heavy frame. The forms are rounded, noble, and remote. The Madonna of the Marsuppini Monument (plate 141), on the other hand, protrudes beyond the frame, and is caught in a moment of entrancing intimacy just before the Virgin drops her eyes and the Child lowers his arm. The forms are not blocked out forcefully as they are by Bernardo Rossellino, but are devised in limited

recession, and their surface is diversified with carving in low relief which derives from Donatello's stiacciato carvings. Admittedly this new territory was not won without some sacrifice, and in the head of the Child we find a tendancy towards flattened, schematic forms which was its natural corollary; the ear, for example, is treated as though it rested on the plane of the relief, the fingers and drapery are ironed out, and the hair is reduced to a calligraphic pattern on the skull. Within the limits Desiderio set himself, however, this is a deeply original and an outstandingly ambitious work of art. The marvel of the Marsuppini Monument is that Desiderio also carries out in three dimensions the effects that he achieves so easily in two. The boys holding up the garlands at the top of the monument are treated with such freshness that they seem scarcely to be posed at all, and so are the confiding, wistful, humorous putti at the base. These are the children of Luca della Robbia rather than Donatello, but they are treated with a surface illusionism to which Luca did not aspire. Very few sculptors have possessed such total mastery over their medium as Desiderio, and even in the decorative sections he addresses us in his own absolutely individual voice, and communicates a sensuous pleasure in the surface of the marble that Donatello would have disdained or repressed.

The Bruni and the Marsuppini monuments now stand alone in S. Croce as an embodiment of the ideals of their time. Had fate not decided otherwise, they would, however, have been accompanied by a third tomb, that of the plate 137 Bernardo Rossellino

The Tomb of the Beata Villana

S. Maria Novella, Florence marble, 160 × 235 cm

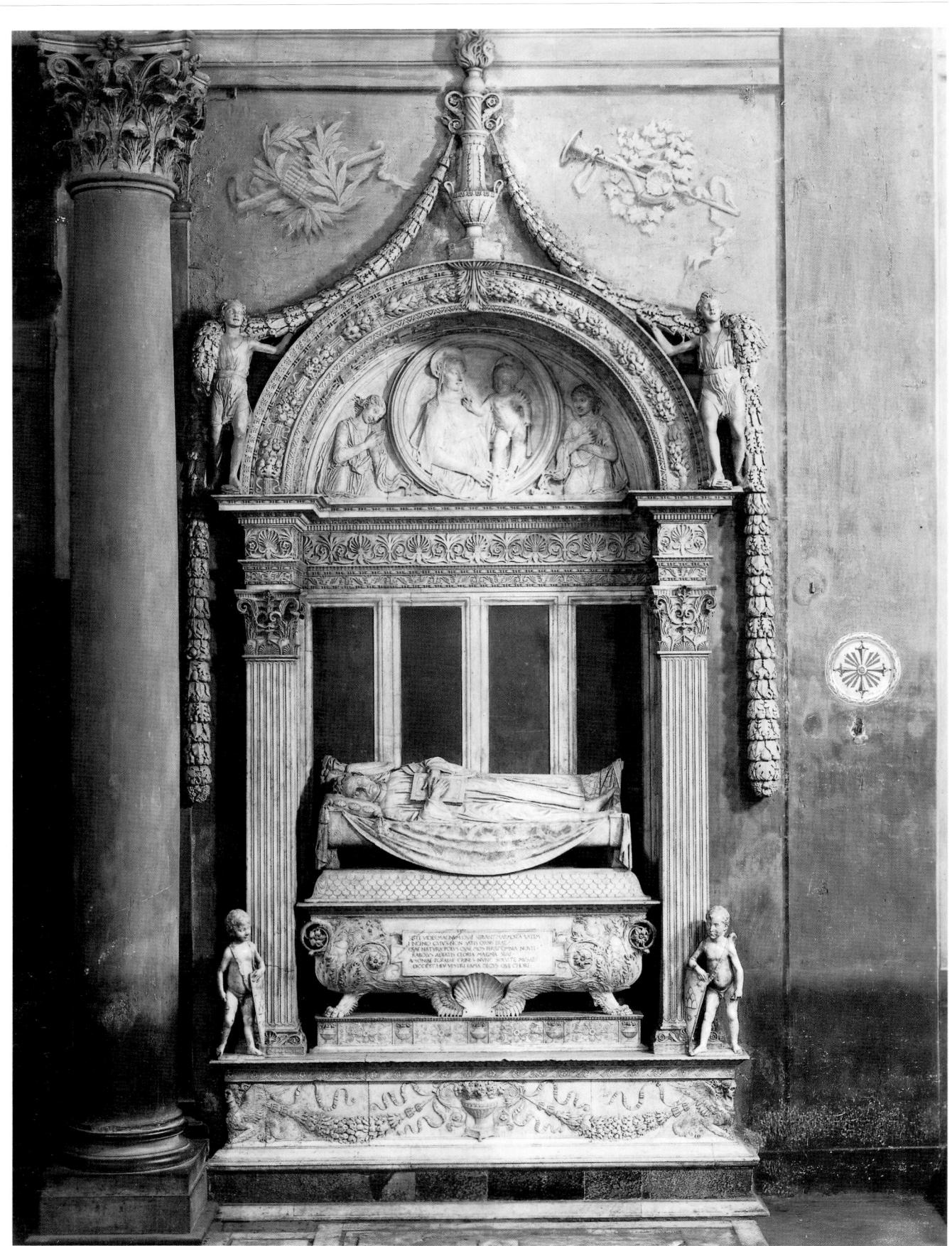

plate 138 Desiderio da Settignano

The Marsuppini Monument

S. Croce, Florence marble, height 601 cm

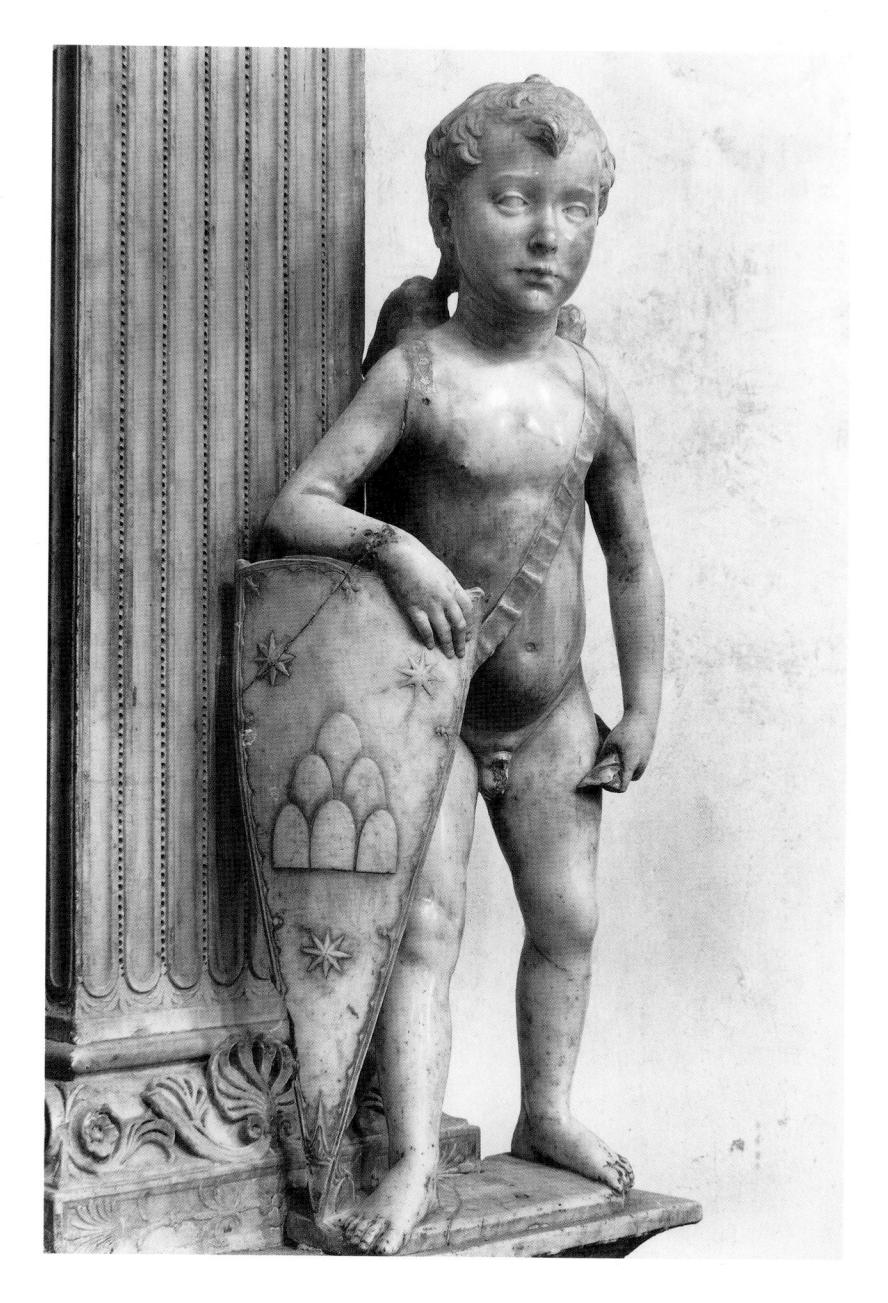

plate 139 Desiderio da Settignano

Putto with Shield
S. Croce, Florence
(detail of plate 138)
height 96 cm

plate 140 Bernardo Rossellino

Virgin and Child

S. Croce, Florence (detail of plate 134)

plate 141 Desiderio da Settignano

Virgin and Child

S. Croce, Florence (detail of plate 138) diameter of roundel 117 cm

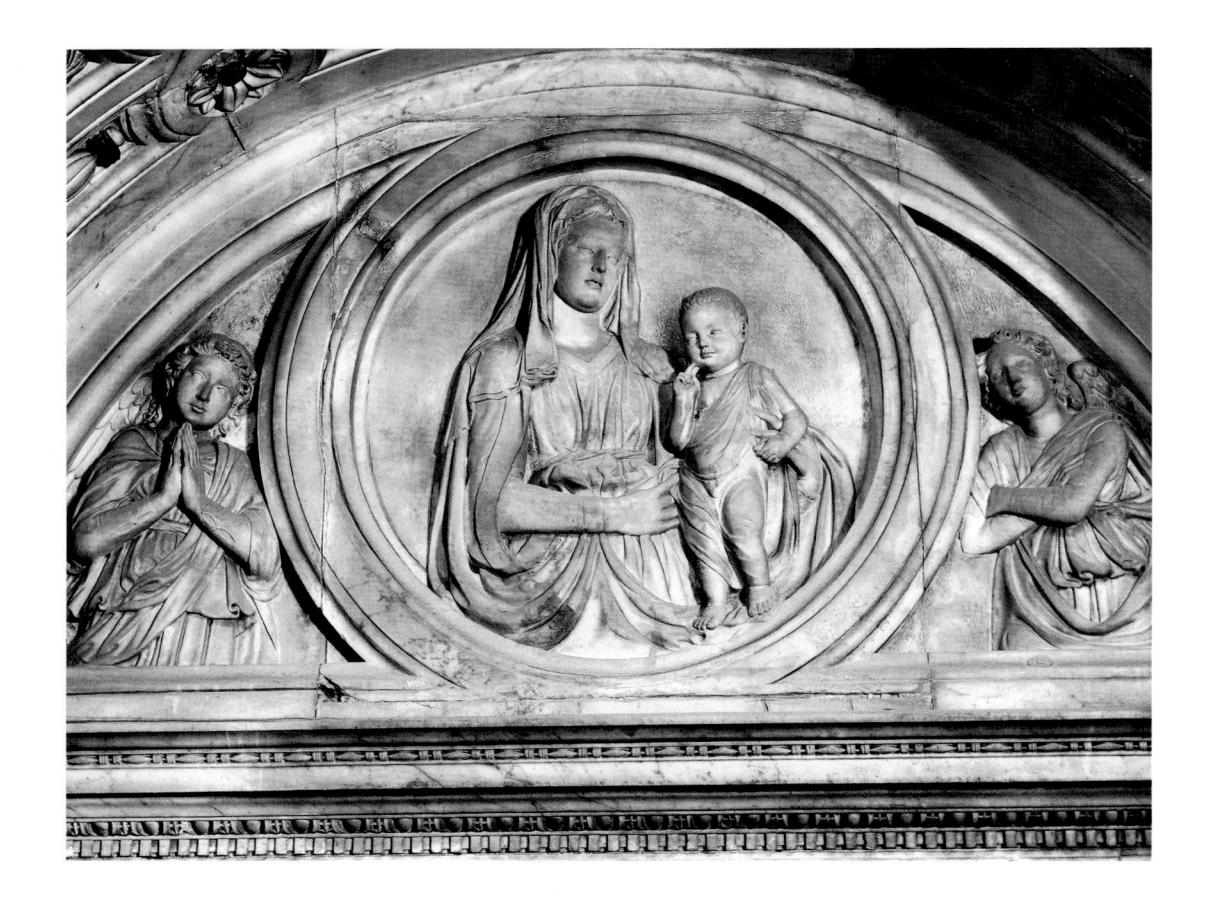

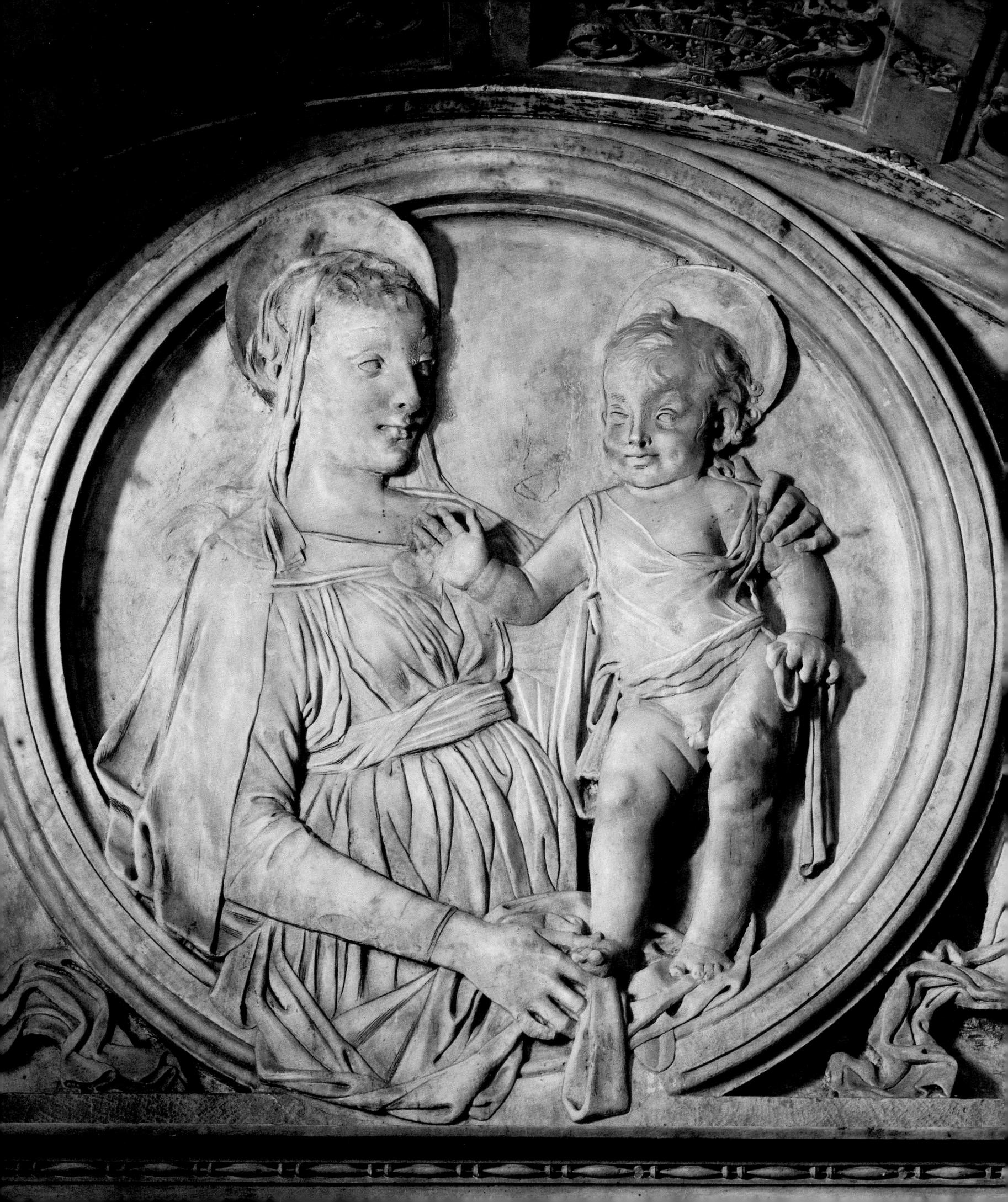

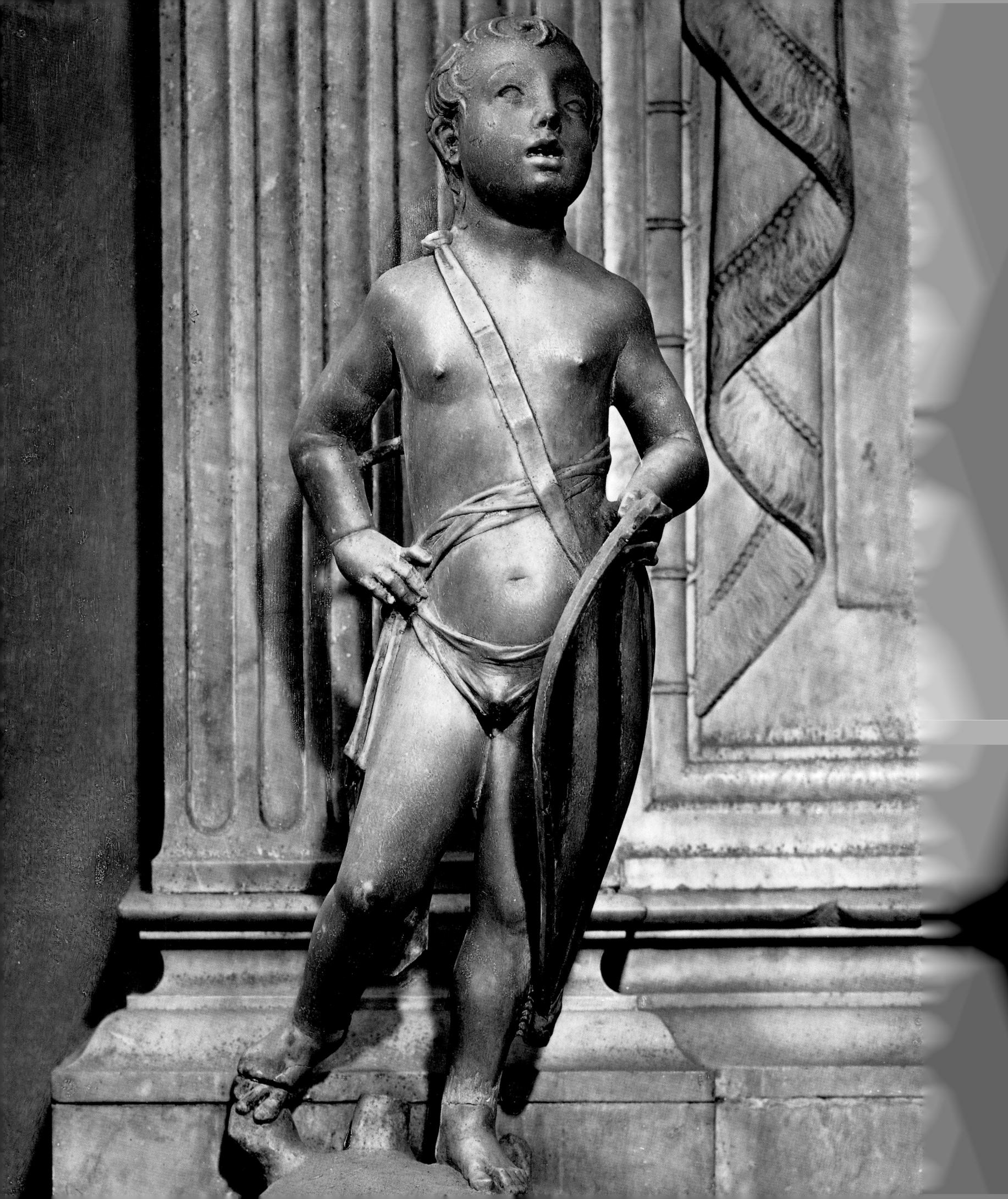

humanist Poggio Bracciolini, who before his death in 1459 provided for a marble tomb in S. Croce, decided 'il modo che voleva ch'ella istesse' ('how it was to look'), and composed his epitaph. In this case money ran out, and the tomb was never built.

Ruskin wrote of a fifteenth-century sculptor that 'his chisel seems to cut life and carve breath, the marble burns beneath it, and becomes transparent with very spirit'. These words refer not to Desiderio (to whose work they might well be applied) but to his contemporary, Mino da Fiesole. There is little in common between the two artists; Mino was a comparatively poor technician, and his emotional repertoire was a vein of frank sentimentality that endeared him to the nineteenth century but is rather unpalatable now. The differences between the sculptors are best brought out if we compare one of Desiderio's putti with a putto from Mino's monument of Count Hugo of Tuscany in the Badia (plate 142). Mino's putto depends directly from Desiderio's and the monument on which it stands (plate 143) depends directly from the Bruni tomb. The equation between them, however, is not that between the Marsuppini and the Bruni monuments; rather is this a conversation between two people who are perpetually at cross-purposes. The externals are the same, the great pilasters at the sides, the triple division of the rear wall, the frieze and the semicircular lunette. But the entablature is defaced with a scroll-motif which conceals its function, the central section of the background is filled with a stiff figurated relief, the central section is framed by conventionalized curtains, and the bier is developed into a sarcophagus so that the front of the sarcophagus can in turn be employed as the back of a seat. More than that, the relations in depth to which the Bruni Monument owes much of its distinction have vanished, and the architectural elements are conceived on a single plane flat against the wall. Not unnaturally Mino da Fiesole made little headway in Florence, and a great part of his life was spent in Rome, where standards were lower and the conception of the tomb remained more rudimentary.

Far more valuable are the monuments carved in Lucca by Matteo Civitali. Born in 1436, Civitali was an associate of Antonio Rossellino. Probably he was trained in Antonio's studio; certainly the two artists were on good terms, for when Rossellino completed a monument at Pistoia its value was assessed by Civitali, and when Civitali completed his first great tomb in Lucca its value was assessed by Rossellino. This is the tomb of Piero da Noceto in Lucca Cathedral (plate 144). Piero da Noceto's contacts were with Roman humanism; he was the secretary of Pope Nicholas V and a lifelong friend of Pope Pius II, and after he died in retirement in 1467, his son determined to commemorate him with a tomb based on the Bruni and Marsuppini monuments. Like Bernardo Rossellino, Civitali was an architect, and in this tomb architecture has the same predominance as in the Bruni Monument; figure sculpture is largely eliminated, save for two shield-bearing putti derived from Desiderio who are set out of harm's

plate 142 Mino da Fiesole

Putto with Shield

Badia, Florence (detail of plate 143)

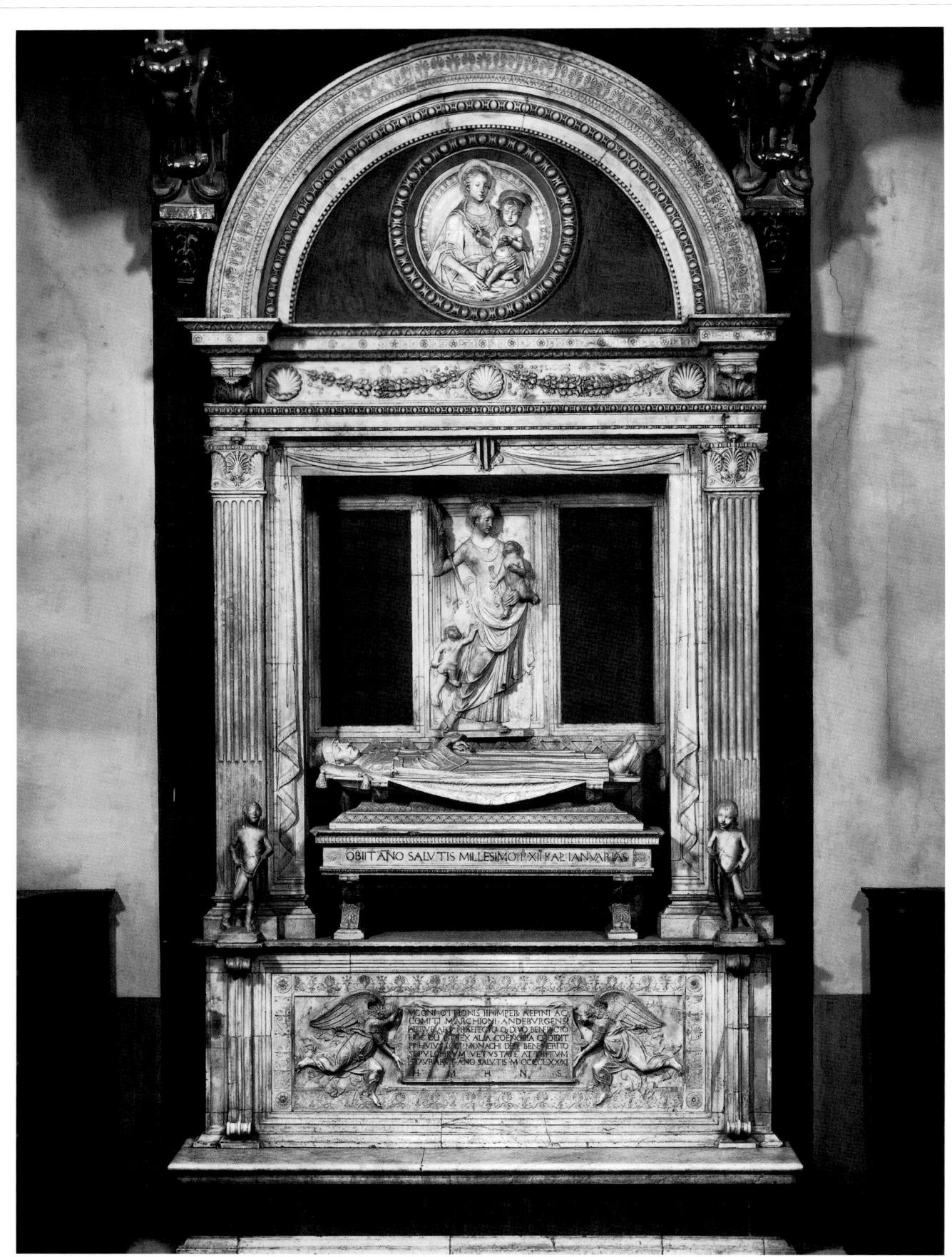

plate 143 Mino da Fiesole

Monument of Count Hugo of Tuscany

Badia, Florence marble, length of sarcophagus 208 cm

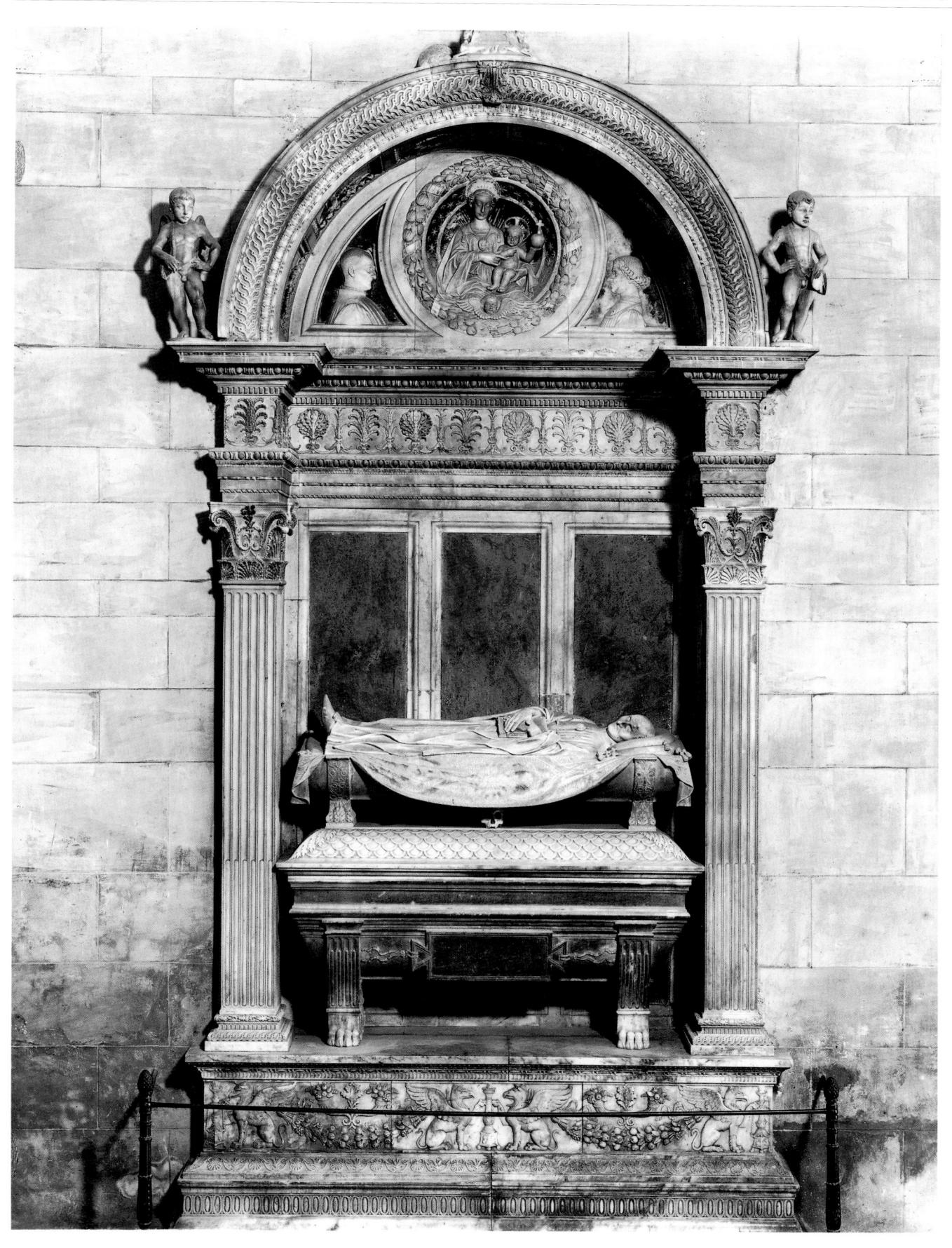

plate 144 Matteo Civitali

The Monument of Piero da Noceto

Duomo, Lucca marble

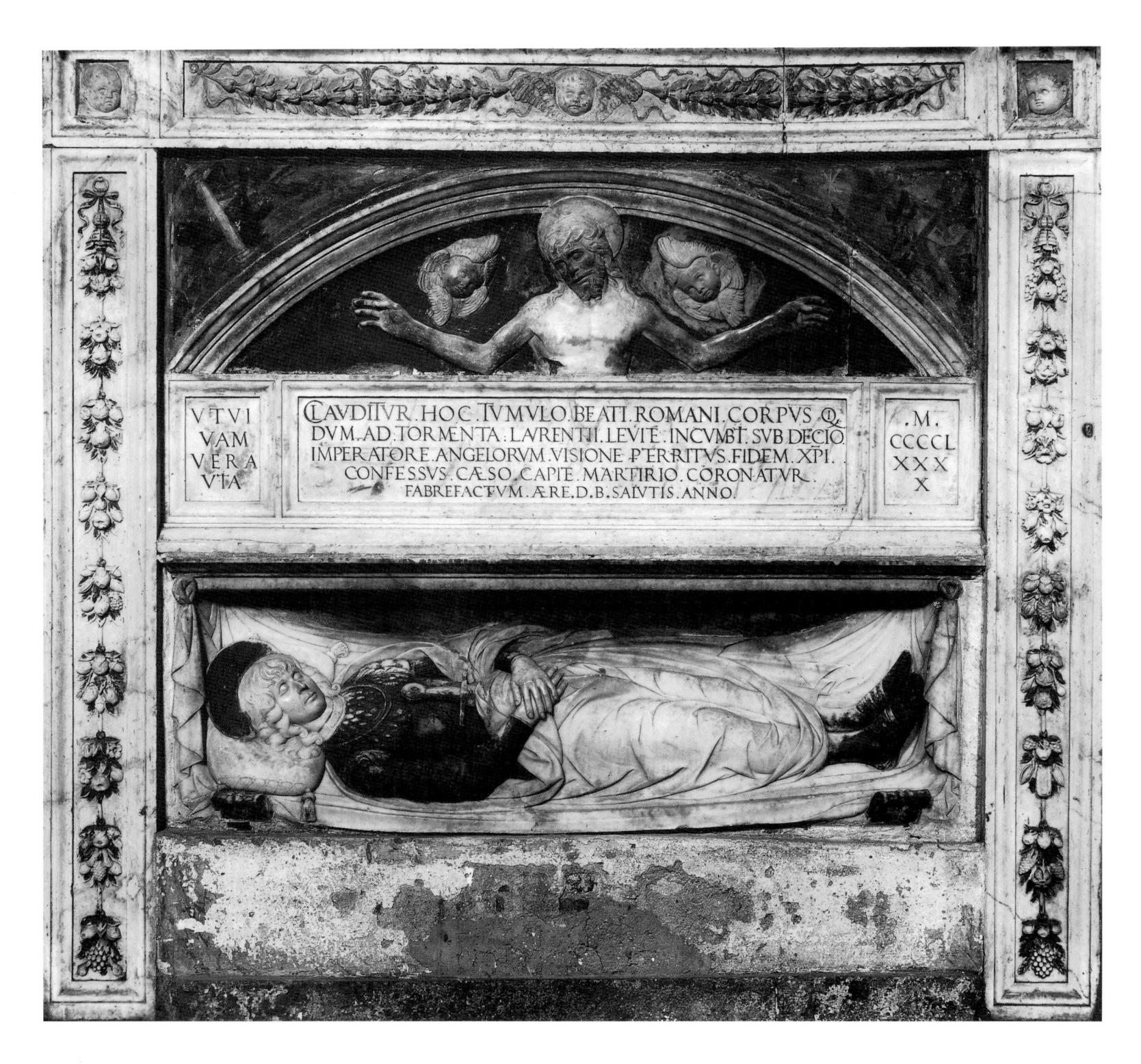

way at the top. Where the tomb departs from the Bruni Monument is in the form of the sarcophagus, which is based on a Roman porphyry sarcophagus that was also reproduced by Antonio Rossellino. Civitali was not an artist of much originality, but he was gifted with great technical proficiency and unfailing taste, and as through his whole life he maintained his studio in his native town, Lucca in the later fifteenth century became the main centre of Tuscan marble sculpture outside Florence.

All these are secular tombs. With religious monuments, religious imagery was predominant. When Benozzo Federighi, the Bishop of Fiesole, died in 1450, his tomb (plate 80) was commissioned from Luca della Robbia. In the form in which it was set up it was raised on paired pilasters flanking a red marble slab, and what we see today is no more than its upper section, a square of marble with an enamelled terracotta frame. In the form of the sarcophagus, with its victory angels, Luca was evidently influenced by the Bruni tomb, but his vision and technique were more staid and rigid than Bernardo Rossellino's, and both the angels and the effigy take on a different inflection at his hands. The hair and wings of the two Angels, the haloes of the background figures, and the mitre, chasuble, cushion and bier-cloth were originally gilded. This gilding served to reconcile the bleached surface of the marble with the brightly coloured flowers and foliage in the surround. For his iconography, Luca turned back to the fourteenth century, perhaps to the Baroncelli Monument in

S. Croce, where the base is divided into three panels with figures of the dead Christ, the Virgin and St John. The back of the Federighi Monument is divided in precisely the same way, though once more the figures take on a personal inflection, and in expressiveness and artistry transcend those of the Baroncelli tomb.

By far the most important of these religious tombs is Antonio Rossellino's monument of the Cardinal of Portugal. All of the tombs discussed up to this point were designed for pre-existing contexts. The Chapel of the Cardinal of Portugal, on the other hand, was that rare thing, a totally new edifice, and the tomb proper (plate 146) was therefore part of a much larger scheme. The ground plan of the chapel was square, and the three walls were treated in a uniform way, each with an arched recess, containing on the wall facing the entrance the altar, on the left a throne and on the right the tomb. The decoration of the chapel involved two sculptors - Luca della Robbia, who designed the enamelled terracotta ceiling (plate 91), and Antonio Rossellino, who executed the tomb and the throne opposite – and two painters - Baldovinetti, who was responsible for the spandrels beneath the ceiling and an Annunciation above the throne, and Antonio Pollaiuolo, who painted the altarpiece and frescoes on the altar wall. The chapel is a unitary conception in which painting and sculpture meet on equal terms. When, for example, Baldovinetti painted his Virgin Annunciate in 1466, he transcribed the formal language of Rossellino's angels on the wall opposite with such precision

plate 145 Matteo Civitali

The Tomb of San Romano

S. Romano, Lucca marble

plate 146 Antonio Rossellino

The Tomb of the Cardinal of Portugal

S. Miniato al Monte, Florence marble

plate 147 (opposite) Antonio Rossellino

Seated Child

S. Miniato al Monte, Florence (detail of plate 146) marble

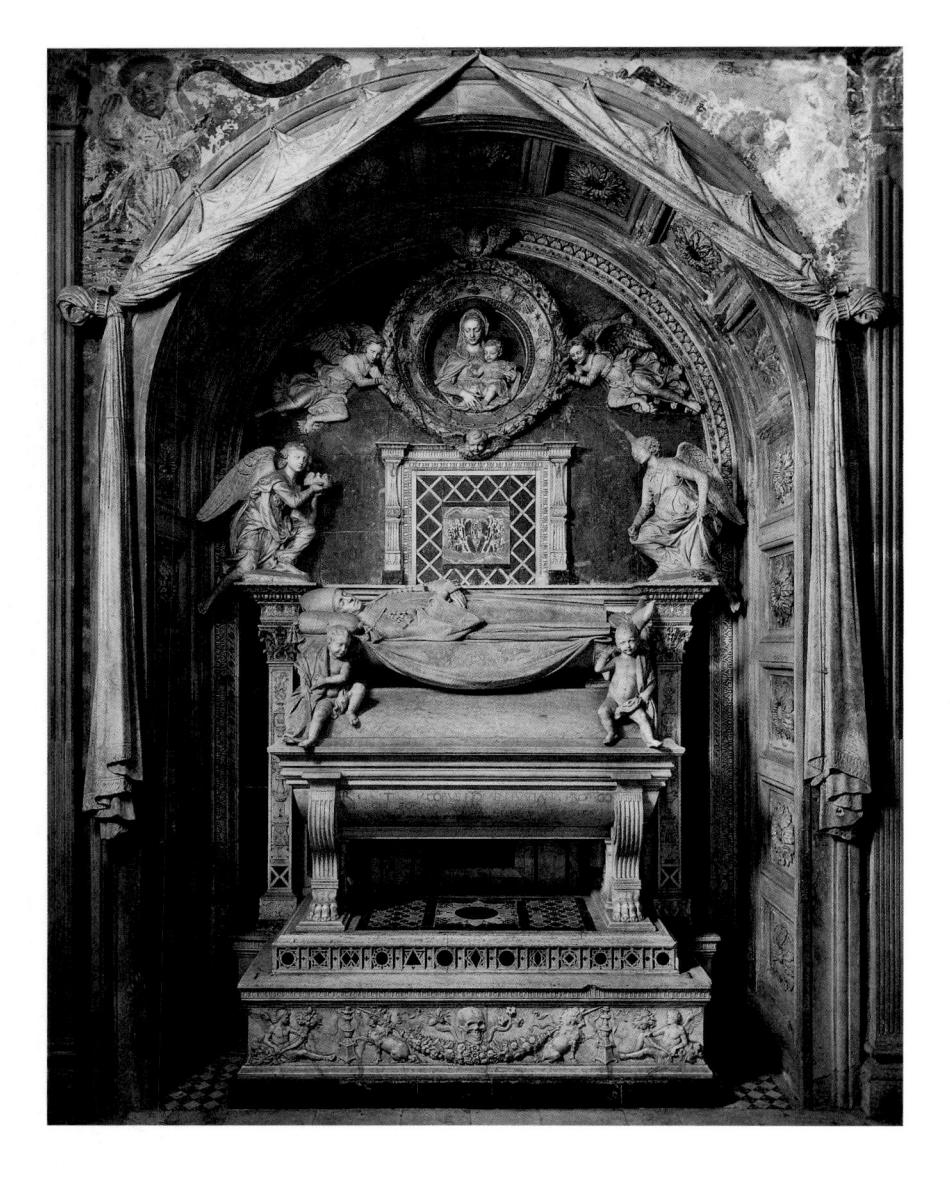

that the fresco and the sculptures seem to be inspired by one stylistic will. Conversely the paintings by Antonio Pollaiuolo afford a clue to the intention behind the monument. The altarpiece shows three Saints, with the Cardinal's patron St James in the centre moving forwards with eyes turned towards the tomb. Above is a circular window framed in painted curtains held back by two foreshortened Angels represented against a painted sky. The tomb (plate 146) is framed by sculptured curtains, and the circular aperture which corresponds with the window on the altar wall contains a Virgin and Child with two Angels depicted as though flying through the air. In front is the Cardinal's effigy, and above are two more Angels who seem to have alighted on the monument. This vision of the tomb as a tableau vivant was a completely novel one.

With the Marsuppini Monument we paused for a moment to look at the components of the tomb as sculpture, and we shall be more than repaid if we treat this tomb in the same way. The relief of the Virgin and Child (plate 148) is carved in considerably greater depth than the Madonna of the Marsuppini Monument. Animation is not the artist's aim, and the figures are shown in repose, no longer absorbed in one another but gazing at the effigy below. The design is one of extraordinary mastery – particularly beautiful is the way in which the Virgin supports the Child's left arm – and by comparison with Desiderio the treatment is staid and classical. For the two children seated beside the bier (plate 147) classical models were employed, and the Angels poised above the monument

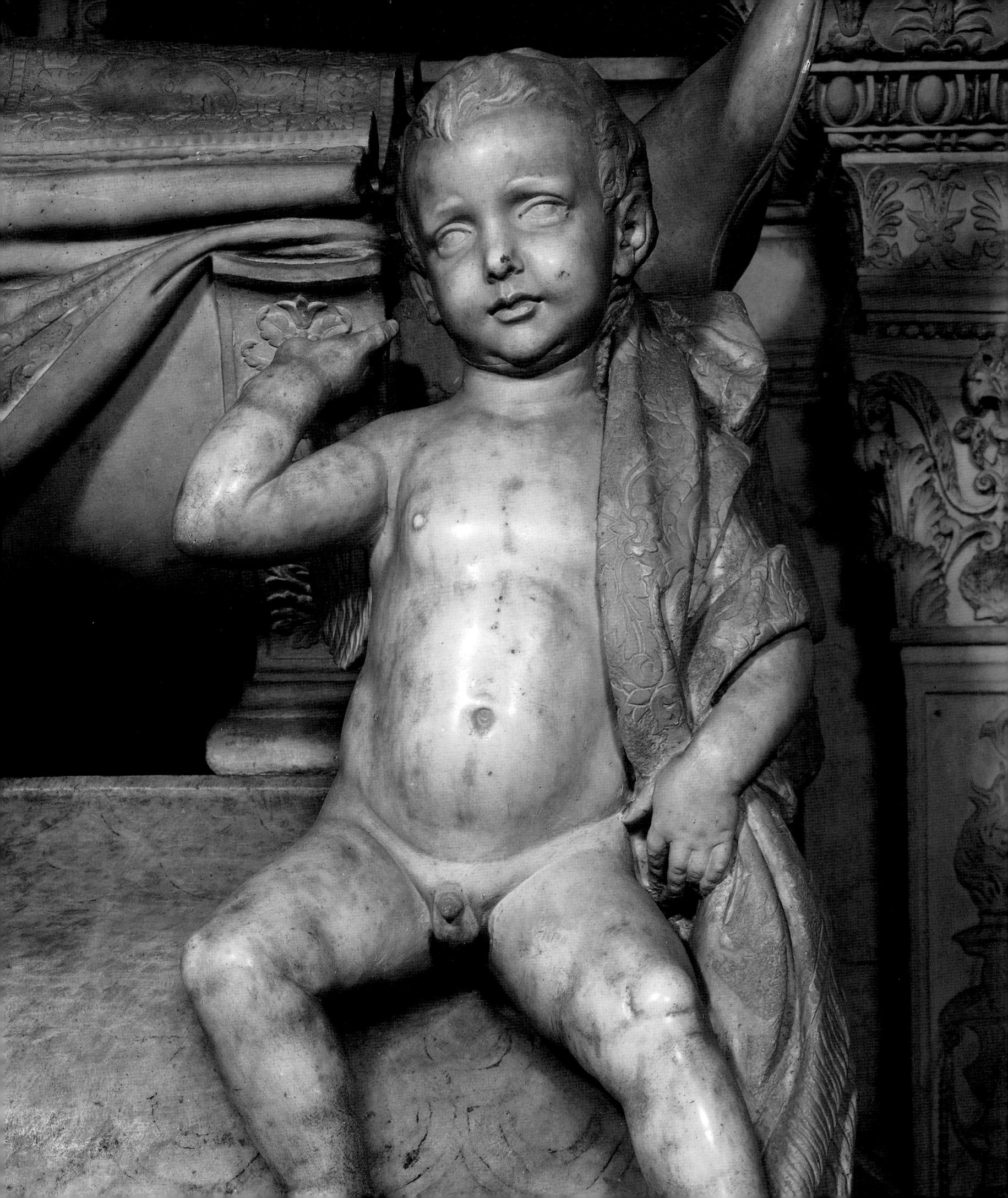

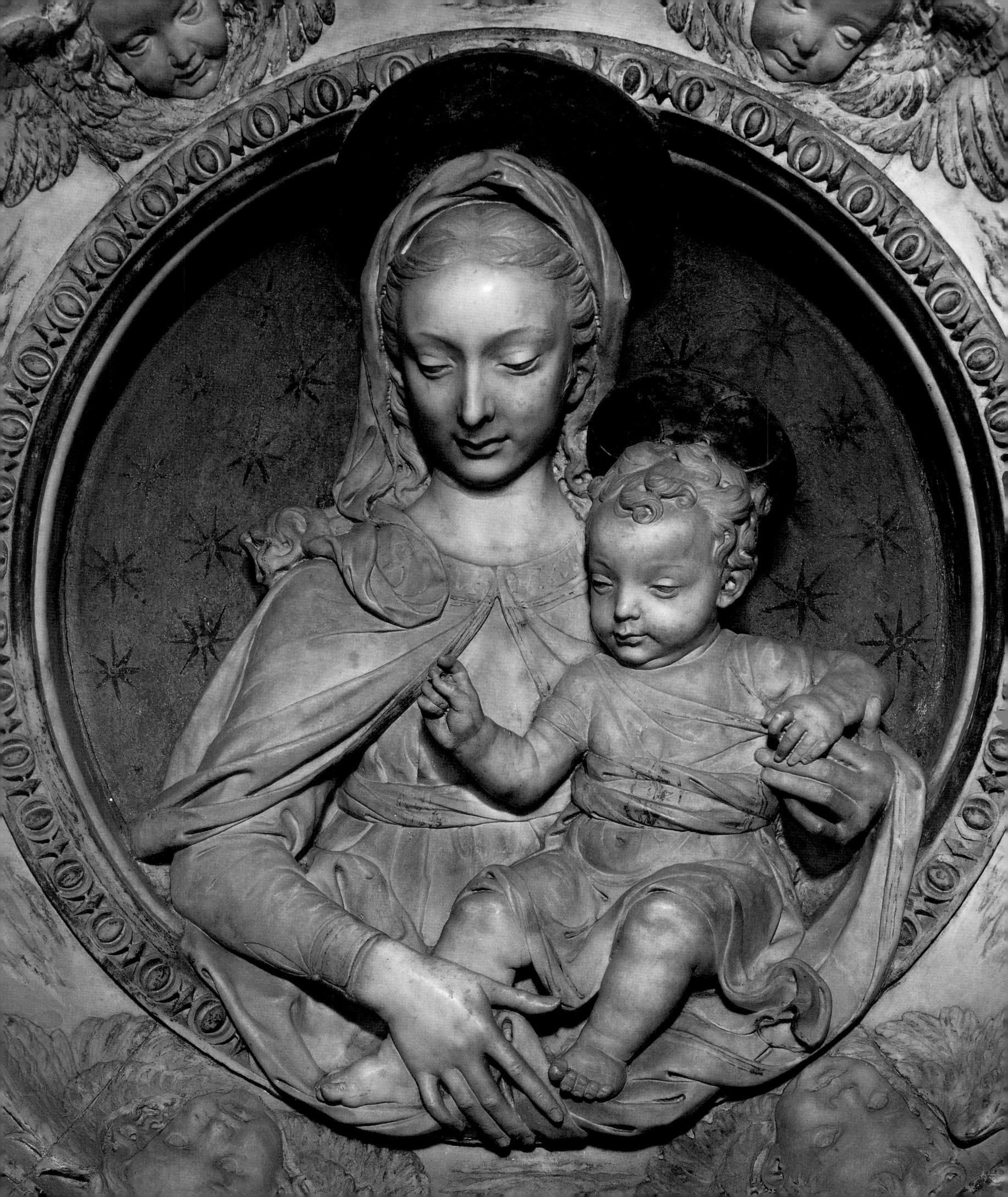

plate 148 (opposite) Antonio Rossellino

Virgin and Child

S. Miniato al Monte, Florence (detail of plate 146)

plate 149 Antonio Rossellino

Angel

S. Miniato al Monte, Florence (detail of plate 146)

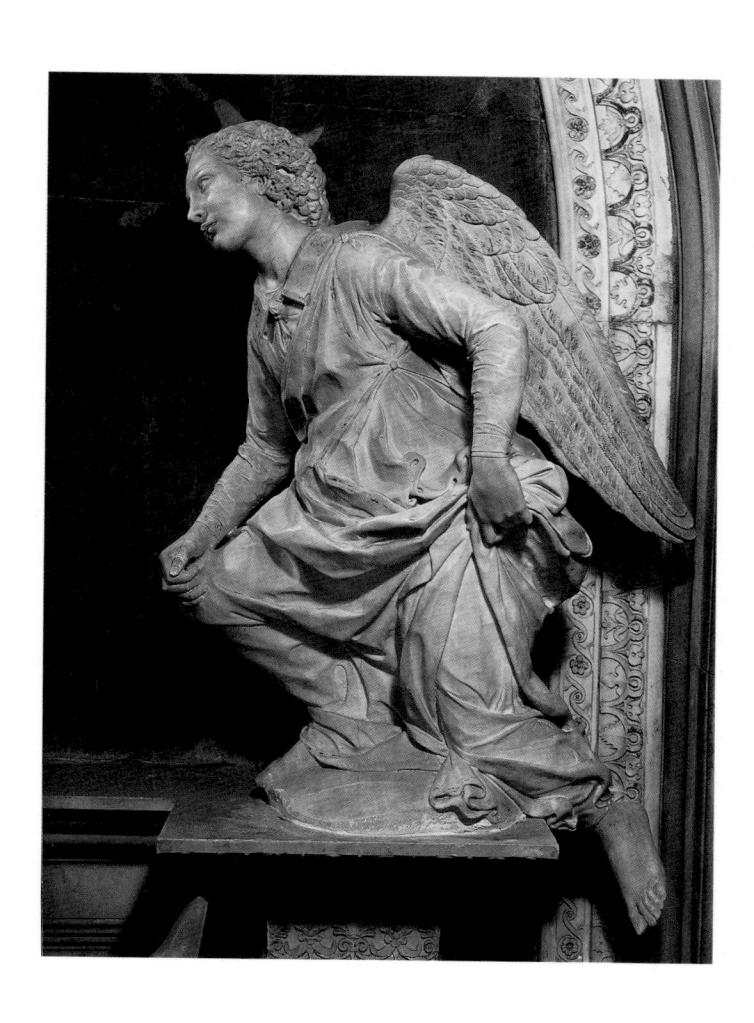

plate 150 Andrea del Verrocchio

The Forteguerri Monument

Duomo, Pistoia marble

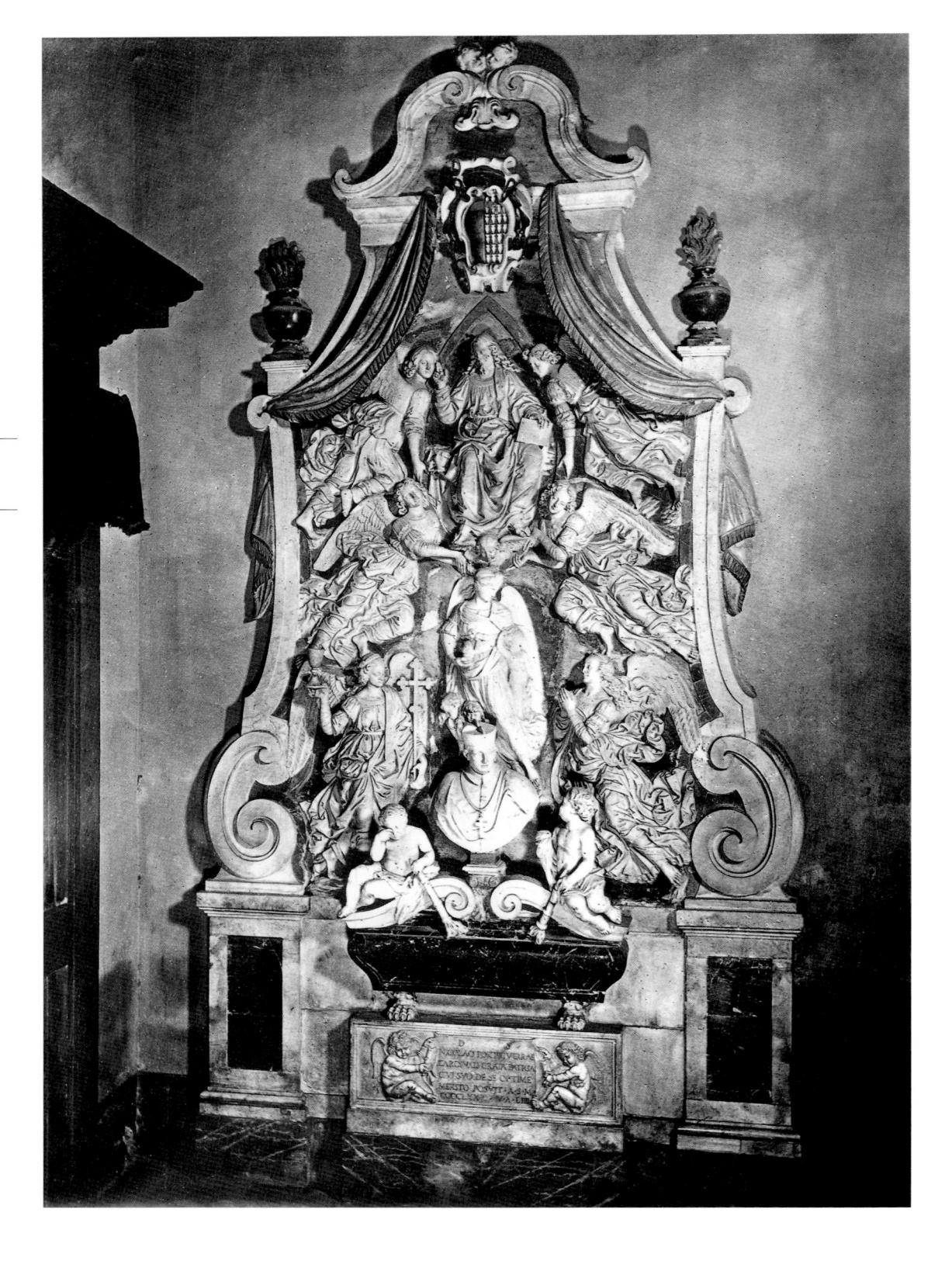

plate 151 Andrea del Verrocchio

Model for the Forteguerri Monument

Victoria and Albert Museum, London terracotta, 39.4×26.7 cm

(plate 149) are handled with a plastic freedom which Desiderio did not command. The complex drapery of these figures anticipates the drapery studies which were produced a decade later by Leonardo.

The chapel of the Cardinal of Portugal is the most important funerary monument produced in Florence after the Bruni tomb, and its merits seem to have been widely recognized. When a chapel was decorated in S. Giobbe in Venice, its roof was reproduced, and when Mary of Aragon died in Naples in 1470, she was commemorated by a copy of Rossellino's monument which has lost almost all the impetus of the original. But only one artist developed the idea that underlay the tomb. That artist was Verrocchio in the Forteguerri Monument in Pistoia Cathedral (plate 150).

Cardinal Forteguerri died in Rome in 1473, and was buried in a tomb by Mino da Fiesole in S. Cecilia in Trastevere. The monument at Pistoia therefore is a cenotaph. Had it been completed, it would have been the most richly figured monument of the whole century. When Verrocchio died in 1488, however, it was unfinished; a quarter of a century later it was added to; and in the middle of the eighteenth century it was given the monstrous form that it has now. If therefore we are to recognize it as the masterpiece it is, we must take away the frame in which the sculptures are now compressed, eliminate the Baroque sarcophgus, the bust and the lamenting putti at the sides, and erase the Charity, the central figure at the bottom, which was added in the sixteenth century. When this is

done, we are left with the Redeemer in benediction in a mandorla supported by four Angels, and flying figures of Faith and Hope below (plate 152). The effect made by these carvings when they were spaced out on the wall can be judged from a sketch-model (plate 151) made in Verrocchio's studio before the poses of the Angels had been finally decided on. In one respect, however, the impression left by the model is also a misleading one, since the original figure of the Cardinal survives, blocked out by Verrocchio and completed early in the sixteenth century, and we know from this that at the bottom of the tomb the Cardinal was seen kneeling in full-face. Only when this statue is replaced in its proper context does the Christ (plate 153), with right arm raised in absolution and eyes gazing compassionately down, take on its full significance. From a formal point of view Verrocchio had a precedent for the Forteguerri Monument in Nanni di Banco's relief of the Assumption of the Virgin over the Porta della Mandorla of the Cathedral, where flying angels also support the central figure in an almond-shaped surround (Vol. I, plate 204). If we compare the angels figure for figure, there can be little doubt that he had this carving constantly in mind, though Nanni di Banco's motifs are translated into alien terms, and the drapery forms have taken on a baroque amplitude. Iconographically Verrocchio had a precedent as well, in the fourteenth-century Bardi Monument in S. Croce, which contains a fresco by Maso di Banco showing Bettino Bardi kneeling before Christ as Judge. Naturally, in Verrocchio's

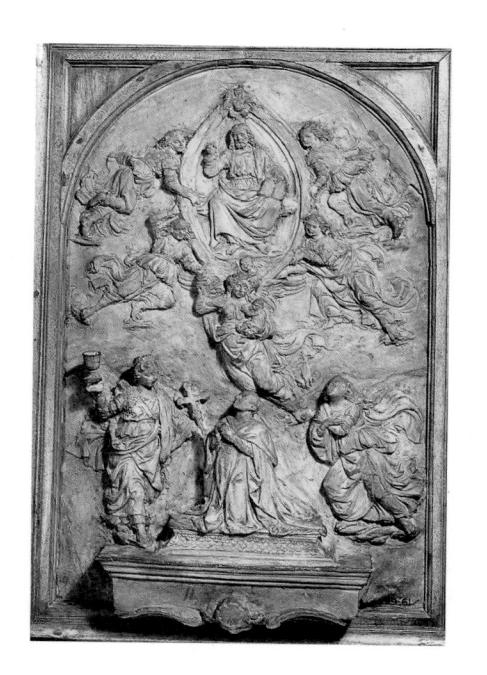

Overleaf plate 152 (left) Andrea del Verrocchio

Virtue

Duomo, Pistoia (detail of plate 150)

plate 153 (right) Andrea del Verrocchio

Christ

Duomo, Pistoia (detail of plate 150)

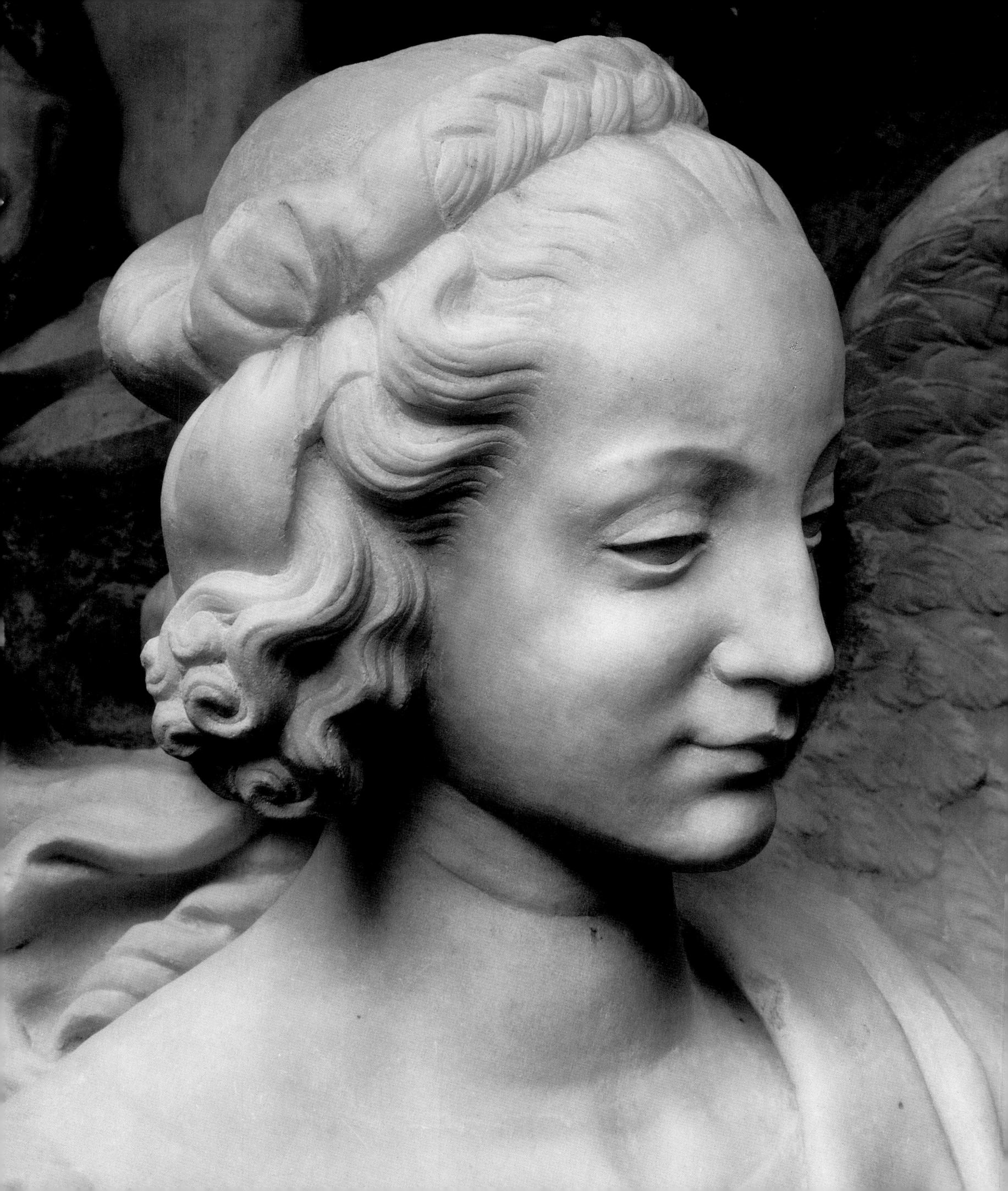

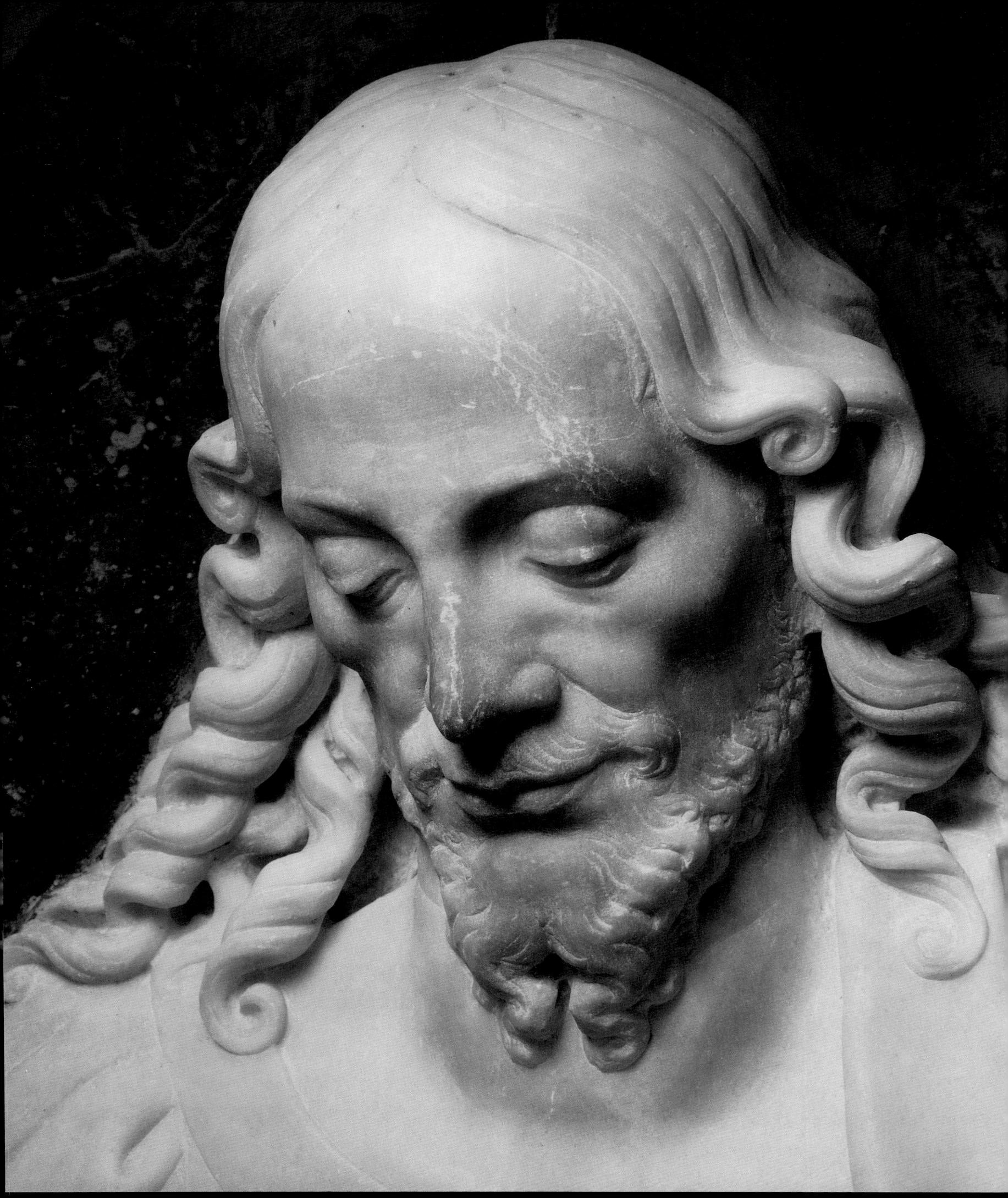

plate 154 Bernardo Rossellino

Tomb of Neri Capponi

S. Spirito, Florence marble, sarcophagus 99 × 214.5 cm

monument this theme is treated with greater insight and wider expressive range, and in this respect too the tomb looks forward to the Baroque. Indeed when we reconstruct the Forteguerri Monument as Verrocchio conceived it, with its emotional tension communicated through the broken rhythms of a continuous plastic surface, it seems utterly irrational that a century and a half of classicism should separate it from the St Teresa of Bernini.

The Forteguerri Monument makes its effect through figure sculpture. In Verrocchio's only other tomb, the Medici Monument in S. Lorenzo (plate 155), there is no figurative element, and at first sight we might think that the two tombs were planned by two quite different brains. Yet on a closer view we find that the stylistic inclination behind them is basically the same. Where they differ is in the tradition from which they depend. In Florence great ceremonial tombs were an exception rather than the rule, and the men who were commemorated by tombs with sepulchral effigies were far outnumbered by those who were commemorated in a less personal and ostentatious way. The type of these more modest tombs was established in 1418 in the well-designed but coarsely executed monument of Onofrio Strozzi in the Sacristy of S. Trinita, which consists of a sarcophagus in a double-sided semicircular frame. As in Bernardo Rossellino's tomb of Neri Capponi in S. Spirito (plate 154), the containing arch was heightened and filled with a simulated rope-work grille in bronze. Verrocchio must have recalled this work when he planned the Medici tomb.

The tomb dates from 1469, and was commissioned by Lorenzo il Magnifico to commemorate his father Piero de' Medici and his uncle Giovanni. Like the Bruni and the Marsuppini tombs, it was designed for a preexisting context, but this time a Renaissance context, the Medici place of burial in S. Lorenzo, where it faced in one direction on to a chapel in the transept of Brunelleschi's church and in the other towards the Old Sacristy. For this reason it was necessary that the framework of the monument should correspond with the frames round the stucco reliefs by Donatello over the two doors. The media employed in the Old Sacristy also dictated the media of the new monument. On one side of the Sacristy were Donatello's bronze doors, and bronze was used throughout the tomb; the marble platform rested on bronze tortoises, the sarcophagus rested on bronze feet, there was bronze foliage at the corners and a bronze superstructure on the lid, and above was a bronze grille. The use of bronze enabled Verrocchio to poise the heavy marble sarcophagus on visually slight supports. At the same time it immeasurably enhanced the effect of the porphyry flanks of the sarcophagus with their central medallions of green porphyry. No one who has seen them is likely to forget these dark-green epitaphs framed in their bronze wreaths, or the smooth red sides of the sarcophagus broken by the boisterous foliage of the bronze supports. There is no work of nonfigurated sculpture in the fifteenth century which gives us the same sense of inventive power as this extraordinary tomb.

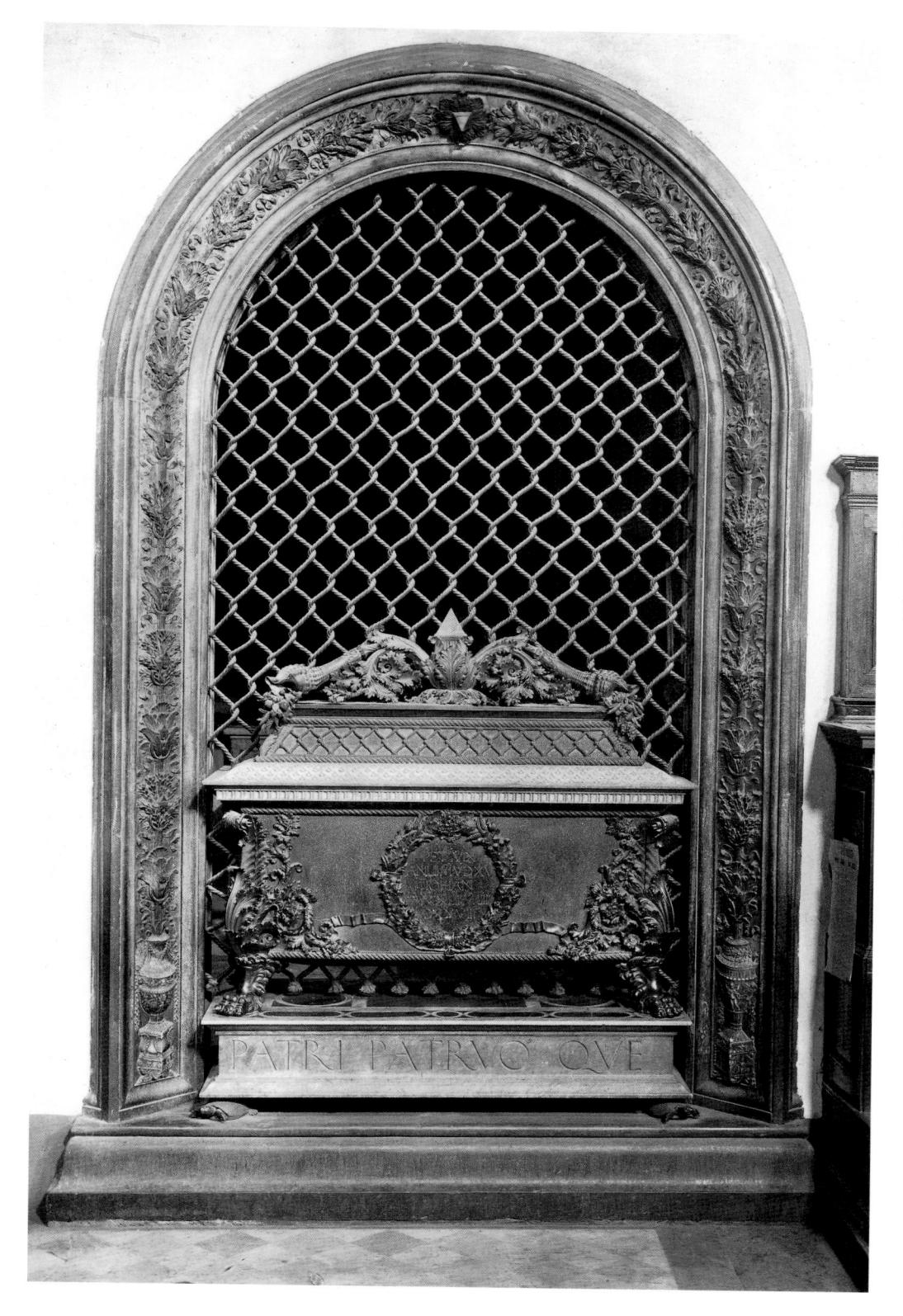

plate 155 Andrea del Verrocchio

The Medici Monument

S. Lorenzo, Florence porphyry and bronze, height of arch 450 cm plate 156 Michelozzo

Tomb Slab of Pope Martin V

St John Lateran, Rome bronze, 286×124 cm

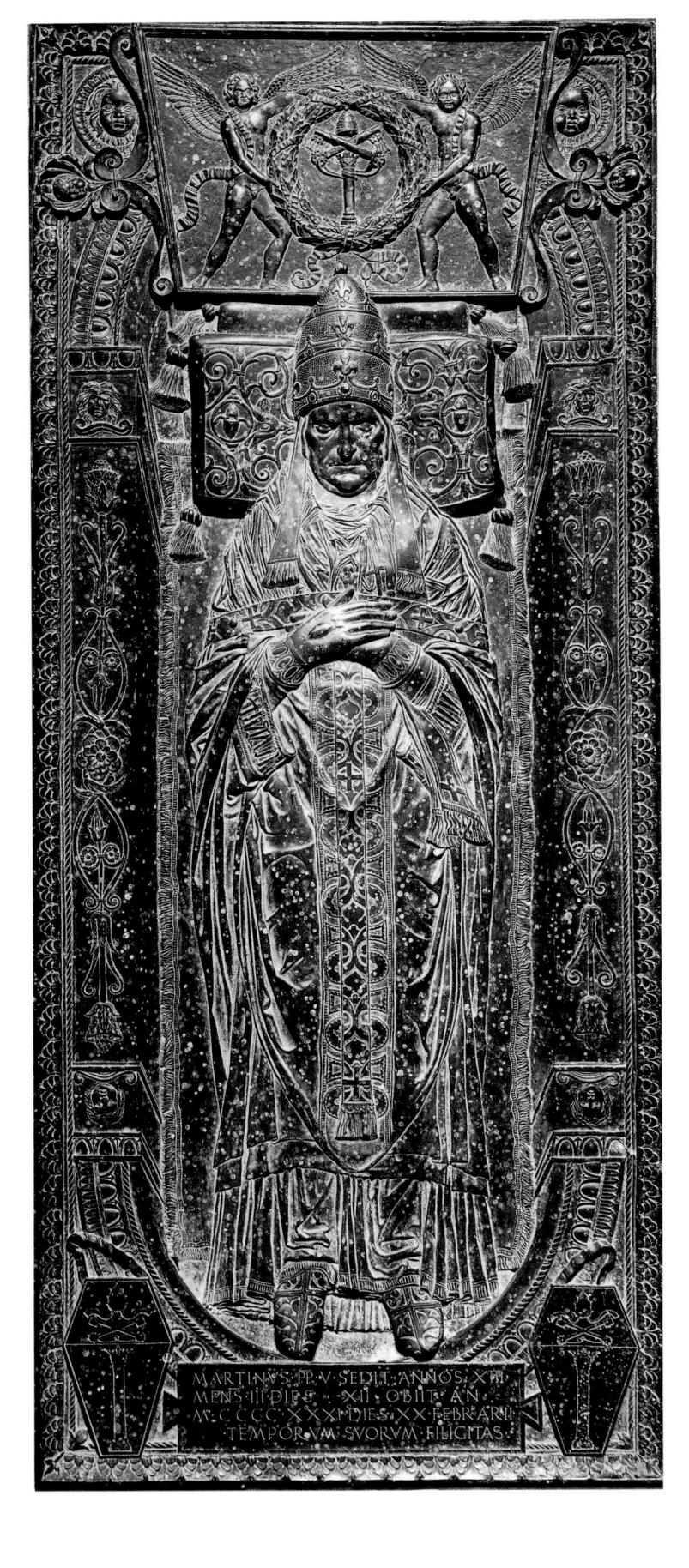

Verrocchio's Medici Monument is the first tomb in Florence after the monument of Pope John XXIII in which bronze plays a substantial part. There was no reason, however, why an entire tomb should not be cast in bronze, and Verrocchio was pre-eminently qualified to carry out just such a monument. Unhappily he never did so, and the first experiments in bronze monumental sculpture were undertaken in Rome by Antonio Pollaiuolo. In 1479, seven years after Verrocchio's Medici Monument had been completed, Pope Sixtus IV issued a bull providing for the building of a funerary chapel in St Peter's. The Pope ordained that he should be buried in the middle of this chapel, and when he died in 1484, his nephew, Giuliano della Rovere, the future Pope Julius II, commissioned Pollaiuolo to carry out a free-standing bronze tomb (plates 157-60).

Throughout the fourteenth and fifteenth centuries one of the commonest types of commemorative monument was a tomb-slab set in the church floor. Occasionally, in the hands of a great sculptor, this was elevated into a work of art. In S. Frediano at Lucca it was stamped with the personal rhythms and rolling drapery of Jacopo della Quercia's mature style; in S. Maria Novella in Florence it took on the flowing silhouette of Ghiberti's tomb-slab of Leonardo Dati; and in Siena Cathedral it embraced the complex space structure of the Pecci tomb-slab of Donatello. On one occasion, and one only, the tomb slab was developed further still, and was raised on a carved marble surround which lent it the status of an

aspirant free-standing monument. The work in question is Michelozzo's tomb-slab of Pope Martin V in St John Lateran (plate 156), and it was this, the only early Renaissance papal tomb in bronze, that served as a point of departure for the Sixtus IV Monument (plate 157).

Antonio Pollaiuolo seems to have been a few years older than Verrocchio. He was 22 or 23 when Donatello returned from Padua to Florence, and was influenced in a decisive fashion by Donatello's late bronze sculptures, above all by his bronze reliefs. The great mountain of bronze that he produced in Rome consisted of a kind of tomb-slab, with a raised effigy, and of a chamfered platform, with 10 reliefs of the Arts and Sciences divided from each other by great curling consoles that tethered the tomb to a green porphyry step beneath. There can be little doubt that Pollaiuolo, before modelling his effigy of Pope Sixtus IV, had looked intently at the Martin V slab and at Donatello's effigy of Pope John XXIII (plate 132). The effigy of Pope John XXIII, however, represented a relatively early phase in the development of Donatello's bronze technique, and if he had produced a bronze effigy during the last decade of his life, it would have been marked by rougher handling and still more uncompromising realism. In the strongly naturalistic head of Pope Sixtus IV and in the broken planes of the Pope's vestments is implicit a close knowledge of the work of Donatello's final phase.

As a sculptor Antonio Pollaiuolo is a less commanding figure than Verrocchio. No large plate 157 Antonio del Pollaiuolo

Tomb of Pope Sixtus IV

Sagrestia dei Beneficiati, St Peter's, Rome

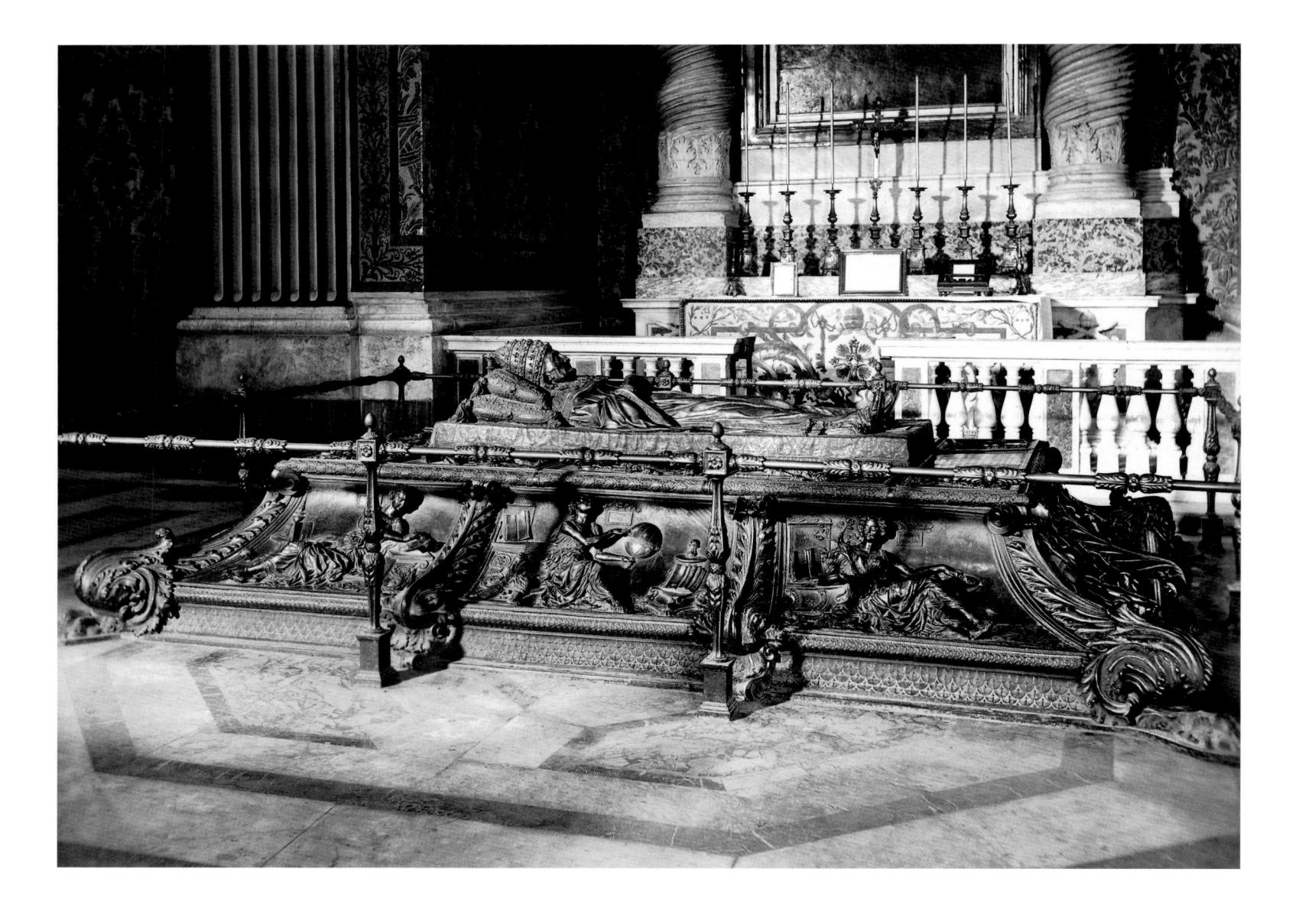

plate 158 Antonio del Pollaiuolo

Rhetoric

Sagrestia dei Beneficiati, St Peter's, Rome (detail of plate 157)

plate 159 Antonio del Pollaiuolo

Arithmetic

Sagrestia dei Beneficiati, St Peter's, Rome (detail of plate 157)

free-standing sculpture by him survives, and in the works we have there is nothing to suggest that he was capable of creating closely meditated, selfconsistent statues like Verrocchio's Christ and St Thomas group (plate 125). Nurtured on the study of classical reliefs, he was temperamentally a relief artist. When, therefore, he was called upon to design the Sixtus IV Monument, he avoided the challenge of the statue or statuette, and planned it as an aggregation of bronze reliefs. The reliefs fall into two groups, the Virtues beside the effigy and the Liberal Arts set round the base. The Virtues are based on a set of paintings that Antonio and his brother Piero had painted for the Mercatanzia in Florence. The Liberal Arts, on the other hand, are original designs, and it is on them that emphasis must rest. The Sixtus IV Monument was based on a scholastic Aristotelian programme, which reflected the interests of the Pope. Music apart, each of the Liberal Arts has a book with an inscription, and very heterogeneous the sources of these inscriptions are - Aristotle, Euclid, the Centiloquium of Ptolemy, and Peckham's Perspectiva communis are among them. There is something almost incongruous in the unity that they acquired at Pollaiuolo's hands; it is as though Giuliano della Rovere were determined to conceal his uncle's medieval mind in a decent Renaissance dress. To the neoclassical taste of Winckelmann the imagery of this monument seemed 'etwas lächerlich', but there is nothing risible in these designs, for Pollaiuolo had a genius for rendering the human figure and for the medium of bronze, and his reliefs

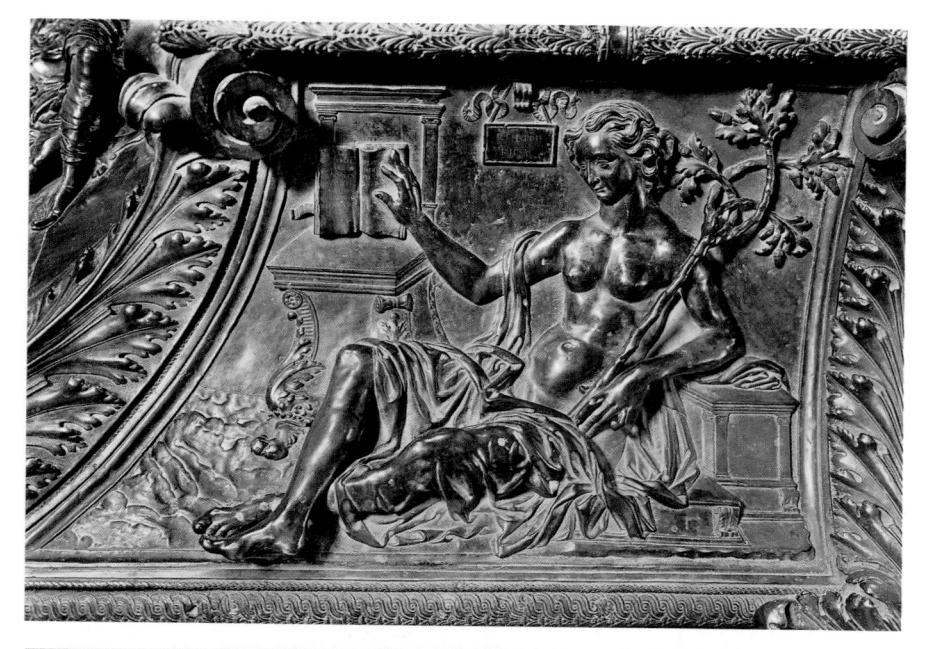

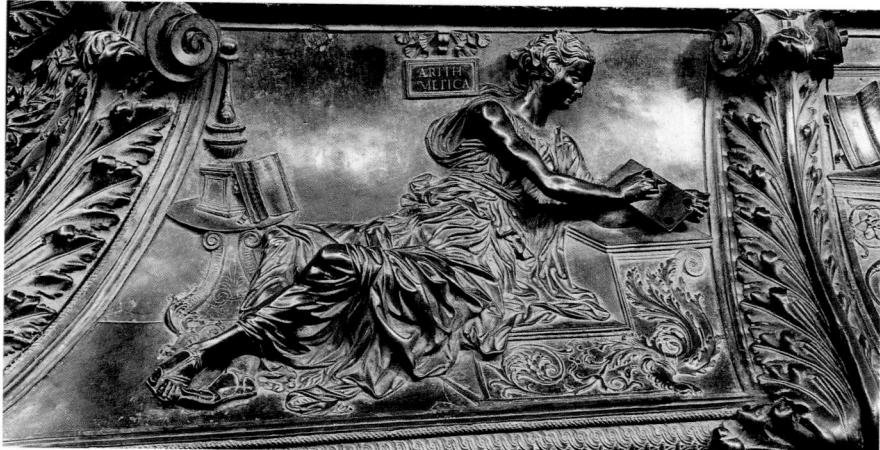

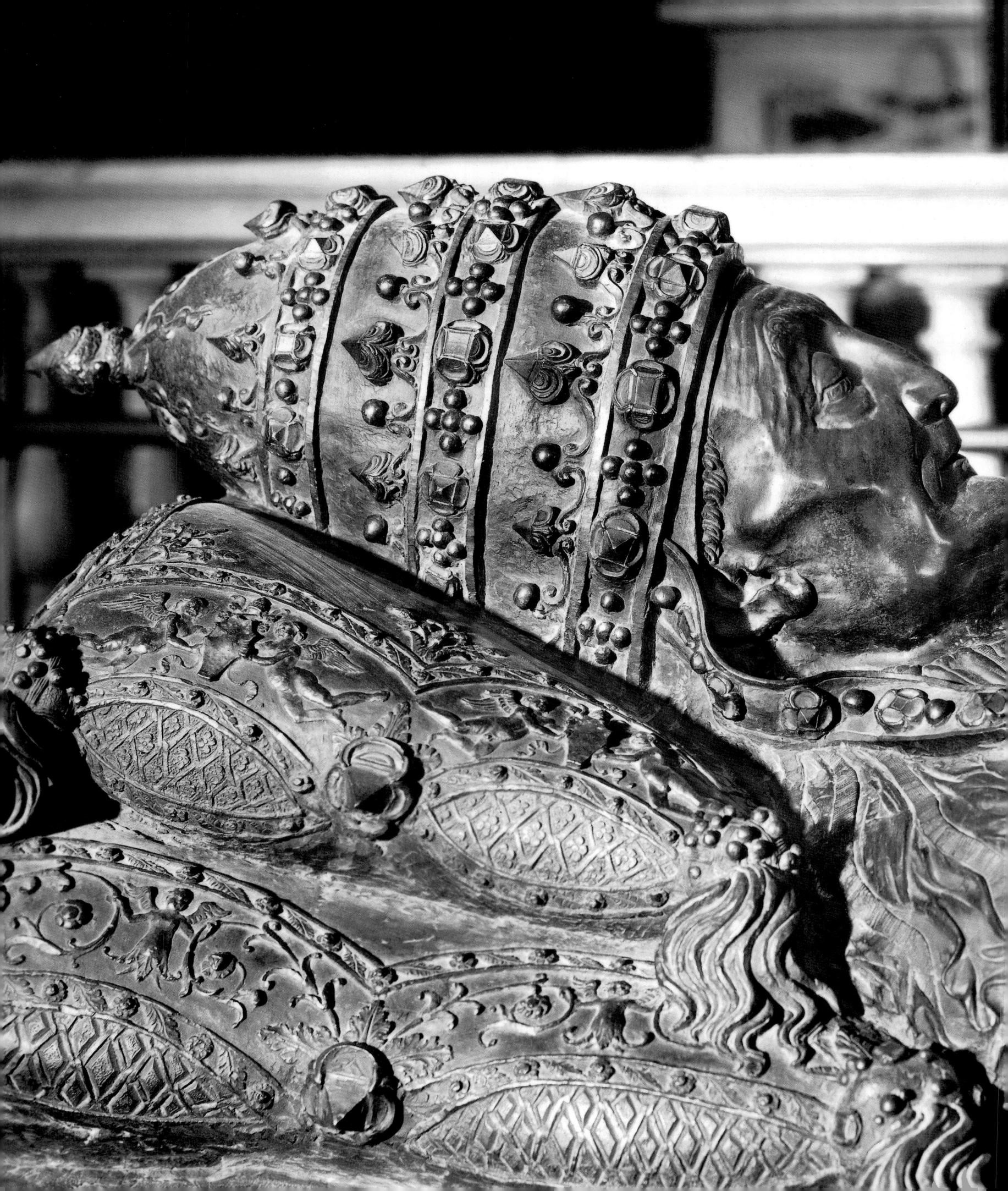

plate 160 Antonio del Pollaiuolo

Head of Pope Sixtus IV

Sagrestia dei Beneficiati, St Peter's, Rome (detail of plate 157)

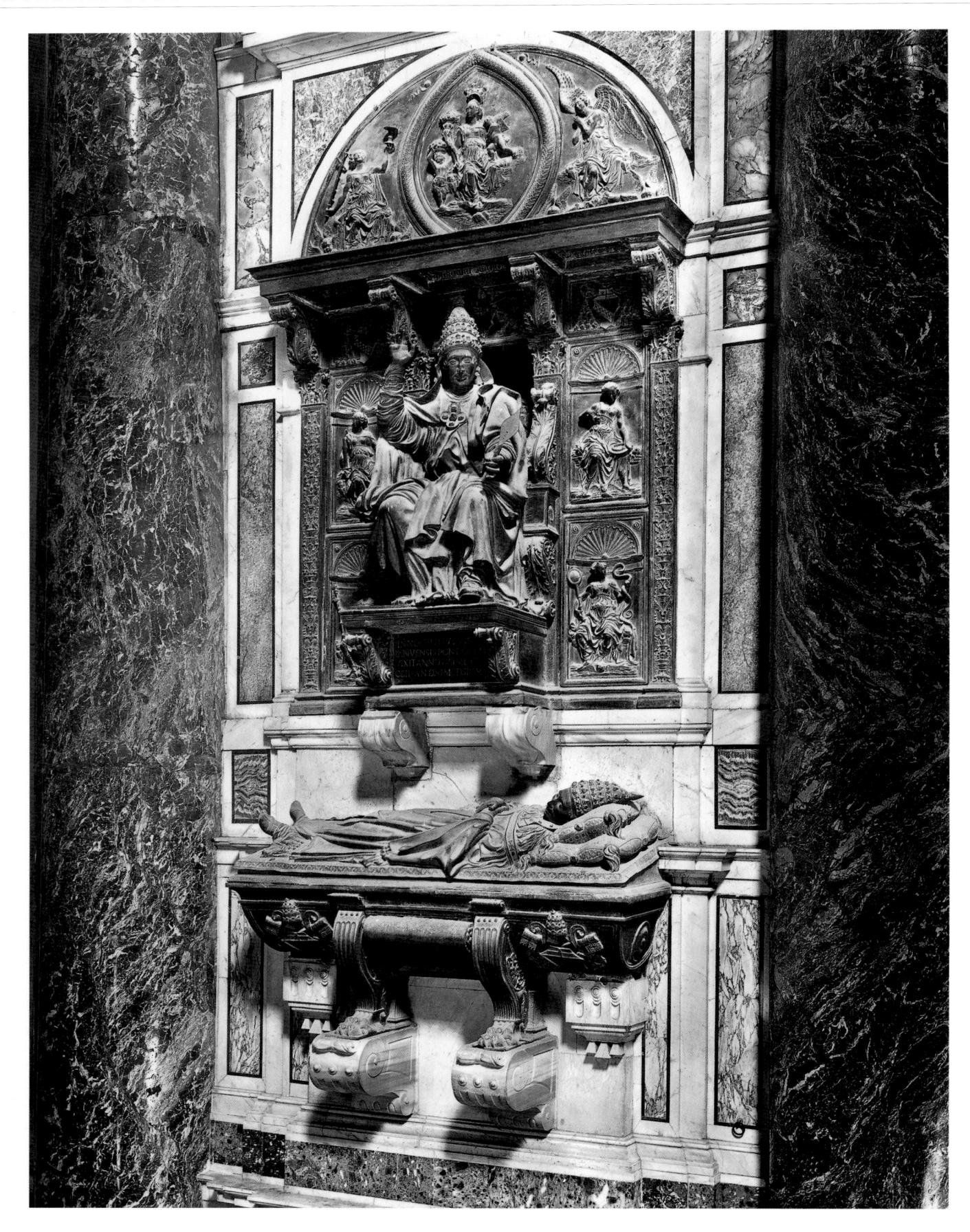

reach great heights of artistry. When we compare the Rhetoric (plate 158) with the Hadrianic coin from which it was evolved, it becomes clear why Pollaiuolo ranks as a great artist. In the Arithmetic (plate 159) the posture he adopted was more elaborate still; one leg is extended and the head turned away, and the resulting pose has something of the character of a sixteenth-century supporting tomb figure, a tiny foretaste of Guglielmo della Porta.

The tomb of Sixtus IV was finished in 1493, but a year before it was installed his successor, Innocent VIII, died, and Pollaiuolo was commissioned to produce a second papal monument (plates 161-63). The tomb of Innocent VIII was a wall monument, set in an arch between richly carved pilasters resting on supports carved with the Pope's arms. The interior once more was bronze, with a lunette at the top and the sarcophagus and sepulchral effigy beneath, and on a lower level four reliefs of Virtues and a platform with a seated figure of the Pope. What is original in the conception is the seated Pope in benediction holding the relic of the Holy Lance. There had been life statues of Popes before, but never previously had the life image coalesced with the sepulchral monument. For that reason Pollaiuolo's monument is a turning point in the history of the tomb; before it was dismantled in 1606 it inspired Guglielmo della Porta's monument of Pope Paul III, and after it was reinstalled in 1621, in a wrong form which reflected the preconceptions of the time, it kindled the imaginations of Algardi and Bernini.

Under Innocent VIII's successor, Pope

plate 161 *(opposite)* Antonio del Pollaiuolo

Tomb of Pope Innocent VIII

St Peter's, Rome

plate 162

Drawing after the Tomb of Pope Innocent VIII

Kupferstichkabinett, Berlin

Alexander VI, there came to Rome in a secondary capacity a young Florentine bronze sculptor, Pietro Torrigiano, who had worked in Florence at the Medici Academy as a pupil of Bertoldo. Alone of his contemporaries Torrigiano read the lesson of Pollaiuolo's monuments. So lively was his memory of the intellectual ferment that had thrown up these tombs, and so enduring his impression of the potentialities which they revealed, that when. fifteen years later, he was commissioned to undertake in London the tombs of Lady Margaret Beaufort and of King Henry VII and Elizabeth of York (plates 164, 165), his point of departure was Pollaiuolo's Sixtus IV Monument. In their incongruous setting, beneath late Gothic vaulting and inside Gothic grilles, these splendid tombs, with their sharply characterized effigies and sumptuous ornament, form the northernmost bridgehead of Florentine Renaissance art.

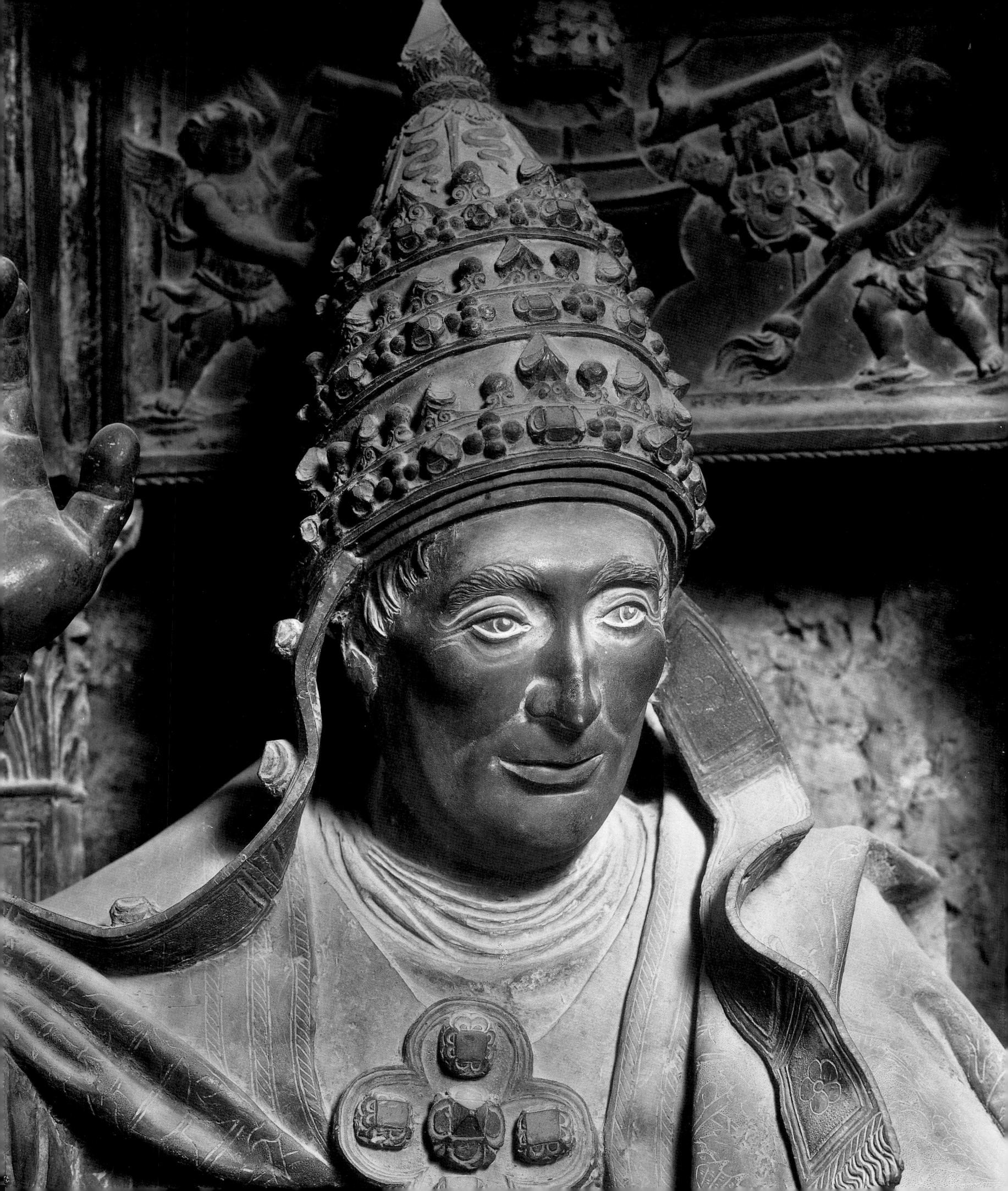
plate 163 (opposite) Antonio del Pollaiuolo

Head of Pope Innocent VIII

St Peter's, Rome (detail of plate 161)

plate 164 Pietro Torrigiano

The Monument of King Henry VII and Elizabeth of York

Westminster Abbey, London gilt bronze, length 274 cm

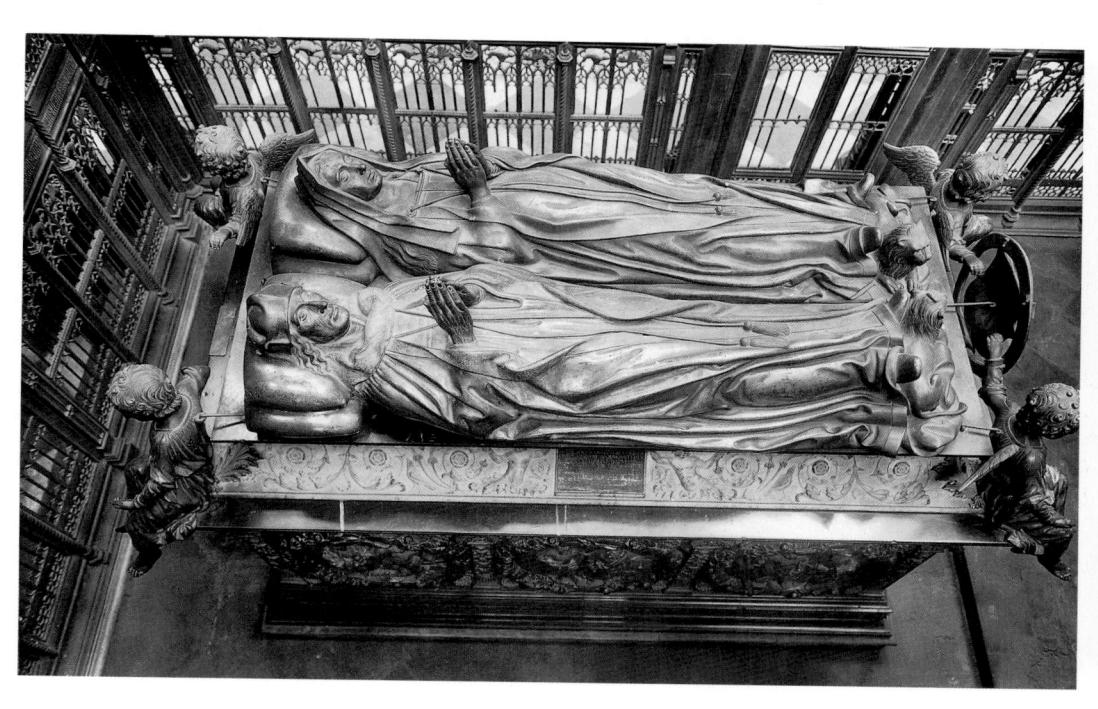

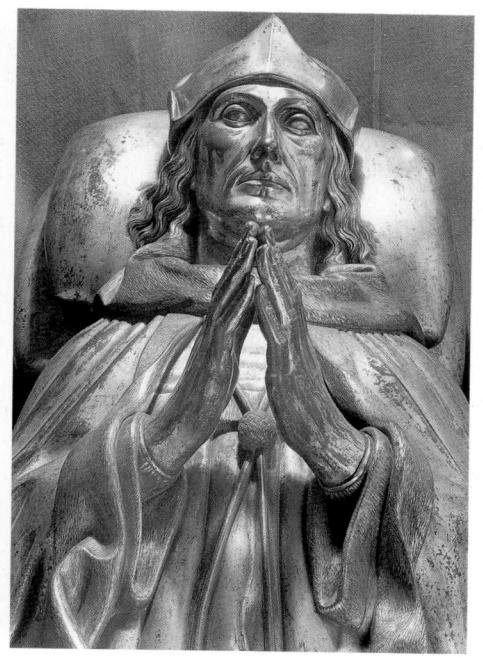

plate 165 Pietro Torrigiano

Effigy of King Henry VII

Westminster Abbey, London (detail of plate 164)

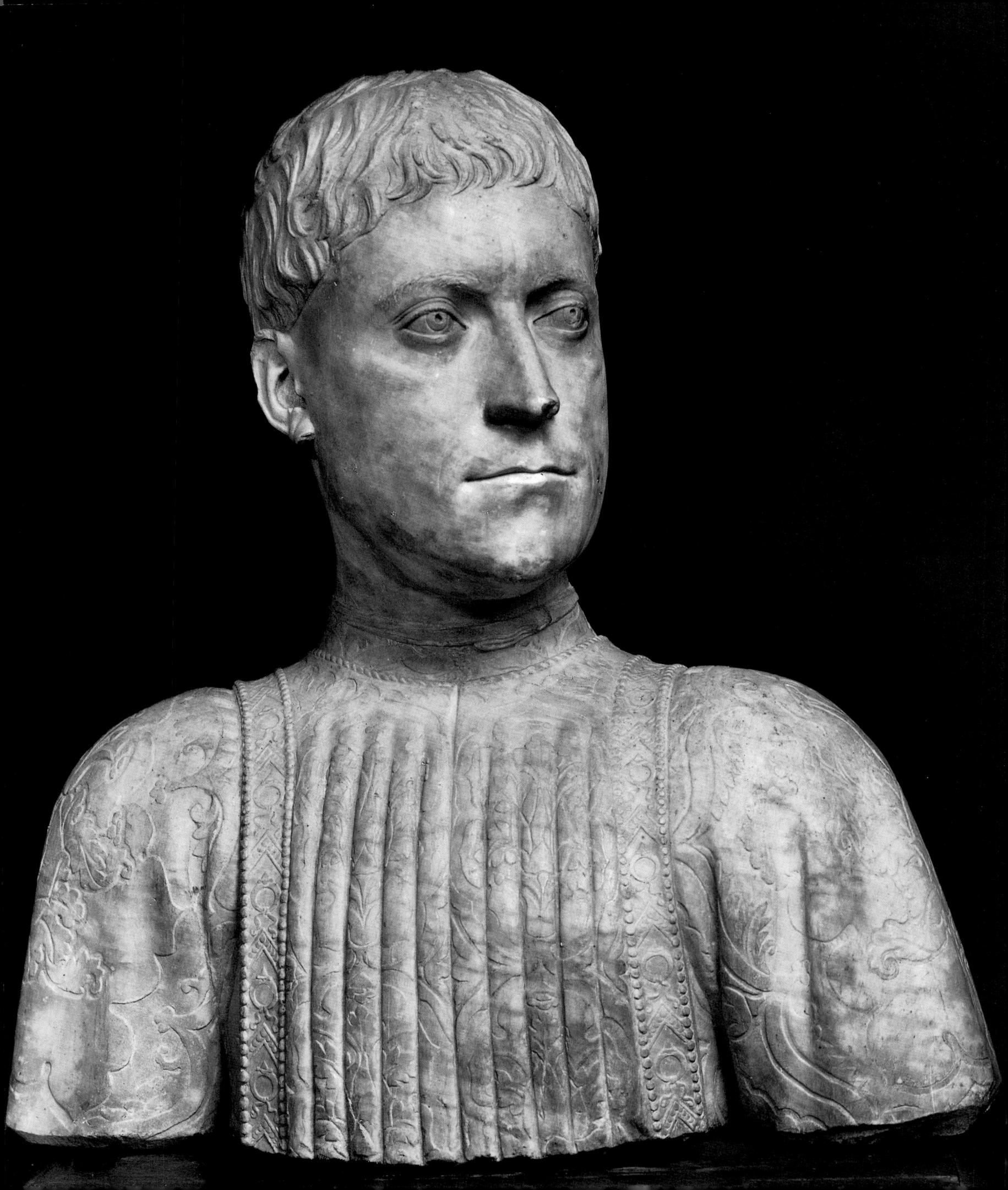

THEN WE ENCOUNTER portrait busts today, we take for granted the fact of sculptured portraiture. Not so the early humanists, who looked back across aeons of emblematic portraiture to a remote age when sculptors had been capable of rendering in marble the lineaments of a specific human face. Sculptured portraits appeared on tombs and monuments, but from these only one inference was possible, that the gulf between the simulacrum and reality was too wide to span. When in 1421 a figure of Pope Martin V was carved for Milan Cathedral (Vol. I, plate 131), the head was treated, with the laborious literalism of late Gothic art, as an accretion of naturalistic detail, and somewhat the same path was followed by Ghiberti, with greater genius and restraint, when modelling the selfportrait on the first of his bronze doors.

As the fifteenth century advanced, the urge towards portraiture increased, and in Florence it became (if Vasari is to be believed) a normal practice among progressive artists to enhance the lifelikeness of figures by giving them the features of individuals. Masaccio, for example, painted in the church of the Carmine a figure of St Paul which was supposed to represent a certain Bartolo di Angiolino Angiolini, and his lost fresco of the Consecration of the Carmine included portraits of Niccolò da Uzzano, Bartolommeo Valori, Lorenzo Ridolfi and other notabilities. In the sixteenth century the heads of Donatello's statues on the Campanile were also looked upon as portraits of Francesco Soderini and Giovanni Chierichini and other figures of the time (plates

14, 15. How far these were really portraits of living persons we shall never know, but it is evident that Donatello could not have carved them had he not been familiar with Roman portrait busts. Perhaps the clearest instance of the function of the Roman bust as a catalyst of contemporary portraiture occurs in what is an indubitable portrait, though couched in a style based on the antique – the self-portrait of Ghiberti on the second bronze door.

There was testimony and to spare of the character of this peculiarly Roman art. In the first place there were the busts themselves, the face sculptures that confront us in so many museums today. And in the second place there were literary accounts of Roman portraiture - Pliny, for instance, lamenting that in his day the sideboards of rich Romans were no longer covered with wax masks. Pliny it was, too, who handed down the name of Lysistratus of Sicyon, 'the first person who modelled a likeness in plaster of a human being from the living face itself, and established the method of pouring wax into this plaster mould, and then making the final corrections on the wax cast', the inventor in short of the life mask. Logically the reanimator of the portrait bust should have been Donatello, and so long as a painted terracotta bust in the Bargello was looked on as a head of Niccolò da Uzzano and ascribed to Donatello, it seemed that this was really so. But there is no proof that Donatello practised portrait sculpture, and the earliest surviving Renaissance portrait bust is by an artist of very different tendencies and calibre. The sculptor is Mino da Fiesole, the sitter is Piero de' Medici, and the date is 1453.

plate 166 Mino da Fiesole

Piero de' Medici

Museo Nazionale, Florence marble, 50 × 48 cm

Mino's bust of Piero de' Medici (plate 166) is important for what it aspires to be rather than for what it is. What it aspires to be is a repristinated Roman bust. Its most classical feature is the head, which suggests that Mino had been looking hard, too hard perhaps, at classical originals, though more of the arms is shown than was customary in Roman portraits and the rendering of the sleeve and surcoat is startlingly unclassical. By comparison with Roman sculptors, Mino was handicapped by a defective grasp of form, and we find the heavy jaw of Piero de' Medici reproduced in other busts, even in what is by far the finest of Mino's portraits, the Niccolò Strozzi in Berlin (plate 167). In the fifteenth century one of the provoking things about the Roman bust must have been its anonymity. Here were the features of an individual perpetuated by an artist, but what individual and by whom? Probably for this reason most male portrait busts in the fifteenth century are inscribed beneath, on a classical cartellino, with the name of the sitter, the name of the artist and the date. This is the case with the Niccolò Strozzi, which was carved by Mino in Rome in 1454. In Rome Mino must have extended his experience of antique portrait sculpture, and this led him on to experiment with busts like the beautiful Diotisalvi Neroni in the Louvre, in which the sitter is dressed in a kind of toga, and the Giovanni de' Medici in the Bargello, where classical armour is substituted for contemporary dress. It taught him, too, to individualize the features in such a way that certain of his later busts, like the finely conceived Astorgio Manfredi in Washington, offer a real challenge to

antiquity. But the possibilities of this type of free, classicizing portraiture were limited, and Mino in effect exhausted them.

At the very time when Mino was engaged in Naples in carving the Manfredi bust, a step taken in Florence changed the whole character of the sculptured portrait. This was the reintroduction of the classical life cast. In one sense the life cast was only an extension of the death mask, and in sculpture, above all in sepulchral monuments, the death mask had long had a major role to play. How much importance attached to verisimilitude in posthumous portraiture we know from the case of the Cardinal of Portugal, whose effigy in S. Miniato al Monte was carved by Antonio Rossellino from a death mask and from a cast of the Cardinal's hands (plate 146). The death mask even gave rise to a bastard form of sculpture, in which a cast from the mask was superimposed on a terracotta bust. These busts form an exact equivalent of the wax masks described by Pliny, and serve only to remind us how dead death masks look.

The life mask, on the other hand, was an aesthetic device, which resulted from a new conception of the purpose of the portrait bust. It was a manifestation of humanist art, and forms a corollary to the humanist sepulchral monument. When the physician Giovanni Chellini died in 1463, his tomb at S. Miniato al Tedesco was constructed by Bernardo Rossellino, and for the effigy, with its sunken face and pendulous fold of skin beneath the chin, a death mask was certainly employed. But Chellini has the singular distinction

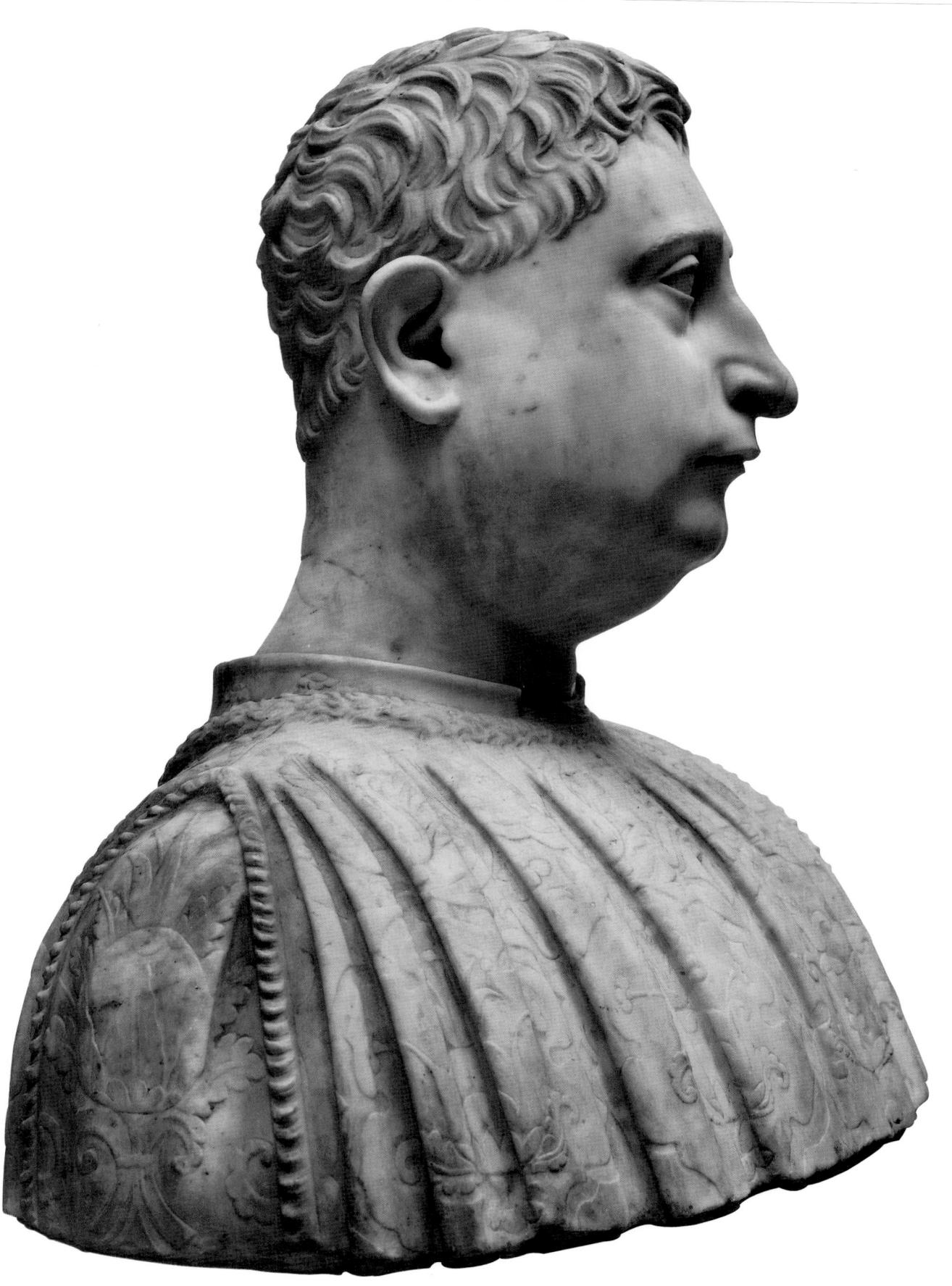

plate 167 Mino da Fiesole

Niccolò Strozzi

Staatliche Museen, Berlin-Dahlem marble, height 49 cm plate 168 Antonio Rossellino

Giovanni Chellini

Victoria and Albert Museum, London marble, height 51 cm

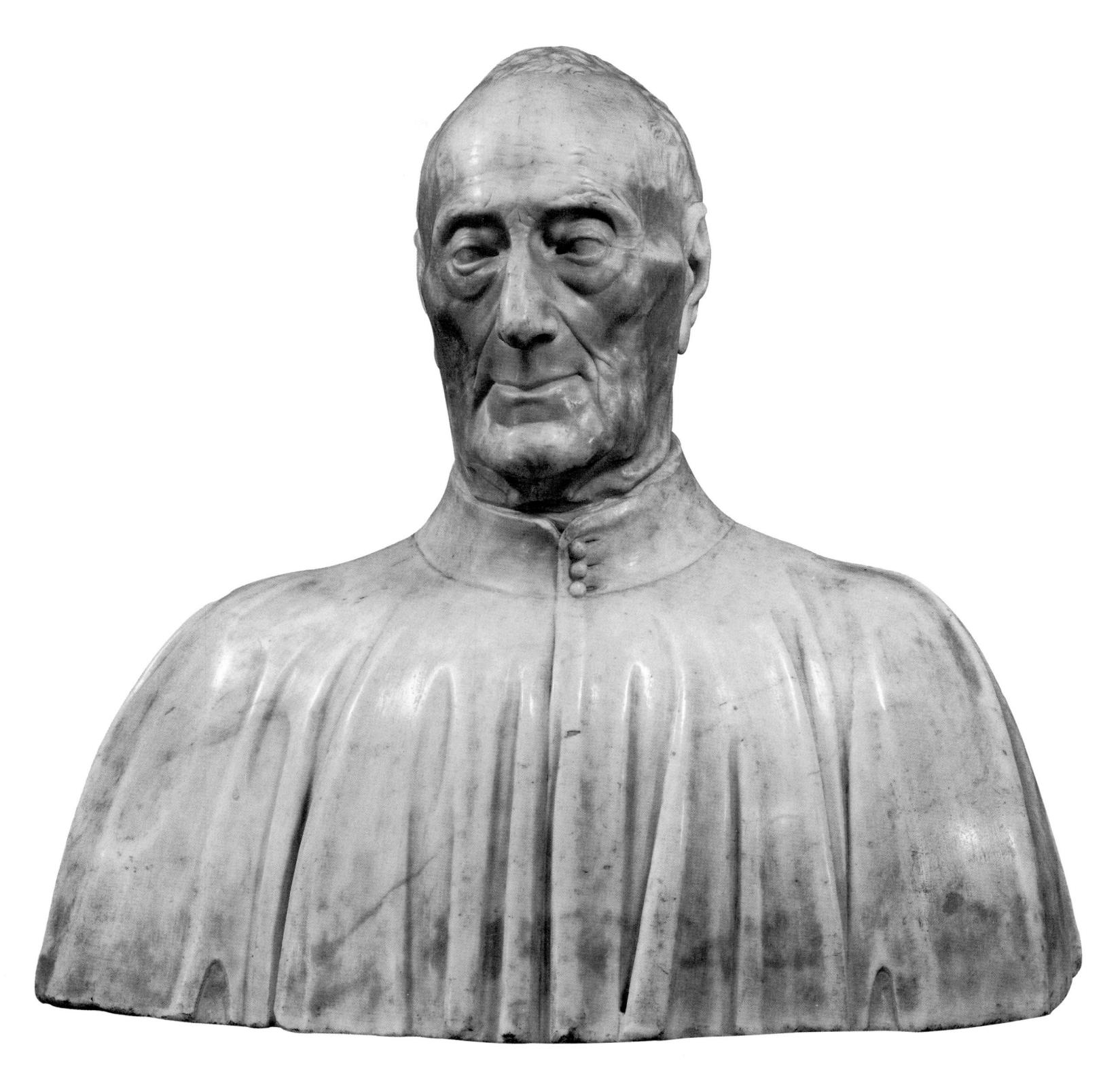

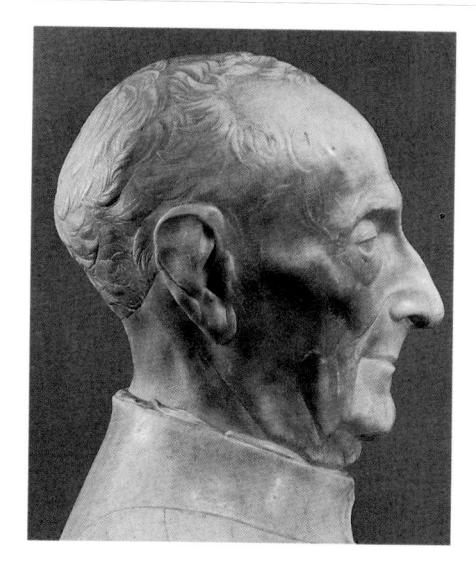

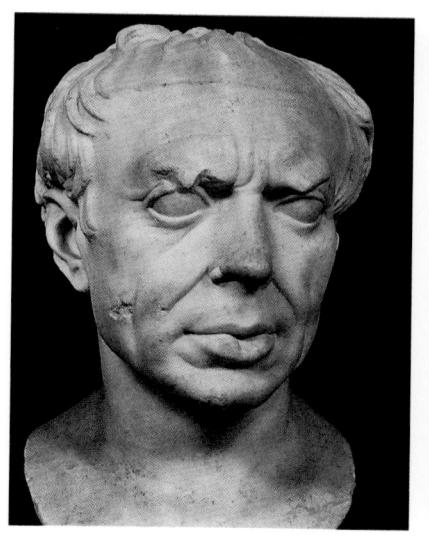

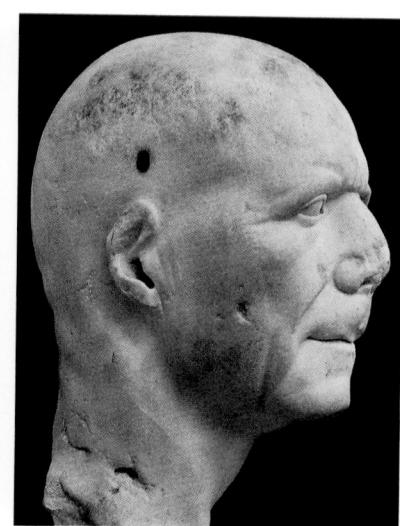

of being the only subject in the entire fifteenth century whose features are also recorded in a bust made from a life cast. The bust (plates 168, 169), which is now in London, was carved by Antonio Rossellino in 1456. We know that it was made from a life cast, because the features are rendered in great detail and the ears are shown pressed back against the head, precisely as they would have been in a wax or gesso mask. By contrast with the busts of Mino da Fiesole, this shows an extraordinary concern with the surface texture of the face. The veins on the temple, the furrows on the forehead, the wrinkles at the corners of the eyes, all are rendered with marvellous exactitude. Rossellino seems to have had a preference for a blotchy brownish marble, which he used for the St Sebastian at Empoli (plate 119), and he employs it again in the Chellini bust, so subtly that the brown stains accentuate the parchment-like texture of the skin. Rossellino must have had in mind Roman busts of the type of a head in the Museo delle Terme (plate 171), but his technique was infinitely more refined. Certainly the humorous eyes and benign, rather cynical smile of the Chellini bust argue a richer and more penetrating sense of character than any implied in the marble snapshots of classical Rome.

Paradoxically, therefore, with the introduction of the life mask there obtrudes into the portrait bust for the first time an interpretative element. Rossellino's aim was to supply not merely a topographical survey, a relief map of his sitter's features, but an image of the whole man: a record, but a record transcendentalized. With the Chellini

bust Renaissance portraiture acquires a third dimension, a new weight and thoughtfulness, and we are face to face for the first time with a portrait from which, had we no written evidence, the Renaissance attitude to human personality might be deduced. In the whole fifteenth century there is no theoretical discussion of the problems of sculptured portraiture, and when we infer that a coherent body of theory stands behind this type of portrait, we are logically on weak ground. Alberti, in his treatise on sculpture, the De statua, talks of the differences between one human being and the next. For Alberti the aim of sculpture was verisimilitude, and since human beings differed from one another, it followed that the sculptor must aim at representing a specific man. No matter if its subject was Socrates or Plato or anybody else, the statue, declares Alberti, must portray an individual; it must provide an image not of man in general but of a man, be he utterly unknown. Alberti, when he wrote these words, was speaking of statuary, but they have an oblique relevance to portrait sculpture too, and fortify the probability that some form of theory underpins the portrait bust. Just as the change in the character of fourth-century Greek portraiture is ascribable to what has been called 'the invention of the soul as a psychological fact', so here we seem to sense the current of thought which culminates thirty years later in Pico della Mirandola's De hominis dignitate.

The Chellini bust does not consist simply of a head, but shows the body as well, and the body organized in rather a peculiar way. The arms, as in

plate 169 Antonio Rossellino

Giovanni Chellini

Victoria and Albert Museum, London (profile of plate 168)

plate 170 Roman, 1st century BC

Male Portrait Bust

Museo Vaticano, Rome

plate 171 Roman, 1st century BC

Male Portrait Bust

Museo delle Terme, Rome plates 172,173 (top) Antonio Rossellino

Matteo Palmieri

Museo Nazionale, Florence marble, height 60 cm (front and profile views)

plate 174 *(below)* Desiderio da Settignano

Bust of a Child

National Gallery of Art, Washington marble, height 28 cm

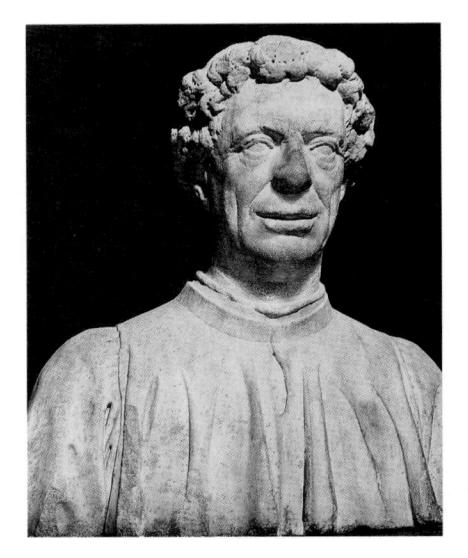

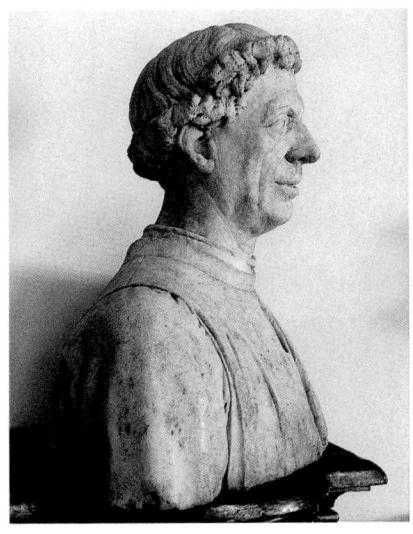

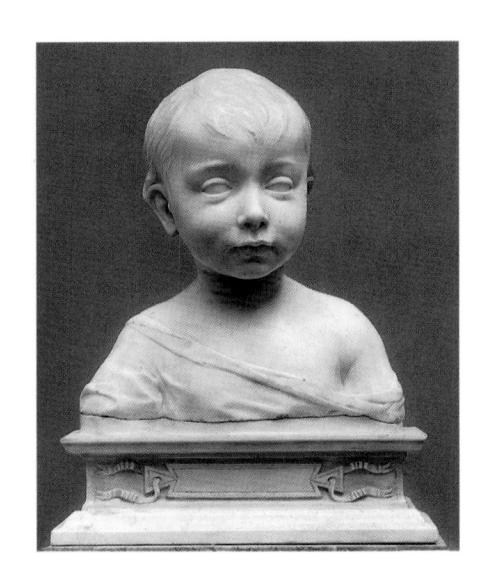

Mino's Niccolò Strozzi, are cut off slightly above the elbows, and the weight of the two shoulders is balanced on a centre marked down the back and front. The presence of this central line establishes that the head is turned a little to the right. All of the great Florentine portrait busts are organized in this fashion, and to this their aesthetic coherence is in large part due. Had Alberti discussed portraiture in the *De statua*, we can imagine that he might have advocated a procedure of this kind.

This procedure appears again in the only other fully authenticated portrait bust by Rossellino, that of the statesman and poet Matteo Palmieri in the Bargello (plates 172, 173). Like Bruni and Marsuppini, Palmieri was a distinguished Latinist, and his bust was assimilated to a Latin portrait type (plate 171). Carved in 1468, it was displayed till the early nineteenth century over the doorway of his house in Florence, remaining there indeed until its surface had vanished and its detail was effaced. In its present weathered state it might suggest that Antonio Rossellino became the Rembrandt of sculptured portraiture. But the large formal relationships through which its effect is made today would originally have been less evident, and the hair, which is now remarkable for its plasticity, is drilled like the hair of the two Angels on the Monument of the Cardinal of Portugal, and must have been finished in rather the same way. The Palmieri bust is seen in its truest perspective if it is regarded as a middle term between the bust of Chellini and the next of the great Florentine male portrait sculptures, the bust of Pietro Mellini by Benedetto da Maiano (plates 176, 177). The

Mellini bust was carved six years later, in 1474. Benedetto, like his contemporary and associate Domenico Ghirlandaio, belonged to a generation for whom the practical problems of artistic production had been in large part solved. On a technical plane he was one of the most accomplished marble sculptors of the quattrocento, but his work lacks the adventurousness and empiricism which stamps the sculpture of the middle of the century. An artist of great fastidiousness, Benedetto da Maiano in the Mellini bust devotes the same attention to the dress as to the head. Its main fascination, however, rests in the handling of the features; the apprehension of their basic form is less firm than it had been with Rossellino, but the surface, covered with a pattern of little runnels that recalls the flattened reliefs of Donatello and Desiderio da Settignano, is treated with consummate mastery, and is inspired by a wealth of human feeling and a rich compassion which lift it to the front rank of portraiture. Benedetto da Maiano's portrait style was taken over by his associate Ghirlandaio in a celebrated painting in the Louvre, but we have only to contrast the Mellini bust with Ghirlandaio's rather desiccated painting to realize the greater richness and far greater sophistication of portrait sculpture.

The only other bust signed by Benedetto da Maiano represents Filippo Strozzi (plate 175). This is the sole Renaissance portrait bust for which a model survives. The terracotta model is in Berlin; it represents an ageing man with head held forwards and turned slightly to the right, and eyes half closed and gazing down. In the marble all this

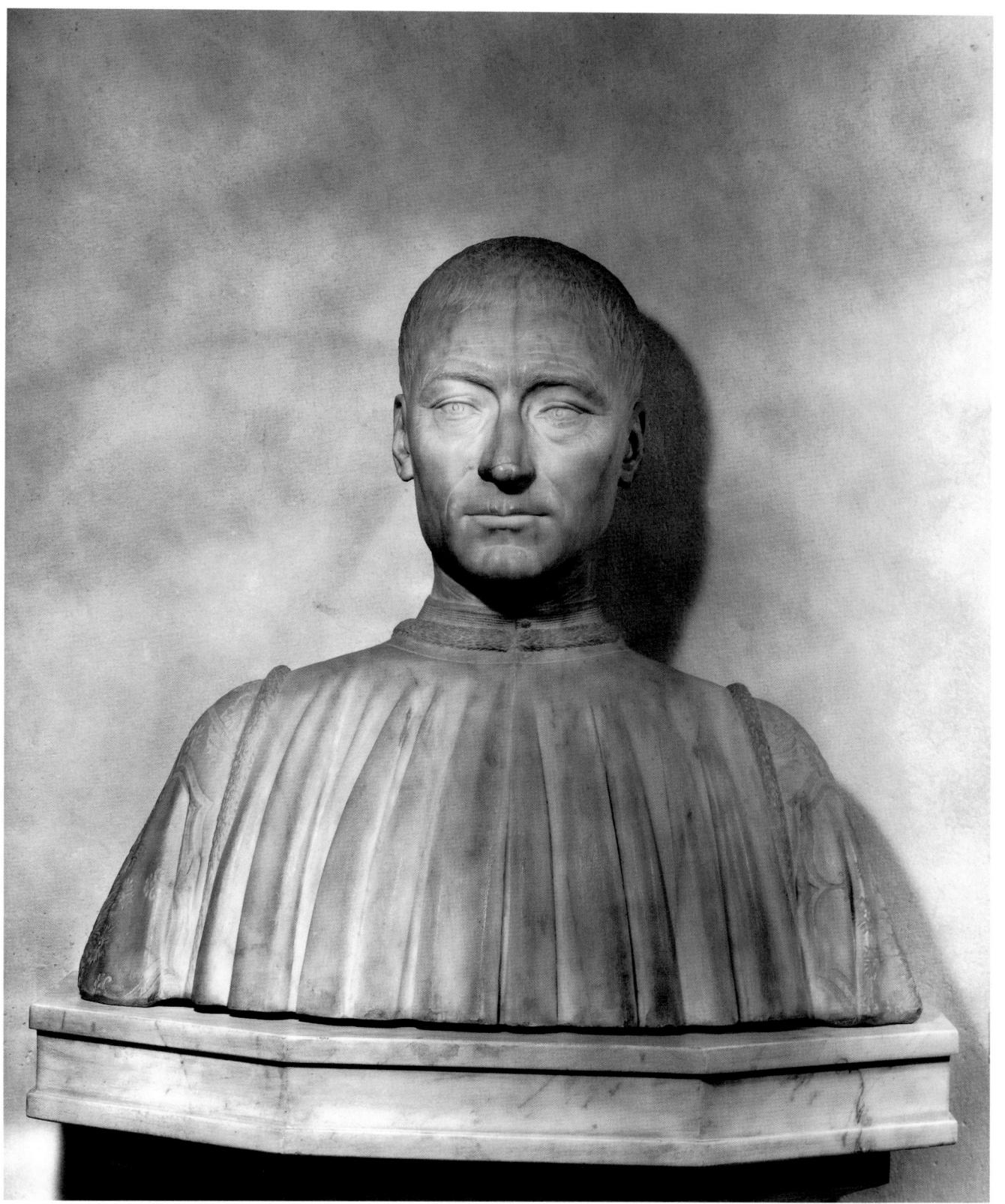

plate 175 Benedetto da Maiano

Filippo Strozzi

Louvre, Paris marble, height 52 cm

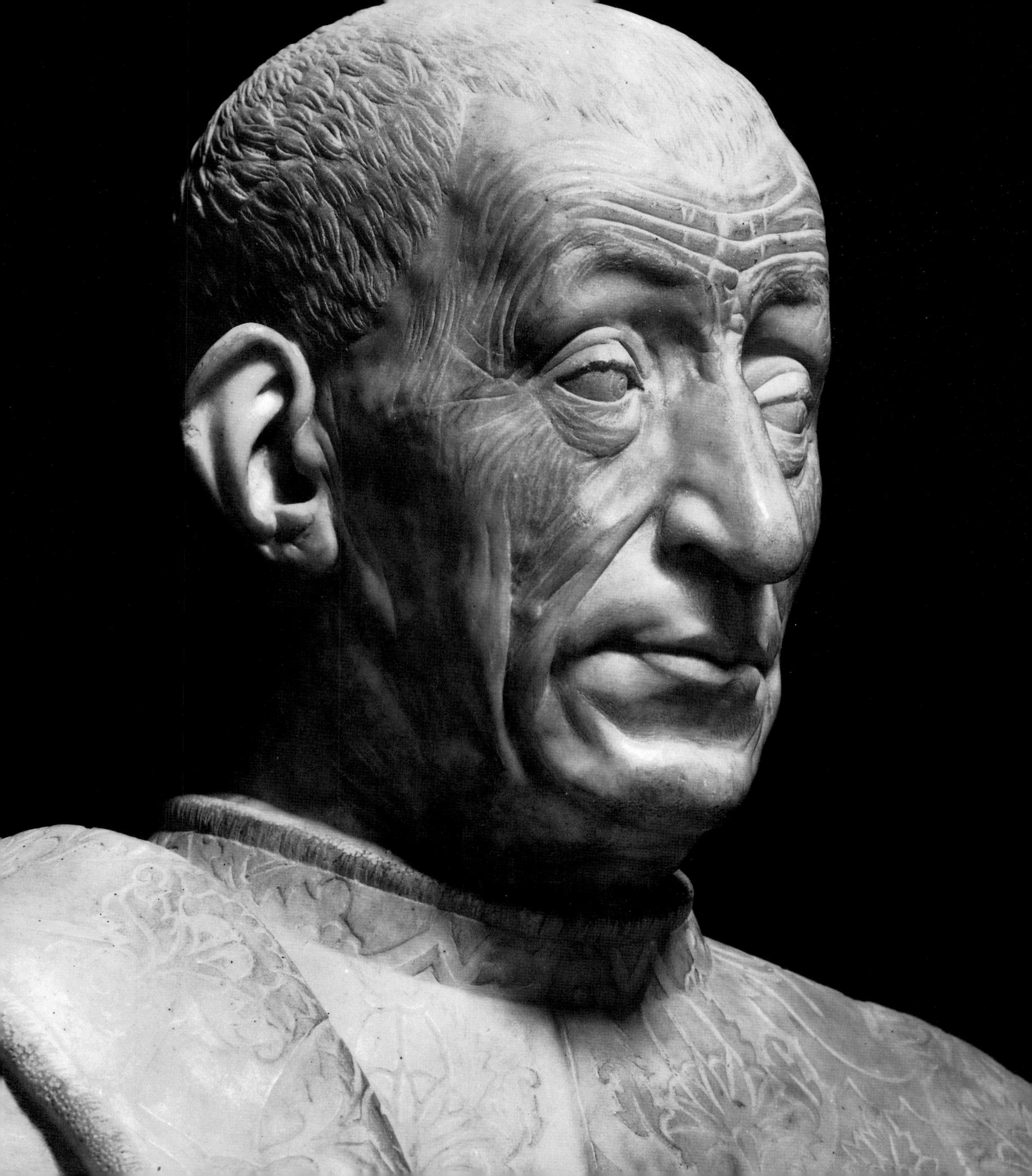

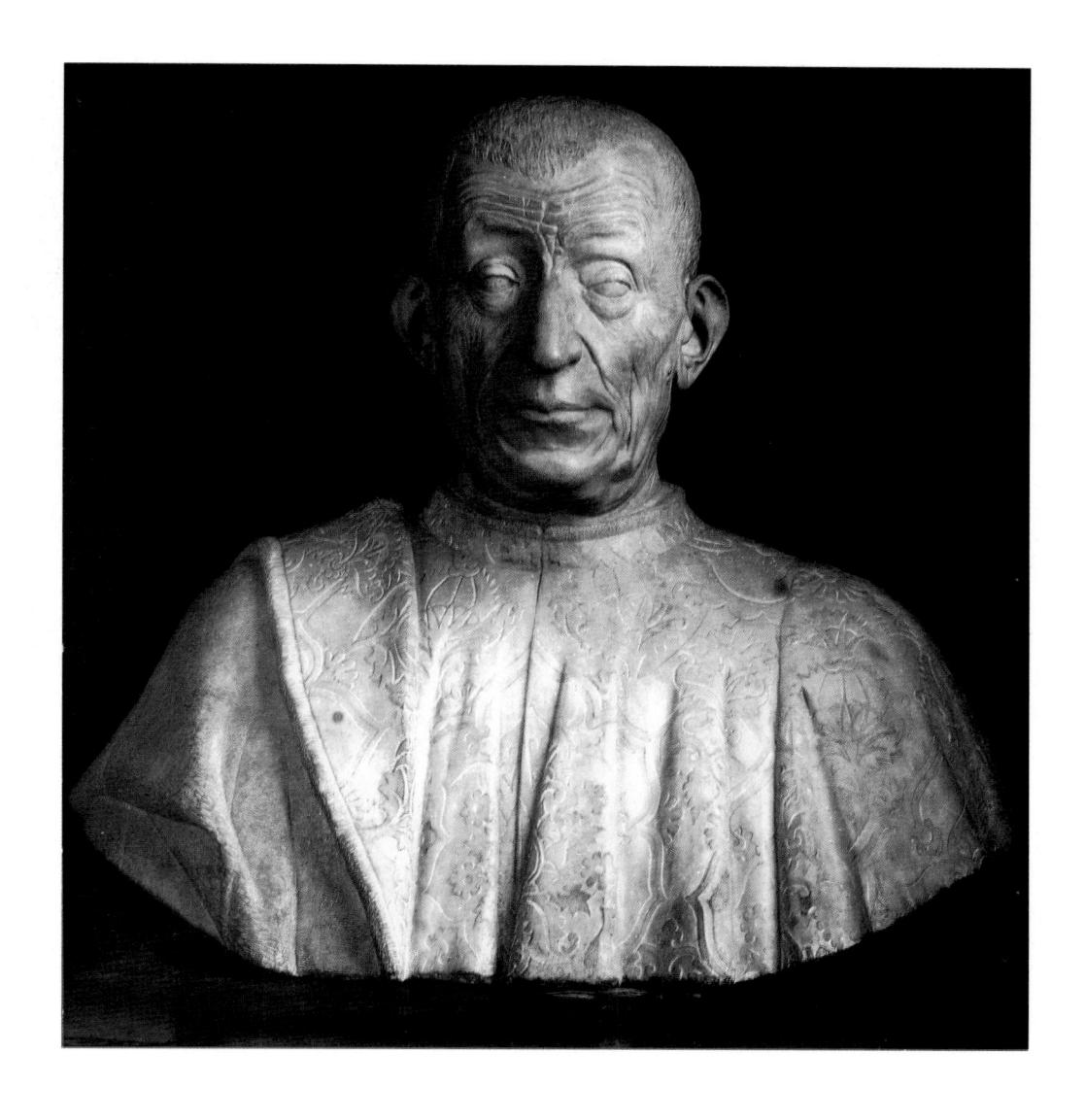

plate 176 (opposite) Benedetto da Maiano

Pietro Mellini

Museo Nazionale, Florence (detail of plate 177)

plate 177 Benedetto da Maiano

Pietro Mellini

Museo Nazionale, Florence marble, height 53 cm

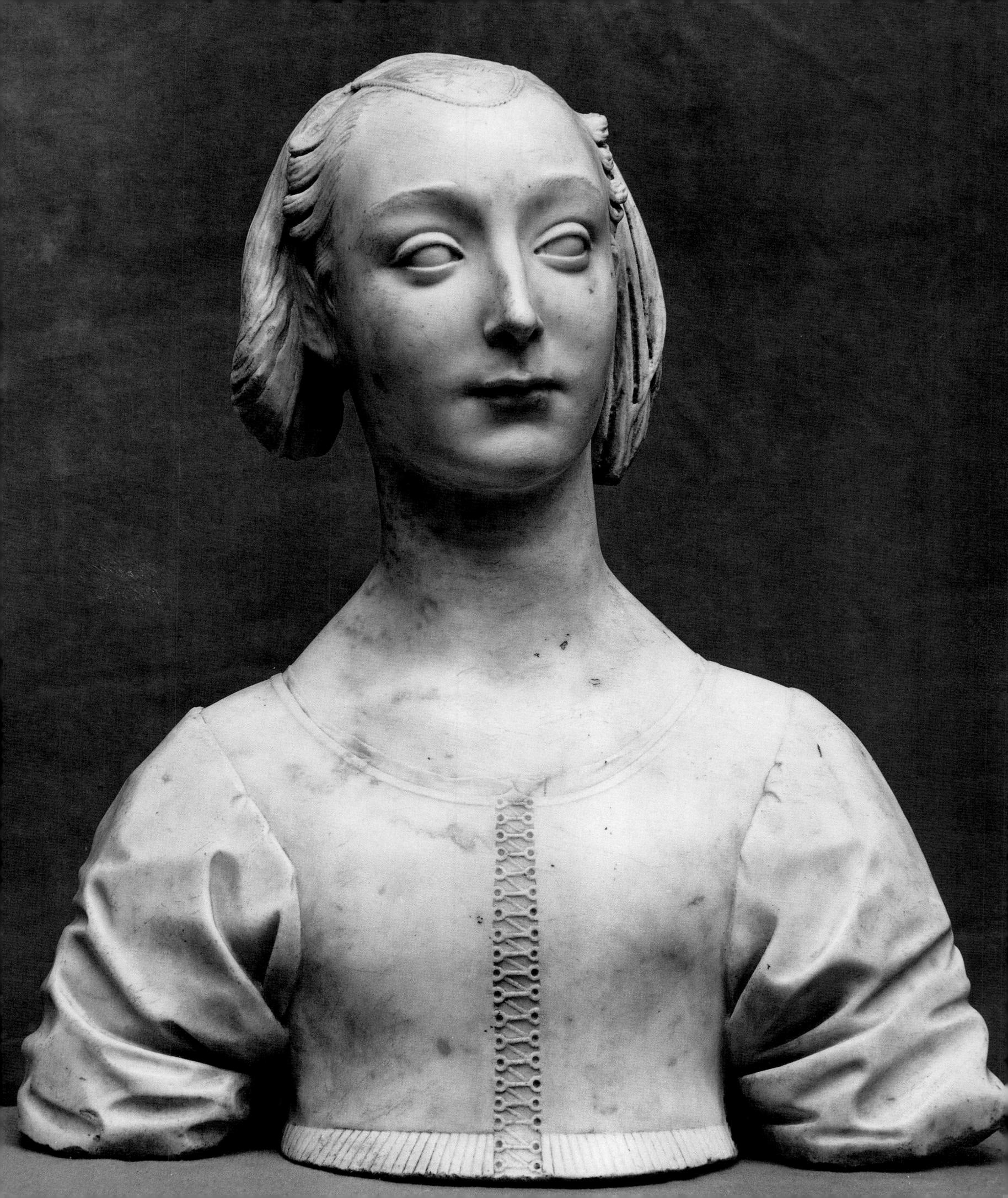

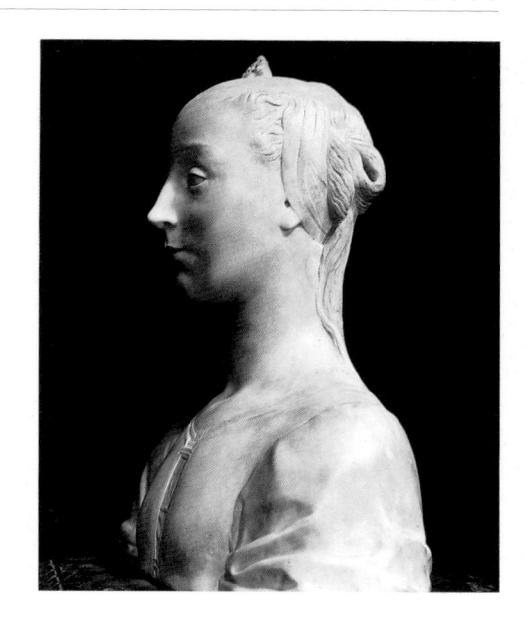

is changed. The form has been condensed and centralized, the head is vigorous and erect, and the eyes look boldly outwards in full face. Without any diminution of its purely naturalistic features, the type has been ennobled and refined, while the back is resolved in a linear pattern which is perhaps the crowning beauty of the bust.

In child portraiture, too, there were lessons to be learned from Roman art. Just as the first generation of Tuscan Renaissance sculptors were attracted to Roman reliefs of putti, so the artists of the middle of the century directed their attention to Roman child portrait busts. There was no vogue for child portraiture as such, and the pretext for these busts was offered by the demand for busts of the young St John and the Child Christ. Not all the busts of the Child Christ and the young St John produced about this time were portraits; on many of them (and especially on the heterogeneous busts that are usually grouped together under the name of Antonio Rossellino) the concept of portraiture, the notion, that is, of modelling the head from the features of an individual child, left no mark at all. But in at least two cases we can argue with confidence that this was the procedure employed. Both busts are by Desiderio da Settignano and are in Washington (plate 174), and in both there is a miraculous play of movement in the cheeks that has no parallel till the child portraits of Houdon.

There is no female portrait bust in the entire fifteenth century which bears its sculptor's name or is attested by any document, and in studying these sculptures we have to cross a fragile bridge of

style analysis. Almost all the surviving female busts are ascribed to Desiderio da Settignano, but in the case of only one can Desiderio's authorship be demonstrated. This is in the Bargello (plate 179), and must have been executed at about the same time as the supporting Angels on the Altar of the Sacrament (plates 102, 103). The Angels are carved with that marvellous softness, that inspired understatement with which Desiderio invariably speaks; the image is built up in terms of surface modelling as though in wax. In the bust in the Bargello the head is treated in precisely the same way; the hair merges with the forehead, the mouth is depicted in arrested movement, and the sleeves beneath are resolved in two contrasting patterns of soft folds. As in all Desiderio's sculptures we are conscious of surface properties rather than of the organic structure under the design. Obviously the whole conception differs fundamentally from that of the putative bust of Marietta Strozzi by Antonio Rossellino in Berlin (plate 178). The Berlin bust is more prosaic, which is another way of saying that it is more lifelike, and it is composed of statements, not of hints or innuendoes, which is another way of saying that each feature is given its true plastic value and is not merely inscribed on the surface of the head. The folds in the sleeves of the Berlin bust are more recessive, details like the juncture and lacing of the bodice are more sharply defined, the mouth and eyelids are deeply carved, the hair is undercut and at the sides stands free of the scalp, and the headdress is treated as a plastic mass whose solidity is emphasized by relatively heavy drilling in the

plate 178 (opposite) Antonio Rossellino

Bust of a Lady

Staatliche Museen, Berlin-Dahlem marble, height 53 cm

plate 179 Desiderio da Settignano

Bust of a Lady

Museo Nazionale, Florence marble, height 46 cm plate 180 Francesco Laurana

Isabella of Aragon

Kunsthistorisches Museum, Vienna marble, height 44 cm folds. More than this, the design of the whole bust is established more firmly than that of the bust in the Bargello. In the Angels on Antonio Rossellino's tomb of the Cardinal of Portugal we find close parallels for these particulars.

Unlike the male portraits, the female portrait busts are relatively little influenced by antiquity. For the fifteenth-century Roman busts of women seem to have had no immediacy, and though the making of female portrait busts represented a return to antique practice, there is nothing about the busts themselves that is specifically classical. Where the male portrait busts are strongly realistic, the features in the female busts are smoothed out till they reflect what is almost an ideal type. Never do we find a record of those minute details of physiognomy on which the effect of the male busts depends. Where the female busts link up most closely with male busts of the type of the Palmieri is in the symmetrical planning of the lower part, from which the column of the neck and head rises with wonderful felicity.

At the same time it would be wrong to regard these busts as mere abstractions, for they are far less abstract than the busts which a contemporary of Rossellino, Francesco Laurana, was carving in Naples at about this time. Laurana's busts belong to the category of court art; their representational aim is deliberately restricted, so that the head is approximated to its nearest geometrical equivalent and the dress beneath is stereotyped. So static and impassive are they that at one time they were looked on as a form of posthumous official portraiture. In point of fact, in every case save one,

those of the sitters who can be identified were very much alive, and the form in which their features were recorded was due to the stylistic preconceptions of the sculptor. Just as Agostino di Duccio in his reliefs at Rimini treats the heads of his figures schematically (plate 233), so Laurana effects a marriage between geometry and portraiture. In one bust (plate 180) a painted surface redresses slightly the defective naturalism of the forms. To speak of defective naturalism is not however to denigrate Laurana's busts. Of their kind they are some of the most sensitive achievements of the fifteenth century, and there is a perennial fascination in their frozen masks. Yet how much more elevated, how much more ambitious, how much more profound is the concept of portraiture espoused by Desiderio and Rossellino.

Painted portraiture in Florence in the fifteenth century was dominated by the profile portrait, and initially fidelity to the profile also affected the portrait bust. It is evident in Rossellino's Giovanni Chellini, where the view in full-face (plate 168) is of secondary importance compared with the views from the two sides (plate 169), and it dogs Desiderio's Bargello bust (plate 179). Only with Antonio Rossellino's bust of a lady in Berlin (plate 178) is the difficulty of reconciling the three views of the head and equating their importance largely overcome. None the less the profile view retained a rather special significance in Renaissance sculptured portraits. This is true even of a head which seems at first sight as solid and as threedimensional as Rossellino's bust of Matteo

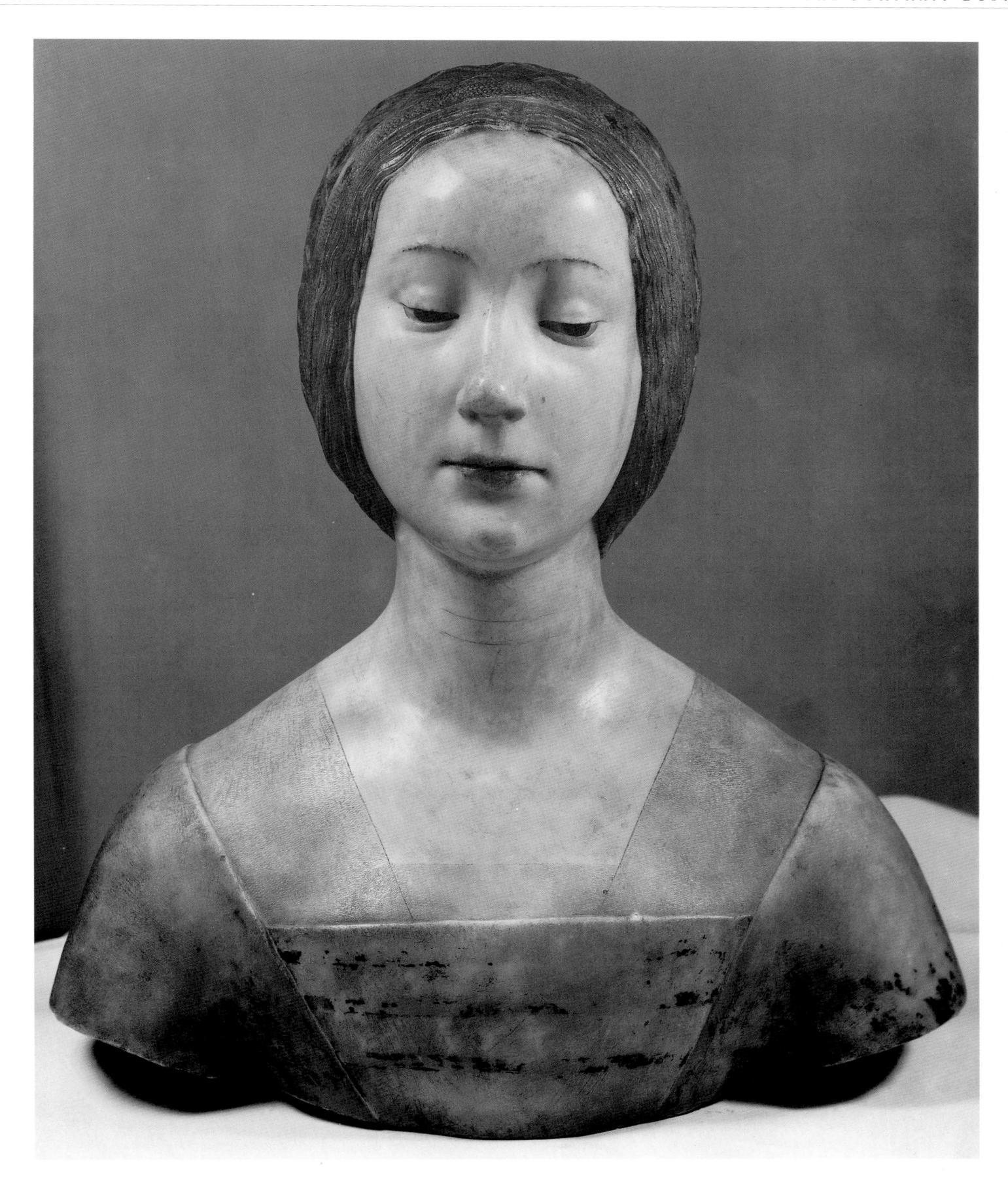

Palmieri (plate 172), where, excellent as is the frontal view, it is the profile through which the character is most graphically expressed. If the profile portrait was a limiting factor in the development of the portrait bust, the portrait bust had a radical influence on painted portraits, and must indeed have been largely accountable for the great step forward through which the rather unambitious female portraits of the 1450s and 1460s developed into the masterly portraits produced by Antonio Pollaiuolo about 1470, where the profile view appears for the first time as one aspect of an image which is fully three-dimensional.

Meanwhile, a new type of portrait sculpture had been gaining ground. Its protagonist was not Pollaiuolo the classicist, but the anti-classicist Verrocchio. Just as Verrocchio evolved the unclassical Forteguerri Monument (plate 150) from the classicizing monuments of the middle of the century, just as he intruded the unclassical Christ and St Thomas into the classical company of the statues on Or San Michele (plates 124, 125), so he transformed the portrait bust. The prime document for this is the beautiful bust of the Lady with the Primroses in the Bargello (plate 181), the first bust in which hands are shown. More important than the inclusion of the hands is the stylistic tendency of which this forms part. The back is once more centralized, but the front, though the centre is marked by a button on the throat, is a denial of centrality. The head looks out and slightly upwards to the left, the hands are placed irregularly on the breast, and the

diaphanous dress falls from the shoulders in folds on which no artificial unity has been imposed. The profile bust of Desiderio was developed by Rossellino into a bust in which the front and side views coexist, and Verrocchio in turn developed this into a sculptured portrait in which all views were fused in a continuous whole. Verrocchio, after Donatello, was the fifteenth-century Florentine sculptor with the strongest feeling for plasticity, and this led him to substitute for the mid-century conception of the portrait bust as a self-consistent unit, a new conception of the bust as a unit in space with an exact spatial reference defined by the receding planes of hands, breasts and head.

What Verrocchio achieved for the female portrait, he did also for its male counterpart. The Giuliano de' Medici in Washington (plates 182, 185) traces its descent from the early Medici portraits of Mino da Fiesole rather than from the busts of Rossellino. It is conceived rhetorically, like the Colleoni statue, with an expression of such lifelikeness that the attention seems to be directed to some unseen incident in its vicinity. Here is a portrait type in which character is sketched not by the particularized rendering of physiognomical detail, but through an intuitive sense for characteristics of deportment and expression, and in it are implicit the principles of portraiture that were to culminate in the succeeding century in Vittoria's portrait busts.

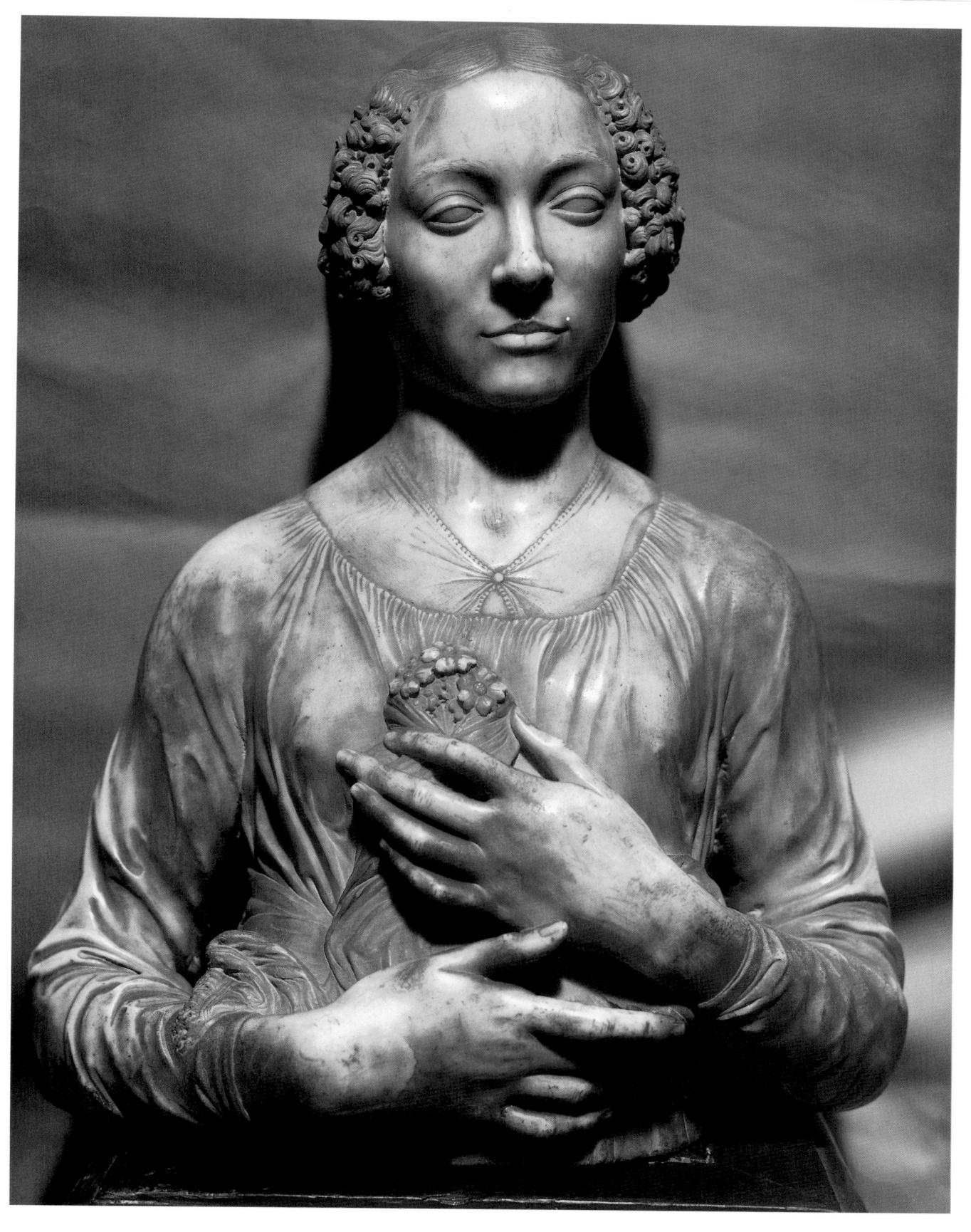

plate 181 Andrea del Verrocchio

Bust of a Lady

Museo Nazionale, Florence marble, height 61 cm plate 182 Andrea del Verrocchio

Giuliano de' Medici

National Gallery of Art, Washington terracotta, height 61 cm

plate 183 *(opposite)* Andrea del Verrocchio

Giuliano de' Medici

National Gallery of Art, Washington (detail of plate 182)

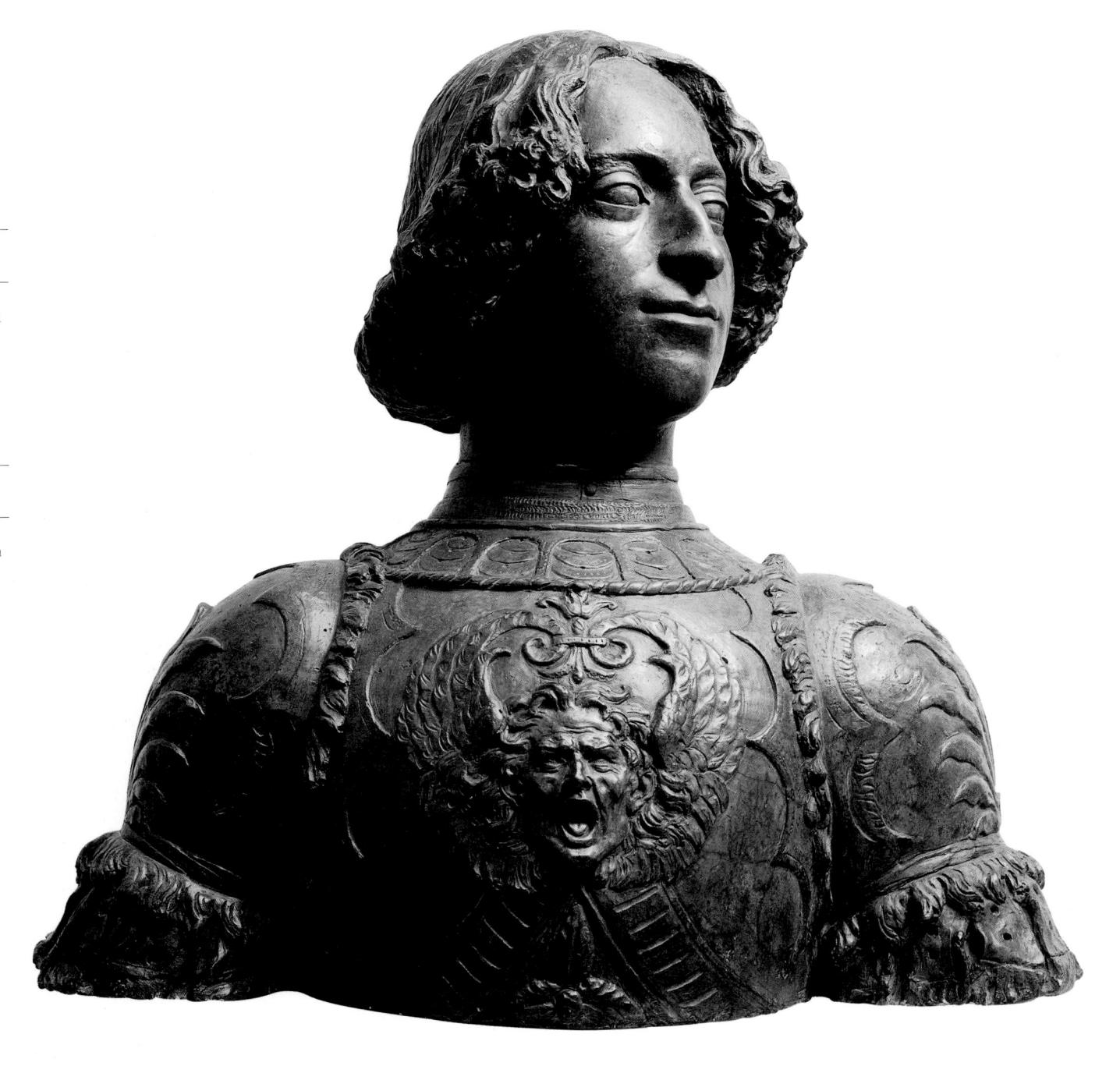

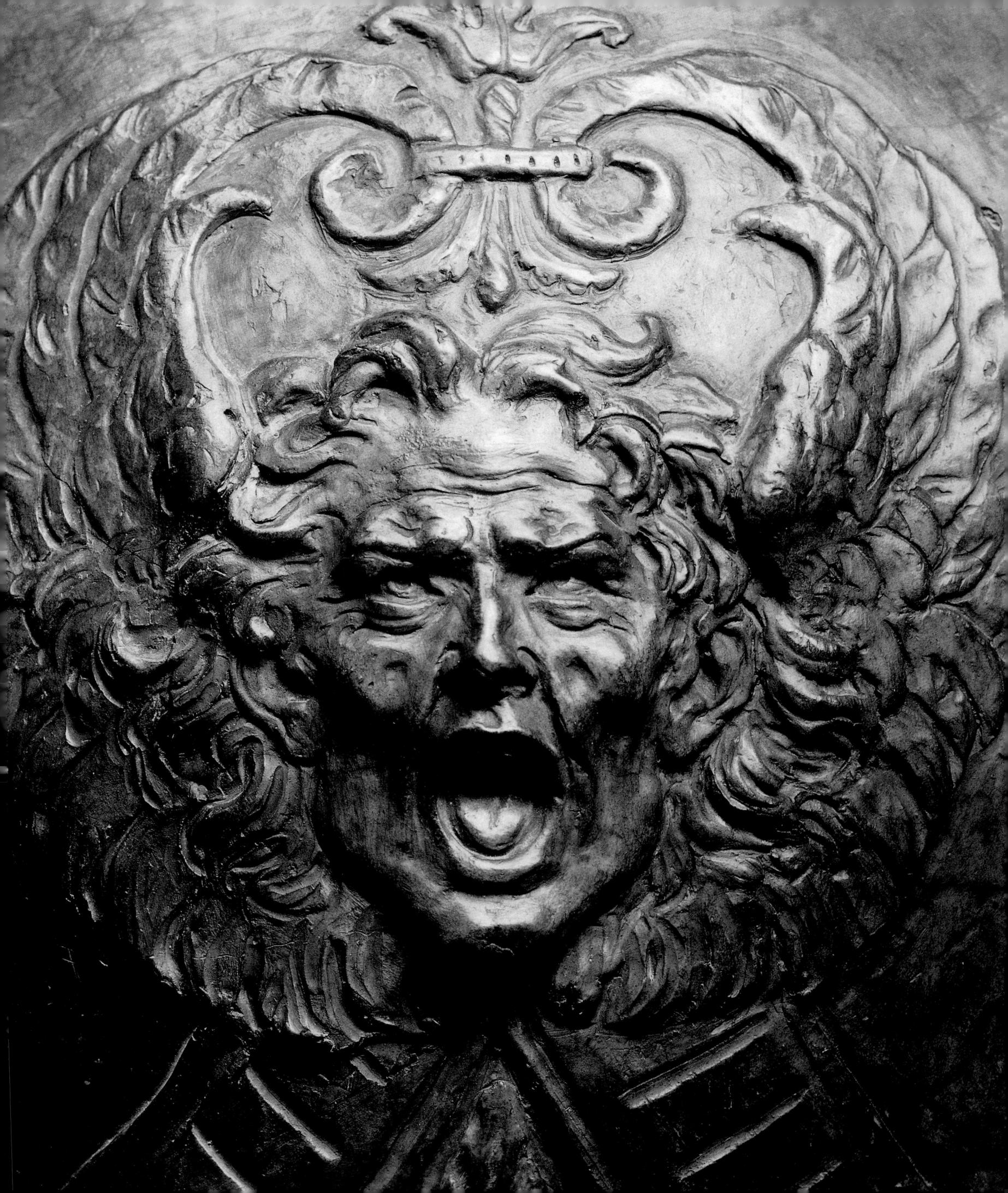

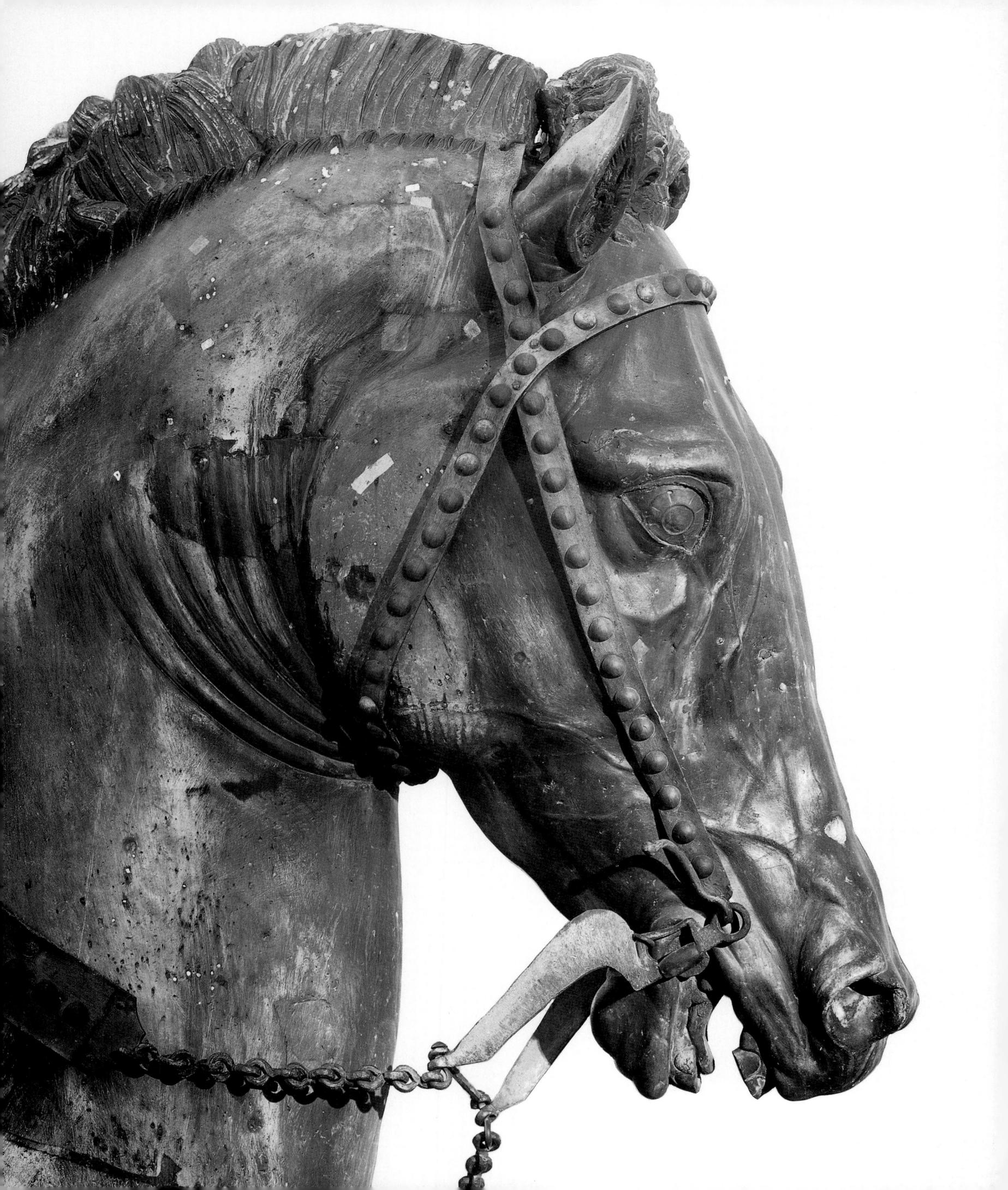

THE REINTRODUCTION in the fifteenth L century of the life-size bronze statue led in turn to the revival of another classical art form, the equestrian monument. In the trecento, especially in North Italy, equestrian figures occur on tombs, but in stone or marble the sculptor was fettered by the block in which he worked. In Verona in the early fifteenth century riding figures were modelled in stucco or cement, and both in Northern and Central Italy they were also carved in wood. In Venice a wooden equestrian statue was incorporated in the Savelli Monument in S. Maria dei Frari, and in Tuscany equestrian figures were carved by Jacopo della Quercia and Agnolo Gaddi, the latter of whom was responsible in 1300 for a statue of Piero Farnese. For all their ease of working, wooden equestrian statues had one overriding disadvantage, that they were impermanent, and five years after it was carved Agnolo's figure was reported to be 'jam antiqua et non apparens'. For this reason it was decided that Piero Farnese and his fellow condottiere Sir John Hawkwood should be commemorated in the Duomo in Florence not in sculpture, but by frescoes painted on the wall. These were entrusted to the author of the wooden figure, Agnolo Gaddi. By the second quarter of the fifteenth century, however, the late-Gothic fresco of Hawkwood seemed unworthy of its place, so in 1436 it was agreed that a new commemorative fresco should be commissioned from a younger artist, Paolo Uccello. Uccello's fresco (plate 185) is an ideal monument. It consists of a platform raised on consoles; on the platform stands the

sarcophagus supported by marble blocks, and on the lid of the sarcophagus is an equestrian figure. As a young man Uccello had been employed in Venice on the mosaics of St Mark's, and as he pressed the tesserae on the façade into their place, he must have looked day after day at the bronze horses (plate 187) above the entrance to the church. When he came to plan the Hawkwood fresco, his memory of these great bronze castings was still fresh, and round his painted horse there blows, for the first time in portrayals of the kind, the life-giving breath of the antique.

If Uccello had travelled more widely, he could have seen two classical equestrian monuments. The first of them was the Marcus Aurelius in Rome (plate 186). Standing in those days outside St John Lateran, on a block of marble which raised it only a little from the ground, it must have seemed astonishing above all for the fidelity with which the horse was reproduced. In the fifteenth century, however, one other classical bronze equestrian monument was rated higher still. 'The movement of the one at Pavia,' notes Leonardo da Vinci in the Codex Atlanticus, 'is more highly praised than any other.' 'The one at Pavia' (also an Antonine monument) stood on a column outside the Cathedral, and because it was gilded was known as the Regisole.

We first hear of a Renaissance equivalent for these monuments in 1444. The place is Ferrara, and the occasion an equestrian statue erected by Lionello d'Este to his predecessor Niccolò III. Two models were prepared by Florentine sculptors. Opinion as to their merits was divided, plate 184 Donatello

The Gattamelata Monument

Piazza del Santo, Padua (detail of plate 188) plate 185 Paolo Uccello

Sir John Hawkwood

Duomo, Florence fresco

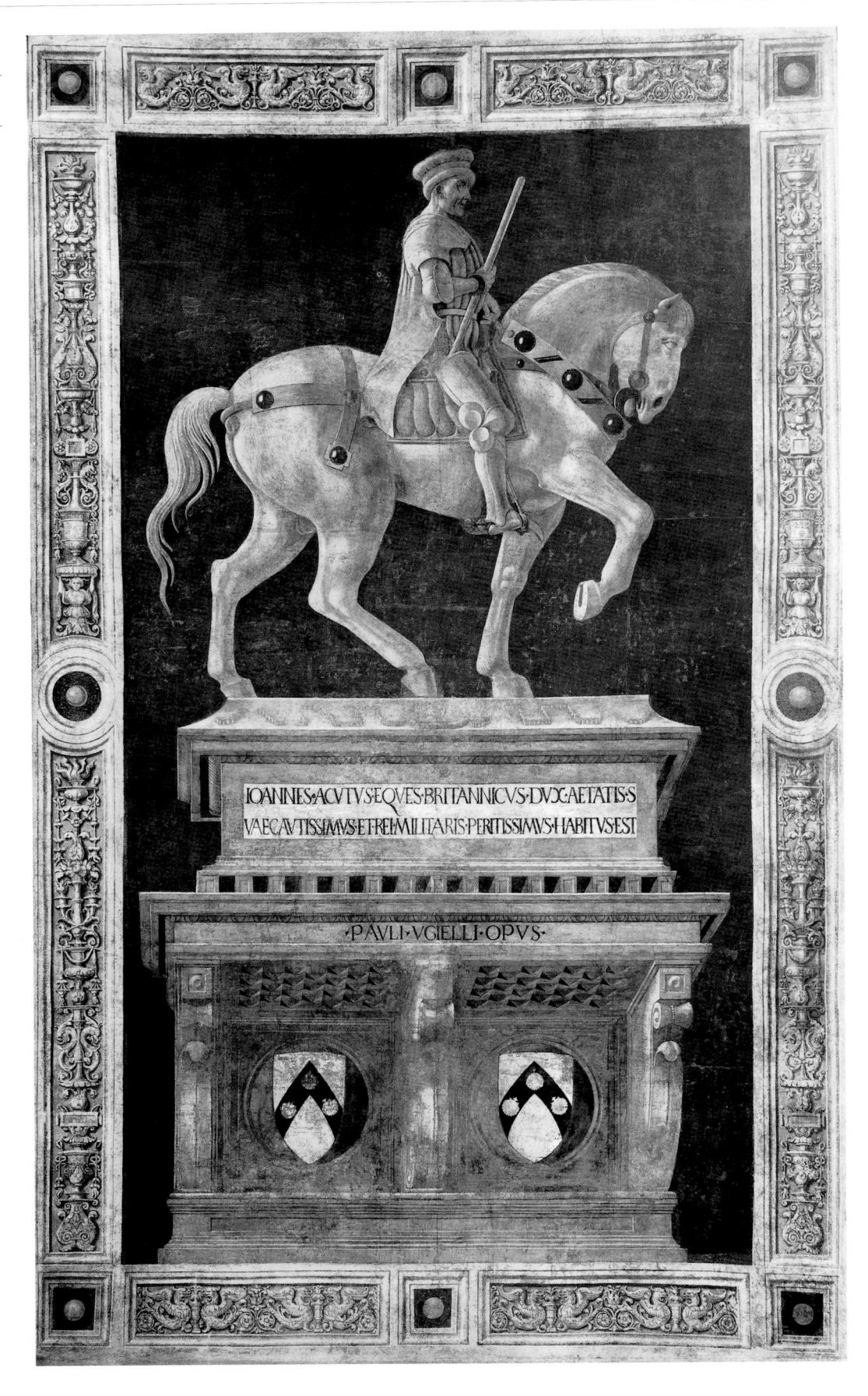

plate 186 Roman, 2nd century AD

Marcus Aurelius

Campidoglio, Rome

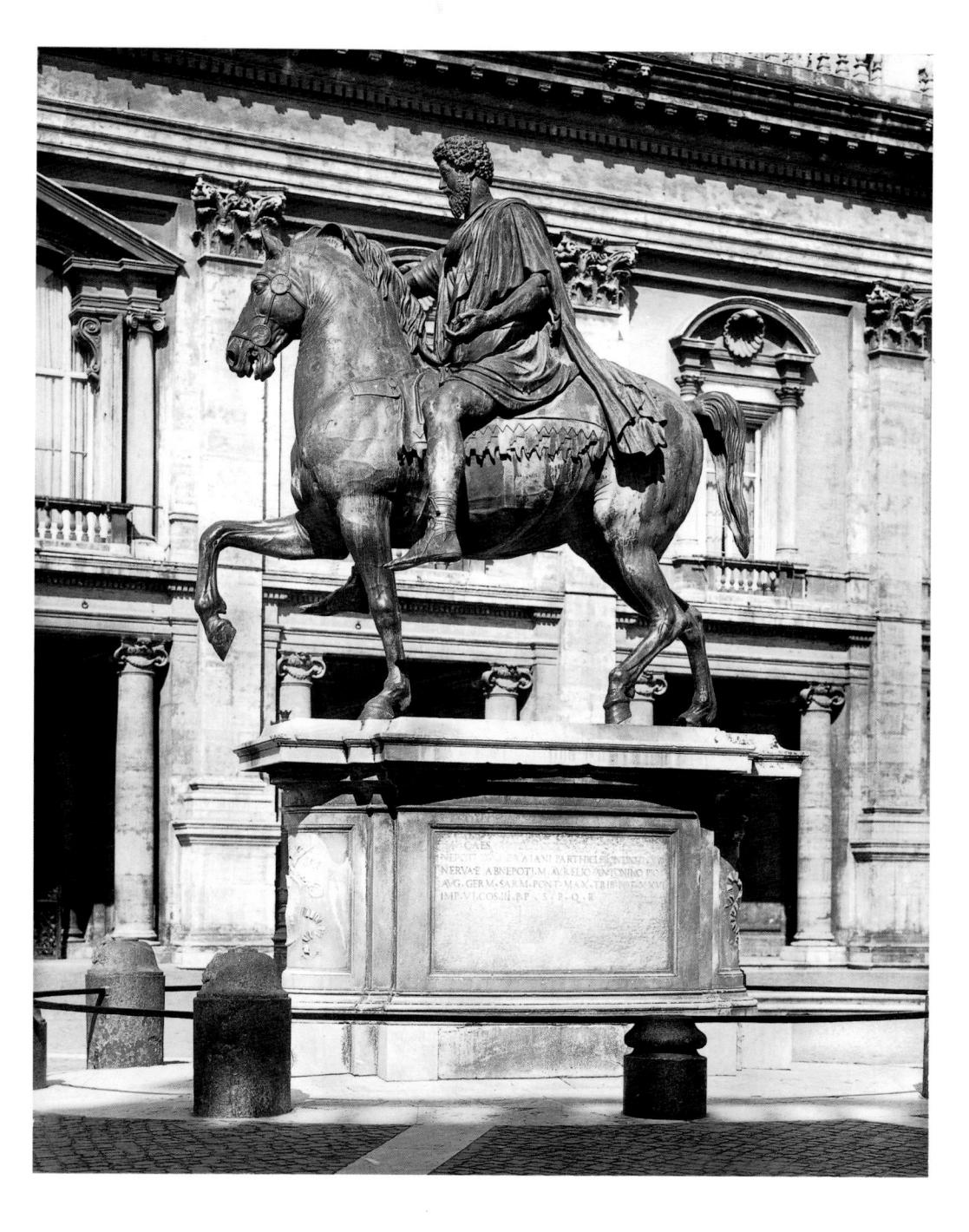

plate 187 Roman, 1st (?) century AD

Bronze Horses

St Mark's, Venice

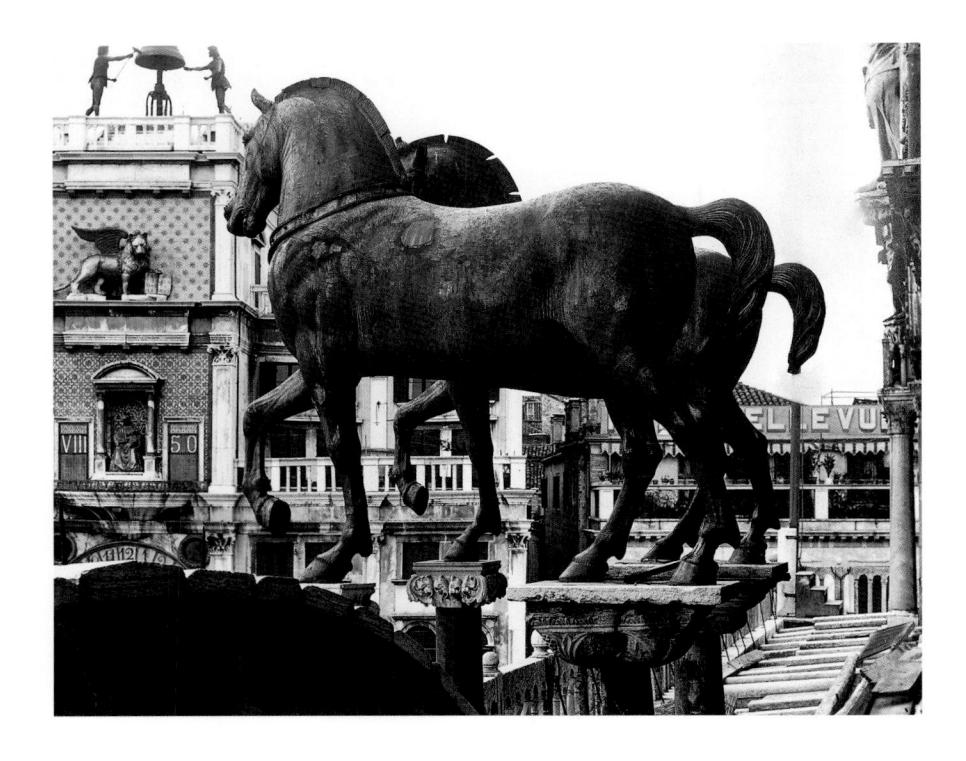

and the architect Alberti, who was in Ferrara, was asked to give a casting vote. The completed monument was set up on Ascension Day 1451 between the Castello and the Cathedral, and remained there till it was demolished in 1796. It is in connection with this statue that we first hear the term that is later to haunt the notebooks of Leonardo, 'il cavallo'. 'Niccolò del cavallo' was the name bestowed upon its sculptor, Baroncelli, and 'Volto del cavallo' was the place where it was set. Such terms were the popular expression of a learned preoccupation, for, the human figure apart, the horse was the canonical subject of Renaissance artists. Alberti, while in Ferrara, wrote an essay De Equo Animante (so called to distinguish it from Baroncelli's bronze horse) and painters from Pisanello down to Leonardo gave the rendering of the horse the same close attention as the rendering of the human form.

The subject of the earliest surviving bronze equestrian monument was Erasmo da Narni or Gattamelata, Captain-General of the Republic of Venice, who died of a stroke at Padua in January 1443. The statue (plates 184, 188, 189) was commissioned from Donatello, and was produced concurrently with the high altar of S. Antonio. Its base was already building in 1447, the chasing was complete in 1450, and in 1453, after prolonged disagreement, the figure was set up outside the church. Unlike Uccello, Donatello was thoroughly familiar not only with the horses on St Mark's, but also with the Marcus Aurelius in Rome, and in his attitude to the commission both seem to have played their part. But the Gattamelata is not an

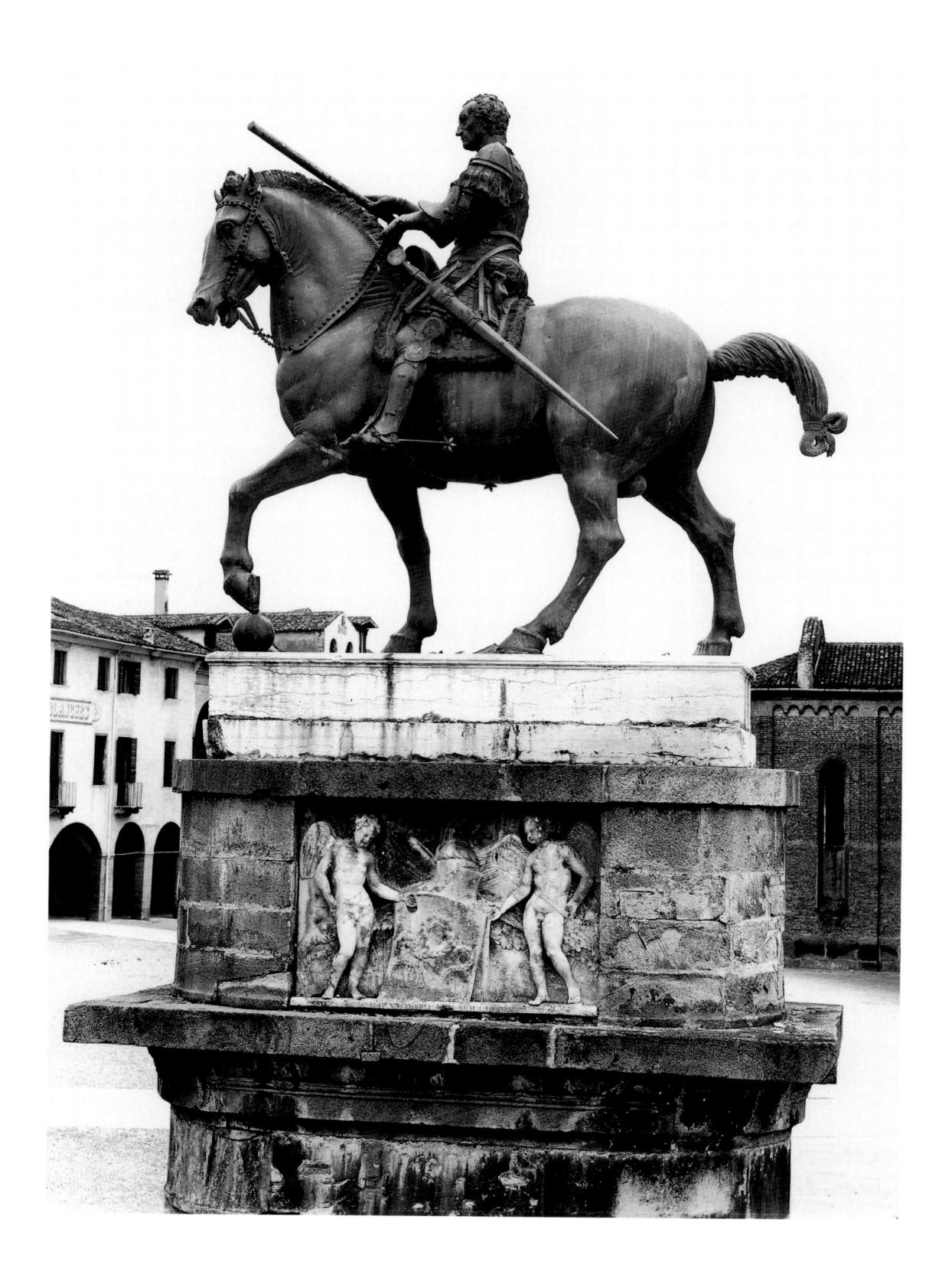

plate 188 Donatello

The Gattamelata Monument

Piazza del Santo, Padua bronze, height (without base) c.340 cm

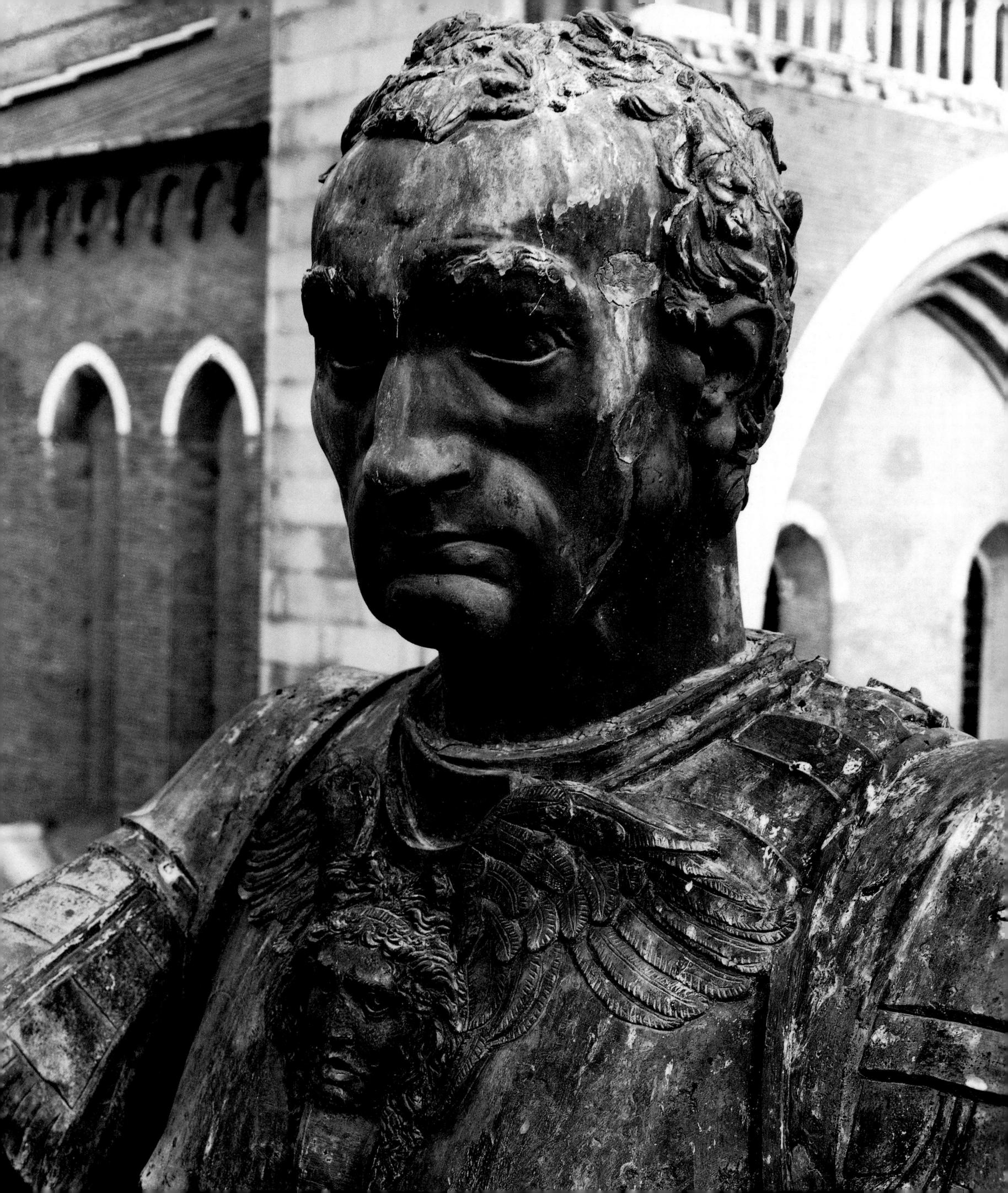

academic synthesis of antique elements; it is inspired by emulation, not the instincts of a copyist, and just as the putti carved by Donatello for the Cantoria and the Prato pulpit were unclassical though they were based on the antique, so the stocky, vigorous forms of the horse at Padua introduce a new realism into the equestrian monument.

The figure mounted on the horse also has a contemporary significance. Like the Judith in Florence, it embodies concepts which are of wider implication and greater depth than the context in itself necessitates. To achieve the effect at which he aimed, Donatello found it necessary to desert antiquity; it was central to his conception that the riding warrior should review his unseen troops with the same directness with which the marble Prophets on the Campanile harangued the crowds beneath. In the head the individual features (eyes, eyebrows, ears and the wild mat of hair behind) are not rendered literally, as they would have been in Roman art, but are subjected to distortions of an audacious and utterly unprecedented kind. Moreover, though the relation of the statue to the Santo may have been decided on with the Regisole in mind, its specific placing was determined by considerations of effect, so that entering the square from the north, it advances towards us, and entering from the west its menacing profile stands out against the sky.

None the less the Gattamelata and the Marcus Aurelius were spiritual counterparts, and when, thirty years later, another monument of the same type was under way in Venice, a clerical observer,

an itinerant Dominican, declared that the Venetians were 'imitating the custom of the heathen nations' in setting up such a memorial. This memorial was Verrocchio's Colleoni Monument (plates 190, 191, 192). Unlike Gattamelata, Bartolommeo Colleoni was of noble birth. He came from the neighbourhood of Bergamo, and financially was one of the most successful military leaders of his time. In his will Colleoni bequeathed part of his personal fortune to the Venetian Signoria, but with the proviso that the Signoria should commission a statue of their benefactor seated on a bronze horse, and that this should be set up in the Piazza San Marco ('super platea sancti Marci') to his eternal memory. After four years of discussion the Signoria decided to comply, placing the statue, by a legal quibble, near the Scuola di San Marco outside SS. Giovanni e Paolo and not in the conspicuous position Colleoni intended it should occupy in front of the basilica. Once more, as with all fifteenth-century equestrian monuments, the emphasis rested not on the rider but the horse, and when the Signoria put out the commission to tender, they offered 'especial honours to the artist who made the bestshaped horse'. Verrocchio's model must have arrived in Venice in the second half of 1481, for in the middle of the year an application was made for the horse ('a life-size horse which is a pretty invention') to be given free passage through Ferrarese territory on its way from Florence to Venice. When Verrocchio died in 1488, the monument had not been cast, and after abortive negotiations with Verrocchio's heir, the painter

plate 189 Donatello

The Head of Gattamelata

Piazza del Santo, Padua (detail of plate 188) plate 190 Andrea del Verrocchio

The Colleoni Monument

Campo di SS. Giovanni e Paolo, Venice bronze, height (without base) 395 cm

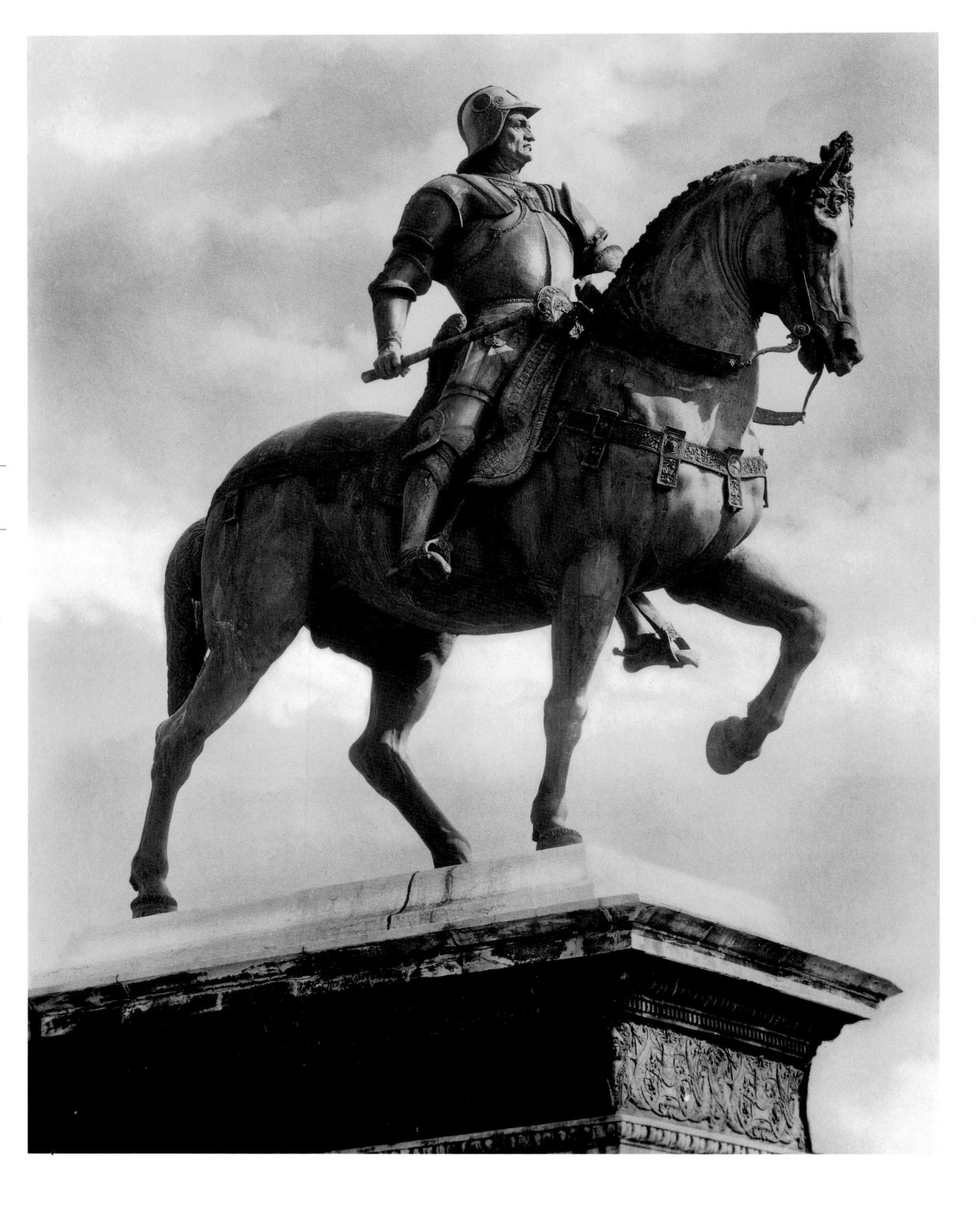

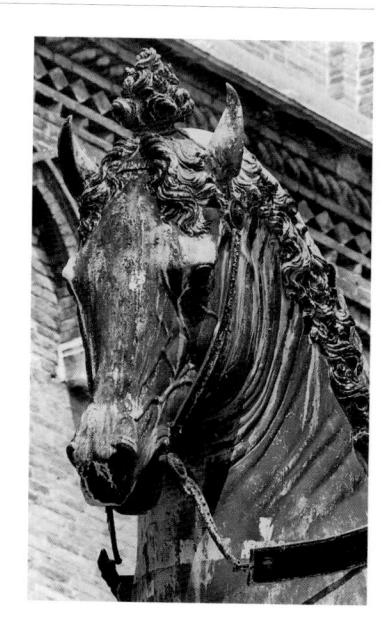

Lorenzo di Credi, the casting was entrusted in 1490 to a Venetian bronze-founder, Alessandro Leopardi, whose confident signature can be read on the girth of Verrocchio's horse. In the Colleoni Monument, therefore, we are confronted not with a finished work of art, but with the ideas of a great artist as they were realized by another hand. The head of Colleoni, for example, is often singled out for special praise, and admirable it is, but if Verrocchio had worked it up himself, it would have been more admirable still, and so would the dry detail of the saddle and the mane and muzzle of the horse.

Verrocchio was clearly aware that in the Marcus Aurelius the implications of movement were greater than in the Gattamelata. The supports were thinner, one fore-leg was held free, and the rear legs of the horse were posed in such a way as to suggest that it was capable of a sudden forward impetus and not merely of a slow advance. It was this sense of implied movement that he aimed at in his monument. Moreover, as a sculptor Verrocchio was repeatedly concerned with the visual effect of a great weight of bronze or marble raised on a seemingly inadequate support. In the Colleoni Monument this led him to modify the ratio between rider and horse, and to substitute for the relatively small figure of the Gattamelata a larger figure of greater weight. He had a preference also for figures turned on their own axis, like the St Thomas in the group of Christ and St Thomas on Or San Michele and the fountain figure of the Putto with the Fish (see plate 127). This preconception too leaves its mark upon the

Colleoni Monument. Where Donatello disposes the shoulders of his rider on a single plane, Verrocchio advances the left shoulder and retracts the right. This rhetorical device accounts for the liveliness of the whole image and divorces it from classical originals.

Since equestrian statues of this class could be made only in bronze, it was inevitable that the only other large-scale bronze sculptor in Florence in the later fifteenth century, Antonio Pollaiuolo, should also become involved in a project of the kind. It was inspired by Colleoni's erstwhile colleague, the Duke of Milan, Francesco Sforza. Francesco Sforza had been a condottiere in the service of the Visconti Dukes of Milan, and in 1450 was elected Duke. He died in 1466, and in 1472 we first hear of a proposed memorial. It was to be commissioned from two Milanese marble sculptors, the brothers Mantegazza, who were employed on the Certosa at Pavia, but with a modesty unusual among artists, the Mantegazzas seem to have turned the commission down. Francesco Sforza's son, Galeazzo Maria Sforza, was assassinated in 1476, and in 1479 he was succeeded by his brother Lodovico il Moro, who at once concerned himself with the projected monument. The little that we know of Pollaiuolo's scheme is due to a passage in Vasari. This is what Vasari says: 'After Pollaiuolo's death, there was discovered a drawing and a model for the equestrian monument of Francesco Sforza, Duke of Milan, which he made for Lodovico Sforza. The drawing is in our album in two versions; in one of these Verona is shown beneath the horse, while in the

plate 191 Andrea del Verrocchio

The Colleoni Monument

Campo di SS. Giovanni e Paolo, Venice (detail of plate 190) plate 192 Andrea del Verrocchio

The Colleoni Monument

Campo di SS. Giovanni e Paolo, Venice (detail of plate 190) other Sforza, in full armour, makes his horse rear over an armed man.' The second drawing showed a base filled with battle-scenes. Pollaiuolo's Sforza Monument was not carried out, but his ambition to execute a bronze equestrian statue simmered on, and at the end of his life, when he was in Rome working on the papal tombs, he offered Virginio Orsini the chance to eternalize himself by commissioning a statue based on the Sforza Monument. The year of the Sforza project is uncertain, but the balance of probability is that it dates from the early 1480s. In this case it would be contemporary with Verrocchio's Colleoni Monument. Two of Pollaiuolo's drawings for the monument survive (plate 193), and they show us that he had in mind something entirely new in the way of an equestrian statue. Pollaiuolo's mind was formed by classical works in small dimensions, above all by classical sarcophagi. One group of sarcophagi, that with battle scenes, held a special fascination for Florentine artists in the later fifteenth century, and to eyes seduced by the riding warriors in these reliefs, sedate statues like the Marcus Aurelius and the Gattamelata must have seemed inadequate. How was this sense of movement, this wildness and ferocity, to be transferred to the full-scale equestrian monument? That question is fundamental for Pollaiuolo's drawings and for the whole later history of the equestrian statue.

Possibly the reason why the Sforza Monument was not entrusted to Pollaiuolo was that in 1482 Lodovico il Moro received a letter from Florence. It was written by Leonardo da Vinci, and it ended with the celebrated sentence: 'Also I can execute sculpture in marble, bronze or clay, and also painting, in which my work will stand comparison with that of anyone else, whoever he may be. Moreover, I would undertake the work of the bronze horse, which shall endue with immortal glory and eternal honours the auspicious memory of the Prince your father and of the illustrious house of Sforza.' As a result of this letter Leonardo was invited to Milan, and began work on the Sforza Monument.

We know absolutely nothing about Leonardo as a sculptor - not one single work survives - but we can reconstruct the milieu in which he was trained. From the late 1460s (probably 1469) till about 1478 he worked as a member of Verrocchio's studio, and he must to a greater or lesser degree have been involved in all the major commissions that were awarded to it at this time. Among them were the Medici Monument in S. Lorenzo (plate 155), which was completed in 1472, the Forteguerri Monument at Pistoia (plate 150), which was begun in 1476, and the group of Christ and St Thomas on Or San Michele (plate 125), one figure of which was finished in 1476 and the other in 1483. Leonardo must also have been in close touch with Verrocchio during the early stages of work on the Colleoni Monument, that is during the preparation of the model for the horse, which was finished in 1481. When he offered his services to Lodovico il Moro in 1482, therefore, so far from having an inadequate knowledge of bronze sculpture, he had behind him the experience accumulated in the only studio in

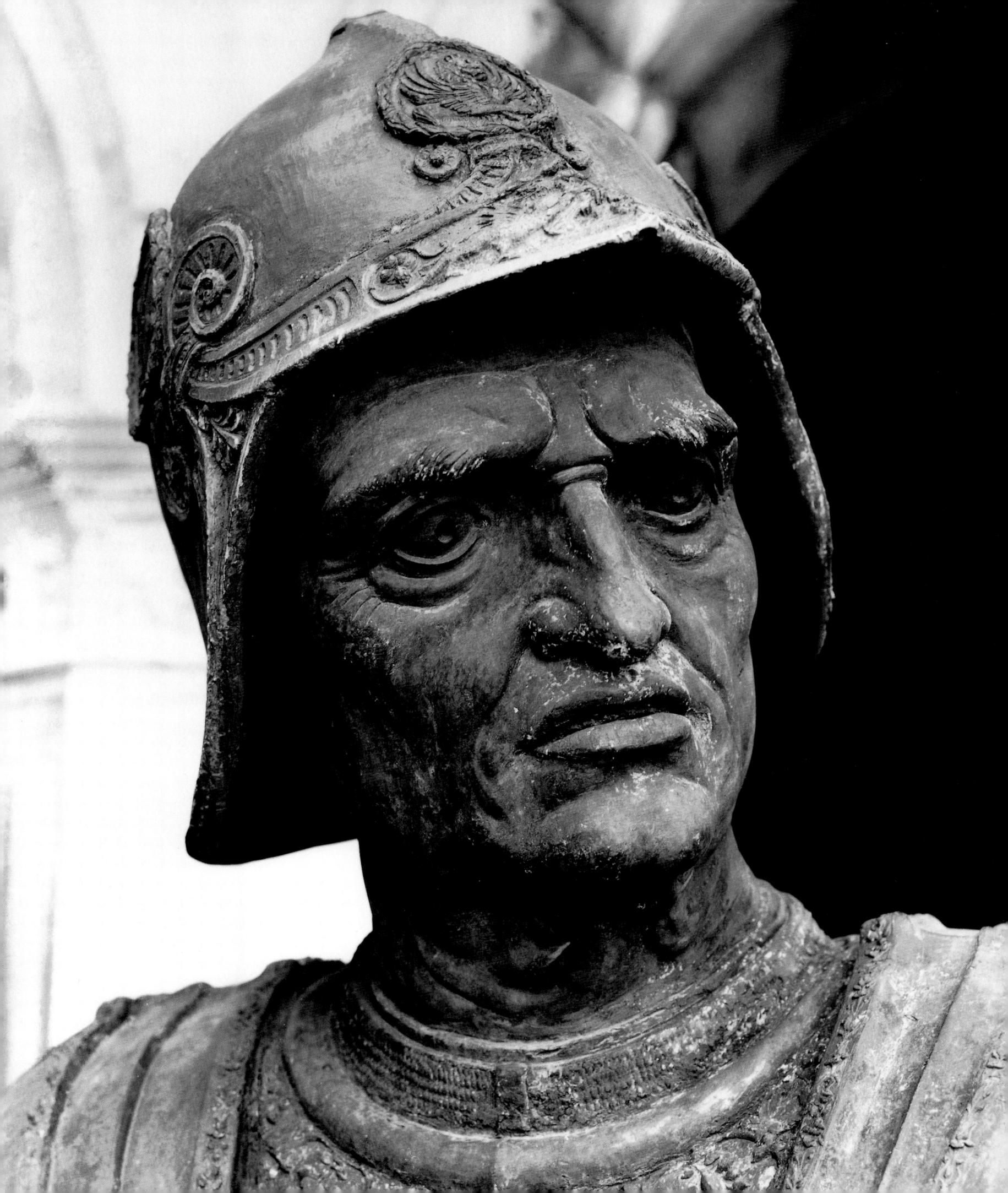

plate 193 Antonio del Pollaiuolo

Drawing for the Sforza Monument

Metropolitan Museum of Art, New York, Lehman Collection

the whole of Italy that was continuously engaged on large-scale bronze casts. Years later Leonardo regarded himself, and was regarded, as a technical specialist in the production of bronze sculpture, and in 1498 he offered his services to Piacenza to make bronze doors for the Cathedral – bronze doors that might have formed the final term in the series that opens with Ghiberti's two doors for the Baptistery, and continues with Luca della Robbia's door in the Cathedral and Donatello's in the Old Sacristy.

When Leonardo moved to Milan, he left unfinished the painting of the Adoration of the Magi which is now in the Uffizi. The background of this altarpiece contains two horsemen fighting and a number of other riding figures, and reveals an obsessive interest in the active representation of the horse. Leonardo made many preliminary drawings for these horsemen, and they formed the point of departure for his work in Milan on the Sforza Monument. He arrived in Milan in 1482, but there is no further mention of the statue until the summer of 1489, when the Florentine agent in Milan informed Lorenzo de' Medici that the Duke was preparing a memorial to his father, and that Leonardo was making a model for it, 'a colossal horse in bronze, with Francesco Sforza armed'. Since Lodovico il Moro, the agent went on, required a statue of superlative quality, he was anxious that Lorenzo de' Medici should send him one or two masters suited to this type of work. The agent added his own gloss on this request: 'Though the Duke has entrusted this matter to Leonardo da Vinci, it does not seem to me that he is fully

confident that Leonardo understands how to complete it.' So far as is known no Florentine bronze founder applied for the post, and in April 1490 we read in Leonardo's notebooks the words: 'Ricominciai il cavallo' ('I began the horse afresh'). By 1493 a clay model of the horse alone was finished, and was shown in the courtyard of the ducal residence, but owing to the French invasion it was never cast. Used as a target by French troops, by 1501 it was already derelict. Thereafter we hear nothing more. Leonardo's drawings, however, enable us to reconstruct, in a very tentative way, some of the stages through which the design passed.

Pollaiuolo's drawings for the Sforza Monument (plate 193) show Francesco Sforza on a prancing horse riding over a vanquished foe. To judge from an engraving which reproduces some of Leonardo's lost sketches (plate 195), Leonardo accepted this idea as well. There is a famous drawing at Windsor which develops the same theme, though the pose of the riding figure, with head turned back and right arm warding off a blow, is so extreme that it can hardly be regarded as a meditated study for the monument. But Leonardo also worked out a variant of this scheme, in which the second figure is omitted, and the fore-leg of the horse rests on a tree-trunk. It is generally assumed that at this stage Leonardo was designing a colossal monument, but there is no conclusive proof that that was so, and these drawings might also be interpreted as studies for a monument on much the same scale as the Colleoni statue, which would have excelled all

previous equestrian monuments not in size but in sheer technical audacity. Suddenly the whole conception implicit in these drawings was set aside. It can hardly have been Leonardo who discarded it, since years later when he designed another equestrian monument he returned directly to this scheme. Perhaps, as events in Milan moved towards their climax, Lodovico Sforza felt that it would be unsuitable to show the founder of a stable dynasty precariously poised astride a rearing horse. Moreover, there was a Lombard tradition of equestrian portraiture, and his mind may have gone back to the statue of Bernabò Visconti in S. Giovanni in Conca, which for more than a century had been the physical expression of the power of the Visconti Dukes. So the galloping horseman was abandoned and replaced by an image that was more dignified and orthodox. But the statue must still surpass previous equestrian monuments, and the problem that confronted Leonardo was one no sculptor had broached before, the creation of an ideal horse of more than twice life-size. The figures here speak for themselves. The height of the Gattamelata including the rider is about 10 feet, the height of the Colleoni is about 13, and the height of Leonardo's horse alone from head to hoofs was 22.

For the Colleoni Monument at Venice and the Gattamelata at Padua the bronze horses at St Mark's had the relevance of physical propinquity. Equally Milan was only a short distance from Pavia, and the determining factor in the new form of the Sforza Monument was the Regisole. 'It is better to imitate the works of antiquity than

plate 194 Leonardo da Vinci

Studies for the Sforza Monument

Royal Library, Windsor Castle

plate 195 Leonardo da Vinci

Studies for the Sforza Monument

British Museum, London modern works,' wrote Leonardo in his notebooks about this time, and imitate antiquity was what he did. For Leonardo, however, as for Donatello and Verrocchio before him, imitating antiquity was a figure of speech. The Regisole was a signpost on the road he travelled, not his goal, and like the arch-empiricist he was, he started measuring horses in the Duke's stables, and drawing them from life. We have a whole series of studies made for this second version of the Sforza Monument: free drawings of standing horses, measured drawings of standing horses, free drawings of raised fore-legs, measured drawings of fetlocks, and last and finest of all a drawing at Windsor (plate 194) that suggests something of the plastic character of the completed work. These drawings prove that there was nothing mannered or unnatural about the Sforza horse; it was a quattrocento solution of a quattrocento problem, and if it surpassed earlier horses this was by virtue of superior size, more elegant articulation and more coherent modelling.

In 1499 Lodovico il Moro was expelled from Milan, and Leonardo returned to Florence, where, in 1503, he received the commission for the fresco of the Battle of Anghiari. Here fighting horsemen were the kernel of the scene. The drawings for the horses in this fresco, fine as they are, lack the simplicity and the directness of the earlier studies, and employ the formal mannerisms that were developing in Leonardo's treatment of the human figure at this time. Work on the fresco continued till 1506, and then, leaving it incomplete, Leonardo returned to Milan.

In Lombardy the political scene had been

transformed. After Lodovico il Moro's expulsion, Trivulzio, the Milanese commander of the French forces and an opponent of the Sforzas, was installed as Regent. By the end of January 1500 the city was once more in revolt, Trivulzio withdrew, and Lodovico il Moro re-entered the town, but before long his forces were routed, and Charles d'Amboise, as representative of Louis XII, took possession of Milan. It was Charles d'Amboise who was responsible for inviting Leonardo to return, and his main work in the seven years he spent there was a monument to the leader of the French party in Milan, Gian Giacomo Trivulzio. Leonardo's artistic aspirations in his first Milanese period were bound up with the maintenance of the Sforza dynasty, whereas in his second Milanese period they were bound up with the opposition, that is with the French conquerors. He left Milan for the first time in 1499, after the expulsion of Lodovico il Moro, and for the second time in 1513 when the French suffered a temporary setback and abandoned the town. Leonardo fled from Milan prematurely, as it turned out, for if he had remained till the victorious campaign of Francis I in 1515, he would have had seven years more of peaceful work under French rule, and the Trivulzio Monument might have been completed.

The Sforza Monument was a simple equestrian statue, but the Trivulzio Monument was a sepulchre incorporating an equestrian figure. What Trivulzio seems to have required was a free-standing tomb with a recumbent effigy under a Renaissance tabernacle, comparable to that which Lodovico il Moro had constructed twelve years

before for Gian Galeazzo Visconti at Pavia (plate 262). But since the artist was Leonardo this was a Lombard tomb with a difference, and we know from specifications by Leonardo himself that the superstructure was to be supported by columns with bronze capitals, that the sarcophagus was to rest on harpies, that there were to be reliefs (presumably of battle scenes as on the Visconti Monument), and that at the corners there were to be eight figures of captives crouching on the cornice or chained at the corners of the monument. We can get a clear impression of the project for this part of the monument from a drawing at Windsor (plate 197) on which three variants are shown. Trivulzio seems also to have had in mind another Lombard model, the fourteenth-century Scaliger tombs at Verona (Vol. I, plates 121, 122), where the tabernacles are surmounted by equestrian statues. The scheme of the Trivulzio tomb was from the first a strikingly unhappy one, and its single merit was that it enabled Leonardo once more to attack the problem of the equestrian statue.

The point from which he approached it was not, as we might expect, the concluding studies for the Sforza Monument, but the sketches for the first phase of the Sforza commission, that is for the equestrian monument with a rearing horse. The base of the Sforza Monument would naturally have been determined by the requirements of the horse, but the base of the Trivulzio Monument was the roof of the tomb, which in turn was related to the sarcophagus, so that the tendency throughout the Trivulzio studies is to abandon the

open pose projected for the Sforza statue, and to compress the whole design, with the horse's muzzle tightly reined in and the vanquished figure beneath the belly of the horse (plate 196). Events once more followed their wonted course, and the rearing horse was set aside, again in favour of a model based on the Regisole. A drawing at Windsor shows a classical riding figure, which may actually be the riding figure from the Regisole, on a horse that is also adapted from this monument. In this scheme one of the two rear legs was to be shown lifted off the ground, so that the horse rested on two legs. In practice this presented difficulties that were insoluble. At first Leonardo experimented with symbolical objects placed under the two raised legs; in one study these comprise a ewer and a tortoise, and in another a helmet. But the gain in the representation of movement through the two raised legs was neutralized by such expedients, and they were discarded in turn. There remained a further possibility, to combine features of both schemes. so that the horse was represented pulled back upon its haunches, about to charge, with head reined in and three feet firmly on the ground. This is the scheme that is worked out in what is probably the latest of the surviving drawings for the tomb.

Though they were not executed, the Sforza and Trivulzio Monuments are works of exceptional importance, in which the future of the equestrian statue is foretold. In a very real sense the history of the equestrian monument in the Renaissance is the whole history of the equestrian monument.

plate 196 Leonardo da Vinci

Studies for the Trivulzio Monument

Royal Library, Windsor Castle

plate 197 Leonardo da Vinci

Studies for the Trivulzio Monument

Royal Library, Windsor Castle plate 198 Antonio Federighi

St Ansanus

Loggia di S. Paolo, Siena marble

THE FACTORS WHICH LED to the emergence ▲ of Florentine Renaissance sculpture were not present in Siena. Two Sienese sculptors, Francesco di Valdambrino and Jacopo della Quercia, took part in the competition for the bronze door of the Baptistery in Florence, and two Florentine artists, Ghiberti and Donatello, were employed on the Sienese baptismal font (plates 30, 55, Vol I, plate 155), but these contacts were sterile and shortlived. When Quercia died in 1438, one of the projects on which he was engaged was the building of an open loggia, known as the Loggia di S. Paolo. Its outer faces contained niches destined for marble figures, and in planning them he and the city authorities must have had Or San Michele in mind. But neither the late Gothic tabernacles which Quercia designed, nor the statues of Sts Ansanus (plate 198), Victor and Savinus with which three of them were filled after 1451 by his pupil Antonio Federighi, have much in common with those on Or San Michele. In the interior of the loggia, however, are two marble seats, one carved in 1462 by a pupil of Donatello, Urbano da Cortona, and the other in 1464 by Federighi, and in the second of these, for the first time in Siena, a consistent effort is made to employ classical imagery, and to imitate Roman foliated carving. Federighi's slow assimilation of antiquity may be followed through two holy-water basins at the entrance to the Duomo and a baptismal font carved for the Cappella di S. Giovanni after 1482 (plate 199), where scenes from Genesis and from mythology are depicted in a hybrid style based in part on Quercia and in part on the antique.

Two of the tabernacles on the Loggia di San Paolo were filled with figures of Sts Peter and Paul (plate 201) by Lorenzo Vecchietta. In the company of Federighi's mannered statues, these saints impress us by their moral earnestness. Trained as a painter, Vecchietta, in the 1440s and 1450s, produced two powerful fresco cycles in the sacristy of Santa Maria della Scala and in the Baptistery. Beside these admirably realized works, his earliest recorded sculpture, a wooden figure of the Risen Christ carved for the Duomo in 1442, seems tentative and inarticulate. And inarticulate his sculptures almost certainly would have remained, had it not been for the fortunate contingency of Donatello's presence in Siena. In October 1457 there arrived in Siena a bronze statue of St John the Baptist (plate 39), which must have been commissioned from Donatello some years previously, and a week before it was delivered the Balia was informed that Donatello wished to settle in the city 'per lo tempo della vita sua', and to undertake work for the Cathedral. A committee of three persons was appointed to decide how the great sculptor could be most usefully employed, and through the autumn and early winter of 1457 he seems to have worked on a project for the decoration of the chapel of the Madonna delle Grazie, for which he designed, and in part executed, a circular relief of the Virgin and Child formerly over the Porta del Perdono of the Cathedral (plate 67). In December, however, this work was superseded by a commission for bronze doors for the Cathedral. Through 1458 and 1459 Donatello (who had been allotted the same studio
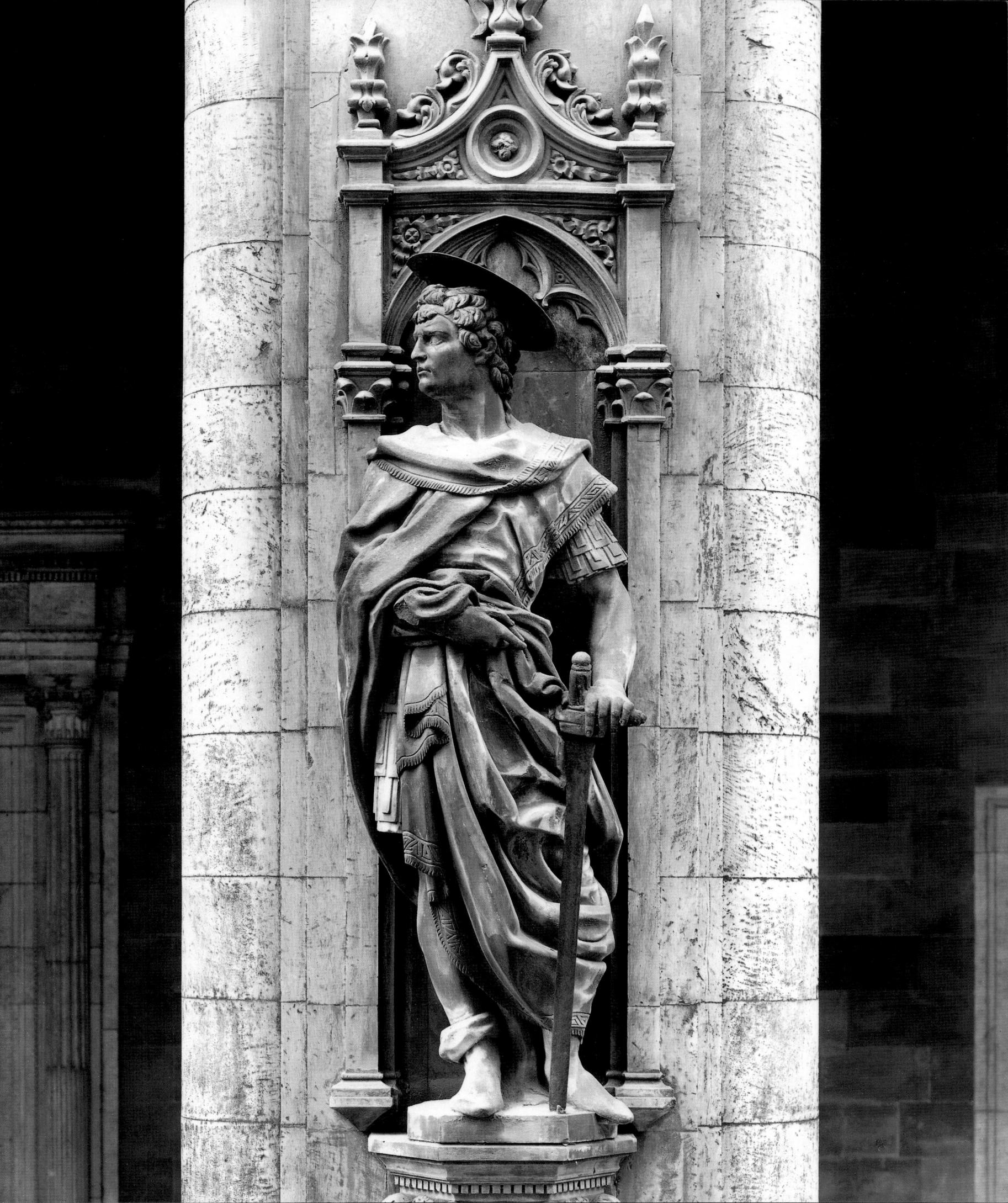

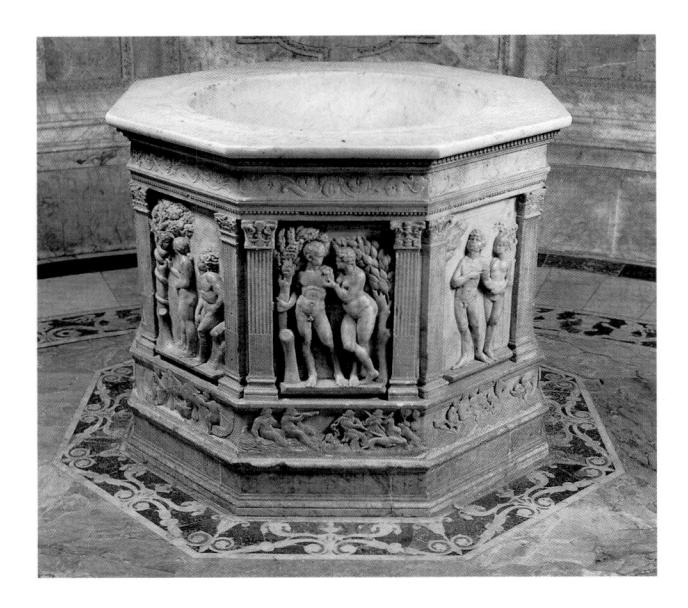

plate 199 Antonio Federighi

Baptismal Font

Duomo, Siena marble, each panel 50 × 45 cm

plate 200 Vecchietta

Flagellation

Victoria and Albert Museum, London bronze, 23.5 × 28.6 cm

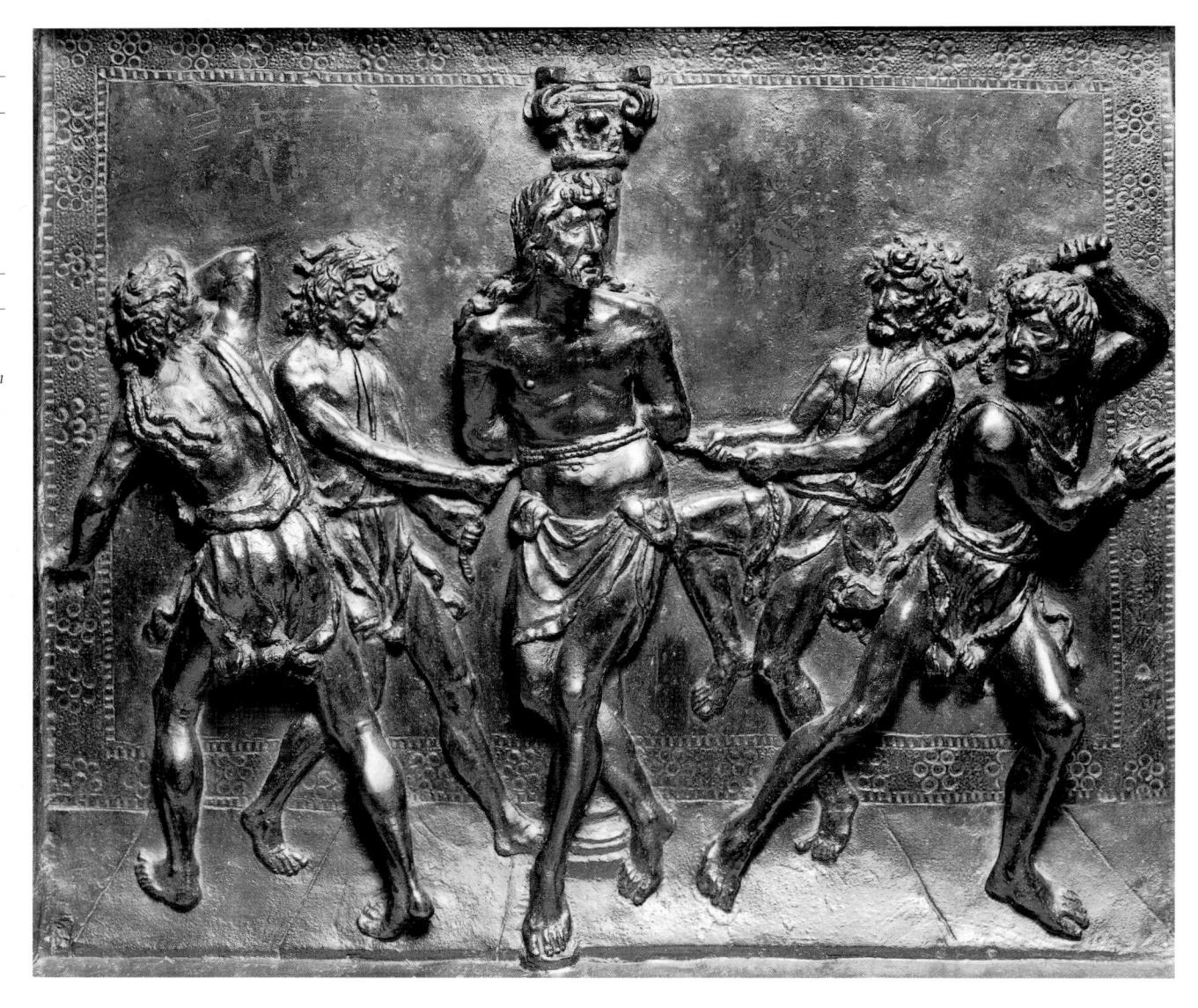

plate 201 Vecchietta

St Paul

Loggia di S. Paolo, Siena *marble*

in which Quercia had carved the Fonte Gaia (Vol. I, plate 172) continued work, planning the framework of the doors and making wax and bronze models for the reliefs. At the same time he entertained a plan for a marble statue of S. Bernardino. The last reference to Donatello in Siena occurs in March 1461. When he left the city, the project for the Cathedral doors was in abeyance, the plan for the statue of St Bernardino (plate 204) had been abandoned, and the bronze St John the Baptist was still disassembled in a room under the Cathedral. But though the tangible results of his years in Siena were scanty, they brought about a fundamental change in the outlook of Vecchietta, and through Vecchietta in that of his pupil, Francesco di Giorgio.

The figures contributed by Federighi to the Loggia di S. Paolo stem from the late work of Quercia; in the St Victor the head is shown in profile, as it is in Quercia's prophets on the Baptismal Font, while the St Ansanus (plate 198) is swathed in the full drapery with rounded folds that is employed by Quercia on the Trenta Altar and in the Bologna tympanum (Vol. I, plates 176, 180). Vecchietta's Sts Peter and Paul (plate 201), on the other hand, have their source in the Campanile statues of Donatello. Still more important for Vecchietta was Donatello's work in bronze. In the 1460s, not long after Donatello left Siena, he cast two bronze sepulchral effigies planned in the spirit of the Coscia effigy of Donatello, and at the same time he experimented with the making of bronze reliefs. In the earliest of these, a Flagellation (plate 200) in the Victoria and Albert Museum, London,

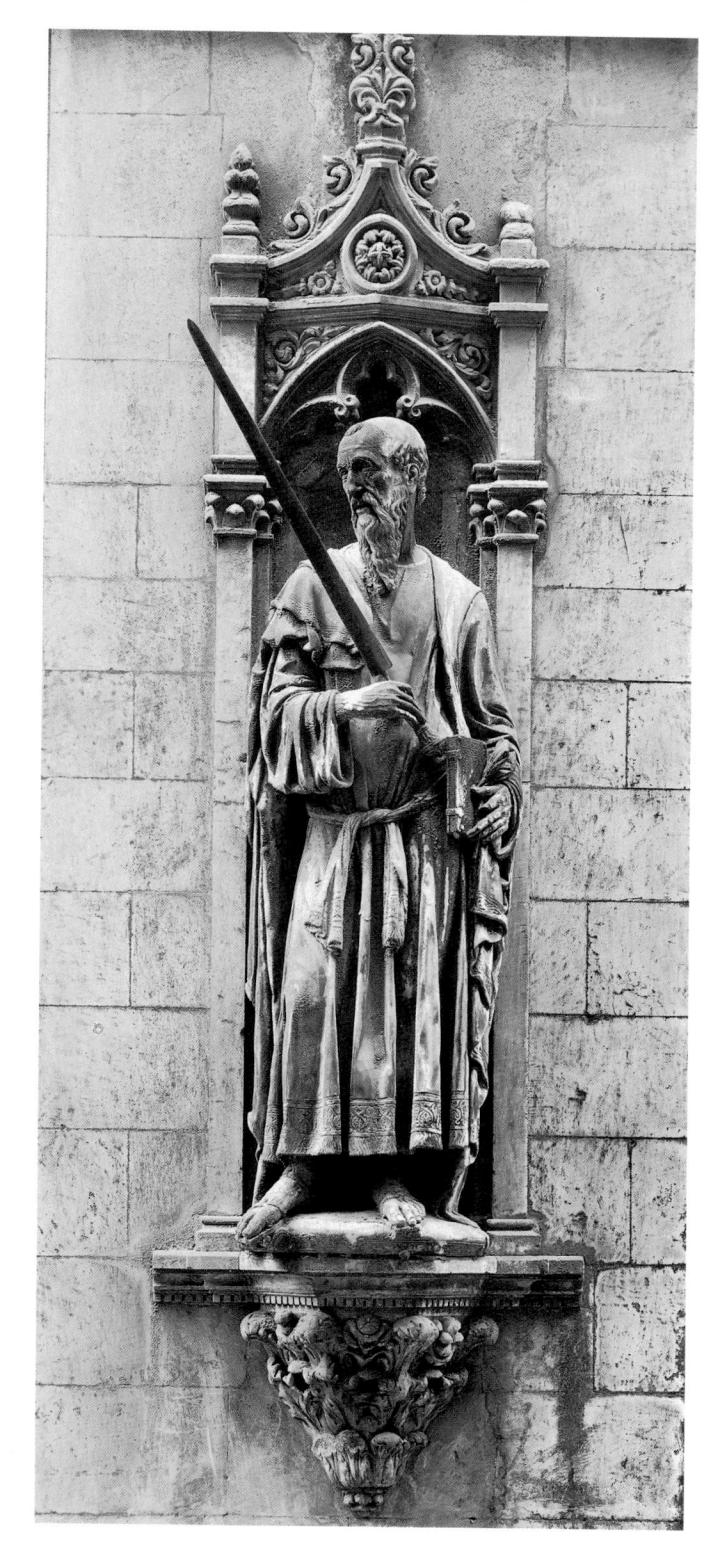

plate 202 Vecchietta

The Resurrection

Frick Collection, New York bronze, 54.3×41.2 cm

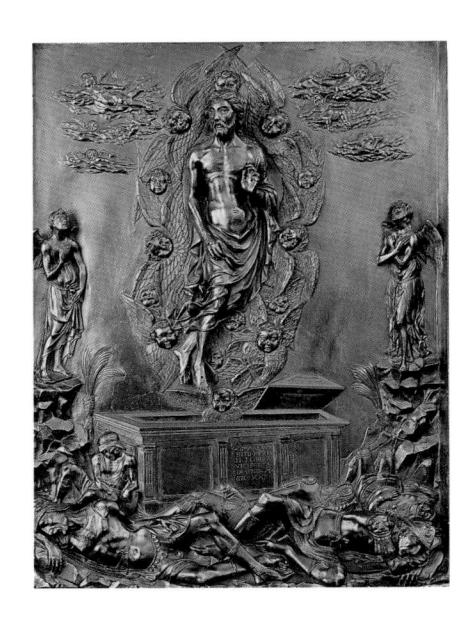

the figures of Christ and the two executioners derive from Donatello, while the spatial scheme, with a shallow receding pavement and a strip of decoration round three sides of the relief, is of a type familiar from the paintings of Matteo di Giovanni. Similarly the Christ rising from the tomb in a relief of the Resurrection of 1472 (plate 202) in the Frick Collection in New York is a compulsive image, which is not unworthy of the Passion scenes in S. Lorenzo. Yet even in this relief Vecchietta remains resolutely Sienese, setting no store by perspective or consistency of scale, and devising an irrational composition which has more in common with the Gothic predella panels of Giovanni di Paolo than with the reliefs of Donatello.

Ten years after Donatello's death, and fifteen vears after his last visit to Siena, his shadow once more falls across Vecchietta's work, in a life-size statue of the Risen Christ completed in 1476 for S. Maria della Scala (plate 203). The Christ must have been inspired in the first instance by the bronze Baptist of Donatello, but its design also implies a knowledge of other works. The arms are not set against the body, like those of the Baptist, but are extended so that a diagonal is formed between the left elbow and right hand, a device used in the bronze David in Florence (plate 33). Moreover, the right hand is extended in a pathetic gesture which again has a precedent in Donatello in the Sts Daniel and Giustina at Padua (plates 23, 25). What Vecchietta achieves, however, is more than a mere synthesis of second-hand motifs, for the imaginative processes which underlie the

statue run parallel to those of Donatello, and the image is instilled with an intensity of feeling of which no other sculptor of the time was capable.

Not only did Donatello's sculptures in bronze and marble exercise an influence in Siena, but his wood sculptures too. In Florence the asperities of the wooden Magdalen in the Baptistery (plate 40) were smoothed out by Desiderio in a statue of the Magdalen in S. Trinita (plate 117). In Siena, on the other hand, its spirit lingered on, in the wood sculptures carved by Vecchietta for Narni in 1475, in a statue of St John the Baptist (plate 206) carved by Francesco di Giorgio for the Compagnia di S. Giovanni Battista della Morte in 1464, and in the extraordinary figure of St Bernardino by Francesco di Giorgio's associate, Neroccio de' Landi, at Borgo a Mozzano (plate 204). The greatest of these wood-carvings, a statue of St Catherine of Siena commissioned from Neroccio in 1470 for the oratory of the Saint (plate 205), once more pays tribute to the all-pervasive influence of Donatello in drapery which reproduces the broken planes of modelled sculpture. An inventory made of Neroccio's studio in 1500 lists a gesso Virgin and Child by Donatello, and in Siena Donatello's reliefs must have enjoyed considerable popularity both at first hand and through derivatives like those of the socalled Piccolomini Master (who carved a number of reliefs based on a composition by Donatello) and of Urbano da Cortona (who turned out in Siena a number of stucco reliefs of the Holv Family with which Donatello was at one time credited). On the marble sculptures of Neroccio,

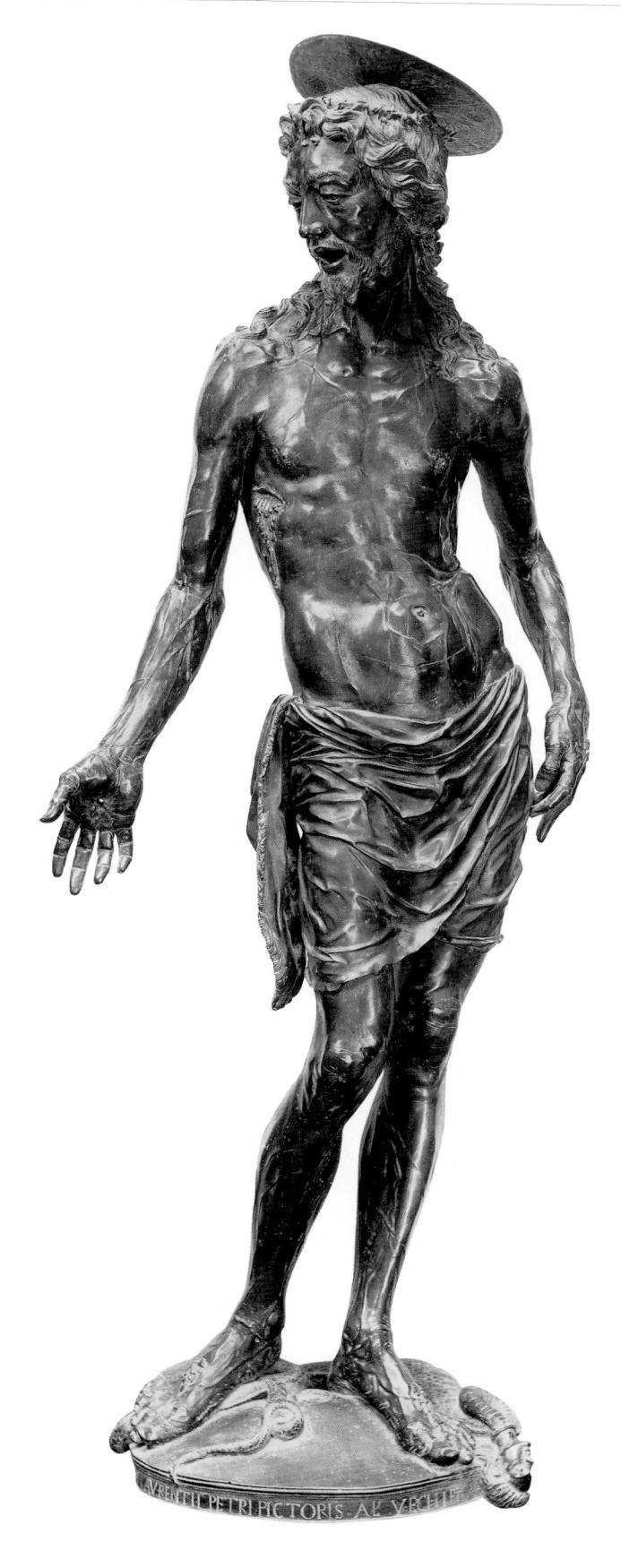

plate 203 Vecchietta

The Risen Christ

S. Maria della Scala, Siena bronze, height 183 cm

plate 204 Neroccio de' Landi

St Bernardino

S. Jacopo, Borgo a Mozzano pigmented wood, height 170 cm however, the personality of Donatello left no mark at all, and their style oscillates between the poles of Mino da Fiesole (in the Piccolomini monument in the Duomo at Siena) and of Matteo Civitali (in a documented statue of St Catherine of Alexandria, also in the Cathedral).

Francesco di Giorgio, with whom Neroccio shared a studio for upwards of ten years, was a less restricted artist. A painter, architect and military engineer, he was employed for long periods outside Siena, and his bronze reliefs have been ascribed to Leonardo da Vinci, Bertoldo and Antonio Pollaiuolo. Minor works apart, they are three in number, a Lamentation over the Dead Christ in the Carmini in Venice, a Flagellation at Perugia, and a relief of Lycurgus and the Maenads. of which the bronze original is lost but which is recorded in two stucco casts. The first of these reliefs was made about 1476 for the Oratorio di S. Croce at Urbino, and the third seems also to have been executed during the sculptor's long residence at the Montefeltro court. Midway between the two stands the Perugia Flagellation (plate 207), where the sophisticated architectural forms used in the background look forward to the Lycurgus and the Maenads and the expressive iconography looks back to the Lamentation over the Dead Christ. At first sight the change from the relief style of Vecchietta appears very marked. In Vecchietta's Flagellation the scene is set on a shallow strip of pavement before a neutral ground. In Francesco di Giorgio's, on the other hand, it takes place on a platform in the middle distance behind a foreground filled with figures. Technically, Francesco di Giorgio is by far the

more accomplished artist. Where Vecchietta's figures are uniform in emphasis, Francesco's vary from barely indicated profiles in the lowest possible relief to fully modelled statuettes. Yet different as is their form, Francesco di Giorgio's and Vecchietta's reliefs are emotionally linked, and the iconography of the Perugia Flagellation, with the Virgin in the foreground pointing towards the suffering Christ and St John with eyes averted from the scene, unmistakably belongs with that of Vecchietta's Risen Christ (plate 202).

The ingredients Francesco added to the relief style of Vecchietta were first a logical representational technique, second a grasp of movement, and third a sense of atmosphere. These qualities he carried on into the two bronze angels on the high altar of Siena Cathedral (plates 208, 209), which he completed in 1492. Here, too, he followed where Vecchietta led, and the nervous drapery of the angels is closely reminiscent of the loin-cloth of the Risen Christ. But where the Risen Christ is set firmly on the ground, the two angels seem to have settled only a moment earlier on the plinths on which they rest. All sense of weight is dispelled by their deceptive buoyancy. Though the heads of the two angels are Verrocchiesque, their wind-blown drapery advances beyond Verrocchio. Francesco di Giorgio had, in fact, been in touch in Milan with Leonardo, and it may well be that just as Donatello found in Vecchietta a sculptor more responsive to the implications of his late style than any member of his studio in Florence, so Leonardo discovered in Vecchietta's pupil an intermediary through whom some facets of his own conception of the art of sculpture could be communicated.

plate 205 Neroccio de' Landi

St Catherine of Siena

S. Caterina, Siena pigmented wood, height 198 cm

plate 206 Francesco di Giorgio

St John the Baptist

Museo dell' Opera del Duomo, Siena pigmented wood, height 185 cm

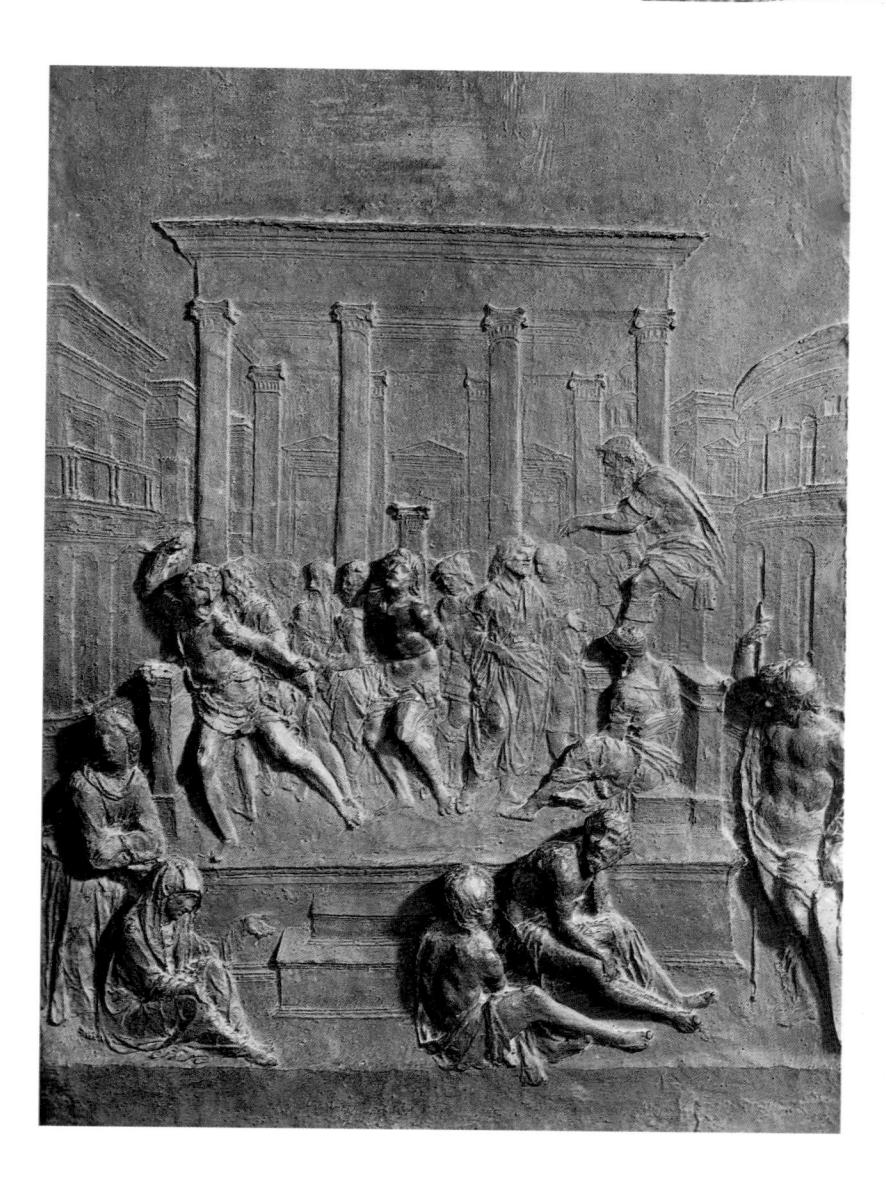

plate 207 *(left)* Francesco di Giorgio

The Flagellation of Christ

Pinacoteca Nazionale dell'Umbria, Perugia

bronze, 56×41 cm

plate 208 *(above left)* Francesco di Giorgio

Angel

Duomo, Siena bronze, height 125 cm

plate 209 *(above right)* Francesco di Giorgio

Head of an Angel

Duomo, Siena (detail of plate 208)

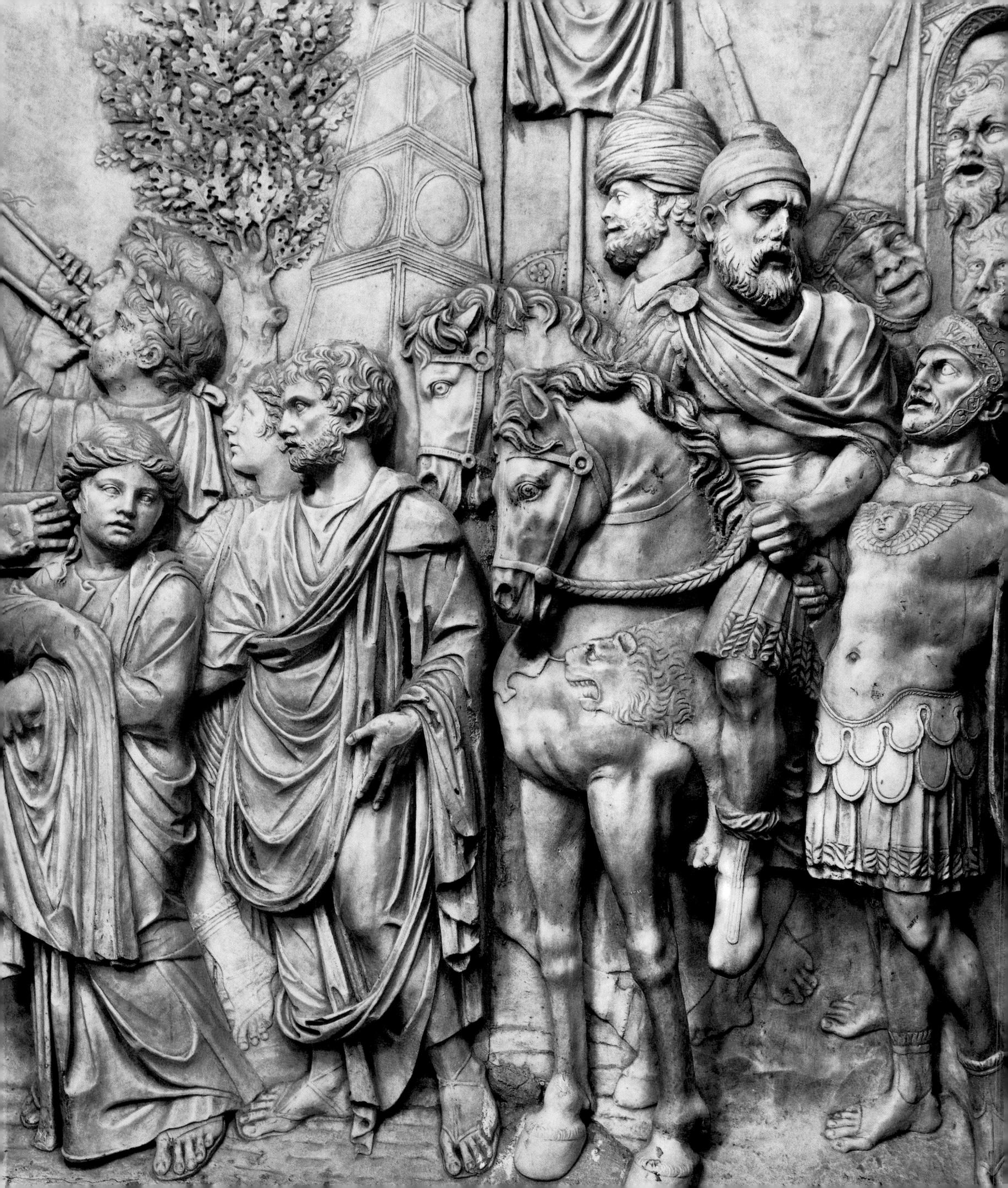

Whereas the principal Roman pictorial commissions of the fifteenth century were awarded to masters from Florence and Umbria and the Romagna, the equivalent sculptural commissions went to artists who had adopted Rome as their main scene of activity. The first and greatest of the sculptors who were employed there, Donatello, was, however, an exception to this rule. Donatello executed two works for Rome, the marble tomb-slab of Giovanni Crivelli (d. 1432) in S. Maria in Aracoeli, and the tabernacle now in St Peter's (plate 96). Logically the tabernacle and the tomb-slabs should have inspired a host of inferior illusionistic works, but in practice they were never imitated.

Roman neglect of Donatello seems to have arisen from a positive repugnance to illusionistic art. In the intellectual climate of the papal court the sculpture of the Florentine Renaissance was an alien phenomenon. Sculptors and their patrons were in continuous contact with the Roman past, and were imbued with a narrow, academic attitude to the antique. In place of a living interest in its spirit, they pursued an arid study of its form. The bronze doors of St Peter's by Filarete (plate 211) were inspired by the classical doors of the Pantheon and S. Adriano, and were filled with classical detail; the Virtues of Isaia da Pisa's Chiaves monument (plate 213) were based on classical reliefs; and the narrative reliefs of the Confessional of Sixtus IV (plate 210) contained figures imitated from Trajan's Column. To Porcellio, when he likened Isaia da Pisa to Phidias and Praxiteles, and to the writer of a funerary

epitaph which compared Andrea Bregno with Polyclitus, it seemed that in Rome in the fifteenth century the great masters of antiquity had been reborn.

The first work in which a Roman style is evident is the bronze door cast by Filarete for St Peter's between 1433 and 1445 (plate 211). A Florentine by birth, Filarete seems to have been a member of Ghiberti's studio while work was in progress on the first bronze door, but in the bronze door of St Peter's there is a little that is Florentine and nothing that is Ghibertesque. Each of its wings consists of three rectangular reliefs of equal width and varying height. At the top are the Salvator Mundi and the Virgin, beneath are Sts Peter and Paul (plate 212), and at the bottom are scenes with the martyrdoms of the two Saints. The attempt of Pope Eugenius IV to reunite the Eastern and the Western Churches is commemorated on horizontal strips between the main reliefs. Filarete was an obtuse artist, and neither in design nor execution can his door compare with the Porta del Paradiso of Ghiberti or with Donatello's doors in the Old Sacristy of S. Lorenzo (plate 50), which were made in the same term of years. In a revealing passage in his Trattato d'architettura he expresses disapproval of Donatello's doors. 'If you have to make Apostles,' he writes, 'do not make them look like fencers, as Donatello did in S. Lorenzo in Florence, that is in the Sacristy in the two doors of bronze.' Filarete practised what he preached, and the Apostles on his own door are represented in static poses, with rigid drapery which must have been suggested by

plate 210 Roman, c.1480

The Crucifixion of St Peter

Grotte Vaticane, Rome marble

Early Christian ivories. Not only are the main figures depicted in a hieratic style derived from late antique reliefs, but the acanthus borders of the wings are crammed with figures from mythology, while classical architectural motifs lend a suspicion of coherence to the dishevelled narrative reliefs. As we see it now, it is difficult to understand the sculptor's boastful references to his own door, but in the fifteenth century, when the gilding described by Flavio Biondo was still fresh and the enamelled decoration was complete, it was a living reminder to visitors to the basilica that the imperial capital and the centre of the Christian world were one.

The style adopted for the bronze door was carried over into marble sculpture in a figure of St Mark over the entrance to S. Marco, which has been inconclusively ascribed to Filarete, and in the Chiaves Monument in St John Lateran (plate 213), which seems to have been commissioned from Filarete in 1447, and of which the surviving parts were carried out by Isaia da Pisa after Filarete had fled from Rome. The most striking example of this distinctly Roman style in marble occurs in a relief of the Virgin and Child with Angels between Sts Peter and Paul (plate 214), which was carved about 1450 for the Chapel of S. Biagio in St Peter's, and is now in the Grotte Vaticane. In this the main figures are carved in great depth and are clothed in classicizing drapery. Both in the Apostles and in the Pope and donor at the Virgin's feet the sculptor deliberately eschews all realistic emphasis. Isaia da Pisa lived on till 1464, and in the reign of Pius II his hand appears again in the disassembled Tabernacle of St Andrew (1462-3) in the Grotte

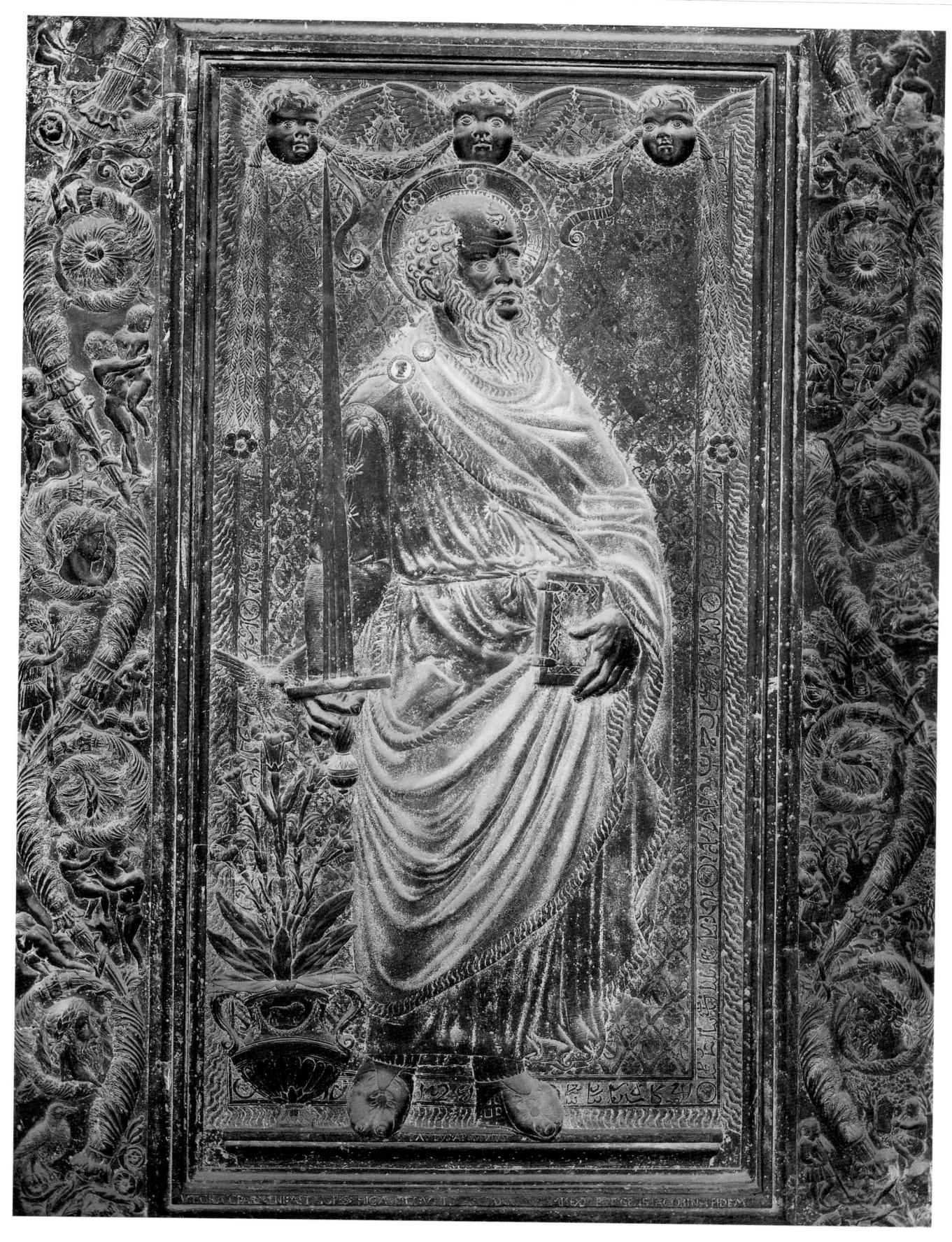

plate 211 (opposite) Filarete

Bronze Door

St Peter's, Rome

plate 212 Filarete

St Paul

St Peter's, Rome (detail of plate 211) bronze with enamelled ornament

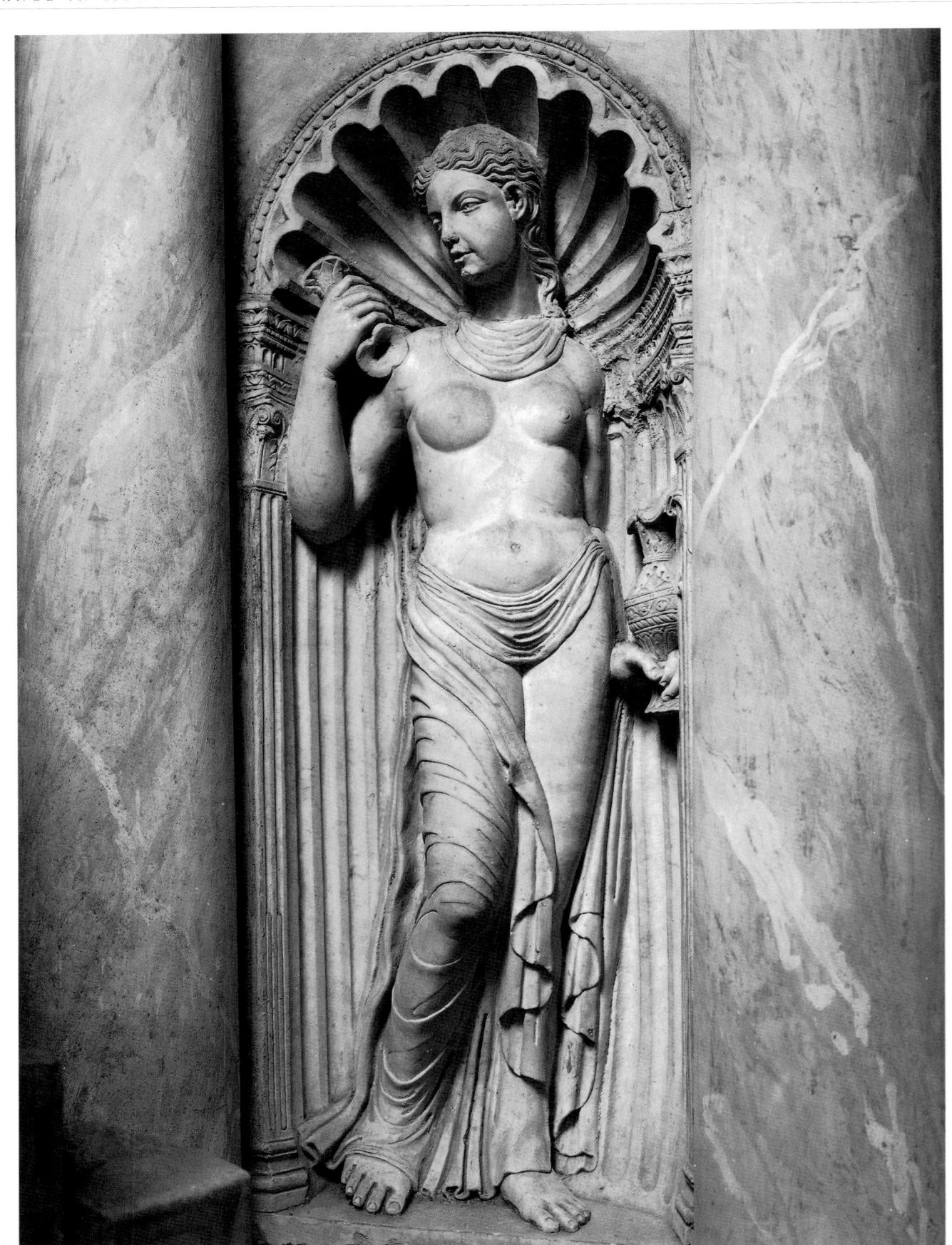

plate 213 Isaia da Pisa

Temperance

St John Lateran, Rome marble

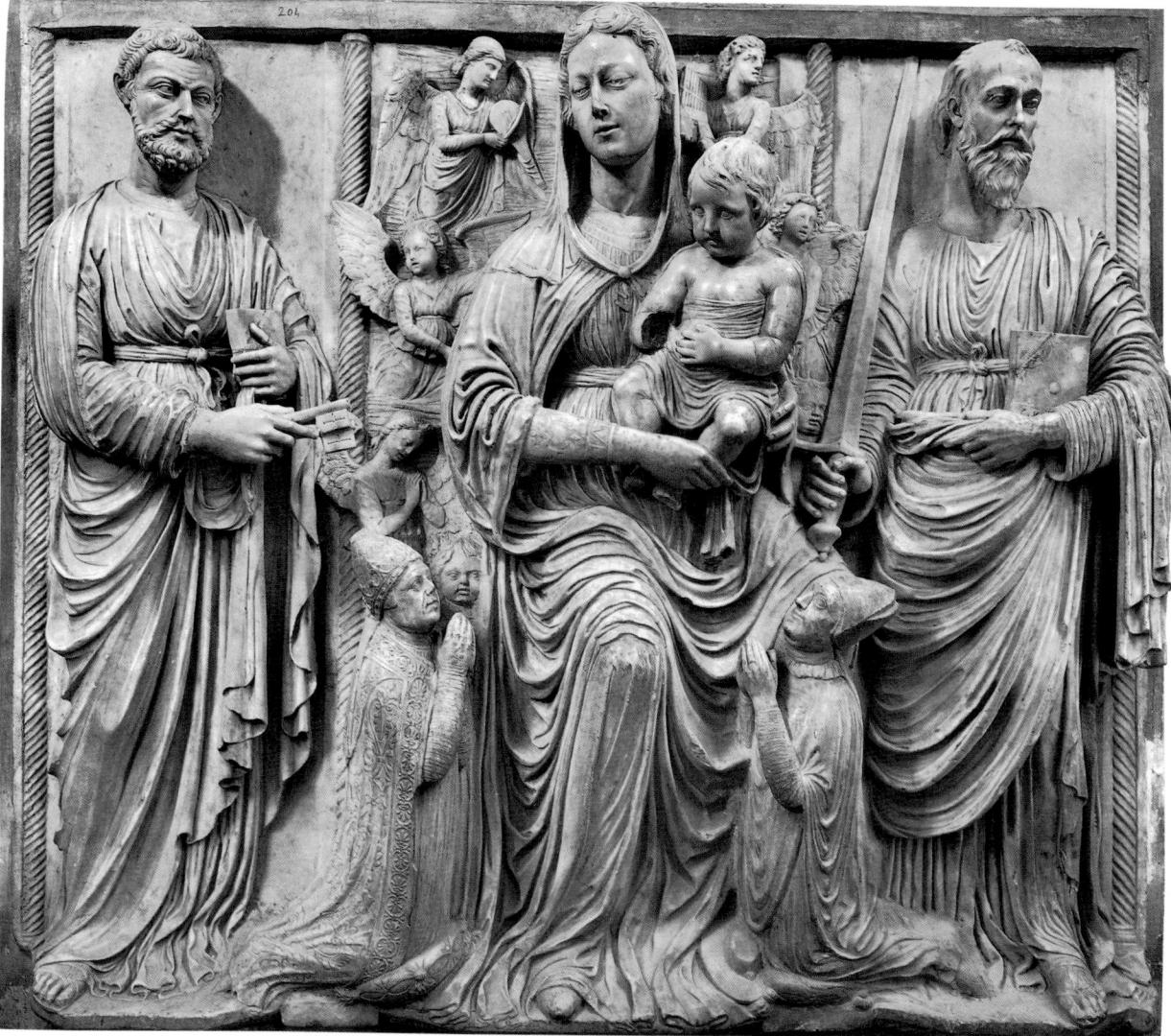

plate 214 (left) Isaia da Pisa

Virgin and Child with Sts Peter and Paul

Grotte Vaticane, Rome marble

plate 215 (above) Giovanni Dalmata and Mino da Fiesole

Engraving after The Monument of Pope Paul II

St Peter's, Rome (formerly)

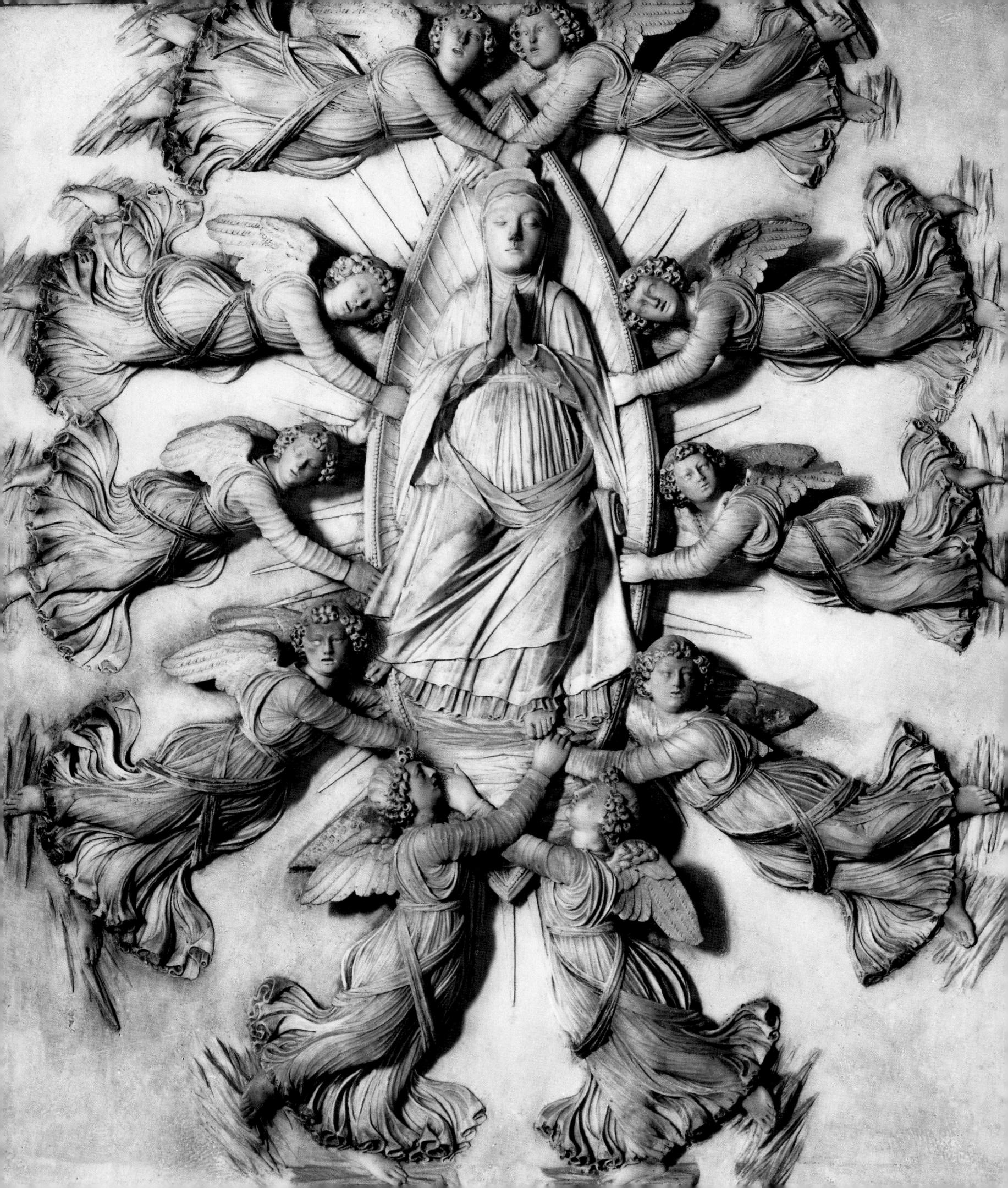

plate 216 *(opposite)* Mino da Fiesole

The Assumption of the Virgin

S. Maria Maggiore, Rome marble

plate 217 Giovanni Dalmata

The Creation of Eve

Grotte Vaticane, Rome marble

Vaticane, where he collaborated with a younger artist, Paolo Romano, who for a time enjoyed great popularity. A third sculptor active in Rome about this time was the Florentine, Mino da Fiesole. Mino had worked in Rome for a short time in 1454; he returned there at the end of the 1450s remaining in the city till 1464. His most considerable commission from this period was the ciborium of Cardinal d'Estouteville in Santa Maria Maggiore. The four faces of the upper part of the ciborium were filled with oblong narrative reliefs which are now preserved in the choir of the church. The classical idiom indiginous to Roman sculpture was, however, at variance with Mino's facile style; rather than be seduced by the naturalism of antiquity he succumbed to its pattern-making aspects. Just as Filarete's static doors for St Peter's are a negation of Donatello's Doors in S. Lorenzo, so Mino's Assumption (plate 216), with its doll-like Virgin in a narrow mandorla supported by ten Angels with vacant faces and splayed skirts, is a negation of the Assumption carved by Donatello for the Brancacci monument (plate 44).

In the 1470s Mino returned to Rome once more. His most important work in this period, the tomb of Paul II, was carried out in conjunction with a Dalmatian sculptor, Giovanni Dalmata. The monument has been dismembered, but from an engraving (plate 215) it is known that it had the form of a triumphal arch. Probably designed by Dalmata, not Mino da Fiesole, it contained an unprecedented quantity of figure sculpture, a lunette of the Last Judgement by Mino, a relief of

God the Father and Angels by Dalmata, a large relief of the Resurrection by Dalmata behind the effigy (also by Dalmata), a number of reliefs of Angels executed by both sculptors, statuettes of four Apostles at the sides (two by Mino and two by Dalmata), figures of Faith and Charity by Mino and Hope by Dalmata, reliefs of the Creation of Eve by Dalmata (plate 217) and the Fall by Mino, and a frieze of putti and garlands carved in part by one and in part by the other artist. This haphazard system of collaboration would have been defensible if the styles of the two sculptors had been congruent, but the carvings undertaken by Mino for the tomb are delicate and stereotyped, while those of Dalmata evince, beneath their swollen forms, a crude feeling for plasticity.

In the sarcophagus of the Riario monument in the SS. Apostoli (plates 218, 219) Mino is found working alongside a more distinguished artist, Andrea Bregno. Bregno's earliest works betray his Lombard origin, but in Rome his style rapidly became more classical, his designs grew tighter and more compact, and he acquired a machine-like precision of technique which in decorative carving stood him in good stead. An abnormally prolific artist, he filled the Roman churches with altars and wall monuments, and we need look no further than the exquisitely carved reliefs of lilies on the Borgia altar (plate 220) in S. Maria del Popolo (1473) or the foliated panels on the tabernacle in the Madonna della Quercia outside Viterbo (1490) to understand his popularity. The demand for works from Bregno's studio spread even to Siena, where the Piccolomini Altar in the

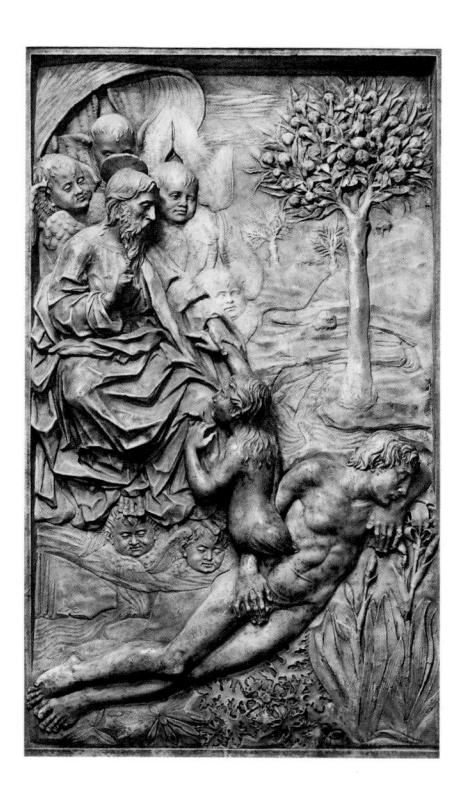

plate 218 Andrea Bregno and Mino da Fiesole

Tomb of Cardinal Pietro Riario

SS. Apostoli, Rome (detail of plate 219)

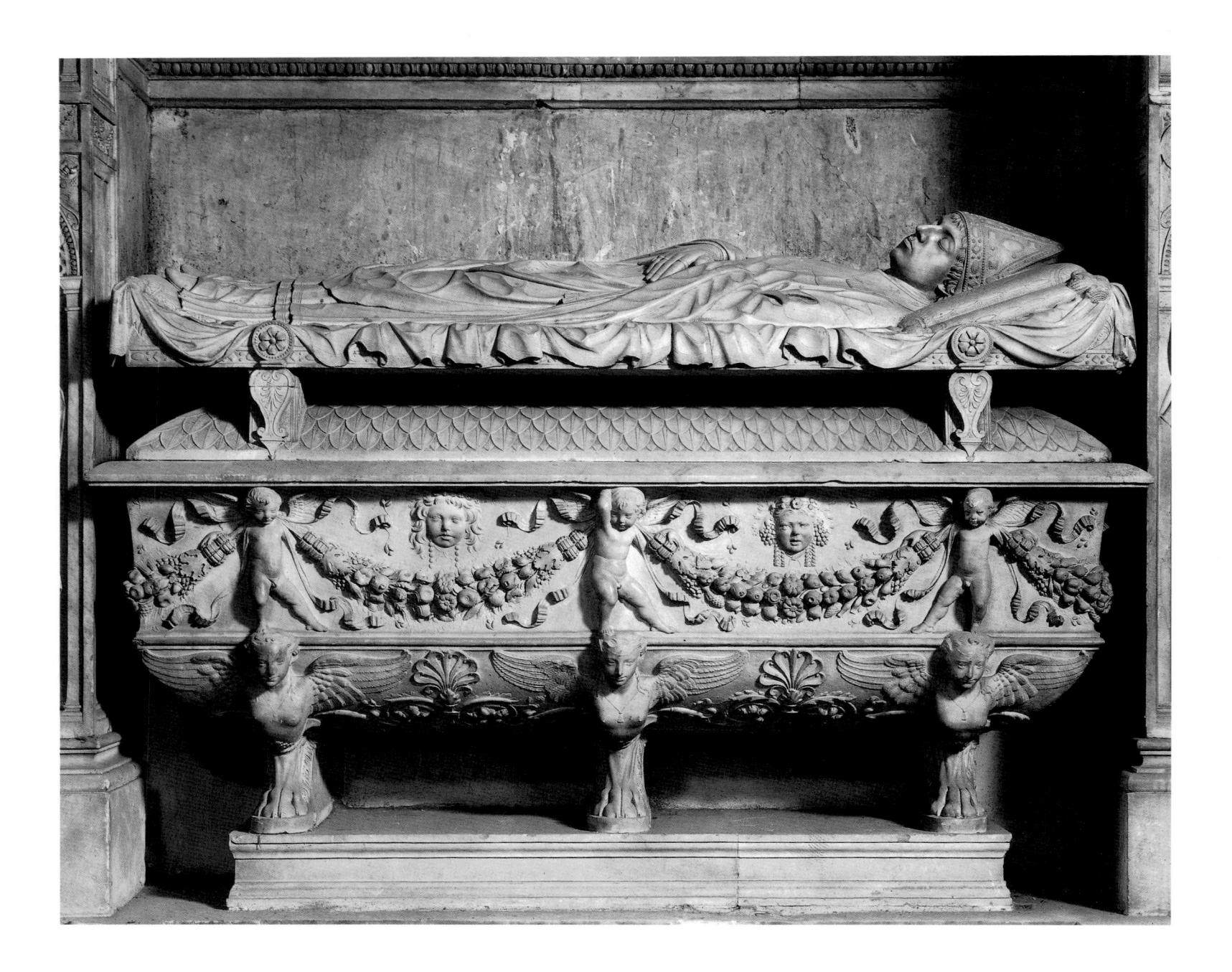

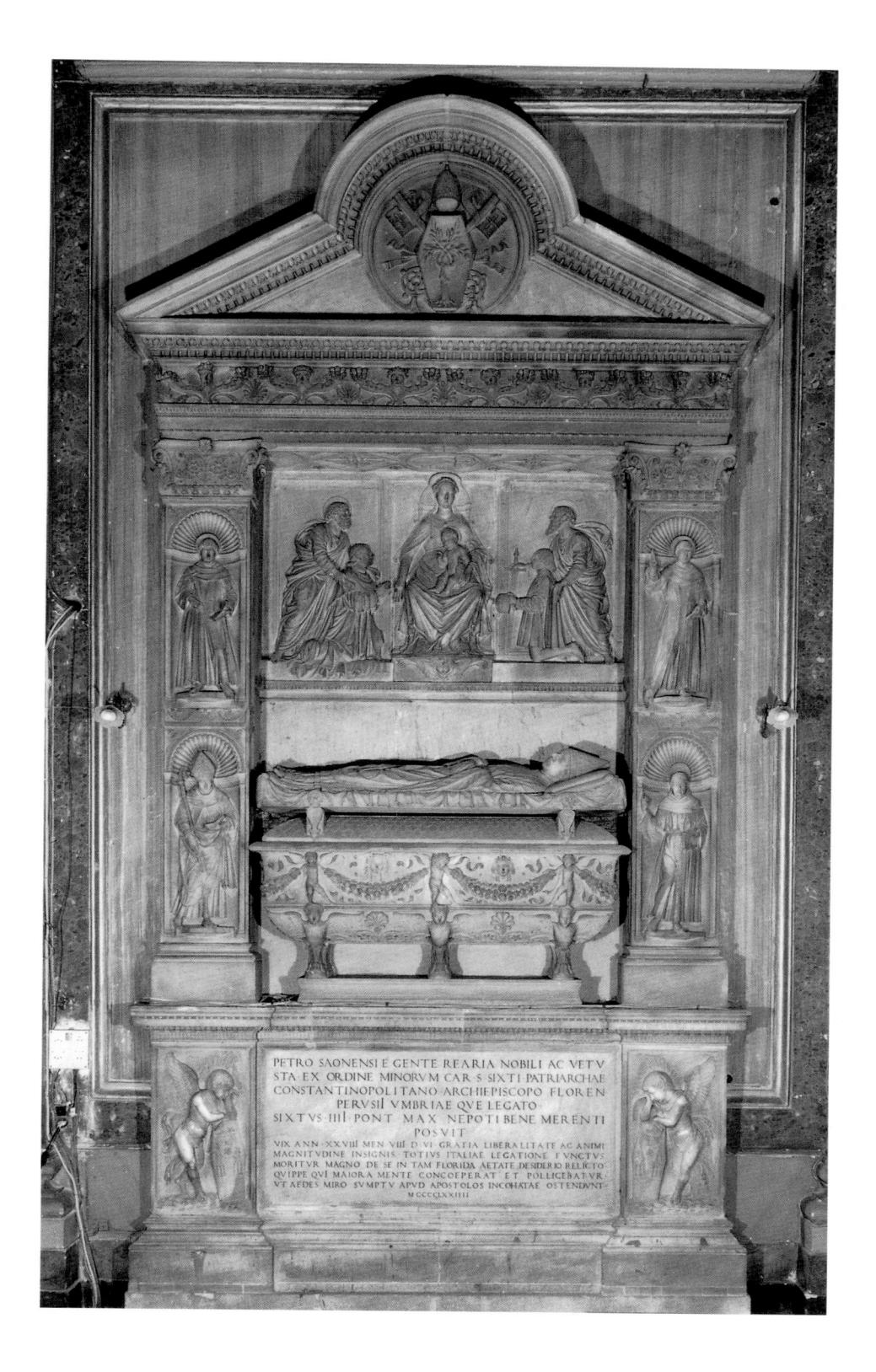

plate 219 Andrea Bregno with Mino da Fiesole and Giovanni Dalmata

The Tomb of Cardinal Pietro Riario

SS. Apostoli, Rome marble

plate 220 Andrea Bregno

Borgia Altar detail showing reliefs of lilies

S. Maria del Popolo, Rome *marble*

plate 221 (opposite) Francesco Laurana (?)

Alphonso of Aragon and his Court

Castelnuovo, Naples marble (detail of plate 222)

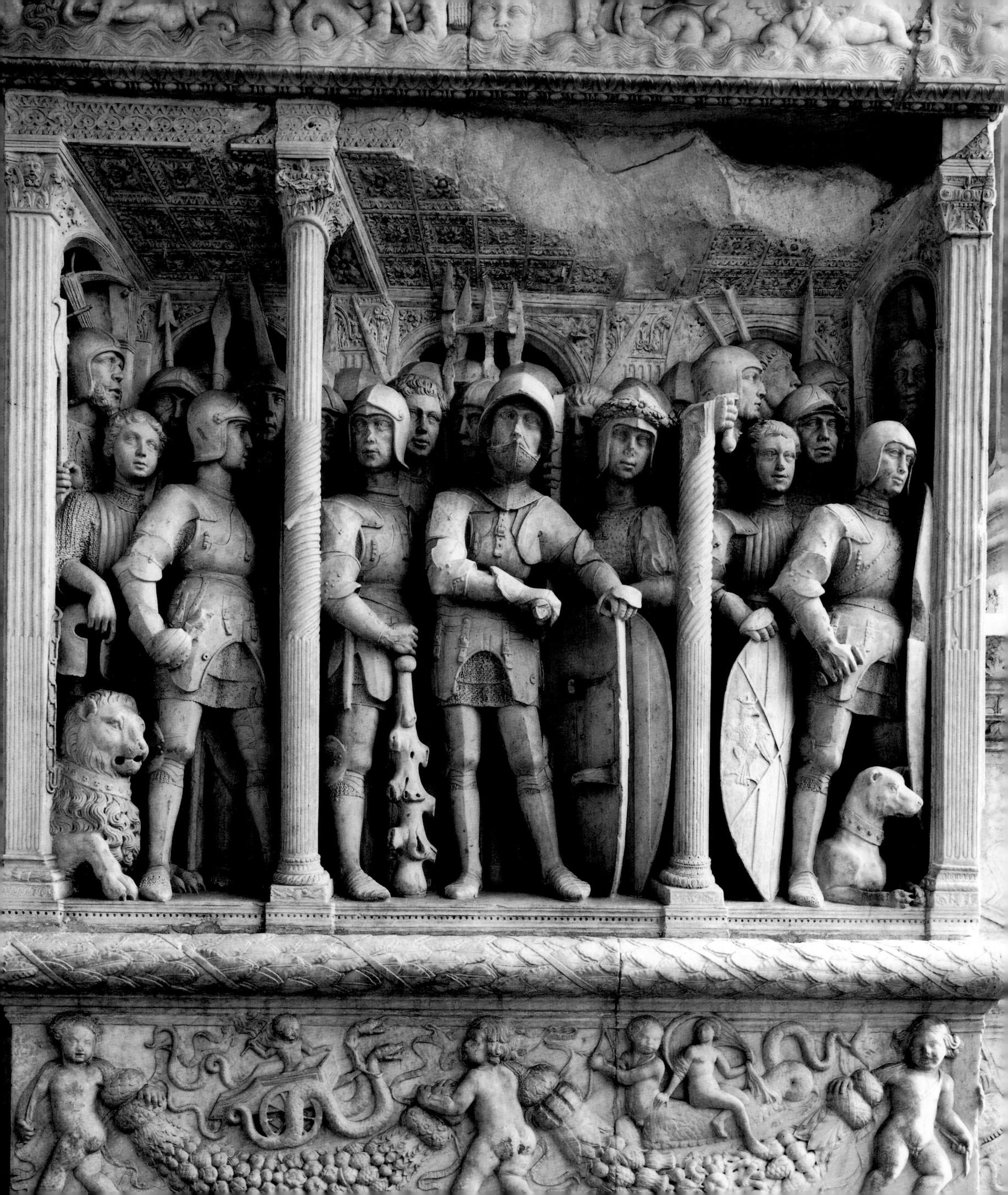

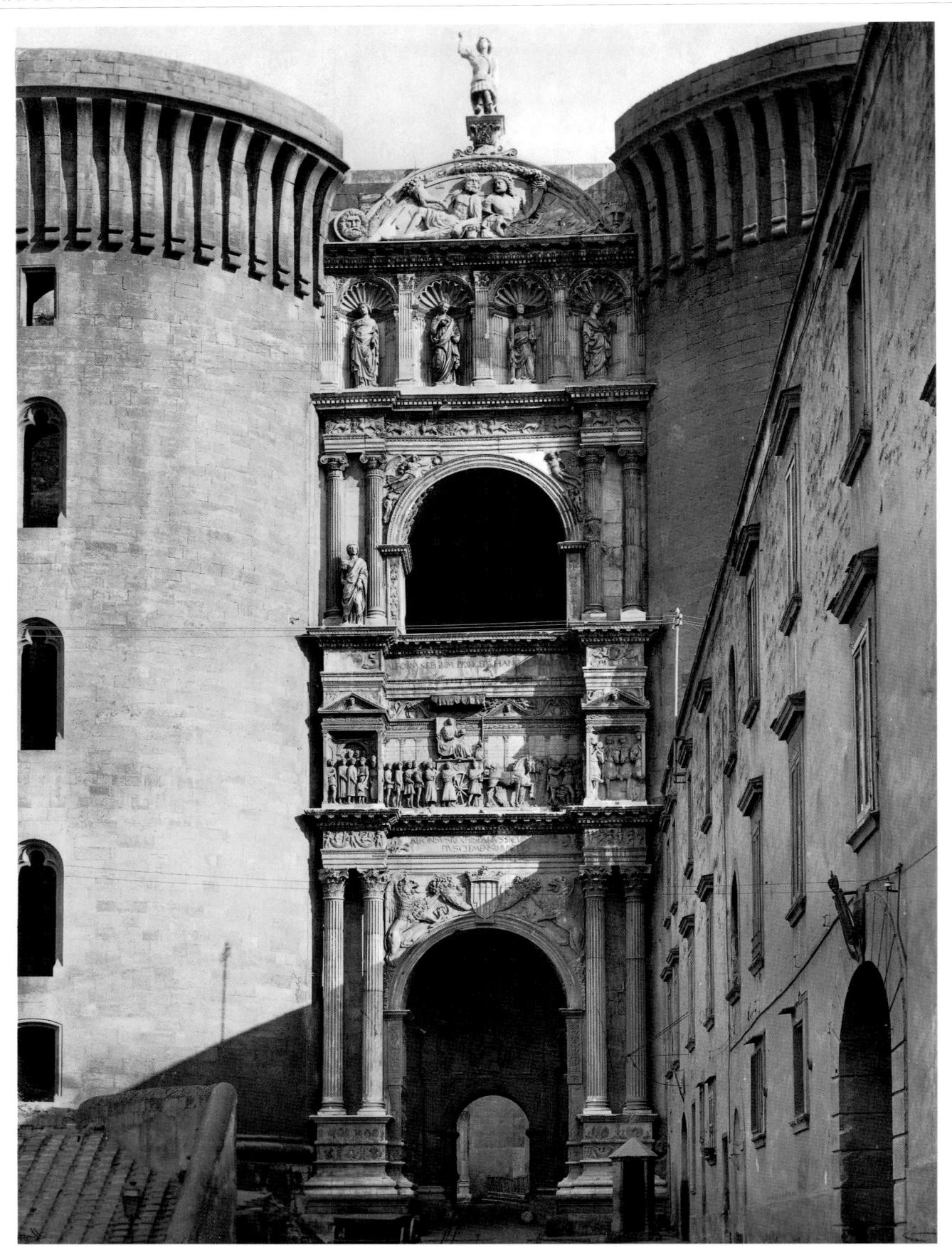

plate 222

The Gateway of the Castelnuovo

Naples

Cathedral (1481-5) included a reproduction of the Borgia altarpiece; and his style was eventually carried to North Italy through the agency of a more lively and more richly gifted artist, Gian Cristoforo Romano, who moved from Rome to Ferrara, executed the Visconti Monument in the Certosa at Pavia, and later joined the sculptors employed by Isabella d'Este at Mantua.

Two leading Roman sculptors, Isaia da Pisa and Paolo Romano, also worked at Naples on the most ambitious sculptural complex in Southern Italy, the triumphal arch at the entrance to the Castelnuovo (plate 222). The history of this project goes back to 1443, when Alfonso of Aragon, who had won control of Naples a year earlier, made a ceremonial entry into his capital, and a wooden triumphal arch was erected in the Piazza del Mercato. Later a plan was mooted for a marble triumphal arch near the Cathedral, and in 1452, when the towers flanking the entrance to the fortress of the Castelnuovo were completed, this scheme was once again revived, this time in the form not of a free-standing arch, but of a gigantic doorway giving access to the castle. The building of the arch continued till Alfonso's death in 1458, was resumed by his son Ferrante in 1465, and was completed in 1466.

Between 1447 and 1454 the artistic scene in Naples was dominated by the medallist and painter Pisanello, and there exists a drawing (plate 223) ascribed to Pisanello which contains what is apparently an early project for the triumphal arch. In this drawing (which reflects the preconceptions of the Catalan architect Sagrera) the entrance is represented as a Gothic doorway flanked by

plate 223 ascribed to Pisanello

Drawing for the Gateway of the Castelnuovo

Museum Boymansvan Beuningen, Rotterdam twisted columns. Above it is a central feature not unlike that ultimately executed, and above this again are Gothic niches filled with statues, with a row of Gothic finials or windows at the extreme top. To a ruler with Alfonso's humanistic tastes this scheme must have appeared thoroughly unsatisfactory, and the arch that he eventually sanctioned belonged, in design as well as in detail, to the Renaissance. Its lowest order is based on the Arch of the Sergii at Pola; above this is a relief showing the triumph of Alfonso; and above this again is a second arch, which was originally designed to house a figure of the king in majesty or an equestrian statue. Higher still are four niches with statues of the Virtues, and at the top St Michael (at one time accompanied by Sts George and Anthony the Abbot) presides over a relief carved with two river gods. Inside the arch are two reliefs showing the King and his court departing for and returning from a victorious exploit (plate 221).

The first artist mentioned in connection with the arch is Pietro da Milano, who was summoned to Naples from Ragusa in 1452. He arrived there a year later, and was rapidly followed by Francesco Laurana, from Zara, and by Paolo Romano. In 1455 Isaia da Pisa began work in Naples, and so did a pupil of Donatello, Andrea dell'Aquila. Two years later there appears the name of another Donatello pupil, Antonio di Chellino, with that of a Genoese sculptor, Domenico Gaggini. Through the second period of construction Pietro da Milano seems to have been in sole control. Sculpturally the arch is an unhappy union of

unrelated styles, a meeting place for sculptors formed in Rome and Florence and Lombardy. When, for example, we look at the two reliefs of Alfonso and his court beside the entrance, we find that in one of them, on the left, the space construction is Donatellesque, while in the other, on the right, the spatial scheme has been designed by a sculptor who was unfamiliar with Donatello's work. Equally in the four statues of the Virtues one, the Justice, is strongly classical, while the figure of Temperance to its right is preponderantly Gothic. Above this again the classicistic River Gods lead the eye upwards to a Lombard figure of St Michael at the top. Architecturally, on the other hand, the structure is conceived, throughout its entire height, as a rational whole, and the clarity of the intention which underlies it largely redresses the defects of the heterogeneous carvings with which it is clad.

Nothing about the triumphal arch is certain. The documents, however, leave little doubt that the merits of the scheme are due to Pietro da Milano, who seems from the first to have been responsible for the design. None the less, by the first quarter of the sixteenth century the name of Pietro da Milano had become dissociated from the arch, which was then credited to Francesco Laurana, and because Laurana, alone of the sculptors mentioned in connection with the work, was a major artist in his own right, analysis of the sculptures has been largely directed to identifying his share in the execution of the arch. Probably Laurana was responsible for one of the scenes beside the entrance (plate 221), part of the large

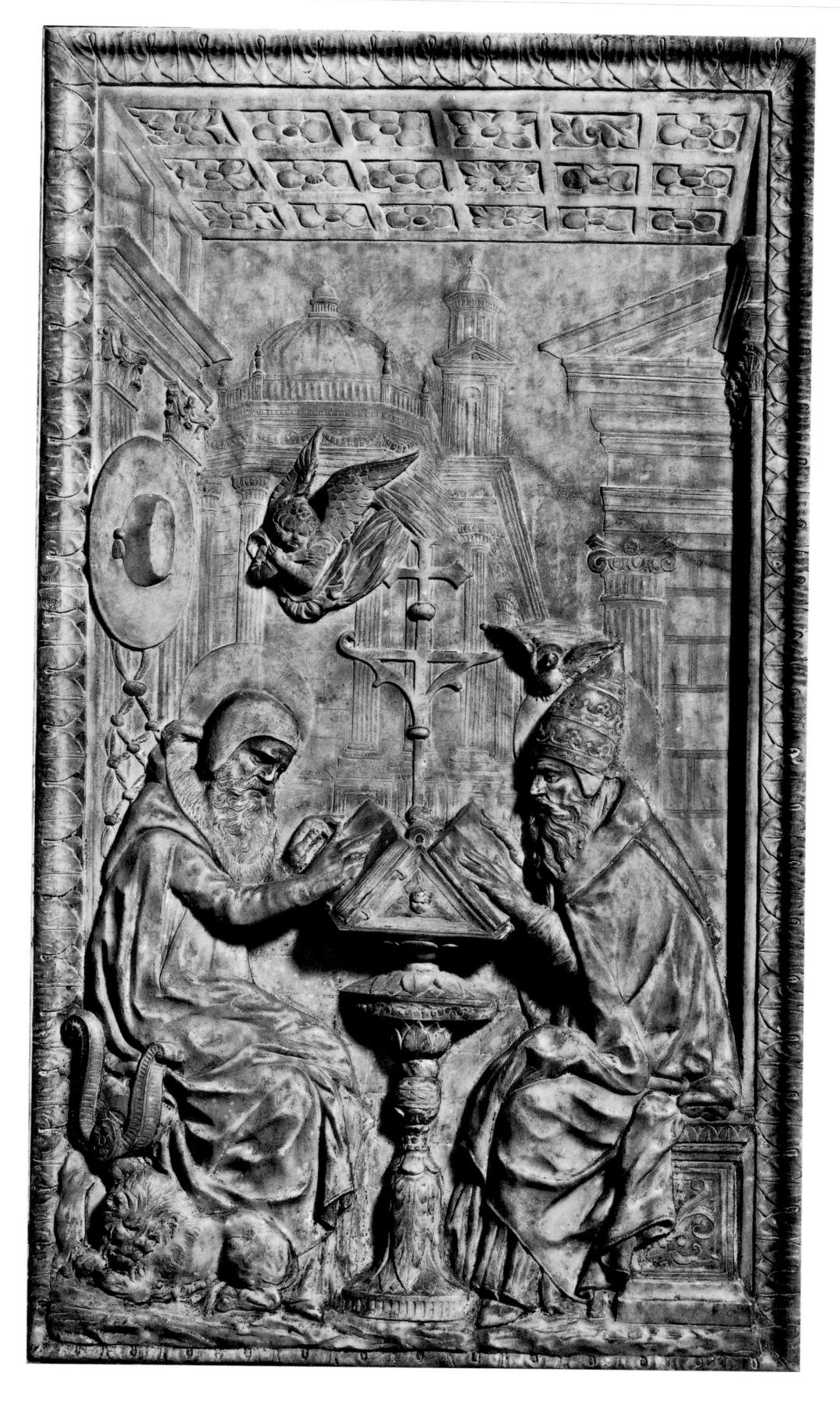

plate 224 Francesco Laurana

Sts Jerome and Gregory

Mastrantonio Chapel, S. Francesco, Palermo

marble, 135 × 73.5 cm

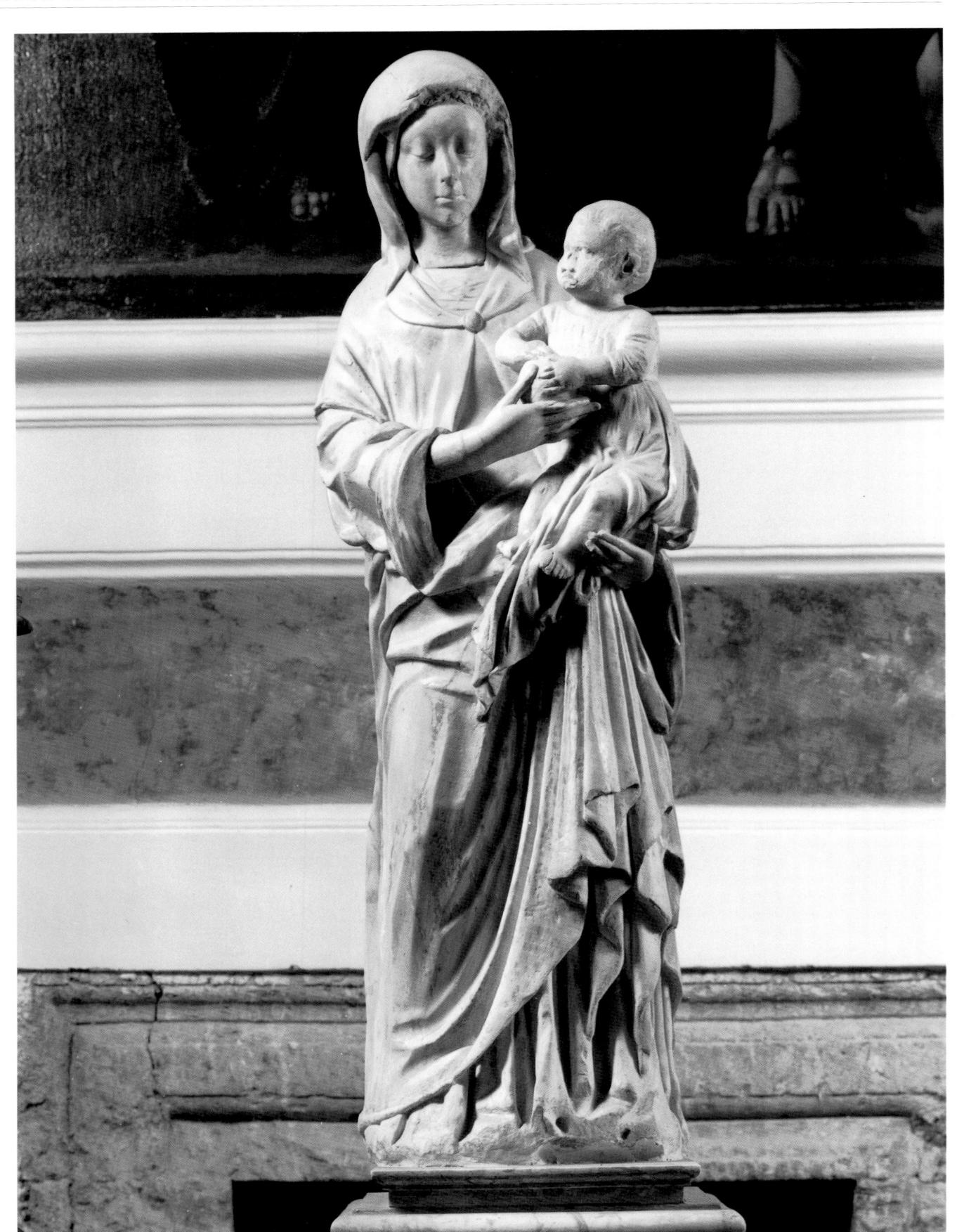

plate 225 Francesco Laurana

Virgin and Child

S. Maria Materdomini, Naples marble, height 160 cm relief, the figure of Justice and a number of subsidiary carvings, but since these sculptures are much weathered and their attribution to Laurana is conjectural, an impression of his style is best formed from other works. Laurana was born near Zara, probably about 1430, and seems to have been trained in a Venetian studio operating in Dalmatia, possibly that of a disciple of Bartolommeo Buon, Giorgio da Sebenico. Nothing is known of his work before 1454, when he arrived in Naples to work on the triumphal arch. Between 1461 and 1466 he was employed as a medallist at the court of René of Anjou; thereafter he moved to Sicily, where in 1468 he received the commission for the Mastrantonio Chapel in S. Francesco at Palermo; in the early 1470s he was once more in Naples; between 1477 and 1483 he was again in France, where he completed the tabernacle of St Lazare for the Cathedral at Marseilles, and a relief of Christ Carrying the Cross at Avignon; between 1483 and 1498 he may have worked in Naples and Sicily once more; and in 1501-2 he died in France.

Laurana found his most congenial vehicle in the portrait bust (plate 180), and a whole series of busts of women by his hand are known. Though the busts he carved in Naples belong to two different periods, separated by as much as fifteen years, the conception of the portrait implicit in them is unchanged, and the formal principles which guide them are no more than slightly modified. The picture they present is one of an extremely subtle but relatively unambitious artist. Like the busts, a number of Madonna statues and

statuettes which Laurana carved in Sicily and Naples (plate 225) owe much of their appeal to absence of overt expressiveness. In such works the problems of depicting space and movement did not arise. In the reliefs in the Mastrantonio Chapel in S. Francesco at Palermo movement is again conspicuous by its absence, but Laurana could not evade the obligation to define the spatial content of his scenes. By the standard of Central Italian sculptors, the means by which he did so were rudimentary, and though the surface of the panel of Sts Jerome and Gregory (plate 224) reveals the same sensibility of facture as the portraits, the conclusion is inescapable that Laurana's intellectual resources were barely adequate for the work he undertook. The subject of Christ Carrying the Cross, which he carved in high relief at Avignon, set a premium on movement, and once more this was a challenge which he could not meet. Moreover, in France Laurana's work veered in the direction of late Gothic, as is evident in the grotesque executioners, the pathetic Christ and the Riemenschneider figure of St John. Only in the Marys on the extreme right of the scene are we reminded that the sculptor is the same artist who at Naples had executed the great portrait busts.

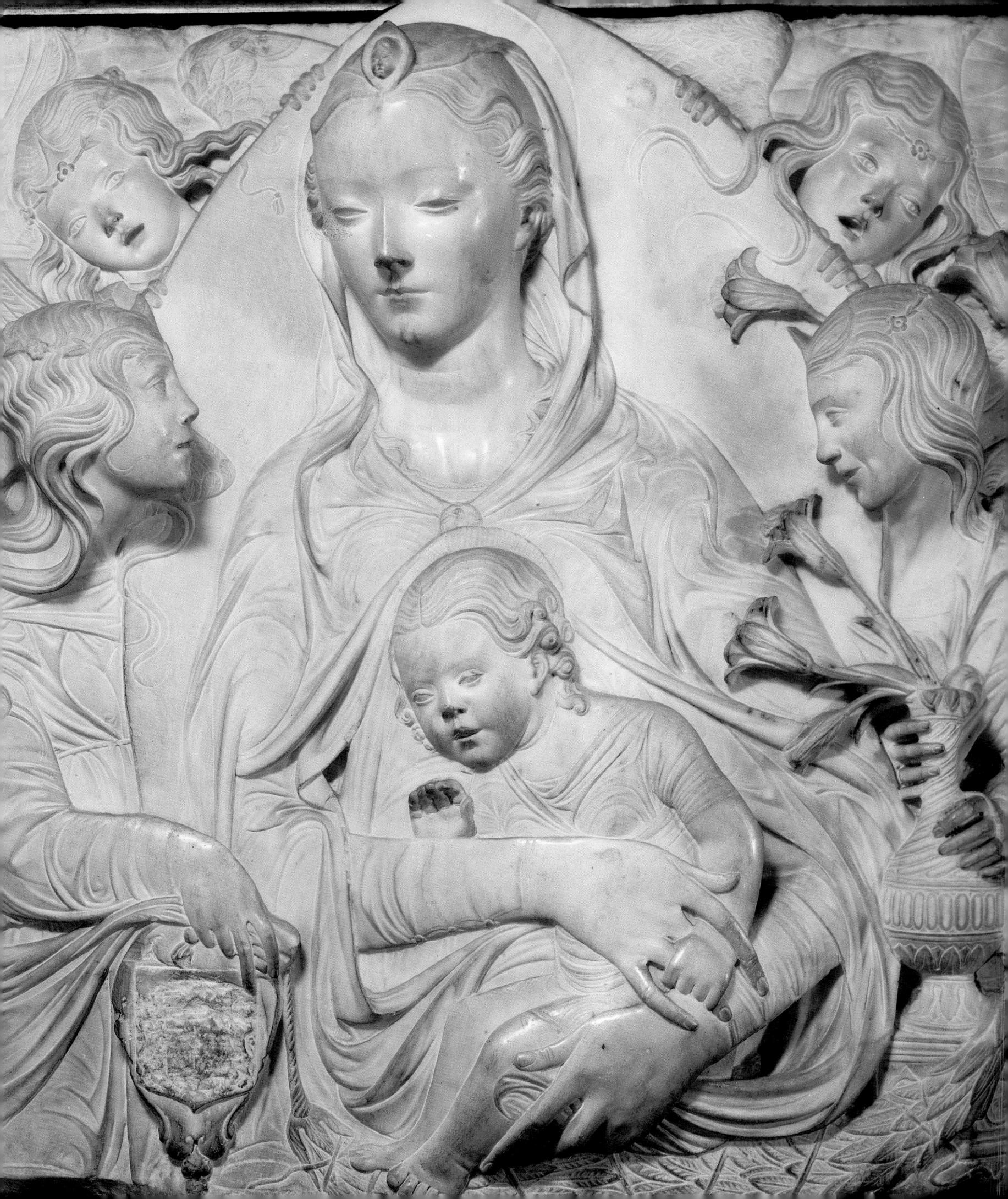

Agostino di Duccio and the Tempio Malatestiano

URING THE FIFTEENTH century a number Of Florentine sculptors made their careers outside Tuscany. Mino da Fiesole won greater popularity in Rome than in his native town; Domenico Rosselli and the sculptor known as the Master of the Marble Madonnas carried a simplified version of the style of Antonio Rossellino to the Marches and Romagna; and Francesco di Simone, a pupil of Desiderio, worked in Bologna and Forlì. The most prominent of these exiles was Agostina di Duccio. Agostino was born in 1418. During his boyhood his father died, his family found itself in financial straits, and in 1433 he enlisted as a mercenary soldier and left Florence. His name does not recur there until 1446, and his earliest surviving works (plate 228), four narrative scenes from a dismembered altar in Modena Cathedral (1442), confirm that he received his training outside Florence. In these the figures are bunched together at the front of each relief, and are not disposed in space, and the drapery, instead of conforming to the action in which the figures are portraved, assumes a late-Gothic rhythm of its own. Our only record of Agostino's presence in Florence in the 1440s relates to his departure from the town in 1446, when, accused of theft, he fled to Venice. Unsuccessful efforts have been made to identify the works he carved there, and it has been suggested that he collaborated with the principal Venetian sculptor of the time, Bartolommeo Buon. Whether or not this was so, his experience of Venetian sculpture left its mark on the sculptures he executed after 1449, when he moved from Venice to Rimini. In 1454 he was still at work in the

Tempio Malatestiano at Rimini, and he seems to have remained there till the summer of 1457 when he moved once more, this time to Perugia, whither he was drawn by a commission for the façade of the oratory of S. Bernardino. Between 1457 and 1462 there are repeated documentary references to the progress of this building, and for this reason it provides a sounder basis than the Tempio Malatestiano for the study of Agostino's style.

The central feature (plate 230), with its high arch, medallions in the spandrels and classical inscription running along the architrave, derives from the central feature of Alberti's Tempio Malatestiano. But the doorway is depressed to make way for a strip of sculptured decoration, and the arch is filled with a carving of the Saint in glory between flying Angels which may well have been inspired by Venetian tympanum reliefs. The sculptured decoration above the doorway includes three narrative reliefs (plate 229). When we compare these with the Modena reliefs of eighteen years before, our first impression must be how constant are the sculptor's mannerisms, how uniform his world peopled by agitated marionettes. At Perugia, however, the tendency towards a prevailing linear rhythm noted in the Modena reliefs is developed to a point at which the forms are organized in a predominantly linear sense. The implications of this change are apparent in the reliefs of Virtues beside the doorway (plate 227) and in the music-making Angels of the tympanum relief, whose idiom derives from Rimini, where it was first employed in the sculptures of the Tempio Malatestiano.

plate 226 Agostino di Duccio

Virgin and Child with Four Angels

Louvre, Paris marble, 81 ×77 cm

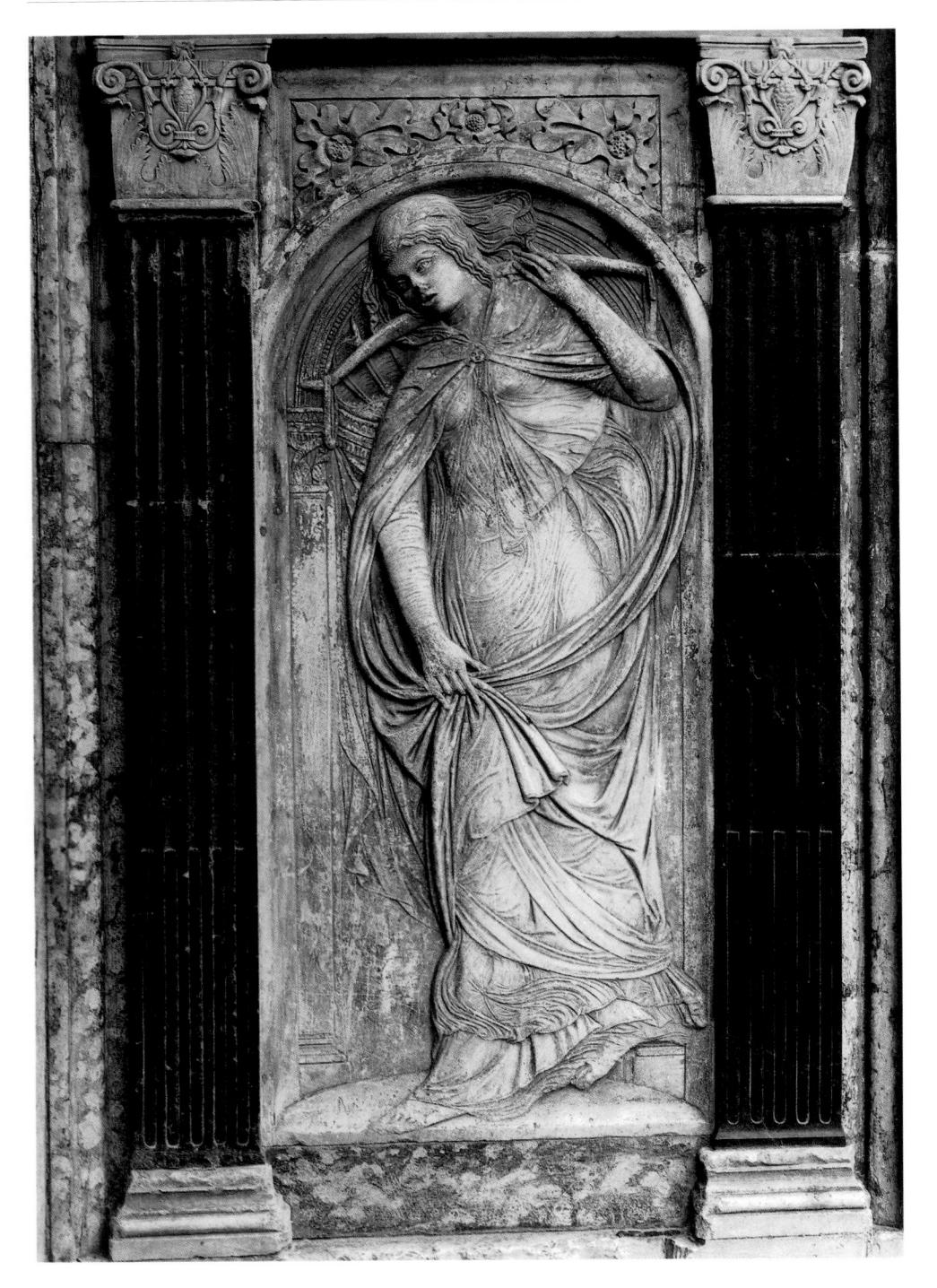

The history of this romantic building (plate 231) opens in 1447, when the Bishop of Rimini laid the foundation stone in the church of S. Francesco of a chapel dedicated by the Lord of Rimini, Sigismondo Pandolfo Malatesta, to his patron saint, St Sigismund. In 1448 marble was being stripped from S. Apollinare in Classe at Ravenna for use in the new chapel, and in 1452 it was dedicated. In this year another chapel, containing the monument of Sigismondo Malatesta's mistress Isotta degli Atti, was also in course of reconstruction but was still incomplete. The chapel of St Sigismund is the first, and the chapel of Isotta the second on the right side of the church. At some date still undetermined, perhaps the jubilee year of 1450, what had begun as the construction of one chapel was merged in a more far-reaching scheme, whereby the whole exterior of the church was to be cased in a Renaissance shell designed by the architect Alberti and the whole interior was to be replanned. In addition therefore to the chapels of St Sigismund and of Isotta, provision was now made for a third monumental chapel on the same side of the church and for three corresponding chapels on the left. In 1454 there is an allusion to work in the first chapel on the left, and in 1455 we hear of the purchase of red marble from Verona, possibly for use in the third chapel on the right. There is no reference to the second and third chapels on the left, but the reconstruction of these was probably completed by 1460, since figures from the latter chapel were imitated by Agostino di Duccio at Perugia. Work in the Tempio must therefore have been finished in about ten years.

plate 227 *(opposite)* Agostino di Duccio

Virtue

S. Bernardino, Perugia (detail of plate 230) marble

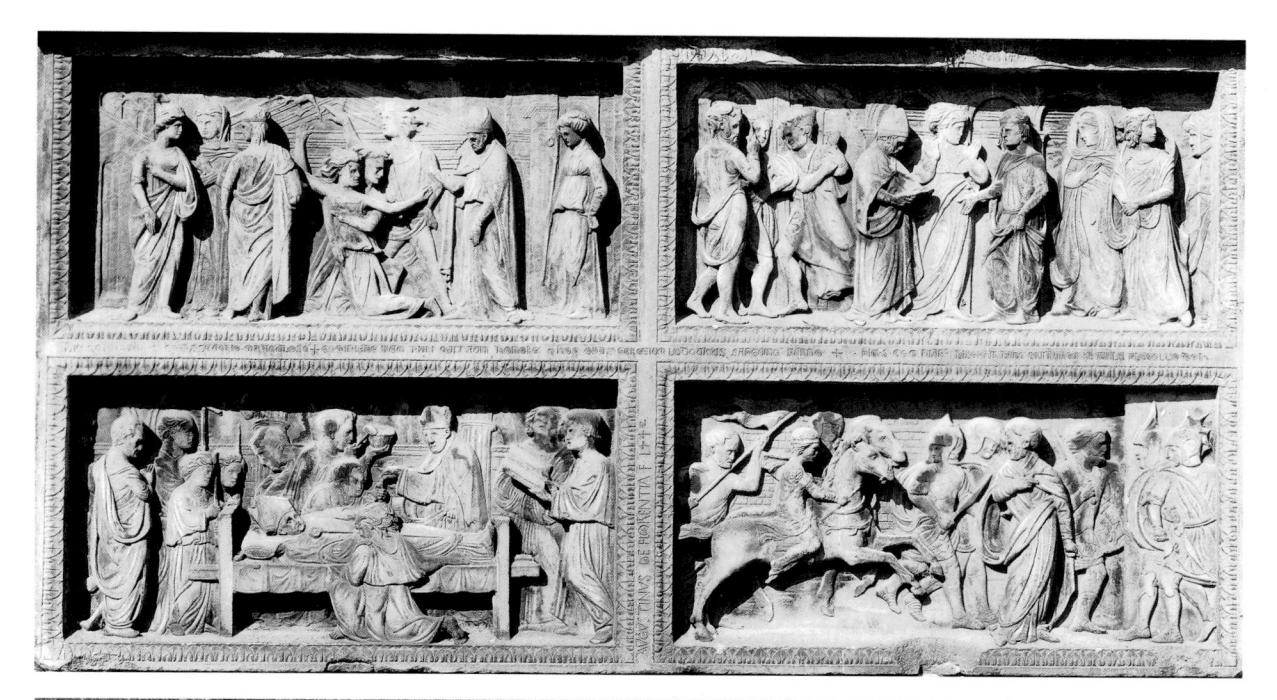

plate 228 Agostino di Duccio

Scenes from the Life of St Gimignano

Duomo, Modena marble

plate 229 Agostino di Duccio

Miracle of St Bernardino

S. Bernardino, Perugia marble

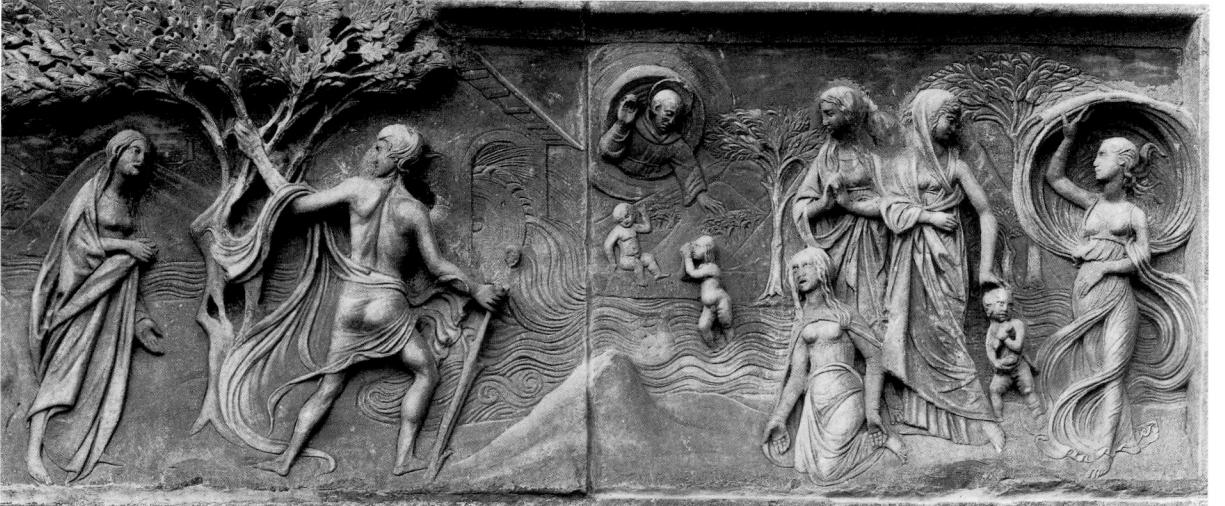

plate 230 Agostino di Duccio

The Façade of S. Bernardino

Perugia

How short was this time-bracket can be seen when we pass through the imposing façade. S. Francesco was a Gothic church, and in the interior, though not on the outside, its Gothic features were retained. It was not reconstructed; it was transformed. The Gothic arches were cased in marble, the spandrels were filled with sculptured ornament, the wall surfaces were broken with pilasters, and the piers supporting the arches were covered with sculptured decoration on three sides. The piers in each of the two bottom chapels contain 12 figures or reliefs, and the piers in each of the four upper chapels contain 18. Disregarding the monuments and wall decorations, the figures on the balustrades, the spandrel carvings, the supports beneath the piers, we thus have to reckon with no less than 96 reliefs.

In documentary terms we know extremely little about the artists who were employed in the church. The medallist Matteo de' Pasti is first mentioned at Rimini in 1449, and remained in close association with the Malatesta court until his death in 1468. All of the evidence seems to indicate Matteo de' Pasti as the artist in whom Sigismondo Malatesta reposed most confidence. In the same year the name of Agostino di Duccio appears in a Riminese document for the first time, and in 1451 Piero della Francesca painted in the Tempio his fresco of Sigismondo Malatesta before St Sigismund. The architect Alberti became involved in the project about 1450, designing the outer shell and the triumphal façade, and also perhaps intervening in the internal reconstruction of the church. The names of Matteo de' Pasti as architect and Agostino

di Duccio as sculptor are recorded inside the Tempio, and on the strength of these inscriptions all the sculptures, with the provisional exception of those in the first chapel on the right, have been ascribed to Agostino. Given the magnitude of the commission, it is inherently unlikely that a single sculptor and his assistants would have been allowed to work their slow way through the church, and the first conclusion on which we are forced back by study of the carvings is that they cannot have been executed by one artist.

Admittedly in reproduction they show a certain uniformity which might suggest the opposite. To understand their idiom we must know something of the culture from which the Tempio Malatestiano sprang. Pope Pius II, in the Commentarii, censures Sigismondo Malatesta with the words: 'He has built a church at Rimini in honour of St Francis, but he has filled it with antique images, so that it seems a temple for the worship not of Christ, but of the pagan gods.' The imagery of the Tempio, with its planetary reliefs based on Macrobius, its representations of the Muses drawn from Apollonius Rhodius, and its exaltation of the divinity of Sigismondo Malatesta in the twin figures of the sun-god Apollo and St Sigismund, is indeed a manifesto of studied paganism. As we might expect, the mainspring of the style of the reliefs is the sculpture of antiquity. But whereas Florentine Renaissance sculpture derives from Roman prototypes, the sculpture of the Tempio seems to have been orientated upon Greece. This finds expression in the conscious re-creation of a neo-Attic style. Precisely because it is a re-creation, and

plate 231

The Interior of the Tempio Malatestiano

Rimini

plate 232 Matteo de' Pasti (?)

Aquarius

Tempio Malatestiano, Rimini *marble*

plate 233 Agostino di Duccio

Angel drawing a curtain

Tempio Malatestiano, Rimini marble

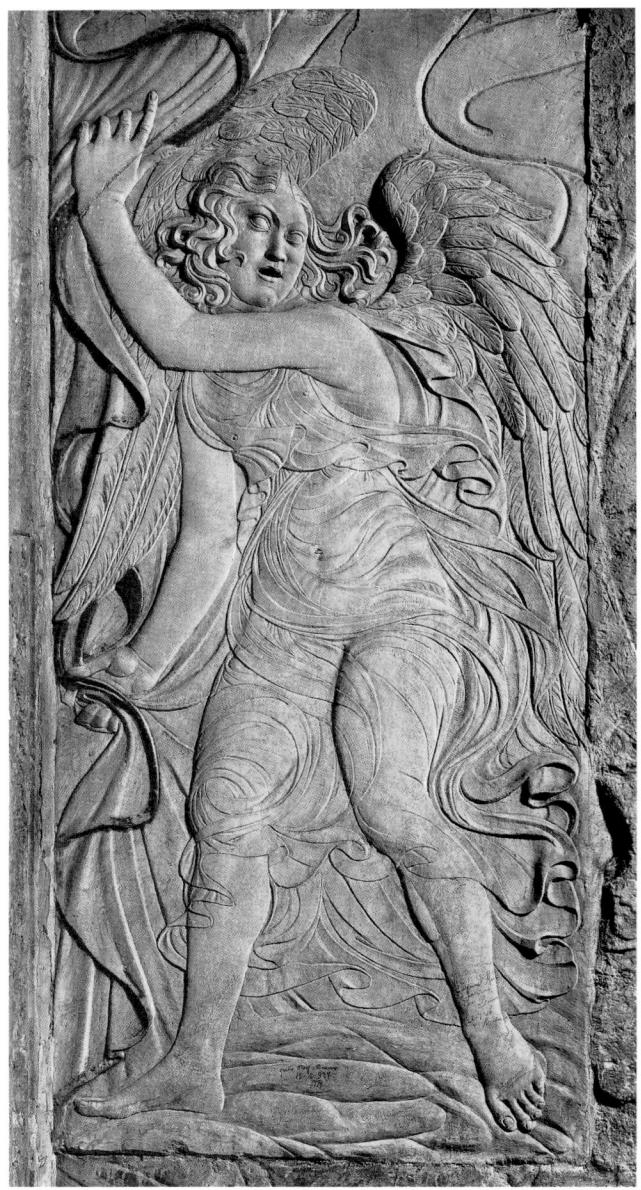

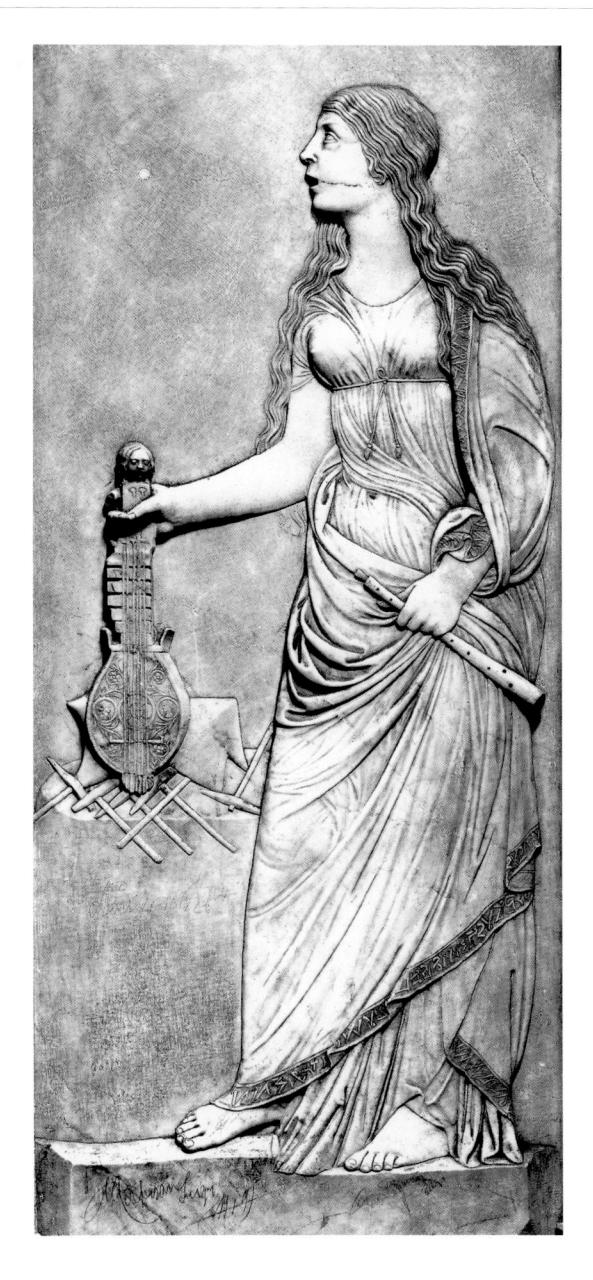

not merely an accretion of antique motifs, the sources from which it derives are more than usually elusive. Probably the sculptor of the Chapel of the Planets (plate 232) was acquainted with neo-Attic carvings like the reliefs of Maenads in Rome and Madrid, and used these as the source of his flowing calligraphic style. Possibly too the author of the Chapel of the Liberal Arts (plate 234) was familiar with reproductions of columnar sarcophagi of the type of the Mourning Women sarcophagus from Sidon, and adapted their use of interval and their relief style for decorative purposes. To our eyes the idiom of these carvings may seem unclassical, but contemporaries saw them in a different light, and the humanist Valturio, speaking in the De re militari of the Tempio and its decorations, affirms that of all the sights of Rimini 'none is more worth inspection, none is more antique'. This neo-Attic style was not decided on at once. It was first introduced in the Chapel of Isotta, the second chapel on the right of the church, in which work can scarcely have been begun before 1451. A year earlier Alberti had arrived at Rimini, and it may well be to him that we owe the decision to impose a classical relief style on the Tempio, as a counterpart to the classical architectural forms of the outside.

Once it is recognised that a uniform idiom was imposed on the sculptures of the Tempio, the idiosyncrasies of the artists employed there become more easily decipherable. In the Chapel of St Sigismund the deeply carved figures of the Virtues (plate 238) are seated in niches between pilasters. The treatment of the drapery recalls that

of the Virtues on Isaia da Pisa's Chiaves monument in St John Lateran (plate 213), and may also have its source in Filarete, who visited Rimini about 1448 after abandoning work on the Chiaves tomb. In the postures, however, there is a residue of Venetian Gothic style. For reasons of symmetry it was essential that there should be some formal correspondence between this chapel and the first chapel on the left-hand side, the Chapel of the Sibyls, which was under way at the end of 1454, and the niches used in the Chapel of St Sigismund were therefore repeated on the opposite side of the church, but with a difference, for where the niches of the Chapel of St Sigismund are concave, these are flat, and the figures (plate 239) are for the most

plate 234 Matteo de' Pasti (?)

Music

Tempio Malatestiano, Rimini *marble* plate 235 Matteo de' Pasti (?)

Music-Making Angels

Tempio Malatestiano, Rimini marble

plate 236 Agostino di Duccio

Playing Children

Tempio Malatestiano, Rimini marble

plate 237 Matteo de' Pasti (?)

Venus

Tempio Malatestiano, Rimini marble part posed on a single plane and do not protrude from the surface of the wall. It may be inferred that in the Chapel of the Sibyls an attempt was made to modify the relief style of the Chapel of St Sigismund in the light of the low reliefs introduced in the Chapel of Isotta. When allowance is made for this change of plan, it becomes clear that the bulk of the reliefs in the Chapels of St Sigismund and of the Sibyls represent two phases in the evolution of one artist.

With the Chapel of Isotta we enter a different world. The reliefs of music-making children (plate 235) are controlled by an exquisitely subtle sense for the placing of the image in its frame. Animated figures are shown in motion, and instead of the abrupt transitions between one plane and the next which we find in the Chapel of St Sigismund, there is a living interplay of line and form. The Chapel of the Infant Games, the second chapel on the lefthand side, was presumably designed to correspond with the Chapel of Isotta, since its piers are decorated with three tiers of playing children (plate 236). But these children lack the surface modelling of the children in the chapel opposite, their movement and their fluent line. The contours are incised at right angles to the plane of the relief, and in many cases the heads are represented as perfect circles and other forms are reduced to their nearest geometrical equivalents. When we compare the technical peculiarities of these reliefs with those of the Chapel of the Sibyls, we can only conclude that both were executed by one and the same artist.

Fortunately the far superior sculptor of the Chapel of Isotta was responsible for the decoration

of at least one further chapel, the Chapel of the Planets, the third on the right side of the church and the greatest single achievement in the Tempio Malatestiano. On a formal plane the carvings in this chapel provide some of the most felicitous and appealing schemes in the whole of Italian relief sculpture. The firm flesh of the Aquarius (plate 232) is treated with the same rotundity and the same smooth transitions as the music-making putti in the Chapel of Isotta, and is seen in part through the transparent water and in part through striated drapery. One of the most attractive carvings is the Venus (plate 237), riding across a sea whose waves seem to have been set by some celestial coiffeur. Especially notable are the landscapes, which proceed from the International Gothic landscapes found in the first half of the fifteenth century throughout North Italy. The last of the chapels to be completed appears to have been the third chapel on the left-hand side, the Chapel of the Liberal Arts. Its carvings (plate 234) are closely related to the Planet reliefs, but tend towards visual patterns of a rather different kind. Instead of a design which fills the whole area of the relief, they contain figures drawn in upon themselves and isolated on their flat grounds. The linear emphasis is less pronounced than in the chapel opposite, and in the handling of the drapery the third dimension is more strongly felt. Despite these differences, the balance of probability is that the Chapel of the Planets and the Chapel of the Liberal Arts are by one artist.

We have then in the Tempio Malatestiano (excluding studio hands responsible for the less exposed reliefs on the insides of the piers) two
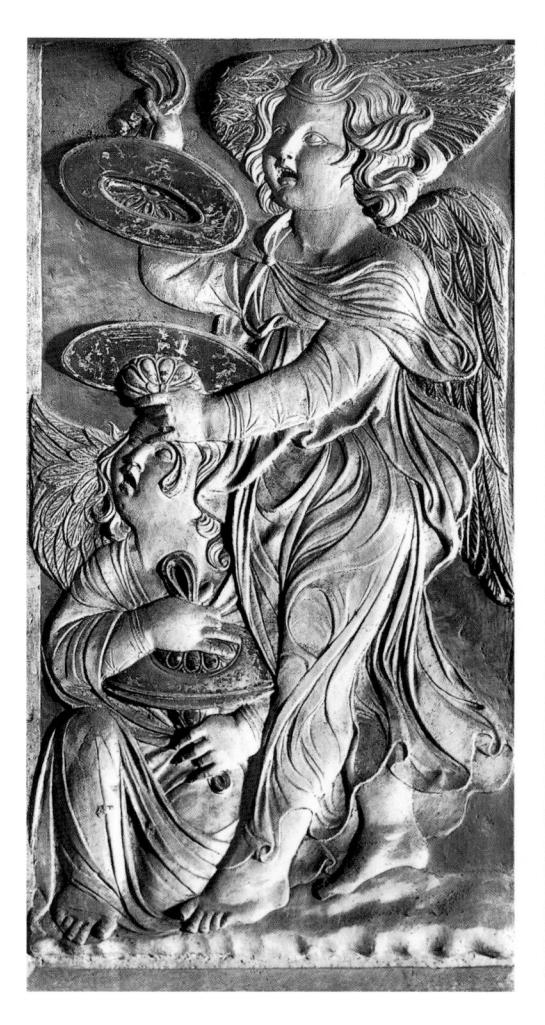

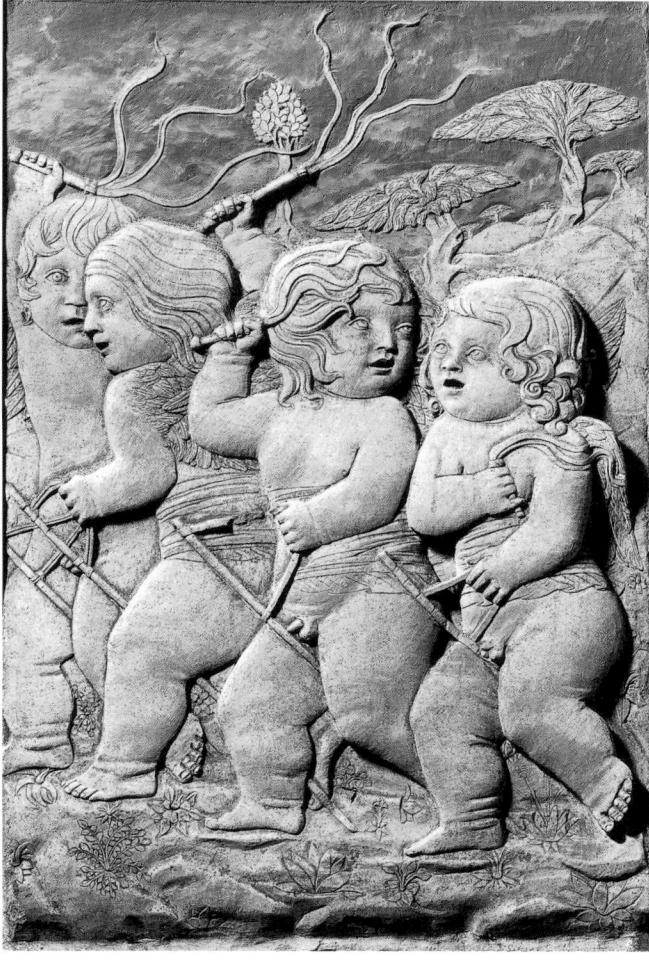

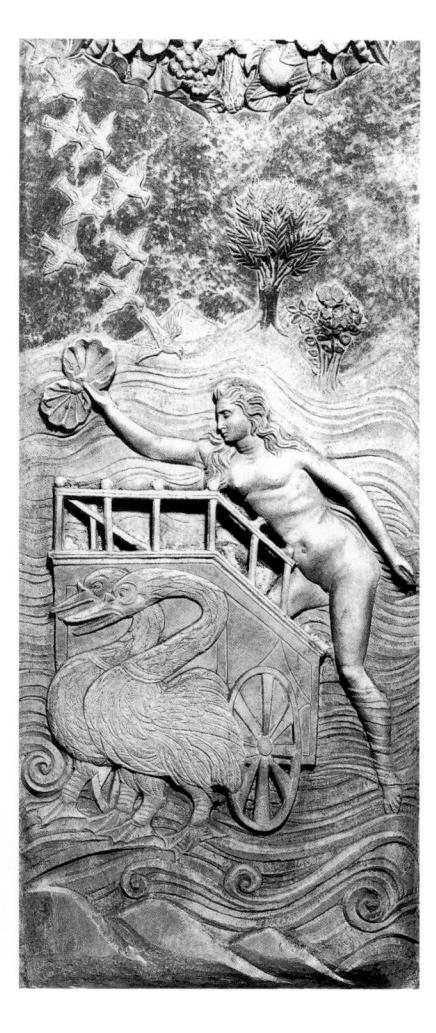

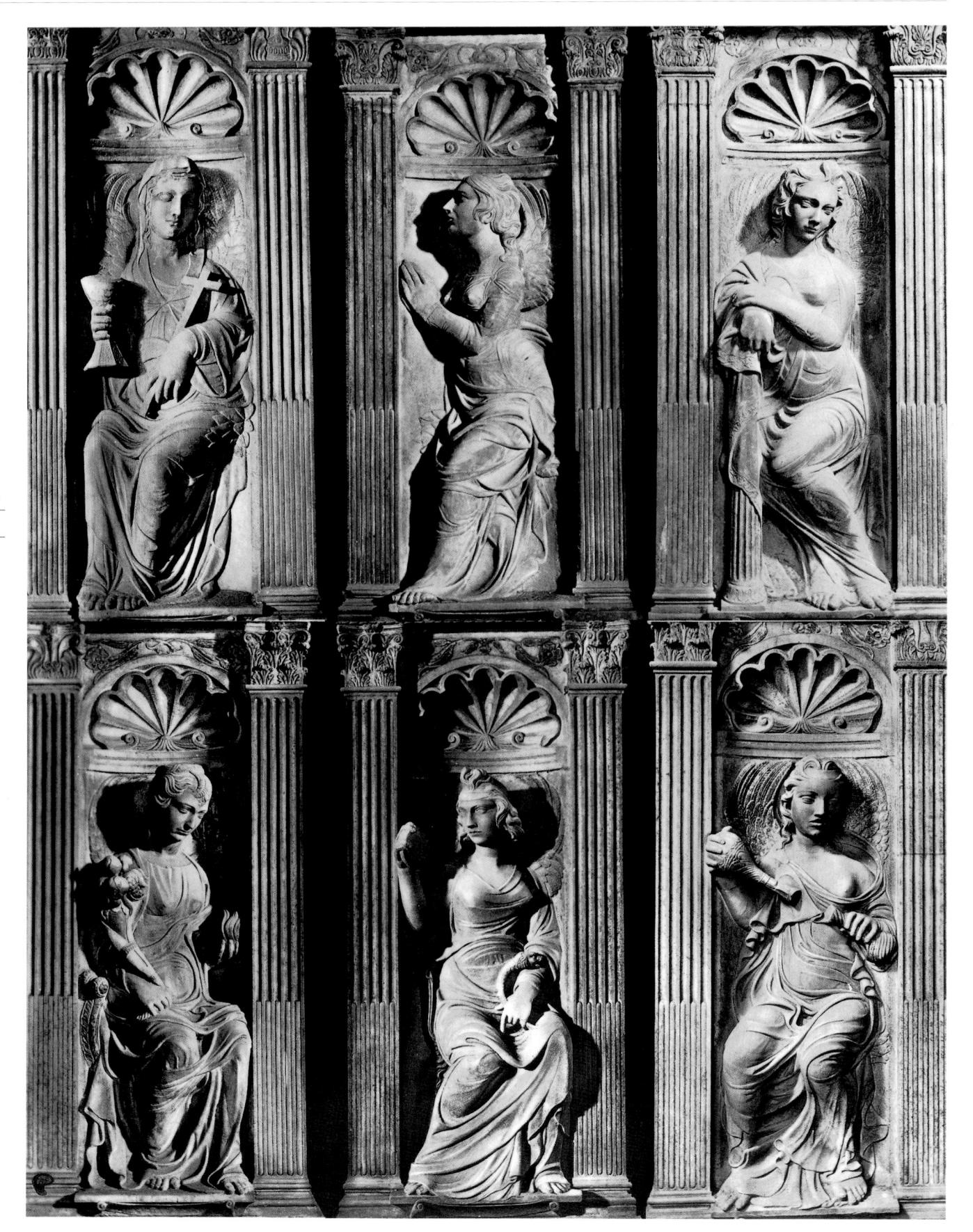

plate 238 Agostino di Duccio

The Virtues

Tempio Malatestiano, Rimini marble

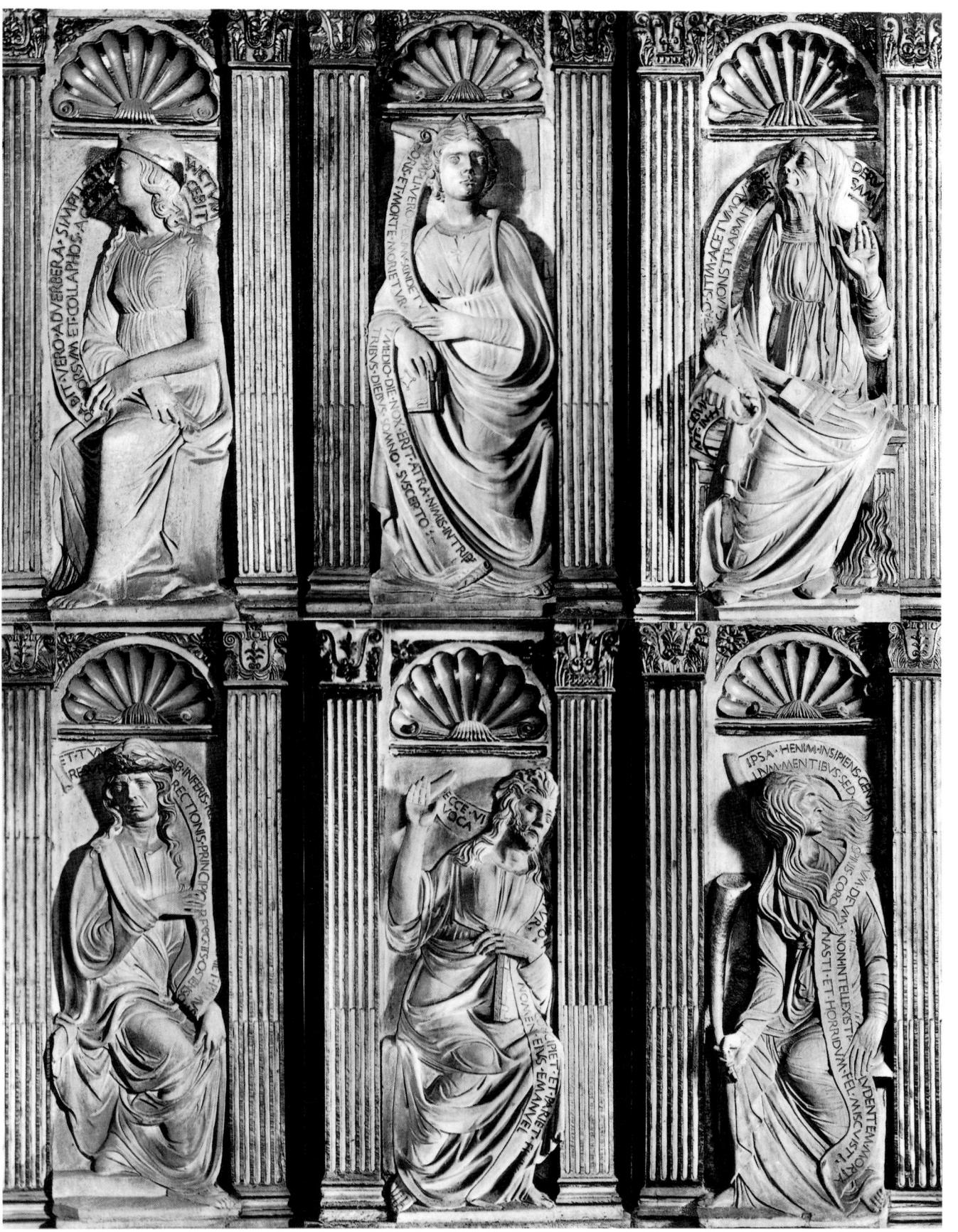

plate 239 Agostino di Duccio

Sibyls

Tempio Malatestiano, Rimini

marble

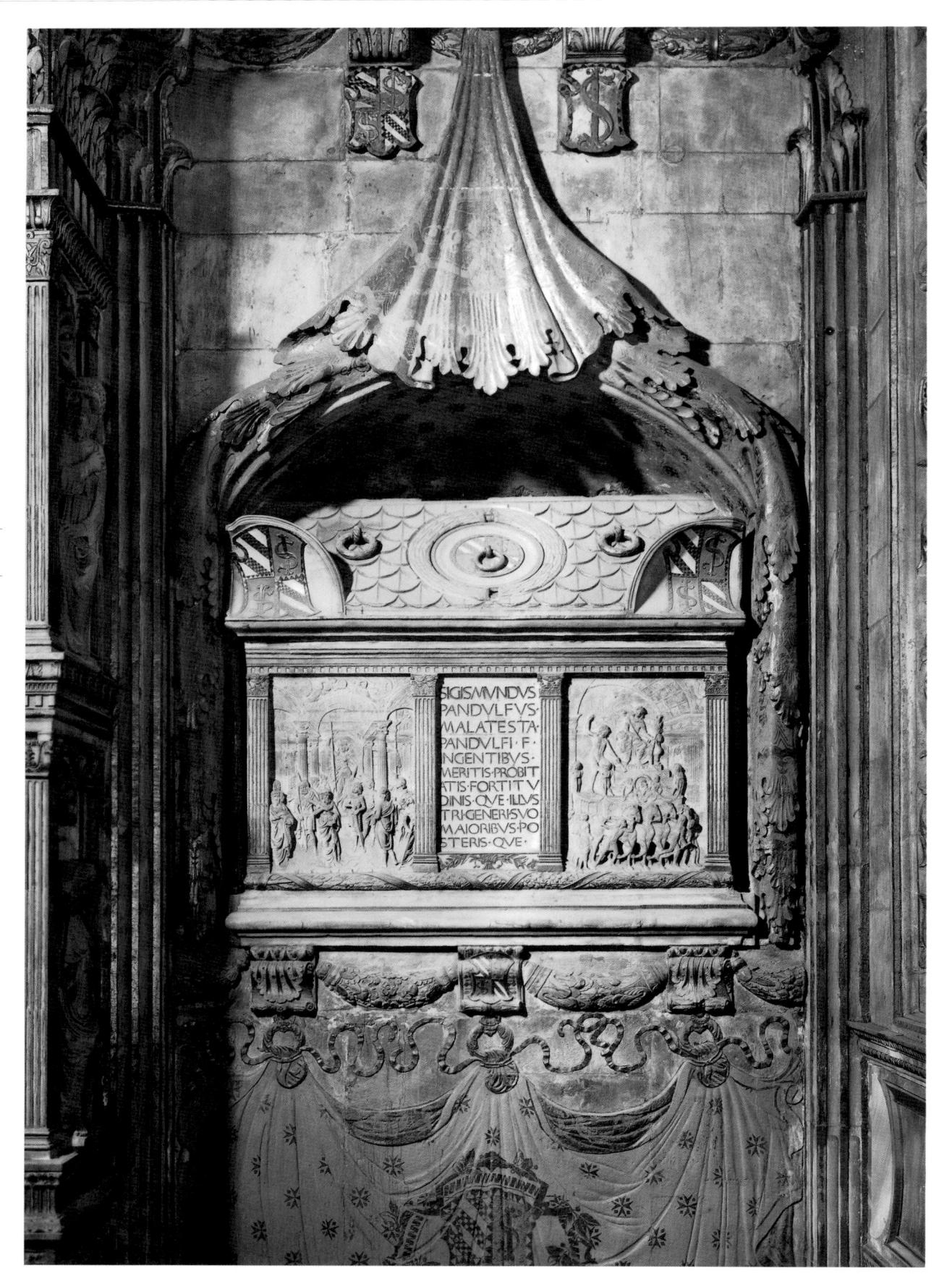

plate 240 Agostino di Duccio

Arca degli Antenati

Tempio Malatestiano, Rimini marble major sculptors. One of these was responsible for the carvings in the Chapel of Isotta (but not for her monument), as well as for those in the Chapels of the Planets and the Liberal Arts. The other was accountable for the carvings in the three Chapels of St Sigismund, the Sibyls and the Infant Games (including the great angels drawing curtains which seem to have been added as a happy afterthought to the Chapel of St Sigismund), and for the Arca degli Antenati (plate 240), the Arca of Isotta, a scene from the legend of St Sigismund in the Museo Civico in Milan which was originally part of the altar in the Chapel of St Sigismund, a vast quantity of decorative carving and the figures of Sts Sigismund and Michael which preside over the first and second of the chapels on the right of the church.

Agostino di Duccio was the second of these artists. We know this because his name is mentioned in connection with the Chapel of the Sibyls and the Arca degli Antenati, the tomb of Sigismondo Malatesta's ancestors, and because this group of carvings, and this alone, conforms in style to his authenticated works. A number of the carvings by Agostino at Perugia (plate 227) depend from reliefs at Rimini. One of the Angels, for example, recalls specifically, and all recall generically, the Angels drawing curtains on the walls of the Chapel of St Sigismund (plate 233), and whether they are examined from the standpoint of style or of technique it is clear that in this case the comparable carvings at Perugia and Rimini are by one artist. On the other hand, one of the single figures at Perugia reproduces the pose of

the figure of Grammar in the Chapel of the Liberal Arts, and here there is a marked disparity between the carvings, the much superior figure at Rimini resting easily within its frame while the flattened, schematic figure at Perugia is ill-adjusted to the area it occupies. Who then was the first of the sculptors in the Tempio Malatestiano? Very probably he was Matteo de' Pasti, whose name appears along with Agostino di Duccio's inside the church. Matteo de' Pasti's few surviving medals do not provide a basis on which to demonstrate the authorship of the reliefs, though the difference between his signed medals and the Rimini reliefs is certainly no greater than that between the signed medals of Laurana and Laurana's marble sculptures. Laurana was a great marble sculptor and an inferior medallist, while Matteo de' Pasti (if the reliefs be his) excelled both as medallist and sculptor. Vasari ascribed the reliefs in the Tempio Malatestiano to Luca della Robbia, and traditionally they have been looked upon as Florentine, but they are the products in part of a Roman, in part of a North Italian visual culture, and historically their relevance is to sculpture in North Italy. In Florence they had no progeny, whereas in Venice the Liberal Arts at Rimini were transformed into the Corneille-like figures of Tullio Lombardo's reliefs, the antependium of the altar of St Sigismund was introduced into St Mark's, and the sarcophagus of the Arca degli Antenati was reproduced in Pietro Lombardo's Mocenigo Monument.

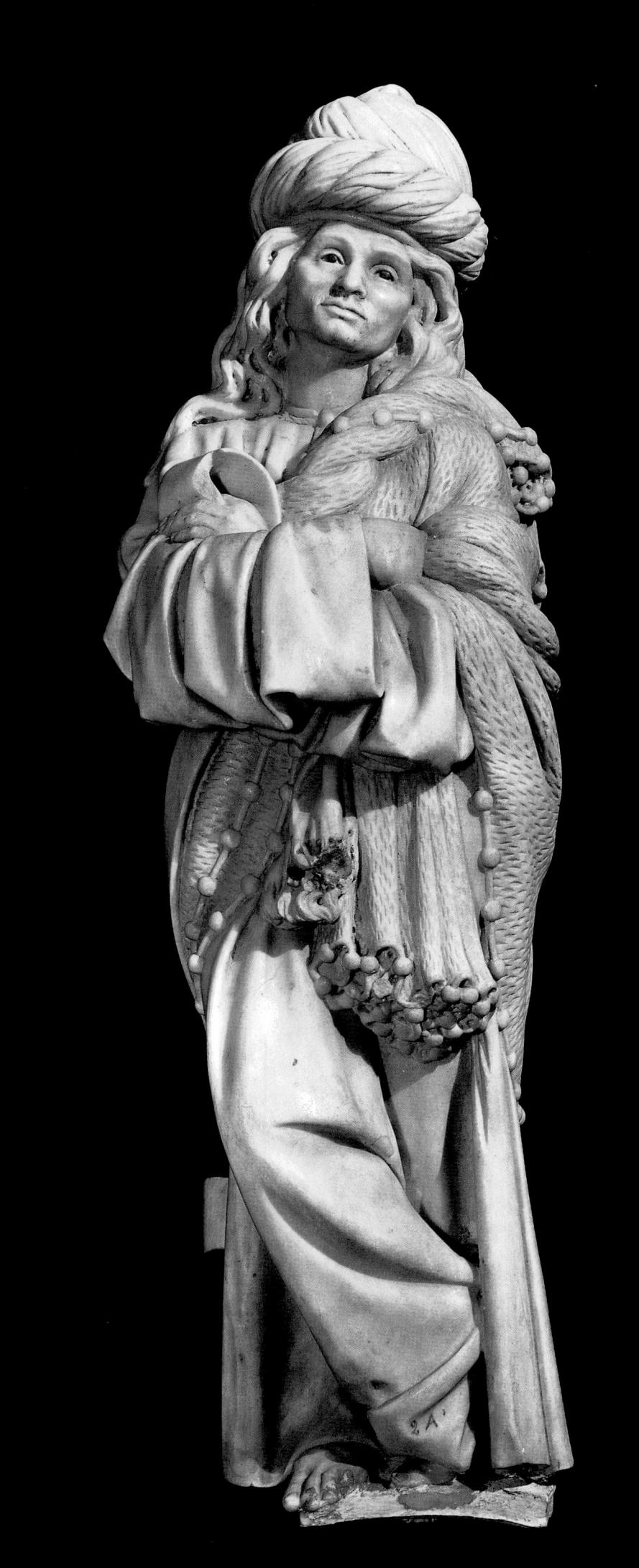

IN THE fIFTEENTH CENTURY, in the field of Asculpture, Ferrara and Bologna were centres of secondary importance. The father of Ferrarese Renaissance sculpture was a Florentine, Niccolò Baroncelli, who was employed by Lionello d'Este initially on a bronze equestrian monument to his predecessor, Niccolò III, and subsequently (1450) on a life-size bronze group of the Crucified Christ with the Virgin and Sts John, George (plate 242) and Maurelius for the Cathedral. According to Vasari, Baroncelli was a pupil of Brunelleschi, but the style of the Ferrara figures stems from Donatello, whose bronze Crucifix at Padua was already cast. In the Christ and the Virgin and St John, however, Baroncelli failed to penetrate the surface of Donatello's work. At his death in 1453 the Sts George and Maurelius were still unfinished, and they were completed in 1466 by his pupil Domenico di Paris. A year after these mannered figures were set in place Domenico di Paris undertook the stucco decoration of the anticamera of the Palazzo Schifanoia, adjacent to the hall which was subsequently filled with Cossa's frescos. This decoration (plate 243) has as its main feature seated figures of the Virtues between music-making putti, couched in an artificial style which recalls that of Tura's panels from Belfiore. Unluckily Domenico di Paris was an artist on a smaller scale than Tura, and his work, for all its charm, is lacking in profundity and in incisiveness. Something of its spirit is preserved in the doll-like Virgin and Child modelled in terracotta in 1482 for the tomb of Pope Alexander V in S. Francesco at Bologna by the Mantuan medallist Sperandio.

Niccolò dell'Arca, a sculptor of South Italian origin who was active at Bologna after 1463, is a more imposing artist. Niccolò derived his name from Nicola Pisano's Arca of St Dominic in S. Domenico Maggiore (Vol. I, plate 50), for which, between 1469 and 1473, he carved a lid decorated with small marble statuettes. When he undertook this task, he must have been familiar with the work of Desiderio da Settignano, and the swags and putti in the centre of the lid offer a graceful tribute to the Marsuppini Monument and the Altar of the Sacrament. The statuettes (plate 241), however, have no parallel in Florence, and remind us now of the statuettes of Quercia on the Vari-Bentivoglio Monument in S. Giacomo Maggiore in Bologna, and now of the Catalan sculptor, Sagrera, whose works Niccolò must have known in Naples. In the large Madonna di Piazza on which he worked in 1478, we find the same synthesis of conflicting elements, a classical frame, drapery forms evolved from Quercia's, and a Child that seems to reveal knowledge of the Madonnas of Verrocchio.

Niccolò dell'Arca's masterpiece is a terracotta group of the Lamentation over the Dead Christ in S. Maria della Vita at Bologna (plates 244, 247). Consisting of a recumbent figure of the Dead Christ, and statues of the Virgin, St John, Nicodemus and three lamenting women, this dramatic work is the only substantial equivalent in sculpture to the paintings of Tura and Cossa at Ferrara. The relation between them cannot be established with any confidence. If the Lamentation dates (as there seems reason to

plate 241 Niccolò dell'Arca

Prophet

S. Domenico Maggiore, Bologna marble

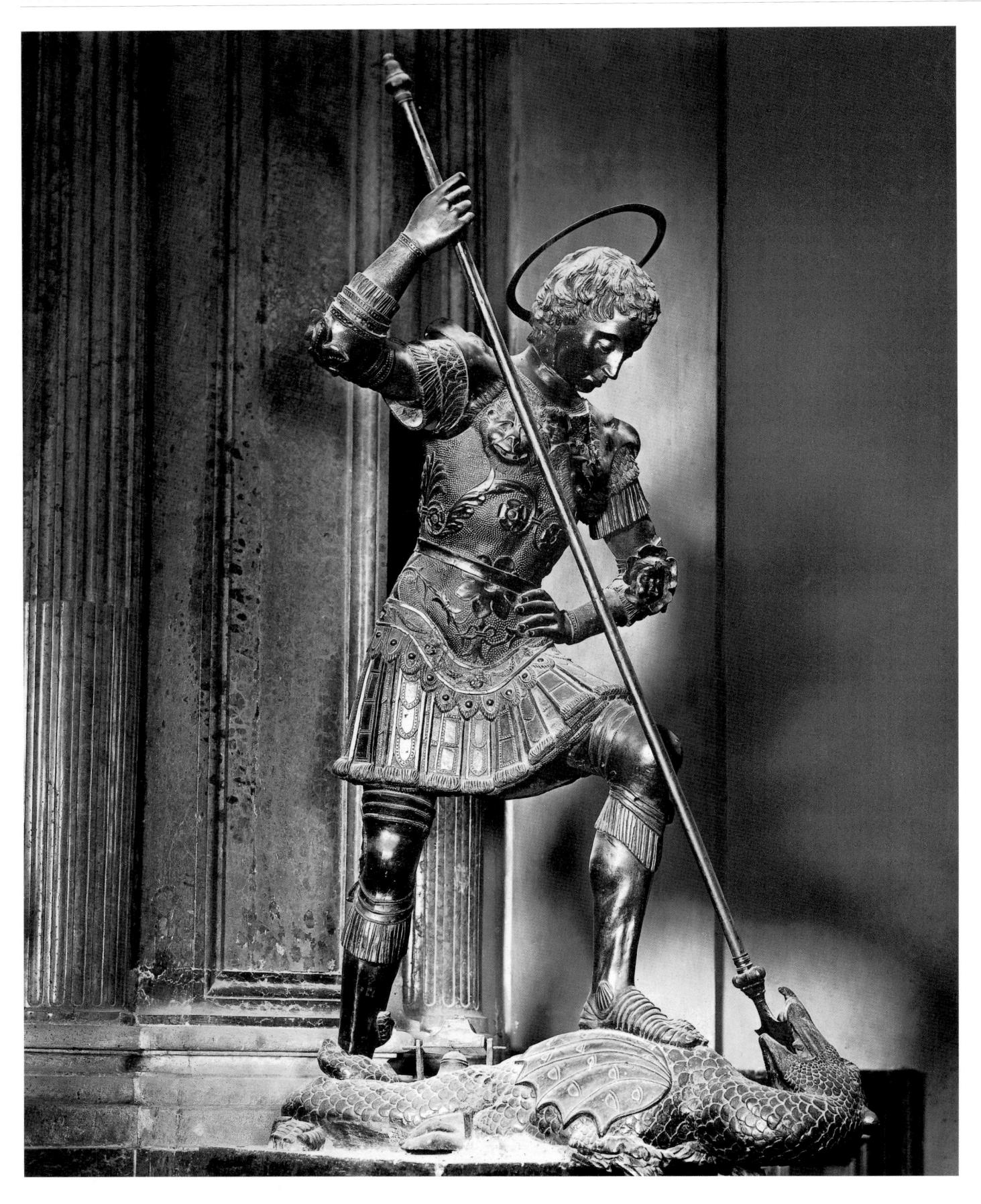

plate 242 (opposite) Niccolò Baroncelli and Domenico di Paris

St George

Duomo, Ferrara bronze

plate 243 Domenico di Paris

Decoration of the Anticamera

Palazzo Schifanoia, Ferrara pigmented stucco plate 244 Niccolò dell'Arca

Lamentation over the Dead Christ

S. Maria della Vita, Bologna terracotta, partially pigmented

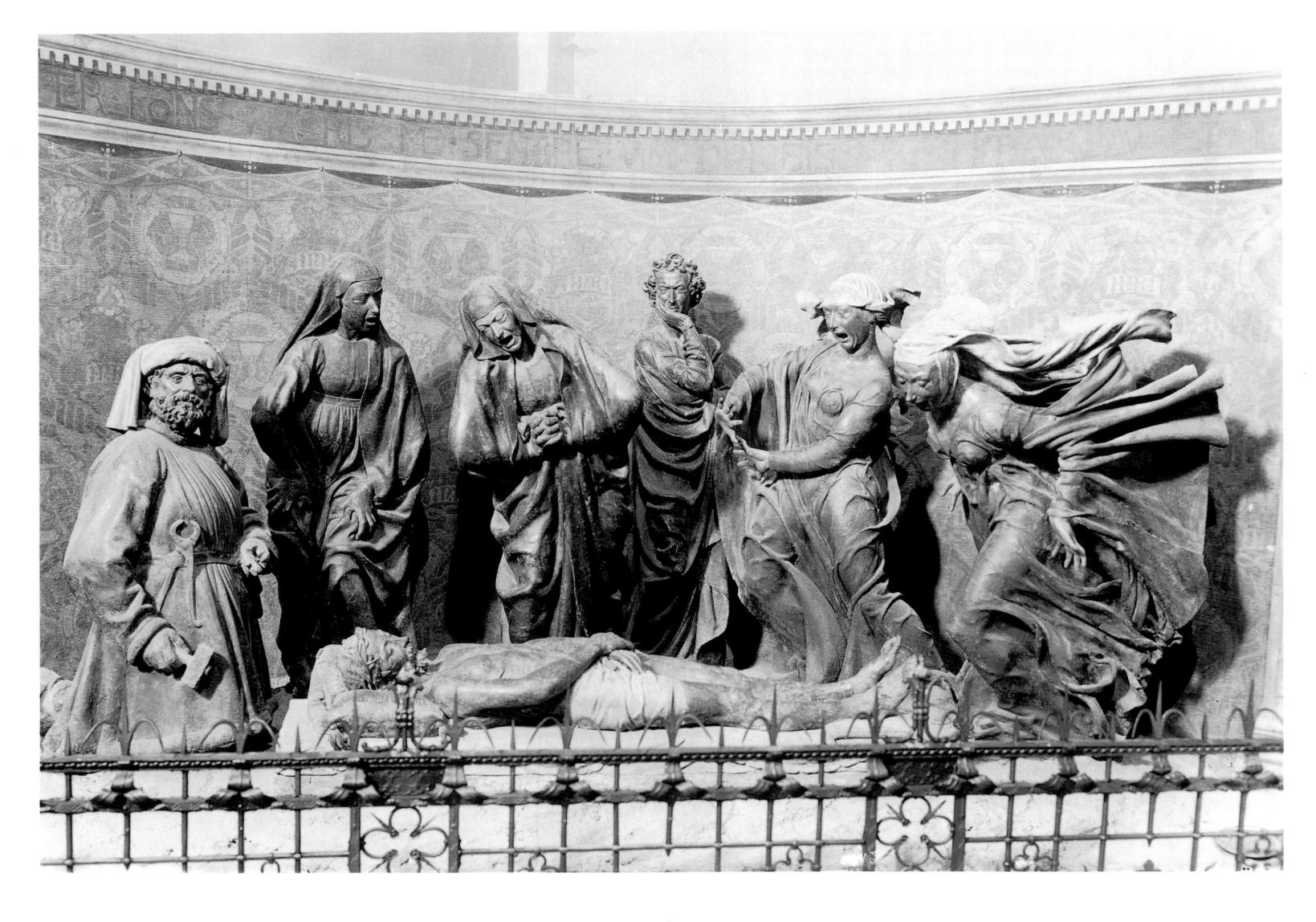

plate 245 Guido Mazzoni

Lamentation over the Dead Christ

S. Giovanni Battista, Modena terracotta, partially pigmented

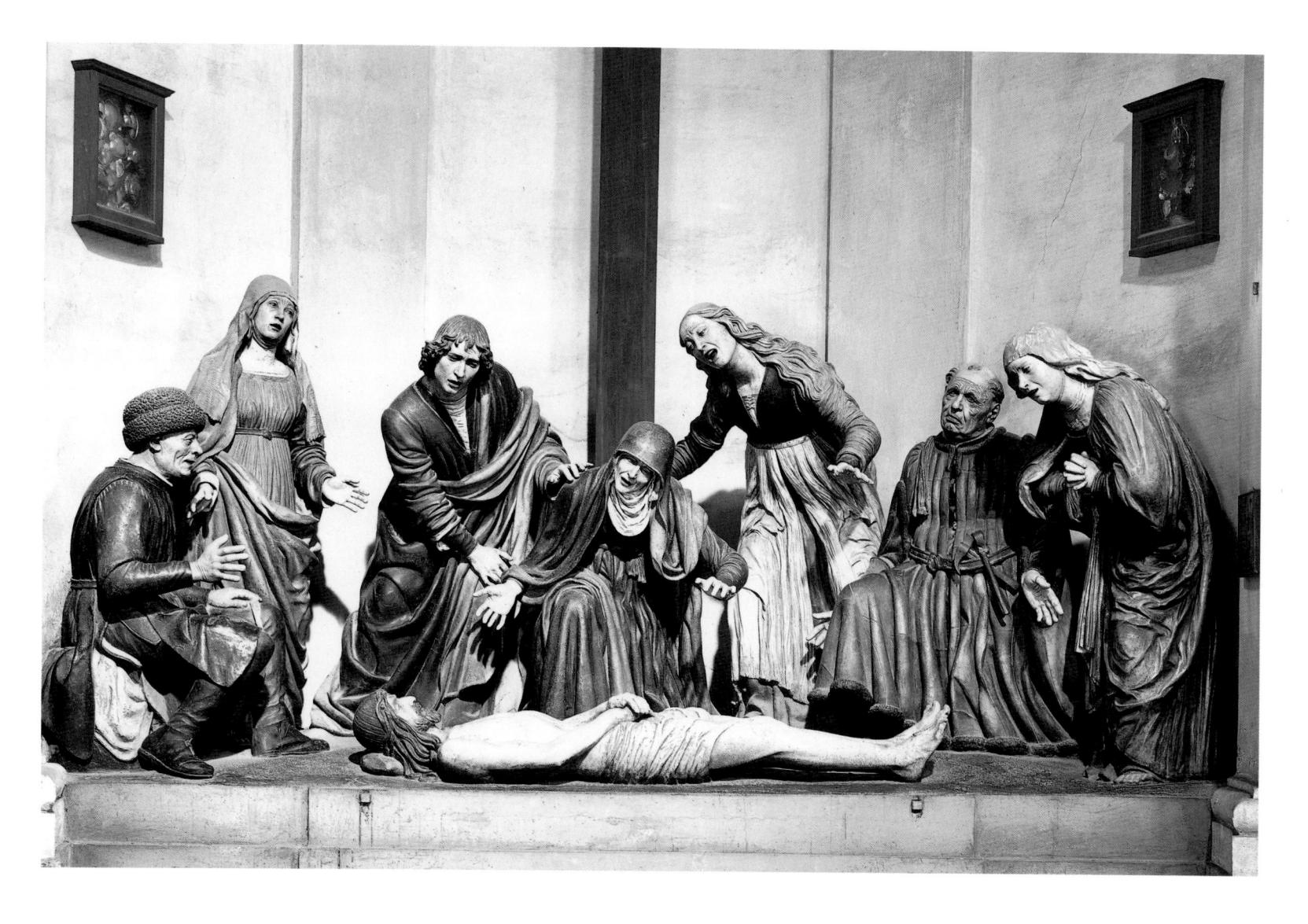

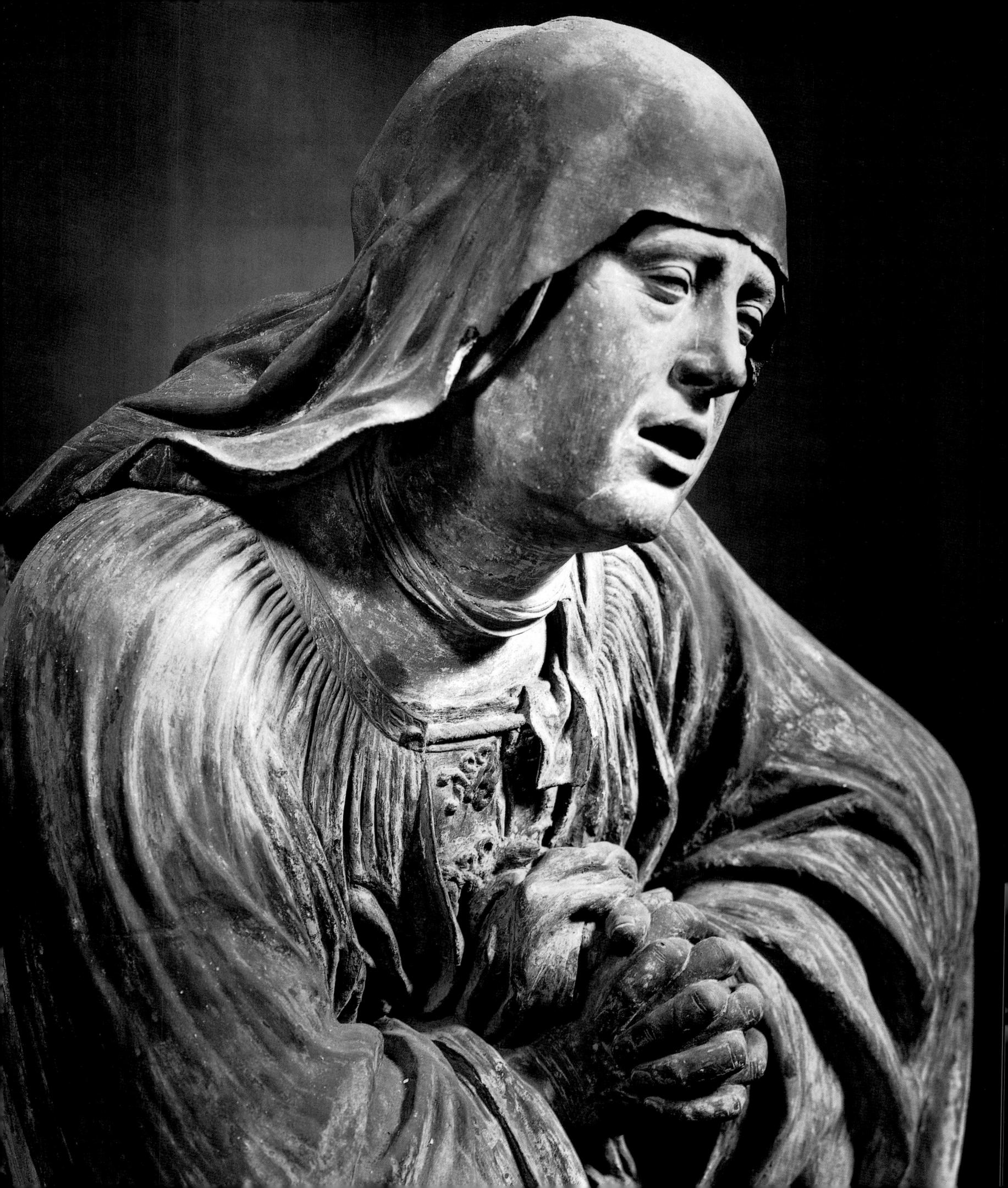

plate 246 *(opposite)* Guido Mazzoni

Lamenting Woman

S. Anna dei Lombardi, Naples terracotta, partially pigmented

plate 247 Niccolò dell'Arca

Lamenting Woman

S. Maria della Vita, Bologna (detail of plate 244)

suppose) from 1463, it would precede Tura's organ shutters at Ferrara, as well as the predella of Cossa's Griffoni altarpiece and Ercole de' Roberti's fresco of the Crucifixion in S. Pietro at Bologna.

A measure of the intensity of Niccolò dell'Arca's Lamentation is provided by the work of his Modenese contemporary Mazzoni, who specialized in painted terracotta groups (plates 245, 246). To contemporaries Niccolò appeared 'phantasticus et barbarus', whereas Mazzoni, working in a more placid style, enjoyed great popularity. The outcome of his tireless industry are life-size tableaux vivants in his native region, and in centres as far apart as Padua (from S. Antonio in Castello in Venice), Naples (in the church of Monteoliveto), and Fécamp. They bear the same relation to Niccolò dell'Arca's Lamentation that the paintings of Cossa bear to Ercole de' Roberti's, and their stolid language was equally acceptable. None the less, they have real sculptural quality, and the conventional pietism of the gestures is often redeemed by genre motifs and naturalistic detail. The tradition of terracotta sculpture initiated by Niccolò dell'Arca and Mazzoni was continued by Vincenzo Onofri in a group in S. Petronio, and in the full tide of the sixteenth century was developed by two younger artists, Alfonso Lombardi in a Death of the Virgin in S. Maria della Vita at Bologna (1519-22) and Antonio Begarelli in a Deposition in S. Francesco at Modena (1531).

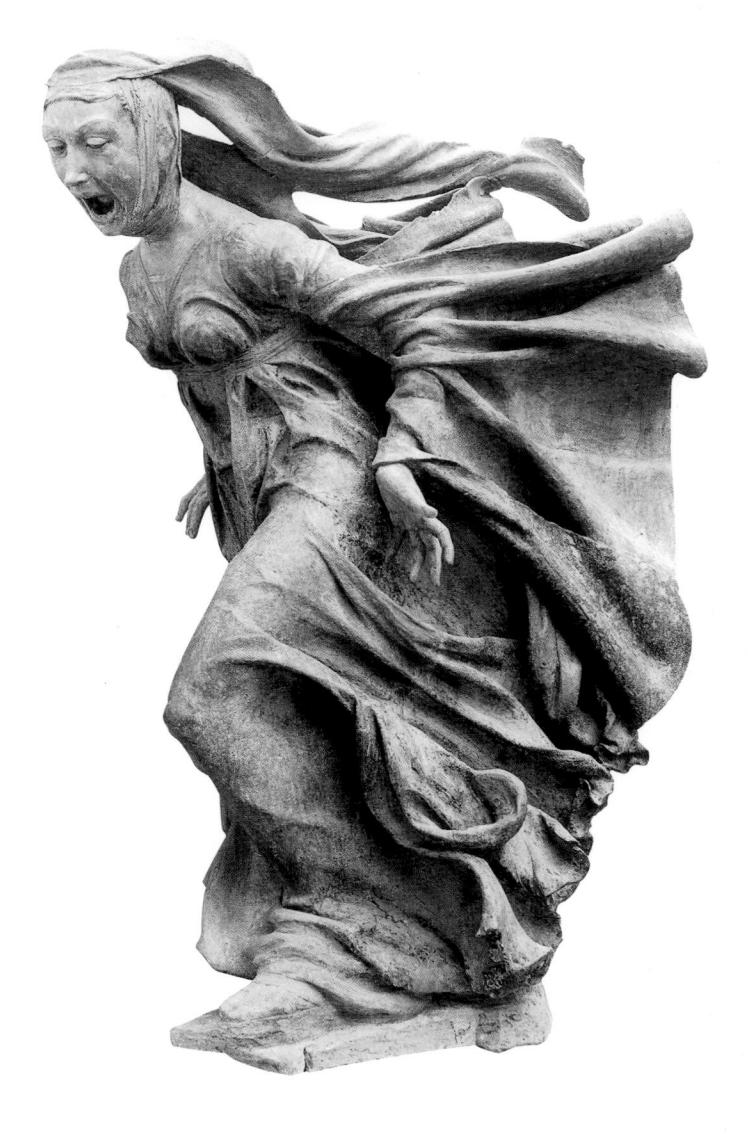

OMBARD ART FOLLOWED a different creative Lprocedure from that of Florence, and obeyed a different aesthetic law. The contrast is best established by passing directly to a typical Lombard Renaissance monument, the memorial chapel built by the condottiere Colleoni in his native town of Bergamo (plate 249). Unlike Verrocchio's monument in Venice (plate 190), which owed its existence to a clause in Colleoni's will, the chapel was built in Colleoni's lifetime to house his tomb. It was his intention that the monument in Venice should be set up in a position of great prominence outside St Mark's, and the same thought was given to the placing of the chapel. At Colleoni's instance the sacristy of S. Maria Maggiore was demolished to provide a site visible through the whole length of the Piazza Vecchia of Bergamo. The Colleoni Chapel is a Renaissance adjunct to a Gothic church. If, however, we approach it expecting a North Italian equivalent for the Pazzi Chapel, we shall be disappointed, for it has nothing in common with this work. Its flat façade is framed by tall pilasters decorated with reliefs of saints and emperor heads, and is broken by an elaborate central doorway with a deeply recessed window over it, by two lateral windows, and by niches filled with busts. Such parts of the wall surface as are free of sculpture are encrusted with marble inlay in the form of cubes. Across the façade runs an open gallery, and over this again is a row of decorative niches which support a cupola. Another smaller cupola crowns the protruding tribune of the chapel. Here then is a building which contravenes

in every way the canons of Florentine Renaissance taste. Its effect is made not by beauty of proportion or harmony of form, but through the richness of its decoration and the brilliance of its polychromy. The circular window in the centre is enriched with consoles of red marble, each of the lateral windows contains six columns, two black, two red, two white, beneath them are white marble reliefs separated by black consoles, and above them runs a frieze of white marble pilasters on a black ground. On the façade of the Colleoni Chapel the carving is not an addition to a self-consistent architectural unit, but the mainstay of the whole design. The sculptor and the architect were one and the same artist. His name was Giovanni Antonio Amadeo, he was born at Pavia, and when he began work at Bergamo he was aged 25.

When we examine the carvings in detail, we find that they, too, are strikingly un-Florentine. In the pilasters beside the doorway the foliage writhes and swirls like the border of an illuminated manuscript. The scenes from Genesis beneath the windows are vivid and grotesque, and the angels above the doorway are posed with enchanting simplicity and naturalness. In the six statuettes of Virtues (plate 250) – two above each of the lateral windows and two beside the entrance - the motifs derive from the antique, though they appear to have been passed through a filter of Gothic mannerism. In the lowest register, beside the doorway, are two rectangular supports of which the outer faces are carved with putti. A Florentine analogy for these reliefs occurs in the Prato pulpit of Donatello, but we have only to compare

plate 248 Giovanni Antonio Amadeo

Effigy of Medea Colleoni

Colleoni Chapel, Bergamo (detail of plate 252) marble plate 249 Giovanni Antonio Amadeo

The Façade of the Colleoni Chapel

Bergamo

plate 250 (opposite) Giovanni Antonio Amadeo

Virtue

Colleoni Chapel, Bergamo (detail of plate 249) marble

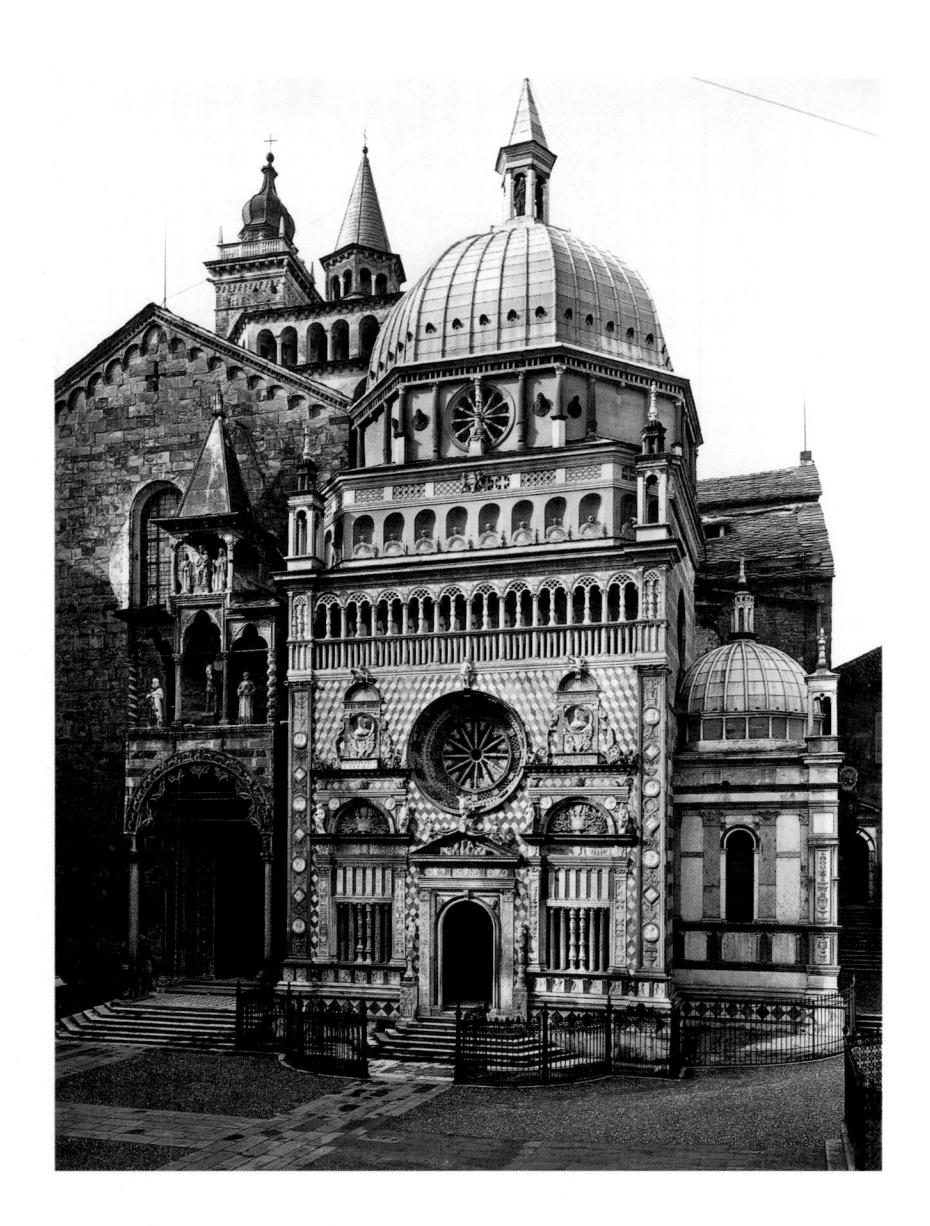

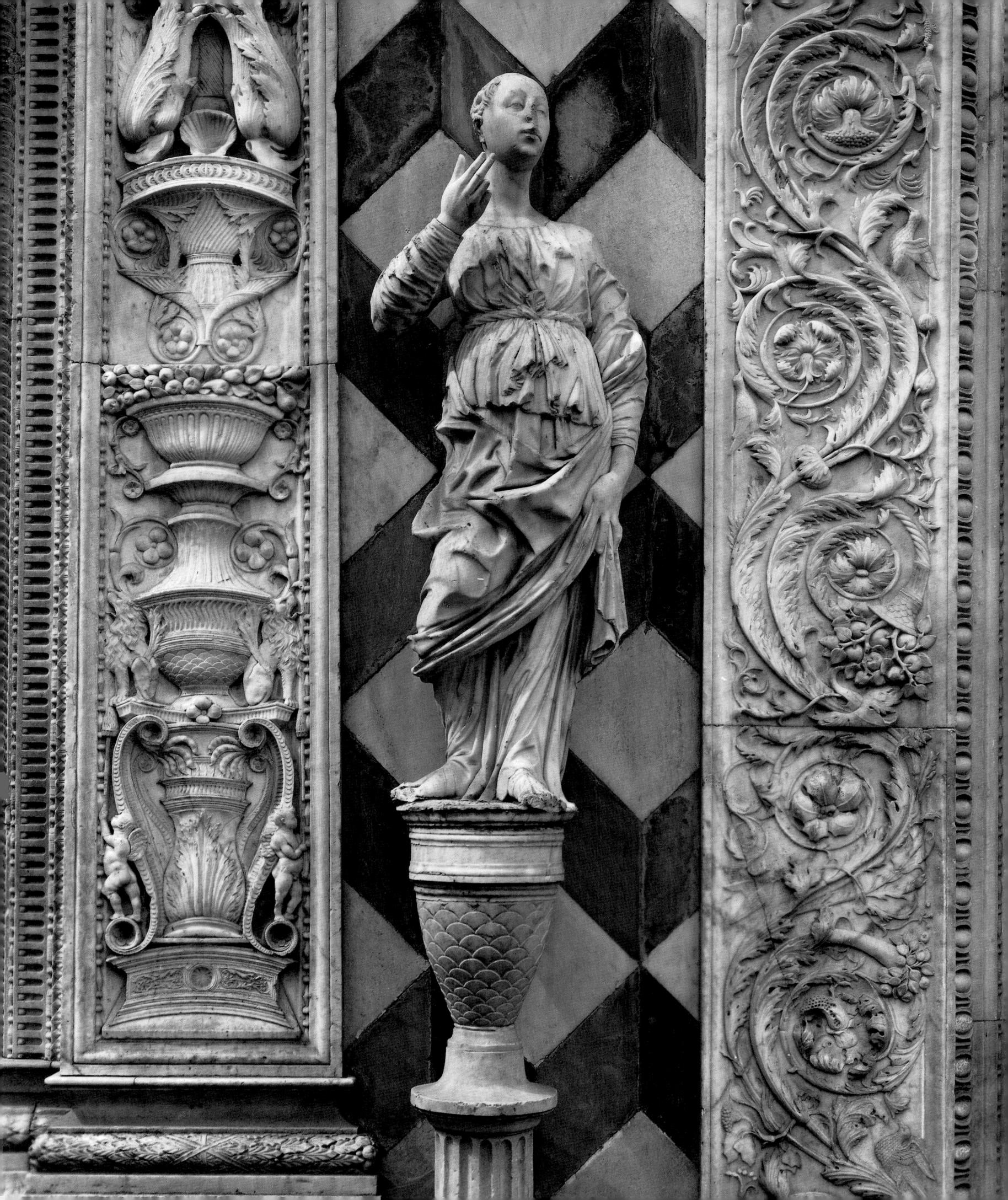

Amadeo's reliefs with a panel from the pulpit to see how weak are the foundations, how lax the discipline from which they spring. Of the handling it is difficult to speak, since the carvings are weathered, and some of the Genesis scenes are practically effaced. Inside the chapel, however, on the tribune arch, are two more pilasters, carved not in marble but in the more accommodating medium of Istrian stone, where we can follow every movement of Amadeo's chisel as he builds up a design of crisp vine leaves and curling tendrils which has more in common with Southwell and Amiens than with Luca della Robbia and Bernardo Rossellino. At the base of these pilasters are two more groups of putti (plate 251), solemn children who would be perfectly at home on the Sebaldus shrine at Nuremberg, treading the grapes with heavy feet and spinning the disc above them like a gigantic top. The monument of Colleoni, on the wall opposite the entrance, offers another illustration of Amadeo's singularity, in four lamenting lions placed, like dogs chained in their kennels, under the supports. In these and in the childlike angels of the Nativity relief, we are closer to the centre of Amadeo's art than in the classicizing statuettes of Virtues in the lower section of the tomb or in the antique heroes seated under the sarcophagus.

To the left of the entrance, facing the tribune arch, is an addition to the chapel, the tomb of Colleoni's daughter, Medea (plate 252), which has occupied its present place only since 1842. Planned on a smaller scale, it rests on consoles, and is closed by pilasters at the sides and knotted curtains at the

top. The epitaph is set above the effigy, and is rendered as though on parchment with one corner turned up. The front of the sarcophagus is carved with heraldic devices and a Pietà, and over the epitaph is a Madonna of Humility accompanied by a kneeling figure of St Catherine of Alexandria with her wheel and a seated figure of St Catherine of Siena. The three figures bring to mind the early paintings of Amadeo's contemporary Foppa, and form a sacred conversation from which only the painted meadow has been left out. The effigy (plate 248) is unusually small, and its scale is still further reduced by the presence of three large cherub heads under the sarcophagus. By comparison with the effigies on Florentine tombs of the same type, this is typically Northern in handling and sentiment. In the head, indeed, with its elongated ears and large protuberant eyes, there is more than a suspicion of Petrus Christus and Jan van Eyck.

To trace the genesis of Amadeo's style we must return to the late fourteenth century when, under Gian Galeazzo Visconti, Lombardy became the most important cultural centre in North Italy. From the time of its foundation in 1387 Milan Cathedral attracted to the city a host of International Gothic sculptors, some of them Frenchmen and Germans and some local artists who worked in the same ornate, pictorial style (Vol. I, plate 118). Of this tradition Amadeo was the beneficiary. When, for example, he designed the Lamentation over the Dead Christ on the Colleoni tomb, his model was a relief carved in 1393 by Hans von Fernach over the door of the

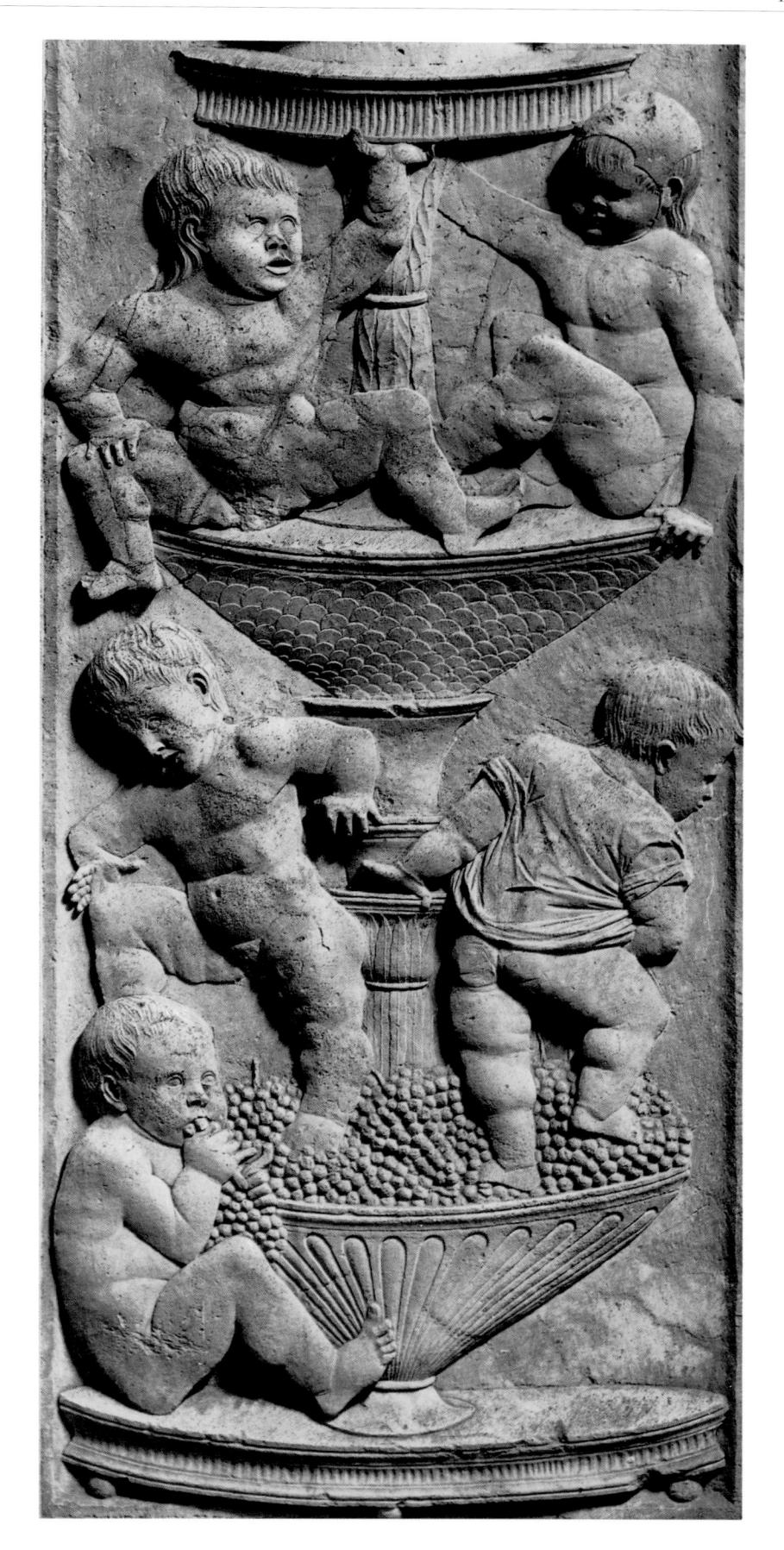

plate 251 Giovanni Antonio Amadeo

Playing Children

Colleoni Chapel, Bergamo Istrian stone

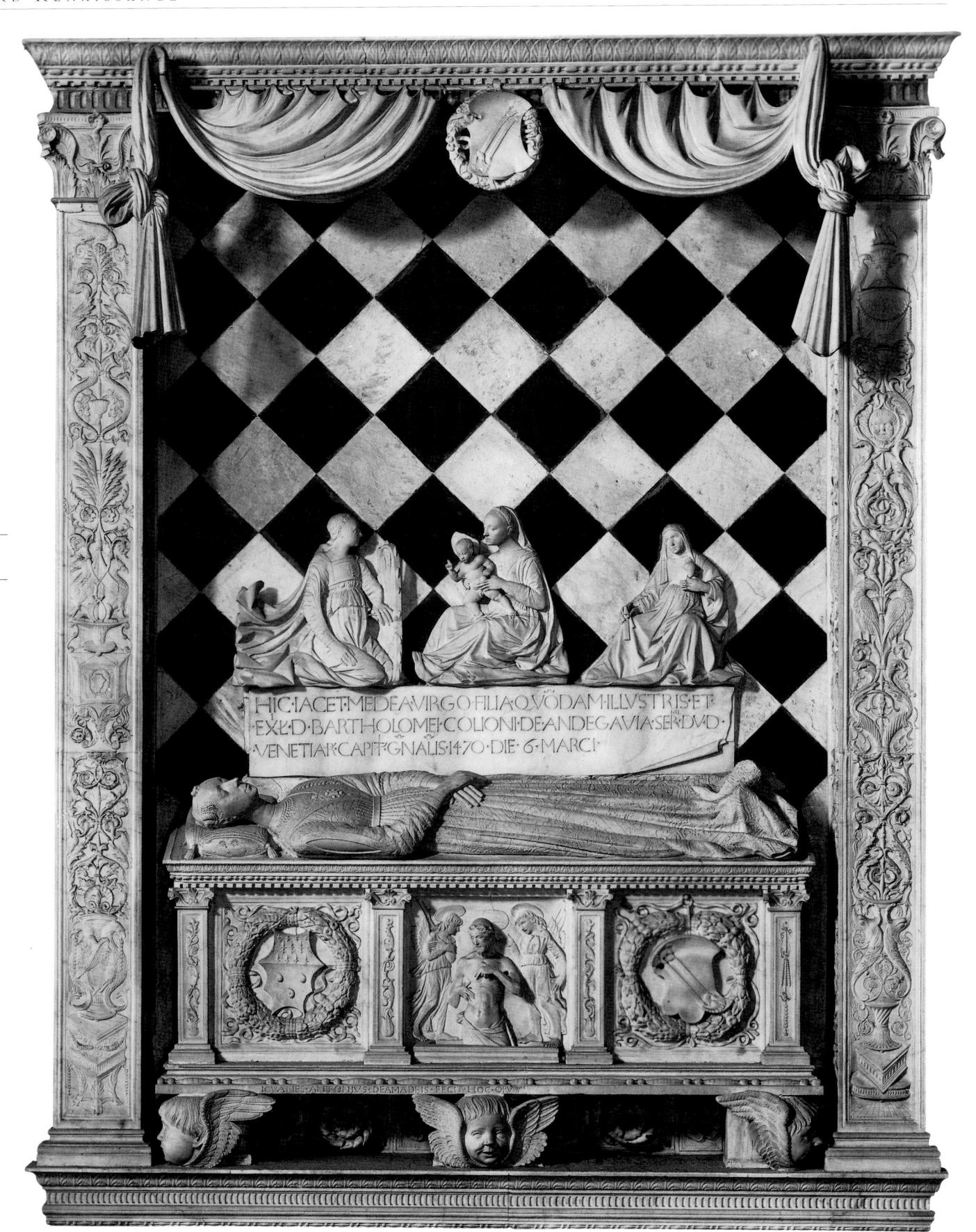

plate 252 Giovanni Antonio Amadeo

Monument of Medea Colleoni

Colleoni Chapel, Bergamo marble south sacristy of the Cathedral. The immediate precedents for Amadeo's style are to be sought, however, not in Milan but at the Certosa at Pavia. Founded by Gian Galeazzo Visconti in 1396, the Certosa was from the first conceived on a substantial scale, with one large and one smaller cloister and an imposing church. The terracotta decoration of the two cloisters was carried out during the 1460s by a group of artists of whom the most prominent was Cristoforo Mantegazza. Some of the sculptors whose names appear in connection with the cloister decoration are shadowy figures, but there is a group of marble sculptures at Pavia that can be associated with Cristoforo Mantegazza and his brother Antonio, and on the basis of these Cristoforo's share in the terracotta sculpture of the cloisters can be elucidated. The Veronese sculptor Antonio Rizzo was also engaged on work for the Certosa at this time, and may have been responsible for modelling certain statuettes in the large cloister, while in the small cloister there appear two further artists, one of whom is generally identified with the young Amadeo (plate 253). The exact extent of Amadeo's intervention in the cloister decoration may never be established, but it is certain that he worked initially as a modeller in terracotta, and this is reflected in his sculptural style.

The artists entrusted with the decoration of the arcades were also responsible for other works. The most important of these is a terracotta Annunciation over the lavabo in the small cloister, which is divided between two lunettes, one with the Angel Gabriel and the other with the Virgin

Annunciate (plate 254). The Virgin sits in the foreground before a lectern, on a low seat with a sewing-basket pushed under it. Behind, unrelated to the main figure, is a receding building in incorrect perspective spread out like a four-fold screen, with a diminutive God the Father peering over the top. The Annunciation is documented as a work of 1466, and was gilded by Amadeo's brother, and since the name of Amadeo first appears in the Certosa records in this year, there is a presumption that he was responsible for the relief. Its style certainly conforms in a convincing fashion to that of a signed marble sculpture which must have been carved soon after this time. This is a doorway leading from the small cloister into the church (plate 255) with a lunette above it showing St John the Baptist and St Bruno presenting four Carthusians at the Virgin's throne. The rather heavy handling of the lunette suggests that at this time Amadeo's experience of marble sculpture was limited, and this impression is reinforced both by the pilasters beside the entrance, which reproduce in marble the terracotta putti round the cloister arcades, and by the strips of decorative carving at the sides, which incorporate angels with instruments of the Passion and a little Pietà at the top. The whole doorway was originally pigmented, and still reveals traces of blue, green, red and purple paint. Not only is the sentiment of the lunette and the pilasters Gothic, but they are carved in a traditional technique which leaves no doubt that Amadeo received his earliest training as a marble sculptor locally in Lombardy. The righthand pilaster is superior to the left, but both are

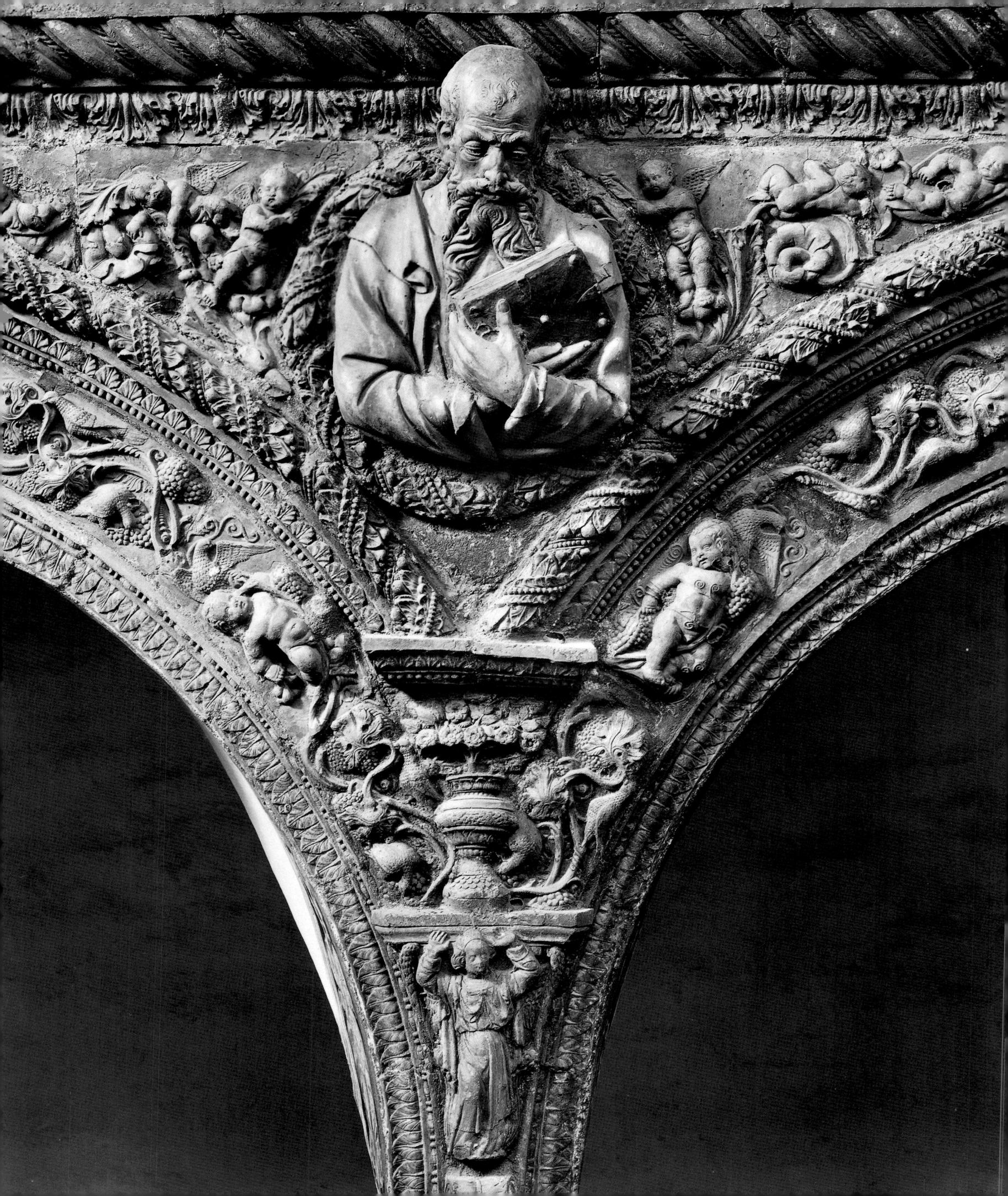

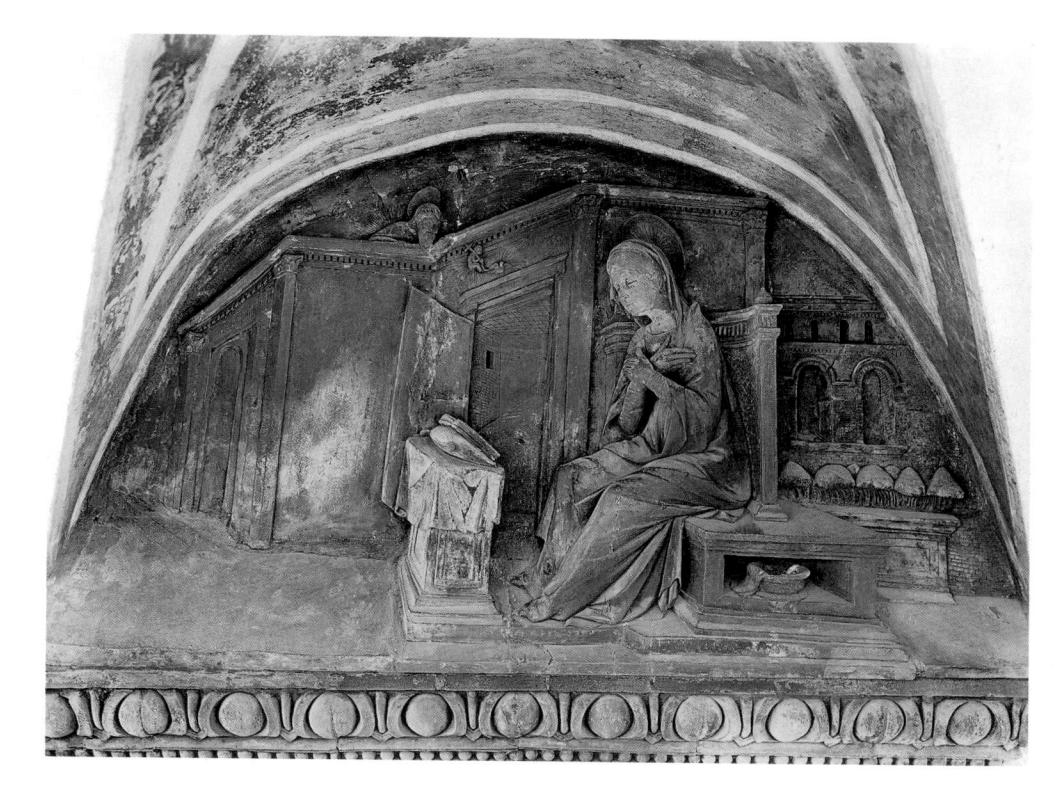

plate 253 (opposite) Giovanni Antonio Amadeo (?)

Spandrel Decoration of the Small Cloister

Certosa, Pavia terracotta

plate 254 Giovanni Antonio Amadeo (?)

The Virgin Annunciate

Certosa, Pavia terracotta

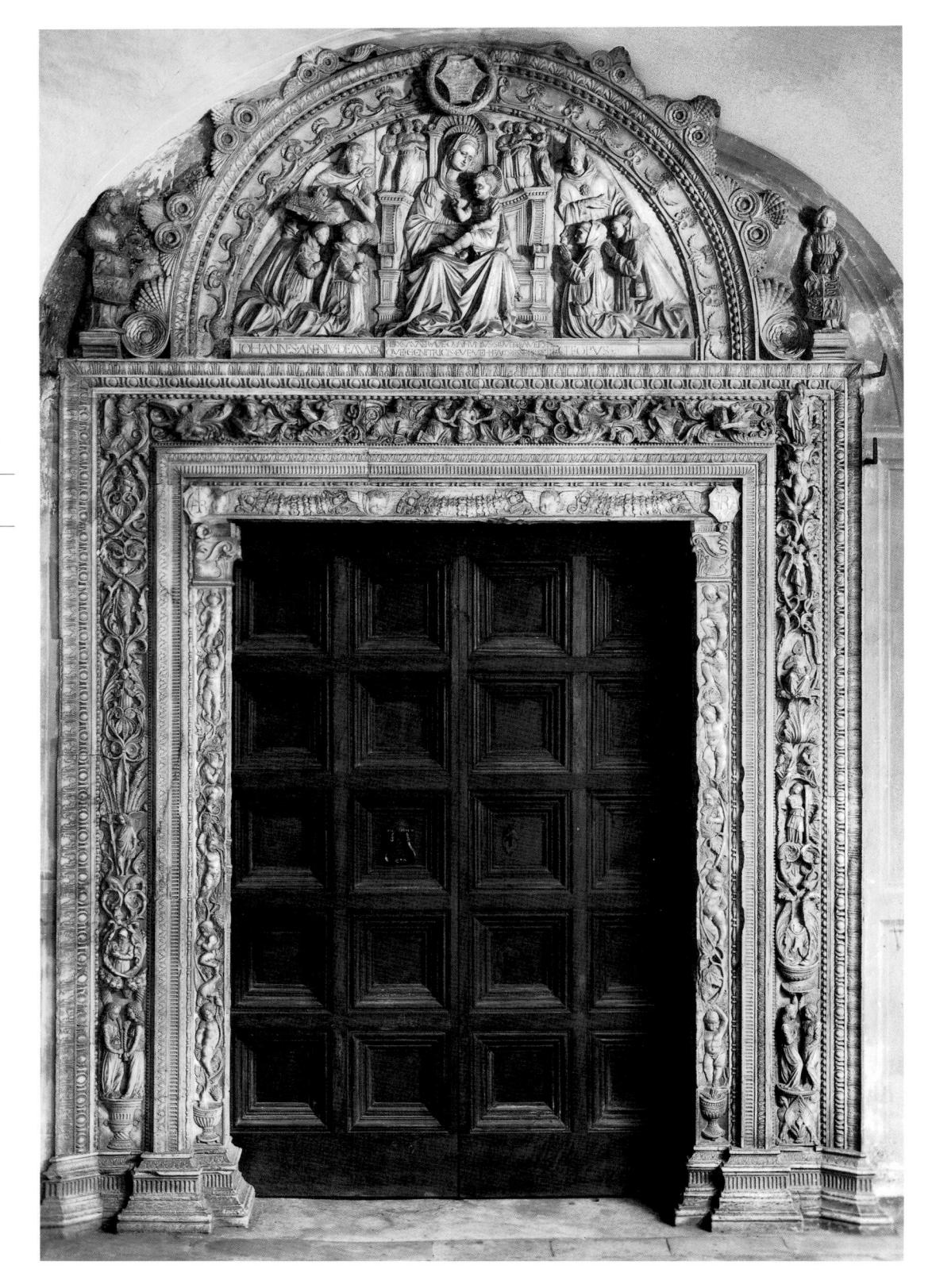

plate 255 Giovanni Antonio Amadeo

Doorway of the Small Cloister

Certosa, Pavia

inferior to the carvings at Bergamo, and though there is no warrant for the view that Amadeo was trained in Florence, it is likely that between the cessation of work on the doorway at Pavia and the commencement of the Colleoni Chapel he became acquainted with Tuscan marble sculptures.

The most prominent of the artists with whom Amadeo was in contact at Pavia were Foppa, Antonio Rizzo and Cristoforo Mantegazza. The part played by Rizzo in the terracotta decoration of the cloisters is conjectural – the documents tell us only that in 1465-6 he furnished Verona marble columns for the large cloister - but Rizzo's influence is perhaps to some extent accountable for the classicizing Virtues on the Bergamo façade. In the same way a cycle of biblical reliefs (now on the façade of the Certosa), which was carved by Cristoforo Mantegazza concurrently with the last stages of work on the cloisters at Pavia, is reflected in Amadeo's Genesis reliefs at Bergamo. Through the 1470s Amadeo and Cristoforo and Antonio Mantegazza were once more working side by side. In 1473 the façade of the church of the Certosa (plate 256) was entrusted to the brothers Mantegazza, and a year later Amadeo was allotted a half-share in this responsibility. In examining the facade it must be borne in mind that the upper part (the section above and including the first gallery) dates from the middle of the sixteenth century, and that as late as 1497 a more modest upper storey was projected, under which the work of Amadeo and the Mantegazzas up to and including the window register would have fallen harmoniously into place. The lowest register of the façade is decorated with a frieze of marble roundels, representing emperors and rulers of antiquity. Above this is a strip of upright rectangular reliefs interspersed with statuettes, the former executed by Amadeo and his studio, and the latter, along with some reliefs of single figures, by the Mantegazzas. As at Bergamo so at Pavia, the external reliefs of Amadeo have suffered from the effects of weathering, and an impression of his mature relief style is best formed not at the Certosa, but at Cremona, from a beautiful relief carved in the early 1480s of S. Imerio giving Alms (plate 257) which employs the same spatial devices as the scenes from the life of Christ at the Certosa, but where the figures are invested with a greater wealth of realistic detail. In the centre of the scene is a Renaissance tabernacle protruding from a ruined Renaissance colonnade, whose main function, as in an International Gothic painting, is to isolate the figure of the Saint, on which the orthogonals converge. In the foreground figures the impact of the Mantegazzas is still clearly evident.

The essential difference between the styles of Amadeo and the Mantegazzas becomes apparent in an altarpiece of the Lamentation over the Dead Christ, which was carved by Antonio Mantegazza, probably in the late 1480s, for the Capitolo dei Fratelli at the Certosa (plates 258, 259). In this the foreground figures are restricted to two planes, and the body of Christ forms a flat pattern with the upper arm parallel to the base. The concept of space in this scene is more primitive than Amadeo's, and at the back we see a number of isolated scenes – the Crucifixion, the soldiers casting lots, the opening of the sepulchre – each

plate 256

The Façade of the Certosa

Pavia

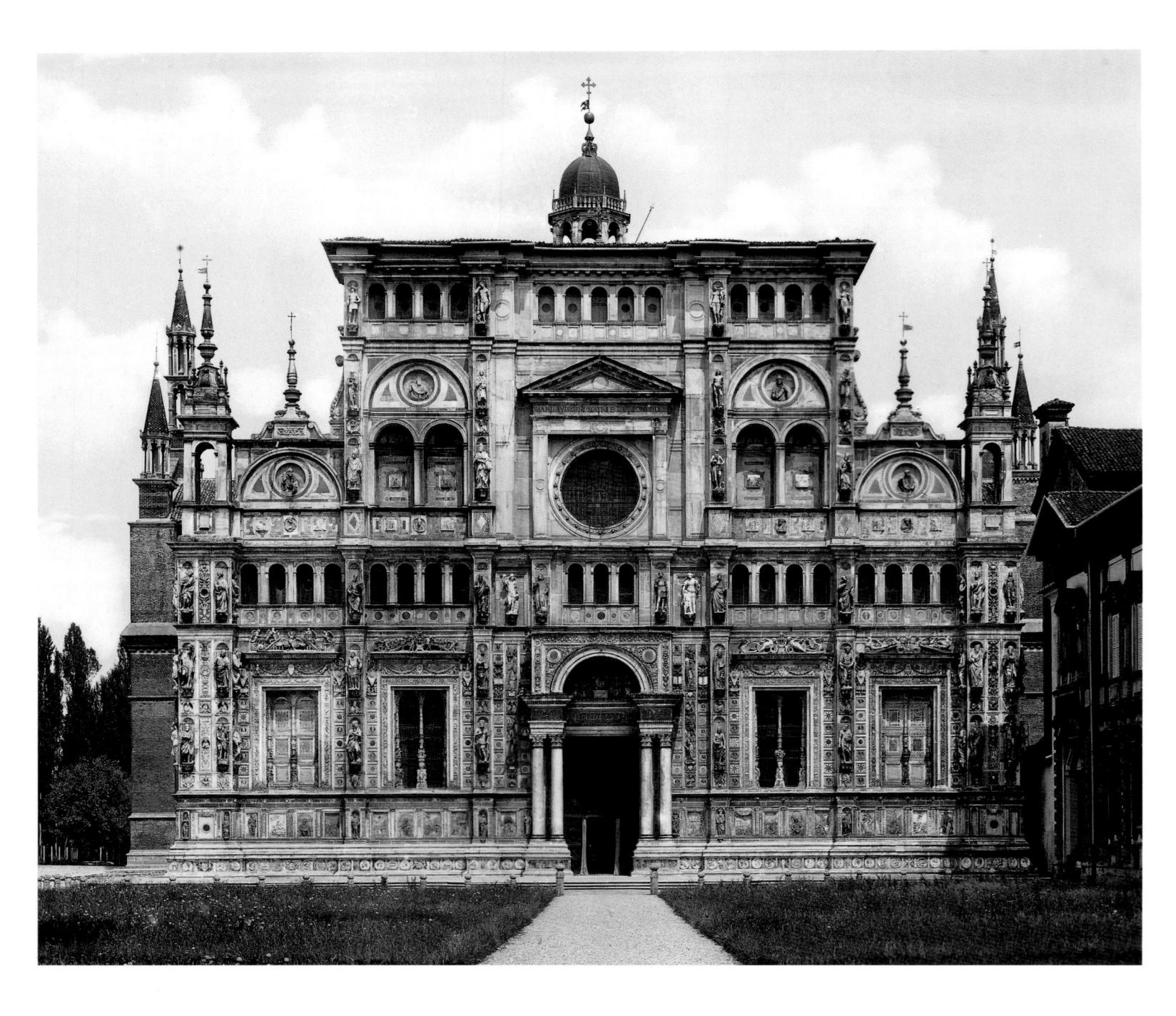

plate 257 Giovanni Antonio Amadeo

St Imerio Giving Alms

Duomo, Cremona marble

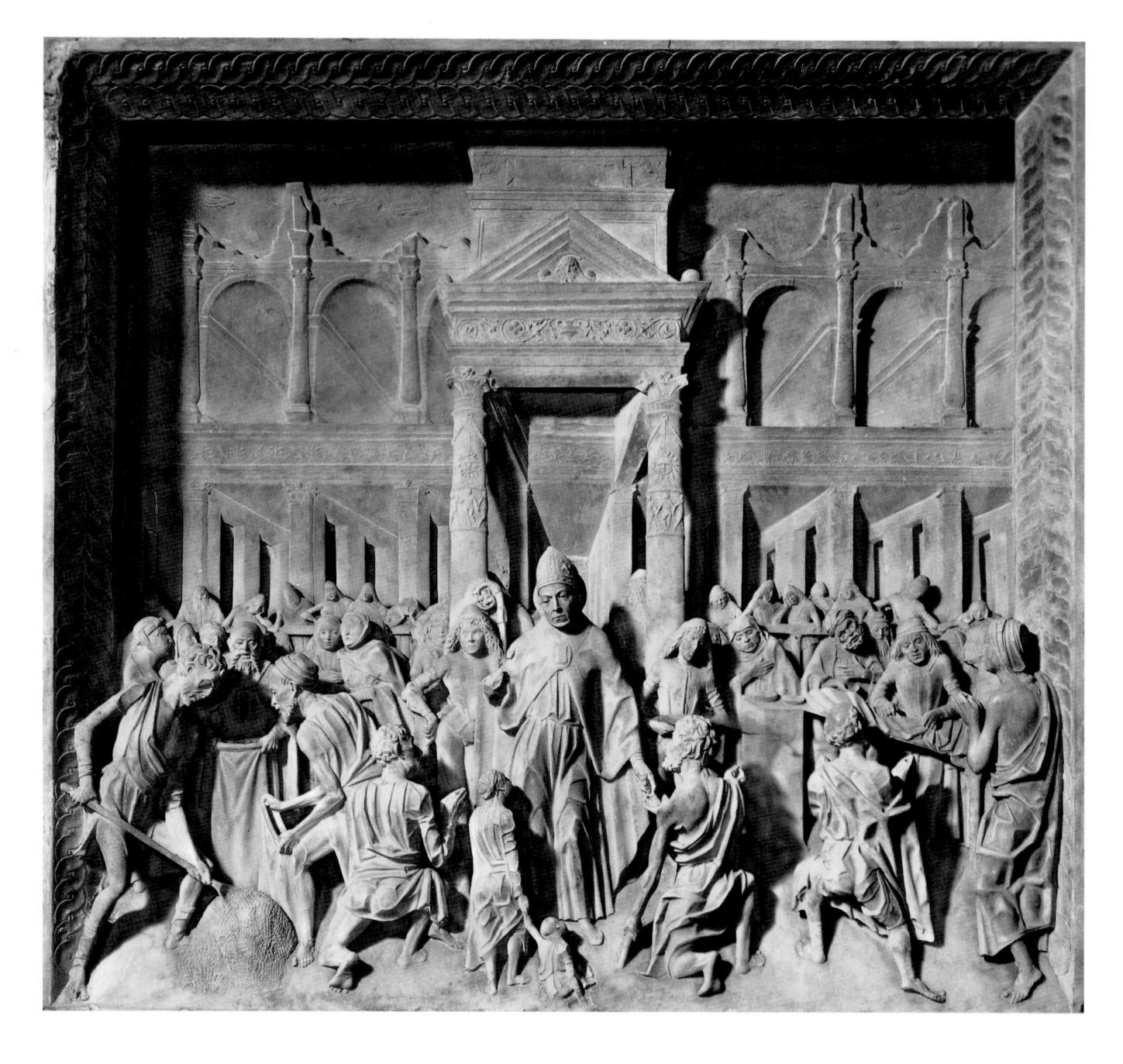

plate 258 Antonio Mantegazza

Lamentation over the Dead Christ

Certosa, Pavia marble, 196×112 cm

plate 259 (opposite) Antonio Mantegazza

The Lamentation over the Dead Christ

Certosa, Pavia (detail of plate 258)

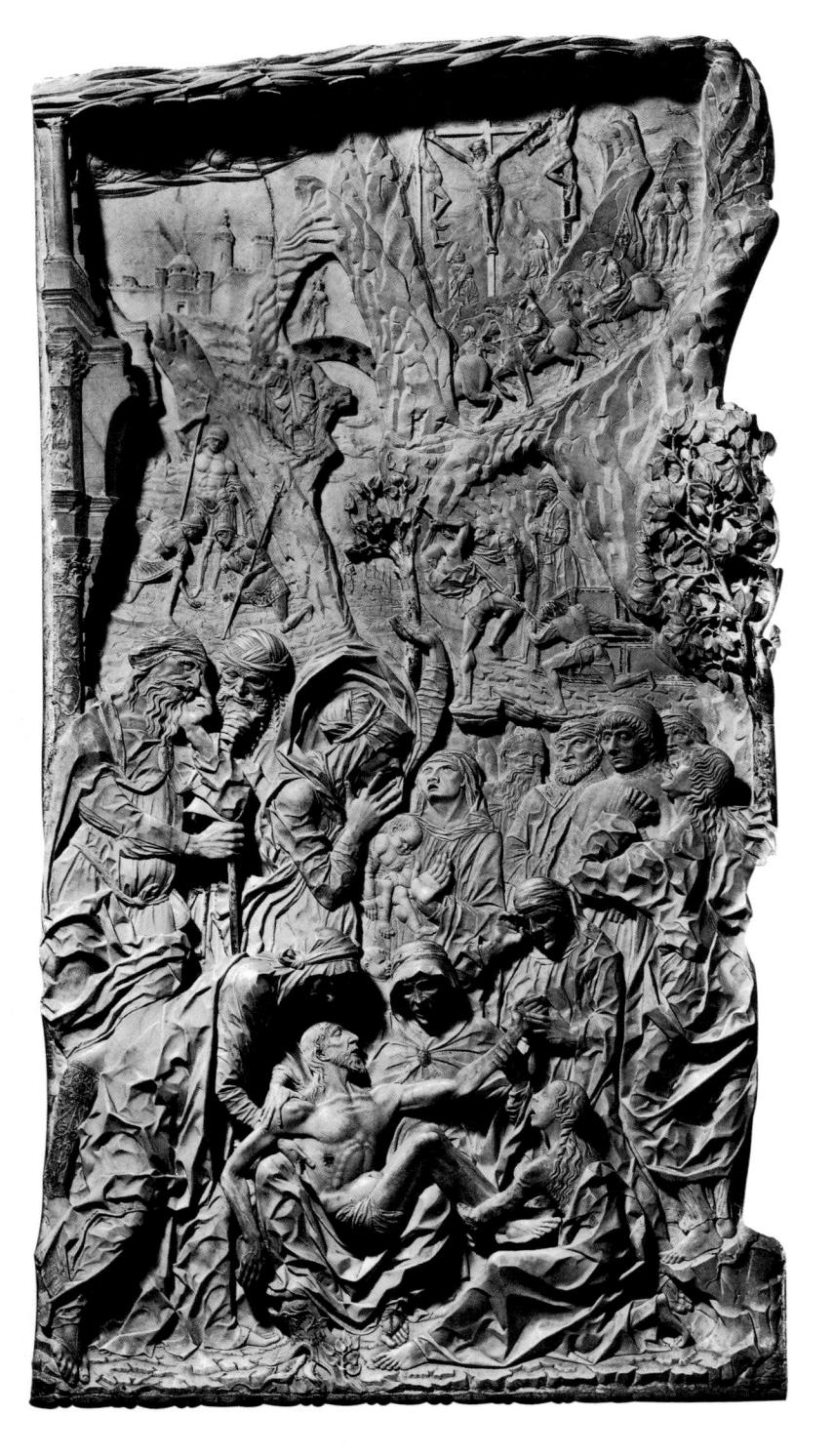

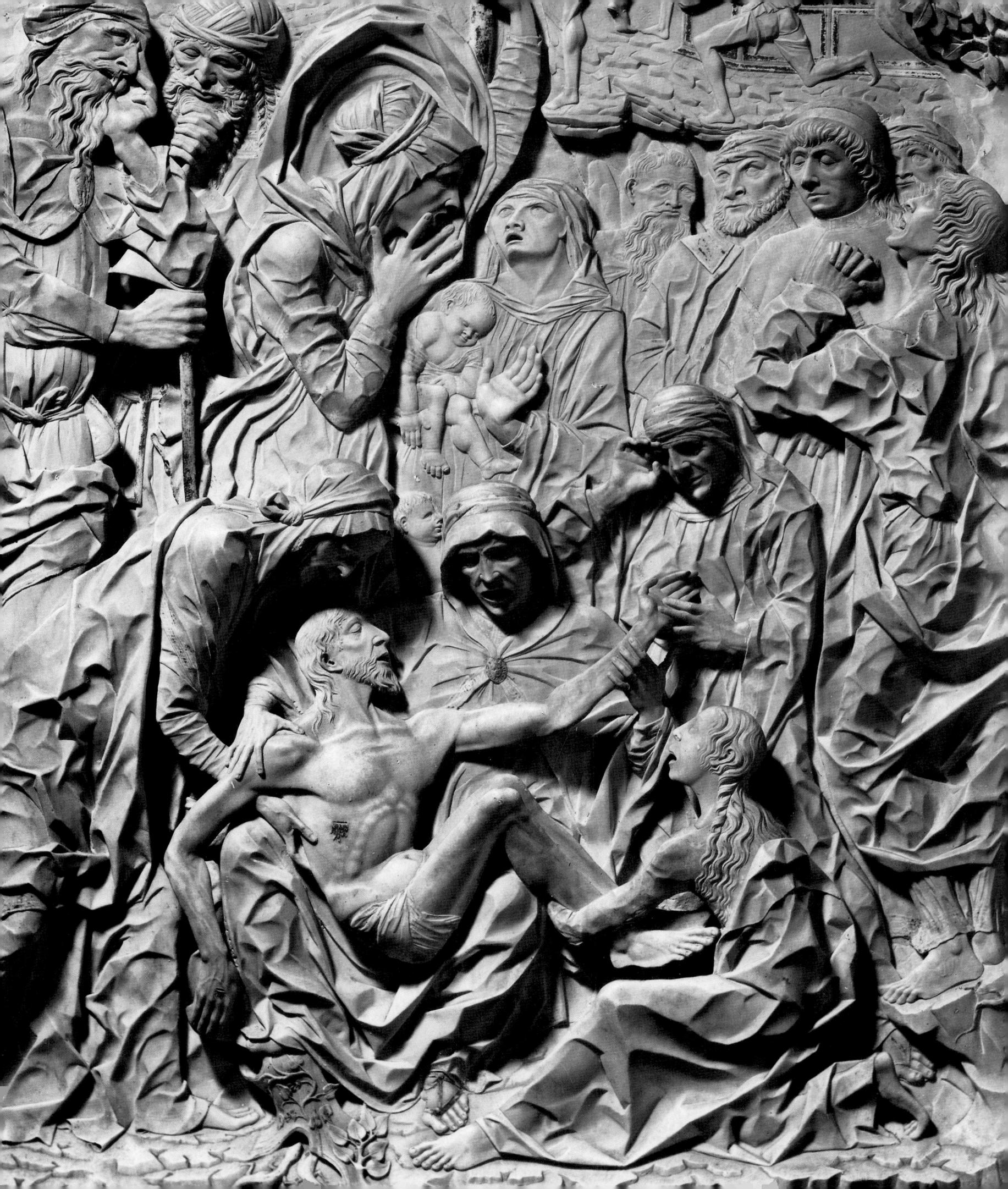

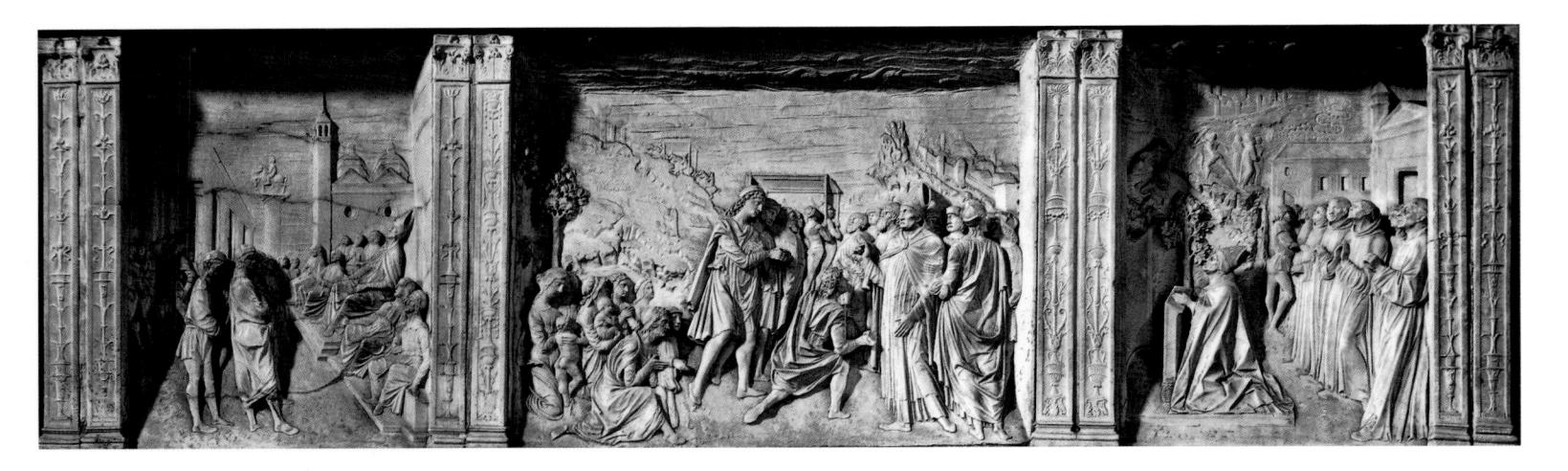

plate 260 Giovanni Antonio Amadeo

Relief from the Arca of St Lanfranco

S. Lanfranco, Pavia

of which is supplied with its own background irrespective of its place in the relief. Like his brother, Antonio Mantegazza approached his subject-matter in a state of fevered exaltation that makes the reliefs of Amadeo look staid and classical. One of the Marys presses her emaciated face against Christ's head, the St John lifts His disproportionately long left arm, and the Magdalen stretches her talons round His legs. Yet in the original this is less apparent than in photograph, since the distant scenes are carved with remarkable delicacy and fastidiousness, and the widespread use of gilding in the figures reduces their expressive force.

Cristoforo Mantegazza died before 1482, and Antonio Mantegazza in 1495, and when work began in 1492 on the window register of the façade, this was undertaken by Amadeo, who designed four windows, two of them blind. In the documents relating to these windows the names of a number of young sculptors appear for the first time, and their handiwork can be detected in the heavy, languorous sentiment and deliquescent forms of the figure carvings on the central supports. Among the artists who intervened in them was Benedetto Briosco, who in 1501 designed the portal of the church (plate 256), a simple entrance with pairs of classical columns in striking contrast to Amadeo's ornate façade. Beside the entrance are reliefs by Briosco showing events in the history of the Certosa. Where Amadeo's scenes from the life of Christ on the façade achieve a strange, visionary intensity, Briosco's reliefs are staid, prosaic and precise. There is evidence that Amadeo was also

infected by this change in taste, for in the Arca of St Lanfranco in the church of S. Lanfranco outside Pavia, he achieved some of his most harmonious carvings and one of his most classical designs (plate 260). The Passion scenes on the Colleoni Monument at Bergamo and the scenes from the life of S. Lanfranco form the terms of Amadeo's growth from an inexperienced provincial marble sculptor into a Northern Benedetto da Majano

When Antonio Mantegazza died, he was succeeded as Ducal Sculptor by a Lombard artist who had made his name in Venice, Cristoforo Solari. Two years later, in 1497, Solari was charged with the monument of Lodovico il Moro and Beatrice d'Este in S. Maria delle Grazie in Milan. The tomb was dismantled in 1564, and the only pieces of it that survive are the two effigies (plate 261) now in the Certosa at Pavia. Solari (who is otherwise known mainly through some flaccid statues carved for Milan Cathedral) was a sculptural Boltraffio, who combined a stolid grasp of form with a lively interest in detail. Alone of his Milanese contemporaries, he was more fully at ease on a large than a small scale, and the drapery of the two figures possesses the buoyant, compulsive rhythm that springs from a masterful technique. Solari's besetting sin (as the deeply incised eyelashes of Beatrice d'Este would alone indicate) was lack of reticence, but the heads of the two effigies suggest that in another setting he might have grown into a portrait sculptor of all but the first rank.

In so far as the change in sculptural style in the last decade of the fifteenth century can be ascribed to any single cause, this was the presence at Pavia of

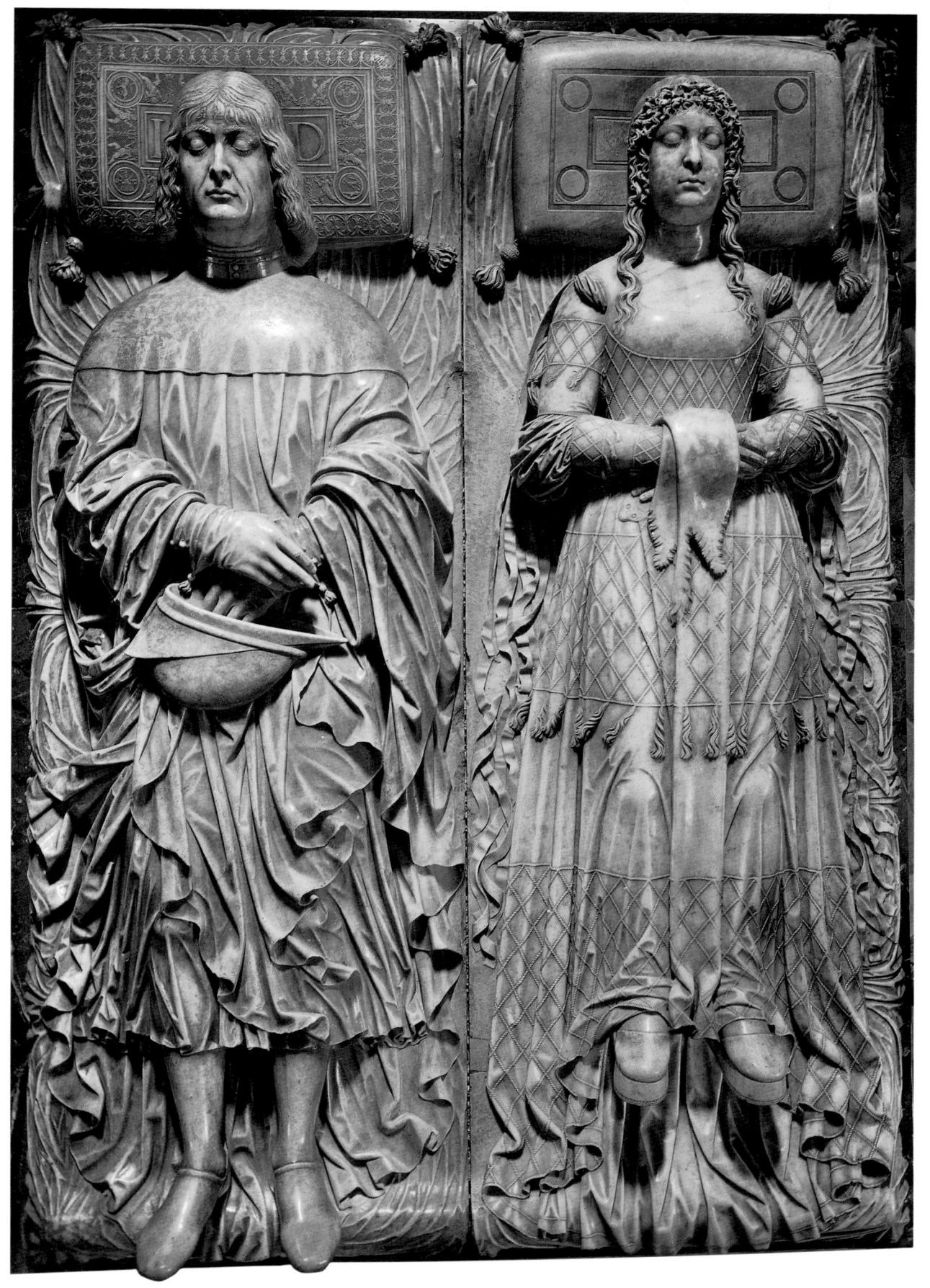

plate 261 Cristoforo Solari

Effigies of Lodovico il Moro and Beatrice d'Este

Certosa, Pavia marble, length 185 cm

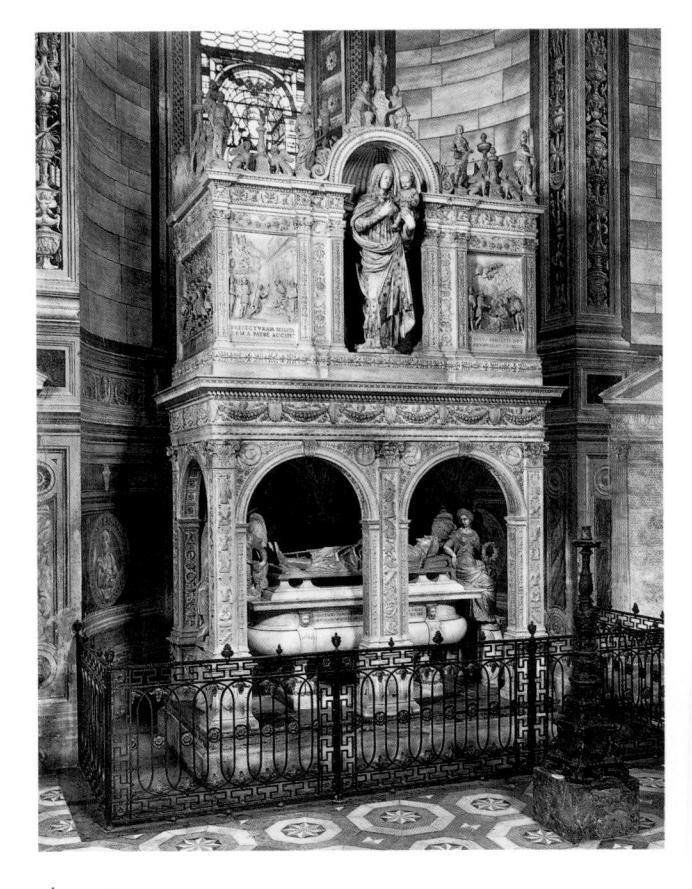

plate 262 Gian Cristoforo Romano

Monument of Gian Galeazzo Visconti

Certosa, Pavia marble, height 602 cm

plate 263 Gian Cristoforo Romano

Scene from the Life of Gian Galeazzo Visconti

Certosa, Pavia (detail of plate 262)

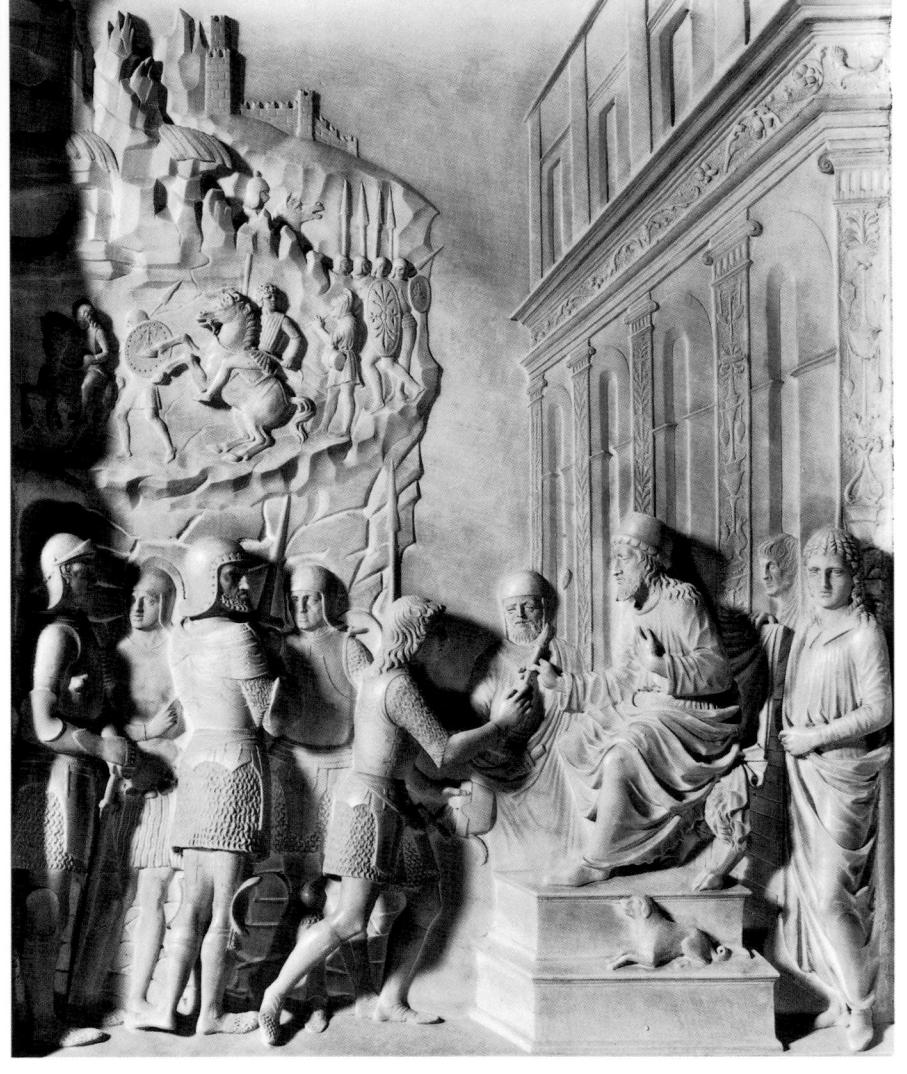

Gian Cristoforo Romano, a Roman pupil of Andrea Bregno. Before he arrived in Lombardy, Gian Cristoforo Romano had perfected a courtly neo-classical style of carving which made systematic use of decorative motifs from imperial art. At the Certosa he was employed during the 1490s on the shrine of its founder, Gian Galeazzo Visconti, inside the church (plate 262). The Visconti Monument is a covered structure, the upper part of which contains narrative reliefs of scenes from Gian Galeazzo Visconti's victorious career. On the front of the tomb are two smoothly executed carvings showing Gian Galeazzo invested by his father with the military command (plate 263) and the election of Gian Galeazzo as Duke, and at one end is a large battle scene which, to eyes used to the façade reliefs of Amadeo and the Mantegazza, must have seemed remarkable for its lifelikeness and for its technical accomplishment.

Gian Cristoforo Romano's style exercised its spell both on Amadeo, in the reliefs on the Arca of S. Lanfranco (plate 260), and on Benedetto Briosco, in the reliefs beside the entrance to the church. But the main tribute to his work was the tomb carved by a pupil of Briosco, Agostino Busti, known as Bambaia, to commemorate the nephew of Louis XII of France, Gaston de Foix. Gaston de Foix's brief and romantic career opened in 1511, when he assumed control of Milan jointly with Trivulzio. No sooner was their regime established than it was threatened by the forces of the Holy League. The main feature of the campaign which followed was a rapid offensive operation carried out by Gaston de Foix in North Italy and the Romagna, which

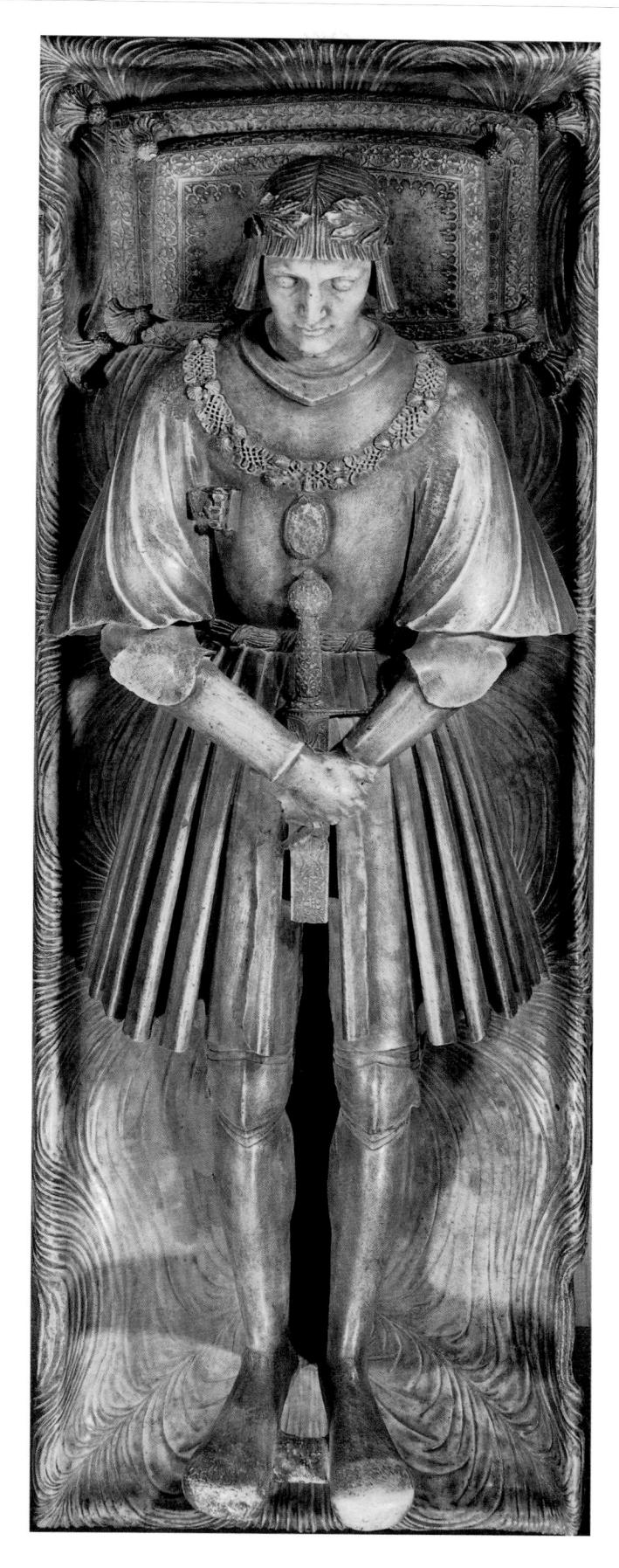

plate 264 Bambaia

Effigy of Gaston de Foix

Museo Civico, Milan marble, 216 × 84 cm plate 265 Bambaia

Charity

Victoria and Albert Museum, London marble, height 66 cm

plate 266 Bambaia

Fortitude

Victoria and Albert Museum, London marble, height 73 cm

plate 267 Bambaia

Carved Pilaster

Museo Civico, Turin marble, 96 × 29 cm

culminated in his death in the Battle of Ravenna at Easter 1512, at the age of 23. After the battle, Gaston de Foix's body was taken back by the French troops to Milan, and placed in the Cathedral, but later in the year when the Sforza forces recaptured the town, it was removed 'with great indignity and like a dog', and exhibited to the French troops who were still besieged in the Castello. Ultimately it came to rest in the Dominican convent of S. Marta. When Francis I entered Milan in 1515 after the victory of Marignano one of his first thoughts was to provide for the young hero's monument. We learn from a letter of 1517 from the Prioress of S. Marta that Lautrec, the regent of Milan, forbade the removal of Gaston de Foix's body from the chapel in which it rested until the tomb was finished, and in 1520 the Fabbrica of the Duomo of Milan gave permission to seven artists to work on the tomb. When Lautrec was expelled from Milan in 1522, however, the body of Gaston de Foix was once more seized and thrown into the moat of the Castello, and work on the memorial was broken off. For more than a century the pieces remained stacked in the church of S. Marta, but after 1629 they were dispersed, and it is no longer possible to determine the exact constituents of the tomb. Of the sculptures which were indubitably destined for it, the most remarkable is the effigy itself (plate 264) which is now in the Museo Civico in Milan. Gaston de Foix is likened by Brantôme to 'verdant grass or a pleasant flower cut in the month of May, and not in July when the heat has made it dry and wan', and this simile comes

vividly to mind as we look at the cleanly modelled head resting with closed eyes and laurel wreath on the elaborately carved cushions of the bier.

Bambaia was also responsible for a cycle of narrative reliefs illustrating events from the campaign of 1511-12 intended for the monument. The point of departure for these carvings is the battle relief on Gian Cristoforo Romano's Visconti Monument, and the reliefs were probably designed to be built into a covered structure like the Visconti tomb. All of the seven surviving scenes are enclosed in foliated borders, and were originally separated from each other by carved pilasters (plate 267). With their corselets and shields, their drums and pikes, their helmets and pennants, their cannon and brands, their lithe athletic figures bearing the spoils of war, these pilasters are some of the most notable carvings from the tomb. Also included in the monument, perhaps on the parapet above, were figures of the Virtues, three of which are now in London. In one of them, depicting Fortitude (plate 266), the pose is adapted from the Leda of Leonardo, and in another, representing Charity (plate 265), the heads of the woman and child are turned in opposite directions, and the child's arms and legs (like those of the Christ in the Mantegazza Lamentation) are disposed on lines parallel with the base. Swathed in tinfoil drapery copied from Hadrianic models, these Virtues combine the sophisticated classicism of the early sixteenth century with the pattern-making that was endemic in Lombard art.

F THE CLASSICAL ART forms that were revived during the fifteenth century the most intimate is the bronze statuette. We know (and the fifteenth century knew too) that in Rome bronze statuettes were prized by connoisseurs. One of the most celebrated was a statuette of Hercules owned by Novius Vindex, which is praised by Martial and Statius. Invited to dine by Novius Vindex, Statius fell 'deeply in love' with the bronze Hercules, 'such dignity had the work, such majesty despite its narrow limits. A god was he . . . small to the eye, a giant to the mind. To think that so tiny a body should create the illusion of so great a frame. What precision of touch, what daring imagination the cunning master had, to model a table ornament, yet to conceive such mighty forms.' The statuette, writes Statius, must have presided over Alexander's banquets, must have been admired by Hannibal and adorned the feasts of Sulla, before it entered Novius Vindex's house. It was against the background of such literary allusions that the making of bronze statuettes was once again resumed.

Classical statuettes were collected in the fifteenth century on a substantial scale, and both Ghiberti (plate 269) and Donatello must have been familiar with them. In the case of Ghiberti it is very doubtful if any independent statuette was made, since he was primarily a relief artist. Our first evidence of Donatello's interest in the statuette is found in the St Louis of Toulouse (plate 17), where the crozier is decorated with six little putti, each standing forward from its niche. A few years later these grew into the putti on the

tabernacle of the Siena font (plate 30), and they in turn developed into a work on a scale midway between the statue and statuette, the Amor-Atys in the Museo Nazionale (plate 31). There is however, only one small bronze that can be ascribed to Donatello or his studio, a figure of a Pugilist, with a raised left arm in the Museo Nazionale in Florence. None the less he was the originator of the statuette, in the first place because he developed and diffused the practice of bronze casting, and in the second because he established the type compositions from which the earliest statuettes derive.

Donatello practised as a bronze sculptor in Padua, Florence and Siena. At Padua his high altar provides a background for the mass of small bronzes that were turned out in the late fifteenth and sixteenth centuries. In Florence he inspired Maso di Bartolomeo, the artist who presided over the bronze grille of the Cappella della Cintola at Prato, where we find, entangled in the scrolls and fronds, small figures (plate 271), adapted from classical originals, which in all but function are statuettes. Finally, in Siena, Donatello left one imitator of the first rank, the bronze sculptor Vecchietta. When Vecchietta designed his great bronze tabernacle on the high altar of the Cathedral (plate 270), he filled it with statuettes. and he also made independent figures of the kind, among them a female torchbearer standing on a shell in Washington and a statuette of St John the Baptist in the Louvre. There are, moreover, statuettes that have a compositional connection with Donatello. Before he left for Padua in 1443,

plate 268 (opposite) Antonio del Pollaiuolo

Hercules and Antaeus

Museo Nazionale, Florence bronze, height with base 45 cm

plate 269 Lorenzo Ghiberti

Samson

Baptistery, Florence (detail of Porta del Paradiso) gilt bronze plate 270 Vecchietta

Tabernacle

Duomo, Siena bronze

Donatello had cast the bronze David which is now in the Bargello (plate 33), and since the hero David had a special significance, this figure was adapted as a statuette (plate 285). But the type of Donatello's figure seems not to have conformed to the popular view of how David should be shown, so the statuette repeated Donatello's pose, but not his iconography, and the naked sixteen-year-old youth of the larger statue was changed into a boy of eight or nine shown fully clad. In this new form the figure was often reproduced.

The rise of the bronze statuette in Florence was bound up with the Medici, and was promoted by two sculptors who can be looked upon as Medicean artists. The first of them was Antonio Pollaiuolo. The only bronze statuette which has never been denied to Pollaiuolo is a little group of Hercules and Antaeus in the Bargello (plate 268), which was owned in 1495 by Giuliano de' Medici. Though the two figures in this group may have been inspired by classical reliefs, it is constructed in a way peculiar to the fifteenth century. Donatello's Judith (plates 34, 35, 36, 37) is planned as a four-sided figure, and stands on a square cushion on a triangular base. In the Hercules and Antaeus the base is also triangular, but the intervening rectangle is done away with, and the group is planned with three faces, not four. In one respect it advances beyond Donatello, in that it also comprises three subsidiary views from the angles of the base; on one the heads of the two figures are aligned, on the second are aligned the left elbow of Antaeus and the left knee of Hercules, and over the third there projects

Antaeus's left leg. We know two other statuettes by Antonio Pollaiuolo. One represents Hercules with the head of the Nemean lion, and is in Berlin. The other, less highly finished, also depicts Hercules, and is in the Frick Collection in New York. In both the pose is again dictated by the triangular base.

By contrast the compositional methods used by Bertoldo, Pollaiuolo's contemporary, are strictly classical. A pupil of Donatello and the master of Michelangelo, Bertoldo has a key place in the story of Florentine sculpture. Nothing is known of his activity before the 1460s, when he was employed on Donatello's unfinished pulpits in S. Lorenzo, casting and perhaps also designing the relief of the Entombment and parts of the frieze. In the last years of his life – he died in 1491 – he was in charge of Lorenzo de' Medici's collection of antiquities at S. Marco, and it was for the Medici that he made the most important of his surviving works, a battle relief in the Bargello (plates 273, 274, 275). The relief is based on a sarcophagus at Pisa (plate 276), and is sometimes spoken of as though it were an academic reproduction of the scene on the sarcophagus. But this is not the case, for in the bronze the loose forms of the marble sculpture have been tightened and compressed, and the visual rhythms differ fundamentally from the rhythms of Bertoldo's prototype. Moreover, in the fifteenth century the sarcophagus was in the same state in which it is today; the figures at the sides, that is to say, had been decapitated, other figures were damaged or missing, and in the centre there was a hole where

plate 271 Maso di Bartolommeo

Detail of Grille

Duomo, Prato bronze

plate 272 Bartolommeo Bertoldo

Bellerophon

Kunsthistorisches Museum, Vienna bronze

plate 273 (opposite) Bertoldo

Battle Scene

Museo Nazionale, Florence (detail of plate 275)

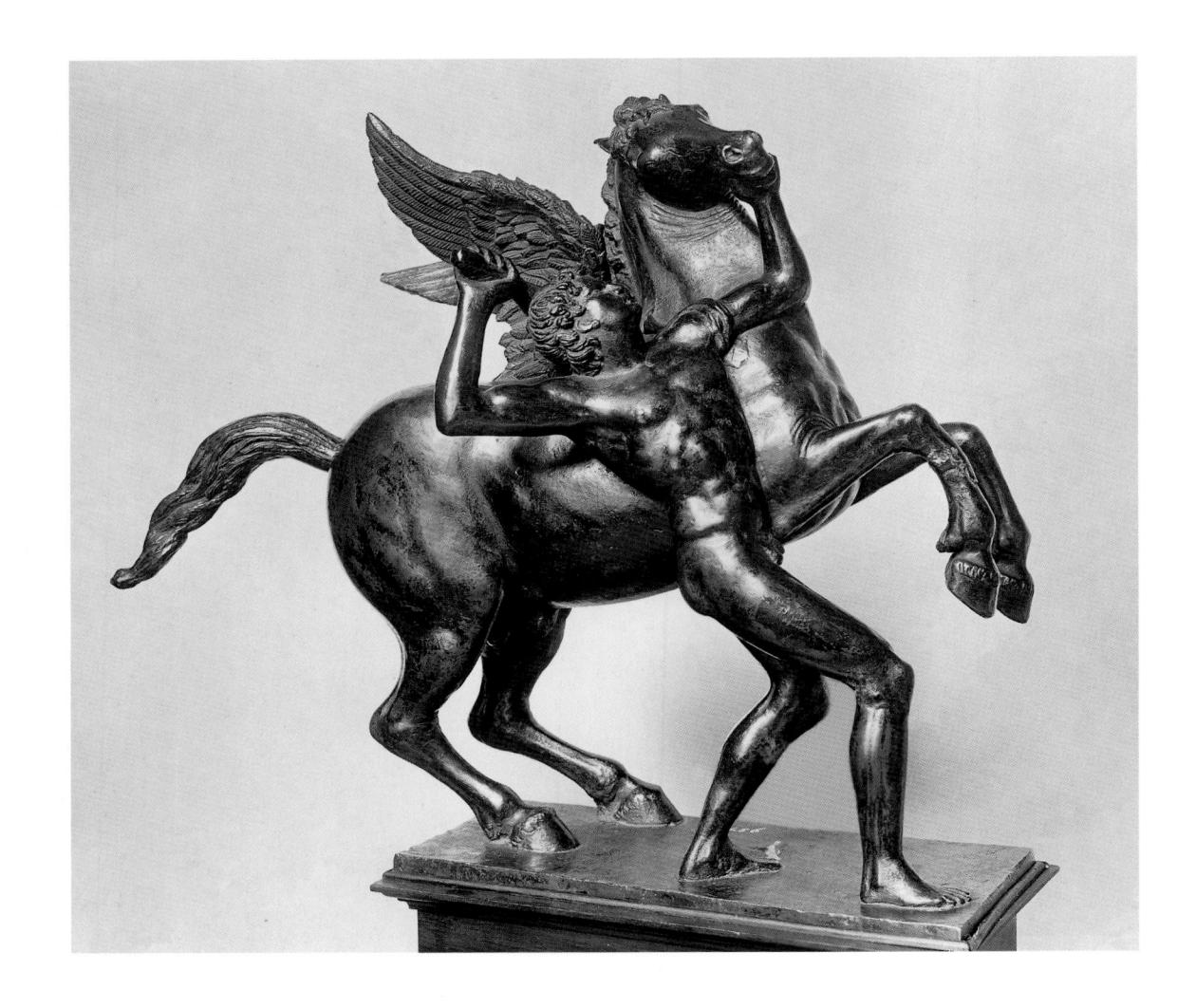

plate 274 (opposite) Bertoldo

Battle Scene

Museo Nazionale, Florence (detail of plate 275)

plate 275 Bertoldo

Battle Relief

Museo Nazionale, Florence bronze, 43 × 99 cm

plate 276 Roman, 2nd century AD

Battle Sarcophagus

Camposanto, Pisa

plate 277 (opposite) Bertoldo

Apollo

Museo Nazionale, Florence bronze, height 44 cm no figures were preserved at all. Reconstruction and not copying, therefore, was the order of the day. In the centre of the composition Bertoldo introduced a riding warrior, more prominent than the rest, attacking two nude figures with a club; and when we isolate this group there can be very little doubt that it has a specific narrative significance. The right side of the sarcophagus is less badly preserved, but even here the interpretative artist in Bertoldo held sway over the copyist. Not only did he introduce a number of motifs of remarkable originality for which there is no warrant whatever in the marble (the horse with head turned frontally is a case in point), but he completed the extreme right side in a way which gave it a different literary emphasis, introducing into the corner a crouching captive with arms bound and completing the standing man immediately beside him with a head turned reflectively towards the now naked woman on the left side of the scene. The psychology of this sentiment-laden relief recalls paintings like Piero di Cosimo's Death of Procris far more closely than it does Roman battle scenes.

This same interpretative gift Bertoldo brought to his bronze statuettes, above all to the figure of Apollo in the Bargello (plate 277). So far as can be judged the Apollo is not based directly on a Roman model, but a classical original certainly underlies the Bellerophon at Vienna (plate 272), one of the most beautiful small bronzes that has ever been produced. In the Apollo statuette there is only one viewpoint from which the silhouette can be captured in its entirety, and the

Bellerophon has this same relief-like character. But the relief system is one of great complexity, and in the ecstatic figure of the youth the impulse of Greek bronzes seems to have been reborn.

No autograph statuette survives by the greatest Florentine sculptor of the later quattrocento, Verrocchio, but a parallel for Bertoldo's bronzes is found at Mantua, where the scene is dominated by the bronze sculptor Antico. Antico was considerably younger than Bertoldo - he was born about 1460 and lived on till 1528 - and was employed by Gianfrancesco and Lodovico Gonzaga and by Isabella d'Este. Under the inspiration of Mantegna he restored antiques, and in 1497 was despatched to Rome to model bronze reductions of marble statues. The making of bronze reductions was practised in antiquity – a group of early fourth-century Greek statuettes seems to have been copied from statues by Polyclitus – and in this sense Antico's work was a reincarnation of the antique. It was a reincarnation of the antique in another sense as well. Whereas Florentine bronze statuettes were left relatively in the rough, Antico's ideal was the refined surface of Hellenistic sculpture. An impression of his technical procedure can be formed from a statuette of Cupid Shooting an Arrow in the Bargello (plate 278), where the surface is highly finished and the hair and the band across the chest are gilt. But Antico, like Bertoldo, was an interpreter and not a copyist. One of the works he studied in Rome was the marble Venus Felix which is now in the Vatican Museum (plate 279), but when he came to copy it he omitted the Cupid which forms part of

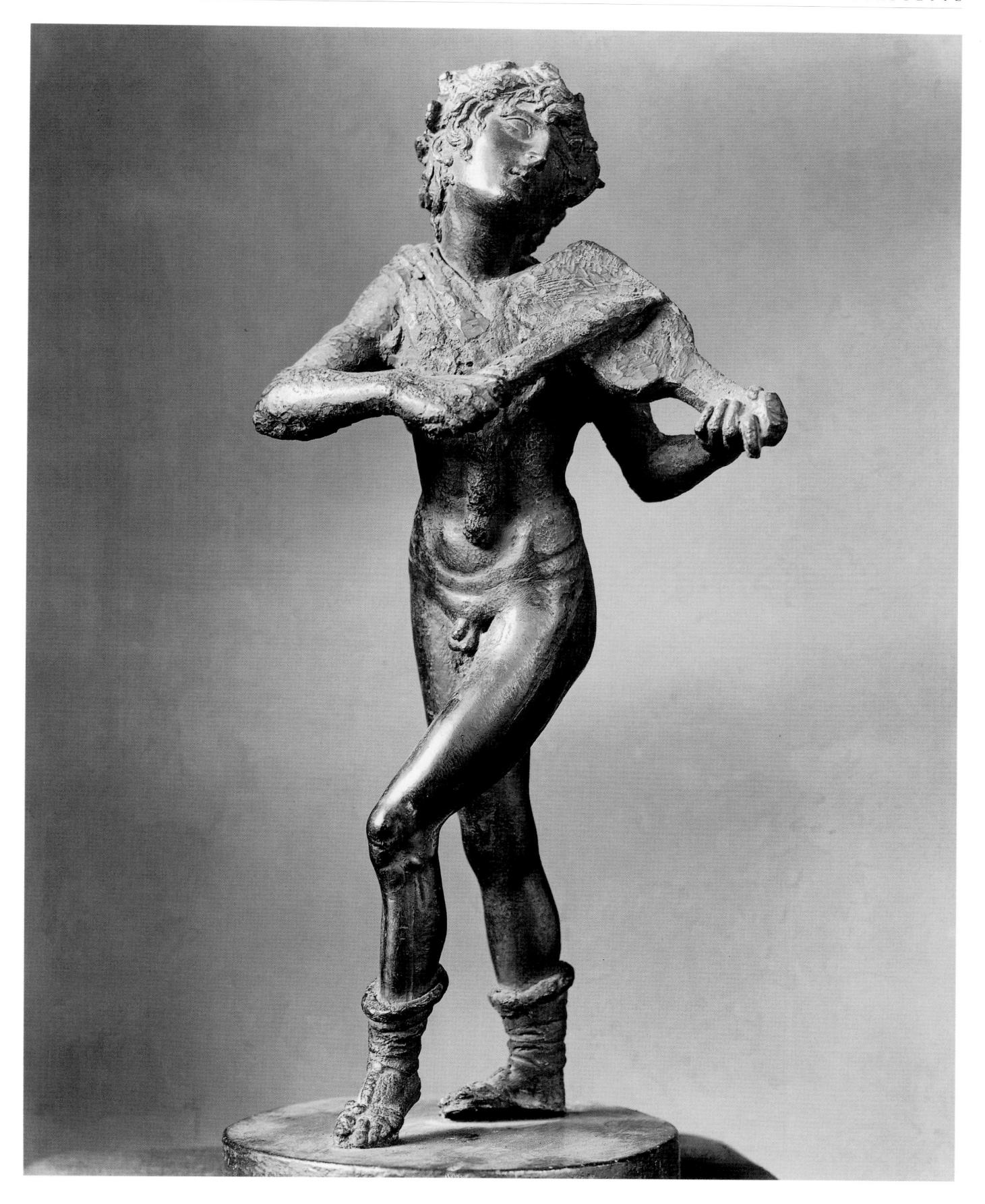

plate 278 Antico

Cupid

Museo Nazionale, Florence bronze

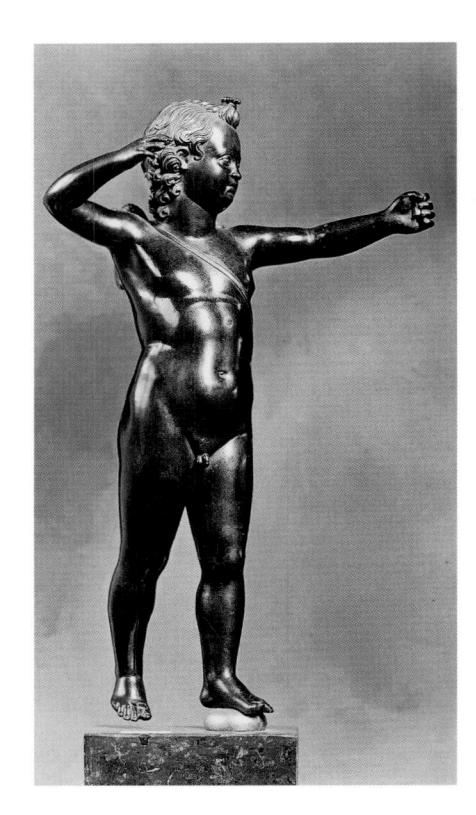

the group, reversed the drapery and changed the expression, producing a fastidious statuette on a base surrounded by gold coins (plate 280). At the end of the fifteenth century one antique group in Rome was specially admired; it represented Hercules and Antaeus, and stood in the Cortile del Belvedere. As we see it in Florence today (plate 281), this statue seems ungainly and contrived, but for the Renaissance it offered the classical solution of one of the central problems with which sculptors were faced. In this spirit Antico studied it, but he introduced (plate 282) two changes into the design. First he accented the pyramidal stance of Hercules, and modified Antaeus's legs till they conformed with it; and second he showed the agonized head of Antaeus turned back in such a way that it forms the emotional and visual climax of the group.

Antico was a court artist, subtle, temperate, refined. Nearby at Padua, in a freer intellectual climate, the small bronze assumed another, more immediately attractive form. Among the members of Donatello's workshop was a young Paduan artist called Bellano, who seems to have followed him to Florence, and like Bertoldo was engaged during the 1460s on the pulpits in S. Lorenzo. In 1483 it was decided to decorate the outside of the choir of the Santo at Padua with a cycle of 10 biblical reliefs. A specimen relief was submitted by Bertoldo, but was turned down, and the contract was awarded to Bellano, probably because he was Paduan by birth. Bertoldo was the more distinguished artist, but taste in North-Eastern Italy was resistant to the intellectual discipline of

Florence, and Bellano was the legatee of a long tradition of encyclopedic naturalism. In the earliest of his Paduan reliefs, the scene of Samson Destroying the Temple (plate 283), space is represented intuitively and not with the aid of an aesthetic device. His aim was lifelikeness, and details like the extraordinary group of figures crushed by falling masonry at the top of this relief would have been unthinkable had the scene been compressed into an artificial mould. Bellano was in touch with one of the leaders of Paduan humanism, the philosopher Leonicus, and the same literal-mindedness which in the Santo he brought to the Old Testament he carried through into classical mythology, in bronzes like the Atlas in Berlin and the Rape of Europa in the Bargello. In the Mountain of Hell in London (plate 284), by a Bellano imitator, Zoppo, the Pluto gazing out balefully at Hercules and the giant embedded in the rock above are treated with memorable pathos and humanity. This pathos and humanity Bellano passed on to his pupil Riccio, the great Italian master of the bronze statuette.

Riccio was a more accomplished sculptor than Bellano, with a superlative mastery over his medium and a personal attitude to the antique. His purpose was not merely to translate mythology into the language of contemporary life, but to interpret the life and the religious symbolism of his time in antique terms. The clearest index to his aspirations is the Della Torre Monument in S. Fermo Maggiore at Verona (plate 286), which consists of a kind of altar raised on short classical columns and surrounded by a classical frieze. On

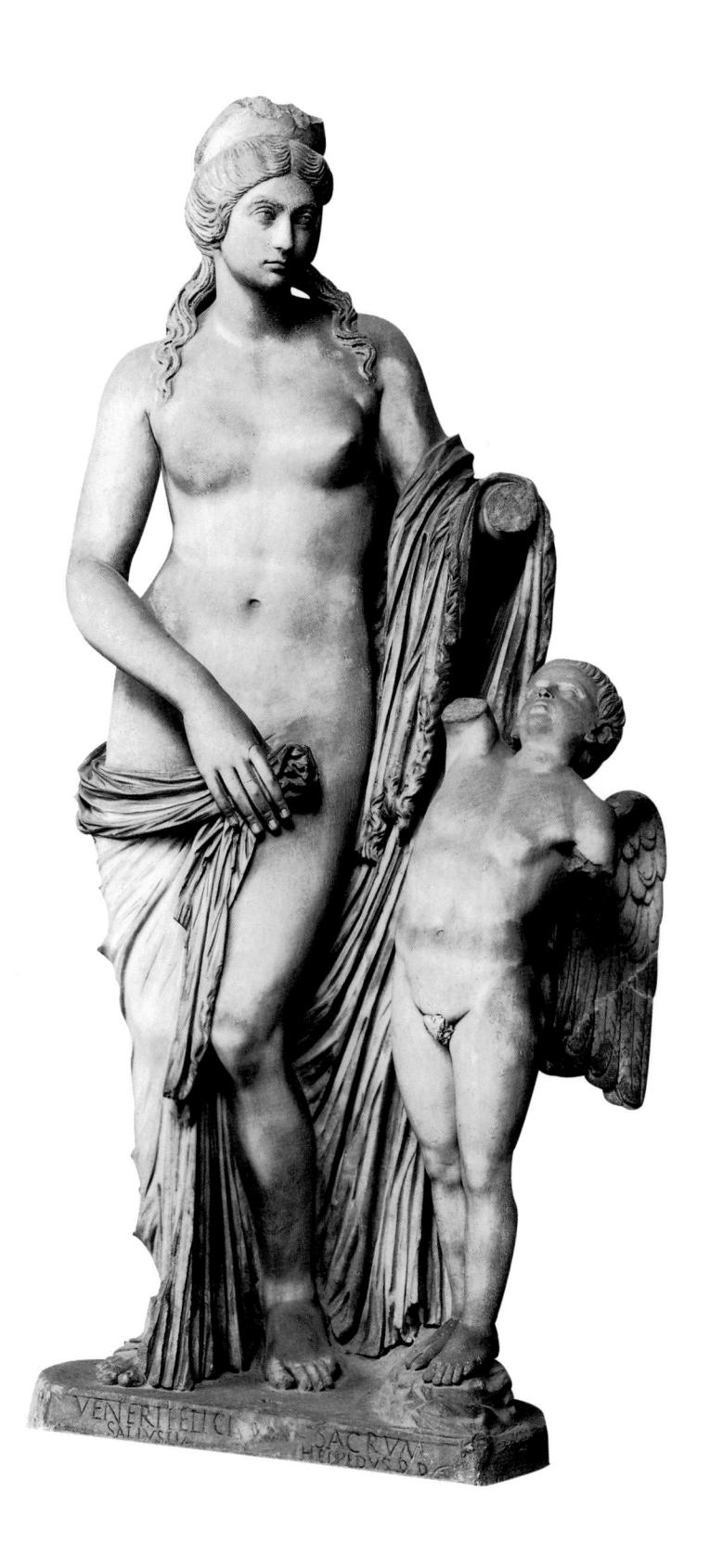

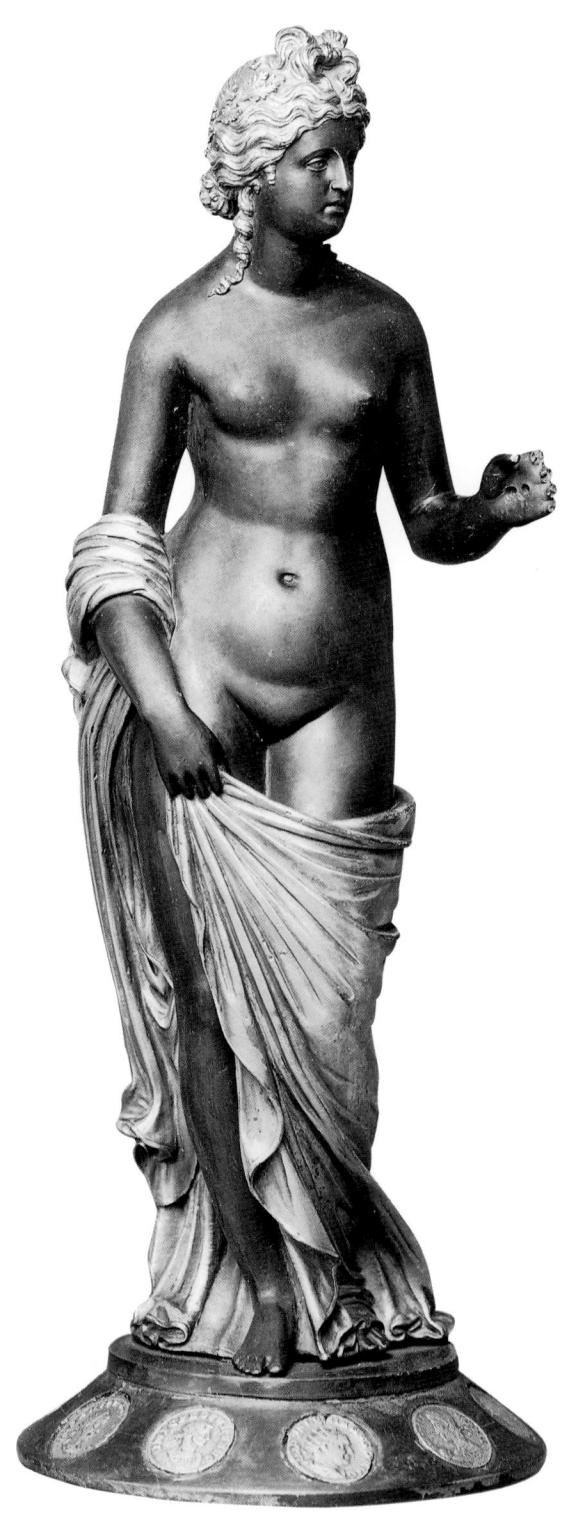

plate 279 Roman, 1st century AD

Venus Felix

Museo Vaticano, Rome

plate 280 Antico

Venus Felix

Kunsthistorisches Museum, Vienna bronze parcel-gilt, height with base 32 cm plate 281 Roman, 1st century AD (restored)

Hercules and Antaeus

Palazzo Pitti, Florence

plate 282 Antico

Hercules and Antaeus

Victoria and Albert Museum, London bronze, height 46.7 cm

plate 283 Bartolommeo Bellano

Samson Destroying the Temple

S. Antonio, Padua bronze, 66 × 83.5 cm

plate 284 Zoppo

Mountain of Hell

Victoria and Albert Museum, London bronze, height 26 cm

plate 285 Bellano

David

Philadelphia Museum of Art bronze

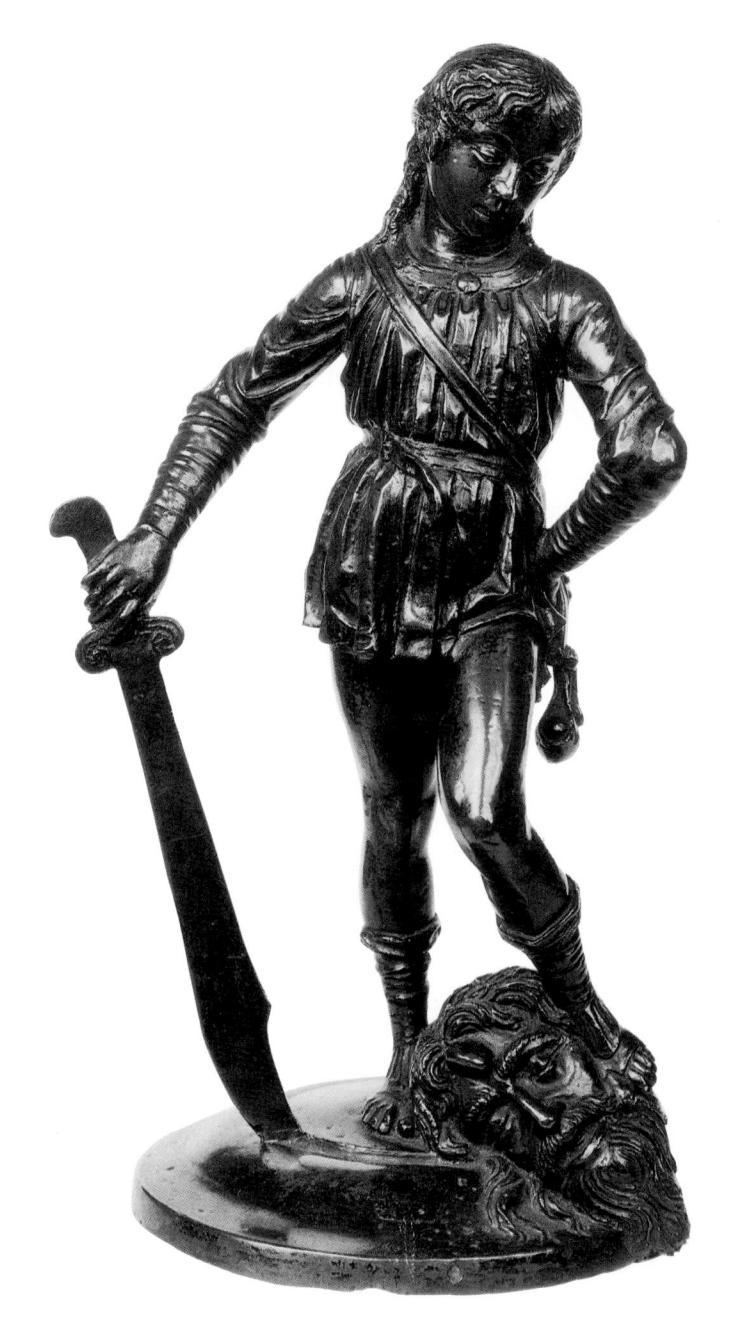

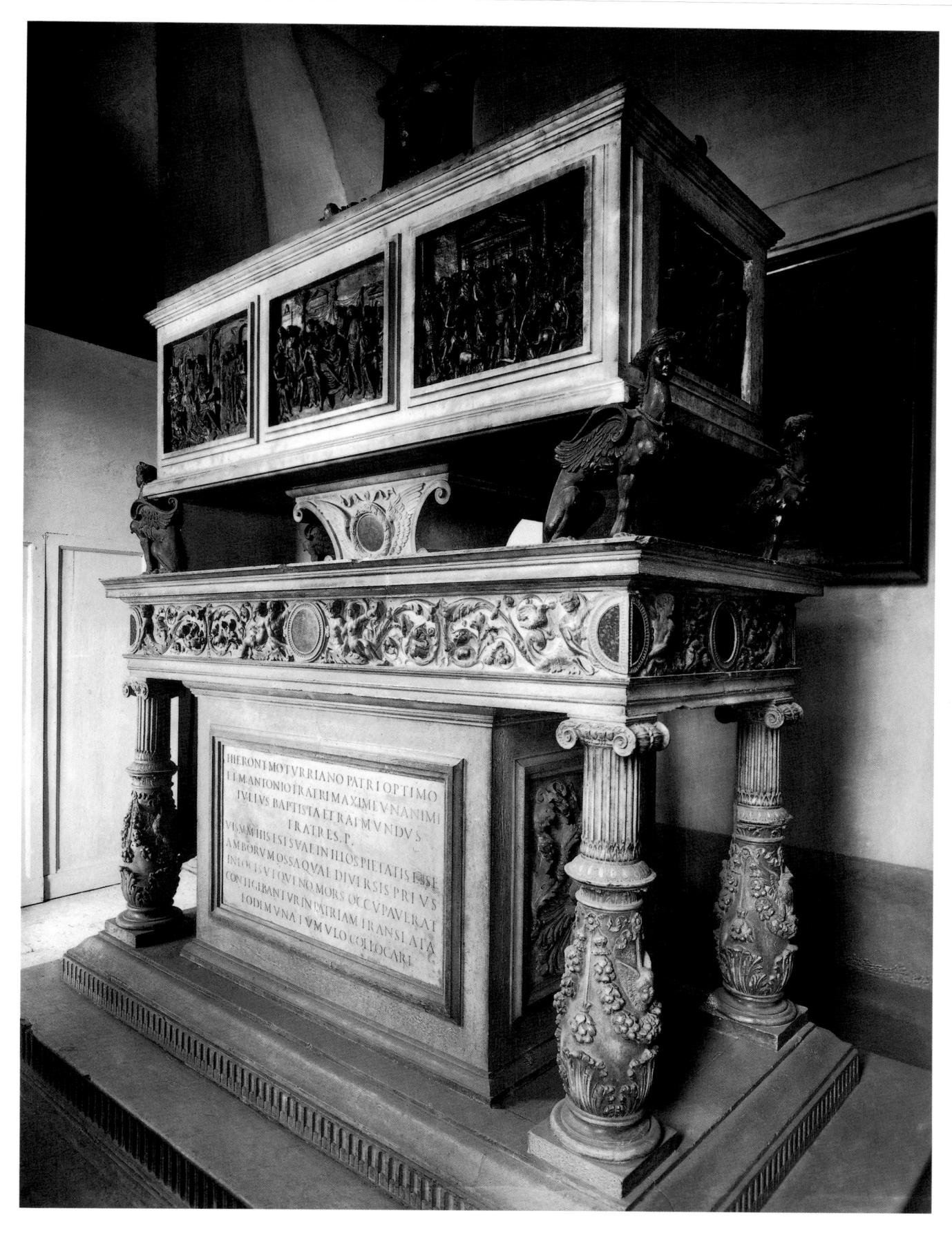

plate 286 Riccio

The Della Torre Monument

S. Fermo Maggiore, Verona marble and bronze, height 354 cm

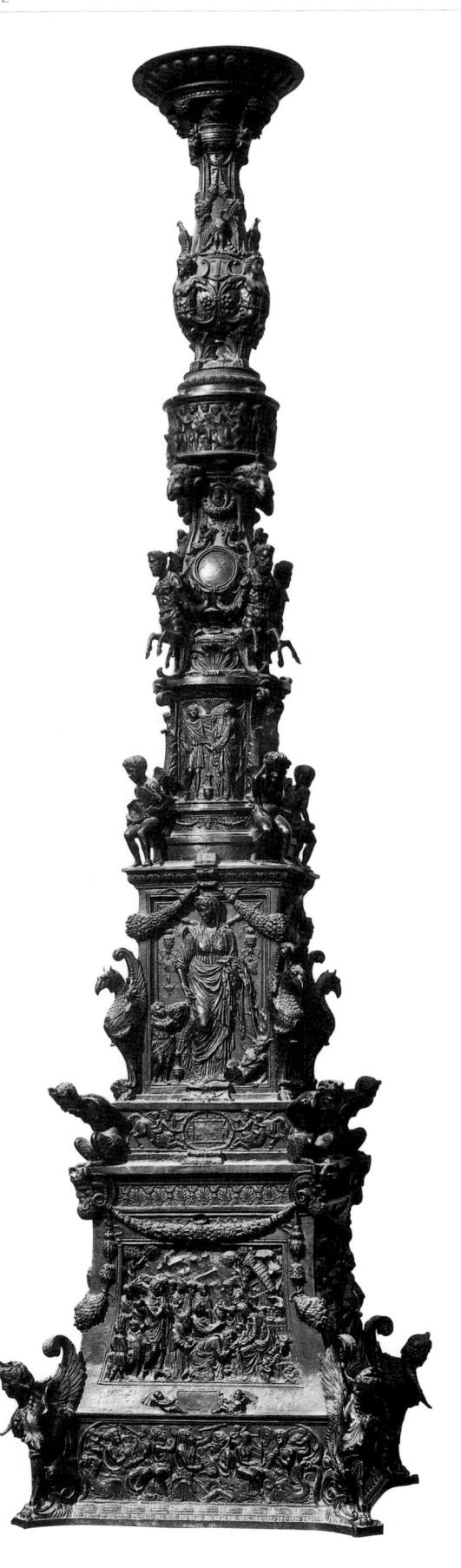

plate 287 Riccio

Paschal Candlestick

S. Antonio, Padua bronze, height 392 cm

centre on a support carved with a winged wreath and at the corners on four sphinxes cast in bronze. Round the tomb-chest were eight bronze reliefs (now in the Louvre), and on the lid there were six putti (which have disappeared), with bronze masks of the two men whom the tomb commemorated, Girolamo della Torre, a learned physician who died at Padua in 1506, and his son Marc Antonio, an anatomist and botanist who died in 1511. The most remarkable feature of the tomb is its six narrative reliefs, which represent the life and death of Girolamo della Torre sub specie antiquitatis, first Della Torre teaching, then the illness of Della Torre, a sacrifice to Aesculapius on the sick man's behalf, the death of Della Torre surrounded by his toga-clad disciples, the purification of Della Torre conducted by a pagan priest before a reproduction of the actual tomb, Charon in the Underworld, and finally Della Torre in a pagan Elysium in communion with the great minds of the past. The description of this programme is strange enough, but the reliefs are stranger still. In the second relief (plate 288), for example, we see Della Torre seated naked on a couch, receiving succour from his friends. Apollo presides over the scene, and on the left Atropos severs the thread of Della Torre's life. Yet the language of the reliefs is so simple, so natural, so transparently sincere, that the imagery is acceptable on a Christian as well as on a pagan plane. In his masterpiece, the Paschal Candlestick at Padua (plate 287), Riccio applied the same narrative expedients to the life of Christ.

top of the altar is the tomb-chest, resting in the

One of the principal members of the humanist

plate 288 Riccio

The Sickness of Della Torre

Louvre, Paris bronze, 37 × 49 cm

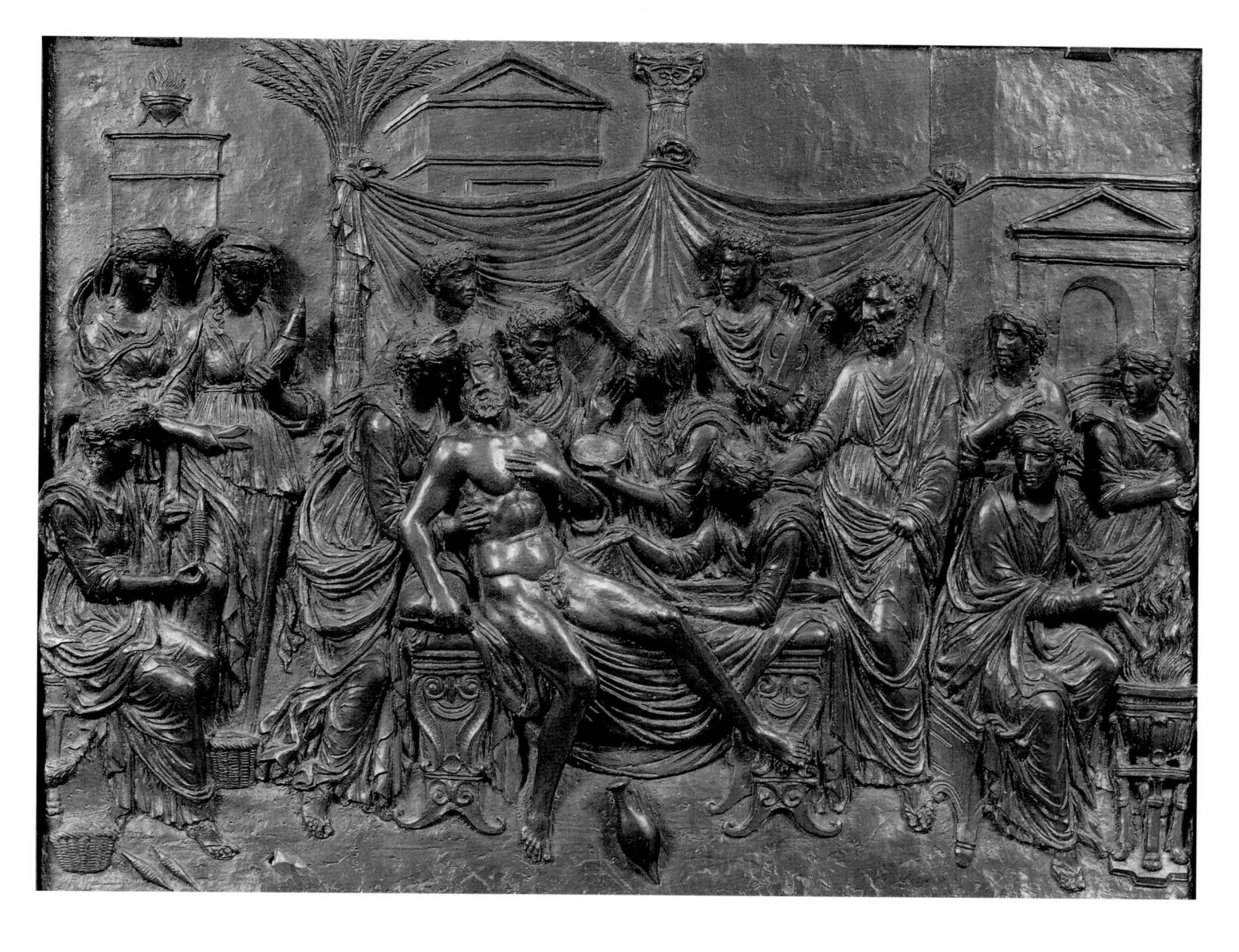

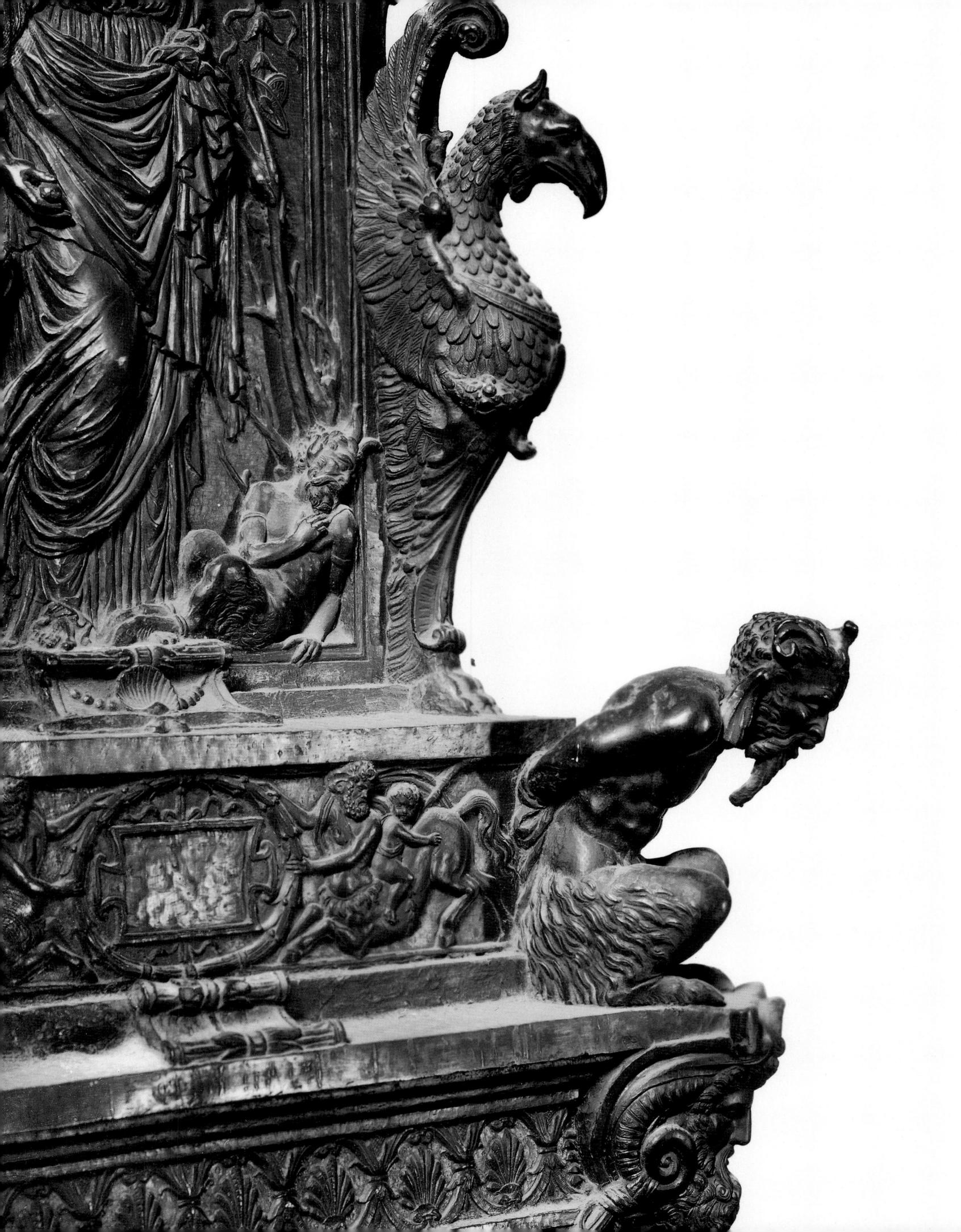

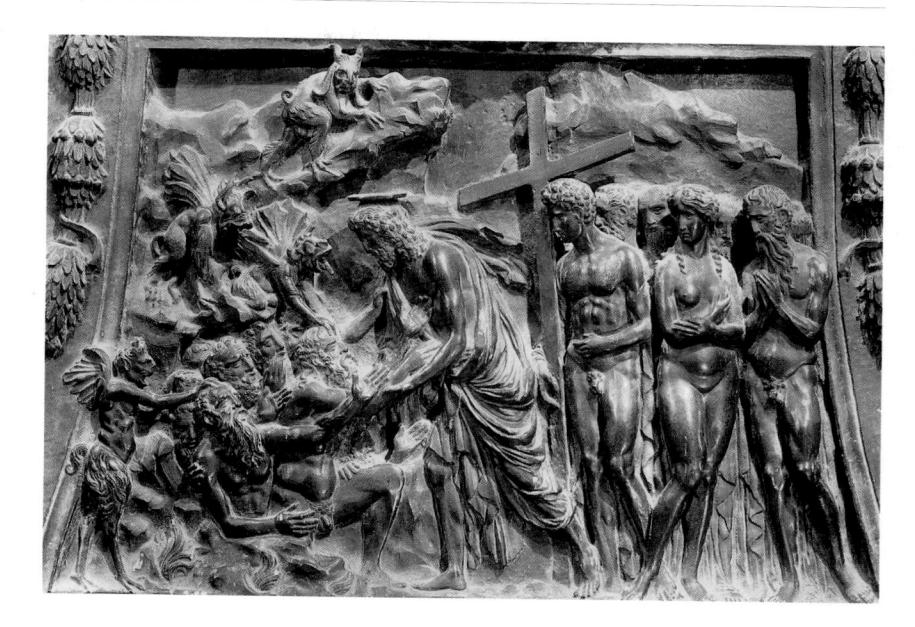

circle in Padua in which Girolamo della Torre moved was Giambattista de Leone. De Leone was a philosopher and scholar, and it was he who was responsible for devising the Paschal Candlestick. The candlestick is planned as a series of ascending elements. At the bottom corners are four sphinxes, flanking oblong allegorical reliefs of Astrology, Music, Cosmography and History. Above these are four trapezoidal scenes from the life of Christ, above these again are four bound satyrs, and above the satyrs are reliefs of Prudence, Temperance, Fortitude and Justice. Higher still are four seated putti ranged round a cylinder with upright allegorical reliefs of Religion, Theology, Simplicitas and History. Above these again we reach four centaurs and four rams' heads and a drum decorated with a frieze of playing putti, and at the extreme top is a base-shaped element with sphinxes, eagles and putto heads. Throughout the whole height of the candlestick religious and profane material alternates. The candlestick is a very large and an immensely complicated work, but there is not a single detail of the decoration, not a garland or mask or eagle head, which does not communicate a sense of the artist's essential individuality. A classicistic style is maintained not only in the superb reliefs of Virtues in the central register, but in the trapezoidal scenes as well. In the Adoration of the Magi the kings are dressed as classical philosophers, and the fourth side is occupied by a unique scene, the sacrifice of the Paschal Lamb in the pagan manner to the Risen Christ. Perhaps the most revealing of the reliefs is the Christ in Limbo (plate 290), where classical

models were naturally of no avail, but which is treated with an instinctive classicism, so that Christ is shown redeeming some of the most beautiful nude figures in the whole of art.

The Paschal Candlestick occupied Riccio for eight years, and into it he poured all of his seemingly inexhaustible inventiveness. The reliefs on it were never reproduced, but from its decorative parts he developed a long series of bronze implements and statuettes. The sphinxes on the base grew into fire-dogs, and with the satyrs above (plate 289) Riccio peopled an entire imaginative world. Many Venetian collections of antiques included satyr representations in bronze or marble, and two reliefs of this kind survive in the Museo Civico at Padua. But never in antiquity did the satyr assume the character it had in the Paduan Renaissance, of a benign primitive being at the mercy of its own sensual appetites, reflecting, in its instinctive actions, the emotions of a more sophisticated form of life. As Riccio matured, his expressive range extended, and the satyr took on a pathos of its own. Two of his most remarkable statuettes of begging satyrs are in the Louvre, one seated with hoofs crossed on the ground, with a shell in the right hand and a candelabrum in the left, and the other sitting on a tree-trunk hopefully holding out an amphora. In other statuettes, like the seated satyr in the Bargello balancing a shell (plate 291), Riccio seems to express all the incoherent aspirations of some subhuman species towards a state that it cannot attain.

The satyr occupied an intermediate position in

plate 289 (opposite) Riccio

Satyr

S. Antonio, Padua (detail of plate 287)

plate 290 Riccio

Christ in Limbo

S. Antonio, Padua (detail of plate 287)

plate 291 Riccio

Satyr

Museo Nazionale, Florence bronze, height 20 cm

plate 292 (opposite) Riccio

Youth with a Goat

Museo Nazionale, Florence bronze, height 26 cm

plate 293 Roman, 1st century AD

Male Nude

Museo Archeologico, Florence

plate 294 (below) Riccio

Seated Shepherd

Louvre, Paris bronze

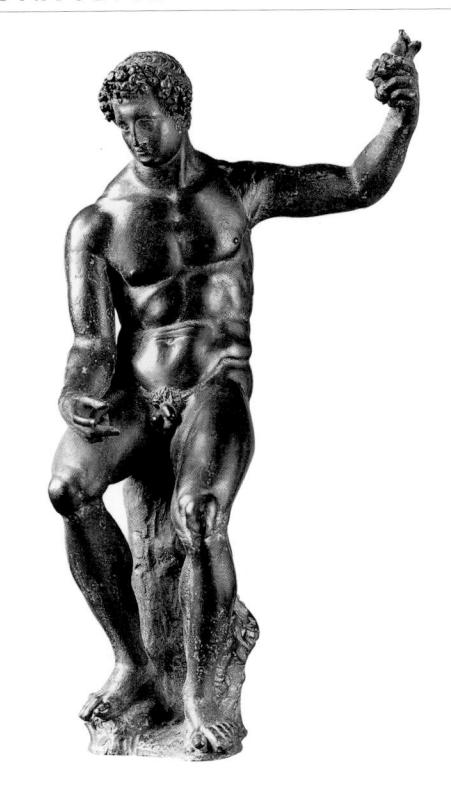

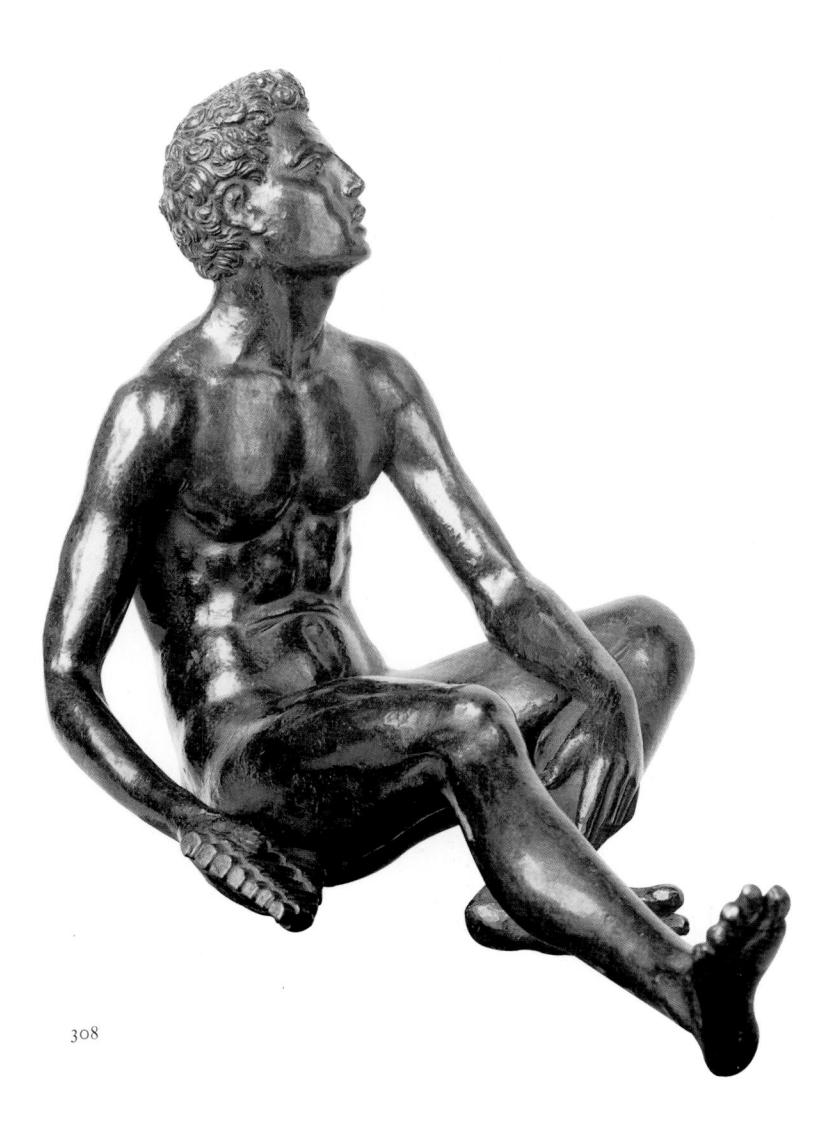

Riccio's world. Below it was the animal kingdom and above it was the human race. To both he dedicated countless statuettes, bronzes of sheep and goats and of the naked shepherds who tended them. Sometimes the two sides of this pastoral world unite, as in the imposing bronze in Florence (plate 292) of a she-goat milked by a naked youth, which represents the goat Amalthea feeding the infant Jupiter. Riccio's main source of inspiration must have been Roman bronzes (plate 293), and from them he evolved not only the Bargello Shepherd, but the Pan in the Ashmolean Museum (plate 295), a similarly posed bronze in the Louvre of a seated shepherd with head upturned holding his pipes in his right hand (plate 294), and the beautiful bronze of a shepherd seated on a rock at Baltimore.

All of these figures are shown in repose, but Riccio possessed a command of movement that in this field sets him in a class apart. The supreme example of this aspect of his work is a statuette of a warrior on horseback in London (plate 296), which must represent some hero of Greek or Roman history. An equestrian monument in miniature, this group was often copied, and when we look at it the reason becomes plain, for it evokes more vividly than any other work of its dimensions the ethos of Renaissance art.

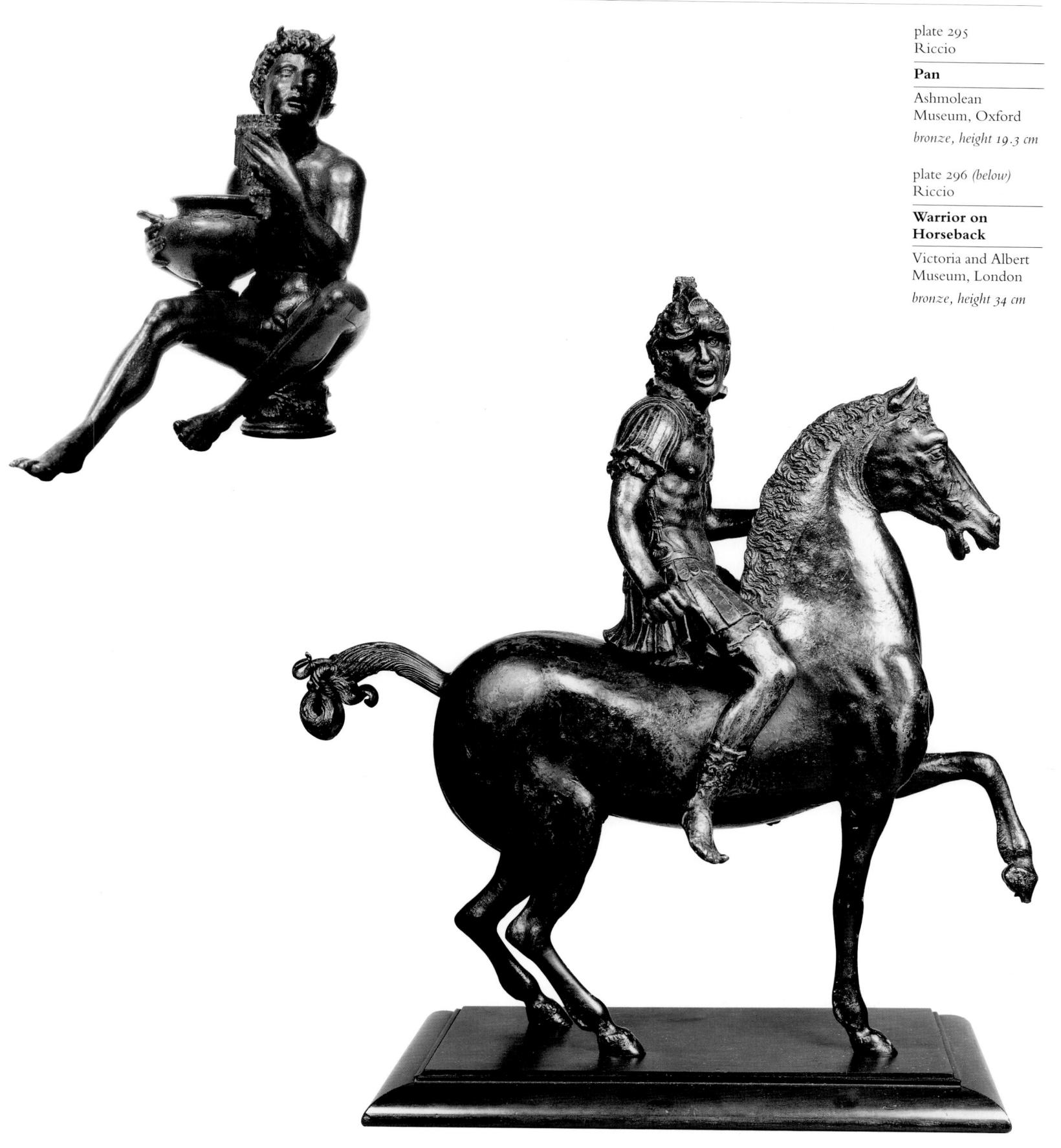

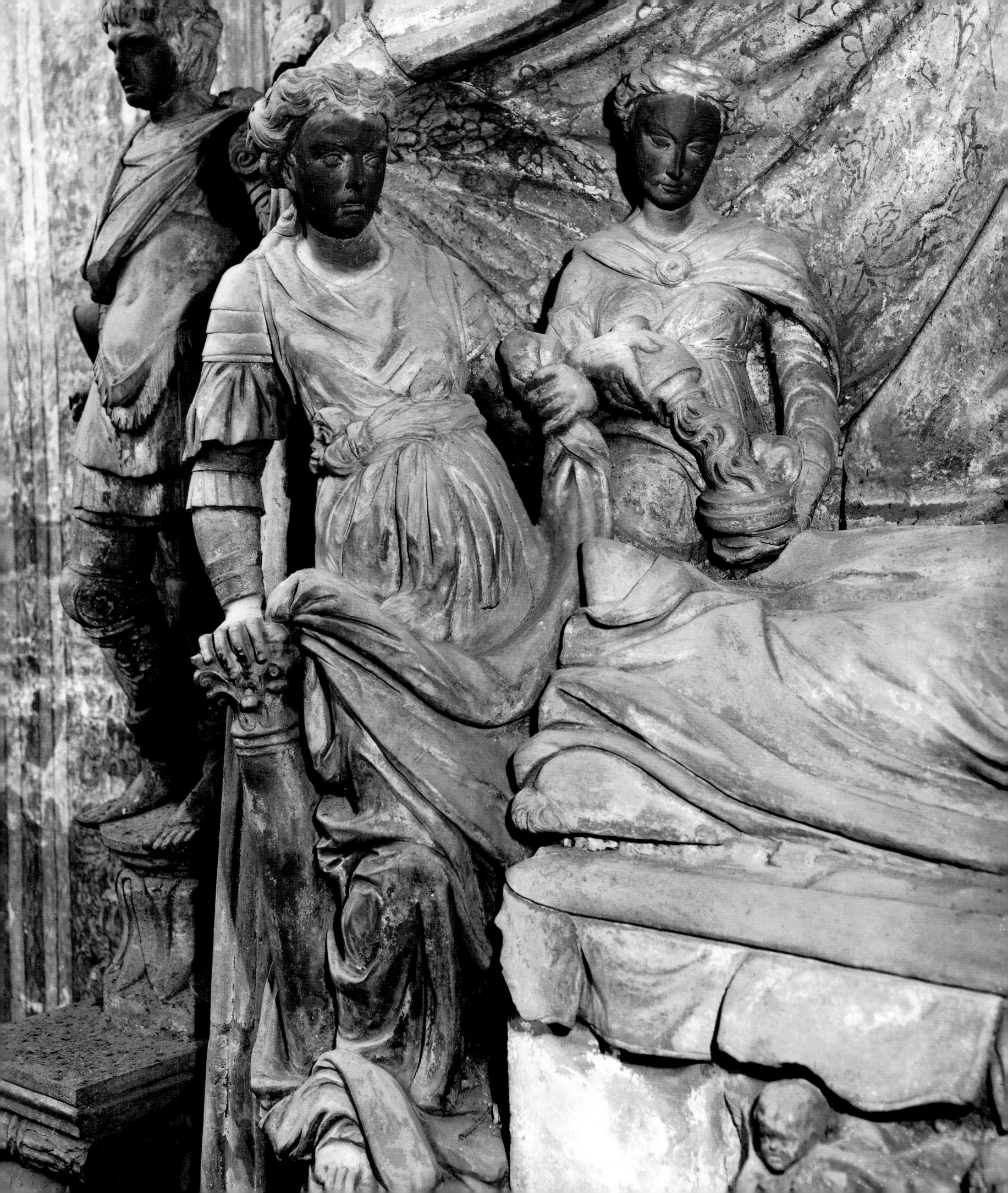

THE RENAISSANCE ARRIVED late in Venice, and till the middle of the fifteenth century Venetian artists remained faithful to the Gothic view of sculpture as a subsidiary, largely collaborative art. Yet once the victory of Renaissance style was won, it was Venice and not Florence that achieved in sculpture the truer recreation of antiquity.

Bartolommeo Buon, whose style dominates Venetian sculpture in the second quarter of the century, lived on till 1464, but already in the lower reaches of the Porta della Carta (Vol. I, plate 220) he is found collaborating with a more progressive artist, and when the interior of the entrance to the Ducal Palace, the so-called Arco Foscari, came to be constructed, much of its figure sculpture was entrusted to this second hand. The name of this sculptor was Antonio Bregno. Bregno was a survivor of the horde of Lombard artists who had arrived in Venice in the 1420s to work at the Ca' d'Oro, and his figure-style is a medley of Lombard elements, of mannerisms derived from Buon, and of features taken over from Florentine sculptors in Venice, notably Pietro di Niccolò Lamberti. All of these are present in the Foscari monument in S. Maria dei Frari (plates 297, 298), where the scheme depends from that of Pietro di Niccolò Lamberti's Tommaso Mocenigo Monument of a quarter of a century before (Vol. I, plate 211). The curtains that frame the effigy are held up by two Lombard warriors, the sarcophagus is carved with Buonlike reliefs of Virtues, and two pairs of Florentine putti are seated beneath the bier. In one respect, however, the monument looks forward to the

future, in that the traditional elements are framed by classical pilasters, which introduce for the first time in Venice the Florentine conception of the tomb as a self-consistent architectural whole.

Twenty years later the tendency initiated in this tomb was carried further by a Veronese sculptor, Antonio Rizzo, in the Niccolò Tron Monument (plate 299). From the first Rizzo's proclivities must have been more classical than Bregno's, and in his earliest independent work, the disassembled tomb of Orsato Giustiniani (d. 1464), the free-standing sarcophagus was decorated with wreathed emperor heads, and was surrounded by figures of the Virtues which had the same oblique relationship to the antique as the Virtues of Amadeo at Bergamo. In Venice the creation of a Renaissance architectural style preceded the creation of a Renaissance style in figure sculpture. and by 1476, when Rizzo began work on the Tron Monument, Codussi's revolutionary church of S. Michele in Isola was already an accomplished fact. 'Come hither,' writes the humanist Paolo Delfin of S. Michele, 'that you may see something great and singular . . . a temple which not only evokes antiquity, but actually surpasses it.' In the Tron Monument the architectural conceptions of S. Michele are applied to a traditional tomb type. Like Pietro di Niccolò Lamberti's Mocenigo Monument, it contains as its central feature a sarcophagus set on the wall with a row of niches over it. The sarcophagus repeats the classical sarcophagus of the Giustiniani tomb, and round it rises a colossal structure closed at the sides by projecting supports and at the top by a semiplate 297 Antonio Bregno

Fortitude and Temperance

S. Maria dei Frari, Venice (detail of plate 298) plate 298 Antonio Bregno

The Foscari Monument

S. Maria dei Frari, Venice

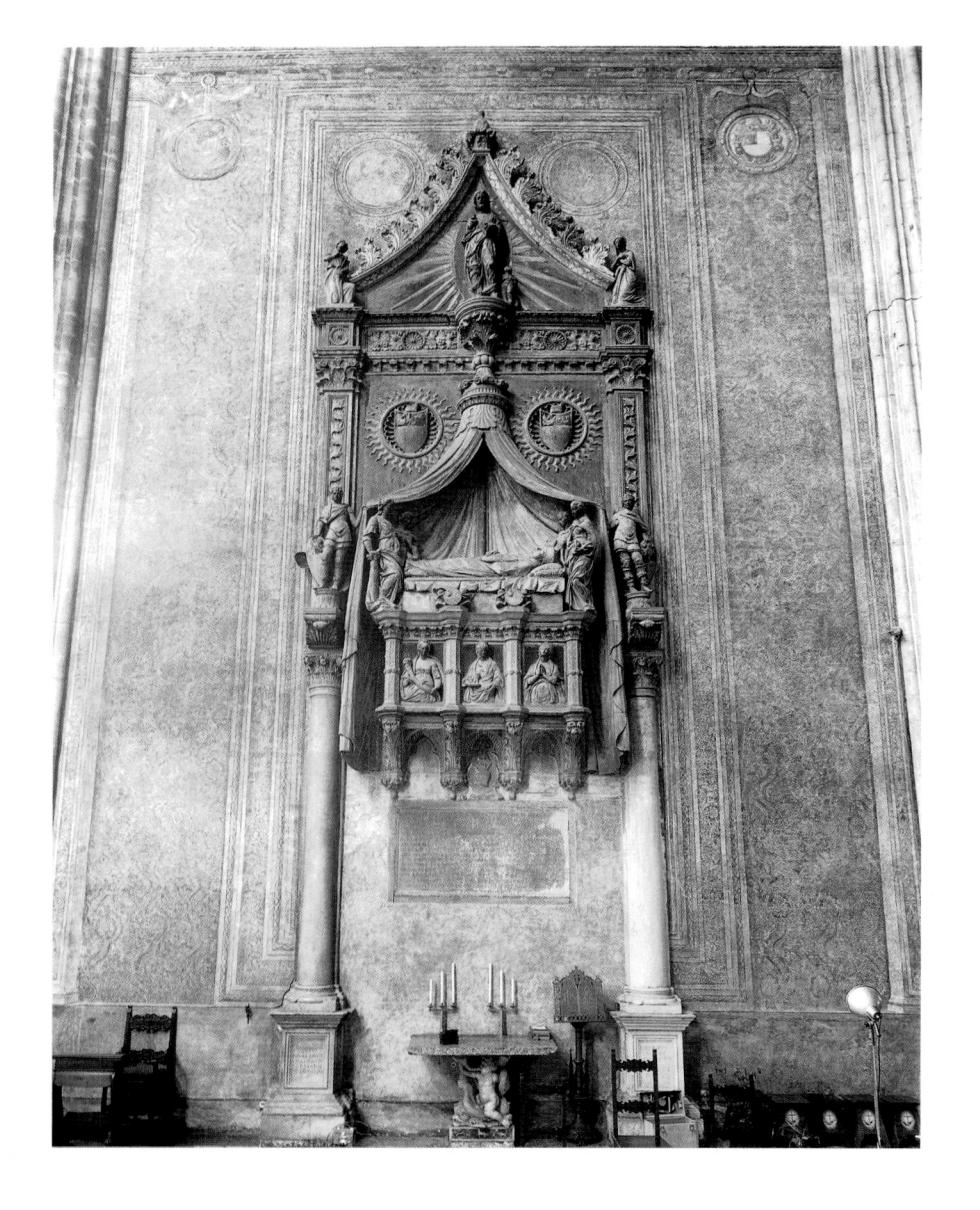

circular lunette. Beneath the sarcophagus is the epitaph, flanked by two reliefs, and under this, in the lowest register, are three large niches containing a statue of the Doge and figures of Prudence and Charity (plate 300). The Virtues at the top, which were carved by Rizzo's assistants, look like Gothic figures which have been told to hold themselves erect, but in the Prudence and Charity the drapery is authentically classical, and derives from a statue of the type of the Hera in the Capitoline Museum. The heads, however, are portrayed with stylized features which are not Gothic but are not specifically antique. In type they have something in common with the head of Gentile Bellini's Madonna in Berlin. The two artists were certainly associated, for in 1476 Gentile Bellini designed a pulpit for the Scuola di S. Marco which was carved by Rizzo. If Vasari is to be trusted, Rizzo was also in touch with Antonello da Messina, whose altarpiece for S. Cassiano was completed in the year in which the Tron Monument was begun. Contacts with these painters, and with Giovanni Bellini, do something to explain the masterly statues of Adam and Eve (plates 301, 302) which Rizzo carved for the Palazzo Ducale after 1483. Never from the unimaginative figure sculpture on the Tron tomb would we guess Rizzo to have been capable of planning these elegant, softly modelled figures, the Eve in a pose deriving from a Venus Pudica and the Adam gazing upwards with raised head and parted lips.

Nearby at Padua events were moving along other lines. Donatello had returned to Florence in 1453, but his style projected itself through the

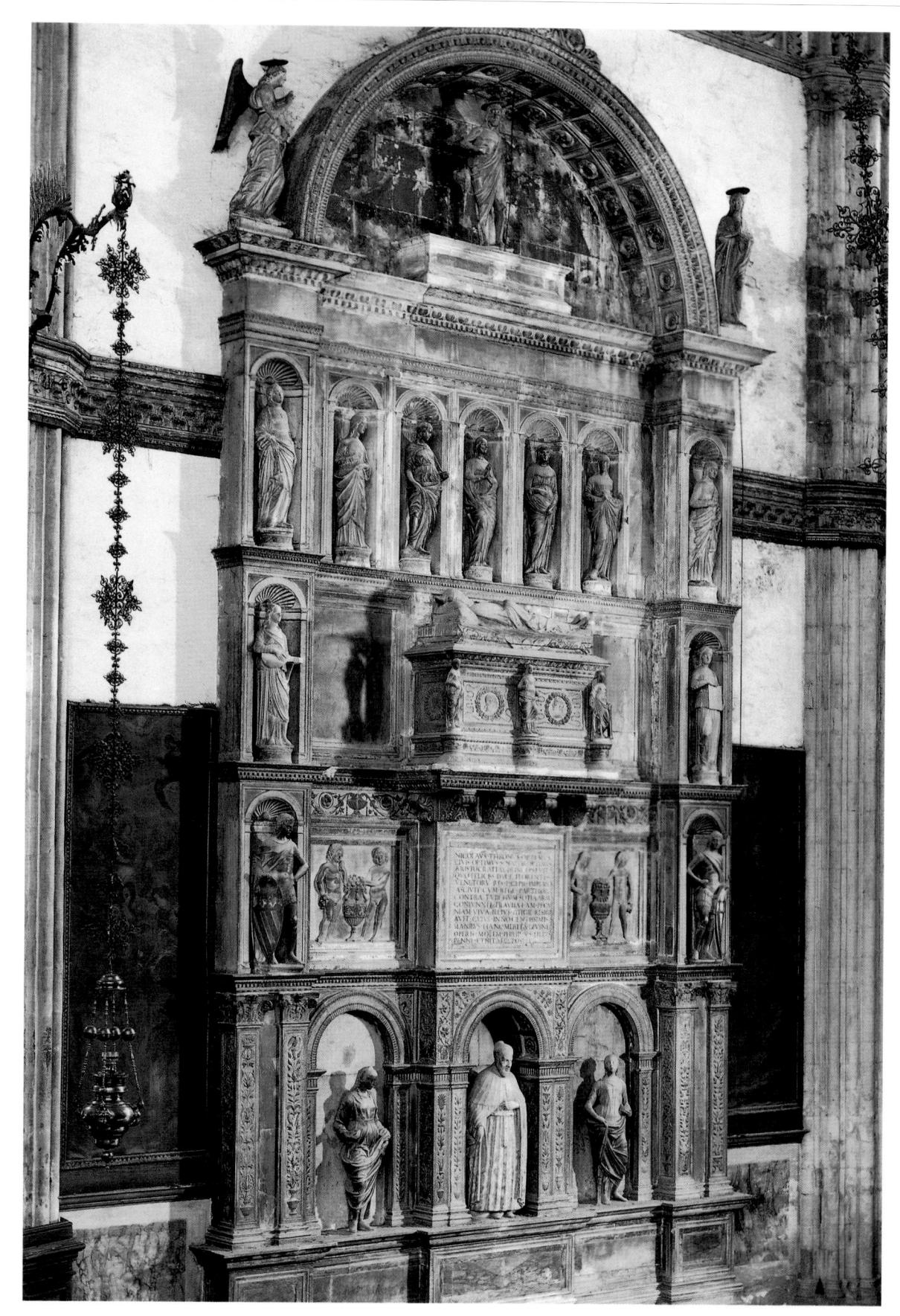

plate 299 Antonio Rizzo

The Tron Monument

S. Maria dei Frari, Venice marble, 13.5×7.5 m

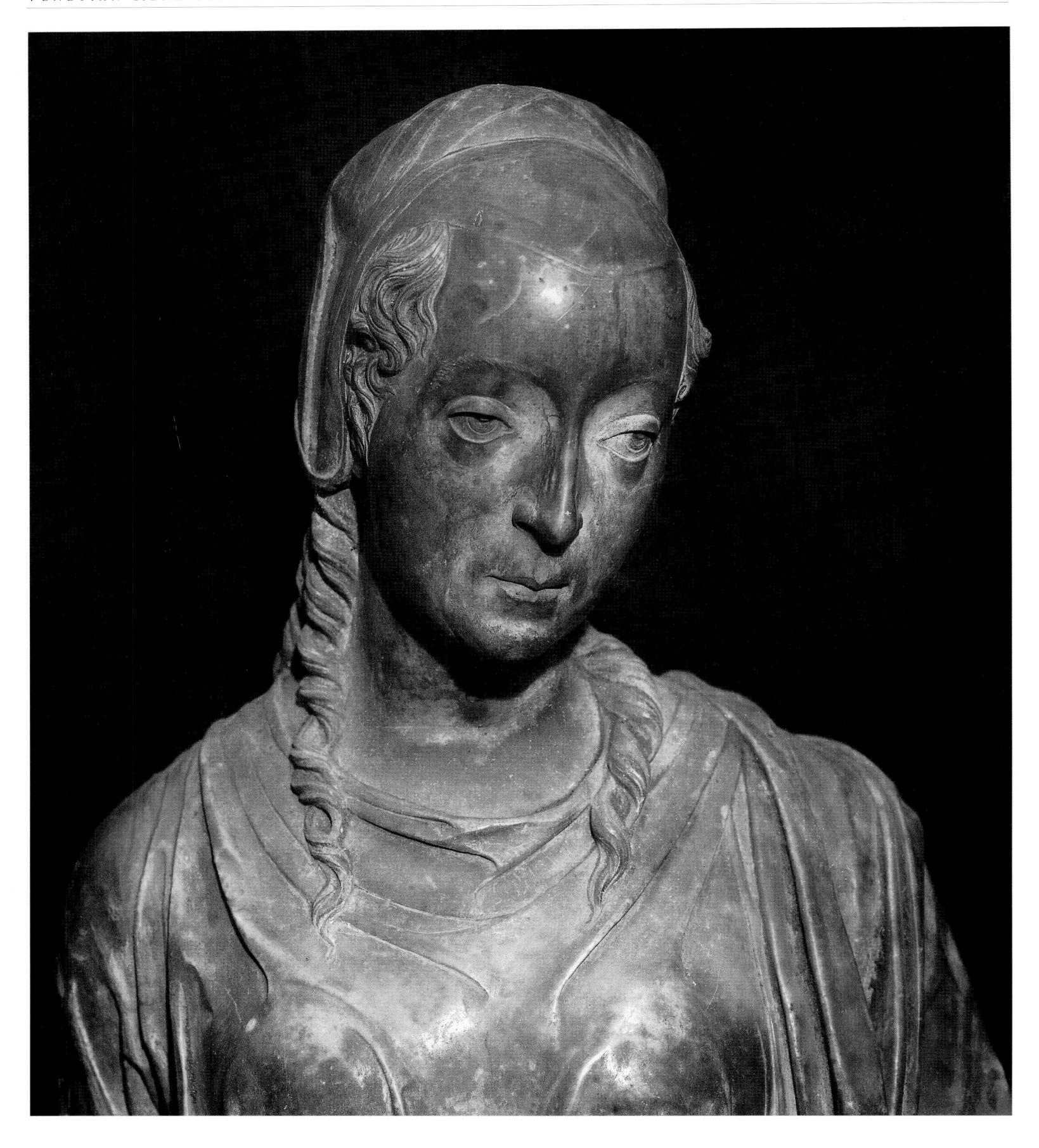

1450s and 1460s, above all through the agency of Mantegna, who was at work after 1449 in the Ovetari Chapel, and may already have been preparing pictorial transcriptions of Donatello's Madonna reliefs. Far earlier than in Venice the antique became a living force in Paduan art and thought, and it is in Padua that we first meet the creator of the Venetian Renaissance, Pietro Lombardo. Pietro Lombardo was born in Lombardy, probably about 1435, and is mentioned at Padua in 1464. There he acquired some celebrity. 'O Padua,' writes Colaccio in 1475, 'thou art resplendent for thy buildings and thy citizens, thou are resplendent also for the art of the famous sculptor Pietro Lombardo.' The most important of Pietro Lombardo's surviving works in Padua is the monument of Antonio Roselli in the Santo (plate 303). Roselli was a jurisconsult from Arezzo, and the tomb (which was completed in 1467) was planned in his own lifetime as a Florentine humanist monument. Its sources were the Bruni Monument of Bernardo Rossellino (plate 134), which had been in existence for about fifteen years, and Desiderio's more recent Marsuppini Monument (plate 138). In the Roselli Monument, however, the achievement falls short of the intention in a number of respects. In the first place the tomb is set inside an immense architectural frame, inspired by Bernardo Rossellino but in its effect totally un-Florentine, and in the second the figure sculpture, by the standard of Rossellino's and Desiderio's monuments, is rigid and inhibited.

The problem of the Roselli tomb was sui generis,

and after he transferred his studio to Venice Pietro Lombardo did not encounter it again. Yet in the first task that he completed there, the Malipiero Monument in SS Giovanni e Paolo (plate 304), the same mind is palpably at work. Much in this monument is derivative – the motif of the curtain derives from the Tommaso Mocenigo and Foscari monuments, the eagle supports from Bernardo Rossellino and the winged shell recalls the Marsuppini tomb – yet what results is a homogeneous work of art. There is a world of difference between this compact design and the arid space-filling of Rizzo's Tron tomb.

For Pietro Lombardo the expedient of enriching a Venetian tomb-type with Florentine motifs was no more than one phase in the development of an autonomous Renaissance style. In architecture he abandoned the predominantly Tuscan idiom of S. Giobbe (begun 1471) for the neo-Byzantine forms of S. Maria dei Miracoli (begun 1481), and in sculpture he felt his way forward from the eclectic Malipiero tomb to the masterly Pietro Mocenigo Monument (plate 305). There is some evidence of rivalry between Pietro Lombardo and Antonio Rizzo, and since the Pietro Mocenigo and Tron tombs were apparently begun in the same year (1476), it is worth while to compare them. Both tombs are flanked by figures in niches. In Rizzo's there is a total lack of surface movement; the forms are closed, and never does a gesture break the containing silhouette. In Pietro Lombardo's, on the other hand, the effect is more animated and more various. Moreover, in the Tron Monument the lateral sections protrude,

plate 300 Antonio Rizzo

Virtue

S. Maria dei Frari, Venice (detail of plate 299) marble, height of figure 167 cm

Overleaf
plate 301 (right)
Antonio Rizzo

Eve

Palazzo Ducale, Venice marble, height overall 204 cm

plate 302 (left) Antonio Rizzo

Adam

Palazzo Ducale, Venice marble, height overall 206 cm

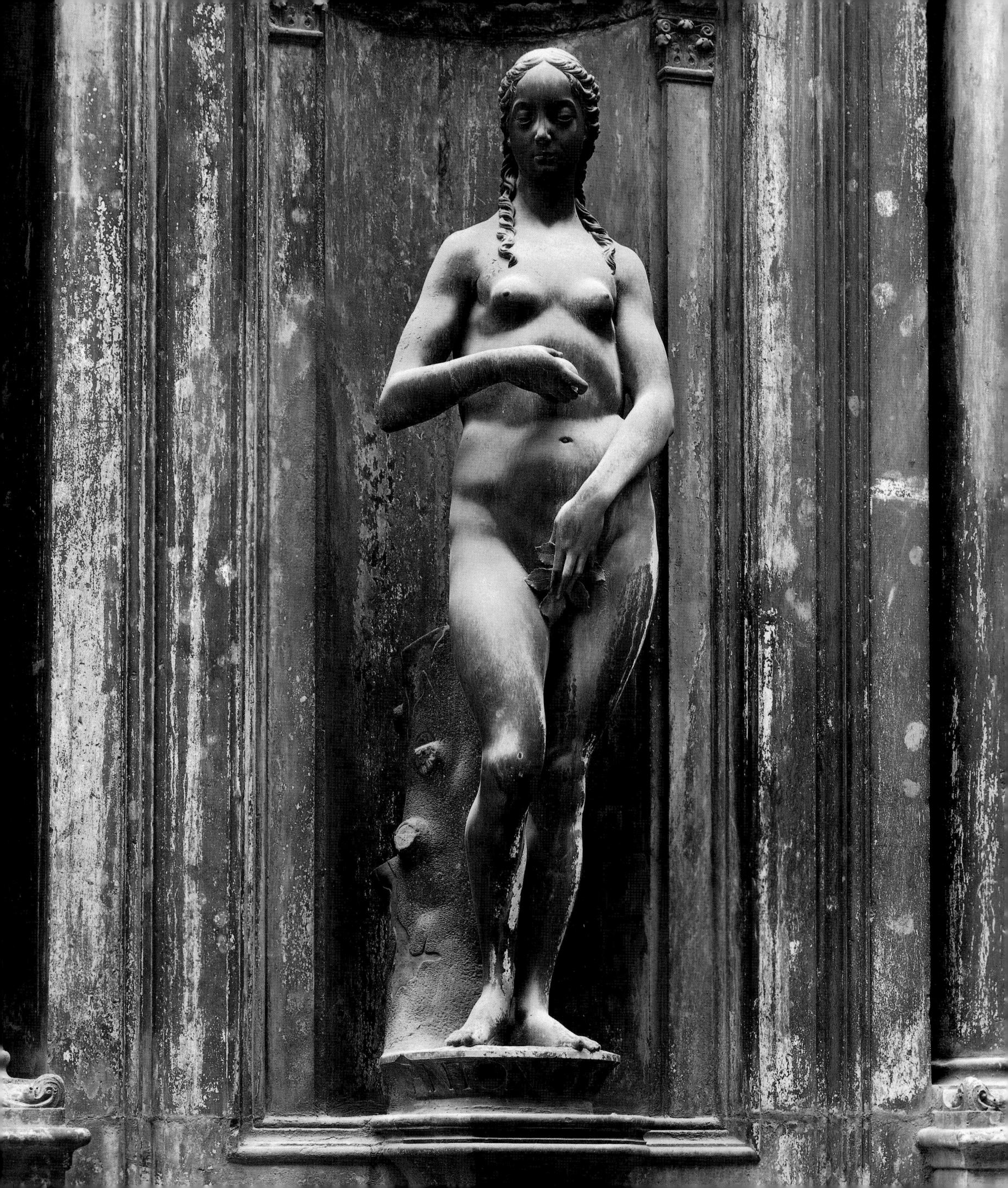

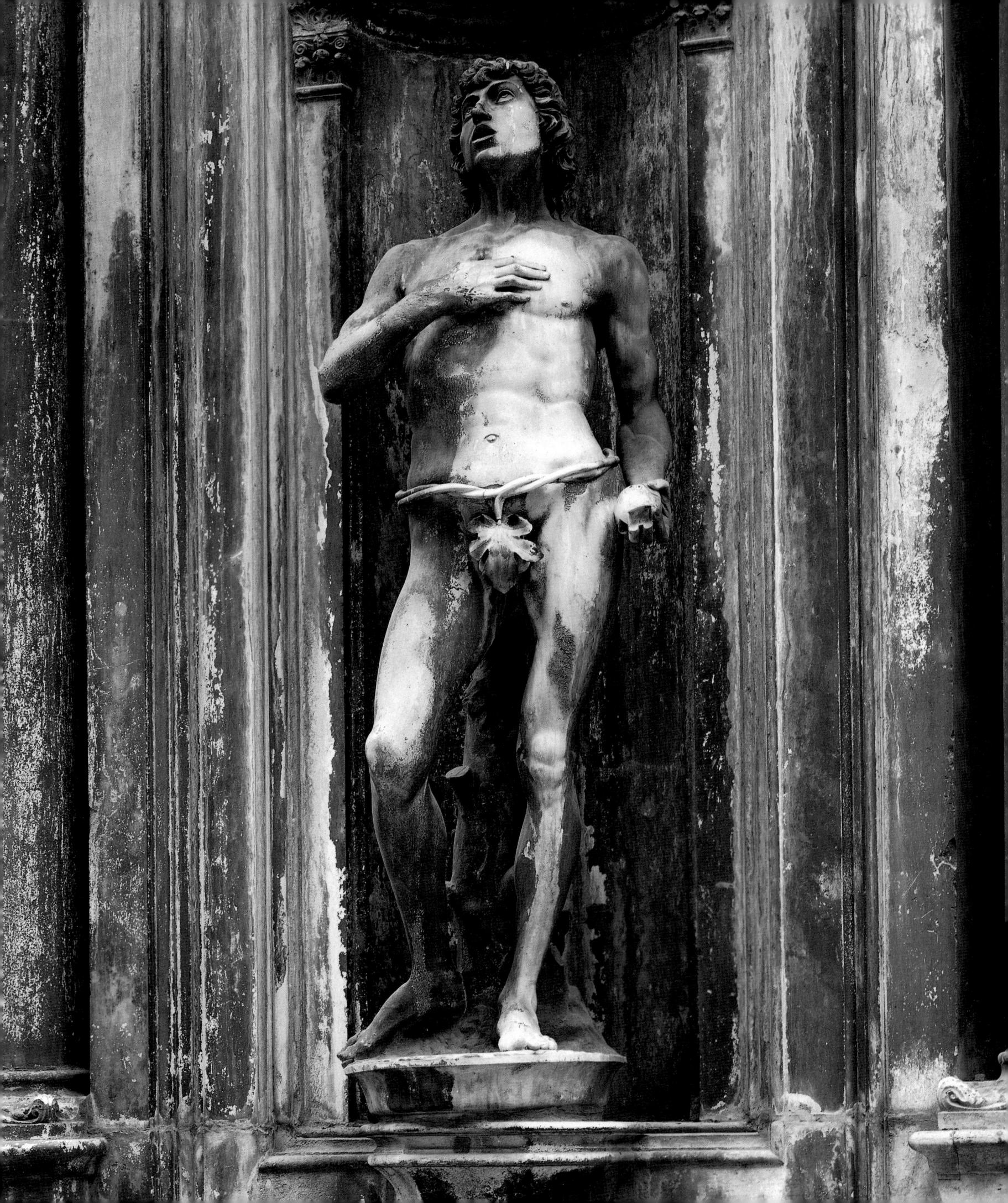

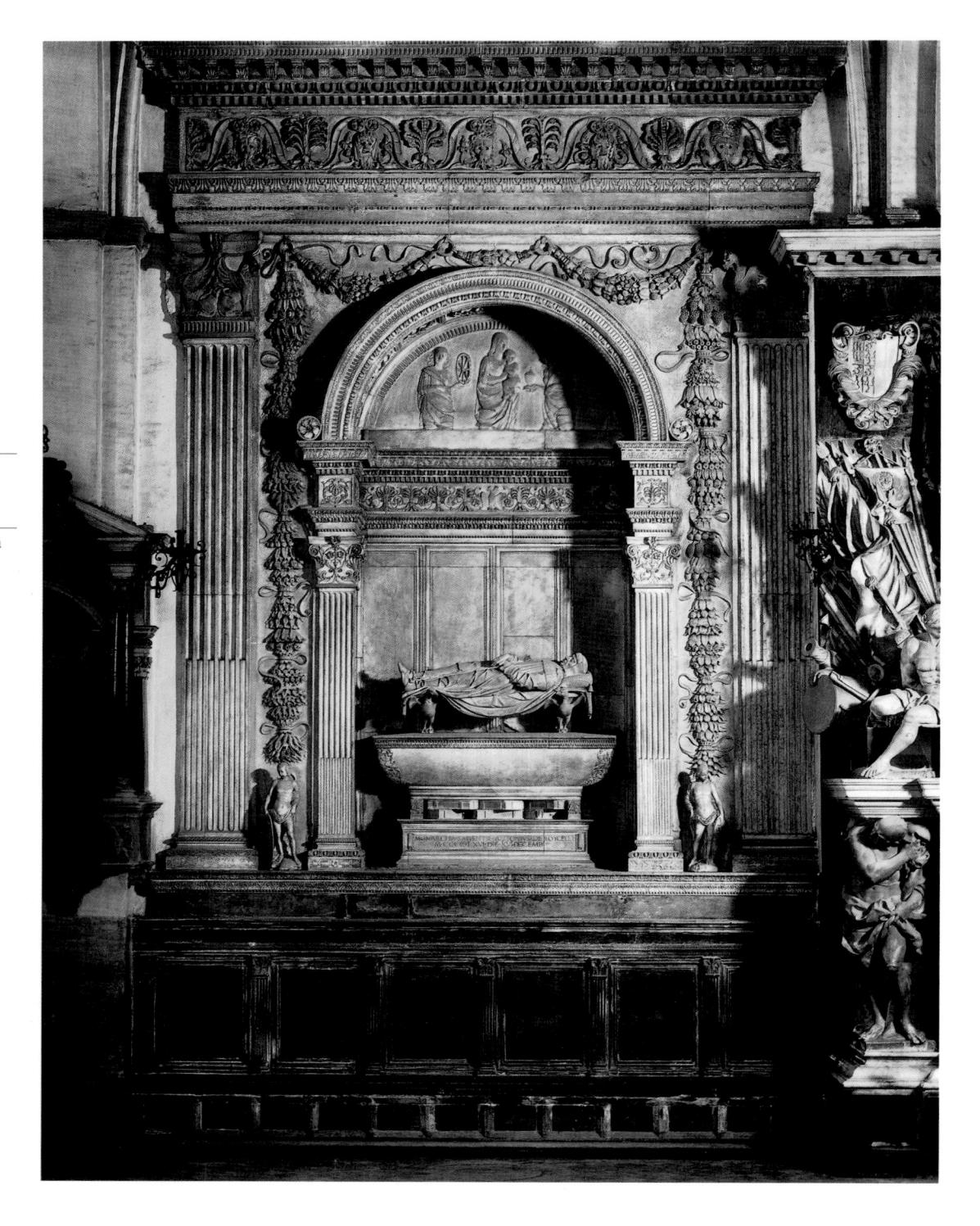

plate 303 Pietro Lombardo

The Roselli Monument

S. Antonio, Padua marble, $c.10 \times 6 m$

plate 304 Pietro Lombardo

The Malipiero Monument

SS. Giovanni e Paolo, Venice marble, height c.9 m

plate 305 Pietro Lombardo

The Pietro Mocenigo Monument

SS. Giovanni e Paolo, Venice marble, c.12.5 × 5 m

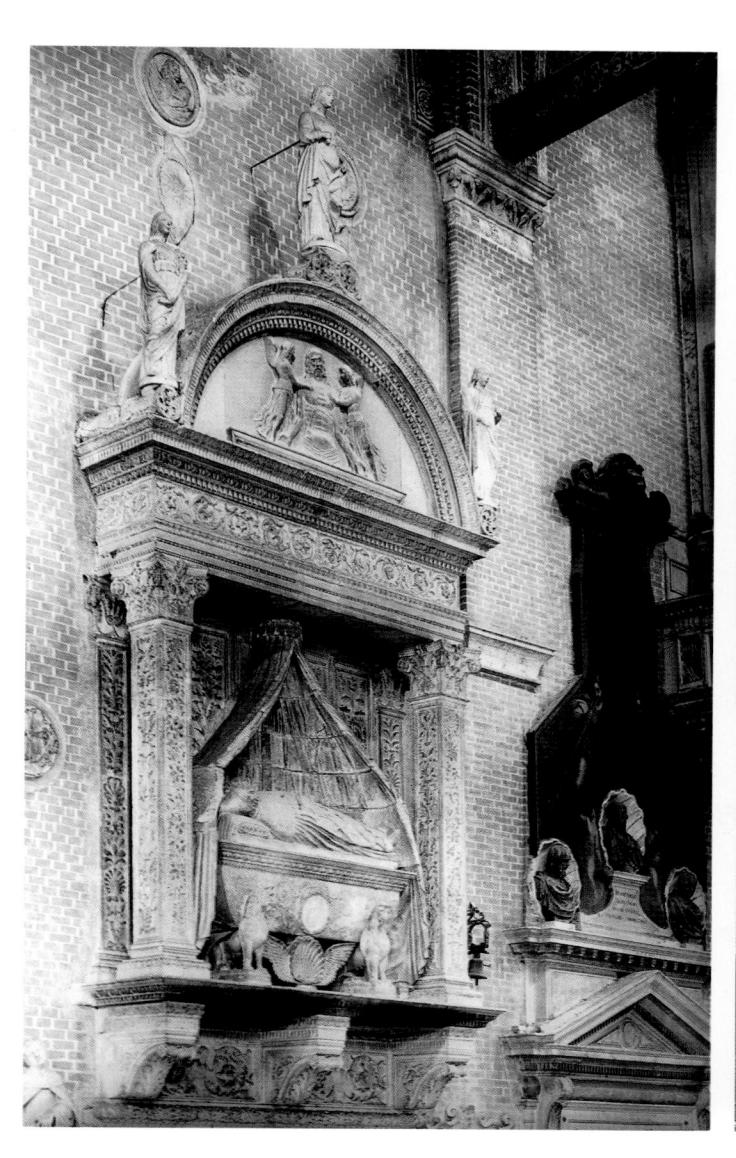

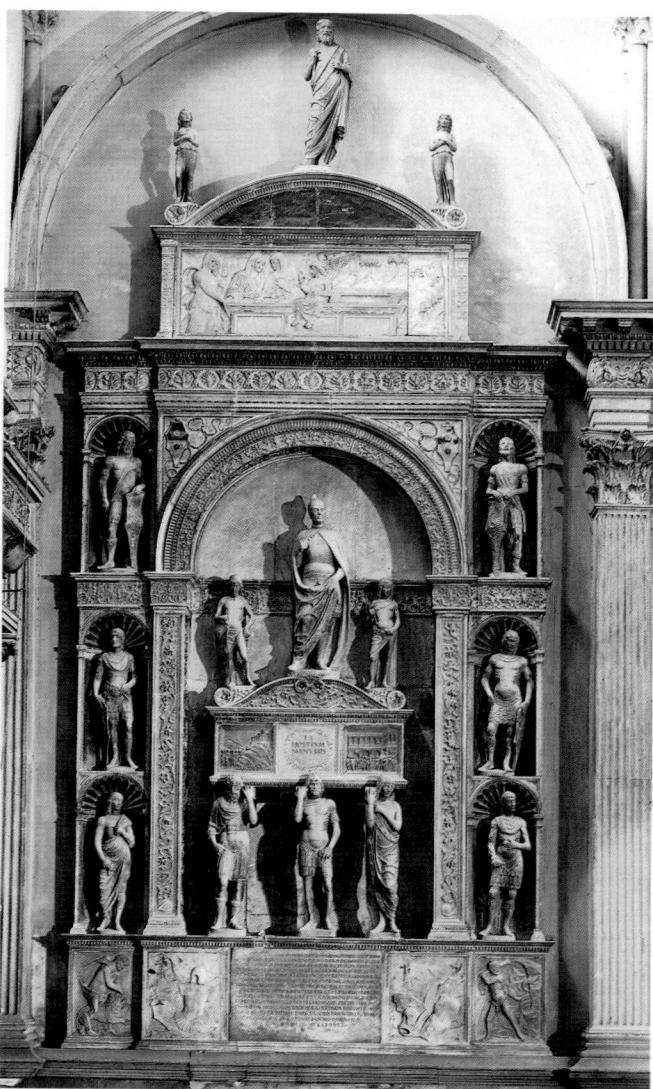

plate 306 Pietro Lombardo

The Risen Christ

SS. Giovanni e Paolo, Venice (detail of plate 305)

plate 307 (opposite) Pietro Lombardo

The Sarcophagus of the Pietro Mocenigo Monument

SS. Giovanni e Paolo, Venice (detail of plate 305)

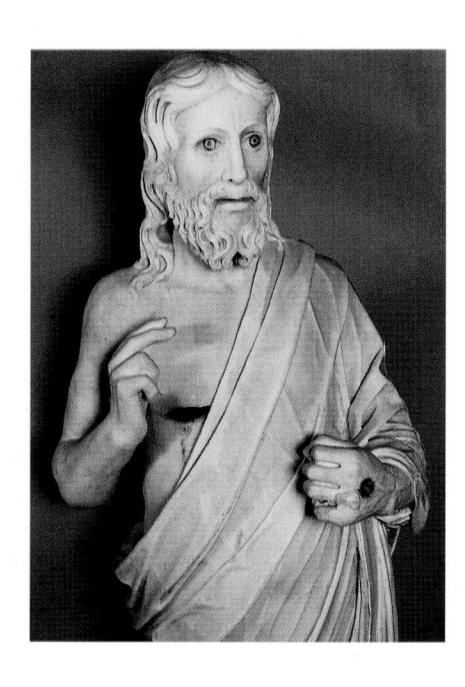

whereas in the Mocenigo Monument they are recessed in such a way as to give emphasis to the central arch containing the standing Doge and the sarcophagus. The form of the sarcophagus (plate 307) was perhaps suggested by Agostino di Duccio's Arca degli Antenati at Rimini (plate 240), though two historical scenes, the Entry of the Venetians into Scutari and the Surrender of Famagusta, replace the allegories on the Rimini sarcophagus. The lamenting warriors under it are some of the most vivid figures on the tomb, and like the Risen Christ above (plate 306) are conceived with great intensity. Significantly enough, the religious images - the Risen Christ, two Saints and a relief of the Marys at the Sepulchre – are grouped together at the extreme top of the monument, while the reliefs on the base show military trophies and two of the labours of Hercules, and the niche figures one and all are classical.

None the less throughout the Mocenigo tomb there is a dichotomy between the method of carving and the classical types that are employed; it is as though the sculptor were wearing garments from two different suits. In the work which succeeds it, the tomb of Mocenigo's short-lived predecessor, Niccolò Marcello (plate 309), this contrast is less evident, for the four Virtues at the sides seem to have been based on Roman originals of the type of the Pudicitia in the Capitoline Museum. Here the classical model is for the first time integrated in a consistent style in figures which could never be mistaken for classical originals, but which evince a deep

spiritual affinity with the antique.

In North-Eastern Italy there was a long tradition of wall monuments proper, monuments, that is, which were supported on brackets and formed a sculptural oasis in the centre of a painted wall. A typical tomb of this kind is the Brenzoni Monument in S. Fermo Maggiore at Verona (Vol. I, plate 215), where the sculpture was by Nanni di Bartolo and the fresco was by Pisanello. This was a Gothic conception, but it persisted on through the Renaissance, and was adopted by Pietro Lombardo after 1485 for the tomb of Giovanni Zanetti, Bishop of Treviso, in Treviso Cathedral (plate 308). The Zanetti tomb is in some respects the finest Venetian sepulchral monument. Its design is exceptionally fluent, and reveals the instinctive sense of rhythm and spacing that sprang from Pietro Lombardo's practice as an architect. Moreover, its technique is far superior to that of the earlier Lombardo tombs. The foliage and figures on the ornate sarcophagus are deeply cut; the eagle beneath is carved with great boldness and vitality; and the three figures above (plate 310) are articulated with new confidence. The causes of this change must be sought in the Venetian workshop system. In the Buon studio in the first half of the fifteenth century the personality of Giovanni Buon is slowly superseded by Bartolommeo's; there is no break in style, vet at a certain point we are aware that the guiding impulse has undergone a change. It is this that occurs in the Zanetti tomb. With the Buon the descent is from father to son, and with the Lombardi from father to sons. The elder of Pietro's

plate 308 Pietro Lombardo

The Zanetti Monument

Duomo, Treviso marble, height c.6 m

plate 309 Pietro Lombardo

The Marcello Monument

SS. Giovanni e Paolo, Venice marble, height c.5.5 m

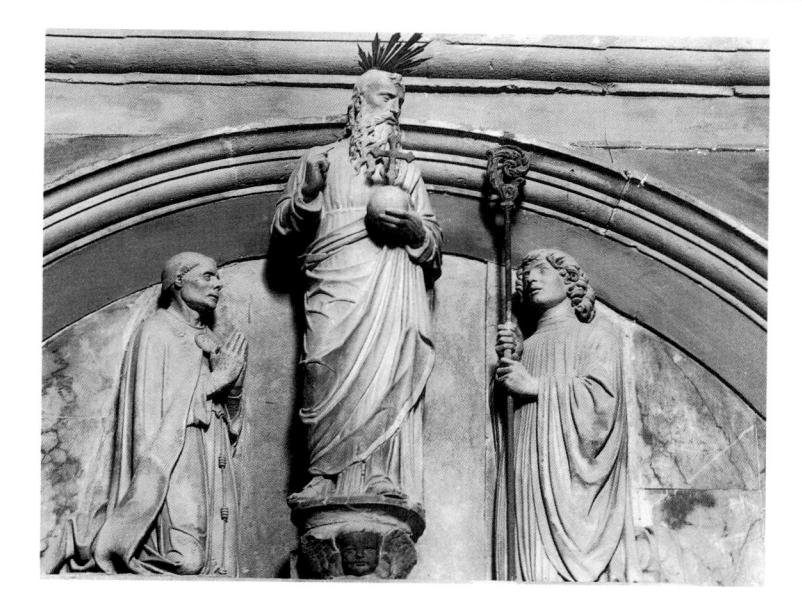

plate 310 Pietro Lombardo

Giovanni Zanetti Kneeling before God the Father

Duomo, Treviso (detail of plate 308)

plate 311 (below) Tullio Lombardo

Adam

Metropolitan Museum of Art, New York marble, height 193 cm

two sons, Tullio, must have played a far from negligible part in the Pietro Mocenigo Monument, but only in the Zanetti Monument do he, and his younger brother Antonio, make their presence felt in such a way as to modify the whole style of the tomb.

In the Vendramin Monument in SS. Giovanni e Paolo (plate 312) the victory of the younger generation is complete, and the dominant personality is Tullio not Pietro Lombardo. The Vendramin Monument is a manifesto of Venetian classicism. 'At the Servi,' writes Sanudo in 1493. 'the tomb of the Doge Andrea Vendramin is now being constructed, and will prove, I am certain, the most beautiful in this city on account of the worthy marbles it contains.' The monument Sanudo saw building is a summing-up of the experiments of Pietro Lombardo. Yet it is at the same time a work of great originality, inspired by the same instinctive classicism that directed the tombs designed in Rome a decade later by Andrea Sansovino. This classicism is carried through into the figure sculpture. By 1493 the collecting of antiques in Venice was widespread, and Marcantonio Michiel frequently refers to antique statues standing in Venetian palaces. Among the sculptures observed by Michiel in the house of Andrea Odoni was a 'marble figure of a woman entirely draped, headless and handless, . . . [which] used to be in the studio of Tullio Lombardo who reproduced it several times in his many works'. Almost all the figure sculptures on the Vendramin tomb testify to Tullio's avid pursuit of the antique, and none more so than the beautiful figure of

Adam in New York (plate 311), where Tullio seems to have combined a headless figure of the class of the Vatican Apollo with a head based on the Capitoline Antinous. Yet so strong was Tullio's feeling for the sensuous human form that his figure speaks the language not of eclecticism but of a romantic silver-age. In the supporting figures which now fill the niches that were originally occupied by Adam and Eve, the heads are treated in the same spirit as that of Adam. and when we look at the hard, boldly modelled features of the figure on the left (plate 313), or the softer, more voluptuous head of the youth standing on the right, we are not immediately conscious that in both the treatment of the body derives from a statue of the type of the Mars in the Capitoline Museum.

A clue to the understanding of this classicistic style is provided by the De sculptura of Pomponius Gauricus, which was written in Padua about 1503 under the spell of the sculptures of Riccio and Tullio Lombardo. In the last section of the treatise Pomponious Gauricus turns to individual sculptors. 'Shall I,' he asks, 'pass Tullio over without praise? Did I not fear the charge that my judgement of him was due to friendship rather than to his true worth, I would name him the greatest of all sculptors that any age has seen, and this praise would not be undeserved. Is not past genius, are not past miracles returned?' The sculptor, insists Pomponius Gauricus, must be a learned artist and a student of antiquity, must know 'why Mars was represented by the Romans in two forms as gradivus and quirinus', and must

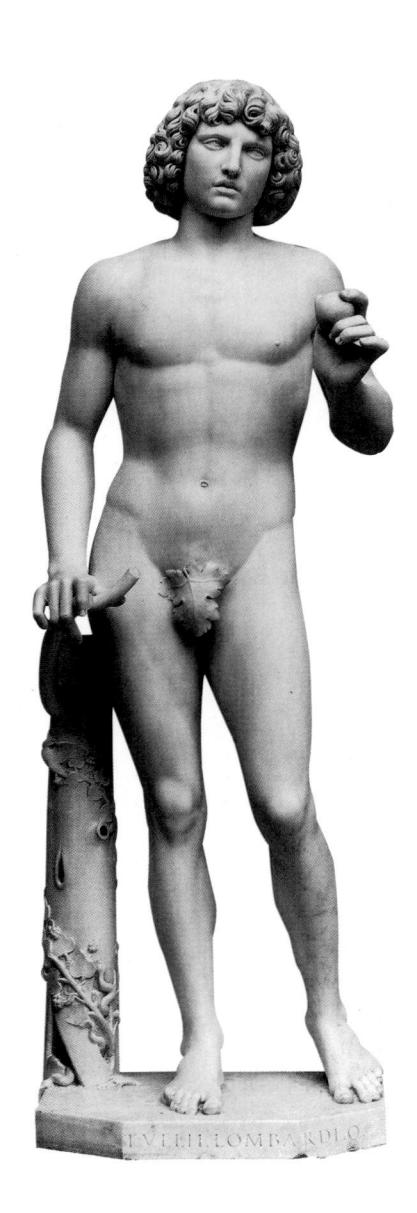

plate 312 Tullio Lombardo

The Vendramin Monument

SS. Giovanni e Paolo, Venice marble, 12 × 7.8 m

plate 313 (opposite) Tullio Lombardo

Head of a Warrior

SS. Giovanni e Paolo, Venice (detail of plate 312)

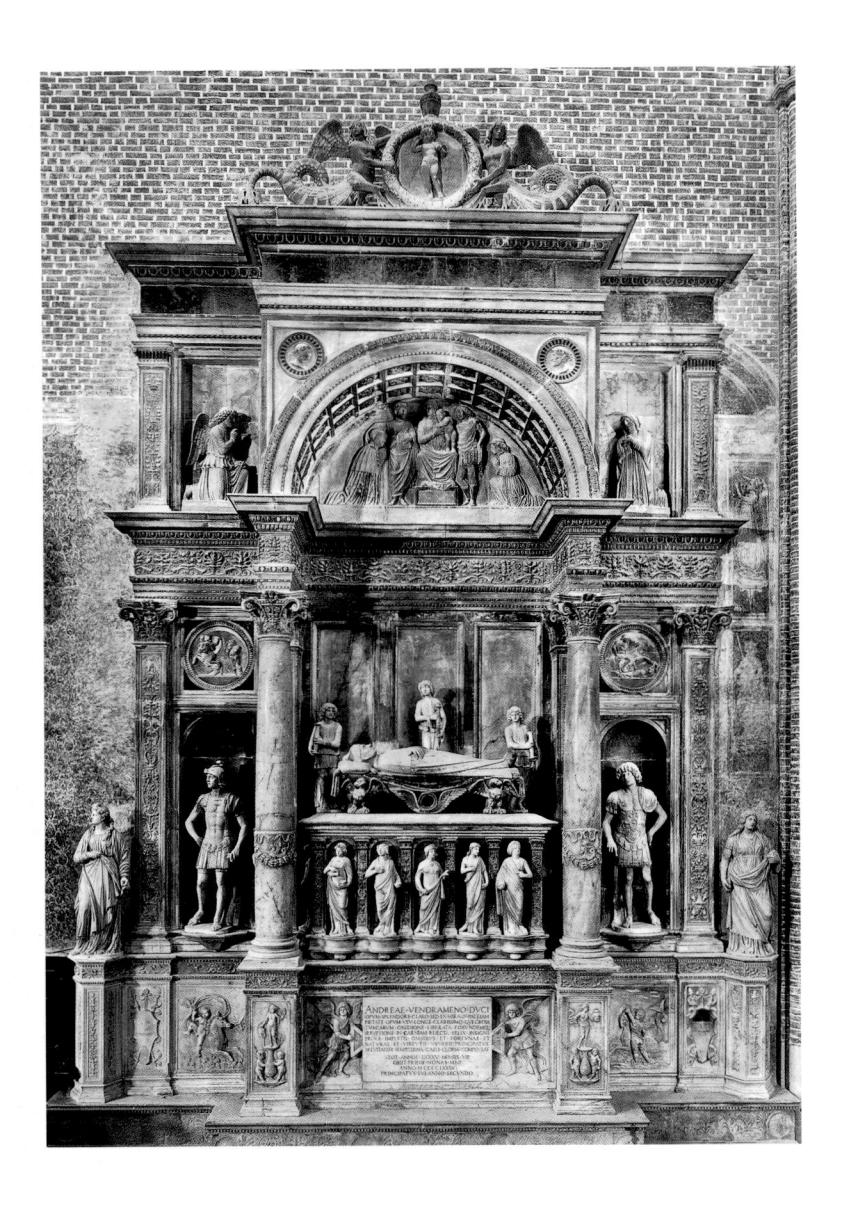

understand the classical representations of Venus and Jupiter. Such was the environment in which the beautiful carving of Bacchus and Ariadne at Vienna (plate 314) was produced.

Many Venetian tombs include carvings in relief, and the history of the relief in Venice runs parallel to that of the sepulchral monument. A convenient point of departure is the year 1449 when Agostino di Duccio arrived in Venice, not because he had at this time any direct influence on Venetian style, but because through the 1450s and 1460s there came a slow backwash from the Tempio Malatestiano, which resulted in the first low reliefs produced in Venice. One of the earliest in date and one of the most palpably Riminese in style is the beautiful paliotto with angels carrying the instruments of the Passion (plate 315), which was carved about 1470 for the church of S. Trovaso. Another is an antependium of the altar of St Sigismund at Rimini. When Pietro Lombardo arrived in Venice, however, there was no established tradition of relief style, and initially his mind once more veered towards Florence. He was too independent an artist to content himself with a pastiche of Florentine motifs, yet the tondi of Evangelists in the spandrels at S. Giobbe could hardly have been designed without knowledge of Donatello's Evangelists in the Old Sacristy of S. Lorenzo (plate 52), nor the beguiling putti beneath the cupola (plate 316) without knowledge of Donatello's putto reliefs at Padua.

The role assumed by the relief in Venice is very different from the part it plays in Florence. Never in Florence do we find reliefs plastered one beside

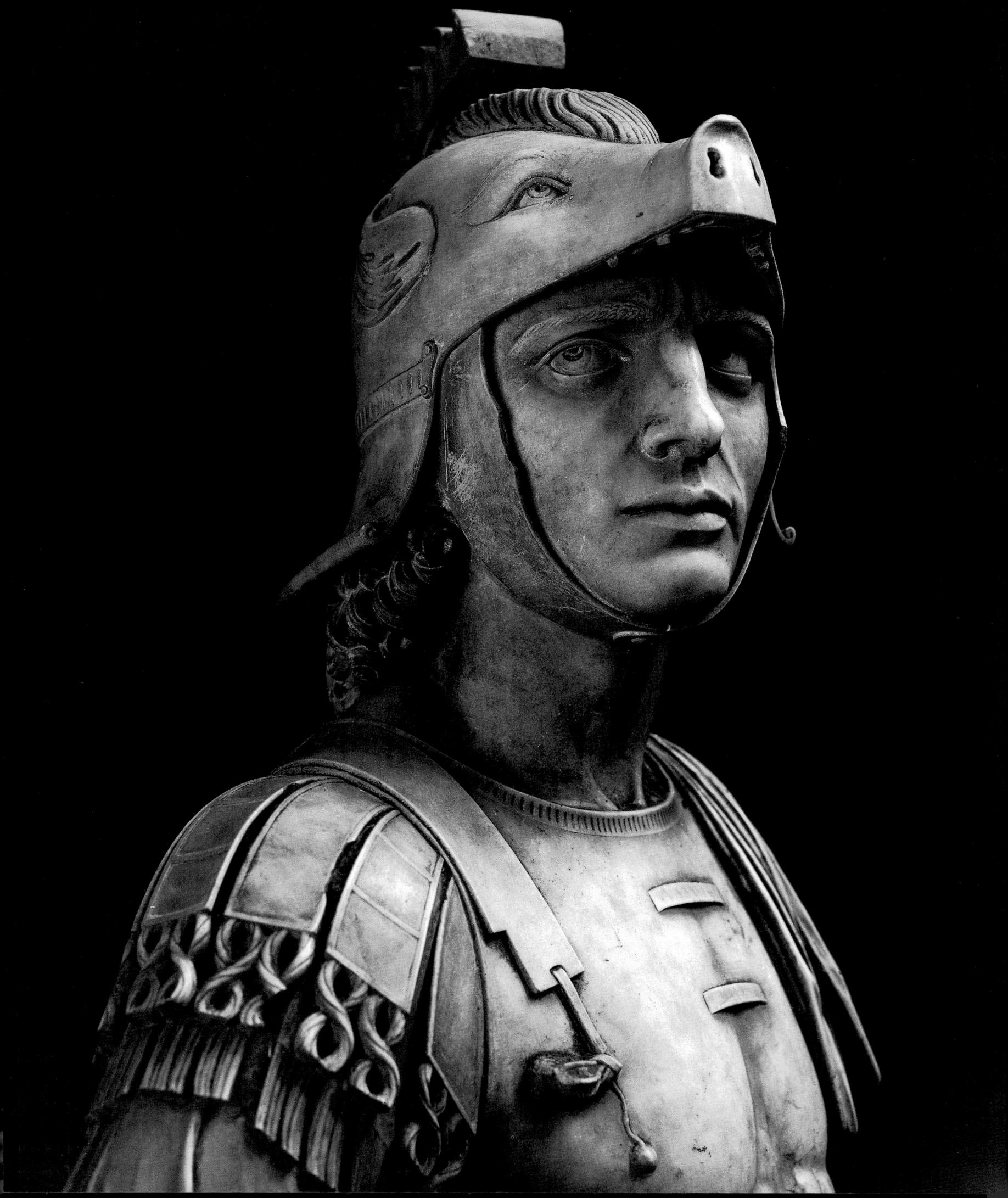

plate 314 Tullio Lombardo

Bacchus and Ariadne

Kunsthistorisches Museum, Vienna marble, 56 × 72 cm

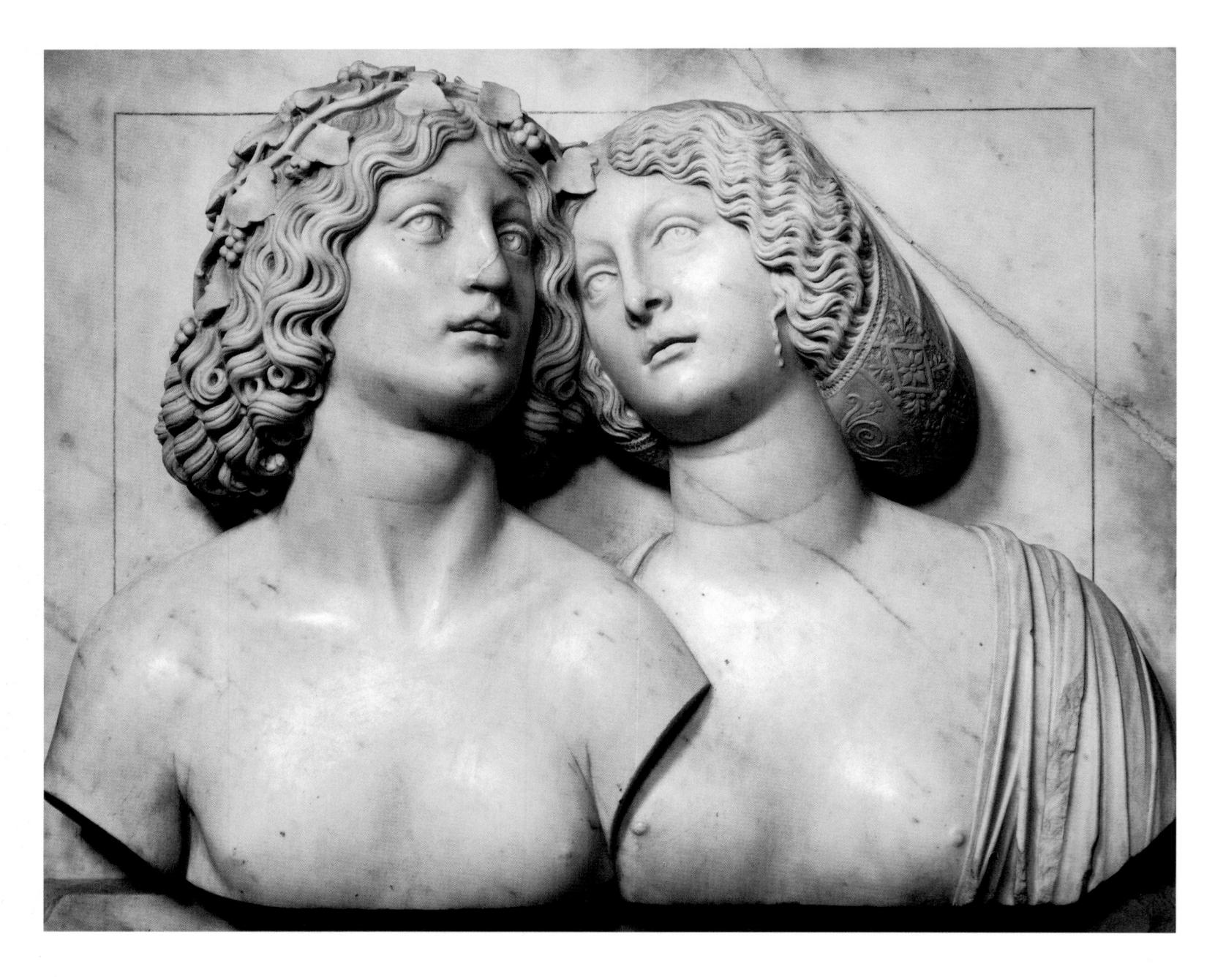

plate 315 (left) Master of S. Trovaso

Angels

S. Trovaso, Venice marble, 76×33 cm

plate 316 *(above)* Pietro Lombardo

Angel

S. Giobbe, Venice *marble*

plate 317 Tullio Lombardo

St Mark Baptizing Ammianus

SS. Giovanni e Paolo, Venice marble, 107 × 154 cm another over a large area of wall-space, as they are in the Giustiniani Chapel in S. Francesco della Vigna; and never in Venice do we encounter isolated low reliefs in marble carved with the utmost skill of which a great artist was capable. The differentiation of texture, the deceptive surface modelling, the interior organization of the relief field that are found in reliefs by Desiderio and Antonio Rossellino were beyond the reach of fifteenth-century Venetian artists. Venetian sculptors seem indeed to have regarded the problems presented by such works with disinterest and even apathy. At all events there is no authentic Madonna relief by Tullio Lombardo, and the most accomplished of the reliefs of Pietro, the Loredano Madonna in the Camera degli Scarlatti (plate 318), which must have been carved after 1501, is comparable not with Giovanni Bellini's half-length Madonnas but with his Murano altarpiece.

From the standpoint of quality the reliefs in the lunettes of Pietro Lombardo's monuments are undistinguished, and even in the Vendramin tomb the relief is still of a resolutely archaic kind. In the lower parts of the Lombardo sepulchral monuments, however, a coherent relief style was gradually evolved. The impulse behind it sprang once more from emulation of antiquity. The largest of the reliefs incorporated in the Pietro Mocenigo Monument, the Marys at the Sepulchre, which runs the whole width of the centre of the tomb, is marred by technical uncertainty. At the bottom of the tomb, however, are two small reliefs of Hercules and the Hydra and Hercules and the Nemean Lion, and these subjects

seem to have supplied the sculptor with the incentive which the larger relief lacked. As with figure sculpture, so with the relief it was left to Tullio and Antonio Lombardo to mould the classical aspirations of their father into a genuinely classicistic style. The success with which they did so may be measured in the lyrical reliefs on the base of the Giovanni Mocenigo Monument (plate 317), in which the legend of St Mark is translated into the firm rhythms of Latin verse. No relief in Florence in the whole quattrocento communicates the same feeling of nostalgia for Roman art.

The representation of space plays no part in Venetian fifteenth-century reliefs. At Padua Donatello had left on the high altar of the Santo a grammar of perspectivism, but only one of his expedients, the receding ceiling of the Miracle of the New-Born Child (plate 56), found its way into the repertory of Venetian motifs. It was employed about 1460 in the altar frontal in S. Trovaso, was taken over by Pietro Lombardo in the tomb of Dante at Ravenna, was used once more in the Giustiniani Chapel in S. Francesco della Vigna, and later still recurs in a bronze relief in S. Stefano. But in the first three cases it is used decoratively, not as a means of establishing a space illusion, and in the fourth the artist's determination to create a space illusion is frustrated by incapacity. Linear perspective became a feature of Venetian relief style only when it grew necessary to correlate the relief surface with an architectural scheme. It appears first in external reliefs. These were especially popular in Venice in the first half of the fifteenth century, and were produced in the

plate 318 Pietro Lombardo (?)

Doge Leonardo Loredano before the Virgin and Child

Palazzo Ducale, Venice marble

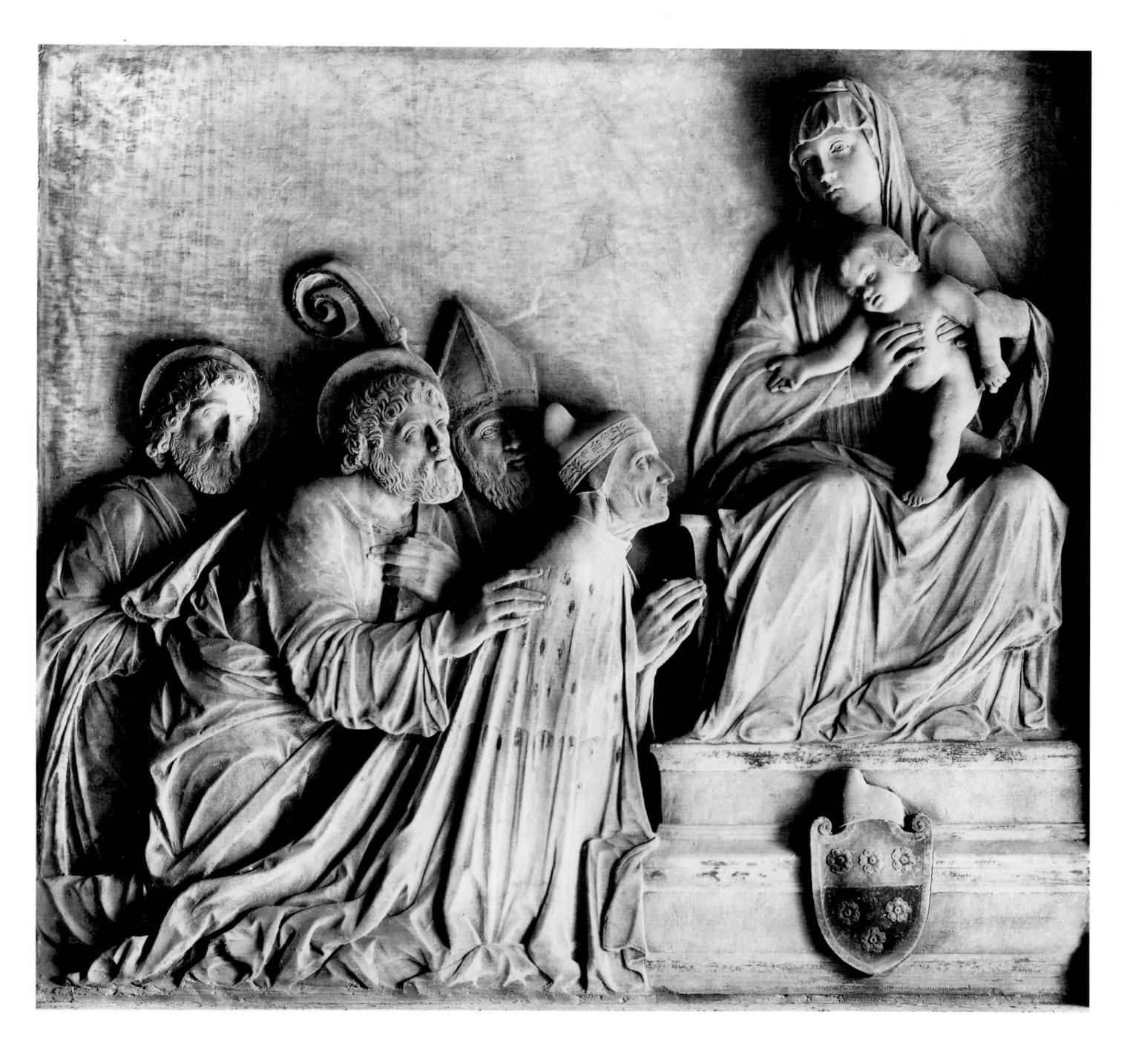

studios of Buon, the Mascoli Master and other artists. As the style of Buon was superseded by Pietro Lombardo's, the type of relief changed but the old shape was retained. Thus Pietro Lombardo's relief of St Mark Curing Ammianus over the entrance to the Scuola dei Calzolai fills a Gothic lunette, and even where the entrance lunette is rounded, as at S. Giobbe, no attempt is made to link the relief to its architectural frame. When the Scuola di S. Marco was rebuilt after the fire of 1485, however, the relation between relief and architectural setting was thought out afresh (plate 319). There were two doorways in the new façade, a principal entrance to the left and a subsidiary entrance to the right, and beside each of them were carvings in relief, in which for the first time the wall surface was treated as a window and the figures were shown in projected space, each pair of reliefs having its vanishing point in the centre of the intervening doorway. Beside the main door two boldly foreshortened lions in a marble hall guard the entrance to the school, while beside the doorway on the right are two scenes from the legend of St Mark based on a relief of the type of the Allocution of Marcus Aurelius in the Capitoline Museum.

Before long linear perspective was introduced in internal as well as external reliefs. Here painting had priority, for as the concept of uniform church architecture was imposed by Codussi and Pietro Lombardo, the interior of the painted altarpiece came to be conceived as an extension of the space of the church. This is the case, for example, with

Giovanni Bellini's S. Giobbe altarpiece of 1488. In the marble altarpiece which Tullio Lombardo constructed about 1500 for S. Giovanni Crisostomo (plates 320, 321), sculpture followed where painting led. None the less, Tullio's relief is a work of great originality, whose design and iconography bring to their logical climax the style tendencies of the Vendramin tomb. Many scenes from the New Testament could readily be represented all'antica, and transposed into the language of imperial art. But this scene of Christ, the Virgin and the Apostles was not among them, and the prospect of portraying this most mystical of scenes as an event in space and time would have daunted an artist less intoxicated with antiquity.

This was the style which the Lombardi after 1500 carried back to Padua. Most visitors to the shrine of St Anthony (plate 323) must feel a sharp sense of discomfort at the contrast between the staid, lucid, classical reliefs which line the chapel walls and the enthusiasm of the pilgrims pressing round the tomb. The carvings seem to illustrate not the hagiographical legend of St Anthony, but some play about St Anthony written by Racine. The magnitude of the decision which led to the commissioning of these reliefs can be judged if we imagine the chapel as it was in 1500, its walls covered with half-ruined International Gothic frescoes of the legend of the Saint. The decision was to cover the wall surfaces beside and behind the altar with nine large-scale marble carvings, each composed of a narrative scene below and a perspective above. A model for the chapel was

plate 319

The Façade of the Scuola di San Marco

Venice

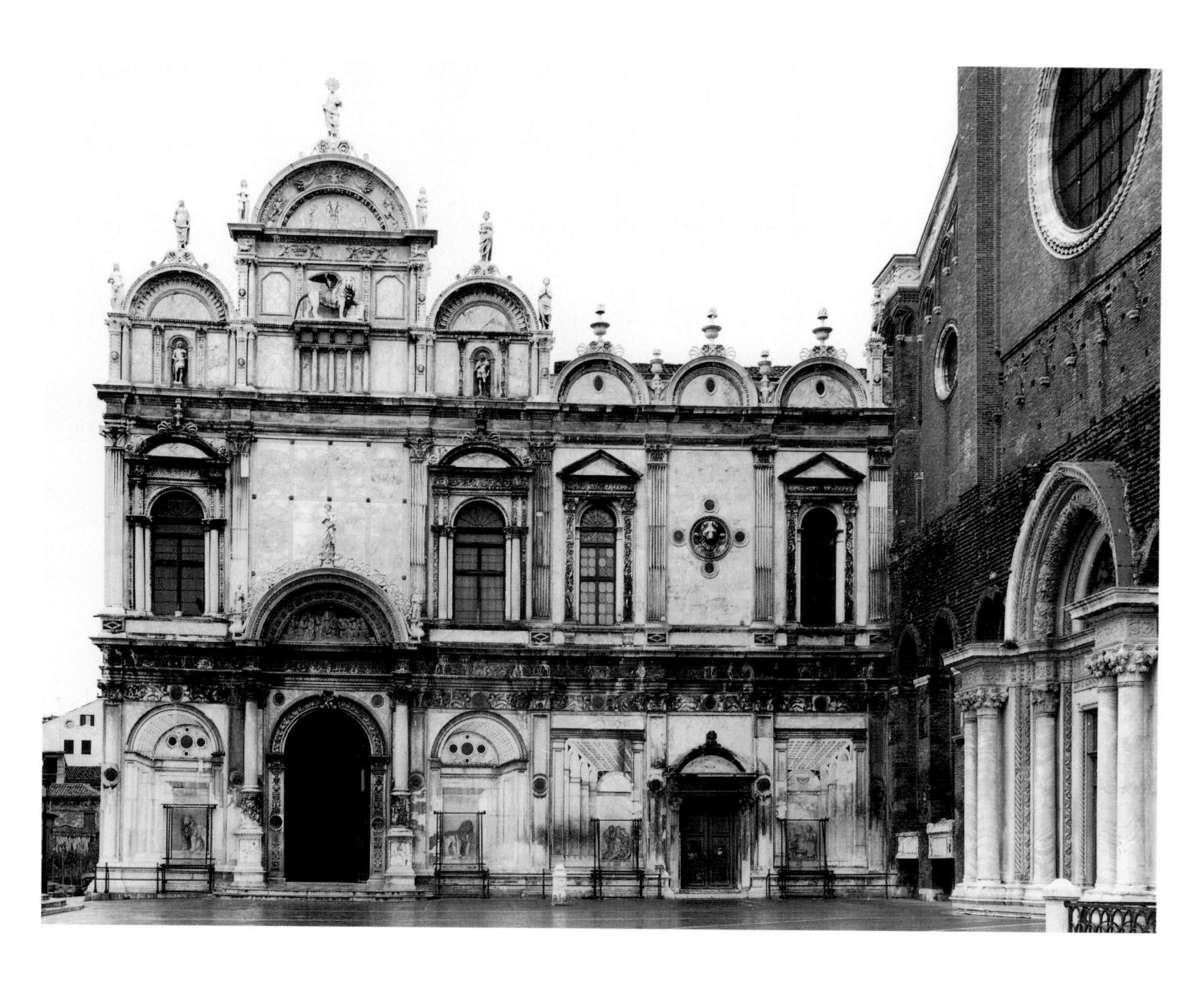

plate 320 Tullio Lombardo

Christ, the Virgin and the Apostles

S. Giovanni Crisostomo, Venice marble

plate 321 *(opposite)* Tullio Lombardo

Christ, the Virgin and the Apostles

S. Giovanni Crisostomo, Venice (detail of plate 320)

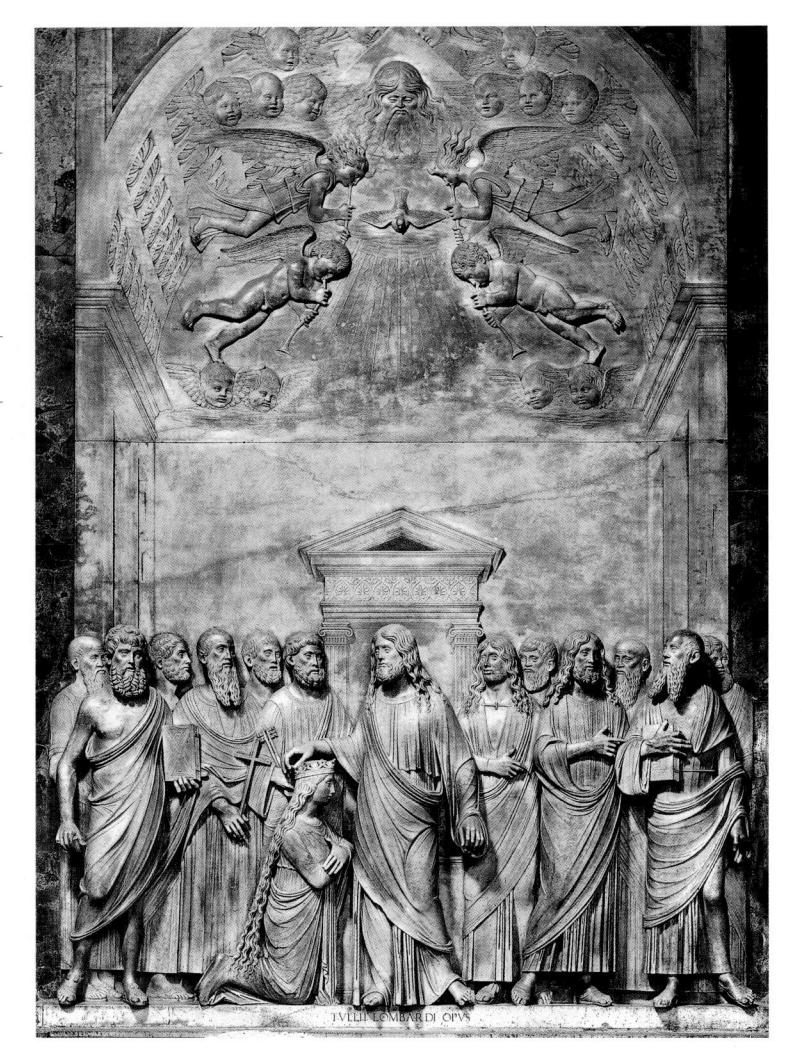

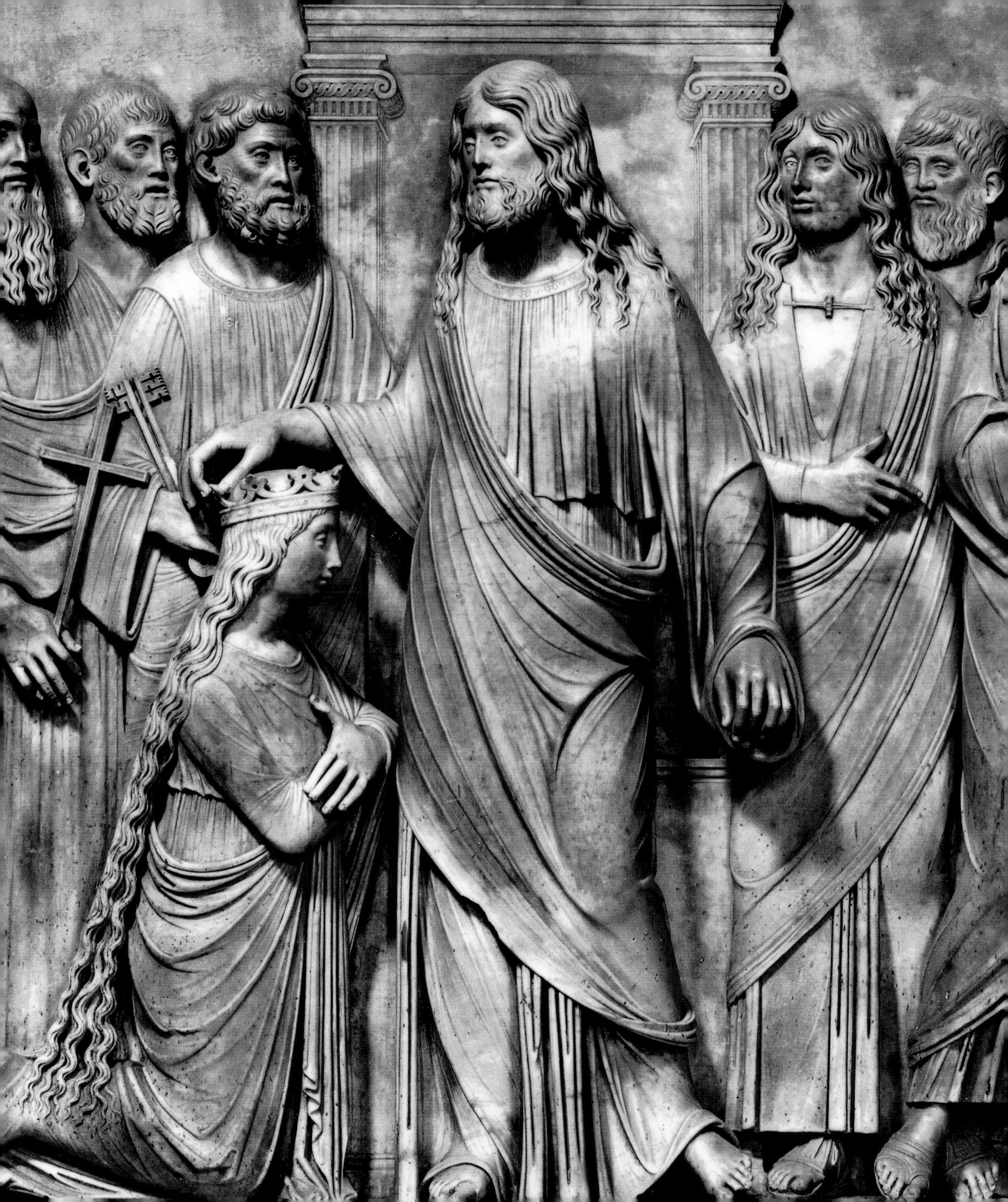

plate 322 (right) Bartolommeo Bellano

Roccabonella Monument

S. Francesco, Padua bronze, 200 × 143 cm

plate 323 (below)

The Chapel of St Anthony

S. Antonio, Padua

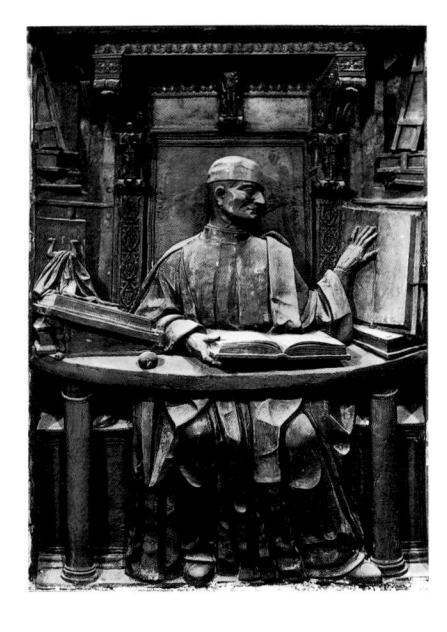

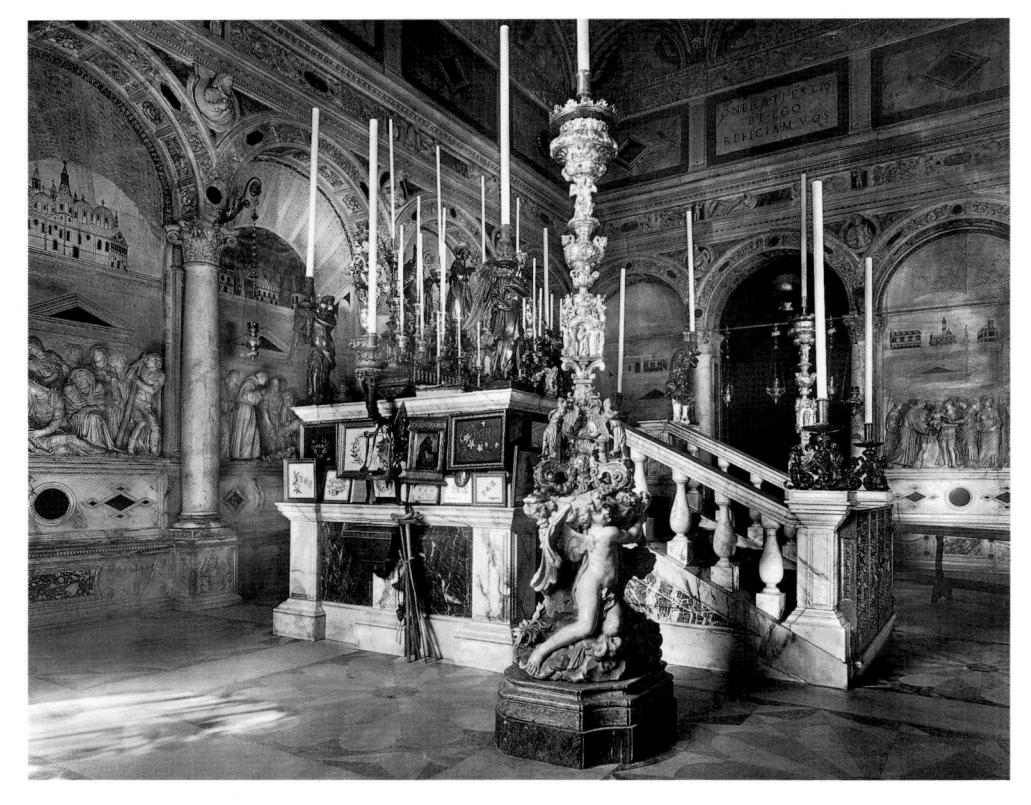

made by Riccio, and the ideas underlying the reliefs must have originated with the humanist circle whose mouthpiece Riccio was. Riccio not long before had been engaged on a classical reinterpretation of that familiar Franciscan subject, the Legend of the Cross, for S. Maria dei Servi in Venice – now shown in the Ca' d'Oro – and it must have appeared logical that the cult of St Anthony should likewise be purged and humanized.

One of the reliefs was carved by Antonio and two by Tullio Lombardo. The earliest of the three is Antonio Lombardo's (plate 324), which was paid for in 1505. This relief is also the most classical; the only realistic features in it are two friars on the left who have strayed into what is otherwise an antique scene. Yet Antonio's reinterpretation of the Miracle of the New-Born Child is not lacking in feeling, and the staid gestures of the outwardly impassive women on the right are imbued with a peculiar gravity and tenderness. In this Antonio's differs from Tullio's reliefs (plates 325, 326), where the poses are less restrained and the overt expression of emotion is more pronounced. No doubt this is due in part to a difference between the temperaments of the two artists, but it also reflects the fact that Tullio's reliefs, though they were commissioned like Antonio's in 1501, were not delivered until 1525. Where Antonio's relief is a product of the classical moment in which the whole scheme was conceived, Tullio's reflect the developed taste of the sixteenth century; their affinities are with the Niobids and the Laocoon. The central figures, both of which seem to derive

plate 324 Antonio Lombardo

The Miracle of the New-Born Child

S. Antonio, Padua marble

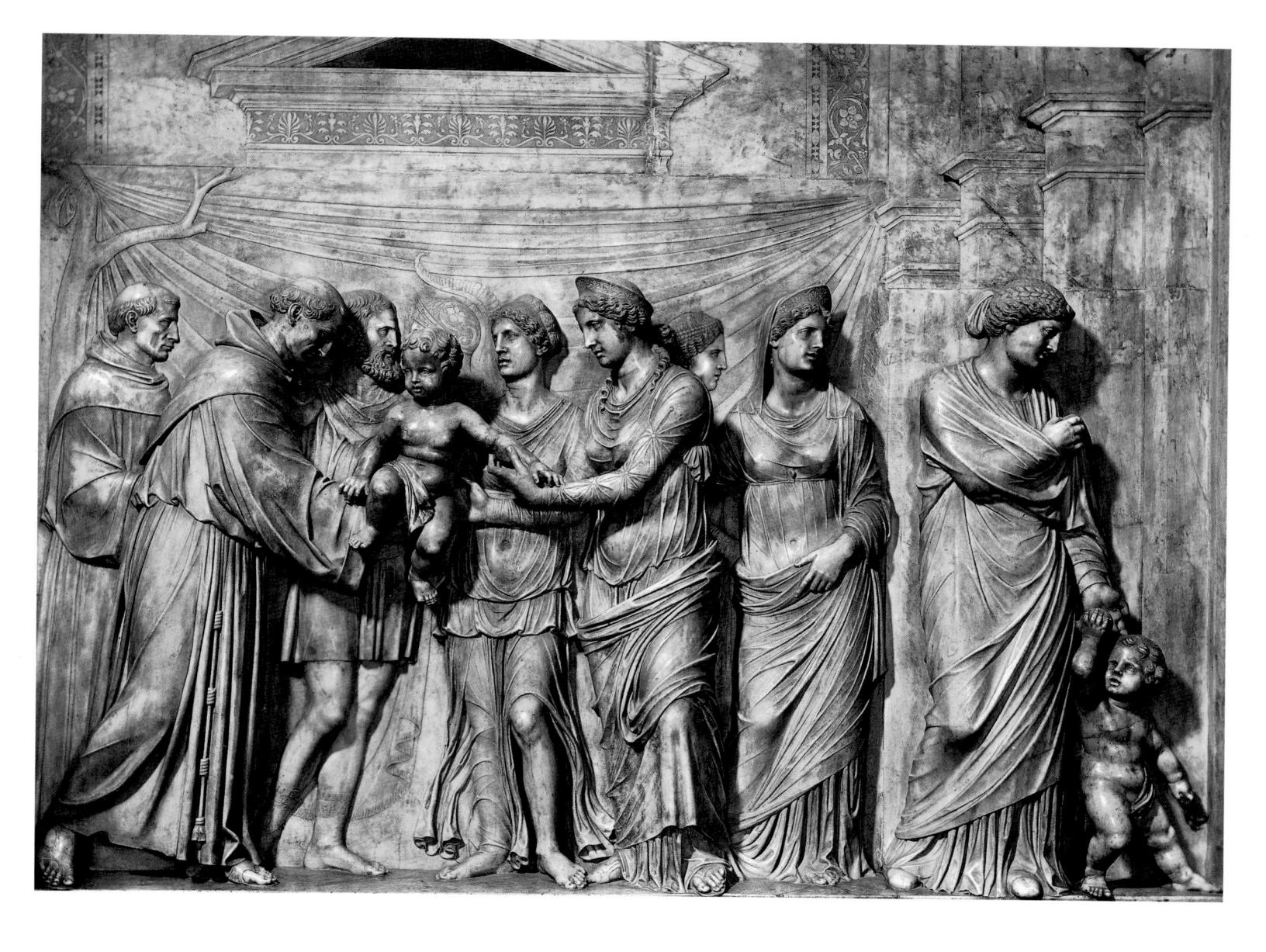

plate 325 Tullio Lombardo

The Miracle of the Miser's Heart

S. Antonio, Padua marble

plate 326 (opposite) Tullio Lombardo

The Miracle of the Miser's Heart

S. Antonio, Padua (detail of plate 325)

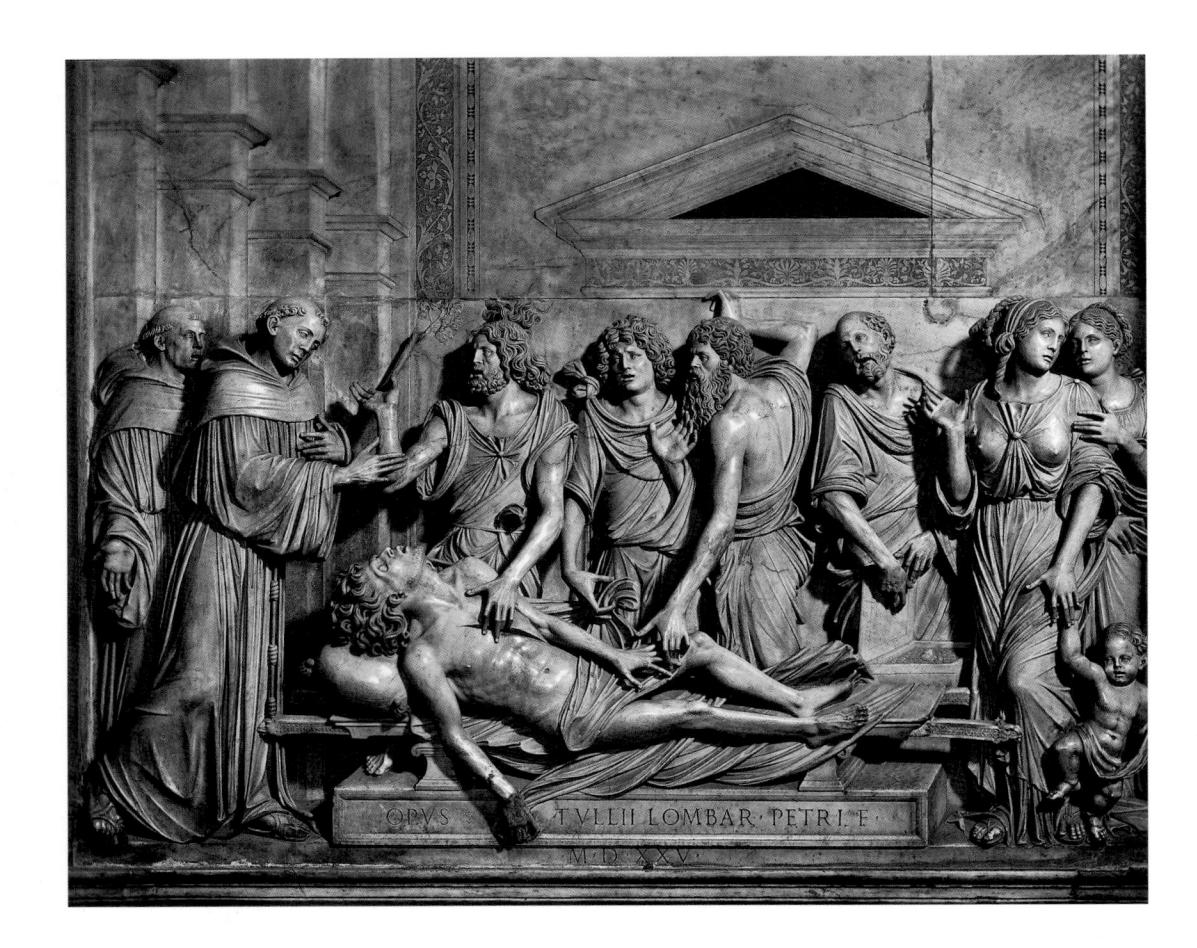

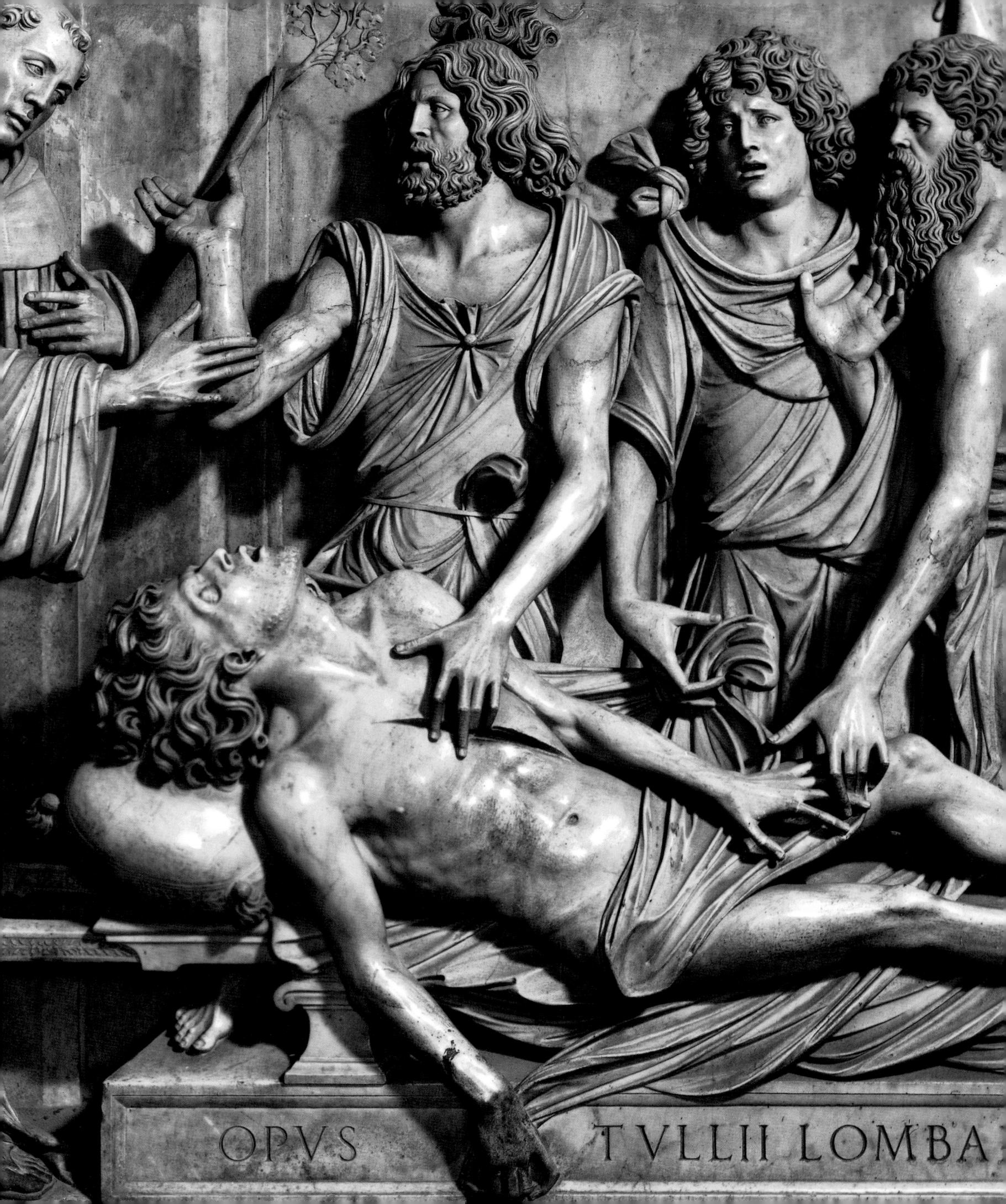

plate 327 Antonio Lombardo

Mythological Scene

Hermitage, St Petersburg marble, 83 × 163 cm

from sarcophagus reliefs, reveal Tullio as an artist of great imaginative force.

The fate of Antonio Lombardo was a less happy one. The Padua relief completed, he started work on the Zen Altar in St Mark's (plate 328). The altar and tomb in the Zen Chapel have a unique importance in that they were the first works in Venice to be planned exclusively in bronze, and Antonio, in undertaking the commission, must have had Donatello's high altar in the Santo and Bellano's Roccabonella Monument in S. Francesco at Padua (plate 322) constantly in mind. The will of Cardinal Zen provided that the epitaph should be as faithful to the antique as was practicable, 'che tenga più all'antica sia possibile', and in the figures on the altar (plate 329) the realism of Donatello and Bellano is replaced by an easy, instinctive classicism which recalls that of the Padua relief. Before long, however, work on the Zen Chapel was broken off, and in 1507 Antonio Lombardo appears at Ferrara, where he lived for the nine years that were left to him. During this time his main task was the decoration of the alabaster chambers of Alfonso d'Este. Among the few works certainly executed by Antonio for Alfonso d'Este are some allegorical reliefs at Leningrad (plate 327), of which the most notable show Neptune and Minerva before Erichthonius and the Forge of Vulcan. Prostituted to interior decoration, Antonio's style becomes more elegant and sheds much of its vitality.

In looking at Venetian sculpture, we have to bear constantly in mind the saying of Goethe

that 'Venice can be compared only with itself'. Though its aggregate value in the fifteenth century is lower than that of Tuscan sculpture, its historical importance is very great. Cima, when he painted his Incredulity of St Thomas in the National Gallery, must have recalled the S. Giovanni Crisostomo Altar of Tullio Lombardo (plate 320); the Zen Altar and Giorgione's Castelfranco Madonna are variations on a single theme; and Sebastiano del Piombo, in the Judgement of Solomon at Kingston Lacey, and Titian, in the Annunciation at Treviso, transfer to painting the system of perspective and relief introduced by the Lombardi on the Scuola di S. Marco and in the Santo. In this respect the Lombardi served as intermediaries between the sculpture of antiquity and the painters of their own day, and Venetian High Renaissance painting is the climax of the movement which they led. In sculpture, however, the precarious equilibrium which they maintained could not be long preserved. When Tullio died in 1532, the statues of the Medici Chapel in S. Lorenzo were all but finished, and the Moses and the Dying and Rebellious Slaves for the tomb of Pope Julius II were complete, while eddies of the new style had reached Venice through Jacopo Sansovino, who for three years had been Protomagister of St Mark's. The humanist synthesis established in the fifteenth century had succumbed to the emotions and ideas of a new age, and mankind stood face to face with the colossus of Michelangelo.

Overleaf

plate 328 (left) Antonio Lombardo

The Zen Altar

St Mark's, Venice bronze

plate 329 (right) Antonio Lombardo

Virgin and Child

St. Mark's, Venice (detail of plate 328)

The bibliographical and other references used throughout the text and notes of the present volume are for the most part self-explanatory. It should, however, be noted that:

- (i) References to my own *Italian Gothic Sculpture* (4th edition, London, 1996) are given in the form Vol. I, followed by page (p.) or plate numbers.
- (ii) Unless otherwise indicated, quotations from the *Vite* of Vasari are from the Milanesi edition of 1906.
- (iii) References to Bode, where no other book or article is cited, are to W. von Bode's indispensable *Denkmäler der Renaissance Skulptur Toskanas*, Munich, 1892–1905.
- (iv) References to Paatz are to W. and E. Paatz, *Die Kirchen von Florenz*, 6 vols., Frankfurt-am-Main, 1955.

361 Michelozzo di Bartolommeo Luca della Robbia 365 Bernardo Rossellino 369 372 Antonio Rossellino Desiderio da Settignano 375 Mino da Fiesole 378 380 Benedetto da Maiano Andrea del Verrocchio 383 388 Agostino di Duccio Andrea della Robbia 391 Matteo Civitali 391 Vecchietta 392 Francesco di Giorgio 394 395 Francesco Laurana 397 **Filarete** Antonio del Pollaiuolo 399 Bertoldo di Giovanni 402 Pietro Torrigiano 403 Isaia da Pisa 405 Giovanni Dalmata 405 406 Andrea Bregno Giovanni Antonio Amadeo 407 Cristoforo and Antonio Mantegazza 409 Cristoforo Solari Bambaia **411** Guido Mazzoni Niccolò dell'Arca Bartolommeo Bellano Riccio 415 Antico 417 Antonio Bregno 418 Antonio Rizzo 419 The Master of San Trovaso 420 Pietro Lombardo **42**I Tullio Lombardo 423 426 Antonio Lombardo

Filippo Brunelleschi

Donatello

344

346

FILIPPO BRUNELLESCHI

(b. 1377; d. 1446)

The greatest architect of the early Renaissance, the discoverer of linear perspective, and one of the prime influences on the development of Renaissance style, Brunelleschi was born in 1377, and was trained as a metalworker. On 18 December 1398 he became a member of the Arte della Seta, and on 2 July 1404 matriculated as a goldsmith. In 1399-1400 he executed two half-length figures for the silver altar in the Cathedral at Pistoia (see below), and in 1401-2 participated in the competition for the second bronze door of the Baptistery in Florence (see plates 1, 3). His name appears in connection with the Duomo for the first time on 10 November 1404. At this time, according to all early sources. Brunelleschi was associated with Donatello, with whom he paid a visit to Rome (date uncertain, after 1402). Manetti, in his life Brunelleschi, states that the purpose of this visit was to study sculpture ('Egli è buono andare veggendo dove le scolture sono buone; e andossene a Roma'), but that while in Rome Brunelleschi's interests veered towards architecture. The project for Bunelleschi's most important and most revolutionary work, the cupola of the Cathedral, dates from 26 May 1417; on 7 August 1420 the supporting wall was in course of construction, and on 30 August 1436 the completed cupola was blessed. The lantern was designed by Brunelleschi, and was completed after his death. Concurrently he was engaged on the Ospedale degli Innocenti (1419-24), the church of S. Lorenzo (begun 1421, unfinished 1446), the Pazzi Chapel in the cloister of S. Croce (begun 1429-30, structure completed 1443), the Sagrestia Vecchia of S. Lorenzo (completed before 30 February 1429), the church of S. Maria degli Angeli (begun 1434, unfinished 1446), and S. Spirito. Brunelleschi died on 15 April 1446. For knowledge of Brunelleschi as a figurative artist, reference must be made to the following works:

(i) Two reliefs of Prophets in halflength, two statuettes of Fathers of the Church, and two half-length Evangelists executed for the silver altar of St James in the Duomo at Pistoia in 1399–1400 (for these see Sanpaolesi and Steingräber).

- (ii) Trial relief of the Sacrifice of Isaac (see plates 1, 3).
- (iii) A wooden figure of Christ on the Cross (Gondi Chapel, S. Maria Novella, Florence) reputedly (Vasari, Codice Gaddiano, and other sources) inspired by rivalry of the wooden Crucifix of Donatello in S. Croce. Though this carving is not documented, its ascription to Brunelleschi is supported by early sources, and is not open to serious dispute. It has been suggested (Paatz) that, contrary to tradition, the Crucifix preceded that of Donatello, and was produced in the decade 1400–10. A dating about 1410–15 (Fabriczy) is more probable.
- (iv) The lavabo in the North Sacristy of the Duomo in Florence (plate 94), designed by Brunelleschi (9 December 1432) and executed by his adoptive son Buggiano (completed 30 April 1440) (Codice Strozziano: 'Hebbe u(n)o suo discepolo quale teneva in casa da Buggiano el quale fe fare l'acquaio di marmo che è nella sagrestia di s(ant) aliparata con q(uel)i bambini in detto lavacro che gettano acqua.') ('He had a pupil from Buggiano who lived in his house, to whom he entrusted the making of the marble lavabo in the sacristy of Santa Reparata with those children in the aforesaid lavabo who spout water.')
- (v) The pulpit in S. Maria Novella, Florence (plate 104), for which a wooden model was prepared by Brunelleschi before 31 August 1443, and of which the construction appears to have been completed by Buggiano in 1448. Four reliefs with scenes from the life of the Virgin in the upper part of the pulpit were completed by Buggiano prior to 5 February 1452; there is no documentary evidence that these reliefs depend from designs by Brunelleschi, and this is improbable.
- (vi) Tomb and altar executed by Buggiano in the Sagrestia Vecchia of S. Lorenzo (1433).
- Brunelleschi also executed the following lost works:
- (i) Wooden statue of St Mary Magdalen in S. Spirito, Florence (destroyed by fire 1471). The fullest

description of this figure occurs in the life of Brunelleschi by Antonio Manetti ('Fece di scoltura di legname, e colorì, una Santa Maria Maddalena, tonda, come naturale, e poco meno di grandezza, molto bella, la quale arse nella chiesa di Santo Spirito nel 1471'). ('He made and coloured a wooden sculpture of St Mary Magdalen in the round like a real figure, rather less than life-size and very beautiful, which was burned in the church of Santo Spirito in 1471.') In the Codice Strozziano the statue is compared with the Magdalen of Donatello in the Baptistery. Though it has been dated c. 1400 (Paatz), there is no evidence as to when it was produced.

- (ii) Tabernacle of the Sacrament in S. Jacopo in Campo Corbellini (executed by Giusto di Francesco da Settignano prior to 13 May 1427).
 - In addition it is known that:
- (i) On 9 October 1415 Donatello and Brunelleschi were paid jointly for 'una figuretta di pietra vestita di piombo dorato' ('a small stone figure clad in gilded lead') made in connection with a statue for the Cathedral. It has been established (Fabriczy) that a similar model was made by Nanni di Banco and Donatello for a gigantic statue, and the 'figuretta' of Brunelleschi and Donatello was presumably a model made for the same purpose. There is no evidence as to whether or not the large figure was executed.
- (ii) According to a persistent tradition, the statues of Sts Mark and Peter on Or San Michele were commissioned jointly from Brunelleschi and Donatello though executed wholly by the latter artist. The most detailed statement of this case occurs in the Codice Strozziano: 'Furono allogate alui et adonato insieme dua figure di marmo che sono nelli pilastri dorto s(ant)o michele cioè la figura di s(ant)o p(ietr)o e q(ue)lla di s(ant)o marco opere molto degne.' ('Two marble figures on the pillars of Or San Michele, that is the figure of St Peter and that of St Mark, excellent works, were commissioned jointly from him and from Donatello.') While the St Mark on Or San Michele is an indubitable work of Donatello (see plate 7), the St Peter was designed and executed by another hand (probably that of Ciuffagni). The possibility of

Brunelleschi's intervention at least in the designing of this statue cannot be ruled out. The design of the niche, which is backed with perspective marble intarsias, has been ascribed independently to Brunelleschi (A. Venturi, contested by Salmi ('Il Palazzo della Parte Guelfa di Firenze e Filippo Brunelleschi', *Rinascimento*, ii, 1951, pp. 3–11) and others)

Bibliography

The standard early source for the career of Brunelleschi is a biography ascribed to Antonio Manetti (Filippo Brunelleschi di Antonio di Tuccio Manetti, ed. H. Holzinger, Stuttgart, 1887); an English translation is edited by H. Saalman (The Life of Brunelleschi by Antonio Tucci, University Park and London, 1970). On this and other sources see C. Frey (Le vite di Filippo Brunelleschi, Berlin, 1887). The documents are assembled and analysed in a standard book and article by C. von Fabriczy (Filippo Brunelleschi: sein Leben und seine Werke, Stuttgart, 1892, and 'Brunelleschiana', Jahrbuch der Preussischen Kunstsammlungen, xxviii, 1903, Beiheft, pp. 1-84). For a serviceable Italian translation of Fabriczy's text, see A. M. Poma (Filippo Brunelleschi: la vita e le opere, 2 vols., Florence, 1979). E. Battisti's survey of Brunelleschi as an architect (Milan, 1989) is superior to a monograph by P. Sanpaolesi (Milan, 1962). The photographs in both are inferior to those in a short book by G. Fanelli (Brunelleschi, Florence, 1980). Outstanding in the extensive literature on Brunelleschi as an architect is an article by L. H. Heydenreich ('Spätwerke Brunelleschis', Jahrbuch der Preussischen Kunstsammlungen, lii, 1931, pp. 1-28) and H. Saalman (Filippo Brunelleschi. The Buildings, London, 1993). On the silver altar at Pistoia, see G. Beani (L'altare di S. Jacopo nella Cattedrale di Pistoia, Pistoia, 1899), P. Sanpaolesi ('Aggiunte al Brunelleschi', Bollettino d'arte, xxxviii, 1953, pp. 225-32), and E. Steingrüber ('The Pistoia Silver Altar; a re-examination', Connoisseur, cxxxviii, 1956, pp. 148-54), and on the trial relief F. R. Shapley and C. Kennedy ('Brunelleschi in Competition with Ghiberti', Art Bulletin, v, 1922, pp. 31-4), A. Marquand ('Note sul sacrificio d'Isacco di Brunelleschi',

conditions and finish of the animals in

L'Arte, xvii, 1914, pp. 385-6), and R. Krautheimer (Lorenzo Ghiberti. Princeton, 1956). The relations between Brunelleschi and Donatello are discussed by G. Castelfranco ('Sui rapporti tra Brunelleschi e Donatello', Arte antica e moderna, 34-6, 1966, pp. 109-22). The conclusion of my earlier account (2nd edn., p. 245) of the spandrel reliefs of the Evangelists in the Pazzi Chapel should be revised. It has been argued, with some conviction (J. Pope-Hennessy, 'The Evangelist Roundels in the Pazzi chapel', in The Study and Criticism of Italian Sculpture, New York, 1980, pp. 106-118), that the roundels are due to Donatello. The building history of the Chapel cannot be reconciled with a dating c.1443, and the roundels are likely to have been modelled and glazed in the late 1450s. H. W. Janson ('The Pazzi Evangelists', in Intuition und Kunstwissenschaft: Festschrift für Hanns Swarzenski, Berlin, 1973, pp. 439-48), on the contrary, regards them as works of small artistic consequence. The catalogue of a small exhibition organized in the Museo Nazionale, Florence, in 1977 (Brunelleschi scultore, eds. E. Micheletti and A. Paolucci) contains useful accounts of Brunelleschi's sculpture, and especially of the Christ on the Cross (S. Maria Novella) which was restored before this exhibition. For this work, see also A. Paolucci ('Il Crocifisso di Brunelleschi dopo il restauro', Paragone, no. 329, 1977, pp. 3-6). Measurements cited in the catalogue demonstrate the proportional system employed by Brunelleschi throughout the figure. The cleaning of the surface leaves little doubt that the Christ was carved about a decade later than was assumed by Fabriczy. New documents for the lost tabernacle in S. Jacopo in Campo Corbellini are published by A. Parronchi ('Tabernacolo brunelleschiano'. Prospettiva, ii, 1977, pp. 55-6, and 'Un tabernacolo brunelleschiano', Filippo Brunelleschi, la sua opera e il suo tempo, Florence, 1980, i, pp. 239-55). A careful analysis of Manetti's life of Brunelleschi is due to G. Tanturli ('Per la paternità manettiana della "Vita di Brunelleschi". Paragone, xxvi, no. 301, 1975, pp. 3-25). For the bibliography of Brunelleschi, see C. Bozzoni and G. Carbonara, Filippo Brunelleschi: saggio di bibliografia, 2 vols,

Rome, 1977–8, and for a general review of Brunelleschi's work E. Battisti, *Filippo Brunelleschi*, Milan, 1976, and *Brunelleschi:* the Complete Work, Milan, 1981.

The Sacrifice of Isaac

Museo Nazionale, Florence Plates 1, 3

Brunelleschi's relief of the Sacrifice of Isaac was made in 1401-2 in connection with the competition for the second bronze door of the Baptistery in Florence. The two primary sources for the story of the competition are the Commentari of the sculptor Ghiberti and the life of Brunelleschi by Antonio di Tuccio Manetti (written after 1471 and before 1497). According to Ghiberti, seven sculptors participated in the competition; these were Simone da Colle, Niccolò d'Arezzo, Jacopo della Quercia, Francesco di Valdambrino. Niccolò di Pietro Lamberti. Brunelleschi, and Ghiberti. Each of the competitors was provided with four plaques of bronze, and was required, within one year, to prepare a trial relief of the Sacrifice of Isaac. The seven trial reliefs were then submitted to a committee of 34 members appointed by the Arte di Calimala, who were charged with supervising the construction of the door. On the unanimous judgement of the committee and of 'the entire body of the Arte Mercatoria', the prize was awarded to Ghiberti's relief, and at some date prior to 25 March 1403 Ghiberti received the contract for the door. It was originally intended that the door should represent subjects from the Old Testament. In the course of 1401-2, however, this plan was changed, and it was decided that New Testament subjects should be represented, the trial relief of Ghiberti being retained for future use in a third door. According to Manetti, two sculptors only, Brunelleschi and Ghiberti, were selected to participate in the competition: 'Filippo fece la storia sua in quella forma, che la si vede ancora al presente, e fecela presto, perchè possedeva l'arte gagliardamente. Fatta che l'ebbe, e netta e ripulita, a tutto, e non fù vago conferirla quasi con persona, che, come io ho detto, non era borioso, ed aspettava il tempo del paragone.'

('Filippo made the scene in the form in which it is still seen today, and made it rapidly, since he was a valiant artist. When it was cast and cleaned and polished, he was not unwilling to consult people about it, since, as I have said, he was not proud, and he awaited the time of the competition.') Manetti (whose account is biased against Ghiberti) goes on to describe the means by which Ghiberti enlisted the support of members of the committee, and the warm reception accorded to his relief. 'E generalmente non avendo alcuno veduto quella di Filippo, non credevano non che Filippo, ma Policleto l'avessi potuta fare meglio, perchè la fama di Filippo non era ancora divulgata, che era giovinetto ed aveva la mente più diretta al fare, che a parere. Ma, quando e' vidono la sua, ch'egli aveva messo innanzi, come fù l'attitudine di Abram. l'attitudine di quel dito sotto 'l mento, la sua prontezza, e' panni, e 'l modo, e la fine di tutto quel corpo del figliuolo, e'l modo, e' panni di quello angelo, e' suoi reggimenti, e come gli piglia la mano, l'attitudine, e 'l modo, e la fine di quello che si trae lo stecco del piè, e così di quello, che bee chinato, e di quanta difficoltà sono quelle figure, e quanto bene elle fanno l'ufficio loro, che non è membro che non abbia spirito, e le condizioni e fine degli animali che vi sono, e così ogni altra cosa, come tutto 'l corpo della storia insieme: il che veggendo chi era deputato e giudicare, diventarono d'un alto parere.' ('And in general since they had not seen Filippo's relief, they did not believe that Policletus, let alone Filippo, could have made a better relief than Ghiberti's, since Filippo's fame was not widespread, he was still young, and was intent on performance rather than attracting attention. But when they saw Filippo's relief and all that he had put into it, the attitude of Abraham, the finger under the chin, the drapery, the pose and finish of the body of the boy, the pose and drapery of the Angel and how he seized Abraham's hand, and the attitude and finish of the man drawing the thorn from his foot, and those of the man who drinks bending down, and how difficult those figures are, and how well they perform their function, that there is no

member which is not spirited, and the

the scene, and everything else, and the entirety of the scene-seeing all this those who were deputed to judge completely changed their view.') Manetti goes on to record that the committee decided to allot the door to both sculptors jointly, that Brunelleschi refused to accept this decision, and that the contract was therefore awarded to Ghiberti alone. Though it can be demonstrated (Krautheimer) that Ghiberti's account reveals a fuller knowledge of the procedure by which the contract was awarded, and is therefore on general grounds the more credible, it is clear that there is none the less a considerable measure of truth in Manetti's account; and the fact that a written decision was called for from the committee and an appeal was made to the members of the Guild as a whole suggests that opinion was closely divided on the respective merits of the two reliefs. None of the five other trial reliefs submitted for the competition survives. Since both Brunelleschi's and Ghiberti's contain the same number of figures, this was presumably laid down in the terms of the competition (Krautheimer), which would have bound the competitors to represent the two attendants in the foreground of the scene. Brunelleschi's relief differs from that of Ghiberti (plate 2) in respect of (i) technique and (ii) style. Whereas Ghiberti's trial relief is cast in a single piece, Brunelleschi's consists of a solid bronze plaque approximately 5 mm thick, on to which are soldered the sections in relief. These comprise (a) the foreground, ass, ram, altar, Isaac, Abraham, the left hand of the Angel and the rock on the right, (b) and (c) the attendants to right and left, (d) the Angel, and (e) the tree in the upper right corner. The weights of the two reliefs are 25.5 kg (Brunelleschi) and 18.5 kg (Ghiberti). That the composition lacks the fluency of Ghiberti's is due in part to its technique. The relief style is dominated by the human figures, and depends, notably in the figure of Abraham, from the style of the silver altars at Pistoia and in the Baptistery in Florence. The treatment of the figures is, however, strongly realistic, and the Isaac has justly been described (Fabriczy) as 'der erste nackte Aktfigur der modernen

Kunst'. Krautheimer (who overstresses the medievalism of the forms) relates the Isaac to a kneeling prisoner on the Arch of Constantine, and the servant on the right to a figure in a Roman carving of the Slaughter of a Pig. An alternative source for the Isaac has been traced (A. Schmitt, 'Gentile da Fabriano und der Beginn der Antikenzeichnung', Münchner Jahrbuch der bildenden Kunst, 3 Folge, xi, 1960, pp. 99-100) in a Marsyas sarcophagus reproduced in the Codex Piglianus, Berlin (f. 247). The figure on the left derives from a version of the Spinario, perhaps through a gem (Fabriczy) or Byzantine derivatives (Krautheimer), which provide analogies for the much modified pose used by Brunelleschi in the relief. The subject of the relief on the altar has been variously described as the Annunciation (A. Venturi) and Abraham presenting Isaac to the Virgin as an allegory of the genealogy of Christ (Marquand). An ingenious article by C. Gilbert ('The Smallest Problem in Florentine Iconography', in Essays Presented to Myron P. Gilmore, Florence, 1978, ii, pp. 193-205) relates it to the action in a play Di Abram e di Isaac performed at Cestello in 1449. The trial relief is stated by early sources to have been presented to Cosimo de' Medici, and was built into the altar of the Sagrestia Vecchia until it was presented by the Grand Duke Pietro Leopoldo to the Uffizi.

Donatello

(b. c.1386; d. 1466)

According to Vasari, Donatello was born in 1383, and according to his tax returns of 1427 and 1433 in 1386. The latter date is the more probable. His father, Niccolò di Betto Bardi, was a member of the guild of the tiratori di lana. Trained by Brunelleschi as a metalworker, he travelled with him to Rome to study classical sculpture. Donatello's name appears among the assistants employed by Ghiberti on the bronze door of the Baptistery between 1404 and 1407. Two documents of 23 November 1406 and February 1408 refer to a marble prophet carved by Donatello for the Porta della Mandorla; for the long and inconclusive controversy to which these documents have given rise, see particularly L. Planiscig ('I profeti sulla porta della Mandorla del Duomo fiorentino', Rivista d'arte, xxix, 1942, pp. 125-42), W. R. Valentiner (in Studies in Italian Renaissance Sculpture, London, 1950), Wundram, Janson, and Rosenauer. A marble statue of David (Museo dell'Opera del Duomo, Florence), executed for the exterior of the Duomo. dates from 1408-9, and was followed (1410) by a gigantic terracotta statue of Joshua (destroyed). After 1408 Donatello was engaged on a seated figure of St John the Evangelist for the façade of the Cathedral (see plate 5), now in the Museo dell'Opera del Duomo. Between 1411 and 1413 he worked on the first of his statues for Or San Michele, the St Mark (see plate 7). For Or San Michele he also executed two further statues of St George (see plates 8-10) and St Louis of Toulouse (see plates 16-17). Concurrently with the first of these (1415), he began work on statues of Prophets for the Campanile (see plates 11-15, 18), the fourth and last of which was completed in 1436. In 1419 Donatello (along with Nanni di Banco and Brunelleschi) submitted a model for the cupola of the Duomo, and in the same year carved the Marzocco for the staircase of the quarters of Pope Martin V in S. Maria Novella (Museo Nazionale, Florence). After the death of Nanni di Banco he carved (1422) two heads of Prophets over the Porta della Mandorla. From 1425 till 1432-3

Donatello shared a studio with Michelozzo. Tax returns of 1427 contain references inter alia to a reliquary bust of S. Rossore executed by Donatello for the Ognissanti (now in the Museo di S. Matteo, Pisa) and to three funerary monuments (see plates 19, 20, 130, 132, 133). Between 1423 and 1434 he was employed on work in connection with the Sienese Baptismal Font (see plate 55), and cast for Siena Cathedral the bronze tomb-slab of Giovanni Pecci, Bishop of Grosseto (d. 1426). In 1430 Donatello served (with Brunelleschi, Ghiberti and Michelozzo) as a military engineer with the Florentine army at the siege of Lucca, and immediately after seems to have moved to Rome, where he is mentioned on 23 September 1430 in a letter of Poggio Bracciolini. For Rome he carved the Tabernacle of the Sacrament, now in the Sagrestia dei Beneficiati of St Peter's, and the tombslab of Giovanni Crivelli. Archdeacon of Aquileia (d. 28 July 1432) in S. Maria in Aracoeli. Summoned back to Florence (1433) to execute the external pulpit of Prato Cathedral (see plate 49), which had been commissioned in 1428, he received the commission (1433) for a Cantoria for the Duomo in Florence (see plates 47, 48). In 1434 he designed a stained-glass window of the Coronation of the Virgin for the Cathedral (for reproductions after cleaning, see G. Marchini, Italian Stained Glass Windows, London, 1957), and in 1437 contracted to make bronze doors for the two sacristies; neither of these was executed, and the contract for one of them was later transferred to Luca della Robbia. A wooden statue of St John the Baptist in S. Maria dei Frari, Venice, is dated 1438. To this time may be assigned three important undocumented works, the Cavalcanti Annunciation in S. Croce (see plates 19, 20), the bronze David in the Museo Nazionale, Florence (see plates 32, 33), and the stucco decoration and bronze doors of the Sagrestia Vecchia of S. Lorenzo (see plates 50, 51). In 1443 he abandoned work in S. Lorenzo and transferred his studio to Padua, which formed the main scene of his activity in the years 1444-53. There he executed a Crucifix and the high altar of the Santo (see plates 21-9, 56-61) and his masterpiece, the equestrian statue of

Gattamelata (see plates 184, 188, 189). Towards the close of this period Donatello visited Ferrara and entered into negotiations (1451) for a statue of Borso d'Este at Modena, and provided (1450-1) a model for the shrine of S. Anselmo at Mantua. His works after November 1454, when he returned to Florence, included the wooden statue of St Mary Magdalen now in the Museo dell'Opera del Duomo, the Judith for the Piazza della Signoria (now inside the palace), and a bronze St John the Baptist for Siena Cathedral. For a short time he was resident in Siena, preparing sketches for the bronze door of the Duomo. On his return to Florence, at an advanced old age, he was engaged on a commission from Cosimo il Vecchio for reliefs now incorporated in the pulpits in the nave of the church of S. Lorenzo. Donatello died in Florence on 13 December 1466.

Bibliography

The literature of Donatello is more extensive than that of any other fifteenth-century Italian sculptor. All of the earlier monographs dealing with the sculptor (with the notable exception of two volumes by H. Semper, Donatello, seine Zeit und Schule, in Quellenschriften für Kunstgeschichte, ix, Vienna, 1875, and Donatellos Leben und Werke, Innsbruck, 1887) are now outdated. Those referred to in this book include the volumes of A. Schmarsow (Donatello, Breslau, 1886), F. Schottmüller (Donatello, Munich, 1904) and P. Schubring (Donatello, Stuttgart-Leipzig, 1907). The latter forms an invaluable corpus of photographs of Donatellesque sculptures. A volume by H. Kauffmann (Donatello: eine Einführung in sein Bilden und Denken, Berlin, 1935) contains much information and many fresh observations. Since the picture of Donatello's personality presented in it is in certain essential respects misconceived, and since its attitude to attribution is uncritical, it will prove useful only to the specialist. A review by U. Middeldorf (Art Bulletin, xviii, 1936, pp. 570ff.) contains additional material.

In the 1930s Donatello criticism was radically changed by a number of specialized articles by J. Lanyi, which for the first time applied the criteria of style analysis to the traditional catalogue of

Donatello's works. These articles are:

'Le statue quattrocentesche dei Profeti nel Campanile e nell'antica facciata di Santa Maria del Fiore', *Rivista d'Arte*, xvii, 1935, pp. 121–59.

'Tre rilievi inediti di Donatello', *L'Arte*, xxxviii, 1935, pp. 284–97.

'Zur Pragmatik der Florentiner Quattrocento Plastik', *Kritische Berichte*, 1932–3 (1936), pp. 126–31.

'Problemi della critica Donatelliana', Critica d'arte, iv, 1939, pp. 9–23.

Their influence may be measured in two brief monographs by L. Planiscig, one (Donatello, Vienna, 1939) published without reference to Lanvi's work, and the other (Donatello, Florence, 1947) based on Lanyi's findings. Though largely derivative and argued on a consistently superficial plane, the later of Planiscig's books is serviceable and well illustrated. The untimely death of Lanvi cut short his preparations for a standard monograph on Donatello, but his material (mainly photographic) was taken over by H. W. Janson and forms the nucleus of the latter's The Sculpture of Donatello, 2 vols, Princeton, 1957. This book provides the best available series of reproductions of the work of any Italian sculptor, and a critical catalogue raisonné of Donatello's works which, though sometimes wrong, is remarkable for its thoroughness and clarity. The conclusions of earlier scholars are fully and fairly summarized throughout this book, and the documentary and stylistic evidence is sifted with precision and intelligence. Disagreement on detail cannot detract from the value of this fundamental work. On a more popular level, reference may be made to volumes by L. Grassi (Tutta la scultura di Donatello, Milan, 1963) and G. Castelfranco (Donatello, Milan, 1963). A number of interesting but largely unacceptable theories on Donatello's early statues are advanced by M. Wundram (Donatello und Nanni di Banco, Berlin, 1969). Excellent surveys of the literature of the Prophets, Cantoria and other works in the Museo dell'Opera del Duomo, Florence, are supplied by L. Becherucci and G. Brunetti (Il Museo dell'Opera del Duomo a Firenze, Florence, 1969). A centenary volume (Donatello e il suo tempo, Florence, 1968) contains a number of specialized studies, for the

most part of somewhat disappointing quality; the most notable of them is an essay on Donatello and the Antique by H. W. Janson, which is cited on a number of occasions in these notes. The conclusions formulated by Janson on the high altar in the Santo at Padua and on the Gattamelata Monument should be reviewed in the light of the new documentary material published by G. Fiocco and A. Sartori ('L'altare grande di Donatello al Santo', Il Santo, i, 1961, pp. 21-99, and 'La statua equestre del Gattamelata', Il Santo, i, 1961, pp. 300-4) and of two articles by J. White ('Donatello's High Altar in the Santo at Padua', Art Bulletin, li, 1969, pp. 1-14, 119-141). Four studies by J. Pope-Hennessy dealing with aspects of Donatello's work are assembled in Essays on Italian Sculpture, London, 1969. On the style and chronology of the S. Lorenzo pulpits see especially G. Previtali ('Una data per il problema dei pulpiti di S. Lorenzo', Paragone, no. 133, 1961, pp. 48-56), N. Huse ('Beiträge zum Spätwerk Donatellos', Jahrbuch der Berliner Museen, n.f. x, 1968, pp. 125-50), and M. Gosebruch ('Osservazioni sui pulpiti di San Lorenzo', Donatello e il suo tempo, Atti dell'VIII Convegno Internazionale di Studi sul Rinascimento, Florence, 1968, pp. 369-86). Aspects of the iconography of the pulpit reliefs are discussed by M. Semrau (Donatellos Kanzeln In S. Lorenzo, Breslau, 1891), I. Lavin ('The Sources of Donatello's Pulpits in San Lorenzo', Art Bulletin, xli, 1959, pp. 19-38, and also in Past-Present. Essays on Historicism in Art from Donatello to Picasso, Berkeley/Los Angeles/Oxford, 1993, pp. 1-28), H. W. Janson ('Donatello and the Antique', Donatello e il suo tempo, Florence, 1968, pp. 77-96), E. Simon ('Dionysischer Sarkophag in Princeton', Mitteilungen des Deutschen Archaeologischen Institutes, Römische Abteilung, lxix, 1962, pp. 136-58), and S. Pfeiffenberger ('Notes on the Iconology of Donatello's Judgement of Pilate at San Lorenzo', Renaissance Quarterly, xx, 1967, pp. 437-54). The treatment of space in Donatello's reliefs is dealt with by J. White ('Developments in Renaissance Perspective-II', Journal of the Warburg and Courtauld Institutes, xiv, 1951, pp. 42-69,

and The Birth and Rebirth of Pictorial

Space, London, 1957).

The most useful single publication on Donatello issued since the second edition of this book is a complete compendium of Donatello documents by V. Herzner ('Regesti Donatelliani', Rivista dell'istituto nazionale di archeologia e storia dell'arte, ii, 1979, pp. 169-272). Documentary additions to our knowledge of Donatello's career include: (i) a reference to his activity in Pistoia in January 1401 (L. Gai, 'Per la cronologia di Donatello con documento inedito di 1401', Mitteilungen des Kunsthistorischen Institutes in Florenz, xviii, 1974, pp. 355-7); (ii) further evidence of his involvement in a projected monument to Borso d'Este at Modena (C. M. Rosenberg, 'Some New Documents concerning Donatello's Unexecuted Monument to Borso d'Este in Modena', Mitteilungen des Kunsthistorischen Institutes in Florenz, xvii, 1973, pp. 149-52); (iii) two letters of 1454/1455 referring to sculptures by him (P. Foster, 'Donatello Notices in Medici Letters', Art Bulletin, lxii, 1980, pp. 148-50); (iv) some supplementary information on his activity in Siena (V. Herzner, 'Donatello in Siena', Mitteilungen des Kunsthistorischen Institutes in Florenz, xv, 1971, pp. 161-86); (v) material relating to his negotiations to move from Siena to Mantua (G. Lawson, 'New Documents on Donatello', Mitteilungen des Kunsthistorischen Institutes in Florenz, xviii, 1974, pp. 357-62).

A number of general books on Donatello have been issued. The most important are A. Rosenauer (Studien zum frühen Donatello, Vienna, 1975; and Donatello, Milan, 1993), and J. Pope-Hennessy (Donatello Sculptor, New York, 1993). The two general monographs disagree on many detailed points. Other books include J. Poeschke, Donatello: Figur und Quadro, Munich, 1980, and a methodologically unsound volume by B. A. Bennett and D. G. Wilkins, Donatello, Oxford, 1984. A careful and original study by R. Lightbown, Donatello and Michelozzo, An Artistic Partnership and its Patrons in the Early Renaissance, 2 vols, London, 1980, deals with the Coscia, Brancacci and Aragazzi monuments. The fifth centenary of Donatello's birth in 1986 resulted in a poor exhibition, of which the best catalogue is that of works

shown in Florence (Donatello e i Suoi, eds, A. Darr and G. Bonsanti, Milan, 1986). An English edition, published in Detroit, is also available. A volume of miscellaneous studies commemorating the centenary (some of interest, others of little value) was issued by the Kunsthistorisches Institut in Florence (Donatello-Studien, ed. M. Cämmerer, Munich, 1989). A volume by L. Becherucci on the pulpits in S. Lorenzo, Donatello: i pergami di S. Lorenzo (Florence, 1979), is of excellent quality. The geometrical problems arising from the Padua altar are further discussed by J. White (in Le Sculture del Santo di Padova, ed. G. Lorenzoni, Vicenza, 1984). A number of major works by Donatello have been cleaned since the first issue of this book. Notes on cleaning and on the reports describing it are included in the individual entries.

St John the Evangelist

Museo dell'Opera del Duomo, Florence Plate 5

Donatello's St John the Evangelist was commissioned for a niche on the façade of the Cathedral on 19 December 1408 along with figures of St Luke by Nanni di Banco and St Mark by Niccolò di Pietro Lamberti. The fourth Evangelist, a St Matthew, was commissioned from Ciuffagni on 29 May 1410. This latter statue was originally to have been allocated to the artist judged to have excelled in work on the preceding statues, and the decision to commission it in 1410 was presumably dictated by the wish to accelerate the completion of the figures. On 17 July 1410 work on the four Evangelists was proceeding in chapels in the Cathedral. The subsequent history of the commission is confused. but a payment referring in part explicitly to the St John occurs on 18 April 1413, and work on the statue was certainly continued between 24 January and 8 October 1415, when it was installed on the façade of the Cathedral. For this reason some students (Kauffmann, Planiscig) have tended to assume that the execution of the figure belongs to 1413–15. An earlier date is supported by Rosenauer. The pattern of payment for the three other Evangelists corresponds with that of the St John, and suggests

that after work on the four Evangelists had been begun the artists responsible were diverted to the Guild statues on Or San Michele. Once these were all but completed the carving of the Evangelists was resumed. The bulk of work on the St John is datable to the years 1410-15. The sequence of the four figures has been established by Munman in Optical Connections in the Sculpture of Donatello (Philadelphia, 1985) as (left to right) St Luke, St Matthew, St John and St Mark. The tip of the nose of the St John is damaged and Janson (mistakenly) supposes that the eyeballs in Donatello's figure were originally uncarved. It is likely that the pupils were added by Donatello in 1415.

David

Museo Nazionale, Florence Plate 4

The first reference to the marble David with the head of Goliath occurs in the summer of 1416 when the Operai of the Cathedral were instructed to transfer a marble David from the Opera del Duomo to the Palazzo della Signoria. At the end of August the statue was moved, and installed in the Sala dell'Orologio on two inlaid consoles with a painted background of lilies on a blue field. According to Albertini (1510), it was inscribed with the words PRO PATRIA FORTITER DI MICANTIBUS ETIAM ADVERSUS TERRIBILISSIMOS HOSTES DEUS PRESTAT VICTORIAM ('To those who strive bravely for their fatherland the gods will lend aid even against the most fearful foes'). By 1592 the last three words were modified to read DII PRAESTANT AUXILIUM. The statue was moved to the Museo Nazionale in 1874. The earlier inscription may have been devised by Leonardo Bruni. The sling, one side of which is damaged, may have been attached with a leather thong to David's right hand. Work on the statue is likely to have been begun c.1412(Wundram, Herzner).

With the exception of Kauffmann, recent students of Donatello (up to and including Janson and Rosenauer) have wrongly identified the Museo Nazionale statue with a marble figure of David commissioned from Donatello on 20 February 1408, a companion piece to the

Isaiah of Nanni di Banco (Vol. I, plate 192) which had been commissioned a month earlier for a buttress on the north transept of the Cathedral ('Item deliberaverunt quod Donatus Betti Bardi possit teneatur et debeat predicte ecclesie edificare seu facere unam figuram de uno ex duodecim profetis adhoc David profete cum modis et cum dictis pactis et salario olim factis cum Johanne Antonii Banchi magistro unius figure per eum accettate ad construendum pro quodam alio profeta, que poni debeant super sprono unius tribune que ad presens edificatur seu completa consistit'). Payments for the David are recorded between 21 June 1408 and 13 June 1409, when the final settlement took place. On 3 July 1409 Nanni di Banco's Isaiah was removed from its buttress, presumably because its size made it unsuitable for so elevated a position; it is now in the Duomo; Donatello's companion figure of 1408 has been identified (Pope-Hennessy, 1993) with a statue in the Museo dell'Opera del Duomo. The base of Nanni di Banco's figure conforms to that of the triangular buttress, and it cannot therefore be associated with the Museo Nazionale David, which has a rectangular base. It has been widely claimed (Lanyi, Janson, Rosenauer) that the figure of 1408 was recut in 1416 to meet the requirements of the Palazzo della Signoria statue (i) by replacing a pre-existing scroll with the drapery under the left hand (Lanyi), (ii) by transferring the sling from the left hand to the right (Janson), or (iii) by recarving the Goliath head (Pope-Hennessy). All of these explanations are untenable since there is no trace of recutting in the statue. Comparison of the Goliath head with, e.g., the relief above the tabernacle containing the St George seems to provide evidence that the two works are of the same date. The wreath has been identified (Janson) as amaranth, and has thus a symbolic significance.

St Mark

Or San Michele (formerly), Florence Plate 7

On 15 February 1409 the sculptor Niccolò di Pietro Lamberti was entrusted by the Guild of Linen-drapers (Arte dei Linaiuoli) with procuring a

block of marble for a statue of their patron saint, St Mark, for the guild tabernacle on Or San Michele. Two years later, on 16 February 1411, a committee of five members was appointed to select a sculptor to carve the figure, and to supervise its installation in the niche. Their choice fell on Donatello, who on 3 April 1411 was commissioned to carve a St Mark four braccia high to be completed by 1 November 1412. On 24 April 1411 two stonemasons, Perfetto di Giovanni and Albizzo di Pietro, were charged with the execution of the tabernacle, which was to be finished within eighteen months. By 29 April 1413 both the statue and the tabernacle were still incomplete, but the expression used to denote this ('di quanto vi mancha') suggests that minor adjustments alone were required. The statue was therefore carved between April 1411 and April 1413. It has, however, also been wrongly contended (Wundram), principally on stylistic grounds, that the figure postdates the St George on Or San Michele, and was executed in the bracket 1415-20. Though the earliest sources (the XIV uomini singhulari in Firenze dal 1400 innanzi of Antonio Manetti, and Albertini) describe the St Mark, along with the St Peter and St George, as a work of Donatello, the story later gained currency that the St Mark and St Peter were commissioned jointly from Donatello and Brunelleschi. This statement occurs for the first time in the Libro di Antonio Billi and is repeated in the first edition of Vasari's life of Donatello. In the second edition of Vasari's life the name of Brunelleschi appears only in connection with the St Mark ('e per l'Arte dei Linaiuoli, il San Marco Evangelista, il quale avendo egli tolto a fare insieme con Filippo Brunelleschi, finì poi da sè, essendosi così Filippo contentato'). There can be no doubt that the St Mark was commissioned from Donatello alone, and that the St Peter was carved by another hand, probably Ciuffagni. Vasari, in the Vite, records that Donatello's statue when on the ground was criticized by the commissioning body for its distortions and was accepted only after it had been set up in its niche.

Janson denies the presence of distortions,

which is, however, accepted by Semper and Kauffmann and is demonstrated in a conclusive fashion by Munman. The tabernacle of the Arte dei Linaiuoli is an enriched version of the tabernacle of 1339-40 on the west side of the Oratory in which Ghiberti's St Stephen was later placed. Analogies with Rheims (Vöge) and Antelami (Middeldorf) are valid only in so far as they relate to a common study of classical sculpture, and it is rightly emphasized by Janson that 'the statue is in all essentials without a source'. It has been suggested (Janson) that the drill-holes on the book in the Saint's left hand were originally decorated with metal studs. Cleaning in 1984-6 recovered traces of extensive gilding on the edges of the dress, cloak and cuffs (for this, see C. Sisi, Capolavori e restauri, Florence, 1986, pp. 47-52). The mutilation of the nose, the left hand and the book occurred during the 1920s. The tabernacle is now filled by a cast. The cushion at the base is widely regarded as an emblem of the rigattieri, who were inscribed in the Arte dei Linaiuoli.

St George

Museo Nazionale, Florence Plates 8–10

Donatello's St George on Or San Michele is described by Vasari in the following terms: 'All'Arte dei Corazzai fece una figura di San Giorgio armato, vivissima; nella testa della quale si conosce la bellezza nella gioventù, l'animo ed il valore nelle armi, una vivacità fieramente terribile, ed un maraviglioso gesto di muoversi dentro a quel sasso. E certo, nelle figure moderne non s' è veduta ancora tanta vivacità, nè tanto spirito in marmo, quanto la natura e l'arte operò con la mano di Donato in questa. E nel basamento che regge il tabernacolo di quella, lavorò di marmo in basso rilievo quando egli ammazza il serpente ove è un cavallo molto stimato e molto lodato. Nel frontespizio fece di basso rilievo mezzo un Dio Padre.' ('For the guild of armourers he made a most lively statue of St George armed. The head exhibits the beauty of youth, its spirit and valour in arms, a proud and terrifying lifelikeness, and a marvellous sense of movement within the stone.

Certainly among modern statues there is none in marble with such vivacity or spirit as nature and art achieved by the hand of Donatello in this. On the base that supports the tabernacle he worked a low relief in marble of St George slaying the dragon, where there is a horse that is highly thought of and praised. On the gable he did a God the Father in middle low relief.') In Donatello's lifetime the statue was highly praised by Filarete (Trattato d'architettura, Book xxiii), and in the sixteenth century its manifold beauties were recounted in an essay by F. Bocchi (Eccellenza della statua di San Giorgio di Donatello, Florence, 1584, also available in a German translation by H. Semper in Quellenschriften für Kunstgeschichte: ix, Donatello, seine Zeit und seine Schule, Vienna, 1875, pp. 176-228).

The statue was carved for the niche of the Arte dei Corazzai on Or San Michele, the westernmost niche on the north side of the oratory. It was moved in the seventeenth century to a niche on the south side of Or San Michele, where it remained until after 1887, when it was replaced in its original niche. In 1892 it was transferred to the Museo Nazionale, a bronze copy being substituted on Or San Michele. The nose was broken in 1858 and restored by A. Costoli.

The single published document for the St George (Pope-Hennessy, 1993, p. 324 n.9) is a payment of 17 February 1417 by the Arte dei Corazzai to the Opera del Duomo for a block or slab of marble for the base of the tabernacle. A further document, which cannot be traced (H. Siebenhüner, Kunstchronik, vii, 1954, pp. 266 ff.), allegedly refers to the purchase by the Arte dei Corazzai in October 1415 of a figure from the Opera del Duomo. This figure is identified by Seibenhüner with a marble David for which Donatello received payments between 1409 and 1413. According to this thesis, the St George was adapted from the David, and would therefore have been carved considerably earlier than had previously been supposed. The overwhelming arguments against this view are marshalled by Janson, who points out that the term 'figura' is used in documents for a block of marble destined for a statue as well as for the complete work. There is thus a

presumption that work on the St George was begun in or after October 1415, and was completed in 1416–17, in approximately the same period of time as the St Mark. An earlier dating is proposed by Wundram.

It has also been claimed (Siebenhüner) that the David from which the St George was allegedly adapted, was completed with a metal wreath attached to the head by drill-holes, and with a sling held in the right hand. Janson (who points out that the drill-holes contain remnants of corroded metal) argues that the statue was originally equipped with a bronze helmet, 'a lance or sword tilted upward at a fairly steep angle' in the right hand, and a sword sheath against the left thigh. The evidence for these accoutrements derives solely from the drill-holes on the statue, which are not mentioned by Vasari or any other source. The pose has also been interpreted (Janson) as 'a gesture of the body in response to a danger signal'. Both aspects of this interpretation are paralleled in the nineteenth-century literature of Michelangelo (where attempts were, for example, made to complete the so-called Cupid with a bronze bow and bow-string and to explain its stance by presuming an invisible target), and both are in the highest degree questionable in relation to the present statue. Iconographically the St George, represented bare-headed in armour with legs apart and with his shield supported on the ground before him, is closely related to the statues of warrior saints on the grille surrounding Bonino da Campione's tomb of Cansignorio della Scala in the Sagrato di S. Maria Antica at Verona. Attempts to explain the pose and type by reference to Byzantine prototypes (Kauffmann, Middeldorf) are unconvincing.

The authorship of the tabernacle in which the statue was originally set is not attested by any document, but is generally credited to Donatello. This view is contested by Janson, but accepted, with varying degrees of reserve, by most other scholars. The relationship between the figure and its setting is more intimate than in any other tabernacle save those of the St Matthew and the Parte Guelfa.

St George and the Dragon

Museo Nazionale, Florence Plates 42, 43

The relief was set beneath the tabernacle of the Arte dei Corazzai on the north side of Or San Michele. It is generally assumed that a document relating to the purchase of marble by the guild from the Opera del Duomo on 17 February 1417 (see plates 8-10) refers to the slab of marble used for the narrative scene beneath the tabernacle; this leaves no doubt that the relief was executed after this time, c.1417–18. A case has been advanced for dating the relief about 1420 (Planiscig) or 1430 (E. Maclagan and M. Longhurst, Catalogue of Italian Sculpture. London, 1932, p.19). If the statue was completed in 1417, it is unlikely that the tabernacle would have been left unfinished for so long a time, and the latest of the datings in particular is based on a radical misunderstanding of the style of the relief.

The importance of the St George and the Dragon resides in its handling of space, its figurative content and its technique. So far as concerns spatial content, the most significant feature is the pavement of the building on the right, in which a perspective construction with a single vanishing point is introduced. It has been claimed (White) that whereas the interval between the transversals is inexact, the orthogonals vanish to a single point placed in the body of the Saint; and alternatively (Janson) that the orthogonals do no more than 'run in the general direction of the main vanishing point' which is placed too high in the scene. Whichever view is accepted, it is clear that the construction belongs to a very early stage in the development of linear perspective technique, and is, from a technical standpoint, on an altogether lower level of sophistication than the Siena font relief. Moreover, in the St George and the Dragon linear perspective is not the sole method employed to define space, but is used pari passu with other means of a more empirical but no less effective kind. It is universally acknowledged that the figure of the Princess was adapted from or strongly influenced by a classical original (Semper; A. Warburg, in Gesammelte

Schriften, Leipzig/Berlin, 1932, i, p. 13; and others). The foreshortened horse is not based on the horse in the relief beneath Nanni di Banco's St Eligius on Or San Michele (Janson) or on a common classical origin (Kauffmann). but both horses may derive from prototypes in Roman battle reliefs. It has also been suggested (Janson) that the St George depends from the relief of a Horseman by Andrea Pisano on the Campanile, and that this explains the posture of the figure on the horse. This is improbable, and the crouching pose seems in the main to have been determined by the limited height of the block.

Throughout the Donatello literature (Janson and all earlier students) it is assumed that the technique of *rilievo stiacciato* was introduced about 1416 in the present scene. The difficulty in this thesis is that whereas the use of linear perspective in the relief is still relatively primitive, the technique for rendering space and atmosphere is correspondingly advanced. There is, therefore, a high degree of probability that *stiacciato* reliefs were produced by Donatello before this time.

The relief, which is much blunted by exposure, was removed from its niche in 1976 and cleaned, and is now shown, with the statue, in the Museo Nazionale.

The Assumption of the Virgin

S. Angelo a Nilo, Naples Plate 44

The relief is set in the front of the sarcophagus of the monument of Cardinal Rainaldo Brancacci (see plate 130). The exact date of the relief cannot be established, but it is likely to have been completed at Pisa, where the rest of the monument was carved, in 1426-7. The subject of the relief must have been selected by the Cardinal in memory of his long association as Arciprete with S. Maria Maggiore in Rome. Kauffmann regards the relief as a conscious adaptation of the Ascension relief on the pulpit by Fra Guglielmo in S. Giovanni Fuorcivitas at Pistoia; the resemblances relate only to the angels supporting the mandorla, and are perhaps due to the derivation of both reliefs from a common classical source. The technique

of the carving is greatly in advance of that of the St George and the Dragon relief, from which it is distinguished by a marked decrease in the depth of the cutting in the forward areas, by greater subtlety in the handling of the intermediate planes, and by its strongly atmospheric character. Iconographically the most important aspect of the Assumption is its deep-seated realism, which stems from the same current of religious thought as the Ascension with Christ Giving the Keys to St Peter (which immediately followed it) and the Masaccio Trinity in S. Maria Novella (which preceded it by a short space of time). The Angels are closely related to those of a Nereid sarcophagus in Siena. The perspective structure of the Virgin's chair forms a parallel to that of the Brunelleschan throne in Masaccio's Pisa altarpiece (1426).

The Ascension with Christ giving the Keys to St Peter

Victoria and Albert Museum, London Plates 45, 46

The relief has been identified with 'uno quadro di marmo, chornicie di legname atorno, entrovi di mezo rilievo, una Ascensione di mano di Donato', in the inventory of the possessions of Lorenzo de' Medici drawn up after his death in 1492, and is certainly identical with a 'quadro di marmo di mano di Donatello di basso rilieuo: doue è effigiato, quando da le Chiaui Cristo a S. Pietro' in the possession of the Salviati listed in the 1591 edition of Bocchi's Le bellezze della città di Fiorenza. The relief remained in Salviati ownership till after 1677, was purchased before 1860 for the Gigli-Campana collection, and was subsequently acquired with the Gigli-Campana collection for the Victoria and Albert Museum (7629-1861). It has been established (Kauffmann) that the unusual combination of the Ascension and Presentation of the Keys has its origin in an Ascension play performed annually in the church of the Carmine in Florence (for this, see A. d'Ancona, Origini del teatro italiano, Turin, 1891, i, p. 253), and a case has been stated (Pope-Hennessy, Janson) for the view that the relief may have been designed as an antependium relief for the predella of the altar in the

Brancacci Chapel in this church. In favour of this thesis it may be noted (i) that the relief was designed to be seen at close quarters at eye level, (ii) that its iconography links it closely to the Carmine, (iii) that the scene of the Presentation of the Keys is omitted in the frescoes of Masaccio and Masolino in the Brancacci Chapel, and (iv) that the composition is bound up with the of Masaccio's fresco of the Tribute Money. An improbable suggestion (P. Meller, 'La Cappella Brancacci: Problemi ritrattistici ed iconografici', Acropoli, I, 1961, 4, pp. 186-227, 273-312) is that it was carved as the upper section of a projected tabernacle to house the Madonna del Carmine in the chapel. One of the unexpected results of the cleaning of the Chapel has been the discovery, at the bottom of the original base of the window, of a strip of angled fresco that would originally have been above the altar. The Ascension relief cannot, therefore, have formed part of a marble altarpiece. Donatello's authorship of the relief is rejected without argument by Planiscig, but is accepted by all other recent authorities, though it is tentatively suggested by Janson that there is some studio intervention on the extreme right-hand side. In technique and figurestyle it falls midway between the Naples Assumption and the Entombment on the St Peter's tabernacle. The developed use of linear perspective is also consistent with a dating about 1430.

Prophets

Museo dell'Opera del Duomo, Florence Plates 11–15, 18

At the beginning of the fifteenth century eight of the 16 niches on the Campanile of the Cathedral, four on the south and four on the west side, were filled with statues of Prophets and Sibyls by or from the workshop of Andrea Pisano (see Vol. I, plate 98). The corresponding niches on the east and north sides were vacant, and between 1415 and 1436 there are repeated references in the Duomo records to payments for statues destined for them. The analysis of these is, however, of special difficulty, since (i) the identity of the Prophets is, with certain exceptions, not clearly established, (ii) figures were in course

of execution in the same term of years for the façade, and (iii) the figures set in place on the north face of the Campanile, towards the Cathedral, were exchanged in 1464 with those on the more exposed west side. Until 1940 (when the figures were finally removed from the Campanile) the eight quattrocento statues occupied the following positions:

East side (left to right):

- (i) Donatello: Bearded Prophet (plate
- 11).
- (ii) Donatello: Unidentified Prophet. (iii) Donatello and Rosso: Abraham and Isaac
- (iv) Donatello: Beardless Prophet (plate 12).

West side (left to right):

- (v) Donatello (assisted): Jonah (so-called St John the Baptist).
- (vi) Donatello: Habakkuk (plate 18).
- (vii) Donatello: Jeremiah (plate 13).
- (viii) Rosso: Obadiah (Vol. I, plate 213)

In the documents Donatello's name appears in connection with five statues, of which one, the double group of Abraham and Isaac, can be identified with complete confidence. The Abraham and Isaac was commissioned jointly from Donatello and Nanni di Bartolo, called Rosso, on 10 March 1421 and was completed eight months later (6 November 1421). Since, however, there is no agreement as to the extent of Donatello's personal intervention in the execution of this group, its evidential value in relation to the four remaining Prophets is correspondingly reduced. Two Prophets for the same side of the Campanile were commissioned from Donatello alone on 5 December 1415. One of these Prophets was completed by 18 December 1418, when its value was estimated at 100 florins, and the other by 24 July 1420, when Donatello was credited with 95 florins. On 1 September 1422 instructions were given that these, the Abraham and Isaac, and a fourth Prophet should be installed in their niches forthwith. After considerable uncertainty on the part of all earlier students of Donatello (up to and including Kauffmann), it is now generally agreed (Lanyi, Janson) that the Prophets in question are those numbered

(i) and (iv) above. Some doubt remains, however, as to which of the two statues is the earlier and which the later Prophet, and a decision on this can be reached only through analysis of style. It is assumed (Poggi) and argued (Janson, Becherucci, Rosenauer) that the beardless Prophet is the earlier and the bearded Prophet the later of these figures. The balance of probability appears in favour of the opposite view, since the head of the bearded Prophet is closely connected with that of the St Mark on Or San Michele, while the head of the beardless Prophet looks forward to the later figures on the Campanile.

The third and fourth Prophets were carved over a longer period of time; the initial contract for them is not preserved. On 9 March 1423 Donatello was working on a further figure for the Campanile, and by 27 August 1423 this was already far advanced. A month later it was decided to cancel the contracts for statues which had not yet been begun, and to limit the commissioning of further statues, and work on Donatello's Prophet appears to have been discontinued or slowed down. The statue seems to have been completed by 1 June 1425, and was valued on 18 March 1426. On 11 February 1427 there is a record of a payment for a further statue on which Donatello was engaged, and this is mentioned again on 11 July 1427 in a tax declaration of Michelozzo (with whom Donatello was at that time in partnership) as being three-quarters complete. In the following year work on the Campanile figures was again suspended, on this occasion for a period of three years, and there is no further reference to work by Donatello for the Campanile till 31 January 1434, when he received an interim payment for a statue of the Prophet Habakkuk ('una fighura di marmo per lui fatta a stanza de l'opera chiamato Abachucho profeta'). A further payment was made for this figure on 15 June 1435, and by 11 January 1436 it was complete. There is thus evidence that Donatello carved two statues, one between 1423 and 1425/6 representing an unidentified Prophet, and the other, between 1427 and 1435/6, representing Habakkuk. All writers on Donatello are unanimous in regarding these figures as

(vi) and (vii) above, but once more there is uncertainty as to which figure is the earlier and which the later statue. One of the two statues (vii) bears on the scroll the name GEMIA (Jeremiah); if this identification is accepted, the second figure must, by a process of exclusion, be identical with the Habakkuk. This is presumed by Lanyi, Planiscig and Paatz. Janson and Rosenauer, on the other hand, contest the validity of the inscription, and revert to the view of Kauffmann and other earlier scholars that (vi) is the earlier of the two figures and that (vii), the so-called Jeremiah, is the Habakkuk. It is difficult to establish a firm chronological relationship between these statues, since the later was blocked out and three-quarters finished a year after the earlier was completed. None the less, stylistic considerations seem again to favour the view of Lanvi that (vi) is the later and (vii) the earlier of the statues. Moreover, since the inscription GEMIA is clearly of quattrocento origin, it is difficult to explain how a wrong designation came to be attached as early as 1464 to a figure which would have been widely recognized as Habakkuk. Both (vi) and (vii) are inscribed on the front edge of the plinths OPVS DONATELLI. At least from the middle of the sixteenth century, and probably earlier, the presumed Habakkuk was popularly known as the Zuccone (bald-pate), and it appears under this designation in Vasari: 'Lavorò di marmo nella facciata dinanzi del campanile di Santa Maria del Fiore, quattro figure di braccia cinque; delle quali due ritratte dal naturale sono nel mezzo: l'una è Francesco Soderini giovane, e l'altra Giovanni di Barduccio Cherichini, oggi nominato il Zuccone: la quale, per essere tenuta cosa rarissima e bella quanto nessuna che facesse mai, soleva Donato, quando voleva giurare sì che si gli credesse, dire: Alla fe' ch'io porto al mio Zuccone; e mentre che lo lavorava, guardandolo, tuttavia gli diceva: favella, favella, che ti venga il cacasangue!' ('For the front of the Campanile of S. Maria del Fiore he did four marble figures five braccia high, the two middle ones being portraits of Francesco Soderini as a youth and Giovanni di Barduccio Cherichini - now known as the baldpate - drawn from the life. This latter

being considered a most rare work, and more beautiful than anything else he made, Donatello, when he wished to swear in such a way that people would believe him, used to say: "By the faith which I bear to my bald-pate"; and while he was working on it, he used to look at it and repeat: "Speak, speak, or may dysentery seize you!"") Though there is a temptation to dismiss the stories contained in Vasari's life of Donatello as mere romancing, it is noteworthy that Vasari (unlike professional art historians before Lanvi) was correctly informed both on the number of statues Donatello executed for the Campanile and on their identity.

St Louis of Toulouse

Museo dell'Opera di S. Croce, Florence Plates 16, 17

Few works by Donatello have provoked more controversy than the St Louis of Toulouse and the tabernacle on Or San Michele (plate 17) for which it was made. Much of this discussion is now of academic interest, and the heterodox views to which the statue has given rise need not be recapitulated here. St Louis of Toulouse was adopted as patron of Florence by the Florentine commune in 1388. A definitive account of the Parte Guelfa, of Donatello's statue, and of the niche in which it was set, is provided by D. F. Zervas (The Parte Guelfa, Brunelleschi and Donatello, New York, 1987). The Parte Guelfa, by whom the statue was commissioned, had been allotted one of the 14 niches on the outside of the oratory in 1339, but despite the progress of work on the niches of other Guilds, no work on the architecture of the tabernacle of the Parte Guelfa seems to have been undertaken before c.1422. This date is given in a deliberation of the Council of the Parte Guelfa on 14 January 1460, recording the removal of the statue of St Louis from its niche, which a fortnight previously had been purchased by the Mercanzia. At the instance of the Mercanzia the niche was later filled with the Christ and St Thomas of Verrocchio (see plates 124-6).

The only direct evidence for the date of the St Louis of Toulouse is provided by a document of 20 May 1423, in

authorize an expenditure of 300 florins for the 'Offitiales ymaginis Beati Lodovici que poni debet in pilastro ecclesie sancti Michaelis in orto ut perfici possit' ('in order to bring to completion the image of St Louis which is to be placed in the niche on Or San Michele'). The statue was complete before 24-28 November 1425 (Fabriczy), when it was enjoined that on the feast of St Louis an offering should be presented at Or San Michele as well as at S. Croce. The fact that the statue is not mentioned in Michelozzo's Catasto declaration of 1427 affords a corroboratory argument that it was already finished by this time. The inference that the statue was begun about 1420 (Janson) and completed in or soon after 1423 is fully in accord with the known facts. According to the Codex of Buonaccorso Ghiberti (Florence, Bibl. Naz. Cent., BR 228, f. 27) the total sum received by Donatello for the figure, ungilded and exclusive of the tabernacle in which it was set, was 449 florins ('la ffiura del Santo Lodovicho, sanza l'oro e sanza el tabernacholo d'or za Michele. A Donatello per suo maestero e di chi a ttenuto cho lui f 449/per libre 3277 d'ottone/per libre 350 di ciera/per rame e ffero libre 122 on. 3 d. 4/per charboni f. 41.94 d.O'). On its removal from Or San Michele, the statue was transferred to a niche on the façade of S. Croce, where it is mentioned by Albertini, and where it remained until, in 1860, the church was supplied with a new façade and the statue was moved inside. In 1903 it was placed in the refectory (now the Museo dell'Opera di S. Croce). As a result of cleaning, the gilding of the statue has been disclosed, and comments on its quality in the pre-war Donatello literature should be read with this fact in mind. At the same time an exceptionally careful study was made of its technique (B. Bearzi, 'Considerazioni di tecnica sul S. Lodovico e la Giuditta di Donatello'. Bolletino d'arte, xxxvi, 1951, pp. 119-23). This shows that it was cast in a number of pieces which were not soldered together as in the Judith but were screwed together at the back. The prime purpose of this procedure was to facilitate fire gilding, though a secondary

which the Council of the Parte Guelfa

reason for adopting it may have been the exceptional size of the statue. The empirical character of the technique can be seen in many parts of the statue, notably (Bearzi) in the left shoulder which was raised by an insertion after its initial casting. It has also been demonstrated (Bearzi) that the base of the crozier was sunk in the floor of the niche. There is evidence that the statue was reduced at the back when it was transferred to S. Croce and placed in a shallower tabernacle.

The tabernacle on Or San Michele has been variously assigned to the early 1420s to a date c.1440, and to a still later date (c.1460). A document of 28 December 1487 refers to architectural features on the tabernacle which were still incomplete. Decisive stylistic arguments in favour of the early dating were advanced by Von Fabriczy, and have since been widely accepted. The early dating of the niche has, however, been contested by Planiscig, who suggested alternatively (i) that the St Louis was set in another niche on the building and that the present niche was designed by Donatello at a later date to contain two figures, or (ii) that the niche in which the St Louis was placed in 1425 occupied the site of the present niche. but was more archaic in style and was later replaced by the niche as we know it today. The first of these theories is untenable, since it can be demonstrated that the St Louis actually stood in the present niche, and the second is improbable, since a tabernacle completed in 1425 would hardly have been replaced by a second tabernacle ten or twelve years afterwards. The figurated detail of the tabernacle is certainly due to Donatello, but doubt has been repeatedly expressed as to the extent to which he was directly responsible for the architectural scheme. It has been suggested (Janson, Castelfranco) that the design was evolved by Donatello with the advice of Brunelleschi, and was carried out in co-operation with Michelozzo. Whether or not we accept this theory, it is clear that the statue and the niche were not discordant (as was claimed by Planiscig and many earlier students) but strikingly harmonious, and that they were planned as a unity.

The Presentation of St John the Baptist's Head to Herod

Baptistery, Siena Plate 55

Donatello's connection with the font in the Siena Baptistery (for the history of which see Vol. I, pp. 266-7) seems to have opened in 1423, when he received the commission (lost) for one of six gilt bronze reliefs of scenes from the life of the Baptist on the base. The commission for this relief had previously been allotted to Jacopo della Quercia (16 April 1417), along with that for a relief of Zacharias in the Temple (Vol. I, plate 170) which Quercia eventually executed. An initial payment to Donatello was made in May 1423. In March 1425 the Cathedral authorities expressed dissatisfaction at the lack of progress on this and the reliefs allotted to Ghiberti, but on 18 August 1425 Donatello's relief is described as already made, and on 13 April 1427 it reached Siena. If the document of 1425 refers to the casting of the relief, it can be deduced (Janson) that this was planned and modelled between 1423 and 1425 and chased between 1425 and 1427. At some date after the delivery of this relief, Donatello received the commission for two statuettes of Virtues for the corners of the base of the font; these figures (Faith and Hope) were projected as early as 9 May 1427, and were executed between 25 September 1428 and the spring of the following year. Thereafter Donatello was engaged on work in connection with the tabernacle of the font; for this he executed a bronze door (payment of 22 April 1429), which was rejected in favour of a door by Giovanni Turini, and three of the six putti which originally crowned the corners of the tabernacle. The literature of these putti is confused, but it has been established (Lanyi, Janson) that two of those contributed by Donatello are among the four still on the font and that the third (as was recognized initially by Bode) is identical with a putto in the Staatliche Museen, Berlin-Dahlem.

Three putti by Giovanni Turini, two of which are still on the font, were paid for on 26 September 1431, and Donatello's figures were presumably completed in this year, though the final payment for his work on the font dates from 18 August 1434. The documentation of the Baptismal Font is well presented by J. Paoletti (*The Siena Baptistery Font*, Ph.D. dissertation, Yale University, 1967; New York, 1979). Some valuable comments on the structure of the relief and the 'Fensterfunktion der Rahmung' are made by Rosenauer.

There is some doubt both as to the identity and sex of the two figures seated beside Herod at the table, since the figure to the right of Herod has been variously interpreted as Herodias (Planiscig) and as a male guest. The scene of the Presentation of the Baptist's Head to Herodias (which is the subject of a separate relief on the bronze door of Andrea Pisano) is represented by Donatello in the extreme background of the relief. The view that the two guests seated at the table are men receives some support from paintings by Giovanni di Paolo in the Art Institute of Chicago and the National Gallery, London, where the schemes depend from Donatello's relief and both guests are unquestionably male. The scene is visualized from a high viewpoint (like the considerably earlier St George relief), and not from the low viewpoint which was introduced in the somewhat later relief of the Ascension (plate 45) and was employed again in three of the four reliefs at Padua. Though the orthogonals in the foreground (as noted by J. White) do not vanish to a single point, the perspective construction of the panel represents a significant advance on that of the St George relief.

External Pulpit

Museo dell'Opera del Duomo, Prato Plate 49

The pulpit projects from the southern corner of the façade of the Cathedral at Prato. Designed for the exhibition of the principal relic of the Cathedral, the girdle of the Virgin, it replaced a rectangular trecento pulpit on the same site. Its history, which is very fully documented, opens on 14 July 1428 with a contract in which Donatello and Michelozzo, then in partnership, bound themselves to execute a pulpit according to a model already made. This was to be

set somewhat lower than the pulpit as executed, was to be supported beneath by two marble Angels (not by a bronze capital) and was to have a parapet decorated with six (not seven) reliefs, carved with putti holding shields (not dancing putti). The work was to be completed by 1 September 1429. Payments to the two masters on account of the pulpit are recorded in the second half of 1428 and in the four following years, but progress was retarded by the absence of Donatello in Rome. In April 1433 Pagno di Lapo was despatched to Rome to fetch Donatello, who had failed to complete his contract, and in July 1433 the task of dismantling the old pulpit began. The capital beneath the pulpit was modelled and cast in the second half of this year. Under pressure from the Operai Donatello returned from Rome, and on 27 May 1434 a further contract was drawn up; in this the name of Michelozzo is not mentioned, and the contracting parties are the Collegiata authorities and 'Donatum et alios'. This contract assured Donatello of a payment of 25 florins for each marble panel carved for the pulpit. On 19 June 1434 it was reported that one of the marble reliefs for the balustrade of the pulpit was complete, and that Donatello had asked that some money should be sent to him to spend during the holiday ('La chagione di questa si è, che Donatello à finita quella storia del marmo; e promettovi per gl'intendenti di questa terra, che dicono tutti per una bocha, che mai si vide simile storia. E lui mi pare sia di buona voglia e servire bene; si che, hora che è in buona dispositione, si vuole che noi lo conosciamo. Lui mi priegha, che io vi scriva che per Dio non manchi che gli mandiate qualche danaio per spendere per queste feste; ed io vi gravo che lo facciate; impero chè è huomo ch'ogni picholo pasto è allui assai, e sta contento a ogni cosa'). The building of the pulpit continued through 1435, and by April 1436 four of the seven marble reliefs were complete. All of the marble reliefs were installed on the pulpit before 14 July 1438, and on 17 September 1438 the final payment for them was made. For reasons which are now unclear, the Operai of the Cathedral were dissatisfied with the pulpit, and in April 1455 a joint

letter was written by Donatello and Michelozzo requesting payment of the balance of the sum due to them and offering to rectify whatever was amiss.

It is frequently assumed that work on the Prato pulpit began only with Donatello's return from Rome in 1433. The recorded payments, however, strongly imply (Janson) that work on the lower part of the pulpit was begun before this time. There is no evidence of the date at which the scheme was changed, but this is likely to have been in 1433. The overall design of the pulpit has been ascribed alternatively to Donatello (Bode, Geymüller, Kauffmann) and Michelozzo (Schmarsow, Janson); a clear distinction between the architectural conceptions of the pulpit and the contemporary Cantoria is made by Janson alone. The principal sculptural sections of the pulpit are the bronze capital beneath, and the seven reliefs of putti round the balustrade. The former, which originally filled both sides of the support and not the west side only as it does now (Janson), was executed by Michelozzo, and there is a strong probability that Michelozzo was also responsible for its design (Lanyi, Marchini, Janson). It is stipulated in the contract that the reliefs of putti should be executed by Donatello's own hand. The style of the seven reliefs, however, is not homogeneous, and in six of the seven it is clear that studio assistants played some part. Many attempts have been made to distribute the reliefs between the members of Donatello's workshop (e.g. by Marchini, 'Di Maso di Bartolomeo e d'altri', Commentari, iii, 1952, pp. 112-17, who regards the central relief as a substantially unaided work of Donatello, the relief to its left as by Maso di Bartolomeo, and the two reliefs to its right as possibly by Michelozzo and Pagno di Lapo Portigiani). It is argued by Janson with some force that the central relief and the three panels to its left must be identified with the four scenes delivered by 1436, and that the three inferior scenes to the right were those completed in 1438. All of the seven reliefs depend from models or designs by Donatello. In each case the relief appears to have been blocked out and carried to an advanced state by a pupil, whose

work was then to a greater or lesser degree retouched by Donatello. The extent of Donatello's autograph intervention is greater in the central relief than in the other six, and is least in the last relief on the right. There is no means of identifying the pupils responsible for individual reliefs, but the hand of one of them, responsible for the basic carving of the first and second reliefs on the left, recurs in the Dead Christ with Angels in the Victoria and Albert Museum, in which the same procedure appears to have been followed, parts of the head and body of Christ being worked up by Donatello.

A classical Roman relief of two boxing putti on a sarcophagus in the storeroom of the Museo Vaticano has been claimed (Janson, 1968) as a prototype for the panels of the pulpit. The original reliefs were long neglected and are now shown in the Museo dell'Opera del Duomo, and having been replaced on the pulpit by casts. The ruinous state of the reliefs is described by Marchini ('A proposito del pulpito di Donatello', Prato, xii, 1971, pp. 55-8) and by Franchi, Galli and Manganelli del Fa ('Researches on the Deterioration of Stonework, VI: The Donatello Pulpit', Studies in Conservation, xxiii, 1978, pp. 23-37). Marchini also discusses ('Nella bottega di Donatello', Prato, xiv, 1973, pp. 5-10) a number of early casts made from the reliefs.

Cantoria

Museo dell'Opera del Duomo, Florence Plates 47, 48

The Cantoria or Singing Gallery of Donatello was commissioned in 1433 for a position above the entrance to the South Sacristy of the Cathedral, where it formed a counterpart to the Cantoria of Luca della Robbia (see plates 74–8) over the entrance to the North Sacristy. The upper section of the Cantoria was dismantled in 1688, but the lower part remained in place until the middle of the nineteenth century, when it too was removed. The lower part, the reliefs, the columns from the front and such parts of the architectural framework as survived were reintegrated after 1883 in the Museo dell'Opera del Duomo in the form shown in plate 47. Though a number of objections have been raised to

this reintegration (for these, see Janson and an exhaustive analysis by Becherucci), the effect of the Cantoria in its present form is substantially that planned by Donatello. The figurated area of the Cantoria consists of a frieze of running putti round the front and sides of the balustrade, and, below, between the consoles, of two reliefs with pairs of putti and two bronze masks. The latter (for the existence of which there is documentary evidence) were added at a late stage to the reconstruction of the gallery, and their authorship has been contested. There are, however, strong but not conclusive reasons (Janson) for accepting them as parts of the original structure.

On 10 July 1433 Neri Capponi

was authorized by the Operai of the Cathedral to place the contract for the Cantoria with Donatello, who had returned shortly before from Rome, and on 14 November 1433 it was agreed that Donatello should be paid at the rate of 40 florins for each panel commensurate with those on Luca della Robbia's Cantoria, and 50 florins for panels superior in quality to Luca's. These figures compare with the sum of 60 florins paid to Luca for the earlier of the reliefs on the front face of his Cantoria, and seem to indicate (Janson) that at this time a structure with a number of isolated panels, not a continuous frieze, was contemplated. Payments for the Cantoria continue till 1440, and the balance of the sum of 896 florins due for it seems to have been paid only in 1446. By 30 October 1438, however, the Cantoria was already 'almost complete', and a careful analysis of the relevant documents by Janson suggests that the bulk of the figurated carvings belong in the bracket 1436-8. It follows that these post-date the earlier of the Prato reliefs (see plate 49), and that the conception of the continuous frieze of the Cantoria was developed from the single panels employed on the pulpit at Prato. It is generally assumed that the frieze was inspired by classical sarcophagi of playing putti, though it has also been suggested (Janson) that Donatello may have known a Byzantine ivory relief of playing putti of the class of the Veroli casket. Unlike the Cantoria of Luca della Robbia, the figurated relief round the balustrade does not illustrate a detailed programme, and

the divergent interpretations of its meaning advanced by Kauffmann and Janson are alike unsatisfactory.

The documents leave no doubt that the architecture of the Cantoria was designed by Donatello without the intervention of Michelozzo, and this is confirmed in Antonio Manetti's life of Brunelleschi, where the Cantoria is cited as evidence of the sculptor's imperfect grasp of architectural design. All of the figurated parts were clearly designed by Donatello, but the execution varies in quality between the poles of the excellent figures on the right side of the front of the parapet reliefs and the weaker reliefs between the consoles. The left half of the parapet relief has been assigned both to Buggiano and Michelozzo; neither ascription is satisfactory, and it seems that in this part of the Cantoria, as in the Prato carvings, we have to reckon with the work of studio assistants summarily re-carved in part by Donatello.

The Annunciation

S. Croce, Florence Plates 19, 20

A detailed description of the Annunciation is given by Vasari: 'Laborò nella gioventù sua molte cose delle quali perchè furono molte, non si tenne gran conto. Ma quello che gli diede nome, e lo fece per quello che egli era conoscere, fù una Nunziata di pietra di macigno, che in Santa Croce di Fiorenza fù posta all'altare e cappella de' Cavalcanti: alla quale fece un ornato di componimento alla grottesca, con basamento vario ed attorto, e finimento a quartotondo; aggiungendovi sei putti che reggono alcuni festoni, i quali pare che per paura dell'altezza, tenendosi abbracciati l'un l'altro, si assicurino. Ma sopra tutto, grande ingegno e arte mostrò nella figura della Vergine, la quale impaurita dall'improvviso apparire dell'Angelo, muove timidamente con dolcezza la persona a una onestissima reverenza, con bellissima grazia rivolgendosi a chi la saluta; di maniera che se le scorge nel viso quella umiltà e gratitudine, che del non aspettato dono si deve a chi lo fa, e tanto più, quanto il dono è maggiore. Dimostrò, oltra questo, Donato ne' panni di essa Madonna e dell'Angelo lo

essere bene rigirati e maestrevolmente piegati, e col cercare l'ignudo delle figure, come ei tentava di scoprire la bellezza degli antichi, stata nascosa già cotanti anni: e mostrò tanta faciltà ed artifizio in quest'opera, che insomma più non si può dal disegno e dal giudizio, dallo scarpello e dalla pratica disiderare.' ('In his youth he made many things, of which little account was taken because they were so numerous. But the work which won him his name and made him known for what he was, was an Annunciation in macigno, placed at the altar and in the chapel of the Cavalcanti in S. Croce in Florence. For it he made an ornament composed in the grotesque manner, with a complex curved base and surmounted by a quarter circle, and added to it six putti holding garlands, who seem frightened of the height and place their arms round one another for reassurance. But he showed great talent and skill above all in the figure of the Virgin, who is frightened at the unexpected apparition of the angel, and moves timidly but gently in an attitude of reverence, turning with lovely grace to him who is saluting her. In her face there is seen the humility and gratitude. that is due to whomever makes an unexpected gift, and how much more so when the gift is greater. This apart, Donatello showed in the draperies of the Virgin and the angel how these could be twisted and folded in a masterly fashion, and revealed his awareness of the nude forms of the figures beneath, as though he were endeavouring to recover the beauty of the ancients which had been hidden for so many years. He showed such facility and skill in this work, that nothing more in respect of design and judgement, carving and practice can be desired.') The tabernacle and figures are carved in pietra di macigno, and the six putti above are modelled in terracotta. The extensive gilding on the tabernacle seems to date in the main from a restoration in the late nineteenth century.

The tabernacle occupies its original position on the right wall of the nave, adjacent to the former tramezzo destroyed in Vasari's reconstruction of the church, behind the altar of the Cavalcanti Chapel, which was dedicated to the Annunciation. The altar included

a predella with scenes from the life of St Nicholas by Giovanni di Francesco in the Casa Buonarroti. For this reason it has been assumed (Kauffmann) that the tabernacle was commissioned by Niccolò Cavalcanti. Kauffmann cites a number of iconographical precedents for Donatello's composition, e.g. an Annunciation by an Agnolo Gaddi follower in the Accademia in Florence and a predella panel by Giovanni da Milano in the Palazzo Venezia, Rome. These throw little or no light on Donatello's scheme, which is not susceptible to this form of academic typological analysis.

The very early dating ascribed to the Annunciation by Vasari was accepted by some early students (Semper and others), but has since by general agreement been revised in favour of a dating in the mid-1440s (Kauffmann, Planiscig). It is wrongly postulated by Janson that the work was executed over a considerable period of time, the figurated area being carved about 1428-30 and the tabernacle about 1430-2, while the terracotta putti would have been added after Donatello's return from Rome in 1433. The classical sources of the Cavalcanti Annunciation are discussed by Rosenauer, who dates both the tabernacle and the figure to the first half of the 1430s and relates their scheme to that of the stained-glass window of the Coronation of the Virgin (1434–7). By comparison both with the architecture of the Prato pulpit and the Cantoria and with the figurated sections of these works, this dating appears premature, and the tabernacle seems to have been planned and executed as a unity about 1436-40.

An attempt to ascribe the Angel of the Annunciation to Michelozzo is fanciful. In an analysis of the architecture Janson (1968) claims that the only valid analogies for the pilasters, with their surface pattern of imbricated leaves, and for the capitals occur not in classical buildings but in Roman funerary urns.

David

Museo Nazionale, Florence Plates 32, 33

The bronze David of Donatello is described by Vasari in the following terms: 'Trovasi di bronzo, nel cortile del palazzo di detti Signori, un David ignudo, quanto il vivo, ch'a Golia ha troncato la testa, e alzando un piede, sopra essa lo posa, ed ha nella destra una spada: la quale figura è tanto naturale nella vivacità e nella morbidezza, che impossibile pare agli artefici che ella non sia formata sopra il vivo. Stava giù questa statua nel cortile di casa Medici, e per l'esilio di Cosimo in detto luogo fu portata.' ('In the courtyard of the palace of the Signoria there is a nude David of life size, who has cut off Goliath's head and places his raised foot upon it, while his right hand holds a sword. This figure is so natural in its lifelikeness and softness that to artists it seems impossible that it was not moulded from a living body. This statue stood in the courtyard of the Medici palace, and was carried to its present place on the exile of Cosimo.')

The earliest reference to the statue occurs in 1469, in an account of the festivities for the wedding of Lorenzo de' Medici and Clarice Orsini, when the statue stood on a column in the centre of the courtyard of Palazzo Medici. In August 1495, after the expulsion of the Medici, the David was moved along with the Judith to the Palazzo della Signoria, and was placed in the courtvard, where it was replaced in the middle of the sixteenth century by Verrocchio's Putto with a Fish (see plate 127). In the Palazzo Medici the statue was displayed on a base which is stated by Vasari to have been prepared by the young Desiderio da Settignano. This base was moved to the Palazzo della Signoria along with the statue, and is now lost. A composite picture of it can, however, be built up from references of 1469 ('the beautiful column'), 1510 ('a column of variegated marble'), 1511 ('some very beautiful marble harpies and some vine tendrils of bronze') and 1568 ('una semplice colonna sula quale posava l'imbasamento di sotto fesso ed aperto, ma fine che chi passava di fuora vedesse dalla porta da via l'altra porta di dentro dell'altro cortile al dirimpetto') ('a simple column on which he placed a hollowed open base, so that passers-by outside might see from the street entrance through the inner doorway of the other courtyard opposite'). These passages suggest that the figure, both in the Palazzo Medici and in the Palazzo della

Signoria, was set relatively high, and that the circular wreath at the base rested on a column rising from a pierced pedestal decorated with bronze foliage. As noted by Janson, the hole in the centre of Goliath's helmet must originally have held a crest or stud. The helmet or headdress of the David is also damaged, and may have terminated in a plume.

Michelozzo's Palazzo Medici was not begun till 1444, and was completed in part only in 1452. If, therefore, the statue were designed for the courtyard of the palace, it would have been produced after Donatello's return from Padua. A dating after 1454 is accepted by Kauffmann and, more tentatively, by Middeldorf. It is contended by Nicholson that 'significant approximations of the posture of this David are to be found only among the figures of (Donatello's) later reliefs'. The overpowering arguments against this view and the attempt of Kauffmann to establish a programmatic connection between this statue and the Judith are well stated by Janson, who points out that the base, if executed by Desiderio in his youth, must date from the late 1440s, during Donatello's absence in Padua. The majority of scholars (Tschudi, Dvorak, Colasanti, Schottmüller, Planiscig, Janson, Rosenauer) assign the figure to a date about 1430-2, while a minority (Frey, Knapp, Goldscheider, Pope-Hennessy, 1993) date it about 1440. These dates imply two different views of the character and progress of Donatello's development. Technically the statue most closely recalls the Crucifix at Padua, and the balance of probability is that it was executed in Florence in the years immediately preceding Donatello's departure, that is, about 1440-2. When in the Palazzo Medici it bore the inscription (G. Agosti in Il giardino di S. Marco, Ed. P. Barocchi, Exh. Cat., Florence, 1992, p. 104, n. 142):

Victor est quisquis patriam tuetur Frangit iniusti deus hostis iras En puer grandem domuit tyrannum Vincite cives

It is likely, therefore, that the statue was originally housed in the old Palazzo Medici. It cannot have been made before Cosimo de' Medici's return to Florence in 1434, and is likely to have been commissioned, as a symbol of civic patronage, after the Battle of Anghiari in June 1440, when Florentine forces won a decisive victory against Piccinino and the Albizzi. An earlier dating proposed by C. M. Sperling ('Donatello's Bronze David and the Demands of Medici Politics', Burlington Magazine, cxxxiv, 1992, pp. 220–4) is untenable. The figure is cast sectionally.

It has been claimed that the relief of putti on the helment of Goliath depends from a sardonyx cameo in the Medici Collection. The treatment of the body is strongly naturalistic, and the attempts of Kauffmann and other students to relate the pose and system of modelling to Ghiberti are irrelevant. The head, however, seems to depend from a classical Antinous type, while the fact that the body is represented nude would be consistent with the view that this was imitated from a fragmentary Hellenistic bronze statue or statuette. An attempt (Janson) to relate the iconography to Donatello's presumed homosexuality is an ex post facto interpretation which throws no light on the original intentions of the artist. For the secondary literature to which Janson's interpretation has given rise, see Pope-Hennessy (1984, 1993). The headdress worn by the naked figure is a petasus, and Lanyi on this account suggested that it was a synthesis of Mercury and David. A. Parronchi ('Mercurio e non David', Donatello e il Potere, Florence/Bologna, 1980, pp. 110-15) argues that the figure represents Mercury, that the object in the left hand is a purse not a stone, and that the head is that of Argus not the maimed Goliath. In Florence the statue was adapted as a David, since in the small bronzes depending from it the figure is clothed and holds a sling and the head is maimed. The statue, with its four interrelated views, is a product of Medicean humanism, and is intelligible only if it is regarded as a synthesis, by an artist of preponderantly naturalistic tendency, of three or more separate antique elements. It is claimed by C. Eisler ('The Athlete of Virtue: The Inconography of Asceticism', in De artibus opuscula xl. Essays in Honor of Erwin Panofsky, vol 1, pp. 82-97, New

York, 1961) on literary grounds that David is represented as the athlete of virtue, and by C. de Tolnay ('Two Frescoes by Domenico and David Ghirlandajo in S. Trinita in Florence', *Wallraf – Richartz Jahrbuch*, xxiii, 1961, pp. 237–50) that the group represents the triumph of humility over voluptuousness.

The Pazzi Madonna

Staatliche Museen, Berlin-Dahlem, Inv. No. 51 Plate 62

The marble relief known as the Pazzi Madonna was purchased for the Kaiser Friedrich Museum in 1886, with an alleged provenance from the Palazzo Pazzi. It corresponds, but imprecisely, with a relief in the Palazzo Pazzi described by F. Bocchi and G. Cinelli (Le bellezze della città di Firenze, 1677, p. 369) as a work of Donatello. The attribution to Donatello, first advanced by Bode, has been accepted by all students save L. Goldscheider (Donatello, London, 1941), who rejects it without argument. The closest analogies for the relief in Donatello's work occur in the Presentation of St John the Baptist's Head to Herod on the Siena font (plate 55), where the left hand of Herod offers a parallel for the foreshortened left hand and stubby fingers of the Virgin in the relief. Datings proposed for the carving have varied between 1415 and 1430, but a majority of scholars have agreed in assigning it to c.1420-2. The relief now seems to date from the c.1430, and not from any earlier time (J. Pope-Hennessy, 1993, pp. 254-6, 344). It seems to have enjoyed great popularity, and versions of it in pigmented stucco are found in the Chiesa della Certosa at Bologna, the Convento della Calza, Florence, the Louvre, Strasbourg and elsewhere. So far as can be judged, the Pazzi Madonna is the earliest marble relief to have been widely reproduced in stucco in this way. The construction is projected from the centre of the base, not from the centre of the relief.

Virgin and Child

Louvre, Paris, No. 389 Plates 63, 64

The relief, which is freely modelled in terracotta with old gilding and pigmentation, was acquired for the Louvre in 1880 by Courajod. Though listed in many of the earlier Donatello monographs as a work of Donatello (Schubring, Schottmüller), it has not been properly discussed, and is omitted from most recent literature (Kauffmann, Planiscig, Janson). W. von Bode ('Die Madonnen-reliefs Donatellos in ihren Originalen und in Nachbildungen seiner Mitarbeiter und Nachahmer'. Florentinischer Bildhauer der Renaissance, Berlin, 1910, pp. 74–105) draws attention to its exceptional quality. Like the stucco tondi in the Sagrestia Vecchia, the relief is conceived as a raised painting. The illusionistic detail of the curtain at the back is noteworthy. When reviewing the Donatello Madonna reliefs (J. Pope-Hennessy, 'The Madonna Reliefs of Donatello', in Apollo, ciii, 1976, p. 178, reprinted in The Study and Criticism of Italian Sculpture, New York, 1980,) I expressed some doubt as to whether the relief was made in Florence about 1440 or after 1443 in Padua. The later date now seems, to me, the more probable

Save for the Pazzi Madonna and the Madonna of the Clouds in the Boston Museum of Fine Arts, the Madonnas of Donatello are ignored in Janson's catalogue. It was, however, recognized by Bode and other early scholars that the Madonna reliefs had an important place in the sculptor's output. The authentic reliefs (for which see Pope-Hennessy, 1976, pp. 172–91; 1980, pp. 71–105; and 1993, pp. 252–72) are:

- (i) A composition recorded in bronze plaquettes and in a pigmented stucco relief in the Victoria and Albert Museum which seems to have originated about
- (ii) A circular gilt bronze Madonna of Humility with Two Angels in the Kunsthistorisches Museum, Vienna.
- (iii) The so-called Verona Madonna, of which an example exists in the via delle Fogge at Verona. The lost original was produced probably about 1450 in Padua.

- (iv) A once strongly pigmented terracotta Virgin and Child with Four Angels, now preserved in a much damaged state in the Kaiser Friedrich Museum, Berlin. This exists only in a single version, probably dating from the same years as (iii).
- (v) A pigmented terracotta Madonna in the Louvre (plate 63), which also exists only in a single version and seems to have been modelled about 1440–5.
- (vi) A circular terracotta Madonna and Child in the Louvre with a background of painted glass inlay. The relief has been damaged by incompetent cleaning. A version in stucco exists in a Florentine private collection.
- (vii) A circular bronze Madonna and Child with Four Angels in the Victoria and Albert Museum, London. This was presented by Donatello to his doctor, Giovanni Chellini, in 1456 and has a unique feature, that it was self-reproducing and has a mould on the reverse (for this, see J. Pope-Hennessy, 1980, pp. 85–93).
- (viii) A circular marble Madonna and Child with Four Angels formerly over the Porta del Perdono of Siena Cathedral, now in the Museo dell'Opera del Duomo. This relief, by Donatello and assistants, was carved for the Chapel of St Calixtus in the Duomo in Siena in 1457–8 (for this commission see Herzner, 'Donatello in Siena', in *Mitteilungen de Kunsthistorischen Institutes in Florenz*, xy, 1971, pp. 161–86).
- (ix) A gilt terracotta Madonna and Child in the Victoria and Albert Museum, seemingly dating from 1458–60. This composition is also known through a number of pigmented stucco variants.
- (x) A pigmented terracotta Madonna and Child in a private collection in Florida (for this, see J. Pope-Hennessy, 'A Terracotta Madonna by Donatello', *Burlington Magazine*, cxxv, 1983, pp. 83–5).
- (xi) A Madonna and Child with Two Angels in pigmented stucco in the Kunsthistorisches Museum, Vienna. This relief appears to reproduce a lost original of 1460, and is related in style to the S. Lorenzo pulpit reliefs.

Stucco Decoration

Sagrestia Vecchia, S. Lorenzo, Florence Plates 53, 54

The stucco decoration of the Old Sacristy (plate 52) comprises three separate elements. These are (i) four roundels with scenes from the life of St John the Evangelist in the pendentives of the cupola (the Raising of Drusiana, the Attempted Martyrdom of St John, the Assumption of St John and St John on Patmos), (ii) four roundels with seated figures of the Evangelists set high on the four walls, and (iii) two arched reliefs above the two doors on the altar wall with figures of Sts Stephen and Lawrence and Sts Cosmas and Damian. The bronze door on the left beneath one of these reliefs, commonly known as the Martyrs' Door, was also carried out by Donatello. There are no documents relating to these works, and there is no direct evidence of the dates at which they were executed. The construction of the Old Sacristy was completed in 1428, and it has been claimed (Sanpaolesi) that the stucco decoration was undertaken at this time. On stylistic grounds this dating is untenable. It has also been wrongly suggested (Semrau) that the pendentive roundels were executed after Donatello's return from Padua. The Manetti life of Brunelleschi states that the doorways on the altar wall were installed by Donatello without reference to the architect of the sacristy, and that Brunelleschi disclaimed responsibility for, and disapproved of, them. This passage relates only to the door frames and not to the stucco roundels, but affords contributory evidence that the decoration of the sacristy was undertaken in Brunelleschi's lifetime, that is before 1446. For this and other reasons the vast majority of Donatello students are agreed in assigning both the stuccos and the doors to the years between 1434, when Cosimo de' Medici returned to Florence, and 1443, when Donatello left for Padua

In discussing Donatello's work in the Old Sacristy allowance must be made for the difference in medium between the two parts of the work. Whereas the doors are in bronze, and must, on the analogy of other commissions of the kind, have taken some years to

complete, the remaining decoration is freely modelled in a form of stucco or cement, and the physical execution of each of the eight roundels must have been measured not in years and months but weeks and days. Apart from surface working with a tool (of which there is evidence in detail photographs), the reliefs could not have been modified after the material in which they are built up had set. Though the figures in the bronze door are (as we might expect from the nature of the medium) more fully worked out than the figures in the pendentive roundels, there is no stylistic discrepancy which would justify us in postulating a working sequence between them. On all counts the most significant of the modifications introduced by Donatello in the sacristy were the door frames and the bronze doors. The modelling of the four large figures above the doorways seems to have been consequential on the introduction of the doors and door frames, and was perhaps undertaken during the work of chasing the bronze doors, that is between c.1437–1443. The space construction of the pendentive roundels is closely related to that of the Padua reliefs, and for this reason a dating towards the end of Donatello's first Florentine period, that is after 1440, is probable. The free use of pigmented stucco in the Old Sacristy is unique in Florentine fifteenth-century sculpture, and was never repeated by Donatello or by any other artist. The spatial devices employed in the pendentive reliefs are discussed by J. White, who makes the important observation that the verticals in three of the four scenes converge, and are planned in such a manner as to lead the eve towards the centre of the dome. The relationship between the projection system employed in the roundels and the architecture of the sacristy is discussed by P. Ruschi in Donatello e la Sagrestia Vecchia di San Lorenzo (exhibition catalogue, Florence, 1986), which also contains an account by C. Danti of the substance and restoration of the roundels. The colouristic changes after the removal of overpainting are very great, and have transformed the eight reliefs into some of Donatello's greatest works. The reliefs are wholly autograph, and both their modelling and colour

throw new light on Donatello as a narrative artist. Two of the four figures over the lateral doorways (Sts. Cosmas and Damian) are not by Donatello, and it is likely that these were modelled in or after 1443 by Michelozzo. While there can be no doubt that the bronze door on the left, the so-called Martyrs' Door, is the work of Donatello, the doorway on the right is heavier in modelling and coarser in execution and is likely to be the work of Michelozzo. The four Evangelists seemingly depend from Byzantine illuminations, but Roman furniture is imitated in their seats and desks. The reliefs must have been constructed under supervision of Cosimo de' Medici, and may relate to the Council of the Eastern and Western Churches held in Florence in 1439.

High Altar

S. Antonio, Padua Plates 21–9, 56–61

Late in 1443 Donatello seems to have left Florence for Padua, where on 24 January 1444 we find him employed on a bronze Crucifix for the church of S. Antonio. Wax for the modelling of the Christ was supplied on 19 June 1444, and the figure was presumably cast soon after this time. On 19 June 1447 a stonemason, Giovanni Nani da Firenze, received a payment for carving the base, between 7 and 20 January 1449 the cross was gilded, by 22 January 1449 it was equipped with a gilt bronze halo, and on 23 January 1449 Donatello received the balance of the money due to him for this work. It has been suggested that in 1444 Donatello was also engaged in work on the choir screen of the church (demolished 1651-2) and that the Crucifix was designed in relation to it (Kauffmann). Conclusive arguments against this view are advanced by Janson. It is established by A. Sartori (Documenti per la Storia dell'arte a Padova, ed. C. Filarini, Vicenza, 1976) that the Crucifix in the Cappella Grande was not, as assumed by Janson, identical with Donatello's Crucifix, which stood 'a meço la iexiea' ('halfway up the church') and was attached to a Cross painted and gilded by Niccolò Pizzolo. The commission for the Crucifix alone is insufficient to explain Donatello's

departure from Florence, which was probably motivated (Vasari) by the prospect of obtaining the contract for the monument of Gattamelata (see plates 184, 188, 189), who had died in Padua on 16 January 1443. The successful completion of the Cavalcanti Annunciation in the Franciscan church of S. Croce in Florence may also have played its part in ensuring Donatello employment in the Santo. The high altar was a double-faced structure, of which the front was visible from the nave and the back faced the choir of the church. The present high altar (reconstructed 1895) is composed of bronze statues and reliefs and one stone relief from the original altar, but omits the roofed architectural structure of which they were originally part. The figure sculpture comprises (i) five free-standing bronze statues, the Virgin and Child enthroned (height 159 cm.) (plate 24), and the patrons of Padua, Sts Prosdocimus (height 163 cm) (plate 29), Daniel (height 153 cm) (plate 23), Giustina (height 154 cm) (plate 25), and Anthony of Padua (height 145 cm) (plate 27), and two independent Franciscan Saints, Francis and Louis of Toulouse (plates 26, 28); (ii) four bronze reliefs with miracles of St Anthony of Padua (the Miracle of the Mule, the Miracle of the New-Born Child, the Miracle of the Repentant Son, and the Miracle of the Miser's Heart) (height 57 cm, width 123 cm) (plates 56-61); (iii) four bronze reliefs with the Symbols of the Evangelists by members of Donatello's shop (height 59.8 cm, width 59.8 cm); (iv) a bronze relief of the Dead Christ supported by two Putti (height 58 cm, width 58 cm); (v) twelve bronze reliefs of music-making Angels (height 58 cm, width 21 cm) of which six can be identified; and (vi) a stone relief of the Entombment of Christ (height 138 cm, width 188 cm). All these sculptures are by Donatello, save for the Symbols of the Evangelists and eight of the Angels, which were contracted to individual

The history of the altar is very fully documented, and opens on 13 April 1446 when a donation of 1,500 lire was accepted from a Paduan citizen, Francesco da Tergola, for the construction of a high altar ('in fabricha

et constructione pale ad altare magnum dicte ecclesie Sancti Antonii confessoris et non alibi'). Plans for the new structure may, however, have been advanced before this time. The initial contract with Donatello is not preserved. The first documentary reference to the new altar occurs on 11 February 1447, and records a payment to Donatello and to five members of his shop (the sculptors Urbano da Cortona, Giovanni da Pisa, Antonio Chellini and Francesco del Valente, and the painter Niccolò Pizzolo) 'per parte over sora la anchona over palla el dicto e i dicti de' fare a l'altaro grande del curo del Santo'. Work had presumably been begun in the second half of 1446, since two entries of the same date relate to the purchase of wax 'per fare le teste de le figure de la anchona oltrescritta'. On 1 April 1447 the bronze-caster Andrea dalle Caldiere was supplied with bronze 'per gettar agnolli e certe cosse per la anchona' ('for casting angels and certain other things for the altar'). Later in the same month (27 April 1447) formal provision is made for the reliefs of Angels (which were at that time to have been ten in number) and for the Symbols of the Evangelists. A further payment of 10 May 1447 provides for the casting of the 10 Angels, two of the Symbols of the Evangelists, and one of the narrative reliefs. On 19 May 1447 a payment refers to the casting of two of the narrative scenes, two of the Symbols of the Evangelists and the statue of St Louis of Toulouse. A detailed agreement of 23 June 1447 records that three of the narrative scenes had been cast but had not yet been chased, and that two statues, the Sts Francis and Louis of Toulouse, were in the same state. The narrative reliefs are named in the document as the Miracle of the Mule, the Miracle of the New-Born Child, and the Miracle of the Repentant Son, and it is expressly stated that the fourth scene, the Miracle of the Miser's Heart, had not so far been modelled. On 4 August 1447, however, bronze was supplied to the foundry for the casting of this scene.

During these months the reliefs of Angels and the Symbols of the Evangelists were in course of being chased. On 23 April 1448 a sum was expended on 'oto colone con li suo

capiteli per far uno altaro el di del Santo per demostrar el desegno de la pala over ancona ali forestieri' ('eight columns with capitals to make an altar on which, on the feast of St Anthony, 13 June, the design of Donatello's altar could be shown to visitors'). A payment to Donatello of 6 June 1448 refers to the Virgin and Child and the patron Saints; the central group had already (25 May 1448) been transported to the church for the provisional installation of the altar in the following month. Through the second half of 1448 the documents refer mainly to the chasing of the sculptures and to the gilding and silvering of the narrative reliefs. The latter were finished by 29 January 1449. At the extreme end of 1448 and through the first half of 1449 there are repeated references to the carving of the architectural components of the altar. Those mentioned in the documents comprise eight marble columns ('cholone' or 'colonete'), of which four were rectangular and four were circular and fluted, bases for the columns, mouldings, and blocks both for the interior and exterior of the altar ('molte cornixe et priede grande ande dentro e de fuore de la pala'), and a cupola with a carved figure or relief of God the Father ('un dio padre de praeda de sora de la chua grande dal altaro'). The last parts of the sculpture to be executed were two additional reliefs of Angels and the bronze Pietà (payment of 23 June 1449) and the stone relief of the Entombment on the back of the altar (payment of 26 April 1449). The assumption in the earlier Donatello literature that the altar was fully installed by 13 June 1450 is contradicted by documents (Sartori) of 1454 which show that the altar was still unfinished when Donatello left Padua. It appears to have been completed only in 1477.

In 1579 it was decided that Donatello's altar should be replaced, and in 1582 a new altar was built in which use was made of many of Donatello's sculptures. This was rebuilt in 1651. Finally, in 1895, the altar was reconstituted in its present form. The existing altar was designed by Boito as an academic reconstruction of Donatello's altar, but the impression which it leaves is a misleading one, and a number of attempts have been made to reassemble

the surviving pieces of the altar in their original architectural context. The single significant piece of literary evidence for the reconstruction is a description prepared about 1520 by Marcantonio Michiel: 'Nella chiesa del Santo sopra l'altar maggiore le quattro figure di bronzo tutte tonde attorno la nostra donna, et la nostra donna. Et sotto le ditte figure nello scabello le due istoriette davanti et le due da dietro pur di bronzo di bassorilievo. Et li quattro evangelisti nelli cantoni dui davanti et dui da diredo, di bronzo et di bassorilievo, ma mezze figure. Et da dietro l'altar sotto il scabello il Cristo morto cun le altere due da man sinistra, pur di bassorilievo, ma di marmo, forono di mano di Donatello.' ('In the church of the Santo above the high altar, the four bronze figures entirely in the round grouped round the Virgin, and the Virgin. And beneath the aforesaid figures in the predella the two bronze narrative low reliefs in front and the two behind. And the four Evangelists at the corners, two on the front and two on the back, of bronze and in low relief. but in half length. And behind the altar beneath the altarpiece the dead Christ with other figures round, and two figures to the right and two to the left, also in low relief but in marble, were by the hand of Donatello.") There are many ambiguities in this description, but it emerges clearly (i) that the altarpiece was double-sided, (ii) that the four narrative reliefs were set at the height of a predella, two in front of the altar and two behind, (iii) that the Symbols of the Evangelists were arranged in a similar way, and (iv) that the relief of the Entombment was set (as it is today) beneath the predella at the back of the altar, and was accompanied by further stone reliefs showing four Saints. A mistaken attempt has been made to identify the latter with two fragmentary reliefs now in the Museo di S. Spirito, Florence (G. Fiocco, 'Fragments of a Donatello Altar', Burlington Magazine, lx, 1932, pp. 198-204). A pair of volutes at the entrance to the library of S. Antonio may have come from the high altar.

Within the limits of this volume, no thorough account can be given of the many attempts to reconstruct the altar. The most important of these are those of F. Cordenons (*L'altare di Donatello*

al Santo, Padua, 1895), D. von Hadeln (Jahrbuch der Preussischen Kunstsammlungen, xxx, 1909, pp. 35-55), Kauffmann, R. Band (Mitteilungen des Kunsthistorischen Institutes in Florenz, v. 1940, pp. 315-41), Planiscig, Janson, and White ('Donatello's High Altar in the Santo at Padua', Art Bulletin, li, 1969, pp. 1-14, 119-41; 'Donatello', Le sculture del Santo di Padova, ed. G. Lorenzoni, Vicenza, 1984, pp. 51-94). The last is the most lucid of recent studies. Of the issues presented by the altar the most important, both from a doctrinal and aesthetic standpoint, is that of the position of the six standing Saints. In an earlier edition of the present book, I followed the view of Janson and White that the six Saints were grouped to right and left of the Virgin and Child. It now seems to me (as it did to Planiscig) that the four statues of patrons of Padua stood on the altar with the Virgin and Child, and that the two statues of Franciscan Saints, Francis and Louis of Toulouse, were placed separately in the vicinity of the altar. The prime considerations are: (i) that the number of Saints seen by Michiel on the altar was four not six, (ii) that the Saints Francis and Louis did not form part of the original commission but were contracted for in April 1447, along with the 10 reliefs of Angels, the Symbols of the Evangelists, and the Miracles of St Anthony, (iii) that whereas the heads of the Saints on the altar are unfinished on one side, the heads of Sts Francis and Louis of Toulouse are finished on both sides and were designed to be seen frontally. Michiel's use of the term 'attorno' offers an argument in favour of the view that the Saints on the altar were not disposed on a single plane; it was proposed for the first time by Band that they were not set in a single line but were disposed in space. A conjectural reconstruction of the altar, based on that of Band, was illustrated in the first edition of this book. The predella at the front comprised (centre) the relief of the Dead Christ flanked by the two reliefs with paired Angels, (left) the Miracle of the Wrathful Son, and (right) the Miracle of the Miser's Heart. At the back of the predella was (centre) a grille which is mentioned in documents, (left) the Miracle of the New-Born Child, and (right) the Miracle of the

Mule. The four Symbols of the Evangelists were probably set on the same level at the ends of the altar, in each case with an Angel between them. The Entombment stood beneath the grille at the back of the altar, and the width of this relief corresponded with the width of the central section of the altar above. It has been suggested that the terracotta altarpiece ascribed to Niccolò Pizzolo in the church of the Eremitani at Padua and the S. Zeno triptych of Mantegna at Verona both reflect features of the Padua high altar. While this can be accepted only in a general sense, it remains the case that in the Eremitani altarpiece the Saints are represented in colloquy, as they were by Donatello, beneath an arched superstructure with a half-length God the Father, and that in the S. Zeno altarpiece the participants stand beneath a roof in space which is delimited at the back (as it was in Donatello's altar) by two supports.

Owing in the main to the fact that the names of the members of Donatello's Paduan studio are recorded in surviving documents, the autograph character of the individual sculptures of the altar was repeatedly questioned by earlier scholars. Janson supports the untenable view that all the sculptures were modelled by Donatello and finished under his supervision. The most remarkable of them are the four narrative reliefs of the predella. Their aesthetic significance and space structure are discussed by I. White. The gilding on these reliefs is well preserved, but the silvering (for which there is evidence in documents) has all but disappeared; it is reconstructed in part by White, who notes a progressive use of silver in the last two reliefs. Though the first three reliefs seem to have been modelled together in a relatively short space of time, some measure of development can be read into them, and a strong case has been stated in favour of the view that the Miracle of the New-Born Child is the earliest, followed in turn by the Miracle of the Mule and the Miracle of the Repentant Son. It is known from documents that the Miracle of the Miser's Heart was modelled after the other three reliefs. The scenes derive from a life of St Anthony prepared in

1433 by the Paduan notary Secco Polentone (C. de Mandach, *St Antoine de Padoue*, Paris, 1899, pp. 195ff.). Both the central group of the Miracle of the Repentant Son and the Entombment behind the altar have been traced to antique prototypes. The prime influence on the Padua altar and its narrative reliefs is that of Alberti (for this, see G. Morolli, 'Donatello e Alberti "amicissimi", *Donatello Studien*, ed. M. Cämmerer, 1989, pp. 43–67).

The Gattamelata Monument

Piazza del Santo, Padua Plates 184, 188, 189

Erasmo da Narni, known as Gattamelata, longtime commander of the Venetian forces, died at Padua on 16 January 1443. In his will (30 June 1441) he enjoined that he should be buried in some monument inside the Santo, and authorized his executors to spend a stipulated sum on his funeral and tomb. In the event a state funeral was decreed and paid for by the Venetian state, and was attended by the Doge of Venice. The chain of circumstances which led to the commissioning of Donatello's equestrian monument is uncertain. On the one hand, there is a persistent tradition that this was commissioned by the Venetian Senate. This is stated in the epitaph of 1457-8 on Gattamelata's tomb inside the Santo ('Munere me digno et statua decoravit equestri/Ordo Senatorum nostraque pura fides'), is repeated in an epitaph of Ciriaco of Ancona (which dates the decree of the Senate to the year 1447), is reiterated about 1455 by a North Italian humanist wrongly identified as Basinio, and recurs again in Sanudo, Vasari and Giovio. On the other hand, the recorded payments for the monument, dating from the summer of 1447, were made by Onofrio di Palla Strozzi, and on account of Gattamelata's widow, Gentile della Leonessa, and her fellow executor Michele da Foce. In the second half of 1453 an accommodation was reached between Donatello, Gattamelata's son, Giovanni Antonio, and his secretaries, Michele da Foce and Valerio da Narni. The overwhelming weight of evidence is in favour of the view that the monument owed its origin to the

initiative of the Venetian Senate, despite the fact that payment for it was made and a (lost) contract was presumably entered into by Gattamelata's heirs. Moreover, a letter addressed to the Doge of Venice by Alfonso of Aragon, King of Naples, on 26 May 1452 (for which see Iordi Rubio, 'Alfons el Magnanim, Rei de Napola, i Daniel Fiorentino, Leonardo da Bisuccio i Donatello', Miscellanea Puig i Cadafalch, i, Barcelona, 1947-51, pp. 25-35) is couched in the following terms: 'Illustrissime Dux, amice noster carissime, cum audiverimus ingeni solertiam atque subtilitatem magistri Donatelli in statuis tam eneis quam marmoreis fabricandis, magna nobis voluntas recessit eundem penes nos et in nostris serviciis per aliquod tempus habere . . . ' ('As we have heard of the skill and subtlety of the master Donatello in making both bronze and marble statues, there has come upon us a great wish to have him at our court and in our service for some time'). This is not susceptible of any other interpretation than that Donatello was at the time in the employment of the Venetian Senate. The date of the inception of the monument is not known, and it was possibly the contract for the Gattamelata Monument, not the prospect of employment inside the Santo, that tempted Donatello to leave Florence for Padua, since the monument, unlike the Crucifix and the high altar, represented a class of commission he could never have received in Florence

The documents (the earliest of which dates from 16 May 1447) refer to the building of the pedestal, the casting of the horse and the transport of the models of the horse and mounted figure to the foundry of Andrea dalle Caldiere, by whom it was cast. Subsequently a dispute over payment appears to have arisen between Donatello and Gattamelata's executors. This was settled on 29 June 1453, when Donatello agreed to place the statue on its pedestal in September of the same year. On 3 July 1453 the value of the statue was estimated at 1,650 ducats. There are no documentary references to the cleaning and chasing of the statue after casting, and it is not therefore known by what date it was

The statue stands on a plinth a little

under eight metres high, bearing on the front the inscription OPVS DONATELLI.FLO. On the sides of the plinth are marble reliefs of lamenting putti with military trophies (now replaced by copies). The site occupied by the monument was on consecrated ground in the Sagrato of the Santo, and it has been suggested (Lanyi, H. Keller) that it was initially planned as a tomb. For the arguments against this view and against the Christian interpretation of the imagery proposed by Lanyi, see Janson (1968). According to Janson, 'the only clearcut element of mortuary significance' is the mausoleum doors on the base, which are related to those in the upper section of the Brancacci Monument and derive from the same class of classical sarcophagus. Decisive arguments for the earlier thesis are marshalled by Fiocco, who establishes that the documents relating to the base refer to the 'pilastro della sepoltura di gattamelata' ('pilaster of the place of burial of Gattamelata'). There can, however, be no doubt that the death of Gattamelata was seized upon, by humanist circles in Padua or Venice or by the sculptor himself, as an occasion for producing a contemporary equivalent for a classical equestrian monument. That it was viewed in this light in the fifteenth century is suggested by a poem of about 1455 (for which see Janson) ironically contrasting Gattamelata with Scipio, Cato and other Roman heroes who were not commemorated by equestrian monuments, by a passage in Filarete's Trattato d'architettura, in which the statue is used as an example of the hazards of employing classical costume, and by a sentence of Michele Savonarola comparing it to a 'Caesar in triumph'. Janson presumes that Donatello knew a classical statue of the class of that of the Augustan tribune Marcus Holconius Rufus in Naples. Other classical prototypes are more probable.

St Mary Magdalen

Museo dell'Opera del Duomo, Florence Plates 40, 41

The wooden figure of St Mary Magdalen formerly in the Baptistery is described by Vasari: 'Vedesi nel medesimo tempio, e dirimpetto a quest'opera, di mano di Donato una Santa Maria Maddalena, di legno, in penitenza, molto bella e molto ben fatta, essendo consumata dai digiuni e dall'astinenza; in tanto che pare in tutte le parti una perfezione di notamia, benissimo intesa per tutto.' ('There is to be seen in the Baptistery, opposite the Coscia monument, a penitent Magdalen in wood by Donatello. This is very beautiful and well made. She is consumed by fasting and abstinence, and in all the parts there appears a perfect comprehension of anatomy.') The first documentary reference to the figure occurs on 3 October 1500, when it was equipped with a halo. It is likely but not certain that the figure was carved for the position on the south-west wall which it occupied till recently. The Libro di Antonio Billi suggests that the figure was carved in competition with the lost wooden Magdalen of Brunelleschi in S. Spirito and for this reason it was regarded by some early authorities as a relatively early work. It is now generally agreed that the statue was carved after Donatello's return from Padua. The presence at Empoli of a wooden figure of the Magdalen dated 1455 has led some students (Planiscig, Janson) to regard this date as a terminus ante quem for the production of the statue in the Baptistery. The relationship between the two is, however, insufficiently explicit to warrant this inference, and the former may have been influenced by Brunelleschi's lost statue. There is some evidence of a recrudescence of interest in the cult of the Magdalen in Florence in the late 1450s, e.g. in the altarpiece by Antonio Pollaiuolo at Staggia, which represents the Miraculous Communion of St Mary Magdalen and not the Assumption of St Mary of Egypt (cf. G. Kaftal, Iconography of the Saints in Tuscan Painting, Florence, 1952, p. 719). As Archbishop of Florence, Sant'Antonino was responsible for inculcating devotion to the Magdalen, and he may have been responsible for the presence of Donatello's Magdalen in the Baptistery in Florence. The context of the statue is provided by the Opera a ben vivere written by Antonino for Deodata Adimari. For Sant'Antonino, the Magdalen, deprived of corporal virginity,
regained her saintly crown through penitence. A suggestion (Grassi) that the monochrome pigmentation of the figure might conceal the original polychromy was proved to be correct when, after the flood of 1966, cleaning revealed that the flesh areas were painted naturalistically and that extensive gilding remained on the hair and dress. As a result, the aesthetic character of the sculpture has been transformed. Examples of the widespread influence exercised by Donatello's statue are a wooden figure by Desiderio da Settignano and Benedetto da Majano in S. Trinita (plate 117) and a number of terracotta reliefs and busts by Rustici. The figure in S. Trinita must have been begun before the death of Desiderio in 1464: this affords the only valid terminus ante quem for Donatello's statue.

Judith and Holofernes

Palazzo della Signoria, Florence Plates 34–8

Donatello's Judith is described by Vasari (ii, pp. 405-6) in the following terms: 'Fece per la Signoria di quella città un getto di metallo, che fù locato in piazza in uno arco della loggia loro ed è Giudit che ad Oloferne taglia la testa; opera di grande eccellenza e magisterio: la quale, a chi considera la semplicità del di fuori nell'abito e nello aspetto di Giudit, manifestamente scuopre nel di dentro l'animo grande di quella donna, e lo aiuto di Dio; siccome nell'aria di esso Oloferne il vino ed il sonno, e la morte nelle sue membra, che per avere perduti gli spiriti si dimostrano fredde a cascanti. Questa fù da Donatello talmente condotta, che il getto venne sottile e bellissimo; ed appresso fù rinetta tanto bene, che maraviglia grandissima è a vederla. Similmente il basamento che è un balaustro di granito con semplice ordine, si dimostra ripieno di grazia, ed agli occhi grato in aspetto: e si di questa opera si soddisfece, che volle (il che non aveva fatto nelle altre) porvi il suo nome, come si vede in quelle parole, Donatelli opus.' ('For the Signoria of Florence he made a metal cast, which was placed in the piazza in an arch of their loggia. It shows Judith cutting off the head of Holofernes, and is a work of great excellence and mastery. To anyone who

considers the outward simplicity of the dress and aspect of Judith, it makes manifest within the great spirit of that lady and the aid of God; just as in the aspect of Holofernes are revealed the effects of wine and sleep, and death in his limbs, which because he has lost his senses are represented as cold and drooping. This work Donatello executed in such a way that the casting came out thin and beautiful; and afterwards it was cleaned so well that it is a marvel to behold. Similarly the base, a granite baluster of simple design, looks graceful and pleasing to the eye. He was so satisfied with this work that he wished to place his name on it - which he had not done elsewhere - as can be seen in the word Donatelli opus.')

The group is inscribed on the cushion between the hands of Holofernes OPVS. DONATELLI.FLOR. A second inscription round the top of the pedestal dates from 1495. There is some evidence that prior to this time the base bore the inscription 'Regna cadunt luxu surgent virtutibus urbes caesa vides humili colla superba manu' ('Kingdoms fall through luxury, cities rise through virtues; behold the neck of pride severed by humility'), and a second inscription: 'Salus Publica. Petrus Medices Cos. Fi. libertati simul et fortitudini hanc mulieris statuam quo cives invicto constantique animo ad rem pub. redderent dedicavit' ('Piero son of Cosimo de' Medici has dedicated the statue of this woman to the liberty and fortitude bestowed on the republic by the invincible and constant spirit of the citizens'). Vasari's statement that the statue was made for the Signoria is incorrect; it was moved to the Piazza della Signoria only after the expulsion of the Medici in 1495, and was later placed in the Loggia dei Lanzi. A document of 9 October 1495 refers to the transfer of the statue to the Piazza della Signoria from the garden of the Palazzo Medici. It is certain that, whatever the position it occupied, it was a free-standing fountain figure, in which water poured from the four corners of the cushion and from the three reliefs in the base.

There is no documentary evidence for the date at which the figure was produced. Initially regarded as a pre-Paduan work (Semper, Schmarsow and others), it is now universally accepted

(Kauffmann, Planiscig, Janson) as executed after Donatello's return to Florence in 1453. A document of September 1457 records a payment by the authorities of Siena Cathedral for bronze for a 'mezza fighura di Guliatte' ('half-figure of Goliath'), and attempts have been made to explain this as a misliterated reference to the Judith. This is unconvincing, as is the suggestion that the statue was originally planned for a location in Siena. The presumption remains that it was commissioned ab initio by Cosimo de' Medici. If the document of 1457 refers to the commencement of the Judith, this would have been completed after 1460. On stylistic grounds, however, the Judith seems to precede the Siena St John of 1457; it may have been begun late in 1454 or early in 1455. The three bacchanalian scenes on the triangular base, on which Bertoldo is likely to have worked, are most readily explained if they fall midway between the Angels on the Padua altar and the S. Lorenzo pulpits. A document in the Cambini account-books records a payment to Donatello of 100 florins on 14 October 1456 and payments by Donatello for 965 pounds of copper and bronze between this date and 19 November of the same year. It has been inferred (G. Corti and F. Hartt, 'New Documents Concerning Donatello, Luca and Andrea della Robbia, Desiderio, Mino, Uccello, Pollaiuolo, Filippo Lippi, Baldovinetti and Others', Art Bulletin, xliv, 1962, pp. 155-67), almost certainly correctly, that these payments relate to the casting of the Judith. The group is mentioned in a letter written to Piero de' Medici on 5 August 1464, transcribed in the Zibaldone of Bartolommeo della Fonte, and must therefore have been completed by this

Technical examination by B. Bearzi (*Donatello, San Ludovico*, New York, 1948, p. 27, and 'Considerazioni di tecnica sul S. Lodovico e la Giuditta di Donatello', *Bollettino d'arte*, xxxvi, 1951, pp. 119–23) has shown that the figure is cast in 11 pieces, that in the drapery the wax was superimposed on actual cloth, and that the legs of Holofernes were moulded from nature. The last of these conclusions has been contested (Janson). In the case of the St Louis of Toulouse,

which was also cast sectionally, the procedure was designed to facilitate the gilding of the statue. Traces of gilding are found locally on the Judith. A number of somewhat later examples of drapery modelled on actual cloth are known (e.g. a male portrait bust ascribed to Riccio in the Museo Correr in Venice). It is possible that in the studio of Vecchietta (whose technical procedure derived from that of Donatello) life casting was also employed. Bearzi's article is reprinted with other technical studies in a publication issued after the cleaning of the statue (Donatello e il restauro della Giuditta, ed. L. Dolcini, Florence, 1988), in which A. Natali unconvincingly ('Exemplum salutis publicae') explains the statue as a commission from Siena.

The most satisfactory interpretation of the imagery of the group is that of E. Wind ('Donatello's Judith: a Symbol of Sanctimonia', Journal of the Warburg Institute, i, 1937-8, pp. 62-3), who interprets the figure of Holofernes, in the light of Durandus's Rationale Divinorum Officiorum, as a symbol of Luxuria and Superbia. That both of these interpretations were in Donatello's mind when the statue was planned is shown first by the orgiastic reliefs on the base, which relate to the first of these vices, and second by the medallion with a rearing horse worn by Holofernes, which is identified by Kauffmann as an emblem of Superbia. The Judith represents the opposing virtues of Sanctimonia and Humilitas. On a narrative plane the interpretation of the group is more problematical. Earlier students (Schmarsow, Semper, Schottmüller) tended towards a literal interpretation of the action, whereas later students (Kauffmann), who visualize the group through a curtain of medieval iconographical analogies, tend towards a symbolic reading. Janson concludes that 'the question as Schottmüller posed it is an idle one; Donatello did not conceive the statue in terms of a specific phase of action'. The question is, however, central to an understanding of Donatello's creative mentality, and if the statue is interpreted in the light of Donatello's other works, it is scarcely open to doubt that the earlier is more fully consistent than the later

interpretation with what we know of his imaginative processes.

Pulpits

S. Lorenzo, Florence Plates 68–73

In their present form the two pulpits in the nave of S. Lorenzo are free-standing. That on the left (Pulpit A, plate 68) contains scenes from the Passion and that on the right (Pulpit B, plate 69) post-Passion scenes. The reliefs on Pulpit A represent (back) the Agony in the Garden, (end) Christ before Pilate and Christ before Caiaphas, (front) the Crucifixion, the Lamentation over the Dead Christ, and (end facing altar) the Entombment. Those on Pulpit B show (end facing altar) the Marys at the Sepulchre, (front) Christ in Limbo, the Resurrection, and the Ascension, (end) Pentecost, and (back) the Martyrdom of St Lawrence. All the reliefs are in bronze save for later panels of the Flagellation and St John the Evangelist on the back of Pulpit A and of St Luke and the Mocking of Christ on the back of Pulpit B, which are in bronzed wood, and are additions made to the series when the pulpits were reconstructed between 1619 and 1637. The reliefs on Pulpit A are flanked by fluted piers with standing male figures in front of them; of these two to the left of the Crucifixion and two at the sides of the Entombment survive. The figures which originally stood in front of the central and righthand pier of the front of Pulpit A have been removed. The front of Pulpit B extends beyond the base and terminates in angled walls unrelated to those of the end panels. Above the scenes on the pulpits is a frieze of putti, horsemen, athletes and vases.

The earliest reference to the two pulpits occurs in Vespasiano da Bisticci's life of Cosimo de' Medici (*Vite di uomini illustri del secolo XV*, Milan, 1951, pp. 418–19): 'Fù molto amico di Donatello e di tutti gli pittori e scultori e perche ne' tempi sua quest'arte degli scultori alquanto venne, che egli erano poco adoperati, Cosimo a fine che Don. non istesse gli allogò certi pergami di Bronzo per San Lorenzo; e ordinò al banco, ogni settimana, che avesse una certa quantità di danari, tanto che bastassino a lui e

quattro garzoni che teneva; e a questo modo lo mantenne.' ('He was a good friend of Donatello and of all painters and sculptors; and because in his time sculptors were little employed, Cosimo, in order not to have Donatello be idle, commissioned him to do some bronze pulpits for S. Lorenzo and some doors which are in the sacristy. He ordered the bank to pay every week enough money for the master and his four assistants, and in this way supported him.') The pulpits are mentioned again in 1510 in Albertini's Memoriale di molte statue e pitture della Città di Firenze (ed. Milanesi, Florence, 1863, p. 11), where it is stated that they were used respectively for the reading of the Gospel and Epistle ('Donato . . . il quale fece li due Pergami di Bronzo per l'Evangelio et Epistola'). The earliest source which refers to the pulpits as unfinished is the Libro di Antonio Billi. This is elaborated by Vasari in three separate passages. The first reads: 'Ordinò ancora i pergami di bronzo . . . quali non potendo egli per vecchiezza lavorare, finì Bertoldo suo creato, ad a ultima perfezione li ridusse.' ('He also designed the bronze pulpits. As he could not work them himself because of old age, his pupil Bertoldo finished them and reduced them to their last perfection.') The second reference confirms the first: 'Rimase a Bertoldo, suo creato, ogni suo lavoro, e massimamente i pergami di bronzo di San Lorenzo; che da lui furono poi rinetti la maggiore parte, e condotti a quel termine che e'si veggono in detta chiesa.' ('All his work he left to his pupil Bertoldo, and especially the bronze pulpits of San Lorenzo; these in large part were cleaned by Bertoldo, and brought to the state in which they are now to be seen in the church.') The third reference occurs in the life of Michelangelo, where it is stated that Bertoldo owed his reputation in part to work which he had undertaken on the pulpits ('non solo per avere diligentissimamente rinettato il getto de' pergami di Donato suo maestro').

A document of 1515 records that at this time the bronze pulpits were brought into the church and set up with wooden supports in connection with a formal visit paid to the church by Pope Leo X, and it has sometimes been

assumed that the pieces of the pulpits were disassembled until this time. Strong arguments have been advanced (Kauffmann, Paatz, Janson) against this view, and the balance of probability is that the pulpits were set up in the church at an earlier date. Permanent installations for the two pulpits were effected respectively in 1558 and 1565. At this time they were set on the columns on which they now stand on either side of the nave against the piers of the crossing of the church. They are shown in this position by Buontalenti, Callot and other artists. Between 1619 and 1637 they were moved to their present positions in the nave, and reconstructed as free-standing pulpits. Study of the physical construction of the pulpits has shown conclusively (Kauffmann, Janson) that the positions in which they were set up in the middle of the sixteenth century were those for which they were originally designed, and that they were planned to rest against the piers with a single bronze relief and an aperture for access exposed at the back. The original form projected for the supports is not

It is generally assumed (Janson and all earlier writers) that the pulpits were commissioned about 1460, after Donatello's return to Florence from Siena, and were left unfinished at Donatello's death in 1466. A single firm point of reference for their chronology is established by the discovery (Previtali) that the Martyrdom of St Lawrence is inscribed 1465 . ADI . GVG . The date is likely to refer to the despatch of the relief to the foundry, not to the date at which the model was produced. The authorship of the reliefs is susceptible to a wide variety of interpretation, and varies between the view of Semrau, who assigned certain panels to Bertoldo (putto frieze on Pulpit B, Entombment, parts of Lamentation and Martyrdom of St Lawrence) and Bellano (Crucifixion, Agony in the Garden and Christ before Caiaphas and Pilate in part), and Semper, who regarded the panels as autograph. It has alternatively been suggested (Bode) that Donatello designed the figurated sections of both pulpits but did not work them up himself, and (Janson) that he left behind him 'wax reliefs intended for the foundry, in various stages

articulated by Bertoldo, Bellano and other pupils. This not implausible theory is elaborated by Previtali and Huse. The former precludes the possibility that the design of the Crucifixion is due to Donatello, but supposes that the Agony in the Garden was modelled in wax by Donatello or was rough cast before his death, that the Entombment and Deposition were probably finished by Bertoldo, and that the Christ in Limbo and Resurrection were completed by assistants under the supervision of the artist. Huse mistakenly suggests that the Christ before Caiaphas and Pilate, the Crucifixion, the Lamentation and Entombment were probably designed for the doors of Siena Cathedral, wax models for which are said to have been finished when Donatello returned to Florence. Between 1461 and the summer of 1465 Donatello would have executed first the Christ in Limbo, Resurrection and Ascension, and subsequently the Marys at the Sepulchre, Pentecost and Martyrdom of St Lawrence. The period between June 1465 and Donatello's death in December 1466 would have witnessed the design and execution of the Agony in the Garden and the execution of Christ before Caiaphas and Pilate and the Crucifixion. After Donatello's death the Lamentation over the Dead Christ and the Entombment would have been completed by Bertoldo. So far as concerns the authorship of the reliefs, it should be remembered that Vasari's reference to Bertoldo's intervention specifically states that this occurred during the master's lifetime, and that this may explain, e.g., the Entombment, where the composition is Donatellesque though the figurative language is characteristic of Bertoldo. An extreme instance of the attributional difficulties presented by the pulpits occurs on the front of Pulpit B, where a relief of supremely high quality of the Lamentation over the Dead Christ is juxtaposed with a Crucifixion which is not only roughly modelled and coarsely executed, but appears to have been planned by an altogether less sophisticated and less enterprising mind. It is difficult to reconcile this scene or the Agony in the Garden on the back of the same pulpit with the compositional

of completion', which were then

procedure of Donatello.

The design of each pulpit is strikingly dissimilar. Whereas the front of Pulpit A consists of three scenes separated by walls thrown forward from the relief plane, the front of Pulpit B consists of two scenes set between flat pilasters with figures placed in front of them. This contrast is also found in the end reliefs of the two pulpits, e.g. the Christ before Caiaphas and Pilate at the east end of Pulpit B, where use is made of interior. projected space, and the Marys at the Sepulchre at the end of Pulpit A, which is set in a building protruding from the background of the scene. Since the compositional types and the space structure of the reliefs on Pulpit B are more closely related to those of the Padua altar than the reliefs on Pulpit A, it may be inferred that the conception of Pulpit B preceded that of Pulpit A. The extent of Donatello's direct intervention in Pulpit A is, however, far greater than in Pulpit B, since all six reliefs in Pulpit A were manifestly designed by Donatello in the last years of his life, and must have been cast under his supervision and in large part worked up with his own hand.

Two major additions to the literature of the pulpits have appeared since the second edition of this book. The first is a dense but highly original and in great part convincing article by V. Herzner ('Die Kanzeln Donatellos in San Lorenzo', Münchener Jahrbuch der bildenden Kunst, dritte Folge, xxiii, 1972, pp. 101-64) and the second a brief and more assimilable book by L. Becherucci (Donatello: i pergami di S. Lorenzo, Florence, 1979). Neither of these studies can be claimed to solve the problem of the pulpits (the problem is, indeed, insoluble since the documentary evidence is incomplete and no serious technical investigation of the reliefs has so far been made), but together they introduce a number of new factors which tend to discredit the analysis of previous scholars that the two pulpits were, from the first, planned as a pair. Herzner takes as his starting point a fourth and hitherto neglected reference to the pulpits in Vasari's Ragionamenti (Vite, ed. Milanesi, viii, p. 99) which links the wax models for the pulpit reliefs with 'il modello dell'altar maggiore con la sepultura di Cosimo

a' piedi'. The document recording the transport of the reliefs to the church in 1515 distinguishes between 'el Pergamo minore, che era in pezzi' ('the small pulpit which was not assembled') and the large bronze pulpit which was apparently complete. Herzner argues that the reliefs on Pulpit B (the Resurrection pulpit) were designed for a tomb for Cosimo il Vecchio, work on which would have been discontinued in Cosimo's lifetime. This is supported by inferences from the viewing points of the reliefs on both pulpits, some of which are designed for inspection from above and some for inspection from below. While Herzner's arguments are not, in their published form, conclusive, they leave little doubt that the reliefs of Pulpit B were originally made for some other purpose than that to which they were later applied. This would explain the present clumsy conjunction of the individual reliefs. Becherucci throws emphasis on Vasari's reference to the high altar, with which these reliefs are conjecturally associated, and follows Semrau in supposing that the Cappella Maggiore of the church may before 1461 have had some form of choir screen to which the pulpit proper (A) was designed to be attached. In this hypothesis Donatello would in 1456 have been in charge of a workshop staffed by Bellano (first mentioned in Florence in this year as working with Donatello), Dogio di Neri and two other assistants, one of them probably Bertoldo, established in connection with work in the choir of S. Lorenzo. The division of hands proposed by Herzner is in broad agreement with that of Becherucci.

The iconographical sources of the pulpit reliefs have been investigated (Lavin) with inconclusive results. It cannot be postulated that the programme of the reliefs is necessarily due solely to Donatello, and account must be taken of some part here played by Cosimo il Vecchio in the planning of the scenes. Certain features of the scenes find a parallel in the frescoes of Castagno in S. Apollonia (mid-1450s). Analyses of the classical sources of certain motifs in the reliefs show (i) that analogies for the putto frieze occur on a sarcophagus in the Walters Art Gallery, Baltimore (Simon), perhaps in the possession of

Matteo Strozzi in Florence, and (ii) that the bicephalic servant in the Christ before Pilate is emblematic of Fortuna.

MICHELOZZO DI BARTOLOMMEO

(b. 1396; d. 1472)

Michelozzo was born in Florence in 1396. His father, Bartolommeo di Gherardo, was of Burgundian origin, and had become a Florentine citizen twenty years earlier (9 April 1376). For a large part of his sculptural career, Michelozzo was associated, first with Ghiberti, then with Donatello, and finally with Luca della Robbia. He is mentioned as an assistant of Ghiberti in 1420, and was employed between 1417 and 1424 on the first bronze door by Ghiberti for the Baptistery and the statue of St Matthew on Or San Michele. Michelozzo's name seems to have become linked with the latter figure (Libro di Antonio Billi), though this is indubitably by Ghiberti. From approximately 1437 till 1442 Michelozzo was re-employed by Ghiberti, working, in association with Ghiberti's son Vittorio, on the cleaning and chasing of the reliefs of the Porta del Paradiso (Krautheimer). Michelozzo's association with Donatello dates from the period of work on the St Louis of Toulouse (see plate 17) and the Feast of Herod on the Sienese Baptismal Font (see plate 55). From 1425 till about 1433 the two sculptors shared a common studio; the beginning of this collaboration is established by a Portata al Catasto (tax return) of 1427, in which Michelozzo refers to 'due anni o incircha siano stati conpagni' ('they have been companions two years or just about'). This Portata refers to four unfinished works in course of execution in the studio, the Coscia Monument in the Baptistery, the Brancacci Monument in S. Angelo a Nilo in Naples (see plates 130, 131), the Aragazzi Monument in the Duomo at Montepulciano (see plates 128, 129). and the Jeremiah on the Campanile (see plate 13). Vasari, in his life of Michelozzo, states with reference to the Coscia Monument, that 'la maggior parte fù condotta da lui' ('the greater part was executed by him'). Whereas in his earlier collaborative works Michelozzo seems to have been regarded as a specialist in bronze-casting, in the Coscia Monument only those parts in bronze are the work of Donatello, and

Michelozzo was responsible for the greater part of the marble figure sculpture. Two figures of the Annunciatory Angel and Virgin Annunciate on the tabernacle containing Ghiberti's St Matthew on Or San Michele are perhaps Michelozzo's earliest marble sculptures. The Prato pulpit was commissioned jointly from Donatello and Michelozzo (14 July 1428, see plate 49), and the bronze capital beneath the pulpit was cast by Michelozzo (9 December 1433). With the departure of Donatello for Padua in 1443 Michelozzo became one of the principal sculptors in Florence, where he was responsible for modelling and casting the bronze tomb-slab of Pope Martin V, which was shipped to Rome in April 1445 and installed before the high altar of St John Lateran. He was also responsible for the right-hand door beside the altar in the Sagrestia Vecchia of S. Lorenzo and for the stucco figures of Sts Cosmas and Damian over it (Pope-Hennessy). A bronze statuette of the Baptist in the style employed by Michelozzo on the Sagrestia Vecchia door is in the Museo Nazionale. A full-scale terracotta statue of St John the Baptist in SS. Annunziata, Florence (lower section made up) is undocumented, but may date from c.1450. Michelozzo was also the author of a much discussed marble relief of the Flagellation of Christ in Berlin (destroyed). In old age he is likely to have been responsible for carving or supervising the execution of the eight roundels after classical cameos in the cortile of the Palazzo Medici. One of the reliefs, of the Infant Bacchus, was ascribed to Michelozzo by Lanyi, and the complete series may have been executed in his shop. In the summer of 1445 Michelozzo, along with Maso di Bartolomeo and Luca della Robbia, was engaged to work on the door of the North Sacristy of the Duomo (which had been commissioned in 1437 from Donatello in a contract denounced in 1445). After long delays and repeated changes of plan the door was installed in 1475. The initial documents (15 January 1445-30 June 1447) seem to refer solely to the framing of the door; in these, reference is made to 'Michelozzo di Bartolommeo e chonpa chonduttori

della porta del bronzo della prima sagrestia' ('Michelozzo di Bartolommeo and his assistant executants of the bronze door of the first sacristy'). Michelozzo's name appears again in 1463 and 1464 in connection with the preparation of the reliefs for the door. The completion of the Aragazzi Monument (q.v.) dates from 1437-8. Three half-length terracotta figures of the Virgin and Child and Sts John the Baptist and Augustine on the façade of S. Agostino at Montepulciano date from this or from a rather later time. From the mid-1430s Michelozzo was increasingly active as an architect, and it is in this role that his work has been most closely studied. After working in the 1420s on the Medici church of S. Francesco in Mugello, he was employed (1436-51) on the reconstruction of the church and convent of S. Marco, and (1444-55) on the tribune, atrium, cloister and sacristy of SS. Annunziata. On 11 August 1446 he succeeded Brunelleschi as Capomaestro of the Cathedral, retaining this post till 1451. The most important of the sculptures which he designed at this time are the Cappella del Crocifisso in S. Miniato al Monte (1447-8; no document) and the tabernacle in SS. Annunziata (completed 1448). A silver figure of St John the Baptist for the altar of the Baptistery, now in the Museo dell'Opera del Duomo, dates from this time (commissioned 3 June 1452). From 1444 till approximately 1459 Michelozzo was responsible for the building of the Palazzo Medici, as well as for work at S. Girolamo at Fiesole (after 1451) and for two tabernacles in the church at Impruneta (about 1460; not documented). Later he seems to have been employed on the Palazzo del Banco Mediceo in Milan and the Portinari Chapel in S. Eustorgio; the extent of his responsibility for these structures has been disputed. On 4 May 1462 Michelozzo was summoned to Ragusa to rebuild the Palazzo del Rettore; his contract for this work was renewed on 13 May 1463. In the last part of his life he was also engaged on work in the Palazzo della Signoria in Florence. Michelozzo died in Florence in 1472 (buried 7 October 1472). Despite his record of collaboration, Michelozzo was a sculptor of great significance, the

skeleton of whose strongly classical style may be filled out with Madonna reliefs in marble.

The only marble relief of the Virgin and Child universally accepted as Michelozzo's is a three-quarter-length Madonna relief in the Museo Nazionale, Florence, carved in one with a tabernacle in which the background and the interior of the arch are decorated with a pattern of blue glass inlay. The relief has been dated (Caplow) about 1430, but the rigid folds of drapery are more readily consistent with a dating c.1450-55, when Michelozzo was collaborating with Luca della Robbia at Impruneta. The incisive silhouette (but not the poses of the figures) recalls that in Luca della Robbia's Stemma of the Arte dei Medici e degli Speziali on Or San Michele (c.1464-5).

The nexus of Michelozzo's Madonna reliefs consists of four reliefs in complexes for which he is known, through documents, to have been responsible. These are (i) a half-length Madonna on the Coscia Monument in the Baptistery in Florence (plates 132, 133); (ii) a half-length Madonna on the Brancacci Monument in S. Angelo a Nilo in Naples (plates 44, 130, 131); (iii) a lost marble tondo formerly in the Mendelsohn Collection, Berlin, allegedly from the Aragazzi Monument at Montepulciano (1437-8); (iv) an enthroned Madonna in a relief of the Virgin Blessing Aragazzi in Paradise in the Duomo at Montepulciano. In these reliefs the type of the Child, with deeply carved hair and extended body, is uniform, as is the classical profile of the Virgin with hair parted in the centre and wide-spaced eyes. A number of freely modelled terracotta Madonna reliefs are demonstrably by the author of these carvings: notably a pigmented Virgin and Child in the Museo Bardini (Il Museo Bardini a Firenze, eds. E. Lusanna and L. Faedo, Milan, 1986, no. 172, under a wrong attribution to Donatello) and two related terracotta reliefs in Berlin. Two further groups of modelled reliefs can be tentatively ascribed to Michelozzo. The first consists of a half-length gilded and pigmented Virgin and Child in the National Gallery of Art in Washington and a full-length pigmented Madonna in the same collection. Though the halflength figure is attributed to Ghiberti and the full-length one to Donatello, they are by one hand, and may have been produced c.1420 by Michelozzo. In both, the placing of the Child and the modelling of the Virgin's face and fingers are closely related to the Bardini Madonna. The second group consists of the Madonna Davilliers in the Louvre and the lost original of a cast Madonna from S. Piero a Grado, now in the Museo Nazionale di S. Matteo at Pisa. Numberless reliefs by secondary sculptors, related in iconography to the work of Donatello and Michelozzo, are unattributable.

Bibliography

The work of Michelozzo as a sculptor has not been thoroughly investigated. An outdated monograph by F. Wolff (Michelozzo di Bartolommeo, Strassburg, 1900) deals briefly with aspects of Michelozzo's sculptural activity, as does a well-illustrated volume by O. Morisani (Michelozzo architetto, Turin, 1951). A general, but inadequately probing, overview is given in a published dissertation by H. M. Caplow (Michelozzo, New York, 1977, 2 vols, Ph.D. dissertation, Columbia University, 1969) The documents relating to Michelozzo are published in a notable article by C. von Fabriczy ('Michelozzo di Bartolommeo', Jahrbuch der Preussischen Kunstsammlungen, xxv, 1904, Beiheft, pp. 34-110) and, less accurately, by R. G. Mather ('New Documents on Michelozzo', Art Bulletin, xxiv, 1942, pp. 226-39). These articles should be read in conjunction with an analysis of U. Procacci ('L'uso dei documenti negli studi di storia dell'arte e le vicende politiche ed economiche in Firenze durante il primo Quattrocento nel loro rapporto con gli artisti', Donatello e il suo tempo. Atti dell'VIII Convegno Internazionale di Studi sul Rinascimento, Florence, 1968, pp. 11-39) and further documents published by H. Saalman ('The Palazzo Communale in Montepulciano: an unknown work by Michelozzo', Zeitschrift für Kunstgeschichte, xxviii, 1965, pp. 1-46) and J. H. Beck ('New Notices for Michelozzo', in Renaissance Studies in Honor of Craig Hugh Smyth, ed. E. Borsook, Florence, 1985, ii, pp. 23-35).

For Michelozzo's relations with Ghiberti, see R. Krautheimer (Lorenzo Ghiberti, Princeton, 1956), and for his relations with Donatello articles by H. Gevmüller ('Die architektonische Entwicklung Michelozzos und sein Zusammenwirken mit Donatello', Jahrbuch der Preussischen Kunstsammlungen, i, 1894, pp. 256-9) and C. von Fabriczy ('Der hl. Ludwig und sein Tabernakel an Or San Michele', Jahrbuch der Preussischen Kunstsammlungen, xxi, 1900, pp. 242-61), and H. W. Janson (The Sculpture of Donatello, 2 vols, Princeton, 1957). Michelozzo's part in the bronze door of Luca della Robbia is discussed by A. Marquand (Luca della Robbia, Princeton, 1914), R. G. Mather ('Nuovi Documenti Robbiani', L'Arte, xxi, 1918, pp. 190-209), and J. Pope-Hennessy (Luca della Robbia, Oxford, 1980). Good early discussions of the sepulchral monuments are those of F. Burger (Geschichte des florentinische Grabmals von den altesten Zeiten bis Michelangelo, Strassburg, 1904) and A. Schmarsow ('Nuovi studi intorno a Michelozzo', Archivio storico dell'arte, vi, 1893, pp. 241-55), which are superseded by two admirably documented volumes by R. Lightbown (Donatello and Michelozzo. An Artistic Partnership and its Patrons in the Early Renaissance, 2 vols, London, 1980). For the Brancacci Monument in Naples they may be supplemented with articles by R. di Stefano ('La chiesa di S. Angelo a Nilo e il Seggio di Nido', Napoli nobilissima, iv, 1964, pp. 3-11) and V. Martinelli ('Le compagnia di Donatello e Michelozzo e la "sepoltura" del Brancacci a Napoli', Commentari, xiv, 1963, pp. 211-26). In the extensive literature of the Palazzo Medici roundels special importance attaches to an article by Wester and E. Simon ('Die Relief Medaillons im Hofe des Palazzo Medici zu Florenz', Jahrbuch der Berliner Museen, vii, 1965, pp. 15-91).

The Monument of Cardinal Rainaldo Brancacci

S. Angelo a Nilo, Naples Plates 130, 131

The Brancacci Monument in Naples is described by Vasari in his life of Donatello in the following terms: 'Fece ancora, e fü mandato a Napoli, una sepoltura di marmo per uno arcivescovo, che è in Sant'Angelo di Seggio di Nido; nella quale son tre figure tonde che la cassa del morto con la testa sostengono, e nel corpo della cassa è una storia di bassorilievo, che infinite lode se ne convengono.' ('He also made and sent to Naples a marble tomb for an archbishop, which is in Sant'Angelo di Seggio a Nilo. In this there are three figures in the round which support the sarcophagus on their heads, and on the body of the sarcophagus is a narrative scene in low relief which has attracted infinite praise.') The church of S. Angelo a Nilo was founded by Cardinal Rainaldo Brancacci, and in 1428, after the Cardinal's death, was handed over by his brothers in an unfinished state, along with the adjacent Spedale dei Poveri, to the nobili of the seggio of Naples known as Nido. It was rebuilt in the late fifteenth or early sixteenth century (completed 1507) and was extended in 1535.

The only documentary source for the Brancacci Monument is a Portata al Catasto prepared by Michelozzo in 1427, which refers to three unfinished monuments commissioned from the joint studio of Donatello and Michelozzo. The first of these is the Coscia Monument in the Baptistery in Florence, the second the Brancacci Monument in Naples and the third the Aragazzi Monument at Montepulciano (see plates 128, 129).

There is some doubt as to the date of inception of the Coscia monument, which owes its origin to a clause in Coscia's will (22 December 1419) instructing four executors to provide for the memorial. One of the executors was Giovanni di Bicci de' Medici, and payment for this monument was made through the Banco Mediceo (and not, as indicated by Vasari, personally by Cosimo de' Medici). A record of 28 January 1427 relates to the sale of

four blocks of white marble by the Capomaestro to one of Coscia's executors, Bartolommeo Valori, for use in the tomb. The siting of the monument appears to have been agreed on 9 January 1421, and work on it was under way by 1424. There is an oblique connection between the Coscia and Brancacci monuments, since it was Cardinal Brancacci who had crowned Baldassare Coscia as Pope John XXIII outside S. Petronio in Bologna (10 June 1410), and who was later responsible for his submission to Pope Martin V (3 June 1419).

A cousin of Pope Urban VI, Brancacci was created Cardinal in 1384. Much favoured by Urban's successors, he investigated the Hussite heresy on instructions of Pope John XXIII, whom he supported till the election at the Council of Constance of Pope Martin V, with whom he visited Florence. A figure of great importance in the Curia, he became involved in 1416 in the refoundation of the church and hospital of S. Angelo a Nilo adjacent to his palace in Naples.

The single payment recorded for the Brancacci Monument was also made through the Banco Mediceo. The reference to this tomb in the Portata of 1427 reads as follows: 'La. sepoltura per a Napoli di mess. Rinaldo cardinale de Branchaci dinapoli dobiamo avere fi. ottociento cinquanta di camera e a tutte nostre spese labiano aconpiere econdurre a napoli, lavorianlla a Pisa, stimiamo ne sia fatto il quarto dessa chennabiano perparte di spese aconducere fi. treciento cioè fj. 300 doro oincircha, arbitrare lutile che in essa si possa fare no so essendo tutto adeto chrom'è.' ('One tomb, for Naples, is that of messer Rinaldo cardinal Brancacci of Naples. For this we should receive eight hundred and fifty florins. The tomb is to be completed and despatched to Naples at our expense, and is being prepared at Pisa. We estimate that a quarter of the tomb is complete, etc.') From this we learn that the monument was one quarter complete, and was to be shipped from Pisa (where Donatello and Michelozzo then had their joint studio) to Naples. If the Brancacci Monument was one quarter completed in 1427, and the Coscia Monument was begun soon

after 1421, a period of five or six years may separate the designs of the two tombs. The scheme of the Brancacci tomb, which is placed under a Renaissance tabernacle supported on columns and backed by pilasters, is indubitably Michelozzo's; it has often been observed (Burger, Wolff, and others) that the plan, with its tabernacle and caryatids, is a Renaissance transcription of the traditional Neapolitan sepulchral monument introduced by Tino di Camaino in, e.g., the Mary of Valois Monument in S. Chiara. The tomb originally stood behind the altar in the church, and was transferred to its present position in 1565, when it was replaced by an altarpiece of St Michael by Marco Pino da Siena.

So far as concerns the figure sculpture of the tombs, the share of Donatello in the Coscia Monument is, by common consent, limited to the effigy. The marble sculpture is regarded as the work of Michelozzo and his shop (perhaps with the assistance of Pagno di Lapo Portigiani). Probably the two putti supporting the cartellino (where the design is more inventive than in the lunette or the Virtues beneath) were planned by Donatello. In the case of the Brancacci Monument the relief of the Assumption is universally accepted as the work of Donatello (see plate 44), and the remaining figure sculpture is ascribed to Michelozzo (again with the assistance of Pagno di Lapo Portigiani and other sculptors). Even when allowance has been made for the fact that much of the detail of the Brancacci Monument is unfinished, it must still be admitted that the execution of the figures is generally coarse. It is, however, conceivable that the three caryatids (but not the angels behind the effigy or the figures blowing trumpets) depend from drawings or small wax models by Donatello. The lunette. which shows the Virgin with open right hand pointing downwards and Child holding a long fold of her cloak. has nothing in common with the comparable group by Michelozzo on the Coscia Monument and may also have been designed by Donatello, though the execution is so weak as to deprive it of all artistic quality. The effigy is by Michelozzo, with possible intervention

by Donatello in the head. The historical background of the Brancacci Monument is well dealt with both by Caplow and Lightbown, though I cannot agree fully with the division of hands proposed by either student.

The Aragazzi Monument

Duomo, Montepulciano Plates 128, 129

The monument (now disassembled) of Bartolommeo Aragazzi (d. 1429) was commissioned during Aragazzi's lifetime from the joint studio of Donatello and Michelozzo. A well-known humanist, he was a friend in Florence of Poggio Bracciolini, Niccolò Niccoli and Ambrogio Traversari, and was responsible for discovering, at Sankt Gallen and elsewhere, the texts of a large number of previously unknown Roman poets and writers. He was himself a poet, and in the 1420s, until his death in 1429, he served as secretary of Pope Martin V. He was rich, and at his death his estate comprised, in addition to his house and vigna, the sum of 4,696 ducats (for this see Lightbown). The tomb was set in a chapel to the right of the high altar of the Pieve di S. Maria at Montepulciano, which was demolished and rebuilt in its present form after 1617. It is mentioned for the first time in 1427 in the Catasto return of Michelozzo after the Coscia and Brancacci monuments: '1a. sepoltura per Montepulciano di mess. Bartolommeo da Montepulciano secretario di papa, della quale niuno pregio se fatto se non che quando il lavorio sara fornito, si deve stimare per amici comuni potra essere di maggiore spesa odi minore che non si stimano prima secondo sirimutasse dipensiero. Abiano per fare venire marmi fj. ciento cioe fj. 100.' ('A tomb for Montepulciano of messer Bartolommeo of Montepulciano secretary of the Pope, for which no price has been fixed. When the work is delivered, its value is to be assessed by common friends. It may be of greater or lesser cost than the initial estimate according to whether or not the plan is changed.') In 1430 Michelozzo is known, from a Catasto return prepared by his brother, to have been absent from Florence on account of business at Montepulciano, presumably in

connection with the Aragazzi tomb, and on 30 September 1437 a further contract was agreed between Michelozzo and Aragazzi's heirs in which the sculptor bound himself to complete the tomb within six months ('quod sepulcrum jam diu incepit, et pro majori parte laboraverit . . . infra sex menses tunc proxime futuros complebit et perficiet dictam sepulturam'). From documents of 21 May and 24 July 1438, in which Michelozzo petitions the commune of Montepulciano for help in collecting fees and the town council agrees to act on his behalf, it appears that the sculptor adhered to this schedule. The final payment for the tomb seems not to have been made, and it is mentioned again in Portate al Catasto prepared by Michelozzo in 1457 ('per resto duna sepoltura glifecj e circha annj 20 passatj') and 1467 ('per resto duna cappella fattali et una sepoltura insino nel 1436'). Contributory evidence for the date of the monument is provided by a letter of Leonardo Bruni to Poggio Bracciolini (Leonardi Bruni Aretini Epistolarum Libri VIII, Florence, 1741, ii, pp. 45-6), paraphrased on pp. 34-5, which is referred by H. Baron (Leonardi Bruni Aretino humanistisch-philosophische Schriften, Leipzig, 1928, p. 210) to the year 1430–1. From this material it may be inferred that the monument was commissioned in or before 1427, and that a sum covering the purchase of part of the marble for it had been paid, though work on the monument had not been begun. By 1431 part of the monument (including the architectural framework and the effigy) was either complete or sufficiently advanced to be transferred to Montepulciano. The monument was completed in 1437-8. It is inferred (Procacci) that the greater part of the figure sculpture on the monument dates from after the resumption of work on the tomb in 1437; in view of the short time-interval before its completion, this is improbable. A suggestion (Janson) that work was resumed c.1434 is incorrect. The tomb is mentioned by Vasari as a work of Donatello: 'Appresso, ritornatosene in Toscana, fece nelle Pieve di Montepulciano una sepoltura di marmo, con una bellissima storia' ('On his return to Tuscany, he made a marble tomb

in the Pieve at Montepulciano with a most beautiful narrative relief'), and on account of this an attempt has been made to ascribe the two Angels from the monument jointly to Donatello and Michelozzo. There is no documentary or stylistic warrant for supposing that Donatello intervened in the design or execution of the tomb.

execution of the tomb. Reconstruction of the Aragazzi Monument is complicated (i) by Michelozzo's reference, in his tax return of 1469, to a memorial chapel ('per resto duna cappella fattali') which is not otherwise mentioned in the documents, and (ii) by the claim of Bruni to have seen not only the effigy of Aragazzi but an effigy of Aragazzi's father which was to be placed beside his own ('Atque haec est imago ejus, quam cernis, altera vero parentis, quam juxta se collocari jussit'). The very elaborate account by Lightbown of the Aragazzi Monument is marginally superior to Caplow's, though the latter's includes accurate measurements of the individual sculptures. The classical central figure is accepted by Caplow as a St Bartholomew and is regarded by Lightbown as Christ in Glory, and the two figures described as Virtues are considered by Lightbown to be angels. Lightbown's conventional interpretation of the iconography of the two reliefs is to be preferred to the elaborate heterodox interpretation of Caplow. Moreover, the presence in the tomb of a second effigy, of Bartolommeo's father Francesco Aragazzi, indicated in the letter of Leonardo Bruni, is accepted on good grounds by Lightbown but rejected by Caplow. The monument is now known, from a transcription of a lost bronze tablet, to have been completed in 1438. A pastoral visitation of 1584 records the presence in the Aragazzi Chapel of the tomb 'on the altar itself' and instructions were given that it should be removed. By 1617 this had been done. Its base, therefore, was the relief of putti now on the high altar, which was set on the altar of the chapel and supported the rest of the tomb. The two narrative reliefs seem to have been inserted in the sarcophagus. The pieces of the tomb preserved at Montepulciano (all of which seem to originate from a single monument) comprise: (i) the

recumbent effigy of Aragazzi, (ii) two reliefs, probably from the sarcophagus, showing the Virgin and Child enthroned with members of the Aragazzi family, and Bartolommeo Aragazzi taking leave of his family, (iii) a frieze carved with garlands and putti, from the base of the monument, now built into the high altar of the church, (iv) two allegorical figures in full-length, Justice and Fortitude, and (v) a full-length male figure alternatively identified as God the Father, the Risen Christ, St Bartholomew and St John the Baptist. Two reliefs of adoring Angels in half-length are in the Victoria and Albert Museum, London. The figure of Christ which presides over the tomb is carved in very deep relief, whereas the Justice and Fortitude, which have been separated from the tomb, are completed in the round. In the strip of putti beneath, in the two narrative reliefs of naked Angels, in the Christ on the tomb and on the two supporting figures, heavy use is made of classical motifs. Efforts to reconstruct the monument made by Marcucci and Burger (both reproduced in the latter's volume) are superseded by that of Lightbown. The width of the tomb is established by the base listed as (iii) above. Bruni's letter refers to 'columnae . . . marmoreae . . . & arculi, & hyperstylia'. If interpreted literally, this would suggest that the monument was flanked by columns, not pilasters, and had an arched upper section; it would thus have followed the model of the Brancacci Monument, to which the upper section, as assumed by Marcucci, may also have conformed. The assumption (Marcucci, Burger) that the figure of Christ listed as (v) above was placed behind and above the effigy is probably correct. The outer parts of the wings of the two Angels in London are later additions, and these figures must therefore have been cut by the inner edge of the columns or rear pilasters or by the moulding of a lunette. In the vicinity of the tomb was set a bronze inscription (discovered by Lightbown) with the words:

AMATORI PATRIAE CONSERVATORI REIPVBLICE BAR THOLOMEO DOC TISSIMO APVD MA RTINVM QVINTVM PONTIFICEM MAXI MVM CONSILIORV M OMNIVM PARTICI (sumpto) POSTERI (dedicaverunt),

LUCA DELLA ROBBIA (b. 1399/1400; d. 1482)

From a tax return prepared by Luca della Robbia's father, Simone di Marco della Robbia, it is known that in 1427 Luca was aged 27; he was therefore born in 1399 or 1400. His family had close associations with the Arte della Lana, and seem to have received their name from the colour of a crimson dye, like the Rucellai, who received their patronymic from the wool dye oricello. For such details of his life as we possess we are indebted to Portate al Catasto (for which see J. Pope-Hennessy, Luca della Robbia. 1980, pp. 83-90). Luca matriculated in the Arte dei Maestri di Pietra e di Legname in September 1432, and initially practised as a marble sculptor. By the time of his first documented commission, for the Cantoria over the door of the North Sacristy in the Duomo in Florence, he was already an established artist. Initially he may have been trained in the studio of Nanni di Banco, and it is possible that he worked on the Assumption of the Virgin over the Porta della Mandorla which was left unfinished by Nanni di Banco at his death in 1421. The Cantoria (see plates 74-8) is carved in marble, and there is no evidence that at this time Luca practised in any other capacity than as a marble sculptor. A payment of 1434 shows that Luca della Robbia and Donatello were modelling colossal heads for the gula of the cupola of the Cathedral, Shortly before the completion of the Cantoria, he received a commission (30 May 1437) for five reliefs of the Arts and Sciences for the Campanile, in completion of the series begun by Andrea Pisano; and after the termination of these (10 March 1439) he was employed on marble altars for the Chapels of St Peter and St Paul in the Cathedral (records of 12 April and 20 September 1439). Two sections of the unfinished predella of the Altar of St Peter (the Deliverance of St Peter and the Crucifixion of St Peter) survive in the Museo Nazionale, Florence. The St Peter altar was followed by a marble tabernacle with local enamel inlay in terracotta for the Cappella of S. Luca in S. Maria Nuova, now at Peretola (begun before 20 January 1441, completed 1443) (plate 81). The latest of Luca's

documented works in marble is the Federighi Monument in S. Trinita (see plate 80).

The innovation with which Luca is most closely associated is that of polychrome enamelled terracotta. His earliest documented work in this medium is a Resurrection lunette in the Duomo (1442-5, see plates 85, 86). but it is also employed in the Peretola tabernacle. The Brunelleschan Resurrection relief in the Cathedral was followed by a companion relief of the Ascension (see plates 87, 88), a magnificent free-standing Visitation in S. Giovanni Fuorcivitas at Pistoia (c.1445), the decoration of Michelozzo's Capella del Crocifisso at S. Miniato al Monte (probably executed between 27 June 1447 and 27 March 1448), two Angels bearing candlesticks for the Duomo, now in the sacristy (28 May 1448-5 August 1451), 13 reliefs for Brunelleschi's Pazzi Chapel (see plate 83), a lunette for S. Domenico at Urbino (documented 19 June 1450), two altars to right and left of the tribune in S. Maria at Impruneta (probably executed in loose association with Michelozzo. c.1452-56), the finer containing a relief of the Crucifixion and a predella with flying angels, and the ceiling of the chapel of the Cardinal of Portugal in S. Miniato al Monte (1461-6). One of Luca's last major works is an altarpiece in the chapel of the Palazzo Vescovile at Pescia, possibly made for S. Biagio at Altopascio after 1472. In many of the later works Andrea della Robbia (b. 1435), the son of Luca's brother Marco, seems to have played some part. Luca also executed non-figurative heraldic sculptures, notably the Stemmi of the Maestri di Pietra e di Legname, the Arte dei Medici e degli Speziali and the Mercanzia at Or San Michele, of King Renè of Anjou (from the Villa Pazzi, now in the Victoria and Albert Museum, London), and of Jacopo de' Pazzi and Maddalena de' Serristori in the Palazzo Serristori, Florence. One of the most popular products of Luca della Robbia were polychrome enamelled reliefs of the Virgin and Child. One of the earliest of these, distinguished by many firing cracks, is the Friedrichstein Madonna at Buffalo, which leads in turn to a relief at Copenhagen, to the S. Pier

Buonconsiglio lunette, now in the Palazzo di Parte Guelfa, the Urbino lunette (c.1450), the Trebbio lunette in Berlin (1451–5), a Madonna in the Spedale degli Innocenti (c.1445–50), a Madonna in S. Michele at Lucca, and the Altman Madonna in New York (c.1455–60). From about 1450 Luca seems to have designed reliefs for reproduction.

Luca also worked sporadically in bronze. The earliest of his bronze sculptures are two Angels from the Cantoria (Musée Jacquemart-André, Paris), and the most important is the bronze door of the North Sacristy of the Cathedral. The project was revived at the end of 1445, and models were prepared by Michelozzo, Luca della Robbia and Maso di Bartolommeo, who were commissioned (February 1446) to execute a door of two wings, each with 12 medallions of Prophets in the frame and containing five reliefs with three figures each, representing the Virgin and Child, St John the Baptist, the four Evangelists and the four Doctors of the Church. The principal difference between the project outlined in the contract and the door as it exists today is that in each relief the central figure was to have been placed in a protruding tabernacle decorated with damascening. Part of the door, probably the framework, was cast by February 1447. After the death of Maso di Bartolommeo (1457) work was suspended till 1461, and in August 1464 a new contract was made with Luca della Robbia to complete the door. The concluding payments to Luca date from 1468 and 1469. The share of Michelozzo in the door has been much discussed, and it is likely that he was responsible for planning the frame, though the modelling of the projecting heads is fully consistent with the style of Luca.

Bibliography

For long the standard volume on Luca della Robbia's work was the fundamental study of A. Marquand (*Luca della Robbia*, Princeton, 1914). A slighter volume by L. Planiscig (*Luca della Robbia*, Florence, 1948) adds little to Marquand's conclusions in a factual sense. Both books are superseded by J. Pope-Hennessy (*Luca della Robbia*, Oxford,

1980). A sensitive and admirably illustrated study by G. Gentilini (I Della Robbia. La scultura invetriata nel rinascimento, Florence, 1993) contains a useful section on Luca, but does not deal systematically with the marble sculptures. Of the periodical articles some importance attaches to G. Cantino Wataghin ('Archeologie e "archeologie". Il rapporto con l'antico fra mito arte e ricerca', Memoria dell'antico nell'arte italiana, i, 1984, ed. S. Settis, Turin, pp. 169-217), and R. L. Mode ('Adolescent Confratelli and the Cantoria of Luca della Robbia', Art Bulletin, Ixviii, 1986, pp. 67-71). The most distinguished of these studies, by C. Del Bravo ('L'Umanesimo di Luca della Robbia', Paragone, xxiv, no. 285, 1973, pp. 3-34), is in effect the first devoted to Luca della Robbia's antique sources. A more systematic account of Luca's debt to sarcophagus reliefs is given by Pope-Hennessy. Four marble reliefs wrongly published by L. Bellosi ('Per Luca della Robbia', Prospettiva, no. 27, 1981, pp. 62-71) and C. Avery ('Three Marble Reliefs by Luca della Robbia', Museum Studies: the Art Institute of Chicago, viii, 1976, pp. 7-37) are not by Luca della Robbia and include one forgery. Of special importance is an article by H. Horne ('Notes on Luca della Robbia', Burlington Magazine, xxviii, 1915-16, pp. 3-7). Some supplementary documents are published by R. G. Mather ('Nuovi Documenti Robbiani', L'Arte, xxi, 1918, pp. 190-209). An excellent analysis of the Cantoria is supplied by G. Brunetti (in L. Becherucci and G. Brunetti, Il Museo dell'Opera del Duomo a Firenze, i, Florence, 1969, pp. 277-80) and its reconstruction is discussed by B. Marrai (Le Cantorie di Luca della Robbia e di Donatello, Florence, 1900). For the original form of the Federighi Monument, see A. Parronchi ('L'aspetto primitivo del Sepolcro Federighi', Paragone, no. 179, 1964, pp. 49-52) and for its history and documentation H. Glasser ('The Litigation Concerning Luca della Robbia's Federighi Tomb', Mitteilungen des Kunsthistorischen Institutes in Florenz, xiv, 1969, pp. 1-32). The documents relating to the ceiling in the Chapel of the Cardinal of Portugal are transcribed and discussed by F. Hartt, G. Corti and C. Kennedy (The Chapel of the Cardinal of Portugal 1434–1459 at San Miniato in Florence, Philadelphia, 1964). Written before the researches of Marquand were made available, M. Cruttwell's Luca and Andrea della Robbia and their Successors (London and New York, 1902) provides a readable account of the activity of the Della Robbia; many of the judgements in it are, however, at fault.

Cantoria

Museo dell'Opera del Duomo, Florence Plates 74–8

The Cantoria or Singing Gallery of Luca della Robbia (plate 75), which was originally set over the doorway of the North Sacristy of the Cathedral and is now in the Museo dell'Opera del Duomo, is described by Vasari (1569) in the following terms: 'Perlochè i detti Operai, che oltre ai meriti di Luca furono a ciò fare persuasi da messer Vieri de' Medici, allora gran cittadino popolare, il quale molto amava Luca, gli diedero a fare, l'anno 1405 [sic], l'ornamento di marmo dell'organo, che grandissimo faceva allora far l'Opera per metterlo sopra la porta della sagrestia di detto tempio. Della quale opera fece Luca nel basamento in alcune storie. i cori della musica che in vari modi contorno; e vi mise tanto studio e così bene gli riuscì quel lavoro, che ancora sia alto da terra sedici braccia, si scorge il gonfiar della gola di chi canta, il battere delle mani di chi regge la musica in sulle spalle de' minori, ed in somma diverse maniere di suoni, canti, balli ed altre azioni piacevoli che porge il diletto della musica. Sopra il cornicione poi di questo ornamento fece Luca due figure di metallo dorate; cioè due Angeli nudi, condotti molto pulitamente, siccome è tutta l'opera, che fù tenuta cosa rara; sebbene Donatello, che poi fece l'ornamento dell'altro organo che è dirimpetto a questo, fece il suo con molto più giudizio e pratica che non aveva fatto Luca, come si dira a suo luogo: per avere egli quell'opera condotta quasi tutta in bozze e non finita pulitamente accionchè apparisse di lontano assai meglio, come fa, che quella di Luca, la quale sebbene è fatta con buon disegno e diligenza: ella fa nondimeno con la sua pulitezza e

finimento che l'occhio per la lontananza la perde e non la scorge bene, come si fa quella di Donatello quasi solamente abbozzata.' ('The Operai, being thus made cognisant of Luca's merits and persuaded by messer Vieri de' Medici, an important and popular citizen of the time, who greatly loved Luca, commissioned him in 1405 to undertake the marble decoration of the organ, which was being built on a large scale to be placed over the door of the sacristy of the church. For the base of this work Luca made scenes representing choirs of music singing in various ways; and so much study did he put into them, and so successful was his work, that although it is sixteen braccia from the ground, one can see the swelling of the throats of the singers, the beating of the hands of those directing the music on the shoulders of the lesser figures, and in short the various ways of playing, singing, dancing and other agreeable actions which constitute the charm of music. Above the cornice of this decoration Luca made two figures of gilded metal, that is two naked angels, beautifully finished, as indeed is the whole work, which was considered something exceptional. It is true that Donatello, who afterwards did the decoration of the other organ opposite this one, carried out his task with much more judgement and skill than Luca, as will be said in the proper place, since he did almost the whole of the work like a sketch and did not finish it carefully in order that it should appear better from a distance, as it does, than that of Luca. Though Luca's is skilful and well designed, the eye from a distance loses it because of its polish and finish, and perceives it less clearly than that of Donatello, merely sketched-out as the latter is.')

The Cantoria was taken down in 1688, when its reliefs were utilized as a parapet for the pulpit in the choir, was later transferred to the Opera del Duomo and in 1822 was placed in the Uffizi. In 1841 the consoles (which had been left in position in the Duomo) were also removed, and in 1883 a conjectural reconstruction of the Cantoria was attempted. The principal objection to this reconstruction (Marrai, Marquand) was that the reliefs in the upper part of the Cantoria were

separated by wide single pilasters, and not, as in the original, by linked pilasters. A section of the original linked pilasters was recovered in 1899 and a section of the upper moulding was found in 1941. As it was planned by Luca della Robbia, the Cantoria consisted of the gallery proper, the front of which was decorated with four reliefs; at each end was a narrow relief. This was supported on five consoles, between which were four further reliefs. The ten figurated reliefs illustrate Psalm CL, and show (at the ends) two panels with singing boys (Alleluia), (front of upper section, left to right) trumpeters (Laudate eum in sono tubae), players on the psaltery (Laudate eum in psalterio), players on the cithara (et cithara), drummers (Laudate eum in timpano), (front of lower section, left to right) choral dancers (et choro), players on the organ and harp (Laudate eum in chordis et organo), tambourine players (Laudate eum in cymbalis benesonantibus), and cymbal players (Laudate eum in cymbalis jubilationis). The two bronze Angels described by Vasari are in the Musée Jacquemart-André, Paris (first identified by E. Bonnafé, Catalogue de la vente E. Piot, Paris, Mai 1890, no. 13); these show traces of gilding. The left ear and temple of the Angel with head turned over its left shoulder are unfinished.

The initial contract for the Cantoria does not survive, but the progress of the work can be traced through payments which run from 4 October 1431 to August 1438, when the gallery had already been set in position over the sacristy door ('è posto e murato nella chiesa maggiore sopra l'uscio della sagrestia di verso i Servi'). It is established from documents that part of the cornice was in course of manufacture on 29 April 1432, and a payment of the same year (29 November 1432) was made 'pro faciendo tabulas perghami'. By 26 August 1434 two large and two small figurated reliefs had been carved ('Item similis modum et forma extimaverunt et extimatum fecerunt quatuor petia seu quatuor petiis storiarum cuiusdam perghami locati luce simonis marci della robbia, videlicet duo maiora et duo minora'). For the large reliefs Luca received fl. 60 each and for the smaller fl. 35. On 22 April 1435 it was agreed that the price paid for certain

reliefs should be increased on the ground that more time and greater work had been involved in them than previously. and that they were better and more beautiful than the earlier reliefs ('Prefati operarii . . . considerantes dictum Lucam fecisse certas alias storias dicti perghami que nondum fuerunt extimate et in quibus maiorem laborem et longius tempus misit, et quod, in magisterio, dicte storie quas facit ad presens sunt pulcriores ac meliores'). The new rate of payment agreed upon was fl. 70 for the larger and a proportionately smaller sum for the smaller reliefs. The total sums paid to Luca in connection with the Cantoria were fl. 872. For the full documentation of the Cantoria see G. Poggi (Il Duomo di Firenze, 1909, i, nos. 1240-85), and J. Pope-Hennessy (pp. 11-29, 225-31). All the material relating to the Cantoria is transcribed and discussed in the latter book.

In the absence of the initial contract for the Cantoria it is impossible to determine how far Luca della Robbia was himself responsible for designing the architectural unit in which the figurated reliefs are set. From other works in which architectural features are incorporated (e.g. the Peretola tabernacle and the Federighi Monument), it does not appear that his capacity as a designer was so great as to permit him to plan an architectural work of such originality and on so large a scale, and the design and detail suggests either that the Cantoria was designed by Brunelleschi or that Brunelleschi was an active participant in the designing stage. The figurated reliefs show remarkable variations of style and scale, and with the help of the published payments these can in large part be explained. Since there are only two smaller reliefs on the Cantoria, the Alleluia reliefs (plate 76) at the end of the gallery, these must have been carved before 26 August 1434. It may be conjectured that the two large reliefs completed at this time were the Players on the Cithara (where the figures, and particularly the children in the foreground, are on a small scale) and the Players on the Psaltery (where the figures and children are somewhat larger, though less large than the full-scale reliefs). The document of 22 April 1435 states specifically that more work was

involved in the more recent reliefs, and this can have been due only to technical change in the form of deeper undercutting by means of which the reliefs would register more clearly from the ground. This explanation is confirmed by the fact that the reliefs with large figures (e.g. the Drummers and the Cymbal Players) are more deeply carved. In these, moreover, interest in movement, resulting from experience of the reliefs of Donatello's Cantoria or of the Prato pulpit, is more evident. It has been claimed (Marquand) that the background of the reliefs was painted blue, that certain details were gilded, and that the hair and eyes of the putti were pigmented or toned. There is, however, no reference in documents to the painting or gilding of the reliefs, and none is visible in them today. The style of the reliefs is self-consistent save for that of the Choral Dancers between the consoles where the freedom of movement looks forward to the work of Bernardo Rossellino.

When the ten reliefs are examined chronologically, one conclusion is mandatory: that they were planned with the advice of a musician in a relief style based, by intention not by accident, on Roman sarcophagus reliefs. Their style becomes intelligible only if it is assumed that the decision to commission the organ loft was taken in the late 1420s and that Luca della Robbia before 1431 visited Rome in order to familiarize himself not simply with a wider range of sarcophagus reliefs than was available in Tuscany, but more broadly with the syntax of Roman sculpture. The epigraphy of the inscriptions, or those parts of them that survive, is strictly classical. Across the front there originally ran the first two verses of the Psalm (of which only the words IN V(IR)TVTIB(VS)EI(VS). LA(VDATE) EV(M) S(ECVNDVM) survive in the original. On the central band are the third verse and the first half of the fourth, and on the lowest band beneath the consoles is the remainder of the Psalm from the second half of the fourth verse to the sixth. The verb Laudate is reduced to the letters LA with a sprig of foliage across them. The style of the lettering is the majuscule formata developed by Poggio Bracciolini and Niccolò Niccoli.

The Resurrection

Duomo, Florence Plates 85, 86

The enamelled terracotta relief of the Resurrection in the lunette over the entrance to the North Sacristy of the Cathedral was commissioned from Luca della Robbia on 21 July 1442: 'Item locaverunt Luce Simonis della Robbia, scultori, ad faciendum in archo supra sacrestiam sui perghami Resurrexionem Domini in terra cotta invetriata prout videntur alia laboreria fieri et secundum designum factum et melius si melius fieri potest . . . Presentibus Filippo Brunelleschi, Ridolfo (Lotti), Andrea Lazeri, Simone Laurentii et aliis.' ('They commissioned Luca di Simone della Robbia, sculptor, to make in the arch over the sacristy where his singing gallery is, a Resurrection of Our Lord in enamelled terracotta . . . according to the design already made and better if this is possible.') An interim payment for the work took place on 18 January 1445, and on 26 February 1445 Luca received 'L. 440 sunt pro recta et integra solutione unius laborerii invetirati (in quo est Resurrexio Domini nostri) facti et positi in prima sacrestia'. By this time the relief had been set in place. The figures in the relief are white, as are the sarcophagus, trees and foreground, and the background is blue; no use is made of other colours save in the cloud (light blue), the eyes (dark pupils and yellow irises in the Christ, grey-blue irises in the angels), and the hair and wings of the Angels, the nimbus of Christ and the glory, where surface gilding is employed. The composition has been wrongly related (by Marquand) to the Resurrection on Ghiberti's first bronze door and to the Resurrection window designed by Uccello. It is, however, autonomous, and constitutes the first Renaissance reinterpretation of the Resurrection of Christ.

The Ascension

Duomo, Florence Plates 87, 88

The enamelled terracotta relief of the Ascension in the lunette over the entrance to the South Sacristy of the Cathedral was commissioned from

Luca della Robbia on 11 October 1446: 'Unam storiam terre cocte Invetriate illius materie qua est illa posita in arcu sacristie que storia debet esse vid. Ascensio dni nri Yhu XRI cum duodecim figuris apostolorum et matris ejus virginis marie et quod mons sit sui coloris arbores etiam sui coloris et secundum disegnum factum in quodam modello parvo' (for this document, which is incompletely transcribed by Marquand following Runohr, see Pope-Hennessy). ('A scene in enamelled terracotta of the same material as that in position in the arch over the sacristy. which shall have as its subject the Ascension of Our Lord Jesus Christ with eleven figures of Apostles and His mother, the Virgin Mary, the mountain to be of its own colour and the trees of their own colour, following the design made in the little model.') Interim payments for the work are recorded on 23 December 1450 and 30 June 1451, and on 5 July 1451 the completed relief was valued by Bernardo Rossellino and Pagno di Lapo Portigiani at L. 500. The figure of the Ascending Christ shows some affinities both with the Christ of Uccello's Resurrection window and with that of Ghiberti's Resurrection relief, and the style is less monumental and less classical than that of the earlier lunette. Grey-green glaze is employed on the surface of the hill, and darker green glaze in the foliage, and in the heads the use of polychromy is not, as in the Resurrection, limited to the iris of the eye, but extends to the stippled blue eyelashes and eyebrows.

Apostle Roundels

Pazzi Chapel, S. Croce, Florence Plate 83

There is no documentary reference to the 13 enamelled terracotta roundels by Luca della Robbia in the Pazzi Chapel. The construction of the chapel was begun in 1429 by Brunelleschi, and by 7 January 1443 was so far advanced that Eugenius IV 'desinò nella camera d'Andrea de' Pazzi a fatta fare sopra al Capitolo di nuovo fatto' ('dined in the room which Andrea de' Pazzi has caused to be built over the newly constructed Chapter House'). On his death (19 October 1445) Andrea de' Pazzi

bequeathed a sum for the completion of the chapel, and in 1451 agreement was reached between his sons on the continuance of this work, which was still in progress till after 1457 but was completed by 1469. The enamelled terracotta decorations of the chapel (excluding the cupola of the atrium) comprise (i) a circular relief of St Andrew over the entrance, (ii) four circular reliefs of the Evangelists in the pendentives of the interior, and (iii) 12 circular reliefs of the Apostles on the walls. Vasari states that Luca della Robbia 'fece tutti l'invetriati di figure che dentro e fuori vi si veggiono' ('made all of the figurated enamelled terracottas which are to be seen inside and out'). The four pendentive reliefs are distinct in style from the remaining 13 roundels, and were not modelled by Luca della Robbia. The Apostle reliefs in the interior show (East wall, left to right) Sts Matthew, Peter, John the Evangelist and James the Great, (South wall) Sts Andrew and James the Less, (West wall) Sts Simon, Thaddeus, Thomas and Philip, (North wall) Sts Matthias and Bartholomew. Though attempts have been made to ascribe the Apostle roundels to a late date (1450-60 M. Reymond Les Della Robbia, Florence, 1897; 1470-8 Bode), there is a high degree of probability that they were produced c.1445-50 (Pope-Hennessy, Gentilini), since their style finds its closest point of reference in the Resurrection lunette in the Cathedral. The colour range also supports this view. Marquand correctly observes that the figures of Sts Matthew, Peter, John the Evangelist and James the Great are set on blue grounds representing the seven circles of heaven, whereas the remaining Apostles are set on neutral blue grounds. All of the reliefs are slightly concave, whereas the pendentive reliefs are flat. The background apart, colour is limited to yellow irises, dark blue round the pupils and in the eyelashes and eyebrows, gilded haloes and auras of gold rays. The St Peter differs from the other Apostle roundels in its viewing point, its striated halo and its archaic head, as well as in the faulty glazing of its right hand. The decoration of the portico must date from after the completion of the cupola (1461), and the roundel of St Andrew over the entrance must, therefore, be later in date than the other roundels. The roundels of Evangelists inserted in the pendentives appear to have been modelled by Donatello after his return from Padua in 1453 (see J. Pope-Hennessy, 'The Evangelist Roundels in the Pazzi Chapel', *The Study and Criticism of Italian Art*, New York and Princeton, 1980, pp. 106–18), and though unorthodox in colour range were glazed in the Della Robbia shop.

The Monument of Benozzo Federighi

S. Trinita, Florence Plate 80

The tomb of Benozzo Federighi, Bishop of Fiesole (d. 27 July 1450), is described by Vasari: 'Fece ancora per messer Benozzo Federighi vescovo di Fiesole, nella chiesa di San Brancazio, una sepoltura di marmo, e sopra quella esso Federigo a giacere ritratto di naturale, e tre altre figure. E nell'ornamento dei pilastri di quell'opera dipinse nel piano certi festoni e mazzi di frutti e foglie si vive e naturali che col pennello in tavola non si farebbe altrimenti a olio: ed in vero questa opera è maravigliosa e rarissima, avendo in essa Luca fatto i lumi e l'ombre tanto bene, che non pare quasi che a fuoco ciò sia possibile.' ('For messer Benozzo Federighi, bishop of Fiesole, he made a marble tomb in the church of S. Pancrazio. On this is the lifelike recumbent effigy of Federigo, and three other figures. In the ornamentation of the pilasters of this work he painted on the flat some festoons and bunches of fruit and leaves so lifelike and so natural that they could not be painted better on panel in oil. In truth this work is most wonderful and rare, for Luca has rendered the lights and shades so well that it would seem impossible to obtain such results in glaze.') The tomb was constructed on the commission of Federigo di Jacopo Federighi for a position on the north wall of the transept beside the Federighi Chapel in S. Pancrazio, was later moved to a site by the side door, was transferred in 1808 to the Federighi church of S. Francesco di Paola, and was finally set up in its present position in S. Trinita in

1896. The monument was originally installed at some distance from the ground, like that of Orlando de' Medici in SS. Annunziata (Glasser and Corti). The original painted pilaster supports are shown in an eighteenth-century drawing in the Sepoltuario Baldovinetti (Bibl. Riccardiana, f.134) identified by Parronchi. On 2 May 1454 Luca della Robbia bound himself to complete the tomb in two years and ten months. Documents establish that Federigo di Jacopo Federighi was dissatisfied with the tomb, and an appeal was made by both parties to the Tribunale di Mercanzia. In the course of this Luca della Robbia declared to the tribunal (16 February 1458) that 'decta sepultura già fa uno anno fù facta et compiuta interamente', and the tomb must therefore have been completed early in 1457. Some light is thrown on the genesis of the monument by a statement of Federighi's procurator that 'insino dell'anno 1454 et a di 2 di magio esso Federigo aluoghò a Lucha di Simone della Robia maestro d'intaglio a fare una sepoltura e rilevo di marmo con fogliami messi a oro e diversi colori invitriati intorno a uno quadro di braccia 41/2 o cira, nel quale a essere decta sepultura suvi il corpo d'un Vescovo di rilevo di marmo con altre figure et adornamenti come appariscie per uno disegno di mano di Giovanni di ser Paulo'. ('On 2 May 1454 the aforesaid Federigo commissioned Luca di Simone della Robbia, sculptor, to make a tomb in relief in marble with foliage round it enamelled in gold and other colours in the form of a square of approximately four and a half braccia, and inside it the body of a bishop in relief in marble with other figures and ornaments as are seen in a drawing by the hand of Giovanni di ser Paolo.') On 21 July 1459 the sculptor Buggiano was appointed 'spetialiter et nominatim ad videndum dictum opus jam factum si in aliquo est defectivum seu si quid in eo deficit et tali defectum declaran dum integram monetur' ('expressly and specifically to see whether the work now completed is deficient in any respect'). A month later Buggiano reported that the tomb was in no way defective, and recommended that it should be gilded under his own

direction and at the joint expense of

Luca della Robbia and Federighi. The mitre, the edge of the chasuble, the pillow and bier-cloth, the hair and wings of the Angels, and the three haloes were to be gilt. Traces of colour are noted by Marquand (now almost imperceptible) on the eyes and eyebrows of the Angels; the haloes show traces of gilding. The tomb consists of a marble sarcophagus surmounted by the sepulchral effigy, with, behind, marble reliefs of the dead Christ, the Virgin and St John. The sarcophagus, with its laurel wreath containing the inscription: R.P. / BENOTTI DEFEDE / RIGIS EPI FESVLANI. / QVI VIR INTEGERIMAE / VITAE SVMA CVM LAVDE / VIXIT. ANNO QVE / M.CCCCL. DEFVN / CTVS EST, recalls that of Ghiberti's Arca of the Three Martyrs of 1428 (Museo Nazionale, Florence), while the effigy and angels seem to have been influenced by those of Bernardo Rossellino's Bruni Monument in S. Croce. The frieze (which includes the Federighi arms in the upper corners) is composed as a mosaic of small pieces of polychrome enamelled terracotta set on a glazed gold ground. It has been suggested that the design of this part of the tomb is due to the painter Baldovinetti (R. W. Kennedy, Alesso Baldovinetti, New Haven, 1939, pp. 81–7); there is no documentary support for this view. An analysis, printed by Marquand, shows that gold was applied in the form of paint to the terracotta, which was then covered with a yellowish glaze. The only point of reference for the technique of the frame in Luca's oeuvre occurs on the Stemma of the Arte de' Maestri di Legname on Or San Michele.

Stemma of the Arte dei Medici e Speziali

Or San Michele, Florence Plate 80

The three circular stemmi made by Luca della Robbia for positions above the guild niches at Or San Michele comprise (i) the Stemma of the Arte dei Maestri di Pietra e Legname, above the niche containing Nanni di Banco's Quattro Santi Coronati on the north side of the oratory, (ii) the Stemma of the Arte della Seta, above the niche containing Baccio da Montelupo's St John the Evangelist

by the commission for the tomb of the

on the south side of the oratory, and (iii) the Stemma of the Arte dei Medici e Speziali, above the niche containing Niccolò di Pietro Lamberti's Madonna della Rosa also on the south side. The first is a flat design in polychrome enamelled terracotta, the second (executed in association with Andrea della Robbia) is a figurated relief showing two putti supporting a doorway, and the third contains a representation of the Virgin and Child enthroned between lilies. There is no documentary evidence of the date of any of the emblems, and the Madonna is plausibly assigned by Marquand (on account of the relation of the moulding of the throne to mouldings in the Chapel of the Cardinal of Portugal) to the bracket 1455-65. The rich polychromy (hair yellow, robe violet with a yellow neckband and green sleeves, mantle blue with green lining, back of throne decorated with whitecentred yellow quatrefoils set against cruciform green fern-leaves) tends to corroborate this relatively late date. The stem is conjecturally dated c. 1440-45 (Bode, Gentilini), c.1455-60 (Marquand, Paatz) and c.1465 (Pope-Hennessy). The stemma is likely to be a replacement for an earlier painted original. As noted by Marquand, 'the outlines of the plants and flowers are incised, and the interspaces are filled with gold beneath the glaze'. This invalidates the proposal for an early dating.

The Four Cardinal Virtues

S. Miniato al Monte, Florence Plates 91, 92

The Chapel of the Cardinal of Portugal in S. Miniato al Monte (see plates 146-9) was begun in 1460 from a model by Antonio Manetti (payment of 7 June 1460) and dedicated in 1466. The decoration of the ceiling is ascribed by all early sources to Luca della Robbia; this tradition is confirmed by a document known to G. Lami (Sanctae ecclesiae florentinae monumenta, i, 1758, pp. 583-4): 'Altra scritta finalmente stipulata ne' 14 Aprile 1461 ho veduta col famoso Luca di Simone di Marco della Robbia per i lavori da farsi di terra cotta della Cupola di essa Cappella del Cardinale, per il prezzo di fiorini 150 larghi, ove

esso Luca si soscrive.' ('Finally I have seen another document of 14 April 1461, signed by Luca di Simone di Marco della Robbia, providing for the work in terracotta to be underaken in the cupola of the chapel of the Cardinal, for the price of 150 large florins'.) The original of this document is untraced. Payments to Luca della Robbia for the ceiling are recorded on 9 April, 13 May, 6 July and 21 July 1462. It was presumably complete by 6 August 1462, when a payment for gilding the ceiling was made to a painter Giovanni d'Andrea. It has been inferred (Hartt) that work on the ceiling was not started 'in earnest' before March 1462, and that the work was therefore completed in four to five months. This is improbable. The ceiling consists of five circular reliefs, in the centre the Holy Ghost surrounded by seven candlesticks representing the seven gifts, and at the corners facing reliefs of Prudence and Justice, and Fortitude and Temperance. The reliefs, which are slightly concave, are surrounded by variegated blue frames and are set in a pattern of large tiles decorated with cubes of green, yellow and dark violet. The hand of Andrea della Robbia has wrongly been detected (Cruttwell, Bode) in the relief of Temperance.

Bernardo Rossellino

(b. 1409; d. 1464)

Bernardo Rossellino was born at Settignano in 1409–10. His father, Matteo Gamberelli, matriculated in the Arte dei Maestri di Pietra e di Legname in 1399. His elder brother Domenico (b. 1402-5) and his younger brothers Giovanni (b. 1412-13), Tommaso (birth date uncertain) and Antonio (b. 1427-8) entered their father's Guild and became participants in the Rossellino workshop. In 1433 he executed a tabernacle (lost) for SS. Fiora e Lucilla at Arezzo. In 1433 he was commissioned to undertake the architectural facing of Palazzo della Fraternità at Arezzo, and in 1434 he is documented as carving the relief of the Madonna della Misericordia with kneeling figures of Sts Lorenzo and Pergentino and statues of Sts Gregory and Donatus. He undertook this work with three assistants from his father's shop, one of whom has been conjecturally identified as his brother Domenico. In 1436-8 he executed a tabernacle for the Badia, Florence, from which only an eagle console and a section of the architectural entablature survive. Between 30 December 1441 and 11 February 1444 he was employed on work for the Duomo in Florence. and on 20 January 1443 he served as a member of a commission dealing with the stained-glass windows of the Cupola of the Duomo and the intarsia decoration of the Sagrestia dei Canonici. In 1445-6 he was commissioned to undertake the tomb of Leonardo Bruni in S. Croce, Florence (see plates 134, 135, 140). In 1446-7 he carved an Annunciatory Angel and Virgin Annunciate for the altar of the Compagnia dell'Annunziata in S. Stefano at Empoli (now in the Museo della Collegiata) and a marble doorway for the Sala del Concistoro in the Palazzo Pubblico in Siena; this doorway is important by reason of its early date, and anticipates the later commissions to Benedetto da Majano for doorways for the Palazzo della Signoria in Florence and to Desiderio da Settignano for the doorway of S. Maria Novella. The commission for a tabernacle for the church of S. Egidio dates from 1449 (see plates 98, 99), and was followed in 1451

Beata Villana in S. Maria Novella (see plate 136). From December 1451 till May 1453 Rossellino was employed in Rome by Pope Nicholas V as 'ingegniere di Palazzo', designing the apse of St Peter's, restoring the church of S. Stefano Rotondo, and undertaking much other work. A number of sepulchral monuments date from the last decade of Rossellino's life; among these are the tombs of Orlando de' Medici in Sts Annunziata, Florence (1456-7) (where Rossellino was also employed on other work between 4 April and 6 November 1462), of the Beato Marcolino da Forlì now in the Pinacoteca Communale at Forlì (1458) (extensive intervention by Antonio and a hand probably to be identified as Giovanni Rossellino's), of Neri Capponi in S. Spirito, Florence (1458), of Giovanni Chellini in S. Domenico at S. Miniato al Tedesco (1462-4), and of Filippo Lazzari in the Duomo at Pistoia (commissioned 20 April 1462; execution principally by Antonio Rossellino and assistants). He also participated in the execution of Antonio Rossellino's tomb of the Cardinal of Portugal (see plates 146-9). From 1460 till 1 June 1463 Bernardo Rossellino was extensively employed by Pope Pius II at Pienza in connection with the building of the Cathedral and the Palazzo Piccolomini; along with the interior of the Palazzo Rucellai in Florence these form his main achievement as an architect. Concurrently, from 1461 until his death on 23 September 1464, he was Capomaestro of the Duomo in Florence. Bernardo Rossellino's productivity seems to have been made possible by the use in his workshop of models provided by the master. There is documentary evidence that a model for the Lazzari tomb was made before 1450, but was completed by Bernardo's brothers after his death. The model for the tomb of Orlando de' Medici was used on other occasions in the master's shop.

Bibliography

The standard monograph on Bernardo Rossellino is a well illustrated volume by A. Markham Schulz (The Sculpture of Bernardo Rossellino and his Workshop, Princeton, 1977). This book is fully

documented, though its qualitative judgements are not always sound. It superseded the earlier monographs on Bernardo Rossellino by M. Tyskiewicz (Bernardo Rossellino, Florence, 1928) and L. Planiscig (Bernardo und Antonio Rossellino, Vienna, 1942). The former is written in Polish, but is valuable for its documentation, which includes some material not at the time available elsewhere. A summary of the main points made in the book will be found in a review by C. Kennedy (Rivista d'arte, xv, 1933, pp. 115-27). Of the periodical literature of Bernardo Rossellino special importance attaches to articles by C. von Fabriczy ('Ein Jugendwerk Bernardo Rossellinos und spätere unbeachtete Schüpfungen seines Meissels', Jahrbuch der Preussischen Kunstsammlungen, xxi, 1900, pp. 33-54, 99-113, M. Weinberger and U. Middeldorf ('Unbeachtete Werke der Brüder Rossellino', in Münchener Jahrbuch für bildende Kunst, v, 1928, pp. 85-92), and M. Salmi ('Bernardo Rossellino ad Arezzo', in Scritti di storia dell'arte in onore di Ugo Procacci, Milan, 1977, i, pp. 254-61. Some interesting material related to Bernardo Rossellino's work in Rome is published by F. Cagliotti ('Bernardo Rossellino a Roma: Stralci del Carteggio mediceo', Prospettiva, no. 64, 1991, pp. 49-59; no. 65, 1992, pp. 31-43). On his work as an architect, see L. Finelli (L'umanesimo giovane. Bernardo Rossellino a Roma e a Pienza, Rome, 1984).

Tabernacle

S. Egidio, Florence Plates 97–9

There are records of three tabernacles executed by Bernardo Rossellino. The first of these, carved in the first half of 1435 for the Badia of Sts Fiora and Lucilla at Arezzo, has been wrongly identified (Fabriczy) with a tabernacle from the workshop of Benedetto da Majano still existing in the church. The second was carved between September 1436 and June 1437 for the sacristy of the Badia in Florence; the eagle console and part of the architrave of this tabernacle exist in the cloister of the Badia (Weinberger and Middeldorf, Tyskiewicz). The third is in the church

of S. Egidio in Florence; payments for this are recorded between 11 February and 23 April 1450, and the construction of the tabernacle was presumably completed in the first half of this year since between 30 July and 27 November 1450 Ghiberti and his son Vittorio were engaged on the preparation of its bronze door. The tabernacle is referred to in documents as 'uno tabernacolo . . . perlo sacramento dallato delle donne', and the words OLEA INFIRMORYM on its base are an indication of the use to which it was later put. The attribution of the tabernacle to Bernardo Rossellino is due to Bode (in W. Burckhardt, Cicerone, 5th edn, Leipzig, 1884, ii, p. 386) and the publication of the documents to G. Poggi ('Il ciborio di Bernardo Rossellino nella chiesa di S. Egidio', Miscellania d'arte, i, 1903, p. 106ff). The tabernacle was designed for use in the chapel of S. Maria Nuova in the 'Spedale delle donne' of the hospital, and was transferred in 1843 to the main church. It has been suggested that the decorative parts of the tabernacle should be regarded as the work of Antonio Rossellino (Tyskiewicz) or alternatively that Antonio Rossellino intervened in the lunette (Kennedy). There is no reason to doubt that Bernardo Rossellino was responsible both for the design and for a great part of the execution of this remarkably accomplished work. A chapter devoted to the tabernacle by Markham Schulz suggests (i) that it 'manifests a basic sympathy for Romanesque architectural forms'; (ii) that the handling of space is explicable only if it is assumed that the lateral walls were intended to be splayed; (iii) that the Angel on the left is by Bernardo Rossellino, since it 'lacks those anatomical and technical errors which mar the right angel'; (iv) that the angel on the right is the earliest extant work by Desiderio da Settignano. In the latter figure 'the confusion of folds surrounding the feet contrasts with the clarity of Bernardo's pattern. Folds crisscross the feet, changing direction with great rapidity . . . Oblong depressions with sharp ridges that flash into existence and as suddenly disappear traverse the ankle' (p. 57). There is no

substance in this analysis.

The Monument of Leonardo Bruni

S. Croce, Florence Plates 134, 135, 140

In his will (1439) Leonardo Bruni, State Chancellor of Florence (1427-44) and author of the Historiae florentini populi, expressed his wish to be buried in the church of S. Croce: 'Sepulturam vero elegit apud ecclesiam S. Crucis in Florentia, in qua sepulcrum sibi fieri voluit in loco convenienti suae qualitati cum lapide marmoreo puro sine pompa.' ('He chose to be buried in the church of S. Croce in Florence, in which he wished a tomb to be prepared for him in a place suitable to his quality with a plain marble slab.') After his death (9 March 1444) the College and Council of his native town of Arezzo determined that, in view of the fame which he had conferred on the town, two citizens should be appointed to confer with Bruni's son Donato with authority 'fieri faciendi unam statuam in figura dicti quondam Domini Leonardi in illis modis et in illo loco et de illa expensa et sorto prout et sicut eisdem duobus civibus Aretinis sicut supra eligendi videbitur et placebit' ('to commission a statue with the figure of the late Lord Leonardo in such a fashion and in such a place and at such a cost as it shall please the same two citizens of Arezzo'). It is possible (Stegmann and Geymüller) that the monument in S. Croce resulted from this decision. It has also been suggested that the tomb was commissioned by the Signoria of Florence as a memorial to Bruni in his capacity as State Chancellor, and that a sum mentioned in the Portata al Catasto prepared by Bernardo Rossellino in 1457 ('Da Cosimo de' Medici Lire 100') arose from expenses in connection with the tomb. There are no documents relating to the monument, which is generally assumed to have been commissioned in 1445-6 soon after Bruni's death, and was probably completed by 1450 (Planiscig) or 1451 (Tyskiewicz, Schulz). Vespasiano da Bisticci describes the funeral of Bruni, which was held 'according to the custom of the ancients', with the corpse dressed in a long silk robe like that which Bruni had worn in life, and with a copy of his history of Florence placed in his hands. At the climax of the ceremony Gianozzo

Manetti, after apostrophizing Bruni, crowned the head of the dead man with a laurel wreath. This ceremony explains the representation of Bruni on his bier in the centre of the monument, wearing a toga-like robe and a laurel wreath. Beneath, on the sarcophagus, a tablet supported by two Angels contains an epitaph by Bruni's successor as Chancellor, Carlo Marsuppini:

POSTQUAM LEONARDUS E VITA
EMIGRAVIT
HISTORIA LUGET, ELOQUENTIA MUTA EST
FERTURQUE MUSAS TUM GRAECAS TUM
LATINAS LACRIMAS TENERE NON
POTUISSE

('After Leonardo departed from life, history is in mourning and eloquence is dumb, and it is said that the Muses, Greek and Latin alike, cannot restrain their tears.')

The Libro di Antonio Billi is the earliest source in which the tomb is ascribed to Bernardo Rossellino. The hypothesis has been advanced that the monument was designed by Alberti; this cannot be seriously sustained. It has also been claimed, wrongly, that the effigy is by Antonio Rossellino, and that the Virgin and Child in the lunette is an early work of Verrocchio (Vasari: 'Mentre che egli conduceva la detta statua [the bronze David], fece ancora quella Nostra Donna di marmo che è sopra la sepoltura di messer Lionardo Bruni Aretino in Santa Croce; la quale lavorò, essendo ancora giovane, per Bernardo Rossellino, architetto e scultore, il quale condusse di marmo, come si è detto, tutta quell'opera.' ['While he was engaged on the aforesaid statue, he also made the marble Virgin which is over the tomb of messer Leonardo Bruni of Arezzo in S. Croce. Being still young, he undertook this work for Bernardo Rossellino, the architect and sculptor, who, as has been said, executed the whole tomb in marble.']) The design of the monument is indubitably by Bernardo Rossellino, as is all of the figurated sculpture with the exception of the Angel on the right of the lunette, which was carved by another member of the Rossellino studio (not, however, Antonio Rossellino). Schulz postulates the intervention of

Antonio Rossellino in the right sleeve of the effigy and that of Desiderio da Settignano in the head and the folds over Bruni's chest. According to this analysis the right leg of the Child Christ in the lunette is the work of Desiderio da Settignano, as is the face of the Madonna, and the putti above the arch are by Buggiano. Though the monument was executed with studio assistance there is no substance in this highly artificial analysis. The Bruni tomb, with its use of a triumphal arch containing the sarcophagus and effigy, inaugurates a new type of sepulchral monument. Though the triple division of the wall behind the effigy and the half-length Virgin and Child in the lunette are developed from motifs in the Coscia Monument of Donatello, the design as a whole is profoundly un-Donatellesque. Desiderio's intervention in the Virgin and Child is postulated by Markham Schulz. There is some reason for supposing that its conception and design are due to Alberti. The form of the pilasters and capitals and the fact that the arch of the lunette springs as it does at Rimini from the outer edge of the supporting moulding tend to confirm Alberti's responsibility for the design. This issue is not confronted by Markham Schulz, who traces its origin to the quite dissimilar tomb of Cardinal Matteo Acquasparta (d. 1302) by Giovanni di Cosma in S. Maria in Aracoeli. On the basis of a conjectural (and fallacious) attribution of the Virgin and Child to Desiderio da Settignano, she concludes that work on the monument was still in progress in 1449-50 and that the tomb was unfinished in 1451. The putti above the arch are wrongly ascribed to Buggiano, the Angels supporting the inscription are attributed to (right) Bernardo Rossellino and (left) Antonio Rossellino, and sections of the effigy are ascribed to these two artists and Desiderio da Settignano. The criteria of connoisseurship throughout this analysis are misapplied. Of special boldness is the crowning feature, which consists of two climbing putti supporting a wreath and garlands surrounding the stemma of Leonardo Bruni. A drawing of the tomb in the Zibaldone of Buonaccorso di Vittorio Ghiberti (c.1472-83) indicates that it was originally coloured, with a

blue curtain with gold edge behind the niche, gilded garlands, a blue ground in the central medallion of the lunette, and gilding on the effigy and angels on the sarcophagus. The effect of polychromy is now limited to the red marble ground behind the tomb (see R. Corwegh, 'Farbige Wandgrüber der Renaissance', *Mitteilungen des Kunsthistoris 'hen Institutes in Florenz*, i, 1911, pp. 168–72). The tomb has been cleaned recently and its state of conservation is the subject of a good article by A. Giusti and A. Venti Conti ('Monumento funebre di Leonardo Bruni', *OPD*, iv, 1992, pp. 161–9).

Monument of the Beata Villana dei Botti

S. Maria Novella, Florence Plates 136, 137

The tomb of the Beata Villana dei Botti (d. 1361) was commissioned from Bernardo Rossellino by her nephew, Fra Sebastiano di Jacopo Benintendi, on 12 July 1451. The contract, which is extremely detailed and throws useful light on the form of the tomb, bound Rossellino to complete the monument by December 1451. The operative passages read as follows: 'una sepoltura di marmo la quale ad astare nelmuro sotto il crocifisso che è disopra al corpo della beata villana in questo mode cioè chella detta sepoltura cominci in terra uno fregio dimarmo Nero alto uno terzo lungho braccia tre e sette ottavj, disopra aquesto una basa dimarmo biancho Lungha braccia tre e mezzo crossa uno sesto scorniciata pulita, disopra una tavola dimarmo rosso. Lungha braccia tre e uno quarto, alta uno braccia e uno terzo recinta Ladetta tavola duna corniciuzza morta dolce e bene pulita. E di sopra Ladetta tavola una cornice di marmo biancho, scorniciata bene con intaglij bellj crossa uno sesto. l'archo uno terzo tutte le dette chose faccino una testa di chassa di sepoltura concornice di sotto e di sopra alta in tutto br. 1 col fregio Nero braccia due. E poj disopra alla detta chassa. Uno padiglione di marmo bianca di larchezza il difuori di braccia quattro iscarso, alto dalla chassa in su braccia due e mezzo colla testa dillione sotto il detto padiglione la figura della beata Villa achiacere intagliata di

mezzo rilievo di lunghezza di braccia tre come sta quella che ve di pocho rilievo. E questo ve aessere dimezzo rilievo Dipoj sotto el detto padiglione ve aessere due angnoli di mezzo rilievo. iquali anno atenere colluna mano il panno del padiglione e collatra una carta cioè uno epitaffio con quelle lettere che Lo gli dirò intagliate e messe di nero a olio. El detto drappo cioè il panno del padiglione vadj giù insino appresso alla basa della chassa. El detto drappo sia frangiato intorno isbrizzato d'oro. E poi dentro nel campo del padiglione di direto brocchato doro edaltro colore Nero e brochato di fuori variato da quello di dentro. E tutto il detto lavorio ritorni alto con ugnj suo lavorio braccia quattro emezzo, elargho come edetto disopra.' ('The contract provides for a tomb to be placed on the wall beneath the crucifix surmounting the grave of the Beata Villana. The tomb is to rest on a black marble frieze, with, above it, a white marble base and a slab of red marble of specified dimensions. Above the sarcophagus there is to be a white marble tent two and a half braccia high, and beneath it a recumbent figure of the Beata Villana carved in half relief with two figures of angels, each holding the curtain of the tent with one hand and an incised and painted epitaph with the other. The curtains of the tent are to reach to the base of the sarcophagus and to be fringed in gold. The brocade in the interior of the tent is to be gilded and painted, and the brocade on the outside is also to be painted, but in another colour.') An amendment to the contract made on 27 January 1452 relates to the provision of a lunette and tabernacle over the monument in connection with the Crucifix suspended over it. This was a trecento Crucifix before which the Beata prayed, and is perhaps identical with a Crucifix now in the Cappella della Pura (Paatz). The monument was moved from its original position in 1579, and is now in the right aisle of the church, and no trace of the tabernacle originally set above it survives. Certain architectural and other features (e.g. the lions' heads) mentioned in the contract no longer form part of the monument. On the cartellino held by the two Angels are the words: OSSA . VILLANE . MVLIERIS . SANCTE / IN . HOC . CELEBRI . TVMVLO

REQVIESCVNT. The tomb type is pronouncedly mediaeval in character, and the motif of the two Angels drawing curtains to disclose the body of the Beata is frequently found in the thirteenth and fourteenth centuries. The figure of the Beata is an autograph work by Bernardo Rossellino, as is the Angel drawing the curtain on the left. The corresponding Angel on the right has been identified (Becherucci) as an early work of Desiderio da Settignano. This is evidently by a different hand from that on the left, but the relationship with Desiderio is not conclusive, and the figure is either by Antonio Rossellino or by an unidentified member of the Rossellino studio. The intervention of Antonio Rossellino in the execution of the Angels has been postulated by Kennedy. Markham Schulz regards the tomb as 'influenced by the Tomb of Doge Tommaso Mocenigo of 1423 by Pietro Lamberti and Giovanni di Martino da Fiesole in Sts Giovanni e Paolo, Venice, which Bernardo might have known first-hand (though no trip to Venice is recorded) or through documents' (p. 59). There is no demonstrable connection between the two tomb types. She repeats her attribution of the effigy to Desiderio da Settignano as vindicating 'the older critics who, unacquainted with the documents from c.1530 to 1755, consistently assigned the tomb to him' (p. 60). A case for Desiderio's intervention elsewhere in the monument has been argued with some cogency, but it has no documentary warrant, and, in the form in which it is presented in this analysis, is fanciful.

Antonio Rossellino

(b. 1427-8; d. 1479)

Antonio Rossellino was born in 1427-8, and was thus seventeen years younger than his brother Bernardo (q.v.), under whose direction he appears to have been trained in association with his brothers Giovanni (b. 1417), Domenico (b. 1407) and Tommaso (b. 1422). He was employed, with Tommaso, in 1449 in carving capitals for S. Lorenzo in Florence, and in 1452 appears as an independent artist acting as joint assessor at the valuation of Buggiano's pulpit in S. Maria Novella. His first signed and dated work (1456) is the bust of Giovanni Chellini (Victoria and Albert Museum, London, see plates 168, 169), and his first recorded commission that for the Monument of the Cardinal of Portugal in S. Miniato al Monte (1461, see plates 146-9). The St Sebastian altar in the Collegiata at Empoli (plate 119) (figure of the Saint and two Angels by Antonio Rossellino and assistant, painted wings by Botticini), the form of which was perhaps modified, was probably carved about 1460 (Weinberger and Middeldorf), though it is now generally assigned to a considerably later date (Gottschalk, Planiscig). Before the commencement of work in the Portuguese Chapel, Antonio Rossellino seems to have worked on two monuments commissioned from Bernardo, the shrine of the Beato Marcolino at Forlì (1458, in association with Giovanni Rossellino) and the tomb of Neri Capponi in S. Spirito (after 1457). On 27 October 1464, while the monument in S. Miniato al Monte was still incomplete, he signed a contract jointly with his brother Giovanni for the completion of the monument of Filippo Lazzari in the Duomo at Pistoia, which had been commissioned from Bernardo Rossellino in 1462, but on which work had scarcely been begun at the time of Bernardo's death (1464). A bust of Matteo Palmieri (plates 172, 173) in the Museo Nazionale, Florence, is dated 1468. In 1471 Antonio Rossellino was employed on work on the Baptistery in Florence, and two years later (27 October 1473) he acted as assessor for Matteo Civitali's monument of Piero da Noceto in the Duomo at Lucca. In the

same year (payment of 23 August 1473) he contributed three reliefs (the Assumption of the Virgin, the Stoning of St Stephen, the Funeral of St Stephen) to the internal pulpit of the Duomo at Prato (plate 105); the pulpit itself appears to have been designed and (with the exception of two reliefs by Mino da Fiesole) executed in the Rossellino studio. Four payments between 12 February and 12 October 1476 relate to the monument of Lorenzo Roverella in S. Giorgio at Ferrara; these are concerned with isolated sculptures on the monument, which was designed and in part executed by Ambrogio da Milano in 1475. The head of Roverella is carved separately from the effigy, and is autograph. Two works for Naples, the monument of Mary of Aragon in the Piccolomini Chapel in S. Anna dei Lombardi, based on the tomb of the Cardinal of Portugal (unfinished in 1479, completed and in large part executed by Benedetto da Majano), and an Altar of the Nativity in the same chapel (plate 108) probably date from 1470-5. A tondo of the Nativity in the Museo Nazionale, Florence (provenance and function undetermined) is connected in style with the latter work. Payments of 1477 relate to the walking figure of the young St John the Baptist formerly over the entrance to the Opera di S. Giovanni and now in the Museo Nazionale. The picture of Antonio Rossellino's late style is completed by a relief of the Madonna and Child over the Nori grave in S. Croce, which seems to have been commissioned and executed before the death of the donor, Francesco Nori, in 1478, though it has also been ascribed (Hartt) to a considerably earlier time. Antonio Rossellino paid the tax of the Arte dei Maestri di Pietra e Legname for the last time in 1478, and died before 1481, when the Duke of Amalfi (who had commissioned the monument in Naples) was in negotiation with his heirs. The principal chronological problem arising from Rossellino's work is that presented by the St Sebastian and Two Angels in the Museo della Collegiata at Empoli. These are sometimes (Gottschalk, Planiscig, Apfelstadt) regarded as late works on account of the commission to Francesco Botticini in 1484 for a painted altarpiece

in which they were exhibited. The objections to this theory are (i) the lack of any precedent for an altarpiece with marble Angels balanced on it, and (ii) the dissimilarity of the St Sebastian from Rossellino's authenticated late works. The presumption is that the three marble figures formed part of a shrine of c.1465-70, which was disassembled and incorporated by Botticini in his altarpiece. A marble relief of the Virgin and Child in the Kunsthistorisches Museum, Vienna, traditionally regarded as a work of Antonio Rossellino, is by Verrocchio. The working methods employed in the studios of Antonio and Bernardo Rossellino have not been satisfactorily analysed. Certain of the disagreements on attribution recorded in the Rossellino literature spring directly from this fact.

Bibliography

An outdated volume by L. Planiscig (Bernardo und Antonio Rossellino, Vienna, 1942) remains the only monograph on Antonio Rossellino. A more systematic survey of the problems arising from Antonio Rossellino's work is contained in a printed thesis by H. Gottschalk (Antonio Rossellino: Inaugural-Dissertation des Christian-Albrechts-Universität zu Kiel, Liegnitz, 1930: unillustrated) and, more briefly, M. Weinberger and U. Middeldorf ('Unbeachtete Werke der Brüder Rossellino', Münchner Jahrbuch der bildenden Kunst, v, 1928, pp. 85-94). For the tomb of the Cardinal of Portugal. see F. Burger (Geschichte des florentinische Grabmals von den altesten Zeiten bis Michelangelo, Strassburg, 1904), C. von Stegmann and H. von Geymüller (Die Architektur der Renaissance in Toscana, Munich, iii, 1885-1907), Paatz, M. Hansmann ('Die Kapelle des Kardinals von Portugal in S. Miniato al Monte. Ein dynastisches Grabmonument aus der Zeit Piero de' Medicis', Piero de' Medici 'il Gottoso' (1416-69), eds. A. Beyer and B. Boucher, Berlin, 1993, pp. 291-316), and especially F. Hartt, G. Corti, and C. Kennedy (The Chapel of the Cardinal of Portugal 1434-59 at San Miniato in Florence, Philadelphia, 1964), which makes available a series of unpublished documents and throws much new light both on the chapel and the tomb. Though some of its conclusions are

illuminating book, and is much superior to a preliminary survey of the same material by F. Hartt ('New Light on the Rossellino Family', Burlington Magazine, ciii, 1961, pp. 385-92), which ascribes to Bernardo Rossellino a number of works here given to Antonio Rossellino, among them the Martelli David in the National Gallery of Art, Washington, the Portrait of a Lady in Berlin (see plate 178), and one of the two Angels on the tomb of the Cardinal of Portugal (see plates 146-9). The last of these attributions is inconclusive and the first two are incorrect. For the attribution to Antonio Rossellino of the Martelli David in the National Gallery of Art, Washington, see J. Pope-Hennessy ('The Martelli David', Burlington Magazine, ci, 1959, pp. 134-7), F. Hartt (as Bernardo Rossellino), and U. Schlegel ('Problemi intorno al David Martelli'. Donatello e il suo tempo, Atti dell' VIII Convego Internazionale di Studi sul Rinascimento, Florence, 1968, pp. 245-58, as Bernardo Rossellino after a bronze model by Donatello). The so-called Virgin with the Laughing Child in the Victoria and Albert Museum London is discussed by J. Pope-Hennessy ('The Virgin with the Laughing Child', Essays on Italian Sculpture, London, 1969, pp. 72-7) and the bust of Giovanni Chellini by R. Lightbown ('Giovanni Chellini, Donatello and Antonio Rossellino', Burlington Magazine, civ, 1962, pp. 102-4) and by J. Pope-Hennessy (Catalogue of Italian Sculpture in the Victoria and Albert Museum, i, London, 1964, pp. 142-6). References to the literature of those works variously given to Antonio Rossellino and to Desiderio da Settignano are listed in the bibliography for the latter artist. D. Carl ('Document for the Death of Antonio Rossellino'. Burlington Magazine, cxxv, 1983, pp. 612-14) publishes a document of 30 March 1484 in the Archivio di Stato, Florence, listing Antonio Rossellino and his sons as having died of plague. A serious outbreak of plague occurred in 1479 in which Antonio and his sons may well have died. J. H. Beck ('An Effigy Tomb-slab by Antonio Rossellino', Gazette des Beaux-Arts, series 6, xcv, 1980, pp. 213-17) attributes to Antonio Rossellino, with some plausibility, the

unacceptable, this is an important and

much damaged tomb-slabs of Leonardo di Lapi Tedaldi and his wife in S. Croce. The Martelli David in the National Gallery of Art, Washington, is wrongly ascribed to Desiderio da Settignano by V. Herzner ('David Florentinus, iii, Der "David Martelli" in der National Gallery zu Washington', Jahrbuch der Berliner Museen, xxiv, 1982, pp. 107-25). S. Ferraldi ('Un monumento contrastato'. in Scritti di storia dell'arte in onore di Ugo Procacci, Milan, 1977, pp. 262-3) publishes documents for the Lazzari monument in S. Jacopo, Pistoia, which was commissioned from Bernardo Rossellino in October 1464 and on Bernardo's death was reallocated to Giovanni and Antonio Rossellino. The same documents are cited by A Markham Schulz (The Sculpture of Bernado Rossellino and his Workshop, Princeton, 1977, pp. 129-30). The attribution and chronology of the Madonna reliefs by or ascribed to Antonio Rossellino are discussed by J. Pope-Hennessy ('The Altman Madonna by Antonio Rossellino', The Study and Criticism of Italian Sculpture, New York, 1980, pp. 135-54), and the St Sebastian at Empoli is discussed by E. C. Apfelstadt ('A New Context and a New Chronology for Antonio Rossellino's Statue of St Sebastian at Empoli', Verrocchio and Late Quattrocento Italian Sculpture, eds. S. Bule et al., Florence. 1992, pp. 189-203).

The Monument of the Cardinal of Portugal

S. Miniato al Monte, Florence Plates 146–9

The genesis of the Chapel of the Cardinal of Portugal is described by Vespasiano da Bisticci in his life of Cardinal Jacopo da Portogallo (d. 1459) in the following terms (Vite di uomini illustri del secolo XV, Milan, 1951, pp. 105-6): 'Ritornando dove abbiamo lasciato, istandi in questi laudabili esercizi, ordinò il suo testamento per autoritate apostolica, che fù d'essere seppellito alla chiesa di Sancto Miniato di Firenze dell'ordine di Monte Oliveto; e volle che vi si facessi una cappella dotata dove s'avessi ogni mattina a dire messa, come oggi si vede, e lasciovi i paramenti e altre cose appartenenti al divino ufficio.

Volle che di quelle sustanze che v'erano, se ne sodisfacesse a quelli che avevano servito, e a' poveri; e così ordinò ogni sua cosa nella morte, come aveva fatto nella vita. Non aveva atteso a cumulare tesoro, perchè nella sua casa da alcuni arienti in fuori, non molti, e assai buona copia di libri, e sua vestimenti e sua massarizi, non v'era altro: che non credo che andassino alla somma di fiorini tre mila; in modo che, sodisfatto a quello che aveva lasciato, la cappella non v'era del suo tanto che si potessi fare; ma questo vescovo Silvense fece fare ogni cosa, e pagò gran parte di quella spesa la duchessa di Borgogna . . . Nella sepoltura che è oggi a Sancto Miniato, la mano fu formato dalla sua propria, il viso in alcuna parte assai lo somiglia, percha dopo la sua vita fù formato.' ('Going back to the point at which we left off, while engaged in these praiseworthy exercises he drew up his will enjoining with papal authority that he should be buried in the church of S. Miniato al Monte in Florence, of the Olivetan order. He wished that a chapel should be constructed and endowed, where mass would be said every morning (as it is now), and to leave it the vestments and other things pertaining to the divine office. He wished that gifts should be made from his possessions to those who had served him and to the poor. Thus he arranged everything in death as he had done in life. He had given no thought to accumulating treasures, and in his house there was nothing but a few silver vessels, a good number of books, and his vestments and household goods. I think that these did not amount to a total of three thousand florins. So that when his legacies had been paid, his estate would have been insufficient to provide for the chapel. But the Bishop of Silves arranged the whole matter, and the Duchess of Burgundy paid a large part of the cost . . . In the tomb which is now at S. Miniato, the hand was moulded from his own, and the face also closely resembles him, since it was moulded after his death.') The design of the chapel was entrusted to the architect Antonio Manetti, and a document of 7 June 1460 establishes that at this time 'cornici di macigno' were being carved to Manetti's design. The Cambini account-books.

rediscovered by Corti and published by

Kennedy and Hartt, show that before and after Manetti's death (8 November 1460) a sequence of payments was made to Giovanni Rossellino for structural work in the chapel; the concluding payment dates from 30 July 1462. Antonio Rossellino seems from the first to have been responsible both for the tomb of the Cardinal of Portugal (plate 146) and for the throne on the opposite wall (payments from January to December 1466). A document relating to the commissioning of the tomb is paraphrased by G. Lami (Sanctae ecclesiae florentinae monumenta, 1758, i, p. 583: original untraced) who had access to 'alcune scritte di convenzioni originali nel sopradetto Archivio di Monte Oliveto concernenti il lavoro di essa Cappella con gli operanti. Una di esse è soscritta di proprio pugno del Vescovo fatta con Antonio di Matteo di Domenico Gamberelli scultore per far esso la sepoltura del Cardinale di Portogallo, che doveva contare fiorini 425 di suggello, cioè di lire 4 e soldi 5 il fiorino, ed è stipulata nel dì primo di dicembre 1461 essendo Abate di S. Miniato D. Giuliano.' ('Some documents with the original agreements with the workmen relating to the work in the chapel. One of these is a contract signed with his own hand by the Bishop for the tomb of the Cardinal of Portugal to be made by Antonio di Matteo di Domenico Gamberelli sculptor.') An analysis of the payments in the Cambini account-books makes it likely, however, that the planning of the tomb goes back at least to the summer of 1461. A second agreement of 23 December 1461, on this occasion jointly with Antonio and Bernardo Rossellino, provides for the completion of the monument by Christmas 1462. Payments to Bernardo Rossellino are recorded in December 1463 and May 1464, and payments to Antonio Rossellino between 24 December 1462 and 8 February 1466, when the tomb seems to have been complete. Bernardo Rossellino evidently worked on the monument in a subordinate capacity, receiving 150 of the total 425 florins for his share in the work, and has been credited, with considerable plausibility, with the execution of the left-hand kneeling Angel, the right-hand flying Angel, and

certain other subsidiary parts of the monument. A small payment made through Giovanni Rossellino on 7 October 1463 to 'Disedero intagliatore' has led to the suggestion that the portrait is based on a death mask by Desiderio de Settignano. The tomb proper forms one element in a decorative scheme which includes a ceiling in polychrome enamelled terracotta by Luca della Robbia (see plate 92), frescoes by Antonio Pollaiuolo and Alesso Baldovinetti, and an altarpiece by Antonio and Piero Pollaiuolo, now in the Uffizi. The chapel was dedicated by Alvaro, Bishop of Silves in Algarve, in October 1466, and the altarpiece seems to have been executed in 1466-7. Baldovinetti's frescoes in the chapel were begun late in 1466, and Antonio Pollaiuolo's frescoes on the altar wall at the end of 1467. The decoration of the chapel was complete by 1477. The niche filled by the tomb corresponds with niches on the left wall containing the throne and on the facing wall containing the altar, and the circular relief of the Virgin and Child above the monument occupies the same position as the circular window on the altar wall. The niche is flanked by pilasters and closed by curtains, which in turn correspond with the painted curtains in the fresco of Antonio Pollaiuolo above the altar. The tomb itself rests on a deep base decorated with a strip of figurated carving with Mithraic and other classical scenes; above this is a shallow platform decorated with an inlaid geometrical design. The effigy of the Cardinal rests on a bier supported by two putti; an analogy for these figures is traced by Burger to a Roman sarcophagus in the Palazzo Torlonia. The sarcophagus, on the lid of which the putti sit, is correctly stated by Vasari to have been adapted from a classical porphyry sarcophagus in Rome, formerly in the Pantheon and now in St John Lateran. On the sarcophagus is the inscription: REGIA STIRPS IACOBVS NOMEN LVSITANIA PROPAGO INSIGNIS FORMA SVMA PVDICITIA CARDINEVS TITVLVS MORVM NITOR OPTIMA VIA ISTA FVERE MIHI MORS IVVENEM RAPVIT VIX . AN . XXV . MXI . D . X . OBIIT AN . SALVTIS

MCCCCLIX

Behind and above the effigy, on the cornice of the rectangular marble background, are two Angels, that on the left holding a crown; the Angel on the right formerly held the palm of chastity. Above is a circular relief of the Virgin and Child framed in cherub heads within a garland supported by two flying Angels. The tomb is conceived as an integral part of the architectural scheme, and not, like the Brancacci Monument of Michelozzo or the Bruni Monument of Bernardo Rossellino, as an independent architectural unit. Though it is preserved in its original form, the original pigmentation has been effaced; in the Zibaldone of Buonaccorso Ghiberti it is noted that the columns and capitals and the Cardinal's robes were gilded, that the Virgin and Child was heightened with gold and set on a blue ground, and that the curtain and wall behind the tomb were red. The word 'dipinti' occurs in a number of places on a contemporary drawing from the completed monument in the British Museum (1891-6.17.24).

Portrait of Lady

Staatliche Museen, Berlin-Dahlem. Inv. No. 77. Plate 178

Purchased in Florence in 1842, the bust was initially identified as a bust of Marietta Strozzi by Desiderio da Settignano described by Vasari in the words: 'Egli, similmente di marmo ritrasse di naturale la testa della Marietta degli Strozzi, la quale essendo bellissima, gli riusci molto eccellente.' The identification of the bust as a portrait of Marietta Strozzi lapsed when a copy of another bust was found in the Palazzo Strozzi, but the attribution to Desiderio was retained by, among others, Planiscig, Lisner, Cardellini, and Schlegel (see bibliography under Desiderio). An attribution to Antonio Rossellino proposed in the first edition of this book is accepted, among others, by Markham Schulz. The attribution rests (i) on the structure of the bust, which, with the strong verticals of the embroidery at the front and ofthe spine at the back, recalls Antonio's signed bust of Giovanni Chellini, (ii) on the sleeves where the horizontal folds are characteristic of

Rossellino, and (iii) on the features, whose impassive, static handling is at variance with the practice of Desiderio. Hartt, followed by Seymour, reattributes the bust to Bernardo Rossellino on the strength of its resemblance to parts of the S. Miniato monument ascribed by him to this sculptor. The sitter cannot be identified.

Giovanni Chellini

Victoria and Albert Museum, London No. 7671–1861 Plates 168, 169

The bust is inscribed within the slightly hollowed base: MAG(ISTE)R IOHAN(N)ES MAG(IST)RI. ANTONII DE S(ANC)TO MINIATE DOCTOR ARTIVM ET MEDICINE. M°CCCCLVI, and in the centre OPVS ANTONII. A generally similar inscription appears beneath Antonio Rossellino's bust of Matteo Palmieri of 1468 (Museo Nazionale, Florence). The Giovanni da San Miniato represented in the bust is identified by Weinberger and Middeldorf with Giovanni Chellini. whose monument by Bernardo Rossellino survives in S. Domenico at S. Miniato al Tedesco, and who is described in the records of S. Domenico as 'medico reputatissimo a Firenze, dove esercitò ed insegnò con molto credito' ('a very well-known doctor in Florence, where he practised and taught with great credit'). This identification is confirmed by the close similarity of the head of the recumbent figure on the monument to the present bust. The bust has a continuous history. From Chellini it passed to the Samminiati, who descended from Chellini's nephew, and thence to the Pazzi family through the marriage in 1751 of Camilla Samminiati and Gian Cosimo Pazzi. It is recorded in the Palazzo Pazzi in 1841. Chellini had served in 1401 as lecturer at the University of Florence, and was eightythree or eighty-four years old when the bust was carved. In the 1450s he was the doctor of Donatello. The head is based not on a death mask, but, as pointed out by Planiscig, on a life mask. One of the earliest and finest Renaissance portrait busts, the sculpture is the first dated work of Antonio Rossellino. Its technique, however, differs from that of

Donatello's Niccolò da Uzzano; in the latter the projecting ears are moulded separately, whereas in the Chellini bust they are pressed back against the skull.

Virgin and Child

Metropolitan Museum of Art, New York Plates 114, 115

Five marble reliefs showing the Virgin and Child with Angels are attributed to Antonio Rossellino; none of them is documented. They comprise: (i) a much weathered relief of the Virgin and Child with Three Angels in the Pierpont Morgan Library, New York (coarse adaptation in marble in the Victoria and Albert Museum, London, also copied in stucco), (ii) a seated Madonna and Child with Four Angels in the Metropolitan Museum of Art, New York (Altman Bequest), (iii) a seated Virgin and Child with Two Angels formerly in the Kaiser Friedrich Museum, Berlin (only fragments survive), (iv) a seated Virgin and Child with Three Angels in the Calouste Gulbenkian Foundation. Lisbon (Child by a member of the Rossellino shop), (v) a Madonna and Child in the National Gallery of Art, Washington (Kress Collection). Two terracotta reliefs which had some claim to be regarded as works by Antonio Rossellino were in the Kaiser Friedrich Museum (nos. 82, 92, destroyed). In addition two compositions are known from derivatives in pigmented stucco, of which no marble prototype survives; these are the so-called Madonna of the Candelabra and a composition without background in the Victoria and Albert Museum, of which a marble copy exists in S. Vincenzo at Prato. The only one of these reliefs that is approximately datable is the Washington Madonna, which seems to have been made to commemorate the marriage of Marietta di Giovanni Ridolfi and Giovanni di Jacopo Martelli in 1469 (Weinberger and Middeldorf). Its style and type are closely related to that of the Nori Madonna in S. Croce. The Altman Madonna in New York (for which see J. Pope-Hennessy, 'The Altman Madonna of Antonio Rossellino', Journal of the Metropolitan Museum of Art, New York, 1970, and The Study and Criticism of

Italian Sculpture, New York, 1980, pp. 135–54) seems to have been carved at the same time as the Monument of the Cardinal of Portugal (1461–8), and is likely to have been preceded by the Morgan Library Madonna. A Madonna in the Kunsthistorisches Museum, Vienna, widely ascribed to Rossellino, is by Verrocchio. The Madonna in the Metropolitan Museum is the most accomplished of these reliefs.

Desiderio da Settignano (b. c.1430; d. 1464)

The son of a certain Bartolommeo di Francesco, Desiderio was born at Settignano about 1430. A Portata al Catasto of 1458 gives his age in that year as 29, while a Portata al Catasto of two years later gives it as 28. If the first of these statements was correct, he would have been born in 1428-9; according to the second, he would have been born in 1431. His two elder brothers, Francesco (b. 1413) and Geri (b. 1424), were stonemasons and matriculated in the guild of the Maestri di Pietra e Legname in 1447 and 1451 respectively. Their father is mentioned as 'scarpellino' after 1451. Desiderio himself matriculated in 1453, and was already an established master by this time, since in this year (26 February 1453) he acted as joint assessor with Antonio Rossellino for the narrative scenes carved by Buggiano for the pulpit in S. Maria Novella. The personal circumstances of Desiderio's life (reconstructed in the main by Kennedy) show that in 1456 he bought a house in the Via S. Maria jointly with his brother Geri, and that both sculptors rented a studio near the Ponte S. Trinita from Andrea Panciatichi (1457). The tax returns of 1458 and 1459 were prepared jointly by Geri and Desiderio. On 28 April 1461 the latter received a payment for a competitive design submitted in connection with the chapel of the Madonna della Tavola in the Duomo at Orvieto (not carried out). Desiderio was buried in S. Pier Maggiore on 16 January 1464. During his lifetime and soon after his death Desiderio da Settignano seems to have enjoyed great fame; Giovanni Santi refers to 'il vago Desider si dolce e bello', and Filarete, in his Trattato d'architettura, also mentions him in connection with sculpture of a decorative character. The only works by Desiderio which are approximately datable are the Marsuppini Monument in S. Croce (begun after 1453; see plates 138, 139, 141) and the Altar of the Sacrament in S. Lorenzo (in progress in 1461; see plates 100-3). Payments or records of 12 November 1453 (12 heads ordered from Desiderio for the study of Giovanni de' Medici), 5 and 16 April 1455 for a Madonna, 11, 13, and 23

August 1455 for 'molte teste', 22 May 1456 for two basins and a mantelpiece, and 24 December 1457 and 7 February 1458 for 'teste' cannot be related to known works, though they have been arbitrarily associated respectively with a relief of Julius Caesar in the Louvre, the Panciatichi Madonna in Florence, the tondi on the Pazzi Chapel, a mantelpiece in London, and a number of surviving busts. The fact that a heterogeneous group of works has accumulated round Desiderio's name is due in large part to uncertainty as to the course and character of his development. Desiderio had financial dealings on a small scale in 1460-2 with Roberto Martelli and one of his greatest sculptures, a full-scale statue of the young St John the Baptist, now in the Museo Nazionale in Florence, was for long in the Palazzo Martelli, where it was (and is by certain critics) ascribed to Donatello. Desiderio was also responsible for a bust of the Child Christ in Washington (formerly in S. Francesco dei Vanchettoni, Florence), and for the smiling head of a Child in the Kunsthistorisches Museum, Vienna. A relief of the Child Christ and young St John is noted by Vasari in the Medici Guardaroba; this appears to be identical with a relief now in the Louvre. Vasari describes a ciborium executed by Desiderio for S. Pier Maggiore; parts of this are now in the National Gallery of Art, Washington. A wooden Magdalen in S. Trinita (plate 117) is mentioned by Vasari as a late work left unfinished at Desiderio's death and completed by Benedetto da Majano. It has been suggested that, on account of its relationship to Donatello's Magdalen in the Baptistery, this should be regarded as an early work (Planiscig), but the stylistic arguments in favour of this view are too fragile to command support. The diary of the painter Neri di Bicci twice mentions work in connection with reliefs of the Virgin and Child by Desiderio; the first entry (3 January 1461) reads: 'A Pietro Tazi orafo 10 tabernacholo da tenere in chamera, drentovi una Vergine Maria di marmo di mano di Disidero', and the second (19 February 1464): 'Uno cholmo da chamera grande, drentovi 1^a Nostra Donna di gesso di mano di Disidero cho

Nostro Signiore in chollo ch'è mezo

fasc[i]ato.' Stuccos after Desiderio's marble Madonna reliefs seem to have enjoyed much popularity, and a number of these were certainly pigmented in the Neri di Bicci studio. In 1462 an attempt was made by Francesco Sforza to procure two stucco Madonnas and one marble sculpture by Desiderio. Two works by Desiderio are mentioned in the Medici inventory of 1492; these are 'una testa di marmo di tutto rilievo di mano di Desiderio', and 'una storia di fuani e altre figure di mano di Desiderio'. For the problem of Desiderio's portrait busts, see plate 179. No mythological relief by the sculptor survives. Vasari states that Desiderio as a youth was responsible for the columnar marble base with bronze foliage for Donatello's bronze David in the cortile of the Palazzo Medici.

The work of Desiderio's brother, Geri, is still unidentified, and it is possible that works by hands that are clearly not identical with Desiderio's may have been produced within the framework of the Desiderio studio (among these are the hands responsible for a magnificent Madonna relief in the Via dei Martelli and a chimneypiece in London, and for reliefs of the Virgin with the seated Child in London and of the Child Christ and the young St John in Washington). So far as concerns the chronology of the homogeneous body of autograph works, it seems that Desiderio proceeded from a more to a less static style. The terminal points of this development are first a group of works produced before the Marsuppini Monument (friezes of putto heads in the Old Sacristy and on the exterior of the Pazzi Chapel, probably after 1451. though a dating a decade later has also been proposed; a related relief of the young Baptist in the Museo Nazionale; a Virgin and Child in the Pinacoteca Sabauda at Turin), and secondly a group of works probably produced after the Altar of the Sacrament (a relief of the Child Christ and the young St John the Baptist in the Louvre, the St Jerome before the Crucifix in Washington, the Panciatichi Madonna in the Museo Nazionale, Florence). The later of these reliefs in particular are executed with great virtuosity and power.

Bibliography

The basis for the study of Desiderio's style was laid in a number of articles by W. von Bode, two of which are reprinted in Florentinische Bildhauer der Renaissance, Berlin, 1910; these are now mainly of historical interest. A monograph by L. Planiscig (Desiderio da Settignano, Vienna, 1942) adopts a more critical attitude to the Desiderio oeuvre catalogue. The most recent monograph on Desiderio, by I. Cardellini (Desiderio da Settignano, Milan, 1962), is meticulous and unreliable, as is a critical review of the volume by A. Markham Schulz (Art Bulletin, xlvi, 1964, pp. 239-47). For the relevant documents see Milanesi's edition of Vasari and C. Kennedy ('Documenti inediti su Desiderio e la sua famiglia', Rivista d'arte, xii, 1930, pp. 243–91), and for the Marsuppini Monument C. von Stegmann and H. von Gevmüller (Die Architektur der Renaissance in Toskana, Munich, iv, 1890–1906). Useful additions are made to the documentation of Desiderio's work by G. Corti and F. Hartt ('New Documents concerning Donatello, Luca and Andrea della Robbia, Desiderio . . . and Others', Art Bulletin, xliv, 1962, pp. 155-67) and J. H. Beck ('Desiderio da Settignano and Antonio del Pollaiuolo'. Mitteilungen des Kunsthistorischen Institutes in Florenz, xxviii, 1984, 203-23). Interpretations, in part tendentious, are supplied in these articles and by I. Cardellini ('Desiderio e i documenti', Critica d'arte, 53-54, 1962, pp. 110-22). Excellent photographs of the Altar of the Sacrament by C. Kennedy are available in Studies in the History and Criticism of Sculpture, V: The Tabernacle of the Sacrament by Desiderio, Smith College, Northampton, 1929. On the tondi of putti on the Pazzi Chapel, see particularly G. Laschi, P. Roselli and P. A. Rossi ('Indagini sulla Cappella dei Pazzi', Commentari, xiii, 1962, pp. 24-7), offering substantial but not conclusive reasons for a late dating for the reliefs. Francesco Sforza's interest in Desiderio's work is well discussed by J. R. Spencer ('Francesco Sforza and Desiderio da Settignano: two new documents', Arte lombarda, xiii, 1968, pp. 131-3). The case for postulating Desiderio's intervention in Bernardo Rossellino's Tomb of the Beata Villana in S. Maria Novella.

Florence, and in the Bruni Monument in S. Croce is presented by A. Markham Schulz ('Desiderio da Settignano and the Workshop of Bernardo Rossellino', Art Bulletin, xlv, 1963, pp. 35-45). For other heterodox attributions, see M. Lisner ('Die Büste des Hlg. Laurentius in der Alten Sakristei von S. Lorenzo. Ein Beitrag zu Desiderio da Settignano', Zeitschrift für Kunstwissenschaft, xii, 1958, pp. 51-70) and U. Schlegel ('Zu Donatello und Desiderio da Settignano. Beobachtungen zur physiognomische Gestaltung im Quattrocento', Jahrbuch der Berliner Museen, ix, 1967, pp. 135-55). Of note is R. Wittkower ('Desiderio da Settignano's St Jerome in the Desert', Studies in the History of Art, National Gallery of Art, Washington, 1971-2, pp. 7-37, reprinted in Idea and Image: Studies in the Italian Renaissance, London, 1978). U. Middeldorf ('Die zwölf Caesaren von Desiderio da Settignano', Mitteilungen des Kunsthistorischen Institutes in Florenz, xxiii, 1979, pp. 297-312), publishes a number of reliefs of Roman emperors, conjecturally reproducing the 12 reliefs of emperors after medallic prototypes commissioned from Desiderio in 1455. The same scholar (Sculptures from the Samuel H. Kress Collection: European Schools XIV-XIX Century, London, 1976, pp. 16-19) gives an exemplary analysis of the tabernacle from S. Pier Maggiore in the Kress Collection in the National Gallery of Art, Washington. The so-called Beauregard Madonna in the Norton Simon Collection is published as a work of Desiderio by C. Avery ('The Beauregard Madonna: A Forgotten Masterpiece by Desiderio da Settignano', Connoisseur, exciii, 1976, pp. 186-95) and a number of other Madonna reliefs by, or ascribed to, Desiderio are discussed in an irresponsible article by D. Strom ('Desiderio and the Madonna Relief in Quattrocento Florence', Pantheon, xl, 1982, pp. 130-5). A number of valid and significant points are made by A. Markham Schulz ('Glosses on the Career of Desiderio da Settignano', Verrocchio, Florence, 1992, pp. 179-88; and in Dizionario biografico degli italiani, xxxix, 1991, pp. 385-90).

Virgin and Child

Philadelphia Museum of Art, Philadelphia Plate 111

The documentation of Desiderio

contains a number of references to reliefs of the Virgin and Child. One such relief was carved for Bartolomeo Serragli (payment of April 1455). Other reliefs are recorded in the Ricordanze of the painter Neri di Bicci, which describe a gilded and painted marble relief (January 1461), a pigmented gesso relief showing the naked Christ embracing the Virgin (June 1462), and a 'Nostra Donna di gesso di mano di Disidero cho Nostro Signiore in chollo ch'è mezo fasc[i]ato' (1465). An attempt has been made to identify the last relief with the Foulc Madonna at Philadelphia (Kennedy). The present relief was originally in the gallery of the hospital of S. Maria Nuova, Florence (Paatz), and later in the Foulc Collection, Paris, and is for this reason known as the Foulc Madonna. Along with the Turin Madonna and the Panciatichi Madonna in the Museo Nazionale, Florence, it is one of the three surviving half-length marble Madonna reliefs by Desiderio da Settignano. The three reliefs appear to belong to separate stages in Desiderio's career, the Turin Madonna to the years 1450-3, before the commencement of work on the Marsuppini Monument. The only Madonna relief which finds a clear point of reference in works by Desiderio is the much damaged Panciatichi Madonna in the Museo Nazionale, Florence, where the head of the Child conforms exactly to those of the roundels with cherub heads on the façade of the Pazzi Chapel (c.1451). A mistaken attempt has been made (Markham Schulz) 'to eliminate the Foulc Madonna from the oeuvre of Desiderio', and it has also been wrongly regarded (Schlegel) as a copy of a lost original. There is no evidence for either view. In composition this is Desiderio's finest and most inventive Madonna relief; the rather dry execution, however, is inferior both to that of the well-preserved Turin Madonna, and to the more deeply carved Madonna in the Bargello. Pigmented stucco versions of all three compositions exist in some

numbers, and it is suggested by Kennedy that the stucco described in Neri di Bicci's studio after the death of Desiderio (see above) was a version of the present relief. There is evidence that the number of Madonnas produced by Desiderio was very small. When in 1463 Francesco Sforza attempted to purchase a relief by Desiderio, his representative visited the sculptor's studio and was informed that no Madonna reliefs 'ne de marmore ne de gesso, ne di pietra cotta ne de verunaltra material' were available, and that none could be produced before Desiderio's work in S. Lorenzo was complete.

The Altar of the Sacrament

S. Lorenzo, Florence Plates 100–3

The second of Desiderio's major works. the Altar of the Sacrament in S. Lorenzo (plate 100) consists of a tabernacle flanked by angels with candelabra, and a relief, probably designed as an antependium, with the Dead Christ between the Virgin and St John. It is described by Vasari in the following terms: 'ed in S. Lorenzo finì di marmo la cappella del Sacramento la quale egli con molto diligenza condusse a perfezione. Eravi un fanciullo di marmo tondo, il quale fù levato, e oggi si metta in sull'altare per le feste della Natività di Cristo, per cosa mirabile; in cambio del quale ne fece un altro Baccio da Montelupo, di marmo pure, che sta continuamente sopra il tabernacolo del Sacramento.' ('In S. Lorenzo he finished in marble the Chapel of the Sacrament, perfecting it with great diligence. On it there was a statuette of a child in marble, which was removed, and is now placed on the altar at the Christmas festival, being a marvellous thing. In substitution for it, Baccio da Montelupo made another, also of marble, which stands continuously on the top of the tabernacle of the sacrament.') On account of its transference to the high altar of the church, the figure of the Child Christ from the apex of the tabernacle became extremely popular, and a number of contemporary versions in marble and pigmented stucco are known. The figure now on the tabernacle is the original statuette by

of the altar form a programmatic unity, and the mystical adoration of the Sacrament by the Angels in the tabernacle proper takes place between the figures of the Lamentation over the Dead Christ at the bottom and the Child Christ adored by two Angels in benediction at the top. It is deduced (Paatz) that the altar was completed in the summer of 1461, since an entry in the Libro dei Sacrestani for that year (transcribed by D. Moreni, Continuazione delle memorie storiche dell'ambrosiana imperial basilica di S. Lorenzo di Firenze, i, 1816, p. 15) reads: 'Per tutto il mese di Luglio 1461 si murò l'Altar maggiore nostro ec. Per tutto di primo d'Agosto 1461 fù murato interamente il Tabernacolo del Corpo di Cristo.' A letter of Nicodemo Tranchedini, however, reveals that Desiderio was still at work in S. Lorenzo in February 1462; on the basis of this it has been argued (Spencer) that the altar was not complete at the time it was installed, and that work on it may have continued till Desiderio's death. The function of the Altar of the Sacrament is still fraught with problems. It is argued by A. Parronchi ('Sulla collocazione originaria del Tabernacolo di Desiderio da Settignano', Cronache di archeologia e di storia dell'arte, iv, Catania, 1965, pp. 130-40) that it was originally commissioned for the altar of the Sagrestia Vecchia in S. Lorenzo but was erected in the Chapel of Sts Cosmas and Damian (or Cappella del Sacramento) in the left transept. In 1677 it was moved to the Neroni Chapel at the end of the right transept, and was then, after the Second World War, transferred to its present position in the nave. There is no evidence to support the first of these contentions, and the second may also be incorrect, since the documents printed by Moreni seem to refer to the high altar of the church and to a wall tabernacle adjacent to it. There is thus some reason to suppose that the present work should be described as the Tabernacle (not Altar) of the Sacrament and was originally planned for one of the lateral walls of the Cappella Maggiore of the church. The issue is, however, complicated by a number of drawings. It is also wrongly claimed by A. Parronchi

Desiderio. The main figurative elements

piumose si mostrano: cosa difficile a

('Un tabernacolo brunelleschiano', Filippo Brunelleschi, la sua opera e il suo tempo, Florence, 1980, i, pp. 139-55) that the figure of the Child Christ at present on the tabernacle is a replacement by Baccio da Montelupo and that the original figure by Desiderio is a Child Christ in the Cleveland Museum of Art. The Cleveland statuette is discussed by P. Verdier ('Il Putto Ignoto: A Marble Statuette of Christ in Quest of a Father'. Bulletin of the Cleveland Museum of Art, lxx, 1983, pp. 303-11). The tabernacle is identified by I. Lavin (in Past-Present. Essays on Historicism in Art from Donatello to Picasso, Berkeley/Los Angeles/ Oxford, 1993, pp. 1-28) as an integral part of the decoration of the high altar. The Lamentation group recalls the Lamentation by Filippo Lippi in the Museo Poldi Pezzoli, Milan. Typical of Desiderio is the flat, graphic style in which the Pietà is carved, which recalls the St Jerome in Washington.

St Jerome before a Crucifix

National Gallery of Art, Washington; Widener Collection Plate 113

The relief, which is possibly identical with a low relief of St Jerome listed in the 1553 inventory of the Palazzo della Signoria, was acquired in Florence by K. E. von Liphardt, and was later in the Widener Collection, Philadelphia. The attribution to Desiderio is due to Bode, and has been generally accepted; G. Swarzenski ('Some Aspects of Italian Quattrocento Sculpture', Gazette des Beaux-Arts, 6th series, xxiv, 1943, pp. 283-304) suggests that it was 'unfinished at the master's death, and may have been terminated especially in the background by Benedetto da Majano'. The entire relief is evidently the work of Desiderio. A point of reference for the composition is provided by works executed by Fra Filippo Lippi in the bracket 1450-60; analogies here are so close as to afford a supporting argument for the late dating proposed on other grounds by U. Middeldorf ('Two Florentine Sculptures at Toledo', Art in America, xviii, 1940, pp. 13-30). An early dating is proposed by Planiscig (c.1450) and C. Seymour (Masterpieces of Sculpture from the National Gallery of Art, Washington, 1949,

pp. 175-6, c.1450-5). All photographs of the relief are to some extent misleading, since it is carved more boldly and with greater variations of depth than reproductions suggest. The handling resembles that of the relief of the Christ Child and the young Baptist in the Louvre. A thorough study by Wittkower establishes that the photograph reproduced by Bode, Venturi, Schubring and Planiscig was made from a cast issued by the firm of Lelli in Florence before 1891, not from the original relief. The apparent difference of condition between the cast and the relief is explained by him as due to 'repeated cleaning and washing' of the marble, but can also be explained by surface working on the cast. The article contains a convincing analysis of the style and iconography of the relief, and arrives inferentially at a correct dating between about 1461 and the death of Desiderio in 1464.

Portrait of Lady

Museo Nazionale, Florence Plate 179

Desiderio's activity as a portrait sculptor is attested by a reference of Vasari to a bust of Marietta Strozzi (b. 1448) in the Palazzo Strozzi, and by the presence in the Palazzo Medici of 'una testa di marmo di tutto rilievo di mano di Desiderio'. A number of attempts have been made (notably by Bode) to identify the bust of Marietta Strozzi, and to establish the characteristics of Desiderio as a portrait sculptor. The contents of a dissertation dealing with the portrait bust by J. Schuyler (Florentine Busts: Sculpted Portraiture in the Fifteenth Century, New York and London, 1976) should be ignored. The principal marble portrait busts ascribed to Desiderio are the following: (i) the present bust of an unidentified lady, in which the shallow expressive carving of the features, the balance of the head and chest, the horizontal folds of the two sleeves and the laced corselet closely recall the Angels in the Altar of the Sacrament. A detailed catalogue entry by F. Cagliotti (in Eredità del Magnifico, ed. P. Barocchi, Florence, 1992, pp. 48-50) implausibly ascribes the present bust to the Ambito di Desiderio da Settignano, and

attributes it to 'un altro scultore, sempre communque sceltissimo, e cresciutosi a fianco del maestro; un Desiderio un po' diminuito, attivo certo nella medesima bottega'. This analysis is wrong, and the bust is certainly by Desiderio da Settignano. (ii) a presumed bust of Marietta Strozzi in the Pierpont Morgan Library, New York, in which the exaggeratedly thin neck and the badly aligned eyes suggest the work of the Master of the Marble Madonnas; (iii) a bust presumed to be of Simonetta Vespucci in the National Gallery of Art, Washington, in which the hair is visible and the unfinished patterned dress suggests the work of Benedetto da Majano, (iv) an unfinished and recut bust of "Marietta Strozzi" in the National Gallery of Art, Washington, in which the hair, protruding to the right and left, is crudely indicated and has been in parts recut, and the eyes and mouth are related to those of the Rossellino bust in Berlin; (v) a presumed bust of Marietta Strozzi in the Staatliche Museen, Berlin-Dahlem; this bust is an autograph work of Antonio Rossellino (plate 178); (vi) a bust of a lady in the Louvre, Paris, wearing a cap through which the hair is visible; this curious bust, with its angular features, the deep carving of the sleeves, the irregular lacing of its corselet, and its hard eyelids, is not necessarily Florentine. In every case the title Marietta Strozzi is, as here, suppositious.

The Monument of Carlo Marsuppini S. Croce, Florence

Plates 138, 139, 141

The Marsuppini Monument in S. Croce is described by Vasari in his life of Desiderio: 'Fece la sepoltura di messer Carlo Marsuppini, aretino, in Santa Croce: la quale non solo in quel tempo fece stupire gli artifici e le persone intelligenti che la guardarono, ma quelli ancora che al presente la veggono, se ne maravigliano dove egli avendo lavorato in una cassa fogliami, benchè un poco spinosi e secchi, per non essere allora scoperte molte antichità, furono tenuti cosa bellissima. Ma fra l'altre parti che in detta opera sono, vi si veggono alcuno ali che a una nicchia fanno ornamento a piè della cassa, che non di marmo, ma

potere imitare nel marmo, atteso ch'ai peli e alle piume non può lo scarpello aggiungere. Evvi di marmo una nicchia grande, più viva che se d'osso proprio fosse. Sonvi ancora alcuni fanciulli ed alcuni angeli, condotti con maniera bella e vivace. Similmente e di somma bontà ed artifizio il morto su la cassa, ritratto al naturale, ed in un tondo, una Nostra Donna, di bassorilievo, lavorato, secondo la maniera di Donato, con giudizio e con grazia mirabilissima.' ('He made the tomb of messer Carlo Marsuppini of Arezzo in S. Croce, which not only astonished the artists and intelligent persons who looked at it at that time, but continues to astonish those who see it now. In the sarcophagus he introduced foliage which, although a little spiky and dry, since not many antiquities had been discovered at that time, was considered very beautiful. Among the other portions of the work are some wings, which decorate a shell at the foot of the sarcophagus. These seem to be feathers and not marble, a difficult effect to achieve in marble seeing that the chisel cannot easily reproduce hair and feathers. There is also a large shell in marble, more lifelike than if it had been made in bone. In addition there are some boys and angels executed in a beautiful and lively style. The effigy on the sarcophagus is lifelike and of the utmost beauty and artifice, and in a tondo there is a Virgin in low relief, worked in the manner of Donatello with most wonderful skill and grace.') The varying dates ascribed to the monument are due to uncertainty as to the date of death of Carlo Marsuppini. A statement that Marsuppini was still alive at Arezzo on 17 February 1455 is incorrect; his death took place on 24 April 1453 and three days later he was buried in S. Croce. Work on the monument was presumably begun soon after this time. Two letters published by Markham Schulz (1992) from the humanist Francesco Griffolini to Piero de' Medici in June and July 1459 contain drafts for the epitaph on the monument, and the tomb itself cannot therefore have been completed before 1460-61. In its pierced design and style, the latter a more decorative variant of that of the Bruni Monument, Piero de' Medici evidently

played some part. Marsuppini succeeded Leonardo Bruni as State Chancellor on the latter's death in 1444, and his tomb is based directly on the Bruni Monument. Desiderio's design is somewhat lower and wider than Bernardo Rossellino's (Bruni Monument height 6.104 m., width 3.160 m; Marsuppini Monument height 6.013 m., width 3.580 m.), and the emphasis throughout rests not on the architectural scheme, but on the ornament and figure sculpture. The tomb is mentioned c.1460 in one of a group of seventy poems by Gentile Becchi (see C. Grayson, 'Poesie latine di Gentile Becchi in un codice Bodleiano', in Studi offerti a Roberto Ridolfi, Florence, 1973, pp. 285-302; and G. Agosti in Il giardino di San Marco, exhibition catalogue Milan, 1992, p. 99) as 'ad marmorariam tabernam dum Carolus Aretinus sculpteretur'. Two early sources, the Anonimo Magliabecchiano and the Libro di Antonio Billi, speak of the intervention of the young Verrocchio in the execution of the tomb, and Verrocchio has been credited with the Angel on the right of the lunette (U. Middeldorf, 'Frühwerke des Andrea Verrocchio', Mitteilungen des Kunsthistorischen Institutes in Florenz, v, 1939, p. 309). The two shield-bearing figures at either end of the base fit awkwardly in a physical sense, and the quadrangular base of that on the right has been cut away to enable it to occupy its present position on the monument. The Angels in the lunette are by different hands. The left-hand Angel in the lunette has also been ascribed (Cardellini) to Desiderio's brother Geri. The same student supposes that the two figures supporting garlands beside the lunette and the relief of the Virgin and Child preceded the other figurated carvings on the tomb. The contrary view has also been advanced (Schlegel). According to an incorrect analysis of Markham Schulz, 'the only autograph portions of the tomb are the face of the putto on our left, the decoration of the sarcophagus, and parts of the base'. It has been suggested (Kennedy) that one of the two children at the base of the tomb represents Desiderio's son Paolo, who was born in the year of Marsuppini's death. The colouristic aspect of the tomb (for which see Stegmann and Geymüller)

is difficult to reconstruct, but there are many traces of gilding in the ornament and it can be established that the biercloth was originally green.

The inscription on the sarcophagus reads:
SISTE VIDES MAGNVM QVAE SERVANT
MARMORA VATEM
I INGENIO CVIVS NON SATIS ORBIS ERAT
QVAE NATVRA POLVS QVAE MOS FERAT
OMNIA NOVIT
KAROLVS AETATIS GLORIA MAGNA SVAE.
AVSONIAE ET GRAIAE CRINES NVNC
SOLVITE MVSAE
OCCIDIT HEV VESTRI FAMA DECVS QVE

('Stay and see the marbles which enshrine a great sage, one for whose mind there was not world enough. Carlo, the great glory of his age, knew all that nature, the heavens and human conduct have to tell. O Roman and Greek muses, now unloose your hair. Alas, the fame and splendour of your choir is dead.')

An alternative inscription composed

for the tomb reads (Grayson):
QVEM MODO FORMARI SPECTAS DE
MARMORE VATEM
VIX SUA CREDIDERANT SECVLA POSSE
MORI.
(NON) FATVM LACHRIME, NON FATVM
NVMINA FLECTVNT
CAROLE, SIC TANDEM MAGNE POETA,

Mino da Fiesole

(b. 1429; d. 1484)

Mino da Fiesole was born at Papiano near Poppi (Casentino) in 1429. According to Vasari, he was trained by Desiderio da Settignano (b. 1428); this is not substantiated by his early works, and there may be some substance in the theory (Carrara) that he was a pupil of Michelozzo. A bust of Piero de' Medici (Museo Nazionale, Firenze) was carved in 1453, and is one of Mino's earliest surviving works. The bust of Niccolò Strozzi (see plate 167) dates from the following year. According to the inscription on the base, this was carved in Rome. In 1455 he was in Naples, where he carved a bust of Astorgio Manfredi (National Gallery of Art, Washington). The bust of the apothecary Alessandro di Luca Mini (Staatliche Museen, Berlin-Dahlem) dates from 1456, and was followed by a bust of Rinaldo della Luna (1461). Rinaldo della Luna was working at the Curia in 1461, and his bust is likely to have been carved in Rome (Zuraw). Mino's last portrait bust is that of Diotisalvi Neroni (1464) in the Louvre, Paris. Mino is likely to have returned to Rome by 1459 to work on the Ciborium of Cardinal D'Estouteville in S. Maria Maggiore (plate 216), which was completed in 1461. Two Angels on the pediment of S. Giacomo degli Spagnuoli, signed OPUS PAULI and OPUS MINI respectively, must date from about this time. Mino's continued presence in Rome is attested by a payment of 5 July 1463 to him to work with Paolo Romano, Isaia da Pisa, Pagno da Settignano and other sculptors, on the Benediction Pulpit of Pius II. He was also responsible for the Altar of St Jerome in S. Maria Maggiore (now dismantled, reliefs in the Museo di Palazzo Venezia), installed in 1464 (Zuraw, 1992). By 28 July 1464, however, Mino had returned to Florence where he was engaged on the Salutati Monument in the Duomo at Fiesole and the Giugni Monument in the Badia. In 1469 he signed a contract for the Monument of Count Hugo of Tuscany in the Badia (completed 1481, plates 142, 143), and in 1471 he executed a tabernacle in the Duomo at Volterra, which was followed in 1472-3 by reliefs

for Antonio Rossellino's pulpit in the Cathedral at Prato. An altarpiece in S. Pietro at Perugia was despatched from Florence in 1473. From about 1474 till 1480 Mino was once more active in Rome. His work in these years presents considerable difficulties, since he frequently collaborated with Andrea Bregno, Giovanni Dalmata and other sculptors. The most important of the complexes on which Mino was engaged in Rome was the tomb of Pope Paul II in St Peter's (probably 1474-7, see plate 215). Among the other Roman tombs which he executed or which incorporate his work are the Forteguerri Monument in S. Cecilia in Trastevere, the Ammanati Monument in the former cloister of S. Agostino, the Riario Monument in SS. Apostoli (see plates 218, 219), the Della Rovere Monument in S. Maria del Popolo, and the tomb of Francesco Tornabuoni (d. 1481) in S. Maria sopra Minerva. Returning to Florence, he executed a tabernacle in S. Ambrogio (1481) and completed the Count Hugo Monument in the Badia. Mino died in Florence in 1484. In two separate passages Vasari refers to a sculptor of Neapolitan origin active in Rome, known as Mino del Regno or Mino del Reame. On the first occasion Mino del Reame is mentioned in association with Paolo Romano: 'Segue ora che noi parliamo di Paolo Romano e di Mino del Regno coetanei della medesima professione, ma molto differenti nelle qualità di costumi e dell'arte . . . Sono di mano di Mino a Monte Cassino, luogo de' Monaci Neri nel Regno di Napoli, una sepoltura, ed in Napoli, alcune cose di marmo. In Roma il S. Pietro e S. Paolo che sono a più delle scale di S. Pietro, ed in S. Pietro la sepoltura di Papa Paolo II.' ('Now we must speak of Paolo Romano and Mino del Regno, contemporaries in the same profession, but very different in their habits and in the quality of their art . . . By the hand of Mino are a tomb at Montecassino, the Benedictine monastery in the Kingdom of Naples, and some marble sculptures in Naples. In Rome he carved the Sts Peter and Paul which are at the head of the stairs at St Peter's, and in St Peter's the tomb of Pope Paul II.') On the second occasion Mino del Reame's name occurs in the

life of Mino da Fiesole in a passage referring to the tomb of Paul II (see plate 215). There is no documentary reference to the activity of Mino del Reame, but it had long been claimed, initially by A. Schmarsow ('Meister Andrea', Jahrbuch der Preussischer Kunstsammlungen, iv, 1883, pp 18-31) and later by Angeli, Venturi, and in earlier editions of this book), that a number of works in Rome signed OPVS MINI were by another hand than that of Mino da Fiesole. The distinction between Mino del Reame and Mino da Fiesole had not been universally accepted and was opposed, in particular, by Bode, Schottmüller, Langton Douglas and Seymour. The case was finally laid to rest by Caglioti (1991) who successfully argued that the sculptures formerly given to Mino del Reame are, in fact, the work of Mino da Fiesole. The main works formerly attributed to Mino del Reame are the Ciborium of Cardinal d'Estouteville (reliefs in S. Maria Maggiore, Rome), a relief of the Virgin and Child in S. Maria Maggiore, a tabernacle in S. Maria in Trastevere, and two Angels above the doorway of S. Giacomo degli Spagnuoli. A joke made at the expense of Mino by the architect Alberti is quoted by Domenichi (Facetiae, Rome, 1584), and at least from the time of Vasari he appears to have been regarded as the inferior of Desiderio da Settignano and Bernardo and Antonio Rossellino. A contrary case is stated by Valentiner. Though he enjoyed a period of popularity in the nineteenth century, his facile sentiment, formal mannerisms and limited technique place him below the level of his great contemporaries.

Bibliography

The standard volume on Mino da Fiesole is that of G. C. Sciolla (*La scultura di Mino da Fiesole*, Turin, 1970; reviewed A. Markham Schulz in *Art Bulletin*, liv, 1972, pp. 208–9) which supersedes a study by W. R. Valentiner, a monograph by Hildegard Lange (*Mino da Fiesole*, Greifswald, 1928) and an earlier volume by Diego Angeli (*Mino da Fiesole*, Florence, 1904). Mino's activity is discussed by W. R. Valentiner ('Mino da Fiesole', *Studies in Italian Renaissance Sculpture*, London, 1950, pp. 70–96). The observations of Bode are vitiated by confusion between Mino da Fiesole and

Mino del Reame. A renewed attempt to synthesize the work of these two sculptors is made by Langton Douglas ('Mino del Reame', Burlington Magazine, lxxxxvii, 1945, pp. 217-24), M. Pepe ('Sul soggiorno napoletano di Mino da Fiesole', Napoli nobilissima, v, 1966, pp. 116-20), who also identifies the sculptor with a Domenico di Montemignano mentioned in Neapolitan documents. and Sciolla. The development of Mino's style is discussed in four important articles by F. Cagliotti ('Sculture di Mino da Fiesole nel Duomo di Olomouc', Prospettiva, no. 49, 1987, pp. 75-9; 'Per il recupero della giovinezza romana di Mino da Fiesole: il "Ciborio della Neve", Prospettiva, no. 49, 1987, pp. 15-32; 'Paolo Romano, Mino da Fiesole e il tabernacolo di San Lorenzo in Damaso', Prospettiva, nos. 53-6, 1988-9, pp. 245-55; and 'Mino da Fiesole, Mino del Reame, Mino da Montemignaio: un caso chiarito di sdoppiamento d'identità artistica', Bollettino d'arte, no. 67, 1991, pp. 19-86). A very good article by S. Zuraw ('Mino da Fiesole's First Roman Sojourn', Verrocchio and Late Quattrocento Italian Sculpture, Florence, 1992, pp. 303-19) on Mino's early Roman work arrived independently at similar results. Mino's birthplace is identified by E. Marucchi ('Dove nacque Mino da Fiesole', Rivista d'arte, xvii-xviii, 1939, pp. 324-6), and his early style is discussed by L. Carrara ('Nota sulla formazione di Mino da Fiesole', Critica d'arte, 13–14, 1956, pp. 76-83). Mino's late works are reviewed in an article by G. C. Sciolla ('L'ultima attività di Mino da Fiesole', Critica d'Arte, 96, 1968, pp. 35-44). For Mino's sepulchral monuments, see F. Burger, Geschichte des Florentinische Grabmals von den altesten Zeiten bis Michelangelo, Strassburg, 1904) and for his Roman works, D. Gnoli ('Le opere di Mino da Fiesole in Roma', Archivio storico dell'arte, ii, 1889, pp. 455-67) and G. Biasiotti ('Di alcune opere scultorie conservate in S. Maria Maggiore di Roma', Rassegna d'arte, v, 1918, pp. 51-7). For the portrait busts, see I. Lavin, 'On the Sources and Meaning of the Renaissance Portrait Bust', Art Quarterly, xxxiii, 1970, p. 216); on the classical style developed by Mino in Rome, see S. Zuraw (1992) and, above

all, an excellent article by the same

author ('The Medici Portraits of Mino da Fiesole', Piero de' Medici 'il Gottoso' (1416-69), eds. A. Beyer and B. Boucher, Berlin, 1993, pp. 317-39). Mino's work in Naples is discussed by M. Pepe. The relations between Mino da Fiesole and the painter Cosimo Rosselli remain to be investigated. On two occasions, at Fiesole (A. Padoa Rizzo, 'La Cappella Salutati nel Duomo di Fiesole e l'attività giovanile di Cosimo Rosselli', Antichità viva, xvi, 1977, pp. 3-12) and in S. Ambrogio, Florence, the artists were closely associated. On the latter, see a brilliant article by E. Borsook ('Cult and Imagery at Sant' Ambrogio in Florence', Mitteilungen des Kunsthistorischen Institutes in Florenz, xxv, 1981, pp. 147-202).

The Assumption of the Virgin

S. Maria Maggiore, Rome Plate 216

The Ciborium of Cardinal d'Estouteville in S. Maria Maggiore, Rome, was disassembled under Pope Benedict XIV, and the present relief is now built into the apse of the church. Its original form can, however, be reconstructed from literary descriptions and from an engraving of 1621 by P. De Angelis. The ciborium rested on four red porphyry columns, still extant in the Chapel of the Relics, S. Maria Maggiore. In the spandrels of the arches were roundels with the Symbols of the Evangelists and the four Fathers of the Latin Church. Above these were horizontal reliefs of the Nativity: Adoration of the Magi, Assumption of the Virgin and the Miracle of the Snow, the latter facing towards of the nave of the church. In the lunettes above were four small vertical reliefs of the Virgin and Child, Sts Peter and Paul and the Annunciation. The Virgin and Child, which bears the inscription OPVS MINI, is now in the Cleveland Museum of Art and was formerly owned by the Capitolo Liberiano. Round it ran the lost inscription: GVGLIELMVS DE ESTOVTEVILLE CARD(INALIS) ROTOMAGENSIS SACRVM FECIT AN(NO) MCCCCLXI . . . In previous editions of this book the Ciborium is described as 'not recognizably related to the architectural forms employed by Mino da Fiesole at this or any later time, and

the style of the reliefs is purely Roman in character.' Mino da Fiesole was engaged on Roman commissions in 1454-5 and 1461-3, but if the ciborium was completed in 1461, it is likely to have been begun c.1459. Both these scenes and the scenes from the life of St Jerome formerly in S. Maria Maggiore, now in the Museo Nazionale di Palazzo Venezia, are highly individual both in technique and in iconography, and are much superior to the narrative reliefs Mino later produced in Tuscany. In the Assumption the classicizing treatment of the ten Angels recalls the work of Isaia da Pisa and Paolo Romano, with whom Mino was closely associated.

Monument of Count Hugo of Tuscany

Badia, Florence Plates 142, 143

The body of Count Hugo of Tuscany (d. 1001), the founder of the Badia. originally rested in an antique porphyry sarcophagus near the high altar of the church. In 1439 (Paatz) it was decided to commission a new commemorative monument. A terracotta sketch-model for this was prepared by Luca della Robbia (tomb not executed), and Count Hugo's remains were temporarily transferred to a painted wooden sarcophagus in the sacristy. Nothing further is heard of the project for the monument till 1469, when it was allotted to Mino da Fiesole, who had undertaken the Monument of Bernardo Giugni (d. 1466) in the same church. On 25 June 1471 a new agreement was reached between the sculptor and the monks of the Badia, whereby Mino bound himself to complete the tomb within eighteen months for a total sum of 1600 lire (including sums already paid). Work on the monument was again interrupted by Mino's return to Rome, and it was completed only on 4 June 1481, when the balance of 1777 lire was paid to the sculptor, the increase over the stipulated payment being due to the addition of the marble seat at the bottom of the monument and to the decision to execute in marble certain parts that were originally to have been made of maciono. It has been inferred (Sciolla) that the figurated sections of the monument

were executed after Mino's return to Florence in 1480, and that the shieldbearing putto on the left and one of the children accompanying Charity are the work of an assistant. The first thesis can neither be demonstrated nor denied, and the second is improbable. The monument (plate 143) was originally set up on the left wall of the Cappella Maggiore of the church, and was transferred to its present position in 1629. It is described by Vasari in the following terms: 'la quale opera fù cagione che l'abate e' monaci della Badia di Firenze, nel qual luogo fù collocata la detta sepoltura, gli dessero a far quelle del conte Ugo, figliuolo del marchese Uberto di Magdeborgo, il quale lasciò a quella Badia molte facultà e privilegi; così, desiderosi d'onorarlo il più che' potevano, faciono fare a Mino, a marmo di Carrara, una sepoltura, che fù la più bella opera che Mino facesse mai; perche vi sono alcuni putti che tengono l'arme di quel conte, che stanno molto arditamente e con una fanciullesca grazia, e, oltre alla figura del conte morto, con l'effigie di lui, ch'egli fece in su la cassa, e in mezzo, sopra la bara, nella faccia, una figura d'una Carità con certi putti, lavorata molto diligentemente ed accordata insieme molto bene. Il simile si vede in una Nostra Donna, in un mezzo tondo, col putto in collo; la quale fece Mino più simile alla maniera di Desiderio che potette.' ('This work was the reason why the abbot and monks of the Badia of Florence, where the aforesaid tomb was set up, commissioned Mino to make the monuments of Count Hugo, son of the Marquis Hubert of Magdeburg, who left the Badia much property and many privileges. Thus, desirous of honouring him to the greatest possible extent, they arranged for Mino to prepare a tomb in Carrara marble. This was the most beautiful work that he ever produced, containing as it does some boys supporting the Count's arms, who stand on the tomb boldly and with boyish charm. Beside the effigy of the dead Count, which he carved on the sarcophagus, he placed on the back wall in the middle above the bier a figure of Charity with some children, very carefully worked and very well composed. This applies also to a Virgin with the child in her arms in a

lunette, which Mino made as like the work of Desiderio as he could.") The base of the monument is planned as a marble seat, on the back of which is a relief with two Angels supporting a cartellino with the inscription:

VGONI OTHONIS III IMPER. AFFINI AC
COMITI MARCHIONI ANDERBVRGENSI
HAETRVRIAE Q. PREFECTO Q. DIVO
BENEDICTO
HOC OL ET SEX ALIA COENOBIA CODIDIT
PII HVIVS LOCI. MONACHI DE SE
BENEMERITO
SEPVLCHRVM VETVSTATE ATTRITVM

H. M. H. N. S.

The initials at the end of the inscription mean HOC MONUMENTUM HEREDES NON SEQUENTER; (for alternative interpretations, see G. B. Uccelli (*Della badia fiorentina*, Florence, 1858, pp. 11ff.). The effigy rests on a bier on top of the sarcophagus; the front of the latter is inscribed with the words:

OBIT ANO SALVTIS MILLESIMO P XII KAL IANVARIAS.

ISTAVUR ARVT ANO SALVTIS M.CCCCLXXXI

The wall behind the sarcophagus is divided into three sections, of which the centre is filled with a relief of Charity. The forward face of the central rectangle is decorated with a shallow curtain, and the lunette above contains a relief of the Virgin and Child. The scheme recalls that of the Bruni Monument, but is not purely Florentine, and reflects the influence of Roman wall monuments.

Niccolò Strozzi

Staatliche Museen, Berlin-Dahlem, Inv. No. 96 Plate 167

The bust was purchased for the Kaiser Friedrich Museum from the Palazzo Strozzi, Florence, in 1877. In the excavated area beneath is the inscription NICOLAVS. DESTROZIS INVRBE A. MCCCCLIIII, and on the rim beneath the right shoulder the signature OPVS. NINI. The banker Niccolò di Leonardo Strozzi (b. 1441, d. 1469) was exiled from Florence in 1434, and the bust, as is indicated by the words INVRBE, was carved in Rome. The misliteration of the name Mino has led to some confusion, and the signature has also been read wrongly as OPVS. DINI; this has led at least one student (Angeli) to

reject the attribution to Mino da Fiesole. The bust is, however, wholly characteristic of Mino's handling and style, and is fully consistent with the bust of Piero de' Medici (b. 1416) in the Museo Nazionale, Florence, which bears the inscription PETRVS COSMI FILIUS AETATIS ANNO XXXVII / OPVS MINI SCVLPTORIS and must, therefore, have been carved in 1453. The two busts, like Mino's other busts, are not based on life or death masks, such as those employed by Antonio Rossellino, but are transcribed from models made from life.

Benedetto da Maiano

(b. 1442; d. 1497)

The son of a stonemason, Leonardo d'Antonio da Maiano, Benedetto da Maiano appears to have been born in 1442. A Portata al Catasto prepared by Giuliano da Maiano in 1469 gives his own age in this year as 38, that of his brother Giovanni as 31, and that of Benedetto as 28. Throughout his whole life Benedetto's career was bound up with that of his architect brother Giuliano. According to Vasari, he was active initially as a worker in intarsia, but there is no confirmation of this, and his earliest attributed work is the shrine of S. Savino in the Cathedral of Faenza, where Giuliano was also employed. This work, listed by Vasari, was commissioned under the will of Giovanna Manfredi (1468) and was completed by the summer of 1471 when Carlo Manfredi was assured that 'dicta capella est constructa et edificata'. The tomb is a variant of the Rossellino Orlando de' Medici Monument in Sts Annunziata, Florence. The narrative scenes reveal the influence of the marble sculptures of Antonio Rossellino. Benedetto matriculated in the Arte dei Maestri di Pietra e Legname in 1473. In the second half of the 1470s he carved an imposing ciborium flanked by two Angels for the high altar of S. Domenico, Siena, of which the central part depends from the S. Pier Maggiore ciborium of Desiderio da Settignano. Benedetto da Maiano's masterpiece, the pulpit in S. Croce, Florence (see plates 106, 107), probably dates from 1472-5. About 1480-1 he was employed in the Palazzo della Signoria in Florence, on a marble doorway in the Sala dei Gigli (see plates 120, 121), where he was once more associated with Giuliano. Between 1472 and 1487 Benedetto was intermittently engaged on work for the Collegiata at San Gimignano (which was freed in 1462 from the Bishopric of Volterra). The chapel of the local S. Fina was erected in 1468-72 by Giuliano da Maiano and the altar in it was carved by Benedetto between 1472 and 1477 (Angels from it now transferred to the high altar, which Benedetto completed at the latest by 1487). In the same decade (payments of 1484 and 1487) he

undertook the making of a lavabo (described by Vasari as an early work) and lunettes of the Evangelists for the Basilica of the Holy House at Loreto. In the 1480s he was also employed upon two major works for Naples. One of these was the completion of the tomb of Mary of Aragon, begun by Antonio Rossellino for the church of Monteoliveto (S. Anna dei Lombardi): work on this monument was probably initiated soon after 1481, and was carried out in the main by studio assistants. The other, the masterly altar for the Mastrogiudice Chapel in the same church (see plates 109, 110), was completed in 1489. Both works appear to have been carved in Florence. In the late 1480s Benedetto da Maiano was employed by Filippo Strozzi, whose tomb in S. Maria Novella he designed and carved; this was still unfinished when Filippo Strozzi died (15 May 1491). He was also involved in the designing of the Palazzo Strozzi (laying of foundation stone 1489). A payment of 1494 relates to the Altar of S. Bartolo in S. Agostino at San Gimignano; this was probably begun in 1493 and finished in 1495. In 1494 he started work on a lifesize frieze representing the Coronation of Ferdinand of Aragon for the Porta Reale in Naples. This commission was abandoned on the abdication of Alfonso II of Naples in 1495. Parts of the frieze are listed among the contents of Benedetto da Maiano's studio at his death. One of them ('re con vescovo di braccia 21/3 is now in the Museo Nazionale, Florence. Six flanking figures of pages and trumpeters (unfinished) are also in the Bargello. In 1496 Benedetto received payment for a death mask of Piero Capponi to be painted by Botticelli. Benedetto died on 24 September 1497, and under an earlier will (19 April 1492) bequeathed to the Bigallo, among his other effects, statues of St Sebastian (plate 122) and the Virgin and Child which are now in the Misericordia, Florence, and must be regarded as his last works. These show a remarkable advance, and are important for the development of Florentine Mannerist sculpture. Some of Benedetto's latest works are commemorative busts of Giotto and Antonio Squarcialupo in the Cathedral.

Benedetto da Maiano seems to have made extensive use of terracotta models. and a number of these were listed in his studio at his death. He is the only Florentine fifteenth-century sculptor a substantial number of whose terracotta sketch-models survives. His most important independent work in terracotta is the Madonna dell'Ulivo in the Duomo at Prato, in a tabernacle originally made to decorate a chapel on land purchased by Giuliano and his brothers in the vicinity of the town. The tabernacle includes an antependium of the Dead Christ between the Virgin and St John, which is perhaps the work of Giovanni da Maiano.

Bibliography

The only available monographs on Benedetto da Maiano (L. Dussler, Benedetto da Maiano, Munich, 1924; L. Cendali, Giuliano e Benedetto da Maiano, San Casciano Val di Pesa, 1926) are perfunctory and poorly documented, and should be read in conjunction with an article by Schottmüller in Thieme-Becker Künstler-Lexikon iii (1909) and with the Milanesi edition of Vasari's life of Benedetto. Some additional material is supplied by R. G. Mather ('Documents Mostly New Relating to Florentine Painters and Sculptors of the Fifteenth Century', Art Bulletin, xxx. 1948, pp. 20-65). For the Arca di S. Savino, see W. von Bode ('Jugendwerke des Benedetto da Maiano', Repertorium für Kunstwissenschaft, vii, 1884, pp. 149–62, and more especially G. Radke ('The Sources and Composition of Benedetto da Maiano's San Savino Monument in Faenza', Studies in the History of Art, Washington, 18, 1985, pp. 7-27). For the doorway of the Sala dei Gigli, see C. von Fabriczy ('Giuliano da Maiano', Jahrbuch der Preussischen Kunstsammlungen, xxiv, Beiheft, 1903, p. 141), for Porta Reale at Naples G. L. Hersey ('Alfonso II, Benedetto e Giovanni da Maiano e la Porte Reale', Napoli nobilissima, iv, 1964, pp. 77-95), for the other Neapolitan commissions C. von Fabriczy ('Toscanische und oberitalienische Künstler in Diensten der Aragonesen zu Neapel', Repertorium für Kunstwissenschaft, xx, 1897, pp. 85-120) and L. Serra ('Due scultori fiorentini del 400 a Napoli', Napoli nobilissima, xv.

1906, pp. 181-5), and for the Filippo Strozzi Monument G. Poggi ('Un tondo di Benedetto da Maiano', Bollettino d'arte, ii, 1908, pp. 1-5). The theory of Michelangelo's participation in the Altar of the Annunciation is advanced by M. Lisner ('Zu Benedetto da Majano und Michelangelo', Zeitschrift für Kunstwissenschaft, xii, 1958, pp. 141–56). An excellent and well-illustrated account of the Piccolomini Chapel is supplied bv R. Pane (Il rinascimento dell'Italia meridionale, Milan, 1975-7, i). A mistaken thesis of G. L. Hersey (Alfonso II and the Artistic Revival of Naples, 1485-95, New Haven, 1969) that the Piccolomini Chapel was designed by Giuliano da Maiano is contested by A. Blunt (Burlington Magazine, cxiv, 1972, p. 243) and E. Borsook (Burlington Magazine, cxiv, 1972, pp. 243-4). The unfinished flanking figures of pages and trumpeters for the Porta Reale in Naples are now in the Museo Nazionale. Florence. They are published by A. Paolucci ('I musici di Benedetto da Maiano e il monumento di Ferdinando d'Aragona', Paragone, xxvi, no. 303, 1975, pp. 3-11). For the ciborium and high altar of the chapel of S. Fina at San Gimignano, see H. Caspary ('Ein Relieffragment des Benedetto da Maiano im Museo Civico von San Gimignano', in Festschrift U. Middeldorf, Berlin, 1968, pp. 165-74); careful examination of the documentary background of the chapel of S. Fina by D. Carl ('Der Fina-Altar von Benedetto da Maiano in der Collegiata zu San Gimignano: zu einer Datierung und Rekronstruktion', Mitteilungen des Kunsthistorischen Institutes in Florenz, xxii, 1978, pp. 265-86; 'Der Hochaltar des Benedetto da Maiano für die Collegiata von San Gimignano', ibid., xxxv, 1991, pp. 21-60) localizes the building of the chapel by Giuliano da Maiano between 1468 and 1472 and the construction of the altar between 1472 and 1477. The kneeling marble angels are here presumed to be associated with the high altar ciborium and not to have been carved for the altar of the chapel; Carl is also responsible for an excellent study on Benedetto's work in San Domenico: 'Il ciborio di Benedetto da Maiano nella Cappella Maggiore di S. Domenico a Siena', Rivista d'arte, xlii, 1990, pp. 3-74. Interesting light is

thrown on the tomb and chapel of Filippo Strozzi in S. Maria Novella by D. Friedman ('The Burial Chapel of Filippo Strozzi in Santa Maria Novella in Florence', L'Arte, ix, 1970, pp. 109-31) and E. Borsook ('Documents for Filippo Strozzi's Chapel in Santa Maria Novella and Other Related Papers', Burlington Magazine, cxii, 1970, pp. 737-45, 800-4; 'Documenti relativi alle cappelle di Lecceto e delle Selve di Filippo Strozzi'. Antichità viva, ix, 1970, pp. 3–20). The bust of Filippo Strozzi in the Louvre (plate 175) is redated by Borsook to 1475. The chronology of Benedetto's late works is discussed in an efficient article by A. S. Tessari ('Benedetto da Maiano tra il 1490 e il 1497', Critica d'arte, n.s., xl, no. 143, 1975, pp. 39-52, and xli, no. 145, 1976, pp. 20-30). An annotated translation of the inventory of Benedetto da Maiano's studio is included by C. Gilbert in Italian Art, 1400-1500: Sources and Documents, Englewood Cliffs, 1980, pp. 42-7. On Benedetto da Maiano's use of models, see I. Lavin. 'Bozzetti and Modelli. Notes on Sculptural Procedure from the Early Renaissance through Bernini', Stil und Überlieferung in der Kunst des Abendlandes, Berlin, 1967, pp. 93–104, and an excellent article by G. Radke ('Benedetto da Maiano and the Use of Full-Scale Preparatory Models in the Quattrocento', Verrocchio and Late Ouattrocento Italian Sculpture, eds. S. Bule et al. Florence, 1992, pp. 217-24). The bust of Giotto in the Duomo is one of Benedetto's last works. For the documents relating to the death mask of Piero Capponi (lost), see S. J. Craven (Aspects of Patronage in Florence, 1444-1512, Ph.D. dissertation, University of London, 1973, p. 66).

Pietro Mellini

Museo Nazionale, Florence Plates 176, 177

The identity, date and authorship of the bust are attested by inscriptions beneath, which read BENEDICTVS MAIANVS FECIT and PETRI MELLINI . FRANCISCI FILII . IMAGO HEC . AN . 1474. The sitter, the merchant Pietro Mellini, was responsible for the construction of the S. Croce pulpit (see plate 107), and for a tabernacle at Arezzo carved in the

Maiano studio. The bust is thus considerably earlier than the second of the authenticated busts of Benedetto da Maiano, the Filippo Strozzi in the Louvre (plate 175), which is inscribed PHILIPVS . STOZA . MATHEI . FILIVS . BENEDICTVS . DE . MAIANO . FECIT, and seems to date from shortly before Strozzi's death in 1491. A terracotta sketch-model preceded the carving of the Mellini bust. No other independent male portrait busts in marble by Benedetto da Maiano are known, though two busts, a posthumous portrait of Onofrio di Pietro at San Gimignano (1493), and a head of an unidentified man in the Victoria and Albert Museum, London, appear to have been carved by a studio assistant from models by Benedetto da Maiano, perhaps in connection with sepulchral monuments.

Altar of the Annunciation

S. Anna dei Lombardi, Naples Plates 109, 110

The Altar of the Annunciation in the church of Monteoliveto (S. Anna dei Lombardi) at Naples is described by Vasari, who attributes the commission to the Conte di Terranuova. who died in 1490. A letter of 21 September 1490 indicates that the chapel was still not complete, while a payment of 21 April 1491 to Benedetto for 'parte della tavola fa al Conte di Terranuova' probably refers to the Annunciation relief (Borsook). It was wrongly assumed by Milanesi that the altar was in fact carved for Alfonso Duke of Calabria after 1492. The altar, which along with the S. Croce pulpit must be regarded as Benedetto da Maiano's masterpiece, depends in form from the altarpiece executed by Antonio Rossellino for the Piccolomini Chapel in the same church (plate 108), and shows in the centre a relief of the Annunciation flanked by niches containing statues of Sts John the Baptist and Jerome. Above the lateral figures are two medallions with Sibyls, and beneath is a predella containing reliefs of (left to right) the Nativity, Adoration of the Magi, Resurrection, Lamentation over the Dead Christ, Ascension, Pentecost and the Death of the Virgin. The putti with garlands described by Vasari stand on the upper edge of the altar. The lateral

figures have been ascribed to Matteo Pollaiuolo but, so far as can be judged, most of the figure sculpture of the altar is due to the shop of Benedetto da Maiano. The carving throughout is of great fastidiousness, and its effect is calculated in relation to the red marble in which it is set. Two terracotta models for the lateral St John the Baptist on the altar are listed in Benedetto's posthumous; one of these (2.8 cm smaller than the marble) is now in the Thyssen Collection, Madrid. Models for the God the Father in the upper left of the main scene are in a private collection in New York. It has been suggested (Lisner) that the young Michelangelo was a member of Benedetto da Maiano's workshop at the time of execution of the Altar of the Annunciation, and was responsible for the putto with a garland that crowns the moulding on the right.

Pulpit

S. Croce, Florence Plates 106, 107

The commission for the S. Croce pulpit is described in detail by Vasari: 'Ritornato finalmente a Fiorenza, fece a Pietro Mellini, cittadino fiorentino ed allora ricchissimo mercante, in Santa Croce, il pergamo di marmo che vi si vede; il qual è tenuto cosa rarissima e bella sopra ogni altra che in quella maniera sia mai stata lavorata, per vedersi in quello lavorate le figure di marmo, nelle storie di San Francesco, con tanta bontà e diligenza, che di marmo non si potrebbe più oltre disiderare; avendovi Benedetto con molto artifizio intagliato alberi, sassi, casamenti, prospettive, ed alcune cose maravigliosamente spiccate; ed oltre ciò, un ribattimento in terra di detto pergamo, che serve per lapida di sepoltura, fatto con tanto disegno, che è impossibile lodarlo abbastanza. Dicesi che egli in fare quest'opera ebbe difficoltà con gli Operaj di Santa Croce, perchè volendo apoggiare detto pergamo a una colonna che regge alcuni degli archi che sostengono il tetto, e forare la detta colonna per farvi la scala e l'entrata al pergamo, essi non volevano, dubitando che ella non s'indebolisse tanto col vacuo della salita, che il peso non la sforzasse, con gran rovina d'una parte di quel tempio. Ma avendo

dato sicurtà il Mellino, che l'opera si finirebbe senza alcun danno della chiesa, finalmente furono contenti. Onde avendo Benedetto sprangato di fuori con fasce di bronzo la colonna, cioè quella parte che dal pergamo in giò è ricoperta di pietra forte, fece dentro la scala per salire al pergamo, e tanto quanto egli la bucò di dentro, l'ingrosso di fuora con detta pietra forte, in quella maniera che si vede; e con stupore di chiunque la vide condusse quest'opera a perfezione, mostrando in ciascuna parte ed in tutta insieme quella maggior bontà che può in simil opera desiderarsi.' ('Returning to Florence, he made for Pietro Mellini, a Florentine citizen and merchant of great wealth, the marble pulpit which is still to be seen in S. Croce. This is considered a work of rare merit, and beautiful beyond all other works in the same style. It contains scenes from the life of St Francis with small marble figures worked with such excellence and care that more expert marble carving could not be desired, and in them Benedetto with great skill has carved trees, rocks, houses, perspectives and some things which are marvellously detached from the ground. Beside this there is a reflection of the aforesaid pulpit on the pavement, serving as a sepulchral slab, which is made with such design that it cannot be praised sufficiently. It is said that while he was engaged on this work, he had difficulties with the Operai of S. Croce, since he wished to attach the pulpit to a pier which supports some of the arches on which the roof rests, and to bore the column in order to make the staircase and entrance to the pulpit. They did not wish him to do this, since they feared that the pier would be weakened by the empty space inside it, and that the weight would bring it down with great damage to part of the church. But after Mellini had given an assurance that the work would be finished without any damage to the church, they finally concurred. Whereupon Benedetto reinforced the pier outside with bronze bands, that is the part between the pulpit and the ground, and introduced the steps to mount into the pulpit. In proportion as he excavated the pier inside, he strengthened the outside with hard stone, as can be seen; and he perfected the work to the astonishment of

everyone who saw it, investing it both in detail and in its entirety with that greater excellence that is desirable in such a work') The upper part of the pulpit contains five narrative reliefs set beneath a frieze decorated with the instruments of the Passion and separated from each other by pilasters. In the base, between protruding supports, are five small niches filled with statuettes of (left to right) Faith, Hope, Charity, Temperance and Justice. The narrative scenes above show (left to right) (i) the Confirmation of the Franciscan Order, (ii) St Francis before the Sultan, (iii) the Stigmatization of St Francis, (iv) the Funeral of St Francis, and (v) the Martyrdom of the Franciscans at Ceuta. An inventory of the contents of Benedetto da Maiano's studio at the time of his death (C. Baroni, Cenni storici della parrocchia di San Martino a Maiano, Florence, 1875, pp. 77ff.) lists '6 storie del modella del pergamo di S. Croce'. Three of these terracotta models, for the reliefs listed as (i), (iv) and (v) above, are in the Victoria and Albert Museum, London, and a fourth, representing the Vision of Pope Innocent III and omitted from the pulpit, was in the Kaiser Friedrich Museum, Berlin. There are a number of small compositional differences between the three terracotta models and the reliefs as they were executed. The sketches for the reliefs in London are 64 cm square, whereas the marbles are twenty per cent larger (77.5 cm square). The nature of the changes between the two and the technique of enlargement are admirably analysed by Radke. There is no documentary evidence for the date of the pulpit, which has been assigned to the date of the Mellini bust (1474-5) (Paatz, Dussler and others), to about 1480 (Schottmüller) and to 1480-90 (Reymond, Le Sculpture florentine, Florence, 1897). On the evidence of Benedetto da Maiano's other works the earliest of these datings is the most probable. The structure of the pulpit was discussed in a first-rate lecture by G. Radke ('Giuliano e la bottega dei da Maiano', Fiesole, 1991; the acts of this conference were not available at the time this book went to press), who concludes that the tomb marker was placed so that its central element related to the reinforced pier behind the pulpit, while

the pulpit proper is planned on the Florentine braccia. The first system would be due to Giuliano da Maiano and the second to Benedetto.

Doorway

Sala dei Gigli, Palazzo della Signoria, Florence Plates 120, 121

On 12 June 1473 it was agreed that the Sala dell'Orologio (or Sala dei Gigli) and the Sala dell'Udienza in the Palazzo della Signoria should be redecorated. Payments to Giuliano da Maiano in connection with this work date from 28 February 1476, 21 December 1480 and 27 November 1481. It is inferred (Fabriczy) that the simpler side of the door facing towards the Sala dell'Udienza was the work of Giuliano da Maiano, and that the richer entrance in the Sala dei Gigli was designed and executed by Benedetto. In this event the door and the figures of putti and of St John the Baptist (plates 120, 121) over it would date from 1480-1. The political significance of the room is discussed in a major article by N. Rubinstein ('Classical Themes in the Decoration of the Palazzo Vecchio in Florence', Journal of the Warburg and Courtauld Institutes, 1, 1987, pp. 29-43), who regards the decoration as 'the first work of art created for the Palace which shows the full impact of classical antiquity'. The reliefs include Hercules, and the remaining Virtues are drawn from or suggested by sarcophagi. Also civic in character are the Justice and the Charity and Temperance in the capitals.

ANDREA DEL VERROCCHIO (b. c.1435; d. 1488)

Verrocchio was born in Florence c.1435. His name occurs for the first time in 1452, when he threw a stone at a fourteen-year-old wool worker and was exculpated from a charge of manslaughter. In 1457 he made his first Catasto return jointly with his brother Tommaso. This is of interest only in so far as it reveals that Verrocchio was trained as a goldsmith, and had left this occupation because of lack of work. By the Anonimo Magliabecchiano he is said to have worked in the studio of Donatello. This is not impossible on chronological grounds, since he was eighteen when Donatello returned to Florence from Padua, but is controverted by the style of Verrocchio's earliest works. Pomponius Gauricus refers to him as Donatello's rival ('Andraeas Alverochius Donatelli sed jam senis aemulus'). He is also said to have participated in the execution of Desiderio da Settignano's Marsuppini Monument (see plate 138). The early works of Verrocchio, however, seem to indicate a close connection with the Rossellino studio, and the practice of this shop is accountable for the style of his earliest marble sculpture, the lavabo in the Old Sacristy of S. Lorenzo, Florence (completed before 1469, probably executed 1465-6). The attribution of the lavabo has been contested, and it is ascribed by one early source (Albertini) to Antonio Rossellino. In 1461 he submitted, in competition with Desiderio da Settignano and Giuliano da Maiano, a model for the Chapel of the Madonna della Tavola in the Duomo at Orvieto (not executed), and probably between 1465 and 1467 designed the Albertian tomb of Cosimo de' Medici in the crypt of S. Lorenzo. At some time between 1463 and 1467 Verrocchio received the commission for the group of Christ and St Thomas on Or San Michele (see plates 124, 125, 126). In 1467 he cast a bronze candlestick for the Sala dell'Udienza of the Palazzo della Signoria (Rijksmuseum, Amsterdam), and in these years was also engaged on a copper ball for the top of the lantern of the Duomo (ordered 19 January 1467,

erected 27 May 1471, destroyed 1600). Probably in the early 1470s he executed the Putto with a Fish in the Palazzo della Signoria (see plate 127), and before 1476 the bronze David in the Museo Nazionale, Florence (see plate 123). The first of his major works to reach fruition, the tomb of Piero and Giovanni de' Medici in S. Lorenzo, Florence (plate 155), is inscribed 1472. In 1473 Verrocchio acted as assessor for the Prato pulpit of Antonio Rossellino, and in 1477 began work on the Forteguerri Monument for the Cathedral at Pistoia (see plates 150-3). Verrocchio's only extant work in precious metal, a relief of the Decollation of the Baptist for the silver altar of the Baptistery, now in the Museo dell'Opera del Duomo, Florence, was commissioned on 27 July 1477 and delivered in 1480. In the early 1480s he appears to have begun work on the Colleoni Monument (see plates 190-2). Two reliefs of Alexander the Great and Darius are said by Vasari to have been cast by Verrocchio for Matthias Corvinus, King of Hungary. A related marble relief of Alexander is in the National Gallery of Art, Washington, and seems to date from about 1480. The other is known through a copy in enamelled terracotta formerly in the Kaiser Friedrich Museum, Berlin. Also from the late 1470s or early 1480s dates a polychrome terracotta relief of the Resurrection from Careggi, now in the Museo Nazionale, Florence. Other autograph works by Verrocchio in terracotta are busts of Giuliano de' Medici (plates 182, 183) and Lorenzo de' Medici in the National Gallery of Art. Washington, and two small sketchmodels for the Angels of the Forteguerri Monument in the Louvre. According to Vasari, Verrocchio was also responsible for the sepulchral monument of Francesca Tornabuoni (d. 1477) in S. Maria sopra Minerva, Rome; this has been destroyed. A reference to material for a fountain ordered by Matthias Corvinus (28 August 1488) suggests that this was, along with the Colleoni Monument, one of the commissions with which Verrocchio was occupied in Venice at his death (June-July 1488). On 27 January 1496 a list of works executed by Verrocchio for the Medici was drawn

up by Tommaso Verrocchio. Verrocchio

also practised as a painter, but little of his work in this medium survives. Of his two altarpieces the more important is the Baptism of Christ painted for S. Salvi, Florence (Uffizi), which was executed after 1470 with the assistance of Leonardo da Vinci. The second, the Madonna di Piazza (Duomo, Pistoia), was painted between 1478 and 1485, in part by Lorenzo di Credi from Verrocchio's cartoon. Painted halflength Madonnas are in the Staatliche Museen, Berlin-Dahlem, and the National Gallery, London. Vasari's life of Verrocchio opens with a criticism of his style: 'in vero, nell'arte della scultura e pittura ebbe la maniera alquanto dura e crudetta' ('to tell the truth, in the arts of sculpture and painting he had a style which was somewhat hard and crude'), and his transcendent importance as a sculptor has not been adequately recognized. Some of his finest works (among them the Portrait of a Lady in the Museo Nazionale, Florence, and the sketches for the Forteguerri Monument in the Louvre) have been ascribed to his pupil Leonardo, and writers on the latter artist have tended as a whole to underrate Verrocchio's significance. His oeuvre catalogue as a sculptor presents few problems of attribution, though a statuette of St Jerome in the Victoria and Albert Museum, London, variously dated c.1465 (Planiscig) and c. 1480 (Dussler, in Thieme-Becker Künstler-Lexikon, xxxiv, 1940), should probably be regarded as the work of an imitator of Verrocchio's late style. A putative terracotta sketch-model for the executioner in the relief on the silver altar appears in photograph to date from the first quarter of the sixteenth century. The main chronological problem arising from his work relates to the dating of the Careggi Resurrection, which is wrongly regarded by Planiscig as an early work.

Bibliography

The most recent and elaborate monograph on Verrocchio, that by G. Passavant (*Verrocchio*, London, 1969), provides an invaluable corpus of photographs of Verrocchio's paintings and sculptures, but must be used with caution, since a number of its attributional and qualitative judgements are heterodox and wrong. Popular

volumes by A. Busignani (Verrocchio, I diamante dell'arte, no. 8, Florence, 1966) and P. Adorno (Il Verrocchio, Florence, 1991) are less accurate than a similar book by M. Chiarini (Andrea del Verrocchio, I maestri della scultura, no. 24. Milan, 1966). A short monograph by L. Planiscig (Andrea del Verrocchio, Vienna, 1941) is serviceable and well illustrated, but does not supersede an earlier volume by M. Cruttwell (Verrocchio, London, 1904), in which a number of documents are reproduced. Both books are much inferior to the detailed and systematic study of Verrocchio's style as manifested in the Forteguerri Monument by C. Kennedy, E. Wilder, and P. Bacci (Studies in the History and Criticism of Sculpture, viii-The Unfinished Monument by Andrea del Verrocchio to the Cardinal Niccolò Forteguerri at Pistoia, Smith College, Northampton, 1932). Useful additions to our knowledge of Verrocchio are made in a documentary study by D. A. Covi ('Four New Documents concerning Andrea del Verrocchio', Art Bulletin, xlviii, 1966, pp. 97-103). The 1496 inventory of Tommaso Verrocchio is reprinted by Cruttwell (without commentary) and, with useful annotations, by C. von Fabriczy ('Andrea del Verrocchio ai servizi dei Medici', Archivio storico dell'arte, 2nd series, i, 1895, pp. 163-76). The best and most detailed contemporary account of the Christ and St Thomas is by A. Butterfield ('Verrocchio's Christ and St Thomas: Chronology, Iconography, and Political content', Burlington Magazine, xxxiv, 1992, pp. 225-33); similar conclusions are reached by D. A. Covi ('Reinterpreting a Verrocchio Document', Source, xii, 1993, pp. 5-12). The relief of Alexander the Great is identified and discussed by L. Planiscig ('Andrea del Verrocchios Alexander-Relief', Jahrbuch der Kunsthistorischen Sammlungen in Wien, n.f. vii, 1933, pp. 89-96), and the Amsterdam candlestick by W. R. Valentiner ('Rediscovered Works by Andrea del Verrocchio', reprinted in Studies in Italian Renaissance Sculpture, London, 1950, pp. 97-192). A careful but mistaken analysis of the Dibblee/Oberlin stuccos is supplied by L. Mack Bongiorno ('A fifteenthcentury stucco and the style of

Verrocchio', Bulletin of the Allen Memorial Art Museum, xix, 1962, pp. 115-38). The tomb-slab of Fra Giuliano del Verrocchio in S. Croce, Florence, is published as a work of Verrocchio of c.1465-70 by D.A. Covi ('An Unnoticed Verrocchio?' Burlington Magazine, cx, 1968, pp. 4-9); in the present state of the slab no firm view can be given on this attribution. For other doubtful attributions, see J. Balogh ('Un capolavoro sconosciuto del Verrocchio', Acta historiae artium, viii, 1962, pp. 55-98, and 'Studi nella collezione di sculture del Museo di Belle Arti in Budapest', Acta historiae artium, xv, 1969, pp. 77-138) and W. Heil ('A Marble Putto by Verrocchio', Pantheon, xxvii, 1969, pp. 271-82. A monograph by C. Seymour, Jr. (The Sculpture of Verrocchio, London, 1971) is planned as 'a critique - that is, an up-to-date and, one would hope, focused view on the main elements, the principal thrusts, of Verrocchio's activity as a sculptor'. For the lavabo in S. Lorenzo, see H. Mackowsky ('Das Lavabo in San Lorenzo zu Florenz', Jahrbuch der Preussischen Kunstsammlungen, xvii, 1896, pp. 239-44) and G. Passavant ('Beobachtungen am Lavabo von San Lorenzo in Florenz', Pantheon, xxxix, 1981, pp. 33-50) who concludes that the lavabo in the Old Sacristy is composite and was not designed for its present function, and includes part of the base carved by Desiderio for the Donatello bronze David. While a number of the observations in this article are valid, its main thesis is unconvincing. The copper ball for the lantern of the Cathedral is discussed by B. Boni ('La palla di rame di S. Maria del Fiore', Notizie vinciano, 1978, pp. 35-44) and D. A. Covi ('Verrocchio and the "Palla" of the Duomo', in Art the Ape of Nature: Studies in Honor of H. W. Janson, New York, 1981, pp. 151-69). An article by J. Clearfield ('The Tomb of Cosimo de' Medici in San Lorenzo', The Rutgers Art Review, ii, 1981, pp. 13-30) deals with the tomb of Cosimo il Vecchio. P. Cannon-Brookes ('Verrocchio Problems', *Apollo*, xcix, 1974, pp. 8–19) ascribes the Putto with a Fish to the early 1460s and the David to a later point in the same decade: both datings seem, to me, slightly too early. A mistaken discussion of the bronze David is

provided by V. Herzner ('David Florentinus, iv, Der Bronze-David von Verrocchio im Bargello', Jahrbuch der Berliner Museen, xxiv, 1982, pp. 125-42). An enamelled terracotta relief of the Rape of Europa by, or after, Verrocchio in the Victoria and Albert Museum is published by J. Pope-Hennessy ('Some Newly Acquired Italian Sculptures: A Relief of the Rape of Europa', Victoria and Albert Museum Yearbook, iv, 1974, pp. 11-19). D. A. Covi ('Verrocchio and Venice, 1469', Art Bulletin, lxv, 1983, pp. 253-73) deals with the implications of a visit paid by Verrocchio to Venice and Treviso in 1469 for the development of his later style. Reflections of Verrocchio's style in Venice are traced in an interesting article by A. Markham Schulz ('A New Venetian Project by Verrocchio', in Festschrift für Otto von Simson, Berlin, 1977, pp. 197-208) on the Altar of the Virgin in SS. Giovanni e Paolo, where three of the upper reliefs seem to reveal Verrocchio's influence. For the Christ and St Thomas, see C. von Fabriczy ('Der hl. Ludwig und sein Tabernakel an Or San Michele', Jahrbuch der Preussischen Kunstsammlungen, xxi, 1900, pp. 242-61) and C. Sachs (Das Tabernakel mit Andreas del Verrocchio Thomasgruppe an Or San Michele zu Florenz, Strassburg, 1904). The group was cleaned in 1990-2. A volume devoted to its restoration contains (Verrocchio's Christ and St Thomas, A Masterpiece of Sculpture from Renaissance Florence, ed L. Dolcini, exhibition catalogue, New York, 1992) admirable photographs of its in part repatinated surface, an account of the restoration by Dolcini, an article by M. Leoni on Verrocchio's founding technique, and an excellent article on the group by A. Butterfield. The results of the cleaning are, however, debatable. A volume of papers on Verrocchio (Verrocchio and Late Quattrocento Italian Sculpture, eds. S. Bule et al., Florence, 1992) contains essays on the current state of Verrocchio study (D. A. Covi, pp. 7-24), on the Corpus Verum in the Incredulity of St Thomas (C. Von Ausdall, pp. 35-49), on the tombs of Cosimo il Vecchio and Piero and Giovanni de' Medici (W. Sperling, pp. 51-61), on the tomb of Piero and Giovanni de' Medici and Verrocchio's relations with Venice (W. S. Sheard,

pp. 63–85), on Verrocchio's David (A. Butterfield, pp. 107–16), and on related subjects.

Virgin and Child

Museo Nazionale, Florence Plate 116

Verrocchio's only autograph Madonna relief, a terracotta Virgin and Child originates from the Spedale di S. Maria Nuova (Paatz). Vasari records that Verrocchio was at one time a patient in the hospital, and Cruttwell suggests that the relief may have been commissioned for the hospital by Tommaso Portinari; there is no corroboratory evidence of this. The dating of the relief is conjectural, and varies between c. 1470 and c.1480 (Planiscig); the drapery is less fully elaborated than that of the St Thomas in the Christ and St Thomas group on Or San Michele, and the relief can scarcely have been modelled after 1476, when the style of the St Thomas was evolved. The scheme is reproduced in reverse with some variations in a marble Madonna in the Museo Nazionale, Florence, by a member of Verrocchio's shop. It is open to question whether the present relief (which shows extensive traces of pigmentation) should be regarded as a completed work or as a full-scale workedup model for a relief in marble. There is no reason to doubt that Verrocchio produced a number of halflength Madonna reliefs, though no other example survives. Stucco Madonnas formerly in the Dibblee Collection, Oxford, and at Oberlin, and in the Kaiser Friedrich Museum, Berlin (formerly), reproduce a lost original by the master. It has been demonstrated by K. Watson ('Sculpture: Hellenistic to Twentieth Century', Apollo, ciii, 1976, pp. 98–105) on the basis of mould marks that the Dibblee and Oberlin Madonnas were cast from one original. A third version of the composition in terracotta, once regarded as a forgery, is in the Birmingham Museum and Art Gallery, where it was restored in 1978. An article by S. Rees-Jones ('A Fifteenth-Century Florentine Terracotta Relief: Technology, Conservation, Interpretation', Studies in Conservation, 23, 1978, pp. 95-113) describes the structure of the relief. It is improbable

that this relief is the original from which the Dibblee and Oberlin reliefs were made, but it is, like them, of conspicuously high quality. The lost prototype of the Dibblee and Oberlin stuccos is mistakenly given by Bongiorno to a follower of Verrocchio and by Passavant to Benedetto da Maiano.

Portrait of a Lady

Museo Nazionale, Florence Plate 181

The bust is generally thought to have come from the Medici Collection, and has sometimes been conjecturally identified as that of the mistress of Lorenzo de' Medici, Lucrezia Donati (Dussler and others). It does not, however, appear in the list of works executed by Verrocchio for the Medici prepared by Tommaso Verrocchio, and the portrait of Lucrezia Donati mentioned in the list ('uno quadro di legname drentrovi la fighura della testa della Lucherezia de Donatj') was evidently either a painting (Fabriczy) or a marble relief. The attribution of the bust to Verrocchio is generally accepted save by those scholars (Mackowsky and others) who ascribe it to Leonardo da Vinci on account of generic resemblances to the portrait of Ginevra dei Benci in the National Gallery of Art, Washington, and to a drawing of hands at Windsor Castle (no. 12558), sometimes regarded as a study for the missing lower part of the Washington painting, in which the hands were originally shown. The relationship between the drawing and painting on the one hand and the bust on the other is analysed by K. Clark (A Catalogue of the Drawings of Leonardo da Vinci in the Collection of Her Majesty the Queen at Windsor Castle, London, i, 1969, pp. 104-5). The Washington portrait seems to date from 1478-80, and it has been suggested that this portrait type (to which the Cecilia Gallerani of c.1483 and the Mona Lisa of 1503 also adhere) originates in Verrocchio's bust. The bust is usually assigned to the late 1470s (Dussler) and can scarcely have been carved later than 1480 (Planiscig) or earlier than 1475. A second marble bust by Verrocchio, the Portrait of a Lady

formerly in the John D. Rockefeller Collection, New York, is less mature in style, and seems to date from about 1470; it reached the Uffizi only in 1825 and cannot therefore have formed part of the Medici Collection. The subject of the Florence portrait is unidentified (for this and for its style, see F. Cagliotti in *Eredità del Magnifico*, Florence, 1992, pp. 50–4).

Putto with a Fish

Palazzo della Signoria, Florence Plate 127

The Putto with a Fish, formerly on a fountain in the cortile of the Palazzo della Signoria, now in the interior of the palace, is described in Vasari's life of Verrocchio: 'Fece anco a Lorenzo de' Medici, per la fonte della villa a Careggi, un putto di bronzo che strozza un pesce; il quale ha fatto porre, come oggi si vede, il signor Duca Cosimo alla fonte che è nel cortile del suo palazzo; il qual putto è veramente maravigliosa.' ('He also made for Lorenzo de' Medici, for the fountain at the villa of Careggi, a bronze putto clutching a fish. Duke Cosimo has caused this to be placed on the fountain in the courtyard of his palace, where it is now to be seen. In truth this putto is marvellous.') The Putto is described by Tommaso Verrocchio in the list of works executed for the Medici ('el bambino di bronzo chon 3 teste di bronzo e 4 bocche di lione di marmo per a Chareggi'). It was moved to the Palazzo della Signoria between 1550 and 1568, as the centrepiece of a fountain designed by Vasari, and executed by Ammanati, Francesco del Tadda and Andrea di Domenico di Polo. It has been argued (Meller in an unpublished lecture) that the figure originally surmounted a marble fountain now in the vestibule of the first floor of the Palazzo Pitti; this case is rightly rejected by Passavant. On the strength of a passage in the late sixteenth-century Raisbuch of Georg Ernstinger (ed. Walther, Tübingen, 1877) describing a fountain in the Palazzo Vecchio 'darauf die Cupido vom Wasser umgetrieben wirt', Passavant ('Uberlegungen zur Rotationsmechanik von Verrocchios Delphin putto', Mitteilungen des Kunsthistorischen Institutes in Florenz, xxxii, 1988, pp. 105-12) suggests that the

putto rotated by mechanical means; the figure itself offers no confirmation of this view. Dates assigned to the figure vary between c.1465-8 (Dussler) and c.1480 (Planiscig); a dating about 1470 is probable. A derivative in terracotta, ascribed to Verrocchio (A. Venturi), exists in a private collection. A figure in terracotta from the Dreyfus Collection, now in the National Gallery of Art, Washington, assigned to Verrocchio by Von Bode, Planiscig and others, has been connected alternatively with a putto stated to have been executed by Verrocchio for the clock tower of the Mercato Nuovo (Cruttwell) and with a fountain destined for Matthias Corvinus on which Verrocchio was working at his death (Seymour). The Washington Putto is cast from a bronze putto in a French private collection. It seems to date from the late seventeenth century and has no connection with Verrocchio.

David

Museo Nazionale, Florence Plate 123

The bronze David appears in the list of works executed by Verrocchio for the Medici prepared by Tommaso Verrocchio: 'uno davitte e la testa di ghulia.' The contract for the statue does not survive, but it was certainly completed before 1476, when it was purchased by the Signoria from Lorenzo de' Medici and placed in the Palazzo della Signoria in front of the entrance to the Sala dei Gigli. It was thus probably executed in 1469-70 (Dussler). The figure is described by Vasari: 'Ritornato poi a Firenze con danari, fama ed onore, gli fu fatto fare un Davit di braccia due e mezzo; il quale finito, fu posto in palazzo al sommo della scala, dove stava la catena; con sua molta lode.' ('Returning to Florence with wealth, fame, and honour, he was commissioned to make a David two and half braccia high. When finished this was placed in the palace at the top of the stairs, where the chain used to be, and was received with much praise.') The figure was originally set up on a porphyry column on the staircase leading to the Sala dell'Orologio, on which it still stands. It has been suggested (Passavant) that it was commissioned as a replacement for the bronze David of

Donatello in the *cortile* of the Palazzo Medici. It is, however, inferred correctly by Butterfield that the support on which the sculpture stood before 1476 was larger than its present base. Modification of the Goliath head suggests that it originally stood beside the David, not between his legs.

Christ and St Thomas

Or San Michele, Florence Plates 124–6

Verrocchio's masterpiece, the group of Christ and St Thomas on Or San Michele (plate 125), is described by Vasari in these terms: 'Dopo, avendo Donatello per lo magistrato de' Sei della Mercanzia fatto il tabernacolo di marmo, che è dirimpetto a S. Michele. nell'oratorio di esso Orsanmichele, ed avendovisi a far un San Tommaso di bronzo, che cercasse la piaga a Cristo, ciò per allora non si fece altrimenti; perchè degli uomini che avevano cotal cura, alcuni volevano che li facesse Donatello, ed altri il Ghiberti. Essendovi dunque, la cosa stata così insino a che Donatello e Lorenzo vissero, furono finalmente le dette statue allogate ad Andrea, il quale fattone i modelli e le forme, le gettò; e vennero tanto salde, intere e ben fatte, che su un bellissimo getto. Onde, messosi a rinettarle e finirle, le ridusse a quella perfezione che al presente si vede, che non potrebbe esser maggiore; perchè in San Tommaso si scorge la incredulità e la troppa voglia di chiarirsi del fatto, ed in un medesimo tempo l'amore, che gli con bellissima maniera metter la mano al costato di Cristo, ed in esso Cristo; il quale con liberalissima attitudine alza un braccio, ed aprendo la veste, chiarisce il dubbio dell'incredulo discepolo; e tutto quella grazia e divinità, per dir così, che può l'arte dar a una figura.' ('After this, Donatello having made the marble tabernacle on the oratory of Or San Michele for the Magistracy of the Six of the Mercanzia, which is opposite S. Michele, and a St Thomas feeling the wounds of Christ being required, this work was not carried out, since some of those charged with supervising it wished that the statues should be made by Donatello and others that they should be entrusted to Ghiberti. The dispute

having endured throughout the lifetimes of these masters, the aforesaid statues were finally allotted to Andrea, who made the models and the moulds and cast them, and they came out so sound and complete and well made that it was a most beautiful casting. Having afterwards chased and finished them, he brought them to the state of perfection in which they are now, which could not be greater. In the St Thomas may be discerned his incredulity and an excessive wish to ascertain the fact, and at the same time the love with which he places his hand on the side of Christ. The Christ with a gesture of great freedom raises his arm and opens his robe, thus dispelling the doubt of the incredulous disciple, and in this figure there is all that grace and divinity, so to say, that art can give.') Vasari's claim that the group was originally to have been executed by Donatello or Ghiberti is incorrect, and the story of the commission can be fully reconstructed from documents. The niche in which it is set is the central tabernacle on the east side of the Oratory, which was designed for the Parte Guelfa and originally housed the statue of St Louis of Toulouse (plate 17). From 1460 negotiations seem to have been in progress between the Parte Guelfa and the Mercanzia for the sale of the tabernacle to the latter body, and when these were complete the statue of St Louis of Toulouse, the patron for the Parte Guelfa, was moved to S. Croce, and the stemma of the Parte Guelfa was erased. At a meeting of 29 March 1463 a body of 'operai del pilastro seu tabernacolo' was appointed to consider the filling of the vacant niche, 'considerantes . . . quod in dicto tunc muro vacuo apponeretur aliqua statua et seu figura aliqua digna et venerabilis ut est in alio tabernaculo ibidem circhum circha positum. Et considerantes quod locus est dignissimus et etiam reputatio Universitatis debet excedere alias inferiores.' ('Considering . . . that some statue or worthy and venerable figure should be set up in the empty niche as in the other tabernacles round. Considering also that the place is very conspicuous and the reputation of the guild should exceed that of the other inferior guilds.") The contract does not survive, but was

probably awarded to Verrocchio about 1465. The first recorded payment for the group dates from 21 December 1466, and on 24 April 1468 it was agreed that a monthly stipend of 25 lire should be paid to the sculptor 'ad faciendum figuras hereas, mictandas et collocandas in dicto tabernaculo'. On 2 August 1470 the bronze 'pro faciendo figuram seu statuam ponendam in pilastro' was weighed. Further payments occur between 1476 and 1480, and by 22 April 1483 the two figures were 'quasi condotte alla loro intera perfetione'. By the Feast of St John (21 June 1483) the figures were placed in their niche, the Christ being described on this occasion in the Florentine diary of the apothecary Luca Landucci as 'la più bella cosa che si truovi, la più bella testa del Salvatore ch'ancora si sia fatto' ('the most beautiful thing that can be found, the most beautiful head of the Saviour that has been made so far'), and on 19 December 1487 the niche is described as the 'tabernaculo d'Orto Sancto Michele dove sono collocate le figure di bronzo di nostro Signore Iesu Cristo e di sancto Thomaso'. The total remuneration paid to Verrocchio in connection with the group was 957 gold florins, of which 306 were paid before 22 April 1483, 94 were paid on completion and the remaining 400 were distributed over four years. The total payments had not been completed when Verrocchio died. Analysis of the documents has demonstrated that the figure of Christ was cast some time between 1470 and 1476, and chased between 1476 and 1479; and that Thomas was cast in 1479 and chased between then and the winter of 1480, and again between April and June 1483. In earlier editions of this book it was stated that the Mercanzia purchased Verrocchio's terracotta model of St Thomas. It has since been shown, however, that this did not take place. The subject of the Incredulity of St Thomas was chosen for two reasons (Butterfield, 1992): first, because the scene was commonly associated with justice and good government in early Renaissance Italy and was often depicted in courtrooms and political assemblies in Tuscany, including the Palazzo Vecchio; second, because the Medici, who were then in the process of taking over the

Mercanzia, had a special devotion to St Thomas. Indeed, the Operai supervising the project included Lorenzo il Magnifico and his closest political associates, and it seems they intended the sculpture to symbolize the justice of Medici rule. A similar group was executed on a panel in the Palazzo Vecchio by Taddeo Gaddi, accompanied by a trecento poem by Francesco Sacchetti. The subject derives from the Gospel of St John and the figural treatment from the Arch of Trajan at Beneventum. On the edge of the robe of Christ are the words QVIA VIDISTI ME THOMA CREDIDISTI REATLOVI NON VIDERVNT ET CREDIDERVNT. The problem confronting Verrocchio when he designed the group was one of special difficulty, since the tabernacle was designed for a single figure, and it was thus necessary first to raise the figure of Christ on a shallow platform, and secondly to place the figure of St Thomas outside the niche. The figure of Christ, with its platform, is somewhat lower than Donatello's St Louis of Toulouse, and the decision to leave the upper part of the niche vacant and to reduce the scale of the two figures is in large part responsible for the conspicuous success of Verrocchio's scheme.

The Forteguerri Monument

Duomo, Pistoia Plates 150, 152, 153

Thanks to an excellent publication by C. Kennedy, E. Wilder and P. Bacci (Studies in the History and Criticism of Sculpture, VII, The Unfinished Monument by Andrea del Verrocchio to the Cardinal Niccolò Forteguerri at Pistoia, Smith College, Northampton, 1932), we are more fully informed on the chequered history of the Forteguerri Monument of Verrocchio than on any other sepulchral monument of the fifteenth century. A native of Pistoia, Cardinal Niccolò Forteguerri died at Viterbo on 23 December 1473, and was buried in Rome in S. Cecilia in Trastevere. Shortly before his death he had endowed the Sapienza (now Liceo Forteguerri) in his native town, and on 2 January 1474 a body was appointed 'pro construenda archa honorabilis seu monumentum cum

nominis et honorem civitatis' ('to arrange for the construction of an honourable tomb or monument with an inscription in memory of his name and to the honour of the city'). The body consisted of four Operarii of the Cathedral and four representatives of the Sapienza, and an expenditure of 300 florins was authorized. By 15 May 1476 five alternative models for the tomb had been submitted, and approval was given to the 'modellum factum per Andream del Verrocchio de Florentia, in quo est Deus Pater cum Virtutibus cardinalibus'. The sum demanded by Verrocchio for this monument was 50 florins in excess of the agreed expenditure, and on 23 January 1477 approval was given for the expenditure of 380 florins for the execution of the 'modellum olim obtentum in Consilio, vel secundum aliud modellum pulchrius'. The acceptance of Verrocchio's model had been approved only by a small majority of the Council (43 votes to 35), and opposition to it seems to have continued, since on 11 March 1477 the responsible Committee wrote to Lorenzo de' Medici explaining that negotiations had been opened between the Committee and Piero del Pollaiuolo, but that the Council had meanwhile, without reference to the Committee. confirmed Verrocchio's contract. In the view of the Committee, and particularly of Piero Forteguerri, the Cardinal's brother, Pollaiuolo's model was superior to Verrocchio's ('Ora Piero del Pollaiuolo à facto il modello che per noi li fù imposto, il quale ci pare più bello et più dengnio d'arte et più piace à contento di messer Piero, fratello di decto Monsignore, et di tucta la sua famiglia, e simil di noi et di tucti e' ciptadini della nostra ciptà, che l'anno veduto, che non fù quello d'Andrea e d'alchun altro'). Verrocchio's and Pollaiuolo's models were both despatched to Lorenzo de' Medici in Florence. The latter's reply is not preserved, but later in the same month the Committee wrote to him again, requesting a decision on which design was the best. The matter of cost seems to have been a preponderant factor with the monument, since it was decided on 7 March 1477 that the money for it should

epitaphio in litteris in memoriam sui

be raised by a tax of one quattrino on every lira of customs dues for a period of two years, and after Verrocchio's death non-payment of certain sums held up delivery of the sculptures. There is no further reference to the monument till 13 March 1483, when the Committee was re-formed, but on 9 April 1483 it is referred to as the 'sepultura jam incepta'. On 10 July 1483 we learn that it had been 'in buona parte tracto a fine' by Verrocchio, and on 14 November 1483 that it was 'quasi conducta . . . ad finem suum'. After this time Verrocchio left Florence for Venice, and was occupied with the Colleoni statue, and the Forteguerri Monument was still unfinished when he died in Venice in 1488. Later in this year (October 1488) measures were taken to ensure the completion of the monument, responsibility for which was assumed by Lorenzo di Credi (5 May 1489). The record of this transaction (transcription of Covi) indicates that at the time of Verrocchio's death seven of the nine marble figures (Christ, the four Angels, Faith and Hope, but not Charity or the portrait of the Cardinal) were in the sculptor's studio in Florence, and that a sum of 182 florins had been paid for them. An undertaking was given by Credi to complete the whole work within fifteen months, that is by January 1490. By 10 November 1489 it was reported in Pistoia that it had been finished ('si dice quella esser facta'). Further payments were, however, necessary before delivery, and the sculptures were not transported to Pistoia till after 12 April 1493. On 22 April 1489 there was some discussion as to whether the monument should be set up inside or outside the Cathedral (the latter position may have been proposed since it was a cenotaph and not a tomb), and after delivery at Pistoia the pieces of the monument remained disassembled till 1514, when (17 June 1514) Lorenzetto Lotti was commissioned to erect the tomb according to 'un certo modello perciò fatto' (probably the original model of Verrocchio). Lotti was to carve a coat of arms supported by two marble putti, and two angels with candlesticks for positions above the cornice, was to rework the figure of the Cardinal and the Charity above it,

remove a pietra serena surround and replace this with marble, and supply a marble ground. The only significant contribution of Lotti to the monument was the Charity, for which he was in large part responsible. The contract with Lotti was guaranteed by Giovanni Francesco Rustici, and when Lotti abandoned work on the monument this was continued by Rustici, who recarved the kneeling figure of the Cardinal (now in the Museo Civico, Pistoia). The monument appears to have been erected in a provisional form in the Cathedral without this figure. In 1753 the monument was moved, and set up in its present position by Gaetano Masoni, who changed its form, cutting down certain of the reliefs, and added a sarcophagus, a bust of the Cardinal and other sculptures. In its present form (plate 150) the Christ, the four Angels supporting the mandorla, the figures of Faith and Hope and the inscribed panel were carved in the Verrocchio workshop and are in part autograph. Owing to Masoni's disastrous intervention, the merits of these parts of the monument were for long unrecognized, and Verrocchio's personal intervention in the carvings was denied. Two small sketchmodels in terracotta for the upper Angels (given by Valentiner to Leonardo da Vinci) are in the Louvre, and a terracotta sketch-model for the complete monument is in the Victoria and Albert Museum (plate 151). In this the heads of Hope and Charity and of the Cardinal are restored, as is the lower part of the tomb. The pose of the lower Angel on the left does not agree with that in the monument as executed, and the model must therefore have been made at a time when this figure had not yet assumed its final form. It has been suggested (Wilder) that the model may represent a simplified version by Piero del Pollaiuolo of Verrocchio's original scheme. The balance of probability is that it was produced by Verrocchio or in his studio, and it may thus be used as the basis for a reconstruction of the monument. The monument is surprisingly dismissed as 'very disappointing in effect' by Passavant, who concludes that 'the quattrocento parts of the cenotaph were probably

produced by a group of Verrocchio's

pupils from his model and detailed studies'.

The Colleoni Monument

Campo SS. Giovanni e Paolo, Venice Plates 190–2

The condottiere Bartolommeo Colleoni (d. 1475) in his will bequeathed to the Venetian republic, whose troops he had commanded, part of his personal fortune, stipulating that a bronze equestrian statue should be erected in his memory in the Piazza San Marco. On 30 July 1479 it was decided by the Senate that a monument should be commissioned, and should be placed not in the Piazza San Marco, but in a location to be determined later. The record of a suit brought by Tommaso del Verrocchio against Lorenzo di Credi in November 1490 (transcribed by Covi) states that the commission for the monument was awarded to Verrocchio in April 1480. According to Vasari the monument was commissioned from Verrocchio, but after Verrocchio had completed a model of the horse it was proposed that the figure should be executed by Bellano. Cruttwell states that 'commissions were given to Verrocchio, to Vellano of Padua, and to Leopardi of Ferrara, to prepare horses of collossal size, the material with which they were to be constructed being left to their own choice'. This inference is based on an account by the Dominican friar Felix Fabri, who, in describing a visit to Venice in 1483 (The Book of the Wanderings of Felix Fabri, 1483, London, i, 1892, pp. 95-6), records 'in a chapel attached to the Church of the Minorites . . . a horse, built together with wondrous art. The Venetians, imitating the custom of the heathen nations, once determined to reward one of their captains who had fought bravely for the Republic and gained much new territory for it by his valour, by setting up an everlasting memorial of him, and placing a brazen statue of a horse and his rider in one of the streets or squares of the city. In order that this might be done as splendidly as possible, they sought out sculptors throughout their country and ordered each of them to make a horse of any material he chose, and they would then choose one out of the three best

horses, and have a horse cast in brass on the model of that one. Besides the price of the statue, they proposed to bestow especial honours upon the artist who made the best shaped horse. So three sculptors met in Venice, and one of them made a horse of wood, covered with black leather, which is the horse that stands in the aforesaid chapel, and so lifelike is this figure that unless its unwonted size and want of motion betrayed that the horse was artificially made, a man would think it was a real living horse. Another sculptor made a horse of clay, and baked it in a furnace; it is admirably formed and of red colour. The third moulded an exquisitely shaped horse out of wax. The Venetians chose this latter, and rewarded the artist. But as to what will be done about casting it, I have not yet heard; perhaps they will give the matter up.' On 12 July 1481 the Ferrarese Ambassador in Florence wrote to the Duke of Ferrara to state that 'uno maestro el quale veria atore a fare bartolamio da bergamo in su uno corsieri ha facto uno cavallo naturale di stracie che è bella fantasia' ('a master who had been commissioned to represent Bartolommeo of Bergamo on a charger has made a life-size horse in pieces which is a beautiful invention'), and to ask that this should be given free passage to Venice.

It may be inferred from a document of 1490 (Covi) that Verrocchio went to Venice to cast the monument between 15 April and 15 May 1486. The monument was unfinished when Verrocchio died in Venice in June/July 1488. In a will drafted on 25 June 1488 he enjoined that his pupil Lorenzo di Credi should complete the monument ('Etiam relinquo opus equi per me principiati ad ipsum perficiendum, si placuerit illmo. Duci Do. Venetiarum ducale dominium humiliter supplico, ut digneter permittere dictum Laurentium perficere dictum opus, quia est sufficiens ad il perficiendum' ('I leave the work on the horse begun by me to him to finish, if it shall please the Doge. I humbly beseech the Doge that he should agree to allow the aforesaid Lorenzo to complete this work, because he is competent to complete it'). On 7 October 1488 Lorenzo di Credi recorded that he had agreed to complete

the work and had entrusted the casting to a Florentine sculptor Giovanni d'Andrea di Domenico.

According to this document, Verrocchio had contracted for a sum of 1800 Venetian ducats, of which 380 ducats were paid before his death. In 1490 responsibility for completing the monument was transferred from Credi to the Venetian bronze-caster Alessandro Leopardi whose signature ALEXANDER. LEOPARDVS . V . F . OPVS . appears on the girth of the horse (plate 190). The base of the statue was also designed by Leopardi. According to the diary of Sanuto the monument 'el qual fina horra erra stato maestri a dorarlo' was unveiled on 21 March 1496. In the sixteenth century the entire monument came to be regarded as the work of Leopardi.

The statement prepared by Lorenzo di Credi on 7 October 1488 specifically states that Verrocchio, at his death, had completed the figure and horse in clay (terra) only. There is no reason to believe that Leopardi, in casting this group, modified the scheme in any significant respect. The surface working of the bronze is, however, rougher and less accomplished than in the David or the Christ and St Thomas group, and had Verrocchio lived to complete the figure, the treatment of the decorative detail and in particular the handling of the head would have been smoother and more refined.

Agostino di Duccio

(b. 1418; d. 1481)

Agostino di Duccio is mentioned for the first time in a Portata al Catasto prepared by his father Antonio di Duccio, a textile worker, in 1427; in this he is stated to be nine years old. A second Portata al Catasto prepared by his elder brother in 1433, after his father's death, reveals that Agostino had left Florence with a mercenary soldier Giovanni da Tolentino. In 1442, on the commission of Lodovico Forni, he carved a statue of San Gemignano and an antependium with scenes from the story of San Gemignano for the Duomo at Modena; these reliefs (signed AVGVSTINVS DE FLORENTIA F. 1442) are now built into the outside of the Cathedral (plate 228). It is unlikely, on chronological as well as on stylistic grounds, that Agostino was trained in the studio of Donatello or some other Florentine sculptor. He returned to Florence, however, before 1441, when we learn (again from a Portata al Catasto) that he had fled with his brother to Venice, accused of stealing silver vessels from the church of the Annunziata. The fact of this theft is mentioned again in a Portata al Catasto of 1451. Inconclusive attempts have been made (Brunetti) to attribute the statue of St Louis over the entrance to the church of Sant'Alvise and certain secondary sculptures in Venice to Agostino, but he may briefly have worked in a subsidiary capacity in the Buon studio. On 19 June 1449 the name of 'Mo. Agostino condam Antonii de Florentia incisore lapidum' appears as fellow-witness with Matteo de' Pasti to a document in Rimini. Agostino di Duccio is mentioned again in Rimini in a document of 13 December 1454 (see plate 233). On 17 July 1457 he moved from Rimini to Perugia in connection with work on the Oratory of San Bernardino (see plates 227, 230), and his presence in Perugia is attested between this date and the completion of the Oratory on 26 June 1462. At this time he also executed an altar for the church of S. Domenico, Perugia (commissioned 10 January 1459, reconstituted 1484). Two marble reliefs of the Archangels Michael and Raphael and Tobias (transferred from an unknown, possibly Ferrarese,

source in April 1493) are in the Duomo at Acquapendente. In December 1462 he moved from Perugia to Bologna, where he was engaged till 10 February 1463 in preparing a model for the completion of the facade of S. Petronio. Thereafter he returned to Florence, where he matriculated and received from the Operai of the Duomo the commission for a 'Gigante' (16 April 1463; completed 23 November 1463). Another colossal statue was commissioned for the Duomo on 18 August 1464, but was abandoned in December of the same year. Agostino completed a Portata al Catasto in 1469, and on 5 January 1470 received the commission for a terracotta Resurrection for the Annunziata (lost). A number of marble reliefs of the Virgin and Child (see plate 226) appear to date from this time. Later he was again active in Perugia, working on the Altar of the Pietà in the Cathedral (begun 8 May 1473; completed 4 April 1474), the Porta alle due Porte (commissioned 17 May 1473; left unfinished), unspecified decorations in the Chapel of S. Bernardino in the Duomo (23 May 1475), and the façade of the Maestà delle Volte (begun 23 September 1475; remains in the Pinacoteca Nazionale, Perugia). Some of the last works turned out from his shop are the weak monuments of Matteo and Elisabetta Geraldini (1477) and Bishop Giovanni Geraldini (1476) in S. Francesco at Amelia. Agostino di Duccio's name does not appear in documents after 27 July 1481, and he is presumed to have died in the second half of this year, though it has been suggested (Brunetti) that he executed the tomb of Ruggero Mandosi in the Duomo at Amelia (after 1484) and was therefore active for a further half decade.

Bibliography

The problems raised by Agostino di Duccio's work and style are of great complexity, and the standard monograph, that of A. Pointner (*Die Werke des Florentinischen Bildhauers Agostino di Duccio*, Strassburg, 1909) is inadequate. For the documentary background of Agostino di Duccio's career see particularly A. Rossi ('Prospetto cronologico della vita e delle opere di Agostino di Duccio', *Giornale*

d'erudizione artistica dell'Umbria, 1875), C. Grigioni ('I costruttori del Tempio Malatestiano in Rimini', Rassegna bibliografica dell'arte italiana, xi, 1908, pp. 117-28, 155-63, 196-203), and R. G. Mather ('Documents Mostly New Relating to Florentine Painters and Sculptors of the fifteenth Century', Art Bulletin, xxx, 1948, pp. 20-65). C. Ricci's substantial and amply illustrated Il Tempio Malatestiano, Milan/Rome, 1925, is of fundamental importance not only for Agostino di Duccio's work at Rimini, but for its many photographs of the sculptor's minor works. A survey of the structure and chronology of the building is provided by C. Hope ('The Early History of the Tempio Malatestiano', Journal of the Warburg and Courtauld Institutes, lv, 1992, pp. 51-152). A small book by G. Cuccini (Agostino di Duccio: Itinerari di un esilio, Perugia, 1990) deals with the artist's Perugian and post-Perugian work. For the post-Second World War reconstruction of the Tempio Malatestiano, see E. Lavagnino, 'Restauro del Tempio Malatestiano', Bolletino d'arte, n.s. iv, xxxv, 1950, pp. 176-84. Light is thrown on the sculptures of the Tempio Malatestiano in an acute and distinguished article by M. Kühlenthal ('Studien zum Stil und zur Stilentwicklung Agostino di Duccios', Wiener Jahrbuch für Kunstgeschichte, xxiv, 1971, pp. 59-100). For the attribution of the Rimini reliefs (details below) see P. Schubring ('Matteo de' Pasti', Kunstwissenschaftliche Beiträge August Schmarsow gewidmet, Leipzig, 1907, pp. 115-28), A. Venturi (Storia dell'arte italiana, vi, 1908, pp. 388-406, viii-1, 1923, pp. 511-50), L. Venturi ('Studi sul Palazzo Ducale di Urbino', L'Arte, xvii, 1914, pp. 415-73), and J. Pope-Hennessy (first edition of this book). Alternative interpretations of the evidence for the chronology and authorship of the reliefs are provided by C. L. Ragghianti ('Problemi di Agostino di Duccio', Critica d'arte, vii, 1955, pp. 2-21), C. Brandi (Il Tempio Malatestiano, Turin, 1956, pp. 29-47), M. Gosebruch ('Florentinische Kapitelle von Brunelleschi bis zum Tempio Malatestiano under Eigenstil der Frührenaissance', Römisches Jahrbuch für Kunstgeschichte, viii, 1958, p. 183) and M. Bacci (Agostino di Duccio, I maestri della

meaning and sources of the imagery of the carvings are discussed by J. Seznec (The Survival of the Pagan Gods: The Mythological Tradition and its Place in Renaissance Humanism and Art, New York, 1953, pp. 132-7, A. Chastel (Art et humanisme à Florence au temps de Laurent le Magnifique, Paris, 1959, pp. 354-9) and C. Mitchell ('Il Tempio Malatestiano', Studi Malatestiani, istituto storico italiano per il medio evo, Rome, 1978, pp. 71-103). On the façade of S. Bernardino at Perugia, see especially S. Hesse (Die Fassade des Oratoriums San Bernardino in Perugia. Ein Beitrag zum Werk des Agostino di Duccio, Freiburg University dissertation, 1979, Groppingen, 1992), P. G. Pasini ('Una Madonna di Agostino di Duccio a Fornò', in Studi in memoria di Mario Zuffa, Rimini, 1984, pp. 533-42) and, on a more popular level, G. Cuccini (Agostino di Duccio: itinerari di un esilio, Perugia, 1990). An admirable analysis of the altar in S. Domenico at Perugia is supplied by F. Santi ('L'altare di Agostino di Duccio in S. Domenico di Perugia', Bollettino d'arte, xlvi, 1961, pp. 162-73). The chronology of the Madonna reliefs of Agostino di Duccio (see plate 226) is discussed incorrectly by H. W. Janson ('Two Problems in Florentine Renaissance Sculpture', Art Bulletin, xxiv, 1942, pp. 326-34), and by G. Brunetti ('Una questione di Agostino di Duccio: la Madonna di Auvilliers', Rivista d'arte, xxxviii, 1953, pp. 121-31). On the works of Agostino di Duccio at Amelia, see G. Brunetti ('Sul periodo "amerino" di Agostino di Duccio', Commentari, xvi, 1965, pp. 47-55). The attribution to Agostino di Duccio of a Putto Carrying a Garland in the Galleria Nazionale at Perugia (M. V. Brugnoli, 'Agostino di Duccio (attr.): Putto reggifestone', Bollettino d'arte, xlvii, 1962, pp. 361-2) is doubtful, as is that of a circular relief of the Virgin and Child in the Museum für Kunst und Gewerbe at Hamburg (H. W. Janson, 'An unpublished Florentine Early Renaissance Madonna', Jahrbuch der Hamburger Kunstsammlungen, xi, 1966, pp. 28-46). The attribution of a marble tabernacle and Madonna at Fornò (A. Zanoli, 'Il tabernacula di Fornò di Agostino di Duccio', Arte antica e moderna, xiii-xvi, 1961, pp. 148-

scultura, no. 45, Milan, 1966). The

50) though never conclusively demonstrated, is possibly correct. A hypothetical and in part correct account of Agostino di Duccio's development is provided in an article by H. W. Janson ('Die stylistische Entwicklung des Agostino di Duccio', Jahrbuch der Hamburger Kunstsammlungen, xiv, 1970, pp. 105-28). A standing marble Madonna and Child in the sacristy of the Carmine in Florence is rightly identified by A. Rosenauer ('Bemerkungen zu einem frühen Werk Agostino di Duccios', Münchener Jahrbuch der bildenden Kunst, xxviii, 1977, pp. 133-52) as a work of Agostino di Duccio carved after the Modena relief (1442) and before the earliest sculptures in the Tempio Malatestiano.

Virgin and Child with Angels

Louvre, Paris Plate 226

Discovered by Gonse in the possession of the Bonnières de Wierre family at Auvilliers (Neuilly-sous-Clermont), the relief was identified by L. Courajod (in Gazette des Beaux-Arts, 3rd series, viii, 1892, pp. 129-37) as a work of Agostino di Duccio, and was acquired for the Louvre in 1903, when it was published by A. Michel (in Monuments Piot, x, 1903, pp. 95ff). A somewhat larger stucco (83 x 79 cm), in which variations are introduced into the shield and the heads of three of the four Angels, now in the Museo Nazionale, Florence, was identified at Castello and published by A. Modigliani (in L'Arte, vi, 1903, p. 296); this bears the Salutati and Ridolfi arms and perhaps commemorates a marriage of 1465. A third version, corresponding to that in Florence, exists in the Thyssen Collection at Madrid; this is variously stated to be in stucco or calcareous stone; it is, in fact, a stucco squeeze from the Louvre relief. The authenticity of the Auvilliers reliefs has been questioned initially by E. Brunelli (in L'Arte, x, 1907, pp. 146-8), and subsequently by A. Venturi (p. 406n: 'abile contraffazione del settecento') and Brunetti (version, possibly contemporary, of the Thyssen Madonna). Though the coat of arms has been recut, there is no reasonable doubt that the whole relief as it now stands

is the work of Agostino di Duccio. Involved in discussion of the authenticity of this relief are two further reliefs, the Rothschild Madonna in the Louvre and a symbolical relief of Christ in the Metropolitan Museum, New York (ex-Aynard Collection, Lyons), both of which are certainly by Agostino di Duccio. In addition to the Auvilliers and Rothschild Madonnas, three other Madonna reliefs by Agostino di Duccio are known. These are in the Museo Nazionale, Florence (from the Carmine), the National Gallery of Art, Washington, and the Victoria and Albert Museum, London, The alternative schemes of dating for these works proposed by Janson and Brunetti are:

Washington Madonna (Janson, shortly after 1442; Brunetti, after 1465).

London Madonna (Janson, 1460s; Brunetti and Pope-Hennessy, mid-

Bargello Madonna (Janson, 1460s; Brunetti, contemporary with later Rimini reliefs).

Auvilliers Madonna (Janson, 1446–50; Brunetti, after 1465).

Rothschild Madonna (Janson, 1470–5; Brunetti, not by Agostino di Duccio).

Neither system is consistent with what is known of Agostino di Duccio's development. It can, however, be established (i) that the London Madonna is contemporary with the Arca degli Antenati at Rimini and must therefore date from about 1454; (ii) that compositional features of the Washington Madonna are paralleled in the Virtues on the Perugia façade, and that this must therefore date from about 1457-62; (iii) that the Angels in the Auvilliers Madonna also find their closest point of reference in the Angels on the Perugia façade; (iv) that the Carmine Madonna was very probably carved during Agostino's second Florentine period (1463-70); and (v) that the Rothschild Madonna reveals a knowledge of the work of Verrocchio, and must therefore date from about 1470-5 (Janson).

Façade of the Oratory of San Bernardino

After the death and canonization of S.

Perugia Plate 227, 229, 230

Bernardino (1450), funds were raised in Perugia for an Oratory to commemorate the Saint (1451). On 17 July 1457 Agostino di Duccio arrived at Perugia in connection with work on the façade, in August he was awarded the commission. and on 17 August 1457 he began the preparation of wax models. The carving of stone for the façade was begun on 25 October 1457. Work on the façade is documented through 1458 and 1459 (when Agostino di Duccio's principal assistant appears to have been Bartolomeo da Torciano). A payment relating to the laying of the pavement dates from 20 May 1461. The building was assessed by the painters Benedetto Bonfigli and Angelo di Baldassare on 13 February 1462, and at the end of May of the same year it was complete. The design of the façade (plate 230) is loosely based on that of Alberti's Tempio Malatestiano at Rimini. At the top is a triangular pediment with reliefs of Christ in benediction and Angels on a blue ground. Beneath this runs an inscription AVGVSTA PERVSIA MCCCCLXI. Below, to left and right, are tabernacles, containing statues of (left) the Annunciatory Angel and (right) the Virgin Annunciate, above reliefs with scenes from the life of S. Bernardino. Below these again are tabernacles with statues of Sts Costanzo and Ercolano. The doorway is surmounted by a semicircular tympanum relief, containing a relief of S. Bernardino in glory with four flying Angels at each side. Beneath this are three further reliefs with scenes from the life of the Saint (plate 229). The entrance is flanked by six reliefs of Virtues, set at an angle to the plane of the façade, and six reliefs of music-making Angels. Many of the carvings on the façade reveal traces of pigmentation, and use is also made of coloured marble (e.g. in the red marble cherub heads surrounding the tympanum relief). For this reason the aggregate effect of the façade differs more markedly from that of the Rimini reliefs than is apparent in photographs. The style of the figures of the Virtues

(which, with the exception of a figure of Hope, cannot be satisfactorily identified) depends from that of the Liberal Arts reliefs at Rimini, and in one case a prototype from the Tempio Malatestiano (the Rimini Grammar) is reproduced. The reliefs of the Perugia façade are not only consistently of lower quality than the comparable reliefs at Rimini, but are more mannered in style, and reveal a defective sense of the relation of the figure to its ground which is nowhere to be found in the Chapels of the Planets or the Liberal Arts. On the other hand, the six reliefs of Angels are closely related both in style and handling to the Angels drawing curtains in the Chapel of St Sigismund at Rimini. The Perugia carvings are, therefore, the criterion by which the extent of Agostino di Duccio's intervention in the carvings at Rimini must be assessed. There is no reason to doubt Agostino di Duccio's authorship of the tympanum reliefs, the 12 reliefs beside the doorway and the five scenes from the life of S. Bernardino. The four statues, on the other hand, are of lower quality, and should probably be looked upon as the work of Bartolomeo da Torciano or some other member of the master's studio.

The Interior of the Tempio Malatestiano

Rimini Plates 231–40

The Tempio Malatestiano is a classicizing temple evolved from an earlier Gothic church. Responsibility for the interior is attested by two inscriptions. The first reads: MATTHEI. VS. D. P. ILLVSTRIS. ARIMINI . NOBILISS DOMINI ARCHITECT OPUS. Of Veronese origin, Matteo de' Pasti was active initially as an illuminator. He moved to Rimini in 1449 and is recorded in notarial documents between 1451 and 1467. One of the greatest Italian medallists, he won the close confidence of Sigismondo Malatesta, and is described (1454) as 'socio et familiare excelsi domini Sigismundi Pandulfi de Malatesta'. A second inscription reads: OPVS AVGVSTINI FLORINTINI LAPICIDAE. In Latin the term 'lapicida' signified not only a sculptor but a cutter of stone, and Agostino seems

to have functioned as an administrator or Maestro dell'Opera as well as artist. The wide range of media used in the interior influenced the style and character of the reliefs. It includes marble, serpentine and porphyry slabs from the basilica of S. Apollinare in Classe and two other Ravennate churches, a hard white stone probably from Cesena and white and Verona marble. The last reference to Agostino di Duccio at Rimini occurs in December 1454, but it is generally assumed that he continued work there till his departure for Perugia in July 1457.

The reconstruction of the church grew from comparatively simple origins, when, in the, for him, conspicuously successful year of 1446, a vow was taken by Sigismondo Malatesta to construct in the church of S. Francesco a chapel dedicated to his patron Saint, St Sigismund. This is the first chapel on the right. According to Vasari, it was originally intended to house a monument to Sigismondo by the Florentine sculptor Ciuffagni (d. 1458). A bull confirming approval of the new chapel was issued in 1448 by Pope Nicholas V. The foundation stone was blessed in 1447 and the chapel was consecrated in 1452. In September 1447 an application from Sigismondo's mistress, Isotta degli Atti, to present five hundred gold florins for the repair and restoration ('reparari et riformari') of the second chapel on the right of the nave, now known as the Chapel of Isotta, was approved by Nicholas V. This and the Chapel of St Sigismund were structurally deepened. In the second is the tomb of Isotta degli Atti bearing superimposed dates of 1446 and 1450, of which the second is likely to be correct. The Chapel of Isotta was still unfinished in 1452. Both Matteo de' Pasti and Agostino di Duccio appear in Rimini in 1449, and there is no reason to associate either artist with the crude Virtues on the piers of the Chapel of St Sigismund (other than the elephants installed at their base). The sculptures in the Chapel of St Sigismund by Agostino di Duccio are two Angels drawing curtains incised on the east wall, the paired elephants at the bottom of the piers, a scene from the life of St Sigismund now in the Museo del Castello Sforzesco in Milan, and (questionably) a seated statue of St

Sigismund over the high altar. The Virtues on the piers at the entrance to the Chapel are relatively coarse works and are likely to have been carved by a Roman or Venetian-trained sculptor before the intervention of de' Pasti and Agostino di Duccio in the decoration of the church in 1449.

On the west wall of the Chapel of the Madonna dell'Acqua, the first chapel on the left of the nave, is a monument to Sigismondo's predecessors, the Arca degli Antenati, which is documented as the work of Agostino di Duccio and appears to have been finished in 1454.

After 1449 work in the Tempio went ahead in a more orderly fashion with the arrival of Agostino and Matteo de' Pasti, and with the intervention of Alberti, who was responsible for reconstructing the outside of the church and whose influence also made itself felt in the interior, and of Piero della Francesco, who painted a fresco of Sigismondo Malatesta Kneeling before St Sigismund in a closed *cella* on the right that intervenes between the chapels of St Sigismund and of Isotta degli Atti.

The piers of the second chapel on the left are decorated with reliefs of playing putti, whose geometrical style is closely related to narrative scenes on the Arca degli Antenati. Opposite, on the piers of the Chapel of Isotta, are paired musicmaking Angels artistically much superior to the Playing Children in the Chapel of the Infant Games and treated with great academic precision (L. Malusi, 'Strumenti musicali del Quattrocento nel Tempio Malatestiano', Romagna, arte e storia, I, 2, 1981, pp. 51-62). Of the same high quality are the reliefs of Planets in the third chapel on the right side of the church, some or all of which are due to Agostino. The imagery of the Planets is associated by C. Mitchell with a statement of Valturio that the Tempio reliefs were 'ex abditis philosophiae penetralibus sumptis' and corresponds with planetary descriptions of Macrobius. The piers of the third chapel on the left are smoother and shallower; they show the Liberal Arts and closely resemble Tarocchi cards by the Master of E series produced at Ferrara c.1465. At least in the last two chapels graphic cartoons seem to have been employed. The imagery of the carvings in the

Tempio Malatestiano is condemned in the strongest terms in the Commentari of Pope Pius II. It has been contended that its iconography is orthodox, but the presence in it of the tomb of Isotta degli Atti, commissioned in the lifetime of Sigismondo's second wife, Polissena Sforza, and the aggressive classicism of the reliefs on the piers were legitimate targets for doctrinal criticism. The status of Sigismondo Malatesta declined after 1455, when at the instigation of the King of Naples he was expelled from the comity of Italian states and was excommunicated. It is not known when the latest chapels, the third to right and left, were completed and with the departure of Malatesta for the Morea work seems to have ceased.

The façade and the two external lateral walls of the Tempio Malatestiano were designed by Alberti, and were constructed independently of the interior of the church, just as, according to Alberti's theory, 'a fur coat can be worn on top of a suit of clothes'. The prime source on which Alberti drew for the façade is the Arch of Augustus in Rimini: the diameter of its four fluted columns is identical with that of the columns of the Rimini arch. A foundation medal by Matteo de' Pasti of 1450 shows the structure crowned by a dome with a base covering the whole width of the church. The north and south sides of the building contain seven niches, inspired by the Mausoleum of Theodoric at Ravenna, designed to house the remains of distinguished humanists. Four on the right of the building are dedicated to the poets Pasinio (d. 1457) and Giusto dei Conti (d. 1449), the philosopher Gemistos Plethon (interred 1465) and the author of the De re militari, Roberto Valturio (d. 1475).

Andrea della Robbia

(b. 1435; d. 1525)

The most popular Tuscan artist of the later fifteenth century, Andrea was the son of a brother of Luca della Robbia, and was trained in Luca's shop. Save for a marble altarpiece in S. Maria delle Grazie at Arezzo, he worked exclusively in enamelled terracotta, and his development can be traced through the roundels of children on the Spedale degli Innocenti, Florence (hypothetically 1463-6), an Assumption at La Verna (1486), the reliefs of the Loggia di S. Paolo, Florence (1498) and a long sequence of more elaborate altarpieces, of which perhaps the finest is in the Osservanza at Siena. Andrea's style changed very little, and his popularity seems to have been bound up with the Franciscan Observant movement, for whose churches a high proportion of his altarpieces were produced. A skilful glazer – he matriculated in the Arte dei Maestri di Pietra e di Legna in 1458 and in the Guild of Painters in 1472 - he was responsible for administering Luca's studio, which he took over after his uncle's death. His works were designed to inspire devotion, and the smaller of them were frequently produced mechanically in Andrea's shop. He also undertook the glazing of works in terracotta by Benedetto da Maiano, Verrocchio, and other artists. His altarpieces had the merit that they were made sectionally and were therefore readily transportable, and were unaffected by climate even in the mountainous Franciscan shrine of Vallombroso. At their best they have a clarity and a sentimentality which is unrelated to their homogeneous claims as works of art.

Bibliography

The most methodical book on Andrea della Robbia remains that of A.

Marquand (Andrea della Robbia and his Atelier, Princeton, 1922) and the best illustrated is that of G. Gentilini (I Della Robbia: la scultura invetriata nel rinascimento, i, Florence, 1992). For Andrea's relationship with the Franciscan and Franciscan Observant orders, see J. Pope-Hennessy

('Thoughts on Andrea della Robbia', Apollo, cix, pp. 176–97, reprinted in The Study and Criticism of Italian Sculpture, New York, 1980, 155–90). For other literature, see G. Corti ('Addenda Robbiana', Burlington Magazine, cxv, 1973, pp. 468–9) Gaeta Bertola (Luca, Andrea, Giovanni della Robbia, Florence, 1977), G. Gentilini (Museo Nazionale del Bargello: Andrea della Robbia: la Madonna, Florence, 1983, and Andrea della Robbia in Dizionario biografico degli italiani, xxxvii, 1989, pp. 253–68). Gentilini includes an extensive bibliography.

Madonna della Cintola

S. Maria degli Angeli, La Verna Plate 90

The mountain of La Verna had been ceded to St Francis, and it was there shortly before his death that the stigmata were conferred on him. Administered from Bibbiena, it was handed over in 1410 to the Friars Minor at Fiesole. In 1433 the Arte della Lana in Florence was charged by Eugenius IV with collecting offerings for the shrine, and it was enjoined that the Guardiano should be a follower of S. Bernardino. An indulgence was granted by Nicholas V to those who contributed to its completion. There were two churches at La Verna, S. Maria degli Angeli and the Chiesa Maggiore, which was still unfinished in 1465. The Chiesa Maggiore was burnt down two years after its completion, a further sum was raised, and in the early 1470s thought was given by the Arte della Lana to the decoration of what were by then four churches. The single reference to Andrea della Robbia in the La Verna documents dates from August 1481, and relates to payment for the Crucifixion altarpiece in the Cappella delle Stimmate. This was preceded by the Incarnation in the Brizi Chapel of the Chiesa Maggiore, the Niccolini Annunciation on the opposite side of the same church, the Virgin dropping her girdle to St Thomas in S. Maria degli Angeli, and the Ascension on the high altar of the Chiesa Maggiore. To these were later added two further altarpieces from Andrea's workshop. The altarpieces in which Andrea

participated are modelled with great freshness and spontaneity, and their powerful compositions have a clarity that has no parallel in his later works.

MATTEO CIVITALI

(b. 1436; d. 1501)

Matteo di Giovanni Civitali was born of parents from Belluno at Lucca on 5 June 1436. It is likely that Civitali worked from early on in Florence, probably in the Rossellino studio. His first important work, the tomb of Piero da Noceto (d. 1467) in the Duomo at Lucca (plate 144), commissioned by Noceto's son Niccolò and completed in 1472, depends from the Bruni and Marsuppini monuments, and makes use of a sarcophagus type deriving from that of the tomb of the Cardinal of Portugal. On its completion, this conspicuously accomplished work was assessed by Antonio Rossellino. The earliest of a number of works commissioned by Civitali's principal patron, Domenico Bertini, the Altar of the Sacrament in the Cathedral at Lucca, was begun in 1473 and finished after 1476 (Angels in the Duomo at Lucca, signed tabernacle in the Victoria and Albert Museum, London), and concurrently with or immediately after this work Civitali supervised the new marble floor of the nave and choir of the Cathedral. The monument of the humanist Domenico Bertini and his wife dates from 1479 (Duomo, Lucca). To the same year belongs a Virgin and Child with Bertini's stemma in S. Michele, Lucca, which was followed (1480) by the so-called Madonna della Tosse, formerly in S. Ponziano, now in S. Trinità. The beautiful Chapel of the Volto Santo in the nave of Lucca Cathedral also owes its origin to a commission of Bertini (1482); the figurative component of the chapel is limited to a figure of St Sebastian at the back, but in its architectural design and decorative carving it is comparable with the S. Croce pulpit of Benedetto da Maiano. In 1483-4 Civitali carved the Altar of S. Regolo for the Duomo at Lucca; this was commissioned by Niccolò da Noceto, and depends in scheme from the Coscia Monument of Donatello. Payments of 1486-8 relate to altars executed by Civitali in the Duomo at Pisa. In 1489 on the commission of Andrea Orsucci he designed a tabernacle for S. Frediano, Lucca, and in 1490 the tomb of S. Romano for the church of

this Saint. The tomb of S. Pellegrino at San Pellegrino in Alpi was executed between 1474 and 1489. Other works carried out for Lucca include a tabernacle for S. Maria del Palazzo (1493) and a pulpit for the Cathedral (1494–8). At Sarzana he carved a riding statue (lost) of St George and the Dragon for a position outside the Palazzo Communale (exhibited 21 January 1500). In a will of 1492 Civitali bequeathed a terracotta statue of St Sebastian to the church of S. Quirico in Monticelli. He died in Lucca on 12 October 1501.

Civitali was a collector of antiques and a painter and in 1477 secured a licence to establish the first printer's shop in Lucca. He is the only major marble sculptor active in Tuscany outside Florence in the fifteenth century. Many of his principal works derive to a greater or lesser extent from Florentine models, but he was at the same time a designer of some originality and a technician of considerable skill. Certain iconographical features of his work (e.g. the Man of Sorrows, which appears on the tomb of S. Romano and elsewhere) have no parallel in Florence, and the source of these has not been investigated. No half-length reliefs of the Virgin and Child by Civitali have been identified, though these must have existed in some quantity. The bust of Domenico Bertini on his monument and the reliefs of Pietro and Niccolò da Noceto on the former's tomb reveal Civitali as a competent portrait sculptor. An unidentified relief portrait of a lady in the Museo Nazionale, Florence, is ascribed to Mino da Fiesole. The circular portrait relief of Pietro d'Avenza in the atrium of the Duomo in Lucca, formerly thought to be his first work, is not by Civitali, but depends from an unrecorded medal by Pisanello of which one version survives (U. Middeldorf, 'Zu einigen Medaillen der italienischen Renaissance', in Festschrift Wolfgang Braunfels, Tübingen, 1977, pp. 263-5). The dating of the tomb in S. Pellegrino in Alpi is advanced to 1475 by L. Angelini ('Documenti per la storia di S. Pellegrino dell'Alpe', La Provincia di Lucca, xiv, 1974, pp. 68-89). U. Middeldorf ('Quelques sculptures de la Renaissance en Toscane occidentale',

Revue de l'art, no. 36, 1977, pp. 7–26) infers very plausibly that Civitali owed his training to Andrea Guardi. Civitali's relations with painting in Lucca are discussed parenthetically by M. Ferretti ('Percorso lucchese (pittori di fine "400")', Annali della Scuola Normale Superiore di Pisa, classe di lettere e filosofia, series iii, v, 1975, pp. 1033–65). For Civitali's statues in the chapel of St John the Baptist in the Duomo at Genoa, see H.-W. Kruft, 'La decorazione interna della cappella di San Giovanni Battista nel Duomo di Genova', Antichità viva, x, 1971, no. 1, pp. 20–7.

Bibliography

The literature on Civitali is very weak. The best biographical account of his life is that of S. Rudolph in Dizionario biografico degli italiani 26 Rome, 1982, pp. 106-10). He is commemorated by a deplorable monograph by C. Yriarte (Matteo Civitali: sa vie et son oeuvre, Paris, 1886), an article by W. R. Valentiner ('Matteo Civitali', Art in America, ii, 1914, pp. 186-200), and a number of local volumes and pamphlets of little interest. Coherent accounts of his work are given by E. Ridolfi, in an elaborate appendix to L'Arte in Lucca studiata nella sua Cattedrale, Lucca, 1882, and by F. Schottmüller, in Thieme-Becker Künstler-Lexikon. Towards the end of his life Civitali was employed at Genoa, carving six free-standing statues for the Chapel of St John the Baptist in the Cathedral (right wall: Habakkuk, Zacharias and Adam; left wall: Isaiah, St Elizabeth and Eve), to which were added after 1501 a Virgin and Child and St John the Baptist by Andrea Sansovino. For the Chapel of St John, see A. Composanto, La Cattedrale di Genova, Genoa, 1959, and for its decoration H.-W. Kruft ('La cappella di San Giovanni Battista nel duomo di Genova', Antichità viva, ix, 1970, pp. 33-50; and 'La decorazione interna della cappella di San Giovanni Battista del duomo di Genova', Antichità viva, x, 1971, pp. 20-7) and S. Bule ('Matteo Civitali's Statues for the Cathedral of Genoa', Verrocchio and Late Quattrocento Italian Sculpture, eds. S. Bule et al., Florence, 1992, pp. 205-10). Bule is also responsible for two good documentary articles on Civitali ('Nuovi documenti per Matteo Civitali', Rivista

d'arte, xl, 1988, pp. 357–67; 'A Unique Partnership: Matteo Civitali and Domenico Orsolini', Verrocchio and Late Quattrocento Italian Sculpture, eds. S. Bule et al., Florence, 1992, pp. 363–4). The style of Civitali is also discussed by F. Negri-Arnoldi ('Matteo Civitali, scultore lucchese', Egemonia fiorentina e autonomie locali, Bologna, 1978) and F. Petrucci (Matteo Civitali e Roma, Florence, 1980).

The Tomb of San Romano

S. Romano, Lucca Plate 145

Like the Altar of the Sacrament in the Duomo and some other works by Civitali in Lucca, the tomb of S. Romano has been dispersed (1635), and its original site and form are not known. In the form in which it is at present set behind the high altar of the church (plate 145) it consists of a relief with the recumbent figure of the Saint and a lunette with the Man of Sorrows with arms extended, separated by the inscription: CLAVDITVR HOC TVMVLO BEATI ROMANI CORPVS QVI DVM AD TORMENTA LAVRENTI LEVITE INCVMBEBAT SVB DECIO IMPERATORE ANGELORVM VISIONE PERTERRITVS FIDEM XPI CONFESSVS CAESO CAPITE MARTIRIO CORONATVS FABBRICATVM AERE D.B. SALVTIS ANNO. To left and right are the subsidiary inscriptions: VT VIVAM VERA VITA and MCCCCLXXXX. The initials D.B. are those of Domenico Bertini. Some architectural fragments, presumably from the tomb, are built round these elements. The pigmentation of the figure and lunette is substantially original.

VECCHIETTA

(b. 1410; d. 1480)

Lorenzo di Pietro, called Vecchietta, was born in 1410 in Siena (Del Bravo). His name appears in the guild of painters in 1428, and he was active as a painter after this date in the choir of the Collegiata at Castiglione d'Olona in Lombardy and was also responsible for a fresco cycle in the chapel of the Palazzo Branda. In 1439 he was engaged with Sano di Pietro in painting a wooden Annunciation on the high altar of the Duomo in Siena, and in 1441 he undertook his first fully authenticated work, a fresco in the Pellegrinaio of the Spedale della Scala. Thereafter he was engaged on fresco cycles in the former sacristy of S. Maria della Scala, now the Sala di San Pietro of the hospital (1446-9), and in the Baptistery in Siena (1459-62). The works he executed at this time are some of the most important frescos produced in Siena in the fifteenth century. Vecchietta remained active as a painter throughout his entire life, completing, among many other works, a fresco of St Catherine of Siena in the Palazzo Pubblico (1461), a triptych of the Assumption of the Virgin for the Cathedral at Pienza (1461-2), and an altar-piece for S. Maria della Scala, now in the Pinacoteca (after 1476). His sculptural activity seems to have been coterminous with his pictorial work. A 'fighura di Nostro Signore Yhesu Christo, resuscitato, la quale si tiene in sull altarmaggiore' ('figure of Our Lord Jesus Christ risen, which is preserved on the high altar') carved for the Cathedral (4 April 1442) has been wrongly identified with a figure of the Risen Christ at Vico Alto. Vecchietta continued to carve in wood throughout the whole of his career; some of the most notable of his wooden sculptures are statues of St Paul in the Museo Horne in Florence, St Anthony the Abbot in the Duomo at Narni (signed and dated 1475), and S. Bernardino in the Museo Nazionale, Florence (also from Narni, probably datable 1475). A Burial and Assumption of the Virgin in the Museo Civico at Lucca was left unfinished by Vecchietta at his death in 1480 and was completed by Neroccio. Little is known of Vecchietta's work in

marble, save for two statues of Sts Peter and Paul (plate 201) on the Loggia di S. Paolo (commissioned 2 March 1460, completed 1462). The medium with which he was most closely associated is that of bronze, and it may be inferred that in 1457-9 he was in close contact with Donatello's studio in Siena. A bronze eucharistic tabernacle for the high altar of S. Maria della Scala was commissioned from Vecchietta on 26 May 1467; this was completed before 29 November 1472. The tabernacle contains a number of bronze statuettes of exceptionally high quality, and since 1506 has stood on the high altar of Siena Cathedral (preliminary drawing in the Pinacoteca at Siena). A bronze relief of the Resurrection in the Frick Collection (inscribed OPVS LAVRENTII PETRI PICTORIS AL VECCHIETTA DE SENIS MCCCCLXXII) may be connected with this commission (plate 202). A Risen Christ on the high altar of S. Maria della Scala, Siena, dates from 1476 (see plate 203). Vecchietta was also active as an architect and metalworker; silver figures of Sts Catherine of Siena and Bernardino (1472-3) and St Sebastian (1478) and a silver-gilt figure of St Paul (1475), all executed for the Duomo in Siena, are untraced. Vecchietta died on 6 June

Bibliography

The relevant documents are printed by G. Milanesi (Documenti per la storia dell'arte senese, Siena, iii, 1854-6) and S. Borghesi and E. Banchi (Nuovi documenti per la storia dell'arte senese, Siena, 1898). A monograph by G. Vigni (Lorenzo di Pietro detto il Vecchietta, Florence, 1937) is available. Vigni's treatment of Vecchietta's sculptures is vitiated by an attempt to incorporate the work of the so-called Piccolomini Master with that of Vecchietta. For the Resurrection relief in New York, see J. Pope-Hennessy (The Frick Collection: An Illustrated Catalogue, iii, Sculpture: Italian, New York, 1970). H. W. Van Os ('Vecchietta and the Persona of the Renaissance Artist', Studies in Late Medieval and Renaissance Painting in Honor of Millard Meiss, New York, 1977, pp. 445-54; 'Lorenzo Vecchietta und seine soziale Stellung als Künstler', Mitteilungen der Gesellschaft für vergleichende

Kunstforschung in Wien, xxx, 1978, pp. 5-6) discusses Vecchietta as uomo universale in the Siena of his time. Van Os is also responsible for the single substantial study of Vecchietta as a painter published in this period (Vecchietta and the Sacristy of the Siena Hospital Church. A Study in Renaissance Religious Symbolism, The Hague, 1974). For a detailed consideration of Vecchietta's sculptures, see C. Del Bravo (Scultura senese del quattrocento, Florence, 1970) and the exhibition catalogue (Francesco di Giorgio e il rinascimento a Siena, 1450-1500, Milan, 1993). There is an excellent dissertation on the Duomo ciborium by A. Pfeiffer (Das Ciborium im Sieneser Dom. Untersuchungen zur bronzeplastik Vecchiettas, inaugural dissertation., Philipps Universität, Marburg/Lahn, 1975). Two bronze sepulchral effigies have been traditionally but wrongly attributed to Vecchietta. The first is the effigy of Cardinal Pietro Foscari (d. 1485) in S. Maria del Popolo, Rome, which has been correctly reattributed by A. Pfeiffer and M. Kühlenthal ('Das Grabmal Pietro Foscaris . . . ein Werk des Giovanni di Stefano', Mitteilungen des Kunsthistorischen Institutes in Florenz, xxvi, 1982, pp. 47-62) to Giovanni di Stefano. The second is the effigy of Mariano Sozzini in the Museo Nazionale, Florence, which is given by Bellosi to Francesco di Giorgio and appears to have been made for the monument to Sozzini (d. September, 1467) in S. Domenico, Siena. For the ascription of this work to Vecchietta, see P. Cellini ('La reintegrazione di un'opera sconosciuta di Lorenzo di Pietro detto il Vecchietta', La Diana, v. 1930, p. 239-43). The bronze figure of the Risen Christ is dealt with in an excellent article by I. Lavin ('The Sculptor's "Last Will and Testament", Allen Memorial Art Museum Bulletin, xxxv, 1977-8, pp. 4-39) which stresses (i) the significance of Vecchietta's funerary chapel as a symptom of the growing importance of the artist in Renaissance society, (ii) the union of painting and sculpture in the decoration of the altar, and (iii) the eucharistic

significance of the statue.

The Risen Christ

S. Maria della Scala, Siena Plate 203

In the last years of his life Vecchietta was preoccupied with the construction of a memorial chapel in the church of S. Maria della Scala in Siena. A petition of 26 December 1476 signed by the sculptor and addressed to the Rector and governing body of the Spedale della Scala reads as follows: 'Sia al nome de lo eterno Dio et de la sua Madre gloriosa et di tutti i suoi Sancti, come io Lorenzo di Pietro dipentore et scultore decto el Vecchietta da Siena fo questa petizione a lo Spedale di S. Maria della Scala. E quando al Rectore, Savi, et Capitulo piaccia darmi una cappella murata secondo el disegno et modello ch'io lo, dò facto di carta, voglio mettere in decta capella uno Christo ho fatto, et non è anco finito, di bronzo di statura di braccia tre, o circa, in su l'altare di decta capella, et dopo l'altare io voglio fare una tavola dipinta di largheza di braccia tre et alta quattro braccia e mezo, dietro al Christo, come ho disegnato in decto modello, quando Idio mi presti vita. . . Et questo fo et voglio sia per l'anima mia, et de la mia donna, et de' miei passati. . .' ('In the name of the eternal God and of his glorious mother and of all his Saints, I, Lorenzo di Pietro painter and sculptor, called Vecchietta, of Siena, make this petition to the Hospital of S. Maria della Scala. When it pleases the Rector, commissioners and Chapter to cede me a walled chapel according to the design and model which I hereby give him made of parchment, I wish to place in the aforesaid chapel on the altar a bronze Christ three braccia high, which I have made but not yet finished. And for the altar, behind the Christ, I wish to make a painting three braccia wide and four braccia and a half high as I have drawn it in the aforesaid model, if God grants me life. And this I do and purpose for my own soul, and that of my wife, and those of my forebears.') The petition was approved on 20 February 1477. The memorial chapel is mentioned again in a will drawn up by Vecchietta on 10 May 1479: 'Inprimis corpus suum sepelliri voluit in et seu ad cappellam sancti Salvatoris quam sibi construi fecit in Ecclesia hospitalis sante Marie della

Schala de Senis, ubi dicta sui corporis propriam elegit sepulturam.' ('In the first place, he wished his body to be buried in or at the chapel of the Redeemer, which he had built in the church of the Hospital of S. Maria della Scala in Siena, where he chose his own tomb in which his body should rest.') Provision was made under the will for a minimum of four masses a week in the chapel, and it was stipulated that in the event of the church being later enlarged or the chapel redecorated, the statue of the Risen Christ should remain in place. If the stipulations of the will were not observed, the figure was to revert initially to the Duomo, and subsequently to the Olivetan community outside the Porta Tufi. The altarpiece painted for the chapel is now in the Pinacoteca at Siena, and the bronze statue of the Risen Christ stands on the high altar of S. Maria della Scala. On the base is the inscription: OPVS LAVRENTII PETRI PICTORIS AL VECCHIETTA DE SENIS MCCCCLXXII SVI DEVOTIONE FECIT HOC. The best analysis of the Risen Christ is that of A. Bagnoli (Francesco di Giorgio e il rinascimento a Siena, 1450–1500, Milan, 1993, pp. 212-15). A drawing of the statue is appended to Vecchietta's will. The site of Vecchietta's funerary chapel in S. Maria della Scala cannot be established. The terms of his will were not observed, and the chapel was rapidly dismantled. In 1509 agreement was reached with a relation of Vecchietta's who had charge of the chapel that the Risen Christ should be moved to the high altar in place of the bronze Eucharist tabernacle by Vecchietta which had been transferred to the high altar of the Duomo, and that masses for the artist should be said at the high altar. The Christ is shown with right hand extended standing on a monster with a serpent's body and a woman's head symbolizing Christ's victory over original sin. The figure is one of the most powerful bronze statues of the fifteenth century.

Francesco di Giorgio (b. 1439; d. 1501)

Francesco di Giorgio Martini was baptized in Siena on 23 September 1439. Trained under Vecchietta, he practised as a painter, sculptor and architect. In 1464 he received a payment for a wooden statue of St John the Baptist for the Compagnia di S. Giovanni Battista della Morte; it is established by Carli that this statue is identical with a figure now in the Museo dell'Opera del Duomo at Siena (plate 206). In addition to the influence of Vecchietta (to whom it was for long ascribed), the St John reveals direct experience of the work of Donatello. Until 1475 Francesco di Giorgio shared a joint studio with Neroccio. From this period date an altarpiece of the Coronation of the Virgin in the Pinacoteca at Siena, painted for Monteoliveto Maggiore (1471), and an altarpiece of the Nativity, also in the Pinacoteca at Siena, painted for S. Benedetto fuori Porta Tufi (1475). At some date between 1475 and 1477 Francesco entered the service of Federigo da Montefeltro, and on 8 November 1477 was living in Urbino. In 1478 he was still in the employment of Federigo da Montefeltro, and though he undertook work for Alfonso Duke of Calabria in 1479-80, he retained his post at Urbino, to which he had returned by 26 July 1480, when Federigo da Montefeltro in a letter to the Signoria of Siena describes him as 'vostro citadino et mio dilettissimo architetto'. After Federigo's death (1481) he continued to work at the court of Guidobaldo da Montefeltro. To these years belong a medal of Federigo da Montefeltro and a bronze relief of the Lamentation over the Dead Christ, cast for the Oratorio di S. Croce at Urbino and now in the Carmini in Venice. Reliefs of the Flagellation in the Pinacoteca Nazionale dell'Umbria at Perugia (see plate 207) and the so-called Allegory of Discord (known through a stucco cast in the Victoria and Albert Museum, London, and an inferior cast from the Chigi-Saraceni Collection, now in the Monte de' Paschi, Siena) were probably produced in the same bracket of time. In 1484-5 Francesco di Giorgio was engaged on the most important of

his surviving churches, S. Maria del Calcinaio at Cortona. On 26 December 1485 he was repatriated as a citizen of Siena, of which he became the official engineer, but he retained his contacts with Urbino and in 1489 was in Gubbio. In the latter year (10 July 1489) he was engaged on two bronze Angels for the high altar of Siena Cathedral, completed by 1492 (see plate 209).

In 1490 Francesco visited Milan, where he prepared a model for the cupola of the Cathedral and came into contact with Leonardo da Vinci, and after his return to Siena he submitted a plan for the façade of the Cathedral in Florence (5 January 1491). On three occasions between 1491 and 1495 he visited Naples. In 1499 he became Capomaestro of the Duomo. Francesco di Giorgio died probably in 1501 and certainly before 9 February 1502. Francesco di Giorgio's sculptures are not directly related to his paintings. Apart from the works noted above, they comprise a wooden figure of St Christopher in the Louvre, a number of secondary reliefs in bronze (Judgement of Paris, St Jerome in the Wilderness, roundels of Sts Sebastian and John the Baptist, all in the National Gallery of Art, Washington, and roundels of St Anthony the Abbot in the Liechtenstein Collection, Vaduz, and St Jerome in Berlin, as well as medals and plaquettes), and one terracotta relief of a mythological scene (formerly Kaiser Friedrich Museum, Berlin). A large bronze statuette of Aesculapius in the Albertinum, Dresden, is also by Francesco di Giorgio (Schubring). A marble relief of the Virgin and Child formerly in the Kaiser Friedrich Museum, Berlin, has also been ascribed to him.

Bibliography

The standard volumes on Francesco di Giorgio as painter, sculptor and architect are the catalogues of two exhibitions held in Siena in 1993: Francesco di Giorgio e il rinascimento a Siena, ed. L. Bellosi. Milan, 1993, and Francesco di Giorgio architetto, eds. F. P. Fiore and M. Tafuri, Milan, 1993. These supersede a number of weak earlier volumes, and especially P. Schubring (Die plastik Sienas im Quattrocento, Berlin, 1907) and S.

Brinton (Francesco di Giorgio Martini of Siena, London, 1934, 2 vols). A volume by A. S. Weller (Francesco di Giorgio, Chicago 1943) covers the artist's work in all media, and is, for its date, well documented; a monograph by R. Papini, on Francesco as an architect (Francesco di Giorgio architetto, Florence, 1946), investigates the relationship between the buildings of Francesco di Giorgio and the architecture shown in his reliefs. Studies of the wooden sculpture are provided by E. Carli ('A recovered Francesco di Giorgio', Burlington Magazine, xci, 1949, pp. 33-9; La scultura lignea senese, Milan, 1951). A bronze Paschal Candlestick in the Duomo at Urbino, corresponding in design with candlesticks illustrated in the codex of the Treatise on Architecture in the Biblioteca Laurenziana, Florence, is rightly identified by G. Marchini ('Il Palazzo Ducale di Urbino', Rinascimento, ix, 1958, pp. 77-8) as a work by Francesco di Giorgio. In view of the multifacial character of Francesco di Giorgio's activity and his prominence as an architect and architectural theorist, his bibliography is exceptionally large, and is listed systematically in the Siena catalogues. Special importance, however, attaches to recent publications by M. Ingendaay ('Rekonstruktionversuch der "Pala Bichi" in Sant'Agostino in Siena', Mitteilungen des Kunsthistorisches Institutes in Florenz, xxiii, 1979, pp. 109-26), M. Seidel ('Die Fresken des Francesco di Giorgio in S. Agostino in Siena', in the same volume of the Mitteilungen, pp. 4-118), R. Toledano (Francesco di Giorgio Martini, pittore e scultore, Milan, 1987) and M. Seidel ('Sozialgeschichte des Sieneser Renaissance Bildnis', Staedel-Jahrbuch, n.f., xii, 1989, pp. 71-138).

The Flagellation of Christ

Pinacoteca Nazionale dell'Umbria, Perugia Plate 207

The relief of the Flagellation of Christ at Perugia is one of a group of interdependent reliefs, comprising (i) a bronze relief of the Lamentation over the Dead Christ in the Carmini in Venice, (ii) a relief of Lycurgus and the Maenads, of which a stucco cast,

presumably made from a lost bronze original, exists in the Victoria and Albert Museum, London, and (iii) a bronze Judgement of Paris in the National Gallery of Art, Washington. The present relief and the reliefs (i) and (ii) above were initially ascribed to Verrocchio (Bode, A. Venturi, Cruttwell), and subsequently given to Leonardo da Vinci (Bode, Müller-Walde), Antonio Pollaiuolo (Berenson, Cruttwell), and Bertoldo (A. Venturi). The ascription to Francesco di Giorgio was first advanced by Schubring, and is now universally accepted (see 1993 Siena Exhibition, p. 360, for full bibliography). Decisive in favour of this attribution are the relation of architectural features in this relief and the Lycurgus and the Maenads to motifs recurring in Francesco di Giorgio's buildings at Urbino and elsewhere (for this, see Papini), and the connection between figures in the relief and those in drawings by Francesco di Giorgio. The figure-style throughout the reliefs is strongly influenced by Antonio Pollaiuolo, and finds a parallel in the Massacre of the Innocents wrongly ascribed to Matteo di Giovanni on the floor of Siena Cathedral (1481), where drawings by Antonio Pollaiuolo seem also to have been employed. The Venice Lamentation appears to have been made for the Oratorio di S. Croce at Urbino, and there is a strong presumption that the present relief was also a Montefeltro commission. Since the Venice relief includes a portrait of Federigo da Montefeltro's son, Guidobaldo, as a child, it may be dated c.1475-7. The Flagellation has been dated (Carli, Gli Scultori Senesi, Milan, 1980, p.45) before 1481, between 1480 and 1495 (Fumi, in Siena catalogue, i, p. 360) and between 1490 and 1495 (Del Bravo, Scultura Senese del quattrocento, Florence, 1970, p.100). The reflections in it of the style of Bramante and Leonardo da Vinci tend to confirm the median date. Its architectural setting is closely related to that of the Lycurgus and the Maenads in London. There is no analogy in the fifteenth century for a Flagellation scene in which the Virgin and St John the Evangelist are, as here, represented in the foreground, and the separation between the foreground and the middle distance in it is unique.
Bottari ('Un'opera di Francesco da

Two Angels

Duomo, Siena Plates 208, 209

Beside the Eucharistic tabernacle of Vecchietta on the high altar of the Duomo in Siena there stand two pairs of torch-bearing Angels by Francesco di Giorgio and Giovanni di Stefano. Whereas the style of Giovanni di Stefano's bronzes depends from Vecchietta, those by Francesco are depicted in movement with one foot free of the ground. A transcript of the documents for this commission is provided by F. Fumi ('Nuovi documenti per gli angeli dell'altare maggiore del Duomo di Siena', Prospettiva, no. 26, 1981, pp. 9-25). Francesco di Giorgio's Angels were commissioned by 1488, cast 1489-90 and chased in 1492. The final payment was made in 1499. Their style. in its concern with movement, reveals further contact with Leonardo da Vinci, whom Francesco di Giorgio encountered once more in June 1490 (C. Del Bravo, Scultura senese del Quattrocento, Florence, 1970, pp. 100-2). Previously (Schubring) the Angels were identified with 'due Angioletti' for which payment was made on 16 July 1489. It is demonstrated by Weller that this document in fact refers to two small half-length Angels emerging from acanthus leaves on the sides of the high altar. In August 1497 Giacomo Piccolomini, Antonio Bichi and Pandolfo Petrucci were appointed as assessors on behalf of the Balia, to determine the sum to be paid to the sculptor; the Angels had by that time (Fiumi) existed in a finished state for five years. A document of 17 August 1497 sets out in detail the sums due to the sculptor 'pro suo magisterio' (1,500 lire) and the money expended on bronze and wax ('ciera per formare li detti angioli in due volte'). Payment of this sum was ordered by the assessors on 21 August 1497. According to a reasonable computation (Weller) the total cost of the two Angels was in the order of 2,429 lire.

FRANCESCO LAURANA (b. c.1430; d. 1502?)

Born at Vrana, near Zara, Francesco Laurana's name first appears in documents in 1453 in connection with work on the triumphal arch of the Castelnuovo in Naples (see plate 222). He is assumed to have been a pupil of Giorgio da Sebenico, and to have accompanied Pietro da Milano from Ragusa to Naples when the latter undertook responsibility for the construction of the triumphal arch. Attempts to identify Laurana's early work in two reliefs of Angels on an altar in the Cathedral of Sebenico (A. Venturi) are unconvincing. The theories have also been advanced that before 1453 Laurana was active in Rimini, executing the carvings in the Chapel of St Sigismund in the Tempio Malatestiano (A. Venturi; L. Venturi), and assisted Domenico Gaggini on the façade of the Chapel of St John the Baptist in the Cathedral at Genoa (Rolfs). Neither view can be sustained. It has also been wrongly suggested (L. Venturi) that in 1459-60 Laurana was employed on decorative carving in the Sala della Iole in the Palazzo Ducale at Urbino. In 1461 Laurana (like Pietro da Milano) moved to France, where he was employed till 1466 by René of Anjou. for whom he produced a number of signed and dated medals. In 1467 he was in Sicily, where he worked for between four and seven years. His presence at Sciacca is recorded in 1468 (Patera). His principal documented work of this time is the Mastrantonio Chapel in S. Francesco at Palermo (see plate 224). Among other authenticated works which he produced in Sicily are statues of the Virgin and Child in S. Maria della Neve at Palermo and at Noto (both dated 1471). In the early 1470s he was again active in Naples, where he carved a Madonna over the entrance to the Chapel of St Barbara in the Castelnuovo (1474) and an undated Madonna over the entrance to S. Maria Materdomini (see plate 225). From 1477 until 1483 he was once more in France, where he worked, in conjunction with Tommaso Malvito, on the Chapel of St Lazarus in the Old Cathedral at Marseilles (completed 1481). In 1479-81 he

executed for the Church of the Célestins at Avignon a relief of Christ Carrying the Cross between Sts Benedict and Scholastica; since the early nineteenth century this has been installed in St Didier. Other works ascribed to Laurana in France are the monuments of Giovanni Cossa in St Marthe at Tarascon and of Charles IV of Anjou at Le Mans. There is no record of Laurana's activity between 1483 and 1498, and it has been suggested (Valentiner) that at this time he returned to Naples, where he would have executed a number of portrait busts (see plate 180), and to Sicily, where he would have been responsible for the tomb-slab of Cecilia Aprilis (d. 1495) in the, museum at Palermo. Laurana died in France prior to 12 March 1502.

Bibliography

Two monographs on Francesco Laurana appeared simultaneously in 1907 (F. Burger, Francesco Laurana: eine Studie zur Italienischen Quattrocento-Skulptur. Strassburg, 1907; W. Rolfs, Franz Laurana, 2 vols, Berlin, 1907). The volume of Burger, though shorter and less amply illustrated, is the more soundly based. Both books, however, require to be read in conjunction with subsequent literature, especially that relating to the medals, the portrait busts and the triumphal arch. For the medals, see G. Hill, A Corpus of Italian Medals of the Renaissance before Cellini, 2 vols, London, 1930. The best account of the portrait busts is given in a suggestive article by W. R. Valentiner ('Laurana's Portrait Busts of Women', Art Quarterly, v, 1942, pp. 273-98), which proposes a number of modifications in the accepted chronology of Laurana's works. On the portrait busts, see also a conventional and in part incorrect account by R. Wedgwood Kennedy (Four Portrait Busts by Francesco Laurana, Northampton, 1962), and articles by M. D'Elia ('Appunti per la ricostruzione dell'attività di Francesco Laurana', Studi e contributi dell'istituto di archeologia e storia dell'arte dell'Università di Bari, v, 1959, pp. 1-23) and B. Patera ('Sull'attività di Francesco Laurana in Sicilia', Annali del Liceo Classico 'G. Garibaldi' di Palermo, ii, 1965, pp. 526-50). The picture of Laurana's style during his first Sicilian period is filled out by articles by S.

Laurana', Bollettino d'arte, xlv, 1960, pp. 213-6), on the tomb of Antonio Speciale in S. Francesco at Palermo, and by M. D'Elia ('Ipotesi intorno a un bassorilievo di Santeramo', Commentari, x, 1959, pp. 108-14), on a relief of the Virgin and Child ascribed to Laurana by Middeldorf. In the vast and inconclusive literature of the triumphal arch, reference should be made to: C. von Fabriczy, 'Der Triumphbogen Alfonsos I am Castelnuovo zu Neapel', Jahrbuch der Preussischen Kunstsammlungen, xx, 1899, pp. 1-30, 125-58, and 'Neues zum Triumphbogen Alfonsos I', Jahrbuch der Preussischen Kunstsammlungen, xxiii, 1902, pp. 3-16; L. Venturi, 'Studi zul Palazzo Ducale di Urbino', L'Arte, xvii, 1914, pp. 415-73; R. Filangieri di Candida, 'L'arco trionfale di Alfonso d'Aragona', Dedalo, xii, 1932, pp. 439-66, 594-626; W. R. Valentiner, 'Andrea dell'Aquila, Painter and Sculptor', Art Bulletin, xix, 1937, pp. 503-36; and R. Causa, 'Sagrera, Laurana e l'arco di Castelnuovo', Paragone, v, 1954, pp. 3-23. Two recent studies deal with the triumphal arch of the Castelnuovo in Naples. The first of these is by G. L. Hersey (The Aragonese Arch at Naples, 1443-1475, New Haven, 1973) and the second is by H.-W. Kruft and M. Malmanger (Der Triumphbogen Alfonsos in Neapel. Das Monument und seine politische Bedeutung, Tübingen, 1977). On the triumphal arch, see also R. Pane (Il rinascimento dell'Italia meridionale, Milan, 1975-77, i, chapter vi), G. C. Sciolla ('Fucina aragonese a Castelnuovo', Critica d'arte, n.s., xix, 1972, no. 123, pp. 15–36; xix, 1972, no. 126, pp. 19–38) and a largely fallacious article by V. Goss ('I due rilievi di Pietro da Milano e di Francesco Laurana nell'arco di Castelnuovo in Napoli'. Napoli nobilissima, xx, 1981, pp. 102-14). B. Patera provides a useful survey of Laurana's work in Sicily (Francesco Laurana in Sicilia, Palermo, 1982). He also ('Scultura del Rinascimento in Sicilia', Storia dell'arte, nos. 24/25, 1975, pp. 151-8) offers a useful review of current Laurana studies, and ('Francesco Laurana a Sciacca', Storia dell'arte, nos. 38/40, 1980, pp. 167-84) publishes documents for Laurana's activity at Sciacca after his return from his first

period in France. Laurana's early style is discussed by H.-W. Kruft and M. Malmanger ('Francesco Laurana: Beginnings in Naples', Burlington Magazine, cxvi, 1974, pp. 9-14) and by V. Gvozdanovic ('The Dalmatian Works of Pietro da Milano and the Beginnings of Francesco Laurana', Arte lombarda, nos. 42/43, 1975, pp. 113-23). For the Madonna over the portal of the chapel of S. Barbara, see H.-W. Kruft and M. Malmanger ('Da Portal der Cappella di Santa Barbara im Castelnuovo zu Neapel', Acta ad archaeologiam et artium historiam pertinentia, vi, 1975, pp. 307-14). The documentation for Laurana's works in France is given in a convenient form in the catalogue of an exhibition at the Musée du Petit Palais, Avignon (Le roi René et son temps. Francesco Laurana, sculpteur du roi René en Provence, 1981).

Virgin and Child

S. Maria Materdomini, Naples Plate 225

Marble, with traces of pigmentation. Identified by R. Longhi in 1916, and published by Causa, the statuette is closely related to the Madonna at Noto (1471) and to the damaged Virgin and Child over the entrance to the Chapel of St Barbara in the Castelnuovo (1474), and was probably produced in this bracket of time.

Isabella of Aragon

Kunsthistorisches Museum, Vienna Plate 180

The nine surviving female portrait busts by Francesco Laurana comprise (i) a portrait of Battista Sforza, wife of Federigo da Montefeltro, Duke of Urbino, in the Museo Nazionale, Florence; (ii) a portrait of Beatrice of Aragon in the Frick, formerly Rockefeller, Collection, New York; (iii) busts of unidentified sitters in the Kaiser Friedrich Museum, Berlin (formerly), the Frick Collection, New York, the National Gallery of Art, Washington, the Louvre, Paris, the Musée Jacquemart-André, Paris, the Museo Nazionale, Palermo, and the Kunsthistorisches Museum, Vienna. De la Mouréyre-Gavoty (Musée

Jacquemart-André: Sculpture italienne, Paris, 1975, no. 159, p. 127) calls attention to the relatively summary handling of the Jacquemart-André bust, and ascribes this to the fact that its original location must have been well above eye-level. H.-W. Kruft (review in Kunstchronik, xxiii, 1970, pp. 151-66) doubts its authenticity. A marginally different chronology for the late busts is proposed by G. L. Hersey, p. 76, who describes the present bust as representing 'a relative of Alfonso of Calabria, resembling Ippolita'. For a detailed discussion of the Frick bust and its relation to Laurana's other portraits, see J. Pope-Hennessy (The Frick Collection: an Illustrated Catalogue, iii, Sculpture: Italian, New York, 1970, pp. 2-9). The Frick bust has a French provenance and was not necessarily carved in Italy. This fact has implications for some of the other busts to which a Neapolitan or Sicilian origin is commonly assigned. Though usually assigned to Laurana's second Neapolitan period (c.1472-4), these busts reveal marked changes of style, and it is argued by Valentiner, with a high degree of plausibility, that they belong in two separate periods. According to this thesis, the bust of Battista Sforza would have been executed posthumously at Urbino in 1475-6, and the Rockefeller/Frick bust would date from about 1473. The Washington bust would represent Ippolita Maria Sforza, wife of Alfonso II of Naples, and would have been carved (along with the busts formerly in Berlin and in the Frick Collection) between 1472 and 1475. The busts in Paris, Palermo and Vienna would be attributable to a third Neapolitan period in the late 1480s (probably 1487-8), the latter certainly and the two former probably representing Isabella of Aragon, wife of Gian Galeazzo Sforza. Though the identity of the sitters in these three busts is accepted by Kennedy, this cannot be seriously maintained, since one component of the group, the bust at Palermo, has been shown to be an ideal reconstruction of the features of Eleanora of Aragon (d. 1405), wife of Guglielmo Peralta, a benefactress of the monastery of S. Maria del Bosco di Calatamauro, over whose tomb it was set (Patera). The identification of the

Vienna bust as a portrait of Isabella of Aragon can be accepted with some confidence.

The Mastrantonio Chapel

S. Francesco, Palermo Plate 224

The documentary material relating to the chapel is printed in extenso by Burger. According to the initial contract, 'Magister Petrus de Bonitate et magister Franciscus de Laurana, scultores, habitatores Panormi' agreed 'pro unciis auri ducentis' to remodel the chapel of Antonio di Mastrantonio in S. Francesco, providing a marble floor and steps, a marble grave, a tomb and altar each resting on four columns, a life-size Virgin and Child, marble vaulting, and figurated reliefs for the façade of the chapel 'iuxta designum datum per eosdem magistros eidem domino Antonio'. The facade of the chapel takes the form of a small triumphal arch, with medallions of the Annunciatory Angel and Virgin Annunciate in the spandrels, and figurated pilasters at the sides. These are composed of reliefs showing (left side, bottom to top): Putto with a Cornucopia, Sts Jerome and Gregory, St Mark, St John the Evangelist, the Prophet Jeremiah; (right side, bottom to top): Sts Ambrose and Augustine, St Luke, St Matthew, the Prophet Isaiah. A precedent for the form of the façade is provided by the chapel of St John the Baptist in the Cathedral at Genoa (executed after 1448 by Domenico Gaggini). The arrival of Gaggini in Palermo in 1463 tends to confirm the existence of a direct connection between the two schemes. No authenticated works by Pietro da Bonitate (a Lombard sculptor active in Palermo and Messina from 1468 till 1495) survive, and the distinction between his work and Laurana's therefore rests solely on inference. There is marked inequality between the two putti with cornucopias, that on the left being presumably due to Laurana and that on the right to a second hand, perhaps Pietro da Bonitate. The relief of Sts Gregory and Jerome is generally accepted as Laurana's. Burger regards the figures of Sts Luke and Mark and Sts Ambrose and Augustine as by Pietro da Bonitate, and the Sts Matthew

and John as by a third hand. Patera credits Laurana with the Putto with Cornucopia on the left, the Sts Jerome and Gregory and Sts Ambrose and Augustine, and the two stemmi above the architrave. Though the quality of execution varies, it is difficult to believe that the six scenes were not designed by one and the same artist. If, as is likely, this artist was Laurana, some importance attaches to the theory (advanced by Burger) that the reliefs of Sts Luke and Matthew presuppose knowledge of Donatello's reliefs of Sts John the Evangelist and Mark in the Sagrestia Vecchia of S. Lorenzo in Florence. The relationship between the carved pilasters of the chapel and those of the Tempio Malatestiano is superficial, and the balance of evidence is against the view that the artist who designed them was familiar with the Rimini reliefs.

Triumphal Arch

Castelnuovo, Naples Plates 221, 222

The entrance to the Castelnuovo at Naples is constructed in six registers, comprising (bottom to top) (i) an entrance in the form of a triumphal arch, surmounted by griffins with the Aragonese arms and flanked by pairs of columns, (ii) a figurated frieze representing the triumph of Alfonso I of Aragon, (iii) a second arch with reliefs of Victories in the spandrels, flanked by pairs of columns in front of one of which (left) stands an allegorical figure of uncertain identity, (iv) a row of four niches separated by pilasters, containing statues of (left to right) Justice, Temperance, Fortitude and Prudence, (v) a lunette with a relief of two River Gods, (vi) a statue of St Michael. The latter was originally accompanied by figures of St George (in large part destroyed) and St Anthony the Abbot, which are no longer in situ on the arch (Causa). Inside the archway are two reliefs showing (right) the departure of Alfonso for war and (left) the return of Alfonso from a victorious exploit. In addition to the main elements, the arch contains a wealth of decorative carving of a subsidiary character.

The plan for the erection of a triumphal arch in Naples seems to date

from the time of Alfonso's triumphal entry into the city on 26 February 1443. Initially this was designed to take the form of a late Gothic entrance to the Castelnuovo in which some classical features were to be incorporated. A record of the scheme in an early phase is contained in a drawing in the Museum Boymans-van Beuningen (plate 223), Rotterdam (L. Planiscig, 'Ein Entwurf für den Triumphbogen', Iahrbuch der Preussischen Kunstsammlungen, iv, 1933, pp. 16-28), which has been ascribed to the painter and medallist Pisanello. The sheet is inscribed 'Bonomi da Ravenna', presumably in reference to a Bonhoms who is mentioned between 1444 and 1448 as administrator of the reconstruction of the Castelnuovo (R. Filangieri di Candida, 'Un più antico progetto dell'Arco Trionfale di Alfonso d'Aragona', Rassegna storica napoletana. 1933). This scheme reflects the influence of the Catalan architect and sculptor Guillermo Sagrera, who was employed as Protomagister of the Castelnuovo in 1448, and till his death in 1454 worked on the Gran Sala and other parts of the building.

The towers flanking the entrance to the Castelnuovo were completed in 1452, and in the spring of that year the sculptor Pietro da Milano was summoned from Ragusa to undertake the construction of the arch. Pietro da Milano arrived in Naples in 1453. Documents of 1453 also record the presence in Naples of two other sculptors, Francesco Laurana and Paolo Romano, who, with 33 assistants, were employed on the arch. In 1455 the names of two further sculptors, Isaia da Pisa and Andrea dell'Aquila, appear in the account books, and in 1457 there are added the names of Antonio di Chellino and Domenico Gaggini. This phase of the construction of the triumphal arch ended with the death of Alfonso in 1458. Work on the arch was resumed in 1465 under Ferrante I, and was completed by 9 May 1466. In this second and concluding phase sole responsibility for the project was vested in Pietro da Milano.

Despite the relatively large number of documents relating to the arch, there has been considerable disagreement first as

to the artist who was responsible for the design, and secondly as to the role of individual sculptors. Disregarding fanciful attributions like that to Luciano Laurana (L. Venturi), authorship of the design is now generally credited either to Pietro da Milano or to Laurana. The attribution to Laurana depends from a letter written by the humanist Summonte to Marcantonio Michiel on 20 March 1524, which includes the sentence: 'In la entrata del Castel Nuovo è un arco trionfale fatto a tempo del re Alfonso primo di gloriosa memoria sono circa 80 anni per mano di maestro Francesco Schiavone, opera per quei tempi non mala.' It is difficult, however, to reconcile the documents with any other view than that the arch was designed by Pietro da Milano. The lower arch appears to have been based on the Arch of the Sergii at Pola, and, as demonstrated by E. Driscoll ('Alfonso of Aragon as a Patron of Art', Essays in Memory of Karl Lehmann, New York, 1964, pp. 87-96), much of the decorative ornament is based on Roman funerary art. The appearance on the arch of a portrait of the Emperor Trajan, the apparent dependence of the processional relief from a Trajanic relief on the arch at Beneventum, and the use of motifs from Trajan's Column have been interpreted as an expression of Alfonso's admiration for this Spanish Emperor.

An exact analysis of the relation between the carvings and the artists known to have worked on them is supplied by Kruft and Malmanger; the earlier proposals of Filangieri and Valentiner, though in part valid, can therefore by ignored. As a result of cleaning it transpires that the decoration of the base beneath the columns is by Isaia da Pisa and his workshop. The griffins over the archway are by Andrea dell'Aquila, and the two reliefs of Alfonso and his Court in the interior of the arch are due to (left) the shop of Isaia da Pisa and (right) Laurana (plate 221). In the central relief of the Triumph of Alfonso the seated figure of the King is by Pietro da Milano and the right side of the scene by Gaggini. The two reliefs to right and left are (left) by Pietro da Milano and Laurana, and (right) by Gaggini. Laurana was responsible for the large military figure standing in front of

the upper columns. In the niches above are four figures, one (*left*) by Pietro da Milano, another (*second from left*) by Gaggini, and two by Isaia da Pisa. The colossal reclining figures above are by Paolo Romano. The entire arch was cleaned in 1984.

FILARETE

(b. c.1400; d. 1469?)

Antonio di Pietro Averlino appears to have been born in Florence. conjecturally about 1400, and is best known under the name Filarete, which he adopted on one occasion in the dedication of his Trattato d'architettura ('a tuo filareto architetto Antonio Averlino fiorentino'). Possibly associated with Ghiberti on work on the first bronze door, he was summoned to Rome to undertake the bronze door of St Peter's (see plate 211). The bronze door was completed in 1445, and is stated by Vasari to have occupied 12 years. For this reason Filarete's arrival in Rome is usually assigned to the year 1433, though the theory that the door was not begun till 1439 has also been advanced. Following the erection of the door Filarete appears to have received a commission for the monument of Antonio Chiaves, Cardinal of Portugal (d. 1447) in St John Lateran. After the death of his patron Eugenius IV (1447), however, Filarete was charged with the attempted theft of the head of St John from St John Lateran, and was compelled to flee from Rome, abandoning the Chiaves monument. All of the surviving sections of the Chiaves monument seem to have been carved by Isaia da Pisa (q.v.), but it is possible that Filarete was responsible for the rigidly classical programme of this tomb. After his return to Florence (1447), Filarete seems to have visited Todi, Rimini, Mantua and Venice (1449). A signed Processional Cross in the Duomo at Bassano is dated 1449; the lower part of this Cross was restored in 1622, but its original form is recorded in a painting by Jacopo Bassano of the Baptism of Lucilla in the Museo Civico, Bassano. In Venice he was associated with the mosaicists Angelo and Marino da Murano. In 1451 Filarete was summoned to Milan by Francesco Sforza, and between this date and 1453 seems to have been engaged on terracotta decoration in part of the Castello. In Milan he practised principally as an architect, designing the central block of the Ospedale Maggiore. In connection with this work, he visited Tuscany in 1456 to study the schemes of the Spedale degli Innocenti in Florence

and the Spedale della Scala in Siena. The foundation stone of this part of the hospital was laid in 1457, and work was completed in 1465. By the latter year Filarete had completed his Trattato d'architettura, which he dedicated not to Francesco Sforza as had been intended but to Piero de' Medici. An autograph letter to Francesco Sforza of 1464-5 confirms that difficulties had arisen between Filarete and his patron, and on 22 November 1465 he was superseded as architect by Guiniforte Solari. A bronze statuette based on the classical equestrian statue of Marcus Aurelius, then outside St John Lateran, was despatched by Filarete in this year; it is now in the Albertinum, Dresden. The terms of the inscription on this statuette (as observed by Oettingen) suggest that it was cast in Rome and is therefore contemporary with the bronze doors. A bronze statuette of Hector on Horseback has been identified (Keutner) in the Museo Arqueologico Nacional in Madrid. It carries the inscription 'OPVS ANTONI /1456' on the inner side of the base (Coppel). According to Vasari, Filarete, after the completion of the Ospedale Maggiore, returned to Rome, dying there in 1469. Filarete's only certain works are the bronze doors of St Peter's, the equestrian statuettes at Dresden and Madrid, the Bassano Cross, and a medallic self-portrait (Victoria and Albert Museum, London) which contains on its reverse a reference to the patronage of Francesco Sforza. A number of other works have also been ascribed to him. In the case of four of these Filarete's authorship can be demonstrated on stylistic grounds; these are a relief of the Triumph of Caesar (Louvre, Paris), a plaquette of the Virgin and Child with Angels (Louvre, Paris, and Kaiser Friedrich Museum, Berlin). a tabernacle door (Kunsthistorisches Museum, Vienna), and a plaquette of Odysseus and Iros (Kunsthistorisches Museum, Vienna). Vasari's reference to the 'sciagurata maniera' of Filarete set the tone of the later literature dealing with the artist. His sculptures, though impoverished by poor workmanship, reveal considerable independence and inventiveness

Bibliography

The sources for Filarete's biography are analysed by W. von Oettingen (Über das Leben und die Werke des Antonio Averlino gennant Filarete, Leipzig, 1888). This excellent short study also gives a useful account of Filarete's work. A volume by M. Lazzaroni and A. Muñoz (Filarete, Rome, 1908) contains many illustrations, but should be read in conjunction with a review by A. Venturi (L'Arte, xi, 1908, pp. 393-400). For the iconography of the bronze door the fundamental study is that of B. Sauer ('Die Randreliefe an Filaretes Bronzethür von St Peter'. Repertorium für Kunstwissenschaft, xx, 1897, pp. 1-22). A good account of the bronze door after cleaning is given by C. Seymour, Jr (Sculpture in Italy: 1400-1500, London, 1966, pp. 116-17). The identity of the assistants whose names appear on the bronze door is discussed by H. von Tschudi ('Filaretes Mitarbeiter und den Bronzethüren von St Peter', Repertorium für Kunstwissenschaft, vii, 1884, pp. 291-4). Aspects of the bronze door are reviewed in an article by J. R. Spencer ('Filarete's Bronze Doors at St Peter's', Collaboration in Italian Renaissance Art. eds. W. S. Sheard and J. T. Paoletti, New Haven, 1978, pp. 33-47). C. Lord ('Solar Imagery in Filarete's Doors to St Peter's', Gazette des Beaux-Arts, series 6, lxxxvii, 1976, pp. 143-50) argues wrongly that the bronze door is 'one of the first Renaissance translations of the classical ekphrasis into bronze', and has its source in Ovid's description of the Palace of the Sun (Metamorphoses, ii, 1-19). An article by E. Parlato ('Il gusto all'antica di Filarete scultore', Da Pisanello alla nascita dei Musei Capitolini, L'Antico a Roma alla vigilia del rinascimento, exhibition catalogue, Rome, 1988, pp. 115-34) deals with the tenuous relation of the door to the Stefaneschi Polyptych on the high altar of St Peter's. For the Madrid bronze, see H. Keutner ('Hektor zu Pferde. Eine Bronzestatuette von Antonio Averlino Filarete', Studien zu Toskanischen Kunst: Festschrift für L. H. Heydenreich, Munich, 1964, pp. 139-56) and R. Coppel ('A newly discovered signature and date for Filarete's "Hector", Burlington Magazine, cxxix, 1987, pp. 801-2); for two bronzes attributed to Filarete in the Ashmolean

Museum, Oxford, J. R. Spencer ('Two Bronzes by Filarete', Burlington Magazine, c, 1958, pp. 392-5). The data relating to the Bassano Cross is summarized by G. Gerola ('Una Croce processionale del Filarete a Bassano', L'Arte, ix, 1906, pp. 292-6). For the plaquette and tabernacle door in Vienna, see L. Planiscig (Kunsthistorisches Museum in Wien: Die Bronze-plastiken, Vienna, 1924, pp. 3-4). A Filarete symposium organized by the Istituto per la Storia dell'Arte Lombarda at Villa Monastero in 1972 gave rise to a number of articles of unequal merit, three of which are printed in Arte lombarda, nos. 38/39, 1973 (J. R. Spencer, 'Il progetto per il cavallo di bronzo per Francesco Sforza', pp. 23-35; C. Seymour, Jr, 'Some Reflections on Filarete's Use of Antique Visual Sources', pp. 36-47; M. Levi d'Ancona, 'Il S. Sebastiano di Vienna: Mantegna e Filarete', pp. 70-4). Seymour's article defines those factors which distinguish Filarete's attitude to the antique from that of his Florentine contemporaries. A marble relief of the Discovery of the Miraculous Image at Impruneta is tentatively and mistakenly ascribed to Filarete by U. Middeldorf ('Filarete?', Mitteilungen des Kunsthistorischen Institutes in Florenz, xvii. 1973, pp. 75–86). The unconvincing identification of Filarete with the socalled Medallist of the Roman Emperors is proposed by J. R. Spencer ('Filarete, the Medallist of the Roman Emperors', Art Bulletin, lxi, 1979, pp. 551-61). Filarete's plaquettes are discussed by P. Cannata ('The Plaquettes of Filarete', Italian Plaquettes. Studies in the History of Art. Washington National Gallery, xxii, 1989, pp. 35-52). These include a Madonna with Angels in the Louvre, the Vienna Christ Carrying the Cross (both c.1445), the Vienna Fight between Ulysses and Iro (before 1445), and a Triumph of Caesar in the Louvre and a Pax at Linari (c.1433).

Bronze Door

St Peter's, Rome Plates 211, 212

The bronze door (plate 211) cast by Filarete for St Peter's was incorporated in the new basilica, and still fills the central entrance to the church. Two strips of bronze were added in 1620 by Pope Paul V, in order to bring the height of the door into conformity with that of the new entrance. The door was erected by 14 August 1445. According to Vasari, work on the two wings occupied Filarete for 12 years; if this statement is correct, work on the door must have been begun in 1433. It has been suggested (Lazzaroni and Muñoz) that work did not begin till 1439, since one of the historical events represented in a subsidiary section of the door occurred only in this year. The earlier date is, however, the more probable, since Eugenius IV (by whom the door was commissioned) left Rome in 1434. The technique of Filarete's door differs so greatly from that of Ghiberti's Porta del Paradiso, that the pattern established for the production of the latter has no relevance for the Roman door. On the one hand the surface working of Filarete's door is less delicate than that of the Porta del Paradiso, and on the other Filarete made use of *champlevé* enamel ornament for which there is no parallel on the Porta del Paradiso. Traces of blue, red and white enamelling survive, and have become increasingly pronounced since the door was cleaned and repatinated in 1962. The use of champlevé enamel ornament appears to have been a normal practice in Filarete's studio, and is found again in the Marcus Aurelius at Dresden and in the Vienna tabernacle door. Filarete's door was originally gilt; evidence for this is supplied by Flavio Biondo and other sources. No trace of gilding was, however, revealed in the course of cleaning. The names of six assistants of Filarete are given on the door, in the form: ANGNIOLVS . IACOBVS . IANNELLVS . PASSQVINVS . IOANNES . VARRVS . FLORENTIE (for these see Tschudi).

Each of the two wings of the door is divided into three panels of unequal height. These represent (top left) Christ enthroned, (top right) the Virgin enthroned, (middle left) St Paul with the vas electionis beside him, (middle right) St Peter with a kneeling figure of Eugenius IV, (bottom left) the Condemnation and Decapitation of St Paul and St Paul's appearance to Plautilla, (bottom right) the Condemnation and Crucifixion of St Peter. Between the six scenes are four

engravings, of which the most important

narrow horizontal strips depicting events in the pontificate of Eugenius IV. These are (upper left) the Coronation of the Emperor Sigismund and the Pope and Emperor riding in procession to the Castel Sant'Angelo, (lower left) the arrival of the Emperor John Palaeologus in Ferrara and his reception by the Pope, (upper right) the Council of Florence and the embarkation of the Greeks at Venice, (lower right) the Abbot Andrew receiving the decree for the unification of the Eastern and Western churches from Eugenius IV, and visiting the graves of Sts Peter and Paul. Beneath and beside each wing are strips of foliated decoration with small figures, for the most part representing scenes from classical mythology or history. The subjects of many of these are undetermined; those which have been identified (Sauer) include (bottom left, left to right) Argus, Hermes, Io, the Death of Argus, Hera and the eyes of Argus, Deucalion and Pyrrha, and Europa, (left side of the left wing, bottom to top) Helle, the transformation of the Tyrrhenian pirates into dolphins, Pyramus and Thisbe, Apollo and Daphne, Hercules and the Nemean Lion, Hercules and Antaeus, and a self-portrait of the sculptor, (right side of left wing, bottom to top) Rape of Proserpine, Jason, Jason and the Argonauts, (bottom right, left to right) Marcus Curtius, Hercules, Deianira, Nessus, (left side of right wing, bottom to top) Perseus Slaving Medusa, the infant Hercules, Ganymede, Persephone, Narcissus, Circe and Picus, Actaeon, Mucius, Scaevola, Daedalus, Eros and Pan, (right side of right wing, bottom to top) Daedalus, Theseus and the Minotaur, Icarus, Amalthea, Leda, Romulus and Remus, the Rape of the Sabines, Cloelia, Horatius Cocles, the Punishment of Tarpeia, and Pan and Syrinx. It has been inferred (Seymour) that the horizontal strips under the four main panels were originally to have been filled with foliated decoration, and that the present narrative scenes, which relate to events of 1438-40, were substituted in 1440-3.

It is generally assumed that the commission for Filarete's door was inspired by the memory of the bronze doors of the Pantheon and St John Lateran (from S. Adriano), and both

in the style of the door and in its iconography antique models played an important part. It is inferred by Tschudi (with a high degree of probability) that the strips of foliated decoration in the borders of the wings owe their origin to some strips of decorative carving, probably from the Circus of Nero, which are still preserved. The mythological and historical figures incorporated in the borders derive for the most part from Ovid, Livy, Valerius Maximus and Virgil. The case has been stated (Sauer) that these scenes are due to free invention and selection on the part of the artist; this is improbable, and the multiplicity of classical models employed, in conjunction with the overall style of the door, suggests that this was executed to a humanist programme (for this, see H. Röder, 'The Borders of Filarete's Bronze Doors to St Peter's', Journal of the Warburg and Courtauld Institutes, x, 1947, pp. 150-3). The antique prototypes from which the figures of Christ, the Virgin and Sts Peter and Paul derive, have not been satisfactorily identified. Mosaics (to which reference has repeatedly been made) do not provide convincing models for these parts of the door. On the other hand, the treatment and posing of the Apostles would be consistent with the view that Filarete was familiar with Early Christian ivory carvings. The two Martyrdom scenes (in which Filarete challenges comparison with the Porta del Paradiso) are in many respects the least impressive sections of the door; in both, the perspective construction is rudimentary and the narrative technique is primitive. These scenes incorporate much classical detail. The function of the door seems in the first instance to have been the celebration of Eugenius IV's attempts to achieve Christian unity, and the four historical scenes, owing in part to their simpler form and smaller scale, are of higher artistic quality than the two Martyrdom reliefs. Filarete's name appears in four places on the door, once in association with the date at which it was completed (ANTONIVUS . PETRI . DE . FLORENTIA . FECIT . MCCCCXLV).

ANTONIO DEL POLLAIUOLO (b. 1431/2; d. 1498)

According to the inscription on his tomb in S. Pietro in Vincoli (VIX ANN. LXXII. OBIT ANNO SAL. M. IID), Antonio Pollaiuolo died in 1498 at the age of 72. If this statement were correct, he would have been born in 1426/7. The Portate al Catasto prepared by his father, Jacopo d'Antonio, in 1433 and 1442, however, give his age in those years as one and a half and 10, and he must therefore have been born in 1431. Perhaps trained by Vittorio Ghiberti, who was engaged till 1466-7 in completing the frieze of the Porta del Paradiso, he practised as a goldsmith and metalworker. In 1457, jointly with Betto di Francesco Betti and Miliano Dei, he received the commission for a silver Crucifix for the Baptistery in Florence (now in the Museo dell'Opera del Duomo), and thereafter (3 January 1460) prepared a tabernacle for the arm of S. Pancrazio for the church of this Saint (lost). The most important surviving example of Antonio Pollaiuolo's work in precious metal is a relief of the Birth of the Baptist on the silver altar of the Baptistery (commissioned 2 August 1477, completed 13 January 1478).

Antonio Pollaiuolo was also engaged after 1466 on designs for the embroidered vestments of the Baptistery (now in the Museo dell'Opera del Duomo). As a painter Pollaiuolo was strongly influenced by Castagno. About 1460, jointly with his younger brother Piero, he painted three celebrated works of the Labours of Hercules for the Palazzo Medici (lost), the compositions of which were perhaps related to two small panels of the Labours of Hercules painted at a rather later date and now in the Uffizi. On 1 October 1467 he was engaged on preparing 'l'archo dell'altare' of the Chapel of the Cardinal of Portugal at S. Miniato al Monte for painting, and the frescoes on the altar wall of this chapel as well as the altarpiece (now in the Uffizi) date from after this time. Later paintings by Antonio Pollaiuolo include a celebrated fresco of dancing nudes at Arcetri, and the altarpiece of the Martyrdom of St Sebastian in the National Gallery, London (1475). His style was also diffused through

is the so-called Battle of the Nudes. In 1469 he visited Rome, and the experience of classical sculpture which he gained there was of fundamental importance for his sculptural activity. Only two dated and fully authenticated works of sculpture by Antonio Pollaiuolo are known. The first of these is the tomb of Pope Sixtus IV (now in the treasury), which was commissioned soon after the Pope's death in 1484 and was completed in 1492 (see plates 157, 158, 159, 160), and the second the Monument of Pope Innocent VIII in St Peter's, commissioned soon after the Pope's death in 1492 and erected in 1498 (see plates 161, 162, 163). A statuette of Hercules and Antaeus from the Medici Collection, now in the Museo Nazionale, Florence (see plate 268). presumably precedes the earlier of the papal commissions, and round this a number of other bronze statuettes have been grouped. Antonio enjoyed great celebrity in Florence, and is described in a letter written by Lorenzo de' Medici to Giovanni Lanfredini (12 November 1489) as 'il principale Maestro della città ... forse per opinione d'ogni intelligente non ci fù mai uno migliore' ('the principal master of the city . . . in the opinion of all intelligent people perhaps there was never a better'). The style of the papal monuments and of the Hercules and Antaeus group is indebted to Donatello, whose work Antonio Pollaiuolo must have studied closely after 1453. Pollaiuolo was also involved in the project for the monument of Francesco Sforza in Milan, for which two drawings survive (Lehman Collection, New York (plate 193), and Gräphische Sammlung, Munich). It is not certain whether these precede or follow (Sabatini) Leonardo da Vinci's acceptance of this commission. In a letter of 1494 Pollaiuolo proposed to Virginio Orsini the making of an equestrian monument and of a bronze bust: 'E mi fù fatta una imbasciata nello orechie esendo a ostia da parte di maestro angiolo medicho dissemi p. parte della S. vostra che vostra S. arebo avuto charo che io facessi la testa di vostra S. di bronzo quanto al naturale io gli risposi subito che io larej di grazia e chosi rafermo che io mi verro a star dua di a bracciano a ritrarovi i disegnio

poi me la rechero a roma a faremola di bronzo ma piu charo avrej farvj tuto itero insu unchavalo rosso che vi farej etterno possiamo p. la prima fare la testa poi penseremo al tutto.' ('Maestro Angelo the doctor whispered to me at Ostia, telling me on your Excellency's behalf that your Excellency would have liked me to make a life-size head of your Excellency in bronze. I told him straightway that I would willingly do this, and I hereby confirm that I shall come for two days to Bracciano to make a portrait drawing. Then I shall return to Rome to make the head in bronze. I would much have preferred to make a whole statue on a bronze horse. In this way I would eternalize you. But we can make the head first and then think about the whole.') This letter provides interesting evidence of Antonio Pollaiuolo's activity as a portrait sculptor and of the methods by which his portraits were produced. The only universally accepted bust by Pollaiuolo, a terracotta portrait of an armed man in the Museo Nazionale, Florence, may have been planned as a model for a bronze statue or bust. There is no independent evidence that Pollaiuolo himself practised as a marble sculptor. Antonio Pollaiuolo was also active as an architect, submitting a project for the façade of the Duomo in Florence in 1491, and working in some unspecified capacity on the cupola of the sacristy of S. Spirito (20 May 1495) and S. Maria dell'Umiltà at Pistoia (payment of 18 August 1495). He died in Rome on 4 February 1498. His brother Piero Pollaiuolo (b. 1443; d. 1496) is known to have assisted Antonio on the papal tombs, and his share in these can be at least tentatively identified. No other sculptures by Piero Pollaiuolo are known.

Bibliography

The standard monograph on Antonio Pollaiuolo is by L. D. Ettlinger (*Antonio e Piero Pollaiuolo*, Oxford, 1978). This provides decent reproductions of Pollaiuolo's work but does less than justice to the problems it presents; it supersedes earlier volumes by A. Sabatini (*Antonio e Piero del Pollaiuolo*, Florence, 1944) and S. Ortolani (*Il Pollaiuolo*, Milan, 1948). In English, M. Cruttwell's

Antonio and Piero Pollaiuolo, London, 1907) offers an adequate, though in part outdated, account of Pollaiuolo's work. The material relating to the tomb of Pope Sixtus IV is re-examined in an exceptionally perspicacious and thorough article by L. D. Ettlinger ('Pollaiuolo's Tomb of Pope Sixtus IV', Journal of the Warburg and Courtauld Institutes, xvi, 1953, pp. 239-74), from which the note to plates 158, 159, 160 is in large part drawn. On the small bronzes of Antonio Pollaiuolo, see particularly J. Pope-Hennessy (Essays on Italian Sculpture, London, 1969, p. 173, and The Frick Collection: An Illustrated Catalogue, iii, Sculpture: Italian, New York, 1970), and for the iconography of the Hercules and Antaeus group U. Hoff ('The sources of Hercules and Antaeus by Rubens', In Honour of Daryl Lindsay: Essays and Studies, Melbourne, 1964, pp. 67-79). Some interesting observations on Pollaiuolo as an anatomist are made by A. Hyatt Mayor ('Artists as Anatomists', Bulletin of the Metropolitan Museum of Art, xvii, 1963-4, pp. 201-10). L. D. Ettlinger ('Hercules Florentinus', Mitteilungen des Kunsthistorischen Institutes in Florenz, xvi, 1972, pp. 119-42) throws much new light on the cult of Hercules under Lorenzo il Magnifico and relates the Hercules representations of Pollaiuolo to the De vera nobilitate of Cristoforo Landino, which contains an extended moral interpretation of the Hercules myth. The bulk of the recent articles on Pollaiuolo deals with metalwork. D. A. Covi ('Nuovi documenti per Antonio e Piero del Pollaiuolo e Antonio Rossellino', Prospettiva, xii, 1978, pp. 61-72) publishes documents relating to a bread knife executed for a Roman patron and a borsa (purse) made for Cardinal Francesco Gonzaga as well as new information on the armour designed for Salutati in the Giostra of 1468/69 which was designed by the Pollajuoli and Antonio Rossellino. Two important letters from Giovanni Lanfredini to Antonio Pollaiuolo, one dealing with two silver candlesticks for the Chapel of St James in the Duomo at Pistoia, are published by E. Borsook ('Two letters concerning Antonio Pollaiuolo', Burlington Magazine, xvi,

1973, pp. 464-8). A substantial addition

to our knowledge of the S. Pancrazio reliquary is made by M. Haines ('Documenti intorno al reliquiario per San Pancrazio di Antonio del Pollaiuolo e Piero Sali', in Scritti di storia dell'arte in onore di Ugo Procacci, Milan, 1977, i, pp. 264-9). D. Liscia Bemporad ('Appunti sulla bottega orafa di Antonio del Pollaiuolo e di alcuni suoi allievi', Antichità viva, xix, 1980, pp. 47-53) and D. Carl ('Zur Goldshmiedefamilie Dei mit neuen Dokumenten zu Antonio Pollaiuolo und Andrea del Verrocchio', Mitteilungen des Kunsthistorischen Institutes in Florenz, xxvi, 1982, pp. 129-66) add significantly to knowledge of the operation of the Pollaiuolo shop. A businesslike account of the silver Cross in the Museo dell'Opera del Duomo, Florence, and its conservation, is to be found in Firenza restaura: il laboratorio nel suo quarantennio, eds. U. Baldini and P. da Poggetto, Florence, 1972, no. 15. D. Carl ('Addenda zu Antonio Pollaiuolo und seiner Werkstatt', Mitteilungen des Kunsthistorischen Institutes in Florenz, xxvii, 1983, pp. 285-306) identifies Pollaiuolo's assistant Attaviano with Ottaviano, the brother of Agostino di Duccio, and provides new information on silver bowls executed in 1467-82. Two articles deal with the silver Cross from the Baptistery: the first, by A. Angelini ('Considerazioni sull'attività giovanile di Antonio Pollaiuolo', Prospettiva, 44, 1986, pp. 16-26) ascribes all the figures to Antonio, whereas the second, by G. Passavant ('Beobachtungen am Silberkreuz des Florentiner Baptisteriums', Studien zum Europäischen Kunsthandwerk Festschrift Yvonne Hackenbroxh, Munich, 1983, pp. 77-105), credits Pollaiuolo only with an Angel on the right and the figures on the base. On Pollaiuolo and the antique, see L. Fusco (The Nude as Protagonist, Ph.D. dissertation, New York University, 1978, summarized in Marsyas, 1977-8, pp. 67-8, and 'Antonio Pollaiuolo's Use of the Antique', Journal of the Warburg and Courtauld Institutes, xlii, 1979, pp. 257-63); and M. Vickers ('A Greek Source for Antonio Pollaiuolo's Battle of the Nudes and Hercules and the Twelve Giants', Art Bulletin, lix, 1977, pp. 182-7). L. Fusco ('Pollaiuolo's Battle of the Nudes', in Scritti di storia dell'arte in

onore di Federico Zeri, Milan, 1984, i, pp.

196–7) in a not wholly convincing article proposes a Roman dating for the engraving of the Battle of the Nudes. Pollaiuolo's papal tombs are the subject of articles by L. D. Ettlinger (1953) and E. Frank ('Pollaiuolo's tomb of Innocent VIII', *Verrocchio and Late Quattrocento Italian Sculpture*, Florence, 1992, pp. 321–42). A thorough and penetrating book on Pollaiuolo's work, in all media and in a valid historical context, is high on my list of desiderata.

The Tomb of Pope Sixtus IV

St Peter's, Rome Plates 157–60

In 1479 Pope Sixtus IV issued a bull appointing as his burial place a projected chapel, the Cappella del Coro, on the south side of St Peter's. The chapel was constructed during the lifetime of the Pope, the altar being flanked by columns and surmounted by a fresco by Perugino showing Sixtus IV presented by Sts Peter, Paul, Francis and Anthony of Padua to the Virgin and Child. A drawing of the altar and fresco exists in Ms. Barb. Lat. 2733, f. 131, Bibl. Vat. (reprinted by Ettlinger). According to Burchard (Johannes Burchardus, Liber Notarum, xxxii-i, 1910, p. 16) the Pope indicated a central position in the chapel in which his tomb was to be set. After the death of Sixtus IV (12 August 1484) his body was temporarily interred in the Cappella del Coro, and the commission for his monument was awarded by his nephew, Cardinal Giuliano della Rovere, the future Pope Julius II, to Antonio Pollaiuolo. Though the tomb (plate 157) is signed by Antonio Pollaiuolo alone (OPVS ANTONI POLAIOLI / FIORENTINI ARG AUR / PICT AERE CLARI / AN DOM MCCCCLXXXXIII), it is stated by the Anonimo Magliabecchiano (C. Frey, Il Codice Magliabecchiano, Berlin, 1892, p. 126) that the tomb was executed by Antonio jointly with his brother Piero. It has sometimes been assumed that work on the tomb was begun only in 1489, but it is virtually certain that the making of the monument was started soon after the Pope's death, since a contemporary witness, Raffaello Maffei, states that it occupied Antonio Pollaiuolo for ten years (E. Müntz, Les Arts à la cour des

Papes, 1878-98, iii, p. 86n). In 1490 the bronze effigy of the Pope was already complete (Lorenzo Buonincontri, Fasti, printed by B. Soldati, Miscellanea Antonio Graf, Bergamo, 1903, p. 416). According to the inscription on the monument, the tomb was completed in 1493. The sum paid to Antonio Pollaiuolo in connection with the work was 5,000 ducats (Janitschek, Repertorium für Kunstwissenschaft, iii, 1880, p. 84). After the basilica was reconstructed the tomb was moved to the Chapel of the Sacrament, was later in the Museo Petriano, and is now in the Sagrestia dei Beneficiati. A drawing by Marten van Heemskerck (C. Hülsen and H. Egger. Die römischen Skizzenbücher von Marten van Heemskerck, i, Berlin, 1913, plate 73) shows the monument in its original state.

The tomb consists of two parts. The first of these is an effigy, in which the head is fully modelled and the body is represented in deep relief, on a flat slab composed of bronze reliefs. These show (head) Charity, (left side, head to foot) Hope, Prudence, Fortitude, (right side, head to foot) Faith, Temperance, Justice. At the foot is an inscription, and at the corners are (top) the arms of Pope Sixtus IV and (bottom) the arms of Giuliano della Rovere. The second part is a high chamfered base composed of figures of the Arts and Sciences set diagonally in deep relief between acanthus foliage. The reliefs show (head, left to right) Philosophy, Theology, (foot, left to right) Rhetoric, Grammar, (left side, head to foot) Arithmetic, Astrology, Dialectic, (right side, head to foot) Geometry, Music, Prospettiva. It has been shown (Ettlinger) that the reliefs of the Virtues beside the effigy, with the exception of the Charity and Fortitude, agree closely with a well-known cycle of paintings of the Virtues commissioned for the Mercanzia in Florence from Pietro Pollaiuolo and executed jointly by both brothers. There is a probability that these reliefs are the work of Piero Pollaiuolo, and that Antonio Pollaiuolo was responsible for the effigy, the relief of Charity, and the entire lower part. Though it is invariably assumed that the monument as it now stands was from the first planned as a unity, the relation of the upper and lower parts is puzzling, since the reliefs of Virtues are not fully

legible from the side. It is possible therefore that the monument was designed initially as a raised tombslab, like the Martin V tomb-slab of Michelozzo in St John Lateran, which is elevated on a marble step carved with putti. In this event the chamfered base would represent a second phase in the designing of the monument. A Roman parallel for the use of a free-standing monument is supplied by Giovanni di Stefano's Foscari Monument in S. Maria del Popolo, where the bronze effigy rests on a marble sarcophagus which can only have been intended for a free-standing position since it is carved behind.

Classical motifs are used extensively in the reliefs of the Liberal Arts. Thus the Rhetoric is based on a Hadrianic coin of Tellus Mater (Ettlinger), the Grammar shows the same figure in reverse, and the Theology depends from a classical Diana type. The programme of the reliefs, on the other hand, is proved by Ettlinger to have been scholastic in character. With the exception of the Music, each of the Liberal Arts carries an inscription. The inscriptions on six reliefs are drawn from the Elementa of Euclid (Geometry and Arithmetic), the Centiloquium of Ptolemy (Astrology), the Perspectiva Communis of Peckham (Prospettiva, or Optics), the Physics and Metaphysics of Aristotle (Philosophy), Genesis and the Gospel of St John (Theology). The inscriptions on the three remaining reliefs appear to depend from Vincent of Beauvais and Roger Bacon (Grammar), Cicero (Rhetoric) and the Summulae of Petrus Hispanus (Dialectic).

The Tomb of Pope Innocent VIII

St Peter's, Rome Plates 161, 163

In its present form the monument consists of a sarcophagus and effigy beneath a seated figure of the Pope in benediction. Beside the seated figure are reliefs of (*left*) Fortitude and Justice and (*right*) Temperance and Prudence. Above is a lunette with reliefs of (*left to right*) Hope, Charity and Faith. It is known, however, from a drawing by Marten van Heemskerck (C. Hülsen and H. Egger, *Die Römischen Skizzenbücher von Marten van Heemskerck*, ii, Berlin, 1916, plate 27) and an early seventeenth-century

drawing in the Kupferstichkabinett, Berlin (plate 162), that the seated figure and the four Virtues beside it were originally placed below the effigy, and that the entire monument was inset in a marble triumphal arch with ornamented pilasters resting on bases decorated with the arms of Pope Innocent VIII. The seated figure of the Pope is shown holding in the left hand the relic of the Holy Lance, which was presented to him by the Sultan Bajazet on 31 May 1492, two months before his death, and the wish to commemorate this scene is perhaps accountable for the innovation whereby a life figure was introduced on to the monument. According to the Anonimo Magliabecchiano, the tomb was originally placed near the altar of St Lucy, where it was associated with the Ciborium of the Holy Lance (for this, see E. Müntz, 'L'architettura a Roma durante il Pontificato d'Innocenzo VIII', Archivio storico dell'arte, vi, 1891, pp. 363-70), which was commissioned by Pope Innocent VIII and contained a fresco by Pinturricchio of the Pope kneeling before the Virgin and Child. In 1507 both the tomb and ciborium were moved to temporary positions where they are shown in a drawing of Grimaldi (reprinted by E. Gregorovius, Le tombe dei Papi, ed. C. Hülsen, Rome, 1932, plate cix). The tomb was disassembled once more in 1606, and in 1621 was reerected in its present position; the marble inscription dates from this time. The tomb was commissioned from Antonio Pollaiuolo by Cardinal Lorenzo Cibo at a cost of 4,000 ducats (Janitschek, 1880, p. 284), and according to Vasari was begun in 1492. It was completed before 30 January 1498, when the Pope's remains were reinterred in the new monument. The execution of the tomb is of lower quality than that of Pope Sixtus IV, and extensive intervention on the part of Piero Pollaiuolo (d. 1496) may be presumed. The reliefs of Virtues depend from those of the Sixtus IV monument.

Burckhardt, the master of ceremonies at the Vatican, records in 1498 that the tomb was set 'juzta murum altaris beate Marie Virginis chori ubi canonici et clerus basilice sanct Petri,' that is, adjacent to the ciborium of the Holy Lance. It was therefore (Frank) on the

wall of the crossing-pier of the transept. The seated statue on the tomb has been linked with the Neapolitan tradition of seated sepulchral figures represented by the tomb of Robert the Wise in S. Chiara in Naples. The distinction between the Theological Virtues (set in the lunette originally above the effigy) and the Cardinal Virtues set beside the seated statue of the Pope is Thomist in origin, and is established visually by the contrast between the flying figures in the lunette and the seated figures at the sides. The Holy Lance, presented to the Pope for political reasons by the Sultan Bajazet, was received at Ancona by a papal delegation and was transported by way of Narni to Rome by Cardinal Giuliano della Rovere where it was greeted with a ceremony based on that of the Head of St Andrew. In Rome it became a basis for propaganda for a new Crusade. The lunette of the monument is likely to be the work of Antonio Pollaiuolo.

Hercules and Antaeus

Museo Nazionale, Florence Plate 268

The bronze is mentioned for the first time in the Medici inventory of 1495 when it was in the former apartment of Giuliano de' Medici ('uno Ercole che scoppia Anteo, bronzo tutto Alto br.1/2'). The subject of Hercules and Antaeus. which was to prove exceptionally popular in the sixteenth and seventeenth centuries, makes its first appearance in Renaissance bronze sculpture in Pollaiuolo's statuette; the academic problems presented by it are mentioned by Alberti in the Della pittura and the De statua. The poses of the figures in the statuette are in general correspondence with a panel of the same subject by Antonio Pollaiuolo in the Uffizi, Florence, which may reproduce a lost painting on linen or canvas executed (along with paintings of Hercules and the Hydra and Hercules and the Nemean Lion) for the Sala Grande of the Palazzo Medici about 1465. Like Donatello's Judith, the figures rest on a triangular base, and have, therefore, three prime views. As violent as its emotional repertory, the organization of the group is linear and strongly

geometrical, and differs from other fifteenth-century representations (e.g. Robetta) in that the head of Hercules faces the chest of Antaeus and is not depicted in profile or full-face. There is no independent evidence of the date of the statuette, which was perhaps executed about 1475. The model does not derive from a classical prototype, though the types of the two figures strongly recall the types of figures represented on sarcophagus ends (e.g. in the Museo del Gesù at Cortona). Two other bronze statuettes can be unreservedly accepted as works of Antonio Pollaiuolo. The first and earlier is an unfinished statue of Hercules in the Frick Collection, New York, in which the base is left unchased (for this, see Pope-Hennessy, The Frick Collection: An Illustrated Catalogue, iii, Sculpture: Italian, New York, 1970, pp. 22-8), and the second is a Hercules in Berlin, which conforms closely with the style of the Hercules and Antaeus.

BERTOLDO DI GIOVANNI (b. c.1420; d. 1491)

The date of Bertoldo's birth is not recorded. At the end of his life he is stated by Vasari to have been 'si vecchio, che non potesse più operare' ('so old that he could no longer work'), and his birth for this reason is assumed to have taken place about 1420. Trained under Donatello, he appears to have gained his reputation 'per avere diligentemente rinnetato il getto de' pergami di Donato suo maestro' ('through having carefully chased the casts of the pulpit reliefs of his master Donato'). Many traces of his hand can be identified in the S. Lorenzo pulpits (see plates 68-73), especially in the frieze, for which he was largely responsible. One relief on the pulpit, the Entombment, is wholly by Bertoldo, as are the two adjacent figures set against the statuettes. Vasari's expression 'rinnetato' may refer to the relief of the Lamentation over the Dead Christ, where the foreground figures have been worked up but the background and its horsemen are left in the rough. The first reference to Bertoldo in documents is a payment of 1474 relating to a transaction with Luigi Pucci. In 1478, along with a goldsmith, Riccio, and a certain Nanni he was fined for the failure of a firework display. A letter of 1478 from Andrea Guacialotti to Lorenzo il Magnifico refers to four medals 'che Bertoldo a facta la prima impronta'. A letter from Bertoldo to Lorenzo il Magnifico survives from 1479, and there is extensive documentation of Bertoldo's work at Padua. In 1485 he carved two Angels for the organ loft over the entrance to the New Sacristy of the Cathedral. He also bought classical medals for Lorenzo de' Medici. A medal of Mohammed II signed by Bertoldo probably dates from 1480-1. In 1483 he was commissioned to execute two bronze reliefs for the choir of the Santo at Padua (see plate 283); this commission was later transferred to Bellano. The Anonimo Morelliano describes a bronze statuette of Bellerophon and Pegasus in the house of Antonio Cappello in Padua ('Lo bellerophonte di bronzo che ritiene el Pegaso, de grandezza d'un piede, tutto tirondo, fù di mano di Bertoldo, ma gettado da Hadriano suo discipulo, ed è

opera nettissima e buona'). The bronze, which is now in the Kunsthistorisches Museum, Vienna (plate 272), has been assigned to the years in which Bertoldo was associated with Padua, and derives from a classical prototype of the class of a relief in the British Museum (Frimmel). The bronze is signed EXPRESSIT ME BERTHOLDVS CONFLAVIT HADRIANVS, and was cast by Adriano Fiorentino. Since the Mohammed II medal was based on a likeness by Gentile Bellini and was cast by Guazzalotti, it has been inferred (Hill) that Bertoldo did not cast his own bronzes. This is unlikely since he is praised by Vasari 'per molti getti ancora che egli aveva fatti di bronzo di battaglie e di alcune altre cose piccole. nel magisterio delle quali non si trovava allora in Firenze chi lo avanzasse' ('For many bronze casts that he had made of battle scenes and of other little things, in the mastery of which there was no one in Florence at that time who surpassed him.'). Since contact between Bertoldo and Adriano Fiorentino seems to have ended when the latter, about 1486, entered the service of Virginio Orsini, the Bellerophon and Pegasus was probably produced before this time. The Medici inventory of 1492 mentions three other works by Bertoldo, a battle relief (see plates 273, 274, 275), a relief of the Crucifixion with attendant Saints, now in the Museo Nazionale, Florence, in which the style approximates that of Botticelli, and a 'Centauro' (lost; it is not known if this was a statuette or a relief). On the basis of the Crucifixion relief it is possible to attach Bertoldo's name to a relief of putti in the Museo Nazionale, Florence, and on the basis of the Bellerophon and the battle relief he can also be credited with statuettes of Apollo (Museo Nazionale, Florence, see plate 277), Hercules (Frederiks Collection, The Hague, formerly Kaiser Friedrich Museum, Berlin), Hercules with the Apples of the Hesperides (Victoria and Albert Museum, London), a Prisoner (Kaiser Friedrich Museum, Berlin, destroyed), St Jerome (Kaiser Friedrich Museum, Berlin, destroyed), Hercules on Horseback (Pinacoteca Estense, Modena) and two bearded male figures with shields (Liechtenstein Collection, Vaduz, and Frick Collection, New York). It is by no means certain that

Bertoldo's activity was confined to work on this reduced scale, and it is likely that he and members of his shop were responsible for 12 large modelled reliefs in the courtvard of the Palazzo Scala-Gherardesca, Florence, and for a frieze in enamelled terracotta at Poggio a Cajano. In his life of Michelangelo Vasari states that towards the end of his life Bertoldo was appointed to take charge of the Medici academy and collection of antiquities: 'Teneva in quel tempo il Magnifico Lorenzo de' Medici nel suo giardino in sulla piazza di San Marco Bertoldo scultore, non tanto per custode o guardiano di molte belle anticaglie che in quello aveva ragunate e raccolte con grande spesa, quanto perchè, desiderando egli sommamente di creare una scuola di pittori e di scultori eccellenti, voleva che elli avessero per guida e per capo il sopradetto Bertoldo, che era discepolo di Donato.' ('At that time Lorenzo de' Medici the Magnificent kept Bertoldo the sculptor in his garden on the Piazza di San Marco, not so much as custodian or guardian of the many beautiful antiquities which he had assembled there and had collected at great expense, but rather because, instilled with the great desire to create an excellent school of painters and sculptors, he was anxious that they should have as their guide and director the aforesaid Bertoldo, who had been a pupil of Donatello.') Bertoldo died in Lorenzo de' Medici's villa at Poggio a Cajano on 30 December 1491. The place of his death is established by a letter written by Lorenzo de' Medici to his son Piero from Poggio a Cajano on 28 December 1491 'a maestro Stefano da Prato che medica Bertoldo' ('to maestro Stefano da Prato, who is treating Bertoldo'), and the date by a letter of ser Bartolommeo Dei of 30 December 1491: 'Bertoldo scultore degnissimo, e di medaglie optimo fabricatore, el quale sempre col magnifico Lorenzo facesse cose degne, al Poggio s'è morto in due dì. Che n'è danno assai e a lui è molto doluto, chè non se ne trovava un altro in Toscana ne forse in Italia di si nobile ingegno e arte in tali cose.' ('In two days there died at Poggio Bertoldo, a most worthy sculptor and excellent manufacturer of medals, who always did worthy things with the Magnifico

Lorenzo. The loss is very great and he is much lamented, since there is not another artist to be found in Tuscany nor perhaps in Italy with so noble a talent and such skill in these things.')

Bibliography

The reintegration of Bertoldo's artistic personality is due largely to W. von Bode, whose essay on the sculptor ('Bertoldo di Giovanni', Florentiner Bildhauer der Renaissance, Berlin, 1902) remains a good general introduction to his work. A later monograph by Bode (Bertoldo und Lorenzo de' Medici, Freiburg-im-Breisgau, 1925) is unduly speculative, and reproduces a large number of works wrongly ascribed to the artist. Neither Bode's book nor article is, however, of the quality of two contributions by T. Frimmel ('Die Bellerophongruppe des Bertoldo', Jahrbuch der Kunsthistorischen Sammlungen in Wien, v, 1877, pp. 90-6) and F. Wickhoff ('Die Antike im Bildungsgange Michelangelos', Mitteilungen des Instituts für Oesterreichische Geschichtsforschung, iii, 1882, pp. 408-35). A published thesis by K. Rohwaldt (Bertoldo: ein Beitrag zur Jugendentwicklung Michelangelos, Inaugural Dissertation der Friedrich-Wilhelms Universität, Berlin, 1896) also provides a careful account of Bertoldo's style. The standard modern monograph is a volume by J. D. Draper (Bertoldo di Giovanni, University of Missouri, 1992), which disregards the artist's early works and ascribes to him inter alia the wooden St Jerome of Donatello at Faenza. The book is, however, well illustrated and admirably documented, though it offers no explanation of the enthusiasm Bertoldo's work enjoyed in Florence. The bronzes ascribed to Bertoldo are briefly discussed by Bode (Die italienische Bronzestatuetten der Renaissance, Berlin, 1923, pp. 12-16), L. Planiscig (Piccoli bronzi italiani del rinascimento, Milan, 1930, pp. 6-7) and H. Weihrauch (Europäische Bronzestatuetten, Brunswick, 1967, pp. 87-9). An admirable account of Bertoldo's medallic activity by G. Hill (A Corpus of Italian Medals of the Renaissance before Cellini, London, 2 vols, 1930, pp. 238-40) supersedes all earlier work in this field. For Adriano Fiorentino, see C. von Fabriczy ('Adriano Fiorentino',

Jahrbuch der Preussischen Kunstsammlungen, xxiv, 1903, pp. 71-98) and Draper. For the relief at Poggio a Cajano, see A. Chastel (Marsile Ficin et l'art, Geneva, 1954), J. Cox-Rearick ('Themes of Time and Rule at Poggio a Cajano', Mitteilungen des Kunsthistorischen Institutes in Florenz, xxvi, pp. 167-210), P. Foster (A Study of Lorenzo de' Medici's Villa at Poggio a Cajano, New York, 1978), F. Ladi (Le temps revients: il fregio di Poggio a Cajano, Florence, 1986) and L. Medri (in L'architettura di Lorenzo il Magnifico, exhibition catalaogue, Milan, 1992, pp. 94-100). On the Palazzo Scala-Gherardesca reliefs (which have also been mistakenly ascribed to Rustici), see A. Chastel (Art et humanisme à Florence au temps de Laurent le Magnifique, Paris, 1959, pp. 76-82), A. Brown (Bartolomeo Scala, Princeton, 1979) and A. Parronchi ('The Language of Humanism and the Language of Sculpture: Bertoldo as Illustrator of the Apologi of Bartolomeo Scala', Journal of the Warburg and Courtauld Institutes, xxvii, 1964, pp. 108-36). Two documents relating to Bertoldo's death are printed by F. W. Kent, the first ('Bertoldo "sculptor" and Lorenzo de' Medici', Burlington Magazine, cxxxiv, 1992, pp. 248-9) reporting Lorenzo il Magnifico's sorrow at his death 'because he loved him as much as any of his familiars', and the second ('Bertoldo "sculptor" again', Burlington Magazine, cxxxv, 1993, pp. 629-30) reporting that in January 1492. thirty Masses and a High Mass were said by the canons of S. Lorenzo for Bertoldo's soul.

Apollo

Museo Nazionale, Florence Plate 277

The subject of this statuette has been variously identified as Aryon, Orpheus and Apollo. In the absence of the dolphin (which appears in the Aryon statuette of Riccio in the Louvre and in the Aryon plaquettes of Moderno) the first identification is improbable. The figure wears a skin over his shoulders terminating in a hoof behind, and a wreath of indeterminate leaves. These features would be admissible both in an Orpheus and an Apollo. The model in its present form is not recognizably

related to any known classical prototype. The statuette is worked up only in the head and legs, and work on it was presumably abandoned as a result of casting flaws. In structure it is none the less one of the most appealing of Bertoldo's single statuettes.

Battle Scene

Museo Nazionale, Florence Plates 273–5

Bertoldo's battle relief in the Bargello is described in the Medici inventory of 1492 above a chimneypiece 'nella saletta rimpetto alla sala grande', and by Vasari: 'le cose d'arte (Donatello) lasciò ai suoi discepoli: i quali furono Bertoldo, scultore fiorentino, che l'imitò assai, come si può vedere in una battaglia in bronzo d'uomini a cavallo molto bella, la quale è oggi in guardaroba del signor Duca Cosimo.' ('Donatello left his works of art to his disciples. These were Bertoldo, a Florentine sculptor who imitated his work closely, as can be seen in a most beautiful bronze relief of a battle of horsemen, which is now in the wardrobe of Duke Cosimo.') The relief was regarded by Wickhoff as a synthesis of elements from Roman sarcophagi (e.g. a sarcophagus in the Galleria Giustiniana), and was interpreted by him as a battle of Romans and Trojans, the figures to left and right being identified as Menelaus and Helen and the central figure as Hector. If this interpretation is correct, the relief (like the early Battle of the Centaurs of Michelangelo) may have been designed to a programme by Politian. It was subsequently established that Bertoldo's relief was based directly on a damaged sarcophagus in the Campo Santo at Pisa (plate 276). Since, however, the lateral figures are additions to the sarcophagus, and the central group is also a free invention of the artist, Wickhoff's interpretation is not invalidated. The lateral figures appear to have been interpolated from a second sarcophagus front, analogous to an example in the Museo delle Terme, Rome. The respective dimensions of the bronze relief and the sarcophagus at Pisa are height: 43 cm (bronze relief), 101 cm (sarcophagus), length: 99 cm (bronze relief), 237 cm (sarcophagus).

PIETRO TORRIGIANO

(b. 1472; d. 1528)

Pietro Torrigiano was born in Florence on 24 November 1472. A member of the Medici academy and a pupil of Bertoldo, he is recorded as executing, under Bertoldo's supervision, freestanding terracotta statues or statuettes (Vasari). No early work made by Torrigiano at this time has been identified, and he is principally remembered for the fact (recorded in two places by Vasari) that he assaulted, and broke the nose of, Michelangelo. As a result of this incident (which must have occurred before 1492) he was exiled from Florence. Thereafter he worked in Rome on the stucco decoration of the Torre Borgia and on terracotta busts (lost) of the Bolognese doctor Stefano della Torre (18 August 1494) and Pope Alexander VI (prior to 18 August 1494). At this time Torrigiano was resident in the house of Stefano Coppi, rector of S. Salvatore in Suburra, and it has been claimed (Ferrajoli), with a high degree of plausibility, that marble busts of Christ and S. Fina and a terracotta bust of St Gregory presented by Coppi to the Ospedale di S. Fina at San Gimignano are by Torrigiano. After 1498 Torrigiano served in the forces of Cesare Borgia in the Romagna, and on 13 January 1500 received the commisson for an altarpiece for Sts Annunziata dei Zoccolanti at Fossombrone. At some date after 1500 he left Italy, and in 1509-10 was in the Netherlands in the service of Margaret of Austria, where he is mentioned as mending the neck of a bust of 'ma dame Marie d'Angleterre' (Mary, daughter of Henry VII). The first evidence of his presence in London occurs on 23 November 1511, when he signed a contract for the tomb of Lady Margaret Beaufort (d. 1509) in Westminster Abbey. It is possible that he was also in England before the death of King Henry VII (1509), and that busts of this King, John Fisher, Bishop of Rochester. and the young Henry VIII (Victoria and Albert Museum, London, and Metropolitan Museum, New York) were executed at this time. On 26 October 1512 he received the commission for the tomb of Henry VII and Elizabeth of York (see plates 164,

165). Before completing this, he undertook responsibility for the altar (destroyed) in the Henry VII Chapel at Westminster Abbey, of which the main features were rectangular pigmented terracotta reliefs of (front) the Resurrection and (back) the Nativity and a recumbent terracotta statue of the Dead Christ. Concurrently he executed the terracotta monument of Dr John Young (d. 25 April 1516) for the Rolls Chapel (now in the Public Record Office, London; marred by modern pigmentation), and about 1518 a bronze relief portrait of Sir Thomas Lovell, now in Westminster Abbey. On 5 January 1519 a project (later abandoned) was advanced for a tomb by Torrigiano for Henry VIII and Catherine of Aragon, larger by one-quarter than the Henry VII monument. After a visit to Florence (18 June 1519), where he recruited a number of Italian assistants, Torrigiano seems to have resumed work in London, but in or before 1522 moved to Spain, where he executed terracotta statues of St Ierome and the Virgin and Child for the convent of Buena Vista at Seville (now in the Seville Museum). According to Francisco d'Hollanda, he also 'fit en argile le portrait de l'Impératrice' (Isabella of Portugal). He died, in the hands of the Inquisition, in 1528. Torrigiano's reputation has suffered from the unfavourable attitude adopted towards his work by Vasari and other supporters of Michelangelo, as well as from the fact that all of his mature works were made in England and Spain. Both the terracotta busts (which depend from the work of Verrocchio) and the St Ierome (in which the composition recalls Bertoldo) are strongly Florentine in character, and his sepulchral monuments at Westminster are some of the finest Tuscan sculptures of their time.

Bibliography

For the career of Torrigiano, see C. Justi ('Torrigiano', *Jahrbuch der Preussischen Kunstsammlungen*, xxvii, 1906, pp. 249–81) and an excellent article by A. Higgins ('On the Work of Florentine Sculptors in England in the Early Part of the Sixteenth Century', *Archaeological Journal*, li, 1894, pp. 129–220). The documents relating to the tomb of Lady Margaret Beaufort are printed by R. S.

Scott ('On the Contracts for the Tomb of the Lady Margaret Beaufort, Countess of Richmond and Derby', Archaeologia, lxvi, 1914-15, pp. 365-76) and those referring to Torrigiano's Roman activity and to the busts at San Gimignano by A. Ferrajoli ('Un testamento dello scultore Pietro Torrigiani e ricerche sopra alcune sue opere', Bollettino d'arte, ix, 1915, pp. 181-92). For the English portrait busts, see F. Grossmann ('Holbein, Torrigiano, and some Portraits of Dean Colet', Journal of the Warburg and Courtauld Institutes, xiii, 1950, pp. 202-36) and H. J. Dow ('Two Italian portrait busts of Henry VIII', Art Bulletin, xlii, 1960, pp. 291-4). The modern literature is principally due to M. G. Ciardi Dupré Dal Poggetto ('Pietro Torrigiano e le sue opere italiane', Commentari, xxii, 1971, pp. 305-25; 'Nuovi contributi sulla attività di Pietro Torrigiano', Scritti in onore di Roberto Salvini, Florence, 1984, pp. 369-77) and a series of important studies by A. Darr ('Verrocchio's Legacy: Observations regarding his Influence on Pietro Torrigiani and Other Florentine Sculptors', Verrocchio and Late Quattrocento Italian Sculpture, Florence, 1992, pp. 125-39; 'The Sculptures of Torrigiano. The Westminster Abbey Tombs', Connoisseur, cc, 1979, pp. 177-84; Pietro Torrigiano and his Sculpture for the Henry VII Chapel, Westminster Abbey, Ph.D. dissertation, 1980; 'From Westminster Abbey to the Wallace Collection. Torrigiani's Head of Christ', Apollo, cxvi, 1982, pp. 292-8; and 'New Documents for Pietro Torrigiani and Other Early Cinquecento Florentine Sculptors Active in Italy and England', Kunst des Cinquecento in der Toskana, ed. M. Cämmerer, Munich, 1992, pp. 108-38). The latter well-documented article deals with the San Gimignano busts, a statuette on the Piccolomini Altar in the Duomo at Siena, a tombslab in S. Maria di Monserrato, Rome, two doorways in the Borgia Apartment of the Vatican, and the Yonge Monument.

Tomb of King Henry VII and Elizabeth of York

Westminster Abbey, London Plates 164, 165

The foundation stone of the Lady Chapel in Westminster Abbey was laid in January 1503, and its fabric appears to have been substantially complete when King Henry VII died (22 April 1509). In a will drawn up shortly before his death the King bequeathed a sum of £5,000 for his own tomb, a 'grate in the manner of a closure', and other furnishings for the chapel. According to this, the tomb was to be placed 'in the myddes of the same chapell, before the high aultier, in such distaunce from the same as is ordered in the plat made for the same chapell and signed with our hande'. The tomb was to contain at the ends and sides 'tabernacles . . . to be filled with ymages, sp'cially of our said avouries of coper and gilt', the Saints concerned being specified elsewhere in the will. Before the commencement of the chapel, preparations had been made for the construction of a tomb at Windsor (1501-2), and it has been suggested (Higgins) that the grille surrounding the present tomb is that designed by Esterfelde for the Windsor monument. Initially it was intended that the tomb should be based on that of Charles VIII of France at St- Denis, and should be executed by Mazzoni. This project (which provided for recumbent statues of the King and Queen, kneeling figures of the King and four of his lords, and 12 gilt bronze statuettes of Saints) was 'disliked' by King Henry VIII, and on 26 October 1512 the commission was awarded to Torrigiano, who agreed 'to make and worke, or doo to be made and wrought, well, surely, clenly, workemanly, curiously and substancyally, for the sum of £1,500 sterling, a tombe or sepulture of whit marbill and of black touchstone wt. ymags, figures, beasts and other things of coppure gilt'. The tomb (plate 164) was complete by 5 January 1519. In Torrigiano's monument the kneeling figures planned by Mazzoni are omitted, and the ends of the tomb are decorated with seated Angels holding the epitaph and the royal arms. The Saints are represented not as statuettes in

tabernacles, but in pairs in relief. It has been plausibly suggested (Higgins) that this device derives from the bronze doors in the Sagrestia Vecchia of S. Lorenzo in Florence. A valid distinction has been made (Grossmann) between the head of the Queen, which is idealized, and that of the King, which is based on a death mask.

Isaia da Pisa

(active 1447-64)

The son of a sculptor, Pippo di Giovanni da Pisa, who had been associated with Donatello during work on the Brancacci Monument, Isaia da Pisa was employed in the Vatican in 1431. Celebrated in a poem by Porcellio de' Pandoni (Ad immortalitatem Isaiae de Pisis sculptoris), he was a productive, though in some respects a mysterious artist. After Filarete's departure from Rome in 1447. he seems to have assumed responsibility for the monument of Martino Chiaves, Cardinal of Portugal (d. 1447), in St John Lateran (plate 213), and undertook the (much modified) monument of Pope Eugenius IV in the ex-refectory of S. Salvatore in Lauro. The attribution of these works, along with an effigy of St Monica in S. Agostino, a lunette with the head of St Andrew (from St Peter's, now in the Grotte Vaticane), the Mazzatesta ciborium in S. Maria della Verità at Viterbo (1461) and the Orsini Madonna (from St Peter's, now in the Grotte Vaticane) rests on the panegyric of Porcellio. In 1450-1 Isaia was employed at Orvieto. In 1460 he was working with Paolo Romano for Pius II, and in 1462-3 worked on the Arch of the Castelnuovo at Naples (see plate 222). In 1463-4 he was engaged on the Tabernacle of St Andrew for St Peter's and on the Benediction Loggia of Pius II. Under the patronage of Ranuccio Farnese, he was (1449) at the Conte di Gradoli and Isola Bisentina. The date of Orsini's death confirms that the tomb is one of Isaia's last works. Porcellio also mentions riding figures of Nero and Poppaea, executed by Isaia da Pisa presumably in relief. The reconstruction of Isaia da Pisa's activity is in part conjectural, and the inequality of handling of the individual sections of the much damaged Chiaves monument (where the figures of Temperance and Prudence are much superior to the Virtues at present behind and beside the effigy) and of the monument of Eugenius IV (where the two Saints in niches to the right were carved by Isaia and the figures on the left were not) to some extent accounts for the uncertainty with which students of Roman sculpture have approached his work.

Bibliography

See F. Burger ('Isaias plastische Werke in Rom', Jahrbuch der Preussischen Kunstsammlungen, xxxvii, 1906, pp. 228-44) and an inaccurate article by L. Ciaccio ('Scultura romana del Rinascimento', L'Arte, ix, 1906, pp. 165-84). Reproductions of the principal works under discussion are available in A.Riccoboni, La scultura a Roma, Rome, 1943. A thorough and well-documented article by M. Kühlenthal ('Zwei Grabmäler des frühen Quattrocento in Rom: Kardinal Martinez de Chiaves und Papst Eugen IV', Römisches Jahrbuch für Kunstgeschichte, xvi, 1976, pp. 17-56) provides valuable information on the form and vicissitudes of the Eugenius IV tomb and attributes the design of the Chiaves monument to Filarete. A relief in the National Museum, Warsaw, is ascribed to Isaia da Pisa by D. Kaczmaryk ('Isaia da Pisa, auteur présumé de bas-relief d'Apollon au musée national de Varsovie', Bulletin du Musée National de Varsovie, xv, 1974, pp. 28-32). Accounts of the work of Isaia da Pisa are supplied by F. Negri-Arnoldi ('Isaia da Pisa e Pellegrino da Viterbo', Il quattrocento a Viterbo, exhibition catalogue, Viterbo, 1983, pp. 324-30) and F. Cagliotti ('Precisazioni sulla "Madonna" d'Isaia da Pisa nelle Grotte Vaticane', Prospettiva, no. 47, 1986, pp. 58-64.

Virgin and Child enthroned with Sts Peter and Paul

Grotte Vaticane Plate 214

According to an inscription at one time set above the relief, this was removed in 1633 from the Orsini Chapel of S. Biagio in St Peter's. The relief shows a Pope (left) and Cardinal (right) kneeling at the Virgin's feet. These have been variously identified as Pope John XXII (d. 1334) and Cardinal Giovanni Gaetano Orsini (d. 1336), to whom the endowment of the chapel was due (Ciaccio), and as Pope Eugenius IV and Cardinal Latino Orsini (d. 1439) (Burger). Comparison with the head of the effigy on the Eugenius IV monument in S. Salvatore in Lauro lends some support to the latter view. The attribution to Isaia da Pisa, proposed by

Burger, is rejected by M. Semrau (in Thieme-Becker Künstler-Lexikon) and Ciaccio. The drapery of the St Peter is, however, very close to that of the Prudence from the Chiaves monument (St. John Lateran), and the attribution to Isaia da Pisa's workshop is not open to serious dispute. The carving is, however, more recessive than that of the figures from the Chiaves monument, or the lunette with the head of St Andrew adored by two Angels in the Grotte Vaticane, from the reliquary-tabernacle of 1463-4, and if, as suggested by Burger, the present relief was commissioned after the death of Cardinal Orsini in 1439, it would be Isaia da Pisa's earliest surviving work. The head and left forearm of the Child have been broken and restored. Cagliotti interprets the kneeling figures as Eugenius IV and the future Paul II. In this case the altar would date from 1451.

GIOVANNI DALMATA

(b. c.1440; d. after 1509)

Giovanni Dalmata, also known as Giovanni da Traù, seems to have been born in Traù about 1440 and to have been trained in the workshop of Giorgio da Sebenico. His earliest work is a statue of St John the Evangelist in the Cathedral at Trogir signed on the base JOANNIS DALMATAE F. (for this, see C. Fiscovic, 'Duknovicen kip apostolo Ivana u Trogiru', Peristil, 1971-2, pp. 123-8). In Rome, where he may initially have been associated with Paolo Romano, he collaborated with Andrea Bregno on the Tebaldi (d. 1466) and Ferrici (d. 1478) monuments in S. Maria sopra Minerva, and with Mino da Fiesole on an altar in the sacristy of S. Marco (1474) and the Monument of Pope Paul II (see plates 215, 217). He appears to have been solely responsible for the Eroli (d. 1479) and Roverella (1476-7) monuments in the Grotte Vaticane and S. Clemente. From 1481 he was employed in Hungary by Matthias Corvinus, and on the latter's death (1490) probably returned to Italy. There is evidence of his presence in Venice in 1498. His last work is the tomb of the Beato Girolamo Gianelli in the Duomo at Ancona (1509). Both in technique and style Dalmata was an artist of notable individuality, and though many of his works are collaborative. there is no evidence of an attempt to approximate his style to that of Mino on the one hand or Bregno on the other.

Bibliography

The fundamental studies of Dalmata's life and work remain those of H. von Tschudi ('Giovanni Dalmata', Jahrbuch der Preussischen Kunstsammlungen, iv, 1883, pp. 169-90) and C. von Fabriczy ('Giovanni Dalmata: Neues zum Leben und Werk', Jahrbuch der Preussischen Kunstsammlungen, xxii, 1901, pp. 224-52). A monograph, in Croatian, by K. Prijatelij appeared in 1957 (Ivan Duknovic, Zagreb) and a short survey of Dalmata's work is supplied by the same writer ('Profilo di Giovanni Dalmata', Arte antica e moderna, vii, 1959, pp. 283-97). On late works by, or ascribed to, Dalmata at Traù see C. Fiskovic ('Ivan Duknovic Dalerate', Acta historiae artium, xiii, 1967, pp. 265-70) and on works at Visegrad and in Budapest P. Meller ('La fontana di Mattia Corvino a Visegrad', Istituto ungherese di storia dell'Arte: Annuario, 1947, pp. 47-73), L. Gerevich ('Johannes Fiorentinus und die pannonische Renaissance', Acta historiae artium, vi, 1959, pp. 309-38) and I. Balogh ('Joannes Duknovic de Tragusio', Acta historiae artium, vi, 1961, pp. 51-78). A useful corpus of reproductions is supplied by A. Riccoboni, La scultura a Roma, Rome, 1943. Excellent accounts of the Paul II Monument are provided by G. Zander ('Novità sul monumento di Paolo II (1464-71) in San Pietro', in Studi di storia dell'arte sul medioevo e il rinascimento nel centenaria della nascita di Mario Salmi, eds. V. Carmi and P. Semoli, Florence, 1992, pp. 543-54) and F. Negri-Arnoldi (Roma 1300-1875. L'arte degli santi, exhibition catalogue, Rome, 1984, pp. 353-7). For a collection of articles on Dalmata see, C. Fiskovic (Ivan Duknovic Iohannes Dalmata u Domovini, Split, 1990), with further documents, one of which suggests that Dalmata was still active

The Monument of Pope Paul $\scriptstyle\rm II$

Grotte, Vaticane Plates 215, 217

The Monument of Pope Paul II (d. 1471) is ascribed by Vasari to Mino da Fiesole: 'Dopo morto quel Papa, a Mino fù fatto allogazione della sua sepoltura, la quale egli dopo due anni diede finita e murata in San Pietro, che fù allora tenuta la più ricca sepoltura che fusse stata fatta d'ornamenti e di figure a pontifice nessuno.' ('After the death of this Pope, his tomb was commissioned from Mino, who completed it in two years and set it up in St Peter's. It was then regarded as the richest tomb, in respect both of ornament and figures, that had been made for any Pope.') The tomb was demolished in the course of the rebuilding of St Peter's, was subsequently re-erected (1547), and was again disassembled. The bulk of the surviving fragments are now in the Grotte Vaticane. Mino da Fiesole's contract with the Badia for the tomb of Count Hugo of Tuscany (see plates 142, 143) had been signed a month before the death of Pope Paul II, and work on this monument seems to have been broken off in favour of the papal commission. Evidence of the original form of the monument (plate 215) is supplied by an engraving (Ciaconius, Vitae Pontificium), two early sixteenth-century drawings in the Uffizi and a drawing by Dosio in Berlin. There is no evidence of the date of the contract, which has been assigned to the years 1471-3 and 1474-7; the date of 1474 is found on the Dosio (Zander). The carving of the monument was executed jointly by Mino and Giovanni Dalmata (in the case of both artists with extensive studio assistance), and as Dalmata appears to have played the more prominent role in the execution of the sculptures, the possibility cannot be ruled out that he was also responsible for the design of the tomb. This was flanked by columns, and rested on a base (now in the Louvre, Paris) carved with putti, garlands and lion masks. The base lacks its central section, and the aggregate width of the two surviving pieces (5.18 m) is rather less than the overall width of the tomb. One part of the base (Louvre. Paris) was executed by Mino and the other by Dalmata. The remaining sections of the monument (with the exception of the columns by which it was flanked and certain other architectural features) are preserved in the Grotte Vaticane. They consist (in ascending order) (i) of upright reliefs of Faith and Charity by Mino and Hope by Dalmata (signed IOHANNIS DALMATAE OPVS), with, between them, reliefs of the Creation of Eve by Dalmata and the Fall by Mino (the latter in large part effaced), (ii) of the sarcophagus and effigy by Dalmata, (iii) of a large relief of the Resurrection set behind and above the effigy, also by Dalmata, (iv) of two pilasters composed of four reliefs of the Evangelists (Sts Luke and John by Mino and Sts Matthew and Mark by Dalmata) and two coats of arms (by Mino), (v) of a large lunette of the Last Judgement (workshop of Mino) set above a frieze of putto heads and beneath a projecting gable (preserved in part). In addition, it is suggested by Burger ('Neuaufgefundene Skulptur- und Architektur-fragmente vom Grabmal Paul II', Jahrbuch der Preussischen Kunstsammlungen, xxvii, 1906,

pp. 129-41) that the monument also contained at the top a feature omitted in the Ciaconius engraving, in the form of a rectangular relief of God the Father in benediction surrounded by flying Angels set above the lunette between pilasters. This reconstruction presents some difficulty, though the carvings (in the main by Dalmata) are consistent in style with the remainder of the monument. A careful but faulty analysis of the monument is supplied by G. C. Sciolla (La scultura di Mino da Fiesole, Turin, 1970, pp. 124-8). The tomb of Paul II was the largest and most complex papal wall monument produced in Rome in the fifteenth century.

Andrea Bregno

(b. 1418; d. 1506)

The dates of Bregno's birth and death are established by the inscription on his tomb in S. Maria sopra Minerva at Rome. Born at Osteno near Como, he came to Rome in the 1460s, and under Sixtus IV became the most popular Roman sculptor of his time. Representative examples of his work are a relief from the demolished tomb of Cardinal Nicholas of Cusa (d. 1464) in S. Pietro in Vincoli, the Labretto (d. 1465) monument in S. Maria in Aracoeli, the Tebaldi (d. 1466) and Coca (d. 1477) tombs in S. Maria sopra Minerva, the Borgia altar (1473) and the Cristoforo della Rovere monument (d. 1479) in S. Maria del Popolo, the Riario (see plates 218, 219) and Raffaello della Rovere (d. 1477) monuments in Sts Apostoli, the tabernacle in S. Maria della Quercia at Viterbo (commissioned 1490) and the Savelli monument (after 1495 and before 1498) in S. Maria in Aracoeli. The Piccolomini Altar in the Duomo at Siena, the only major work by Bregno in Tuscany, was commissioned early in 1481 and completed four years later. A sculptor of refined taste and great technical proficiency but of limited inventiveness, Bregno is mentioned by Giovanni Santi alongside Verrocchio ('L'alto Andrea del Verrocchio, e Andrea ch'a Roma/Si gran compositore e cum belleza') and is referred to by Platina, in a letter to Lorenzo de' Medici, as 'sculptor egregius, vicinus meus et ea mihi necessitudine conjunctus quae rara est'. The few critical problems arising from his work relate in the main to the distinction between autograph works and the many works turned out by his studio.

Bibliography

The sculptor's correct birth date (1418 not 1421) is deduced by H. Egger ('Beiträge zur Andrea Bregno Forschung', *Festschrift für Julius Schlosser*, Vienna, 1927) and E. Battisti ('I Comaschi a Roma nel primo Rinascimento', *Arte e artisti dei laghi lombardi*, i, Como, 1959, pp. 3–61). The standard survey of Bregno's work is E. Steinmann ('Andrea Bregnos Thätigkeit in Rom', *Jahrbuch der Preussischen*

Kunstsammlungen, xx, 1899, pp. 216-32). An article by A. Schmarsow ('Meister Andrea', Jahrbuch der Preussischen Kunstsammlungen, iv, 1883, pp. 18-31) contains some useful material, but is vitiated by a confusion between Andrea Bregno and the Milanese sculptor Andrea Fusina. A number of Bregno's sepulchral monuments are discussed by F. Burger (Geschichte des florentinische Grabmals von den altesten Zeiten bis Michelangelo, Strassburg, 1904). On the tomb of Cardinal de Coëtivy in S. Prassede, Rome, see I. Toesca ('Il sacello del cardinale de Coëtivy in Santa Prassede a Roma', Paragone, no. 217, 1968, pp. 61-5). Excellent general accounts of Bregno's activity are supplied by A. Venturi (Storia dell'arte italiana, vi, 1908, pp. 939-69) and W. Friedlaender in Thieme-Becker Künstler-Lexikon. On Bregno as a collector of antiques, see H. Egger ('Beiträge zur Andrea-Bregno Forschung', Festschrift für Julius Schlosser, Vienna, 1927, pp. 122-36) and, particularly, S. Maddalo ("Andrea scarpellino" antiquario lo studio dell'antico nella bottega di Andrea Bregno', Roma centro ideale della cultura dell'antico . . . da Martino V al sacco di Roma, ed. S. D. Sguarzina, Milan, 1989, pp. 229-36). Substantial additions to the bibliography of Bregno are made by G. S. Sciolla ('Profilo di Andrea Bregno', Arte lombarda, no. 15, 1970, pp. 52-8, with a good analysis of the style of the Riario monument) and B. Cetti ('Scultori comacini: I Bregno', Arte cristiana, lxx, 1982, pp. 31-44, of special interest in connection with monuments elsewhere than in Rome).

The Monument Cardinal Pietro Riario

SS. Apostoli, Rome Plates 218, 219

Commissioned after the death of Cardinal Riario (1474), the tomb (plate 219) appears to have been completed in 1477. Its design is variously ascribed to Mino da Fiesole (Burger), who was responsible for carving a relief of the Virgin and Child for a position behind the effigy, Dalmata (Venturi, *Storia*, viii–I, 1923, p. 632), and Bregno. There is a high degree of probability that the monument, with its four Saints in niches

at the sides, an effigy resting on a classical sarcophagus, and two angels on the base beside the epitaph, is due in the main to Bregno, since not only does the design (with the exception of the irregular gable above) fall logically into place in the sequence of Bregno's dated tombs, but the Angels on the base are reproduced in Bregno's Raffaello della Rovere monument in the crypt of Sts Apostoli and the sarcophagus recurs in Bregno's Savelli monument. The ornament on the sarcophagus derives from a classical prototype. Both the effigy and the sarcophagus are ascribed by Venturi to Dalmata. Steinmann correctly observes that the sphinx heads under the sarcophagus were carved by Mino da Fiesole. The attribution of the effigy and sarcophagus to Bregno is contested by J. von Schmidt ('Pasquale da Caravaggio', Kunstwissenschaftliche Beiträge August Schmarsow gewidmet, Leipzig, 1907, pp. 115-28), and W. R. Valentiner ('The Florentine Master of the Tomb of Pope Pius II', Art Quarterly, xxi, 1958, pp. 116-50), who ascribes the whole tomb to Mino da Fiesole and assistants, but is accepted by G. C. Sciolla (La scultura di Mino da Fiesole, Turin, 1970, pp. 88-90). The view that the tomb is wholly autograph and the derivation in it from the antique is well presented by S. Maddalo ('Il monumento funebre tra persistenze medioevali e recupero dell'antico', Un pontificato ed una città. Sisto IV (1471-1484), Rome, 1986, pp. 447-50). For Bregno's annotations on drawings after the antique, see Maddalo

GIOVANNI ANTONIO AMADEO

(b. 1447; d. 1522)

Born at Pavia in 1447, Amadeo's name occurs in the records of the Certosa in 1466-70 in connection with work on the terracotta decoration in the large cloister. The name of his brother Protasio appears in the records in the same year in reference to the painting of a terracotta lavabo with the Annunciatory Angel and Virgin Annunciate (plate 254) in the small cloister. This has been identified (Dell'Acqua) as Amadeo's work. Of the same date is a terracotta relief in the Museo Civico, Milan, of a Carthusian prior presented by a female Saint to the Virgin and Child. An attempt has also been made to identify Amadeo's share in the terracotta decoration of the north and east sides of the small cloister (Lehmann). The signed marble doorway of the small cloister is widely assumed to have been carved between 1466 and Amadeo's departure for Bergamo in 1470. It is argued (Lehmann) that the lunette of this doorway presupposes some knowledge of Florentine Renaissance sculpture. This view is contested by Dell'Acqua and Middeldorf, the latter adducing convincing analogies with a carved lunette of 1428 in the Collegiata at Castiglione d'Olona. A signed relief of the Virgin and Child with Three Angels in the sacristy of the Misericordia, Florence (Middeldorf), which appears to have been carved at about the same date as the Certosa doorway, also acts in favour of the view that the formation of Amadeo's style was local and not Florentine. Amadeo's share in the decoration of the Portinari Chapel in S. Eustorgio, Milan, where he would have come into contact with the painter Foppa, is uncertain. From 1470 Amadeo was employed at Bergamo on the monument of Medea Colleoni (see plates 248, 252) and the construction of the Colleoni Chapel (see plate 250). The latter was completed in 1476. In 1474 Amadeo undertook jointly with the Mantegazza (q.v.) responsibility for the façade of the Certosa at Pavia. At this time he appears to have fallen under the influence of the Mantegazza, which is

reflected both in the reliefs of Old and New Testament scenes carved after 1485 for the façade, and in a number of works executed for Cremona (see plate 257). Amadeo seems to have been solely responsible for the design of the window register of the Certosa façade. Some of the last works he executed for the Certosa are a group of scenes from the history of the Carthusian Order and the life of St Bruno executed jointly with Benedetto Briosco in 1501 (for these, see Dell'Acqua). Other late works are the Arca of S. Lanfranco in S. Lanfranco outside Pavia (probably completed for the tercentenary of this Saint in 1498) and a Coronation of the Virgin over the lavabo of the Church of the Carmine at Pavia. In the last two decades of his life Amadeo was increasingly active as an architect and engineer, designing the courtyard of the Palazzo Bottigella at Pavia (1492) and additions to the Cathedral at Pavia, of which he became 'ingeniario' (1502). He was also at this time closely associated with the Duomo in Milan, in connection with which his name appears on many occasions after 1490. On the building is a portrait medallion of Amadeo with the inscription: IO. ANTONIVS HOMODEVS. VENERE . FABRICE MLI . ARCHITECTVS. He was resident in the vicinity of the Cathedral in 1514, and was succeeded as architect of the Fabbrica by Cristoforo Solari on 7 November 1519. His death is recorded on 28 August 1522.

Bibliography

The essential documents relating to Amadeo's activity at Pavia are published by R. Majocchi ('Giovanni Antonio Amadeo . . . secondo i documenti negli archivi pavesi', Bollettino della Società Pavese di Storia Patria, iii, 1903) and C. Magenta (La Certosa di Pavia, Milan, 1897). A monograph by F. Malaguzzi-Valeri (Giovanni Antonio Amadeo, Bergamo, 1904) is valuable above all for its illustrations. A good account of Amadeo as an architect is supplied by A. Venturi (Storia dell'arte italiana, viii-2, 1924), and a serious analysis of Amadeo's sculpture by H. Lehmann (Lombardische Plastik im letzten Drittel des XV Jahrhunderts, Berlin, 1928). The best critical account of Amadeo's work is, however, that of G. A. Dell'Acqua

('Problemi di scultura lombarda: Mantegazza e Amadeo', Proporzioni, iii, 1950, pp. 123-40), which should be read in conjunction with an article by J. G. Bernstein ('A Reconsideration of Amadeo's Style in the 1470s and 1480s and Two New Attributions', Arte lombarda, xiii, 1968, pp. 33-42). Useful material is also contained in A. G. Meyer's now largely outdated Oberitalienische Frührenaissance: die Blüthezeit, ii, Berlin, 1900, and in three contributions by E. Arslan to the Storia di Milano, vii, Milan, 1957 ('Toscani e lombardi prima di Bramante', pp. 634-7; 'Le opere mature di Amadeo', pp. 670-8; 'La scultura nella seconda metà del Quattrocento', pp. 713-24). For an analysis of Amadeo's early style, see U. Middeldorf ('Ein Jugendwerk des Amadeo', in Kunstgeschichtliche Studien für Hans Kauffmann, Berlin, 1956, pp. 136-42), and for material relating to the Colleoni Chapel, B. Belotti ('Le origini della cappella Colleoni in Bergamo', Emporium, liv, 1921, pp. 289-302, and La vita di Bartolommeo Colleoni, Bergamo, 1923). A penetrating account of Amadeo's relief style is given by U. Middeldorf (Sculptures from the Samuel H. Kress Collection: European Schools, XIV-XIX Century, London, 1976), who convincingly identifies the reliefs of New Testament scenes in St Philip's-onthe-Hill, Tucson (Arizona), as part of the Altar of St Joseph in the Duomo in Milan (begun 1471/72). Amadeo's association with the Duomo is also dealt with by R. Bossaglia ('La Scultura', Il Duomo di Milano, Milan, 1973, ii, pp. 65-176). A dissertation of C. R. Morscheck (Relief Sculpture for the façade of the Certosa at Pavia, 1473-1499, Ph.D. dissertation Bryn Mawr, 1977, New York; 1978) for the first time puts the study of Amadeo's work at Pavia and elsewhere on a basis that is thoroughly reliable. R. V. Schofield ('Avoiding Rome: an Introduction to Lombard sculpture and the Antique', Arte lombarda, c.1991-2, pp. 27-44) deals with Amadeo's debt to Filarete and ancient coins and plaquettes rather than copybooks. The imagery of the Arca di San Lanfranco at Pavia is summarized by E. Facioli (L'Arca di San Lanfranco by G. Amadeo, Pavia, 1933). The most penetrating study of Amadeo's activity,

principally as an architect in Milan, is Giovanni Antonio Amadeo: i documenti, eds. R. V. Schofield, Janice Shell, and Graziosa Sironi, Como, 1989. For other material on the Colleoni Chapel, see A. Meli (Bartolomeo Colleoni nel suo mausoleo, Bergamo, 1966), F. Piel (La cappella Colleoni e il luogo della Pietà in Bergamo, Bergamo, 1975), G. A. Dell'Acqua ('Problemi di scultura lombarda: Mantegazza e Amadeo', Proporzioni, ii, 1948, iii, 1950), and an admirably well-argued article by J. Shell ('The Mantegazza Brothers, Martino Benzoni and the Colleoni Tomb', Arte lombarda, i, 1992, pp. 53-60). The Colleoni Chapel after cleaning is discussed by J. G. Bernstein ('Il restauro della cappella Colleoni: primi ritrovamenti', Arte lombarda, xcii-xciii, 1990, pp. 147-53). The year of Colleoni's death was 1475, not 1473 as stated in an earlier edition of this book. It is argued by F. Piel (p. 57) that the inscription in the epitaph demonstrates only the date of the epitaph not the date of the monument. An excellent volume (Giovanni Antonio Amadeo. Scultura e architettura del suo tempo, eds. J. Shell and L. Castelfranchi, Milan, 1993) deals with Amadeo's putative master, Francesco Solari, and the sculpture of S. Maria Incoranata,

The Monument of Medea Colleoni

Cappella Colleoni, Bergamo Plates 248, 252

The tomb, which was designed for the Dominican church of S. Maria della Basella and was moved to its present position on the wall of the Colleoni Chapel in 1842, is flanked by carved pilasters and a carved frieze, with curtains caught up in the upper corners. Against a white and black marble ground in the centre of the monument behind the sarcophagus is the epitaph with reliefs of the Madonna of Humility with Sts Catherine of Siena (right) and Catherine of Alexandria (left). The sarcophagus beneath rests on cherub heads, and is carved on its front face with the Pietà between the Colleoni arms. Across the bottom of the sarcophagus runs the inscription: IOVANES . ANTONIVS . DEAMADEIS . FECIT . HOC . OPVS. The monument is assumed to have been

commissioned soon after the death of Medea Colleoni (6 March 1470), and was presumably unfinished at the time of the death of Bartolommeo Colleoni (2 November 1475) since the epitaph reads HIC IACET MEDEA VIRGO FILIA QVODAM ILLVSTRIS ET EXL D BARTHOLOMEI COLIONI DE ANDEGAVIA SER^{MI} DV D VENETIAR CAPIT GNALIS 1470 DIE 6 MARCI. Unlike the Monument of Bartolommeo Colleoni on the adjacent wall of the chapel, which reveals the hands of at least two assistants of Amadeo, the figure sculpture of the Medea Colleoni Monument is rightly (Lehmann, Dell'Acqua) regarded as autograph.

The Colleoni Chapel

Bergamo Plates 249–51

The construction of a chapel attached to the church of S. Maria Maggiore at Bergamo appears to have been decided on by Bartolommeo Colleoni at some date between the death of his daughter Medea (6 March 1470) and his own death (2 November 1475). There is a tradition that in order to obtain a suitable site for the chapel, Colleoni seized and demolished the sacristy of the church; this is confirmed by documents, which record the visit to Colleoni's castle at Malpaga of two emissaries from the Misericordia at Bergamo to protest against the destruction of the sacristy, and the promise of Colleoni to build a new sacristy in some other area contiguous to the church ('una più bella e più comoda ale mie spese'). Though it is sometimes stated that work on the chapel was begun in 1470 (Meyer), it has been demonstrated (Belotti) that the two emissaries who visited Colleoni were administrators of the Misericordia between February 1472 and March 1473, and that the year 1472 is therefore the earliest date at which the construction of the chapel can have been initiated. The chapel was still unfinished on 31 October 1475, when a codicil relating to Colleoni's will refers to 'Capellam suam, sitam in Civitate Pergami, prope Ecclesiam S. Marie Majoris Pergami, in que elegit sepulchrum, ubi cadaver ejus recondi debeat, debere complere et finiri, et sumptuose ornari'. ('His

church of S. Maria Maggiore, in which he chose the tomb wherein his body should be buried, must be completed and finished and sumptuously decorated.') The façade was presumably completed in the following year, since a circular slab inserted in the side of the façade bears the date MCCCCLXXVI. Documents published by A. Meli ('Cappella Colleoni: i tre santi dell'ancona', Bergomum, n.s. xxxix, 1965, pp. 3-46) seem to indicate that Amadeo's work in the chapel was completed by 1477. The façade is flanked by pilasters, which are repeated at the sides, and are decorated with heads in relief of Saints and Apostles and with medallions of emperors and other heads. Beneath each of the façade pilasters are two reliefs with scenes from the legend of Hercules. The doorway in the centre is surmounted by a relief of God the Father and, above, by three statuettes of Angels grouped round the Colleoni arms. Above is a circular window. On either side of the doorway are windows filled with small columns and flanked and surmounted by pilasters. Above these are lunettes with foliated decoration, and above these again are niches with busts of (left) Caesar and (right) Trajan. To right and left of the entrance are two allegorical female figures of Fortitude and Constance, on supports rising from reliefs with putti. Corresponding pairs of allegorical figures appear above each of the two lateral windows. Below each window is a group of five reliefs with scenes from Genesis from (left) the Creation of Adam to the Labours of Adam and Eve, and (right) Cain and Abel to the Sacrifice of Isaac. The flat surface of the façade is covered with a geometrical pattern of red, white and black marble. The facade of the chapel was radically and admirably cleaned in and after 1975, and now presents a different impression from the photographs published in earlier editions of this book. According to a report of 1991, the polychromy is established by seventeen types of stone and marble, the figure sculpture being white Apuan marble. The free-standing figures on the façade represent St Alexander, Fortitude and Constance and four other Virtues in addition to the figure carvings noted

Chapel, in the city of Bergamo, near the

above. A clear account of the restoration of the façade is given in a small local publication by F. rossi et al., *Restauro: Cappella Colleoni in Bergamo, sculture*, Bergamo, 1991.

In the interior the principal feature is the triumphal arch on the right (north) wall, constructed of Istrian stone and carved (right) with grapes and vine leaves and (left) with other foliated decoration with putti at the bottom on either side. On the wall facing the entrance is the tomb of Bartolommeo Colleoni (in which the gilded wood equestrian figure surmounting the sarcophagus is an addition of 1501). There is no parallel for the form of this monument, which consists of two parts, that beneath a deep platform with reliefs of the Flagellation, Christ Carrying the Cross, the Crucifixion, the Lamentation over the Dead Christ and the Resurrection, statuettes of Virtues and a frieze of playing putti, resting on pilasters, and that above a triumphal arch supported by columns, containing a sarcophagus with reliefs of the Annunciation, the Nativity and the Adoration of the Magi, two female figures standing on the lid, and three seated and two standing statuettes of classical warriors in front of it. The execution of the monument reveals extensive studio intervention. In the lower part the frieze of putti, the statuette of Charity and the reliefs of the Crucifixion and Lamentation are generally accepted (Lehmann, Dell'Acqua) as works by Amadeo. The reliefs of the Flagellation and Resurrection are by an independent artist, whose hand has also been identified (Lehmann) at the Certosa at Pavia. In the upper part of the monument the three scenes from the infancy of Christ are also autograph. The monument, however, appears to have been completed over a long period of time, and in the autograph areas there is a marked discrepancy between the three Passion reliefs (where the technique approximates to that of the door of the small cloister at Pavia), the more accomplished frieze of putti, and the reliefs on the sarcophagus, which can hardly have been executed before 1480. There is no record of the date at which it was set up.

St Imerio Giving Alms

Duomo, Cremona Plate 257

During the 1480s a number of works were executed by Amadeo and his studio for Cremona. These comprise (i) the Arca of S. Arealdo, from which reliefs of St Jerome (signed and dated 1484) and the Stigmatization of St Francis are now in Cremona Cathedral; (ii) the Arca of the Persian Martyrs (1482), carved in the studio of Amadeo for the church of S. Lorenzo and since 1814 built into the pulpit of Cremona Cathedral; (iii) the Arca of S. Imerio, from which there survives a single relief, on a considerably larger scale, of S. Imerio Giving Alms. Payments for the Arca of S. Imerio occur between 18 August 1481 and 11 October 1484. A sixth-century Saint, the remains of S. Imerio were transferred to the Duomo at Cremona in 965. There is no evidence as to the subjects of the other scenes included in the shrine.

Cristoforo (d. 1482) And Antonio (d. 1495) Mantegazza

Of Milanese origin and the son of a certain Galeazzo, Cristoforo Mantegazza is mentioned for the first time in 1464, when he was engaged in furnishing 'bottazoli' for the Certosa at Pavia. Between 1464 and 1466 he was employed on the terracotta decorations of the cloisters of the Certosa, and a generally convincing attempt has been made (Arslan) to identify his share in this work. In 1467 he was in Milan. occupied with unspecified marble carvings for the Castello Sforzesco. After abortive discussions regarding the projected equestrian statue of Francesco Sforza (on which Leonardo da Vinci was later employed), the Mantegazza in 1473 contracted to undertake the construction of the facade of the Certosa at Pavia ('totam fazatuam dicte ecclesie ac por tam cum finestris et aliis laboreriis necessariis'). In 1474, however, a halfshare in the Certosa façade was allotted to Amadeo, who appears from this point on to have assumed direction of the work. Two years later there is a reference to the completion of unspecified works by the Mantegazza for the Certosa, and in 1478 they received payment for certain works, among them five 'sacrarii' and a marble Pietà (see plates 258, 259). Cristoforo Mantegazza died in February 1482, but his brother continued to work at the Certosa at least till 1489 when he ceded his workshop to Alberto Maffiolo da Carrara. Antonio Mantegazza died in 1495, and was succeeded as Ducal Sculptor by Cristoforo Solari. In a letter written by Beatrice d'Este at this time he is referred to as the 'compagno' of Amadeo. No documented work by either Cristoforo or Antonio Mantegazza survives, and attempts to differentiate between the style of the two artists (Dell'Acqua, Arslan) have achieved contradictory results. According to one hypothesis (Dell'Acqua) Cristoforo Mantegazza was responsible for the superior and Antonio for the inferior reliefs and statuettes on the Certosa facade, and Antonio would have executed about 1480-90 the remarkable reliefs of biblical scenes

on the upper part of the building. According to the other hypothesis (Arslan) the biblical scenes would have been executed about 1467-70 by Cristoforo Mantegazza, and Antonio Mantegazza would have been responsible, after the former's death, for executing a number of the facade reliefs and statuettes, the large Lamentation over the Dead Christ in the Capitolo dei Fratelli, the Adoration of the Magi in the Capitolo dei Padri, the relief of Christ Washing the Feet of the Disciples on the lavabo in the sacristy (1488), and the Pietà over the door in the right transept. The balance of probability is in favour of the second hypothesis.

Bibliography

The documentary basis for knowledge of the Mantegazza is supplied by G. L. Calvi (Notizie sulla vita e sulle opere dei principali architetti, scultori e pittori che fiorirono in Milano durante il governo dei Visconti e degli Sforza, ii, Milan, 1865), and C. Magenta (La Certosa di Pavia, Milan, 1897). The style of the two brothers is discussed by H. Lehmann (Lombardische Plastik im letzten Drittel des XV Jahrhunderts, Berlin, 1928), G. A. Dell'Acqua ('Problemi di scultura lombarda: Mantegazza e Amadeo', Proporzioni, ii, 1948, pp. 89-107), E. Arslan ('Sui Mantegazza', Bollettino d'arte, xxxv, 1950, pp. 27-34), and A. M. Romanini ('L'incontro tra Cristoforo Mantegazza e il Rizzo nel settimo decennio del Quattrocento', Arte lombarda, ix, 1964, pp. 91-102). See also under Amadeo.

The Lamentation over the Dead Christ

Certosa, Pavia Plates 258, 259

The relief (plate 258), which still occupies its original position over the altar of the Capitolo dei Fratelli on the Certosa, shows in the foreground the Lamentation over the Dead Christ, and in the background the Crucifixion, the Soldiers Throwing Dice for Christ's Garments, and the Opening of the Sepulchre. Framed in a black marble surround and flanked by carved pilasters, it has beneath it a predella of the Annunciation. The scenes in the

background are designed independently of one another and of the central scene, each with its own landscape background, and are carved with great refinement and delicacy. Extensive use is made of surface gilding in the pilasters, and traces of gilding survive also in the main relief: the relief of the Pietà listed among certain 'laboreria facta per magistros Cristoforum et Antonium de Mantegaciis' in a stima of 1478 (Dell'Acqua). This identification has been challenged (Arslan) on the ground first that the Pietà listed in the stima ('Pietas una marmoris posita in capella dupla ecclesie') appears to have been destined for the transept of the church, and secondly that the framing of the altarpiece (which reveals the influence of Gian Cristoforo Romano) would be consistent with a considerably later date. If the altarpiece was carved in 1478, it would have been executed jointly by Cristoforo and Antonio, while if (as is more probable) it was carved about 1490, it would be the work of Antonio Mantegazza. The relief is not only from a technical standpoint the most accomplished work associable with the Mantegazza, but also marks the extreme point in the expressionist tendency latent in the Mantegazzas' style; this has been inconclusively explained by reference to German woodcuts (Malaguzzi-Valeri), Mantegna (Calvi), and the paintings of Tura and Cossa (Dell'Acqua).

CRISTOFORO SOLARI (active by 1489 – d. 1524)

The family of the Solari descended from a family of sculptors from Carona. In 1421 Pietro and Giovanni Solari were employed at Castiglione d'Olona. The name of Cristoforo Solari appears for the first time in connection with an altarpiece by Cima (Accademia) from the church of S. Maria della Carità in Venice. Solari's altar (destroyed), which is first mentioned in a document of 24 June 1489, is listed by Sansovino (Venetia città nobilissima, Venice, 1581, c. 96). A surviving work of the same time is a bust of Christ in the church of S. Pantaleon. Thereafter he appears to have returned to Lombardy, and in 1495 was appointed Ducal Sculptor in succession to Antonio Mantegazza. In 1497 he received the commission for the tomb of Beatrice d'Este (see plate 261). Between 1501 and 1503 he was engaged on work for the Cathedral in Milan, of which he became Operaio in 1506. His fame rested on the emotional naked statues he executed for the Duomo in Milan, especially a statue of Adam (1502) and a Christ at the Column (undated) in the South Sacristy. In 1512 he was employed as an architect on S. Maria presso S. Celso, and in 1519 he designed the apse of the Duomo in Como. In 1514 he appears to have paid a brief visit to Rome. When the St Peter's pietà of Michelangelo was first exhibited, it was, according to Vasari, popularly ascribed to Cristoforo Solari, and evidence that Solari's reputation extended beyond the bounds of Lombardy is provided by commissions for a group (lost) of Hercules and Cacus executed for the Duke of Ferrara (completed 1516-17) and for a fountain for Isabella d'Este.

Bibliography

For the documentation of Pietro and Giovanni Solari see G. Sironi ('I fratelli Solari, figli di Marco (Solari) da Carona: nuovi documenti', *Arte lombarda*, cii—ciii, 1992, pp. 65–9). The available information on the career of Cristoforo Solari is assembled by F. Malaguzzi-Valeri ('I Solari architetti e scultori lombardi del XV secolo', *Italienische Forschungen herausgegeben vom Kunsthistorischen Institut in Florenz*, i,

1906, pp. 133-63). Solari's activity in Venice is discussed by G. Mariacher ('Contributi sull'attività di scultori caronesi e comaschi a Venezia nei sec. XV-XVI', Arte e artisti dei laghi lombardi, i, Como, 1959, pp. 191-206) and A. Markham Schulz ('Cristoforo Solari at Venice. Facts and Suppositions', Prospettiva, 53-6, 1988-9, pp. 309-16). For Solari's work for the Duomo at Milan, see U. Nebbia (La scultura nel Duomo di Milano, Milan, 1908) and for the monuments of Lodovico il Moro and Beatrice d'Este, articles by L. Beltrami ('Le statue funerarie di Lodovico il Moro e di Beatrice d'Este alla Certosa di Pavia', Archivio storico dell'arte, iv, 1891, pp. 357-62) and D. Sant'Ambrogio ('Il Pallio o Trittico marmoreo di Vighignolo nel patrio museo archeologico di Milano', Archivio storico dell'arte, ii, 1896, pp. 189-94). For a general article on Cristoforo Solari see G. Agosti ('La fama di Cristoforo Solari', Prospettiva, 46, 1986, pp. 57-65) who establishes that Solari died in 1524, not 1520 as stated in earlier editions of this book.

Effigies of Lodovico il Moro and Beatrice d'Este

Certosa, Pavia

After the sudden death of Beatrice d'Este on 29 January 1497 one hundred masses were celebrated on the command of Lodovico il Moro in the church of S. Maria delle Grazie. The commission for the tomb of Beatrice d'Este appears to date from immediately after her death, and in any event from before 18 April 1497, when a letter of Battista Sfondrato to Lodovico il Moro refers to the purchase at Venice of Carrara marble in blocks of a weight and size specified by Cristoforo Solari 'per far la fabrica designata in Sta. Maria de le Gratie'. Some difficulty seems to have been experienced in securing the necessary marble from Venice, and thereafter marble 'per uso de la sepoltura' was secured by Cristoforo Solari from the Certosa at Pavia. The progress of the monument appears to have been rapid, and in June 1497 we hear of an inquiry by Lodovico il Moro as to whether Solari, in addition to the monument,

would be able to undertake work on the altar in the chapel in the same year. There is no direct evidence as to the commissioning of the tomb of Lodovico il Moro, but both effigies appear to have formed part of a single monument, which was completed before the flight of Lodovico il Moro in 1499. Over and above the reference to an altar, the only evidence for the original form of the tomb is supplied by Pasquier Lemoyne, who visited S. Maria delle Grazie in 1515 and observed: 'singularitez la sepulture de Beatrix femme du more est eslevé en hault bien richement et dessoulez près terre notre seigneur en tombeaux' ('a singular thing is that the tomb of Beatrice, wife of Il Moro, is raised up high and richly decorated, and beneath, near the ground, is Our Lord in the tomb'). According to Vasari, the sarcophagus was designed by Gian Giacomo della Porta. A mistaken effort to identify the Pietà mentioned by Pasquier Lemoyne with a relief now in the Museo Civico in Milan is made by Sant'Ambrogio. The monument was disassembled in 1564, and the two effigies were removed to the Certosa at Pavia, where they were set into the wall in an upright position near the Gian Galeazzo Visconti Monument. They were replaced in a horizontal position between 1818 and 1836, and set up in their present form in 1891. According to the Libellus sepulchorum of S. Maria delle Grazie, the tomb was originally set up in the choir (M. Rossi, 'Novità per Santa Maria delle Grazie di Milano', Arte lombarda, no. 66, 1983, p. 40; S. Aldeni, 'Il "Libellus Sepulchorum" e il piano progettuale di S. Maria delle Grazie', Arte lombarda, no. 67, 1983-4, pp. 77-8).

BAMBAIA

(b. 1483; d. 1548)

A record of Bambaia's death (11 June 1548) gives his age at that time as 65. Born at Busto Arsizio and described in documents as Agostino Busti or de Busto, Bambaia appears to have been trained at the Certosa at Pavia under Benedetto Briosco, and is mentioned for the first time on 21 January 1512, when, with his brother Polidoro, he applied for inscription in the workshop of the Cathedral in Milan. In 1513 he received a commission for the monument of Lancino Curzio (d. 2 February 1512), which was executed jointly with Cristoforo Lombardi and is now in the Museo Civico in Milan. This monument was still unfinished in 1515. In January 1516 Bambaia received the commission for the Francesco Orsini Monument, completed March 1517 (disassembled; pieces in S. Fedele and the Museo Civico, Milan). At some date after 14 September 1515, when Francis I of France entered Milan, he was entrusted with the tomb of Gaston de Foix (see plate 264), on which he worked till 1521. Thereafter Bambaia worked on the Franchino Gaffurio monument (reliefs and statuettes now incorporated in the Bua monument in S. Maria Maggiore, Treviso) and the Birago monument for the Cappella della Passione in S. Francesco Grande, Milan (begun 1522; now distributed between Isola Bella, the Pinacoteca Ambrosiana and the Museo Civico in Milan). In 1528 he was commissioned for the tomb of Giovanni Antonio Bellotti in S. Maria, Milan, and in 1536 he was in receipt of a fixed stipend from the Fabbrica of the Cathedral of Milan. In 1537 he became sculptor to the Fabbrica, and in 1543 received the commission for the Vimercati Altar of the Presentation (still in situ in the Cathedral). Other later works (in part executed in association with other sculptors) are the Arca and Altar of S. Evasio at Casale Monferrato (re-commissioned from Cristoforo Lombardi and Bambaia in 1547 original commission 1525 - and completed by Ambrogio Volpi) and the Marino Carracciolo (d. 1538) and Vimercati monuments in the Duomo in Milan.

Bibliography

A monograph by G. Nicodemi (Il Bambaia, Milan, 1945) contains a number of useful photographs, but is carelessly compiled and frequently inaccurate. This has been superseded by a broadly based book by G. Agosti on Bambaia e il classicismo Lombardo (Turin, 1990), who discusses Bambaia's relations with his Milanese contemporaries, and especially with Leonardo da Vinci, in whose company he may have visited Rome in 1513. The penultimate chapter of this highly imaginative book is devoted to the tomb of Gaston de Foix. The tomb is also discussed by M. T. Fiorio (Bambaia: catalogo completo, Florence, 1990, pp. 27-35) and by Fiorio ('Agostino Busti: uno scultore lombardo per il re di Francia') and J. Shell ('Il problema della ricostruzione del monumento a Gaston de Foix') in a volume on the artist (Agostino Busti detto il Bambaia, Milan, 1990). A number of reliefs once attributed to Bambaia are the work of Benedetto Cervi (Death of Lucretia, Milan, Castello Sforzesco; a relief in the Prado. Madrid: and three reliefs in the Victoria and Albert Museum, London); for these, see S. Gatti ('Nuove aggiunte al catalogo di "Benedetto Pavese", collaboratore di Agostino Busti detto il Bambaia', Arte lombarda, xcvi-xcvii, 1991, pp. 117-19). For the monument of Gaston de Foix, see also G. Bossi (Descrizione del monumento di Gastone di Foix scolpito da Agostino Busti detto il Bambaia, Milan, 1852) and G. Clausse (Les tombeaux de Gaston de Foix et de la famille Birago par Agostino Busti, Paris, 1912) and for the so-called Bambaia sketchbook in Berlin, of which extensive use is made by Nicodemi, P. Dreyer and M. Winner ('Der Meister von 1515 und das Bambaja-Skizzenbuch in Berlin', Jahrbuch der Berliner Museen, vi, 1964, pp. 53-94).

The Monument of Gaston de Foix

Museo Civico, Milan Plate 264

The death of Gaston de Foix in the Battle of Ravenna occurred on 11 April 1512. Owing to the subsequent reversal in the fortunes of the French occupying forces, no monument was commissioned after the body was brought back to Milan, and the contract for the tomb is presumed to have been placed after the entry of Francis I into Milan on 14 September 1515. Bambaia seems to have worked on the monument till 1521-2, after 1520 with the assistance of Cristoforo Lombardi, Ambrogio da Cremona, Agostino del Pozzo, Ambrogio da Airuno, Giovanni Antonio da Osnago, Andrea da Saronno, Antonio Dolcebuono and (according to Lomazzo) Benedetto Cervi. As late as 1528 it was assumed by the sculptor that work on the monument would be resumed, since in a will dated in this year (29 April 1528) he bequeathed to the Fabbrica of the Cathedral 'omnem quantitatem marmoris de Carraria, quae supererit sepulture construi cepte et quae construebatur per me testatorem pro Ill. mo quondam domino de Foys. Et hoc postquam finita fuerit ipsa sepultura et quod omnis quantitas marmoris quae supererit ultra illam quantitatem marmoris necessariam pro finiendo fabricam et opus ipsius sepulture remaneat et detur ac tradetur prefate fabrice in remedium animae meae cum qualitate et conditione infrascriptis.' ('The whole amount of Carrara marble from the tomb under construction and already constructed by me, the testator, for the late most excellent lord of Foix. After the tomb shall have been finished all the marble left over from it, over and above the amount necessary for finishing the structure and the work of the monument itself, is to be given and ceded to the aforesaid Fabbrica for the benefit of my soul with the above mentioned quality and condition.') The completed carvings from the monument were seen by Vasari in the Augustinian convent of S. Marta in Milan: 'comminciò la sepoltura di Monsignor di Foix oggi rimasta imperfetta; nella quale si veggiono ancora molte figure grandi e finite, ed alcune mezze fatte ed abbozzate, con assai storie di mezzo rilievo in pezzi, e non murate, e con moltissimi fogliami e trofei.' ('He began the tomb of Monsignor de Foix, which today is still unfinished. In this many large completed figures can still be seen, as well as some half finished and roughed out, with many narrative scenes in half relief in pieces, not built up, and a

large number of carvings of foliage and trophies.') There is no direct evidence of the form of the monument; a drawing in London (Victoria and Albert Museum), widely regarded as a study for the tomb (Clausse, Nicodemi), is not explicitly connected with it. With the exception of statuettes of Virtues which also appear on other monuments, and certain similarities in the treatment of the pall, the sculptures shown in the drawing do not correspond with the surviving sculptures from the monument.

In addition to the effigy of Gaston de Foix (Museo Civico del Castello Sforzesco, Milan), a large number of fragments of the monument survive. The most important are seven reliefs illustrating the career of Gaston de Foix. Formerly the property of Marchesa Crivelli at Castellazzo, these are now in the Museo Civico, and represent (a) the Capture of Brescia, (b) the Battle of Ravenna, (c) the Funeral Procession of Gaston de Foix, (d) the Entry of the French Forces into Bologna, (e) the Departure of the French from Bologna, (f) the Battle of Isola della Scala, and (g) the Death of Gaston de Foix. Six statuettes of Apostles, from Castellazzo, are also in the Museo Civico. Three statuettes of Virtues in the Victoria and Albert Museum, London, and a headless Virtue from Castellazzo, now in the Museo Civico, also formed part of the monument. Four decorative panels, carved in deep relief with military decoration, are distributed between the Museo Civico, Turin (plate 267), and the Pinacoteca Ambrosiana, Milan. Four smaller decorative panels, analogous in style to the decoration on the seats of the Apostles, are in the Pinacoteca Ambrosiana, and two similar panels (from Castellazzo) are in the Museo Civico, Milan. Also in the Museo Civico is a carved platform on which the sarcophagus was set. It is likely that there was originally an eighth narrative relief, and six further Apostles, all of which (if they were carved) have disappeared. If the London drawing is disregarded, a tentative reconstruction of the tomb can be arrived at only by analysis of the carvings listed above. There is a strong presumption that all of the Castellazzo narrative scenes (unlike the similar scenes on the Birago monument) were,

like those on the Monument of Gian Galeazzo Visconti in the Certosa at Pavia, intended for inspection from below, as three of the reliefs (a-c) are oblong and four (d-g) upright. There was presumably an eighth relief which has disappeared. All of the narrative carvings and the effigy are to a greater or lesser degree unfinished. The six decorative panels were presumably (as on the Birago monument) set between the narrative scenes. In this event the upper part of the monument would have resembled the Gian Galeazzo Visconti Monument at Pavia. The story of the dispersal of the pieces of the monument has been well reconstructed by Agosti. The intended appearance of the tomb is likely to have been an upper section in which the narrative reliefs were flanked by the decorative carvings in Turin and Milan. Beneath this was the effigy resting on a lost sarcophagus which stood on a platform that is now in the Museo del Castello Sforzesco. The Apostles would have been seated beneath the level of the sarcophagus and the Virtues would have presided in front of it. Gaston de Foix wears an olive wreath and the order of St Michael. His hands are crossed on an elaborate sword.

Guido Mazzoni

(active after 1473; d. 1518)

Born in Modena, Mazzoni is mentioned as supervising a pantomime in celebration of the entrance of Eleanora of Aragon, wife of Ercole I d'Este, in 1473. Throughout his career he was associated with the stage, and known as a painter as well as a sculptor. His earliest recorded work, a terracotta Entombment in S. Maria degli Angeli at Busseto, was installed before January 1478 (Mingardi). A disassembled Nativity group for Busseto (fragments in the Museo Civico, Modena) dates from the same time. In 1477-80, he modelled a group of the Lamentation in S. Giovanni della Buona Morte in Modena, and after 1480 a Nativity group for the Osservanza, now in the crypt of Modena Cathedral. This was followed by Lamentation groups of S. Lorenzo at Crema (1485) and S. Antonio in Castello, Venice (completed 1489; fragments in the Museo Civico, Padua), the Pieve at Guastalla and the Chiesa del Gesù at Ferrara. The latter is one of the finest and most richly pigmented works. An Adoration of the Virgin and Child in the crypt of the Duomo at Modena is of approximately the same date. Also in the crypt of Modena Cathedral is a Lamentation group (date uncertain). Fragments of another Lamentation group made in 1489 are in the Museo Civico at Padua. The earliest of these groups reflects the influence of Cossa and the latest that of Venetian painting. A bust of a child (pigmentation almost perfectly preserved) is in the Royal Collection at Windsor Castle. By 1489 Mazzoni had moved to Naples, where (22 October 1489) he executed 'certi lavori d'immagini' for Alfonso Duke of Calabria, and (31 October 1492) 'giganti' for a farce by Sannazaro. His most important work of this time is a Lamentation group in the church of Monte Oliveto (see plate 246). In 1495 he accompanied Charles VIII to France, and in 1498 executed the tomb of Charles VIII in St-Denis (destroyed 1793). In 1507 he returned briefly to Modena, but thereafter again worked in France, executing an equestrian statue of Louis XII at Blois and returning to Italy only on the death of Louis XII in 1515.

About 1509 he made a sketch for the Monument of King Henry VII (see plate 165). In 1516 he is once more recorded in Modena, where he died on 12 September 1518.

Bibliography

The principal publication on Mazzoni is a valuable dissertation by T. Verdon (The Art of Guido Mazzoni, New York and London, 1978), which includes a documented catalogue raisonnè and a careful examination of the devotional function of Mazzoni's work; also see A. Lugli (Guido Mazzoni e la rinascita della terracotta nel quattrocento, Turin, 1990). The problem of Mazzoni's chronology is also discussed by C. Mingardi ('Problemi mazzoniani', Contributi dell'istituto di storia dell'arte medioevale e moderna, ii, 1972, pp. 163-87). The Lamentation group in S. Maria degli Angeli at Busseto is shown by the will of Gian Lodovico Pallavicino to have been installed before January 1478 (C. Mingardi, 'Il Montorio di Guido Mazzoni in Santa Maria degli Angeli a Busseto', Biblioteca, xxx, 1975, pp. 99-110). For the group in S. Anna dei Lombardi, Naples, see especially R. Pane ('Guido Mazzoni e la Pietà di Monteoliveto', Napoli nobilissima, xi, 1972, pp. 49-69, and Il rinascimento nell'Italia meridionale, Milan, 1975-7, ii, chapter iii). A brief monograph by A. Pettorelli (Guido Mazzoni da Modena, Turin, 1925) adds little to a useful article by A. Venturi ('Di un insigne artista modenese del sec. XV', Archivio storico italiano, series iv, xiv, 1884, pp. 339ff) and to the relevant chapter in the Storia dell'arte italiana, vi, 1908, pp. 768-84. Some suggestive observations are made by C. Gnudi (Niccolò dell'Arca, Turin, 1942, pp. 56-7, and 'L'arte di Guido Mazzoni', Istituto Universitario di Magistero Salerno, bollettino di btoria dell'arte, ii, 1952, pp. 1-17) and O. Morisani ('Mazzoni e no', Arte in Europa. Scritti di storia dell'arte in onore di E. Arslan, Milan, 1966, pp. 475-9). Some useful reproductions are supplied by E. Riccomini (Guido Mazzoni, i maestri della scultura 66, Milan, 1966). For Mazzoni's connection with the stage, see J. Mesnil (L'Art au nord et au sud des Alpes à l'époque de la Renaissance, Paris, 1911).

The Lamentation over the Dead Christ

S. Anna dei Lombardi, Naples Plate 246

One of Mazzoni's most important works, the Lamentation group is known to have been executed in 1492, when (27 December 1492) the sculptor received 50 ducats 'per commando del Duca per il sepolcro che ha fatto a detto Signore' ('by command of the Duke for the sepulchre he has made for the said Duke'). The tradition that the group was commissioned by Alfonso, Duke of Calabria, is confirmed by Summonte (F. Niccolini, 'Pietro Summonte, Marcantonio Michiel e l'Arte Napoletana del Rinascimento', Napoli nobilissima, n.s. iii, 1923, p. 127), who writes: 'In opera di plastice è in Monte Oliveto la Schiovazione di Nostro Signore dalla Croce, con le figure delli signori re Ferrando primo e re Alfonso secondo di felice memoria, expresse ben dal naturale, di mano del Paganino di Modena, conducto olim qua con ampla provisione per lo Signor re Alfonso secondo.' ('In the field of sculpture there is, in the church of Monteoliveto, a group of the removal of the nails from Our Lord's body, with figures of King Ferrante I and King Alfonso II of happy memory, by the hand of Paganino of Modena, which was made with ample provision for King Alfonso II.') There is no indication of the original disposition of the figures, which may, however, have been more concentrated than the present wide symmetrical spacing of the group. The effect of the group has been impaired by the removal of much of the original paint: extensive traces of colour remain in the figure of St John. It has been inferred (Gnudi and Riccomini), probably correctly, that the figures were executed by Mazzoni jointly with one or more assistants. The group is discussed in detail by G. L. Hersey (Alfonso II and the Artistic Revival of Naples, 1485-1495, New Haven, 1969) and Verdon. A lost inscription recorded in a seventeenthcentury source testified that Alfonso 'commended himself in clay, as a witness to adamant faith, to his Olivetan brethren'. The figures include some of Mazzoni's greatest portraits: of Alfonso II (as Joseph of Arimathea) and, probably,

Giovanni Pontano, but not Ferrante I, a portrait bust of whom was shown in the same chapel (Verdon).

Niccolò dell'Arca

(b. c.1435; d. 1494)

Nothing is known of the activity of Niccolò dell'Arca before his appearance in Bologna on 5 April 1462, when he rented a workshop. There is no evidence of his having worked in Bologna before this time, but it has been suggested (Belli d'Elia) that he may have worked about 1460 in the Palazzo Bentivoglio. All that is known of his place of origin derives from the signatures on his works: Niccolò dell'Arca; Nicolai de Apulia (signature); 'Barrensem' (document of 1473); de Ragusa (Fabbrica di S. Antonio, 1493). He is described in 1479-80 in the Inscriptionem libellus of Jacopo Zaccaria as 'Nicolao da Bononia sculptori celeberrimo amico dilecto'. For these dates, see G. Agostini and L. Ciammitti (Tre artisti nella Bologna dei Bentivoglio: Niccolò dell'Arca. Il compianto sul Cristo di Santa Maria della Vita (exhibition catalogue Bologna, 1985). It is assumed that he was a native of Bari. who migrated to Dalmatia and Naples. It has been suggested (Gnudi) that after the cessation of work on the triumphal arch of the Castelnuovo in Naples (1458) Niccolò dell'Arca moved to France, but what have been loosely described as Burgundian features in his early style may be due to contact in Naples with the Catalan sculptor Sagreta. A group of the Lamentation over the Dead Christ in S. Maria della Vita dates from 1463 (see plates 244, 247). Niccolò's earliest documented work is the cover of the Arca of St Dominic in S. Domenico Maggiore, Bologna. The completion of the Arca was decided on in 1469, and the upper part was put in place on 16 July 1473. It is possible that Niccolò also worked on additions to the cover of the Arca between this date and his death in 1494, since in the latter year Michelangelo executed three missing figures for it. There is no explanation of why these were not undertaken by Niccolò dell'Arca. The sculpture of the Arca includes statuettes of the four Evangelists (plate 241), Sts Francis, Dominic, Florian, Agricola and Vitale, a Dead Christ adored by Angels, two adoring Angels and an Angel carrying a candlestick with putti and swags; a group of the Resurrection was originally to

have balanced the Pietà. The style of the figures is part Spanish and part Tuscan. A 'scabellum marmoreum' was to have been executed by Niccolò dell'Arca; the present predella is an addition by Alfonso Lombardi. At least one of the figures added to the Arca by Michelangelo, the S. Procolo, appears to have been begun by Niccolò dell'Arca. The large Madonna di Piazza in Bologna (inscribed NICOLAVS F. MCCCCLXXVIII) reveals, in the Child, the influence of Verrocchio (Gnudi). A terracotta bust of St Dominic in S. Domenico Maggiore, Bologna, was commissioned in 1474 and installed on 16 May 1475, and a terracotta eagle over the entrance to S. Giovanni in Monte (inscribed NICOLAVS F.) dates from before 1481. A marble figure of St John the Baptist, signed NICOLAVS and recorded in the Escorial, has been identified by De Salas as a work bequeathed to Niccolò's wife and in 1586 to Philip II of Spain for use in the Escorial. The sculptor's responsibility for the effigy of Andrea Manfredi in S. Maria dei Servi, Bologna (Beck) is problematical. Niccolò dell'Arca died on 2 March 1494.

Bibliography

A monograph by C. Gnudi (Niccolò dell'Arca, Turin, 1942) has been in part overtaken by more recent research and presents an unacceptable chronology, in which the Lamentation is presented as a late work. This is corrected by De Salas and is now generally discredited. A restatement of Gnudi's thesis (Nuove ricerche su Niccolò dell'Arca, Rome, 1972) contains some useful observations on the relation of the Lamentation to Ercole de' Roberti's lost Lamentation in the Garganelli Chapel in San Pietro, Bologna. An article by J. H. Beck ('Niccolò dell'Arca: A re-examination', Art Bulletin, xlvii, 1965, pp. 335-44) adds significantly to the documentation of the sculptor's career. Some interesting suggestions are also contained in an article by P. Belli d'Elia ('Niccolò dell'Arca; aggiunte e precisazioni', Commentari, xv, 1964, pp. 52-61). The history of the Arca of St Dominic is reviewed by S. Bottari (L'Arca di S. Domenico in Bologna, Bologna, 1964). The date of the bust of St Dominic in S. Domenico Maggiore, Bologna, is established by P. Venturino Alice

('Documenti per la data del busto di S. Domenico di Niccolò dell'Arca', Arte antica e moderna, iv, 1958, pp. 406-7), and a terracotta bust of a nun in the Galleria Estense at Modena is published by A. Ghidiglia Quintavalle ('Una terracotta di Niccolò dell'Arca', Arte antica e moderna, iv, 1958, pp. 373-4). The figure of the Baptist in the Escorial is discussed by X. de Salas ('The St John of Niccolò dell'Arca', in Essays in the History of Art Presented to Rudolf Wittkower, London. 1967, pp. 89-92). N. Grammaccini ('La déploration de Niccolò dell'Arca. Religion et politique aux temps de Giovanni II Bentivoglio', Revue de l'art, lxii, 1983, pp. 21-34) gives an admirable account of the iconography and historical context of the Lamentation group. In substitution for a monograph, a volume of essays (Niccolò dell'Arca: seminario di Studi, eds., G. Agostini and L. Ciammitti, Bologna, 1989) contains valuable essays by M. Fanti ('Nuove ricerche sulla collocazione del Compianto in Sant Maria della Vita'), M. Ferretti ('Per la ricostruzione e la cronologia del Compianto in Santa Maria della Vita'), T. Verdon ('Se tu non piangi quando questo vei') and A. Emiliani ('Dal realismo quattrocentesco allo stile patetico e "all'antico""). See also Tre artisti nella Bologna dei Bentivoglio: Niccolò dell'Arca. Il compianto sul Cristo di Santa Maria della Vita, eds. G. Agostini and L. Ciammitti, exhibition catalogue, Bologna, 1985, and a review by A. Bacci in Arte cristiana, lxxiv, 1986, pp. 283-93. Niccolò dell'Arca may have worked on five reliefs on the windows on the east side of S. Petronio (for this, see R. Grandi, La Basilica di San Petronio in Bologna, ii, Bologna, 1984, pp. 43-60, following Supino and Gnudi).

The Lamentation over the Dead Christ

S. Maria della Vita, Bologna Plates 244, 247

The group (plate 244), which was originally pigmented, shows the Dead Christ with the Virgin, St John the Evangelist, St Mary Magdalen, two Marys and Nicodemus. A figure of Joseph of Arimathea as Giovanni II Bentivoglio is presumed to have been destroyed. Niccolò dell'Arca's

authorship of the group is attested by an inscription, but there is a wide divergence of view as to its date. The figures are referred to in the Campione dell'Hospitale di Madonna S. Maria della Vita as 'un sepolcro . . . fatto per mano di Maestro Niccolò da Puglia, dal quale l'hospitale le ebbe nell'anno MCCCCLXIII' (an Entombment . . . made by the hand of maestro Niccolò of Apulia, from whom the hospital received it in the year 1463), and are for this reason customarily (A. Venturi) assigned to the year 1463. This date is rejected by Gnudi in favour of a late dating (c.1485-90) on account of (i) the difficulty of explaining a stylistic development which leads from the Lamentation group through the Arca of St Dominic to the Madonna di Piazza, and (ii) analogies with the Griffoni predella of Ercole dei Roberti and the copy of the Garganelli Crucifixion of Ercole dei Roberti in S. Pietro, Bologna. A further volume by Gnudi (Nuove ricerche su Niccolò dell'Arca, Rome, n.d.) reaffirms the chronology proposed in his monograph of 1942 and prints a number of previously unpublished documents from the Archivio di S. Petronio, Bologna. Gnudi's view that the S. Maria della Vita Lamentation is a work of the 1480s, which depends from and does not precede the terracotta Lamentation groups of Guido Mazzoni, is accepted by Verdon. The available evidence is insufficient to enable a firm decision to be reached. If the later dating were accepted, Niccolò dell'Arca's group would be dependent from, e.g., the Lamentation group by Guido Mazzoni in S. Maria della Rosa at Ferrara (c. 1485), and would be a translation into sculpture of a style developed in painting at least a decade earlier. The original form is uncertain (G. Agostini, 'La disposizione delle figure', Tre artisti nella Bologna ..., Bologna, 1985, pp. 325-8). If the earlier dating were accepted, it would develop from the work of Domenico di Paris at Ferrara, and would represent a significant anticipation of a style later popularized in painting. There can be little doubt that the early date is in fact correct. It has been argued, probably correctly, that the group originally included a figure of Joseph of Arimathea

in the likeness of Giovanni II Bentivoglio, which would have been destroyed in 1506, when the Bentivoglio were exiled from Bologna (A. Bacchi, Arte cristiana, lxxiv, 1986, pp. 283-93). A useful note on the group, which has been mutilated by recent cleaning, is supplied by G. Agostini (Tre artisti nella Bologna dei Bentivoglio: Niccolò dell'Arca. Il Compianto sul Cristo di S. Maria della Vita, exhibition catalogue, Bologna, 1985, pp. 325-8). A payment made by 'lo spedale della vitta' on 5 April 1462 to the Fabbrica of S. Petronio may have been connected with this commission. The validity of the early dating is also accepted by De Salas. S. Maria della Vita was a major Flagellant centre, and from 1463, (when a bull supporting it was issued by Pope Paul II) was closely associated with the Bentivoglio family (Grammaccini). In 1463, when on his father's death Giovanni II Bentivoglio was elected Gonfaloniere di Giustizia, the adjacent hospital was directed by Anton Galeazzo Bentivoglio. The group had the same function as that of Mazzoni in S. Anna dei Lombardi in Naples, which included the portraits of two kings of Naples, or the group in S. Maria della Rosa at Ferrara with Ercole d'Este as participant.

BARTOLOMMEO BELLANO

(b. c.1437; d. 1496/7)

The son of a Paduan goldsmith, Bellano appears to have been born about 1437. He is assumed to have been a member of Donatello's studio in Padua (though there is no documentary evidence of this) and to have followed Donatello on his return to Florence (1453). He is recorded as an associate of Donatello in a document of 14 October-19 November 1456. He seems thereafter to have returned to Padua since a document of 1463 (Rigoni) refers to his impending journey to Florence. His earliest documented work, a seated bronze statue of Pope Paul II cast for Perugia in 1466-7, is lost. This was inscribed HOC BELLANVS OPVS PATAVVS CONFLAVIT HABENTI / IN TERRIS PAVULO MAXIMA IVRA DEL., and dated 10 OCTOBRIS 1467. In documents relating to this work Bellano is described as 'magister Bellanus de Florentia', and must therefore have been domiciled in Florence at this time. At the end of Donatello's life, or soon after his death (1466), Bellano appears to have worked on the pulpit reliefs in S. Lorenzo (see plates 68-73). He had returned to Padua by 1 April 1468, when he assumed responsibility for the monument of Raimondo Solimani in the Eremitani. Between 1469 and 1472 he was domiciled in Padua, where he carved the marble decoration of a reliquary chest in the sacristy of S. Antonio. The most important feature of this decoration is a large oblong relief of the Miracle of the Mule. A relief of the Lamentation over the Dead Christ in the Victoria and Albert Museum, London, is closely related to this work, and appears to date from the same time. At this or a rather later time Bellano seems to have executed works in Venice, since on 1 August 1479 he was nominated to visit Mahomet II with the painter Gentile Bellini. A will made by Bellano before his departure is preserved (7 September 1479). It is assumed that he returned to Venice with Gentile Bellini in 1480. Thereafter he was continuously employed in Padua, initially on a cycle of 10 bronze reliefs for the choir screen of S. Antonio (see plate 283), and subsequently on the De Castro Monument in S. Maria dei Servi (1492;

1491) Monument in S. Francesco. From the latter a relief with the seated figure of Pietro Roccabonella, a relief of the Virgin and Child with Sts Anthony of Padua and Peter Martyr, and two bronze statuettes of putti survive. According to the Anonimo Morelliano, this monument was completed after Bellano's death by Riccio; this statement is correct. The monument was completed in 1498, and there is evidence that Bellano was still alive on 27 October 1495, so that his death must have occurred in 1496/7. Bellano is described by Pomponius Gauricus with the words: 'Sed et Donatelli discipulus Bellanus tuus Leonice, inter hos quoque nomen habebit, quamquam ineptus artifex.' ('But, Leonicus, Donatello's pupil, thy Bellano, will also be numbered among them, though he is a clumsy craftsman.') In interpreting the term 'ineptus artifex' ('clumsy craftsman') it must be remembered that the De sculptura was composed in 1504, when the more accomplished bronzes of Riccio were in general currency. Such evidence as is available suggests that in his lifetime Bellano enjoyed a considerable reputation as a bronze sculptor. The problem of Bellano's statuettes has not been properly ventilated. Two of them (a statuette of David in the Philadelphia Museum of Art (plate 285), from which a large number of derivatives are known, and a statuette of St Jerome in the Louvre) may have been produced in Florence, while others (notably a figure of Atlas in the Louvre and a statuette of Europa in the Museo Nazionale. Florence) are so closely related to the reliefs in the Santo as to make an origin in Padua virtually certain. Bellano was admired by Vasari (Vite, ed. G. Milanesi, 1906, pp. 604-9), who describes his relief of Samson Destroying the Temple (see plate 283): 'where among other things is Samson, breaking the columns showing the falling pieces, together with the death of that great throng, with a great variety in the attitudes, some perishing by the ruins and some by fear, all marvellously expressed by Bellano'.

no document), and the Roccabonella (d.

Bibliography

The work of Bellano is discussed, with a wealth of reproductions, by L. Planiscig

(Andrea Riccio, Vienna, 1927, pp. 27-74), but the documentation in this book is superseded by a monograph by V. Krahn (Bartolomeo Bellano. Studien zur Paduaner Plastik des Quattrocento, Berlin, 1988). which takes account of material published by E. Rigoni ('Notizie riguardanti Bartolomeo Bellano e altri scultori padovani', Atti e memorie della R. Accademia di Scienze, Lettere ed Arti in Padova, n.s. xlix, 1932-3, pp. 199-219; reprinted in L'arte rinascimentale in Padova. Studi e documenti, Padua, 1970), G. Corti and F. Hartt ('New Documents concerning Donatello, Luca and Andrea della Robbia, Desiderio ... and Others'. Art Bulletin, xliv, 1962, pp. 155-67), and A. Sartori ('L'armadio delle reliquie della Sacrestia del Santo e Bartolomeo Bellano', Il Santo, ii, 1962, pp. 32-58). Bellano's artistic beginnings are discussed by F. Negri-Arnoldi, 'Bellano e Bertoldo nella bottega di Donatello', Prospettiva, nos. 33-6, 1983-4, pp. 93-100. For Bellano's bronze statuettes, see also I. Pope-Hennessy (Essays on Italian Sculpture, London, 1969, pp. 86-91, 175-6) and H. R. Weihrauch (Europäische Bronzestatuetten, Brunswick, 1967, pp. 96-8). For the activity of Bellano in the church of the Santo at Padua, see G. Lorenzoni ('Dopo Donatello: Da Bartolomeo Bellano ad Andrea Riccio', Le sculture del Santo di Padova, Vicenza, 1984, pp. 95-107). The so-called Atlas in the Louvre is associated with a bronze Child in the National Gallery of Art, Washington, as a Christopher Carrying the Child Christ by B. Jestaz ('Une statuette de bronze: le Saint Christophe de Severo da Ravenna', La Revue du Louvre, xxii, 1972, pp. 67-78) with an ascription to Severo da Ravenna. The Bargello Europa is tentatively traced back by J. Fletcher ('Marcantonio Michiel's Collection', Journal of the Warburg and Courtauld Institutes, xxxvi, 1973, pp. 382-5) to the Venetian collection of Marcantonio Michiel. A bronze group of the Mountain of Hell, (plate 284), is by Agostino Zoppo (for this, see M. Leithe-Jasper, 'Beiträge zum Werk des Agostino Zoppo', Jahrbuch des Stiftes Klosterneuburg, n.s. ix, 1975, pp. 109-38). For the activity of Bellano in the church of the Eremitani at Padua, see S. Bettini and L. Puppi (La chiesa degli Eremitani

di Padova, Vicenza, 1970, pp. 95-8).

Samson Destroying the Temple S. Antonio, Padua

Plate 283

In 1482 a contract was awarded to Giovanni Minelli to cover the outer faces of the choir screen in S. Antonio with marble, and in 1483 provision was made for a cycle of 10 bronze reliefs of scenes from the Old Testament. In the latter year Bertoldo was requested to make two reliefs ('duos quadros de metalo unum vz habens Istoriam Jone prohete alterum habens submersionem faraonis in transitu maris'). Payments to Bertoldo are recorded in 1483, 1484 and 1485, when the first relief was delivered. This was found unsatisfactory ('perchè non parea sufiziente'), and Bertoldo's second relief was not proceeded with. Meanwhile, a contract for specimen or trial reliefs appears also to have been awarded to Bellano, who was paid on 29 November 1484 for the first of his scenes, the Samson Destroying the Temple ('Maistro Bartolommaio Bellan de' dare-adi 29 novembre per essa contada a lui per il quadro de Samson fasich sua . . . Duc. XL L. 248'). This was regarded as satisfactory, and in 1485 a contract for all ten reliefs was signed by Bellano ('et in achordo afare tuti decti quadri con maestro bartollamio belan'). The reliefs were finished by 1488, and in 1490 provision was made for the marble frames in which they were set. In the seventeenth century the choir of the Santo was modified, and the reliefs are now set in the interior of the choir. In their present order they represent (i) Cain and Abel, (ii) the Sacrifice of Isaac, (iii) Joseph Sold by his Brethren, (iv) the Crossing of the Red Sea, (v) the Worship of the Golden Calf, (vi) the Brazen Serpent, (vii) Samson Destroying the Temple, (viii) David and Goliath, (ix) the Judgement of Solomon, and (x) the Story of Jonah. Unlike Ghiberti in the reliefs on the Porta del Paradiso, Bellano offers a global picture of the world that is not inhibited by geometry or structural consistency. Though a very large number of figures is shown in the foreground, middle distance and rear of Ghiberti's Joshua relief, a uniform scale is employed throughout the

scene. In Bellano's reliefs the figures are multiplied, and though coarse and undifferentiated are depicted in movement, for which there is no equivalent elsewhere. The principal event is depicted in the centre at top or bottom, sometimes with a triangle of space behind them. The scenes reflect the taste of the members of a small jury and 'zerti frati' by whom they were approved.

Riccio

(d. 1532)

Andrea Briosco, called Riccio or Crispus, is generally thought to have been trained in the studio of Bellano. His father Ambrogio was a goldsmith from Trent and his mother was a Paduan. Since Ambrogio was engaged in Padua in 1476 on work for the Bishop, Giacomo Zeno, it is likely that Riccio was born in Padua. In May 1488 he is described as 'magister' and was a Paduan citizen. By 1504, when Riccio is mentioned in the De sculptura of Pomponius Gauricus, he was a wellknown artist in touch with humanist circles in his native town. The passage in question reads: 'Quin et Bellani uti volunt discipulus Andraeas Crispus familiaris meus, cuius inter Plastas quoque mencionem fecimus, podagrarum beneficio ex aurifice Sculptor.' ('And then my friend Andrea Crispus - whom they call a disciple of Bellano - him whom we have also mentioned among the sculptors, thanks to his gout abandonded goldsmith's work and became a sculptor.') A second passage in the De sculptura associates Riccio with Guido Mazzoni and Luca and Andrea della Robbia, presumably as an artist in terracotta. Of the many works in terracotta conjecturally ascribed to Riccio, the most notable is a group of the Dead Christ with the Virgin and St John in the Abbey of Carrara, near Padua. According to Marcantonio Michiel, three figures on Bellano's Roccabonella Monument in S. Francesco at Padua were executed by Riccio after Bellano's death (1496/7). These have been convincingly identified (Planiscig) with statuettes of Faith, Hope and Charity, which constitute Riccio's earliest authenticated works. In 1500 he designed the Chapel of the Saint in S. Antonio (see plates 323-6). About this time he appears to have produced the reliefs of the Legend of the Cross for the Servi in Venice, now in the Ca' d'Oro, and on 1 July 1506 he received the commission for two bronze reliefs of the Story of Judith and David with the Ark of the Covenant for the choir screen of the Santo. These were completed and put in position by 22 March 1507. Subsequently he was engaged on the

Paschal Candlestick for the same church (see plates 287, 289, 290). To a rather later phase of Riccio's development belongs the Della Torre Monument at Verona (see plate 288) and the monument of Antonio Trombetta (d. 1518) in the Santo (payments of 1521-4). No dated work survives from the years between the completion of the Trombetta Monument and the sculptor's death in July 1532 (date recorded on a sepulchral slab on the cloister of the Santo). The chronology of Riccio's many small-scale works can be determined only in a tentative manner. The two statuettes described on plates 292 and 296 below can scarcely have been produced before the completion of the Paschal Candlestick, but may date from any time thereafter.

Bibliography

The sculptor is the subject of an elaborate monograph by L. Planiscig (Andrea Riccio, Vienna, 1927). This sound and useful book reproduces a large number of statuettes by Riccio or from the Riccio workshop, but deals in a comparatively superficial manner with the iconographical and other problems arising from Riccio's major works. A booklet by F. Cessi (Andrea Briosco detto il Riccio, Trent, 1977) is in large part misconceived. Some useful photographs are contained in M. Ciardi Dupré (Il Riccio. I maestri della scultura, no. 58, Milan, 1966). For the documentation of Riccio's early years, see G. Pollard ('A document for the career of Riccio', Mitteilungen des Kunsthistorischen Institutes zu Florenz, xiii, 1968, p. 193); it should, however, be recognized that the documents published here as proof that Riccio was in Florence in 1480 refer to another artist with the same name. Some profitable lines of iconographical inquiry are sketched out in a remarkable article by F. Saxl ('Pagan Sacrifice in the Italian Renaissance', Journal of the Warburg Institute, ii, 1938-9, pp. 346-67); aspects of Riccio's iconography are also discussed by R. Enking ('Andrea Riccio und seine Quellen', Jahrbuch der Preussischen Kunstsammlungen, lxii, 1941, pp. 77-107); U. Schlegel ('Riccios "Nackter Mann" mit Vase', Festschrift U. Middeldorf, Berlin, 1968, pp. 350-7); and P. Meller ('Riccio's Satyress

Triumphant: Its Sources, Its Meaning', Bulletin of the Cleveland Museum of Art, 1976, pp. 324-34). The study of Riccio's work (in relation especially to that of two other bronze sculptors, Severo da Ravenna and Desiderio da Firenze) is, however, in a state of flux. Of fundamental importance are documents from the Archivio Capitolare, Padua, published by L. Montobbio ('Testimonianze sulla giovinezza padovana di Andrea Briosco', Atti e memorie dell'Accademia Patavina di Scienza, Lettere ed Arti, n.s. lxxxvii, 1974-5, pp. 297-300) which establish Riccio's paternity, and J. D. Draper ('Andrea vocato il Riccio orafo', Burlington Magazine, cxxv, 1983, pp. 541-2). Riccio's relations with Michiel are discussed by J. Fletcher ('Marcantonio Michiel: His Friends and Collection', Burlington Magazine, cxxiii, 1981, pp. 453-67). Of recent studies, the most useful are those by B. Jestaz ('Une bronze inédit de Riccio', Revue du Louvre, xxv, 1975, pp. 156-162; 'Un groupe de bronze érotique de Riccio', Institut de France . . . Fondation Eugen Piot. Monuments et mémoires, lxv, 1983, pp. 25-54), A. Radcliffe ('Bronze Oil Lamps by Riccio', Victoria and Albert Museum Yearbook, iii, 1972, pp. 29-58; 'Ricciana', Burlington Magazine, cxxiv, 1982, pp. 412-24; 'A Forgotten Masterpiece in Terracotta by Riccio', Apollo, cxviii, 1983, pp. 40-8), J. D. Draper ('Andrea Riccio and his Colleagues in the Untermeyer Collection', Apollo, cvii, 1978, pp. 170-89; Natur und Antike in der Renaissance, exhibition catalogue, Frankfurt-am-Main, 1985-6, pp. 98-121, 382-4; and Italian Plaquettes: Studies in the History of Art, National Gallery of Art, Washington, xxii, 1989, pp. 175-88, 191-202). F. De la Mouréyre-Gavoty (Musée Jacquemart-André, Sculpture italienne, Paris, 1975, no. 159) establishes that the Moses in the Musée Jacquemart-André was executed about 1505 for a fountain or lavabo in the refectory of S. Giustina at Padua. Riccio's small bronzes were for long confused with those of Severo da Ravenna, whose work is established in a number of articles and catalogues, of which the most useful is that of C. Avery

and A. Radcliffe ('Severo Calzetta da

Ravenna. New Discoveries', in Studien zum Europäischen Kunsthandwerk. Festschrift Yvonne Hackenbroch, ed. J. Rasmussen, Munich, 1983, pp. 107–26).

Youth with a Goat

Museo Nazionale, Florence Plate 292

It is clear that the two figures originally formed part of a larger group, and that the udder is extended either to a kid or to a human child. It has been suggested (Planiscig) that the statuette originally belonged with a second statuette in the same museum showing a nude female figure seated with a child on her left arm and a receptacle in her extended right hand. According to this interpretation, the female figure (which is generally designated Abundantia) would represent 'die Mutter, welche die Schale zur Aufnahme der Milch bereit hält'. The two figures are somewhat different in handling, and there is no warrant for assuming an iconographical or formal connection between them. The true subject of the bronze is identified by T. Buddensieg ('Die Ziege Amalthea von Riccio und Falconetto', Jahrbuch der Berliner Museen, v, 1963, pp. 121-50) as the goat Amalthea feeding the infant Jupiter. The group recurs in a fresco by Falconetto at Mantua, datable to 1520, and it must therefore have been produced before this time. It is stylistically associable with the reliefs from the Della Torre Monument.

The Sickness of Della Torre

Musée du Louvre, Paris Plate 288

The tomb of Girolamo della Torre (d. 1506) and of his son Marc Antonio (d. 1511) in S. Fermo Maggiore at Verona (plate 286) is a free-standing structure consisting of two parts. The lower, an altar-like table, rests on four columns and on a central chest bearing an epitaph. Above this, supported at the corners by four bronze sphinxes, rises a sarcophagus decorated with eight bronze reliefs. Since 1796 the originals of these have been in the Louvre, and they are replaced by copies on the monument. On the lid of the sarcophagus are bronze death masks of Girolamo and Marc

Antonio della Torre. It is known that the lid was originally decorated with four bronze genii or putti on the corners and with two seated putti with lamps beside the central tabernacle. Lombard monuments (to which reference is made by Planiscig) do not explain the form of the tomb, which is in all essentials without precedent. The scenes round the sarcophagus (for which see Saxl) represent (i) Girolamo della Torre teaching at the foot of a statue of Minerva with Apollo and Hygea looking on, (ii) the sickness of Girolamo della Torre, (iii) a sacrifice to Asclepius on the sick man's behalf, (iv) the death of Della Torre, (v) a ceremony of purification, (vi) Girolamo della Torre embarking for the Underworld, (vii) Della Torre in Elysium in contact with the great minds of the past, and (viii) Humanist Virtue triumphant over Death. There are no documents relating to the tomb, and it is conjecturally assigned by Planiscig to the years 1516–21. Since (as noted by Saxl) the narrative scenes relate only to the life of Girolamo della Torre and not to that of his son, it is likely that the tomb was commissioned before the death of Marc Antonio della Torre, and that the programme was devised or at least approved by Girolamo's surviving sons, Giulio, the jurist and medallist, and Giovanni Battista, a philosopher and astronomer. The subjects of the reliefs are explained by Saxl in terms of the humanist dialogues and poems of Fracastoro, who was on intimate terms with Giovanni Battista and Marc Antonio della Torre, and of the oration delivered at the funeral of Girolamo by the humanist Pierio Valeriano. A. Radcliffe (in The Genius of Venice, exhibition catalogue no. S22, London, 1983, pp. 372-4) relates the reliefs to a dialogue Alverotus by the Paduan philosopher Niccolò Leonico Tomeo, which discusses the account of the wanderings of the soul in the sixth book of the Aeneid; Riccio followed the texts in great detail, and 'the reliefs which follow the death scene therefore depict the fortunes of the soul of the professor (whether Girolamo or Marcantonio, or indeed both) in pagan terms'.

Paschal Candlestick

S. Antonio, Padua Plates 287, 289, 290

On 18 December 1506 it was decided by the Arca del Santo that a bronze Paschal Candlestick with a marble base should be commissioned for the church. The project for the candlestick seems to have been due to Giovanni Battista de Leone, who had been responsible for the commissioning of the two reliefs by Riccio on the choir screen (completed 22 May 1507). On 22 March 1507 it was proposed by De Leone that Riccio should receive the contract for the candlestick for a total sum of 600 florins, and this was approved unanimously. A drawing of the candlestick had been completed by this time, and was in De Leone's possession, though it was indicated that this was liable to be modified 'mutando in meglio'. The candlestick was set up in the church on the Vigil of Epiphany 1516 (5 January 1516). The date 1515 appears on the marble base. At some uncertain time (probably in the late sixteenth century) an inscription on lead (now lost) was discovered beneath the base, which read: 'Joannes Baptista de Leone philosophus hanc pyramidem faciendam curavit ex thesauro divi Antonii Andrea Crispo patavo sculptore primario anno Christi 1507, et Ludovicus ejus frater J. C. posuit anno 1515. Erat opus annorum 3 nisi Maximiliani atrocissimum bellum cum partibus venetis impedimento fuisset.' ('Giovanni Battista de Leone, the philosopher, cared for the making of this pyramid at the expense of the treasury of S. Antonio and by the hand of Andrea Crispus, foremost Paduan sculptor, in the year of Christ 1507. His brother Lodovico set it up in the year 1515. It would have been completed in three years if the atrocious war of Maximilian with the Venetian lands had not impeded it.')

The form of the candlestick (plate 287) is related by Planiscig to that of a pyramid illustrated in the *Hypnerotomachia Poliphili*, and both this and its iconography proceed (Saxl) from the Paduan humanist circle of De Leone and Leonicus. The iconography is the subject of a careful and convincing study by G. Lorenzoni ('Dopo Donatello: Da

Bartolomeo Bellano ad Andrea Riccio', Le Sculture del Santo di Padova, Vicenza, 1984, pp. 95-108). The iconography corresponds with that described in Valerio Polidoro's Le religiose memorie. The candlestick stands on a rectangular marble base (carved by Francesco di Cola from Riccio's design) representing (front face) the instruments of the Passion, the Victory of Christ, Ecclesia ex circumcisione and Ecclesia ex gentibus. Above this are four shallow classical scenes set between sphinxes. Above these are the principal narrative reliefs: Christ and the Sacrifice of the Paschal Lamb, the Adoration of the Magi, the Entombment and Christ in Limbo. Above these again are standing female figures of Prudence with two serpents, Temperance offered fruit by a putto, Strength, and Justice chastizing a Satyr. In the element above are convex scenes representing Religion, Consolation, Simplicity and Fame, with four seated putti between them.

Warrior on Horseback

Victoria and Albert Museum, London Plate 296

Nothing is known of the history of the statuette prior to its appearance in the Salting Collection. It appears, however, to have enjoyed some celebrity, and versions of the model are found in the Beit Collection at Russborough, the Wernher Collection at Luton Hoo, the Liechtenstein Collection at Vaduz and elsewhere. In these versions the rider is consistently of lower quality than in the present example, and the mount is replaced by a less refined horse of conventional classical cast. The right fore-leg of the horse is repaired. The right hand holds the hilt of a weapon, presumably a sword. Commenting on its expressive character, Planiscig rightly notes that 'der Schrei ist es, der diesem Reiter Charakter verleiht, jener Schrei, der zu einem Hauptmoment wird und die Komposition zu absorbieren scheint. Damit lebt keineswegs die Antike wieder auf; damit findet jene Tendenz, wilden Affekt in extremster Form darzustellen, die wir von Donatellos letzter Schaffenzeit, von Bellano und Minelli her kennen, ihre Fortsetzung, ungeachte des antiken Pompes, in den

nun die Werke der neuen Zeit gehüllt werden.' A. Radcliffe (in *The Genius of Venice*, London, 1983, exhibition catalogue no. S22, pp. 376–7) proposes that the posture and style derive from descriptions in Pomponius Gauricus's treatise *De Sculptura*. Jestaz (1983, p. 45) suggests that the rider represents Alexander; for this work, see the excellent entry in the 1985 Frankfurt exhibition catalogue (pp. 382–4).

ANTICO

(d. 1528)

Piero Jacopo Alari Bonacolsi, called Antico, appears to have been born in Mantua, where his father lived. The date of his birth is not known, and is conjecturally placed about 1460. It is not known in what studio Antico received his training, but through his whole recorded career he was patronized by members of the Gonzaga family, and his highly individual work is thus an expression of Mantuan humanist taste. A connoisseur of the antique, he was despatched to Rome early in 1497 to study and copy sculptures in the Belvedere for the Gonzaga court; a letter written by him from Rome on 5 February 1497 to his patron Francesco Gonzaga survives. After the death of Gianfrancesco Gonzaga, Antico worked for his brother Lodovico at Bozzolo. There are a number of documentary references to works - a Hercules, a Spinario, a bust of Scipio among them cast by Antico at this time after the antique. Thereafter he worked for Isabella d'Este as a silversmith, maker of bronze statuettes and restorer of antiques. Many works by Antico can be identified in the Mantuan inventories. Antico's autograph bronze statuettes are of considerable rarity; important examples exist in the Kunsthistorisches Museum, Vienna, the Pinacoteca Estense at Modena, the Victoria and Albert Museum, London, and the Museo Nazionale, Florence. His death is reported in a letter of 19 July 1528.

Bibliography

A monumental article by H. J. Hermann ('Pier Jacopo Alari-Bonacolsi, gennant Antico', Jahrbuch der Kunsthistorischen Sammlungen des allerhöchsten Kaiserhauses, xxviii, 1909-10, pp. 201-88), deals both with the documentary framework of Antico's activity and with the relation of his bronzes to their antique originals. A short survey of Antico's work with useful illustrations is supplied by D. Heikamp (L'Antico. I maestri della scultura, no. 61, Milan, 1966). In an article on Antico's technique R. Stone ('Antico and the Development of Bronze Casting in Italy at the End of the Quattrocento', Metropolitan Museum Journal, xvi, 1981,

pp. 87-116), establishes that Antico modelled in wax on a wire armature and that a plaster mould was then made from the wax model, and argues that indirect casting technology was more advanced in Mantua than in Tuscany. An admirable general study of Antico's Mantuan bronzes is supplied by A. Radcliffe ('Antico and the Mantuan Bronze', in Splendours of the Gonzaga, exhibition catalogue, London, 1981, pp. 46-9 and nos. 49-61). Four bronzes by Antico in the Seminario at Mantua, probably made for Lodovico Gonzaga, are published by A. Allison ('Four new Busts by Antico', Mitteilungen des Kunsthistorischen Institutes in Florenz, xx, 1976, pp. 213-24). A hitherto unnoticed inscription ANTICVS MANTVANVS R. (refecit) on the back of the plinth of the right-hand group on Monte Cavallo, Rome, is published by A. Nesselrath ('Antico and Monte Cavallo', Burlington Magazine, cxxiv, 1982, pp. 353-5). Though Antico is documented in Rome in 1495 and 1497, it is suggested that this restoration was undertaken during Raphael's tenure as Superintendent of Roman Antiquities under Pope Leo X. Antico's classical sources are discussed by W. S. Sheard (Antiquity in the Renaissance, Northampton, Massachussetts, 1979, pp. 67-9). For Antico's relationship to the antique, see R. Bobe and N. Rubenstein (Renaissance Artists and the Antique, Oxford, 1986, passim). Antico's style is also discussed by J. Pope-Hennessy (in 'An Exhibition of Bronze Statuettes', Essays on Italian Sculpture, London, 1969, pp. 179-80), A. Legner ('Antico's Apollo von Belvedere', Jahrbuch des Kunstitut-Staedel, n.f. i, 1967, pp. 103-18) and C. List (Kleinbronzen Europas, Munich, 1983).

Venus Felix

Kunsthistorisches Museum, Vienna Plate 280

The statuette (which exists in at least two other somewhat inferior versions) is discussed by L. Planiscig (*Kunsthistorisches Museum in Wien: Die Bronze-plastiken*, Vienna, 1924, p. 56). The model depends from the statue of Venus Felix now in the Museo Pio Clementino of the Vatican, formerly in the Cortile del Belvedere (plate 279). The hair and

drapery are gilt, the eyes are inlaid with silver, and the circular base is inset with nine silver-gilt coins of Gordian III, Philip the Younger, Valerian, Probus and Constans.

Antonio Bregno

(active 1425-after 1457)

The identification of the work of Antonio Bregno rests on the attribution of the Francesco Foscari Monument in S. Maria dei Frari (see plate 297). There are no documents relating either to the Foscari Monument or to Bregno's work in the Palazzo Ducale. A native of Righeggio on the lake of Lugano, he appears to be identical with an Antonio de Rigesio da Como who was at work in the Ca' d'Oro in 1425-6, probably as an assistant of Matteo Raverti. There is no basis for determining whether Bregno is also identical with a 'maestro Antonio da Lugano' who was active in Padua in 1449. After his activity in the Ca' d'Oro, Bregno seems to have become an associate of the Buon workshop, and participated in the execution of the Porta della Carta of the Palazzo Ducale, executing figures of Fortitude and Temperance (Planiscig) or Charity and Prudence (G. Mariacher) and the kneeling figure of the Doge in the centre of the door (head in Museo Correr, Venice). Bregno was also responsible for much of the sculpture of the Arco Foscari, where he worked side by side with Antonio Rizzo (q.v.). The confusion between the work of Bregno and Rizzo, initiated by J Sansovino (Venezia città nobilissima, 1581), has been largely dispelled through the work of Paoletti, Planiscig and Mariacher, and Bregno emerges as the principal Venetian sculptor of the transitional period between Bartolommeo Buon and Antonio Rizzo.

Bibliography

For Bregno's activity, see P. Paoletti, L'Architettura e la scultura del rinascimento in Venezia, Venice, i, 1893, pp. 146–7; L. Planiscig, Venezianische Bildhauer der Renaissance, Vienna, 1921, pp. 30–7; G. Mariacher, 'Antonio da Righeggio e Antonio Rizzo', Le arti, ii, 1941, pp. 193–8, and 'New Light on Antonio Bregno', Burlington Magazine, xcii, 1950, pp. 123–8.

The Monument of Francesco Foscari

S. Maria dei Frari, Venice Plates 297, 298

The attribution of the Foscari Monument (plate 298) to Bregno goes back to an engraving of 1777 (version in the Museo Correr), which bears the inscription 'opera d'invenzione e travaglio dell'architetto Paulo, e dello Scultore Antonio Fratelli Bregno da Como' ('Work designed and executed by the architect Paolo and the sculptor Antonio Bregno of Como'). It is suggested by Paoletti that this inscription must have had a documentary basis, and this view has been generally accepted by later students (Planiscig, Mariacher). The Doge Francesco Foscari died in 1457, and the tomb is usually assumed to have been begun soon after this time. It has also been suggested that it dates from 'around or shortly after 1454' (Mariacher). The tomb shows at the top the Risen Christ, the Annunciatory Angel and Virgin Annunciate, at the sides two warriors who hold up the curtain behind and beside the effigy, at the head and foot of the sarcophagus two pairs of Virtues in full length, and on the front of the sarcophagus reliefs of Faith, Hope and Charity. In style it is a transitional work, which depends in form from the Tommaso Mocenigo Monument in Sts Giovanni e Paolo and the Brenzoni Monument of Nanni di Bartolo in S. Fermo Maggiore at Verona; the warriors are related, e.g., to such Lombard prototypes as the base of the Borromeo Monument at Isola Bella (Mariacher). On the other hand, the figures of the Virtues have some significance for the formation of Antonio Rizzo, and the tomb type (the progressive features in which are presumably attributable to the 'architetto Paulo' mentioned in the inscription noted above) was adopted and modified by Pietro Lombardo in the Pasquale Malipiero Monument.

The problem of authorship of the Foscari Monument has been thrown into confusion by two books. The first, by A. Markham Schulz (Niccolò di Giovanni Fiorentino and Venetian Sculpture of the Early Renaissance, New York, 1978) identifies the artist of the tomb with

a minor Florentine sculptor, Niccolò di Giovanni Fiorentino, who is documented after 1467 at Trogir and is known from a number of sculptures there and at Sebenic. There is no evidence that Niccolò di Giovanni Fiorentino was at any time active in Venice, and his documented works in Dalmatia bear no resemblance to the sculptures of the Foscari tomb. The figures on the Arco Foscari commonly given to the author of the monument are also attributed by Schulz to Niccolò di Giovanni. The Foscari Monument is discussed in an appendix to an elaborate and well researched dissertation by D. Pincus (The Arco Foscari: the Building of a Triumphal Gateway in Fifteenth Century Venice, New York, 1976, pp. 401-38). Pincus concludes that 'the tomb does not fall into the standard categories of fifteenth-century tomb imagery but is a hybrid that, on the one hand, derives from the canopy tomb of the first half of the fifteenth century, and on the other hand from the monumental ducal tombs of the second half of the century' and 'should be viewed as substantially a product of the middle to late 1480s'. This analysis and the late dating it involves seem to me incorrect. A firstrate account of the architecture of the Foscari Monument is given by I. McAndrew (Venetian Architecture of the Early Renaissance, Cambridge, Mass., 1980, pp. 8-10), who infers that work on the tomb was begun c.1466, nine years after the Doge's death, and was probably completed c.1470. The architectural arguments in favour of this dating are mandatory. On Niccolò di Giovanni Fiorentino, see S. Stefanac ('Niccolò di Giovanni Fiorentino e l'Arco di San Nicola a Tolentino', Povijesti Umjetnostivv Dalmaciji, xxviii, 1989, pp. 51-67, for a statue of St Nicholas at Tolentino, 'Ein unbekanntes Werk des Niccolò di Giovanni Fiorentino: die Ceres-Figur im Kunsthistorischen Museum in Wien', Wiener Jahrbuch für Kunstgeschichte, xliii, 1990, pp. 169-74, and, debatably, 'Le traccie di Niccolò di Giovanni Fiorentino a Venezia', Atti dell'Istituto di Venezia di Scienze, Lettere, ed Arti, cxlviii, 1988-9, pp. 356-70).

Antonio Rizzo

(documented after 1465; d. 1499/1500)

A native of Verona, Rizzo is mentioned for the first time in 1465 at the Certosa at Pavia, where he was engaged in a subordinate capacity in carving columns and capitals. It has been suggested that at this time he exercised some influence on the work of Amadeo; this is possible, though the name of Amadeo does not appear at the Certosa before 1466, and by the following year Rizzo was working at S. Andrea della Certosa in Venice. His name appears in two epigrams of the Protonotary Apostolic Gregorio Cornaro (d. 1464), one of which is dedicated 'Ad Antonium Riccium Sculptorem'. Rizzo must therefore have been active in Venice for some years prior to 1464. It has been suggested (Mariacher) that he collaborated with Antonio Bregno in work on the Arco Foscari. This thesis is very probable. In the earlier literature Rizzo is confused with Bregno on the one hand and Andrea Riccio on the other. The earliest of Rizzo's independent works, the Orsato Giustiniani (d. 1464) monument formerly in S. Eufemia, has been destroyed, but is recorded in a drawing by Grevenbroeck; statuettes from this survive in the Metropolitan Museum, New York, the El Paso Museum of Art and the Cassa di Risparmio at Padua. This was followed by the monument of Vittore Cappello (d. 1467), incorporated in the lunette of a doorway formerly at S. Elena in Isola and now at S. Aponal, and by the Niccolò Tron Monument in S. Maria dei Frari (see plates 299, 300). On 21 July 1476 Rizzo undertook to execute for the Scuola di S. Marco from designs by Gentile Bellini 'una scala a chiocciola pensile con tre porte ed un ambone o pergamo di marmo in forma pentagona, sorretto da una mensola' ('a hanging spiral staircase with three doorways, and a pentagonal marble ambone or pulpit supported on a bracket'); this was destroyed in the fire of 1485. After the fire of 1483 in the Palazzo Ducale, Rizzo became Protomagister of the palace. At some time after this date he executed the figures of Adam and Eve for the Arco Foscari (see plates 301, 302). The most

important of the architectural features he contributed to the Ducal Palace is the Scala dei Giganti, which was under construction by 1491 and includes a number of shallow classicizing Victory reliefs. In 1498 he fled from Venice accused (according to Sanudo) of largescale peculation in connection with the Ducal Palace. Thereafter he moved to Ancona, Cesena and Foligno, where he died. Rizzo is last mentioned in 1499; the name of his widow is recorded in Venice in March 1500. Concurrently with his work in the Ducal Palace, he was engaged in the last fifteen years of his life on the tombs of Giovanni Emo (after 1483) in S. Maria dei Servi, Venice (destroyed; standing figure in Museo Civico, Vicenza, two pages with shields in the Louvre, Paris), and of the Doge Antonio Barbarigo in the Chiesa della Carità (in position before 1493; kneeling figure of Doge in the sacristy of S. Maria della Salute).

Bibliography

The basic documentation of Rizzo's activity is assembled by P. Paoletti (L'Architettura e la scultura del rinascimento in Venezia, Venice, i, 1893, pp. 141-63). Good surveys of Rizzo's style are supplied by L. Planiscig (Venezianische Bildhauer der Renaissance, Vienna, 1921, pp. 56-72), and by G. Mariacher (Rizzo. I maestri della scultura, no. 35, Milan, 1966). Rizzo's early style is discussed by E. Arslan ('Oeuvres de jeunesse d'Antonio Rizzo', Gazette des Beaux-Arts, 6th series, xlii, 1953, pp. 105-14) and A. M. Romanini (L'incontro tra Cristoforo Mantegazza e il Rizzo nel settimo decennio del Quattrocento', Arte lombarda, ix, 1964, pp. 91-102). For the documentation of the Scala dei Giganti, see P. A. Ranbaldi ('La Scala dei Giganti nel Palazzo Ducale di Venezia', Anteneo veneto, xxxiii, 1910, part 2, pp. 87-121, 193-239), and V. Franzoi ('La Scala dei Giganti', Bollettino dei Musei Civici Veneziani, x, 1965, no. 4, pp. 8-30), and for the Orsato Giustiniani Monument L. Planiscig ('Das Grabdenkmal des Orsato Giustiniani', Jahrbuch der Kunsthistorischen Sammlungen in Wien, n.s. i, 1926, pp. 93-102). Some useful supplementary information is contained in two articles by G. Mariacher ('Note su Antonio da Righeggio e Antonio Rizzo', Le arti, iii,

1940-1, pp. 193-8; 'Profilo di Antonio Rizzo', Arte veneta, ii, 1948, pp. 67-84). The information on the artist recorded by Sanudo is analysed by G. Zorzi ('Notizie di arte e di artisti nei diarii di Marino Sanudo', Atti dell'Istituto Veneto di Scienze, Lettere ed Arte, cxix, 1960-1, pp. 471-604, Appendix C, n.1). A monograph by A. Markham Schulz (Antonio Rizzo, Sculptor and Architect, Princeton, 1983) has the double demerit of excluding major works for which Rizzo was almost certainly responsible (the tomb of Orsato Giustiniani, the Vittore Cappello Monument at S. Elena and the Barbarigo Monument from the Chiesa della Carità) and of including a number of works which Rizzo cannot have carved. Niccolò di Giovanni Fiorentino (see under Antonio Bregno above) is here presented as 'Venice's foremost sculptor' in the years around 1465, who 'seems to have succeeded Bartolommeo Buon as protomaestro of the Ducal Palace'. Not only is there no evidence of this, but there is also none that he was at any time active in Venice. The belief that Rizzo twice visited Florence (on the strength of a supposed resemblance between the low relief altar frontal of the Conversion of St Paul in St Mark's and Donatello's rilievi stiacciati, and between ornament employed by Rizzo and that employed by Desiderio da Settignano) is simply myth. D. Pincus (see under Antonio Bregno above) states a strong case for the attribution of the structure of the Arco Foscari to Buon, not Rizzo, and opts for a relatively late date for Rizzo's Adam and Eve.

The Monument of Niccolò Tron

S. Maria dei Frari, Venice Plates 299, 300

The monument of the Doge Niccolò Tron (d. 1473) is planned in five registers (plate 299). The best account of its architecture is that of J. McAndrew (*Venetian Architecture of the Early Renaissance*, Cambridge, Mass., 1980, pp. 65–81), who notes resemblances in the pilasters of the bottom sphere to the gilt wood frame of Giovanni Bellini's St Vincent Ferrer polyptych in Sts Giovanni e Paolo. The effect of verticality is due in part to three superimposed niches filled with figures

at either side. D. Pincus ('The Tomb of the Doge Niccolò Tron and Venetian Ruler Imagery', Art the Ape of Nature, eds. M. Barasch and L. F. Sandler, New York, 1981, pp. 127-50), in a careful and largely convincing study, discusses the iconography of the monument. At the bottom is the standing figure of the Doge between elaborately carved pilasters, flanked by figures of Charity and Prudence (Planiscig) or Charity: Amor proximi and Charity: Amor Dei (Pincus). In the register above are reliefs of paired putti flanking an epitaph describing Tron's career and the name of his son Filippo Tron who was responsible for commissioning the monument. In the niches at each side are armed figures of warriors carrying Tron arms. The third register contains the sarcophagus and effigy between Hope and another Virtue and the fourth is filled with seven statuettes which include Pax, Abundance and Security. The fifth register contains a lunette of the Risen Christ with figures of the Annunciation. For Pincus (as earlier for Paoletti), the two lower registers represent a life zone, and are surmounted by a zone of religious imagery centring on the Resurrection. The dress of the Doge was originally strongly pigmented. R. Munman's breakdown of hands throughout the monument and especially his appreciation of the recumbent effigy (1973) is more reliable than that of Markham Schulz. The monument cannot have been begun before 17 April 1476, when the site which it occupied to the left of the high altar in the Frari was ceded to Filippo, son of Niccolò Tron. There is no evidence of the date of its completion, which is usually assigned to the early 1480s (Planiscig). Extensive studio intervention is apparent throughout the execution of the tomb, and the only parts universally accepted as the work of Rizzo are the portrait, the two statues of Virtues in the lowest register and the two shield-bearing pages and reliefs of putti immediately above. It is, however, argued with considerable cogency (unpublished thesis by R. Munman) that the effigy is autograph. The statue of the Doge in the lowest register is wrongly rejected by Planiscig, on account of its supposed inferiority to the comparable

standing figure from the Emo tomb. The form of the sarcophagus depends from that of the Orsato Giustiniani Monument. Colour appears to have been used extensively throughout the tomb, and there are traces of gilding in the standing statue of the Doge and of pigmentation in the lunette.

Adam and Eve

Palazzo Ducale, Venice Plates 301, 302

The two figures, now in the interior of the Palazzo Ducale, were designed for niches on the Arco Foscari, in which they are shown on plates 301 and 302. The Eve is signed on the base ANTONIO RIZO. The construction of the Arco Foscari was begun soon after 1438, and was completed under the Doge Giovanni Mocenigo (d. 1485). The Adam and Eve appear to have enjoyed considerable celebrity, and are referred to by Vasari ('lavorò di marmo le due statue che si veggiono ignude di Adamo ed Eva che sono tenute belle') ('in marble he worked two nude statues of Adam and Eve which are still to be seen, and are looked upon as beautiful'). They are mentioned in Rizzo's lifetime in a distich by Raffaello Zovenzonio, Crispo Veronehsi marmorario clarissimo:

Si tua forma fuit, quae marmore vivit in isto,

Quod mirum, si vir paruit, Aeva, tibi. ('If thy form, Eve, were as it lives in this marble, what wonder that man has yielded to thee.')

A wide variety of view has been expressed on the date of the two figures, which have been assigned to the year 1462 since the arms of the Doges Francesco Foscari and Cristoforo Moro appear in the vicinity of the niches in which they were set, to a date not far removed from that of the Tron Monument (1476) (Mariacher), to the period after the fire of 14 September 1483 when Rizzo became Protomagister of the Palazzo Ducale (Planiscig) and to the early 1470s (Markham Schulz). It is suggested (Planiscig) that the figures were still incomplete in 1491, when (9 October 1491) the Signoria instructed the Provveditori del Sale that 'debino esser cum maistro Antonio Rizo et veder di romagnir dacordo cum lui cerca il

perseverar di la fabrica del Palazzo nostro cussi per le figure come per la scala' ('They should get in touch with maestro Antonio Rizzo and reach agreement with him about continuing the construction of the Palace both as regards the figures and the staircase'). The staircase referred to in this entry is the Scala dei Giganti, and the figures are possibly, but not certainly, the Adam and Eve. It is pointed out by W. Pohlandt ('Antonio Rizzo', Jahrbuch der Berliner Museen, xiii, 1971, pp. 162ff.) that the bases of the Adam and Eve are classical, whereas that of Rizzo's Mars, also on the Arco Foscari, is polygonal.

THE MASTER OF SAN TROVASO

The term Master of San Trovaso denominates an artist responsible for three reliefs now built into an altar in the church of S. Trovaso, Venice (see plate 315). Attempts have been made to identify the sculptor with Agostino di Duccio (A. Venturi) and Pietro Lombardo (Fiocco), and to establish a group of works round the S. Trovaso altar. None of these is successful, and the only surviving work probably by the same hand as the altar frontal is a carved medallion with the head of the young Baptist in the sacristy of S. Maria del Giglio. The style of the S. Trovaso reliefs seems to imply some knowledge of the sculptures of the high altar of the Santo and of relief style in Padua, and they appear to date from about 1470.

Bibliography

The most extensive treatment of the S. Trovaso carvings is a relatively brief discussion by L. Planiscig ('Pietro Lombardi ed alcuni bassirilievi veneziani del "400", Dedalo, x, 1929-30, pp. 461-81), the relevant section of which supersedes the same student's Venezianische Bildhauer der Renaissance, Vienna, 1921. A reply by A. Venturi to this article ('Pietro Lombardi e alcuni bassirilievi veneziani del "400", L'Arte, n.s. i, 1930, pp. 191-205) is of polemical interest. The S. Trovaso reliefs are included by P. Paoletti (L'Architettura e la scultura del rinascimento a Venezia, Venice, 1893, ii) as works by Antonio Rizzo.

Angels with the Instruments of Passion

S. Trovaso, Venice Plate 315

The three reliefs built into the S. Trovaso altar consist (i) of an oblong relief with Angels holding the instruments of the Passion, and (ii) of two somewhat higher upright reliefs of music-making Angels, each flanked by carved pilasters. It is not certain that the three reliefs were designed as an antependium, and it is possible that they are not complete in their present form since not only are they of different heights, but there is a discrepancy

a Venezia', Arte veneta, ix, 1955, pp.

between the space construction of the relief in the centre and that of the reliefs at the sides. Moreover the iconographical relationship between the music-making Angels at the sides and the lamenting Angels in the centre is unclear. On the other hand, the three carvings are reproduced in three much inferior reliefs in the Kaiser Friedrich Museum, Berlin (no. 218, destroyed), by a sculptor who seems also to have been responsible for the Madonna della Biade in the loggia of the Palazzo Ducale, a comparable Virgin and Child in London, and parts of the Giustiniani Chapel in S. Francesco della Vigna. An iconographical precedent for the central panel, with Angels holding the instruments of the Passion, occurs in an altarpiece of the Coronation of the Virgin by Antonio Vivarini in S. Pantaleon (1444).

PIETRO LOMBARDO

(b. c.1435; d. 1515)

Pietro Lombardo was born at Carona (Lombardy), conjecturally in 1435, and is mentioned for the first time in 1462-3 at Bologna, where he was responsible for executing carvings for the Rossi Chapel in S. Petronio. In 1464 he was active at Padua. His principal work of this time, the monument of Antonio Roselli in S. Antonio (completed 8 April 1467) (plate 303), reveals strong Florentine influence. and since this persists in works executed after the transfer of his studio to Venice, there is an a priori case for presuming a visit to, or short period of activity in, Tuscany prior to 1462. His name appears in Venice for the first time on 11 August 1474, but he was almost certainly resident there soon after 1467. The principal works of this time are the monument of Pasquale Malipiero (d. 1462) in Sts Giovanni e Paolo (plate 304) and the reconstruction of S. Giobbe (see plate 316). In 1479 he was resident in the 'casa del Doxe' in the contrada of S. Samuele (probably the palace of Francesco Sforza, where Bartolommeo Buon had had his studio). From the last quarter of the century there dates a succession of sepulchral monuments, designed by Pietro Lombardo and carried out in part with the assistance of his sons, Tullio and Antonio. The most important of these are the monuments of Niccolò Marcello (d. 1474) in Sts Giovanni e Paolo, Pietro Mocenigo (see plates 306, 307), Jacopo Marcello (d. 1484) in S. Maria dei Frari, Lodovico Foscarini (d. 1480) formerly in S. Maria dei Frari, the Zanetti Monument at Treviso (see plates 308, 310), and the tomb of Dante at Ravenna (1482). In the 1480's Pietro Lombardo was also employed on two major architectural projects, the churches of S. Maria dei Miracoli (established by a bull of Sixtus IV of 13 January 1481, completed 1489) and S. Andrea della Certosa (destroyed). Pietro Lombardo was employed at the Scuola di S. Marco from 1488 till 7 November 1490 (when he was superseded by Rizzo and Codussi), designing the lower part of the new façade, with reliefs executed by his two sons. Three figures of Saints on the altar of the Colleoni Chapel in Bergamo date

from 1490. After the flight of Antonio Rizzo (1498) he became Protomagister of the Palazzo Ducale, retaining this post till his death in June 1515. In 1495 he was engaged on a project for a chapel in the Palazzo Ducale at Mantua. In 1509 he prepared a model for the new building of the Scuola Grande della Misericordia. Though the bibliography of Pietro Lombardo is extensive, much of his activity remains obscure, in particular the extent of his responsibility for certain major projects (the choir screen of the Frari and the Giustiniani Chapel in S. Francesco della Vigna) which cannot be ascribed to a known hand in the Lombardo studio, and the authorship of a number of Madonna reliefs. Pietro Lombardi's sculpture has been sporadically but not systematically studied. The principal impediment to serious analysis is that from the time of his arrival in Venice his workshop was very large, and by the 1470s included two sons of genius, Tullio and Antonio Lombardo. The work of the studio was organized as a company, of which Pietro was the titular head, and through his life he continued to sign contracts for work that he did not himself perform; the presence of his name on any document is thus no proof that he was responsible for the planning or execution of the commission. He was also, on a commercial level, an important dealer in marbles of every kind. At the end of the century he was an archaizing artist, and control of the studio passed to his two sons. The relative parts played by Pietro Lombardo, on the one hand, and Antonio Rizzo, on the other, in the formation of Venetian Renaissance style are still unclear, and the tendency of recent criticism has been to overrate the contribution of the latter and underrate that of Pietro Lombardo.

Bibliography

The standard account of the work of Pietro Lombardo is that of L. Planiscig (Venezianische Bildhauer der Renaissance, Vienna, 1921, pp. 41–80). P. Paoletti (L'Architettura e la scultura del rinascimento in Venezia, Venice, ii, 1893) gives an invaluable survey of the documentation of Pietro Lombardo's work both as sculptor and architect. A general article by G. Mariacher ('Pietro Lombardo

36-53) clarifies a number of points, but is critically inadequate. The documents relating to Pietro Lombardo's early activity at Bologna are published by J. H. Beck ('A notice for the early career of Pietro Lombradi', Mitteilungen des Kunsthistorischen Institutes in Florenz, xiii. 1968, pp. 189-92). For his activity in Padua and for the Roselli Monument, see A. Moschetti ('Un quadriennio di Pietro Lombardo a Padova', Bollettino del Museo Civico di Padova, xvi, 1913, pp. 1-99, xvii, 1914, pp. 1-43). Evidence for the presence of Pietro Lombardo at Vicenza in 1470 is published by G. Zorzi ('Architetti e scultori dei laghi di Lugano e di Como a Vicenza nel secolo XV', Arte e artisti dei laghi lombardi, i, Como, 1959, pp. 343-71). The part played by the Lombardi in the reconstruction of the Scuola di San Marco is analysed by P. Paoletti (La Scuola Grande di San Marco, Venice, 1929), and the documents relating to the Treviso commissions are published by G. Biscaro ('Pietro Lombardo e la Cattedrale di Treviso', Archivio storico dell'arte, n.s. iii, 1897, pp. 142-54, and more fully, 'Note storicoartistiche sulla Cattedrale di Treviso', Nuovo archivio veneto, xvii, 1899, pp. 135-94). For the Bergamo statues, see A. Meli ('Cappella Colleoni: i tre santi dell'ancona', Bergomum, n.s. xxxix, 1965, pp. 3-46). A useful summary of the literature on Pietro Lombardo as an architect is supplied by E. Bandelloni ('Pietro Lombardo architetto nella critica d'arte', Bollettino del Museo Civico di Padova, li, 1962, no. 2, pp. 25-56). An excellent survey of the tombs attributed to Piero Lombardo is given in a Ph.D. thesis by R. Munman (Venetian Renaissance Tomb Monuments, Harvard University, Cambridge, 1968) which is commonly ignored in the later literature. For a detailed study of the form and sculptural content of the Barbarigo double tomb and its dispersed sculptures, see A. Markham Schulz ('Pietro Lombardo's Barbarigo Tomb in the Venetian church of S. Maria della Carità', Art the Ape of Nature, eds. M. Barasch and L. F. Sandler, New York, 1981, pp. 171-92) and for the sculptures formerly at Roncade, see D. Lewis ('The Sculptures in the Chapel of the Villa Giustiniani at Roncade and their

Relation to those in the Giustiniani Chapel of S. Francesco della Vigna', Mitteilungen des Kunsthistorischen Institutes in Florenz, xxvii, 1983, pp. 307-92) and A. Markham Schulz ('The Giustiniani Chapel and the Art of the Lombardo', Antichità viva, xvi, no. 27, 1977, pp. 27-44). J. McAndrew's volume on Venetian Architecture of the Early Renaissance (Cambridge, Mass, 1980) contains notable pages on the architecture of S. Giobbe (plate 316) and on the Pietro Mocenigo Monument (plates 305, 306, 307). New light is thrown by R. Munman on the Zanetti Monument at Treviso ('The Lombardo Family and the Tomb of Giovanni Zanetti', Art Bulletin, lix, 1977, pp. 28-38). R. Munman ('Giovanni Buora: the 'Missing' Sculpture', Arte veneta, xxx, 1976, pp. 41-61) rightly eliminates the Onigo Monument in S. Niccolò at Treviso from the list of works by Pietro Lombardo and reattributes it to Giovanni Buora (c.1450–1513).

Decoration of Cappella Maggiore S. Giobbe, Venice Plate 316

The building of the Franciscan Observant church of S. Giobbe seems to have been begun in 1451, probably by Antonio Gambello (Paoletti), the Campanile being completed in 1464. The church was selected as the place of burial of the Doge Cristoforo Moro (elected 1462), who in his will (1 September 1470), bequeathed a sum for the completion of the church 'per lungarla e far le cappelle segondo il bixogno' ('to lengthen it and construct chapels as they may be required'), and this bequest was confirmed in a codicil of 29 October 1471 providing for work to be undertaken 'segondo l'ordene dato'. A terminus ante quem for the sculptures in the church is provided by a letter of 1485 from Collaccio to Cristoforo and Lorenzo da Lendinara (printed in Philologica Opuscola, Venice, 1486), in which reference is made to Pietro Lombardo 'cujus statuas in divi Job aede pridie sum plurimum inviatus'. The result was that the church assumed a form influenced by the Sagrestia Vecchia of Brunelleschi in Florence which conformed to Moro's Roman taste.

Though Paoletti suggests that Pietro Lombardo was employed initially in S. Giobbe as a sculptor not as an architect, he has been generally and rightly credited with the designing of the Cappella Maggiore and the chapels contiguous to it, and these almost certainly constitute 'la prima grandiosa opera architettonica del Lombardo' (Mariacher). The figure sculpture in the church by Pietro Lombardo and from his studio is confined to the doorway (which has a lunette with the Stigmatization of St Francis and St Job surmounted by statuettes of Sts Bernardino, Anthony of Padua and Louis of Toulouse), the triumphal arch (which contains in the interior reliefs of prophets in half length and at the outer sides figures of the Annunciatory Angel and Virgin Annunciate), and the Cappella Maggiore (which shows in the spandrels circular reliefs of the four Evangelists supported by figures of Angels or putti). The latter figures contain reminiscences of the putto reliefs of Donatello at Padua, and in handling recall the putti with shields on the Roselli Monument in the Santo. The presumption is that these figures (which, with the relifs above them, are autograph works by Pietro Lombardo) date from a somewhat earlier phase than the more classical Annunciation figures, and were perhaps carved about 1475.

The Monument of Pietro Mocenigo SS. Giovanni e Paolo, Venice

SS. Giovanni e Paolo, Venice Plates 305–7

The monument was begun after the death of the Doge Pietro Mocenigo (23 February 1476), and was completed by 4 March 1481 when the contract signed by Pietro Lombardo for the erection of the church of S. Maria dei Miracoli mentions it in the past tense. The tomb is described by Sansovino: 'Sts Giovanni et Paulo . . . Pietro Mocenigo Doge 72, che fù l'anno 1475, in richissima sepoltura di pietra Istriana con 17 figure di marmo al naturale, scolpite da Pietro Lombardo, et da Antonio et Tullio suoi figli, con la statua pedestre di sopra al cassone, con queste parole nel suo corpo EX HOSTIUM MANUBIIS et meritamente, perciochè per cose belliche di mare fù molto eccellente.' ('Doge Pietro

Mocenigo, aged seventy-two, who was elected in the year 1475, in a very rich monument of Istrian stone, with seventeen life-like marble figures carved by Pietro Lombardo and his sons Antonio and Tullio, with the standing figure of the Doge over the sarcophagus, and on the body of the sarcophagus the inscription FROM HOSTILE BOOTY, and deservedly, since in sea battles he was of outstanding merit.')

Erected by Mocenigo's heirs, Niccolò and Giovanni, it appears to have been paid for from military spoils, hence the inscription on the sarcophagus. It consists (plate 305) of a triumphal arch, flanked by three niches containing statues of warriors and pages with shields. Inside the arch is a standing figure of the Doge with two attendants behind the sarcophagus, which rests on the shoulders of three classical male figures. On the front of the sarcophagus are reliefs of (left) the entry of the Venetian forces into Scutari, and (right) the surrender of the keys of Cyprus to Caterina Cornaro. Below is an epitaph, flanked by reliefs of military trophies, and, at the extremities of the tomb, carvings of Hercules and the Hydra and Hercules and the Nemean Lion. Between the Hercules reliefs is an epitaph describing Mocenigo's military achievements. Above the triumphal arch is a relief of the Marys at the Sepulchre, and above this again, at the apex of the monument, is a statue of the Risen Christ. As noted by R. Munman (unpublished thesis), the monument was originally gilded and pigmented; extensive traces of paint in the niches and on the figures, especially in the eyes, have been recovered in recent cleaning.

To right and left of the Christ were statues of Sts Mark and Theodore, now removed from the tomb and installed beside the main entrance of the church. The share of Tullio and Antonio Lombardo in the execution of the monument cannot be identified. It has been claimed (Mariacher) that the scheme of the Mocenigo Monument is based on that of the Tron Monument of Rizzo; for chronological and other reasons this is unlikely. An attempt to relate the drapery forms used throughout the monument to the style of Rizzo is also unpersuasive.

Both in style and iconography the Pietro Mocenigo Monument is one of the most important landmarks in the history of Venetian sculpture.

Monument of Giovanni Zanetti

Duomo, Treviso Plates 308, 310

In his will (1484) Giovanni Zanetti, Archbishop of Thebes and Bishop of Treviso, bequeathed the sum of three hundred ducats for the reconstruction of the Cappella Maggiore of the Duomo in Treviso and the building of his own monument. A contract was signed by Pietro Lombardo on 25 January 1485, and a statement of 22 January 1485 gives details of the projected tomb, of which the 'primo circulo de fuora' was to be executed in 'medollo dai brioni' (marble from Brioni) of a type similar to that used in the monument of Alvise Foscarini in S. Maria dei Frari, and the 'secondo circulo' was to be of Pisan marble. The statement refers to the base of the monument ('il feston con una aquila cum uno baston scaiado'), and indicates that the sarcophagus was originally to be surmounted with 'cinque figure lavorade ben a diligentemente, retrata sua segnoria al naturale'. The newly constructed Cappella Maggiore and the cupola above it were badly built, and collapsed in 1486, and a document recording this fact (15 September 1486) states that at this time the sarcophagus of the Zanetti Monument ('cassone di pietrae ornato di fogliami e di mostri marini') was complete. The erection of the whole monument probably dates from 1488, when Tullio Lombardo arrived at Treviso (6 May 1488) to supervise the reconstruction of the Cappella Maggiore. According to Tommaso Temanza (Vite dei più celebri architetti e sculturi Veneziani che fiorono nel secolo decimosesto, Venice, 1778), the carving of the monument was undertaken in the workshop of Pietro Lombardo at S. Samuele in Venice, and the disassembled pieces were transferred by water to Treviso. An account of the effect produced in Treviso by the arrival of the monument and other decorative carvings for the Duomo is given by Pomponius Gauricus (De sculptura, ed.

Brockhaus, Leipzig, 1886, pp. 113-15): 'Petrus Insuber, Tullius atque Antonius ejus filii; sed ne ego Tullium praeterierim illaudatum? . . . Circumferebantur in pompae morem Tarvisii epistyliorum coronae quas ille junior variis intercelerat foliorum ornamentis. Aderat Crispus partim aemulatione quam eum patre Tullii gerebat, partim et tantae novitatis fama permotus, conctis igitur admirantibus, qui tanta veritate fieri potuerit nunquam prius e marmore coronas factas fissus est quam gladiolo id ita esse depraehenderit.' The monument (plate 308) consists of a sarcophagus, with an eagle and epitaph beneath and, above, figures of God the Father, Giovanni Zanetti, and a figure variously described as S. Liberale, a member of Zanetti's family or an acolyte. The scheme derives from that of the Lodovico Foscarini Monument in the Frari (destroyed). Documents and style leave no doubt that the designing mind in the Zanetti Monument was that of Pietro Lombardo, but that the execution was due in large part to Tullio and Antonio Lombardo. Thus the eagle at the base has been ascribed to Tullio Lombardo (Temanza, Mariacher) and Antonio Lombardo (Paoletti, Planiscig), and the decorative carving throughout is due to one of the younger members of the Lombardo studio. Of the upper figures the God the Father and the Giovanni Zanetti are given by Paoletti to Pietro Lombardo and the third figure to Antonio and Tullio. It has also been suggested (Mariacher) that the God the Father is by Pietro and the two remaining statues by Antonio Lombardo. The present epitaph (above the eagle by Tullio at the base) is modern, and includes the incorrect date of 1483. A careful and convincing analysis by Munman (unpublished thesis) establishes that the God the Father is the work of Pietro Lombardo, that the portrait of Zanetti is almost certainly by Antonio, that the third figure is by Tullio Lombardo with workshop assistance, and that the sarcophagus must be credited to Antonio Lombardo.

TULLIO LOMBARDO

(b. c.1455; d. 1532)

The activity of Tullio and Antonio Lombardo is mentioned by Collaccio (1475) ('et patrio artificio surgentes filios'), and from this time on both sculptors seem to have participated in works turned out by the Lombardo studio. According to Sansovino, Tullio 'scolpì le statue di marmo della cappella grande' in S. Maria dei Miracoli, and though these have disappeared, a number of figures of subsidiary importance inside the church can be ascribed to him. With Antonio (q.v.) he participated in the execution of the Treviso Monument (see plate 308), and on 6 May 1488 assumed responsibility for the reconstruction of damaged parts of the Cathedral. It is likely that the designs of the Andrea Vendramin and Giovanni Mocenigo monuments (plates 305, 312) were both due to Tullio Lombardo. In 1484 he worked on a Holy Sepulchre for S. Sepolcro (kneeling Angels now in S. Martino), the execution of which has also been assigned (Mariacher) to the years c. 1500, and in 1500-2 he executed an altarpiece for S. Giovanni Crisostomo (see plate 320). Thereafter he worked in the Chapel of St Anthony in S. Antonio at Padua (see plates 324-6), and in 1505-7 was employed on decorative carving in the Palazzo Ducale. In 1515 he was engaged on work in connection with the Cappella dell'Argento in the Duomo at Ravenna, and for this town he also executed the Guidarelli effigy now in the Museo Civico (payment of 21 June 1525). In 1517 he prepared a model for the Palazzo Ducale at Mantua on the commission of Isabella d'Este, by whom he was again employed in 1527. The last dated work of Tullio Lombardo is the Matteo Bellati Monument in the Duomo at Feltre (1528). Four years later (17 November 1532) he died in Venice. For Pomponius Gauricus Tullio Lombardo enjoyed unrivalled supremacy as the greatest Venetian marble sculptor, and the merits of his work have as a whole been underestimated by recent students. As a humanist sculptor he occupied a position closely analogous to that of Riccio in Padua. The Anonimo Morelliano mentions a headless classical

figure in his possession.

Bibliography

The most reliable standard account of Tullio's style and of certain of his works is that of S. Wilk (The Sculpture of Tullio Lombardo: Studies in Sources and Meaning, New York, 1978), which deals in detail with the Bernabo Chapel in San Giovanni Crisostomo, the double portrait busts, and the tomb of Guido Guidarelli at Ravenna. Adequate surveys of Tullio's work are supplied by L. Planiscig (Venezianische Bildhauer der Renaissance, Vienna, 1921, pp. 226-55, and 'Pietro, Tullio und Antonio Lombardo; neue Beiträge zu ihrem Werk', Jahrbuch der Kunsthistorischen Sammlungen in Wien, xi, 1937, pp. 87–115). For the documentary background of Tullio Lombardo's works in Venice, see P. Paoletti (L'Architettura e la scultura del rinascimento in Venezia, Venice, i, 1893) and for the reliefs in the Chapel of St Anthony in S. Antonio at Padua B. Gonzati (La Basilica di S. Antonio di Padova, 2 vols, Padua, 1852-3) and S. Wilk ('La decorazione cinquecentesca della Cappella dell'Arca di S. Antonio', Lorenzoni, Le sculture del Santo di Padova, Vicenza, 1984, pp. 109-71). A number of documents published by Gonzati are redated by A. Sartori (Documenti per la storia dell'arte a Padova, Vicenza, 1976), with results summarized by W. S. Sheard ('The Birth of Monumental Classicising Relief on the Façade of the Scuola di San Marco', in Interpretazioni Veneziane. Studi di storia dell'arte in onore di Michelangelo Muraro. Venice, 1984, pp. 149-74), who dates the designing of the reliefs to c.1499 and their commission to July 1500 and believes them to have been 'nearly complete' ('pro maiori parte complectis') by June 1501. This alternative chronology raises a number of problems which have not been satisfactorily resolved. The assumption in the recent literature on the Chapel of St Anthony that Tullio Lombardo, not Riccio, was the motivating force behind the classicizing style of the narrative reliefs can neither be substantiated nor disproved. The principal contributions to study of the Vendramin Monument are those by R. Munman (Venetian Renaissance Tomb Monuments, Ph.D.

dissertation, Harvard University, 1968) and W. S. Sheard (The Tomb of Doge Andrea Vendramin in Venice by Tullio Lombardo, Ph.D. dissertation, Yale University, 1971, and "Asa Adorna": the Prehistory of the Vendramin Tomb'. Jahrbuch der Berliner Museen, xx, 1978, pp. 117-56). Excellent accounts of the church of S. Maria dei Miracoli and the façade of the Scuola di San Marco are given by J. McAndrew (Venetian Architecture of the Early Renaissance, Cambridge, Mass, 1980, pp. 150-93). The subject of the classical prototypes employed by Tullio Lombardo has not been systematically investigated. Tullio's relations with the antique are explored in two articles by D. Pincus ('The Antique Fragment as Workshop Model: Classicism in the Andrea Vendramin Tomb', Burlington Magazine, cxxiii, 1981, pp. 342-7; 'Tullio Lombardo as Restorer of Antiquities: An Aspect of Fifteenth Century Venetian Antiquarianism', Arte veneta, xxxiii, 1979, pp. 29-42). Tullio's will and a letter from him to Marco Casalini, enabling two statues in S. Francesco at Rovigo to be dated in or after 1526, are published by L. Puppi ('Per Tullio Lombardo', Arte lombarda, xvii, 1972, pp. 100-3). I have not read a dissertation by M. Maek-Gerard (Tullio Lombardo, ein Beitrag zur Problematik der Venezianischen Werkstatt bis zu den Auswirkungen des Krieges gegen die Liga von Cambrai, Ph.D. dissertation, 1974, Johann-Wolfgang-Goethe Universität, Frankfurt-am-Main (from which a good article ['Die "Milanexi" in Venedig. Ein Beitrag zur Entwicklungsgeschichte der Lombardi-Werkstatt', Wallraf-Richartz Jahrbuch, xli, 1980, pp. 105-30] derives). An article by G. Mariacher ('Tullio Lombardo Studies', Burlington Magazine, xcvi, 1954, pp. 366-74) presents a retarded chronology which is questionable both on stylistic and on documentary grounds.

St Mark Baptizing Ammianus

SS. Giovanni e Paolo, Venice Plate 317

Giovanni Mocenigo, elected Doge in 147, died in 1485, and was buried initially in the vicinity of the Tommaso Mocenigo Monument. There is no document relating to the tomb with which he was eventually commemorated, which is described by Sansovino as 'un sepolcro di finissimo marmo, con belle figure di mano di Tullio Lombardo scultore eccellente' ('A tomb of finest marble, with beautiful figures by the hand of Tullio Lombardo, an excellent sculptor'). It is generally assumed (Paoletti, Planiscig, Mariacher) that the monument dates from the first decade of the sixteenth century, since the classicism both of the figure sculpture and of the architectural scheme is more developed than in the Vendramin Monument. Both the relationship to the Zen Chapel (noted by Paoletti) and the horizontal rhythms of the architecture (noted by Mariacher) tend to support this view. The lunette over the sarcophagus (showing the Doge presented by St John Baptist to St (?) Theodore and the Virgin and Child) and the effigy are less advanced than the other figure sculptures of the monument. Beneath the statues of Virtues which flank the sarcophagus are reliefs of (left) the Baptism of Christ and (right) the Baptism of Amianus. L. Planiscig ('Del Giorgionismo nella scultura veneziana all'inizio del cinquecento', Bollettino d'arte, xiv, 1934-5, pp. 146-55) draws a convincing distinction between the pictorial, atmospheric style of the relief on the left and the more classical style of the relief on the right, assigning the first to Antonio and the second to Tullio Lombardo. A late date is accepted by Wilk on grounds of the relationship of the figure sculptures to those of the Padua relief of the Miracle of the Miser's Heart, from which it is deduced that Tullio worked on the tomb for over twenty years. If this hypothesis is correct, work on the monument would have been suspended as a result of the war of the League of Cambrai. It is, however, possible that the monument was completed c.1515. In the only valid study of the architecture of the monument, by McAndrew, it is assumed that the tomb was begun c.1495, and proceeded from a new relationship between Tullio Lombardo and the architect Codussi. Giovanni Mocenigo's period of office was brief and unsuccessful, and for that reason his tomb, 'unlike that of his more active and successful brother (Pietro

Mocenigo) . . . had to be more abstract and symbolic than historically illustrative.

Christ, the Virgin and the Apostles

S. Giovanni Crisostomo, Venice Plates 320, 321

The very early church of S. Giovanni Crisostomo was seriously damaged by fire in 1475. Thirteen years later a papal indulgence was offered to contributors to the cost of a new church, and in 1496 the old church was demolished. In 1497 a new church was commissioned from Mauro Codussi, and in 1500 the building was practically finished. It was completed by Domenico Codussi and was consecrated in 1525. A chapel in the old church was patronized by Bernabo, and was replaced in the north aisle of the rebuilt church by a new chapel dedicated to the Apostles, probably designed by Codussi. For this an altarpiece in the form of a high marble relief was commissioned in 1500 from Tullio Lombardo. The two large marble slabs from which the altarpiece was carved were supplied in 1500, and work on them by Tullio Lombardo is likely to have been completed by 1502, when a gilded Virgin and Child formerly on the altar was transferred to S. Maria Maggiore. The relief has the form of a colossal triumphal arch. In the centre is a tabernacle carved in very low relief with above it a foreshortened God the Father and Holy Ghost with music-making Angels and a host of cherubim. In the centre of the base stands Christ, his head isolated against the tabernacle and one hand extended to a kneeling figure of the Virgin. At either side are six Apostles distributed across three planes in deep, medium and very low relief. The subject is commonly identified (Planiscig, Wilk, and earlier editions of this book) as the Coronation of the Virgin. Doctrinally, however, the Coronation followed the Dormition and Assumption, and the Apostles who witnessed the Virgin's ascent to heaven could not therefore have been participants. No contemporary account of the content of the altar survives, but eighteenth-century references to it described it as Christ and the Apostles, and it is to the Apostles that the chapel is dedicated. Wilk,

on a suggestion of Lavin, connects the iconography of Tullio's relief with an Early Christian relief in the treasury of St Mark's showing Christ and the twelve Apostles, known as the Traditio Legis. The Virgin does not appear in the relief, but there can be little doubt that it is the source of Tullio Lombardo's altarpiece, which would likewise represent the foundation of the new law.

Bacchus and Ariadne

Kunsthistorisches Museum, Vienna Plate 314

For the provenance of the relief (which comes from the Obizzi Collection at Catajo) see L. Planiscig (Die Estensische Kunstsammlung, i, 1919, no. 100, pp. 58-9). The relief, along with a comparable relief containing a male and female head in the Ca' d'Oro, Venice, seems to have been inspired by Roman grave portraits of the class of those of Julia Secunda and Cornelia Tyche (see P. Williams, 'Two Roman Reliefs in Renaissance Disguise', Journal of the Warburg Institute, iv, 1940-1, pp. 47-66). A third relief of the same class by Tullio Lombardo, showing a single female head, was formerly in the Huldschinsky Collection, Berlin. The function of the reliefs is not established, and the identification of the present relief as Bacchus and Ariadne derives from the vine leaves in the hair of the male figure. Wilk (chapter IV) identifies the Vienna relief as Bacchus and Ceres, while A. Luchs ('Tullio Lombardo's Ca d'Oro relief: A self-portrait with the artist's wife?', Art Bulletin, IXXI, 1989, pp. 230-6) identifies, implausibly, the Ca d' Oro relief as a portrait of the artist with his wife. The relief is related by O. Egger and H. J. Hermann ('Aus den Kunstsammlungen des Hauses Este in Wien', Zeitschrift für bildende Kunst, xvii, 1906, pp. 84-105) to the later of Tullio Lombardo's reliefs at Padua (1525), but is probably earlier in date, since the treatment of the head of the male figure recalls that of the Adam from the Vendramin Monument and the vertical drapery on the shoulder of the female figure finds a parallel in the S. Giovanni Crisostomo altarpiece.

Monument of Andrea Vendramin

SS. Giovanni e Paolo, Venice Plates 312, 313

The prehistory of the Vendramin tomb is discussed in detail by Sheard (1978). In a will dated 24 March 1472, Vendramin though not yet Doge made the key provision of a family tomb, specifying directions as to its size and quality. After Vendramin died (6 May, 1478) his heirs sought the best living artist for the monument. They first enlisted the services of Verrocchio, who was working in Venice on the Colleoni Monument. Verrocchio prepared designs which are recorded in two drawings (in the Victoria and Albert Museum, London, and the Louvre, Paris) showing a suspended wall monument related in style to the Forteguerri Monument at Pistoia on which he was also engaged. After Verrocchio's death in 1488, plans for the tomb in S. Maria dei Servi were entrusted to Tullio Lombardo. In accordance with Vendramin's will, the tomb was to be placed in the nave 'by our family chapel where the Sacrament is kept'. Whereas the tomb originally planned was to be placed high on the wall over another tomb, the tomb commemorating Vendramin as Doge rose from the floor of the church.

The tomb is first mentioned by Sanudo in 1493: 'Ai Servi è l'archa d'Andrea Vendramin Doxe che al presente si fabricha che sara diro cussì la più belle di questa terra perli degni marmi vi sono.' ('At the Servi the tomb of the Doge Andrea Vendramin, which is now being constructed, will in my view be the most beautiful on earth because of the worthy marbles it contains.') This reference suggests that by 1493 a substantial part of the figure sculpture of the monument was in existence, and it is generally assumed (Planiscig) that the monument was completed in the mid-1490s. As noted by A. Da Mosto (I dogi di Venezia, Venice, 1960, p. 203), a firm date for its completion is provided by Sanudo's Vite de' duchi di Venezia of 1494 which records that in that year the whole tomb, save for the epitaph and for one figure, was complete. The tomb, in the choir of S. Maria dei Servi (A. Vicentini, Santa Maria de' Servi in Venice, Treviglio,

Heart inscribed OPVS TVLLII LOMBAR.

1920), is shown in its original state in an engraving prepared for Cicognara. In 1810 the church was secularized by the French and the tomb was dismantled, and seven years later was re-erected in SS. Giovanni e Paolo. In 1819 the figures of Adam and Eve, which originally occupied the lower niches of the tomb, were removed from the monument, and transferred to the Palazzo Vendramin. The Adam (signed on the base TVLLII LOMBA/RDI O.; plate 311) was acquired in 1937 by the Metropolitan Museum, New York. Two figures of pages with shields were also removed from the monument, and were acquired in 1841 by the Kaiser Friedrich Museum, Berlin (destroyed). The Eve is in the Palazzo Vendramin-Calergi. Venice.

In its present form (plate 312) the monument consists of a central triumphal arch supported on columns, containing the sarcophagus and effigy, three figures of Angels behind the bier. and a lunette with the Doge Andrea Vendramin presented to the Virgin and Child. On the sarcophagus are statuettes of (left end) Fortitude, (front, left to right) Temperance, Charity, Hope, Faith and Prudence, (right end) Justice. The bier is supported by two eagles. Above the triumphal arch are two circular reliefs with emperor heads. At each side is a niche (now containing a statue of a warrior, and originally containing the figures of Adam and Eve), surmounted by a medallion of (left) Perseus and Medusa and (right) the Rape of Deianira, and figures of (left) the Annunciatory Angel and (right) the Virgin Annunciate. At the extremities of the monument in its present form stand two figures by Lorenzo Bregno from S. Marina; these spaces were originally filled by the two warriors now in the niches of the monument. The design of the monument is traditionally ascribed to Alessandro Leopardi; this view is contested by Paoletti and all subsequent writers, and the scheme of the tomb as well as a large part of the figure sculpture is generally credited to Tullio Lombardo. Though it has been claimed that the structure is 'not fundamentally different from that of the (Pietro) Mocenigo tomb' (Mariacher), the architectural conception is more progressive and

more classical. A serious and not unsuccessful attempt to attribute the individual sculptures of the monument is made by Planiscig, according to whom Tullio would have been responsible for the Adam, the two statues of warriors, the two pages in Berlin, the Angels behind the bier (extensive studio assistance), the two Angels holding up the epitaph, and six of the seven Virtues (extensive studio assistance, perhaps by Mosca). According to the same analysis, Antonio would have carved the two medallions of Perseus and Medusa and the Rape of Deianira, the emperor heads, the socle reliefs under the columns, and the two large reliefs of putti on the base, while the figure of the Doge, the Annunciation and the lunette above the effigy would be the work of unidentified assistants in the Lombardo studio. The style in the latter parts of the monument is more archaic, and the lunette recalls the late work of Pietro Lombardo. The figure of Eve was perhaps added in 1563, when work was undertaken in Sts Giovanni e Paolo by Zaccaria Vendramin, and Tullio Lombardo's Eve (if this existed) has disappeared. The present figure is ascribed by Planiscig and Mariacher to Francesco Segala on the strength of inconclusive analogies with two figures of Abundantia and Caritas in the Palazzo Ducale. Andrea Vendramin, whose period as Doge fell between those of Pietro and Giovanni Mocenigo, formed a large collection of antiquities, which was the subject of a 14-volume catalogue (McAndrew) and whose contents may have inspired the classical imagery of the tomb. The two roundels with Nessus and Deianira and Perseus and Medusa over the lateral arches derive from the Arch of Constantine, with which Vendramin would have been familiar through his services as Venetian ambassador to Pope Paul II (McAndrew).

The Chapel of St Anthony of Padua

S. Antonio, Padua Plates 323–6

In the fifteenth century the tomb of St Anthony of Padua stood in the left transept of S. Antonio (known as the Santo) in a chapel decorated with

frescoes of the Saint's life by Stefano da Ferrara. In 1470 the interior of the chapel had deteriorated, and the presiding authorities, the Massari dell'Arca, took steps to provide for its restoration. This led in 1500 (for the documents, see Gonzati, Sartori, and Wilk [1984, pp. 109–171] to a proposal for the rebuilding of the interior of the chapel, in which the frescoes of the Saint's life would be replaced by marble reliefs. According to a note by the Anonimo Morelliano, 'questa cappella era dipinta, e la pittura, per esser vecchia, è caduta essa: fù ruinata per refarla de sculpture de marmi. Dipinsela Stefano da Ferrara, bon maestro a quei tempi. Auctore Riccio.' ('This chapel used to be painted, but the painting, because of its age, started to peel, and was destroyed to allow the chapel to be redecorated with marble sculptures. It was painted by Stefano da Ferrara, a good artist of those times. Author Riccio.') This statement is confirmed by documents, from which we learn that in 1500 'lo modello ultimo' by Riccio was in course of construction by the sculptor Giovanni Bartolommeo da Ponte, Pier Antonio da Lendinara, and Vettore da Feltre. On 21 June 1500 Giovanni Minelli was appointed to direct work in the chapel in accordance with Riccio's design, and was employed in this capacity till 1521. After the death of Riccio (1532) the upper part of the façade of the chapel was completed by Giammaria Falconetto. On the rear and side walls of the chapel (plate 323) provision was made for nine large reliefs of miracles of St Anthony of Padua. As these were eventually executed, they consist (left to right) of the following scenes: (i) the Clothing of St Anthony carved by Antonio Minelli (payment of 20 May 1512), (ii) the Miracle of the Slain Wife signed by Giovanni Dentone (payment of 11 October 1524), (iii) the Raising of a Dead Youth begun by Danese Cattaneo and completed after his death (27 December 1572) by Girolamo Campagna (documents of 1572-3), (iv) the Miracle of the Drowned Girl signed by Jacopo Sansovino (payment of 1536), (v) the Raising of the Child Parrasio begun by Antonio Minelli (payment of 1522), taken over by Jacopo Sansovino (document of 1528) and completed in 1534, (vi) the Miracle of the Miser's

PETRI . F and dated MDXXV (commissioned 17 June 1501), (vii) the Miracle of the Repentant Youth inscribed TVLLII LOMBARDI OPVS (commissioned 27 July 1501, last documentary reference 16 June 1520), (viii) the Miracle of the Glass, according to the Anonimo Morelliano 'de mano de Zuan Maria Padoano, finito da Paulo Stella Milanese nel 1529', payment of 28 April 1520, (ix) the Miracle of the New-Born Child inscribed ANTONII LOMBARDI O.P.F. (payment of 28 April 1505). It appears originally to have been envisaged that the reliefs would be completed in a uniform style and in a shorter space of time; there is documentary evidence that (v) was originally allotted to Giambattista Bregnon (document of 20 October 1502) and that (iv) was to have been executed by Tullio Lombardo. Thus of the nine reliefs three were allotted to Tullio Lombardo, one to Antonio Lombardo, one to an imitator of Tullio Lombardo, Mosca, and one to an artist influenced by Antonio Lombardo, Antonio Minelli. Nothing is known of the style of Giambattista Bregnon. The reliefs were executed from models presumably made at an early stage in the construction of the chapel - in the seventeenth century a gesso model for Antonio Lombardo's relief was in a private collection at Vicenza and in the sixteenth century a terracotta model for Mosca's relief was owned by the father of Tiziano Minio - and it cannot. therefore, be presumed that the date of completion of Tullio Lombardo's reliefs has any relevance to the date at which they were designed. Both reliefs are. however, more advanced in style than the S. Giovanni Crisostomo altarpiece. In the documents payments for the perspectives in the upper parts of the scenes are shown independently of the payments for the main reliefs. The sum paid to Antonio Lombardo for the Miracle of the New-Born Child represents a total of L. 2480. Gonzati suggests very plausibly that the reputation enjoyed by Tullio and Antonio Lombardo about 1500 is responsible for the fact that they received commissions for the three scenes which correspond with scenes represented on

Donatello's high altar. The long delay in realizing the reliefs is almost certainly attributable to the war of the League of Cambrai in the Venetian outpost of Padua. As in the narrative reliefs on the Scuola di San Marco in Venice, the reliefs are planned in two sections, that at the bottom containing a narrative scene in a perspectival hall with a doorway at the back, and that above an arched vault opening to a perspective of Paduan churches and buildings. The figures at the base are carved in deep relief. Though the sequence of commissions for the reliefs is clear, there is no means of establishing by whom the whole scheme was devised. We know only that the plan reordering the chapel was presented to the Massari in 1497 by Francesco Sansone, the Supervisor General of the Franciscan order, and it is possible that the humanist patron of the Paschal Candlestick, Giovanni Battista de Leone, who was also one of the Massari of the Arca, exercised some influence on the scheme.

Antonio Lombardo

(b. c.1458; d. 1516?)

The career of Pietro Lombardo's younger son, Antonio, is inadequately documented. It is generally assumed that he participated in the work of the Lombardo studio at least from the time of the Pietro Mocenigo Monument (see plate 305), in which his share cannot be readily identified. Attempts have been made (Planiscig) to identify his hand in reliefs on S. Maria dei Miracoli, and, more convincingly, on the Andrea Vendramin and Giovanni Mocenigo monuments (see plates 313, 317). Antonio Lombardo was an active participant in the Zanetti Monument at Treviso (see plate 308). A figure of the Child Christ in the Victoria and Albert Museum, London, has been identified (Planiscig) as an early work of Antonio Lombardo on the strength of resemblances to the Onigo sarcophagus at Treviso, which was however carved by Giovanni Buora (Munman 'Giovanni Buora: the 'missing' sculpture', Arte veneta, xxx, 1976, pp. 41-61). Antonio's main documented activities relate to the Zen Chapel in St Mark's (see plates 328, 329) and the Chapel of St Anthony in S. Antonio at Padua (see plates 323, 324, 325). After 1506 he was active at Ferrara, dying there in 1516. At Ferrara he executed for Alfonso I d'Este a number of mythological carvings of a decorative character set in the so-called Camerini di Alabastro of the Castello. Of the many reliefs referred to this commission, twenty-eight carvings at Leningrad (one inscribed with the name of Alfonso I d'Este and dated 1508) (plate 327), two reliefs of Venus and Apollo in the Museo Nazionale, Florence (one with a tablet inscribed AL . D . III .), and a relief with two eagles formerly in the possession of the Bardini, Florence (with an inscription ending AL . D . III .), were certainly carved for the Camerini di Alabastro.

Bibliography

A good general account of the work of Antonio Lombardo is supplied by L. Planiscig (*Venezianische Bildhauer der Renaissance*, Vienna, 1921, pp. 209–5), who was also responsible for the conjectural identification of works

the framework of the Lombardo studio ('Pietro, Tullio und Antonio Lombardo; neue Beiträge zu ihrem Werk', Jahrbuch der Kunsthistorischen Sammlungen in Wien, xi, 1937, pp. 87-115). Some suggestive points are made in a second, less systematic article (L. Planiscig, 'Del Giorgionismo nella scultura veneziana all'inizio del cinquecento', Bollettino d'arte, xiv, 1934-5, pp. 146-55). As with other members of the Lombardo family, a useful documentary background is supplied by Paoletti (L'Architettura e la scultura del rinascimento in Venezia, Venice, ii, 1893). For the documentary material relating to the Zen Chapel in St Mark's and the Chapel of St Anthony in S. Antonio at Padua, see respectively F. Ongania (Documenti per la storia dell'augusta ducale Basilica di San Marco in Venezia, Venice, 1886) and B. Gonzati (La Basilica di S. Antonio di Padova, 2 vols., Padua, 1852-3). A volume devoted to the chapel, tomb and monument by B. Jestaz (La Chapelle Zen a Saint Marc de Venise. D'Antonio et Tullio Lombardo, Stuttgart, 1986) is well documented. E. Ruhmer ('Antonio Lombardo: Versuch einer Charakteristik', Arte veneta, xxviii, 1974, pp. 39-74) proposes some new attributions to Antonio Lombardo. The Ferrara reliefs are discussed by J. von Schlosser ('Eine Relief-serie des Antonio Lombardo', Jahrbuch der Kunsthistorischen Sammlungen des allerhöchsten Kaiserhauses, xxxi, 1913, pp. 87-100), and G. Gruyer (L'Art Ferrarais à l'epoque des Princes d'Este, i, 1897, pp. 412-13). For a number of mythological reliefs variously associated with the Camerini di Alabastro and with an independent commission, see especially W. Stechow ('The Authorship of the Walters Lucretia', Journal of the Walters Art Gallery, xxiii, 1960, pp. 72-85), J. Pope-Hennessy (Catalogue of Italian Sculpture in the Victoria and Albert Museum, i, London, 1964, pp. 353-7) and U. Schlegel ('Mars, Venus and Amor. Ein relief von Antonio Lombardo', Mitteilungen des Kunsthistorischen Institutes in Florence, XXVIII, 1984, pp. 65-76). J. Biscontin ('Une frise de marbre d'Antonio Lombardo au Musée du Louvre', Revue du Louvre, xxv, 1975, pp. 234-6) publishes a relief in the Louvre from the

executed by Antonio Lombardo within

Camerino d'Alabastro at Ferrara, and identifies the source of the Ferrara reliefs as Alberti's Della tranquillità dell'animo. The Camerino d'Alabastro is also dealt with by D. Goodgal ('The Camerino of Alfonso I d'Este', Art History, i, 1978, pp. 162-90), with documents of 1515 relating to the transport of marble to the Castello from Antonio Lombardo's shop, and in a partly mistaken article by C. Hope ('The "Camerini d'Alabstro" of Alfonso d'Este', Burlington Magazine, cxiii, 1971, pp. 641-50, 712-21), who concludes that the reliefs were intended for a room in the vicinity of the Camere Dorate in the old Castello.

The Zen Chapel

St Mark's, Venice Plates 328, 329

A nephew of Pope Paul II, Cardinal Giovanni Battista Zen, before his death on 8 May 1501, drafted a will (29 April 1501) bequeathing the sum of 5,000 ducats for the construction of a tomb and altar at the south end of the transept of St Mark's. After his death it was decided that this position was inadmissible, and the project for the chapel was transferred (1503) to the Chapel of St Theodore. The will gives a detailed indication of the intentions of the Cardinal: 'El corpo volemo sia sepulto in la chiesia de san marco de Venesia in uno sepulcro eneo zoe de bronzo, el quale sia posto sopra terra sul pavimento chome se entra dentro dela chiesia de s. marco per la porta del palazo a man destra . . . et sia facta la sepoltura tuta de bronzo lavorata a figure de sancti e feste al anticha bellissima. In la qual se metta el Corpo et se faza li una taola di bronzo per altare large cum quatro colone enee quadre incanelate sopra, la quale taola se faza tre figure grande de statua de uno homo de tutto reliefo de bronzo, le qual figure sia la gloriosa Vergine m^{ia} con miser Jusu christo in brazo in mezo, a man dextra san piero, a man sinistra san Zuan Bap^{ta} tute de grandeza de statura de un homo lavorate singularmente per maistro excellentissimo, et de sopra sia uno dio padre pur di bronzo cum angeli et altri lavori enei in forma de una pala belissima, che vada alta quanto el volto, et che lo empia tuto e largo quanto le

due colonne, e de sotto sia la sepultura la quale raxa overo stia su quatro pomi de bronzo dorati alti da terra sei ditta con el corpo dentro come e dicto e sia dorato tuta la sepultura e le figure e pala, et in la faza davanti de dicta sepultura se faza una immagine, de prelato apparato conlo piviale mitra e rocheto et poi lettere intorno del nome nostro et le arme una per testa con artificio et magisterio bellissimo, che tenga piu al antiqua sia posibele.' ('We wish that our body should be buried in the church of S. Marco in Venice, in a bronze tomb which should be set on ground level on the pavement to the right of where one enters the church by the Porta del Palazzo . . . Let the tomb be worked entirely in bronze with figures of Saints and classical garlands of great beauty. Let our body be placed in it, and let a big bronze altarpiece be made for the altar with four fluted columns, containing three life-size figures in the round with the glorious Virgin Mary in the centre with the Child Christ in her arms, and on the right St Peter and on the left St John the Baptist, all of them life-size and worked in a singular fashion by an excellent artist. Above let there be a bronze God the Father with angels and other works in bronze in the form of a most beautiful altarpiece as high as the roof of the altar and equal in width to the distance between the columns. Below let there be the tomb, which should stand on four gilt bronze apples six fingers high, with the body inside it as has been said, and let the entire tomb and statues and altarpiece be gilded. On the front of the aforesaid tomb let there be a representation of a prelate vested with cope, mitre, and rochet, and let there be an inscription with our name and arms at the head made with consummate artistry and skill, and as faithful to the antique as is possible.') The tomb and altar were commissioned jointly from Alessandro Leopardi and Antonio Lombardo. The respective shares of the two artists in the creation of the chapel is uncertain. On 3 December 1503 Leopardi preferred a claim for unspecified expenses in connection with work in the chapel, and on 18 January 1504 a joint sum was paid to both artists. On 23 May 1504, however, Leopardi appears to have been eliminated from

the contract, and work thereafter was entrusted to Antonio Lombardo, Tullio Lombardo (who was paid on 2 October 1506 for the socles of two columns on the altar) and two bronze-casters, Giovanni Alberghetto and Pietro delle Campane. It has been suggested conjecturally (Planiscig) that Leopardi was responsible for the architectural and Antonio Lombardo for the sculptural features of the chapel. 'Un dio pare in bronzo' (perhaps the God the Father on the baldacchino of the altar) appears to have been complete in 1503, and Antonio Lombardo's model for the central Virgin and Child was probably produced in 1506. In the latter year Antonio Lombardo left Venice for Ferrara, leaving his father as his representative; in 1511 a payment is made to Pietro Lombardo on Antonio's behalf. Thereafter control of work in the chapel seems to have passed to Paolo Savin, who appears to have been a close associate of Antonio Lombardo ('come fratello di M^{ro} Antonio Lombardo'), and who on 14 October 1507 completed the models of four figures for the side of the sarcophagus. The date of the casting of the Virgin and Child is uncertain; the socle, modelled by Savin and cast by Pietro delle Campane, is inscribed PETRI IOANNIS CAMPANATI M . DXV. The figure was put in position on the altar in 1518, and the sarcophagus was ready for the reception of the Cardinal's remains on 29 March 1521. The project is unique among Venetian Early Renaissance monuments in that it was designed to be constructed in gilt bronze not marble. Unlike Antonio Lombardo, Leopardi was known exclusively as a bronze sculptor, working in Venice from 1482 till 1506, where he was responsible for the completion of Verrocchio's Colleoni Monument and the bronze flagstaffs in the Piazza San Marco; he later moved to Padua, where he died in 1522. He was succeeded (Jestaz) in 1504 by two bronze casters, Piero di Zuane and Polo Savin. When Antonio Lombardo moved to Ferrara, Tullio and Zanin assumed responsibility for the chapel. Work seems to have been suspended during the war with France and the Empire, but in September 1510 a financial audit was undertaken on the sum of 1150 ducats expended by that time. This included

the bronze Virgin and Child on the altar, the altar itself, a substantial amount of work in marble, circular and square bronze supports, a bronze frieze over the architrave, a God the Father with cherubim, and two large and four small bronze angels. The statues of Sts Peter and John the Baptist are given by Jestaz to Paolo Savin, who was also responsible for the relief of the Resurrection on the altar, and the elegant statuettes of Virtues round the tomb are variously given to Paolo Savin and (Jestaz) Zuan Battista di Brioni on the basis of a dissimilar marble figure in the Duomo at Treviso. The statuettes of Virtues (like the form of the sarcophagus) were imitated from Rizzo's Orsato Giustiniani Monument. It is, however, likely that the chapel was planned as a unity, and even those parts modelled and finished by Paolo Savin (e.g. the sarcophagus and the antependium relief) may have been based, albeit loosely, on designs by Antonio Lombardo. The detailed terms of the will of Cardinal Zen suggest that preliminary discussions regarding the form of the chapel and memorial had taken place, with Leopardi or with Antonio Lombardo, before the death of the Cardinal.

Indexes

Page numbers in **bold** type indicate principal references

ACQUAPENDENTE

Duomo

Agostino di Duccio: Archangels Michael and Raphael 388 Agostino di Duccio: Tobias 388

AMELIA

Duomo

Agostino di Duccio: Tomb of Ruggero Mandosi 388

S. Francesco

Agostino di Duccio: Monument of Bishop Giovanni Geraldini 388 Agostino di Duccio: Monument of Matteo and Elisabetta Geraldini 388

AMSTERDAM

Rijksmuseum

Verrocchio: Bronze Candlestick 383

ANCONA

Duomo

Giovanni Dalmata: Tomb of the Beato Girolamo Gianelli 405

AREZZO

Misericordia

Bernardo Rossellino: Façade 103, 140, 369; plates 93, 95

SS. FIORA E LUCILLA

Workshop of Benedetto da Maiano: Tabernacle 370

AVIGNON

ST DIDIER

Francesco Laurana: Christ Carrying the Cross 241, 395

BALTIMORE

Walters Art Gallery Riccio: Shepherd 308

BASSANO

Duomo

Filarete: Processional Cross 397

BERGAMO

Colleoni Chapel

Giovanni Antonio Amadeo: *Façade* **265–8**, 407, **408–9**; plates 249, 250

Giovanni Antonio Amadeo: Monument of Bartolommeo Colleoni 408

Giovanni Antonio Amadeo: Monument of Medea Colleoni **268–71**, 280, 407, **408**; plates 248, 252

Giovanni Antonio Amadeo: Playing Children **268**; plate 251 Pietro Lombardo: Three Saints 421

BERLIN

HULDSCHINSKY COLLECTION Tullio Lombardo: *Head of a Woman* 424

KAISER FRIEDRICH MUSEUM
Bartolommeo Bellano: Atlas 296
Benedetto da Maiano: Vision of
Pope Innocent III 382
Bertoldo di Giovanni: Hercules 402
Bertoldo di Giovanni: Prisoner 402
Bertoldo di Giovanni: St Jerome 402
Filarete: Virgin and Child with

Angels 398
Francesco di Giorgio: Marble relief of Virgin and Child 394

Francesco di Giorgio: Mythological Scene 394

Francesco Laurana: *Bust of a Lady* 396

Master of San Trovaso, style of: Reliefs of Angels 421

Michelozzo di Bartolommeo: Madonna 362

Antonio Rossellino: Terracotta Madonna 374

Antonio Rossellino: Virgin and Child 374

Tullio Lombardo: Two Figures from Vendramin Monument 425

Verrocchio, after: Stucco Madonna 384

Kupferstichkabinett

Drawing after Tomb of Pope Innocent VIII plate 162

STAATLICHE MUSEEN

Donatello: Pazzi Madonna 66, 355; plate 62

Donatello: Virgin and Child 66; plate 65

Francesco di Giorgio: Roundel of St Jerome 394

Mino da Fiesole: Bust of Alessandro di Luca Mini 378

Mino da Fiesole: Niccolò Strozzi

182, 186, 378, **380**; plate 167 Antonio del Pollaiuolo: *Hercules* 289

Antonio Rossellino, *Bust of a Lady* **191–2**, **374**, 377; plate 178

BIRMINGHAM

BIRMINGHAM MUSEUM AND ART GALLERY

Verrocchio: Terracotta Madonna 384

BOLOGNA

CHIESA DELLA CERTOSA
Donatello, style of: Madonna 355
PALAZZO DEL COMMUNE
Niccolò dell'Arca: Madonna di

Piazza 257, 413, 414
S. DOMENICO MAGGIORE

Niccolò dell'Arca: Prophet 413; plate 241

Nicola Pisano: Arca of St Dominic 257, 413, 414

S. Francesco

Sperandio: Tomb of Pope Alexander V 257

S. GIACOMO MAGGIORE
Jacopo della Quercia:

Vari-Bentivoglio Monument 257

S. Giovanni in Monte

Niccolò dell'Arca: Eagle 413

S. Maria dei Servi

Niccolò dell'Arca (?): Effigy of Andrea Manfriedi 413

S. Maria della Vita

Alfonso Lombardi: Death of the Virgin 257

Niccolò dell'Arca: Lamentation over the Dead Christ 257–63, 413–14; plates 244, 247

S. Petronio

Jacopo della Quercia: Doorway 1,

Vincenzo Onofri: Terracotta Group 263

S. Pietro

Ercole de' Roberti: Crucifixion 263

BORGO A MOZZANO

S. Jacopo

Neroccio de' Landi: *St Bernardino* **217**, 218; plate 204

BOSTON

Museum of Fine Arts Donatello: *Madonna of the Clouds* 355

BUDAPEST

SZEPMUVESZETIMUSEUM Michelozzo di Bartolommeo: *Madonna* 362

BUSSETO

S. Francesco

Guido Mazzoni: Entombment 412

CARRARA

S. STEFANO

Riccio: Dead Christ with the Virgin and St John 415

CASALE MONFERRATO

S EVASIO

Bambaia, Cristofori Lombardi and Ambrogio Volpi: Arca and Altar 411

CASTELLAZZO

CRIVELLI COLLECTION

Bambaia: Sculptures from the tomb of Gaston de Foix 411

CASTIGLIONE D'OLONA

Collegiata

Lunette 407

CREMA

S. LORENZO

Guido Mazzoni: Lamentation 412

CREMONA

Duomo

Giovanni Antonio Amadeo: Arca of the Persian Martyrs 409 Giovanni Antonio Amadeo: Arca of S. Arealdo 409

Giovanni Antonio Amadeo: St Imerio Giving Alms 275, 407, 409; plate 257

DRESDEN

Albertinum

Filarete: Marcus Aurelius 398 Francesco di Giorgio: Aesculapius 394

EL PASO

Museum of Art

Antonio Rizzo: Statuettes from the Monument of Orsato Giustiniani 418

EMPOLI

Collegiata

Antonio Rossellino: *St Sebastian* **126**, 185, 372; plate 119

Musec

Bernardo Rossellino: Annunciation 126, 369 Wooden Magdalen 358

FAENZA

Duomo

Benedetto da Maiano: Shrine of S. Savino 380

FÉCAMP Guido Mazzoni: Terracotta Group **FELTRE D**иомо Tullio Lombardo: Monument of Matteo Bellati 423 FERRARA **D**иомо Niccolò Baroncelli and Domenico di Paris: St George 257; plate 242 Palazzo Schifanoia Domenico di Paris: Decoration of the Anticamera 257; plate 243 S. GIORGIO Antonio Rossellino: Monument of Lorenzo Roverella 372 S. Maria della Rosa Guido Mazzoni: Lamentation Group 412, 414 **FIESOLE** Duomo Mino da Fiesole: Salutati Monument **FLORENCE** ACCADEMIA Michelangelo: David 37, 130 Mino da Fiesole: Giugni Monument 378, 379 Mino da Fiesole: Monument of Count Hugo of Tuscany 155, 378, 379-80, 406; plates 142, 143 Bernardo Rossellino: Tabernacle 370 BAPTISTERY Andrea Pisano: Bronze Door 9, 44, 53 Donatello and Michelozzo di Bartolommeo: Monument of Pope John XXIII (Coscia Monument) 142, 171, 361-2, 363, 364, 371, 391; plates 132, 133 Lorenzo Ghiberti: First Bronze Door 181, 210, 367, 397 Lorenzo Ghiberti: Porta del Paradiso 181, 210, 225, 287, 345, 398,

Luca della Robbia: Reliefs of Arts and Sciences 365 Casa Buonarroti Michelangelo: Battle of the Centaurs 403 Convento della Calza Donatello, workshop of: Painted Stucco Relief 355 Duomo Virgin and Child with two Angels 15 Arnolfo di Cambio: Façade 10 Filippo Brunelleschi and Buggiano: Lavabo 103, 344; plate 94 Donatello: Prophet over Porta della Mandorla 15 Nanni di Banco: Assumption of the Virgin 165, 365 Nanni di Banco: Isaiah 16, 348 Luca della Robbia: The Ascension 92, 99, 365, 367; plates 87, 88 Luca della Robbia: The Resurrection 88-92, 365, 367; plates 85, 86 Luca della Robbia: Sacristy Door 85, 210, 365; plate 79 Paolo Uccello: Sir John Hawkwood 199; plate 185 MEDICI CHAPEL Michelangelo: Medici Chapel 339 MISERICORDIA Giovanni Antonio Amadeo: Virgin and Child with Three Angels 407 Benedetto da Maiano: St Sebastian 126-30, 381; plate 122 Benedetto da Maiano: Virgin and Child 381 Museo Archeologico Male Nude, 308; plate 293 MUSEO HORNE VECCHIETTA: St Paul 392 Museo Nazionale (Bargello) Agostino di Duccio: Virgin and Child 389 Antico: Cupid 294; plate 278 Antonio Lombardo: Venus and Apollo 426 Bartolommeo Bellano: Rape of Europa 296, 414 Benedetto da Maiano: Coronation of Ferdinand of Aragon 381 Benedetto da Maiano: Pietro Mellini 186, 381-2; plates 176, 177 Bertoldo di Giovanni: Apollo 294, 402, 403; plate 277 Bertoldo di Giovanni: Battle Relief **289–94**, 402, **403**; plates 273–5 Bertoldo di Giovanni: Crucifixion with Saints 402 Bertoldo di Giovanni, Relief of Putti

Filippo Brunelleschi: The Sacrifice of Isaac 9-10, 15, 345-6; plates 1, 3 Desiderio da Settignano: Bust of a Lady 191-2, 377; plate 179 Matteo Civitali: Portrait of a Lady 392 Desiderio da Settignano: Panciatichi Madonna 118, 126, 375, 376; plate 112 Desiderio da Settignano: Relief of Young Baptist 375 Desiderio da Settignano: St John the Baptist (Martelli Baptist) 126, 375; plate 118 Donatello: Amor-atys 37, 287; plate 31 Donatello: Bronze David 37, 126, 130, 218, 289, 346, 354-5, 375, 385; plates 32, 33 Donatello: Figure of a Pugilist 287 Donatello: Marble David 16, 19, 37, 42, 346, 348; plate 4 Donatello (?): Niccolò da Uzzano 181 Donatello: St George 20, 346, **348-9**; plates 8-10 Lorenzo Ghiberti: Arca of Three Martyrs 368 Lorenzo Ghiberti: The Sacrifice of Isaac 9, 10, 345; plate 2 Francesco Laurana: Bust of Battista Sforza 396 Michelangelo: Bacchus 126 Michelozzo di Bartolommeo: Madonna and Child 362 Mino da Fiesole: Bust of Giovanni de' Medici 182 Mino da Fiesole: Bust of Rinaldo della Luna 378 Mino da Fiesole: Piero de' Medici **181–2**, 378, 380; plate 166 Niccolò di Pietro Lamberti: St Luke 16, 19, 21; plate 6 Antonio del Pollaiuolo: Hercules and Antaeus 289, 399, 401-2; plate 268 Antonio del Pollaiuolo: Terracotta Portrait Bust 400 Riccio: Satyr 305-8; plate 291 Riccio: Youth with a Goat 308, 416; plate 292 Luca della Robbia: St Peter Predella Antonio Rossellino: Matteo Palmieri **186**, 192-4, 372, 374;

plates 172, 173

Baptist 372

Antonio Rossellino: St John the

Antonio Rossellino: Tondo: Nativity

Vecchietta: St Bernardino 392 Andrea del Verrocchio: Bust of a Lady 194, 383, 385; plate 181 Verrocchio: David 130, 383, 385, 388; plate 123 Verrocchio: Resurrection 383 Verrocchio: Virgin and Child 126, 384-5; plate 116 Museo dell'Opera del Duomo Andrea Pisano: Statues from Campanile 21, 350 Ciuffagni: St Matthew 347 Donatello: Cantoria 49-53, 80, 103, 205, 346, 352, **353**, 367; plates 47, 48 Donatello: Habakkuk 26, 350-1; plate 18 Donatello: Jeremiah 25-6, 350, 361; plates 13, 15 Donatello: St John the Evangelist 15-16, 346, **347-8**; plate 5 Donatello: St Mary Magdalen 41-2, 126, 218, 346, **358-9**, 375; plates 40, 41 Donatello: Unidentified Prophets **21-5**, 126, 181, 346, **350-1**; plates 11, 12, 14 Michelozzo di Bartolommeo: St John the Baptist 362 Nanni di Banco: St Luke 15, 16, 347 Nanni di Bartolo and Donatello: Abraham and Isaac 350 Niccolò di Pietro Lamberti: St Mark 15, 347 Antonio del Pollaiuolo: Birth of the Baptist 399 Antonio del Pollaiuolo: Crucifix 399 Luca della Robbia: Cantoria 79-80, 85, 99, 103, 140, 353, 365, 366-7; frontispiece, plates 74-8 Verrocchio: Decollation of the Baptist Museo dell'Opera di S. Croce Donatello: St Louis of Toulouse 25, 56, 130, 287, 346, **351**, 359, 361, 386; plates 16, 17 Museo di S. Spirito Donatello (?): Two fragmentary reliefs OR SAN MICHELE Baccio da Montelupo: St John the Evangelist 368 Ciuffagni: St Peter 344 Donatello: St George and the Dragon 44-7, 349, 350; plates 42, 43 Donatello: St Mark 19-20, 126, 136,

346, 348, 396; plate 7

399; plate 269

Baptist 399

del Duomo)

BARDINI COLLECTION

Two Eagles 426

Andrea Pisano: Reliefs 349

Antonio del Pollaiuolo: Birth of the

Antonio Lombardo: Relief with

CAMPANILE (see also Museo dell'Opera
Donatello and Michelozzo di Bartolommeo: Parte Guelfa Tabernacle 103; plate 16 Lorenzo Ghiberti: St John the Baptist 25 Lorenzo Ghiberti: St Matthew 25, 35, 136, 139, 361, 362 Nanni di Banco: Quattro Santi Coronati 130, 368 Nanni di Banco: St Philip 16-19 Niccolò di Pietro Lamberti: Madonna della Rosa 369 Orcagna: Tabernacle 44, 47 Luca della Robbia: Stemma of the Arte dei Maestri di Pietra e Legname Luca della Robbia: Stemma of the Arte dei Medici e Speziali, 92, 364, **368-9**; plate 89 Luca della Robbia: Stemma of the Arte della Seta 368 Verrocchio: Christ and St Thomas 130-6, 173, 194, 207, 208, 351, 383, 384, **385-6**, 388; plates 124-6 Palazzo di Parte Guelfa Luca della Robbia: Lunette from S. Pierino 365 Palazzo della Signoria Benedetto da Maiano: Doorway 369 Benedetto da Maiano: St John the Baptist 126, 380, 383; plates 120, 121 Donatello: Judith and Holofernes **37-41**, 136, 289, 346, **359-60**, 402; plates 34-8 Verrocchio: Putto with a Fish 130, 136, 207, 354, 383, 385; plate 127 Palazzo Pitti Hercules and Antaeus (Roman), 296; plate 281 S. Ambrogio Mino da Fiesole: Tabernacle 378 SS. Annunziata Michelozzo di Bartolommeo: St John the Baptist 362 Michelozzo di Bartolommeo: Tabernacle 362 Bernardo Rossellino: Tomb of Orlando de' Medici 369, 380 S. CROCE (see also Museo dell'Opera di S. Croce) Bardi Monument 165 Benedetto da Maiano: Pulpit 107-14, 380, 382-3, 391; plates 106, 107

Filippo Brunelleschi: The Pazzi

Chapel 79, 85, 88, 92, 367; plate 82 Desiderio da Settignano: Frieze of Putto Heads 375 Desiderio da Settignano: The Marsuppini Monument 146-9, 155, 160, 168, 257, 315, 375, 377-8, 383, 391; plates 138, 139, 141 Donatello: The Cavalcanti Annunciation 26, 28, 114, 130, 346, **353-4**, 356; plates 19, 20 Donatello: Wooden Crucifix 344 Giovanni di Balduccio: Baroncelli Monument 159 Luca della Robbia: St Matthew 88, 99, 367-8; plate 83 Antonio Rossellino: Madonna del Latte 118, 372 Bernardo Rossellino: The Bruni Monument 142-6, 149, 155, 159, 165, 168, 315, 368, 369, **370–1**, 374, 377-8, 380, 391; plates 134, 135, 140 S. Egidio Lorenzo Ghiberti: Tabernacle Door Bernardo Rossellino: Tabernacle 103, 107, 369, 370; plates 97–9 Filippo Brunelleschi: The Old Sacristy 53-6, 85-8, 168, 324; plate 52 Buggiano: Altar 344 Desiderio da Settignano: The Altar of the Sacrament, 107, 118, 191, 257, 375, **376-7**; plates 100-3 Donatello: The Assumption of St John the Evangelist, 56, 85-8, 346, 355-6, 396; plate 54 Donatello: Pulpits 72-5, 289, 360-1, 402, 414; plates 68-73 Donatello: Sacristy Door 53, 85, 225, 231; plates 50, 51 Donatello: Sts Stephen and Lawrence 346, **355-6**; plate 53 Donatello: Two Bronze Doors 168 Andrea del Verrocchio: Lavabo 383 Andrea del Verrocchio: The Medici Monument 168-71, 208, 383; plate 155 S. Maria Novella Benedetto da Maiano: Monument of Filippo Strozzi 381 Filippo Brunelleschi: Wooden Crucifix 344 Filippo Brunelleschi and Buggiano: Pulpit 107, 344, 372, 375;

plate 104

Desiderio da Settignano: Doorway 369 Lorenzo Ghiberti: Tomb-Slab of Fra Leonardo Dati 171 Masaccio: Trinity 47-9 Orcagna: Strozzi Altarpiece 49 Bernardo Rossellino: The Tomb of the Beata Villana 369, 371; plates 136, 137 S. MINIATO AL MONTE Michelozzo di Bartolommeo: Cappella del Crocifisso 362, 365 Luca della Robbia: The Ceiling of the Chapel of the Cardinal of Portugal 99, 159, 365, 369, 373; plates 91, 92 Antonio Rossellino: The Tomb of the Cardinal of Portugal 159-65, 182, 186, 192, 369, 372, **373-4**, 391; plates 146-9 S. SPIRITO Bernardo Rossellino: Tomb of Neri Capponi 168, 369, 372; plate 154 S. TRINITÀ Desiderio da Settignano: St Mary Magdalen 126, 218, 359, 375; plate 117 Luca della Robbia: The Federighi Monument, 80-5, 159, 365, 367, 368; plate 80 Spedale degli Innocenti Andrea della Robbia: Foundlings 391 Via dei Martelli Desiderio da Settignano, style of: Madonna 375 **FLORIDA** PRIVATE COLLECTION Donatello: Madonna and Child 355 PINACOTECA COMUNALE Bernardo Rossellino: Monument of Beato Marcolino da Forlì 369, 372 **GENOA D**иомо Domenico Gaggini: Façade of the Chapel of St John the Baptist 395 THE HAGUE FREDERIKS COLLECTION Bertoldo di Giovanni: Hercules 402 ISOLA BELLA PALAZZO BORROMEO Bambaia: Sculptures from the Birago

Monument 411 Borromeo Monument 418 LA VERNA CHIESA MAGGIORE Andrea della Robbia: Altarpieces 391 S. Maria degli Angeli Andrea della Robbia: Madonna della Cintola 99, 391; plate 90 LAMMARI SS. JACOPO E MARIA Matteo Civitali (?): Man of Sorrows 392 LE MANS Francesco Laurana: Monument of Charles IV of Anjou 395 LISBON Gulbenkian Foundation Antonio Rossellino: Madonna 374 LONDON British Museum Leonardo da Vinci: Studies for the Sforza Monument, 211, 213; plate 195 PUBLIC RECORD OFFICE Pietro Torrigiano: Terracotta Monument of Dr John Young 404 VICTORIA AND ALBERT MUSEUM Agostino di Duccio: Virgin and Child 389 Antico: Hercules and Antaeus, 296; plate 282 Antonio Lombardo: Child Christ 426 Bambaia: Charity 285, 411; plate 265 Bambaia: Fortitude 285, 411; plate 266 Bartolommeo Bellano: Lamentation over the Dead Christ 414 Benedetto da Maiano: Sketch-models for S. Croce Pulpit 382 Benedetto da Maiano, workshop of: Bust 382 Bertoldo di Giovanni: Hercules with the Apples of the Hesperides 402 Matteo Civitali: Tabernacle 391 Desiderio da Settignano: Virgin and Child 375 Desiderio da Settignano, workshop of: Chimneypiece 375

Donatello: The Ascension with Christ

350, 352; plates 45, 46

giving the Keys to St Peter 49, 56,

Donatello: Dead Christ with Angels Donatello: Madonna and Child 355 Donatello: Madonna and Child with Four Angels 355 Filarete: Medallic Self-portrait 398 Francesco di Giorgio: Allegory of Discord 394 Michelozzo di Bartolommeo: Adoring Angels 364 Pietro Lombardo, style of: Virgin and Child 421 Riccio: Warrior on Horseback 308, **417**; plate 296 Antonio Rossellino: Giovanni Chellini 182-6, 192, 372, 374; plates 168, 169 Pietro Torrigiano: Bust of Henry VII Vecchietta: Flagellation 217-18, 221; plate 200 Andrea del Verrocchio: Model for the Forteguerri Monument 387; plate 151 Verrocchio (?): St Jerome 383 Zoppo: Mountain of Hell 296;

LORETO

plate 284

WESTMINSTER ABBEY

plates 164, 165

Pietro Torrigiano: Bronze Relief

York 177, 403, 404, 412;

Margaret Beaufort 403

Pietro Torrigiano: Tomb of Lady

Portrait of Sir Thomas Lovell 404

Pietro Torrigiano: The Monument of King Henry VII and Elizabeth of

Basilica of the Holy House Benedetto da Maiano: *Lavabo: Evangelists* 381

LUCCA

Duomo

Matteo Civitali: Altar of St Regolo

Matteo Civitali: Altar of the Sacrament 391, 392

Matteo Civitali: Chapel of the Volto Santo 391

Matteo Civitali: Monument of Domenico Bertini 391, 392

Matteo Civitali: The Monument of Piero da Noceto 155–9, 372, 391, 392; plate 144

Matteo Civitali: Pulpit 392 Pisanello: Portrait Relief of Pietro d'Avenza 392 Museo Civico

Vecchietta: Burial and Assumption of the Virgin 392

S. FREDIANO

Matteo Civitali: Tabernacle 391 Jacopo della Quercia: Trenta Altar 217

Jacopo della Quercia: Trenta Tomb-Slabs 171

S. Maria del Palazzo Matteo Civitali: *Tabernacle* 392

S. MICHELE

Matteo Civitali: Virgin and Child 391

S. Romano

Matteo Civitali: The Tomb of San Romano 391, **392**; plate 145

TRINITA

Matteo Civitali: Madonna della Tosse 391

LUTON HOO

WERNHER COLLECTION
Riccio, workshop of: Warrior on
Horseback 417

MADRID

Escorial

Niccolò dell'Arca: St John the Baptist 413 MUSEO ARQUEOLOGICO NACIONAL Filarete: Hector on Horseback 398

Filarete: Hector on Horseback 398
THYSSEN COLLECTION

Agostino di Duccio: Virgin and Child with Angels 389

Benedetto da Maiano: St John the Baptist 382

MARSEILLES

CATHEDRAL

Francesco Laurana: Tabernacle of St Lazare 241, 395

MILAN

Duomo

Bambaia: Marino Carracciolo
Monument 411
Bambaia: Vimercati Monument 411
Hans von Fernach: Relief 268
Jacopino da Tradate: Pope Martin V
181

Cristoforo Solari: Adam and Eve 280, 410

Cristoforo Solari: Christ at the Column 280, 410

Museo Civico del Castello Sforzesco

Agostino di Duccio: Scene from the

Legend of St Sigismund 255, 390

Giovanni Antonio Amadeo: A Carthusian Friar presented to the Virgin and Child 407

Bambaia: *Effigy of Gaston de Foix* **285**, **411–12**; plate 264

Bambaia: Sculptures from the Birago Monument 411

Bambaia: Sculptures from the Monument of Francesco Orsini 410 Bambaia: Sculptures from the Tomb of

Gaston de Foix 411, 412 Bambaia and Cristofori Lombardi: Monument of Lancino Curzio 411

Cristofori Solari: *Pietà* 410 Pinacoteca Ambrosiana

Bambaia: Sculptures from the Birago Monument 411

Bambaia: Sculptures from the Tomb of Gaston de Foix 411

S. Eustorgio

Giovanni Antonio Amadeo: Decoration of the Portinari Chapel

S. FEDELE

Bambaia: Sculptures from the Monument of Francesco Orsini 410

MODENA

Duomo

Agostino di Duccio: Scenes from the Life of St Gimignano, 243, 388; plate 228

Guido Mazzoni: Adoration of the Virgin and Child 412

Guido Mazzoni: Lamentation Group

Guido Mazzoni: Nativity 412

Museo Civico

Guido Mazzoni: Fragmentary Nativity 412

PINACOTECA ESTENSE

Antico: Bronze Statuettes 417

Bertoldo di Giovanni: Hercules on Horseback 402

S. Francesco

Antonio Begarelli: Deposition 257

S. Giovanni Battista

Guido Mazzoni: Lamentation over the Dead Christ **263**; plate 245

S. GIOVANNI DELLA BUONA MORTE Guido Mazzoni: *Lamentation* 412

MONTEPULCIANO

Duomo

Michelozzo di Bartolommeo: Bartolommeo Aragazzi Bidding Farewell to his Family **139–40**, 142, 361, 362, **363–4**; plate 128

Michelozzo di Bartolommeo: St Bartholomew 139; plate 129

S. AGOSTINO

Michelozzo di Bartolommeo: Virgin and Child with SS. John the Baptist and Augustine 362

NAPLES

Castelnuovo

Gateway **237–41**, **396–7**, 405; plate 222

Francesco Laurana: *Madonna* 395, 396

Francesco Laurana: Alphonso of Aragon and his Court 238, 395, 396–7; plate 221

S. Angelo a Nilo

Donatello and Michelozzo di Bartolommeo: *The Brancacci*

Monument **47–9**, **140–2**, 231, **349–50**, 358, 361, **363**, 374, 405; plates 44, 130, 131

S. Anna dei Lombardi

(Monteoliveto)

Benedetto da Maiano: *The*Annunciation 114, 382;
plates 109, 110

Guido Mazzoni: Lamenting Woman **263**, **412–13**, 414; plate 246

Antonio Rossellino: The Adoration of the Shepherds 114, 372, 382; plate 108

Antonio Rossellino: Tomb of Mary of Aragon 372, 381

S. CHIARA

Tino di Camaino: Monument of Mary of Valois 363

S. MARIA MATERDOMINI

Francesco Laurana: Virgin and Child, 241, 395, 396; plate 225

NARNI

Duomo

Vecchietta: St Anthony the Abbot 392

NEW YORK

FRICK COLLECTION

Bertoldo di Giovanni: Male Figure with Shield 402

Francesco Laurana: *Bust of a Lady* 396

Francesco Laurana: Portrait bust of Beatrice of Aragon 396 Antonio del Pollaiuolo: Hercules

Vecchietta: The Resurrection 218, 393; plate 202 METROPOLITAN MUSEUM Agostino di Duccio: Relief of Christ Antonio del Pollaiuolo: Drawing for the Sforza Monument, 207-8, 211, 399; plate 193 Antonio Rizzo: Statuettes from the Monument of Orsato Giustiniani Antonio Rossellino: Virgin and Child 118-26, 374; plates 114, Pietro Torrigiano: Busts of St John Fisher and Henry 403 Tullio Lombardo: Adam 323, 425; plate 311 MORGAN LIBRARY Desiderio da Settignano (?): Bust of a Lady 377 Antonio Rossellino: Madonna 374 PRIVATE COLLECTION Benedetto da Maiano: God the Father 382 JOHN D. ROCKEFELLER COLLECTION Verrocchio: Bust of a Lady 385 NOTO Francesco Laurana: Virgin and Child 395, 396

289, 402

OXFORD Ashmolean Museum

OBERLIN

ORTIGNANO

384, 385

S. MICHELE A RAGGIOLO

Madonna 362

Riccio: Pan 308; plate 295 DIBBLEE COLLECTION Verrocchio, after: Stucco Madonna 384, 385

Verrocchio, after: Stucco Madonna

Michelozzo di Bartolommeo:

PADUA

CASSA DI RISPARMIO Antonio Rizzo: Statuettes from the Monument of Orsato Giustiniani 418 EREMITAN Bartolommeo Bellano: Raimondo

Solimani Monument 414 Niccolò Pizzolo (?), Terracotta Altarpiece 357 Museo Civico Guido Mazzoni: Fragments of Lamentation Group from S. Antonio in Castello, Venice 412 PIAZZA DEL SANTO Donatello: The Gattamelata Monument 202-5, 207, 208, 211, 346, 356, 358; plates 184, 188, 189 S. Antonio Antonio Lombardo: The Miracle of the New-Born Child 334, 425; plate 324 Bartolommeo Bellano, Miracle of the Mule 414 Bartolommeo Bellano: Samson Destroying the Temple 296, 414, 415; plate 283 Cattaneo and Girolamo Campagna: St Anthony Resuscitating a Dead Youth 425 Chapel of St Anthony 330-4; plate 323 Giovanni Dentone: The Miracle of the Slain Wife 425 Donatello: Crucifix 257 Donatello: The High Altar 26-37, 56-9, 218, 287, 328, 339, 346, 356-8; plates 21-9, 56-61 Donatello: The Miracle of the Miser's Heart 59, 356-8; plate 59 Donatello: The Miracle of the Mule 59, 356, 357-8; plate 57 Donatello: The Miracle of the New-Born Child 59, 66, 328, 356, 357-8; plate 56 Donatello: The Miracle of the Repentant Son 59-66, 356, 357-8; plates 58, 60, 61 Antonio Minelli: The Clothing of St Anthony 425 Antonio Minelli and Jacopo Sansovino: The Raising of the Child Parrasio 425 Pietro Lombardo: The Roselli Monument 315, 421, 422; plate 303 Riccio: David with the Ark of the Covenant 415 Riccio: Paschal Candlestick 302-5,

416-17; plates 287, 289, 290

Riccio: The Story of Judith 415

Drowned Girl 425

Riccio: Trombetta Monument 416

Jacopo Sansovino: The Miracle of the

Stella: The Miracle of the Glass 425 Tullio Lombardo: The Miracle of the Miser's Heart 334-9, 424, 425; plates 325, 326 S. Francesco Bartolommeo Bellano: Roccabonella Monument, 339, 414, 415; plate 322 S. Maria dei Servi Bartolommeo Bellano: De Castro Monument 414 PALERMO Museo Nazionale Francesco Laurana: Bust of a Lady Francesco Laurana: Tomb-Slab of Cecilia Aprilis 395 S. Francesco Francesco Laurana: The Mastrantonio Chapel 241, 396; plate 224 S. Maria della Neve Francesco Laurana: Virgin and Child 395 **PARIS** LOUVRE Agostino di Duccio: Rothschild Madonna 389 plate 226 375, 377

Agostino di Duccio: Virgin and Child with Four Angels 388, 389; Bartolommeo Bellano: Atlas 414 Bartolommeo Bellano: St Jerome Benedetto da Maiano: Filippo Strozzi 186-91, 382; plate 175 Desiderio da Settignano: The Child Christ and the Young Baptist 118, Donatello: Virgin and Child 66, 114, 355; plates 63, 64 Filarete: Triumph of Caesar 398 Filarete: Virgin and Child with Angels Francesco di Giorgio: St Christopher Giovanni Dalmata: Base of Monument of Pope Paul 406 Francesco Laurana: Bust of a Lady Michelangelo: Dying Slave and Rebellious Slave 339 Mino da Fiesole: Diotisalvi Neroni 182, 378 Riccio: Aryon 403 Riccio: Satyr 305

Riccio: Seated Shepherd, 308; plate Riccio: The Sickness of Della Torre 302, 416; plate 288 Antonio Rizzo: Supporting Figures from Emo Monument 419 Vecchietta: St John the Baptist 287 Verrocchio: Sketch-Models of Angels for Forteguerri Monument 383, 387 Musée Jacquemart-André Francesco Laurana: Bust of a Man Luca della Robbia: Angels with Candlesticks 366

PAVIA

CARMINE Giovanni Antonio Amadeo: Coronation of the Virgin 407

Façade 275, 409; plate 256 Giovanni Antonio Amadeo: Doorway of the Small Cloister 271-5, 407; plate 255 Giovanni Antonio Amadeo:

Spandrel Decoration of the Small Cloister 271; plate 253

Giovanni Antonio Amadeo: The Virgin Annunciate 271, 407; plate 254

Benedetto Briosco: Reliefs 280, 283 Gian Cristoforo Romano: Monument of Gian Galeazzo Visconti, 213, 237, 283, 285, 412; plates 262, 263

Antonio Mantegazza: Lamentation over the Dead Christ, 275-80, 285, 409-10; plates 258, 259

Cristoforo Solari: Effigies of Lodovico il Moro and Beatrice d'Este, 280, 410; plate 261

S. Lanfranco

Giovanni Antonio Amadeo: Relief from the Arca of St Lanfranco 280, 283, 407; plate 260

PERETOLA

S. Maria Luca della Robbia: Tabernacle 85, 88, 365, 367; plate 81

PERUGIA Agostino di Duccio: Porta alle Due Porte 388 **D**иомо Agostino di Duccio: Altar of the Pietà 388 PINACOTECA NAZIONALE

DELL'UMBRIA
Agostino di Duccio: Sculptures from
the Maestà delle Volte 388
Francesco di Giorgio: The
Flagellation of Christ 221, 394–5;
plate 207
S. BERNARDINO
Agostino di Duccio: Façade 243,
255, 388, 389–90; plates 227, 230
Agostino di Duccio: Miracle of
St Bernardino 243, 389; plate 229
S. DOMENICO
Agostino di Duccio: Altar 388
PESCIA
PALAZZO VESCOVILE

PHILADELPHIA

PHILADELPHIA MUSEUM OF ART
Bartolommeo Bellano: *David* **289**,
402, 414; plate 285
Desiderio da Settignano: *Virgin and Child (Foulc Madonna)* **114**, 126, **376**; plate 111

Luca della Robbia: Altarpiece 365

PISA

BAPTISTERY
Nicola Pisano: Pulpit 10, 13
CAMPO SANTO
Battle Sarcophagus 289–94, 403;
plate 276
DUOMO
Giovanni Pisano: Pulpit 13
S. CATERINA
Nino Pisano: Annunciation 10

PISTOIA

DUOMO Filippo Brunelleschi: Figures on

Silver Altar 344
Bernardo Rossellino: Monument of
Filippo Lazzari 369, 372
Andrea del Verrocchio: The
Forteguerri Monument, 165–8, 194,
208, 383, 386–7, 424; plates 150,
152, 153
MUSEO CIVICO
Rustici: Kneeling Figure of Cardinal

Forteguerri 387
S. GIOVANNI FUORCIVITAS
Fra Guglielmo: Pulpit 349–50

Fra Gughelmo: *Pulpit* 349–50 Luca della Robbia: *Visitation* **92**, 365; plate 84

POLA

Arch of the Sergii 397

PRATO

DUOMO
Benedetto da Maiano: Madonna dell'Ulivo 381
Donatello: External Pulpit 49, 80, 107, 205, 265–8, 346, 352–3, 362, 367; plate 49
Maso di Bartolommeo: Detail of Grille 287; plate 271
Antonio Rossellino: Pulpit 107, 372, 378, 383; plate 105
S. VINCENZO
Antonio Rossellino, after: Virgin and Child 374

RAVENNA

Pietro Lombardo: *Tomb of Dante* 328, 421 MUSEO CIVICO Tullio Lombardo: *Guidarelli Effigy* 423

RIMINI

S. Francesco (Tempio Malatestiana) 244–55, 389, 390; plate 231

244-55, 389, 390; plate 231 Agostino di Duccio: Angel drawing a curtain 192, 255, 390; plate 233 Agostino di Duccio: Arca degli Antenati 250, 255, 320, 389, 390; plate 240

Agostino di Duccio: *Playing Children* **250**, 255; plate 236
Agostino di Duccio: *Sibyls* **249–50**,

255; plate 239 Agostino di Duccio: *The Virtues* **249**; plate 238

Matteo de' Pasti: Aquarius 249, 250; plate 232

Matteo de' Pasti: Music 249, 250; plate 234

Matteo de' Pasti: Music-Making Angels 250; plate 235

Matteo de' Pasti: Venus 250; plate 237

ROME

Campidoglio

Marcus Aurelius (Roman) 199, 202, 205, 207, 208; plate 186

MUSEO DELLE TERME

Male Portrait Bust, 185; plate 171

MUSEO VATICANO

Male Portrait Bust plate 170

Venus Felix 294–6; plate 279

S. AGOSTINO

Isaia da Pisa: Effigy of St Monica 405

SS. Apostoli

Andrea Bregno, Monument of Raffaello della Rovere 406, 407 Andrea Bregno and Mino da Fiesole: Tomb of Cardinal Pietro Riario, 231, 378, 406, 407; plates 218, 219

S. CECILIA IN TRASTEVERE
Mino da Fiesole: Monument of
Cardinal Forteguerri 165, 378

S. CLEMENTE Giovanni Dalmata: Roverella Monument 405

S. Giacomo degli Spagnuoli Mino da Fiesole: *Angels* 378, 379 S. Giovanni in Laterano

Filarete and Isaia da Pisa: *Chiaves Monument* 397, 405
Isaia da Pisa: *Temperance* 225, 226,

Isaia da Pisa: Temperance **225**, 226, 249, 405; plate 213

Michelozzo di Bartolommeo: *Tomb* Slab of Pope Martin V 171, 362, 401; plate 156

S. MARCO
Filarete: St Mark 226
Mino da Fiesole and Giovanni
Dalmata: Altar 405

S. Maria in Aracoeli Andrea Bregno: *Labretto Monument* 406

Andrea Bregno: Savelli Monument 406, 407

Donatello: Tomb-Slab of Giovanni Crivelli 225, 346

Giovanni di Cosma: Tomb of Cardinal Matteo Acquasparta 371

S. MARIA MAGGIORE Mino da Fiesole: The Assumption of the Virgin 231, 379; plate 216

S. MARIA DEL POPOLO Andrea Bregno: *Borgia Altar* **231**, 406; plate 220

Andrea Bregno: Monument of Cristoforo della Rovere 406

Giovanni di Stefano: Foscari Monument 401

Mino da Fiesole: Della Rovere Monument 378

S. Maria sopra Minerva Andrea Bregno: *Coca Monument* 406

Andrea Bregno and Giovanni Dalmata: *Ferrici Monument* 405 Andrea Bregno and Giovanni

Andrea Bregno and Giovanni Dalmata: *Tebaldi Monument* 405, 406

Mino da Fiesole: Monument of Francesco Tornabuoni 378 S. Maria in Trastevere Mino da Fiesole: *Tabernacle* 378 St Peter's

Donatello: *Tabernacle* **103**, 107, 225, 346; plate 96

Filarete: *Bronze Door* **225–6**, 231, 397, **398–9**; plates 211, 212

Michelangelo: Pietà 410

Antonio del Pollaiuolo: Tomb of Pope Innocent VIII, 177, 399, 401; plates 161, 163

Antonio del Pollaiuolo: *Tomb of Pope Sixtus IV* **171–7**, 399, **400–1**; plates 157, 158, 159, 160

Guglielmo della Porta: Monument of
Pope Paul III 177

ST PETER'S (Grotte Vaticane)

The Crucifixion of St Peter, 225;

plate 210

Giovanni Dalmata: *The Creation of Eve* **231**, 405; plate 217

Giovanni Dalmata: Eroli Monument

Giovanni Dalmata and Mino da Fiesole: *The Monument of Pope Paul II*, **231**, 378, 379, **406**; plate 215

Isaia da Pisa: Orsini Madonna 405 Isaia da Pisa: Tabernacle of St Andrew 226–31, 405

Isaia da Pisa: Virgin and Child with Sts Peter and Paul 226, 405; plate 214

S. PIETRO IN VINCOLI
Andrea Bregno: Relief from Tomb of
Cardinal Nicholas of Cusa 406
Michelangelo: Moses 16

S. SALVATORE IN LAURO
Isaia da Pisa: Monument of Pope
Eugenius IV 405

ROTTERDAM

Museum Boymans-van Beuningen Pisanello: *Drawing for the Gateway of* the Castelnuovo, 237–8; plate 223

RUSSBOROUGH

BEIT COLLECTION
Riccio, Workshop of, Warrior on
Horseback 417

ST PETERSBURG

Hermitage

Antonio Lombardo: *Mythological Scene* **339**, 426; plate 327

SAN GIMIGNANO Collegiata Benedetto da Maiano: Altar of
S. Fina 380
Benedetto da Maiano: Bust of
Onofrio di Pietro 382
OSPEDALE DI S. FINA
Pietro Torrigiano: Marble Busts of
Christ and S. Fina 403
Pietro Torrigiano: Terracotta Bust of
St Gregory 403
S. AGOSTINO
Benedetto da Maiano: Altar of
S. Bartolo 381

SAN MINIATO AL TEDESCO

S. Domenico

Bernardo Rossellino: *Tomb of Giovanni Chellini* 182, 369, 374
SAN PELLEGRINO IN ALPI
Matteo Civitali: *Tomb of St Pellegrino* 392

SANTA FIORA

SS. FIORA E LUCILLA Andrea and Giovanni della Robbia: *Altarpiece* 99

SEBENICO

Dиомо

Francesco Laurana (?): Angels 395

SEVILLE

Museum

Pietro Torrigiano: St Jerome 404 Pietro Torrigiano: Virgin and Child 404

SIENA

BAPTISTERY

Baptismal Font 352, 361, 214
Donatello: The Presentation of
St John the Baptist's Head to Herod
56, 59, 352, 355, 361; plate 55
Donatello: Putto 37, 136, 287;

plate 30 Lorenzo Ghiberti: St John preaching before Herod 56

Jacopo della Quercia: Zacharias in the Temple 352

CHIGI–SARACENI COLLECTION
Francesco di Giorgio: Lycurgus and
the Maenads 221, 394

Duomo

Andrea Bregno: Piccolomini Altar 231–7, 406 Matteo Civitali: St Catherine of Alexandria 221 Donatello: Pecci Tomb-Slab 171, 346 Donatello: St John the Baptist 41, 214, 218, 346; plate 39 Antonio Federighi: *Baptismal Font* **214**; plate 199

Antonio Federighi: Holy-Water Basin 214

Francesco di Giorgio: *Angel* **221**, 394, **395**; plates 208, 209

Mino da Fiesole: Piccolomini monument 221

Vecchietta: *Tabernacle* **287**, 393; plate 270

Loggia di S. Paolo

Antonio Federighi: St Ansanus 214, 217; plate 198

Vecchietta: St Paul 214, 217, 393; plate 201

MUSEO DELL'OPERA DEL DUOMO Donatello: Madonna and Child with Four Angels 355

Donatello: Virgin and Child, 72, 214; plate 67

Francesco di Giorgio: St John the Baptist, 218, 394; plate 206 Giovanni Pisano: Façade Sculptures

13 Osservanza

Andrea della Robbia: Altarpiece

PALAZZO PUBBLICO
Bernardo Rossellino: *Doorway*369

S. Caterina

Neroccio de' Landi: St Catherine of Siena 218; plate 205

S. DOMENICO

Benedetto da Maia

Benedetto da Maiano: Ciborium 380

S. MARIA DELLA SCALA Vecchietta: *The Risen Christ*, **218**, 221, **393**; plate 203

STRASBOURG

Donatello, after: Painted Stucco Relief 355

TARASCON

STE MARTHE

Francesco Laurana: Monument of Giovanni Cossa 395

TREVISO

Duomo

Pietro Lombardo: *The Zanetti Monument*, **320–3**, 421, **422–3**, 426; plates 308, 310

S. MARIA MAGGIORE
Bambaia: Bua Monument 411

TROGIR

Duomo

Giovanni Dalmata: St John the Evangelist 405

TURIN

Museo Civico

Bambaia: Carved Pilaster 285; plate 267

Bambaia: Sculptures from the tomb of Gaston de Foix 411

PINACOTECA SABAUDA

Desiderio da Settignano: Virgin and Child 375, 376

URBINO

S. Domenico

Luca della Robbia: Lunette 365

VADUZ

LIECHTENSTEIN COLLECTION

Bertoldo di Giovanni: Male Figure
with Shield 402

Francesco di Giorgio: St Anthony

Abbot 394

Riccio, workshop of, Warrior on Horseback 417

VENICE

Ca' d'Oro

Riccio: Legend of the Cross 334, 415 CAMPO DI SS. GIOVANNI E PAOLO Andrea del Verrocchio: The Colleoni Monument 205–7, 208, 211, 265, 383, 387–8, 427; plates 190–2

Carmini

Francesco di Giorgio: Lamentation over the Dead Christ 221, 394

MUSEO CORRER Riccio: Bust of a Youth 359

Palazzo Ducale

Antonio Bregno: Arco Foscari 418,

Bartolommeo Buon: Porta della Carta 311, 418

Pietro Lombardo: Doge Leonardo Loredano before the Virgin and Child 328; plate 318

Pietro Lombardo, style of: Madonna delle Biade 421

Antonio Rizzo: *Adam* **312**, 419, **420**; plate 302

Antonio Rizzo: *Eve* **312**, 419, **420**; plate 301

PALAZZO VENDRAMIN-CALERGI Francesco Segala: *Eve* 425 Tullio Lombardo: *Eve* 425 S. Aponal

Antonio Rizzo: Monument of Vittore Cappello 419

S. Francesca della Vigna Pietro Lombardo: style of: *Sculpture* in Giustianini Chapel 328

S Clopp

Pietro Lombardo: *Angel* **324**, 421, **422**; plate 316

Pietro Lombardo: Sculpture in the Cappella Maggiore 324, **422**

S. GIOVANNI CRISOSTOMO

Tullio Lombardo: The Coronation of the Virgin 330, 339, 423, 424; plates 320, 321

SS. Giovanni e Paolo

Lorenzo Bregno: Statues on Vendramin Monument 425

Pietro di Niccolò Lamberti and Giovanni di Martino: Monument of Tommaso Mocenigo 311, 315, 371, 418, 423

Pietro Lombardo: The Malipiero Monument 315, 418, 421; plate 304

Pietro Lombardo: *The Marcello Monument* **320**, 421; plate 309 Pietro Lombardo: *Monument of*

Pietro Mocenigo, 255, **315–20**, 323, 328, 421, **422**, 425, 426; plates 305–7

Tullio Lombardo: St Mark Baptizing Ammianus (Monument of Giovanni Mocenigo) 328, 423–4; plate 317 Tullio Lombardo: The Vendramin

Monument **323**, 328, 330, 423, **424–5**, 426; plates 312, 313

S. Marco

Bronze Horses, 199, 211; plate 187 Antonio Lombardo: *The Zen Altar*, **339**, **426–7**; plates 328, 329

S. Maria dei Frari

Savelli Monument 199 Antonio Bregno: The Foscari

Monument **311**, 315, **418–19**; plates 297, 298

Donatello: St John the Baptist 41 Pietro Lombardo: Monument of Alvise Foscarini 422

Pietro Lombardo: Monument of Jacopo Marcello 421

Pietro Lombardo: Monument of Lodovico Foscarini 421, 423

Antonio Rizzo: *The Tron Monument* **311–12**, 315, **419–20**, 422; plates 299, 300

S. Maria del Giglio

Master of San Trovaso: Medallion

with Head of the Young Baptist 420

S. Maria della Salute

Antonio Rizzo: Figure from the Tomb of Antonio Barbarigo 419

S. Martino

Tullio Lombardo: Angels from S. Sepolcro 423

S. Pantaleon

Cristoforo Solari: Bust of Christ 410

S. TROVASO

Master of S. Trovaso: *Angels* **324**, **420–1**; plate 315

SCUOLA DEI CALZOLAI

Pietro Lombardo: St Mark Curing Ammianus 330

Scuola di San Marco

Façade, 330; plate 319

VERONA

S. FERMO MAGGIORE

Nanni di Bartolo: *Brenzoni Monument* 320, 418

Riccio: The Della Torre Monument

296-302; plate 286

Sagrato di S. Maria Antica

Bonino da Campione: Monument of Cansignorio della Scala 349

Via delle Fogge

Donatello: Virgin and Child (Verona Madonna) **66**, 355; plate 66

VICENZA

Museo Civico

Antonio Rizzo: Statue of Giovanni Emo 419

VIENNA

Kunsthistorisches Museum

Antico: *Venus Felix* **294–6**, **418**; plate 280

Bertoldo di Giovanni: *Bellerophon* and *Pegasus* **294**, 402; plate 272

Desiderio da Settignano: *Head of a Child* 375

Donatello: Madonna and Child with Two Angels 355

Filarete: Odysseus and Iros 398

Filarete: *Tabernacle Door* 398 Francesco Laurana: *Bust of a Lady*

396 Francesco Laurana: *Isabella of Aragon*

192, 241, 396; plate 180 Tullio Lombardo: *Bacchus and Ariadne* 324, 424; plate 314

Andrea del Verrocchio: *Madonna* 372, 374

VITERBO

S. Maria della Quercia

Andrea Bregno: Tabernacle 231, 406

S. Maria della Verità

Isaia da Pisa: Mazzatesta Ciborium

VOLTERRA

Duomo

Mino da Fiesole: Tabernacle 378

WASHINGTON

NATIONAL GALLERY OF ART

Agostino di Duccio: *Madonna* 389 Desiderio da Settignano: *Bust of a*

Child 191, 375; plate 174 Desiderio da Settignano: Ciborium

375 Desiderio da Settignano: *St Jerome*

before a Crucifix, 118, 375, 377; plate 113

Desiderio da Settignano (?): Portrait of Simonetta Vespucci 377

Desiderio da Settignano (?):

Unfinished Bust of a Girl 377 Francesco di Giorgio: Judgment of Paris 394

Francesco di Giorgio: Roundels of SS. Sebastian and John 394

Francesco di Giorgio: St Jerome in the Wilderness 394

Francesco Laurana, Bust of a Lady

Mino da Fiesole: Astorgio Manfredi 182, 378

Antonio Rossellino: Madonna 374 Vecchietta: Female Figures with a Torch 287

Andrea del Verrocchio: Giuliano de' Medici, 194, 383; plates 182, 183

Andrea del Verrocchio: Lorenzo de'
Medici 383

Andrea del Verrocchio: Relief of Alexander the Great 126, 383 Andrea del Verrocchio (?): Putto

WINDSOR CASTLE

385

ROYAL COLLECTION

Leonardo da Vinci: *Studies for the Sforza Monument* **208–12**, 213;
plate 194

Leonardo da Vinci: Studies for the Trivulzio Monument 212–13; plates 196, 197

Guido Mazzoni: Bust of a Child 412

Page numbers in bold type indicate	311, 407-9 , 419	139-40, 142, 361, 362, 363-4 ; plate	Bellini, Gentile 402, 414, 419
principal references	Arca of the Persian Martyrs 409	128	Madonna (Berlin) 312
	Arca of St Arealdo 409	Aragazzi, Francesco 364	Scuola di S. Marco pulpit 312
Acquasparta, Cardinal Matteo, Tomb 371	Arca of St Lanfranco 407	Aristides 13	Bellini, Giovanni 312, 328, 419
Adriano Fiorentino 402	A Carthusian Friar Presented to the	Aristotle 139, 173	S. Giobbe Altarpiece 330
Agostino del Pozzo 411	Virgin and Child 407	Arnolfo di Cambio 10, 13	Bellotti, Giovanni Antonio 411
Agostino di Duccio 243, 244, 246, 324,	The Coronation of the Virgin 407	Arte di Calimala 345	Benedetto Bonfigli 389
388–91 , 420	Decoration of Portinari Chapel 407	Arte dei Corazzai 349	Benedetto da Maiano 107, 126, 359, 369,
Altar of the Pietà 388	Doorway of the Small Cloister (Pavia)	Arte della Lana 365	372, 375, 377, 380–3 , 385, 391
Angel drawing a Curtain 192, 255, 390;	271–5 , 407; plate 255	Arte della Mercanzia 130	Altar of St Bartolo 381
plate 233	Façade of the Colleoni Chapel	Averlino, Antonio see Filarete	
Arca degli Antenati 250, 255, 320, 389,	265–8 , 407, 408–9 ; plates 249, 250	Thermo, thromo set I harete	Altar of St Fina 380
390; plate 240	Monument of Medea Colleoni 268-71,	Baccio da Montelupo 376, 377	The Annunciation 114, 382; plates 109,
Façade of S. Bernardino 243, 255,	280, 407, 408 ; plates 248, 252	St John the Evangelist 368	Flore of Countries I' Discussion
388, 389–90 ; plates 227, 230	Playing Children 268; plate 251	Bajazet, Sultan 401	Bust of Onofrio di Pietro 382
Miracle of St Bernardino 243, 389; plate	Relief from the Arca of St Lanfranco 280,	Baldovinetti, Alesso 159–60, 368, 373	Ciborium 380
229	283; plate 260	Bambaia 283, 411–12	Coronation of Ferdinand of Aragon 381
Monument of Bishop Giovanni Geraldini	St Imerio Giving Alms 275 , 407, 409 ;	Bua Monument 411	Filippo Strozzi 186–91 , 382; plate 175
388	plate 257		God the Father 382
Monument of Matteo and Elisabetta	Spandrel Decoration of the Small Cloister	Clarity 285; plate 267	Lavabo: Evangelists 381
Geraldini 388	(Pavia) 271 ; plate 253	Charity 285, 411; plate 265	Madonna dell'Ulivo 381
Playing Children 250, 255; plate 236	Virgin Annunciate 271, 407; plate	Effigy of Gaston de Foix 285, 411–12;	Monument of Filippo Strozzi 381
Porta alle Due Porte 388	254	plate 264	Pietro Mellini 186, 381-2; plates 176,
Rothschild Madonna 389	Virgin and Child with Three Angels 407	Fortitude 285, 411; plate 266	177
Scene from the Legend of St Sigismund	Amadeo, Protasio 407	Monument of Marino Carracciolo 411	Pulpit (Florence) 107-14, 380, 382-3,
255, 390	Amalfi, Duke of 372	Monument of Lancino Curzio 411	391; plates 106, 107
Scenes from the Life of St Gimignano		Sculptures from the Birago Monument	St John the Baptist 126, 380, 382, 383;
243 , 388; plate 228	Ambrogio da Airuno 411	411, 412	plates 120, 121
Sculptures from the Maestà delle Volte	Ambrogio da Cremona 411	Sculptures from the Monument of	St Sebastian 126-30, 381; plate 122
388	Ambrogio da Milano 372	Francesco Orsini 410	Shrine of St Savino 380
	Ammanati, Bartolommeo 385	Vimercati Monument 411	Tabernacle 370
Sibyls 249–50 , 255; plate 239	Andrea dell'Aquila 238, 397	Barbarigo, Doge Antonio 419	Virgin and Child 381
Tomb of Ruggero Mandosi 388	Andrea dalle Caldiere 356, 358	Baroncelli, Niccolò 202, 257	Vision of Pope Innocent III 382
Virgin and Child with Four Angels 388,	Andrea di Domenico di Polo 385	St George 257; plate 242	Benedict XIV, Pope 379
389 ; plate 226	Andrea di Lazzaro see Buggiano	Bartolo di Angiolino Angiolini 181	Bentivoglio, Anton Galeazzo 414
Virtues 249; plate 238	Andrea Pisano 9, 21, 44, 53, 349, 350,	Bartolomeo da Torciano 389, 390	Bentivoglio, Giovanni II 414
Alari Bonacolsi, Piero Jaciopo see Antico	365	Bartolommeo di Gherardo 361	Bernini, Giovanni Lorenzo 26, 177
Alberghetto, Giovanni 427	Andrea da Saronno 411	Bassano, Jacopo 397	St Teresa 168
Alberti, Leon Battista 202, 370, 371, 379,	Angelo di Baldassare 389	Battle Sarcophagus 289–94, 403; plate 276	Bertini, Domenico 391, 392
389, 390	Angelo da Murano 397	Beato Marcolino da Forlì, Monument	Monument 391, 392
De equo animante 202	Antico 294, 417–18	369, 372	Bertoldo di Giovanni 177, 221, 289, 296,
De statua 10-13, 185, 186, 401	Cupid 294 ; plate 278	Beatrice of Aragon, Portrait bust 396	359, 360, 361, 394, 402–3 , 404
Della pittura 79, 401	Hercules and Antaeus 296; plate 282	Beaufort, Lady Margaret, Tomb 403	Apollo 294, 402, 403; plate 277
Tempio Malatestiano, Rimini 243,	Venus Felix 294–6 , 418 ; plate 280	Begarelli, Antonio, Deposition 257	Battle Relief 289-94, 402, 403; plates
244, 246, 249	Antonello da Messina, 312	Bellano, Bartolommeo 296, 339, 360,	273-5
Alberto Maffiolo da Carrara 409	Antonio di Chellino 238, 397	361, 414–15	Bellerophon and Pegasus 294, 402; plate
Albizzo di Pietro 348	Antonio di Duccio 388	Atlas 296, 414	272
Alessandro di Luca Mini 378	Antonio Lombardo 323, 328, 339, 421,	David 289, 402, 414; plate 285	Crucifixion with Saints 402
Alexander V, Pope, Tomb 257	422, 423, 426-7	De Castro Monument 414	Hercules 402
Alexander VI, Pope 177, 403	Child Christ 426	Lamentation over the Dead Christ 414	Hercules on Horseback 402
Alexander the Great 287	The Miracle of the New-Born Child 334,	Miracle of the Mule 414	Hercules with the Apples of the Hesperides
Alfonso, Duke of Calabria 382, 394, 412	425; plate 324	Monument of Raimondo Solimani 414	402
Alfonso II, King of Naples 381, 396	Mythological Scene 339, 426; plate 327	Rape of Europa 296, 414	Male Figure with Shield 402
Alfonso of Aragon, King of Naples 237,	Relief with Two Eagles 426	Roccabonella Monument 339, 414, 415;	Prisoner 402
238, 358, 396–7; plate 221	Venus and Apollo 426	plate 322	Putti 402
Alfonso Lombardi 413	Zen Altar 339, 426-7; plates 328,	St Jerome 414	St Jerome 402
Algardi, Alessandro 177	329	Samson Destroying the Temple 296, 414,	Betto di Francesco Betti 399
Alvaro, Bishop of Silves 373	Apollonius Rhodius 246	415 ; plate 283	3//
Amadeo, Giovanni Antonio 280, 283,	Aragazzi, Bartolommeo, Monument	Bellati, Matteo, Monument 423	Bichi, Antonio 395 Biondo, Flavio 226
,J,	o,	2 - Law, Macco, Monument 423	Diolido, Flavio 220

Bisticci, Vespasiano da 142	377-8	St Catherine of Alexandria 221	St John the Baptist (Martelli Baptist) 126,
Uomini illustri 139	History of Florence 142	Tabernacle 391	375; plate 118
Boito 357	Laudatio florentinae urbis 13	Tomb of S. Pellegrino 392	St Mary Magdalen 126 , 218, 359, 375;
Bonino da Campione	Monument 142-6 , 149, 155, 159, 165,	Tomb of San Romano 391, 392;	plate 117
Monument of Cansignorio della Scala 349	168, 315, 368, 369, 370–1 , 374,	plate 145	Virgin and Child (Foulc Madonna) 114,
Borgia, Cesare 403	377-8, 380, 391; plates 134, 135,	Virgin and Child 391	126, 376 ; plate 111
Botticelli, Sandro 381, 402	140	Coducci, Mauro 421, 424	Virgin and Child (Turin) 375
Botticini, Francesco 372	Buggiano 353, 368, 371	Codussi, Domenico 311, 330, 424	Dogio di Neri 361
Bracciolini, Poggio 155, 346, 363, 364,	Lavabo 103, 344; plate 94	Colaccio 315	Dolcebuono, Antonio 411
367	Pulpit (Florence) 107, 344, 372, 375;	Colleoni, Bartolommeo 265, 408, 409	Domenico di Paris 414
Bramante, Donato 394	plate 104	Monument 205-7, 208, 211, 265, 383,	Decoration of the Anticamera 257; plate
Brancacci, Cardinal Rainaldo, Monument	Buon, Bartolommeo 241, 243, 311, 320,	387–8 , 427; plates 190–2	243
47–9 , 140–2, 231, 349–50 , 358, 361,	330, 418, 420	Colleoni, Medea, Monument 268–71,	St George 257; plate 242
362–3 , 364, 374, 405; plates 44,	Porta della Carta 311	280, 407, 408 ; plates 248, 252	Domenico Veneziano 92
130, 131	Buon, Giovanni 320	Coppi, Stefano 403	Donatello 9, 15-42 , 44-75 , 79, 99,
Brantôme 285	Buora, Giovanni 426	Cornaro, Gregorio 419	114–18, 130, 149, 171, 181, 186, 194,
Bregno, Andrea 225, 231-7, 283, 378,	Busti, Agostino see Bambaia	Cossa, Giovanni 257, 263, 410, 412	212, 214–21 , 225, 238, 287–9 , 296,
406-7		Monument 395	312–15, 324, 339, 344, 346–61 , 363,
Borgia Altar 231, 406; plate 220	Campagna, Girolamo 425	Costoli, A. 349	364, 365, 366, 368, 374, 375, 383,
Coca Monument 406	Cappello, Antonio 402	Crispus see Riccio	386, 388, 393, 394, 399, 402, 403,
Ferrici Monument 405	Cappello, Vittore, Monument 419	Cristoforo Lombardi 411	414, 422, 425
Labretto Monument 406	Capponi, Neri 353	Monument of Lancino Curzio 411	Abraham and Isaac 350
Monument of Cristoforo della Rovere 406	Tomb, 168, 369, 372; plate 154	Crivelli, Giovanni, Tomb-Slab 225, 346	Amor-atys 37, 287; plate 31
Monument of Raffaello della Rovere 406,	Capponi, Piero 381	Crucifixion of St Peter (Roman) 225;	The Ascension with Christ giving the
407	Carracciolo, Marino, Monument 411	plate 210	Keys to St Peter 49, 56, 350, 352;
Piccolomini Altar 231–7, 406	Castagno, Andrea del 75, 399	Curzio, Lancino, Monument 411	plates 45, 46
Relief from Tomb of Cardinal Nicholas of	Catherine of Aragon 404		The Assumption of St John the Evangelist
Cusa 406	Cattaneo, Danese 425	Dalmata, Giovanni see Giovanni Dalmata	56 , 85–8, 346, 355–6 , 396; plate 54
Savelli Monument 406, 407	Cavalcanti, Niccolò 354	Dante, Tomb 328, 421	Baptismal Font (Siena) 214
Tabernacle 231, 406	Cervi, Benedetto 411	Dati, Leonardo, Tomb-Slab 171	Brancacci Monument 47–9, 140–2,
Tebaldi Monument 405, 406	Charles IV of Anjou, Monument 395	De Angelis, P. 379	231, 349–50 , 358, 374, 405; plates
Tomb of Cardinal Pietro Riario 231, 406,	Charles VIII, King of France 404, 412	Delfin, Paolo 311	44, 130
407 ; plates 218, 219	Charles d'Amboise 212	Della Torre, Giovanni Battista 416	Bronze David 37, 126, 130, 218, 289,
Bregno, Antonio 418–19	Chellini, Antonio 356	Della Torre, Girolamo, Monument	346, 354–5 , 375, 385; plates 32, 33
Arco Foscari 418, 419	Portrait bust 182–6 , 192, 372, 374 ;	296–302 , 305, 416 ; plate 286	Bronze Door for Siena Cathedral 72,
Foscari Monument, 311, 315,	plates 168, 169	Della Torre, Giulio 416	168, 210
418–19 ; plates 297, 298	Chellini, Giovanni 355	Della Torre, Marc Antonio, Monument	Cantoria 49–53, 80, 103, 205, 346,
Bregno, Lorenzo 425	Tomb 182, 369, 374	296–302 , 416; plate 286	352, 353 , 367; plates 47, 48
Bregnon, Giambattista 425	Chiaves, Antonio, Cardinal of Portugal,	Dentone, Giovanni 425	Cavalcanti Annunciation 26, 28,
Briosco, Ambrogio 415 Briosco, Andrea see Riccio	Monument 397, 405 Chierichini, Giovanni 181	Desiderio da Settignano 103–7, 114–18 ,	114, 130, 353–4 , 356; plates 19, 20
Briosco, Benedetto 407, 411	Christus, Petrus 268	155, 186, 192, 194, 243, 257, 315, 328,	Crucifix (Padua) 257
		354, 369, 370, 371, 373, 374, 375–8 ,	Dead Christ with Angels 353
Reliefs (Pavia) 280, 283	Cibo, Cardinal Lorenzo 401	379	External Pulpit (Prato) 49, 80, 107,
Bronze Horses (St Mark's) 199, 211; plate	Cima 339, 410	The Altar of the Sacrament 107, 118,	205, 265–8, 346, 352–3 , 362, 367;
187	Ciminal of Amount 258	191, 257, 375, 376–7 ; plates 100–3	plate 49
Brunelleschi, Filippo 9, 15, 19, 79, 146,	Ciriaco of Ancona 358	Bust of a Child 191, 375; plate 174	Figure of a Pugilist 287
168, 257, 344–6 , 348, 355, 358, 362,	Ciuffagni 15, 390	Bust of a Lady 191-2, 377; plate 179	Gattamelata Monument 202-5, 207,
367, 422	St Matthew 347	The Child Christ and the Young Baptist	208, 211, 346, 356, 358 ; plates 184,
Lavabo 103, 344; plate 94	St Peter 344	118, 375, 377	188, 189
Old Sacristy (Florence) 53–6,	Civitali, Matteo 107, 155, 391–2	Ciborium 375	Habakkuk 26 , 350–1; plate 18
85–8, 168, 324; plate 52	Altar of the Samurant 201, 202	Marsuppini Monument 146–9, 155,	High Altar of S. Antonio, Padua
Pazzi Chapel 79, 85, 88 , 92, 367;	Altar of the Sacrament 391, 392	160, 168, 257, 315, 375, 377–8 , 383,	26–37 , 56–9, 218, 287, 328, 339,
plate 82	Chapel of the Volto Santo 391	391; plates 138, 139, 141	346, 346, 356–8 ; plates 21–9
Pulpit (Florence) 107, 344; plate 104	Madonna della Tosse 391 Man of Sorrows 392	Panciatichi Madonna 118, 126, 375,	Jeremiah 25–6 , 350, 361; plates 13, 15
The Sacrifice of Isaac 9–10, 15, 345–6;		376; plate 112	Judith and Holofernes 37-41, 136, 289,
plates 1, 3 Bruni, Donato 370	Monument of Domenico Bertini 391, 392	Relief of Young Baptist 375	346, 359–60 , 402; plates 34–8
Bruni, Leonardo 139, 142, 186, 348, 364,	Monument of Piero da Noceto	St Jerome before a Crucifix 118, 375,	Madonna and Child with Four Angels
Diam, Econardo 139, 142, 100, 340, 304,	155–9 , 372, 391, 392; plate 144	377 ; plate 113	355

Madonna of the Clouds 355 Marble David 16, 19, 37, 42, 346, 348; plate 4 The Miracle of the Miser's Heart 50. 356-8; plate 59 The Miracle of the Mule 59, 356, 357-8; plate 57 The Miracle of the New-Born Child 59, 66, 328, 356, **357-8**; plate 56 The Miracle of the Repentant Son 59-66, 356, 357-8; plates 58, 60, 61 Monument of Pope John XXIII (Coscia Monument) 142, 171, 361-4, 371-391; plates 132, 133 Niccolò da Uzzano 374 Pazzi Madonna 66, 355; plate 62 Pecci Tomb-Slab 171, 346 The Presentation of St John the Baptist's Head to Herod, 56, 59, 352, 355, 361; plate 55 Prophet over Porta della Mandorla 15 Pulpits (Florence) 72-5, 289, 360-1, 402, 414; plates 68-73 Putto 37, 136, 287; plate 30 Sacristy Door (Florence) 53, 85, 225, 231; plates 50, 51 St George 20, 346, 348-9; plates 8-10 St George and the Dragon 44-7, 349, 350; plates 42, 43 St John the Baptist 41, 214, 218, 346; plate 39 St John the Evangelist 15-16, 346, **347-8**; plate 5 St Louis of Toulouse 25, 56, 130, 287, 346, **351**, 359, 361, 386; plates 16, St Mark 19-20, 126, 136, 346, 348, 396; plate 7 St Mary Magdalen 41-2, 126, 218, 346, 358-9, 375; plates 40, 41 Sts Stephen and Lawrence 346, 355-6; Tabernacle 103, 107, 225, 346; plate 96 Tomb-Slab of Giovanni Crivelli 225, 346 Unidentified Prophets 21-5, 126, 181, 346, 350-1; plates 11, 12, 14 Virgin and Child (Berlin) 66; plate 65 Virgin and Child (Paris) 66, 114, 355; plates 63, 64 Virgin and Child (Siena) 72, 214; plate Virgin and Child (Verona Madonna), 66, 355; plate 66 Virgin and Child with Four Angels 355 Donati, Lucrezia 385 Dosio 406

Eleanora of Aragon 412 Elizabeth of York, Monument 177, 403, 404; plate 164 Emo, Giovanni 419, 420 Erasmo da Narni see Gattamelata Ercole de' Roberti 414 Crucifixion 263 Este, Alfonso d' 339, 426 Este, Beatrice d' 280, 409, 410; plate 261 Este, Borso d' 346 Este, Ercole d' 412, 414 Este, Isabella d' 237, 294, 410, 423, 417 Este, Lionello d' 199, 257 Este, Lodovico il Moro 280, 410; plate 261 Este, Niccolò III d' 199, 257 Estouteville, Cardinal d' 231, 378, 379 Euclid 173 Eugenius IV, Pope 225, 367-8, 391, 398, 399 Monument 405 Eyck, Jan van 268 Fabri, Felix 387 Falconetto, Giammaria 425 Farnese, Piero 199 Farnese, Ranuccio 405 Federighi, Antonio Baptismal Font 214; plate 199 St Ansanus 214, 217; plate 198 Federighi, Benozzo, Bishop of Fiesole, Tomb 80-5, 159, 365, 367, 368; plate Ferdinand of Aragon 381 Fernach, Hans von 268-71 Ferrante I, King of Naples 237, 397, 412, 413 Filarete 249, 349, 397-9, 405 Bronze Door 225-6, 231, 397, 398-9; plates 211, 212 Chiaves Monument 397 Hector on Horseback 398 Marcus Aurelius 398 Medallic Self-portrait 398 Odysseus and Iro 398 Processional Cross 397 Tabernacle Door 398 Trattato d'architettura 225, 358, 375, 397, 398 Triumph of Caesar 398 Virgin and Child with Angels 398 Fisher, John, Bishop of Rochester 403 Foppa, Vincenzo 268, 275, 407 Forni, Lodovico 388 Forteguerri, Cardinal Niccolò, Monument 165-8, 194, 208, 378, 383, 386-7, 424; plates 150, 152, 153

Forteguerri, Piero 386

Foscari, Doge Francesco 420 Monument 311, 315, 418-19; plates 207. 208 Foscarini, Alvise, Monument 422 Foscarini, Lodovico, Monument 421, 423 Fracastoro 416 Francesco di Cola 417 Francesco di Giorgio 217, 221, 394-5 Aesculapius 394 Allegory of Discord 394 Angel 221, 394, 395; plates 208, 209 The Flagellation of Christ 221, 394-5; plate 207 Judgement of Paris 394 Lamentation over the Dead Christ 221, Lycurgus and the Maenads 221, 394 Marble relief of Virgin and Child 394 Mythological Scene 394 Roundel of St Jerome 394 Roundels of Sts Sebastian and John 394 St Anthony Abbot 394 St Christopher 394 St Jerome in the Wilderness 394 St John the Baptist 218, 394; plate 206 Francesco da Settignano 375 Francesco di Simone 243 Francesco del Tadda 385 Francesco da Tergola 356 Francesco di Valdambrino 214, 345 Francesco del Valente 356 Francis I, King of France 212, 285, 411 Gaddi, Agnolo 199, 354 Statue of Piero Farnese 199 Gaddi, Taddeo 386 Gaggini, Domenico 238, 395, 396, 397 Gambello, Antonio 422 Gamberelli, Matteo 369 Gaston de Foix 283-5, 411-12; plate 264 Gattamelata 202-5, 207, 208, 211, 346, 356, 358; plates 184, 188, 189 Gauricus, Pomponius 415, 417, 422-3 De sculptura 323-4 Gentile della Leonessa 358 Geraldini, Elisabetta, Monument 388 Geraldini, Bishop Giovanni, Monument Geraldini, Matteo, Monument 388 Geri da Settignano 375, 378 Ghiberti, Lorenzo 15, 53, 56, 79, 225, 354, 361, 364, 367, 370, 386, 415 Arca of Three Martyrs 368 Baptismal Font (Siena) 214 Commentari 10, 345 First Bronze Door 92, 181, 210, 361, Porta del Paradiso 181, 210, 225, 287,

345, 398, 399; plate 269 The Sacrifice of Isaac 9, 10, 345; plate St John the Baptist 25 St Matthew 25, 35, 136, 139, 361, 362 St Stephen 348 Tomb-Slab of Fra Leonardo Dati 171 Ghiberti, Vittorio 361, 370, 399 Ghirlandaio, Domenico 114, 186 Gian Cristoforo Romano 283, 410 Monument of Gian Galeazzo Visconti 213, 237, **283**, 285, 412; plates 262, Gianelli, Beato Girolamo, Tomb 405 Ginevra dei Benci 385 Giorgio da Sebenico 241, 395, 405 Giorgione 339 Giotto 10, 44, 381 Giovanni d'Andrea 369 Giovanni d'Andrea di Domenico 388 Giovanni Antonio da Osnago 411 Giovanni di Balduccio, Baroncelli Monument 159 Giovanni di Barduccio Cherichini 351 Giovanni Bartolommeo da Ponte 425 Giovanni di Cosma, Tomb of Cardinal Matteo Acquasparta 371 Giovanni di Francesco 354 Giovanni da Maiano 381 Giovanni di Martino, Monument of Tommaso Mocenigo 311, 315, 371, 418, 423 Giovanni da Milano 354 Giovanni di Paolo 218, 352 Giovanni da Pisa 356 Giovanni di Stefano 395 Foscari Monument 401 Giovanni da Tolentino 388 Giovanni Dalmata 378, 405-6 The Creation of Eve 231, 405; plate 217 Eroli Monument 405 Ferrici Monument 405 Monument of Pope Paul II 231, 406; plate 215 Roverella Monument 405 St John the Evangelist 405 Tebaldi Monument 405 Tomb of the Beato Girolamo Gianelli 405 Tomb of Cardinal Pietro Riario 407; plate 219 Giovanni Nani da Firenze 356 Giovanni Pisano 10, 13 Giovanni Turini 352 Giugni, Bernardo, Monument 378, 379 Giuliano da Maiano 380, 383 Giustiniani, Orsato, Tomb 311, 419, 420,

Giusto dei Conti 390

Giusto di Francesco da Settignano 344 Goethe, Johann Wolfgang von 339 Gonzaga, Francesco 417 Gonzaga, Gianfrancesco 294, 417 Gonzaga, Lodovico 41, 294 Gonzaga family 417 Griffolini, Francesco 377 Guardi, Andrea 392 Guazzalotti 402 Guglielmo, Fra, Pulpit (Pistoia) 349-50 Hannibal 287 Hawkwood, Sir John 199; plate 185 Heemskerck, Marten van 401 Henry VII, King of England 403 Monument, 177, 403, 404, 412; plates 164, 165 Henry VIII, King of England 403, 404 Hercules and Antaeus (Roman), 296; plate

Houdon, Jean-Antoine 191

Hugo, Count of Tuscany, Monument

155, 378, 379-80, 406; plates 142, 143

Innocent VIII, Pope, Tomb 177, 399, **401**; plates 161-3 Isabella of Aragon 396 Portrait Bust 192, 241, 396; plate 180 Isabella of Portugal 404 Isaia da Pisa 237, 238, 378, 379, 397, 405 Chiaves Monument 397, 405 Effigy of St Monica 405 Mazzatesta Ciborium 405 Monument of Pope Eugenius IV 405 Orsini Madonna 405 Tabernacle of St Andrew 226-31, 405 Temperance 225, 226, 249, 405; plate Virgin and Child with Sts Peter and Paul, 226, 405; plate 214 Isotta degli Atti 244, 390 Tomb 390

Jacopino da Tradate, Pope Martin V 181
Jacopo della Quercia 9, 199, 214, 345
Fonte Gaia 217
Loggia di S. Paolo 214
Trenta Altar 217
Trenta Tomb-Slabs 171
Vari-Bentivoglio Monument 257
Zacharias in the Temple 352
John XXII, Pope 405
John XXIII, Pope 363
Monument, 142, 171; plates 132, 133
Julius II, Pope 171, 173, 400
Tomb 339

Laurana, Francesco 192, 238-41, 255,

Alphonso of Aragon and his Court 238, 395, **396-7**; plate 221 Bust of Battista Sforza 396 Bust of a Lady 396 Christ Carrying the Cross 241, 395 Isabella of Aragon 192, 241, 396; plate 180 Mastrantonio Chapel 241 Monument of Charles IV of Anjou 395 Monument of Giovanni Cossa 395 Portrait Bust of Beatrice of Aragon 396 Tabernacle of St Lazare 241, 395 The Mastrantonio Chapel 241, 396; plate 224 Tomb-Slab of Cecilia Aprilis 395 Virgin and Child 241, 395, 396; plate 225 Lautrec, regent of Milan 285 Lazzari, Filippo, Monument 369, 372 Leo X, Pope 360 Leonardo da Vinci 165, 199, 202, 221, 383, 385, 387, 394, 395, 409 Adoration of the Magi 210 Battle of Anghiari 212 Leda 285 Studies for the Sforza Monument 208-12, 213; plates 194, 195 Studies for the Trivulzio Monument 212-13; plates 196, 197 Leonardo d'Antonio da Maiano 380 Leone, Giovanni Battista de 305, 417, 426 Leonicus 206 Leopardi, Alessandro 207, 388, 425, 427 Lippi, Fra Filippo 118, 377 Lombardi, Alfonso, Death of the Virgin 257 Lombardo, Antonio see Antonio Lombardo Lombardo, Pietro see Pietro Lombardo

Louis XII, King of France 212, 283, 412 Lysistratus of Sicyon 181 Macchiavelli, Niccolò 139 Macrobius 246 Mahomet II, Sultan 414 Malatesta, Sigismondo Pandolfo 244, 246, 255, 390 Male Nude (Roman) 308; plate 293 Male Portrait Busts (Roman) 185; plates 170, 171 Malipiero, Pasquale, Monument 315, 418,

Lombardo, Tullio see Tullio Lombardo

Loredano, Doge Leonardo 328; plate

Lorenzo di Credi 207, 383, 387-8

Lotti, Lorenzetto 387

318

421; plate 304 Malvito, Tommaso 395 Mandosi, Ruggero, Tomb 388 Manetti, Antonio 369, 373 Manetti, Gianozzo 142, 370 Manfredi, Andrea 413 Manfredi, Astorgio, Portrait bust 182, 378 Manfredi, Carlo 380 Manfredi, Giovanna 380 Mantegazza, Antonio 207, 271, 275, 280, 283, 407, **409-10** Lamentation over the Dead Christ 275-80, 285, 409-10; plates 258, Mantegazza, Cristoforo 207, 271, 275, 280, 283, 407, 409-10 Mantegna, Andrea 294, 315, 357, 410 Marcello, Jacopo, Monument 421 Marcello, Niccolò, Monument 320, 421; plate 309 Marco Pino da Siena 363 Marcus Aurelius (Roman), 199, 202, 205, 207, 208; plate 186 Margaret of Austria 403 Marino da Murano 397 Marsuppini, Carlo 142, 186, 370 Monument 146-9, 155, 160, 168, 257, 315, 375, 377-8, 383, 391; plates 138, 139, 141 Martelli, Giovanni di Jacopo 374 Martelli, Roberto 375 Martial 287 Martin V, Pope 181, 346, 363 Tomb-Slab 171, 362, 401; plate 156 Mary of Aragon 165 Tomb 372, 381 Masaccio 47-9, 66, 79, 118, 181, 350 Mascoli Master 330 Maso di Banco 165 Maso di Bartolommeo 352, 362, 365 Detail of Grille 287; plate 271 Masolino 350 Masoni, Gaetano 387 Master of E 390 Master of the Marble Madonnas 243, 377 Master of S. Trovaso 420-1 Angels 324, 420-1; plate 315 Matteo di Giovanni 218, 394 Matthias Corvinus, King of Hungary 383, 385, 405 Mazzoni, Guido 404, 412-13, 415 Adoration of the Virgin and Child 412 Bust of a Child 412 Entombment 412 Fragmentary Nativity 412 Lamentation 412, 414

Lamentation over the Dead Christ 263;

plate 245

Lamenting Woman 263, 412-13, 414; plate 246 Nativity 412 Medici, Cosimo de' 346, 354, 355-6, 359, 360, 363 Tomb 383 Medici, Cosimo il Vecchio 346, 361 Medici, Giovanni de' 375 Monument 168-71, 208, 383; plate 155 Portrait Bust 182 Medici, Giovanni di Bicci de' 363 Medici, Giuliano de' 289, 401 Portrait Bust 194, 383; plates 182, 183 Medici, Lorenzo de' 210, 289, 350, 354, 385, 386, 399, 402 Portrait Bust 383 Medici, Lorenzo il Magnifico 168, 386, Medici, Orlando de' 368 Tomb 369 Medici, Piero de' 359, 377, 398 Monument 168-71, 208, 383; plate 155 Portrait Bust 181-2, 378, 380; plate 166 Medici, Vieri de' 366 Medici family 289 Mellini, Pietro 382 Portrait bust 186, 381-2; plates 176, Michelangelo 15, 41, 289, 339, 349, 382, 403, 404, 410, 413 Bacchus 126 Battle of the Centaurs 403 David 37, 130 Dying Slave and Rebellious Slave 339 Moses 16 Pietà 410 Michele da Foce 358 Michelozzo di Bartolommeo 85, 103, 146, 346, 350, 351, 352, 353, 354, 356, **361-5**, 378 Adoring Angels 364 Bartolommeo Aragazzi Bidding Farewell to his Family 139-40, 142, 361, 362, 364; plate 128 Brancacci Monument 140-2, 358, 361, 363, 405; plates 130, 131 Cappella del Crocifisso 362, 365 Madonna 362 Madonna and Child 362 Monument of Pope John XXIII (Coscia Monument) 142, 171, 361-4, 371, 391; plates 132, 133 St Bartholomew 139; plate 129 St John the Baptist 362 Tabernacle 362 Tomb-Slab of Pope Martin V 171, 362,

401; plate 156

Virgin and Child with SS. John the St Philip 16-19 Pasinio 390 Pinturicchio 401 Baptist and Augustine 362 Nanni di Bartolo (Rosso) 41 Pasti, Matteo de' 246, 255, 388, 390 Pippo di Giovanni da Pisa 405 Michiel, Marcantonio 323 Abraham and Isaac 350 Aquarius 249, 250; plate 232 Pisanello 202, 397 Miliano Dei 399 Brenzoni Monument 320, 418 Brenzoni Monument 320 Music 249, 250; plate 234 Minelli, Antonio 425 Music-Making Angels 250; plate 235 Obadiah 350 Drawing for the Gateway of the Minelli, Giovanni 415, 425 Neri di Bicci 375, 376 Venus 250; plate 237 Castelnuovo 237-8; plate 223 Minio, Tiziano 425 Neroccio de' Landi 218-21, 392, 394 Paul II, Pope 405, 414, 425, 426-7 Portrait Relief of Pietro d'Avenza 392 Mino da Fiesole 155, 185, 194, 231, 243, St Bernardino 217, 218; plate 204 Monument 231, 378, 379, 405, 406; Pius II, Pope 155, 369, 378, 405 372, 378-80, 405 St Catherine of Siena 218; plate 205 plate 215 Commentarii 246, 390 Neroni, Diotisalvi 182, 378 Angels 378, 379 Paul III, Pope, Monument 177 Pizzolo, Niccolò 356, 357 The Assumption of the Virgin 231, 379; Paul V, Pope 398 Niccoli, Niccolò 363 Plethon, Gemistos 390 plate 216 Niccolò d'Arezzo 345 Pazzi, Andrea de' 368 Pliny 181, 182 Astorgio Manfredi 182, 378 Niccolò dell'Arca 257-63, 413-14 Pazzi, Jacopo de' 365 Politian 403 Bust of Alessandro di Luca Mini 378 Eagle 413 Peckham 173 Pollaiuolo, Antonio del 159, 160, 194, Bust of Giovanni de' Medici 182 Effigy of Andrea Manfredi 413 Peralta, Guglielmo 396 221, 358, 373, 394, **399-402** Bust of Rinaldo della Luna 378 Lamentation over the Dead Christ Perfetto di Giovanni 348 Birth of the Baptist 399 Della Rovere Monument 378 257-63, 413-14; plates 244, 247 Perugino 400 Crucifix 399 Diotisalvi Neroni 182, 378 Petrucci, Pandolfo 395 Madonna di Piazza 257, 413, 414 Drawing for the Sforza Monument Giugni Monument 378, 379 Prophet 413; plate 241 Phidias 225 **207–8**, 211, 399; plate 193 Monument of Cardinal Forteguerri 165, St John the Baptist 413 Philip II, King of Spain 413 Hercules 289, 402 Niccolò di Betto Bardi 346 Piccolomini, Giacomo 395 Hercules and Antaeus 289, 399, 401-2; Niccolò di Giovanni Fiorentino 418–19 Monument of Count Hugo of Tuscany Piccolomini Master 218 plate 268 155, 378, 379-80, 406; plates 142, Niccolò di Pietro Lamberti 345, 348 Pico della Mirandola 185 Terracotta Portrait Bust 400 143 Madonna della Rosa 369 Pier Antonio da Lendinara 425 Tomb of Pope Innocent VIII 177, 399, Monument of Francesco Tornabuoni 378 St Luke 16, 19, 21; plate 6 Piero da Noceto, Monument 155-9, 372, **401**; plates 161-3 Monument of Pope Paul II 231, 378, St Mark 15, 347 391, 392; plate 144 Tomb of Pope Sixtus IV 171-7, 399, 379, 406; plate 215 Niccolò da Noceto 391, 392 Piero della Francesca 75, 246, 390 400-1; plates 157-60 Niccolò Strozzi 182, 186, 378, 380; Niccolò da Uzzano 181, 374 Piero di Cosimo, Death of Procris 294 Pollaiuolo, Matteo del 382 plate 167 Nicholas V, Pope 155, 369, 390, 391 Piero di Zuane 427 Pollaiuolo, Piero del 173, 373, 386, 387, Piccolomini Monument 221 Nicholas of Cusa, Cardinal, Tomb 406 Pietro da Bonitate 396 399, 400, 401 Piero de' Medici 181-2, 378, 380; plate Nicola Pisano Pietro delle Campane 427 Polyclitus 225, 294 Arca of St Dominic 257, 413, 414 Pietro da Milano 238, 395, 397 Pontano, Giovanni 413 Salutati Monument 378 Pulpit (Pisa) 10, 13 Pietro di Niccolò Lamberti, Monument of Porcellio 225 Tabernacle (Florence) 378 Nino Pisano, Annunciation 10 Tommaso Mocenigo 311, 315, 371, 418, Porcellio de' Pandoni 405 Tabernacle (Rome) 378 Nori, Francesco 372 Porta, Guglielmo della, Monument of Tabernacle (Volterra) 378 Novius Vindex 287 Pietro Lombardo 315-23, 324, 330, 420, Pope Paul III 177 Tomb of Cardinal Pietro Riario 231, 378, **421-3**, 425, 426, 427 Portinari, Tommaso 384 406, 407; plates 218, 219 Odoni, Andrea 323 Angel 324, 421, 422; plate 316 Portugal, Cardinal of, Tomb 159-65, 182, Mino del Reame 378-9 Onofri, Vincenzo, Terracotta Group 263 Doge Leonardo Loredano before the Virgin 186, 192, 372, **373-4**, 391; plates Mocenigo, Doge Giovanni 420 Onofrio di Pietro 382 and Child 328; plate 318 146-9 Monument 328, 423-4, 426; plate 317 Orcagna: Malipiero Monument 315, 418, 421; Praxiteles 225 Mocenigo, Pietro 424 Strozzi Altarpiece 49 plate 304 Ptolemy 173 Monument 255, 315-20, 323, 328, 421, Tabernacle 44, 47 Marcello Monument 320, 421; plate Pucci, Luigi 402 Orsini, Clarice 354 422, 425, 426; plates 305-7 Mocenigo, Tommaso, Monument 311, Orsini, Francesco, Monument 411 Monument of Alvise Foscarini 422 Raverti, Matteo 418 315, 371, 418, 423 Orsini, Cardinal Giovanni Gaetano 405 Monument of Jacopo Marcello 421 Rembrandt 75 Mohammed II, Sultan 402 Orsini, Cardinal Latino 405 Monument of Lodovico Foscarini 421, René of Anjou 241, 365, 395 Montefeltro, Federigo da 392 Orsini, Virginio 208, 399, 402 Riario, Cardinal Pietro, Tomb 231, 378, Montefeltro, Guidobaldo da 394 Orsucci, Andrea 391 Pietro Mocenigo Monument 255, 406, 407; plate 219 Moro, Doge Cristoforo 420, 422 315-20, 323, 328, 421, 422, 425, Riccio 296-308, 323, 334, 402, 414, Pagno di Lapo Portigiani 352, 363, 367 Mosca 425 426; plates 305-7 415-17, 425 Pagno di Settignano 378 Roselli Monument 315, 421, 422; Bust of a Youth 359 Nanni di Banco 44, 47, 79, 344, 346, Palmieri, Matteo, Portrait Bust 186, plate 303 David with the Ark of the Covenant 415 349, 365 192-4, 372, 374; plates 172, 173 St Mark Curing Ammianus 330 Dead Christ with the Virgin and St John Assumption of the Virgin 165, 365 Panciatichi, Andrea 375 Three Saints 421 Paolo Romano 231, 237, 238, 378, 379, Isaiah 16, 348 Tomb of Dante 328, 421 Della Torre Monument 296-302; Quattro Santi Coronati 130, 368 397, 405 Zanetti Monument 320-3, 421, plate 286 St Luke 15, 16, 79, 139, 347 Parte Guelfa 130, 351 422-3, 426; plates 308, 310 Legend of the Cross 334, 415

Pan 308; plate 295 Paschal Candlestick 302-5, 416-17; plates 287, 289, 290 Satyr (Florence) 305-8; plate 291 Satyr (Paris) 305 Seated Shepherd 308; plate 294 The Sickness of Della Torre 302, 416; plate 288 The Story of Judith 415 Trombetta Monument 416 Warrior on Horseback 308, 417; plate 206 Youth with a Goat 308, 416; plate 292 Ridolfi, Lorenzo 181 Ridolfi, Marietta di Giovanni 374 Rinaldo della Luna 378 Rinuccini 13 Rizzo, Antonio 271, 275, 315, 418, **419-20**, 421 Adam 312, 419, 420; plate 302 Emo Monument 419, 420 Eve 312, 419, 420; plate 301 Figure from the Tomb of Antonio Barbarigo 419 Tomb of Orsato Giustiniani 311, 420, Tron Monument 311-12, 315, 419-20, 422; plates 299, 300 Robbia, Andrea della 88, 99, 365, 369, 391, 415 Foundlings 391 Madonna della Cintola 99, 391; plate Robbia, Giovanni della 99 Robbia, Luca della 79-99, 149, 255, 268, 346, 361, 362, 364, **365-9**, 379, 391, Altarpiece (Pescia) 365 Angels with Candlesticks 366 The Ascension 92, 99, 365, 367; plates 87,88 Cantoria 79-80, 85, 99, 103, 140, 353, 365, **366-7**; frontispiece, plates 74-8 Ceiling of the Chapel of the Cardinal of Portugal 99, 159, 365, 369, 373; plates 91, 92 Federighi Monument 80-5, 159, 365, 367, 368; plate 80 The Resurrection 88-92, 365, 367; plates 85, 86 Sacristy Door (Florence) 85, 210, 365; plate 79 St Matthew 88, 99, 367-8; plate 83 St Peter Predella 365 Stemma of the Arte dei Medici e Speziali 92, 364, 368-9; plate 89 Tabernacle 85, 88, 365, 367; plate 81

The Visitation 92, 365; plate 84 Robbia, Simone di Marco della 365 Robert the Wise 401 Roccabonella, Pietro, Monument 339, 414, 415; plate 322 Rodin, Auguste 35 Roselli, Antonio, Monument 315, 421, 422; plate 303 Rosselli, Domenico 243 Rossellino, Antonio 103, 107, 114, **118-26**, 155, 159, 191, 192, 194, 243, 328, 369, 370, 371, **372-4**, 375, 379, 380, 383, 391 The Adoration of the Shepherds 114, 372, 382; plate 108 Bust of a Lady 191-2, 374, 377; plate 178 Giovanni Chellini 182-6, 192, 372, 374; plates 168, 169 Madonna del Latte 118, 372 Matteo Palmieri 186, 192-4, 372, 374; plates 172, 173 Monument of Lorenzo Roverella 372 Pulpit 107, 372, 378, 383; plate 105 St John the Baptist 372 St Sebastian 126, 185, 372; plate 119 Tomb of the Cardinal of Portugal **159-65**, 182, 186, 192, 369, 372, **373-4**, 391; plates 146-9 Tomb of Mary of Aragon 372, 381 Tondo: Nativity 372 Virgin and Child 118-26, 374; plates 114, 115 Rossellino, Bernardo 103, 268, 367, **369-71**, 372, 373, 374, 379 Annunciation 126, 369 Bruni Monument 142-6, 149, 155, 159, 165, 168, 315, 368, 369, **370-1**, 374, 377-8, 380, 391; plates 134, 135, 140 Façade of the Misericordia 103, 140, 369; plates 93, 95 Monument of Beato Marcolino da Forlì Monument of Filippo Lazzari 369, 372 Tabernacle 103, 107, 369, 370; plates Tomb of the Beata Villana 369, 371; plates 136, 137 Tomb of Giovanni Chellini 182, 369, Tomb of Neri Capponi 168, 369, 372; plate 154 Tomb of Orlando de'Medici 369, 380 Rossellino, Domenico 369, 372 Rossellino, Giovanni 369, 372, 373 Rossellino, Tommaso 369, 372

Rosso see Nanni di Bartolo

Rovere, Cristoforo della, Monument 406 Rovere, Raffaello della, Monument 406, Roverella, Lorenzo, Monument 372 Rufus, Marcus Holconius 358 Ruskin, John 155 Rustici, Giovanni Francesco 359 Kneeling Figure of Cardinal Forteguerri Sacchetti, Francesco 386 Sagrera, Guillermo 237, 257, 397 Sagreta 413 Sannazaro 412 Sano di Pietro 392 Sansone, Francesco 426 Sansovino, Andrea 323 Sansovino, Jacopo 339, 425 Sanudi 323 Savin, Paolo 427 Savonarola, Michele 358 Sebastiano del Piombo, Judgement of Solomon 339 Sebastiano di Jacopo Benintendi, Fra 371 Segala, Francesco 425 Serragli, Bartolomeo 376 Serristori, Maddalena de' 365 Sforza, Battista, Portrait bust 396 Sforza, Francesco 375, 376, 397, 398, 399, 409, 421 Monument 207-12, 213, 399; plates Sforza, Galeazzo Maria, Duke of Milan Sforza, Gian Galeazzo 396 Sforza, Ippolita Maria 396 Sforza, Lodovico il Moro, Duke of Milan 207, 208, 210-11, 212-13 Sforza, Polissena 390 Simone da Colle 345 Sixtus IV, Pope 406, 421 Tomb, 171-7, 399, 400-1; plates 157, 158, 160 Soderini, Francesco 181, 351 Solari, Cristoforo 280, 407, 409, 410 Adam and Eve 280, 410 Bust of Christ 410 Christ at the Column 280, 410 Effigies of Lodovico il Moro and Beatrice d'Este 280, 410; plate 261 Solari, Giovanni 410 Solari, Guiniforte 398 Solari, Pietro 410 Solomani, Raimondo, Monument 414 Sperandio, Tomb of Pope Alexander V 257 Squarcialupo, Antonio 381 Statius 287

Stefano da Ferrara 425

Stella, Paulo, The Miracle of the Glass 425 Strozzi, Filippo Monument 381 Portrait Bust 186-91, 382; plate 175 Strozzi, Marietta 374, 377 Strozzi, Niccolò, Portrait bust 182, 186, 378, 380; plate 167 Strozzi, Onofrio 358 Monument 168 Sulla 287 Terranuova, Conte di 382 Tino di Camaino 10, 140 Monument of Mary of Valois 363 Tintoretto 75 Titian 339 Tomeo, Niccolò Leonico 416 Tornabuoni, Francesco 383 Monument 378 Torrigiano, Pietro 177, 403-4 Bronze Relief Portrait of Sir Thomas Lovell 404 Bust of Henry VII 403 Busts of St John Fisher and Henry VIII Marble Busts of Christ and S. Fina 403 Monument of King Henry VII and Elizabeth of York, 177, 403, 404, 412; plates 164, 165 Monument of Dr John Young 404 St Gregory 403 St Ierome 404 Tomb of Lady Margaret Beaufort 403 Virgin and Child 404 Traversari, Ambrogio 363 Trivulzio, Gian Giacomo 283 Monument 212-13; plates 196, 197 Tron, Filippo 420 Tron, Niccolò, Monument 311-12, 315, 419-20, 422; plates 299, 300 Tullio Lombardo 9, 255, 323-4, 328, 339, 421, 422, **423-6**, 427 Adam 323, 425; plate 311 Bacchus and Ariadne 324, 424; plate 314 The Coronation of the Virgin 330, 339, 423, 424; plates 320, 321 Eve 425 Guidarelli Effigy 423 The Miracle of the Miser's Heart 334-9, 424, 425; plates 325, 326 Monument of Matteo Bellati 423 St Mark Baptizing Ammianus (Monument of Giovanni Mocenigo) 328, 423-4; plate 317 Vendramin Monument 323, 328,

330, 423, **424–5**, 426; plates 312,

313

Tura 257, 263, 410

Sir John Hawkwood 199; plate 185 Urban VI, Pope 363 Urbano da Cortona 214, 218, 356 Valeriano, Pierio 416 Valerio da Narni 358 Valori, Bartolommeo 181, 363 Valturio, Roberto 390 De re militari 249 Vasari, Giorgio 9, 19, 85, 88, 181, 207-8, 255, 257, 312, 348-9, 351, 353, 354, 359, 360, 361, 362-3, 366, 368, 374, 375, 376, 378, 380, 382, 385-6, 387, 390, 398, 402, 404, 411 Vecchietta 217-18, 359, **392-3**, 394, 395 Burial and Assumption of the Virgin 392 Flagellation 217-18, 221; plate 200 The Resurrection 218, 393; plate 202 The Risen Christ 218, 221, 393; plate 203 St Anthony Abbot 392 St Bernardino 392 St John the Baptist 287 St Paul 214, 217, 392, 393; plate 201 Tabernacle 287, 393; plate 270 Vendramin, Doge Andrea, Monument **323**, 328, 330, 423, **424–5**, 426; plates 312, 313 Vendramin, Zaccaria 425 Venus Felix (Roman) 294-6; plate 279 Verrocchio, Andrea del 37, 126, 130-6, 194, 208, 212, 221, 257, 294, 370, 374, 378, 383-8, 389, 391, 394, 406, 413, 424 Alexander the Great 126 Bronze Candlestick 383 Bust of a Lady 194, 383, 385; plate 181 Christ and St Thomas 130-6, 173, 194, 207, 208, 351, 383, 384, **385–6**, 388; plates 124-6 Colleoni Monument 205-7, 208, 211, 265, 383, **387-8**, 427; plates David 130, 383, 385, 388; plate 123 The Decollation of the Baptist 383 Forteguerri Monument 165-8, 194, 208, 383, 386-7, 424; plates 150, 152, 153 Giuliano de' Medici 194, 383; plates 182, 183 Lavabo 383 Lorenzo de' Medici 383 Madonna 372 Medici Monument 168-71, 208, 383; plate 155 Model for the Forteguerri Monument 387;

plate 151

Uccello, Paolo 66, 202, 367

Putto with a Fish 130, 136, 207, 354, 383, 385; plate 127 Relief of Alexander the Great 383 Resurrection 383 Sketch-Models of Angels for Forteguerri Monument 383, 387 Virgin and Child 126, 384-5; plate 116 Verrocchio, Tommaso 383 Vespucci, Simonetta 377 Vettore da Feltre 425 Villana dei Botti, Beata, Tomb 369, 371; plates 136, 137 Visconti, Bernabò 211 Visconti, Gian Galeazzo 13, 268, 271 Monument 213, 283, 285, 412; plates 262, 263 Vittoria, Alessandro 194 Vivarini, Antonio 421 Volpi, Ambrogio 411

Winckelmann, Johann Joachim 173

Young, Dr John, Monument 404

Zanetti, Giovanni, Monument 320–3, 421, 422–3, 426; plates 308, 310 Zen, Cardinal Giovanni Battista 339, 426 Zoppo, Mountain of Hell 296; plate 284 Zuan Battista di Brioni 427 Zuan Maria Padovana see Mosca Archivi Alinari

Front cover, back cover, 3, 5, 9, 20, 21, 24, 34, 41, 44, 50, 58, 61, 67, 68, 72, 74, 78, 83, 89, 90, 92, 94, 95, 98, 99, 101, 105, 112, 132, 133, 140, 144, 150, 198, 209, 211, 234, 235, 236, 237, 244, 245, 260, 262, 263, 269, 270, 293, 316, 320, 321

Aurelio Amendola Fotografo 84, 276

© Ashmolean Museum, Oxford

Niccolò Orsi Battaglini Fotografo ©

Staatliche Museen zu Berlin - Preussischer Kulturbesitz Skulpturensammlung 65

Osvaldo Böhm

191, 192, 297, 304, 306, 310, 315, 319, 322

Soprintendenza, Archivio Fotografico, Bologna

Photograph © Copyright British Museum

Courtauld Institute of Art, Conway Library 51, 80, 81, 108, 116, 117, 199, 206, 208, 219, 288, 298, 314, 327

Musei Civici Arte Antica Fototeca, Ferrara 243

Opificio delle Pietre Dure, Archivio - Firenze 53, 54

Index/Vasari 171, 220

Nicola Lorusso Fotografo 93, 173, 204, 271, 291 The Metropolitan Museum of Art, Fletcher Fund 1936 (36. 163).

311

© Luciano Pedicini/Archivio dell'Arte 221, 225

Philadelphia Museum of Art, Foule Collection 272

© Photo R.M.N. 63, 64, 175, 294

© Crown Copyright RCHME 164, 165

Walter Steinkopf 161

© The Board of Trustees of the Victoria and Albert Museum

46, 200, 283, 285, 296

National Gallery of Art, Washington DC, Widener Collection 1942 113

National Gallery of Art, Washington DC, Mellon Collection 1937 182, 183

Royal Collection © H. M. Queen Elizabeth II 194, 196, 197